A Library
of Literary
Criticism

A Library of Literary Criticism

VOLUME 2

Falcón
to
Lynch

MODERN WOMEN WRITERS

Compiled and edited by
LILLIAN S. ROBINSON

A Frederick Ungar Book
CONTINUUM · NEW YORK

1996
The Continuum Publishing Company
370 Lexington Avenue
New York, NY 10017

Printed in the United States of America

Library of Congress Cataloging-in-Publication Data

Modern women writers / compiled and edited by Lillian S. Robinson.
 p. cm. — (A library of literary criticism)
 "A Frederick Ungar book."
 Includes bibliographical references and index.
 ISBN 0-8264-0823-0 (set). — ISBN 0-8264-0813-3 (v. 1). — ISBN
0-8264-0814-1 (v. 2). — ISBN 0-8264-0815-X (v. 3).—ISBN 0-8264-0920-2 (vol. 4)
 1. Literature—Women authors—History and criticism.
 2. Literature, Modern—20th century—History and criticism.
 3. Women authors—Biography. I. Robinson, Lillian S. II. Series.
PN471.M62 1996
809'.89287'0904—dc20 94-43197
 CIP

AUTHORS INCLUDED

Volume 2

Godwin, Gail	U.S.
Goldberg, Lea	Israel
Goldman, Emma	Russia–U.S.
Goll, Claire	Austria
Gonçalves, Olga	Portugal
Goodison, Lorna	Jamaica
Gordimer, Nadine	South Africa
Gordon, Caroline	U.S.
Gordon, Mary	U.S.
Gorodischer, Angélica	Argentina
Goto Miyoko	Japan
Grau, Shirley Ann	U.S.
Gregory, Lady (Augusta)	Ireland
Guidacci, Margherita	Italy
Guido, Beatriz	Argentina
Guiducci, Armanda	Italy
Guró, Elena	Russia
Hall, (Marguerite) Radclyffe	Great Britain
Hansberry, Lorraine	U.S. (African American)
Hareven, Shulamit	Israel
Harjo, Joy	U.S. (Native American)
Harrower, Elizabeth	Australia
Harwood, Gwen	Australia
Hayashi Fumiko	Japan
Hazzard, Shirley	Australia
Head, Bessie	South Africa
Hébert, Anne	Canada
Hellman, Lillian	U.S.
Henley, Beth	U.S.
Herbst, Josephine	U.S.
Hernández, Luisa Josefina	Mexico
Hill, Susan	Great Britain
Hirabayashi Taeko	Japan
Hodge, Merle	Trinidad
Holtby, Winifred	Great Britain
Hopkins, Pauline Elizabeth	U.S. (African American)
Howard, Elizabeth Jane	Great Britain
Hoyos, Angela de	U.S. (Mexican American)

Huch, Ricarda	Germany
Hulme, Keri	New Zealand
Hurston, Zora Neale	U.S. (African American)
Hyvrard, Jeanne	France
Ibarbourou, Juana de	Uruguay
Idström, Annika	Finland
Jackson, Shirley	U.S.
Jameson, Storm	Great Britain
Jansson, Tove	Finland
Jellicoe, Ann	Great Britain
Jennings, Elizabeth	Great Britain
Jewett, Sarah Orne	U.S.
Jhabvala, Ruth Prawer	Poland–Great Britain–India
Johnson, Pamela Hansford	Great Britain
Johnston, Jennifer	Ireland
Jolley, Elizabeth	Australia
Jong, Erica	U.S.
Jordan, June M.	U.S. (African American)
Jorge, Lídia	Portugal
Joubert, Elsa	South Africa
Kahana-Carmon, Amalia	Israel
Kaschnitz, Marie Luise	Germany
Kaye-Smith, Sheila	Great Britain
Keane, Molly (M. J. Farrell)	Ireland
Kennedy, Margaret	Great Britain
Keun, Irmgard	Germany
Kilpi, Eeva	Finland
Kincaid, Jamaica	Antigua–U. S.
Kingston, Maxine Hong	U.S. (Asian American)
Kirsch, Sarah	Germany
Kobylyanska, Olga	Ukraine
Kogawa, Joy	Canada
Kolb, Annette	Germany
Kollontai, Alexandra	Russia
Kolmar, Gertrud	Germany
Königsdorf, Helga	Germany

Koroleva, Natalena	Ukraine
Kossak, Zofia	Poland
Kostenko, Lina	Ukraine
Koziol, Urszula	Poland
Kunewicz, Maria	Poland
Lacrosil, Michèle	Guadeloupe
Laforet, Carmen	Spain
Lagerlöf, Selma	Sweden
Lagorio, Gina	Italy
Langgässer, Elisabeth	Germany
Larsen, Marianne	Denmark
Larsen, Nella	U.S. (African American)
Lasker-Schüler, Elsa	Germany
Laurence, Margaret	Canada
Lavant, Christine	Austria
Lavin, Mary	Ireland
Leduc, Violette	France
Lee, Vernon (Violet Paget)	Great Britain
Le Fort, Gertrud von	Germany
Le Guin, Ursula K.	U.S.
Lehmann, Rosamond	Great Britain
L'Engle, Madeleine	U.S.
Lessing, Doris	Zimbabwe–Great Britain
Le Sueur, Meridel	U.S.
Leutenegger, Gertrud	Switzerland
Levertov, Denise	U.S.
Lewis, Janet	U.S.
Li Ang	China
Lidman, Sara	Sweden
Lindgren, Astrid	Sweden
Linhartová, Vera	Czech Republic
Lisnyanskaya, Inna	Russia
Lispector, Clarice	Brazil
Livesay, Dorothy	Canada
Loranger, Françoise	Canada
Lorde, Audre	U.S. (African American)

FALCÓN, LIDIA (SPAIN) 1937–

The personality, the life, and the work of Lidia Falcón are united by a cease-less feminist effort and it is impossible to encounter one of her works for the theater without considering the author's political and feminist struggle. . . .

As a writer, her books belong as much to the genres of the theoretical study and the essay as to the narrative. Their content and their subject matter have always been those of the female condition in its various aspects and a clear wish to raise feminist consciousness capable of broadly establishing the necessity of women's struggle and revolution. Among her studies there should be cited as fundamental on the world historic level the two volumes of *La razon feminista* (The feminist account), the first on woman as a social class and the second on human reproduction, a profound study, erudite and docu-mented that establishes in a detailed and unquestionable way the theory of woman as an economic and social class.

And if her work is entirely feminist, as are each of the acts of her life, it is beyond a doubt that her plays must be considered first and foremost within this context.

But at the same time that the basis of her theater is without a doubt that of the most radical feminism, it should be added that the qualities of clarity, agility, and capacity for synthesis reach their highest level in the work.

While in an earlier theatrical work, part of the show *Mujeres y Cataluña* (Women and Catalonia) . . . which later would develop into a full-length work whose title is *Las mujeres caminaron con el fuego de siglo* (The women march with the fire of the century), the subject dealt with is woman in the history of Catalonia in our century in connection with all the public successes that preceded, succeeded and were contemporary with our Civil War, here we are dealing with a daily, habitual, and current condition of many women; their defenselessness before the man with whom they live.

Three short acts show us three situations represented by three women— three, who are all one woman—in a historic progression of the institution in which they are caught, different in the three cases while behaving identically with regard to the woman. . . .

As we have said, the language is agile, the situations touch the spectator effectively, the theatrical rhythm is dynamic, and the humorous tone with which the author is able to express the women's tragedy make the short play an attractive offering in the context of a feminist theater of urgency, dedicated to raising women's consciousness through drama.

<div align="right">

Maria-José Rague-Arías. *Estreño: Quaderno del Teatro Espanol Contemporaneo.* 10, 1983, p. 26

</div>

Throughout her life, Lidia Falcón, a lawyer and long-time political activist, has seen her writing as an integral part of her struggle. She speaks of composing her first feminist articles in the school paper when she was twelve years old. Four decades later, she is the author of three novels, three social and political testimonies of an autobiographical nature, over ten works of non-fiction and numerous newspaper and magazine articles, a complex network of texts which seek to expose, denounce, explore and improve women's status in Spain and in the world. Among her many theoretical works, two in particular, *La razón feminista,* vol. 1 (1980), vol. 2 (1982), and *Mujer y sociedad* (1969) contain a profound analysis of the female condition as viewed from the context of Spanish society and the development of woman as a "social class." . . .

If in the last decade Falcón has had success in publishing her works and expressing her ideas, during the Franco years she was a frequent target of the Regime's oppressive ideology and system of censorship. Her book, *Mujer y sociedad* was held up for a year by the Bureau of Censorship until its publication was authorized, and she was fired from the magazine, *Sábado gráfico* for her scathing articles on the condition of women in Spain. More importantly, her political militancy in the clandestine left resulted in arrest, torture, and two prison sentences. These experiences were described in both a poignant and analytical fashion in *En el infierno, Ser mujer en las cárceles de España* and *Viernes y 13 en la calle del Correo. En el infierno,* in particular, is a testimony of life in Franco's jails and documents the marginal position occupied by female prisoners in the greater superstructure of the male penal system.

Falcón has also presented in fictional form the complex issue of women's militancy. Her novel, *Es largo esperar callado* pits a weak male intellectual figure of the left against a militant female, also of the left, who cannot be silenced by the impositions of clandestinity. Although Falcón has been attacked by both the left and the feminists for her critique of her own comrades, she insists that the left has suffered from its refusal to look clearly at its own problems. She sees herself as "criticizing from the left." Falcón's novel is unusual in that it portrays the activities of women involved in political struggle first within and then in opposition to their party and thus it provides a unique perspective on an area of political activity that is practically unknown to the greater reading public.

As one approaches the fiction of Falcón in greater depth, certain questions inevitably come to mind: How does Falcón's feminist ideology affect her presentation of the characters? How does she portray the diverse ideologies within the feminist movement? Does she view fiction as a vehicle for expressing solutions to complex social and political issues or as a mirror for merely reflecting such issues? The present paper attempts to respond to these inquiries and to contemplate Falcón's contribution to pursuing what Terry Eagleton has called "one of the most vital tasks of the socialist intellectual— that of the resolute popularization of complex issues."

Falcón's most recent novel, *Rupturas* (1984) provides a significant link in Falcón's continual endeavor to use her writings as a means of engaging the reader in a process of discovering aspects of women's lives hitherto absent from literature. . . . Falcón has not given us the future on a platter. Rather, she has given her character the strength to arrive at the place where she can begin to create her own future. Falcón shows that it is through struggle around ideological issues that one achieves one's freedom. Similarly, through Elena's questioning, Falcón raises many vital questions about the paths that feminist struggle should take. Indeed, she appears to be critical of at least certain manifestations within the feminist movement. But, as shown before, Falcón has stated that feminists must be honest and criticize the movement where necessary. She feels that it is dangerous to let the enemy control one's vision of the movement's problems. And it is true that at no point in the novel is there any indication that any of these women will give up their struggle.

Thus, without offering specific solutions, Falcón does offer a path, an arena for change and an ideology with which to work. She has broadened our understanding of the Spanish woman's experience and asked us to consider it in the light of its uniqueness and its wider connections. In portraying these new experiences, she prompts us to envision new circumstances and to conceive of new possibilities. Lidia Falcón, author, activist, provokes us. Thank goodness!

Elizabeth Starčevic. *ALEC.* 12, 1987,
pp. 175–77, 187

[Falcón's] autobiographical books and articles reflect the experience of growing up under Franco as a child of the vanquished Republicans, especially *Los hijos de los vencidos* (1979; Children of the defeated), which documents her first fourteen years, picturing a sordid Spain with prevalent poverty, black marketeering, prostitution, and police oppression. Another fictional work with an autobiographical basis is *En el infierno (Ser mujer en las cárceles de España)* (1977; In hell: to be a woman in Spanish jails), a novelized account of conditions faced by women in jails, reformatories, prisons, and prison hospitals, written while Falcón herself was imprisoned. Still another autobiographical novel is *Viernes y trece en la Calle del Correo* (Friday the thirteenth on Correo Street) that recounts the arrest and trial of activists and intellectuals accused of collaboration with ETA, the Basque terrorist organization (Falcón, arrested along with others in September 1974, remained in the women's penitentiary for nine months).

Falcón has also employed humor in her irreverent critique of male exploitation of women, using the device of letters from a female lawyer (herself) to a friend, in *Cartas a una idiota española* (1974; Letters to a Spanish idiot), presenting the stories of a broad range of women from university students to factory workers, peasants to typists, housewives to nuns, and prostitutes to diplomats' wives. *Es largo esperar callado* (1975; The long silent wait) centers

upon twenty years of clandestine activity by the Spanish Communist party, its internal conflicts, and power struggles. In addition to portrayal of such key political figures as Santiago Carrillo and Dolores Ibarruri, this novel re-creates the lives of Spanish exiles in France and various socialist countries. Significantly, it shows that women encounter difficulties not only in Spanish society, but within the supposedly more progressive context of leftist parties. *El juego de la piel* (1983; The skin game) reflects the European hippie scene in the 1970s, with drugs, delinquency, and near-death from addiction all viewed from the feminine perspective of Elisenda, a middle-class girl from Barcelona.

Janet Pérez. *Contemporary Women Writers of Spain* (Boston: Twayne, 1988), pp. 155–56

Falcón moves easily between fiction and nonfiction and between a strong critique of inherent structures of male dominance found in Spanish society and a sense of optimism toward possibilities for future change. She situates her novel *El juego de la piel* (1983; Skin games) in what is for her an unusual venue—Europe during the hippie era of the 1970s, she describes the communes, drug addiction, and juvenile delinquency that the heroine experiences until she returns to Barcelona, where she finds herself through the incipient feminist movement. The novel *Rupturas* (1985; Breakups), is the Spanish equivalent of Marilyn French's *The Women's Room*. Situated in a university setting, it explores Spain's era of transition to socialism, feminism, and a new sense of possibility, through the lens of the forty-five year old apolitical female protagonist.

Falcón's fictions may be read as thinly veiled social history. Each is a pretext to examine another facet of Spanish society: the drug-addicted and disaffected youth of the 1970s *(El juego);* the sexist and power-hungry Communist Party and its betrayal of the real struggle to end fascism in Spain *(Es largo);* the beginnings of the feminist movement in the 1970s and its effect on a middle-class, apolitical married woman *(Rupturas);* and, finally, the clandestine world of anti-Franco activities in her latest book, *Camino sin retorno* (1992; No way back). This novel incorporates many of Falcón's previous themes and centers on a five hour conversation between Elisa and her ex-husband Arnau, in which they explore leftist politics, male deception, women who love too much, self-discovery, and the recognition that women need each other to move to the next stage of personal and national consciousness.

Camino sin retorno, Falcón's best fictional work to date, and the most novelistic, multidimensional, and stylistically sophisticated, establishes an internal rhythm and maintains a complex narrative structure. Elisa engages in a collage of conversations with the major secondary characters that moves smoothly from the present to the past and back to the present, but not before exposing Elisa's conservative childhood and adolescence, imbued with traditional religious training, her ten-year militancy in an offshoot of the Communist Party, and her incarceration in a Spanish prison. Falcón cleverly weaves

together characters and events alluded to in her previous books. The middle-aged revolutionary and staunch feminist named Octubre, falsely imprisoned for her involvement in the Calle Correo bombing, recalls Falcón herself, and Elisenda is reminiscent of the drug-addicted hippie protagonist of *El juego* who eventually embraces feminism. The reader is also reacquainted with some of the women whose dramatic stories were told in *En el infierno* as well as the unacknowledged female militants from *Es largo esperar*. This novel, as only an insider like Falcón could have written, is her homage to the militant women who were tortured in Franco's jails and psychiatric wards, never offered leadership positions in their own party, never acknowledged in the new democratic Spain, and never vindicated.

Two new books are scheduled for publication in 1993: the second volume of her memoirs, *El amor acosado (1949–1956)* (Troubled love), which uses her adolescence, young married life, and separation as a backdrop for an account of female repression during the Franco years, and a novel, *"Postmodernos,"* a profound and biting description of the defeat of the Left in Spain after Franco's death.

Gloria Feiman Waldman. In Linda Gould
Levine, Ellen Engelson Marson, and Gloria
Feiman Waldman, eds. *Spanish Women
Writers: A Bio-Bibliographical Source Book*
(Westport, Connecticut: Greenwood Press,
1993), pp. 167–80

FARROKHZAD, FORŪGH (IRAN) 1935–67

[T]he promise of personal, intimate poems couched in personal, intimate terms flies in the face of the mainstream of traditional Persian poetry, a basically convention-bound and conservative craft with a thousand-year history. Though Forūgh was not a shaping force in modern Persian poetry, which formally came into existence in the early 1920s, she, as a second-generation modernist, entered an arena where the battle lines between the forces of tradition and innovation and past and present are still drawn and the conflict persists. . . .

[A]s a woman in a predominately Shi'ite Muslim society, Forūgh's commitment to poetic statements of frankness and self-revelation flies in the face of an equally long standing and just recently challenged tradition of feminine circumspectness, public modesty, and conscious avoidance of attention and competitiveness in a male-dominated society. Forugh may not have been a feminist, but as a free spirit and poet, she was perforce at the forefront of the new consciousness of women in Iran, another continuing conflict of past

versus present, religion versus secularism, and traditional mores versus changing attitudes and common sense.

Forūgh's corpus of poems, fewer than two hundred, mostly short lyrics, composed during a period of about fifteen years from her school days through 1966, demonstrates the truth and consistency of her view of the nature and function of her craft, and—more importantly—establishes her as a first-rate modern Iranian poet. Thus, her work obviously deserves consideration, first, as poetry of perhaps lasting value.

<div style="text-align: right">

Michael Hillman. In Elizabeth Warnock
Fernea and Basima Qutta Bezirgan. *Middle
Eastern Muslim Women Speak* (Austin:
University of Texas Press, 1977), p. 292

</div>

For centuries the subject matter of Persian poetry had been love, the suffering of the lover, the fickleness of the beloved, and the joys of reunion, but the poets had been men. This is not to imply that there were no female poets before Forugh. There were, but their mastery of the art, with the exception of one, Parvin Etesami (1907–41), was not equal to hers nor did any of them bare their souls in frank and uninhibited confessions of romantic and physical love. . . .

Forūgh's opinion of her early poetry does not detract from its importance. To the mature and developed Forugh the early poems may have seemed trivial, but in the history of Iranian women's writing, they were revolutionary. Her only assent to convention is formal; the poems follow the classical Persian format of rhyming couplets in quatrain stanzas. There were few exceptions. The form was not revolutionary but the content was. For the first time in the history of Persian poetry a woman had published poetry speaking explicitly of love, passion, and sex.

<div style="text-align: right">

Shireen Mahdavi. *Parnassus: Poetry in
Review.* 12–13, 1985, pp. 393–94, 396

</div>

Forūgh Farrokhzad . . . is perhaps the only important figure among the new [Persian] poets whose work, *in toto,* reflects the whole spectrum of change and development in contemporary Persian poetry and is therefore worth a more detailed treatment. Her first published volumes were *Asir* (The captive), *Divar* (The wall), and *'Osyān* (The revolt), whose themes are well indicated by the titles—the captivity of the sensitive individual, the poet herself, within the walls of tradition and intolerance, which create the feeling of the necessity of revolt. The language of these volumes is extremely personal and more realistic than romantic/symbolist. The tone often fluctuates between the outcries of a creative artist on the one hand, and the desires and frustrations of a young woman, on the other.

With her fourth collection of poems, *Tavallodi digar* (A second birth), Farrokhzad entered a distinctly new phase and proved to have matured into a poet of rare originality and vision. In this volume, and in the poems that

appeared in the pages of *Arash* (1964–67), one finds that this poetic sensibility has grown in all directions, stretching with it the poetic form. . . .

[T]he work of Forūgh Farrokhzad demonstrates, besides the making of an unusually good poet, the range and diversity of the new Persian poetry. Starting with more or less traditional forms and rather banal but obviously genuine concern with the desires and frustrations of self-fulfillment, she surprises her readers with a poetic "second birth," in which, while still concerned with the "I," she shows a growing awareness of people and the world around her, and herself *vis-à-vis* this world. She does not become an "objective" poet, but internalizes her observations. The self remains but becomes a larger entity, with more possibilities of sorrow and joy. . . .

Besides being the best representative of the new Persian poetry in all its change and development, Farrokhzad was also, during the first half of the 1960s, a pivotal force and a salutary example.

<div align="right">

Massud Farzan. In Ehsān Yarshater, ed.
Persian Literature (Albany: SUNY Press for
the Persian Heritage Foundation, 1988),
pp. 355, 364–65

</div>

In her early poetry Forūgh is attracted to women's independence and intellectual growth, but she cannot abandon the traditional virtues expected of a woman: purity expressed by chastity, devotion expressed by commitment to domestic concerns. Confronted with issues of economic security, the future of her only child, and the exacting glances of the "other," she voices the painful tension between independence and, conversely, domestic security and traditional women's roles. . . .

Implicitly, and at times explicitly, she seeks a conflict-free sanctuary, a refuge from the burden of responsibility and doubt. She is tempted by socially-validated codes of conduct and convenient, mapped-out paths. She is tired of swimming against the current, but her body, stretched to new experiences, never returns to its original dimension; her mind, exposed to new horizons, refuses confinement.

The Captive, The Wall, and *Rebellion* are fraught with conflicts: between sensuality and the safety of puritanical morality, between freedom and its accompanying anxieties and uncertainties. There is resentment of men's absolute right to give free rein to their sexual whims, and her demand that pleasure be women's right as well. And yet relations that do not extend beyond the immediate passionate union to a mutually-cherished, longterm relationship, are unsatisfying. In short, the boundaries between delight and disgust, between attraction and aversion are not clear.

In her early poetry Forugh is a marginal character who has adopted new values without quite rejecting the old ones. . . .

Forūgh's technical development is closely linked to her growth as a poet who seeks to transcend traditional limitations. Although in the 1950s, when

she was writing her first poems, the modernistic poetic movement had gained prominence in Iran, Forūgh continued to write traditional verse. . . .

If the shattering of classical restraints did not find its way into Forugh's poetry until the publication of *Born Again,* it is because the poet had been on a journey of her own, taking her own time to change. . . .

It is through the development of poetic personae that the poet freed herself from rules of classical versification. Forūgh had reached a point where her poetic impulses could no longer be contained within traditional boundaries. The breadth of her content required new words, new images, and a well developed sense of irony. . . .

Forugh's rebelliousness is thus conveyed throughout her poetry. In the early writings, it takes the shape of disdain for worn-out, conventional subject matter, coupled with an attempt to express herself openly. In the later writings, the adventurer in life becomes an adventurer in language and poetic forms as well. Regularity of line length and strophic organization is abandoned in favor of a freeflowing structure. A language refreshing in its burgeoning colloquialism, a style marked by inclusion of new words, peculiarities of syntax, and exclamatory sentences and interjections further heighten the intensity already imparted to her work by candor.

<div style="text-align: right;">

Farzaneh Milani. In Ehsan Yarshater, ed.
Persian Literature (Albany: SUNY Press for
the Persian Heritage Foundation, 1988),
pp. 373, 375–76

</div>

The titles of Farrokhzad's books published during her short lifetime reveal her interests: *The Captive, The Wall, Rebellion,* and *Another Birth.* As Farzaneh Milani points out, the first three collections, printed between 1955 and 1957, indicate the "general mood" of Farrokhzad's attraction to the themes of "women's independence and intellectual growth," but the poems in these early volumes are "fraught with conflicts: between sensuality and the safety of puritanical morality, between freedom and its accompanying anxieties and uncertainties. There is resentment of men's absolute right to give free rein to their sexual whims, and [the poet's] demand that pleasure be woman's right as well." . . . The early poems, therefore, explore repeatedly the nature of love—not just idealized love but sexual intimacy and romantic enjoyment. Farrokhzad ponders the nature of sex and gender, constructing an art that confronts the traditions of her background, and by the time she publishes *Another Birth* in 1963, she offers an image of a new, liberated, thoughtful Iranian woman: sensual, caring, complex, confident, and free. The intensity of expression in her poetry becomes the fierce cry of a woman seeking identity in the repressive world of twentieth-century Iran, a world heir to centuries of closed opportunities for women in all endeavors but particularly in art. Her work is strongly autobiographical, "honest, unposturing, and reflective of her innermost thoughts and feelings . . . open, frank, and intimate," quali-

ties that "might not have a place" in the "authoritarian, patriarchal Iranian environment." . . .

Moving from an acknowledged captivity to a self-conscious awareness of the nature of the particular barriers around her and then to a rebellious, complex struggle with wide-ranging issues of human value and human identity, Farrokhzad must have sensed in 1957 that she was on the verge of great personal and artistic change.

Consequently, Farrokhzad's personal, social, and artistic rebirth is the focus of *Another Birth*. . . .

Farrokhzad's later poems, then, are complex and dichotomous, reflecting the poet's shift from private warfare upon her predominantly masculine Persian world to consideration of greater issues of general human isolation, universal order, and spiritual rebirth from a more truly feminist perspective, in that she arrives at a more inclusive rather than exclusive understanding of the human condition. . . .

She offers her readers not only an impressive and sensitive treatment of the bold themes of modern feminist concerns but also—in a daring, singular, and compelling poetic voice—a generous and perceptive study of the greater, wider mysteries of human love, of the human ache for freedom, and of the transfiguring vitality of spiritual renewal.

<div align="right">

John Zubizarreta. *World Literature Today.*
66, 1992, pp. 421, 423, 425–26

</div>

According to many critics, Forūgh Farrokhzad is not only the most important poet since Nima Yushij but also Iran's best poet after the great classical period of the fifteenth century. In her poetry she violates not only the norms of form but also those of expression by freely stating her feelings unencumbered by symbolic representations and metaphor. Her uncensored personal communications are startlingly plain, but in a way innocent. *Tavvalod-e degar* (1964; Another birth), the last volume before her untimely death in an automobile accident, is a personal and artistic climax—a victory for a woman who could free herself from the fetters of the alienation and frustration of that male-dominated society and a victory for artistic achievement in modern Persian poetry. . . .

Farrokhzad's first collection of verse, *Asir* (the captive), was published in 1952. In 1955 a different collection with the same title appeared. This second volume made her the subject of scandal: for the first time in Persian poetry a writer spoke about her love for a man with all the sensuality and frankness of a personal confession. For perceptive critics, however, this volume signaled the appearance of a shining star among the poets of the so-called "new wave."

The four volumes of her poetry provide us with a guide by which to analyze Farrokhzad's development until just before her fatal accident. In her simple and clear poetic style, these poems reflect a transition, both personal and artistic; her art was inextricably bound to her personal growth. She

gradually moves away from the bonds of tradition to a yearning for an attainment of freedom and ultimately to a new self and a pure art.

The titles of the collections indicate this progression: *Asir; Divar* (1956; The wall); *'Osyan* (1958; The rebellion), and *Tavvalod-e degar* (1964; Another birth) reflect a move away from the restrictions of traditional poetry; in this, she was a close follower of the doctrines of Nima Yushij (1895?–1959), the pioneer of Persian free verse. The first two titles represent the poet's understanding and assessment of those bonds; the second two, the struggle against them and the emergence, from their destruction, of a new poetic form.

She did not, however, cut herself off from the literary past. She took many of her best images from the classical mystical repertoire, particularly her use of light versus dark and her concentration on shadows. Her most consistent appeal is to love, love that ranges from the contentment felt among friends to the devotion of religious activity or the passion of human sensuality. On a deeper plane, Farrokhzad's poetry represents the struggle of the individual against the power of evil and ugliness, alienation, fear, and frustration. She is rightly acclaimed a master of modern Persian poetry and the second female poet of greatness in the language.

> Peter J. Chelkowski. In Leonard S. Klein, ed. *Encyclopedia of World Literature in the 20th Century,* (New York: Frederick Ungar, 1982), pp. 455, 79–80

FAUSET, JESSIE REDMON (UNITED STATES) 1886–1961

This novel [*There Is Confusion*] is significant because it is the first work of fiction to come from the pen of a colored woman in these United States. It is evidence that we can with assurance look forward in the near future to having our fiction dealing with life among the Negroes written by the Negroes themselves. And this is as it should be. Long the object of burlesque and pitiless satire, it is natural that the Negro in his upward plunge should want to strike back, to write out of his own rich and varied experience, not for the delectation of the whites, but for the edification and enjoyment of his own people.

The mushroom growth of magazines published by the Negroes and the fiction to be found in them, the serialization of stories of obscure colored authors in Negro newspapers, the establishment, even, of reputable Negro publishing houses—all point to this new, up and pushing spirit.

Having as its motif the futility that must not arrest the conquering progress of the Negroes, Miss Fauset's book, however, is not really "younger generation Negro" stuff. Toomer's insouciant *Cane* in this respect is miles beyond it. Indeed, it is a sort of bridge between the old and the new Negro

generations. For the literature of these strident neophytes is of a shockingly esoteric nature—full of beauty and passion and blackly steering clear of the inferiority complex. Mediocre, a work of puny, painstaking labor, *There Is Confusion* is not meant for people who know anything about the Negro and his problems. It is aimed with unpardonable naiveté at the very young or the pertinently old.

E.D.W. *The New Republic.* July 9, 1924,
p. 192

Sir: Your review of Jessie Fauset's *There Is Confusion* is really not worthy of the *New Republic.* It is not a review or even a comment, but a quite gratuitous slur upon a work which, whatever its merits, is at least a sincere and unusual product.

W. E. B. DuBois. *The New Republic.*
July 30, 1924, p. 274

For once, a book has been advertised too modestly. *The Chinaberry Tree* has been recommended by its publishers, and by Miss Gale, its sponsor, as a revelation of the life led by educated Negroes. But it is considerably more than that. Though faulty, it is the work of a remarkable psychologist who can be congratulated not simply because her material is interesting but because she has understood so well the human factors involved in it.

The greater portion of *The Chinaberry Tree* is devoted to the love affair of two colored high-school students who do not know that they are brother and sister. This dramatic theme, singularly enough, is the least exciting part of the story. We learn most about Miss Fauset's book as a whole not through Melissa and Malory, or their narrowly averted incestuous marriage; but through Laurentine, the beautiful apricot-colored dressmaker who is the book's real heroine and symbol of the world it depicts; Laurentine, who sat as a child under the Chinaberry Tree and wondered why other children, either white or black, wouldn't play with her.

The best part of the story lies in the background. Colonel Halloway, a wealthy white factory-owner, while still a college student falls in love with his mother's Negro maid. He marries a white woman, but his real love is given to the colored girl, whom he handsomely establishes in a white house with green shutters, a well-kept garden, and the Chinaberry Tree. His daily visits to her are concealed from no one. Their love is a scandal to both black and white inhabitants of the New Jersey town. And Laurentine is their child. She is brought up in comparative luxury, but is a double outcast. And the passion which animates her is closely allied to the passion which animates the book. What does the illegitimate mulatto grow up to want? Respectability. Once she cries: "Oh God, you know all I want is a chance to show them how decent I am." This might serve as the motto for *The Chinaberry Tree.* It is so much the book's real theme that once recognized it helps to explain the striking gentility of certain passages, as well as the exceptional importance

attached to small material comforts that most white people would take for granted. . . .

It is a world in which such little things mean much, a touching world, its humility displayed through its pride. The book attempts to idealize this polite colored world in terms of the white standards that it has adopted. And here lies the root of Miss Fauset's artistic errors. When she parades the possessions of her upper classes and when she puts her lovers through their Fauntleroy courtesies, she is not only stressing the white standards that they have adopted: she is . . . minimizing the colored blood in them. This is a decided weakness, for it steals truth and life from the book. Is not the most precious part of a Negro work of art that which is specifically Negroid, which none but a Negro could contribute?

We need not look for the reason for Miss Fauset's idealization. It is pride, the pride of a genuine aristocrat, and it is pride also that makes her such a remarkable psychologist. However many her artistic errors, Miss Fauset has an understanding of people and their motives. I suppose there is no better way to come to understand others than to be extraordinarily sensitive to one's self. . . . Considering the position of [the] educated Negro in America, it is no wonder then that an aristocrat like Miss Fauset has idealized her little world, has made it over-elegant! Inspired by the religious motive which so many Negro writers seem to feel, she has simply been trying to justify her world to the world at large. Her mistake has consisted in trying to do this in terms of the white standard.

"To be Negro in America posits a dramatic situation." Yes, and to be one of Miss Fauset's amber-tinted . . . refined Negroes—not having to deal much with whites, but surrounded on all sides by the white standard—posits a delicate psychological situation. It is for this reason that few white novels have anything like the shads of feeling to be found in *The Chinaberry Tree*. Every moment speaks of yearning. That is why, once it is seen as a whole, even its faults are charming, for the story they tell is poignant and beautiful.

Gerald Sykes. *The Nation.*
July 27, 1932, p. 88

Viewing the Negro Renaissance in retrospect, Richard Wright has written caustically of "the prim and decorous ambassadors who went a-begging to white America, dressed in the knee-pants of servility, curtsying to show that the Negro was not inferior, that he was human, and that he had a life comparable to that of other people." Without a doubt one of the prime offenders whom Wright had in mind was Jessie Fauset. Yet with all her primness, Miss Fauset presents something of a paradox, for in her editorial work on the *Crisis* she often championed the young rebels of the Harlem School. . . .

Claude McKay writes of Jessie Fauset in his autobiography, "All the radicals liked her, although in her social viewpoint she was away over on the other side of the fence." But if Miss Fauset won personal acceptance among Harlem's colorful Bohemians, in her novels she maintained an irreproachable decorum. . . . From the first. . . . her literary aspirations were circumscribed by her desire to convey a flattering image of respectable Negro society.

Jessie Fauset was the most prolific of the Renaissance novelists, publishing four novels during a ten-year period from 1924 to 1933. But in spite of an admirable persistence, her novels are uniformly sophomoric, trivial, and dull. *There is Confusion* (1924) is nothing if not well titled, for it is burdened with a plethora of characters whose complex genealogy leaves the most conscientious reader exhausted. *Plum Bun* (1928) is a typical novel of passing. . . . *The Chinaberry Tree* (1931) seems to be a novel about the first colored woman in New Jersey to wear lounging pajamas. *Comedy American Style* (1933) is an account of a colored woman's obsessive desire to be white, not unlike the novels which condemn passing in its nationalist implications.

Undoubtedly the most important formative influence on Miss Fauset's work was her family background. An authentic old Philadelphian (known as "O.P.'s" in the colored society of that day), she was never able to transcend the narrow limits of this sheltered world. It accounts for her gentility, her emphasis on heredity and genealogy, and her attitude toward race. Miss Fauset's characters are bred to "rise above" racial discrimination, to regard it merely as "an extra complication of living." Yet "the artificial dilemma," as she calls it, is always present as an obstacle to gracious living, and is the real antagonist of her novels. Racial protest, be it ever so genteel, *is* an irrepressible feature of bourgeois nationalism.

<div style="text-align: right">

Robert Bone. *The Negro Novel in America*
(New Haven: Yale University Press, 1958,
rev. 1963), pp. 101–2

</div>

Bone, Littlejohn, and Gayle, in three of the most popular and simultaneously distorted, partisan and inaccurate critical works on Afro-American literature, have consigned Fauset's work to a very narrow groove and have failed to probe beneath its surface realities. In their disproportionate emphasis on her literary traditionalism, for example, they draw hasty and not totally accurate conclusions about her fictional intentions. To be sure, she was traditional to some extent, both in form and content, but as Gary de Cordova Wintz rightly observes, "in spite of her conservative, almost Victorian literary habits," Fauset "introduced several subjects into her novels that were hardly typical drawing room conversation topics in the mid-1920s. Promiscuity, exploitative sexual affairs, miscegenation, even incest appear in her novels. In fact prim and proper Jessie Fauset included a far greater range of sexual activity than did most of DuBois's debauched tenth.

When attention is given Fauset's introduction of these challenging themes, it becomes possible to regard her "novels of manners" less as an indication of her literary "backwardness" and more as a self-conscious artistic stratagem pressed to the service of her central fictional preoccupations. Since many of Fauset's concerns were unpalatable to the average reader of her day and hence unmarketable in the publishing arena, the convention of the novel of manners can be seen as protective mimicry, a kind of deflecting mask for her more challenging concerns. Fauset uses classic fairy tale pat-

terns and nursery rhymes in a similar fashion; however, although these strategems are consciously employed, they are often clumsily executed.

In addition to the protective coloration which the conventional medium afforded, the novel of manners suited Fauset's works in that the tradition "is primarily concerned with social conventions as they impinge upon character." Both social convention and character—particularly the black female character—jointly form the nucleus of Fauset's literary concerns. The protagonists of all of her novels are black women, and she makes clear in each novel that social conventions have not sided well with them but, rather, have been antagonistic.

Without polemicizing, Fauset examines that antagonism, criticizing the American society which has institutionalized prejudice, safeguarded it by law and public attitude, and in general, denied the freedom of development, the right to well-being, and the pursuit of happiness to the black woman. In short, Fauset explores the black woman's struggle for democratic ideals in a society whose sexist conventions assiduously work to thwart that struggle. Critics have usually ignored this important theme which even a cursory reading of her novels reveals. This concern with exploring female consciousness and exposing the unduly limited possibilities for female development is, in a loose sense, feminist in impulse, placing Fauset squarely among the early black feminists in Afro-American literary history. . . .

The idea of Fauset, a black woman, daring to write—even timidly so—about women taking charge of their own lives and declaring themselves independent of social conventions, was far more progressive than critics have either observed or admitted. Although what Fauset attempted in her depictions of black women was not uniformly commensurate with what she achieved, she has to be credited with both presenting an alternative view of womanhood and a facet of black life which publishers, critics, and audiences stubbornly discouraged if not vehemently opposed. Despite that discouragement and opposition, Fauset persisted in her attempt to correct the distorted but established images of black life and culture and to portray women and blacks with more complexity and authenticity than was popular at the time. In so doing, she was simultaneously challenging established assumptions about the nature and function of Afro-American literature. Those who persist, then, in regarding her as a prim and proper Victorian writer, an eddy in a revolutionary literary current, would do well to read Fauset's work more carefully, to give it a more fair and complete appraisal, one that takes into account the important and complex relationship between circumstances and artistic creation. Then her fiction might finally be accorded the recognition and attention that it deserves and Fauset, her rightful place in the Afro-American literary tradition.

<div style="text-align: right;">

Deborah E. McDowell. In Marjorie Pryse
and Hortense J. Spillers, eds. *Conjuring:
Black Women, Fiction, and Literary
Tradition* (Bloomington: Indiana University
Press, 1985), pp. 87–88, 100

</div>

Audience was a consideration . . . for Jessie Fauset, the most published Afro-American woman novelist of the Harlem Renaissance. She, together with Nella Larsen, wanted to correct the impression most white people had that all black people lived in Harlem dives or in picturesque, abject poverty. In her preface to *The Chinaberry Tree* (1931) she tells us why she chose to create the heroines she did. Beginning with the disclaimer that she does not write to establish a thesis, she goes on to point out that the novel is about "those breathing spells, in-between spaces where colored men and women work and live and go their ways in no thought of the problem. What are they like then? So few of the other Americans know." And she concludes her preface by identifying the class to which her characters belong: the Negro who speaks of "his old Boston families," "old Philadelphians," "old Charlestonians."

Both [Frances E. W.] Harper and Fauset were certainly aware of the images, primarily negative, of black people that predominated in the minds of white Americans. They constructed their heroines to refute those images, as their way of contributing to the struggle of black people for full citizenship in this country. Of necessity their language was outer-directed rather than inwardly searching, for their characters were addressed to "the other Americans" who blocked group development. To white American readers, self-understanding for black characters might have seemed a luxury. To the extent that their writers emphasized the gender as well as the race of their heroines they were appealing to a white female audience that understood the universal trials of womanhood. These writers' creations, then, were conditioned by the need to establish "positive" images of black people; hence, the exploration of self, in all its complexity, could hardly be attempted.

<div style="text-align: right">

Barbara Christian. In Marjorie Pryse and
Hortense J. Spillers, eds. *Conjuring: Black
Women, Fiction, and Literary Tradition*
(Bloomington: Indiana University Press,
1985), pp. 234–35

</div>

Jessie Fauset, whose fiction falls to some extent within the romance genre, makes . . . use of the Cinderella Line as narrative strategy. . . . Olivia Cary, the unpleasant central character of *Comedy: American Style,* resembles the "typical mother" in marriage novels—Mrs. Bennett in *Pride and Prejudice,* for example. The subtext of Faust's novel follows the Cinderella Line: Olivia dreams her lightskinned daughter Teresa marries a princely (white, rich) husband. The achievement of Olivia's dream, however, is thwarted by the larger racial issue which informs the novel, the issue of passing. Jessie Fauset, whose novels espouse essentially middle-class values, nevertheless offers, particularly in *Comedy: American Style,* a critical perspective of these very values. This ambivalence results in a subversions of the Cinderella Line. Teresa, who has passed at her mother's insistence, marries not a prince but a pauper. At the end of the novel both mother and daughter, defeated in the

marriage quest, are left without a culture and without a language, in the threadbare clothing which signifies an unhappy ending.

Clothing and skin are meticulously described throughout *Comedy: American Style,* mirroring as they do the values and attitudes of the various characters . . . [Fauset's] deftness and attention to shades of skin are evident also in her many descriptions of clothing. One might say that, for Fauset's characters, clothing often becomes a second skin, at times meant to enhance the complexion, at other times meant to disguise, to be used as a vehicle for passing.

Mary Jane Lupton. *Black American*
Literature Forum. 20, 1986, pp. 410–11

Issues of race and gender are major concerns in Fauset's fiction. Adhering to principles she adumbrated in her reviews, she claimed that her novels were not propagandistic. Neither, she averred, were they constrained by issues of race. Both claims are false in precisely the same way her observation that McKay did not write propaganda was false. Fauset believed that Afro-American writers had a role to play in the political struggle; they had a duty, as she put it in a wide-ranging interview in 1932, to "tell the truth about us." But she thought Afro-American writers discharged this duty best when they wrote skillfully and truthfully.

Fauset did not find a fictional form conducive to the truth she wanted to tell. *There Is Confusion* (1924), *Plum Bun* (1929), *The Chinaberry Tree* (1931), and *Comedy: American Style* (1933) are all sentimental novels. The plots often strain credulity, and their resolutions are uniformly happy: the still courageous but chastened heroine finds happiness with a protective yet more understanding hero. Yet, as McDowell has noted, Fauset's novels use literary and social conventions partly as a "deflecting mask for her more challenging concerns." The clichés of the marriage plot and the "passing" novel notwithstanding, *Plum Bun* reveals a sophisticated understanding about the politics of race and gender. Fauset's protagonist, Angela Murray, is aware of the hierarchical arrangement of race and gender relations, but she is naive about their implications. Her creator was not.

The foreword to *The Chinaberry Tree,* the most cogent statement of Fauset's personal aesthetic, has often been cited and frequently censured as a betrayal of a racial birthright. The weaknesses inherent in Fauset's position are clear; the racial defensiveness is palpable. Yet Fauset's "breathing-spells, in-between spaces where colored men and women work and love," may in fact be comparable to Hurston's renderings of the Eatonville store porch whose "sitters had been tongueless, earless, eyeless conveniences all day long." On the porch Hurston's characters cease to be mules and become men and women. For Hurston such "in-between spaces" are inscribed by cultural differences; Fauset emphasizes commonality. Taken in tandem, the fiction of these two women explores the multidimensional experiences of Afro-Americans.

In this regard, Fauset's refusal to write about the kinds of characters and situations white readers expected and her insistence that all the drama in Afro-American life did not revolve around interracial conflict are important. Indeed, they are part of a larger effort waged by black women writers collectively to create a space in which they could tell their own stories.

Cheryl A. Wall. In Bonnie Kime Scott, ed.
The Gender of Modernism (Bloomington:
Indiana University Press, 1990), pp. 158–59

FELL, ALISON (GREAT BRITAIN) 1944–

Why do some of us cherish the memory of adolescence? Is it because that moment before adulthood seems to contain all the things we might have become before real possibilities encroached on our fantasies? Or is it simply that our teenage years, with all their embarrassments and longings, are a time when we begin to own something of ourselves, to nurture our difference from all other generations?

In her first novel for adults, *Every Move You Make,* Alison Fell attempted to chart the guilt, confusion, and catastrophe of the 1970s London counterculture. The radicalism which surrounded and absorbed her protagonist was both heady and problematic, caught as she was in the crossfire of an embryonic Women's Lib, daring and outspoken, and a new sexual standard defined and directed by men. It was a brave book, but an unsuccessful one, partly, I think, because that seventies past is still so close; its meanings in the dour and strident 1980s remain fragile and uncertain.

In *The Bad Box,* Fell ventures further back, to the 1950s and rural Scotland, forging her narrative from the wealth of interpretations of the period and the experiences she described in her autobiographical essay in *Truth, Dare or Promise.* But this is not simply autobiography disguised as fiction. In *The Bad Box,* Fell has found a sympathetic detachment and a poetic control which perfectly capture the rush of emotions and impressions that shape her protagonist's adolescence. Through a chain of small but significant events and crisp images, the narrative glides onto a social terrain which is both sufficiently distant and yet familiar enough to be made strange. . . .

The vicissitudes of Isla's inner life are woven into a vivid social fabric—the register both of a specific class and place and the eternal antagonism of generations. As she grows up, her father's strong communist sympathies seem both dangerously different and anachronistic; "their" world becomes "our" world as adult preoccupations with Suez and the pages of the *Daily Worker* give way to the symbols of a burgeoning youth culture—Ban the Bomb T-shirts, Radio Luxembourg, Gold Leaf cigarettes, the *Six Five Special* show.

But the most poignant moments in the novel are those given over to Isla's friendship with Ray, whom she leaves behind in the Highlands but continues to idealize: "Ray and Isla, Isla and Ray. It simply was like a silver bracelet that each year you added new charms to." Their relationship marks the moment when girls are admitted to the boys' world, where friendship is competitive and spiced with risk. Her return to the Highlands and Ray is scarred by loss and betrayal; Isla discovers the pain of sexual difference, pays the price of naivety.

The novel works so well as a haunting picture of adolescence that Isla's fable of dumb "hind girl" which is scattered through the narrative seems superfluous. Read in isolation, the tale has a certain mythic power, but the girl's quest after truth and her attempt to affect the adult world has the effect of overburdening the central drama. It is a shame that Fell, like so many novelists and filmmakers, seems to want to invest adolescent experience with a romantic significance it cannot bear.

<div style="text-align: right">

Helen Birch. *New Statesman.*
July 10, 1987, p. 28

</div>

Alison Fell's *The Crystal Owl* is a tricky book to gauge because of the variety of its themes and free verse forms, though this variety alone—its refusal to be limited—should be the occasion of praise. Her poems, though always personal, and often introduced here in irritatingly unnecessary epigraphic notes, range from angry tirades on sexual politics in fascist South Africa to spiky recollections of childhood and family; from brief jazz songs to an extended "Fantasia for Mary Wollstonecraft"; from reflections on Mark Rothko to addresses to the muse. The unifying quality of her verse is its combination of directness with her eye for the apposite detail. The painful fragility of an uncertain relationship ("A week away from whispers") is imaged in "Interlude—the windmill":

> In the mirror we are
> inside out
> like a dog's ear, unprotected
> and flushed.

Experience of the elements itself is almost an antidote for such feelings:

> we lean our cheeks against
> ice and for once
> there is no sensation
> of pain.

<div style="text-align: right">

Robert Sheppard. *New Statesman and Society.* December 23–30, 1988, p. 36

</div>

Is sin a feminist issue? Do women sin differently from men? Since the days of the archdemons, Alison Fell points out in her introduction to these seven

stories from the near side of hell, the Deadly Sins have been personified as male—Lucifer is Pride, Leviathan is Envy, and so on. "Woman, when she appears, is Virtue: Meekness, Patience, Abstinence, Industry, Chastity, Charity, Generosity. Otherwise she is Lust, the body rampant."

Why? Possibly because through the Middle Ages nobody thought women were intellectually capable of *morality*, much less of turpitude, of thinking through such challenging matters as revenge and murder and taking the Lord's name in vain. The famous exception, of course, was Lust. Well before anybody hit on the idea of a G-spot, Chaucer knew that even married women could have fun in bed.

Now it is time to settle the score. In these seven stories, Kathy Acker, Leslie Dick, Zoë Fairbairns, Alison Fell, Sara Maitland, Agnes Owens, and Michèle Roberts take on Lust, Envy, Covetousness, Sloth, Gluttony, Pride, and Anger. "After so many centuries of upholding Virtue," says Fell, "surely our imaginations contain all the resplendent crimes our history lacks."

There are no ordinary people in *The Seven Deadly Sins*. These women are obsessive; they go too far. The stories assert themselves boldly on the page, mix myth, hallucinations, stories within stories, and even realism that would make Dreiser look misty-eyed, especially in two of the strongest stories, Fell's work on Sloth and Dick's on Envy. There is a desperate, I'll-try-anything quality at work here—but these are desperate times, the stories teach us, and require extreme acts. Which brings us to our second question: If these women are so *sinfully* excessive, bizarre, manic, virulently premenstrual, bitchy, etc., why do they remind us so much of you and me? . . .

"The devil's sexual appetites being common knowledge, it came to pass that in the course of his several marriages seven children were born," writes Alison Fell in "Sister Whale," her tale of Sloth. "Much to the devil's chagrin, every last one of them was a daughter, and having little patience with girls or their names, he simply called each one after whatever sin happened to take his fancy at the time of her birth."

And little Sloth grows up in Fell's story of mistaken—lost—identity. Dee returns to Australia to visit her sister, Mona, whom she has not seen for twenty years. In the meantime, Dee has become a feminist, a European, and a writer (who has written "hundreds and thousands of words and not one of them about Mona"). Mona has not had it so good. When her husband "upped and offed with a married woman," Mona sought comfort in food—half-pound chocolate bars and Smarties and orange squash. Now she wears tent dresses and spends her evenings eating and renting the kind of mass-market videos in which the heroes are supermen, unreal. Worse, Mona identifies not with Dee's feminist heroines but with beached whales. She confides tearfully, "Their own weight can crush them to death."

Throughout the story, Dee tries to define herself as Industry, as a thin person, to differentiate herself from Sloth in the lumpy form of Mona. Dee prunes Mona's hydrangeas, determines to take on all the cooking, to *get things done*, as if a reunion with Mona were another item listed To Do in her

Filofax. Yet however much Dee shows herself the opposite of Mona, two new heads of the Hydra pop up. Dee wakes in the night to "Pre-Menstrual Mean Time," and her "whale-self wakes on a wave." Harpooned in her dreams by Jack Kerouac, Dee "rolls and dives for safety. . . . In a minute she'll outgrow all narrowness and then who will she be, who, if not narrow any longer?" And again, Dee wonders, what did it mean, exactly, that their mother bought Dee a Mona-sized brown evening dress last Christmas? "Now it's eerily clear that Mother couldn't tell one daughter from the other; Mother simply got her daughters mixed up."

Fell is the author of two collections of poetry and several novels, including *The Bad Box,* in which she also uses cubist effects, placing dream and reality in violent proximity to expose the frailty of ego. Fell is gritty and wry, and though neither Mona nor Dee emerges as a particularly sympathetic character, by making us mindful of the tide of Sloth we all swim against, the author has made "Sister Whale" into a deep, sad, funny story.

<div align="right">Carolyn Cooke. The Nation. January 22, 1990, pp. 98–99</div>

Love, of the passionate, consuming heterosexual kind, is a wretched subject for contemporary novelists, particularly for those whose thinking has been rattled or shaped by feminism.

The thirtyish or fortyish political female has absorbed the theory; she knows that love for a man is not supposed to dominate, turn her inside out and leave her stranded, and that submission to it taints her. As a result, love seems to have become more of a footnote and less of a centerpiece for many of our best women novelists.

All credit to Alison Fell then, for daring to plunge her novel into the center of the chaos and leave something of the political edifice still standing. At forty, Kathleen, her protagonist, is a successful novelist, an exile from Belfast who has settled in London because: "Sometimes you have to leave to reclaim your heritage." At a writing class, she meets and falls in love with Will, a student ten years her junior. Will belongs to the chattering classes, happiest when discussing Freud, feminism and the Labour Party, and passionately devoted to the cause of the New Man. With his wife, Joanna, he carelessly pursues open marriage. With men, he climbs mountains, high on the fear and the sense of control it gives him.

Scraps of Will's notebooks, and fragments of letters, diaries, narrative, and conversation between Kathleen and an unknown interlocutor, perhaps a therapist, gradually disclose the contradictions of passion. . . .

This is messy stuff; willfully indulgent even. But Fell keeps tight rein on her material. In prose as hard and clear as ice, she holds a mirror up to femininity. She sees heterosexual love as a form of narcissism, a desire for completion; the atavistic lure of martyrdom; and the moment, in Lacanian theory, of misrecognition, when the child looks into the mirror of the mother's face and sees a whole, smooth image of itself reflected there.

Like Alice, Kathleen/the writer is curious enough to step beyond the looking glass to see what she can find there. And love, because irrational, impossible to pin down in neat, well-structured sentences, reflects the earliest memories and the deepest longings. The effect is kaleidoscopic.

Helen Birch. *New Statesman and Society*.
February 22, 1991, p. 33

FERRE, ROSARIO (UNITED STATES–PUERTO RICO) 1940–

Rosario Ferre, a young Puerto Rican writer, is, without a doubt, a key figure in the new feminist literary tendency whose self-defined task is to unmask cultural myths with respect to woman and, at the same time, to inspire action that will change the present situation. *Sitio a Eros,* a book of essays published in 1980, bears unmistakable witness to the author's feminist ideology. One of her basic objectives is to enter into a female subculture that is a mixture of marginal voices produced within a hegemonic official culture which interpreted the genius of the woman intellectual and writer on the basis of scandal, immorality, or anomalous exceptionalism. For this reason, it is no accident that Rosario Ferre in this essays distinguishes the predominant sexism of each era, documenting these judgments concretely. . . . Contrasting this traditional vision with a more current feminist perspective, the Puerto Rican author reevaluates the cultural production of a group of women not only according to its intrinsic value, but also within the lived context of frustration, misunderstanding, and isolation, feelings that are of vital importance for the female *corpus* given that for these women intellectual and artistic activity meant a transgressive act that made them beings who were rejected by their society. Moreover, in presenting the revolutionary ideology of Flora Tristan and Alexandra Kollentai, she underscores the sexist discrimination prevalent in groups generally considered politically advanced. . . .

The new feminist aesthetic starts from a historic and social vision of woman that reveals a furibond erotic zone that, with limited exceptions, has been keep silenced. Rosario Ferre conceives woman as a social being trapped between the virtuous role of wife and mother and the impulse to break with the moral restrictions of a system that assigns her a one-dimensional identity. According to the characters assigned to the two sexes by our society, woman is essentially a passive, intuitive, sentimental, pure, fragile, and irrational being. However, despite these social categories that have been assumed to be inherent to the female character, ontologically woman also possesses erotic, aggressive, and violent impulses that tend to transgress the system's repressive regulations.

In *Papeles de Pandora* (Pandora's papers) (1976), this ontological duality is developed on the basis of linguistic and characterological opposites that

constitute an extended oxymoron, a form of condensed paradox in which two contradictory elements are fused. Together with the diction conventionally assigned by society to woman, that of recipes, fashion news, table settings and makeup is counterposed angry blasphemy, obscenity, the displaced euphemisms for naming the sexual organs. The contrast of a feminine discourse accepted by the dominant cultural masters and the transgression of conventional feminine discourse subject to prohibitions that Michel Foucault has analyzed as a total network that reveals its connections with desire and power. . . .

In her short stories, Rosario Ferre reveals the silenced zone of female life by exploring the dark continent of eroticism, anger, and rebellion in a contemporary feminist perspective that validates questioning this process by unmasking how much its structure is fed by the principle of opposition characteristic of the phallogocentric system. An implicit ideological derailing that, in our opinion, is expressed in the themes of vengeance and death without offering alternatives for a true liberation that would entail feminine values that hitherto have been marginalized.

<div style="text-align: right">Lucía Guerra-Cunningham. Chasqui. 13,
1984, pp. 14–16, 22</div>

Rosario Ferre belongs to the generation of the 1960s although in my opinion it would be more apt, if this zeal to classify is apt in any way, to include her in the generation of the 1970s. The mark that Julia de Burgos has left on Ferre is apparent in her works in many ways and may be seen in its most explicit form in the essay "Letter to Julia de Burgos" which is part of the collection Sitio a Eros in which Ferre reveals . . . her literary models. The essence of the essay devoted to de Burgos could be reduced to a recognition on Ferre's part of the importance of the figure of de Burgos in Puerto Rican literature as someone who did not lose sight in her works of the necessity for a political and sexual revolution. In her collection of stories and poems, Pandora's Papers, Ferre includes a poem that reveals her literary debt to Julia de Burgos and, in particular, to the poem "To Julia de Burgos." . . . If de Burgos's poem announced a division of the speaker's being, Ferre's poem from its title on announces something similar. The title "Eva Maria" suggests a divided and contradictory entity. . . .

In Pandora's Papers the thesis is developed on the authorial level that woman is capable of destroying archaic orders to create a better world. This poem is related to this thesis and also establishes the idea of antidomesticity as a requisite for a better world in which woman liberated from her bonds will be able to produce and create artistically also.

<div style="text-align: right">Luz Maria Umpierre. Imagine. 2, 1985,
pp. 134, 136</div>

Among the younger generation of writers who express the new sensibility in language and form, the work of Rosario Ferré has received increasing critical

attention. Her family has been active in Caribbean political life (her father, Luis Ferré, is a former governor of the Island), but rather than enjoy the confined privileges of the wealthy upper class, Ferré has chosen to explore the values of the traditional bourgeoisie from a feminist perspective. Just as Luisa Capetillo had founded the journal *La mujer* in 1910 as a vehicle for her progressive ideas, Ferré and other like-minded writers began *Zona Carga y Descarga* (Loading zone) in 1972 as a journal committed to literary and sociopolitical change. Her first collection of poems and short stories, *Papeles de Pandora* (Pandora's papers) reflects her social commitment to feminist ideology. Most of her women protagonists are "niñas buenas" (good girls), the daughters of the bourgeoisie whose experiences cause them to realize their position of subservience in their society. "La muneca menor" (The youngest doll), "Amalia," "La bella durmiente (Sleeping beauty), and "Cuando las mujeres quieren a los hombres" (When women love men) serve as good examples of her reaction to patriarchal authority, her questioning of the power and status of men in relation to the subjugation of women. As so many other women writers before her (Lorenza Brunet, Maria Molina, Isabel Cuchi Coll, etc.), Ferré has also written works for children, which can be read as political and social allegories.

"When Women Love Men" has received much critical scrutiny because it epitomizes the exploration of the image of women from a feminist perspective. The story recounts the lives of two very different women whose paths cross because of a man; Isabel Luberza is Ambrosio's legitimate wife, the white woman of the bourgeoisie, symbol of repressed sexuality similar to the wife of Senator Vicente Reinosa in *Macho Camacho's Beat*. If Isabel Luberza functions in the traditional role of women in a patriarchal society, being the "good woman," the other woman, also Isabel, serves as a symbol of the "fallen woman," for she is a prostitute. The particulars of class and race are also explored, for the prostitute is a black woman who depends on white men for her economic sustenance. Despite their different racial and class origins, both women are shown to be objects of the patriarchy. The two women whom society would judge so differently are seen to behave similarly in the economic sphere: they exchange sex for economic support. Their inherent similarity as women is shown stylistically in a number of ways, from their common name, their shared preference for Cherries Jubilee nail polish, (a direct reference to American cultural imperialism), and from the narrative perspective, in the blending of their two narrative points of view. The story shows expert handling of the narrative, and with its verbal facility, thematic sophistication and humor, should maintain a place in the history of the narrative.

Sandra Messinger Cypess. In Carole Boyce
Davies and Elaine Savory Fido, eds. *Out of
the Kumbla: Caribbean Women and
Literature* (Trenton, New Jersey: Africa
World Press, 1990), pp. 83–84

FIELD, MICHAEL (pseud, KATHERINE HARRIS BRADLEY) 1846–1904, and EDITH EMMA COOPER (GREAT BRITAIN) (1862–1913)

The undoubted taste and feeling displayed in Michael Field's *Wild Honey from Various Thyme* are largely discounted by a serious lack of discriminating power. Of the sonnets and short poems which make up the contents the former are, contrary to custom and in spite of their fetters, the more successful. They are felicitous in expression, and generally classic in tone and subject, and, though nowhere aspiring to the first rank, have an atmosphere of their own, scholarly and restrained. . . . The principal fault—looseness of expression—is to be attributed to ideas insufficiently developed, and imperfectly conveyed—a fault the more regrettable in that those ideas are frequently of great beauty.

The Athenaeum. April 4, 1908, p. 414

Restraint and chiseled beauty of form mark the poems of Miss Bradley and Miss Cooper, who wrote under the pseudonym, Michael Field. . . . There is little contact with the actualities of everyday life in Michael Field's lyrics and shorter poems. Art, literature, nature and love seen through the haze of literary culture, these are the writers' sources of inspiration. But the gemlike finish and perfection, the harmony of style and thought, the simple directness of these poems lends them a unique beauty. And, if the stress of life is not felt, these brief lyrics are far from empty of matter; if they do not bear the impress of thought and great emotion, they generally express something that was worthy the singing, and always the expression is finely and delicately wrought. . . . There is here no great writing; but within their own limits Michael Field's lyrics almost reach perfection.

Harold Williams. *Modern English Writers*
(n.p.: Sidgwick and Jackson, 1918),
pp. 146–47

Michael Field was really two people, this "double-headed nightingale," as an American critic elegantly phrased it, being composed of two maiden ladies, an aunt and niece, Miss Katharine Harris Bradley and Miss Edith Emma Cooper. These ladies came from Birmingham, and were endowed with a modest but sufficient income derived from a tobacco-factory in that city. They were united by the closest bond of a passionate adoration for each other, and by a common enthusiasm for high and passionate verse. . . . From the suburbs of Birmingham they went to live near Bristol, where they prepared themselves for their high career by classical and other studies, and when they wrote their first play, *Callirrhoë*. This play, on its publication in 1884, made a considerable stir in literary circles, and was highly praised by Robert Browning. Although the cup of success was soon dashed from their lips, they never forgot its intoxicating taste; it proved . . . a poisoned draft, and the memory

of it made all the more bitter for them the dismal failure of their future publications. . . .

Steadily, year after year, for almost thirty years, they went on composing tragedies in verse; they wrote in fact twenty-eight of these dramas, full of grandiose passions, dreadful deeds of lust and horror, incest and assassination, hells of jealousy, and great empires tottering to their fall. These somber and fiery volumes, with eight volumes of fiery lyrics, which they published mostly at their own expense, fell all of them one after the other, into blank oblivion; the British public took no notice of them, the literary journals gave them scanty consideration. . . . But this deepening gloom of non-appreciation only served to increase their belief in their own genius; posterity, they were passionately convinced, was to pay them in full requital the fame which their contemporaries had denied. . . .

Michael Field had not many acquaintances; there were, however, a few friends who would be now and then summoned to Reigate or to Richmond [to which they moved after 1897], where they held, like royalties in exile, their imaginary court. . . . One felt at first as if one might be almost taking tea in Cranford; but this was the maddest of illusions. Never in Cranford was heard talk like their talk when once their inspiration fell upon them. . . . Like the world in general . . . I did not, when I knew them, read their books. . . . But now . . . opening their unopened books of verses on my shelves, I rub my eyes at the beauty of their lyrics. . . . It is a certain intensity of lyric feeling and splendor of diction which, as I now read it, seems to give their best work a beautiful distinction.

<div align="right">Logan Pearsall Smith. The New Statesman.
April 12, 1924, pp. 12–13</div>

The Paragon, the Michael Fields's house at Richmond, was an eighteenth-century house, with a garden running down to the river. In the living-rooms the furniture was of satinwood, chosen by Ricketts, and on the walls hung Shannon's lithographs, and prints by Ricketts and Sturge Moore, exquisitely mounted. Ricketts and Shannon gave to mounting and framing the care which only Eastern artists give as a rule. There were always choice flowers, lovingly arranged, and in a large cage cooed a pair of doves. Field, wan, a little drooping, with her large eyes, clear forehead and sensitive lips looked the poet she was; Michael, stout, with a high color, masterful, protecting, was the active, managing spirit of the Paragon. Field again looked the poet in any dress she wore; but a dress, like everything else, must for long be discussed and pondered and finally ordered from the modiste with elaborate directions. But most important were the hats. Once a year a visit was paid to Kate Riley, a Dover Street milliner, and imperial hats were chosen; purple, with superb feathers, that drooped over Field's small ear, and waved proudly above Michael's head. But these poetesses were fiery ladies. There were grass borders in the gardens of their minds on which one must never tread. For they were both ardent converts to Roman Catholicism, and they gave all the wealth of

their imaginations, their entire obedience, and somewhat, I fancy, of their worldly wealth to what was for them the only true church. And what a rich fantasy was theirs; what lightning play of mind, and how they valued the same in others! They knew but few people, but from these few they expected—everything, all they had to give. They were imperious ladies, these exquisite poets, Michael especially. They knew the value of their friendship; if they gave it, it must be with both hands; but those to whom they gave must be worthy of their trust every moment, whether in their company, or out of sight and hearing. None were more sensible of beauty, of the fine shades of life, or wittier than Michael and Field; to re-read their letters is to evoke their lively spirited and spiritual souls. . . .

The Michael Field books are now little read; but what Field wrote of the shining stuff I sent her is true of their poetry—"it has gold in it—it has the grays of frankincense, the blond and austere suggestion of preciousness." Their poetry but sleeps; but not the sleep of death.

<div style="text-align:right">

William Rothenstein. *Men and Memories*
(New York: Coward-McCann, 1932),
pp. 115, 172

</div>

"Michael Field" is the pseudonym used by Edith Cooper and Katherine Bradley, whose unique collaboration amounts to a staggering twenty-five "tragedies," a masque, and eight volumes of verse. In addition, the British Museum collection contains a number of unpublished manuscripts, extensive correspondence, and detailed journals, excerpts of which have been edited and published under the title *Works and Days* by Sturge Moore. Male critics, inclined to note prolific nineteenth-century men writers, regardless of their talents, have ignored or misrepresented these two women more often than not, but what is as disconcerting, feminist critics have ignored them as well, despite the fact that they worked in a genre which is, even today, dominated by men as critics, writers, and producers. Without question Katherine Bradley's and Edith Cooper's experience serves as a protocol for the rediscovery of not only the nineteenth-century woman writer, but all those writing against the accepted societal and cultural grain. . . .

The real key to the paradox of Katherine and Edith lies not in whether they lived blameless lives, but in their unique collaboration, which for Mary Sturgeon stands "as a robust denial that women are incapable of greatness in art and comradeship," and represents a discovery of "the secret of psychological truth," "a great capacity for life," "an immense love of liberty, and hatred of every kind of bondage," and "a prevailing love of freedom, which takes many forms and is apparent everywhere." All of this is accompanied, according to Sturgeon, by "the fragmentary, the suggestive and often complex wisdom" of the collaboration.

And yet Sturgeon also misses the real paradox and ultimate reason for the women's obscurity, that these poets of liberty never succeeded in breaking through the confines of their passionate devotion to each other. . . .

Yet it is the tragic element of their own lives that—permitted an economic independence not afforded many Victorian women, which enabled them to escape the stifling drawingrooms for a "room of their own"—they insured their obscurity. In retreating to this room to create their "mosaics," they allowed it to become a Palace of Art and, like Tennyson's "Lady of Shalott" and the captive women in their own dramas, in seeking to express in their art the experience of life denied to so many women, they came to be prisoners of their art. Confusing their dramas with the experience of life, their art became their life.

David J. Moriarty. In Rhoda E. Nathan, ed.
*Nineteenth-Century Women Writers of the
English-Speaking World* (Westport,
Connecticut: Greenwood Press, 1984), pp.
131–34

FLEISSER, MARIELUISE (GERMANY) 1901–74

Ingolstadt is here or nowhere. But Ingolstadt stands for a lot of cities. "It really should not be said that this could only happen in Ingolstadt." Because [Marieluise] Fleisser has become renowned as an "observer," a "recorder," and "a precious copyist" of the petty bourgeois milieu, the "little man's predatory character," and, in a word, of small-town life. As the chronicler of patriarchical "habits and customs as exhibited on special occasions," Fleisser writes "always and only about things between men and women," and, in fact, "reveals them in such a high fashion that they [the habits and customs] are typically constructed, fundamentally striking and original." Ever since the Berlin premier of *Fegefeuer in Ingolstadt* (Purgatory in Ingolstadt) in 1926, critics have been sufficiently occupied with that which Marieluise Fleisser sees, observes, records, and points out, as well as with how this all achieves a fundamentally striking and original effect. Here, however, an attempt will be made to point to all that which Fleisser does not record. This includes a closer examination of the points of fracture and the gaps in her earlier works, and a closer definition, in particular, of Fleisser's view of the role of women in patriarchical society.

For the patriarchical world, shown here functioning as a representation for Fleisser's Ingolstadt, is recognizable neither as a reflection of the existing "habits and customs" of the petty bourgeois world, nor as a typicalization of provincial life. Perhaps in this deviation lies the most radical emancipatory statement of Fleisser's early writings. . . .

In the narrative and dramatic works which Marieluise Fleisser composed up until her marriage to Bepp Haindl in 1935, some groupings occur—according to themes, the shaping of the main character, the image of the family,

the image of society, and autobiographical elements—which point to the gradual development of a consciousness one could almost call feminist, as well as to a problematization of marriage, family and masculine authority that is formulated with increasing explicitness. . . .

When Marieluise Fleisser resumes writing at the end of the war—since practically no business and no household remain—she writes about herself, and about her experiences as a wife, and as a girlfriend of Brecht, Haindl and Draws. She still writes "something between men and women," but it is no longer naive. In her later works, the gaps from her earlier works are closed, and the yearning for liberation that had such an indirect effect there in the background through the disappearance of system-preserving elements now become the main theme in the autobiographical notes. The emancipatory potential of such yearning for liberation spawns documents now describing the repression of a woman trying to write in a patriarchical society.

<div style="text-align:right">

Susan L. Cocalis. In Irmela von der Lühe,
ed. *Entwürfe von Frauen in der Literatur
des 20. Jahrhunderts* (Hamburg: Argument-
Verlag, 1982), pp. 64–66, 83

</div>

Fleisser, in an answer to a question of what she had found to be the most significant characteristic of the first third of this century, wrote that it was the changing position of women. Yet she remained negative in her assessment, pessimistically commenting that male brutality prevents women from gaining by force what is their due. Admiration of the strength and determination of their forerunners was not accompanied either by a desire to carry on the tradition or an optimistic belief that such a continuum was possible or indeed desirable. . . .

For Fleisser, men are alternately saviors and monsters, but their role is vital to her existence despite their always ruinous effect on her. In a less violent account of her relationship with Brecht, the short sketch "Fruhe Begegnung (Early meeting)," she pointedly uses the first person: "And yet in my personal fate Brecht was the enduring force that continued to pierce me—and it also brought me bitter fruit." Her report on the influence of Lion Feuchtwanger upon her is equally insecure: in the short story "Aus der Augustenstrasse (From Augustus Street)," she says that after Feuchtwanger had read all that she had written and had labeled it "expressionism and convulsion," she burned everything except the one story he had liked. Draws-Tychsen is described by her as egotistical, overpowering, and completely dictatorial in his relationship with her; her later husband Josef Haindl is depicted as a source of great misery and unhappiness in her life. In an agonized tale entitled "Der Rauch (Smoke)," for example, one senses no irony and only a maddening martyrdom when she comments: "If I had run away from him, it would have been better for him, but I didn't know where to go." Patricia Meyer Spacks has described such an attitude as typical for women autobiographers who see their vulnerability as virtuous, but Fleisser's per-

ception of herself is more like that of someone trapped in horror, who strikes
out at all those in power over her, but who is only ineffectual in her anger.

As members of a generation characterized by suppression and defeat on
many fronts, [Marie Luise von] Kaschnitz and Fleisser illustrate how fragile
the emancipation proclaimed with the enfranchisement of German women in
1919 really was. Germany's turn to National Socialism was, in fact, a direct
blow to women's rights: women, as Fleisser tells us, became "Weiberfleisch,"
wares, more powerless even than the most impotent men around them. But
in addition to the concrete effect of the war upon their thinking about them-
selves is the sense of lasting insecurity that continuously encircled them. At
the time of the war, they seem to have entered a sort of vacuum, a breath
held that was not released again until the decade of their death, when their
country had once again begun to take cognizance of women and their rightful
place in the world.

<div style="text-align:right">

Ruth-Ellen B. Joeres. In Alice Kessler
Harris and William B. McBrien, eds. *Faith
of a (Woman) Writer* (1984; Westport,
Connecticut: Greenwood Press, 1988),
pp. 150–51, 153

</div>

Dialogue in Marieluise Fleisser's milieu plays *Fegefeuer in Ingolstadt, Pio-
niere in Ingolstadt,* and *Der starke Stamm* constitutes an ineluctable web
which constricts everywhere the interplay of characters with one another.
The communication ranges from the grossly destructive exchanges between
the adolescents in *Fegefeuer* and the overweening authoritarian discourse of
the sergeant in *Pioniere* to the probing negotiations between Berta and Korl
in *Pioniere,* ultimately foiled by Korl's fear of allowing feelings to enter their
relationship. Fleisser's dialogue also includes the guarded, misleading, basi-
cally manipulative talk in *Der starke Stamm* as well as rare moments of
rapport and openness in all her plays. Her characters are highly verbal peo-
ple. It is purposive, though faulty, communication with varying degrees of
responsiveness and distortion which gives shape to the experiences and the
worlds Fleisser portrays. Her spoken situations draw on a subtext, the richer
significance outside the tight package of explicit verbal content, which is
both culturally determined as well as influenced by the vast undersea of the
subconscious. . . . Ultimately, by depicting the disorders in the personal life
of her characters, Marieluise Fleisser is giving voice to small-scale human
tragedy in the provinces. . . .

Marieluise Fleisser is sensitive to the subtleties of human communica-
tion, and particularly to the phraseology, cadences, and expressions of lower
Bavaria. . . . Fleisser's remarkable dialogue which gives a realistic impres-
sion of spoken speech and calls forth, at the same time, a critical, alienated
view of precisely this spoken speech depends, in my view, on the incongruous
relationship of dialogue to plot. To be more precise, her dialogue seems to
play against a smooth, coherent, conventionally flowing plot line and an ex-

pected continuity of time, which is quite unique since plot most often develops from dialogue.

Otto Ludwig's term polyphonic dialogue, a simultaneity of independent voices with little order or progress, might well describe the volatile, fast-paced dialogue in Marieluise Fleisser's plays. An uninhibited, informal tone prevails, permitting everyone to have his say and no one person determines the course of the talk for very long. It is a dialogue of cross-talk which proceeds in spurts and is frequently elliptical and abrupt. Incomplete sentences abound and blend together as fragmentary sentences normally do in everyday conversation. The irregularity of real life conversation is caught in the unpredictable, and not totally relevant flow from one topic to another. The talk is a chain reaction with detours, distractions, and tangential thoughts. Answers often either do not quite fit the questions or are pseudo-answers which aim to evade questions. Characters sometimes find it advantageous to ignore what has just been said. The "talking past one another" is sometimes a calculated maneuver; understandings are purposely by-passed and meanings are conveniently misunderstood; in fact, much is communicated through implication alone. Messages arrive too early or too late or are inappropriate to the action or the situation. Sometimes, in addition, such tangential interaction ensues when messages are simply too intense. Disturbed communication, when examined subtextually, often reveals a purpose and plan, although not necessarily a consciously intended one. Glibness of tongue seems necessary for survival in the worlds Fleisser creates; under duress her characters parry well. . . . There is an acute sense of the moment in the plays of Fleisser; one is almost always in the midst of what E. Goffman calls "focused interaction."

> Donna L. Hoffmeister. *The Theater of Confinement: Language and Survival in the Milieu Plays of Marieluise Fleisser and Xavier Koertz* (York, South Carolina: Camden House, 1985), pp. 20, 22–24

The "Engineers of Ingolstadt," this "Comedy in 14 Images" (in the 1968 version), deals with the problems of petty soldiers, and has no intent of being an anti-military piece, but rather is against abuses within the military. Primarily through its use of elements from epic theater, however, this theater piece impresses greatly with its depiction of the merciless oppression of individuals in a small-town life that is stamped with the norms of the bourgeoisie, the Church, and the military. And in its best coinage, this folk-play exposes with utmost force the brutal mechanisms of mutual dependence. For parallel to the progress made in the construction of the bridge on the Danube, a task the engineers are to complete as an exercise, there develops among the soldiers an animosity toward the brutal sergeant as well, and a growth of love relations (or what the military views as such) with the girls of the city.

Of course all of them are oppressors: the stronger ones tyrannize those who are weaker, take advantage of them both physically and spiritually, until the weakest ones of all—always with Marieluise Fleisser the women and the girls—fall to psychological ruin. One hundred percent of the time it is the feminine portion of society that bears the costs of the human pecking order in the totally male-dominated society, which functions according to the norms issued exclusively by men: "We have left out something very important. Love is what we have left out." These are Bertha's words, directed at *her* Korl, as they emerge once again from the bushes. "A love," the engineer Korl coolly responds, "that doesn't even need to be there. . . . You've got to forget about all that."

With a good eye for social and interpersonal problems, and with her fine, downright highly poetic art of representing the psyche, above all of young women and girls, the author writes here not only her best piece, but one of the most convincing examples of critical-realistic folk theater as well. Especially since she succeeds, like hardly any other woman writer of this century, in rendering the deficiency of language, as caused by deficiencies in society, this "inability to express oneself" among persons of the lower classes, and the poetic condensation of social conditions.

<div align="right">

Hannes S. Machen. In Albrecht Weber, ed.
Handbuch der Literatur in Bayern (Munich:
Pustet, 1987), pp. 547–48

</div>

There is an astounding paradox connected with Fleisser's not inconsiderable standing as an artist. The play for which she is best known; the play which made her famous and even notorious in the late Weimer period; the play which, alone among all plays not written by Brecht, is acknowledged by him to have had a major influence on the evolvement of his Epic Theatre: the play which earned Fleisser the distinction of having her books banned by the Nazis and, for all practical purposes, of being forbidden to publish; the play which actually inspired Rainer Werner von Fasbinder to become a writer; the play which was an indispensable factor in the revival of the socio-critical *Volksstück* of Weimar days undertaken by Fassbinder, . . . Sperr, and Franz Xaver Kroetz; the play which, thanks to these same playwrights, launched the so-called Fleisser boom not too long before her death; the play that made it possible for her to resecure and enhance the reputation she . . . enjoyed in the last years of the Weimar Republic; this play, *Pioniere in Ingolstadt* is not the work that will guarantee Fleisser's aesthetic survival . . . as a part of the living theater. The play made history three times, as the . . . scandalous production of the German theater of the 1920s, as a key work in the development of the most innovative and influential German playwright in our time, and as a major influence on the Bavarian critical-realist theater which has in recent years been casting hard and lean glances at provincial life in . . . West Germany. Taken by itself, *Pioniere in Ingolstadt* will assure Fleisser an honorable mention in the future histories of literature, but, I am afraid, noth-

ing more. The play has its insightful, touching, and even beautiful moments. However, it is all in all as historical as its historic achievements. The gallant attempts at revival by her admirers and disciples in the late 1960s and 1970s seem to leave little room for doubt on that score. It is too much of a *Zeitstück,* too concretely wedded to the era whence it issued, and even the post-war revisions in the direction of greater actual social relevance in the spirit of Brecht only serve to compound the problem of the play's historicity. . . .

What happened to account for the difference in quality between the two works, [*Fegefeuer in Ingolstadt* and *Pioniere in Ingolstadt*] and, in an extended sense, for this dichotomy in Fleisser's career as a writer? The answer, in a word, is Brecht. Not long before her death Fleisser told an interviewer that the playwright had destroyed something in her. To be convinced of this, she said, all one has to do is compare *Fegefeuer* with *Pioniere.* Her first play was written in secret, totally free of the influence of Brecht's theorizing and of his overwhelming and often overbearing personality. For Fleisser the writing of this play shortly before her first meeting with the much-admired playwright was an existential necessity. The urge to express herself was born of the mental anguish produced by the sudden clash of two diametrically opposite worlds. There was the confining, rigid, and narrowly moralistic world of a Gretchen who had grown up in the provinces. And there was the wide-open, liberating, and neo-pagan world of the big city in the Roaring Twenties where Gretchen encountered Mephisto (Lion Feuchtwanger), who is turn introduced her to the genius of Faust (the works of Brecht).

<div align="right">Ralph Ley. University of Dayton Review. 11,
Summer, 1988, pp. 4–5</div>

Nearly everything Fleisser wrote was based on a combination of personal experiences and observations of her immediate surroundings. She found it very difficult to create out of thin air. In other words, she was subject to the impulses and urges of an intensely autobiographical writer. For this reason there is no consequent development in the five plays she authored. There is, however, a significant difference in literary approach and quality between her first play and the other four. . . . Brecht much preferred her [second] drama, *Combat Engineers in Ingolstadt,* which he had practically commissioned Fleisser to write [to her first]. When the scandal provoked by Brecht's salacious and anti-militaristic staging of the play in Berlin in 1929 erupted, Fleisser became the most maligned woman in the history of the Weimar Republic. The nationalist press as well as her fellow townspeople back in Ingolstadt accused her of betraying and perverting German womanhood by writing the lowest sort of Jewish-Bolshevist gutter trash. Fleisser finally faced up to the fact that if she were to save her writer's soul she would have to make a clean break with Brecht. She was constitutionally opposed to his insistence that an author should sacrifice his or her uniqueness to the collective production of socially significant literature. In cutting herself off from Brecht, Fleisser

regained her independence as a writer. But she could not cut herself off from his influence. In this regard she won a great deal but lost even more. After Brecht one finds her autobiographical bent reinforced by a sharper sense of naturalness or naivety. There is also a greater openness to the sociological side of human existence. These elements account for much of the strength of her novel of 1931 with the intriguing title, *Frieda Geier, Traveling Sales- woman in Flour. A Novel about Smoking, Sporting, Loving, and Selling (Mehlreisende Frieda Geier. Roman vom Rauchen, Sporteln, Lieben und Ver- kaufen).* Their presence in her last play, the *Volksstück Of Sturdy Stock (Der starke Stamm),* helps explain why, after resuming relations with Fleisser in 1950, Brecht went out of his way to secure a world première. . . .

Purgatory in Ingolstadt is a highly charged study of a Catholic town in the Germany of the early 1920s, and, at the same time, an intuitive portrayal of certain realities which made possible Hitler's great election victories in the provinces. It focuses on a small band of high-school students who are the exemplars of the milieu at large. Actually this group within a group can be described in terms of a pack or gang, for it is characterized by mean- spiritedness and narrow-mindedness. Its members reflect the ugliness of life in a small town which, to borrow the words of the West German theater critic, Benjamin Henrichs, is caught between a clerical past and a fascistic future. The young people of Fleisser's play are trapped in their own vicious world of hatred and envy, of spying and extortion, of humiliation and oppres- sion, of excruciating loneliness and of an emptiness which cries out for a redeemer. This redeemer can only be somebody who will appeal to the baser side of their nature. The type of Christianity practiced by these young people (and, behind the scenes, their elders) is actually a perversion of religion, since it excludes its most essential component—love. The negative Catholicism of the play puts its emphasis on a harsh God eager to punish sinners, on rigid commandments, stern moral principles, endless prohibitions. Under its in- fluence self-esteem is torn down and the personality deformed; the major concern is with one's own sins and salvation rather than with the liberation of one's neighbor from oppression. The central sacrament of this negative Catholicism is penance and the central sin impurity. All morality tends to become equated with sexual morality; as a result, the social, political, and economic aspects of life are excluded from the moral sphere or relegated to its outer fringes. Religion fosters a spirit of exclusivity which makes it easy to look inward and hard to look outward. Unwilling to reach out to the "oth- erness" of neighbors, the townsfolk concentrate almost exclusively on their own survival and on parochial issues, on questions of dogma and morality connected with their myopic view of the world. In her tersest description of the plot of *Purgatory in Ingolstadt,* Fleisser said simply that it is "a play about the law of the herd and about those forcefully excluded from it." . . .

I would argue that with the clear exception of *Danton's Death* by Georg Büchner, no *first* play in the history of German drama has been more provoca-

tive, more prognostic, and ultimately, more powerful than *Purgatory in Ingolstadt.*

<div align="right">Ralph Ley. Modern Drama. 31, 1988,
pp. 340–42, 349</div>

FORCHÉ, CAROLYN (UNITED STATES) 1950–

Kinship is the theme that preoccupies Carolyn Forché. Although she belongs to a generation that is reputed to be rootless and disaffiliated, you would never guess it from reading her poems. Her imagination, animated by a generous life-force, is at once passionate and tribal. Narrative is her preferred mode, leavened by meditation. She remembers her childhood in rural Michigan, evokes her Slovak ancestors, immerses herself in the American Indian culture of the Southwest, explores the mysteries of flesh, tries to understand the bonds of family, race, and sex. In the course of her adventures she dares to confront, as a sentient being, the overwhelming questions by which reason itself is confounded: Who am I? Why am I here? Where am I going? . . .

Carolyn Forché's poems give an illusion of artlessness because they spring from the simplest and deepest human feelings, from an earthling's awareness of the systemic pulse of creation. The poems tell us she is at home anyplace under the stars, wherever there are fields or mountains, lakes or rivers, persons who stir her atavistic bond-sense. . . .

She listens. At Justin Morrill College, an experimental residential branch of Michigan State University, where five years ago the earliest parts of *Gathering the Tribes* were conceived, she began her avid consumption of languages. Now she studies Russian, Spanish, Serbo-Croatian, French and Tewa (Pueblo Indian), listening beyond grammar for the secret texts. She acknowledges a primal sense of the power of words. The power to "make words"— in the mouth, in the heart, on the page—is the same to her as to give substance. Aiming at wholeness, strength, and clarity, she works at language as if it were a lump of clay or dough in her hands. In her search for poetry, in her effort to understand it, she has bent over the potter's wheel, climbed mountain ranges, ventured into the Mojave Desert. . . .

The places dearest to her include the south Michigan heartland where she was raised, Truchas and the Pueblo village of Taos in New Mexico, the Washington coast, and the Okanogan region of southern British Columbia. Anna, Alfansa, Teles Goodmorning, the dulcimer maker, Rosita, Jacynthe, the child born in the Okanogan, the monks of the mountain abbey, and Joey, a first love, who went off to study for the priesthood, are all characters clearly drawn from life and attached to specific locations. One might say that they are embodiments of the reality of their settings.

If I am right in supposing that "Year at Mudstraw," "Taking Off My Clothes," and "Kalaloch" are among the last poems written for this book, it would appear that Forché is moving toward a tauter line, packed with incisive detail, and a firmer dramatic structure than is evident in her earlier narratives. . . .

I have little doubt that the poem in *Gathering the Tribes* that will be most discussed, quoted, and anthologized is "Kalaloch" (pronounced ka-lā'-lok), an almost faultlessly controlled erotic narrative of 101 lines. In its boldness and innocence and tender, sensuous delight it may very well prove to be the outstanding Sapphic poem of an era.

<div style="text-align:right">Stanley Kunitz. Foreword to Carolyn
Forché. Gathering the Tribes (New Haven:
Yale University Press, 1976), pp. xi–xiv</div>

Carolyn Forché's second book of poems is interesting both because Forché is a talented poet—her first book, *Gathering the Tribes,* was a Yale Younger Poets selection—and because it tackles the political subject matter I [have been] arguing is so uncongenial to young poets. The first section, dedicated to the memory of Oscar Romero, the murdered archbishop of San Salvador, is set in El Salvador, where Forché lived for two years and worked as a journalist. Other poems are addressed to old friends from the working-class Detroit neighborhood of Forché's childhood: one has become a steelworker haunted by memories of Vietnam; another, with whom Forché had shared adolescent dreams of travel and romance, lives with her husband and kids in a trailer. Elsewhere in the poems we meet a jailed Czech dissident, the wife of a "disappeared" Argentine and Terrence Des Pres, author of *The Survivor,* a study of the death camps. This is strong stuff, and the excited response *The Country Between Us* has already provoked shows, I think, how eager people are for poetry that acknowledges the grim political realities of our time.

At their best, Forché's poems have the immediacy of war correspondence, postcards from the volcano of twentieth-century barbarism. . . .

Testicles are "crushed like eggs," rats are introduced into vaginas, José waves his bloody stumps in the air, Lil Milagro is raped and forced to defecate in public. "There is nothing one man will not do to another," Forché tells us. So shocking are the incidents reported here—so automatic is our horror at a mere list of places where atrocities have occurred ("Belsen, Dachau, Saigon, Phnom Penh")—that one feels almost guilty discussing these poems as poems, as though by doing so one were saying that style and tone and diction mattered more than bloody stumps and murdered peasants and the Holocaust.

This unease, though, should not have arisen in the first place, and it points to an underlying problem: the incongruity between Forché's themes and her poetic strategies. Forché's topics could not be more urgent, more extreme or more public, and at least one of her stated intentions is to make

us look at them squarely. And yet, she uses a language designed for quite other purposes, the misty "poetic" language of the isolated, private self. She gives us bloody stumps, but she also gives us snow, light and angels. You have to read "The Island" several times, for instance, to get past the exotic tropical scenery, the white dresses, the "seven different shawls of wind," the mist that is like bread and so forth, and realize that this is a poem of homage to Claribel Alegría, a heroic woman whom Forché would like to resemble, and that Claribel is telling Forché not to give up hope for El Salvador. At least, I think that's what it's about. . . .

Whether or not one admires Forché for stressing the intensity of her responses to the sufferings of others—many readers, I should point out, do not share my discomfort with this emphasis—the intensity is vitiated by the inadequate means by which it is conveyed. It is embarrassing to read that Forché goes "mad, for example,/in the Safeway, at the many heads/of lettuce, papayas and sugar, pineapples/and coffee, especially the coffee." It trivializes torture to present it in terms of lunch:

> The *paella* comes, a bed of rice
> and *camarones,* fingers and shells,
> the lips of those whose lips
> have been removed, mussels
> the soft blue of a leg socket.
> ("In Memory of Elena")

It is wildly histrionic—and slanderous, too—to accuse politically moderate human-rights activists of deriving masturbatory pleasure from torture reports:

> they cup their own parts
> with their bedsheets and move
> themselves
> slowly, imagining bracelets
> affixing
> their wrists to a wall
> ("The Return")

Does Forché think we read her poems as pornography?

It is not enough—this too may be a minority opinion—to dedicate one's poetry to the defeat of the torturers, to swear that

> I will live
> and living cry out until my voice is
> gone
> to its hollow of earth, where with our
> hands and by the lives we have

chosen
we will dig deep into our deaths.
("Message")

The boldness of the promise is undermined by the commonplace rhetoric ("hollow of earth" for "grave") and woolly syntax (the hands and lives dig into our deaths *after* the voice is dead?).

On the other hand, to make such a promise is not nothing, either. If poetry is to be more than a genteel and minor art form, it needs to encompass the material Forché presents. Much credit, then, belongs to Forché for her brave and impassioned attempt to make a place in her poems for starving children and bullet factories, for torturers and victims, for Margarita with her plastique bombs and José with his bloody stumps. What she needs now is language and imagery equal to her subjects and her convictions. The mists and angels of contemporary magazine verse are beneath her: she *has* seen too much, she has too much to say. Of how many poets today, I wonder, could that be said?

Katha Pollitt. *The Nation.* May 8, 1982,
pp. 562–64

Is the country between us a medieval sword laid down between sleeping lovers on a soft pine forest floor like a steely oath of obdurate sublimation? Is it a country you would have to visit in order to be where I now am on the other side of the frontier? (Until you understand the horror, the horror, the cold chills, the sweat and oil, all that I saw, that I went through, we'll never be able to communicate with each other again.) Or, is it by any chance a country we implicitly share—roads groping from your flesh to my flesh? Or perhaps our territory . . . both . . . and . . . the sacramental conjunction of bread?

Whatever, between *us.* It is not only the lyric plurality of the pronoun that is important here, where two or three are gathered together, but its objective case—implying a sort of paralysis of the communal will, a screen (like that between the living and the dead) through which we (whoever we are) would have to burst with enormous energy in order to come out into the nominative light of existential affirmation. And were we fully to become it, whatever country (including the pun embedded there) formerly kept us apart would contain us whole, all of us, leaven of a deeper plenitude than want could possibly be aware of.

At this particular moment in history the country between us happens to have an incredibly suggestive name: El Salvador, where these bones and this flesh (as Aquinas said)—that body, hers, his—are being continuously broken and blood shed beyond the power of the outraged earth to absorb it. El Salvador, that is, where masses are hourly said over massacred fragments of our common humanity.

> Those who commit themselves to the poor have to be open to
> the same destiny as the poor; and in El Salvador we already

know the destiny of the poor: to disappear, to be captured, to
be tortured, to reappear as corpses.

The man who said these words out loud above a whisper, who lived to be
himself the language of truth incarnate, was shot saying mass on March 31,
1980. It is to him, Monsignor Oscar Romero, that Carolyn Forché dedicates
the first section of this, her second book. A section of her life for the first time
publicly located in time and space: "In Salvador, 1978–80," she calls it. . . .
 We waited decades to hear how Akmatova waited outside Leningrad
Prison for months during the Yezhov terror. Carolyn Forché's poems from
El Salvador reach us while events duplicate to those she describes are still
taking place. It's not as though we were waiting for faded or blurred records
of ignominious naked genocide to be salvaged from history and released like
a nightmarish family album. The film these days is smuggled out, processed,
and wired almost immediately. Those maimed, violated bodies seem to be
falling and decomposing before our very eyes severed heads of youths falling,
as it were, on our breakfast plates. With words alone Carolyn Forché bril-
liantly records such characteristic dismemberments.

<div style="text-align: right">

Judith Gleason. *Parnassus*. 10,
Spring–Summer, 1982, pp. 9–12

</div>

The Spring 1982 publication of *The Country between Us* by Carolyn Forché
has stirred the old cauldron, painstakingly labeled in our culture, "political
poetry." The book has already made literary history, winning the di Castag-
nola and Lamont prizes, going into its second printing in six weeks, with
reviews in *Time* and *People Magazine* and other non-literary "mainstream"
publications. As one poet put it, *The Country between Us* is close to becom-
ing, unlike any poetry book of our times, a bestseller. In a culture noted for
its disdain of poetry, and, among its poets, a disdain (in regards to subject
matter) of the political, this is a phenomenon that cannot be readily
dismissed. . . .
 It is against [her] brilliantly perceptive description of contemporary po-
etry's dominant aesthetic that Pollit . . . discusses *The Country between Us*.
But in doing so I think she misses a great point of the book. Forché's book
is not a book of "political poetry," at least not in the way that concept is
normally held. As Forché herself has said, "My poetry is no more political
than that of a poet who is celebrating an afternoon as the sun sets in the
Mediterranean. It's foolish to say because you're talking about poor people,
or because your poetry celebrates or gives witness to the plight of the poor,
that it's political. That is the perception of the right. The *status quo* never
views itself as political, so it's only others, others in opposition or in striking
contrast, who are viewed as political." And she has said it the other way:
"'Political poetry' often means the poetry of protest, accused of polemical
didacticism, and not the poetry which implicitly celebrates politically accept-
able values. . . . There is no such thing as a nonpolitical poetry." . . .

As everyone knows poetry *matters* in Latin America; it is the voice, or one of them, of the people. Were Forché's Salvadorean "educators" ignorant of the impoverished status of poets in the States, or is this book not, in fact, a message to us about the only path our culture grandly opens to poets: that city walk-up in dead of winter where personal redemption from our corrupt and evil country is silence, insanity, suicide.

I am taking liberties. The book, in our tradition at least, must stand on its own. Hints of the turmoil and sense of inadequacy of being "just a poet" in witness to such a place and ordeal *are* strewn throughout the poems—that is, the story continues, even in Salvador, of the Northamerican wanderer seeking her work, her words, her world. "The Colonel," the most oft-quoted and reprinted poem of the book is, interestingly, set in prose and the witness breaks down midpoint when the Colonel spills a sack of human ears onto the dinner table: "There is no other way to say this." Who is it that is breaking down here? Not the witness, but the poet with the burden of her U.S. aesthetics. Who is she apologizing to? First and foremost, to us, her fellow poets (or is it to her teachers and critics who will disapprove?). The opening lines of the piece are also addressed to us, I think. "What you have heard is true. I was in his house," as if a poet should not have been, as if to answer her poet friends who warned her about this. The ears "are like dried peach halves," the poet's only simile here and one I think that undeniably authenticates her experience. *We* need this simile, for how many of us have had the experience? It brings the ears alive for us, just as the one dropped in the glass of water by the Colonel "came alive." And even he addresses the poet's "problem" as he performs his heinous act. "Something for your poetry, no?" . . .

For me, Forché's book is "political"—to try here to understand, to perhaps even claim the word—in that it is the female voice in many ways of my generation, representative of a vast number of women who are living outside of, and have been for some time now, the lives we were programmed for, the lives of our mothers. This is a poetic voice from which we have not heard much yet. The powerful, revolutionary female voice of our generation, besides that of popular music, has been the inestimably important lesbian-separatist one. (The majority of other well-published women poets write from the conservative, domestic stance Pollit describes.) Forché is clearly a nonseparatist feminist, the one we are familiar with in our music, though strangely, not our poetry: very female, erotic, sexual, mobile, independent, exploratory, nondomestic, childless (a nagging awareness in the book typical of the many still childless women who came to puberty with the advent of the Pill). "In what time do we live that it is too late to have children?" ("Selective Service"), a woman traveling alone, the hunter rather than the hunted, a very lonely *caminante*—but not a loner and not a separatist. . . .

The Country between Us is the work of a late-twentieth-century-educated-and-trained Midwest poet. The work does contain many of the characteristics and values Pollit describes of our contemporary literary form. Forché is working within the current "tradition," except perhaps for subject

matter. And perhaps it is that subject matter—in both of her books—along with her wonderfully wild sensuous energy, her commitment to the present rather than the past, her subliminal ethic of action, that causes her always to transcend the static, "fascist" form. How true her language is to the "real" voice and the land and experience from which she comes is a question perhaps time will help to answer (though time is not necessarily free of the coercion of culture). But this poet, this extraordinary woman has already gone further than most ever will in trying to authenticate her voice, immersing herself and her language in the "real" and very dangerous world. She has used her verbal training like a guerrilla uses intimate knowledge of the land, taking the aesthetic jammed into her as a young working class woman gone to college and jamming it right back into the real, the political. This is a poetry of terrible witness, the strains of our villainies on the language and ethical constructs undoubtedly show. Thus the phrase, "the country between us."

<div style="text-align: right">

Sharon Doubiago, *American Poetry Review*.
January–February 1983, pp. 35–36, 39

</div>

What is. . . . "allegiance to Art?" And what, given the circumstances, is sensationalism? I think, in the case of Carolyn Forché's second book, *The Country between Us,* the poet undergoes and records a journey that reconciles the political with the artistic rather than severs that vital connection—for, finally, there is nothing sensationalistic about setting down the facts of a dinner party. If one argues that such facts remain sensationalistic in the context of poetry it may be because readers no longer expect facts from poems. . . . And if this is so isn't one really arguing for that "inward" aesthetic that Hans Magnus Enzensberger criticizes? And isn't. . . . such an aesthetic designed to limit poetry in its subjects? Therefore, isn't it, really and finally, another kind of censorship?

Forché's position in the poems about El Salvador is admittedly partisan. She is, as are many of the people *in* El Salvador, against the military, against the government, the landowners, the mockery of "land-reform," and against all U.S. aid, especially military aid. But such partisanship seems, under the conditions now apparent in that country, not Leftist so much as simply decent and human, and describable in many ways as a concern for the poet's friends in El Salvador. . . .

Forché, in discovering another country, discovers herself—discovers, too, how American she is ("a country you never left"). Part of that discovery is the discovery of limits. It is a mature and brilliant act when Forché relinquishes her poem and allows Josephine to speak, when the poet becomes a listener as well as a speaker. For one of the ironies about the poems is the learning process, a reciprocal or dialectical process that resembles and actualizes the paradigm of Paulo Freire's in *Pedagogy of the Oppressed,* a book that Forché acknowledges as an influence on her work and on her life. Moreover, the irony of learning in the poem is positive just as the poet learns to

be more human from Josephine. Josephine herself, in speaking of what most torments her, becomes a poet. The poem's relationships are unshakably egalitarian. And so it is proper that Forché listens, for the duty of a poem like this is to witness and report, to detail a particular misery, to try to rescue some of the dead from an almost certain oblivion.

<div align="right">Larry Levis. American Poetry Review.
January–February 1983, pp. 10–11</div>

Forché had already created a sensation among poets by describing her experience in war-torn El Salvador and calling for "a poetry of witness" more accountable than ever before to "the twentieth century human condition." *The Country between Us,* Forché's second volume of poetry, has reached a surprisingly large audience, and apart from the book's topical interest, one can sense in its powerful impact on readers and hearers an important argument for poetry. Initial commentary on the book evokes an old fear, the New Critics' fear of the corrupting influence of politics on the purity of the poem's language. Actually, Forché's book goes beyond the question "Can a good poem be political?" to some far more significant and fearful ones: Is poetry adequate to a century of holocaust? Can an intensely personal language and vision of things suffice? Can poetry help us? (*Are* we still human? some have asked.) *The Country between Us* possesses one of the severest orderings of poems of any collection in recent memory, and an examination of its three-part structure will help us ponder some of these questions. The book embodies the process by which Forché became a survivor who somehow found the courage and honesty to make of the atrocities she witnessed the test and education of her moral will. Her personal transformation becomes in the reading of the book an exemplar for our collective response. Above all, the book will suggest what a poetry of witness might involve in a time such as ours. *The Country between Us* enacts with intense drama and sensuous immediacy the agony of human survival in an age of mass death, and as such it is the compelling story for our century's ninth decade.

<div align="right">John Mann. American Poetry. 3, Spring,
1986, pp. 51–52</div>

In the four years since their publication, the poems of Carolyn Forché's *The Country between Us* have been identified with a renewed debate concerning the claims, the merits, and the possibilities for "political poetry" in contemporary America. They have been taken as an occasion for critical pronouncements on the question of "mixing art and politics" and have been widely praised as well as strenuously criticized. The apparent plurality of critical opinion surrounding *The Country between Us* would seem to suggest that the question of poetry's relationship to politics is once again productively open, but in fact it masks a more disturbing consensus: whatever their merit, these poems belong to a specialized genre—"political poetry." They are to be evaluated for their ability to "reconcile" or "balance" impulses generally

regarded as contradictory: the personal or lyrical on the one hand, the political or engaged on the other. I see several problems with such a notion of political poetry. First, it implies that certain poems are political while others (the majority) are not, and it thus functions to marginalize those poems regarded as political without yet having explored the social and political constitution of all literary discourse. More importantly, such a notion of political poetry adopts unquestioningly an already reified conception of the social; it is incapable of helping us to think of relationships between individuals and society in terms other than those of opposition. As a result, it replicates the split in contemporary ideology between private and public. That subjects may be socially constituted is a question usually not asked. Finally, this taken-for-granted definition of political poetry is not a *historical* definition: it fails to consider the ways in which lyric poetry, since the Romantics at least, has been constituted *in opposition* or reaction to dominant modes of social and political discourse. Severed from history, the lyric poet becomes an isolated voice crying out in the empty wasteland of modernist despair: politics becomes mere psychologism and the struggle to wrest freedom from necessity is rewritten as a purely individual quest. The compulsion to read Forché's poetry as political in this narrower sense, then, has resulted in readings that distort and diminish the real accomplishments of the poems while undermining any claim they, or any contemporary poems, have to be political in any deeper sense.

In the autobiographical "El Salvador: An Aide-Memoire," Forché herself has provided us with a text that asks to be read as both a preface to and a theoretical defense of the project undertaken in *The Country between Us.* "Aide-Memoire" is pervaded by an uneasiness regarding the critical terms in which the poems have been received and discussed. In response to critics' classification of the poems as "political poetry," Forché writes: "I suspect that underlying this . . . is a naive assumption: that to locate a poem in an area associated with political trouble automatically renders it political." The essay, in fact, concludes with an enumeration of several of the more problematic questions concerning the theoretical status of poetry as political—suggestions, perhaps, of ways in which the political constitution of all poetry might more productively be explored. What emerges is the notion that there are really two different senses of the term "political." The first, more limited sense sees "politics" as the largely institutionalized, two-dimensional discourse of political programs and "ideologies" in the official sense; the second, invoked in response to the confinement of the first, defines politics far more broadly and flexibly as any action or discourse carried out in a social world. These two competing definitions are made dramatically clear in the juxtaposition, on the final pages of "Aide-Memoire," of the following two statements. First, Forché's own allegation that "there is no such thing as nonpolitical poetry"; second, a statement from Hans Magnus Enzensberger's "Poetry and Politics": "The poem expresses in an exemplary way the fact that it is not at the disposal of politics: this is its political content." Where most American

readers of Forché seek to reduce the political to the more limited of these two senses, Forché and Enzensberger attempt to open up the notion, to make "the political" again the site of an ongoing, daily contestation.

Michael Greer. *Centennial Review.* 30, 1986, pp. 160–62

FORNÉS, MARÍA IRENE (UNITED STATES) 1930–

In the spring of 1965 I directed María Irene Fornés's *Successful Life of 3* for the Open Theatre. The other members of the company and I had been unhappy with a production of the play that the group had done earlier, and felt in need of some principle of performance and presentation that would do justice to Miss Fornés's imagination and dramatic powers. And so I queried myself about just what kind of imagination she had and about her particular strengths as a playwright, and I thought I knew. She was "absurd," (the term was still new enough for you to think it told you something) blessed with a sense of the incongruities and discontinuities of language, zany, fruitfully illogical and tuned in to social inanity as a kind of radical parodist. All of which advanced textbook notions were of course entirely useless for knowing how to stage her work.

And then something happened during an early rehearsal, one of those windfalls which a director had better be able to recognize, that gave me the clue I needed. In the scene in the doctor's office at the beginning of the play, one of the men is ushered into an inner room; we assume he is seeing the doctor but learn, when he comes back, that he has "banged" the nurse who led him in. The script merely indicates that they return, but our actors came back instantly, which suggested that the act had been consummated with blinding, unheard-of speed. It struck us all as wonderfully funny and, more than that, as being exactly true to the way Irene Fornés organizes her stage time and, by extension, her stage space. Things happen outside chronologies and beyond known boundaries; the center of the action is sometimes in language, sometimes in gesture or sheer *mise-en-scène,* but always in a dimension unlocatable by any of our ordinary means of determining the whereabouts of what we consider truths.

This may be simply to say that Miss Fornés is a dramatist of almost pure imagination (as pure as imagination can be in an age of mixed media and life styles contending with those of art) whose interest in writing plays has little to do with making reports on what she's observed, in parodying society or behavior, or in "dramatizing" what already exists in the form of ordinary emotion or experience. But if this is a simple thing to say about her, it isn't any less important, because there are exceedingly few playwrights, particularly in America, of whom it can be said. Our genuine avant-garde is

for the most part heavily implicated in the uses of the stage for therapy or social action, while our surrogate avant-garde goes on turning out its little "human" playlets about people who can't communicate, and so on.

In any case, we staged *Successful Life of 3* as a lucidly demented paradigm of human relationships, doing it as though it were a movie (Keaton, the Marx Brothers, the Keystone Kops: nothing to be imitated, but a spirit to assimilate) with the film's freedom precisely from the oppressions of finite time and space. We speeded up the action to a whirlwind pace, eliminating all the integuments, the texture of verisimilitude and logical connection which, to be sure, Miss Fornés had excluded as part of her principle of writing but which conventional theater wisdom would have put right back in. At other times we slowed things down to a crawl, violently exaggerating that emptiness, that duration in which nothing *active* happens, which the same received wisdom would have regarded as fatal to theatricality. In other words, we staged the play as it had been written, only we had to find out this manner for ourselves; like any true and confident artist, Miss Fornés doesn't tell you what she is doing, she does it.

Successful Life of 3 remains one of my favorites among Irene Fornés's works, along with *Dr. Kheal* and *A Vietnamese Wedding*. I admire to one major degree or another each of the other four plays in this volume—*Molly's Dream* and *The Red Burning Light* are especially interesting for the new density and range of the former and the surreal political intelligence of the latter—but the three works I mentioned above seem to me the essential products of Miss Fornés's dramatic imagination so far.

All three plays exhibit in very different ways her occupation of a domain strategically removed from our own not by extravagant fantasy but by a simplicity and matter-of-factness that are much more mysterious. *Successful Life of 3* organizes the "story" of a shifting triangle whose members behave much the way we do—once our behavior has been stripped of rationalizations. The play abstracts behavior patterns from ordinary life, removing the illusion of continuity, the sense of fitness which we too often suppose to be truth itself. *Dr. Kheal* is an exercise in plausibility, a seeming parody of pedagogy but in fact a brilliant investigation of the myths of knowledge itself. Reminiscent (but by no means derivative) of the professor in Ionesco's *The Lesson,* its single character is a lecturer for whom "poetry is for the most part a waste of time, and so is politics . . . and history . . . and philosophy"—in short, everything sanctified—and who proceeds to offer a wholly new epistemology, logical, convincing, aggressive, far-seeing . . . and entirely unreal.

A Vietnamese Wedding is the play of Irene Fornés which least resembles conventional drama, even of a radical kind, yet it is also the quietest and seemingly most artless of all. Constructed in the form of a re-enactment of a traditional Vietnamese betrothal and marriage ceremony, it calls upon members of the audience to participate in its rites, without having to learn any roles or indeed to "act" at all, and upon the rest of the spectators to

imagine themselves present at something historical and actual. Yet from this sober summons to reality, so lacking in the superficies of drama, we experience a strange displacement; in imitating an exotic social custom and limning it as though it were an actual event, we find ourselves in the very heart of the country of the dramatic. For theater is the imagining of possible worlds, not the imitation of real ones, and what could be more unreal to us than a ceremony like this play? In enacting it we learn not how other people live but how we are able to imagine ourselves as others, which is what drama is about. If María Irene Fornés had given us nothing else, it would be a remarkable thing to have accomplished. But of course she has given us much more.

> Richard Gilman. Introduction to María Irene
> Fornés. *"Promenade" and Other Plays*
> (New York: Winter House, 1971), pp. 1–3

Fornés's plays are whimsical, gentle and bittersweet, and informed with her individualistic intelligence. Virtually all of them have a characteristic delicacy, lightness of spirit, and economy of style. Fornés has always been interested in the emotional lives of her characters, so human relationships play a significant part in the plays (*The Successful Life of 3, Fefu and Her Friends*). She apparently likes her characters, and often depicts them as innocent, pure spirits afloat in a corrupt world which is almost always absurd rather than realistic (*Fefu and Her Friends* is the exception). Political consciousness is present in a refined way.

Fornés's characters have rich fantasy lives (*Tango Palace, Aurora*) which tend to operate according to their own laws of time and space. Small wonder the structure of playacting frequently shapes her plays (*Tango Palace, Red Burning Light, A Vietnamese Wedding*). And if the entire play isn't constructed as an "entertainment" there is, nonetheless, always some sort of inner theater or "turns" for the actors (*Molly's Dream*).

Sometimes the characters parody film stars or scenes from films; at other times the dramatic structures spring from American "popular" forms such as vaudeville, burlesque, and musical comedy. High camp, too, provides much of the fun in Fornés's comedies, which reflect an idiosyncratic wit. There is also plenty of word play and reversals of cliches and conventions (*Dr. Kheal*).

Frequently, however, the warmth and good humor in these plays is counterpointed by large doses of irony or melancholy (*Promenade*). For Fornés's character's relationships just don't seem to turn out the way they do in the movies (*Molly's Dream*). Human nature has its way of intruding, and games and playacting end all too quickly. . . .

Fefu and Her Friends has the delicacy of tone and economical style of Fornés's earlier plays; the keen intelligence has always been there. What makes this play stand apart—and ahead—of the others is, more than the inclusiveness of the experiment in text and performance, the embodiment of a deeply personal vision.

It is encouraging to find María Irene Fornés speaking in a more revealing voice. She is an immensely intelligent and witty woman who, up until now, has only teased us with her intelligence. Though not a few of her non-realistic plays—*The Successful Life of 3* and *Promenade,* in particular—are stunning stylistic realizations, this new move into realism reflects a generosity of spirit and self-assuredness that makes its presence more commanding than the others.

Fornés is one of the few contemporary experimenters in play writing who doesn't suffer from self-indulgence, and she has a refinement of technique and expression that most others lack. If she continues in this more personal approach to drama, we have much to look forward to.

<div style="text-align: right">

Bonnie Maranca. In Gautam Dasgupta and
Bonnie Maranca, eds. *American
Playwrights: A Critical
Survey* (New York: Drama Book Specialists,
1981), pp. 53–54, 62–63

</div>

A clown tosses off witty repartee while tossing away the cards on which his lines are written; a love scene is played first by actors and then by puppets they manipulate; the audience sits in a semicircle around a woman desperately negotiating with invisible tormentors: the plays of Maria Irene Fornés precisely address the process of theater, how the authority of the word, the presence of the performer, and the complicity of the silent spectator articulate dramatic play. Throughout her career Fornés has pursued an eclectic, reflexive theatricality. *A Vietnamese Wedding* (1967), for instance, "is not a play" but a kind of theater ceremony: "Rehearsals should serve the sole purpose of getting the readers acquainted with the text and the actions of the piece. The four people conducting the piece are hosts to the members of the audience who will enact the wedding." In *Dr. Kheal* (1968) a manic professor addresses the audience in a form of speech torture; the stage realism of *Molly's Dream* (1968) rapidly modulates into the deliquescent atmosphere of dreams. *The Successful Life of Three* (1965) freezes the behavioral routines of a romantic triangle in a series of static tableaux, interrupting the actors' stage presence in a way that anticipates "deconstructive" theater experiments of the 1970s and 1980s. And the "Dada zaniness" of *Promenade* (1965; score by Al Carmines)—a musical parable of two Chaplinesque prisoners who dig their way to freedom—brilliantly counterpoints Brecht, Blitzstein, Bernstein, and Beckett, viewed "through Lewis Carroll's looking-glass." . . .

Despite their variety, Fornés's experiments share a common impulse: to explore the operation of the mise-en-scène on the process of dramatic action. Rather than naturalizing theatrical performance by assimilating the various "enunciators" of the stage—acting, music, set design, audience disposition— to a privileged gestural style encoded in the dramatic text (the strategy of stage realism, for instance), Fornés's plays suspend the identification between the drama and its staging. The rhetoric of Fornés's major plays—*Fefu and Her Friends* (1977), *The Danube* (1983), and *The Conduct of Life* (1985)—is sparked by this ideological dislocation. At first glance, though, to consider

Fornés' drama as "ideological" may seem capricious. . . . [But] to constrain theatrical ideology to the "thesis play"—as though ideology were a fixed body of meanings to be "illustrated" or "realized" by an "Idea Play" or an "ideological drama"—is to confine ideology in the theater too narrowly to the plane of the text. For like dramatic action, theatrical action—performance— occupies an ideological field. Performance claims a provisional "identity" between a given actor and dramatic "character," between the geography of the stage and the dramatic "setting," and between the process of acting and the play's dramatic "action." The theater also "identifies" its spectator, casts a form of activity within which subjective significance is created. In and out of the theater, ideologies function neither solely as "bodies of thought that we possess and invest in our actions nor as elaborate texts" but "as *ongoing social processes*" that address us, qualify our actions with meaning, and so continually "constitute and reconstitute who we are." . . .

Despite the success of *Fefu and Her Friends* and of several later plays— *Evelyn Brown* (1980), *Mud* (1983), *Sarita* (1984)—addressing gender and power issues, Fornés refuses to be identified solely as a "feminist" play- wright. Spanning the range of contemporary theatrical style (experimental theater, realism, "absurd" drama, musical theater, satiric revue), Fornés's drama resists formal or thematic categorization. What pervades her writing is a delicate, sometimes rueful, occasionally explosive irony, a witty moral toughness replacing the "heavy, slow, laborious and pedestrian" didacticism we may expect of "ideological" drama. Brecht was right, of course, to encour- age the members of his cast to play against such a sense of political theater: "We must keep the tempo of a run-through and infect it with quiet strength, with our own fun. In the dialogue the exchanges must not be offered reluc- tantly, as when offering somebody one's last pair of boots, but must be tossed like so many balls." Like Brecht's, Fornés's theater generates the "fun," the infectious sophistication of a popular art. Juggling the dialectic between "theater for pleasure" and "theater for instruction," Fornés is still—earnestly, politically, theatrically—"playing games."

W. B. Worthen. In Enoch Brater, ed.
Feminine Focus: The New Women Playwrights (New York: Oxford University Press, 1989), pp. 167–68, 180–81

In marked contrast to Shepard, and regardless of the number of Obie awards she collects, [María Irene] Fornés remains on the fringe, known primarily to feminist scholars and to those dwindling audiences who will still pay the price of a ticket to be offended, bemused, and befuddled by the experimental theater experience.

This discrepancy is puzzling for several reasons. First, Shepard and Fornés are part of a handful of survivors of the alternative, experimental theater of the 1960s and 1970s and thus share a history in the American avant-garde. Second, both have developed into skilled craftspersons whose plays reflect at least some similar social, political, and formal concerns.

Fornés apparently believes that confused, hostile responses to her work are the inevitable result of her continuing desire to engage in radical experiments with form. In a recent interview, she stated: "I realized that what makes my plays unacceptable to people is the form more than the content. My content is usually not outrageous. I think it's mild!" Although her argument may be a bit disingenuous, it contains at least a grain of truth. . . .

Ultimately, however, Fornés's argument about form is not entirely convincing. With the possible exception of *The Danube,* her most recent plays, including *Fefu and Her Friends, Mud, The Conduct of Life,* and *Sarita,* are quite straightforward. Yes, *Fefu* requires a peripatetic audience, and photographic freezes punctuate the action of *Mud,* but, in general, these plays conform to relatively linear patterns of development that should be easily understood even by unsophisticated spectators. Perhaps the thematic content of her most recent work is *too* clear; because she is regarded in many circles as a feminist playwright, perhaps Fornés is being deliberately disingenuous when she insists that the mass audiences that currently flock to Shepard's latest plays and films reject her work on the basis of form rather than content. . . .

Although Fornés resists ideological labels and refuses to align herself with any particular feminist position, it is impossible to ignore the explicit critique of patriarchy in *Fefu and Her Friends.* This critique is general, symbolic, and tends more toward radical feminism than do her most recent plays, but it is eminently clear that Julia's madness and genuine physical and mental anguish are the consequences of psychic violence perpetrated on all women who resist the unwritten rules of patriarchy. Mae, in *Mud,* and Sarita, in *Sarita,* suffer similar fates. Mae is destroyed by the insatiable demands of Lloyd and Henry, and Sarita, perhaps a victim of internalized oppression, destroys herself by maintaining a destructive relationship with the physically and emotionally abusive Julio. Violence against women remains the dominant issue, but in both of these plays, the radical feminist critique is considerably modified by the influence of class and ethnicity.

Regardless of specific ideological intent, Fornés's plays deconstruct the dynamics of gender hierarchy with profoundly disturbing results. Her images—violent, unsentimental, and unremittingly pessimistic—recall a statement by Marguerite Duras, who wrote: "I think 'feminine literature' is an organic, translated writing . . . translated from blackness, from darkness. Women have been in darkness for centuries . . . and when they write, they translate this darkness." Duras goes on to say that genuine women's writing is a new way of communicating; it uses a new language. There are, she admits, many female plagiarists—women who write to please men or in imitation of men, but this is not authentic feminine literature. True feminine literature "is a violent, direct literature."

<div style="text-align: right">

Catherine A. Schuler. In June Schlueter, ed.
*Modern American Drama: The Female
Canon* (Madison, New Jersey: Fairleigh
Dickinson University Press, 1990),
pp. 218–19, 226–27

</div>

FRAME, JANET (NEW ZEALAND) 1924–

[*The Lagoon*] is a collection of short stories with obvious faults but still more obvious merits. Miss Frame is a writer of considerable promise: with sympathy and passion and humor she sweeps away the mists of one's imperceptiveness showing loneliness and fear and despair, so that reading her book is an experience that cannot leave one unmoved. The framework of her stories is narrow—home, school, boarding-house, mental hospital—but within these limits she finds almost all the elements of human suffering and tragedy, and she writes of them unsentimentally, but with great compassion and understanding. (She reminds me in this of the work of Denton Welch, a writer with whom she has a distinct affinity.) These are her particular merits.

Her literary style, however, though at times powerful and beautiful, does not always match the subtlety of her perceptions. Too often she lapses into an uncontrolled, rather infantile babbling. . . . Miss Frame gives the impression that she has allowed herself to be submerged by her experience instead of exercising the controlled selection of detail essential to satisfying artistic form. Yet at times this rapid formlessness is exact and appropriate in conveying the apparent irrelevance of childish thought, for example, or in "Jan Godfrey" where the experience of a disintegrating personality is precisely communicated.

Patricia Guest. *Landfall.* June, 1952,
pp. 152–53

[*Faces in the Water*] is a record of life, though that is too big a word, in institutions for women "mentally disturbed," or more sweetly, for the ease of their families, those who had had "nervous breakdowns." All is there, in this beautifully written book: the miserable food, frightful sleeping conditions, shocking scarcity of doctors, and the horrid brutality of nurses. Yes, it is always fascinating to read of the insane—but there is a deeper exercise to a book which treats of them not poetically or comfortably, but as they are and as they are treated.

You cannot choose from Miss Frame's book outstanding cases (I hate that word, "cases"). Almost most terrible to me is the lot of those considered cured and able to return to their pre-institution lives "if their people will have them." But in so many instances, their "people" will not have them—oh, the disgrace of acknowledging a relative who had been in an "asylum"! So the unwanted cured ones must stay on, for the rest of their lives.

I cannot sort out the individuals—I suppose from some sort of desire to sleep undisturbed. But there is one I cannot banish; she is a dwarf, though not deformed, who had been in the institution from the time she was twelve until, at the time the book was written, she was twenty-one. She was cheerful and busy—almost everybody had to be busy—but there was something she loved and waited for. It came over the radio—a song: *Some enchanted evening you will see a stranger. . . .*"

Dorothy Parker. *Esquire.* October, 1961,
pp. 56–57

Scented Gardens for the Blind, by the New Zealand writer Janet Frame, is the most remarkable novel that I have read in a long time. If it is not a work of genius (I feel that all such heady possibilities should be kept in pickle for a few years), it is surely a brilliant and overwhelming tour de force. I was held captive by it from the first page to the last, as they lightly say of thrillers. Although it is obviously not a novel for everybody, it is assuredly for anybody who values in the novel the qualities more often associated, in our diminished time, with poetry: intellectual complexity, ornate and figurative language, intense moral seriousness.

This amazing novel consists of three strands, in cycles of successive chapters. . . . For fifteen marvelous chapters, five devoted to each character, [the] symphony of mad voices goes on, like the blending of three different pitches of derangement on the heath in *King Lear.* Then it is all abruptly resolved in the sixteenth and last chapter, given to Dr. Clapper. All the voices, he reveals, are those of Vera Glace, a spinster of sixty who has been a patient in his asylum since she was mysteriously struck dumb thirty years before. Another patient named Clara Strang looks after her. For a moment we feel a pang of disappointment, a sense of being cheated, as we do at the end of William Golding's *Pincher Martin* when we discover that Martin died instantaneously and that all his resourceful survival has been imaginary. . . .

It is hard to guess at the influences behind this amazing book. Lewis Carroll, primarily. Certainly Golding, probably Djuna Barnes (if Dr. O'Connor wrote a novel, this would be it), possibly Virginia Woolf, perhaps William Faulkner, maybe even John Hawkes. It remains a unique and unclassifiable work. I have not read Miss Frame's earlier books, and I am almost afraid to start.

<div align="right">Stanley Edgar Hyman. <i>The New Leader.</i>
August 31, 1964, pp. 23–24</div>

This finely imaginative novel [*The Adaptable Man*] presents the lives of a number of people in a tiny Suffolk village. Miss Frame's lively wit creates an absurd world, where there are no "characters" but only bores; people "whose lives contained so little of interest that their death passed unnoticed, brought no protest or mourning." Each of her people has lost contact with the world, living life as though through a mirror. When reality comes to them, as in death or disaster, they merely subside or "adapt." . . .

Man's "adaptability" is the theme of the book: his ability to cripple his life to suit the environment he creates. Man, granted life, cannot look it in the face. Given a shortcoming, a wrong move, each person spends his time consolidating a worthless position against invisible assailants; letting emptiness grow round him. The dentist who turns from a day of teeth to an evening with his stamp collection. The clergyman who has lost God and thinks he may find Him by immersing himself in a life that is a cross between that of St. Cuthbert, and that of Wordsworth's leech-gatherer. The frustrated wife who lives by "Mapleston's Chart"—a guide to pestkillers. . . .

Miss Frame steps boldly along the fence between the sentimental and the callous, and the reader follows unaware of the remarkable feat of balance in which he is participating. It is only at the end, when he steps down, that he sees how far he has traveled. But then he also sees the same two sides confronting him, as before. Was the novel a brilliant *trompe d'oeil,* or the magic it had seemed?

Desmond Graham. *The Journal of
Commonwealth Literature.* December, 1967,
pp. 149–50

Janet Frame is a poet, though to my knowledge she has published no book of poetry. Her novels exist for the purpose of illuminating certain mysteries for us—Miss Frame is obsessed with the mysteries of madness and death— but the illumination is attempted through language, not through dramatic tension of one kind or another. . . .

Janet Frame . . . suffers from an inability to create a fable strong enough to bear the weight of her thematic obsessions. Apart from *Faces in the Water,* which dealt impressionistically with madness, her novels begin by delighting and promising much, then undergo a peculiar flattening-out as the reader catches onto the point that will be made. In *Yellow Flowers in the Antipodean Room* the "idea" is that normal men so abhor death and the mere thought of death that they hate anyone who has knowledge of death, and that death itself, the near-experience of it, renders us afterwards incapable of normal life. . . .

Much of the novel is finely written, in a peculiar limpid style that seems a cross between Virginia Woolf and Samuel Beckett. Miss Frame takes her time with writing. Time yawns in her works while people think, have impressions, come to tentative conclusions about the meaning of life. When something does happen—an act of violence, perhaps—it is almost too late dramatically for by then we are convinced that nothing much can happen to surprise a character who has thought about so much, who has analyzed his own predicament with such compulsive thoroughness. . . .

While *Faces in the Water* succeeded brilliantly in its poetic evocation of a world of mad details, *Yellow Flowers in the Antipodean Room* fails. Where one novel made no special attempt to be a novel, with no devotion to a realistic society or to the tyranny of plot and chronology, the other sticks doggedly to a chapter-by-chapter advancement of the fate of a "dead man" in a real world. But it is only a fantastic world where wives should continually remind their husbands of the day they have "died," and where prospective employers should speak sanctimoniously to a healthy man of "hiring the handicapped."

Joyce Carol Oates. *The New York Times.*
February 9, 1969, pp. 5, 46

Unlike earlier provincial writers, such as Frank Sargeson, [Janet Frame] is not interested in delineating the manners of provincial life. Such records tend

to be of interest only to the province and may be the mark of the many provincial writers who constitute the body of New Zealand or any other local fiction. The term "regional" is suitable to describe a writer who somehow manages to stay firmly in provincial life but at the same time show something universal in that life. Janet Frame escaped the realistic limitations of provincial writing by making her hero the artist in a provincial milieu, an unhappy creature but one obviously in tune with the universal concerns of art which exist outside provincial society. Joyce adopted the same ploy with its consequently strong emphasis on autobiographical materials and nonrealistic style. The first decade of Janet Frame's career shows her transformation from a provincial to a regional writer. . . .

Janet Frame shares an imaginative continuum with her fellow provincial artists not in the superficial resemblance of her pattern of development from short stories to novels or from local to metropolitan publication but in the early enunciation of a fable that would guide the development of her work. This fable is in the childish tale that Janet Frame made up for herself, "that first story which she still considers her best," as she reported in her essay entitled "Beginnings": "Once upon a time there was a bird. One day a hawk came out of the sky and ate the bird. The next day a big bogie came out from behind the hill and ate up the hawk for eating up the bird." "Bird . . . hawk . . . bogie." It suggests the terror which Northrop Frye proposed in 1943 as the Canadianness of Canadian poetry, but also a way of dealing with the terror. In a provincial society, the hawk is the society; in a colonial provincial society, the hawk is both the society and untamed nature; and the bogie is the art which eats up both for eating up the bird of inspiration or imagination in an unimaginative society.

<div align="right">Robert T. Robertson. Studies in the Novel.
Summer, 1972, pp. 188, 192</div>

Though it has the qualities for which New Zealand's leading novelist is now famous—eerie characters, macabre happenings, and mythopoeic language—Frame's latest novel on the subject of death [*Daughter Buffalo*] suggests that her talent is also stuck on dead center. It is difficult to see, for example, that this one is an advance on her last novel, *Intensive Care,* or even such earlier efforts in similar vein as *Yellow Flowers in the Antipodean Room* and *The Adaptable Man.* Indeed, its carelessness and unevenness of execution suggests the formula novelist (though it is her own formula) somewhat less than wholly committed to the task at hand. In a New York setting, the story probes American attitudes toward death from the viewpoint of a marginal medical student repelled by his family's efficient disposal of its elderly members into rest homes, etc. The findings and insights are hardly new. Perhaps it takes more than living "off and on in New York for several years," as the blurb has it, to write with true originality about something as complex as the American psyche.

<div align="right">John H. Ferres. Choice. May, 1973, p. 454</div>

Janet Frame may eventually be seen as one of the last writers in a strongly established tradition of New Zealand writing, or at least as the last major figure of the tradition, able to take its themes and conventions and to use them in a consummate way. The further we move from her early work, the more clearly the later writing can be seen to resemble other works which have gone before. Like Jane Mander, Robin Hyde, Sargeson, John Mulgan, and others, she is a writer whose origins are in the first half of the twentieth century and not the second. The tradition shared by these writers is a provincial one, a single step beyond the colonial; and, as Frank Sargeson has said, "if you're provincial certain things happen." . . .

[But] Janet Frame gains stature as an author the further her work is removed from its regional provenance. Looking back, one could guess that without the tragic bereavements of her early years she might have become a minor novelist with a flair for satire but without a reputation overseas. As soon as death enters her vision, her art breaks the limitations of the provincial mode and begins to speak to all readers; her concern is not merely with what it means to be a New Zealander but with what it means to be a human being living in the twentieth century. The breakthrough in the fourth novel is just the kind of liberation which elevated other provincial writers (George Eliot and Joyce have been cited as similar cases) and enabled them to speak *for* men and women and not simply *of* men and women. It is from this point that her fiction gains overseas recognition; the American critic, Stanley Edgar Hyman, for example, has described *Scented Gardens for the Blind* as one of the best novels written since the war and "a brilliant and overwhelming tour de force." Steeped from girlhood in the tradition of world fiction, she has inevitably entered that world in her own right.

<div align="right">Patrick Evans. Janet Frame (New York:
Twayne, 1973), pp. 196, 199</div>

Janet Frame has traveled often to the "Is-Land," the "Table" where the angel hovers, to "Mirror City," then returned to tell the truth allotted her. But she owns only language to transform this "view over all time and space" into a coherent vision that reflects the "treasures" she beheld and touched during her travels. Often, she admits, "the medium of language" fails, for the revelations she attempts "have acquired imperfections . . . never intended for them . . . have lost meaning that seemed, once, to shine from them." Frame has, nonetheless, consistently demonstrated that the tradition-bound barriers of language need not constrict—in fact, demonstrated this so fully that she has invented a new kind of novel that contradicts its very form.

Those approaching Frame's work critically always note its non-novelistic tenor. For instance, Margaret Atwood says in a review of *Living in the Maniototo,* "Frame spurns plot except as a device for prodding the reader." To C. K. Stead the work "challenges its own genre, questions its own 'reality,' and finally collapses in upon itself." Carole Cook, reviewing *Living in the Maniototo,* observes that "Geography and language stand in for plot." Patrick

Evans talks of how in Frame's work "the rigidities of characterization have crumbled"; and H. Winston Rhodes of how the "power" of "Frame's imagination" does not show itself in "plot structure, in the creation of character, nor even in her capacity for 'naming things.'"

Thus, bypassing the accepted requirements of fiction, Frame carries out in their place a linguistic process of transformation and reflection. That is, she engages language in such totality that her fiction transcends conventional narrative and turns instead into an often anguished, sometimes comic, private record made public, in which narrator, plot, character, setting, and theme are subordinated to their determiner, language.

The struggle to harness language as a means to transform and to reflect experience overlies Frame's three autobiographical volumes, *To the Is-Land* (1983), *An Angel at My Table* (1984), and *The Envoy from Mirror City* (1985). Although concrete in their treatment of her life, these books—as their titles suggest—more accurately provide a gloss to the fiction which that life has engendered, recording as they do her growing awareness of language, its weaknesses, inadequacies, mysteries, strengths, elusiveness. "I was learning words, believing from the beginning that words meant what they said," she recalls in *To the Is-Land*'s opening pages devoted to early childhood, then tells how she read an adventure story titled *To the Island* but aloud called it *To the Is-Land*. Once corrected on pronounciation she "had to accept the ruling," but within herself "still thought of it as the Is-Land." So, early on, the vagary of language led her to entangle the outer world with the inner, a paradox central to her fiction. In *An Angel at My Table* she speaks of the private language which provides the substance for her writing: "My only freedom was within, in my thoughts and language most of which I kept carefully concealed, except in my writing."

Frame has continually sought the freedom this hidden language provides, a quest which has yielded astounding effects in her writing. Critics, on making passing reference to this phenomenon, have attempted to name it, albeit not always accurately or appropriately. It has been described as an "interest in communication," or by H. Winston Rhodes as "the gift of parabolic utterance," by Margaret Atwood as a "voice" which is "quirky, rich, eccentric, nervous and sometimes naive," or by Carole Cook as "coy but militant solipsism," even by Patrick Evans as "esoteric experimentation." In grander terms, C. K. Stead has called this singular talent with language "the instrument of the imagination . . . the hawk suspended over eternity"; or as Frame herself says: "the hawk suspended above eternity."

Although touching the edge of Frame's genius, such phrases fail to penetrate its core. In 1973 Patrick Evans observed that Frame may well be New Zealand's most successful contemporary novelist but one who "has reached this position, curiously enough, without the impetus of unified critical understanding"; the reason: "the difficulty of sensing immediately where the center of her work lies." As I see it, the center, the core, lies in language for whose sake Frame has forfeited the conventions of prose narrative. Such has been

the case to varying degrees in all her novels; but the one published just before the autobiographies, *Living in the Maniototo* (1979), shows that the linguistic transformation and reflection process has appropriated the fictional properties and made them its own.

<div align="right">Robert L. Ross. World Literature Written in English. 27, 1987, pp. 320–21</div>

The unifying principle behind all Janet Frame's novels is the theme of fiction building which is central to human life. In each of her novels, a distinct but related aspect of these, acknowledged and unacknowledged, fictions is examined.

Two of these positions, for example, are considered in the novels *The Adaptable Man* and *Yellow Flowers in the Antipodean Room.* In these works the biblical and classical myths of the past are shown to cast light on the fictions of the present and the future.

With the development of a structured rationality, modern human beings can no longer be myth-makers in the true sense of the term. They no longer possess the "abstracting, god-making, fluid, kaleidoscopic world view of the ancients." For this reason writers must revisit "the fabulous to probe beyond the phenomenological, beyond appearances, beyond randomly perceived events, beyond mere history," to challenge the assumptions of ages which have passed and to set the Poetic Imagination on new journeys of exploration towards new worlds. It is this process of probing and this function of challenging, that Frame engages in through the use of myth in her fiction. . . .

The message of these two novels, if they can be said to have one, is simply to urge human beings to make better use of their minds. By calling attention to the unacknowledged fictions people indulge in and live by, Frame encourages them to become more logical and aware but also more intellectually adventurous and imaginative.

<div align="right">Carol MacLennan. Kunapipi. 9, 1987, pp. 105, 113</div>

Janet Frame's novels reflect a fascination with the abyss between the unknowable and the knowable, between the unpresentable and the presented. Aware that her medium, language, is always already inadequate, Frame must nevertheless translate the unpresentable into the presented discourse of fiction. Critics, however, have pointed out that this theme, the failure of language, leads Frame into another abyss, the failure of art. That is, for some, Frame does not overcome the difficulty of representing the unrepresentable.

How does Frame articulate the ineffable in her most recent novel, *The Carpathians?* Previous fiction sought to approximate a "new" language: *The Rainbirds* with its "icy" spellings; *A State of Siege* with its "stone" messages; or *Intensive Care's* occasional "dollnormill" spellings. In contrast, *The Carpathians* narrates the collapse of language without attempting to symbolize its possible replacement. In other words, this novel alludes to, rather than

represents the unpresentable. We witness through the eyes of wealthy American, Mattina Brecon, as a phenomenon called the "Gravity Star," demolishes "all the words . . . all the concepts" for the inhabitants of Kowhai Street, Puamahara, New Zealand. The catastrophic event is marked by a midnight rain: specks like "dewdrops set with polished diamonds" and "smears of dung, animal and human" fall in the "shapes of the "old punctuation and . . . letters of the alphabets of all languages," the remnants of the old mode for conceiving of the world. Deprived of language, these "Puamaharians" respond with a "chorus of screams, shrieks, wailings" described as "primitive." Rather than narrate the consequences after this loss of language, Frame has the mute victims inexplicably (and conveniently) carted away by "white-coated" figures driving a "fleet of dark vans," never to be seen or heard from again.

Janet Frame assures one interviewer that the "Gravity Star" actually exists although the name is her own. . . .

However, as if to relinquish responsibility for the events described, Frame attributes authorship of the entire novel to one of its participants, John Henry Brecon, the son of two characters, Mattina and Jake Brecon. To complicate matters, an interpolated typescript by a third "author," New Zealander Dinny Wheatstone, breaks into John Henry's narrative and forms a sort of pocket inside the supposedly "main" text, a frame within a frame. It usurps and then advances the action: for one third of the novel Mattina finds herself "seized" by, and trapped inside Dinny's typescript. Or as she puts it, "in parentheses." To further complicate the narrative structure, this interpolated (retrospective) section is apparently written *before* the supposed events it describes. It is Mattina's process of reading the typescript which makes these events actual or "real." That is, she finds her past being created by her present moment of reading.

Narrators in *The Carpathians* are disconcertingly multiple and hard to pin down. Both John Henry and Dinny exist and act in their own as well as in each other's narratives, problematizing interpretation. We must question if it is possible to know [to] which "author" to attribute specific ironies. In other words, we are dealing in a complex way with the fundamental problems of: Who is speaking? and How do we determine an utterance's origin? . . .

Where does the parergon (narrative frame) take place in *The Carpathians?* How does it function? What is the effect of this simultaneously multinarratorial presence? And finally, where do we position Janet Frame herself in a structure in which she deliberately defers "authority?" . . .

[I] identify Frame with particular "beliefs" expressed in the novel. That we are "surrounded" by "intimations of truth," that fiction itself is a "form of truth" are notions, I would argue, that Frame shares with her characters. Even as this novel troubles ontological boundaries with its narrative indeterminacies, even as it subverts notions of "truth," it remains firmly underpinned by a dependence on some inaccessible, but nevertheless existing

"hinterland" of essential truth. And as a work of fiction, Frame offers us *The Carpathians* as one "intimation" of that "hinterland."

Susan Ash. *Australian and New Zealand Studies in Canada.* 5, Spring, 1991, pp. 1–3, 13–14

FRANKLIN, MILES (AUSTRALIA) 1879–1954

My Brilliant Career succeeded at once, though naturally it gave some offence in the district with which it deals. A critic said at the time that the frame of mind in which it was written was like that which found expression in Emily Brontë, and there is a certain amount of truth in this, though, in spite of the atmosphere of gloomy and passionate discontent which pervades a great part of this book, it is by no means without humor. It is a wonderful achievement for a girl under twenty. Naturally it is crude and immature as compared with, for instance, the best of Lawson's work, but it is simple and direct and sincere, the natural expression of a personality of considerable individuality and force. It is the story of an extremely self-centered young girl, perverse, impatient and pessimistic, full of undeveloped possibilities, as frank as Marie Bashkirtseff, selfish and yet fervently idealistic in the cause of Australia, democracy, and feminism.

Miles Franklin is a keen observer of people, scenes, and events. Her characters, who belong to station and struggling small selection, are lifelike—and mostly unpleasant. . . . Her second book [*Some Everyday Folk and Dawn*] is far riper, and contains more humor and less discontent and perversity, though it has not the same force. It also is told in the first person, but the interest is no longer centered in the narrator, and the other characters are more fully drawn.

H. M. Green. *An Outline of Australian Literature* (Sydney: Whitcombe & Tombs, 1930), pp. 134–35

The [books Miles Franklin published under the name of Brent of Bin Bin] are a work of genius; hence the critical suspicion of them. Greatness in art can be analyzed; the work it produces is as near permanent as humans can achieve. Genius, however, can mean oddity, eccentricity, individuality to the point of crankiness. . . . It is to be loved or resented, as the Bin Bin books must be. They are lit by the author's personality in a way which is not compatible with the highest art and, consequently, even their admirers have done them a disservice by comparing them with Tolstoy and the like.

The Bin Bin books spring from impulse and the need to put impulsive action into a framework which will justify it; their characterization is con-

cerned not with the display of life and the creation of people capable of moving on their own (the method of a Tolstoy) but with the discovery of that action which will justify a life by making it memorable. A. G. Stephens compared one of them with *The Dynasts* of Hardy and he was right. . . .

The later work tries to use the standards of other people, of mother, of father, of the people observed, of the collaborator; only by implication can she speak for herself until Brent of Bin Bin masks her and sets her free.

Ray Mathew. *Miles Franklin* (Melbourne: Landsowne, 1963), pp. 19–20, 30

All [Miles Franklin's] books are books about love. At the heart of most of them is a gifted young woman who fights against the oppressive, practical-minded averageness of her society, the lower rungs of the Squattocracy. Whether they appear in *Ten Creeks Run* or *Back to Bool Bool* or *Cockatoos,* all these young women are reincarnations of Miles Franklin. They are essentially tragic heroines: singers, artists, or just creatively gifted people who usually lose out in the end.

Why, then, has Miles Franklin not given us a great tragic novel? How is that her books do not read like tragic books, that their tragic themes are disguised? The answer is a twofold one. Miles Franklin lacked a clear conception of the full scope and implications of her approach. Unlike Henry Handel Richardson (with whom her work has certain similarities, and who is her only rival in vigor of dialogue), she could not subjugate her exuberant detail to a central, organizing and tragic idea. She was too domestically interested in all her characters, probably because she knew them all so well. This is what makes it sometimes hard to read certain chapters—the family-tree enthusiasm becomes tiring at times.

But there is something more important. Miles Franklin shared the prejudices of her circle as she shared its strength. She could satirize them effectively, but so strong were her ties and the affection that bound her to the Oswalds, the Mazeres and the Pooles of her novels that she never quite managed to grow beyond them. She had all their good sense, their shrewdness and their love of the bush. But she had their superstitions and limitations too. Thus, her bitterly sincere and scathing dislike of the exploiting appetites of the male sex never becomes a real indictment or the reflection of even more far-reaching depravities, but remains a somewhat dated idiosyncrasy. Miles Franklin's own position was tragic, although there is an optimistic driving force behind her work. Her wit, insight, and genius alienated her from her own class, at the same time as her outlook in many ways bound her to it. Both in time and place she was caught in a contradiction from which she had never quite the strength to escape.

David Martin. In S. Murray Smith, ed. *An Overland Muster* (Brisbane: Jacaranda, 1965), pp. 13–14

My Brilliant Career was a startling and unexpected success; *Mary Anne* a serious and not "popular" study could find no audience. Perhaps the pastures might be greener in America. At least it throws doubt on the generally accepted theory that Stella Franklin's motive for going to America was to help reform the world. There is just as much reason to believe that she hoped to find a freer, fresher air that would feed the fire of her ambition to do something creative. . . .

In August 1915 she was working full tilt on the novel *On Dearborn Street,* the typescript of which is now in the Mitchell Library. As the title indicates it is about Chicago, and is the only full-length work she wrote against the background of her American years. There is a great deal of autobiography in this story. . . . One of the mechanical defects of the novel is the outrageous use of slang by Americans of some culture and education. Miss Franklin should have known that such Americans do not talk that way. But there are excellent flashes of insight in such scenes as where Cavarley destroys the personal effects of his dead friend Robert, and the sequence of the dancing lessons. Even some of the sophistries of little Sybyl, when she dwells on her phobia against marriage, are moving if not entirely convincing. But overall the work is not a good novel, even though it is an honest and sincere attempt to reveal the confusion and uncertainty of a heart deeply troubled in a world gone mad.

<div style="text-align:right">Bruce Sutherland. Meanjin. December,
1965, pp. 442, 453</div>

[Miles Franklin's] is a very special place in Australian literature and in the Australian legend. It is not her style or her technique that is important; it is her subject matter. In her novels she summed up for Australians their pastoral age, the day-to-day life of the squatter and the small farmer, in a way that it has never been done before or since. She knew it at first hand, though only in her youth. Her parents, her grandparents, her uncles, and aunts had been pioneers. She had a great fund of memories, experienced and related, to draw upon. She recreated an era that has gone and will never come again. The future historian, the student of economics, the sociologist, will read Miles's books for the living pictures of a time and place that they present. Others will read them for their natural verve and the lively stories they tell.

To Australians, pioneers and the pastoral age have a very special significance. Our pride is rooted in them. The peaceful conquest of a continent is our saga and is, we think and feel, uniquely Australian. . . . Miles Franklin, like her hero Joseph Furphy, was Australian to the core and gave back to her countrymen their own image in the most acceptable form. On that her immortality rests.

<div style="text-align:right">Marjorie Barnard. Miles Franklin
(New York: Twayne, 1967), pp. 177–78</div>

The first edition of *My Brilliant Career* was published in 1901, with a Preface by Henry Lawson which presupposes categories for reading Australian fiction, as it gives the novel a seal of approval from the established male literary world by praising its realism: "The descriptions of bush life and scenery came startlingly painfully real to me. . . . the book is true to Australia." Lawson dismisses the novel's female aspect: "I don't know about the girlishly emotional parts of the book." For Lawson, bush life is Australian life and admirable, emotion is girlish and therefore unacceptable. The Preface also indicates the separation of male and female life in Australia. It sentimentally patronizes the author, whose pseudonym is no protection against Lawson's discerning from a manuscript reading that "she is just a little bush girl." Franklin is both tolerated because her topic is approved, and belittled by notation of those characteristics which are made to seem exclusively female. She is "little," young "barely twenty one," and lacks life experience, having "scarcely ever been out of the bush in her life." The tone of the Preface, its insinuations and the reductive attitudes it discloses, all pronounce the female author a member of a minority group, excluded from the male world which Lawson represents in both its socio-cultural and its literary aspects. . . .

A hastily written first work, *My Brilliant Career* is technically crude. The beliefs and attitudes it reproduces by way of its heroine's life and psyche and through its narrative structures are obtrusive, and thus easily identifiable. Its thematic tensions and narrative weaknesses arise in part from the female author's acknowledged desire to write according to the received masculine literary conventions: she calls her tale a "real yarn," placing it in the nationalist-realist tradition. In part, of course, they stem from her own lack of aesthetic control. But *My Brilliant Career* in its awkwardness allows its reader to perceive very clearly the problems facing the Australian woman writer, who lacks a literary model or a cultural identity. The novel is the tale of Sybylla Penelope Melvin's childhood and adolescence. Sybylla's life veers from pastoral to pigfarm, from happiness to misery. Her narrative remains unresolved, and its irresolute structure reflects Franklin's inherently negative reaction to the male tradition she seeks to be part of. . . .

The very conspicuousness in *My Brilliant Career* of masculine Australian ideologies and those attitudes to women which derive from these ideologies exposes the difficulty of a woman writing in a culture which denies her aesthetic or cultural worth. Sybylla's constantly ambiguous reaction to the masculine world she inhabits is echoed by the awkwardness and ambiguity of her narrative. Interestingly, Sybylla tries to escape the choice offered to Australian women between two equally undesirable female roles as either "good sort" or "good woman"—"damned whores or God's Police" according to Anne Summers's terminology—by the only possible route as she adopts masculine behavior. This reflects Franklin's need, to which I've already referred, that she write in the Australian male literary tradition. Each attempt to enter the male world, Sybylla's or Franklin's, results in confusion.

Women in both novels are often strong, practical, honest, and uncomplaining, displaying qualities the male world values, yet whose presence does not allow women to become part of that male world. These women are also sometimes intelligent, sometimes creative, and all have the potential for deep feeling. Those are the conventional attributes assigned to female life, yet it is precisely these that the masculine culture derides and rejects. Sybylla, too, rejects these qualities. Her inability to achieve a positive role is clear as she equates her weary life with her female expectations: "I am only—a woman!" in a tone which combines self-denigration and self-congratulation. Sybylla remains Australian by her final, forceful (and forced) identification with the male nationalist myth, but this conclusion is hopelessly at odds with the narrative movement of the text. The textual shifts—formally from romanticism to realism, thematically from optimism to pessimism, or as a discourse, from biographical narrative to apologia or apostrophe—denote the helplessness of the woman who lives in a world she can neither control nor become part of. These narrative movements also betray the uncertainty of the woman who writes from this world, as Franklin seeks to integrate into her fiction an Australian ideology which makes female life worthless.

<div align="right">Delys Bird. Australian Literary Studies. 11,
May, 1983, pp. 174–75, 177–78</div>

Despite the acclaim surrounding *My Brilliant Career,* Miles Franklin could never feel comfortable with the first heroine she had so successfully created. Because her family and friends believed themselves travestied in its pages, Miles attempted a corrective in a companion piece, *My Career Goes Bung.* Bristling with the same theme of rebellion that had characterized her earlier book, this novel bears mentioning because it brings Sybylla into sharper focus. She is now described as handsome, more poised and ready to be feted in Sydney after the publication of her first novel. Using the autobiographical form again, Franklin through Sybylla once more targets her attack against the inequitable position of women forced upon them by the social system. Familiar themes and attitudes recur, such as the indispensable need to write and probe the feelings of an Australian girl, an anti-heroine of sorts who differs from the conventional fictional heroine. So that her future books would not be interpreted literally and intrude upon her family's privacy, Sybylla announces her decision to adopt a "nom de plume," pointing the way to Franklin's own use of the pseudonym, Brent of Bin Bin.

If *My Brilliant Career* remains the cornerstone for all of Miles Franklin's subsequent novels, the Brent of Bin Bin series, published in England in the late 1920s and early 1930s, constitutes her masterpiece. The series comprises six books, five of which chronicle life in the Monaro over nearly a century. They can best be understood as an almost perfect combination of the directions charted out by Miles Franklin in her early novel: feminist concerns wedded to her concept of Australianism of the nineties—all within the framework of her circular vision of life with its inevitable repetitions from one

generation to another. Again we see her fiction of non-fiction focus on women who are spirited, rebellious, competent, and always, like Sybylla, eager for a measure of autonomy. . . .

[T]he case of Miles Franklin remains worthy of re-examination today. Because her personality was so brilliant, there were some scholars who wondered if her works would outlive her memory. Others believed her novels would indeed endure, especially *All That Swagger,* which one critic called "history for common man." The Australianism, the passionate love of her country, was the quality most seized upon by the critics of her day. The Brent of Bin Bin books, the rambling and discursive saga, were judged favorably because of the resemblance to life in southeastern New South Wales. All critics joined in unanimous acclaim for *My Brilliant Career* because of its sheer originality. But unlike many critics who, upon Franklin's death in 1953, felt her feminism and social work to be wasted efforts, today's reader finds precisely these aspects of the author's life and work to be most appealing and significant. Her clearsighted depiction of Australia's women in the environment she knew best and loved the most, the Monaro, warrants the increased attention of an international readership.

A surprisingly contemporary image of women emerges from the Franklin novels. *My Brilliant Career,* an indubitably feminist work with its accent on female narcissism and alienation, is still an exquisite and relevant study of female adolescence. Sybylla's awakening to early feminist and artistic yearnings coincided with Franklin's own development. And apart from the more apparent theme of the victimization of woman by man and Franklin's pleas for birth control, the notion of the single woman that the author treats in the Brent of Bin Bin sequence and in *All That Swagger* is an arresting one. Instead of portraying single women—widows or spinsters—as unfortunate or disadvantaged, Miles Franklin depicts them as independent, capable, and in control of their lives. Moreover, the subtle suggestion of a support network for the artistic woman remains a valid concern for today's feminist scholars. Franklin is especially effective when describing the plight of the artist, singer, musician, and above all the writer who, set apart from the mainstream of the community of women, attempts not only to survive as a woman in a man's world but to fulfill that creative urge which is as crucial to her as were the flow of the Murrumbidgee River and the song of the Kookaburras to Australia's pioneers.

Paulette Rose. In Alice Kessler-Harris and
William B. McBrien, eds. *Faith of a
(Woman) Writer* (1984; Westport,
Connecticut: Greenwood Press, 1988),
pp. 121, 125

FREEMAN, MARY E. WILKINS (UNITED STATES) 1852–1930

It is difficult not to prepare oneself for a village tale on opening a book by Mrs. Freeman; and indeed it is probable—at least it is to be hoped—that her villaginous manner will always hang about her work whether she be describing a New England town or, as in *The Debtor,* a New Jersey suburb of New York. If mute, inglorious Miltons and bloodguiltless Hampdens flourish in obscure hamlets, why should not the reverse be true? A special gift is required to deal with all sorts and conditions of men and yet to disclose the village trait that lies at the back of the brain of each—his little ways, his little interests; her bonnets and lace frills; their gossip, their curiosity, their ham and eggs.

The Debtor is the story of a man who lost his moral poise through being ruined at the hands of a friend, and who regained it in ways more harrowing to his proud Southern temperament than fire and the stake would have been. The first interest of the book lies in its fidelity to the small things that make up manners and customs. From enjoyment of the fine, miniature-like technique of the opening chapters one mounts to absorption in a broad canvas full of human portraits, and one ends by gazing at a great fresco depicting moral conflict, the deep issues of life, the exaltation of character by self-abasement. Or, to put it differently, one starts on a walk in a commonplace country with commonplace companions, content with sweet air and homely surroundings, but in no wise exhilarated. Wider, greener open the pastures, as the road goes always mounting, till at last one stands on a noble height looking over a noble landscape by a golden light, and the heart stirs within. If, as Mr. Henry James has said, the view from Vallombrosa is "a warm shimmer of history," this view may be called a warm shimmer of human nature—the trivial and even the dusty touched to radiance.

There is a great variety of portraits in *The Debtor,* from fine, sharp pen-pictures of the rank and file, foreign and domestic, to richly colored paintings of the principals. Delicious in their solemnly humorous irresponsibility is the Kentucky family to whom belong the beguiling little heroine and her father, the charming man of "wrong courses, but right instincts." Their fascination and their weakness are wonderfully conveyed. The barber shop congregation is a group well painted in, as one might see it in a Flemish picture. The toilers in the city, though only sketches, are exceedingly vivid, minute to the last feather and the sly roll of the eye. It would be easy, if it were worth while, to point out little flaws. It is a better use of space to hope that Mrs. Freeman may give us many volumes of State differences and American likenesses with human effort and victory crowning all. "When comedy becomes tragedy," she says, "when the ignominious becomes victorious, he who brings it about becomes majestic in spite of fate itself."

The Nation. December 14, 1905, p. 488

[*The Winning Lady and Others*] is altogether the best collection of short stories that Mrs. Freeman has published. It marks a definite return to her original theme and manner, with such development of both as time should naturally have brought. Her experiments in other fields, if they have seemed in themselves of comparatively little value, have no doubt served their disciplinary purpose. At all events, in these studies of rural New England character, her hand seems firmer than ever.

If it were not for her comparative indifference to the out-of-door setting, she would strike us as very closely comparable to Mr. Phillpotts. The grimly humorous aspects of rustic life have a similar attraction for her; and when she gives herself up to the pursuit of humor, she is equally likely to fall into the commonplace. "Billy and Susy," the story of a pair of cats who are quarrelled over by two New England sisters on the ground of their supposed difference of sex, and who prove to be "both Susys," is the one story in the present volume which we could have done just as well without. The plot is not new, and the handling is rather clumsily farcical. In "The Selfishness of Amelia Lamkin" and "Old Woman Magoun," on the other hand, the writer is on her own ground. Amelia Lamkin is another case of over-developed "New England conscience"—a self-effacing type to be found on any Yankee countryside; while Old Woman Magoun is of a type hardly less common and not less difficult to portray—the Roman mother who stands ready to slay that which she loves for its soul's welfare. These are the pathetic or sombre aspects which Miss Wilkins was from the first most successful in presenting. The new thing in her—or the newer thing—is a vein of tender and unstrained sentiment which here yields a really beautiful study of what we rudely call "calf-love." "The Joy of Youth" represents the achievement of the writer who, because he is so faithful to the soil and the human beings he knows, succeeds now and then in creating something that the whole world must recognize as its own. So what in a narrow sense seems most provincial—a sketch of La Mancha, of Simla, or of Thrums—will turn out to be of more general appeal than all the vague and pretentious fictions that spring up year by year—whose scene is Everywhere, and whose theme is Everything.

The Nation. January 13, 1910, pp. 36–37

[*The Winning Lady and Others*] reminds one anew that in her chosen field— the delineation of New England rural types—Mary Wilkins Freeman has no equal. No character is too humble or insignificant to escape her notice; with unerring instinct she seizes upon distinctive characteristics and thus gives to so-called commonplace lives new meaning and interest.

The volume comprises eleven short stories. They are mostly humorous, but scarcely ever free from the pathos which is always associated with true humor. "The Winning Lady" is an amusing, up-to-date sketch, showing how bridge prizes proved too strong a temptation for two eminently respectable matrons. The longest story is "The Selfishness of Amelia Lamkin," a character sketch of a patient, overworked mother suggestive of George Eliot's Milly

Barton, whose "selfishness" consisted in appropriating all the undesirable tasks of a large household. The familiar elderly spinster figures in more than one of these tales—the gentler side of her character being given fully as much prominence as her stern, unbending qualities. Nothing could be finer than "The Traveling Sister," who achieves the reputation of being a great traveler, while in reality she spends her lonely summers at home, at the same time providing out of her slender resources a suitable vacation for her sisters. "Little-Girl-Afraid-of-A-Dog" and "Her Christmas" prove that the writer is no less an adept at understanding the world of children than that of their elders. These stories will strike a responsive chord in the hearts of readers to whom simplicity and sincerity appeal.

Literary Digest. January 22, 1910, p. 152

Survivors of the 1890s will remember the thrill when Miss Wilkins's brush first put New England on the color map of short stories—her canvas, the gray of November skies, streaked with the pastel shades of sunset only rarely deepening to a primal color. Underneath the Puritan façade of speech-lessness, self-preservation made right and wrong the creed of Miss Wilkins's characters part of their defensive tissue. Pioneer conflict handed down rigidities of conduct as their tradition. "I guess you find I shan't fret much over a married man," Lily says to Joe from whom she is separated (in "A New England Nun"), by his pallid engagement to another woman. For Joe has given his word and it must bind them both.

Right and wrong dominate life and death as well as love. When Old Woman Magoun's grandchild is menaced by her father, her grandmother conducts her to a bush of deadly night shade, "Come Lily, it's time you were going," she says with biblical sparseness, "I guess you've set long enough." Lily dies, her life sacrificed to her chastity and her grandmother's anguish rising to an ecstasy, the Bible speech surges up above the border of consciousness and the New England woman becomes apocryphal—"You will come to a gate with all the colors of a rainbow, it will open and you will go right up a gold street," she chants in an epic eloquence that is like the wound of the red sun on the line of New England hills.

In the winnowing of her descriptions Miss Wilkins is herself of New England. "In the sky was faintly visible a filmy arc of new moon. A great star was slowly gathering light near it," she says, taking us by a short cut into her November night. . . . Beauty is here in this book, walking beside the characters in their rut of drudgery, beauty which we get as love. Not love of sudden emotion but love as the long miracle—trellising in and out of the cumulative commonplace of daily living, until it becomes part of the finished pattern. "Why, mother," an old man says in "The Revolt of Mother," facing himself at the end of life's journey, "I hadn't no idee you was so set on't as all this come to."

Yes, there's beauty in this book [*The Best Stories of Mary E. Wilkins*] aplenty, but not rapture. For rapture is nature's technique! reality escaping

in spite of the author through a sudden rift of life, sharp as an arrow to the heart.

Nathalie Sedgwick Colby. *Saturday Review of Literature*. May 14, 1927, p. 819

Although others had long been working in similar materials, Miss Wilkins was not shaped by any previous writer. In fact she would not read anything which she thought might influence her. She had not even read Miss Jewett. But whether she was conscious of it or not, her view of the New England temperament was very like Mrs. Stowe's. Yet there is this significant difference. Mrs. Stowe saw that the tragedy of New England lay in the relentless wrestling of the mind against the forces of evil. The abnormal struggle of the conscience cast a shadow across the lives of nearly every one who grew up here, the shadow in which Hawthorne dwelt and which formed the very substance of his romances. Miss Wilkins does not portray this struggle, but the result of generations of such a struggle. Her characters do not brood much upon the mysteries of sin and death, but the pattern of existence into which they are born has been warped and twisted by all the intense introspection of their ancestors. Mrs. Stowe thought of New England as the region which had cradled the destinies of America; Miss Wilkins simply sees the implications of life in a country town from which the high tide of achievement has long since fallen away.

F. O. Matthiessen. In John Macy, ed. *American Writers on American Literature* (New York: Liveright, 1931), p. 323

When *A Humble Romance* appeared in 1887, it produced no sensation among American critics. In a perfunctory notice, *The Critic* reviewer remarked: "They are tales of New England life, told with a good deal of originality and cleverness." *The Literary World* of Boston relegated the volume to "minor fiction," admitting however that the "simplicity, purity, and quaintness of her stories set them apart from the outpouring of current fiction in a niche of distinction where they have no rivals." The warmest commendation came from the most distinguished critic—Mr. Howells writing in "The Editor's Study" of *Harper's Monthly*. After caviling at occasional suggestions of sentimentality, he concluded, "They are good through and through, and whoever loves the common face of humanity will find pleasure in them. They are peculiarly American, and they are peculiarly 'narrow' in a certain way, and yet they are like the best modern work everywhere in their directness and simplicity." The reading public apparently agreed with Howells, for *A Humble Romance* gained almost immediate popularity. And it remains today one of Miss Wilkins's two or three best volumes of stories.

Though the story is the thing, something is to be gained by glancing at several aspects of its origin. What, first, was the writer using for copy? For

characters and situations, Miss Wilkins went directly to her own experience and that of her family and friends. . . .

Confronted with [the] terminology of the literary critic and historian, Miss Wilkins, like most artists, made little attempt to understand and less to force her writing within any category other than local color. Called upon to write a short preface, she used the language of the realist and the social historian. Such was the fashion of the moment. And certainly she was devoted to some sort of truth; she was, in some sense of the term, a realist. But despite the prefaces, she also told friends that until she was labeled by reviewers, she had no consciousness of writing within this mode. Mr. Alden wrote tellingly of her impressionism, "with a dominant subjective motive"; Charles Miner Thompson would later use the phrase "an idealist in masquerade." All of these elements are in her writing and in addition much that is frankly romantic within the spirit of Emerson, more than a touch of the symbolism in which the image of moral or social significance is sustained throughout the story, and even some understanding of a naturalism rooted in cultural determinism.

Considering characteristic stories of A Humble Romance and A New England Nun, the critic is forced into a grotesque litter of terms something like this. Miss Wilkins wrote local color stories of an inner feeling at once romantic, naturalistic, and symbolic and of a surface texture realistic and impressionistic. And such, insofar as these terms are meaningful, was her way of voicing her truth, her own intensely personal interpretation of life and character in the New England village.

Edward Foster. *Mary E. Wilkins Freeman*
(New York: Hendricks House, 1956), pp. 64,
90–91

When Hamlin Garland awarded Mary Wilkins Freeman the Howells Medal for Fiction in 1926, he praised her work as providing "unfaltering portraits of lorn widowhood, crabbed age and wistful youth . . . cheerful drudgery, patient poverty." For forty years, literary historians have persisted in this view of Freeman as a pessimistic recorder of New England's decline. Larzer Ziff sees in her tales "the piercing northern night which had descended on a land now barren," Jay Martin sweepingly enfolds her characters into one general type, "the humorless, vacant, mindless, narrow New Englander," and Austin Warren has clinically classified her morbid cases of New England conscience. After concluding that most critics since 1900 have treated Freeman as "a historian of New England rural life and as an anatomist of the Puritan will in its final stages of disintegration," Perry Westbrook himself stresses Freeman's sociological value as "our most truthful recorder in fiction of New England village life," a life drawing to an isolated and impoverished conclusion by the 1880s and 1890s.

Although these judgments have sound basis, their cultural and historical focus on gloom, misery, decay, and extinction has obscured the real dramatic conflict at the heart of Freeman's best short stories. It is a conflict whose

positive aspects need to be recognized. Many of her characters suffer, but they also fight their way to significant victories. Living in drab poverty, they still struggle with courageous spirit toward self-expression and independence. This vital struggle is far from being dated as a past or purely local condition that existed only in New England in the decades following the Civil War.

Freeman has a surprisingly modern and complex sense of the constant mutual adjustment necessary between individual and community, between need for independence and social insistence on conformity, between private fulfillment and social duties. Her men and women must assert themselves in ingenious ways to maintain their integrity in the face of community pressures, and Freeman records their varying successes with a wry but sympathetic spirit.

<div style="text-align: right">

Susan Allen Toth. *New England Quarterly.*
46, 1973, pp. 82–83

</div>

Although she was one of the women writers who managed to "ascend" to the novel, Freeman's twelve volumes of short stories are of particular interest because they present works that typify the writing done by women during the reign of the local color tradition in the late nineteenth and early twentieth centuries. Just as certain genres are undervalued, so are some literary historical periods—perhaps, in the case of the local color tradition, because of the predominance of the short story genre, or even because so many women wrote and published at the time. One of the many local colorists whose works have been undervalued and even misrepresented, Freeman gives us more than most critics after William Dean Howells have led us to believe. Few writers of equivalent, albeit modest, stature have elicited so many erroneous, personal attacks masquerading as literary criticism. She deserves renewed and careful consideration.

Whether through malice or narrowness of view, traditional (masculinist) critics have interpreted Freeman's work as though she structured a determinate and decidedly negative view of her characters, their relationships, and settings. They feel the need to pass judgment on these obscure women struggling with their relationships to the social institutions that attempt to command their loyalties. I would like to propose another view of Freeman's response to the content of her work: her own experience of sexual politics led her to represent the interplay of forces through undecidable or purposefully "unreadable" images that both affirm and negate, sometimes alternately and at other times simultaneously, but always resisting a determination of the text's meanings. A strong argument can be made for Freeman's strategic approach to these complexities and for her persistent refusal to inscribe within her fiction the simple or singular judgment of her female characters that her role as a writer within her sociohistorical context might have dictated and that later critics seem to want. These signs of undecidability, then, can be read as demonstrations of how the author reflects the conscious and unconscious experiences of her personal inner life and her perception of the

public expectations for women in society; their differential treatment, privilege, and status, as presented in the external world; and the differences between the social codes for women and for writers. These discrepancies form the site of more or less conscious tension, alienation, and dissonance, creating a break within an otherwise self-perpetuating, self-conforming system.

Elizabeth Meese. *Crossing the Double-Cross*
(Chapel Hill: University of North Carolina
Press, 1986) pp. 158–59

With *A Humble Romance* and *A New England Nun* Freeman established a reputation that endured throughout her life. Reviews of her work over a period of forty years were overwhelmingly favorable. Prototypical of her press notices is one in the London *Spectator* on *A New England Nun:* "The stories are among the most remarkable feats of what we may call literary impressionism in our language, so powerfully do they stamp on the reader's mind the image of the classes of individuals they portray without spending on the picture a single redundant word, a single superfluous word." Holmes and Lowell and, as we have seen, Howells and Henry James were admirers of the vividness and power of her stories in the 1890s. Enhancing her transatlantic reputation was an article "Un Romancier de la Nouvelle-Angleterre," by the French author Madame Thérèse Blanc-Bentzon, in the *Revue des Deux Mondes.* . . .

Among academic critics Fred Lewis Pattee was the first to give Freeman serious and extensive attention, first in *A History of American Literature Since 1870* (1915) and later in "On the Terminal Moraine of New England Puritanism," a chapter in *Side-Lights on American Literature* (1922). . . . [H]e views Freeman as a realist of the Hardy, Flaubert, and Howells variety (the juxtapositions are his). . . . To him Freeman is the anatomist of the Puritan will, the recorder of the last gasp of the old theocracy, the laureate of New England's decline.

Perry D. Westbrook. *Mary Wilkins Freeman*
(Boston: Twayne, 1988), pp. 134, 136

To propose a humorous reading of Mary Wilkins Freeman's work certainly contradicts most published criticism. Yet her earliest important critic, William Dean Howells, and most contemporary reviewers, even as they gave her the "local color realist" label that has so limited reading of her work, saw a mixture of "humor and tenderness" or "humor and pathos," particularly in her stories.

It was scholars like Fred Lewis Pattee and Perry D. Westbrook who established Freeman as the "grim recorder of the last act of the Puritan drama in America," or, to quote a Pattee title, the "Terminal Moraine of New England Puritanism"—with *Puritanism* defined as a dark and bitter creed having no redeeming virtues. Sadly, much of the criticism that followed built on these established perceptions. According to Perry D. Westbrook, "one

need read very few pages of Mary Wilkins to realize that to her . . . life is moral struggle within the soul of two wills opposing each other, one driving the individual on to destruction, the other to salvation."

But there is more to Freeman than the Howells label and the limited vision and direction of Pattee, Westbrook, and others perceived, and to read her work without these preconceptions, as her contemporaries did and now as more recent critics with wider viewpoints are beginning to do, brings unexpected discoveries and pleasures. Newer scholarship is in fact reaching out in a variety of ways and finding that Freeman's work is neither so restricted nor so repetitive as earlier scholars believed—finding that she is concerned with individualism, with integrity, autonomy, and self-definition, and that her "puritanism" is laced with wry humor.

> Shirley Marchalonis. In *Critical Essays on
> Mary Wilkins Freeman* (Boston: G. K. Hall,
> 1991), p. 222

As they strive to form and maintain relationships with parents, men, other women, and with their God, Freeman's female protagonists attempt to come to terms with the roles and responsibilities prescribed for women in their time and place, the preindustrial turn-of-the-century New England village. Through their affiliations with others, they learn to define, accept, or compromise themselves; in their relationships, therefore, lie the seeds of their identities as both women and as human beings. . . .

As a woman author writing to a primarily though not exclusively female audience about women's concerns, Freeman wrote tale after tale of women struggling in and with relationships. An acute observer of women's lives and an accurate student of women's psychology, Freeman strove to "tell the truth," writing of what she knew first-hand or from the lives of those around her. Her immense popularity in her day testifies to her ability to touch the heart and emotions of a generation of readers. . . .

Freeman wrote of women in relationships; paradoxically, her women remain fundamentally alone. Their lifelong search for connection and intimacy is more often than not frustrated; they find it ultimately impossible to achieve fulfillment or realize their dreams in a society that has defined the role of women—and therefore the extent and magnitude of their relationships to others—in a narrow and constricting manner. . . .

As Freeman saw it, a woman's role in the New England village at the turn of the century was one fraught with tension and ambiguity. Writing at a time and in a place marked by transition from an older, more stable, and more uniform world to one in which lifestyles and gender roles were changing, Freeman was aware that she was recording an era that was, even as she wrote, already receding. "I have . . . a fancy that my characters belong to a present that is rapidly becoming *past,* and that a few generations will cause them to disappear," she wrote. . . .

Little "happens" of an overt nature in a Freeman story, but great adventures are undertaken and great discoveries made; Freeman's women live

intense, vibrant—and often fearful—interior lives as they seek in their loneliness to form human and spiritual bonds.

> Mary P. Reichardt. *A Web of Relationships:*
> *Women in the Short Stories of Mary Wilkins*
> *Freeman* (Jackson: University Press of
> Mississippi, 1992), pp. 152–54

FRISCHMUTH, BARBARA (AUSTRIA) 1941–

Is there a case to be made for a specifically female literature? Regarding Barbara Frischmuth, this question cannot yet be answered. On the other hand, this deficiency opens up a great deal of space for free play to the woman writer, as well as possibilities for trying out different literary methods and processes.

For Barbara Frischmuth the decisive factor is entry into the world of the fantastic, a world that enables her to expand her perspective to include events of both the distant past and the utopic, just as, in our thoughts, past and future can proceed into one another seamlessly, without calling reality into question. . . .

Barbara Frischmuth puts up a defense against a limited understanding of Realism, defending herself against the critics who brand her trilogy of novels as escapist flights from reality.

Irmtraud Morgner shares with Barbara Frischmuth a very similar conception of literature; comments she made in a conversation about her manner and method of writing also characterize Barbara Frischmuth's own understanding of the fantastic. . . .

The woman author does not allow herself to be pinned down in her literary method and process, trying in each of her works to attain a unity of theme, subject, situation, and form. Constant throughout is her choice of themes: women and children. "What interests me in my literature, in terms of themes, is the evaluation of the possibilities arising out of so-called emancipation."

> Christa Gürtler. *Schreiben Frauen anders?*
> *Untersuchungen zu Ingeborg Bachmann und*
> *Barbara Frischmuth* (Stuttgart: Heinz,
> 1983), pp. 104–5

In *The Mystifications of Sophie Silber*, the heroine did not know "what she should do with herself. A good thing she had learned to take on an appearance of superiority in those situations where she felt like crying." This sentence could characterize any one of Barbara Frischmuth's female characters, for each one experiences hours of doubt, yet still affirms life, arranging it ac-

cording to her own views because she is autonomous and responsible enough to succeed in developing her strengths and talents. In this work, the heroine questions herself constantly, breaking through traditional boundaries in order to experience new forms of living. Daring and curiosity are her characteristic traits. Her personality is an extremely dynamic one: "risk-taking" seems to be her motto. Because she constantly subjects social structures and human relationships to revision, her second motto could be "metamorphosis." The third motto of Barbara Frischmuth's heroine is certainly "the dream," for the alternatives she suggests, and the journeys she undertakes into the realms of the fantastic, lend her life a new dimension: the heroine lives with intensity in the imaginary realm, and it is here that she can best be creative. In reading these works, one is struck by the breadth of possibilities that present themselves to us. . . .

The heroine is an extremely mobile woman. Sometimes she wanders through the streets like a nomad, or a half-nomad, who wishes to be in a number of places at one time. She will always feel a longing for far-off lands. And yet this type of life in no way indicates an asocial bent. . . .

If the heroine is a nomad with "risk-taking" as her slogan, she is also a magician. Her motto here would be metamorphosis, as the opposite of solid forms. She speaks of magical moments of transformation, and of her being different. She plays with potentialities for change because this befits the nymphlike character of women. . . .

In "Musil's and My Neighbor," the female narrator's statements illustrate the phrase "utopic geography" in the passage stating: "I've lived, ever since, in the spirit of the Salmgasse." The heroine usually lives caught up in a day-dream "in which her dreams are not subject to censorship." The ensuing passage in "Head-Dancers" provides a definition of this type of day-dreaming: "awake, and yet still caught up in the rapid sequence of images in the dream." The heroine groups these images together like pieces in a puzzle; allowing herself to be guided by the strength of her imagination, she looks for connections, secret classifications, affinities. . . .

The works of Barbara Frischmuth defy containment within a precise system. Any given interpretation is necessarily one-sided, corresponding above all to the personality of the critic; it mirrors his own problematic nature and is almost always a text super-imposed over the original. In the works of Barbara Frischmuth, the reader finds that which he seeks: the possibility of becoming better acquainted with and of more closely defining his own way of living. In an interview with Josef Hermann Sauter in the *Weimarer Beitrager,* Barbara Frischmuth makes the following assertion: "The more levels and perspectives one brings to an object or idea, the more clearly one can grasp it on the whole. That is why I really dislike one-dimensional stories. I juxtapose different ways of viewing things." The reader is free to choose which way of viewing things he will accept.

<div style="text-align:right">

Marie-Odile Blum. In Carine Kleiber and
Erika Tunner, eds. *Frauenliteratur in
Österreich von 1945 bis heute* (Bern: Lang,
1986), pp. 15–16, 18, 20, 23

</div>

Barbara Frischmuth . . . is an excellent example of the transition of Austrian literature in the past decade from the preoccupation with language that dominated the 1960s to a more traditional mode of literature featuring social concern. As a member of the Forum Stadtpark, the organization of writers in Graz, and through her training as a translator, she confronted the language skepticism that was so prevalent when she began to write, as she stated in an early radio interview entitled "Zweifel an der Sprache."

Concern about language, particularly language used to inculcate ideas, is reflected in Frischmuth's first narrative tale *Die Klosterschule* (1968; The convent school), an autobiographical depiction of life in a girls' Catholic boarding school. This work brought her considerable attention, although some of the publicity was in the form of notoriety rather than appreciation of the work as a literary achievement, for the book created controversy because of its attack on the traditional form of Catholic education. In *Die Klosterschule,* which reflects the influence of Handke in subject matter and style, an attempt is made to demonstrate how the young impressionable schoolgirls are brainwashed by the constant repetition of dogmas that present an orthodox Catholic philosophy of life. Frischmuth examines the preconceptions and presuppositions that are contained in the phraseology, which is intended as a subtle form of thought control. She presents the formulations and propositions in a straightforward precise manner and without further commentary allows the reader to react to the delimiting and demeaning view of women that they contain. . . .

The evolution evident in the progression of Frischmuth's writings not only involves a shift of perspective from language to character, but also includes a return to an emphasis on nature, a feature that was largely ignored by writers during the phase of linguistic experimentation in the late 1950s and 1960s. She has noted recently the renewed feeling for nature evident in contemporary literature: "I would even go so far as to consider this feeling for landscape in contrast to urban phenomena and vice versa a characteristic of contemporary prose in Austria." Frischmuth herself exemplifies this change, and nature has become a prominent feature in her recent novels. . . .

In the decade and a half since *Die Klosterschule* Frischmuth has produced a variety of works in different styles. She has a degree from the Interpreter's Institute in Graz in Turkish and Hungarian, which she also studied in Erzurum and Debrecen as well as at the University of Vienna from 1964 to 1967. She has made translations from both languages into German. In addition she has re-created children's language in the two collections of fairy tales for adults as well as children, *Geschichten für Stanek* (1969; Stories for Stanek), and *Amoralische Kinderklapper* (1969; Amoral children's noisemaker), and in the children's books *Der Pluderich* (1969; The Pluderich), *Philomena Mückenschnabel* (1970; Philomena mosquito beak), *Polsterer* (1970; Polsterer), *Die Prinzessin in der Zwirnspule* (1972; The Princess in the yarn spool), *Ida—und ob!* (1972; Ida—and how!), and *Grizzly Dickbauch und Frau Nuffl* (1975; Grizzly Potbelly and Mrs. Nuffl). These works show her rich imagination in plot invention, her humor, and her playful facility in creat-

ing a children's vocabulary not accessible to their parents. In form, the stories contain the same blend of the real and the fairy-tale world that characterizes her subsequent major novels. . . .

In her most recent works, the drama *Daphne und Io* (1982), which had been performed but not published, and the novel *Die Frau im Mond* (1982; The woman in the moon), Frischmuth attempts to raise her familiar material—the relationships of men and women—to literary significance by introducing a dual level to the narrative: allusions to mythology in the drama and to the tradition of Columbina and Pierrot in the novel. By this device she lends greater significance to the characters. Unfortunately, while she was credited for her ambitious efforts, critics failed to consider either work a success. However, such works show that she knows the direction to follow to produce the major work she is capable of writing.

The thirteen selections in her newest collection . . . *Traumgrenze* (1983; On the boundary of dreams), . . . show again the blend of the spirit world with the real world, as she has so successfully done in a number of works, particularly in the novel trilogy. Here, as there, the two worlds are not separate but intermixed. These tales again provide eloquent testimony of her vivid sense of fantasy, which for her, as for many great writers, is as vital as reality. They also show Frischmuth's increasing turn to reflectiveness, for thoughtful comments and observations are interspersed throughout the stories. Like the other works of the last few years these tales may be considered experiments showing her continuing development both as a thinker and as a stylist.

Frischmuth is a genuinely gifted author, whose writings show a constant progression over the span of her career to date. As she has shifted away from a narrow focus on language to concern for social problems she has developed steadily in sureness of technique, style, maturity of theme, and particularly in her unique ability to combine her own fictional worlds, whether they be that of spirits and elves or of children at play, with the real world. She has consistently expanded the range of her forms and themes, and she shows every indication of continuing to progress toward more demanding accomplishments in the future. The hope is that at some point she will find it possible to combine all of her rich talents to produce the major work which she is so eminently capable of writing and on which her lasting reputation will be based.

<div style="text-align: right">

Donald G. Daviau. *Major Figures of
Contemporary Austrian Literature*
(New York: Peter Lang, 1987),
pp. 185–87, 202–3

</div>

FUERTES, GLORIA (SPAIN) 1918–

Gloria Fuertes's collection *Poemas del suburbio* (*Suburban Poems*) is one of the works that best represent the Spanish writer's social conscience. In Yndurain's prologue to *Antologia poetica 1950–1969,* he quotes Fuertes's idea that "today more than ever the poet must write clearly, for everyone, that they may understand. But while there are more people who write poetry than readers of poetry [it] will not go anywhere." The writer adds that with her writings she believes she is "avoiding a worse world."

"Avoiding a worse world" by means of her poetry. The radical feminist perspective of the new order . . . shows us that Fuertes, without ostentation or presumption, with sincerity in her language and mastery in her technique, has opened up a new relationship between the imminent and the transcendent, as well as between the reader and the text. This has been achieved without didactic sermons on God, heaven, the world, social classes, and the role of man in the creation of change. . . . The new order that is arising created by the writer is due to the fact of seeing her work intimately connected to change in the world in which she lives and in which her texts will have to live—in relation to the reader.

<div align="right">Luz Maria Umpierre. Plaza. 5–6, 1981–82,
pp. 132, 142</div>

In this brief discussion, I would like to focus specifically on one aspect of the work of Gloria Fuertes. . . . [She] frequently incorporate[s] the most over-used expressions into [her] work: clichés, street language, advertising, hackneyed metaphors, rhetorical conventions. In reference to these expressions and set phrases, the word transparent, taken in its etymological connotation, indicates the intertextual nature of the poem: the process of seeing through to the parent, to the word behind the word. Sometimes, as indicated above, this results in irony. But frequently it goes beyond irony to produce something entirely new: at once the re-establishment of literal language and the infusion of new meaning into empty expressions. This reclamation of language depends on a four stage process both on the part of the poet and on the part of the reader.

In the beginning, let's say, someone creates a "new" expression—teeth like pearls or cheeks like roses, for example—which is intended to be both accurate as a description and poetic. Those images then become (in the Renaissance) established poetic conventions (stage two). They are no longer new nor original. They do not startle or surprise, but neither are they considered clichés, and are used frequently as accepted and serious attempts to describe feminine beauty. In stage three, having worn out their poetic welcome, these metaphors may be placed *as* clichés in contexts which allow them to convey irony, satire or parody. Fuertes . . . however, take[s] this process still one step further by manipulating such clichés so that they must

once again be taken literally. The expression has come full circle: from new, to convention, to irony or parody, to old and new at the same time. In these contexts, the expressions both contain and transcend the irony of stage three. Fuertes . . . then create[s] new language out of old. She returns used expressions, where meaning has worn thin, to pristine condition. This can only happen because the language is trans-parent, allowing the reader to perceive and integrate the three prior stages of the expression along with its present status, to see the ancestors in the offspring. The clichés are self-referential and incorporate the entire poetic or linguistic tradition. Their new meaning is a product of intertextual space, distance and development. The expression does and does not mean exactly what it says. It both confirms and violates the reader's expectations. (Confirms because it is so common, so familiar. Violates because it appears to be either unpoetic or bad poetry.) The poem then, is metapoetic—self-referential—and the transparent process through which the reader perceives that *is* the meaning of the poem.

The reclamation of outworn language occurs not only with regard to the kind of poetic conventions described above, but with slang expressions, advertising slogans and street language as well. Certain expressions are so common, so ordinary, that the reader/hearer automatically understands the intent of the comment without assigning any literal meaning to it. In ordinary speech, "reaching for the moon," "a piece of cake," "a horse's ass" have nothing to do with moons, cake or horses. Fuertes . . . place[s] such expressions in contexts where the reader cannot fail to recognize the ordinary or vulgar intent of the phrase, *but* must also take it literally. Again, the language is self-referential and the meaning is derived from the transparent process of seeing through one level to another, of seeing the parent in the child, the literal in the figurative.

<div style="text-align: right;">Nancy Mandlove. Revista Canadiense de Estudios Hispanicos. 7, 1983, pp. 301–2</div>

A fundamental principle in Gloria Fuertes's work is the conscious rejection of a hermetic discourse. The author herself declares: "My work will never be obscure, difficult, cerebral, cultivated." Critics often refer to her as the singer of daily reality, the poet (and she likes being called this) with prosaic and colloquial language. . . . The reader of Gloria Fuertes does not have to struggle with the resistance of a hermetic and obscure text. On the contrary, he or she discovers quickly that the point of departure of the great majority of the poems is in fixed phrases, songs, refrains, and other extremely well known formulas, and that the principles that govern this work are based in the original transformation that such material undergoes in the author's hands. Through a series of substitutions that change the order of that which is established, Gloria Fuertes arrives at a new and different re-elaboration of a topical material, at an original and surprising poetic creation. The result is a new and unexpected dimension of the language, a revitalization of certain areas that had lost all their semantic force. . . .

Fuertes starts from the common language of dead words and sentences, [she] revisions verbal associations already exhausted, frees them from their ordinary context to arrive at a new and original reorganization. In this way, she exposes the mechanization of language. With a colloquial expression, her poems say something and much more, as the author breathes new life into them. Her compositions are verbal artifacts where the semiosis is achieved entirely on the basis of the intertexuality inherent in plays on words about conflictive systems. The poem is thus a means of transmitting a message at the same time as a verbal game or artifact.

<div style="text-align: right">Candelas Newton. Letras femeninas. 13,
1987, pp. 1–2, 9–10</div>

Gloria Fuertes forms part of a group of poets who became active in Spain in the 1950s and 1960s. Similar to that of Dámaso Alonso, with its iconoclastic tone, her poetry generally is devoid of traditional poetic diction and tropes; her texts are written in the everyday language of ordinary existence, with its disposition toward slang, ellipsis, and most importantly, humor. Although humor is present in all of the poetry of Gloria Fuertes, her ability to elicit and control in a masterly fashion the particular reader response of laughter and make it a part of the aesthetic experience is most evident in her later books of verse, most especially in *Poeta de guardia* (1968) and *Cómo atar los bigotes al tigre* (1969). Indeed Fuertes herself acknowledges the importance of humor in her poetry, since one of her most recent works contains a reference to this very human perspective in its title, *Historia de Gloria (Amor, humor y desamor)* (1980).

The humor in Gloria Fuertes's poetry functions on two levels. On the first level, the language of humor refers only to itself: the reader laughs at the poet's tricks, changes, and foolery on the linguistic plane. This brand of humor may include puns, double-entendres, intertextual incongruities, and changes in language level. On the second or semiotic level, Fuertes's humor goes beyond the text and encourages the reader to see not only her poetry but also the reality that it wishes to communicate in a new light. Through humor, whether linguistic or semiotic, Fuertes is able to broaden the reader's experience by allowing an intellectual distancing to take place. From the vantage point of such distance the reader is able to become detached enough from the scene or event presented to make an intellectual judgment, and also to see a higher level of meaning. . . .

It has been shown that Fuertes's humor has two functions, both of which contribute to her poetry's unique tenor. First, it encourages the reader into becoming aware of the surface level of language and the artistic process operant at that level. And second, it also induces the reader to go beyond the text at hand: that which is presented in the text must be related to the reader's own world. Humor fulfills this second function by pointing to the present human condition, and what can be done to improve it. Fuertes's poetry conveys a message that goes beyond the confines of the text, and

reaches out to the community at large. Through humor, humanity can face common problems and defeat them, or at least defeat the terror that they have come to represent. Thus, through her verse Fuertes gives her readers some insights on *Cómo atar los bigotes al tigre.*

It has been said that tragedy is universal because of its ability to transverse time and culture. But humor is the common bond that cements the community's purpose and the poet to the community. Through humor, Fuertes is able to make us laugh at ourselves and our weaknesses, and to see the bonds which unite us all. Her use of humor is an element that grants her work singularity but, through its artfulness and dual function, also gives her poetry beauty and transcendence. She sings the song of the community and through her verse, proves that the female voice is capable of expressing the poetic song of twentieth-century life. Her range is unique, but her art still remains true to the eternal poetic ideal.

Margaret Persin. *Revista Hispanica Moderna.* 16, 1988, pp. 143–44, 156–57

Among the poets of post-Civil War Spain, Gloria Fuertes is a beneficiary of the Spanish grotesque tradition. Gloria Fuertes shares with the first generation of postwar poets her view of poetry as an instrument for righting the social injustices born of the Civil War and its aftermath. Like those of the second generation, Fuertes has committed herself to the distinctively personal creative vision only made possible by the breakdown of the earlier repressive system. Fuertes's poetry, however, diverges from the poetic generations of postwar Spain because of the exultant, celebratory quality that marks her as a direct descendent of the ancient carnival spirit. As in the carnival tradition, laughter and revelry are central to her world view and thus to her conception of poetry as a means to counteract the ills—social, artistic, and sexual—of official society. The clowns, trapeze artists, vendors and street figures who people Fuertes's verses evidence her affinity for popular, "unofficial," culture. So too do the double entendres, colloquialisms, and vulgar expressions with which she spices her language. Her poetry mirrors the ancient dichotomies of reverence and subversion, manifested on the one hand by prayers, litanies, and verses in a contemplative vein; on the other hand, by diatribes, reprimands, and billingsgate. The co-existence of such contradictory forms is concordant with the carnival spirit, especially in its preference for the grotesque. Allusions to food and drink, to the human body and its natural impulses, abound in her work. Disease and health, both physical and emotional, are of equal poetic import: in Gloria Fuertes's vision, life is an open-ended cycle of death and rebirth, just as poetry itself is the continuing process by which she denounces official culture and reaffirms her faith in popular renewal.

What is more, Gloria Fuertes stands apart from her poetic compatriots by virtue of her gender. For this reason she maintains a unique position in relation to an official culture historically molded by and destined for men.

Fuertes unabashedly confesses that her work "en general, es muy autobio-gráfica, . . . muy 'yoista,' . . . muy 'glorista,'" and it is clear that she insis-tently employs poetry as a way of creating her own personal and artistic identity. Yet her work transcends the private issues of her "autobiografismo irremediable," for it is by means of her poetry that Fuertes confronts the male-ordained codes by which women have historically been constrained, the male-sanctioned hierarchies from which women have traditionally been excluded. Armed, therefore, with the forms and rhetoric of carnival, Fuertes assumes the "negative function" within the existing official structure that obliges women to "reject everything finite, definite, structured, loaded with meaning . . . [and which] places women on the side of the explosion of social codes: with revolutionary moments."

The ancient carnival tradition is Gloria Fuertes's happy inheritance. As such, her work bears the joyous stamp of much of popular recreational litera-ture, which she reinvents with her own womanly imagination. Laden with disease, loneliness, and other forms of human suffering, her verses are also rich with celebratory rituals and festive activities. Poetry is, for her, a way of marking each phase in the cycle of life and death. She enters the merriment with a laughing heart to free her from fear and constraint, to restore her world from pain and death.

Sylvia Sherno. *MLN.* 104, 1989, pp. 371–72,
391

In "Isla ignorada," the poem that shares its title with her first published collection of poetry (1950), Gloria Fuertes revealed an awareness of her own separateness and individuality. Isolated and ignored like the island in her poem, she described herself "en el centro de un mar / que no me entiende, / rodeada de nada, / —sola sólo." Although she later dismissed the "sinceridad y lógica inmadurez" of the poem, penned when she was just seventeen years old, the verses disclose as much their author's prescience as her precocious self-knowledge. The isolation visible in this youthful literary effort certainly responds to the poet's awareness of herself as a woman and, perhaps too, to her own incipient experience of sexuality.

In fact, Fuertes's individuality as a woman and nonconformity with tradi-tionally prescribed female roles have been the hallmarks of her career as a poet. She repeatedly highlights her own uniqueness, presenting herself as a "fabuloso desastre," a "tierna amazona," an outlandish character who leads a strange life. Her verses are filled with allusions to a space outside of the social, literary, and emotional mainstreams. She views herself as a marginal figure grasping at life's outer edges. . . . Poetry allows her to occupy a space at the very center of her imagined world: "Mi yo soy yo, / y estoy en mí." It is therefore by means of her poetry that she achieves centeredness and bal-ance and invites others to share that central space.

The distinctiveness of Fuertes's voice and vision, then, has given her work its personal stamp. It enables her to assert confidently in that earliest

of poems: "Para mí es un placer ser ignorada, / isla ignorada del océano eterno." Even as a literary novice, Fuertes could look upon her solitude with benign and placid regard, not least because of the consoling charms of poetry. She has always been conscious, of course, of the mysterious possibilities inherent in the process of creating poetry. She has likened the birth of a poem to the marvels of childbirth: "Primero siento, después pienso, en ese sentir-pensar se engendra el poema y, veloz, se inicia el recorrido mágico: corazón-mente-dedos, y entre los dedos—muslos creadores—se produce el parto, el asombroso nacimiento del nuevo poema." Not coincidentally, Fuertes is drawn to the magic of the creative act, an act for which her heart, mind, and fingers are transformed into beings endowed with their own creative vitality. . . .

Curiously, it is in the role of seamstress, long considered one of the most feminine of occupations, that Gloria Fuertes most certainly fulfills her poetic mission. Designating herself "doctora en bordados a mano / y a máquina," she depicts herself over and over in her poetry stitching, embroidering, crocheting, mending—tasks which she unites in her imagination with those of the poet. . . . Magically, she stitches together the loose threads of her imagined world—the beasts, the machines, the genderless humans—and weaves her way to the center.

<div style="text-align: right">Sylvia R. Sherno. Hispania. 72, 1989,
pp. 253–54</div>

If the somber hues of the Castillian countryside have been most memorably painted by Antonio Machado; if the brilliant colors of Andalucía have been captured by any number of poets, including Lorca and Alberti; then the favored landscape of Gloria Fuertes is undoubtedly the city of Madrid. The colloquial character and the insouciant tones of Fuertes's language lovingly duplicate the flavorful rhythms and patterns overheard in any street corner conversation in Madrid. Busses, trains, and cars traverse the streets and barrios of her native city, cited along with other place names like the Rastro and the department store, Galerías Preciados. The title of one of her early collections of poetry, *Antología y poemas del suburbio* (1954), attests to the poet's very urban sensibility, as does the presence in her verses of telephones and doorbells, typewriters and telegraphs, robots and, in a more sinister vein, the atomic bomb. Her most common themes are those of everyday life: the joys and disappointments that accompany love and the loss of love, alienation and the desire for human connection, the injustices suffered by those at the lower reaches of society. In short, Fuertes's voice is that of the ordinary inhabitants of Madrid or perhaps of any other modern metropolis. In her own words, "en la ciudad me dirijo a todo ser que sufre o goza sobre el asfalto."

Despite these myriad manifestations of modern urban life, it is clear that nature is an equally felt presence in her work. While Fuertes acknowledges that "no soy demasiado descriptora de exteriores. No soy paisajista," she gives ample evidence of an active, even symbiotic relationship with nature

in the form of sky, moon, trees, and animals. It is in the natural world that Fuertes experiences a rebirth from the nothingness that for Carol Christ is "a spiritual experience, a stripping away of the facade of conventional reality." In nature Fuertes emerges into a new light of heightened consciousness. Merging with nature, less an objective reality than an expression of metamorphosis, she undergoes the transformations that allow her to create her authentic selfhood. Nature becomes a new space where she retrieves a lost paradise of harmony and freedom.

Ultimately, whether in the midst of the natural world or in the center of Madrid, Gloria Fuertes creates a room of her own, a space to conform to what she calls her own "geografía humana," what Gaston Bachelard has designated the "topography of . . . intimate being. Fuertes's verses are filled with references to rooms, cells, and attics on the one hand; on the other hand, to the open, empty spaces of islands and windows. Employing her own body as a point of spatial reference, Gloria Fuertes draws upon images of miniature and immensity, inside and outside, to mirror the expansion and compression of her own voice, to suggest the enclosure and freedom of her intimate self, and in turn, to explore issues of being and non-being.

<div style="text-align: right">Sylvia R. Sherno. Letras Femeninas. 26,
1990, pp. 85–86</div>

GALLANT, MAVIS (CANADA) 1922–

Mavis Gallant's novels are so much in the modern mode that if we approach them carelessly we are apt to see them merely as explorations of the shadow side of life, resolutely turning their backs on any hint of the heroic or the romantic. But as we read we become aware that they are finely shaped, and at the farthest extreme from those works which hope to suggest the incoherence of life by a want of artistic form; these three novels are classically spare, their feeling for the significant detail is unerring, the tone controlled, ironic, and wryly humorous. Her novels, like her short stories, are works of art, and produce in the reader the special, unmistakable satisfaction that belongs to literary art.

They are marked by lucidity, elegance, and individuality. . . . Mavis Gallant's stories of miserable women stand apart from most writing of the kind because there is no current of anti-masculine grievance in them—no sound of an axe being remorselessly ground without ever achieving an edge; they are pathetic, and compassionate but they are also reserved in tone and touched with a humor that is ironic rather than exuberant. The language of literary criticism fails me in describing Mrs. Gallant: I must resort to calling her a cool customer—never a tough customer, but a cool one. . . .

Her novels are short but they are not, like some economical novels, dense in texture. On the contrary, they are perspicuous, but we should be greatly mistaken if we supposed that for that reason they could be read in a hurry. They yield up their secrets slowly, and we must be watchful, for the shades are minutely distinguished and we must never suppose we have seized the author's meaning before she has finished expressing it. The form is modern but the quality of the art is classic.

Classicism observes from without, romanticism from within. Mavis Gallant observes from without, not clinically but with calm, not from above, but at a sufficient distance to provide a full view and a perspective. The classic attitude is not wanting in pity, but it is aware that pity can do extremely little for its subject, and may become self-indulgence in the one who feels it. Mavis Gallant permits herself no self-indulgence as a writer, and invites none from her reader. But it would be a very great mistake to suppose that the classic attitude, functioning under such controls, is wanting in life. On the contrary, the controls enhance and intensify the life, and it is such intensified life that we feel in these novels. And the strongest intensification of life is that which they evoke in the reader. It is not often that one can say that a writer's work

enlarges and cleanses one's understanding of life, but we may say so honestly of the art of Mavis Gallant.

<div align="right">Robertson Davies. Canadian Fiction
Magazine. 28, 1978, pp. 69–70, 72–73</div>

Mavis Gallant may well be the most frequently "discovered" contemporary writer in English.

My own discovery came some years ago while reading an anthology of Canadian short stories which included "The Accident," later part of the novel *A Fairly Good Time.* Not only was "The Accident" far and away the best of the collection, but its style and tone were arrestingly different. The prose had a density of texture, a solidity of association most unusual in Canadian writing. Gallant herself commented to Geoff Hancock that her work undergoes a long process of paring, and no doubt this partially explains the strong sense of significant detail, in which lengthy periods of fictional time seem to blossom from small incidents. Also, Gallant, a "realist" writer, takes pains with the everyday world of her characters; she emphasizes setting—the place *where* characters live and think. Unlike most realist writers who use setting as a literary environment for their characters' psyches, Gallant often "mutes" her characters so that their everyday world comes to the forefront, laying bare cultural patterns and forces. But I don't wish to reduce Gallant's writing to a pattern, especially with a writer whose characters often unwittingly and self-defeatingly attempt to render the prolixity of life in rigid patterns. Indeed, in the interview with Geoff Hancock, Gallant mentioned she never writes consciously to a formula, never begins with an idea, but allows her characters to follow their own directions. Curiously, this immersion of character in incident often results in a kind of "historical fiction"—where the forces of history and culture act upon the characters. In such "historical fiction," a term coined by George Lukacs, the principal actors are the forces of history themselves.

Yet, an explanation of Gallant's fiction in terms of history is only partially adequate. In her early writing is a strong romantic influence whereby the outside world is portrayed as a product of her characters' perception. Yet Gallant's romanticism does not create strong, self-actuating people, as is normally the case with romantics; rather, her characters are troubled, somewhat beleaguered souls. A vision of a better, freer life is usually present, but inevitably this is circumscribed by a larger set of impulses towards censorship and control. One of the more noticeable features is the expatriates who people her pages. Generally English speaking, they attempt to eke out a life on the Riviera or some such place. With little money, they are forced to live frugally in material as well as spiritual ways. Even Canadian characters with modest wealth and liberal sentiments, such as the Knights in "Bernadette," appear fenced round by conventions. It is almost as if these characters are unhappy until they have sought out their own prisons.

In looking closer at typical characters, one discovers Gallant is fascinated by individuals who desire to rebel against their circumstances. While Gallant

writes from within the romantic tradition that sees the individual rebelling against society to attain dignity and freedom, she also places this rebellion within the larger perspective of liberal, middle-class norms. Although in the early stories, Gallant's characters may seem merely weak romantics caught in the debris of history, any sustained reading of Gallant soon reveals that her main interest is not the individual's problems in their own right, but the manner in which liberal ideology has spawned a nightmare of history. Taken as a whole, Gallant's fiction offers a devastating critique of liberal humanism, devastating, precisely because the account is also sympathetic. Indeed, this sympathy keeps Gallant's cutting edge sharp, revealing new insights, new involutions of liberal paradox. Moreover, as her work progresses—from the early stories of the 1950s through the German material of the 1960s and early 1970s to her most recent Montreal stories in *The New Yorker*—her portrayal of man's entrapment in liberal, romantic ideals changes considerably, and may even hint at the escape route.

Ronald B. Hatch. *Canadian Fiction
Magazine.* 28, 1978, pp. 92–93

[T]hough Mavis Gallant has written on occasion about Canadians in Europe, who usually find it hard to accept the life-styles they encounter (or avoid encountering), it took her twenty years after her departure from Montreal to turn to the imaginative reconstruction of the vanished city of her childhood and youth, in the five interlinked Linnet Muir stories which have appeared in *The New Yorker* but are as yet uncollected. These examples of memory transmuted, which in intention at least bring Mavis Gallant very close to the Proust she has admired so greatly, form one group among the stories I shall be discussing.

It is virtually impossible to escape memory as a potent factor in Mavis Gallant's stories, and the next group of fictions, while they do not draw on the memory of personal experience, are imaginative constructions in which remembered observations and remembered history play a great part. They concern the Germans (a people Mavis Gallant does not know from experience as well as she knows the Canadians or the French or even the English), and specifically the post-Nazi Germans. One novella and six stories are here involved. The novella and five of the stories comprise the volume entitled *The Pegnitz Junction;* one other German story, "The Latehomecomer," appeared in *The New Yorker* (July 8, 1974), but so far it has not been collected.

The last group are tales of people trapped as foreigners in the meretricious vacation worlds of continental Europe. The main characters in three of the stories—all set on the Riviera—are English, remnants of a decaying imperial order, at once predators and victims: these are "An Unmarried Man's Summer" (*My Heart is Broken*, 1964), "The Tunnel" (*The End of the World and Other Stories*, 1974), and "The Four Seasons" (*The New Yorker,* June 16, 1975). The fourth, "Irina" (*The New Yorker,* December 2, 1974), is one of those rare stories in which Mavis Gallant touches on the literary life; its

eponymous heroine is the widow—Russian by descent—of a famous Swiss novelist, but here too there is an English character who is not quite minor. . . .

[T]here is no real generic division so far as Gallant is concerned between short stories, novellas, and novels. She rarely writes the kind of story which Chekhov and de Maupassant so often produced, in which an episode is treated as if it were a detached fragment of life, and the psychological insight or the moving symbol or even the ironic quip at existence is regarded as sufficient justification for the telling.

Mavis Gallant never uses fiction with such aphoristic intent; she is neither an episodic writer nor an intentional symbolist, though in her own way she is certainly an ironist. Her stories are rarely bounded by time or place. Where the overt action is trapped in a brief encounter at one place, memory is always there to deepen and extend whatever action we have witnessed; sometimes the memory emerges in dialogue, sometimes in the thoughts of the participants, sometimes it is offered by the narrator, and this multiplicity of viewpoints is again typical of Mavis Gallant, and creates a kind of story never bounded by what "happens" within it, always extending in time beyond the overt present, and tending, no matter what way of evoking memory is used, to produce a kind of fictional "life," however condensed it may be. . . .

I think the point I have made about Mavis Gallant's lack of an inclination towards intentional symbolism is really related to this aspect of her fiction. It is not a naturalistic fiction, but it is a fiction of enhanced reality, in which life is reshaped by artifice, but not distorted; part of the artifice is in fact to give this imaginative reshaping of existence a verisimilitude more self-consistent than that of existence itself. This means that what the story actually contains and not what it may suggest is of primary importance. The final effect of the story may be symbolic, but it is not written with symbolic intent in the same way as, say, plays like Ibsen's *Wild Duck* and Chekhov's *Seagull,* in which the named and central symbol becomes so important that the very action is shaped to fit it and in the end the ultimate goal of the whole work seems to have been no more than to give the symbol a manifestation in human life.

<div align="right">George Woodcock. Canadian Fiction
Magazine. 28, 1978, pp. 95–97</div>

[Sylvia] Fraser situated women in a threatening familial structure, in a culture that assumes a number of Fascist characteristics. Mavis Gallant places her characters in reactionary political locations at moments of historical crisis. In Gallant's work, numerous connections appear between racism and sexism. The title story of *The Pegnitz Junction* and the six Linnet Muir stories in *Home Truths* resonate with references to World War Two; "The Pegnitz Junction" refers to the war as it touched Europe since its conclusion; the Linnet Muir stories refer to war as it was reflected in Canada during its occurrence. . . . The author also overtly experiments with literary creativity, spe-

cifically with the idiosyncrasies of female creativity. Inevitably, Gallant's theories of literary production merge with her politics, a politics that includes gender. She joins with many women writers in focusing subversively on war. Through truncated narrative patterns, she demonstrates violence's dead end while balancing destruction with an alternative narrative, one that stresses creative production. Her female characters establish a game plan that revises traditional western culture. This is art at its most engaged.

Her fiction has not always appeared in such a light. An early reviewer of *The Pegnitz Junction* wrote that its stories evoke a "stagnant woman-crowded world that is hinged on ritual, where the figures display a recurrent impotence in rebelling against a conservative code of feminine behavior which is serving only to destroy them." Ritual there certainly is, and women characters dominate much of the action. But instead of demonstrating female passivity in the face of recurrent violence, Gallant's stories celebrate the activity of the female imagination. . . .

To some extent, "The Pegnitz Junction," prepares the way for the later Künstlerroman, the Linnet Muir stories, by dramatizing creativity in the process of developing. Christine is immediately involved in translating experience into stories. . . . "The Pegnitz Junction" exhibits an . . . extroverted imagination. Where Jean Price is a reflector, Christine is a conductor. A creator, Linnet Muir, comes even later. For Mavis Gallant, the female imagination is a complex mechanism. It develops, in relation to culture, intricate devices for exhibiting degrees of authority. The social and cultural milieus she invokes interact with women's stories, dramatizing not the traditional literary view of women's outsidedness or their concern with the petty and the small, but exhibiting their profound connection with human survival. Neither utopian nor escapist, these narratives function as guides toward rethinking the whole human experiment. . . .

The novella establishes connections between Fascist ideology and truncated narrative patterns. The six Linnet Muir stories also make political connections that underline the importance of ideology in shaping the ways in which stories are told. Because they are Künstlerroman, they make particularly clear the relationship between culture and the formation of the artist. Linnet Muir, the writer, reflects her experience of Canada during the years of World War Two, and her developing ability to write about that experience. She is able, retrospectively, to write her autobiography. In the novella, Christine seems to have been an earlier representation of the creative process, the stage at which material is filtered and organized. Occasionally, she also undertakes the beginnings of stories. Linnett is concerned with structuring stories and with the uses of journal material, the connections between drama and fiction, poetry, all the various genres that suggest her apprenticeship and that reveal some of the ways in which experience dictates form. Linnet is a representative writer, particularly sensitive to the female voice. . . .

Together "The Pegnitz Journal" and the Linnet Muir stories are narrations that place women in central positions as narrators and as subjects. At

the same time, they emphasize the emergence of women's stories from the gaps and fissures of texts. . . .

In the novella and in the short stories, men are associated with endings, often violent endings, whereas women are metaphorically associated with creative beginnings. . . .

Finally, Gallant insists on a female imagination that celebrates creation rather than destruction. Like *Pandora,* her stories politicize the private. They are neither escapist nor utopian, but seem to be alternatives to total destruction. The "hidden threads of connectedness" that Daly mostly relates to women's age-old magic have here been translated into the contemporary world where, after long silence, women writers are beginning to structure narratives in ways that produce new, tentative visions of a world no longer dominated by destructive plots. This is indeed "creative weaving."

Lorna Irvine. *Sub/Versions* (Toronto: ECW Press, 1986), pp. 133–34, 139, 145–47

With Mavis Gallant, though we may feel that the full truth of the matter has eluded *us,* we rarely—or so it seems to me—feel that it has eluded Gallant. She seems to claim a larger intelligence than she imputes to the reader. [Margaret] Laurence does not, and [Alice] Munro does not, even though both of these writers are more open about where they stand than Gallant is. It might seem that Gallant, who does not very often choose to place a platform within the work from which to address the reader or guide her response, therefore *trusts* the reader more . . . that she assumes the reader's power to understand the text. But this is not quite the effect achieved. Rather, Gallant is like a harsh mother, who can swim very ably herself, and chooses to instruct her children simply by tossing them into the deep end. If this is an expression of confidence in the child's (or the reader's) powers, it also feels rather like disdain for ineptitude. There is something rather chilling in Gallant—brilliant and painful as her work is—and it is related (in the way I have just suggested) to this author/reader axis, as well as to the more obvious author/character axis. In Gallant's fiction, the author seems disengaged, her judgment withheld: yet we sense her authority and we feel that her irony has depths that we do not quite plumb. If there are still ambiguities and contradictions in the lower depths—where Mavis Gallant stands alone—she is not telling.

The lure to character/reader identification is much less in Gallant's fiction than in Laurence's or Munro's, partly because the character/author bond is so much weaker. The Gallant protagonist is often not much of a quester; and there is a large gap between the level of expertise of the interpretant and the knowledge implied by the cool, mysterious tone of the narration, the implied author. That knowledge—that authorial clout—also occasionally announces itself very directly. Sometimes her judgment will descend like mercy, as in this authorial comment from her novel *Green Water, Green Sky:* it "was a test too strong for their powers. It would have been too strong for anyone; they were not magical; they were only human beings." But what she is talking

about here, the test she refers to, is the need for two of her characters to look clearly at themselves and to acknowledge their share of responsibility for what has happened to a third character. It may well seem to the reader that the test should not be too strong for nonmagical human beings: that we should not be expected to get first-class marks, but that a fair number of us ought to be able to make a respectable showing. Gallant is not that optimistic; and if she goes mellow on her characters, there is often this barb attached—that not much should be expected of them. . . .

The reader's fear that she may mistake the author's intent, or fail to discover some stable meaning in the text, may lead her to behave defensively, to shut the compelling complexities out. That species of the fear of the open heart, I suggest, and discover through my students, happens quite commonly with the work of Mavis Gallant. Her "coldness," a function of the mysterious distance from both character and reader, leaves the reader in uneasy proximity to the character—as if both were committed to one of Gallant's many pensions and did not much care for one another's company. Gallant, meanwhile, remains outside of that garrison in a superior sort of exile.

<div style="text-align: right">

Constance Rooke. *Fear of the Open Heart:*
Essays on Contemporary Canadian Writing
(Toronto: Coach House, 1989), pp. 25–27

</div>

Gallant is most commonly commended for an uncanny mastery of language and form: in Margaret Atwood's astute words she is "a terrifying good writer." . . .

The role of language in Gallant's fiction is a matter of structure as well as style: one of the important ways in which her fiction works is by the arrangement and playing out of ironic contrasts, and one of the cardinal contrasts is that between the reduction of character and the closure of experience on the one hand, and on the other the freedom of language either to pin down the most finicky detail of a situation or else to cloud and obscure what seem the simplest and most general precepts. And the contrast in Gallant's fiction between the dazzling and delicious language, the appreciative joy such marvelous fluency produces, and the reductive world this language portrays, is one of the constant shocks her readers encounter. . . .

Gallant's fiction . . . imposes a purely nominal and temporary order on the "useless chaos" of experience. We have seen that for her this chaos is not teeming with new forms and untried possibilities: it is more like an indefinite dead end, the gargantuan smash-up of all illusions and desires against a metaphysical brick wall. There are no brave new worlds awaiting us in our lives, only the eternal return of fixed, unpalatable, and unavoidable truths; that "grief and terror" which "after childhood, we cease to express" would seem to have to do with our early recognition of this state of affairs. It is a recognition brought home to us by our experience of utter vulnerability in the "prison of childhood" where we spend those few years in which we have "all [our] wits about [us]". . . .

Gallant's disquieting portrayal of childhood is one of the triumphs of her fiction. In these stories evoking "the prison of childhood" the reader perceives narrative disinterestedness and detachment as technical devices whereby the painful source of memory itself can be portrayed with neither self-righteousness nor self-indulgence. In fictions as diverse as "Rose" and "The Rejection," "Going Ashore" and "Jorinda and Jorindel," "Voices Lost in Snow" and "The Doctor," Gallant has produced distinctive variations on a common theme: yet for all her insistence on the "grief and terror" that characterize our experience of childhood, she writes of children in ways that open, rather than shut, the doors of our perception. . . .

What do we make of the way Gallant presents the world of women? We have seen that her pessimism regarding women's roles, status, and possibilities for self-transformation, a pessimism registered most strongly in her fiction of the 1950s and 1960s, is modulated but not renounced in her later writing: we are given a Linnet Muir, an Irina, a Lydia Cruche, and a Berthe and Marie Carett to weigh in the balance against the mass of Flors and Shirleys. This is not, of course, to demand that Gallant's fiction should present us with a panoply of positive feminist role models. Nevertheless, it is impossible not to notice her insistence on the generally closed nature of female experience.

<div style="text-align: right">

Janice Kulyk Keefer. *Reading Mavis Gallant*
(Toronto: Oxford University Press, 1989),
pp. 56–57, 118, 153

</div>

The politics of gender and the politics of colonialism are . . . part of the same historical enterprise which Canadian fiction has consistently sought to "represent." It is in this context that the short stories of Mavis Gallant exert their claim to recognition, and it is in terms of their specific historical and cultural determinants that the stories are most likely to be appreciated and understood. Her sharp focus on the lives of women both in Canada and in Europe during the war years intensifies the question of what it means to be Canadian, but also reveals a continuing anxiety about the ways in which that experience might be conveyed through the language and techniques of fiction. A deep unease about selfhood and nationhood manifests itself in the accompanying distrust of inherited forms of realism. A persistent concern with dispersal and displacement is rendered through the twists and turns of dislocated narrative.

The title of Mavis Gallant's selected "Canadian" short stories, published in 1981 as *Home Truths,* is doubly ambivalent; the instability and uncertainty of our concept of "home" is intimately bound up with the provisionality and indeterminacy of "truth(s)." The effect is to challenge and undermine the proverbial wisdom associated with such customary clichés. The volume is structured around three related sections: "At Home," "Canadians Abroad" and "Linnet Muir," with each section exploring a variety of regional, national, and international perspectives through multiple narrative strategies. In the

process these stories break down the traditional distinctions between history and fiction and suggest that both are discourses by which we structure our sense of social reality; together they challenge any simple, objective or neutral recounting of the past.

There is throughout *Home Truths* an insistent recognition that the "culture" of a nation is shaped by the complex and often devious processes of memory and language as well as by the obvious and identifiable historical "events." The "At Home" and "Canadians Abroad" sections are concerned with a fictional rearrangement of choices and possibilities which is not an end in itself but part of a larger enquiry into what W. H. New calls "political modality"; they offer a way of rethinking the past, proposing renewed perspectives and new beginnings. The final effect of these formal and structural shifts is "to probe the attitudinal fluctuations which result in political choices, or, broadly speaking, political action."

The frankness of this fictional voice, openly declaring its own procedures, commenting on the processes of memory and knowledge, and thereby conceding its own vulnerability, is strikingly reminiscent of the narrative strategies at work in Alice Munro's short fiction, and it points more generally to a persistent trait already alluded to: the ability of the Canadian short story to maintain a vigorous skepticism about the representational claims of fiction and yet continue to grapple with social and political "realities." Such a trait demands that the stories be read in terms of their engagement with precise historical and cultural determinants and not as a universal expression of that much loved liberal humanist catchphrase, "the human condition."

> Stephen Reagan. In Coral Ann Howells and
> Lynette Hunter, eds. *Narrative Strategies in*
> *Canadian Literature* (Milton Keynes,
> England: Open University Press, 1991),
> pp. 115–16, 119

GALVARRIATO, EULALIA (SPAIN) 1905–

A retrospective look at Eulalia Galvarriato's *Cinco sombras* (Five dreams), published in 1947, reflects great irony around the fact that the effort to preserve the past from the threat of oblivion, which constitutes the narrative's basic inspiration, also plays a part in the fate of the book itself. A finalist in the Nadal Prize competition for 1946, the novel received two votes from the five-member jury which, after much deliberation, awarded the prize to *Un hombre* by Jose Maria Gironella. One member of the jury, Nestor Lujan, considered *Cinco sombras* "a truly artistic narrative of infinite humanity, and a work at the same time delicate, transcendent. It is an exquisite, consummate book, an unforgettable novel." Its publication attracted commentary from

distinguished writers and literary authorities. . . . For this reason, it is very strange that some thirty years after such a warm welcome, the author's name does not appear in many major histories of the twentieth-century novel. . . .

We cannot help relating this apparent oblivion to the fear that the novel's male protagonist expresses that the story of the five dreams of women will be lost in oblivion; indeed, the domestic and emotional life of five sisters . . . may constitute material unworthy of a "great novel" after a period of national trauma like the Spanish Civil War. However, there is something so peaceful in the pages of a book that aroused the enthusiasm of the critics of the time. Perhaps they felt attracted by its uniqueness, since it was different from the majority of the books of the time. It may be considered a slightly anachronistic interlude in the literary panorama of a postwar era where most novels were devoted to portraying and exploring the impact of that conflict on individuals and on society. The novel inspired no movements or imitators. It is unique in one other way, as well: it is the only long novel its author has published. . . .

Within the postwar neorealist panorama, a novel as tender and lyrical as *Cinco sombras,* with no relation to Spanish reality constituted an extraordinary deviation. . . .

The significance of *Cinco sombras* as a novel of the first decade after the war, whose inextricable presence is felt in the form of explicit or covert reference in other novels, is that that war is completely absent here. This is so unusual, given the fact of its creation, that one wonders if it was really as divorced from the prevalent preoccupations as one might think. The emotional story of the five enclosed dreams, whose intimate drama unfolds apart from external political and social realities, acquires relevance only if we consider it as an "intra-history" in Unamuno's sense of the silent march of humble lives that are lived out within the grandiose borders of history.

<div style="text-align: right">

Estelle Irizarry. In Janet W. Pérez, ed.
*Novelistas Femeninas de la Posguerra
Española* (Madrid: José Porrúa, 1983),
pp. 47–49

</div>

An . . . example of a family whose structure is based on the hierarchical idea that makes one member of the relationship the group's dictator, is apparent in *Cinco sombras.* The system represented contains two levels of entire generations, the father, Don Carlos, and the five daughters, separated off from the former's field of action and relegated, without distinction of age, to fulfill functions assigned by reason of sex.

In this model of a family, the paternal norm determines the female function within and outside the home. It consists of the imposition of a series of restrictions that limit the freedom of action of the young women who "never go out of the house, never go further than the church where they attend mass." Any initiative on the part of the young women is subject to the paternal will and their most innocent desires depend on "if Daddy lets me,"

allowing the father's demands to condemn them to isolation, personal sacrifice, and the renunciation of love relationships.

Obviously, the father's relationship with his daughters is manifested in a narrative dominated by "sullen silence" and rejection,

> without words . . . by that permanently sealed office door, hostile; by that father's face, that face even more silent and closed-off than the sullenly locked door.

Not arriving at appropriate means of verbal communication between the two levels that make up the family structure, they create a symbolic communication. . . .

As a reaction to the lack of communication between the two hierarchies, the five daughters reinforce the mutual relations within their own subsystem. They share with one another the simple joys that occur within their limited world by the imperceptible accidents of nature observed in the garden or the little coquetries with which they try to express their femininity. Together, they speak, laugh, and keep silent before paternal impositions, helping one another in the moments of crisis that accompany the marriage of one of them or the death of the youngest sister. They also share the sense of guilt that the father's attitude makes them feel by connecting them indirectly with the cause of their mother's death. The five young women, united, resigned to continuous frustration and tragedy, become part of one another's souls and interpenetrate to the point of developing, within their own group, a total, single interaction.

<div style="text-align: right">

Maria Jesús Mayans Natal. *Narrativa Feminista Española* (Madrid: Pliegos, 1984), pp. 50–51

</div>

The neglected condition—"between dreams"—of Eulalia Galvarriato is unique within the postwar literary scene and is chiefly due to the fact that her career did not follow the tendencies of the time and that not all her work was published. . . . Apart from critical work, Galvarriato wrote one novel, *Cinco sombras,* which was a finalist for the Nadal prize in 1946 and received considerable critical attention. But her literary reputation was chiefly due to her short stories which appeared in magazines and anthologies during the postwar years. She has recently published her provocative book, *Raices bajo el tiempo* (Roots beneath time), showing that, despite her apparent silence, Galvarriato has continued to write for more than forty years.

In this book are collected the thirty stories that form her "corpus" in this genre that she admittedly prefers. . . . Jose Antonio Muñoz Rojas, poet and fiction writer, testifies in his introduction to the lyrical value of Eulalia Galvarriato's prose. . . . The character of this entire collection is very personal and has autobiographical features; at the same time, some of the stories are directly related to her life although . . . they are not autobiographical.

The stories date from the 1940s through the 70s, with the majority belonging to the 50s. A number of them were published previously. . . . In any event, her reputation as a short story writer was well established in the postwar period, before the publication of the present collection. . . .

In agreement with Garcia Pavon's criterion, which considers short stories written by women "more emotional than social," Galvarriato tends toward a subject matter that is sensitive by preference, although it is not always possible to discern it in such a categorical manner, and she has also attempted social and existential short stories with good results. . . .

The fact that Eulalia Galvarriato has written short stories for nearly all her adult life reflects the constancy of her calling as a short fiction writer. Her talent is apparent in the narrative variety, the diversity of her subjects and, above all, in her expressive style, with a careful prose, full of nuances and suggestions. We might conclude . . . that time in its multiple facets, personal, oneiric, existential, intrahistoric, is the true protagonist of these unique narratives.

<div style="text-align:right">

Concha Alborg. *Monographic Review/
Revista Monografica*. 4, 1988,
pp. 278–79, 284–85

</div>

In 1947, Eulalia Galvarriato won literary renown for her highly acclaimed novel *Cinco sombras*. A contender for the prestigious Premio Nadal, *Cinco sombras* attracted attention because of the delicately sensitive and introspective style of its author. Its . . . ambiance as well as the underlying thematic currents of cyclical timelessness and the tyranny of repressed passion, bears witness to the ongoing influence of Generation of '98 giants such as Azorín, Miró, Baroja, and Unamuno.

In *Cinco sombras,* . . . form and content are intertwined determinants of Galvarriato's unique use of *le* and *lo* as masculine direct object pronouns. . . .

Eulalia Galvarriato is a resident of Madrid and, as such, her writing reflects the generally accepted [standard Castilian] practice of using *le* to refer to persons and other animate beings but *lo* when the direct object is inanimate. Nevertheless, she shifts to *le* whenever the inanimate object is replete with emotional significance and/or represents a crucial juncture in plot development. Thus, *deseo* is referred to as *le* when the character Don Diego tries unsuccessfully to explain the depth and intensity of his feelings for the five sisters whose life story he is recounting. . . .

Cinco sombras is the story of five sisters who led brief and sheltered lives under the domination of a stern, dour father embittered by the premature death of his young and much-beloved wife. The girls are tutored at home and spend the major part of their days sitting together around a five-sided sewing table.

The table, a gift from their mother, is the center of their cloistered lives. . . .

In the last chapter, the author bewails the passage of time and the ephemerality of life by using the familiar *ubi sunt* theme. . . . As *Cinco sombras* draws to a close, the *costurero* stands alone and lonely, and in the very last sentence, *lo,* not *le,* is the direct-object pronoun chosen by Galvarriato. . . .

Inasmuch as *le* had been employed consistently to refer to the *costurero,* a central component and centripetally controlling element of the novel, it must be assumed that the changeover to *lo* in the final sentence represents a deliberate attempt on the part of the author to highlight the *costurero* and to envelope it in a semiotically different context. . . .

The *costurero* is symbolic dominant force in the lives of the sisters. Given to them by their mother shortly before her death, it stood as a mute yet constant symbol of her influence. Each day as they gathered around it they were, in a manner akin to worship, paying homage to her memory. Now, all five sisters are dead and the *costurero* is alone in the darkened, tomblike room. It is aloof and impervious to all it has witnessed or, illogical as it may be, does it suffer and mourn the passing of the family and also of a gentler and simpler way of life?

Eulalia Galvarriato has, perhaps, chosen to use *le* to accentuate the enigmatic and metaphysically problematic nature of the question she has posed for herself as well as for her readers.

<div style="text-align: right">Judith S. Merrill. USF Language Quarterly.
17:1–2, 1988, pp. 7–8</div>

GÁMBARO, GRISELDA (ARGENTINA) 1928–

Gámbaro has successfully drawn from the intellectual, coldly clinical and pessimistic theater of Ionesco and Beckett. And from Kafka, she produces precise and meticulous interpretations of the real world with nightmarish, wild situations which thwart her characters. These characters desperately try to solve the riddles of life only to be hopelessly frustrated and trapped by unfathomable internal and external forces. Gámbaro's theater basically partakes of existentialism and the theater of the absurd; she is preoccupied with man as an individual who seeks freedom from both himself and society. Following the existential ethic, she focuses on a few major characters, studies the individual in depth, and underplays the temporal and physical setting. Up to the present moment, Gámbaro has avoided the immediate Argentine reality and culture . . . in favor of a total concern for universal man. . . .

The Siamese Twins speaks convincingly to the contemporary audience in its elaboration of the Cain and Abel parable within the framework of modern man's schizophrenia. The work is a cold requiem for the spirit of good and evil in which the latter triumphantly annihilates the good and the weak. Written in two acts and blending a noisy and often chaotic dialogue with

touches of black humor and mythic symbolism, *The Siamese Twins* [presents] two brothers, heirs to loneliness and fear, who are now bound as figuratively as they once were physically. Sadistic Lorenzo plots diabolically against ingenuous Ignacio; both characters represent the two poles of human existence, perhaps the total personality of man. Gámbaro dramatizes the tragedy of man's anguish and the futility of hope by means of a dialectic interplay in which the two brothers synthesize ideological frustration, anxieties, loss of innocence and many doubts regarding society and the new generation.

Virginia Ramos Foster. *Latin American Theatre Review.* 1:2, Spring 1968, pp. 55–56

[In *A Happiness with Less Pain* Gámbaro tries] to express the lack of communication within a group of human beings and the way such a lack can affect one's life. Moreover, there is an attempt to represent, through the use of absurdist techniques, our acceptance of the canons of bourgeois thought— not of bourgeois *life,* but of its *mental mechanisms.* Thirdly, by abandoning logical argument . . . the novel does away with everyday problems and strives for a continuity based on alogical and apsychological approaches.

Since the intensity of the novel makes us think again and again of the theater, one cannot help but recall [Alfred] Jarry's theory—which Jean Genet and others were to reformulate—of the need to eliminate psychological characterization in order to stress the *sign* [that is, how a character, like a word, is an element of meaning in a higher scheme of things]. The novel is written with a firmness and coherence . . . [that] gives an almost visual quality to events and dialogues. Familiar with the language of the theater, Gámbaro attempts to do what Beckett, Ionesco, Brecht, and Peter Weiss have already done in other ways: to depict archetypes rather than stereotypes and to abandon conventional approaches in the drama or the novel. . . . [One] is reminded of the theme of Boris Vian's *Les bâtisseurs d'empire,* in which, as in Gámbaro's work, all of the characters converge in a simple room in which anything can happen. But unlike Vian's work, at the end of which only a single person is left in the room, in Gámbaro's work the area becomes more and more crowded with characters, until space is devoured by a multiplicity of presences.

Elizabeth Azcona Cranwell. *Revista Sur.* 315, November–December, 1968, pp. 92–93

[In Gámbaro's *The Camp* Peter Weiss's] Hospice of Charenton [in *Marat/ Sade*] becomes a Nazi concentration camp, its guests are transformed from imprisoned madmen into crazed prisoners, and the theatrical representation directed by the Marquis de Sade is converted into a piano recital by the insane Emms (Griselda Gámbaro's Charlotte Corday), organized by the very sadistic head of the concentration camp. It would not be inappropriate here to recall what Borges tells us about certain productions that "do not belong to literature but to crime: they are a deliberate sentimental blackmail, reduc-

ible to the formula 'I will present you with suffering and if you are not moved, you are heartless.'" What am I trying to say? Not that the use of concentration camps should be forbidden, but that it is an easy way out. One has the right to demand . . . either greater profundity or a focus for the poetic flight. In sum, there should be something new to say, something other than what has been already said and repeated so often, a virtue that in this case we have not been able to find.

Originality and necessity aside, the work does demonstrate a solid familiarity with theatrical devices, and not only the heavy ones, like startling the spectator with machine-gun bursts and [torture] sessions or making the protagonists run through the theater, a Pirandellian procedure that seems disjointed here. There is also a control over the dialogue, a capacity to create atmosphere and to resolve dramatic situations. . . .

Everything depends on the prior convictions of the spectator, who will thus find himself either pleased or annoyed but not indifferent, as is always the case with these didactic or propagandistic pretensions in the theater.

José Luis Sáenz. *Revista Sur.* 315,
November–December, 1968, pp. 122–23

The Folly contains elements that are obviously symbolic. Lily (Lilith) represents sexual obsession; Viola, the mother, appropriately violates her son's masculinity. The strong youth stands for the working class, Luis for the selfish middle class. These symbols suggest an allegory about contemporary Argentine or Latin American society in which the middle class male (Alfonso) is fettered by his own self-indulgent sexual fantasies, by a matriarchally dominated family, and by a calloused and shallow society. The efforts of the working class, although well-meant, are arrogantly scorned by and ultimately wasted on the degenerate middle class.

Griselda Gámbaro presents her Kafkaesque tale in a very theatrical manner. By stressing physical language as advocated by Artaud, she addresses the play to the senses, not to the intellect. The iron fetter on Alfonso's foot as well as various other objects are used to emphasize his helplessness: he knocks out of his reach a ringing alarm clock; chamber pots multiply in successive scenes under his bed; the worker uses a little vegetable cart to move Alfonso about on the stage, etc. Other dramatic techniques in accordance with Artaud's theories involve the use of an oversize mannequin to represent Lily, and many sound effects, such as the annoying grating noise of the filing in the last scene while the mother is trying to entertain her guests.

Cruelty is perhaps the most notable Artaudian element in the play. There are moments of outright sadism when Luis, pretending to be playing, burns Alfonso's eyelashes with a cigarette and almost strangles him with a shawl. The incidents of physical violence and moral cruelty are very numerous. Combined, they convey a sense of despair which turns into a kind of metaphysical experience for the viewer.

Tamara Holzapfel. *Latin American Theatre
Review.* 4, 1, Fall, 1970, p. 7

Miss Gámbaro is without doubt one of the most exciting surprises that I encountered in my search for viable Latin American plays and playwrights. When I met her the first time I was impressed by her gentleness and intelligence. Her gentle disposition in no way prepared me for the quality of her plays. Upon reading them for the first time I was stunned by their brutality and vigor, their economy of means, and their cruel, almost Strindbergian assessment of life. Miss Gámbaro shows promise of becoming one of the most powerful playwrights in Latin America.

Her plays tend to be free of folkloric limitations. She is certainly as strong a writer as many of the best young playwrights in current European theater. . . . *The Siamese Twins* is, like *The Camp,* a relentless investigation of aggression and submission, of love and hatred, of dependence and independence. Some indication of the international focus that Miss Gámbaro gives to her plays is to be discerned in her amusing suggestions that the song heard in *The Camp* be altered to suit the audience for which it is translated. "What is needed is something utterly corny. I recommend that you use 'Oh Susanna.'"

William J. Oliver. *Voices of Change in the Spanish American Theater* (Austin: University of Texas Press, 1971), p. 49

Las paredes (1963), Griselda Gámbaro's first published play, was written in her native Argentina. The play has a metaphysical and universal dimension, but also dramatizes the political situation in her strife-torn country. . . .

Props and stage setting are active components of Gámbaro's dramatic ambience. They play essential roles in communicating her themes and in contributing to the efficacy of the drama as a staged work in the theater. They also help to underscore the circularity inherent in both the structure and the theme of the drama. The picture of the languid youth staring out of the window is removed from the room, and the Official informs us that it is now hanging in a different room (or prison cell). Thus, the dehumanization of man, effected in part through the undermining of his reality perceptions, is shown to be an ongoing process. This circularity manifests itself in a number of ways in the work.

Peter L. Podol. *Modern Drama.* 24, 1981, pp. 44, 46

Although Griselda Gámbaro is now widely recognized as one of Spanish America's most important and original contemporary playwrights, critics have only recently begun to examine her individual works. Her best-known dramas are *Las paredes* (1963), *El desatino* (1965), *Los siameses* (1967), and *El campo* (1967). A common theme in these plays, many of which have been staged both in her native Argentina and abroad, is the dehumanization of average men and women by repressive social and political forces. . . .

The one component of Gámbaro's plays that has been consistently ne-
glected in both the early and the more recent critical studies is language. A
number of critics have called attention to Gámbaro's extensive use of Artau-
dian techniques that stress the communicative power of gesture, facial expres-
sion, lighting effects, and a variety of human and non-human sounds designed
to surprise or shock the audience. One goes so far as to claim that "dialogue
can be considered of secondary importance" in Gámbaro's theater. This may
appear to be so because Gámbaro's characters use short sentences, non-
rhetorical language, and uncomplicated grammatical structures. Precisely
these qualities, however, make language an efficient instrument of coercion.
Moreover, although it is terse and laconic, the language of the dialogue is
often deceptively complex and highly ambiguous within the specific contexts
of Gámbaro's plays.

The relationship between dialogue and theatrical effects in Gámbaro's
plays is both contradictory and complementary. In *Las paredes,* for example,
the frequent incongruity between sounds, gestures, and movements, on the
one hand, and the sense of the dialogue, on the other, serves to enhance
rather than diminish the power of language. This is because the contradictory
relationship between dialogue and theatrical effects reinforces the contradic-
tory logic within the dialogue itself. . . .

The abuse of language, its use as a tool of coercion, deception, and
behavioral manipulation in *Las paredes,* has important political implications.
As in Orwell's *1984,* subversion of the function of language is a primary
means of exercising control over human behavior. The Joven's passive accep-
tance of his fate in the final scene is much the same as the "learned help-
lessness" of experimental subjects who are unable to take advantage of
opportunities to flee after being subjected to inescapable forms of punish-
ment. In subverting the power of language, the Funcionario and the Ujier
assert their own power to control, shape, and define reality according to their
purposes or perhaps to a larger design of the State, implied in the totalitarian
microcosm of *Las paredes.*

<div align="right">
Robert A. Parsons. In Elias L. Rivers, ed.
*Things Done with Words: Speech Acts in
Hispanic Drama* (Newark, Delaware: Juan
de la Costa, 1986), pp. 101–2, 113
</div>

GARNER, HELEN (AUSTRALIA) 1942–

Helen Garner's latest book *The Children's Bach* is a beautiful piece of fiction.
With its bewitching shape and gleaming surface it should put paid to the myth
of Garner as a mere literalist or reporter. It is also the sort of book which
will make a certain kind of reader say that at last she is writing about ordinary

intelligent people. Of course Helen Garner has always written about ordinary intelligent people, though the fact that they were sticking needles in their arms or sleeping with more than one person tended to blind those who had different habits.

The hallmark of Garner's work has always been, for better or ill, its near absolute aura of authenticity. In her first book *Monkey Grip* some parts are ragged and some parts are gooey. Sometimes too much seems to be happening and sometimes too little. Often, very often, the writing is terrific but even when it isn't you can always see plainly the effort to wrestle a real emotion to the ground. "Real" emotions may seem pretty imponderable literary qualities these days but the effect of Helen Garner's writing in *Monkey Grip* and ever since has tended irresistibly to suggest the echo of experience, of imagination representing experience, rather than invention. Naturally technique, an energized practical command of language, was the necessary medium but the energy always seemed to subsume the artifice. In *Monkey Grip* Garner had stacks of "technique," if by technique we understand the creative vitamin that makes a work breathe, but she seemed too to be following the contours of an intimate form of reportage rather than any formally or externally imposed ideal of shapeliness. No one needed the gossip to tell that some of the book at least was barely fictionalized. But there was a lot of strength in the comparative roughness of *Monkey Grip*. Whatever else Helen Garner was, from the outset she was never a faker. The book is an almost entirely convincing piece of Australian legend which will probably prove a classic. An improbable one: this tale of sad and unseemly things told with the buoyancy and candor of a child's dream of summer. . . .

[T]he transition from *Monkey Grip* to *Honor and Other People's Children* is from free-wheeling naturalism to a tighter more formally thrifty realism. *The Children's Bach* is light years from any sprawling tell-it-all naturalism. It is concentrated realism of extraordinary formal polish and the amount of tonal variation which it gets from its seemingly simple plot is multifoliate to the point of being awesome. Hence no doubt the self-reflexive, though to Helen Garner I would suspect less important, aspect of the title. Bach is, preeminently, an artist who compressed so much music into so few bars, to adapt a phrase of Basil Bunting's. Like some of the longer stories of Chekhov or Katherine Mansfield, *The Children's Bach* is the kind of short work which can make a lot of "large scale" fiction look merely footling. Garner has achieved an exact economy of means which makes the musical analogy inevitable rather than forced or self-conscious. She approximates to that most mysterious quality fiction can possess, of allowing everything to take exactly the right amount of time. When a writer gets that then there's no stopping her.

Peter Craven. *Meanjin*. 44, 1985,
pp. 209–10, 212–13

Helen Garner writes, increasingly, with a fine sense of craft. Her short novel, *The Children's Bach,* was so perfectly spare, such an exquisite integration of

observed details and selected incidents, that I, for one, finally closed the book with an audible sigh of satisfaction. Her short story collection, *Postcards from Surfers,* demonstrates further Garner's ability to refine subject matter so that meaning emerges from accumulated detail rather than exhaustive explanation or description. In *Postcards from Surfers* the title story sets the tone for the collection. The postcards, written cryptically to a former lover, are eventually deposited in a rubbish-bin rather than a mailbox and the narrator returns to accept a quiet reality, an ordinary life. But it is Garner's celebration of the ordinary that is so rewarding. The practiced ritual of making a sandwich becomes an affirmation of life and a metaphor for continuity. . . .

In contrast to the stolid reality of her father, the narrator's former lover is a mere phantom, named but never known. Communication between father and daughter is naturally implied in daily rituals and unspoken words. It is a complex relationship, as indeed are all the "ordinary" relationships (mother/daughter, aunt/niece, sister/sister)—in one sense vital and still evolving, in another timeless, unchanged, institutional.

Garner does not have to state truths about relationships: they are artfully extracted, from random incidents and conversations. . . .

Typically, Garner does not allow herself or her characters to indulge in futile longings. As in the title story, the myth of the lover is dismissed and reality and true friendship once more embraced with dignity. "My friend stopped crying. I played the ukelele. My friend drank from the cup."

It is an extraordinary difficult task to produce a collection of consistently good, let alone outstanding, stories. In this respect Helen Garner has done magnificently. Of the eleven stories in the collection only one, "La Chance Existe," strikes me as being unsatisfactory, forced. Garner is at her best, so far, when dealing with the significance within and beyond ordinary, urban, middle-class, contemporary living and relationships. This is her great talent. It remains to be seen whether this is also her limitation.

<div style="text-align: right">Susan Hosking. Overland. 104, 1985,
pp. 67–68</div>

As Mary Ellmann revealed so wittingly in her pioneering *Thinking about Women* (1968), acceptance of the dominant male culture by a woman writer is mocked, resistance is belittled. Helen Garner, writing in the decade of the women's movement, met a response that shows how the Jacobean patriarchal culture faced by Wroth mutated, by the 1970s, into a culture just as bound up in a system of expectations that women writers would have to imagine themselves past. *Monkey Grip,* which appeared in 1977, did not receive completely uniform, or for that matter completely negative, reviews. Nevertheless, reviewers constantly fix upon the (possible) autobiographical elements in the novel, its formlessness (the two are often seen to go together), and its self-indulgence. . . .

Monkey Grip received some very good reviews and, eventually, the National Book Award. But with a few exceptions (basically John Larkin in the *Age* and Edna Carew in the *Sydney Morning Herald*) reviewers harp on their sense that the novel is in some way a *roman à clef* and the fact that it is artless or formless. These two assessments range in tone from benign to vitriolic. . . . Garner's reviewers all too often patronize her. . . .

Despite the report by the judges of the National Book Council Award for 1978, which clearly tries to balance [the] view of *Monkey Grip* (saying, for example, that it is "beautifully constructed," *ABR,* October 1978), as the "artistry" in Garner's later books has been hailed, her first novel has remained a supposedly formless outpouring. . . . A partial explanation for these contrasting responses is that *Monkey Grip* was approached in a particular spirit by many reviewers caught up in ideological battles over issues like drugs, the family, sexuality, and so on. At the heart of these, though it is often difficult to detect, is the debate over feminism that, in the mid 1970s, was being attacked in a particularly reductive fashion.

<div style="text-align: right">Paul Salzman. Southerly. December, 1989,
pp. 542, 544</div>

Even in Australia, where short fiction of a very high order is by no means uncommon today, Helen Garner's *The Children's Bach* is an outstanding work. Its brevity, its clarity and its apparently effortless economy should not blind us to the novel's considerable ambitiousness, which goes beyond a depiction and analysis of a section of contemporary Australian society in order to raise fundamental questions about the nature of morality, desire, and order. The scope of the book's questioning is almost disguised by the narrative's faultless pace and its spare, oddly spacious sense of organization. Despite its brevity (it is only ninety-six pages long), *The Children's Bach* is both detailed and uncluttered, showing an unfailing sense of just what to put in, and what to leave out. . . .

The "mix" in *The Children's Bach,* is just right. The lives of eight people are intertwined and played off against each other in a way that distinctly recalls the music of the composer in the book's title: there is a similar combination of complex detail and austerity. But the mix is also, this passage reminds us, a matter of "taking bits out." What is left out results in the creation of the silences, the absences of language, which give shape and a sense of meaningfulness to the phrases. In the construction of the narrative text of fiction (and, of course, in the interplay of phrase and silence in poetry), what is left out allows, by its absence, what is left in to speak and be heard. Yet what is left out is not simply absent from the text, is not merely "not there." Rather, it finds ways of revealing itself, rendering itself discernible in the complex weave which is the text—and which, in its peculiar way, it enables, which it permits to come into intelligibility.

When one compares *The Children's Bach* with Helen Garner's first novel, *Monkey Grip,* it becomes quickly clear that one of the things that the

later book appears to leave out is the earlier's sense of repetition. . . . But it would not be true to say that repetition is totally absent from the book, despite the stringent economy of its organization, the success of the "taking bits out" business. On the contrary, it animates and underpins the novel's moral concerns in a pervasive and subtle way. This is not simply a matter of Helen Garner's learning to write a more deftly edited second novel than her first. It is a matter of the narrative striking a remarkably rewarding poise, in which desire and its frustration, and the potentially tragic conflict between desire's several ends, are all held in successful balance. . . .

The Children's Bach is a subtle and fine exploration of the origin of both disorder and order, meaningless repetition and significance, within desire. They are variations on a common theme, a theme which has no pure, "original" form—that is, no form or definition outside the variations, like the Bach that Athena practices. Mrs. Fox claims of the Goldberg Variations, "Variations? They all sound the same to me!" Her life has been rigidly circumscribed by patriarchal inattention: her "opinions, when they were freshly thought and expressed, had never received the attention they deserved." The same cannot be said of Helen Garner; and even if the confines of phallocentrism can still be discerned, and their dues still have to be paid, The Children's Bach clearly provides the reason why.

Andrew Taylor. In Alan Brissenden, ed. *Aspects of Australian Fiction* (Perth: University of Western Australian Press, 1990), pp. 113–14, 118–19, 125–26

GARRIGUE, JEAN (UNITED STATES) 1914–72

Using such symbols as the forest, the zoo, the statue and the centaur, Jean Garrigue explores the loves, loneliness and anxieties of modern man, crystallizing them in poems that have the sensuous immediacy of actual experience. The effect is achieved in an idiom that is always fresh and meaningful, capable of analysis and with a music that has just the right amount of dissonance to identify it as contemporary. Miss Garrigue has passion and intellect and fine technical equipment with which to give them embodiment.

Stephen Stepanchev. *New York Herald Tribune*. September 28, 1947, p. 18

Jean Garrigue is a very resourceful young American poet, and *The Ego and the Centaur* is a rich and full record—if rather too much so—of her self-exploration. It leaves little doubt of her ability to range in any one of several directions and to learn from a number of people without losing her own identity. But the general effect of this book is one's feeling that Miss Garrigue

finds it easier to try out the same idea in a number of different poems, all of them more or less unfinished, than to stake all her possibilities in one definitive poem and let it stand. The poetry is all over the book instead of being a number of poems in the book and the ink sometimes seems to run.

Henry Rago. *Commonweal.* January 16, 1948, p. 353

Miss Garrigue's first book of poems is notable for two qualities: an acute introspective sensibility, at its best in such delicate probings of mood and motive as "Letter for Vadya," and an unusual accuracy of physical observation, especially when she is dealing with animals. The verse is relentlessly honest, stripped of tricks—too stripped, perhaps—alive at every point. . . . Unhappily . . . the greater part of the poems, for all their vitality, are marred by a sloppiness that seems to be the result less of obtuseness than of impatience. There is *brio* enough here, and to spare; but there is a tendency to sag, to go unkempt.

Dudley Fitts. *Saturday Review of Literature.* June 19, 1948, p. 26

This poet, whose first poems ten years ago were in a metaphysical-imagist vein and showed the influence of John Crowe Ransom and Marianne Moore, now steps forward with a very personal style of her own. When this style . . . is used to convey a lyrical ecstasy or a sensory nostalgia, it is effective. When it is used for straight description, it can be magnificent. . . . Unfortunately Miss Garrigue is not partial to . . . simplicity. Like Ransom, but without that poet's saving wit, she prefers the oblique, metaphysical, verbally affected and syntactically confused.

Selden Rodman. *The New York Times.* November 8, 1953, p. 30

It takes but a few lines of Jean Garrigue's second volume *(The Monument Rose)* to hear a really significant voice sing out with deep internal drama and verbal excitement. . . . Being inventive, sensual, and lyrical—word-inventive—her language is often just as startling as her imagery and her original phrasing, the essential elements if poetry is to remain alive and not become just a sentimental sewer. Even originality is not enough if it is merely sensational or extravagant; but when originality is allied to a critical intelligence and is embedded in the systematic values of poetry, then poetry renews itself and the reader, adding another page to literature's uncertain history. Jean Garrigue has done that, if modestly, with a dignified attitude and an exciting air.

Harry Roskolenko. *Poetry.* December, 1953, pp. 177–79

[Jean Garrigue's] poetry is at once lush and cryptic, extravagant and concise. It is elaborate with color and imagery, rich with alliteration and a frequent Elizabethan elegance. . . . There are occasional overtones of Hopkins and Dylan Thomas in her work, but she is undeniably original and individual as an artist and a craftsman in complete command of her medium. . . . The poetic intensity, the wealth of light and color, and the real distinction of Miss Garrigue's work cannot fail to impress the perceptive and careful reader.

Sara Henderson Hay. *Saturday Review of Literature.* January 16, 1954, pp. 19–20

The world of *The Monument Rose* is romantic in its richness and strangeness and curious elaboration of detail. . . . Most of all, though, and for all the elegance in particular words, the character of this poetry is just where it belongs, in the play between rhythms and syntax, the wave-motion, so to say, which makes the identity of passage after passage and makes all one and most fine. This thing, the weaving and stitching, is the most neglected part of poetry at present, but attention to it is a mark of mastery, and the gift for it, the melodiousness which is, as Coleridge claimed, the final and distinguishing sign of a poet, is something Miss Garrigue wonderfully has.

Howard Nemerov. *Sewanee Review.* Spring, 1954, p. 31

Single lines, sudden perfect phrasings, real poetic breath—should one not be content with this? In the abstract there is more in Miss Garrigue than in many contemporary poets, yet it remains abstract and fragmentary, a playing of scales rather than a virtuoso incantation. . . .

Two poems, in fact, the "Discourse from Firenze" and "Soliloquy in the Cemetery of Père Lachaise," deplore the loss of the ancient gods and the freedom of the Renaissance or Keatsian artist who took from the heaven of man's imagination whatever he wanted, Christian or Pagan . . . mingled forms. She calls on the cemetery ornaments of Père Lachaise to come alive, not for the sake of the buried but for the sake of poetry. Yet she knows (although she does not always accept her own conclusion) that the modern poet must walk naked. "The passion is to keep the ignorance up," she remarks in her most finished poem ("The land we did not know").

Geoffrey H. Hartman. *The Kenyon Review.* Autumn, 1960, pp. 694–96

Leaving aside the poems about Colette, cats, country gardens, etc., her work contains a core of intensely and I should say fully humane poems, which are increasing in proportion to the whole. If they never rise to anything that can be called a pitch, they nevertheless preserve the attractive quietness of steady intellectual warmth. At the same time there can be no doubt that she has a splendid lyrical gift and uses rhyme and meter elegantly. This is a less rare attainment then her others; some of her poems could be transposed to

volumes she never wrote and no one would know the difference; but in the best poems her softly modulated rhymes and assonances together with unexpected variations in the length and pace of her lines produce what she (elegantly) calls "a little native elegance": the effect is right and original.

Hayden Carruth. *Hudson Review.*
Spring, 1965, p. 134

The extraordinary radiance pervading *A Water Walk by the Villa d'Este,* Miss Garrigue's preceding book, is more than often held to a congenial shimmer in this fifth collection of her poems [*Country without Maps*]; and though the far-flung verbalism of before now looks, in relaxation, only more native, the mood seems agreeably broadened: with much of the ecstatic remaining, has come a pausing for judgment. And it is within that pause that variations of style now chart and compass her moderating extravagance. Unlike Colette, who is commemorated here by a fine opening poem, Miss Garrigue seems no longer bowed to the hauteur of the rapturous alone, but rather to heavier indulgences which ask not only sympathy but the utmost care.

Frederick Bock. *Poetry.* June, 1965, p. 229

Miss Garrigue is perhaps more skilled than any other poet writing today with the power to dramatize emotional thresholds between jeopardy and renewal. She has a genius for returning to life's viable starting points following defeats, disappointments, hovering over the twin craters of frustrated love and failed art, owning up to the bleakest shortcomings in the self. In poem after poem, her subject is the failure of events in daily life ever to measure up to her spirit's esthetic craving for perfectibility. . . . She relentlessly subjects her keenest life-experiences to the refining "restless eye" of her dream-life. It is because she is able to enjoy all living beauties so much, strictly for themselves, that one is assured of the tragic heroism of her deprivations, of the demands her theology imposes on her responsive being. Her triumph is one of restraint, a succession of inured resistances to all pleasures easy of access, delaying and forestalling her natural gift for spiritual uplift until she has reached the supreme moment in which we are able to "think all things are full of gods." She will settle for nothing short of that arrival, and if she has had to sacrifice the more fashionable virtues of poetry in our time—expressiveness and immediacy—to evolve a middle range, a plateau, of vision (halfway between the language of feelings particularized and the language of elusive dream-states), we can only be as grateful for the qualities her art withholds as for those it affords, for there are rewards to be secured in reading her best poems of a kind that can be found in no other body of work.

Laurence Lieberman. *Poetry.* May, 1968,
pp. 121–22

The sumptuary must convince the skeptical reader that so much strenuous emotion is warranted and not just self-indulgence. The overingenious design of Miss Garrigue's poems cannot support so much emotion.

When she restrains her impulse to shock, however, when her self-consciousness is in abeyance, she writes finely and movingly. My favorite poems are "This Swallow's Empire," "A Fable of Berries," most of "Pays Perdu," "Address to the Migrations," with its controlled oratory, "Of a Provincial City," and "Nth Invitation." Miss Garrigue has a gift for song, and many of her best pieces are love ballads which either *Christabel*-like blend romance with black irony, or in the manner of songs in Jacobean plays express a macabre love-wit ("The Strike of the Night" and "Gravepiece"). Beginning with *Country without Maps,* she achieves a comely lyrical calm; the shorter lines provide a welcome enlivening of the rhythm.

Herbert Liebowitz. *Hudson Review.*
Autumn, 1968, p. 560

It emerges gradually that Miss Garrigue has taken up her rich, mannered style with her eyes open. There are prose stanzas in this book [*Studies for an Actress*] in which that style is dropped, and they are good. But they do not contain those lines of poetry which appear in her other verse. Her style, then, is the only way in which she can realize her potential for certain thoughts; thoughts which cannot form in the mind unless the emotional conditions are propitious to them and the clock is turned back. They cannot form in this mind and be recognized as poetry unless they resemble what has already been poetry. For she has no vision of a lyric poetry which is new in kind. . . .

In her last book she has made an effort to bring both sensibility and manner up to date; possibly she had at last woken up to the fact that her traditional poetic abilities were strangling her. The mixture is of old and new. But she begins to know herself well enough to hear her own voice.

Rosemary Tonks. *New York Review of*
Books. October 4, 1973, p. 10

Once in a while [in *Studies for an Actress*] there are echoes, strains of the old magic, of the enchantment her poems can convey when she mingles dream and reality, magic and fact. "Pays Perdu" from *Country without Maps* may sum up and distill that essence more perfectly than any other poem of hers. In this volume [*Studies for an Actress*] though I find a diffuseness and uncertainty that may not have been a matter of "failing powers" but rather a function of a new start, an engagement with new material. To our loss Jean Garrigue did not live to finish what she began.

Louis Coxe. *The New Republic.* October 6,
1973, p. 28

For me, the poets Jean Garrigue came closest to "being like" are Hart Crane and John Keats—Crane for wildness and the leap of language and getting into a really dangerous metaphor and then having to track a way through it. She took those chances. She was a poet of risk. But then, like Keats, she

was also great at distillation and the pure poem. As Marianne Moore sought a purity, Jean did also. But I don't think she put any label on what she was doing. She avoided that.

There is another element in her resemblance to Keats: the way she *identified* with everything. She identified with animals, clouds, people, and that was part of her listening. She really absorbed the atmosphere. I think of Keat's great letter, the one in which he talks of the "chameleon" poet. Jean was a chameleon poet, in the sense that, as Keats said, if he were in a room with a child, he became the child. He penetrated into that experience. In her longer and more intricate poems, sometimes Jean's penetration gets so abstract that one loses the thread of what she's saying. And yet, if you study it, you find that, at no point has she departed from her subject. In the shorter poems, as in Mozart, you imagine you are going to hear a simple melody and then she turns the simple melody into all sorts of (well, not always all sorts of) strange harmonies and, as it were, canonic inventions. And she deviates from the course you anticipate. She was very musical. Not only did she have an ear for music, she was musical in the sense of structure, motifs, orchestral effects in the way she handled ideas, themes, emotional resoundings and emphases.

Jane Mayhall. *Twentieth Century Literature.*
29, 1983, p. 8

Jean's [Garrigue] short poem "Catch What You Can" very directly shows her personality, I think, at the same time as it indicates *how she lived.* And it describes for *us* the way to live vividly. . . . [W]ith the poem "Catch What You Can"—having it in front of me and not merely a recollection—I can get "deep inside" each intuitive, tart line. It's from a solid core of character that ripeness and beauty of the outer person derives, says the first five lines. Then, it would seem there's an abrupt shift to other metaphors: flowers, a moth, a rock, honey, clove. But this is kindred imagery symbolizing the same truth. Mountain flowers look fragile; they are tough. The fragile moth survives the storm. There is sweetness and freshness in living spontaneously, even wildly, dangerously, like nature itself. Determination, endurance is what it's about. It's about staying power! About "staying deep inside" one's self, until a leaf-of-the-heart pushes out of "bald rock," becomes a strong vine. Born of imagination is this vine and now we know that the poem is not only about character in a human being, but about art. Making art means to penetrate to the deep hand core of experience, and *stay,* until the sweetness, smoothness, ripeness of the developed thing is complete. There was effort and ruthlessness and courage to carry through and endure in Jean's art and in her life. She did burn her candle at both ends and she adored the flame. And consider her title, "Catch What You Can." A command to herself, and to anyone. There's so much to catch—in life, in art—and the pursuit is difficult, chancy, perhaps

wounding. But risk it, catch all that you can of those potent moments of total joy.

> May Swenson. *Twentieth Century*
> *Literature.* 29, 1983, pp. 31–32

GARRO, ELENA (MEXICO) 1920–

In spite of being almost unknown outside her own country, Elena Garro is one of the most interesting figures in contemporary Mexican play writing. She fully participates in the conception of the theater as illogical poetic communication, and despite the differences in techniques and contents, it would also be possible to situate her within the movement called "theater of the absurd." Despite the lively thematic and technical variety of her work, we consider that the theater of Elena Garro shows a marked preference for the theme of relations between different aspects of reality and even between different realities. Her characters oscillate between reality and illusion, and this movement is reflected in the scintillating mirror of illusions through which they pass. On the basis, frequently, of folkloric elements, she constructs a world in which the borders between reality as we perceive it daily [and illusion] disappear; she thus gives us another world, illusory, but perhaps also more real in that it touches man's reality of soul. . . .

Through her short works, Elena Garro reiterates her predilection for the relationship between a prosaic, mortal reality and another, superior, reality, which is the only one capable of raising existence. . . . This higher reality, this illusion, escapes almost all her characters, leaving them facing an existence that does not seem to have any remedy beyond cyanide or jumping off the balcony. Elena Garro leaves us facing a false but none the less apparent crossroads, where both roads lead us to failure, beaten down by the overwhelming external reality that is the fate that humanity must live. To communicate this bitter message to us, she uses the most diverse theatrical techniques, from realism—the mirror of the fate that lies in wait for us—to the most illusory stylization, the mirror of a mirror.

> Frank Dauster. *Revista Iberoamericana.* 30,
> 1964, pp. 81, 88–89

Elena Garro is the author of various one-act fantasies that come close to the theater of Ionesco in its emphasis on illogical communication; without being widely known, she has influenced the younger generation. In *Un hogar solido* (1957; A stable home), which gave its title to the volume published in 1958 that brings together the majority of these plays, she plays with the world beyond the tomb; *Andarse por las ramos* (1958; Going through the branches) dramatizes a refrain in a poetic sketch of the everyday world. In almost all

of these and the other works of Elena Garro, we sense the conflict between everyday reality and another higher reality, but in a play of mirrors, abandoning the supposed external reality to enter into illusion; her characters either have to sacrifice the illusion or see it destroyed by the attack of those who seek themselves outside. In *La mudanza* (The change) and *La señora en su balcón* (The lady on her balcony), both from 1959, we find this same trajectory drawn more sharply.

Frank Dauster. *Historia del Teatro Hispanoamericano* (Mexico City: Edison, 1966), pp. 84–85

Among those works that for some reason distinguish themselves from the mass [of mediocre recent Latin American plays] those that appear to me to be the most worthwhile are *Las pinzas* by the Venezuelan Roman Chalbaud and *La señora en su balcon* (The lady on her balcony) by the Mexican Elena Garro. . . . Elena Garro is almost a specialist in the short dramatic genre and the themes of home and married life in an invariably poetic key. The technique of *La señora en su balcon* is simple but effective: three instances in the frustrated life of a woman—at eight, twenty, and forty years old—are evoked from the perspective of her present age of fifty and presented as so many other personifications of the same Clara who carry on a dialogue with her in a disquieting negation of real space and time; the dimension of the play is mental, psychological—if not psychotic. The tone of good old dramas of sentiment is zealously maintained all through the play (except for some twist where the lyricism goes too far and spills over into a pseudo-poetic rhetoric. . . . But the real tragedy breaks out in the last lines, in this brutal and grotesque finale: Clara's suicide commented on in the cruel colloquial diction of the milkman who arrives and who transforms the necessary beauty of the sacrifice into a mere item for the police blotter.

José Miguel Oviedo. *Revista Iberoamericana*. 76–77, 1971, pp. 758–59

History, mythology and the unsuspected dimensions of reality are also the basis of Elena Garro's vision of Mexico. In 1963 she published a novel, *Los recuerdos del porvenir,* set during the presidency of Calles (1924–8) which illustrates episodes of political tyranny of that period. Among these, the most fierce was the persecution of members of the Church, which developed into a war known as *"la Guerra cristera."*

Ixtepec, the town in which the action of the novel takes place, is occupied by a group of military under the command of General Francisco Rosa, the archetypal Latin American dictator. (It is interesting, incidentally, to observe how his characterization anticipates the many novels on dictatorship written at the end of the 1960s and during the 1970s throughout Latin America; for example, *Conversación en la catedral* (1969) by M. Vargas Llosa; *El secuestro del general* (1973) by Aguilera Malta; *Yo el supremo* (1974) by Roa Bastos;

El recurso del método (1974) by A. Carpentier; *El otoño del patriarca* (1975) by G. García Márquez. . . .

The study of the Indian mentality and the ambiguous relationship between the indigenous population of Mexico, with its legends and beliefs, and the incredulous *"criollos,"* with their fictitious sense of reality and personal superiority, form the theme of a story by Elena Garro entitled "El arbol." Marta and the Indian Luisita are its two characters. The first looks on the other with contempt: "Many of her relatives and friends thought that the Indians were much closer to animals than to man and they were right." In fact, as it turns out, the Indian woman is much more familiar with the tools of civilization (showers and telephone) than Marta thinks. Yet the *"criolla"* still believes that it is easy to manage the Indian by making use of superstitions: "It was enough to name the devil." Only later, too late, does Marta realize that what she considers to be Luisita's silly beliefs is a concrete awareness of evil which the more sophisticated mind has lost, that the childish voice and apparently naive ways of the Indian woman disguise a cruelty and a wisdom a thousand years old.

It is then that the magic evoked by Luisita begins to invade Marta's household: "El arbol seco," the tree on which the Indian woman had unloaded her secret sins and which dried out afterwards, "entered the room; the whole night was drying within the walls and the dried-out curtains." And with it enters the concept of the sacrifice which must be performed, for Marta too has heard Luisa's confession and she too will have to die, like the tree.

<div style="text-align: right">

Psiche Hughes. In Mineke Schipper, ed.
*Unheard Words: Women and Literature in
Africa, the Arab World, Asia, the
Caribbean, and Latin America* (London:
Allison and Busby, 1985), pp. 242, 244–45

</div>

La culpa es de los tlaxcaltecas, by Elena Garro, is an outstanding example of the blending of history and myth in contemporary Mexican fiction. In this work, the past and present co-exist on the same plane of mythical time and vie for the loyalties of the story's protagonist, Laura Aldama. Temporal boundaries are erased as Laura moves back and forth with ease between the twentieth and sixteenth centuries. One moment, she is safely ensconced in her comfortable, well-to-do Mexico City home, and the next she is witnessing her native Tenochtitlán being destroyed by the Spanish in 1521. In both lives, Laura's identity is closely linked with that of her husband, but she is married to two men from very different worlds. Her modern husband, Pablo, is successful, arrogant, and jealous. He provides Laura with material needs but leaves her emotionally unfulfilled. The Indian husband from Laura's past is more in spiritual harmony with her, and he embodies many virtues: he is brave, noble, compassionate, and loving, and unlike Laura, he values loyalty to his race more than life itself. He chooses to stand against the whites, although he faces certain defeat, while Laura chooses to escape through time

and enter the world of the victors in a future existence. Laura's betrayal of the past has allowed her to survive in the present, but a conflict arises when she realizes that she cannot reconcile her dual existence and lead two lives indefinitely. As the tale unfolds, she must come to grips with her weaknesses and learn to understand better her own nature before she can make the final choice between the past and the present and all they represent. . . .

The concept of time and memory play a very important role in *La culpa es de los tlaxcaltecas,* since everything related in the story is "remembered," and the narrative moves in everwidening concentric circles which reach farther and farther into the past. A third person omniscient narrator, whose presence is scarcely felt throughout most of the tale, provides the external frame for the story. . . .

As mentioned earlier, *La culpa es de los tlaxcaltecas* has a mythological foundation supporting it which is based on the prehispanic conception of time and the fate of the human soul. Characters in the story who are familiar with that mythology are able to accept the truth of the events Laura describes. The reader, however, may not share the same worldview and, if he is to be drawn into the narrative, his rational defenses must be worn down. He must be made willing to suspend his disbelief and accept that the "impossible" can happen. This is accomplished through a process of mythopoesis, the creation of myth, which allows *La culpa es de los tlaxcaltecas* to function as a myth in its own right. Myth widens the dimensions of reality and imparts an air of truth to even the most illogical occurrences. It appeals to the emotions rather than to reason, and it needs no explanation. Almost all the narrative elements in *La culpa es de los tlaxcaltecas* work toward elevating the story to a mythic level. . . .

La culpa es de los tlaxcaltecas raises the same philosophical questions present in many other contemporary Mexican works of fiction and nonfiction: Has Mexico taken the wrong turn and identified with the wrong side of her dual heritage? What would it be like if Mexicans could go back in time and choose again? As Laura discovers, the choice is still a hard one to make. Mexicans must first overcome shame, fear, and prejudice against the "defeated race" of Indians who make up a large part of the national culture. They must also break out of the pattern of violence and aggression associated with the conquering Spanish. Mexico's indigenous heritage has many positive things to offer, even though, throughout the past four centuries, success in Mexico has been identified solely with the "victors" of the conquest. *La culpa es de los tlaxcaltecas* suggests that all Mexicans, like Laura, should take a close look at themselves to try to determine where and whether they fit into the world around them. The past *is* alive in Mexico, perhaps not as Laura experiences it, but it does continue to make its presence felt. Why is this so? As Garro infers, it may be because Mexicans have betrayed their authentic heritage and turned their backs on their true selves. Only through a mythic reevaluation of the past can the Mexican come to terms with his

identity in the present and break out of the oppressive cycle of history which haunts him in the modern world.

Cynthia Duncan. *Critica Hispanica*. 7, 1985, pp. 107–8, 114, 118, 120

Elena Garro's position with regard to the radical solitude found in the modern individual is revealed in her treatment of time in several works. Her early writings manifest a fascination with time that is explored from many different angles: as a structural device closely related to the characterization process, which, in turn, becomes an important thematic element that ultimately reveals the author's world view. . . .

In her novel *Los recuerdos del porvenir* (1963) as well as in her drama *Un hogar sólido y otras piezas en un acto* (1956) and her short stories, *La semana de colores* (1964), time is viewed as an oppressive element that renders a life of boredom and monotonous existence from which the characters seek to escape. They are in search of illusion, in a quest for the world of the marvelous which can only exist in the timeless dimension of fantasy and imagination, free from the confines of chronological time. Because this timeless dimension corresponds to the time-space of magic and enchantment of childhood, it is best described in those stories that have children as protagonists, although it is also evident in other works in which the protagonists are women or Indians. Garro sees these character-types endowed with an intuitive nature that is in constant clash with the adult world in which order and reason impose strict limitations on the possibilities offered by the imagination and suggested by desire.

Five stories in the collection *La semana de colores* have children as protagonists and are characterized by a magical realism that complements Garro's special concept of time. . . .

[Many of Garro's] characters live a life of boredom from which they seek to escape. While it is almost universally the women who search for the marvelous in opposition to stereotypical male adherence to reason, this does not preclude men from participating in the same yearning, as evident in the last two stories discussed above. Garro's view of life is a pessimistic one. In her world the tensions between intuition, and logic, magic and reason, that identify the relationship between children and adults are parallel to the relationship between women and men, and between the Indian peasant and the Mexican of the city. An individual's attempts to reconcile these tensions and to maintain an integrated self heighten the sense of alienation. In Garro's view, these tensions cannot be resolved except in the limitless freedom of death.

Carmen Salazar. In Elizabeth F. Rogers and Timothy J. Rogers. *In Retrospect: Essays on Latin American Literature* (York, South Carolina: Spanish Literature Publishing, 1987), pp. 121, 126–27

Temporality in Garro's theater performs a multitude of functions: existence in time operates on both thematic and structural levels in her plays. Garro's emphasis on alternative modes of existing in time points to her thematic explorations of the nature of appearance and reality, and her use of flashbacks and other temporal frames of reference helps to structure many of her works. Her interest in temporality posits the creation of dramatic worlds in which diachronic or historical measurements, cyclical measurements, and repetitions, and timelessness all merge. She underscores these divergent, yet curiously unified concepts of temporal reference via her own stylistic repetitions: repeated motifs (for example, the use of "por los siglos de los siglos," often in reference to the search for a temporal utopia), frequent flashbacks or time shifts, her stress on both memory and prophecy, and the use of intertextual echoes (reminders of her debts to past texts and past myths). These elements surface so often in her works that they indicate thematic and structural patterns clearly linked to a pervasive interest in time and to its relationship with reality. . . .

[Garro's theater reflects] her overwhelming interest in the relationship between the past and the present, and the appearance and reality. Garro's plays present us with the harsh, cold realities of modern relationships, with magical worlds beyond the scope of human comprehension, and with the reincarnation of past texts and past actions in present-day experiences. The dramatist pursues the roles of memory and prophecy in creating these experiences, and she conflates diachronic notions of time with cyclical repetitions. In that sense, Garro's plays do, indeed, present time as a type of a repeating spiral, an image that focuses on the past but also points toward the future. Garro's theater, like her prose fiction, gives us many recollections of things to come; this union of memory and foreshadowing helps to create an often magical present in which, as Francisco of *La dama boba* noted, we live in so many different times that at the end, we don't even know who we are or what we were.

> Catherine Larson. *Latin American Theatre Review.* 22, Spring, 1989, pp. 14–15

GENNARI, GENEVIÈVE (FRANCE) 1920–

I mean Geneviève Gennari no harm when I say that her novels are well and substantially made. We should be suspicious of the snobberies of the present moment. For my part, I like an author who does not proceed by allusions, who evades nothing, who even dares to say everything (with decency). Geneviève Gennari is this way. She gives us good French realism. But handled with finesse. So psychological realities are more important than anything else in her work.

From *The Muller Cousins* to *The Curtain of Sand,* Miss Gennari's novels all go beyond anecdote. By means of dissertations, abstractions, precautionary symbolism? Not at all. On the contrary, by means of deep penetration into very particular, very specialized destinies that are generalized in the human destiny because of their very precision. . . .

It is—happily—through her general orientation and how moving her narrative is that Miss Gennari prefers to show her intentions as a novelist. . . .

We see Miss Gennari's women clutching onto love with a sort of panic rage and mad terror. Why? Because of their fear of isolation, which threatens them all the more, the more gifts they possess, the more intelligent they are. . . .

Do women then irremediably lack the means to escape the joke? Miss Gennari is obviously not unaware of woman's advances in society. But she does not seem to think that this raising of her external condition will help her to free her internal being, to assure independence for her secret being, to draw her out of the militant and suffering church of love. And haven't I made it clear, she might insist, that without love we cannot have a meaningful life? Love is a scourge precisely to the extent that it is a need. A scourge of God. . . .

Genevieve Gennari's novels are full of brilliant pages where the unjust fate reserved by nature for "the second sex" is seen lucidly and fully, denounced sadly. But have I made it possible to glimpse or guess how marvelously constructed, solid, and complete all this appears?. . . .

In all her novels, more or less deliberately, Miss Gennari has provided a historical background—the period between the wars in *The Sealed Fountain,* the war itself in *The Muller Cousins* and *I Will Wake the Dawn*—up to the moment when she decided to write a real historical novel: *The Napoleon Star,* which tells the story of a family divided between two opposing ideologies, paralleling the ideologies of the Revolutionary and Napoleonic periods. . . .

The Napoleon Star is a great book. It gives promise of another, of more great books. Always inspired by her feeling for everything that separates individuals, social classes, countries, always in search of a unity for the individual or for social groups, Geneviève Gennari now has the choice for her next production of a love story following the great novels of the Breton Middle Ages, a somber drama of religious passion, or a broad narrative fiction set at the crossroads of family traditions, social policy, and Europe.

She will then succeed in placing herself securely in the first rank of the contemporary novel, while reviving *its* own destiny as tragedy.

<div style="text-align:right">Henri Clouard. Revue des deux mondes.
April, 1957, pp. 133–36</div>

The feminine vein in contemporary French writing has been growing richer in the last two decades. Geneviève Gennari writes under the double aegis of the two Simones of France; she shares the passionate disillusion of the late

Simone Weil and subscribes to the practical aspects of existentialism as espoused by Simone de Beauvoir.

But unlike Nathalie Sarraute and other "new" writers, Miss Gennari adheres to the traditional storytelling techniques as she unfolds in *The Other Woman I Am* the plight of a forty-three-year-old Parisian widow of Corsican descent, member of the upper middle class and the possessor of an upper-middle-grade intelligence, struggling against sudden solitude with the weapons of friendship, infatuation, and work. Sylvestre is ultimately faced with a choice between renewal of the broken pattern of a life of ease by means of a convenient remarriage, or a venture in which, as a roving ambassadress in South America, she may be able to implement her theories about international understanding. Will she relinquish the prey for the shadows? Will she continue as an "anesthetized" European mandarin or seek through the freedom of the working woman a sense of moral purpose and social responsibility? The anguish with which she faces her dilemma turns what might have been a trite situation into a philosophical self-search. Sylvestre's thoughts and actions build up to a genuine climax as she decides to which of the two women in her she will commit her destiny.

If this is a "woman's novel," it portrays neither the elemental sex symbol, nor the intellectualized imitation-man of the feminist era. Miss Gennari's heroine is a thinking, troubled member of the "condemned last generation" of a "minority world." She is obsessed with concern for the 600 million Chinese who live on the brink of starvation; she gives vent to cruel criticism of defeated, unhappy Europe. She believes that love is not all of her life, nor the only basis of communication with man; yet the world and its problems could well be lost when an old flame is sparked by a chance encounter.

One might say that important issues are too rapidly passed over. But they are stated, often strikingly, as the author casts disquieting glances upon arresting though sketchy characters such as the existentialist spinster professor, flanked with her gigolo and her cat, "Néant" (Nothingness), the free-spirited Finnish Amazon, the heavily-made-up beauty who is a defrocked nun, and the little secretary who aspires to bourgeois status.

Although Miss Gennari's style has not come through Linda Asher's translation, her personality is a compelling one, which towers over the words.

<div align="right">Anna Balakian. Saturday Review of
Literature. July 22, 1961, pp. 25–26</div>

To reopen the curio cabinet, walking the reader under dusty ceilings, raising the draperies gnawed by bugs, to dust off the volumes with faded bindings and find, between a hunting horn, a papal guard's uniform, and a portrait of the Count of Chambord, some picturesque originals: the eccentric uncle, the tender, scolding old maid, the poor but proud young lady, the crazy adolescent, to adapt Balzac's recipes to the necessities of the contemporary bookshop, to juggle with those two infinities that are the knitting needle and the interplanetary rocket, is to win the sympathy of visitors to the Chateaux of

the Loire, who are infinitely more numerous than the lovers of literature. Thus the tourist and the weekend reader, who like only tricked-up novels, will probably hardly appreciate *The Nostalgics*. A family of country bump-kins, the Traberts, infused with a certain aristocratic and peasant tradition, where generosity of the heart is more important than the prejudices of the mind—from this one expects to be taken through a gallery of highly colored portraits; but Geneviève Gennari's entire art aims at destroying this illusion. The Traberts live neither in the past nor in the present; they keep themselves slightly apart from history, like children eternally caught in their games and their fantasies. The old chateau, the paths on the grounds, the nightingale nights, babbling brook, the lawns bordered with yews, everything that Gene-vieve Gennari suggests without describing it, for fear of interrupting our dream, no longer appears as an empty decor or a setting, but as the very principle of this "other world" whose fascination both the Traberts and the narrator are under. Diane de Trabert may marry a Lyon industrialist before falling for the progressive schoolteacher, Jean-Julien de Trabert may take part in the Indochina and Algeria wars while disapproving of them, they still remain more or less faithful to the pure commitment of their early youth. A novel of manners, a novel in a classic form, a slice of life (1938–63); it is not hard to imagine the traps that Geneviève Gennari might have fallen into: a tolerance of satire, a taste for the outdated, arbitrary or conventional situ-ations, Puvis de Chavannes-ism, extracts from history textbooks. The novel-ist's talent, her conviction, her energy, her feeling for the passage of time, her art of making us conscious of her characters' aging process through the working out of their fate, restores that virtue so rare among imaginative writers today: the ability to move the emotions.

Willy de Spens. *Nouvelle Revue Française*.
December, 1963, pp. 1112–13

Gennari has gradually liberated herself from the traditional, bourgeois values of her family upbringing, as well as from the dominance of existential writers and philosophers of the 1950s. More recent influences include Western mys-tics (particularly Teilhard de Chardin), Eastern religions, and psychological studies concerned with the subconscious. Throughout her adult life she has read extensively among classical French, British, and American fictional writers, and has been particularly cognizant of the tradition of great women writers from the nineteenth and twentieth centuries. . . .

Recurrent themes and supporting metaphors reveal Gennari's particular and evolving poetic and sociophilosophical vision. Although we cannot speak of a symbolic system, certain themes and supporting metaphors retain a particular meaning or significance throughout her novels, for example, sleep connotes an ever-present temptation to shrink from human responsibility and creativity, thereby denying the highest potential of human consciousness. In extreme situations, sleep symbolizes spiritual or intellectual death. Gennari repeatedly envisions traumatic life changes as physical uprootings (in the

form of immigration, travel, or displacement in time and space, determined, for example, by marriage, career, or war). Other metaphors maintain consistent meanings throughout her novels. National borders create physical or psychological barriers; sinking ships convey the precariousness of life and the fear of unforeseeable dangers. Gennari's use of light imagery and her attention to sources of light creates a multifaceted metaphor signifying the promise of life and hope for understanding.

Ambivalence toward social or philosophical systems characterizes the attitude and tone of Gennari's novels. Many characters come to acknowledge that absolute truth does not exist—a situation that establishes a dichotomy between expectations and realization. Similarly, a dichotomy exists between the characters' longing for unity (often expressed as nostalgia) and their confrontation with pluralism or fragmentation in concrete life situations. This conflict creates ambiguous conclusions to several of Gennari's novels. This ambiguity is an important aspect of her writing, and one which links her works to a dominant posture among contemporary novelists.

Nevertheless, one result of Gennari's own ambivalence toward intellectual-artistic systems and doctrines has been to keep her on the periphery of contemporary social and intellectual movements such as existentialism, feminism, and recent schools of experimental art. . . .

Though writing in a conventional mode, Gennari has by no means sought to be a popularizer of contemporary thought and attitudes. Her strength reveals itself in her ability to create concrete, personal examples of various precepts which test their validity. For example, the theme of alienation dominates her novels—whether set in the contemporary world or the Napoleonic period. Gennari's powerful treatment of that theme results primarily from the lucidity and eloquence with which the characters in her novels express the pain of alienation.

Although many of Gennari's fictional characters suffer from a profound sense of solitude, they rarely lose the ability to feel, both sensually and emotionally, the world that surrounds them. The dilemma for many of these characters may be described as that of an "inside outsider," who experiences solitude, even while living in the midst of his or her social group or socioeconomic class. For most of Gennari's characters that class is the bourgeoisie.

Although the "inside outsider" characters of Gennari's novels almost never revolt openly, or profess allegiance to a class different from their own, they view the world from the privileged position of an articulate observer. They sense acutely the failures of a stratified society, its denial of the complex realities of the twentieth century, and its inability to respond to an individual's personal needs. They view life within society critically, sometimes pessimistically or even tragically, but in contrast with much twentieth-century fiction their conclusions are never nihilistic.

Some characters' need for security is so overwhelming that they succumb to societal conformity at the expense of their search for personal truth or transcendence. . . .

The concepts of class and caste in society have fascinated Gennari since her first novel. Some class-conscious critics have ignored or misunderstood her ambiguous statements concerning class—resulting, perhaps, from an overly restrictive definition of terms. Class for Gennari implies all kinds of visible and invisible barriers that classify or categorize people, including castes which define and divide people from birth, according to sex, race, and ethnic origin. . . .

Each novel focuses on the difficulty experienced by one or more individuals in coping with a rapidly changing world. Most principal characters are nonheroic in the traditional sense of heroism, but Gennari treats with sympathy and understanding the courage with which the frightened and weak undergo life's trials. Her impersonal narration betrays a special admiration for those who are drawn to such unifying forces as humanism, love, or internationalism, and who surmount manifold obstacles in order to cross social or political boundaries. Their reward is the expansion of the peripheral walls of their worlds. Once these characters have moved beyond the restrictive limitations of their class or caste, none can easily return to former awareness. Gennari treats harshly the few characters who *choose* ignorance or smugness. . . .

Gennari's fiction portrays particularly well the constraints confronting females who seek to define their own destinies, and shows sensitivity to the destructive influence which discrimination against women has perpetuated in twentieth-century French society. While such awareness has enriched her depiction of women, her consciousness of their restricted destinies is so acute that she has rarely imagined a woman as hero—one who approaches a totally free and self-actualizing role. Her 1980 novel, *Vague,* demonstrates the most substantive departure from that mold.

In addition to analyzing the problems of individuals in society, Gennari has created several characters who seek their raison d'être apart from it. *Fugue* (1973) reflects the recurring theme of detachment from sociological concerns in her fiction. The link with society remains, however, if we view *Fugue* as an illustration of the difficulty (or the impossibility) of stepping entirely out of civilization as we know it. . . .

In Gennari's later novels thematic development has turned from social criticism toward metaphysical inquiry. . . .

The concluding paragraph of *Monde* (1972) reveals Gennari's underlying approach to fiction that has contributed to both strengths and weaknesses in her novels: "Precisely at the crossroads of pathways and of eras, I cannot live without human happiness or without searching for transcendence, however relative. I must admit that for the moment, the search suffices. But I willingly run the marvelous risk of one day finding the answer."

<div align="right">Jean Hardy Robinson. *Geneviève Gennari*
(Boston: Twayne, 1984), pp. 126–31</div>

GILMAN, CHARLOTTE PERKINS STETSON (UNITED STATES)
1860–1935

It would seem that Charlotte Perkins Stetson felt trapped by the role assigned the wife within the conventional nineteenth-century marriage. If marriage meant children and too many children meant incapacity for other work; if she saw her father's abandonment and her mother's coldness as the result of this sexual-marital bind; if she saw herself as victimized by marriage, the woman playing the passive role—then she was simply seeing clearly.

It was out of this set of marital circumstances, but beyond that out of her larger social awareness of the situation of women in her century, that "The Yellow Wallpaper" emerged five years later. Witness to the personal and social anguish of its author, the story is of the incompetent medical advice she received. . . .

The story is narrated with clinical precision and aesthetic tact. The curt, chopped sentences, the brevity of the paragraphs, which often consist of only one or two sentences, convey the taut, distraught mental state of the narrator. The style creates a controlled tension: everything is low key and understated. The stance of the narrator is all, and it is a very complex stance indeed, since she is ultimately mad and yet, throughout her descent into madness, in many ways more sensible than the people who surround and cripple her. As she tells her story the reader has confidence in the reasonableness of her arguments and explanations.

The narrator is a woman who has been taken to the country by her husband in an effort to cure her of some undefined illness—a kind of nervous fatigue. Although her husband, a doctor, is presented as kindly and well meaning, it is soon apparent that his treatment of his wife, guided as it is by nineteenth-century attitudes toward women, is an important source of her affliction and a perhaps inadvertent but nonetheless vicious abettor of it. Here is a woman who, as she tries to explain to anyone who will listen, wants very much to *work*. Specifically, she wants to write (and the story she is narrating is her desperate and secret attempt both to engage in work that is meaningful to her and to retain her sanity). But the medical advice she receives, from her doctor/husband, from her brother, also a doctor, and from S. Weir Mitchell explicitly referred to in the story, is that she do nothing. The prescribed cure is total rest and total emptiness of mind. While she craves intellectual stimulation and activity, and at one point poignantly expresses her wish for "advice and companionship" (one can read today respect and equality) in her work, what she receives is the standard treatment meted out to women in a patriarchal society. Thus her husband sees her as a "blessed little goose." She is his "little girl" and she must take care of herself for his sake. Her role is to be "a rest and comfort to him." That he often laughs at her is, she notes forlornly and almost casually at one point, only what one expects in marriage.

Despite her pleas he will not take her away from this house in the country which she hates. What he does, in fact, is choose for her a room in the house that was formerly a nursery. It is a room with barred windows originally intended to prevent small children from falling out. It is the room with the fateful yellow wallpaper. The narrator herself had preferred a room downstairs; but this is 1890 and, to use Virginia Woolf's phrase, there is no choice for this wife of "a room of one's own." . . .

The wallpaper consists of "lame uncertain curves" that suddenly "commit suicide—destroy themselves in unheard-of contradictions." There are pointless patterns in the paper, which the narrator nevertheless determines to pursue to some conclusion. Fighting for her identity, for some sense of independent self, she observes the wallpaper and notes that just as she is about to find some pattern and meaning in it, it "slaps you in the face, knocks you down, and tramples upon you." . . .

It is no surprise to find, therefore, that at the end of the story the narrator both does and does not identify with the creeping women who surround her in her hallucinations. The women creep out of the wallpaper, they creep through the arbors and lanes and along the roads outside the house. Women must creep. The narrator knows this. She has fought as best she could against creeping. In her perceptivity and in her resistance lie her heroism (her heroineism). But at the end of the story, on her last day in the house, as she peels off yards and yards of wallpaper and creeps around the floor, she has been defeated. She is totally mad.

But in her mad-sane way she has seen the situation of women for what it is. She has wanted to strangle the woman behind the paper—tie her with a rope. For that woman, the tragic product of her society, is of course the narrator's self. By rejecting that woman she might free the other, imprisoned woman within herself. But the only available rejection is suicidal, and hence she descends into madness. Madness is her only freedom, as, crawling around the room, she screams at her husband that she has finally "got out"—outside the wallpaper—and can't be put back.

<div style="text-align: right">Elaine Hedges. Afterword to Charlotte
Perkins Gilman. The Yellow Wallpaper
(Old Westbury, New York: Feminist Press,
1973), pp. 46, 48–53</div>

Successively isolated from conversational exchanges, prohibited free access to pen and paper, and thus increasingly denied what Jean Ricardou has called "the local exercise of syntax and vocabulary," the protagonist of "The Yellow Wallpaper" experiences the extreme extrapolation of those linguistic tools to the processes of perception and response. In fact, it follows directly upon a sequence in which: (1) she acknowledges that John's opposition to her writing has begun to make "the effort . . . greater than the relief"; (2) John refuses to let her "go and make a visit to Cousin Henry and Julia"; and (3) as a kind of punctuation mark to that denial, John carries her "upstairs and laid me on

the bed, and sat by me and read to me till it tired my head." It is after these events, I repeat, that the narrator first makes out the dim shape lurking "behind the outside pattern" in the wallpaper: "it is like a woman stooping down and creeping."

From that point on, the narrator progressively gives up the attempt to *record* her reality and instead begins to *read* it—as symbolically adumbrated in her compulsion to discover a consistent and coherent pattern amid "the sprawling outlines" of the wallpaper's apparently "pointless pattern." Selectively emphasizing one section of the pattern while repressing others, reorganizing and regrouping past impressions into newer, more fully realized configurations—as one might with any complex formal text—the speaking voice becomes obsessed with her quest for meaning, jealous even of her husband's or his sister's momentary interest in the paper. Having caught her sister-in-law "with her hand on it once," the narrator declares, "I know she was studying that pattern, and I am determined that nobody shall find it out but myself!" As the pattern changes with the changing light in the room, so too do her interpretations of it. And what is not quite so apparent by daylight becomes glaringly so at night: "At night in any kind of light, in twilight, candle light, lamplight, and worst of all by moonlight, it becomes bars! The outside pattern I mean, and the woman behind it is as plain as can be." "By daylight," in contrast (like the protagonist herself), "she is subdued, quiet."

As she becomes wholly taken up with the exercise of these interpretive strategies, so, too, she claims, her "life is very much more exciting now than it used to be. You see I have something more to expect, to look forward to, to watch." What she is watching, of course, is her own psyche writ large; and the closer she comes to "reading" in the wallpaper the underlying if unacknowledged patterns of her real-life experience, the less frequent becomes that delicate oscillation between surrender to or involvement in and the more distanced observation of developing meaning. Slowly but surely the narrative voice ceases to distinguish itself from the woman in the wallpaper pattern, finally asserting that "I don't want anybody to get that woman out at night but myself," and concluding with a confusion of pronouns that merges into a grammatical statement of identity:

> As soon as it was moonlight and that poor thing began to crawl and shake the pattern, I got up and ran to help her.
> *I* pulled and *she* shook, and *I* shook and *she* pulled, and before morning *we* had peeled off yards of that paper.
>
> [my italics]

She is, in a sense, now totally surrendered to what is quite literally her own text—or, rather, her self as text. But in decoding its (or her) meaning, what she has succeeded in doing is discovering the symbolization of her own untenable and unacceptable reality. To escape that reality she attempts the destruction of the paper which seemingly encodes it: the pattern of bars entrapping

the creeping woman. "'I've got out at last,' said I, 'in spite of you and Jane. I've pulled off most of the paper, so you can't put me back!'" (p. 36). Their paper pages may be torn and moldy (as is, in fact, the smelly wallpaper), but the meaning of texts is not so easily destroyed. Liberation here is liberation only into madness: for in decoding her own projections onto the paper, the protagonist had managed merely to reencode them once more, and now more firmly than ever, within.

<div align="right">Annette Kolodny. New Literary History. 11,
1980, pp. 457–59</div>

Gilman gave little attention to her writing as literature, and neither will the reader, I am afraid. She wrote quickly, carelessly, to make a point. She always wrote fiction to meet a deadline. Still, she had a good ear for dialogue, was adept at sketching within a few pages a familiar but complicated set of relationships, and knew well the whole range of worries and joys women shared. She wrote to engage an audience in her ideas, not in her literary accomplishments.

"The Yellow Wallpaper," initially published in 1892, is the first selection in this collection [*The Charlotte Perkins Gilman Reader*]. It is easily the best of Gilman's fiction, and the single piece for which she is now most recognized—an odd situation because her once-formidable reputation did not in the past rest on her imaginative work. Her fame came from her studies in sociology and social theory, *Women and Economics* bringing her immediate international acclaim when it appeared in 1898. "The Yellow Wallpaper," a study of a young mother painstakingly and lovingly driven into madness by a well-meaning husband following S. Weir Mitchell's notions, is Gilman's retaliation against the psychiatric profession. It stands apart from her other fiction for two overriding reasons, which, when set out together, seem to be contradictory. It is the best crafted of her fiction: a genuine literary piece, unlike the rest of her creative writing. It is also the most directly, obviously, self-consciously autobiographical of all her stories. It was drawn from anguish and pain. In no other fictional writing did Gilman give so much of herself, expose her feelings so fully.

In the remaining stories in this collection, and in the entire body of published and unpublished fiction from which they were selected, Gilman examines, clearly and pointedly, a variety of problems women share and a variety of proposed ways of dealing with those problems. . . .

Many Gilman enthusiasts do not much like her fiction. They consider it too ideological, too didactic. Gilman mischievously used the commonly shared forms and structures of her day—farces, domestic novels, mysteries, adventure stories—and infused them with her own brand of feminism and socialism. Her work is ideological, but she implies that all literature is ideological, only its familiarity, its "naturalness" to us, makes it appear to reflect all possible world views. Although she does not challenge all the conventions of her day, she introduces a new sense of intellectual play when she poses

her "What if" questions in the arena of traditional male-female relations, thereby exposing the absurd pieties embedded in domestic life. . . .

Gilman was determined to package her social vision in ways persuasive to a general audience. These short stories are written in the style and with the simplicity common to women's magazines of the day. Each story is a lesson. Each focuses on a specific problem, usually but not always a problem shared primarily by women, and each has a happy resolution. The happy ending, however, comes about as a result of a good deal of intelligence, resourcefulness, and, most important, a willingness to defy convention, to look afresh at an old situation. What each story requires is the shaking off of traditional ways of doing things, especially as they relate to accepted male or female behavior. One can almost assume that as part of the formula some usual mode of thought or action will be replaced by a different, but possible, method of thinking about or doing things.

<div style="text-align: right">

Ann J. Lane. Introduction to *The Charlotte Perkins Gilman Reader* (New York: Pantheon, 1980), pp. xvi–xix

</div>

In its time and until the last eight years, "The Yellow Wallpaper" was read, when it was read at all, "as a Poesque tale of chilling horror," designed "to freeze our blood," praised, when it was praised, for the detail with which it recorded developing insanity. Even as late as 1971 Seon Manley and Gogo Lewis included it in a collection entitled *Ladies of Horror: Two Centuries of Supernatural Stories by the Gentle Sex* and introduced it with the following words: "There were new ideas afloat: perhaps some of the horrors were in our own minds, not in the outside world at all. This idea gave birth to the psychological horror story and 'The Yellow Wallpaper' by Charlotte Perkins Gilman shows she was a mistress of the art."

No earlier reader saw the story as in any way positive. When Horace Scudder rejected it for publication in *The Atlantic Monthly,* he explained that he did not wish to make his readers as miserable as the story had made him. As Elaine Hedges points out, "No one seems to have made the connection between insanity and the sex, or sexual role of the victim, no one explored the story's implications for male-female relationships in the nineteenth century."

Feminist critics approach "The Yellow Wallpaper" from the point of view of the narrator. "As she tells her story," says Hedges, "the reader has confidence in the reasonableness of her arguments and explanations." The narrator is seen as the victim of an oppressive patriarchal social system which restricts women and prevents their functioning as full human beings. The restrictions on women are symbolized by the narrator's imprisonment in a room with bars on the window, an image the narrator sees echoed in the patterns of the room's yellow wallpaper. "The wallpaper," claims Hedges, symbolizes "the morbid social situation." Gilbert and Gubar talk of "the anxiety-inducing connections between what women writers tend to see as their parallel confinements in texts, houses and maternal female bodies" and describe the

wallpaper as "ancient, smoldering, 'unclean' as the oppressive structures of the society in which she finds herself." The women the narrator "sees" in the wallpaper and wants to liberate are perceived to be "creeping." "Women must creep," says Hedges, "the narrator knows this." I see the indoor images of imprisonment echoed in the natural world of the garden with its "walls and gates that lock, and lots of separate little houses for the gardeners and people." Like so many other women in literature, the only access to nature the narrator has is to a carefully cultivated and confined garden. Gilbert and Gubar point out that in contrast the idea of "open country" is the place of freedom.

<div style="text-align: right">Jean Kennard. <i>New Literary History.</i>
13, 1981, pp. 74–75</div>

As a particular historical product . . . "The Yellow Wallpaper" is no more "*the* story that all literary women would tell" than the entirely white canon of *The Madwoman in the Attic* is *the* story of all women's writing or the only story those (white) texts can tell. "The Yellow Wallpaper" has been able to pass for a universal text only insofar as white, Western literatures and perspectives continue to dominate academic American feminist practices even when the most urgent literary and political events are happening in Africa, Asia, and Latin America, and among the new and old cultures of Color in the United States. . . .

"The Yellow Wallpaper" also calls upon us to recognize that the white, female, intellectual-class subjectivity which Gilman's narrator attempts to construct, and to which many feminists have also been committed perhaps unwittingly, is a subjectivity whose illusory unity, like the unity imposed on the paper, is built on the repression of difference. This also means that the conscious biographical experience which Gilman claims as the authenticating source of the story is but one contributing element. And if we are going to read this text in relation to its author, we may have to realize that there are dangers as well as pleasures in a feminist reading based on a merging of consciousness. Once we recognize Gilman as a subject constituted in and by the contradictions of ideology, we might also remember that she acknowledges having been subjected to the narrator's circumstances but denies any relationship to the wallpaper itself—that is, to what I am reading as the site of a political unconscious in which questions of race permeate questions of sex. . . .

I suggest that one of the messages of "The Yellow Wallpaper" is that textuality, like culture, is more complex, shifting, and polyvalent than any of the ideas we can abstract from it, that the narrator's reductive gesture is precisely to isolate and essentialize one "idea about sex and gender" from a more complex textual field.

<div style="text-align: right">Susan S. Lanser. <i>Feminist Studies.</i>
15, 1989, pp. 434–35</div>

From 1909 to 1916, Charlotte Perkins Gilman was the editor and sole writer for the feminist monthly *The Forerunner.* The lifespan of *The Forerunner* was one of the high periods in the history of U.S. radicalism, witnessing, among other events, the founding of the Niagara Movement, the first national black civil rights organization; the flowering of the Wobblies, the Industrial Workers of the World; an unprecedented number of socialist electoral victories at the local level; the renewed militancy of the women's suffrage movement; and mass strikes among shirtwaist makers in New York, copper miners in Colorado and Montana, woolen mill hands in Lawrence, Massachusetts, and silk workers in Paterson, New Jersey. In 1911, *The Forerunner* serialized Gilman's first utopian novel, *Moving the Mountain,* which appeared in book form later that year. *Moving the Mountain* takes place in 1940 and centers on a Rip van Winkle figure in the person of an American explorer lost in Tibet for thirty years, who has to be introduced to the changes that have occurred in his own society since his disappearance. More particularly, he learns the motivations and operations of a new American society that is no longer "his own," although members of his family are active and enthusiastic participants in it. This is the society that came into being with the election of 1920, which established socialism. Within two decades, America has gone beyond socialism to an ideal order based chiefly on the human strengths and skills developed by women in their years of subordination. The members of this polity have established a new religion called Living and Life in a world that historian and Gilman biographer Ann Lane describes as one "in which the profit motive has been eliminated and social, not individual goals are sought." The explorer's brother-in-law explains that, nowadays, "Society is not somebody else domineering over us. Society is us taking care of ourselves."

Although Gilman was to publish two more fully realized feminist utopias in *The Forerunner*—*Herland* in 1915 and *With Her in Ourland* in 1916— *Moving the Mountain* retains a particular interest because, coming out of that high period of progressive activity, it does not create an exotic ideal, but a home-grown one, projecting its socialist feminist vision forward onto American society of the 1920s and '30s. Just as Gilman's earlier essays in social theory, *Women and Economics, Concerning Children,* and *The Home: Its Work and Influence,* imagined a revolution in daily life on the basis of the lived experience of American domesticity, *Moving the Mountain* builds a better future on the basis of a known and examined history.

Socialism, at once utopian and profoundly materialist, is at the heart of Gilman's theories about a community life that would draw on women's gifts and serve their needs. Indeed, what she envisions in her theoretical and fictional writings is both a higher privacy and a higher community. But she is also capable of imagining certain improvements in women's lot, domestic and public, under capitalism; several of her short stories and her one-act play *Three Women* suggest individual solutions to the privatized and feminized version of housework and child-rearing that was the universal norm in her

time. Her novel *What Diantha Did,* serialized in *The Forerunner* from 1909 to 1910, published separately in 1912, and dedicated to The Housewife, even proposes the capitalization rather than the socialization of housework. What Diantha Bell does, in fact, is to start a highly profitable business for the scientific management of housework, with the actual labor being done by former servant girls whom she organizes into the self-managed House Workers Union. . . .

The 1920s had been a discouraging time for anyone with Gilman's political views. World War I saw widespread repression of dissent—not only socialist and pacifist, but also suffragist—and the postwar era was ushered in with the vicious Palmer Raids and the consequent mass deportation of foreign-born radicals. Repression of blacks took the form of escalating lynchings, as well as systematic denial of the vote and other civil rights; the black-run Niagara Movement, in order to combat these conditions effectively, had to merge with the white-controlled NAACP. The schism in the socialist ranks and the establishment of a Communist Party were no cause for rejoicing for a non-Marxist radical like Gilman, either. Although in 1920, the socialist candidate Eugene Debs, campaigning from Federal prison, won nearly a million votes, the outcome of the election was far from the joyous progressive transition projected in *Moving the Mountain;* rather, the first presidential poll in which women voted in every state resulted in the election (Sinclair Lewis called it the "appointment") of the Republican candidate, Warren G. Harding. What is worse, passage of the Nineteenth Amendment, while assuring women the franchise, also signaled the disintegration of organized feminism. Indeed, in 1919, a group of radical women in Greenwich Village rededicated their publication *Judy* to human liberation beyond the now-resolved male-female dialectic; they called this new position of theirs "post-feminism." . . .

Women in the 1920s had achieved a measure of emancipation—the vote and wider educational and job opportunities as well as a degree of sexual freedom—but these developments looked both feeble and distorted beside the full-grown, healthy liberation, the new social relations, that Gilman had dreamed of and worked for. What was worse, the dissolution of a mass women's movement meant that a new generation of Americans was growing up without exposure to the message of feminism. To remedy this absence, Gilman took decisive political action: she wrote a novel, a spirited novel in a popular genre, the murder mystery, that would encapsulate her version of feminism for the new times. The idea, this time, was not so much to hurl feminism into the jaws of post-feminism as to pry open those jaws and slip in a sugar-coated pill.

There may appear to be a certain bathos in concluding my summary of what Gilman considered a grim situation by saying that the decisive political action for which she marshaled her forces was a light novel. But the great-niece of Harriet Beecher Stowe could hardly doubt the power of a popular novel to enter into political discourse or even to shape world-historic events. *Unpunished* [Gilman's unpublished detective novel], is no *Uncle Tom's*

Cabin, and Gilman probably had no illusions that it was, but then the problems she identified and the remedies she proposed were also of a different order. All her fiction was radical in that it was written with the purpose of accomplishing something revolutionary. The distinction between literature and propaganda was factitious to her, and she believed that art, to be most successful, must firmly bond its ideas to its formal elements. The detective genre, up through Gilman's time, tended to be conservative in its approach to existing social arrangements, including the sanctity of private property, the right of inheritance, the privileging of property rights over civil liberties, and the prevailing inequality of opportunity and power between the sexes. Gilman manages to develop her thesis in accordance with these restrictions as part of the Faustian bargain she seems to have made with the genre: in order to reach a wide audience with the ideas that she deemed most essential, she was prepared to compromise almost everything else. The resulting denatured version of her politics is the best she could—or thought she could—work into the detective genre. Her initial choice of the genre suggests that a decade of post-feminist history had convinced her that only a watered-down message would get across at all, but that that little was absolutely vital.

Lillian S. Robinson. *Tulsa Studies in Women's Literature.* 10, 1991, pp. 274–77

GILMORE, MARY (AUSTRALIA) 1865–1962

Before Mary Gilmore's time, the Commonwealth had produced many poetical writers; but—with the exception of three, perhaps—no poets. Most of these writers were journalists; and, although they wrote well, a trade in rhyme, driven across the counters of newspaper proprietaries, never has been, never can be, poetry. Also, there were some ultra-literary ones, book-bound, making paraphrases in their libraries; not aware of life, as Mary Gilmore is aware of it: a woman who has worked eagerly from the time when she was a child. She helped to advance Australia by setting her shoulder to the wheel; politically, as well as poetically.

Her verses are indigenous of the soil; so that wherever we see a native tree, a bird, or a fish, we are reminded of words she has written. Moreover, she records history; and, through prophetic power, sometimes would seem to guide it. Such an active well-advised pen takes front rank with the best writers of English, anywhere, today, in the world. It is our glory, as much as her own; and, on this account, she appears the greater patriot.

Hugh McCrae. *Australian Quarterly.* September, 1933, p. 94

To judge by what is usually quoted, I doubt whether many of [Mary Gilmore's] keenest supporters have read her best work. You certainly cannot judge her by what you see in the anthologies; most of them had only her first book [*Marri'd, and Other Verses*] to go on, and her best work is in her second book, *The Passionate Heart,* and here and there in her later books. What is needed is a book of selections from her poems, made after careful sifting. Then it will become clear that she is not only by far the best of our woman poets, but among the best of all our poets, men or women. But it will also become clear that a great deal has had to be sifted away. . . .

In Mary Gilmore's later poems the main element is not lyricism, but thought and experience, though a lyrical and even a personal element still persists. As wife, mother, social experimenter, hard-working practical idealist, she has had a wider and deeper experience of life than most people, and especially in her later poetry she draws upon this experience. She seems to draw upon it unconsciously, and she does not systematize its results into a philosophy. But at times it is almost as though she drew also, without being aware of it, from a deeper source, from the accumulated knowledge of generations, from life itself. All this gives her work, at its best, a content greater than that of many poets, and without it she would not hold the place she does hold in Australian poetry.

This strange power of drawing, apparently, from some deep and hidden reservoir of wisdom is evident in Mary Gilmore's imagery. She has to an unusual degree the poet's faculty for conveying what he has to say by means of images. Her images lack McCrae's perfection of vivid beauty, and O'Dowd's striking and compulsive force; but they go deeper than McCrae's images, and they are simpler and more natural than O'Dowd's.

H. M. Green. *Fourteen Minutes* (Sydney: Angus & Robertson, 1944), pp. 84–87

[Mary Gilmore] expresses in her poetry the dream of a society which is as complete and simple as a lyric. And I think it is significant that her work has been hailed newly by every generation. It would be hard to account for this in terms of its intrinsic poetic value; for it seems to me a very inferior kind of lyric. But there does seem to be some way in which its very limpidity and seeming unselfconsciousness, its demand for completion, get an answer from the responses of many Australians in each succeeding generation. It is not merely the historical aura of her name or of her affiliations with William Lane and his fated expedition to Paraguay. It is something in the poetry itself; I think it is the note of the utopian, acceptable now in the vague and over-simplified context of the lyric in a way it wouldn't be if expressed by a contemporary poet as O'Dowd expressed it even thirty or forty years ago.

Vincent Buckley. *Quadrant.* 3:2, 1958–59, p. 44

Mary Gilmore's life could in itself be said to be a chronicle of Australia. During her ninety-seven years there was no aspect of it she did not touch: social, literary, political. When she died in December 1962 she was mourned throughout the continent by people from all social strata, all religions, all political parties. She was given a State Funeral. The great of the land gathered to pay their last respects to a great woman, one of our most distinguished poets, who had, at the same time, inscribed our little-known history in limpid, evocative prose. Had she been able to foresee it she might have found it ironical that such public honor should be bestowed on her who, all her life, had fought not only against the values of the society in which she lived, but *for* a different one in which the ideals she cherished could root and flower.

But her life had been full of such paradoxes and age had brought her wisdom and serenity to match her courage. Besides, though she had always fought for revolutionary causes, during her lifetime she had all the honor that the most demanding (which she never was) could have wanted. Publicity came to her unsought as fame did. Along with Sybil Thorndike she was, I think, the only avowed socialist who was made a Dame of the British Empire—for her services to Australian literature.

Dymphna Cusack. In *Mary Gilmore: A Tribute* (Sydney: Australasian Book Society, 1965), p. 18

Mary Gilmore is not as much at home in the ballad as she had been in the lyric and often lacks the needed vitality, but *The Tilted Cart,* with its copious appendix of notes, does mark the beginning of her long struggle to record, and have recorded, the minutiae of daily life in the Outback in days gone by. This may eventually be regarded as her most notable contribution to Australian culture. It was continued ten years later in her two volumes of reminiscences, *Old Days, Old Ways* and *More Recollections,* which contain the best prose she wrote. In the sixty or more separate anecdotes and discussions which comprise these two books, her object was, as she wrote in the foreword to *More Recollections,* to present the Australia of the pioneering days through which she herself had lived. . . .

Mary Gilmore was not a great poet and it is easy to point out where the faults lie in her verse. It has not often been done, partly out of respect for Dame Mary as a person. . . . She wrote too much; she gave a momentous tone, often enough, to trivia; she easily became sentimental; she was capable of lapses of technique that utterly mar a poem. Her style was based on simplicity but simplicity became merely banality in much of her hastily written verse. There were definite limits to her craftsmanship. But her strengths are equally obvious. She emphasized the ageless values of love, courage, selflessness, sympathy, patriotism, and reverence, and her best writing is filled with the awareness that whoever relinquishes these values brings about his own impoverishment. Her lyric gift was varied and lively, reflecting in its language, rhythm, and melody her changing emotions: joy, grief, fierce

aggression, maternal protectiveness, deep contentment, agonizing doubt. Above all her poetry carries with it an honest and steady attitude towards the reader, with an obvious desire that he should quickly understand and share in the experience of the poetry. For this her reward has been the ready response of several generations of readers.

W. H. Wilde. *Three Radicals* (Melbourne:
Oxford University Press, 1969),
pp. 12, 19–20

The pain . . . of a continuous conflict between the desire for love and the need for independence emerges again and again in Mary Gilmore's poems. The letters themselves manifest a loneliness, a reaching out for contact, partly in the very extensiveness of the correspondence, especially after she retired in 1930. When her husband and her son both died within a few months of each other in 1945, her solitariness was exacerbated by doubled grief: "I would have held you safe my son / But you were a man and / As a man you had to go."

In the poetry the conflict is most clearly articulated in her first volume, *Marri'd and other verses* published in 1910 when she was struggling to make her decision. . . . While there are poems strong in the joy of a man's love, expressing a willing and almost submissive pleasure in the domesticity of marriage, waiting for the husband's step at the door, even in their midst are openly spoken the stark fears of the woman rejecting and rejected by love:

And, so, no child plays at her knee,
No man looks longing in her eyes,
No heart leaps throbbing as she comes,
Alone she lives, alone she dies.

In some poems the fear is ominous and foreboding: "The rats have bitten the baby face / And eaten the baby hand." In others it is the wear . . . a routine that grinds the women down, making "us hard an' cold," things that erupt through the surface of celebration in a volume entitled *Marri'd*.

In her later poetry this fear is less explicit, but there echoes through it a litany that is recognized as extending from the personal to the collective experience of women handed down through the generations: "My mother's terrors wake in me / And all her fears are mine." In exploring the conflict between love and independence and the contradictory expectations and desires of women, Mary Gilmore's poetry utilized traditional metaphors of wild nature and the elements in a subtle inversion of traditional and usually affirmative poetic images. Poems employing the metaphor of the storm, for example, interrogate states of feeling characterized by loss and fear, penetrating the emptiness to probe the possibilities of a barely understood and female power. In *Marri'd and Other Verses*, the storm anticipates the fear of the loss that is also independence: "A sweeping wind and blinding rain, / And a brown

bee caught in the clover." In the poems originally published in 1918 as *The Passionate Heart,* the images of the bee and of the storm flattening the crop before harvest, recur in "The Corn," and "The Satin of the Bee," two of her finest poems, indeed two of the finest of women's antiwar poems from the First World War. In 1939 she published another volume anticipating war, *Battlefields,* and this included a short poem which finally took the title "Storm," and broke through the anger and loss and fear to an affirmation and optimism in the power of independence, albeit an independence that sets up its own problems:

> Sometimes it comes and it comes to each,
> In the heart's ebb, and alone,
> To hear, like waves on a distant beach,
> The life submerged and unknown.

<div align="right">

Drusilla Modjeska. *Meanjin.* 41, 1982,
pp. 230–31

</div>

GILROY, BERYL (GUYANA) 1924–

Gilroy's slight but touching novel [*Frangipani House*] is set at a Caribbean nursing home called Frangipani House, where elder, infirm women reside. These once hardworking women are the products of a third world society suspended between past and present. After having loved, worked and sacrificed to raise families amid poverty and ignorance, they have seen their children leave for the United States. The narrative centers on Mama King and her shock at being emotionally abandoned and effectively held prisoner at Frangipani House. This determined woman, haunted by memories and driven by love, eventually escapes the home and forces a painful reunion with her children. The writing is lyrical and clear, marred only by a succession of overly literary declarations at novel's end. With intelligence, grace and social insight, Gilroy presents the inner lives of strong women.

<div align="right">

John Mather. *Publishers Weekly.*
November 21, 1986, p. 51

</div>

Frangipani House, Beryl Gilroy's novel, [is] named for the expensive nursing home to which Mrs. Mabel Alexandria King, Mama King, has been committed by her well-meaning daughters. Like Lebert Joseph, who mourns his "grands and great-grands born in that place [he] has never seen," Mama King lives far from her children and American-born grandchildren. And . . . Mama King's daughters have assumed the values of their adopted country and the White race. They agree to pay five-hundred dollars a month to have "white

people care for her," and they mistakenly assume that because the rest home is costly, their mother is content to live there.

Nothing, however, could be farther from the truth. Life in Frangipani House has systematically robbed Mama King of everything that gave her life meaning. . . .

Gilroy's Mama King continues to experience life on a day-to-day, even minute-by-minute basis; her rituals are the daily, intimate motions of life, which she shares with her granddaughter: "The women from the lane often stopped for 'woman-talk and time-waste,' which meant discussing their own childbirth experiences." Cindy thanks Mama King and the other women for their strength and support, adding that "Chuck sure will get the same support from your men. Sure thing." The women respond: "Support! They wouldn't give him support. They will give him rum—white rum, bush rum and five year rum. Shoor ting." . . . Gilroy's *Frangipani House* captures the lyrical rhythms of tropical life and language.

Lucy Wilson. *Journal of Caribbean Studies.*
7, 1989, pp. 192, 196–97

Most West Indian fictions about migration have been concerned with an individual's adjustment to a new social environment and have been written in the autobiographical mode. *Boy-Sandwich,* however, expands the range of this type of writing by considering the experiences, aspirations, and reactions of three generations of an island family long settled in Britain, though it retains the form of an autobiographical narrative embellished with astute social observations and penetrating analyses of interracial and interpersonal behavior.

The narrator is an eighteen-year-old boy of Guyanese heritage burdened with the responsibility of caring for his institutionalized grandparents, who have lived in Britain longer than most of their neighbors and who are Empire loyalists who have worked hard, paid their taxes, been frugal, and raised a family that includes a grandson now ready to go up to Cambridge. As the protagonist Tyrone Grainger comments, "I was the filling and they were the slices of bread." Such figurative language abounds in the novel; in fact, the texture of the style is a delight in a time when language is not always valued and crafted in fiction. The bananas in an old people's home are described as "like fingers covered with large neglected sores," and an elderly inmate is said to be "tucking pain away in his body like a coin in his purse." Fear is "a solid rock inside people's hearts." Dialect, not always handled convincingly, is here used with great skill as an elucidation of character and role; it is neither an entertainment nor a decoration. Language, perhaps more than any other element, differentiates the three generations of the family and the family from others.

There are the usual embarrassing members of the extended family, but their peccadilloes are treated sympathetically if not understandingly; the range of characters is extensive, yet none is superfluous. On returning to the

Caribbean, Tyrone realizes that "I don't belong here . . . I am British." Implicit is the idea that British no longer means white-skinned, Anglican, and Eurocentric, but this is offered in a discreet, muted manner as befits a novel that examines the nature of a changing, postcolonial society in a mature and exploratory manner. *Boy-Sandwich* is a fine sequel to Gilroy's *Frangipani House* of 1985.

<div style="text-align: right;">

A. L. McLeod. *World Literature Today.* 64,
1990, p. 348

</div>

The Guyanese writer Beryl Gilroy identifies her approach to writing fiction as existential. In her works she investigates the processes by which humans struggle for identity. According to Gilroy, "An existentialist approach with the power of its key themes [subjectivity, choice, free will, and individuality] gives me the ability to confront the issues of 'black' life in process." Her first novel, *Frangipani House,* examines the process by which both the infirm and the émigrée come to terms with the changing panorama of neocolonial Caribbean life. Her second novel, *Boy-Sandwich,* explores the process by which an eighteen-year-old boy of Guyanese heritage comes to terms with his British existence. In her third novel, *Stedman and Joanna,* Gilroy returns to the Caribbean to make a statement about an illicit interracial love that runs the risk—like the identities of the characters about whom she writes—"of being forgotten."

 Stedman and Joanna is a well-written and, above all, convincing account of an interracial love affair set in eighteenth-century Surinam (and in fact received an award in Gilroy's native Guyana for historical fiction). Divided into three parts—"Before Joanna," "Joanna, My Love, My Life," and "The Sea Change"—the novel chronicles John Gabriel Stedman's life from his gaming and womanizing youth, through his adventures and coming of age in Surinam, to his decline in Europe.

 Stedman is both a poet and a naturalist in the guise of a soldier. After an aborted effort to secure his fortune through marriage, he signs on with a group of men appointed by the Dutch crown to put down the slave revolts in Surinam. Upon meeting Joanna, whose father was a man of "culture and learning" and whose mother was a slave woman, Stedman decides "to be her friend and to protect her . . . for to agitate such a fine body with the whip, hot iron rods, or any other instrument of torture would be sacrilegious." As sculptured as Stedman's initial impression of Joanna is, however, he soon discovers her fortitude. Subsequently he learns to respect her rights as a person, something he had been conditioned to exclude as a possibility before encountering Joanna.

 The impetus for the novel is the Scotsman's journal. The story is entirely John Stedman's, told from his point of view and with amazing insight into what must have been the daily conflicts of his existence in the Dutch-owned colony of Surinam. Gilroy offers a faithful rendering of Stedman's language

throughout the novel. Never is this made more clear than when she deftly interweaves a passage from the journal itself into her narrative.

Apart from linguistic achievement, the novel offers valuable insight into the age in which Stedman is born. Forcing Stedman's womanizing as an object of debate, Joanna points out to Stedman his lack of reverence for women. At one point she explains: "Being European is not your color. It is what you do." That simple statement held much truth about men living in the Age of Reason.

Among other themes and motifs, the novel examines the debilitating effects of slavery: the sexually abused slave woman, the failure of Christianity, the cruel mistress, the horror of the black codes, and the maroons who fought against colonial powers for independence. Running throughout the novel is the suggestion that death—of one sort or another—accompanies the institution of slavery. As Stedman reflects: "The most common death in this colony was death from beating, from mosquitoes, from diseases, and from murder, though for murder a small fine might be charged. The slaves fought back with their spells and their poisons, and it was not unusual to hear of whole families being poisoned for cruelty to their slaves. Death came easily. It came as easily as life."

What remains the crowning achievement of the novel, however, is the depiction of the love between Joanna and Stedman. It is a love that transcends color and class. Even though Joanna is never fully able to discard her "coat of deception" (the multifaceted personas she must adopt as a black slave woman), she enjoys with Stedman an enviable love. One is tempted to compare the work with Barbara Chase-Riboud's *Sally Hemings* (1979), whose story opens in 1787, ten years before the death of Stedman. Although both novels offer fictionalized accounts of historical personages, Gilroy is more convincing in the ethics that inform the individual lovers.

A. S. Newson. *World Literature Today.* 67,
1993, p. 219

GINZBURG, NATALIA (ITALY) 1916–91

The two novelettes that make up this little book [*The Road to the City*] are sicklied o'er with the Chekhovian cast of a sense of the futility of daily living. . . . Miss Ginzburg is artist enough to put her protagonists through their petty paces without attempting to enlist for them the reader's sympathy. The schoolteacher and the ignorant country girl are alike trapped in the vacuum of their empty little souls. Each, on an infinitesimal scale, is destined to torment and be tormented. Each, in her own bleak fashion, is committed to the fate inherent in her own stupidity.

Yet, perhaps because of his impatience, the American reader remains an incurable do-gooder. He feels that there must be something that will help Miss Ginzburg's heroines—a psychiatrist, a hobby, a bland diet, maybe Dorothy Dix. Certainly a sense of humor would fill some of the psychic void.

Ann F. Wolfe. *Saturday Review of Literature.* September 17, 1949, pp. 37–38

[*A Light for Fools*] is written in those short sentences, loosely joined by a lot of casual commas, so beloved in Italian writing today. . . . The life it conjures, rather than describes—though youths may blow out their brains on park benches, and schoolgirls become pregnant, and people may be shot . . .—is, in fact, characterized by monotony, by the peculiar temperamental gloom, that domestic greyness and uneventfulness and general air that nothing will ever happen so pleasant for an Italian provincial fortnight, so terrible for a year. Inevitably, Chekhov comes to mind: not only because the long summer days, the endless agreeable but unrewarding chat, the whole provincial-intellectual set-up, recall him, but because the Italian charm, and volatility, and loquacity, and unselfconscious egocentricity, and inability to move out of grooves, and so on, that Miss Ginzburg so brilliantly captures, are all Chekhovian qualities. . . . She has an extraordinary gift for what you might call cumulative characterization—a method that dispenses almost entirely with description and builds up solid and memorable people by the gradual mounting up of small actions, oblique glances, other people's opinions.

Isabel Quigly. *The Spectator.* August 24, 1956, p. 269

Natalia Ginzburg belongs to the post-war generation of Italian writers who were instrumental in the recent revival of native arts and letters. . . . She rapidly acquired the reputation of a skillful and sensitive storyteller.

A Light for Fools has all the characteristics of her genuine literary gift. . . . Vivid and often brilliant characterizations are not the only merit of this family novel. Through hints and intimations, the author succeeds in drawing a picture of Italian society between 1934 and 1944 and in revealing the hidden connection between the fate of individuals and the pressure of the times. The narrative has force and directness and there are delicate, impressionistic touches which remind us of Chekhov. Natalia Ginzburg is at her best when dealing with detail, and her descriptions of children and adolescents have a definite poetic flavor. Most of the incidents and characters are seen through the eyes of an adolescent, and the book has much of the naïveté and charm of a child's vision. This "point of view" in the Jamesian sense gives a unity of diction to the whole narrative.

Marc Slonim. *The New York Times.* January 5, 1957, p. 5

Her themes are the solitude and anguish of life as well as the impossibility of communicating our despair to other humans. The situations depicted in her fiction are quite stark. Life is not only a wretched thing but a meaningless business. . . . Relatively little happens in her novels: Signora Ginzburg relies for her effects less on a story rich with incidents and surprises than on a subtle manner of relating a tale. . . . Whatever tension there is, is generated by the careful manner in which the author depicts the emotional or psychological state of her heroes and moves them slowly toward the climax. . . . Natalia Ginzburg's achievement is primarily a stylistic one. Her prose has a rhythm of its own and through it the author projects, with unusual simplicity, her conception of how people act, think, and behave. The texture of her style is replete with past descriptive indicative tenses; one sentence joined with another by means of the conjunctive "and." Through such deceptively simple techniques Ginzburg recaptures the rhythms of human discourse and elevates it from trifle to poetry.

Sergio Pacifici. *A Guide to Contemporary Italian Literature* (Cleveland: World, 1962), pp. 136–37, 140

Voices in the Evening is neither inspired nor competent: trying to make a virtue of its clumsiness, it reads pretentiously. For want of a personal inflection, the narrator's tone is *faux naif;* for want of a story, she takes us piecemeal through a Piedmontese family, recounting the fortunes of each member before, through and after the war, in a manner which may aim at the dispassionate but comes out perfunctory: the result is an academic but maladroit frieze in very low relief.

Brigid Brophy. *New Statesman and Nation.* August 2, 1963, p. 147

Natalia Ginzburg is certainly one of the most competent writers of her generation in Italy. . . . *Voices in the Evening* is a fair example of her art. What she has to say she says economically and with a minimum of rhetoric. This book even seems at times more an outline than a final draft. . . . Signora Ginzburg's characters are, for the most part, like excellent line drawings, quite real but somehow not "filled in." Their bone structure is magnificent, but there is no flesh.

Thomas G. Bergin. *Saturday Review of Literature.* September 21, 1963, p. 36

Miss Ginzburg has been attracting attention in the literary world of Italy—and this novel tells us why. The style of *Voices in the Evening* is crisp, brittle, entertaining and informative. . . . The very coolness of the style tends to defeat the subtle theme of the death of a family (and a love) through sheer lack of gumption. The brevity of the book and its semi-comic treatment of a muted tragedy come to seem, not a strength but part of the general, fatal

weariness. The "voices in the evening" tend to cancel each other out—succeeding only too well in presenting people who, pallid to begin with, end as mere phantoms.

Yet the heroine, her mother, the whole tone of small-town domestic concerns, have a curious, attenuated resemblance to characters in the work of Elizabeth Gaskell, or even Jane Austen. It is as if a whole set of inquietudes, hidden in these earlier women authors, had come briefly to the surface; not to be allayed by happy marriages or even by the pleasure of accurate, small observations but merely to be seen and endured.

Otis K. Burger. *The New York Times.*
October 6, 1963, p. 38

Natalia Ginzburg's literary production calls at first glance for the alluring equivocations of the easy, the limpid, the immediately comprehensible; novels, tales, and works for theater are centered on reduced family nuclei, cultivated in the ritual pattern of everyday experiences, in the external mechanics of gestures and actions registered in a sober, atonal, anti-lyrical manner, far from direct theoretical abstractions or imposing historico-social schemas.

The non-sensuality and the hardly evolving rhythms of the domestic events narrated are entrusted to diminished linguistic structures, colloquial, simplified in vocabulary and syntax and free of formal acrobatics. . . .

This lowering of tone, however, while it does not prevent the Ginzburg literary universe from maintaining a complex poetic dignity "without ever slipping"—to express ourselves in Montalean terms—"into the realistic phonograph," is supported, at the theoretical level, by a lively participation on the author's part in the literary climate in which she works and by her thoughtful conceptions of art and the problems inherent in its realization. . . .

At the center of the Ginzburgian poetics is a demand for honest, adherence to reality, that is born, however, unchained from the pursuit of practical goals and deviant ideological programs.

Luciana Marchione Picchione. *Natalia
Ginzburg* (Florence: La Nuova Italia, 1978),
pp. 5, 7

Natalia Ginzburg has established her identity and her independence in a muted manner, aiming the complexities of her art at producing a series of novels that find their most appropriate measure in a brief, tight narrative not so much interested in facts and events as in capturing moments and meanings in the lives of a small group of figures who share with their author a precarious sense of human existence. This restriction on the range of the novels has been accompanied by the verbal and structural economy that Natalia Ginzburg is famous for. Yet it is precisely in this reversed chic of the novels, in their measured expression, in their tendency toward understatement and in their surplus of potential meaning that we find the roots of poetic tension and esthetic clarity. . . .

With her latest books, *Caro Michele* and *Famiglia,* Natalia Ginzburg's fictional world has not changed. Relationships, family situations, the theme of endings are still there. If any change at all is to be noticed in relation to her previous work, it is in a certain crispness of movement and detail, in the effective portrayal of contemporary urban background, say in the manner of a Lessing, a Spark, a Rhys. In *Famiglia* there is also a more consistent overlay of the symbolic dimension, an element of unity that remains nonetheless tenuous and understated. In this book the author has chosen to deal with the most irrevocable of endings, death. The two stories that make up the text, "Famiglia" and "Borghesia," are linked by the same subject, the sudden illness and impending death of their respective protagonists Carmine and Ilaria. . . .

Since Natalia Ginzburg's main concern is condition and not action, the story line moves once again more through the characters' perceptions of the physical reality around them than through plot, which in her novels is practically nonexistent. As such, the material world is given high specificity in her fiction. Things are very real and very present, and they remain wholly concrete and wholly themselves. But where does all this contingency lead to? Does attention given to physical reality yield a cognitive dimension, say in the line of Proust, who saw through perceptions and emotions a way to metaphysics? This would seem to be the case, for through the taking in of impressions Ginzburg seems to want to lead us to read contingency for meaning. Through things characters get in touch with the world around them and, most of all, with themselves in a kind of mystical contingency that can be taken as the key to her art. And yet truth ultimately eludes her, as it does the characters in her novels. Her loyalty of vision, her fundamental honesty in attending, in being a witness, does not allow the emergence of a clear-cut message. Montale, in speaking of Natalia Ginzburg's fiction, has said it best in observing that when reading her work "we are in front of the acceptance of an intelligent animal who gathers his little happiness wherever he finds it, but who knows that happiness is short-lived and that the meaning of life is all in living it without asking oneself why."

The specific clarity that Ginzburg's art gives to life is the awareness that we are what we learn, and what we learn is our limitations. There is no vantage point in this world for anyone, and experience most often leads only to dead ends. In "Famiglia" Carmine's last memory is an incidental one. One cannot be satisfied with this ending, but that is precisely the point. Destinies are irrelevant. Shaped by change, they have no meaning. The question of why things happen or fail to echo throughout her books, only finds the most abiding silence. This is Natalia Ginzburg's perspective, her philosophy and therefore her manner. It is well represented in her novels, where meaning is reached through a process, not a statement, a process wherein words and structures, forms and figures all become relevant signs.

<div align="right">

Rosetta D. Piclardi. *World Literature Today.*
53, 1979, pp. 585, 587–89

</div>

Natalia Ginzburg is a prolific author whose work has produced a wide range of critical response. Thomas G. Bergin defines her uncompromisingly as "one of the most competent writers of her generation in Italy," and an anonymous reviewer in the *Times Literary Supplement* has noted that "when it comes to disentangling delicate feelings in what seems a quite effortless way she has no rival," judgments which recall the statement by her fellow-novelist Italo Calvino that "lo spirito che le è piú vicino è quello di Jane Austen." Alongside these enthusiastic comments we find in marked contrast references by Brigid Brophy to an "academic frieze in very low relief" in her discussion of the English translation of *Le voci della sera,* while Clotilde Soave Bowe describes the material which makes up the novel as being "loose and tenuous." In 1968 Irving Wardle ended his review of Ginzburg's play *The Advertisement (L'inserzione)* by defining its appearance on the stage of the National Theatre as "a disgrace," an extreme pronouncement acting as a perfect balance to Calvino's comparison with one of the great figures of English literature. . . .

Le voci della sera is perhaps the work in which Ginzburg's talents are most evenly distributed and in which the reader is most aware of her ability to create a bitter-sweet atmosphere by the juxtaposition of contrasting effects, a technique which reaches its climax in Matilde's final monologue to her victimized daughter. Elsa's progression from initial loneliness through temporary fulfillment to a final isolation more painful than her original ignorance confirms Ginzburg's inherently pessimistic view of the female condition, here softened by her judicious use of comic effect in a novel which both stimulates and entertains, amply fulfilling the definition that the function of literature is to demonstrate the reality of human experience.

Since 1961 Natalia Ginzburg has written four more novels and twice as many plays, as well as publishing three collections of essays. During her career she has won four literary prizes and had the doubtful honor of seeing two of her books turned into films. In recent years her writing has become darker, her sense of humor being subjected to increasing strain. The death of her second husband from hepatitis in 1969 was a blow which inevitably reinforced her pessimistic approach to life's problems, confirming a tendency to dwell on the negative aspects of old age and solitude already apparent in her essay *La vecchiaia,* published in *La Stampa* the previous year and developed in *Le donne,* two years later. In her subsequent work she identifies increasingly with representatives of the older generation, whether neglected wives, like Flaminia in *Fragola e panna,* middle-aged intellectuals suffering from writer's block, like Stefano in *La porta sbagliata,* or aging mothers anxious to communicate with their disaffected offspring, such as Adriana in *Caro Michele.* While conscious of the limitations of old-fashioned attitudes Ginzburg is equally aware of the disadvantages implicit in total rejection of the family as a spiritual unit, a recent development in Italian society which she sees as detrimental to both young and old. Her latest work, *Famiglia,* consisting of two long short stories each having as protagonist an individual at grips with a specific aspect of this problem—in *Borghesia* a middle-aged

widow and in *Famiglia* a male architect of forty-three—is proof of her continuing sympathy for all humanity, and if the bleakness of her theme necessarily implies a reduction in humor it also ensures the continuance of her ability to respond to the simple things of life as signs of deeper realities lurking below the surface of everyday existence, an unfashionable talent unperceived by her detractors and admirably defined in the comparison with Jane Austen quoted at the beginning of this introduction.

> Alan Bullock. Introduction to Natalia
> Ginzburg. *Le voci della sera* (Manchester:
> Manchester University Press, 1982),
> pp. vii–ix

Natalia Ginzburg has been described by Cesare Garboli as "la scrittrice più femminile e meno femminista che esista" (the most feminine and least feminist woman writer in existence). If we accept the traditional assumption that one of the typical characteristics of women writers is an absorbing preoccupation with family relationships, then Garboli's statement about the strikingly "female" quality of the author's work can be accepted. With regard to the more complex and controversial question of feminism, however, his contention is debatable. Although in recent years Natalia Ginzburg has declared herself opposed to the women's movement, there is a contrast between her current denial of feminist sympathies, and the sensitive portrayal of the alienation of women found in her early novels. Few writers have described as poignantly as Ginzburg the situation of women as "outsiders" in the traditional Italian family, and the feminine internalization of patriarchal norms. This inspiration which dominates her first six novels, has, however, been discarded in recent years. . . . radical shift in thematic preoccupation which occurred in the middle of the author's career.

Although Ginzburg, during the past decade or so, appears to have abandoned her interest in the problems of women, her fascination with the institution of the family still persists. The household looms large in all of the author's writing. It is the uncontested given which provides the perameters of her fictional world. Lilia Crescenzi has aptly named her "la poetessa dell'ambiente domestico" (the poet of the domestic environment), for all her works unfold against the backdrop of the home and are circumscribed by the concerns of this limited setting. Even important events of history—the rise of Fascism, the Second World War and the terrorism of the 1970s—are glimpsed only to the extent that they impinge upon the lives of a particular household. Yet two quite different attitudes towards the family prevail in Ginzburg's writing: the first, an increasingly critical view, is expressed in the novels which precede the autobiographical *Lessico famigliare* (1963), and the second, characterized by a profound nostalgia for the disciplined stability of the patriarchal family, is voiced implicitly or explicitly in most of the works she has written since that time. Both attitudes are pessimistic, but in the early period the author's pessimism is alleviated by a mood of gentle irony or

melancholy, whereas in more recent years this mood has given way to an unrelenting despair.

Anne-Marie O'Healy. *Canadian Review of Italian Studies.* 9, 1986, pp. 21–22

There exists . . . another aspect of a conjugal coexistence whose sharpness, filtered through an affectionately humorous tone, takes shape in a climate of more distinct antagonism. This is the case of the couple that carries on the dialogue in *Lui e io* (He and I) in the volume *Le piccole viriù* (The little virtues).

In the context of the family theme, among the figures that recur, that of the father and of the mother always reproduce, albeit with slight variations, certain archetypes that we find in *Lessico famigliare* (Family handbook): the gruff and authoritarian father, a presence whose authoritarianism does not sow panic, whose authority is more potential than effective, the mother, a sweet, vague, superficial woman, a bit frivolous.

In contrast to the paternal figure as seen and judged by Ginzburg, without sentimentality but with affectionate tolerance, not without a bit of pride, may be placed the Kafkaesque paternal figure, with a resulting strident contrast. . . .

Basically, what saves the children in the families in the Ginzburgian narrative is the entirely modern anarchy that frees them from atavistic guilt complexes, polemically destroying the positions of traditional structures. The paternal tones, far from provoking a rigidification in the other members of the family, waste themselves on the desert air and the new disorder, which has a savor of freedom and self-government, victoriously rises on the ashes of the old constituted order. . . .

It has already been said that the children, for Ginzburg, are always predestined victims, the corporeal representation of a failure, even in their physical aspect, we do not meet one of them who suggests the rosy image of a happy childhood. Children are always graceful, pallid, sickly, from their birth, the pain of their mother and her sad fate are reflected in them. . . .

In contrast to many contemporary, Italian writers, especially Piedmontese ones, Ginzburg has not written a real novel of the Resistance to place besides those of Pavese, Calvino, Fenoglio, or *L'Agnese va a morire* (Agnes goes to die) by Renata Vigano. The climate that breathes through many of her pages, however, is that of the antifascist struggle, especially in *Tutti i nostri ieri* (All our yesterdays) and *Lessico famigliare* (Family handbook). . . .

But, among the dominant themes of loneliness, time, love, and death, history also has its place, it provokes confrontations . . . destroys lives, gradually making its presence larger and larger until it fills the whole space of days.

Thus, in *Tutti i nostri ieri* and in *Lessico famigliare,* the little follies of the characters that happen as in an album of private memories rise little by

little almost to the rank of historic text that signals an epoch and the family saga is opened to bear living witness to the struggle of a people for the reconquest of freedom, with the difficulties, the sacrifices, the ideals, the heroisms great and small that marked it.

<div style="text-align: right">

Elena Clementelli. *Invito alla lettura di Natalia Ginzburg* (Milan: Mursa), 1986, pp. 120–22

</div>

From the primordial love-hate feeling for those who brought one into the world, dealt with in *Madre e figlia* (Mother and daughter), we pass, in the novels of another contemporary woman writer, Natalia Ginzburg, to the description of much more delicate relations between children and their parents. Especially in *Caro Michele* (Dear Michael), the obvious loneliness of the mother seeks comfort in the son, but does not find it. Michele, a painter and aspiring terrorist, is far and remains absent for the entire novel, until his death, which is announced in the last chapter. The structure of the book is mixed narratives in the third person with letters that become metaphors for an impossible communication, because the dialogues take place at a distance and is difficult and unilateral. In fact, the letters often go without an answer, because Michele and his girl Mara with their son are constantly moving around following different itineraries. The mother tries to reach them with letters that follow and cross one another, often without reaching their destination, desperate and useless attempts to fill the void and break the silence. Even the journey may be considered as a metaphor for a space that is a physical and moral divide. . . .

In Ginzburg's works . . . children make concrete and solid the relation with life. Everything waves, fluctuates, and distances itself, following the current of an ineluctable fate. No mistake can be avoided or remedied, no alternative exists once moral values are missing. Not only is it no longer possible but it is extremely sad to invent a story. . . .

Natalia Ginzburg makes of everyday reality, limited and perfectly comprehensible, her poetic world. To poets, she gives the advice that "movement should be not in the direction of the good, the beautiful, but in the direction of reality."

Yielding at last to the autobiographical temptation with *Lessico famigliare* (Family handbook), Ginzburg goes from the "horror and terror of autobiography" to a novel of "pure, bare, uncovered and declared memory." She confesses that she finally finds herself in a state of "absolute freedom" in which writing, for her, "is absolutely like speaking." This feeling of liberation and joy shows that the writer has found her just dimension, the autobiographical memoir, which for her means;

> to speak only of what we love. Because memory is loving and never casual. It merges the roots of our own life, and for this

reason its choice is never casual, but always passionate and imperious.

Paola Blelloch. *Quel Mondo dei Guanti e delle Stoffe: Profili di Scrittrici Italiane del' 900* (Verona: essedue, 1987), pp. 107–9, 123–24

These five short novels (*Voices in the Evening, Valentino, Sagittarius, Family,* and *Borghesia*) written over the last three decades and recently published here, are the work of a mature Italian writer famous in her own country, little heard of in the United States. Natalia Ginzburg's fiction is like wonderfully composed photographs of the bombed-out city, the barren landscape, the starving Ethiopian mother and child. The most interesting thing about these pictures is their aesthetic tension: the harmony of the shapes versus the grimness of what these shapes represent.

Natalia Ginzburg's prose is hard, clear, evocative, controlled, understated, and as powerful as a stranglehold. She uses it to depict impoverished lives, shattered hope, resignation, compromise, regret, betrayal, envy, loss of love, death. Her art consists in keeping her reader attentive and sympathetic while her characters struggle to maintain dignity and sanity in the face of one disappointment after another.

In *Family* two young people, Carmine and Ivana, live together briefly. Ivana bears a child who dies at eighteen months; the couple split. Carmine marries Ninetta and Ivana has another child, Angelica, by a "Jewish glottology student she met at a party." It is soon clear that Carmine and his wife dislike one another. Carmine begins to spend more time with his old flame Ivana. Carmine's wife eventually takes a lover even though she "had always thought adultery was a sad, degrading thing." Carmine mopes around, regretting the shape and substance of his existence, deciding that Ivana and her circle are "the only trusted friends he had in the world." A few minor twists of fate later, Carmine falls sick. Dying, he feels "an agonizing nostalgia" for a day he spent with Ivana not long before. This man can only *think* about living, lamenting things not done, not said. He dies of cancer.

Voices in the Evening, written in 1961 and published here this month, is a novel only insofar as its parts have overlapping characters at the same vintage locale. The "voices" most often talk at cross-purposes—few people hear what they are being told. The mother puts it this way: "One tells stories and talks, someone says one thing, and someone else another."

In the center is Elsa, deeply in love with Tommasino, who is almost incapable of feeling anything but regret. Ginzburg's extraordinary understanding married to extraordinary prose gives these unhappy people not only reality but a poignancy impossible to ignore.

In *Borghesia,* Ilaria, a widow who once wrote a novel, is given a cat, a gift that triggers the action in this story about family dynamics—"They learned not to talk about painful things, and prudence became a habitual part

of their relationship." Ilaria's daughter, Aurora, makes a bad marriage and the cat dies. Ilaria was "discovering that even poor sorts of pain are acute and merciless, and quickly take their place in that immense, vague area of general unhappiness."

The standard Ginzburg text—as well as subtext—maintains that in spite of the best intentions, in spite of trying, things do not come out all right in the end, and that the most one can hope for is to muddle along and not put one's foot in it more than is absolutely necessary. Every so often this bleak philosophy takes a wry turn: "Valentino is lucky: self-love never leads to disappointment." It is a tribute to Ginzburg's skill that she can make this young man—narcissistic, selfish, and blessed with the sensibility of a dog louse—uncommon enough to care about.

In much the same way, the main character in *Sagittarius* is tiresome, a classic whiner; ten minutes in a room with her would be too long. And yet Ginzburg, through the magic of her crystalline prose and her total grip on the way to tell a story, not only brings this woman to life but gives her the appeal of poignant sorrow.

Although these novels contain flashes of a waspish sort of humor, they are few and far between and more like tics than genuine smiles. Nevertheless, I find something admirable in a writer who refuses to dilute or moderate her vision in order to make her readers feel good.

You don't feel good after reading these stories; you do feel that you have been presented with a truth, which—like those Ethiopian children with their wide, hopeless eyes—you would rather not have to think about.

<div align="right">Anne Bernays. Ms. October, 1989, pp. 20–21</div>

Scholars and admirers of Natalia Ginzburg's writings *(On believing and Not Believing in God)* will welcome the publication of her collected works in the Mondadori series, "I Meridiani." Volume 2 opens with a group of articles previously published in *La Stampa* and *Il Giorno* between December 1968 and October 1970, plus a few pieces such as "Sul credere e non credere in Dio" which appear here for the first time. In an authorial note preceding this section Ginzburg describes its selections as constituting something of a diary, in the sense that they are the result of what she remembered and thought.

Part 2 contains the two-character *Dialogo*, the three-act plays *Paese di mare* and *La porta sbagliata,* and the monologue *La Parrucca*. The common denominator in these works is the married woman in love with someone other than her husband, ready to sacrifice her marriage to follow her lover yet always frustrated and disappointed by this lover. The novel *Caro Michele* is then followed by "Vita immaginaria," a gathering of articles which appeared in *La Stampa* and in the *Corriere della Sera* between 1969 and 1974: one subgroup is devoted to writers, movies, and film directors (Ginzburg's favorites include Bergman and Fellini); the other incorporates pieces on such important topics as the role of woman in society and the modern-day state of Israel. The novels *La famiglia*—Ginzburg's least autobiographical work—

and *La famiglia Manzoni,* a section of newspaper columns dating from the years 1975–78, the two-act play *La poltrona,* and the novel *La città e la casa,* round out the collection.

Through the volume's assembled works Ginzburg's philosophy of life emerges clearly: her articles on the existence of God and on abortion, her plays, and her novels reveal a thinker who does not have any answers on the major questions life poses to human beings, one who strenuously defends freedom of thought and respect for the individual. For her, no one, not even husband and wife, must control another's choices. A strong advocate of friendship, Ginzburg believes in a warm relationship where friends can openly criticize each other and unconditionally accept each other despite their short-comings. Throughout, the reader can savor the author's use of the intellec-tual's everyday conversational language, the vivid immediacy with which she conveys her thoughts, and her disdain for the established values by which many critics approach music, painting, cinema, and politics.

<div align="right">Michela Montante. World Literature Today.
63, 1989, p. 85</div>

Although Ginzburg is not normally classified as a feminist writer alongside such typical representatives of the genre as Marilyn French or the younger Germaine Greer her most obvious talent and thus her main claim to fame is clearly an undoubted ability to communicate the complex subtleties of female sensibility through the portrayal of fictional characters whose context is al-most invariably one of submission or exploitation, whether active or passive, in a society where women are still more often than not relegated to positions of inferiority and where masculine values are correspondingly seen as natu-rally and necessarily predominant. If Ginzburg's intuitive rejection of this assumption and her resulting sympathy and compassion for the female of the species is thus the basic stimulus for most of her writing, as already indicated, she has always been equally aware that although the dice are heavily loaded in men's favor the so-called stronger sex are in essence just as vulnerable as their female counterparts; further, that their superiority is frequently deter-mined by the sacrifice, willing or otherwise, of a woman whose aims and desires are viewed solely in relation to those of her nearest and dearest and ruthlessly subordinated to men's unquestioned need to maintain their posi-tion, a process especially insidious because usually gradual and imperceptible over an extended period rather than sudden and brutal. Alongside these ap-parently superior characters, whose natural dominance is more apparent than real and whose affection more a liability than an advantage, Ginzburg also shows us men possessed of a genuine sensitivity and anxious to do the best for those around them, but who are unable to affirm themselves in an environ-ment where success is essentially reserved for the more cynical or more corrupt members of society; or men who are basically honest but who lack power or are too weak to assert themselves or change things for the better, their good nature paradoxically sometimes detrimental to themselves or to

others. Last of all we find rare instances of men who appear to know their limitations and organize their lives accordingly, men in control of their passions and able to evolve a life-style which ensures their emotional survival while at the same time allowing them to provide counsel and assistance to their partners; in short men who appear to deserve the status that society automatically assigns to their sex.

<div style="text-align: right">

Alan Bullock. *Natalia Ginzburg: Human Relationships in a Changing World* (Providence: Berg, 1991), pp. 175–76

</div>

GIOVANNI, NIKKI (UNITED STATES) 1943–

Power and love are what are at issue in Nikki Giovanni's poetry and life. In her earlier poems (1968–1970), these issues are for the most part separate. She writes of personal love in poems of private life; of black power and a public love in political poems. She won her fame with the latter.

In poems such as ["The True Import of the Present Dialogue, Black vs. Negro"], Giovanni speaks for her people in their own language of the social issues that concern them. Her role is that of spokeswoman for others with whom she is kin except for the fact that she possesses the gift of poetry: "i wanted to be / a sweet inspiration in my dreams / of my people. . . ." The quotation is from a later poem in which she is questioning that very role. But as she gains her fame, the concept of poet as "manifesting our collective historical needs" is very much present.

In defining poetry as "the culture of a people," Giovanni, in the statement from *Gemini* quoted earlier, uses "musician" and "preacher" as synonyms for "poet." All speak for the culture; all *speak,* with the emphasis on the sound they make. Making poems from black English is more than using idioms and grammatical idiosyncrasies; the very form of black English, and certainly its power, is derived from its tradition and preeminent usage as an oral language. . . .

The act of naming, of using language creatively, becomes the most powerful action of all—saying, calling. Calling fudge love, calling smiling at old men revolution is creative (rather than derivative) action that expresses more than her own powers as woman and poet. In "Seduction" there was a significant gap between language (rhetoric) and action, between male and female. In that fable, men and words were allied and were seen by the woman poet as impotent. The woman was allied with action (love), but she was, in the poem, mute. The man calls her action "counterrevolutionary." Now, in "My House," the woman's action, love (an overt expression of the personal, private sphere), is allied to language. Giovanni brings her power bases together in this poem, her dominion over kitchens, love, and words. No longer passive

in any way, she makes the food, the love, the poem, and the revolution. She brings together things and words through her own vision (dream, poem) of them, seeing that language (naming) is action, because it makes things happen. Once fudge has been named love, touching one's lips to it becomes an act of love; smiling at old men becomes revolution "cause what's real / is really real." Real = dream + experience. To make all this happen, most of all there must exist a sense of self on the part of the maker, which is why the overriding tone of the poem is the sense of an "i" who in giving need feel no impotence from the act of taking (both become aspects of the same event). Thus this is *her* house and he makes her happy, thus and only thus—"cause" abounds in this poem, too: this, her poem, can be his poem. Not silly at all.

In bringing together her private and public roles and thereby validating her sense of self as black woman poet, Giovanni is on her way towards achieving in art that for which she was trained: emotionally, to love; intellectually and spiritually, to be in power; "to learn and act upon necessary emotions which will grant me more control over my life," as she writes in *Gemini*. Through interrelating love and power, to achieve a revolution—to be free. She concludes her poem "When I Die" *(My House)* with these lines:

> and if i ever touched a life i hope that life knows
> that i know that touching was and still is and will always
> > be the true
> revolution

These words of poetry explain the way to enact a dream, one that is "a real possibility": "that I can be the first person in my family to be free . . . I'm twenty-five years old. A revolutionary poet. I love."

Wherever Nikki Giovanni's life as poet will take her, she will go there in full possession of her self.

<div align="right">

Suzanne Juhasz. *Naked and Fiery Forms*
(New York: Harper & Row, 1976),
pp. 157–58, 173–74

</div>

It was the publication of *Black Feeling, Black Talk, Black Judgement* (1968, 1970) that began her rise to national prominence. She captured the fighting spirit of the times with such lines as "Nigger can you kill?" (in "The True Import of Present Dialogue, Black vs. Negro") and "a negro needs to kill / something" ("Records"). These poems were distinguished more by the contrast between the words and the image of their author than by anything else. Also in the volume were a number of personal poems, including gentle satires on sexual politics, and introspective, autobiographical ones, such as "Nikki-Rosa," still one of her best. It talked about growing up, the value of a loving childhood and challenged the stereotype of the angry militant: ". . . they'll/ probably talk about my hard childhood/and never understand that/all the while I was quite happy," she wrote.

From the beginning, the personal, feeling poems were juxtaposed against those of violent militancy. But in subsequent books she spurned the latter completely. Her vision in *Black Feeling* which saw "our day of Presence/ When Stokely is in/The Black House" ("A Historical Footnote to Consider Only When All Else Fails") narrowed, in her autobiographical essays *Gemini* (1971), to the conclusion that "Black men refuse to do in a concerted way what must be done to control White men." In any case, as she wrote in *My House* (1972), "touching" was the "true revolution" ("When I Die").

But Giovanni's books after *Black Feeling* did more than repudiate violence. As critic Eugene Redmond pointed out, they offered her view from a new perspective: that of the rite of passage toward womanhood. The growing-up motif is a common one in literature, especially among women writers. It has provided some of their most memorable work and, in Giovanni's case, a unifying theme in her work.

> Paula Giddings. In Mari Evans, ed. *Black Women Writers (1950–1980)* (New York: Doubleday, 1984), p. 212

Giovanni is a frustrating poet. I can sympathize with her detractors, no matter what the motives for their discontent. She clearly has talent that she refuses to discipline. She just doesn't seem to try hard enough. In "Habits" she coyly declares:

> i sit writing

> a poem
> about my habits
> which while it's not
> a great poem
> is mine

It isn't enough that the poem is hers; personality isn't enough, isn't a substitute for fully realized poems. Even though she has created a compelling persona on the page, she has been too dependent on it. Her ego has backfired. She has written a number of lively, sometimes humorous, sometimes tragic, often perceptive poems about the contemporary world. The best poems in her three strongest books, *Black Feeling, Black Talk, Black Judgement, Re: Creation,* and *Cotton Candy,* demonstrate that she can be a very good poet. However, her work also contains dross: too much unrealized abstraction (flabby abstraction at that!), too much "poetic" fantasy posing as poetry and too many moments verging on sentimentality. In the early 1970s, after severely criticizing Giovanni's shortcomings, Haki Madhubuti said he eagerly awaited the publication of her new book, *Re: Creation;* he hoped that in it she would fulfill the promise of her earlier poetry. Even though it turned out to be one of Giovanni's better books, I find myself in a similar situation to Madhubuti's. I see that not only does Giovanni have promise, she already has written some

good poems and continues to write them. Yet I am concerned about her development. I think it is time for her to stand back and take stock of herself, to take for herself the time for reflection, the vacation she says Aretha deserves for work well done. Nikki Giovanni is one of the most talented writers to come out of the Black 1960s, and I don't want to lose her. I want her to write poems which grow out of that charming persona, not poems which are consumed by it. Giovanni must keep her charm and overcome her self-indulgence. She has the talent to create good, perhaps important, poetry if only she has the will to discipline her craft.

<div style="text-align: right">William J. Harris. In Mari Evans, ed. *Black Women Writers (1950–1980)* (New York: Doubleday, 1984), p. 228</div>

Upon reading Nikki Giovanni's early poetry, one immediately notes the ferocity of her verse. Its force, its passion, and its hatred startle, but the 1960s were startling years. Hers is a message of revolution, killing, changing. The cry is for a strong sense of individualism and for an individual who will stand up to effect the changes society demands. The combined volume containing the texts from her two books, *Black Feeling Black Talk/Black Judgement,* illustrates this emphasis. A later volume, *My House,* is much more personal and concentrates on the influences at work on the poet.

The Women and the Men continues that sense of mellowing, of shifting focus and emphasis in the poetry, as the poet stresses personal contacts. It is interesting to note that many of her individual poems are dedicated to specific people, often identified by name or by initials. In the most recent volume, the mellowing is not only evident; it is the thrust of the book.

One critic of contemporary poetry praised Giovanni for her ability to use simple folk and blues rhythms and techniques. That strength is evident in . . . of her verses about strong black women she has met.

<div style="text-align: right">Dennis Lloyd. In Ray Willbanks, ed. *Literature of Tennessee* (Macon, Georgia: Mercer University Press, 1984), pp. 197–98</div>

While Giovanni has received more attention first for her militant poems on racial themes and later for her feminist writing, the poems that will finally determine her position in the canon of American poetry are, almost without exception, ones in which place functions not only as a vehicle, but also as a theme. In her most recent work, her themes are becoming increasingly complex, reflecting her maturity as a woman and as a writer. Traditionally in Southern writing, place has been associated with themes of the past and the family; these themes are seen in Giovanni's poems of the late 1960s and the early 1970s, with the added dimension of a desire to understand the faraway places from which black slaves were brought to the American South. Her later poetry reflects a changing consciousness of her role in society as a single woman, the need to adjust her concept of home and family and of the

importance of smaller places, such as houses and rooms, to fit her own life, a life that many American women and men, black and white, can identify with. In her best poems, places grow into themes that convey the universal situation of modern humanity, a sense of placelessness and a need for security. . . .

For her, place is more than an image, more than a surface used to develop a narrative or a theme, just as place functions in the best poetry of the Southern tradition lying behind her work. Further, the changing sense of place in these poems can be seen to reveal Giovanni's developing sense of herself as a woman and as a poet. Suzanne Juhasz, Anna T. Robinson, and Erlene Stetson all emphasize in their recent critical discussions the growing feminist consciousness they find in Giovanni's work. Her use of place is broader than simply a feminist symbol, though, just as her poetry has developed beyond purely racial themes. The relationships of people to places and the ways people have responded to and tried to control places are important themes for Giovanni, as are the ways places sometimes control people. Greatest in thematic significance are the need to belong to a place or in a place and the necessity of moving beyond physical places to spiritual or metaphysical ones.

> Martha Cook. In Tonette Bond Inge, ed.
> *Southern Women Writers: The New*
> *Generation* (Tuscaloosa: University of
> Alabama Press, 1990), pp. 228, 299

GIPPIUS, ZINAIDA (also transliterated as HIPPIUS) (RUSSIA) 1869–1945

Hippius's poetry reveals—more than the works of any other Russian modernist writer—that special love for beauty, that antinomy between the poet's religious impulses and simultaneous blasphemy, and that bond between religion, poetry, and mystical sensuality which characterized Russian belles-lettres at the time. Her intentional violation of the canons of established traditions and her attempts at reevaluation were also typical of the unique atmosphere which prevailed in Russian literature of the 1890s and early 1900s. She was a highly cultured poet, with a wide range of interests and learning; as such, she contributed to a change in the symbolist writer's concept of the world. Together with Merezhkovsky, Minsky, Rozanov, and Fyodor Sologub, she advocated a new artistic taste, creating new patterns of sound and rhyme, and revealed new literary values to the Russian reader.

Hippius also occupies an important place in the history of Russian versification. In the majority of her poems she used traditional classical meters, but she was at the same time a true representative of the "age of experimenta-

tion" in Russian poetry (1895–1930). Endowed with a sensitive ear for metrical composition, sounds, and rhythmical designs, she explored and experimented with various latent possibilities of Russian versification by writing poems in "dol'niki," tonic verse, and free verse. "Among the modernists, she was one of the first to write poems in these new kinds of verse, and to a certain extent she was one of the innovators and popularizers of them," asserts James O. Bailey in his unpublished dissertation. "The breadth and variety of her versification, consequently, is exceptionally large. Few other poets in the early twentieth century have such a diversity of both traditional and non-traditional verse."

Hippius was not content with merely repeating classical meters. She aided and fostered their development and application. All her experiments, both in classical and nonclassical traditions, as well as in her exploratory work with rhythm and vocabulary, were always carefully conceived and guided. She displayed a keen sense of form and did not let her experiments "dissolve into amorphous rhythmical rhapsodies," as happened with so many Russian poets in the twentieth century. . . .

During the "age of experimentation" many poets and their sympathetic critics, who had lost artistic perspective while diligently searching for new forms, meters, and sounds, were bewildered by Hippius's control of poetic technique and expression. This perplexity of her contemporaries, who mistook restraint for "cold intellect," explains their frequently unjustified criticism of her poetic achievements. Moreover, many conjectures, often ludicrous, were made concerning Hippius's predilection for using the masculine endings of verbs and personal possessive pronouns. Hippius herself explained to her friend Georgy Adamovich, a Russian writer in emigration, that she wanted to write poetry not just as a woman but as a human being. . . .

In poetic technique Hippius excelled in accentual, "interrupted" verse (pauzniki), based on purely tonic metrics. She invented her own "poetic garments," which are striking both in their originality and artistic power, as a protest against hackneyed images. Her images, although surprising and at times uncanny, are not the result of any experimentation with "trans-sense" modes. They are an integral part of her verse structure—she never used them as poetic decorations.

Hippius found the play of intellect a passionate experience. She drew on her extensive knowledge for abstract ideas and clothed these ideas in "poetic garments" that were both ambiguous and paradoxical. Her verse abounds in unexpected ingenious parallels, contrasts, oxymorons, and comparisons, which are interlaced with details taken both from Russian folklore and from the most recondite philosophical, psychological, and theological thought. The solemn emotional overtones of her essentially tragic poems are often relieved by a delightful play of intellect and occasional sophistry.

Hippius's path to God began with introspection. In her desire to rise above the banality and mediocrity of others, she developed her own personality to an eccentric degree. Her early eccentricity was expressed not only in

her appearance and behavior, but also in her verse. Hippius's poetry of those early days was full of symbols of evil, darkness, and loneliness. Several ingenuous critics saw in it only a manifestation of the poet's morbid attraction to "decadent" moods and visions. They failed to perceive the affirmative note in Hippius's writing, which was apparent in her aspiration toward God. . . .

Without Zinaida Hippius the Silver Age of Russian poetry and the Russian religious renaissance would have been unthinkable. She was one of the most stimulating minds of her time, a sophisticated poet, an original religious thinker, and an inimitable literary critic. In her work the four chief aspects of the Russian cultural tradition—art, religion, metaphysical philosophy, and socio-political thought—receive their harmonious embodiment.

Temira Pachmuss. *Zinaida Hippius: An Intellectual Profile* (Carbondale: Southern Illinois University Press, 1971), pp. 15–17, 407–10

If one disregards a few of the early typically decadent poems, such as "Cvety noči" (1894), in which she pays tribute to contemporary literary modes, and bases one's judgment on the totality of Gippius's poetry, one can only conclude that she was basically a religious poet. In spite of the fact that such poems as "Cvety noči" were very popular in their day, precisely because of their obvious decadence, and still remain among Gippius's best known poems, it would not be fair to generalize on the basis of these isolated examples. It is especially unfair to neglect the intense religiosity of her poetry on the basis of the capricious and arrogant personal image that she projected.

If one must classify Gippius the poet, one should consider her together with the second generation symbolists, who in contrast with the decadents associate their art with religion rather than pure aestheticism. In attempting to overcome the loneliness and total self-centeredness of the decadents, the second generation poets wish to find meaning outside of themselves by reaching out to God in their poetry. The poet's sincerity or his success or lack of success in these attempts to find God are not the important criteria which distinguish decadents and symbolists. It is the act of reaching out toward what they called the "other reality," the attempt to penetrate what V. Ivanok called the *realiora* of the other world which is characteristic for the "symbolist visionaries," an appropriate term used by V. Markov to describe the second generation. The factor of success is irrelevant. Gippius's poetic visions are more akin to the younger generation's in that she hopes and attempts to escape the spiritual loneliness of her existence by finding her own path to God. . . .

Since Gippius's poetry is highly abstract and philosophical, it is difficult on the whole to relate it to her biography. In 1895, she noted in her diary that while writing a poem she never dedicates it to any earthly relationships or to any particular individual. Baluev feels that this abstractness allowed Gippius to express her strong feelings about such universal themes as God,

love and death without becoming intimate. In this respect Gippius is closer to the classicists than to the neo-romanticists of her generation. Probably it is this abstractness which created the erroneous impression of impersonality, a characteristic frequently mentioned in connection with Gippius. Actually she was a very personal poet, recording her innermost philosophical and metaphysical conflicts in a somewhat detached, intellectual manner.

Another peculiarity of Gippius's poetry is the lack of chronological development. Zlobin writes that chronology does not play a significant role in her art and life. Her original attitudes remained with her always, as she so frequently emphasizes by poetically asserting her absolute faithfulness. The fact that the arrangement of her books of poetry is not strictly chronological reinforces this general observation. Already her first well known poem "Pesnja" contains the basic theme of all of Gippius's poetic works—the search for that indefinable, never fully attainable, faith in God. (This, however, does not mean that Gippius's poetry lacks movement; movement in a metaphysical sense represents the cornerstone of her poetic vision.) From the point of view of technique and form, it can also be stated that Gippius develops her specific poetic style in the very beginning of her career. Consequently her early poems are already formally mature, reflecting her characteristic unadorned, yet expressive, conciseness.

Olga Matich. *The Religious Poetry of Zinaida Gippius* (München: Fink Verlag, 1972), pp. 15, 33–34

As a poet, Zinaida Gippius is the equal of these two great younger contemporaries [Akhmatova and Tsvetaeva]. As a historical phenomenon, she is probably more important than either of them. One of the guiding spirits of the entire Symbolist movement, and a pioneer of the turn-of-the-century religious revival among the liberal intelligentsia, a revival that had incalculable consequences for twentieth-century Russian culture, Gippius was also a remarkable early theoretician and practitioner of androgyny and psychological unisex, who rejected the traditional male/female roles as early as the 1890s. . . .

A careful reading of the entire oeuvre of Zinaida Gippius that has now been made available in Russian in the West will confirm that her contemporaries at the turn of the century were right to place her in the front rank of Russian poets of that or any time. Her ability as a playwright is also beyond dispute. Her dramatic fantasy *Sacred Blood* and the more realistic *Poppy Blossoms* (written jointly with Merezhkovsky and Filosofov, but very much of a piece with her other works in conception and style) hold up remarkably well. Her play *The Green Ring,* which in a brilliant production by Vsevolod Meyerhold was the major event of the 1916 theatrical season, remains to this day one of the finest genuinely revolutionary and genuinely poetic plays in the Russian language.

In her prose writings, Gippius was at her weakest in the area where [her husband], Merezhkovsky was at his best and most enduring: in literary

criticism. The very qualities that made her such an original thinker and poet also made her blind as a critic. Her single critical feat—her early recognition of the genius of Osip Mandelstam—was never recorded in her essays and is known to us only through the accounts of others and a brief mention in her memoirs. By and large, as a critic she expected her own kind of metaphysical subtlety from all other writers and was incapable of taking an interest in any writing that did not derive from Dostoyevsky. . . .

Her two big political novels, *The Devil's Puppet* and *Tsarevich Roman*, for all the knowledgeable and sympathetic glimpses they offer of life among turn-of-the-century revolutionaries, remain pallid and ineffectual imitations of Dostoyevsky's *The Possessed*. But in the prose genres where Merezhkovsky did not leave his mark, the short story and the memoir, Gippius comes into her own and produces work that is superior to anything by Merezhkovsky and as good as anything written by the Symbolist prose writers of her generation. Her book of literary memoirs *Zhivye litsa* (reprinted by Professor Pachmuss as *Living Portraits,* although either *Living Persons* or *Lifelike Faces* would have been closer to the multi-leveled meaning of the Russian title) and her biography of Merezhkovsky (published in 1951 as *Dmitry Merezhkovsky;* her original title for this book was *He and We*) are basic documents for the study of the momentous literary epoch during which Gippius lived and to which she so prominently contributed. Together with her poetry, her plays, and her diaries, these two books add up to one of the more valuable literary treasure troves of our century.

<div style="text-align: right;">

Simon Karlinsky. Introduction to Vladimir Zorin. *A Difficult Soul: Zinaida Gippius* (Berkeley: University of California Press, 1980), pp. 1–2, 19–21

</div>

Zinaida Hippius, one of the greatest religious poets in Russia, conceived of her works as a direct path to a perfect unity with God. Even the erotic quality in her writing is always tempered by spirituality and is organically fused with the poet's personal visions of Christ and the Holy Trinity. Since she represented the current of social, religious, and political thought of her time, her literary work is also important in the study of the prerevolutionary intelligentsia and its deep involvement in the Russian Religious Renaissance at the turn of the century. Hippius may be referred to as one of the formative figures in the progressive and intellectually alert group of the Russian intelligentsia at that time. She engendered new ideas, took an active part in the spirited exchange of opinions, and played a vital role in the religious revival of her country. In Nikolay Lerner's words, Hippius's activities embraced a "broad philosophical scope." "Zinaida Hippius's works espouse lofty and spiritual values. They express the aspirations of an entire decade in our literature: a search for God."

<div style="text-align: right;">

Temira Pachmuss. *Melbourne Slavonic Studies.* 15, 1981, p. 18

</div>

GLASGOW, ELLEN (UNITED STATES) 1873–1945

In all her novels one is aware of an attendant keenly observant ethical spirit. Her morality is her own, tolerant of nature, intolerant of cant and humbug, but her consciousness is as unmistakably ethical as that of George Eliot. She likes to see the wheel come full circle. She builds her stories with a view to showing Time bringing in revenges.

Her style is firm, lucid, and if I were not afraid of giving offense, I should add, it has a masculine rhythm. It has wit and beauty. At its best it has a proud and impressive reserve, and goes over depths with the tension and moving stillness of deep rivers.

<div align="right">Stuart Sherman. Critical Woodcuts (New
York: Scribner's, 1926), pp. 79–80</div>

In reality, Ellen Glasgow has invariably been as much preoccupied with form as with subject matter; almost instinctively, when she proclaimed a discordant truth she stated it in sonorous prose, a prose that somehow disguised the fact that it was harsh and anathema. In her brilliantly epigrammatic style many of her most acidulous commentaries have had a universal rather than a personal challenge. Whether she meant it to be so or not, the way she expressed a thing, rather than the thing itself, is what impressed her audience and, however inverted or contraverted, this is a Victorianism certainly.

<div align="right">Sara Haardt. The Bookman. April, 1929,
p. 134</div>

Ellen Glasgow has shown a remarkable receptivity to new ideas. She began to publish when the idealistic treatment of the romantic material of Southern life had reached its climax of popular appeal. She did not break sharply with the traditions of that school, but she took the best lessons it had to teach, and turned them into a new achievement. Through her the Puritan strain, always present in Virginia, which had animated Bacon's rebellion in the seventeenth century and had reached its height in the iron tenacity of Stonewall Jackson, came into its proper place in the panorama of fiction.

<div align="right">Arthur Hobson Quinn. American Fiction
(New York: Appleton-Century, 1936), p. 681</div>

Miss Glasgow has refused to consider herself less than an artist. She has not written of Virginian life but of human life in Virginia. She has taken two or three years to perfect a book, not because she wanted to be sociologically accurate but because she wanted to be artistically mature, and this sense of pace and dignity, this tacit assumption that the novel is a major work of art— these are the qualities she has brought to her interpretation of immediate environment.

<div align="right">Howard Mumford Jones. Saturday Review of
Literature. October 16, 1943, p. 20</div>

You have in the work of Ellen Glasgow something very like a complete social chronicle of the Piedmont section of the State of Virginia since the War Between the States, as this chronicle has been put together by a witty and observant woman, a poet in grain, who was not at any moment in her writing quite devoid of malice, nor of an all-understanding lyric tenderness either; and who was not ever, through any tiniest half-moment, deficient in craftsmanship. You have likewise that which, to my first finding, seemed a complete natural history of the Virginian gentlewoman throughout the last half-century, with all the attendant features of her lair and of her general habitat most accurately rendered. But reflection shows the matter to be a great deal more pregnant than I thought at outset; for the main theme of Ellen Glasglow, the theme which in her writing figures always, if not exactly as a Frankenstein's monster, at least as a sort of ideational King Charles's head, I now take to be The Tragedy of Everywoman, As It Was Lately Enacted in the Commonwealth of Virginia.

<div align="right">James Branch Cabell. Let Me Lie (New
York: Farrar, Straus, 1947), p. 243</div>

Ellen Glasgow was a literary rebel in the first half of her career, a literary ancestor in the second half, but her work has never had the full recognition it deserves. One of our top three women writers, she has been eclipsed by the glow of Willa Cather's lovely fairy tales and by the cool glitter of Edith Wharton's social snobbery. Yet as a literary figure Miss Glasgow was superior to these ladies in many respects, and her best novels are of equal interest and importance with theirs.

<div align="right">Maxwell Geismar. The Nation. November
13, 1954, p. 425</div>

The social historian cannot become personally involved at the expense of his own satirical objectivity, for at that moment true satire becomes impossible. All of which is a way of saying that Miss Glasgow's success at applying blood and irony in pursuit of the social history of Virginia depends upon her own detachment; and too often she is not at all detached, but instead is so intensely engaged and identified with the supposed objects of irony that she can be neither ironic nor realistic. She surrenders her objectivity to the private demands of her characters; instead of creating Dorinda in *Barren Ground,* she becomes Dorinda. Or rather, it is Dorinda who ceases to be a fictional character and becomes an extension of Miss Glasgow's own life and personality, until it is Miss Glasgow who is undergoing the experience.

It is a good rule of thumb for the Glasgow novels that whenever the author begins identifying a character's plight with her own, begins projecting her personal wishes and needs into the supposedly fictional situation, then to that extent both the character and the novel are weakened. Contrariwise, Miss Glasgow's success as a novelist is in direct proportion to her success

in standing away from her characters and letting them find their own fictional level, as created figures in a story.

<div align="right">
Louis D. Rubin. No Place on Earth (Austin:

University of Texas Press, 1959),

pp. 13–14
</div>

Like Thomas Hardy's, Miss Glasgow's central, spiritually perceptive characters strive to maintain a sense of equanimity, even though their personal universe may crumble. Despite a failure at times to see some facts clearly, Miss Glasgow possessed a critical acuity sufficiently strong to distinguish illusion from reality. She possessed, moreover, a well-developed sense of humor which was awake both to the perversities apt to govern the individual's existence and to the absurdities present even in a cosmos governed by natural laws. These two intellectual attributes in Miss Glasgow induced in her a conviction that an absolute pessimism was too pretentious to provide a balanced interpretation of experience.

<div align="right">
Frederick P. W. McDowell. Ellen Glasgow

and the Ironic Art of Fiction (Madison:

University of Wisconsin Press, 1960), p. 233
</div>

In the novels which compose her triptych of manners, Ellen Glasgow explored the meaning for her Virginians of a change in moral attitudes. In these novels she showed plainly that she could neither accept nor wholly reject the code of behavior which had governed polite society or, indeed all of society in Virginia since colonial times. Earlier she had attacked the features of that code which she found debilitating, or even evil in their effect. Especially had she objected to what she called "evasive idealism." For against all forces in the life of an aristocratic society which prevented men and women from living rich lives, or which protected barbarity, weakness and greed in the name of tradition, Ellen Glasgow sternly waged war. Yet, if she attacked the code as faulty, she could not readily accept what was usually offered as its alternative: the abandonment of all rule in human relationships. . . .

The Sheltered Life (1932) is Ellen Glasgow's finest novel, for in this tragedy of manners she combined most effectively all the elements of her material and art. In it character, action, and atmosphere interact to reveal not only the tragedy in lives shaped by the code of polite behavior and by the pretenses of a cult of Beauty but also the evil lurking in assumptions of innocence. She cast over these people a magic portrayal, a brilliance of life, and a beauty which makes superb the irony in the charm of their outward lives and their darker implications.

<div align="right">
Blair Rouse. Ellen Glasgow (New York:

Twayne, 1962), pp. 98, 108
</div>

It is unfortunate for the artistic stature of her short stories that Miss Glasgow did not continue writing them after 1924. Although she dated *Virginia* (1913)

as her first mature work, it is generally agreed that her "major phase" began with *Barren Ground* (1925). This novel, together with *The Sheltered Life* (1932) and *Vein of Iron* (1935), remains unchallenged by anything she wrote in a shorter form. "Jordan's End" gives us a hint of what she might have done if she had taken the short story as seriously as she took the novel, if she had not been so obsessed with her "social history of Virginia."

From our perspective today, we can see that Ellen Glasgow kept maturing stylistically, but that her moral and social concepts solidified in the middle of the 1920s. The rebel of the 1890s found herself the conservative of the 1920s. Nevertheless, the advice of Walter Hines Page and her own iron vein kept her writing fiction even after she had lost faith in her readers, even when she knew she was celebrating lost values. For this she has earned her status as one of America's leading woman novelists.

<div style="text-align: right">

Richard K. Meeker. Introduction to *The Collected Stories of Ellen Glasgow* (Baton Rouge: Louisiana State University Press, 1963), p. 23

</div>

The advantages that she brought to her task and ambition were indeed considerable. Out of her wide reading she selected the mightiest and probably the best models to guide her in her re-creation of the Virginia scene. She used Hardy as her master in rustic atmosphere, George Eliot as her guide in morality, Maupassant for plot, and Tolstoy for everything. She had the richest source material that any author could wish, consisting simply of a whole state and its whole history, a state, too, that occupies the center of our eastern geography and of our history and that not coincidentally has produced more Presidents than any other. And the social range among Miss Glasgow's characters is far greater than that of most twentieth-century novelists, suggesting that of such Victorians as Trollope, Dickens, Elizabeth Gaskell, and, again, George Eliot. . . .

Miss Glasgow had the same range in scenery that she had in human beings, and she could make the transfer without difficulty from the grim mountains and valleys of *Vein of Iron* to the interminable fields of broomsedge in *Barren Ground* and thence to the comfortable mansions of Richmond and to the smaller gentility of Petersburg and Williamsburg. Highly individual in American letters is her ability to pass with equal authority from country to city, from rusticity to sophistication, from the tobacco field to the drawing room, from irony to tragedy.

Yet for all her gifts and advantages she does not stand in the very first rank of American novelists. She was unable sufficiently to pull the tapestry of fiction over her personal grievances and approbations.

<div style="text-align: right">

Louis Auchincloss. *Pioneers and Caretakers* (Minneapolis: University of Minnesota Press, 1965), pp. 86–88

</div>

In the history of Southern literature Ellen Glasgow's place is assured. She was, simply, the first really modern Southern novelist, the pioneer who opened up for fictional imagination a whole spectrum of her region's experience that hitherto had been considered inappropriate for depiction in polite letters. From the very beginning she meant business, and she had no patience with those who would have literature be anything less or other than an honest portrait of human experience and human meaning. Decades before Faulkner, Wolfe, Warren, Caldwell, Welty, and the others, she did her best to write about Southern experience as she actually viewed it, not as her neighbors thought she ought to be seeing it. In the words of the historian C. Van Woodward, "When eventually the bold moderns of the South arrested the reading and theatrical world with the tragic intensity of the inner life and social drama of the South, they could find scarcely a theme that Ellen Glasgow had wholly neglected. She had bridged the gap between the old and the new literary revival, between romanticism and realism."

<div style="text-align: right">

Louis D. Rubin, Jr. In M. Thomas Inge, ed.
Ellen Glasgow: Centennial Essays
(Charlottesville: University Press of
Virginia, 1976), p. 4

</div>

Ellen Glasgow, . . . who died in 1945, is not at all highly regarded at present; yet she was a distinguished American novelist and the first of the Southern women writers . . . to repudiate the "willed heroic vision." Her primary theme, indeed, is the way in which grand ideas and facile goodwill interfere with the capacity to perceive ordinary miserable truths. . . .

What fascinates Ellen Glasgow is the paradox involved in the correlation between integrity and dissembling; in her novels it is always those of the highest moral character who are most reluctant to take account of domestic or social ills. They become adept at pretending. She makes the point over and over: "Her higher nature lent itself to deceit"; ". . . both clung . . . to the belief that a pretty sham has a more intimate relation to morality than has an ugly truth." The characters—most of them at any rate—are not at all critical of society's arrangements, but the author is: she is openly a crusader for social reforms, but she avoids a haranguing note by keeping her tone sardonic rather than impassioned. Benign obtuseness, willed or otherwise, is her target; but she understands how this quality can make life more agreeable for those who possess it. . . .

Ellen Glasgow's objective . . . is to underline the harm occasioned by self-deceits and wilful delusions, and to suggest, as far as possible, a wider social parallel for the personal failures and tragedies her novels depict. At best, her work is authoritative and graceful; and her social observation is always acute.

<div style="text-align: right">

Patricia Craig. (London) *Times Literary
Supplement.* November 13, 1981, p. 1319

</div>

Ellen Glasgow's autobiography, *The Woman Within,* resembles these others as a therapeutic enterprise. Written at intervals over the last ten years of her life, a period of descent into "mortal illness," it chronicles a career but also, and perhaps more importantly for her, a lifelong struggle with debilitating physical illness and mental anguish. The narrative both relates and enacts an emergence from the triumph over conditions that had drained her energies, threatened her physical and mental health, and driven her to shut out most of the world that she believed incapable of understanding or helping her to bear her fate. After forty years of writing novels that indirectly addressed the profoundly personal issues that dominated her life and thought, she undertook to treat those issues directly and candidly and, laying aside her habitual masks of detachment and diplomacy, to commit her secrets to writing before she died. It was a way of setting the record straight. It was also a way of purging her soul of the sorrows that had festered there and healing the "wound in the soul" that lay beneath the smooth facade of technical mastery.

The personal issues paramount in the autobiography cannot be understood, however, without reference to some of the ways in which they analogously reiterate cultural issues she defined as peculiarly southern. Again and again in Glasgow's work one finds evidence of a belief in the historical contingency of the self. Explicit analogies are drawn between the self and the South, both suffering from conditions of chronic ambivalence about identity, both suffering from the effects of exaggerated gender polarities, both caught between acceptance and denial of the terms of strict Calvinism and Victorianism, and both victims of misunderstanding by "outsiders." Being "inside" the South, like being inside her own body, affected this "woman within" as a species of ambiguous entrapment, and the insularity she describes as having characterized her intellectual and spiritual life is repeated in her portrayals of southern culture as a phenomenon unto itself, easily misunderstood from without. . . .

In her passionate identification with the South and especially with Virginia (the name of one of her more autobiographical heroines in her 1913 novel, *Virginia*), Glasgow had available to her a ready source of metaphors of the self and a way of understanding bodily life that gave it a symbolic importance as an enactment of a communal fate. Her strategies for coping with physical illness serve, among other things, to illuminate her ways of coming to terms with living in a South she cherished in its uniqueness even as she vehemently resisted the appellation of "southern" or "regional" writer, wanting to be understood as a scholar of human nature. Both involve rather insistent intellectualization of experience, a habit of careful denial, and a certain refined defensiveness that expressed itself as a posture of dignity.

<div style="text-align: right;">

Marilyn R. Chandler. In J. Bill Berry, ed.
*Located Lives: Place and Idea in Southern
Autobiography* (Athens: University of
Georgia Press, 1990), pp. 94–95

</div>

The ghost stories value sympathy, compassion, and sensitivity, and portray these qualities as a primary source of bonds between women. These are qualities that men neither possess, nor understand, nor value, the stories imply. Glasgow's familiarity with a female tradition in the ghost story is suggested by her personal library holdings at the time of her death: in addition to Bronte's *Wuthering Heights* and Radcliffe's *The Mysteries of Udolpho,* she owned two of Cynthia Asquity's ghost story collections, Edith Wharton's *Tales of Men and Ghosts* and *Ghosts,* Katherine Fullerton Gerould's *Vain Oblations,* Isak Dinesen's *Seven Gothic Tales,* Virginia Woolf's *A Haunted House and Other Stories,* and miscellaneous collections by Mary Wilkins Freeman, Elizabeth Bowen, Marjorie Bowen, and Vernon Lee. . . .

In the ghost stories, adherence to rationality prevents white men, and especially professional men, from seeing ghosts. The same quality promotes a generalized insensitivity to atmosphere and environment, and to the feelings of the women around them. It may make them distinguished politicians, but it hardly suits them for matrimony; "Dare's Gift" and "The Shadowy Third" suggest that it may make them renowned doctors, but it cannot make them good ones. Thus while contemplating marriage and accepting a male collaborator for her work, Glasgow continued her more radically feminist tradition in her ghost stories, choosing a genre she knew to be appropriate to her concerns. Living unhappily in a house she perceived to be haunted, she wrote of other unhappy women and their hauntings. Sensitive to the presence of the past at One West Main Street, she portrayed other houses as texts in a female history available to anyone sensitive enough to read them properly. Dependent upon a female companion for the understanding and sympathy her male lover seemed unable to offer, she celebrated the bond of female friendship as a more fulfilling tie than that of heterosexual romance and marriage.

> Lynette Carpenter. In Lynette Carpenter
> and Wendy K. Kolmar, eds. *Haunting the
> House of Fiction: Feminist Perspectives on
> Ghost Stories by American Women*
> (Knoxville: University of Tennessee Press,
> 1991), pp. 120, 137–38

GLASPELL, SUSAN (UNITED STATES) 1876–1948

This book is the biography of a real man, George Cram Cook; but so varied was this man's life that monotony is the last thing the reader need fear to find in it.

It is difficult to write even a review that concerns Cook without emotion; for his glowing, rich, child-sweet personality haunts, like the echoes of a bell,

the memories of all who knew him. Therefore it is no small achievement for Miss Glaspell that she has created here a vivid, moving, but never sentimental picture of this man who was her husband. . . .

This story of Cook's life—and it is really a story, not a dry account of dates and deeds—begins with Cook's early days on the old Mississippi Valley farm which he always managed to make so romantic. He made the farm romantic by virtue of his own deep sense of past lives and future lives hovering around the old place; he lived with depths of time around him, and the air was thick for him with invisible presences. He thus gave to his own life a kind of symbolic dignity: on the one side, he was always conscious of the great Mississippi River rolling endlessly down the valley; on the other side, he always felt the great river of civilization flowing down the ages from those Greek hills where he was eventually to die. During all the years of his varied life, these two things were his spiritual well-springs. The story ends when, at the age of fifty, he lay dead at Delphi, with a chorus of lamenting Greek shepherds around him.

He was novelist, philosopher, teacher, playwright, farmer, poet, soldier, violinist, lover, drinker, dreamer, actor, revolutionist, mystic. He made endless fragmentary notes about everything that interested him—and that included almost everything in the world, past, present, or future. With great skill, Miss Glaspell incorporates some of these passages in her narrative, and produces an effect of almost startling vividness and reality. One actually hears the man's voice—that deep rich voice, with its great laugh never very far away. One of these notes,—unconsciously symbolic, perhaps,—says of his boyhood days beside the Mississippi: "I built the city of Troy in the sand on the shore of the island, while Dad and his friends fished from the boat or along the shore. They seldom caught anything." George Cook, also, seldom caught anything; he never tried; but his city of Troy still exists: it is this book.

"'Capacity for thought and feeling is the test of man or woman. The production and appreciation of noble beauty is the test of civilization.' So, in the year 1896, spoke Instructor Cook, aged twenty-three, to the boys and girls of the cornfields." When he died at Delphi, twenty-eight years later, it was in the same faith.

Heaven help America when the last futile dreamer has been standardized out of existence!

Brilliant writer of fiction though Susan Glaspell is, one may well doubt whether she has ever invented a tale that is quite as thrilling as this true history—which she has related with fine artistry, and with the most noble respect for the memory of a noble man.

Arthur Davison Ficke. *Saturday Review of
Literature.* March 26, 1927, p. 675

Alison's House, Susan Glaspell's play which I finally got around to seeing at the Civil Repertory Theatre, is a peculiarly exasperating piece of work. It purports to deal, rumors assiduously circulated by Miss Le Gallienne's press

department and others have it, with the effects on Emily Dickinson's family of the discovery, years after her death, of some of her poems previously unknown. Although the locale of *Alison's House* is Iowa the allusions to Emily Dickinson and her family are sufficiently direct to be obvious even to one who knows as little about the poetess's circumstances as I do. Referring you all the way back to the beginning of this paragraph and to the word "exasperating," I used it because the play always seems on the point of getting somewhere and coming to life and, as far as I am concerned, never does. I suspect that it reads beautifully and that possibly to those better versed in the family history of the Dickinsons than I it has vitality. Even I am able to perceive and admire Miss Glaspell's careful, skillful and clear-cut characterization. Her characters are all real people still living under the spell of the retiring yet strangely powerful personality of the dead woman—call her Alison or Emily. For the most part Miss Eva Le Gallienne and her company act with uncommon skill and intelligence. However, I must pause to wonder if there was no way to avoid having an Iowa high school senior of pure New England stock played by so aggressively Jewish, kittenish and effeminate a little thing as Mr. Shapiro. If things are at such a pass as all that in Fourteenth Street, it might be better if one of Miss Le Gallienne's aspiring young actresses donned trousers, let her hair grow a little and played the part as it ought to be played.

Otis Chatfield-Taylor. *The Outlook*.
December 31, 1930, p. 711

Susan Glaspell who definitely belongs to the period of the beginnings of the American theater, sums up in her work all the qualities and trends of those early years. She is the Puritan struggling toward freedom, toward unaccustomed expression. The life in her one-act plays, with which the new theater began, is strong but never rich. In truth, it is a thin life. Only it is thin not like a wisp of straw but like a tongue of flame. She is morbidly frugal in expression, but nakedly candid in substance. Her form and, more specifically, her dialogue, have something of the helplessness and the numb pathos of "the twisted things that grow in unfavoring places" which employ her imagination. She is a dramatist a little afraid of speech. Her dialogue is so spare that it often becomes arid. The bleak farmsteads of Iowa, the stagnant villages of New England touched her work with penury and chill. She wants to speak out and to let her people speak out. But neither she nor they can conquer a sense that intimate or vigorous expression is a little shameless. To uncover one's soul seems, in these plays, almost like uncovering one's body. Behind Miss Glaspell's hardihood of thought hovered the fear and self-torment of the Puritan. She was never quite spontaneous and unconscious and free, never the unquestioning servant of her art. She brooded and tortured herself and weighed the issues of expression. Thus the fault of her early one-act tragedies was an insufficiency of actual speech. Somewhere in every drama words must ring out. One ached in her plays for something to release the dumbness,

complete the crisis, and drive the tragic situation home. Yet these plays were, except for O'Neill's, the first American plays that belonged to dramatic literature and not to the false and tawdry artifice of the uncreative theater. Their importance remains great and greater still the importance of Miss Glaspell's three full-length plays: *Bernice, Inheritors, The Verge.* . . .

I have dwelt upon these plays of Susan Glaspell not only because they were profoundly significant for their day. Their significance remains. Their psychological, their creative structure is a thing apart. A libertarian mysticism inspires them, a fresh and inimitably American quality, the very essence of that rebellion of the children of the Puritans against their forbears and their forbears' folk-ways, which is the most notable as well as the most hopeful mark of the entire period. They shot beyond all other isolated attempts of the period to renew the delineation of American life through the medium of the drama.

Ludwig Lewisohn. *Expression in America*
(New York: Harper, 1932),
pp. 393–94, 397–98

Images of seeing appear often in Susan Glaspell's work. In *The Comic Artist* and in *The Morning Is Near Us,* she adapts this quotation from Corinthians to emphasize the importance of this special kind of vision: "For now we see through a glass, darkly; but one day we shall see face to face; Now I know in part; but then shall I know even as also I am known."

Images of light and darkness form a second motif which complements that of seeing. To some this kind of imagery might suggest a rather simplistic view of life as the battleground on which the forces of good and evil collide. However, in Susan Glaspell's work, light and darkness suggest two antithetical modes of apprehending reality. . . .

The notion of insight is also crucial to Susan Glaspell's notion of seeing; in the literal sense of the word, it is a seeing into oneself that is the basis for the understanding of all else in life.

In contrast to the limitations of Craig Norris's vision [in *Bernice*] is the kind of vision achieved by Ernestine Hubers in *The Glory of the Conquered,* Ruth Holland in *Fidelity,* and Irma Schraeder in *Fugitive's Return.* These women are able to achieve insight into the meaning of life because they have achieved self-awareness and because they are as sensitive to what is unseen and ineffable as they are to the more tangible aspects of human existence.

In her fiction and drama, Susan Glaspell emphasizes the importance of the spiritual and the intangible in our lives by the use of a unique device: the building of a play or story around a character who never appears onstage or takes part in the action of the plot. In *Trifles, Bernice,* and *Alison's House,* all of the elements in the play converge to evoke the spiritual presence of the unseen woman in the midst of mundane reality, just as the Ideals that

reside in the mind of God are evoked by their shadowy representations that we apprehend with our senses.

Marcia Ann Noe. *A Critical Biography of Susan Glaspell* (Ann Arbor, Michigan: University Microfilms, 1976), p. 5–7

The opening paragraph of Glaspell's story ["Trifles"] serves, essentially, to alert the reader to the significations to follow: Martha Hale, interrupted at her kitchen chores, must drop "everything right where it was in order to hurry off with her husband and the others. In so doing, "her eye made a scandalized sweep of her kitchen," noting with distress "that her kitchen was in no shape for leaving: her bread all ready for mixing, half the flour sifted and half unsifted." . . . the men intend to seek clues to the motive for the crime, while the women are, ostensibly, simply to gather together the few necessities required by the wife incarcerated in the town jail. Immediately upon approaching the place, however, the very act of perception becomes sex-coded: the men look at the house only to talk "about what had happened," while the women note the geographical topography which makes it, repeatedly in the narrative, "a lonesome-looking place." . . .

[I]t is the peculiar irony of the story that although the men never question their attribution of guilt to Minnie Foster, they nonetheless cannot meaningfully interpret this farm wife's world—her kitchen and parlor. And, arrogantly certain that the women would not even "'know a clue if they did come upon it,'" they thereby leave the discovery of the clues, and the consequent unraveling of the motive, to those who do, in fact, command the proper interpretive strategies.

Exploiting the information sketched into the opening, Glaspell has the neighbor, Mrs. Hale, and the sheriff's wife, Mrs. Peters, note, among the supposedly insignificant kitchen things, the unusual, and on a farm unlikely, remnants of kitchen chores left "half done," denoting an interruption of some serious nature. Additionally, where the men could discern no signs of "'anger—or sudden feeling'" to substantiate a motive, the women comprehend the implications of some "fine, even sewing" gone suddenly awry, "'as if she didn't know what she was about!'" Finally, of course, the very drabness of the house, the miserliness of the husband to which it attests, the old and broken stove, the patchwork that has become Minnie Foster's wardrobe—all these make the women uncomfortably aware that to acknowledge fully the meaning of what they are seeing is "'to get her own house to turn against her!'" Discovery by discovery, they destroy the mounting evidence—evidence which the men, at any rate, cannot recognize as such; and, sealing the bond between them as conspirators in saving Minnie Foster, they hide from the men the canary with its neck broken, the penultimate clue to the strangling of a husband who had so systematically destroyed all life, beauty, and music in his wife's environment.

Opposing against one another male and female realms of meaning and activity—the barn and the kitchen—Glaspell's narrative not only invites a semiotic analysis but, indeed, performs that analysis for us. If the absent Minnie Foster is the "transmitter" or "sender" in this schema, then only the women are competent "receivers" or "readers" of her "message," since they alone share not only her context (the supposed insignificance of kitchen things) but, as a result, the conceptual patterns which make up her world. To those outside the shared systems of quilting and knotting, roller towels and bad stoves, with all their symbolic significations, these may appear trivial, even irrelevant to meaning; but to those within the system, they comprise the totality of the message: in this case, a reordering of who in fact has been murdered and, with that, what has constituted the real crime in the story.

Annette Kolodny. *New Literary History*. 11,
1981, pp. 460–62

Trifles is not merely a play which proposes that meaning may reside in the unconsidered trifles of experience; it is also a play about desperation, about the corner of experience into which women have been manœuvred, about the indifference of men and, in a disturbing way, about the extent to which human needs bow to other necessities—power, custom, self-concern. The intuitive knowledge of the women who are capable of solving the mystery both because of the acuteness of their attention and because they are able to inhabit that mystery and the lives which generated it, is contrasted with the logical ponderousness of the men, who observe but do not see, who seek to understand without the sympathy which generates understanding. The male world seems callous and Mrs. Peters is a special victim of that. A pet kitten had been destroyed in front of her eyes, as John Wright, we assume, had wrung the neck of his wife's canary; she had lost a two-year-old child to the bleakness of a Dakota homestead and has to survive not only this but also condescension and disregard. It is men who determine the world in which the women are then required to live. But, remarkably it seems, they retain a grasp on moral realities as they acknowledge that shared experience which is the basis of the moral demand.

Not the least remarkable aspect of *Trifles* is the extent to which Susan Glaspell herself makes the slightest of dramatic forms carry such a burden of meaning. . . .

Susan Glaspell's work is at its weakest in those moments in which she does allow her characters eloquence, fluency and explicitness, since language is in many respects at the heart of their dilemma. The crucial problem which confronts them is how to emerge into the communality of language without being contained by it; how to express yourself in words shaped by other consciousnesses. Bernice's words are bequeathed to those who survive her. Their problem is to invest them with a meaning which can sustain their own lives. In *Inheritors* the rhetoric of the past has to be revivified by a new language of social responsibility. In *The Verge* language restrains a spirit

which would free itself from the social contract implied by speech. Susan Glaspell does indeed weigh the issues of expression. They are the essence of her work. Neither was she unaware of the extent to which her own freedoms were circumscribed by a language which tied her to social and biological function. Her plays both placed this concern at their center and constituted a statement of her own independence. It is, however, no incapacity which leads her to create dramatic metaphors or to expose a tension between her characters and the language which they deploy but of which they remain profoundly suspicious. That is the essence of the irony which defines them. As a dramatist she acknowledged the need "to gain control over the tunes of the speaking voice—the actual melodrama created by successive changes of pitch when we speak to one another," but she equally knew that silence or the stuttering incompletions of language under stress had its own force, its own meaning.

> C. W. E. Bigsby. Introduction to Susan
> Glaspell. *Plays by Susan Glaspell* (New
> York: Cambridge University Press, 1987),
> pp. 12, 28–29

Interest in Glaspell and her work began to resurface only in the last ten years, when research devoted to women writers uncovered her masterpiece *Trifles,* and the play, along with the short story version, "A Jury of Her Peers," began to appear in anthologies of women's writing. . . .

While feminist criticism has brought Glaspell's name back from the dead and uncanonized, it has not yet produced studies of Glaspell's contributions to dramatic writing. Most discussions of her plays concentrate on them as documents of female exploitation and survival. Certainly, they are important because they are among the first modern writings to focus exclusively on female personae, but they go even further. They offer a new structure, a new dramatic language appropriate to their angle of vision, and a new depiction of character which accommodates the experience of the central figure they delineate, a woman seeking her way in a hostile and often unfamiliar world.

Glaspell's relevance to women playwrights is particularly important because she illustrates in the body of her works the kinds of questions they must face, questions of form determined by the sensibility that the plays embody. Glaspell was among the first writers to realize that it was not enough to present women at the center of the stage. If there were to be a radical break with plays of the past, women would have to exist in a world tailored to their persons and speak a language not borrowed from men. . . .

Glaspell's women *are* what they seem to be: tentative and often halting, trying to find themselves and their voices. . .

While Glaspell indicates that both men and women need constantly to question institutions and to change them and themselves if both become too rigid—a situation she describes in *Interiors*—it is to her women characters that she usually attributes the desire for change. It is they who seem to suffer

most from the fixity of society. Glaspell continually sunders the stereotype of women desiring stability and the comfort of place. . . . Glaspell's women, for the most part, are required to uphold traditional patterns and remain in place—both physically and mentally.

Mrs. Peters in *Trifles* is typical of such personae. She is described as "married to the law," and expected as such to mouth the ideas of her husband, the sheriff, to trace his conservative path, reflecting his opinions and his decisions. Mr. Peters and the men in the play are untouched and unchanged by the events they witness at the scene of a murder; they are "the law," and the law, Glaspell indicates, is a fixed thing incapable of dealing with either nuances of a case or variations of human behavior. Mrs. Peters, however, assimilates the evidence she stumbles across; she "opens out" into new areas of self-awareness. It is her emancipation which becomes the central theme of the play, overshadowing the murder investigation, the ostensible subject of *Trifles*.

In *The Verge,* Glaspell's expressionist masterpiece, her protagonist Claire Archer experiments with plants in an attempt to move vicariously in new directions that have not been attempted before. . . .

Nothing in a Glaspell play is linear. Plots do not have clearly defined beginnings, middles, and ends; they self-consciously move out from some familiar pattern, calling attention as they go to the fact that the expected convention will be violated, the anticipated order will be sundered. If the play seems to be a traditional detective story, as in *Trifles,* the emissaries of the law—the men—will not be the focus of attention. The center of interest, instead, will be the women, those peripheral, shadowy figures in the play who have come on the scene to accompany their husbands and each other.

The notion of linearity in Glaspell's plays is always connected with suppression and with social institutions which have become rigid and confining. . . .

Even more innovative is Glaspell's manipulation of point of view. What she is able to do in this play and in her other works is to force the audience to share the world of her women, to become fellow travelers with her pioneering protagonists. . . .

Glaspell's plays foreground women and provide open, unrestricted, asymmetrical dramatic structures in which women operate. The same can be said for the language characters use. Repeatedly, Glaspell connects language to action. Since her women are exploring new areas of their lives, they find traditional language unsuited to their needs. They may be women unused to speech or women all too aware that the words they speak do not express their thoughts. In either case the results are the same. Her characters are virtually inarticulate, or are rendered so because of the situations in which they find themselves. The most common punctuation mark she uses is the dash. It is used when the character is unsure of the direction in which she is going, as yet unprepared to articulate consciously a new awareness or unwill-

ing to put into words feelings and wishes which may collapse under the weight of words.

One of Glaspell's most important contributions to drama is to place these inarticulate characters in the center of her works, to allow them to struggle to say what they are not sure they even know.

Linda Ben-Zvi. In Enoch Brater, ed.
Feminine Focus: The New Women Playwrights (New York: Oxford University Press, 1989), pp. 148–56

GODWIN, GAIL (UNITED STATES) 1937–

Back in the days before the Women's Liberation Front changed everything it used to be possible to think of women who wrote novels as a different order of beings from male novelists. Now, we are supposed to think of all women as essentially identical with men, except for some slight variations in plumbing, etc.

Yet the desire to think of women who write as dissimilar in some real and important sense to men who write persists, and Gail Godwin's first novel, it seems to me, has to be thought of in relation to this difference. Her book is very much a woman's novel, and I want to discuss it in those terms. But let me say first that it is an excellent piece of work, shrewdly observed and carefully crafted, deserving of the praise that such established writers as Kurt Vonnegut, John Fowles, and George P. Elliot have already bestowed on it. *The Perfectionists* is, in fact, too good, too clever, and too finished a product to be patronized as a "first novel." It deserves better; it deserves criticism. And that is what I will try to give it.

The Perfectionists is a novel of domestic life or, more accurately, of sexual partnership. The "perfectionists" of the title are an English psycho-therapist, Dr. Empson, and his American wife, Dane, who come to Majorca for something like a belated honeymoon, along with the doctor's three-year-old illegitimate son and one of his female patients. The relationship between husband and wife, as complicated by the strange little boy, is the central concern of the novel, and it is developed with a satiric and symbolic vigor that suggests a combination of Jane Austen and D. H. Lawrence. The eerie tension that marks this complex relationship is the great achievement of the novel. It is an extraordinary accomplishment, which is bound to attract and hold many readers. . . .

My principal criticism of these proceedings has to do with the resolute femininity with which they are presented. By this I mean not that metaphysical womanhood which Dickens perceived behind the pseudonym of "George Eliot" when he reviewed her amazing first novel, *Adam Bede,* but a narrower

and pettier kind of thing. The women in this novel are, all of them, more or less interesting, more or less sympathetic. The men, starting with the doctor . . . are all fatuous and self-centered creatures.

This is, then, a woman's novel in a narrow and constricting way. I suspect that Miss Godwin can extend the range of both her sympathy and her satire. I hope that she will want to. From Jane Austen to Iris Murdoch, the great women of our fiction have been metaphysically female and not merely feminine.

Robert Scholes. *Saturday Review of Literature.* August 8, 1970, pp. 37–38

Gail Godwin's *The Odd Woman* (1974) does not at first glance seem to be in the currently popular mode of self-conscious fiction—and perhaps for this reason has not attracted the critical attention it deserves. Neither a work as involuted as one by Borges nor a *Kuenstlerroman, The Odd Woman* centers on the relation between literature and life, especially on the effect that litera-ture—and the lies it often tells—has on those who believe it. Of special interest is the novel's focus on fiction's traditional portrayal of women and its effect on women's relations with and reactions to men. . . .

To Jane, a professor of English, literature serves as far more than simply vocation or avocation. It is not just an object of perception but conditions her very mode of seeing. She views her own life through the refracting filter of literature. . . .

The full insight that the literary world has no necessary correlation with the actual world bursts on Jane. Villains in art need not be villains in life. Moreover, her insight confirms the truth of Jane's early wondering whether or not the concept of the self is itself a myth—"Characters were not so wholly good or bad, heroes or villains, anymore," whether or not the very notion of personality—the staple of fiction—is itself false. As the concepts of personal-ity and of heroes and villains die, so does "all the stuff of novels" on which Jane depends to give meaning to her life.

Unfortunately, *The Odd Woman* does not end on an optimistic note of lessons learned. . . . The novel closes with the snow falling, reminding us of Jane's retreat when writing her dissertation, and pointing to another such frozen retreat from the actual world.

Godwin seems to offer a forceful indictment of literature and the harmful effects it can have on its readers. Jane can never be happy except, perhaps, in the safe world of the imagination, the only world which can begin to fulfill the expectations literature has fostered in her. We must go on to ask how Godwin can escape her own indictment of literature, whether her message does not undermine the very novel in which it is embodied. . . .

As Jane notes, Gissing's novel [with almost the same title] displays his "unrelenting pessimism. It was one of the few nineteenth-century novels she could think of in which every main female character who was allowed to live through the last page had to do so alone. The book's ending depressed her

utterly." Godwin might find her defense against the charge she, too, levels against literature in pointing to the pessimistic ending of Jane's story as an example of the truth-telling that we must require from contemporary fiction. Godwin, however, has some of the Jane Clifford in her, and her novel still embodies some of the old attractive lies.

<div align="right">Susan E. Lorsch. Critique. 20:2, 1978,
pp. 21, 31</div>

Gail Godwin's newest novel, Violet Clay, [is] a terrifying example of sentimentality in the disguise of contemporary sensibility. . . .

None of the novel's characters has been translated by Godwin's imagination into credibility. They speak to each other in prolix and tendentious conversations, so unedited by personality that they are droll. . . .

Well, to be fair, a lot of this is the fault of bad writing, an inability to describe exactly or to transcribe the sound of different voices into anything resembling living language. . . .

But there is worse than this, the basis from which the flabby language, the insubstantial characters, the odd lapses of taste seem to spring; the novel is simply half-baked, half-created, and so far from inevitable that one reads it constantly reminding oneself that it could easily have been avoided. . . .

If the book carries any conviction with it, it is that Violet's esthetic is pretty much molded by her author's, a schoolgirl sensibility in search of vocation. Gail Godwin has been regarded highly as a novelist for some time, certainly since The Odd Woman was published in 1974, and I wonder unhappily how much of that regard is due to the fashionable nature of her themes, which can create, without feeling for character, language, ambience, or moral significance, a job lot of current concerns that passes as "Women's Fiction."

<div align="right">Edith Milton. The New Republic. July 8–15,
1978, pp. 40–41</div>

Gail Godwin, on first reading, seems to stand apart from contemporary women writers. She appears immune to experiments with style and the contemporary raw language of sexuality. Her works are plotted symmetrically in the manner of George Eliot, whom she admires, and at a time when many women writers are primarily concerned with woman's emerging sexuality as well as with her active participation in the outside world, Godwin maintains that the demands of the inner woman are much more complex than this. Inner life, says her heroine, Jane Clifford (The Odd Woman, 1974), is as important as outer life. But it is obvious that the author considers the inner life even more important. Her first two novels, The Perfectionists (1970) and Glass People (1972), are clever, well-executed works about women who attempt to grapple with the domestic life and with sexual partnership. More specifically, the heroine of Glass People is confronted with what she comes to regard as the awful responsibility of freedom.

How to achieve freedom while in union with another person, and impose one's own order on life so as to find self-fulfillment, is the theme which runs through Godwin's works and becomes the major theme of exploration in her third novel, *The Odd Woman*. . . . Where some other women writers maintain a pessimism about the man/woman relationship, Godwin has her heroine doggedly affirm that man and woman can be a unit; man and woman need each other. Yet it is worth noting that the heroine is alone in the end. The open ending, however, indicates that the author is still the writer of freedom, marriage, love, children, and the relationship between generations. Her subsequent work, *Dream Children* (1976), continues these themes with variations.

Anne Z. Mickelson. *Reaching Out: Sensitivity and Order in Recent American Fiction by Women* (Metuchen, New Jersey; Scarecrow Press, 1979), p. 68

Gail Godwin's heroines have abandoned their soapboxes, and thank goodness for that. Godwin is by now an "established" writer; she has four novels and a collection of short stories to her credit, not to mention a National Book Award nomination. Her complex and fascinating characters, like Jane Clifford in *The Odd Woman* and Violet in *Violet Clay,* have until now suffered from two crippling flaws: they have repeatedly indulged in long, often boring, interior monologues—"meandering and distinctly tedious," huffed novelist Larry McMurtry of an earlier novel—and they have had no sense of humor whatsoever.

However, the news of Godwin's latest novel, *A Mother and Two Daughters,* is good, in fact, very good indeed. Nell, Cate, and Lydia Strickland, the three women who dominate the stage, are—like Violet Clay and Jane Clifford—thoughtful, well-educated, self-analytic people, but Godwin hustles them along at a brisk pace through this long, but definitely never tedious tale. They don't opine about the meaning of love or the perils of George Eliot, but do share with us their attempts to make a good job of an ordinary daily life familiar to us all. . . .

Only a few times in this long novel does Godwin falter. A digression on contemporary fiction seems jarringly self-conscious. The requisite eccentrics are skillfully drawn, but show up right on cue: the overbearing, curious spinster aunt Theodora and the disfigured Uncle Osgood with his heart of gold and his redemptive role for latter-day sinners. The middle-class black couple seem plopped down in order to stir up a few thoughts on prejudice and change. All the characters take themselves very seriously, but it is part of their astonishing strength that they persuade us to do likewise.

Anyone from an average family will find themselves drawing a breath and muttering: "Yes, that's how *I* felt, that's how it always is." Godwin wrote of Jane Clifford in *The Odd Woman:* "Her profession was words and she believed in them deeply. The articulation, interpretation, and preservation of

good words." She could have been describing herself. She pilots her cast of characters with infinite care, through turbulence, clouds, and sparkling skies. The smooth landing at the novel's end is deeply satisfying: not a neat tying up of loose ends, but a making sense of the past and a hint of the possibilities of the future. Gail Godwin is not just an established writer, she is a growing writer.

<div style="text-align: right">Brigitte Weeks. Ms. January, 1982,
pp. 40–41</div>

In general, Miss Godwin's gifts (like Margaret Drabble's) have been best served by the spacious dimensions of the conventional novel. Her talent lies in creating intelligent woman protagonists—usually middle-class and imaginative, often with artistic aspirations—who struggle to lead examined lives in the face of self-imposed as well as cultural constraints. Blessed with humor as well as perceptiveness, they are nearly always sympathetic, even when they behave badly. (Their amiability can be irritating. I sometimes wish Miss Godwin's characters would behave worse more often; her women often suffer from the excess of politesse common to children of the 1950s.)

In any case, her reflective characters come to life slowly, emerging as much from thought as from action, and Miss Godwin's novels have generally accommodated them. I especially liked the edgy perversity of *The Perfectionists* (1970) and the irony and insight of *The Odd Woman* (1974), as well as the gentler but widening vision of *A Mother and Two Daughters.*

I wish I could be as enthusiastic about *Mr. Bedford and the Muses,* a short novel and five stories. The stories have the more obvious problems, which are at least partly due to brevity and partly to their tucked-in edges. Shapeliness is deadly in short fiction. At best, it creates an excess of charm; at worst, it kills the story on the page. . . .

On its own terms, which are not those of Miss Godwin's larger novels, *Mr. Bedford* is a memorable portrait of the kind of people who might have known Scott Fitzgerald during their "better days." It is wry, haunting, and sharp.

<div style="text-align: right">Judith Gies. The New York Times.
September 18, 1983, pp. 14, 37</div>

This author recognizes the beauty of ordered lives, and clings to hopes that Southern grace in its best sense can be cherished, can still enhance the old South's new daughters. But more emphatically she cautions that traditional roles when merely traditionally fulfilled endanger the spiritual lives of two generations: both the Southern mothers who model such roles and the daughters whom they dutifully try to mold toward the confining Ideal of Southern Womanhood. Women reared to reenact the traditional values must learn, Gail Godwin insists, to see their fallacies, explore them openly among critical friends and find new ways to be themselves, continually self-creating. And the three Southern women delineated in Godwin's latest work, *A Mother and*

Two Daughters, all manage to sustain their self-creativity without permanent flights from the South and without romantic denials of contemporary realities; as a result they can be shown moving into a wholesome future, not problem-free by any means but free of the problems imposed by the rigid model of constraining Southern Ladyhood.

> Carolyn Rhodes. In Peggy Whitman
> Prenshaw, ed. *Women Writers of the*
> *Contemporary South* (Jackson: University
> Press of Mississippi, 1984), pp. 64–65

The *Odd Woman* is a novel of an odd moment—one that was perhaps not so decisive as the moment when the literate women of England picked up Samuel Richardson's *Pamela,* but that is now as interesting to reflect on. When it first appeared, the new wave of feminist literary criticism was just cresting: Mary Ellman's *Thinking about Women,* Kate Millett's *Sexual Politics,* and Elaine Showalter's *A Literature of Their Own* had already been published, along with several influential essays on women and art; Patricia Spacks's *The Female Imagination,* Ellen Moers's *Literary Women,* and Sandra M. Gilbert and Susan Gubar's *The Madwoman in the Attic* would round out the decade. Like these books Godwin's addresses the question of how literature and the values a woman reader derives from it reflect and determine women's lives. Although *The Odd Woman* takes pains to distinguish its protagonist (and itself?) from the excesses of man-hating feminists, Gerda Mulvaney and her basement-full of unattractive staff members of *Feme Sole,* it is hard not to read the novel today as an expression of the feminism of the 1970s. The conclusion Jane Clifford comes to, about going with or through one's own oddnesses so as to transcend them, asserts the importance of personal liberation rather than the liberation of a group; still, the problems and specificities of women as a group are what the novel most closely attends to.

> Rachel M. Brownstein. In Mickey Pearlman,
> ed. *American Women Writing Fiction:*
> *Memory, Identity, Family, Space* (Lexington:
> University Press of Kentucky, 1989),
> pp. 176–77

GOLDBERG, LEA (ISRAEL) 1911–70

The poetry of Lea Goldberg shows strong affinities for the Symbolists of both Eastern and Western Europe. . . .

Although associated with the modernist movement of the 1930s, Lea Goldberg uses traditional verse forms. Her modernism is reflected in the conversational style of her work and in her rejection of both the rhetoric of

her predecessors and the bombast of some of her contemporaries. A taste for simplicity leads her to limit her symbolic vocabulary to the familiar, investing everyday words, images, rhythms, and even rimes with astonishing freshness.

She is one of the few poets of her generation to eschew ideological versifying. She writes about such universal matters as childhood, nature, love (especially mature love), aging, and death. And her poems are highly personal and introspective. . . .

In an enthusiastic essay on Avraham Ben Yitshak . . . whose views had deeply impressed her, Lea Goldberg recalls the older poet's description of an arrested flash of perception: "I remember standing at the entrance of a house, on a staircase. The house was built of wood and painted green. The sand that covered the porch steps was made up of small bits of colored glass. . . . They possessed the magic of a summer's evening and I knew that only once in my life would I see such a sight."

For Lea Goldberg such a moment of insight contains the essence of youth in the ever flowing stream of time. It arises out of ordinary phenomena—an orange, a peasant girl, a fragment of memory—to flash upon the dark screen of human consciousness in a sudden moment of grace. . . .

Although she was born and reared in Kovno, a famous center of talmudic learning, Lea Goldberg rarely alluded to traditional Jewish life in her early poetry: her commitment was Western in outlook. In the wake of Hitlerian persecution, however, a change occurred. In the 1940s, for example, she devoted an entire book to the country of her birth *(From My Old Home)*— "I departed never to return / Never wanting to return; / The past which I did not love / Has become my beloved past."

> Ezra Spicehandler. In Stanley Burnshaw,
> T. Carti, and Ezra Spicehandler, eds. *The*
> *Modern Hebrew Poem Itself* (New York:
> Schocken, 1965), pp. 120, 123, 129

Although her earliest work reflects the Russian poetry of her childhood environment, Leah Goldberg's visual imagery and musical ear were formed by Verlaine and the French poets. Her style also mirrors her admiration for classical and contemporary Italian poetry. Fichman called her poetry "wisdom that sings." Despite its intellection, her poetry is the lyric of a woman's world, where the sense of beauty, love, and compassion prevail over loss and disappointment to find refuge in understanding. Her imagery is rooted in no tradition save art.

> Ruth Finer Mintz. Introduction to *Modern*
> *Hebrew Poetry: A Bilingual Anthology*
> (Berkeley: University of California Press,
> 1966), pp. li–lii

The death of Lea Goldberg now leaves a still space of felt absence in Israel because in her life she was so much a cultural presence there, and because

her life marked a moment in culture that now seems irrevocably past, both in Israel and everywhere else. She was not what one would call a commanding figure, but she managed to become a necessary one. She translated from half a dozen languages with grace and precision, everything from Petrarch and Shakespeare to Tolstoy and Brecht; she wrote children's poetry and stories with a warmth and lively inventiveness that have delighted a generation of young Hebrew readers; she initiated the study of comparative literature as an academic discipline in Israel; and, surely most important, one can say with some confidence of her what one would venture to say of very few contemporary poets anywhere—that she has written a good dozen poems, perhaps twice that many, which will continue to give pleasure in another hundred years. . . .

The commitment to civilized discourse may also explain something about the nature of Lea Goldberg's poetry, which, written with the fullest awareness of the labyrinthine obliquities and bold discontinuities dominating modern poetic idiom, remained always direct, lucid, almost deceptively simple in form. She was a devoted student of the French, German, and Russian Symbolists, but the only poet close to the Symbolist movement she noticeably resembles is Verlaine, with his melodic orchestration of assonance, alliteration, and rhyme, his attachment to stanzaic forms, and the general attitude toward style he announced in his famous *Art Poétique:* "Take eloquence and wring its neck." Modern Hebrew poetry, freighted with allusion, rising against a vast background of biblical high style, had characteristically cultivated grand effects, pathos, passion, and prophetic rage, while Lea Goldberg brought to Hebrew verse a subtle sense of beauty in small words and small things, a gracefulness and even playfulness of style. . . .

I do not mean to imply that poetry for Lea Goldberg was in any way a flight from the horrors of history or the pain of adult life into a world of pretty little things. On the contrary, one senses in the quietly stated beauty of her brief lyric poems a certain tough strength precisely because that ordered beauty stands in tense relation with a dark background of chaos, ugliness, suffering. If she shows great fondness, at times to an excess, for the legacy of imagery of Romantic poetry and traditional folksong—setting suns, lonely birds in the sky, blossoming cherry trees, the murmur of strummed instruments—these traditional properties often seem freshly perceived and surprisingly persuasive because the poet has rediscovered them, somehow through inner struggle has won back from the chaos of modern experience the recurrent objects of eternal beauty. Blood-madness and death wait in the shadow of the flowering cherry tree, which is why we are ready to believe that the tree—"a white storm of florescence"—is really there for the poet, not simply an easy invocation of literary tradition.

In this regard, Lea Goldberg's single ventures into drama and fiction, her play, *The Mistress of the Castle,* and her novel, *That Is the Light,* make explicit a pattern that is implicit, or has already been worked through psychologically, in the best of her poems. . . .

The simplicity . . . of Lea Goldberg's language represents in part an almost ascetic avoidance of any stylistic intimation of sublimity or profundity or exaltation that have not been fully earned by the poet through her experience. . . .

If there is an element of starkness in her late work that does not entirely typify the earlier poems, her poetic style on the whole is nevertheless spare, understated, at its weaker moments perhaps too given to easy musicality and obvious conventional imagery, but for the most part orchestrating avowedly traditional materials with exquisite tact. . . .

What Lea Goldberg's poetry has meant to many Hebrew writers and readers is itself testimony to the abiding strength of this most fragile form of human discourse.

> Robert Alter. *Defenses of the Imagination:*
> *Jewish Writers and Modern Historical Crisis*
> (Philadelphia: Jewish Publication Society,
> 1977), pp. 92, 94–97

GOLDMAN, EMMA (RUSSIA–UNITED STATES) 1869–1940

God was supposed to be punishing Moses when he denied him entrance into the Promised Land. But rightly viewed, this was an act of rare consideration. The reflection is prompted by Emma Goldman's experience. The United States Government, lacking that haughty conviction of stability so marked in Jehovah, and too timid to let Miss Goldman continue her wanderings in the American wilderness, dispatched her to the Promised Land in December, 1919. She sailed to Russia in a trance of expectation: she was to behold Mother Russia, "the land freed from political and economic masters," where the peasant was raised from the dust and the worker, the modern Samson, "with a sweep of his mighty arm had pulled down the pillars of decaying society." Two years later she came out of Russia convinced that state-centralization had paralyzed individual initiative and effort; that the people were cowed into slavish submission, depraved and brutalized by organized terrorism; that every idealistic aspiration was stifled, human life cheapened, all sense of the dignity of man eliminated; that coercion had turned existence into a scheme of mutual deceit and revived the lowest and most brutal instincts of man. In brief, the Bolsheviki had not established, and were not trying to establish, the cooperative, decentralized, Anarchist commonwealth. And to Emma Goldman that is the only revolution that matters. . . .

A minor satisfaction furnished by this book [*My Disillusionment in Russia*] is that of reading quotations from *Mother Earth* and interpretations of the Anarchist ideal under the Doubleday-Page imprint. One remembers how the shocked Czarist officers who arrested Catherine Breshkovsky read aloud

to an ever-increasing throng of interested peasants extracts from the revolutionary pamphlets just seized among her effects. Some young and plastic minds exposed to this book, may be more impressed by the Anarchist point of view, ably expressed, than by the denunciation of Bolshevism, staled by repetition. Conservatives, now and then, appear in delightfully unexpected positions.

Dorothy Brewster. *The Nation.* February 18, 1925, pp. 189–90

Her autobiography. . . . two long volumes, [is] richly alive . . . possessing that special quality of power that comes from unrestraint. If the story is a record of many defeats, it is at least a brave achievement in its own right. The author manages at the same time to order events and to loose the whole flood of her emotion. One recalls the dismal chaos of adventure and confession that usually results from such copious exposure. But Emma Goldman's nature is a large one: her emotions are terrific and her mind surprisingly orderly. The result of these forces, working for once in easy unison, is a fine piece of writing, unnecessarily full and detailed but always absorbing.

The story of her life is almost too voluminous to summarize. It reaches over sixty-two full years and describes her active participation in the turmoil of the revolutionary movement during more than forty of them. Emma Goldman herself marks her real "birth" by the date of the Haymarket hangings in 1887, for it was that tragic event which woke the passion of revolt that has flamed through all the years. Since then she has written and lectured, published a magazine, led strikes, fought the police, endured the third degree, addressed mass meetings, been in and out of jail. She helped Alexander Berkman in the preparations for his attempt on the life of Frick during the Homestead lockout; and for years afterward she fought for Berkman's release from prison. She defended the boy who shot McKinley and was accused of instigating his act. She has lectured on the drama and argued for birth control. She opposed the war and the draft and the repressions that followed them. She worked for the release of Mooney and Billings. She was deported to Russia—without doubt illegally—and there she plunged into the post-revolutionary struggle. Outraged by the ruthless repression and centralized control of the Bolshevik Government, she left Russia, and since then has bitterly attacked Soviet methods.

Through all this Emma Goldman has led a vivid personal life; she is no ascetic devotee. She has loved many men, hated a good many more, and has established friendships that seem to have outlasted the more intense relations. Her range of acquaintance is impressively varied, outside as well as within the revolutionary army: writers and politicians, actors and ministers and prostitutes crowd the pages of the book.

But her personal affairs and emotions should in no way be segregated from her more public ones. Emma Goldman displays a complete incapacity for, or disinterest in, the usual sorts of differentiation. The emotion that

drove her was a single force, whether it was directed against the might of the government of Russia or toward the fulfillment of personal passion. . . Similarly, Emma Goldman's response to the misery of mankind at large was as strong and personal as her sympathy for a suffering friend. Her collective emotions moved her as only private feelings move most of us. And she talks of all her passions with impartial frankness—a frankness surpassingly simple and pure, even childlike.

Herein lies her undeniable power. Her emotion is both intense and universal, her expression of it—in words and actions—unrestrained, her courage completely instinctive. She is contemptuous of any intellectualizing that stands in the way of faith and action. Always she feels first and thinks later—and less. I realize that I am describing here a process common to the rest of the human breed, but a difference is created by the range and strength of Emma Goldman's capacity for emotion, which render insignificant by comparison the "wishful thinking" of most of us.

How attractive and how terrifying is this unabashed acceptance of feeling as the test of action! The primitive passions are justified, even harnessed to high and impersonal aims; the laborious processes of analysis are made to appear sterile; realism becomes something rather anemic and cynical. Life itself is lent color and warmth and meaning. We may reject such satisfactions as immature, but some part of our being remains envious, feels itself "petty and unblest"—and unfulfilled. No wonder the authorities, whether in Soviet Russia or the United States, consider Emma Goldman a menace. Such consecration and abandon are permissible only when they are on the "right" side, and they are seldom to be found on the right side for they ally themselves naturally with rebellion. They become of value only when wars are to be fought, religions founded, or revolutions made, and then only for a brief while. Emma Goldman was created to ride whirlwinds.

But the value of such emotion to the individual seldom fails. A person like Emma Goldman needs, I feel sure, few external rewards. She thrives not on success but on opportunities for expression, and her vitality is renewed from springs of feeling that never go dry for reasons of outward circumstance. Her publishers advertise her book as a record of defeat. So it is if one is to judge it in terms of objective results. But as a study in subjective achievement what a personal triumph these volumes reveal!

<div style="text-align:right">Freda Kirchwey. The Nation. December 2,
1931, pp. 612–14</div>

Until somewhere toward the end of the 1960s, anarchism and feminism seemed irrelevant anachronisms to most Americans, each an old joke which in one version had Emma Goldman as the punch line. Like the punch line of other passé stories, Goldman's name, if remembered at all, was slightly offensive, flat, recalling a style that had long since passed. Even among radicals, in the last few decades, few have shared her disgust with the regimented . . . mechanization that characterizes modern life. Her libertarian vision was

derided as hopelessly utopian and laughably naive. In 1969 almost every word she wrote had long been out of print and her life—which Theodore Dreiser once described as "the richest of any woman's of the century"—all but forgotten. Even her vigorous and lucid autobiography, *Living My Life,* went out of print.

Now, as everyone knows, things have changed. Old punch lines are new slogans. "Anarchism," proclaims an article in a recent . . . journal, "was dead and is alive." Likewise, feminism. And likewise, the anomalously named "Queen of the Anarchists" [came back, with all her works in print in 1970]. . . . The revolutionary Goldman is back in her old haunts, up to her old tricks. "For further information [about me]," she advises her readers, "consult . . . any police department in America or Europe.". . .

In 1900 Goldman [became] the publisher of a new radical monthly, *Mother Earth.* [Alexander] Berkman, released from prison that same year, joined her as coeditor of the journal, and together with a coterie of friends they kept it running for twelve years, with only occasional lapses due to police interference. Van Wyck Brooks described "the tumultuous office of *Mother Earth*" as "one of the lively centers of thinking New York" at a time when Greenwich Village "swarmed with the movers and shakers who were expressing a new insurgent spirit." The Goldman flat at 210 East Thirteenth Street was a place, said Big Bill Haywood, where one could always get a cup of coffee "black as the night, strong as the revolutionary ideal, sweet as love."

In Europe in 1895 Goldman had fallen under the spell of such writers as Ibsen, Strindberg, Shaw, Hauptmann, Nietsche. She wanted *Mother Earth* to be a forum for discussing their ideas and presenting "socially significant" art, as well as a platform for her own circle's anarchist commentary. "My great faith in the wonder worker, the spoken word, is no more," she wrote in 1910 as preface to her only published volume of essays, *Anarchism and Other Essays.* "The very fact that most people attend meetings only if aroused by newspaper sensations, or because they expect to be amused, is proof that they really have no inner urge to learn. It is altogether different with the written mode of human expression." Her own book contained essays on anarchism, education, prisons, political violence, and five pieces on the oppression of women, always one of her major concerns.

> Alix Kates Shulman. Introduction to Emma
> Goldman. *Red Emma Speaks* (New York:
> Random House, 1972), pp. 3–4, 14

By 1927, she felt that her usefulness was at an end. Like "the real revolutionist—the dreamer, the artist, the iconoclast" she had described in her criticism of Gerhart Hauptmann's play *Lonely Lives,* Emma began to feel ever more detached from her environment. She had provided the inspiration for many others to reject a cruel and unjust world. She had boasted that the ability to imagine a life of freedom was a necessary step toward a new order. But she herself was preoccupied with memories and doubts about whether her place

in history was secure, uncertain that her vision would ever become a reality. She began to retreat emotionally from the frustrations of her life as an exile into the glories of her past in America.

In planning her book [*Living My Life*], she relied on her thousands of letters to chart her turbulent political career. She had always found letters easier to write than books or lectures, particularly because "I know they will not be published while I am alive." For this woman who lived alone most of her life, letters meant camaraderie at any time of the day or night. In her correspondence, Emma had written as frankly about her sexual feelings as she had about her political leanings. She gradually retrieved more of her past, as friends agreed to part, sometimes reluctantly, with the letters she had sent them.

Emma had resolved that hers would not be a conventional autobiography: she would not present the public figure without giving an account of her struggle to realize her political ideals in her personal life. But she expressed ambivalence about where to put the emphasis in her work. She felt that she was "woven of many skeins, conflicting in shade and texture," and that to the end of her days she would "be torn between the yearning for a personal life and the need of giving all to [her] ideal." . . .

Emma's early writing, speeches, and lectures centered on a vision of a total, liberating transformation in every realm of human life. Her dreams had not materialized, and the writing of the autobiography was a lonely coming to terms with a long series of disappointments. Her many political defeats, however, had never succeeded in destroying her spirit. . . .

But the autobiography gave expression to only the heroic part of Emma's life. The tension between great ideas and individual limitations tormented Emma. She did not want her letters, which she considered the artifacts of her weaknesses, published in her lifetime, while she was trying to show the world her strengths. But she wanted them published eventually, for she believed that they were critical to an understanding of the woman who stood behind the podium. She deliberately dated and ordered her letters, and addressed herself to her friends, lovers, and comrades, and perhaps, to those in an unknown future audience, who could hear their own voices in her voice, envision their own struggles in hers.

> Candace Falk. *Love, Anarchy, and Emma*
> *Goldman* (New York: Holt, Rinehart &
> Winston, 1984), pp. 2–3, 9

To isolate the historical Emma Goldman from myth, fiction, and controversy is no easy task. Besides the political argument she generated, there is the demonic legend that surrounded her during her years in America: an image created partly by a hostile government and sensationalizing press, but one that she herself exploited to popularize her ideas. Certainly she was one of a very few radicals with a fine grasp of public relations. In addition, there is her own myth of herself as earth mother and as tragic heroine, which she

dramatized in her massive autobiography, *Living My Life* (1931). This memoir is the starting point for any biography, but we should note that it was written as Goldman approached sixty, long after most of the events it describes had taken place and with few available records of these events—apart from letters she had written to friends, mainly after 1917—to correct the vagaries of memory (her papers had been confiscated by the Justice Department in 1917 and were never returned). Written, moreover, from exile in the south of France, the autobiography was aimed at an American audience in the hope that it might facilitate Goldman's reentry into the United States and perhaps even yield an income that would ease her desperate financial straits: a perspective that may have led her to play down her European childhood and adolescence in order to emphasize her American identity. In addition, the memoir was heavily edited by Alexander Berkman, Goldman's most intimate lifelong friend, and in certain ways was almost a joint effort. We know from Berkman's diaries the extent to what he changed, cut, and polished the manuscript. "The Ms., after I correct it, looks worse than an ordinary battlefield," he boasted one day. "Some pages, half of it crossed out by me, the other half every word, literally, changed by me." Sometimes Goldman's constant litany of complaint made him laugh aloud; he managed to delete the worst excesses. Neither Goldman nor Berkman deliberately tried to eliminate painful episodes or idealize the central character of *Living My Life*. Still, like any autobiography, Goldman's is a partial account, both of the anarchist movement in America and of her life within it.

Alice Wexler. *Emma Goldman: An Intimate Life* (New York: Pantheon, 1984), xvii–xviii

GOLL, CLAIRE (AUSTRIA) 1890–1979

Claire's letters to Rilke are filled with the rich ornaments of the poetess's very imaginative conception of their love affair. The landscape of their encounter is adorned with magnificent horses, lizards and the white elephants of Rilke's carrousel. Claire strews flowers in the poet's path, particularly roses and tulips, and lines it with trees, most frequently mimosa, acacia and chestnut trees, from which she entreats special blessing from him. Her letters are occupied with concern for Rilke's health, welfare, and finances, his ability to survive in an alien Paris, and his lodging needs there. She petitions him to assist her with the publication of her poems and most importantly to help her resolve her own feelings upon the death of her father. . . . Frequent reference is made in her letters to mutual friends, especially Gide, Charles Vildrac, Maurice Betz, Marie Laurencin, as well as to her husband Yvan Goll, to the exchange and receipt of books, notably works by Elizabeth Barrett-Browning and Francis Jammes, and to commissions for translations by Claire and her

friends. She laments the long periods of silence that existed between Rilke and herself, particularly his failure to respond to her letters, threatens him with a planned escape into the African jungles and everywhere lavishes praise upon her demigod and his productions. . . . In her letters she looks to him for counsel, support, and affection. . . .

In shared literary pursuits and in their personal contacts the poet and the poetess sought to expand their level of consciousness by exploring sense perception, in particular the sense of touch, and by probing the depth of their own silences. In his association with Claire Goll, Rilke explored notions about sense perception that had occupied his attention as early as 1898 in his essay *Moderne Lyrik*. His concern then as in subsequent exchanges of letters and poems with Claire Goll was with the limited ability of the senses to audit the world. In the exchange of letters with Claire Goll he strove to develop the notion, already expressed in his study, *Auguste Rodin* (1902), of an aesthetics, of a culture, of a history of experience generated entirely by hands. In the Rilke-Goll correspondence hands toy with the realities of the world; they become attached to things; they convert these things into feelings.

<div style="text-align: right">Bernhardt Blumenthal. Modern Austrian
Literature. 15, 1982, pp. 170–71, 174</div>

What little interest has been afforded the writings of Clair Goll née Clara Aischmann . . . has been given to her verse, written largely in conjunction with and in response to, her husband Yvan Goll; her several autobiographies which document her varied contacts with leading writers and painters of her times, among them Rilke, Joyce, Werfel, and Chagall; and her efforts as the principal editor and translator of her husband's works. Her short stories, legends, and novels, however, have been largely ignored. Even Thomas Mann's flattering epithets failed to attract any significant attention to her novels. Understood in the context of his general practice on supplying aspiring writers with gracious but empty compliments, often written beforehand according to stock formulas and available for release to whomever, this does not entirely surprise. In point of fact he, too, may have been unfamiliar with her work. Karl Krolow in a tribute to a departed Claire Goll summed up the situation: "Fast unbekannt blieb Claire Goll als Erzählerin." . . .

In her novels, stories, and tales Claire Goll is preoccupied with notions of man's insensitivity. Her best efforts recount the destroyed lives of individuals who have been exploited by others and the sad fate of animals who suffer at the hand of uncaring masters. Her prose laments man's fall from innocence and grace, and with continual reference to the good deeds of the legendary St. Francis she seeks to restore a modicum of decency to our relationships with each other and to our treatment of animals. . .

Claire Goll's prose treats the lives of individuals who struggle vainly against their fate. It intends to underscore the suffering of the poor, the seduced and abandoned, the homeless and stateless. It appeals to the reader to identify with the plight of the least of mankind and thereby to help alleviate

their suffering. . . . Most of these stories are occupied with the fate of individuals whose self-hatred leads to self-destruction, individuals for whom the death instinct is greater than the life instinct. They are not happy tales, and they are not all of even quality. . . .

Claire Goll's production of stories and novels is extensive and includes some gems, some finely chiseled short stories, rich in their local color and in their sensitive depiction of the fate of human or animal heroes. Her prose expresses a very elemental love for all living things—the humbler and more vulnerable the creature, the greater the love. Literary criticism should regard Claire Goll not only as a poet, a translator and editor of her husband's works, and a chronicler of European artistic life, but also as a story-teller of considerable merit. It is regrettable that, to date, this aspect of her work has been largely ignored.

<div style="text-align:right">Bernhardt Blumenthal. Monatshefte. 75,
1983, pp. 258–59, 263, 269</div>

In reference books, the writer Claire Goll receives mention—if at all—only as the life companion and literary partner of the expressionist poet Ivan Goll (a pseudonym for Isaac Lang). Although literary critics agree that some of the love poems in her earlier cycles, works written together with Ivan which exhibit the character of antiphony, count among the most beautiful of this century, they have given sufficient notice neither to the woman author as an autonomous person, nor to her voluminous prose works. This is unfair, in my opinion, because the novels which she published between 1926 and 1932 are much more multilayered than may appear on first glance to be the case. Often wrapped in the cloak of the light novel, Goll's protagonists act against the backdrop of a society which imposes certain behavioral norms and constraints on the members of each sex, the boundaries that the heroes are in no position to cross. . . .

The manner in which Claire Goll thinks and acts in certain life situations is often just like the manner of the heroes in her books; in part consciously, and in part unconsciously, Claire Goll lets parts of herself flow into her works. In the novel *The Negro Jupiter Rapes Europa,* Goll deals with matters of conflict derived from the life of women, that is to say, from her own life. She works through the experiences of her failed marriage to Heinrich Studer by tying autobiographical elements into the fictional literary text. . . .

On a variety of levels, the novel narrates a love story with a tragic ending that is wrapped in the cloak of a trivial novel. In the article above, both the author and the novel have been subjected to a psychoanalytic examination. It may well be clear that it is impossible to treat the topic exhaustively within this framework, not to mention that other angles of approach, such as those grounded in ethics, aesthetics and cultural history, have had to be disregarded here. However, if these statements succeed in placing the oeuvre of Claire

Goll—which, I argue, literary critics have undervalued—under a new light of interest, then I have achieved my goal.

Anna Hausdorf. *Neophilologus*. 74, 1990,
pp. 265, 270, 277

GONÇALVES, OLGA (PORTUGAL) 1929–

Perhaps the most significant body of fiction produced since the 1974 Portuguese revolution has been taped/constructed/written by Olga Gonçalves. In her first two novels, *A floresta em Bremerhaven* (The forest in Bremerhaven: 1975), awarded the Richardo Malheiros Fiction Prize, and *Mandei-lhe uma boca* (Smarty-Pants: 1977), and in *Este verão o emigrante là-bas* [The emigrants down home this summer]. Gonçalves presents the Portuguese passing through a state of trauma owing to the swift social changes taking place around them. Although "Smarty-Pants" deals with a "lost-generation" of Portuguese youth, the author's other two novels construct the attitudes of that extremely large group of Portuguese emigrants in Germany and France. In the 1975 work we hear from a family of emigrants who returned to Portugal after the revolution, wealthier both financially and spiritually.

The latest work is a series of "interviews" of the Portuguese who remain in France and return to Portugal during their August vacations. These interviews make clear that the people have traveled from one set of repressions in Portugal (social class abuse, rural poverty et cetera) to another set in France (discrimination based on race, urban poverty, et cetera). Their attempts to maintain their Portuguese heritage are stymied. Keeping the Portuguese language alive in France is a difficult task. Although they favor some sort of bilingual bicultural education for their children, they themselves speak a macaronic combination of Portuguese and French, in which the key words of daily existence only have significance in the latter language. Their hope is to become a minority force in French life. Those emigrants returning to Portugal for their vacations encounter a somewhat alien nation. To a certain extent, they have become yet another generation of Portuguese without a homeland. Reading this true proletarian fiction, one is often reminded of the "exposés" of the hard lives of emigrants which were so popular in the Portuguese news media during the late 1960s and early 1970s.

The author employs the techniques of the "new novel" throughout her fiction. In this volume an extremely poetic effect is achieved through a leitmotiv comparing the difficulties of the emigrants to those experienced by Claude Monet. Gonçalves's presentation of the Portuguese is astute but, at times, quite disheartening.

Irwin Stern. *World Literature Today*. 53,
1979, p. 659

Olga Gonçalves's fiction has vibrantly chronicled the social upheaval wrought by the Portuguese revolution of 1974. Since her first award-winning novel, *A floresta em Bremerhaven,* she has made her reader an intimate participant in the situation of various levels of Portuguese society: the economic émigrés who returned from France and Germany; the *retornados* from the old colonies; and, quite notably, the teen-agers and young adults who matured under a chaotic "new" social order. Her latest work, *Armandina e Luciano,* is itself thematically revolutionary and original: a novel about the pulsating lives of the lower classes of Lisbon's shantytowns.

The voice in Gonçalves's stream-of-consciousness monologue/testimonial novel belongs to a young ex-prostitute who, although now established as a maid to an upper-middle-class family, seems occasionally to relapse into her prior existence both physically and psychologically. Carla Cristina, whose code name among her pals is Sheila, narrates not only her own and her family's background and existence, but also those of her wide variety of friends participating in Lisbon's underground: other prostitutes, low-level pimps, thieves, smugglers, drug dealers, and bizarre bohemian spirits. Carla is an astute observer (but not a dogmatic one) of many realities: women's situation, racism, sexual perversion and abuse, and even incest—relationships about which she nonchalantly can reveal positive qualities. Her sense of justice is born of direct contact with these realities. Neither resentful nor maudlin about her (and the society's) situation, she is often poetically brutal and honest in her judgments.

Gonçalves places her novel within a variety of important social and artistic traditions of the Iberian peninsula: a preoccupation with the *povo,* the poor people, whose prominent role in the society has been a leading issue since the medieval chronicles of Fernão Lopes; the picaresque novel, which serves as the context for her story; and an evocation of Lisbon's own late-nineteenth-century social poet, Cesário Verde. In reality, however, it would be indeed difficult to discover a precursor in Portuguese fiction about Lisbon to Gonçalves's linguistic virtuosity and sensitivity. *Armandina e Luciano,* together with her earlier works, allows Gonçalves to be recognized, without doubt, as the true chronicler of the contemporary sociocultural Portuguese reality.

<div align="right">Irwin Stern. World Literature Today. 63,
1989, p. 462</div>

Gonçalves's fiction has vibrantly documented the social changes wrought on Portuguese life during the post-1974 revolutionary period. . . .

Although Gonçalves's literary career began with lyric poetry in the 1960s, which she continues to write, she has distinguished herself as a novelist. Gonçalves's fiction may have been inspired by the testimonial literature form. It shows direct influence of the "new novel's" concern with detail. Using what appears to be the interview format, her characters narrate their personal situations and beliefs about the events of the revolution and beyond. . . .

Gonçalves's *Ora esguardae* (1982; Hark ye, now!) is a mural of Portuguese life in the early 1980s. She invokes the medieval chronicler Fernão Lopes (ca. 1380–ca. 1460) through the voices and complaints of the Portuguese *povo*, the common people, who had defiantly supported the nation's existence since medieval times. Linguistic subversion (present in the earlier works) assumes greater importance here. For example, the *retornados*, returnees from the old Portuguese African colonies, have brought with them a new register of speech; the political opening has given new connotations to old words; and the now popular Brazilian soap operas reveal new social and linguistic possibilities. This novel possesses an optimistic tone about Portugal's future. Gonçalves suggests that the young postrevolutionary generation will "cleanse" the language of its past linguistic and cultural dilemmas.

Gonçalves's fiction has also expressed a special interest in women's situations. Her *Mandei-lhe uma boca* (1978; Smarty-Pants) describes the change taking place in the cultural situation of Portuguese teenagers. Sara, the protagonist, is revisited, eight years later, in *Sara* (1986; Sara), upon obtaining her M. A. in philosophy. She is still confronting the changes in Portuguese women's lives. Gonçalves's *Armandina e Luciano, o traficante de canários* (1988; Armandina e Luciano, the "canary" trafficker) is a striking stream-of-consciousness monologue-testimonial novel in which the voice belongs to a young ex-prostitute (often relapsing), Carla Cristina. . . .

Gonçalves's fiction has earned for her the title of portraitist of the sociocultural reality of today's Portugal, in particular the urban existence of Lisbon.

Irwin Stern. In Steven R. Serafin and
Walter D. Glanze, eds. *Encyclopedia of
World Literature in the 20th Century* (New
York: Continuum, 1993), pp. 262–63

However palpable the historical reality evoked in *A floresta em Bremerhaven* [The forest in Bremerhaven] is made to feel, the device of a daily record that obscures and nonetheless unveils the problematic relationship of the subject with the written words functions as a parenthesis in any referential expectation. Participating as it does in various registers of the ideological, philosophical, and formal tendencies implied by the label "postmodern," Olga Gonçalves's novel cannot—and indeed must not—be reduced to being read as a simplistic documentary or testimony. . . .

The text does not attract attention through a complexity inherent in literary representation so much as by the fact that a subject without a voice of her own is able to express herself through the word of the "Other." The operational concept of "the scene of writing" as memory of the textual unconscious, understood in terms that are simultaneously psychoanalytic, political, and textual, appears, effectively, to be dramatized in its deepest implications by feminine writing. In the radical alterity on which the discourse is based, in the relationship of interdependence between the (absent) subject and the

woman writer, in the representations in which she is situated and the world that these representations evoke, albeit in an elliptical fashion, we are forced to come face to face with the question that insinuates itself under the apparent silence of the narrative voice: "What is the meaning of this word 'freedom' coming out of April 25[,1974]?"

Nonetheless, it is not a matter of analyzing a word that has been able to be taken over by the evils of power and the meaning imposed by a (symbolic) order that is called "democratic." Olga Gonçalves attempts a different critical project in the effort to find a solution for the impasse that the writer faces. Because, after all, what matters is to represent history. . . . In order to be understood, then, as the writer aims in the final analysis at "reflecting" or rethinking/re-presenting history, she has to supply among her voices those that signal the memory of other texts of the past—representations of other realities that . . . remain unchanged in the present. . . .

By rejecting the status of a mere testimony of victimization and imposed silence, the text reflects [the fact] that its own writer-woman—the space *par excellence* of the voice and dominion of the Other—potentially signals the space of subversion, of the historical struggle that . . . cannot be considered finished.

For this reason, instead of "documenting" the emergence of the new Portuguese reality, Olga Gonçalves is able rather to suggest its future possibility. She shows how and in what conditions this reality remains the same, or changes and becomes alienated from itself, when Mena, finally, can express herself without reference to any other order than herself and thus make possible the transformation of consciousness—the first and decisive step in any social and political revolution whatsoever.

Ana Paula Ferreira. *Hispania.* 75, 1992,
pp. 84–85

Women's writing in Portugal has undergone a boom since the overthrow of the Salazar-Caetano dictatorship on April 25, 1974. A large number of women novelists have been successful within the contemporary literary mainstream. There has not, however, been a corresponding boom in Portuguese feminist theory which might enable the critic to study the relationship between gender and creativity. The feast has occurred in fiction. The famine has been in feminist theory. . . .

Olga Gonçalves's *Ora Esguarda* opens . . . with a profusion of speech. The first word of the novel is "falaria." "Falaria do júbilo, do frenesim, de glória e da coragem do acontecer." The reader is then invited to observe the drama unfolding before her/him as the narrator retreats leaving the "stage" to a series of extracts from dialogues "overheard" at the time of April 25. . . .

On the days following April 25, the women in *Ora* protest against household servitude in an obvious and immediate way by pouring onto the streets for the first time in decades, participating in residents' associations' demonstrations, trade union work, factory occupations and cooperatives. . . .

Gonçalves shows women's political, and thence fictional, identity as intimately bound up with the complex processes of change before and after April 25. She differs from Halia Correia, however, in adding race and colonialism to the list as an opportune reminder that the seeds of Marxist rebellion which led to the coup were first planted among the troops fighting in the colonial wars in Angola, Mozambique, Guinea-Bissau and Cape Verde. . . .

The role of women in the Estado Novo and April 25 remains, to date, curiously absent from much political science and modern history. It has been left to narrative fiction to give women a lasting voice in the otherwise male chorus line of national consciousness. The absence of feminist literary theories to ensure this fiction a place in women's cultural history will mean that much of it is not identified or classified, in Portugal at least, as "women's writing." Women's creativity has now far outstripped the feminist political activism which helped to make this creativity possible. Women's writing may be booming in the 1990s but the angry 1960s feminist has become the specter at the feast.

Hilary Owen. *Forum for Modern Language Studies.* 28, 1992, pp. 363, 370–71, 373–74

GOODISON, LORNA (JAMAICA) 1947–

Lorna Goodison's *Tamarind Season* is important in the developing body of poetry in the anglophone West Indies for a variety of reasons. For one thing, it is the most accomplished collection of poems to be produced by a woman since Louise Bennett's *Jamaica Labrish* appeared in 1966. For another, it handles the creole continuum (that is, the range of language between the deepest Jamaican Creole and "Standard" Jamaican English) with a versatility demonstrated by only one other poet in the region, Barbadian Edward Kamau Brathwaite.

This versatility in language is accompanied by and informs a comfortable socio-cultural attenuation, a width of *self,* that is peculiarly the poet's and is perhaps related to the fact that, as a woman, she is disposed not only to direct, but also to receive experience. Whether she is reflecting on "all the things New York is," or "dealing with a peasant/Bout a feeder road," or proclaiming triumphantly her victory over a would-be robber and rapist, or describing "The road of the dread" in a poem so named, the absolute assurance of the language, its clear authenticity, is witness to the realness of the experience. The poet does her living and loving all over the place; sometimes she is a lady; sometimes she is a "boasie bitch." Always she is herself, a brown poet with a marvelously variable voice and a person open to the whole of experience.

This enthusiasm about Miss Goodison's book needs no apology. I have remarked elsewhere that the literature of the English-speaking West Indies has, up till now, suffered from an unfortunate lopsidedness in that the experience of these societies has largely been recorded in its poetry, plays and fiction, by men. Similarly, the body of criticism that has sought to grapple with the literature derives from perspectives that are masculine. This pleasure with the poet's work is not because she is a woman; nor is this any shrill feminist quarrel. But it is interesting that the first *folk* poet of stature in the region is a woman, Louise Bennett, and that her work managed to celebrate continuities with Africa, in a language that is the first creation of the New World communities, in poems that deal honestly and affectionately with the ordinary lives of ordinary people, *at the same time* that a whole generation of Caribbean novelists, all men, were lamenting our lack of identity and the fragmentation of our island societies. In the extent to which Lorna Goodison is comfortable with the native voice and happy to record the local experience even in its most anguished aspects, her work is in line with a tradition that finds a direct antecedent in Louise Bennett. . . .

The sensibility in *Tamarind Season* is a woman's—intimate, gentle, shy, painstakingly honest, acerbic, maniac, mercurial. This is the important other half, the perspicacity missing from the current record of the literature of the Caribbean.

Lorna Goodison's use of language is exciting in its versatility; it is married to the range of content of the poetry and deployed with the confidence which perhaps resides only in the supposed "matriarchs" who (our men tell us) make these societies. The poetry rejoices in this place and the myriad facets of life experience which it offers. The exhilaration of beating the would-be robber and rapist in "For R & R in the Rain" is the excitement of overcoming the impulse to violence in these societies. For the present, at least, it is truly a woman's triumph.

<div style="text-align: right;">Pamela Mordecai. Jamaica Journal. 45,
1981, pp. 34–35, 40</div>

Lorna Goodison has spoken recently about a sequence of poems on which she has been working, a sequence which may in effect constitute one long poem under the title *Heartease*. It appears that a recurring and unifying metaphor in the sequence will be that of a journey towards a place called Heartease. As she explains, and we should expect, Heartease signifies "an internal and a spiritual freedom:"

> Heartease sort of tries to speak to a place inside you, because that is very true too, that there is this place inside you that if you're lucky to find it then exterior hardships become much easier.

The choice of Heartease as geographical metaphor brings a communal and folk dimension to this idea of private, inner peace. To a Jamaican reader, Heartease would easily seem like the name of an actual place, even if such a place did not exist, on the analogy of places on the island with names such as Tranquility and Content. It turns out that there are at least three places in Jamaica called Heartease, all being fairly remote rural hamlets, situated in relatively hilly country. One of them, in the May Day Mountains, is at the heart of the island so to speak. In this geographical context, the name connotes rural folkways, the simple strength of peasant values, the rigors and deprivations as well as the blessings and the peacefulness of hill-country life. It connotes, too, the idea of walking, of repeated journeys on foot over steep, rugged terrain, and of rest and solace at the end of the climb uphill. For the poet's purposes (and she has not visited any of these places named Heartease) it does not matter whether or not actual experience of these places brings such connotation to mind. Nor does it matter for the purposes of this paper.

The idea of the journey on foot as fact and symbol of life is a deep archetypal reality in Jamaican folk consciousness. . . . Sooner or later, as the work of a poet assumes volume and personality, a few key images are likely to emerge, which serve as distinguishing marks, signatures of a sensibility. So we notice, for example in Goodison's work, developing from *Tamarind Season,* a fascination with imagery of water and wetness—rain, river, sea. This water imagery signifies variously fertility, creativity, the erotic, succor, freedom, blessing, redemption, divine grace, cleansing, purification and metamorphosis. . . .

Then there is the continuous extending of linguistic possibility, which has been one of Goodison's most distinctive features. She has been steadily refining her skills at sliding seamlessly between English and Creole . . . interweaving erudite literary allusion with the earthiness of traditional Jamaican speech, images from modern technology with the idiom of local pop culture. This process is the perfecting of a voice at once personal and anonymous, private and public. It may reach a kind of maturity in *Heartese* and will be an important factor in the increasing "largeness" of her work, as that work fuses private and communal pain and resolution.

<div style="text-align: right">Edward Baugh. Journal of West Indian
Literature. 1:1, October, 1986, pp. 12–13, 20</div>

At its more obvious level of meaning, "I Am Becoming My Mother" is about woman's sense of identity through identification or bonding with the mother, with the female line of ancestry, and with whatever suffering and strength distinguish it. This awareness is described as a process of becoming; through this process the persona comes fully into being, becomes herself. She grows towards her birth, a psychic birth which complements her physical birth. The dynamism of the process is enhanced by the fact that it is two-way: "my

mother is now me"—the mother is growing into the daughter just as the daughter is growing into the mother. . . .

"I Am Becoming My Mother" is also a poem about woman's recognition and celebration of her inheritance and power as artist. In a general way, giving birth may be read as a metaphor for artistic creativity. But, more specifically, the idea of giving birth is imaged in the active terms of "birth waters," which suggest not only fertility/creativity (water) but also continuity (flowing), And these birth waters are a joyous, beautiful, vitalizing utterance—"her birth waters *sang* like rivers" (my emphasis). Besides, the mother is also imaged as artist in that she "raises rare blooms." Goodison like Walker, has also "found" her mother's garden—and is identified with beautiful works of art, albeit domestic, her "linen dress/the colour of the sky" and her "lace and damask/tablecloths." And since the poet has become her own mother, it is she who now "raises rare blooms" (her poems); it is her work which sings like rivers.

<div align="right">Edward Baugh. Journal of West Indian Literature. 4:1, January, 1990, pp. 2, 12</div>

Compared with Christine Craig, Olive Senior, and Esther Phillips, Lorna Goodison is presently most verbally fascinating, sensuous and musical. Her two volumes of poetry to date, *Tamarind Season* and *I Am Becoming My Mother*, show a progression towards harmony. Less polemical than Phillips, (although some poems, like "Judges" in *Tamarind Season* are very strong) Goodison is a very skilled craftswoman of sounds. In "Judges" the point is partly the rhythm, which beautifully mirrors the Jamaican voice:

> I am lining up these words
> holding them behind the barrier of my teeth
> binding my time as only a woman can.
> I have a poem for you judge man.

The placement of "man" here rings with her anger. But often Goodison is a resolver of tensions, as in her poems "For My Mother (May I Inherit Half Her Strength)." . . .

But the poem becomes very cozy and proceeds to present the portrait of the mother, full of the enchantment of myths, as all of our images of our mothers tend to be. Goodison's image of the emotional texture of her mother's life is honest and emotionally appealing. . . .

Some of Goodison's poems find the crossroads between gender and race, and are neither strongly polemical nor primarily sensuous and resolving of issues. In "England Seen," for example, there is a very good sense of humor about Icylyn "chief presser hair," who goes "afro" in the summer, and the poem plays with the anxieties of women about looks (particularly here of black women in a white society). . . .

Goodison occasionally treats class as a theme (as also do Phillips, Senior and Craig). In Goodison, voice of the dialect or creole speaker is much more often interwoven into the texture of the line that it is in the other writers who tend to write either in one linguistic mode or the other in different poems. Goodison's humor is a medium for dealing with potential confrontation. Her portrait of a "rural revolutionary" is very acute:

> my head agrarian
> I know
> Textbook, how it grow.

But for the most part, she is a poet of sensuous language, who, to judge from her newest work, like "Heartease," is both technically confident and moving toward harmony and healing:

> while the rest of we planting the
> undivided, ever-living
> healing trees. . .
> what a glory
> possibility
> soon come
> HEARTEASE.

It may therefore seem churlish to find her rich style, resolving tensions, has any dangers to it, and this is where my own subjectivity as a critic and poet comes in. I acknowledge that Goodison is undoubtedly a poet of the greatest potential in terms of language technique and the ability to weave different aspects of experience together (as for example she uses Catholic and African elements in the passage quoted above). For many readers, this might seem an ideal solution to the tensions which surround us and also to inner conflict. But I find Craig and Senior, remaining clearly aware of different and colliding elements of experience, are the closest to the nature of the life I know. The question really is how we take the different aspects of a life into account: deal with them separately (as often Phillips does), resolve them into a harmonious whole (as Goodison's major recent work seems to want to do), or present them as ever present and shifting elements in the experience, unavoidably separate and troublesome, as in Craig's work.

At the moment, however, it would only be true to say that Goodison is the most achieved of the three writers and that her poetry does give immense satisfaction.

Elaine Savory Fido. In Carole Boyce Davies
and Elaine Savory Fido, eds. *Out of the
Kumbla: Caribbean Women and Literature*
(Trenton, New Jersey: Africa World Press,
1990), pp. 37–39

GORDIMER, NADINE (SOUTH AFRICA) 1923–

The theme of *The Lying Days* is the turbulent adolescent passage into wisdom and reconciliation: the hardest subject of all, exhausted, a plundered vein. . . . Miss Gordimer solicits the attention with a portrait sure and eloquent: no one will dispute the authenticity of this grave and humorless young heroine, immensely touching in her over-riding egotism, blindly groping into the adult world of love and responsibility and human commitment. Indeed, in Miss Gordimer's drawing of her shy response to the charm and pleasure of the sensuous, physical world, the novel achieves a kind of hazy bloom of perfection which cannot but be called masterful.

When the center of her narrative moves, however, from the idyllic pastoral landscape—a tissue of life beautifully rendered—to the complex implications of an urban scene, Miss Gordimer's writing declines in chastity and poise. I would ascribe this softening to an improper discrimination the novelist has made between the two imaginative modes of recollection and recreation. She has indulged herself with remembrance, and in consequence her subject, which importunes the shaping of art, is bound only by the tenuous unity of personality. She cannot dominate her experience—the venomous family ruptures, the slow attritions of a compulsive love affair—because she does not exist at a sufficient distance from it; the page is still freshly dusted with the heat and squalor of battle.

Nor has Miss Gordimer, with absolute success, imposed her private drama on the larger context of South African actuality. This is, of course, a generous, possibly a noble, failure. In the humiliating presence of *apartheid,* under the sullen eye of Dr. Malan, how is one even to sustain the illusion of personal worth? With guilt suppurating at every pore of a society, to counsel the refinements of moral taste is tantamount to an act of frivolity. Numbness or hysteria would seem to be the logical alternatives, and for all the tact of her conscience and the restraint of her art, Miss Gordimer has completely eschewed neither.

Richard Hayes. *Commonweal.* October 23,
1953, p. 66

Not many authors in her field [of the short story] accomplish what [Nadine Gordimer] sets out to do with so much force and grace. Her aim is nothing less than to advance the amenities of civilization. A tall order. But she goes about it with a kind of brilliantly deceptive casualness. You are caught up, first of all, in a story—the loves of men and women, the confrontations of growing up—the elemental business, in short, of life, liberty and the strenuous, faltering pursuit of happiness. Along the way, though, Miss Gordimer never fails to dramatize the dreams of glory, the petty subterfuges born of elemental insecurity, the odious side of power. . . .

There's no use trying to kraal her as South African regional writer. True, she lives there. But her field is people and people are the world. Superficial proof lies in noticing that she sometimes sets her scene in England, on shipboard, or elsewhere. A deeper confirmation may be observed when you see her turning a Johannesburg suburb into an annex of Westchester or Grosse Pointe. She is quick to examine persons called troublemakers—and quicker to expose the mean disquiet of authoritarians who try by foul means to get rid of "troublemakers." The slave-driving instinct, she shows us, has an amazing variety of manifestations in our world.

Illustrated Weekly of Pakistan. June 6, 1965,
p. 42

I think that Nadine Gordimer has tried to say in *The Late Bourgeois World* that white South Africa is becoming dehumanized, that it is afraid to live and feel as human beings do because it has agreed to live by a set of rules which are themselves inhuman, and that once it has accepted that premise, it must watch its own humanity withering away. Some atrophy must set in. This, I think, is her criticism; this I think is her protest. There is this disadvantage, that I am afraid that Nadine Gordimer would find the same lack of humanity in other societies. This is because there is in her the kind of impersonality that you find in a microscope. She does not herself react to feeling. In her books even the emotional relationships are forced, are conjured up, are synthetic. Though Nadine Gordimer would say that she is condemning South African society for being dehumanized, I would say that Nadine Gordimer, who is one of our most sensitive writers, is also the standing, the living example of how dehumanized South African society has become—that an artist like this lacks warmth, lacks feeling, but can observe with a detachment, with the coldness of a machine. There is in her, herself, no warmth and feeling.

Dennis Brutus. In Cosmo Pieterse and
Donald Munro, eds. *Protest and Conflict in
African Literature* (New York: Africana,
1969), p. 97

In this long and thickly textured novel [*A Guest of Honor*], full of shrewd, seasoned observations, we get a very full picture of an emergent African country today: the physical sense of it, the complex economic and social tensions, the range of its population. There is a journalistic fidelity to Gordimer's picture which wins our respect, though it means also that her book takes some time getting into, and I must confess that my interest was secured only after the love affair (fairly well done but not in itself distinguished) was under way.

Gordimer's hero [James Bray] is in some ways a figure of romance—a man who has given up security for adventure, who is free of internal complications, who is even pointedly taller and more virile than other men. Of

course the author succeeds in getting us to think of him also as an emotionally mature man, one who lives life "as a participant rather than an adversary," who is realistic about history and death. . . . But the real sophistication of her book is in its convincingly detailed and unsimplified picture of how political events work themselves out in a particular economic and social context. Bray's choice is certainly romantic (an epigraph from Che Guevara points that up), but there are places and times in history—and emergent Africa in the 1960s appears to be one of them—when romance and reality are one, when reality becomes adequate to the imperious demands of the imagination. Wallace Stevens's phrase "connoisseurs of chaos" accents the resourcefulness of imaginative men in the face of stern reality. It would be true to his sense of things to add that the exploitation of a romantic reality is itself a worthy act of imagination.

David J. Gordon. *The Yale Review.* Spring,
1971, p. 437

Interviewed a few months ago in London, Nadine Gordimer said: "Liberal is a dirty word to me. I am a radical." She is one of the few. Most other African writers have opted to become Ph. D. fodder and scholar-gentry, they shunt back and forth on the American college lecture circuit, having cut themselves loose from countries in which the illiteracy rate—according to the latest UNESCO figures—has risen sharply in the past few years. One wonders who speaks for the African. . . . Really, Miss Gordimer's vision of Africa is the most complete one we have, and in time to come, when we want to know everything there is to know about a newly independent black African country, it is to this white South African woman and her *Guest of Honor* that we will turn.

If we want an overview of bewildered whites, well-intentioned liberals, foundation men, lost Africans and burnt-out firebrands, her collection of stories, *Livingstone's Companions* is an invaluable guide. Now that the black South African writers have chosen silence, exile or cunning, only Miss Gordimer remains to record the complex fate of a continent that had a mere decade of notoriety before lapsing into tropical senescence. . . .

Her latest novel, *The Conservationist,* shared the highest British literary award last year, The Booker Prize. It is the story of Mehring, a gruff, likable tycoon—a pig-iron dealer—and the people who live near him, Africans, Indians, a liberal girlfriend and assorted witnesses to his dilemma of rootlessness. Mehring is the withdrawing spokesman for the absence of hope in Africa, a man for whom wealth has made possible a limited vision of the world. . . .

[*The Conservationist*] is an intensely wrought book, and if it has a fault it is that there is no diminution in its intensity: a hovering seduction in an airplane gets the same solemn treatment as a field of wildflowers or the casual beating-up of an African. And there is no humor, apart from a description of the voices recorded on Mehring's telephone-answering device, a marvelous exercise in various tones of sluttishness. The farm Mehring briefly colonizes

becomes the novel's reference point, like Africa itself; but he is a doomed man, the last alien. His pity—which is what many outsiders feel about Africa while giving it a different name—is only pity, the feeblest mimicry of love.

Paul Theroux. *The New York Times.*
April 13, 1975, pp. 4–5

Nadine Gordimer is the most important South African writer since Olive Schreiner. In an age when political exile is often a mark of respectability for the creative artist, she chooses to stick to her post in the face of a situation of moral, cultural and political repression that is frightening in its intensity. She continues to record the realities of South African life with the sensitivity and dedication that mark everything she writes; but the conception of the novelist's task that appears in her work does not stop at that of the faithful recorder.

Nadine Gordimer is also a passionate interpreter of South African reality. The perspective of her interpretation has evolved over the years and changed. At the beginning of her career it tended to embody the main assumptions of the European liberal moral tradition, though even then these assumptions were not granted the status of unquestioned validity. She came to see them later as components of a larger historical reality, rather than as definitive standards of judgment; and her interpretation of South African life thus achieved a new dimension, unprecedented in any South African fiction, of accuracy and insight.

In establishing this new appreciation of Southern African reality as not a European phenomenon, not subject to the rules and criteria of a code of judgment evolved within a different scale of experience, Nadine Gordimer has subjected the governing notions of European liberalism, as these are conventionally expressed in fiction, to the most appropriate (and stringent) form of critical scrutiny—by embodying them within her novels. In particular, she has focused on the central problem of the moral status of action, through an extensive creative probing of what has happened to the conventional liberal hero, rooted in romantic ideology and subjected to the post-Darwinian (and post-Auschwitz) doubts of contemporary technological civilization.

Her conclusion, that heroic action on the liberal-romantic scale possesses a distorted significance in the context of the post-colonial realities of the "third world," works in both directions, because it illuminates the moral situation within the metropolitan culture at the same time as discovering the ground rules for moral action in the local culture. Through her explicit challenge to most of the European conventional (and conventionally experimental) conceptions of the function and meaning of time, both for the individual and the history of a group, she becomes a pioneer in the crucial task of establishing a new South African historiography. No group can understand its present or its future (or itself) without first coming to terms with and understanding its past. By liberating the South African past from European

conceptions—whether of the moral status of action, of heroism, of the shape or function of time—Nadine Gordimer shows in her novels the way to a fresh understanding of the combination of processes and events that shaped South Africa's reality. Since that reality, and its future course, constitute one of the most crucial test cases for the moral experience of the twentieth century, the importance of Nadine Gordimer's work is evident.

By placing South African reality firmly within the context of the post-colonial experience of the "third world" Nadine Gordimer has located her own work within that context as well. She has moved from being a European writer born in exile, to a writer inhabiting and understanding a reality once organically related to and dependent on Europe, but now essentially separated from it. Thus, as an African writer, she is in the same literary category as Borges or Marquez as South Americans, in relation to their respective "metropolitan" cultural roots. And as an African novelist writing in English, there can be little doubt that Nadine Gordimer occupies the leading position in her chosen field.

<div style="text-align: right">

Michael Wade. *Nadine Gordimer* (London: Evans Brothers, 1978), pp. 228–29

</div>

July's People is the latest novel by the astonishing South African writer Nadine Gordimer, and it's one of her best to date. It's set in a future that could be tomorrow: the blacks of South Africa have finally staged a general uprising and the country is in a state of civil war, with predictable foreign participation: Cuba and Mozambique on one side, the United States on the other, the outcome in doubt.

The war itself and the rights and wrongs of the participants do not form Gordimer's primary subject, however. Rather she focusses on its effects at the private and human level. "July's People" are Bam and Maureen Smales and their three small children, a white, middle-class, self-consciously liberal family for whom their black manservant, July, has worked with apparent devotion for the past fifteen years. When it's become obvious that the rioting and killing are out of control and that the Smales have left flight too late, July rescues them by guiding them to his own family village hundreds of miles away in the middle of the African bush. They take with them only what they have remembered to snatch up at a moment's notice. For everything else, they realize, they are now dependent upon their former dependent.

In less skilled hands this could have become a self-righteous and potentially malicious cautionary tale, of the "Look what's going to happen to you" variety. But Gordimer handles the nuances of the relationships involved with exquisite dexterity. The Smales in their pre-revolutionary suburban colonial setting were not *bad* whites. They were not bigots, they told themselves, they favoured more self-determination for blacks, they went jogging. They are not depicted as angels, however; only as typical of their kind. July is no angel. His rescue of them is motivated more by habit and the desire to main-

tain a status quo in which he has a relatively favored place than by charity. . . .

July's People delivers its characters over to the reader with a chilling precision and a degree of understanding which would not ordinarily be called compassionate. Yet compassionate it is, for Gordimer is not accusing. *July's People* is not concerned with villains and heroes but with the depiction of a next-to-impossible situation. Novels about the future, as Ursula Le Guin has said, are really about the present. The situation in South Africa is already impossible on any human level, Gordimer is saying, not only for the blacks but for the whites. The blacks at least have a sense of belonging. The whites, if the Smales are any example, don't even have that.

This is a densely yet concisely written book, beautifully shaped, powerful in its impact. It should gain for its author the wide audience she deserves.

Margaret Atwood. *Chicago Sun-Times Book Week.* May 31, 1981, p. 26

In Gordimer's later novels the landscape ceases to serve as a background in which the characters attempt to read "outward signs." It becomes a living force—the moving force—in her fictional world. Indeed, there had been indications from her earliest years that Gordimer had seen the landscape of her world as inhabited by life. In "A South African Childhood: Allusions in a Landscape," she recalls being aware as a child of the vast system of mine tunnels beneath the ground, which would periodically send tremors throughout the Witwatersrand. In 1968 she would draw on these mines again in "The Witwatersrand: A Time of Tailings" as a metaphor for the suppressed imperatives of her society. "The social pattern," she wrote, "was, literally and figuratively, on the surface; the human imperative, like the economic one, came from what went on below ground. Perhaps it always remained 'below ground'; in men's minds too. It belongs to the subconscious from where what matters most in human affairs often never comes up to light." In her later novels "what matters most"—the human imperatives buried in the landscape—does come up to light. Gordimer would begin the 1981 essay "Apprentices of Freedom" by asserting that essential questions burst "with the tenacity of a mole from below the surface of cultural assumptions in a country like South Africa." In *A Guest of Honour, The Conservationist,* and *July's People,* Gordimer no longer attempts to capture the "surface shimmer" of her world's landscape; she uses it to embody a living, tenacious force—the human imperatives of her world.

John Cooke. *The Novels of Nadine Gordimer: Private Lives/Public Landscapes* (Baton Rouge: Louisiana State University Press, 1985), pp. 131–32

History may well end up being harsh to white South African novelists of the twentieth century. It might happen that their work will come to be seen as

the final surface flourish—or beneath-the-surface agony—of an oppressive and exploitative political and economic system. There will probably in the end be some truth in such a judgment. Yet it will not be the whole truth. For history also applies to those who are born on its "bad side" as it were. We have seen here the development of one writer from a position of relative acceptance of the world around her to one in which her work calls an alternative future into being and makes its way towards that future. A great drama unfolds in the novels of Nadine Gordimer, but it is not the expected one of what her work observes in the world it depicts; rather it is the drama of the novels themselves, in their own development from one world to another, one culture to another in the making, from one historical life to the next. It is a fitting irony that whereas Gordimer began her life as an author as apparent mistress of all she surveyed, as she has become more powerful and accomplished as a writer she has had to fight for her historical existence, to justify her place in a new world by the issues she deals with in the present.

The transformations we have seen in her work are perhaps the best evidence of this. Gordimer has moved from political ignorance to a profound politicality, from aspects of a racist mental world to one approaching a revolutionary alignment. She has progressed from an account of growing up as a woman to a politicized feminism adapted to the realities of South Africa.

There have also been formal changes in her writing, embodying some of these shifts. The genre of the *Bildungsroman* has been transformed in its passage from *The Lying Days* to *Burger's Daughter*. Gordimer has gone from the lengthy, prosaic picaresque of her first novel to the pithy poetics of *July's People;* language itself has become a site of historical struggle. In modal terms the transition from *A World of Strangers* to *The Conservationist* reveals the most significant historical change we have seen in the period, through a transformed framework of reality. On this question of form Gordimer's novels prove what Lukács pointed out some time ago: that there is no separable "historical novel" as a genre. Gordimer's novels, mostly written in the present, establish deep links with broader and more continuous processes because it is here that they find the meaning of the present. And this surely leads us to an important finding: that history can be a mode of existence as well as a temporal locality; it is in history that Gordimer's novels live. From this point of view, perhaps surprisingly, we have seen just how far the future governs an "historical" consciousness, for this dictates a history that has to be made, one that—for those who take it up—makes few concessions to the present.

Thus it is nothing less than Nadine Gordimer's "consciousness of history" that defines the special character of her writing and her stature as a novelist. There are no doubt any number of reasons for reading her novels; for many it will be their craftsmanship, or Gordimer's response to the details of her natural environment, that attracts them. This study has suggested another: that if we are searching for an inner pathway to guide us through South African history over the past forty or so years, there are few better places to look for it than in the novels of Nadine Gordimer. Gordimer has

not written a history of the whole of her society; this has necessarily been beyond her. On the other hand it is not clear how far it is possible for any novelist anywhere to do so. But Gordimer's work has *responded* to the whole history of her society. With meticulous attention and unremitting clarity she has persistently measured its demands against the circumstances of her world. To this extent her work has been fashioned, even in its marginality, by a much larger totality. And to this degree, in its absences, indirections and contradictions, as well as in those areas of which it is "conscious" it tells a story much larger than itself.

This has been our history "from the inside." We have seen a dramatic ideological shift in Gordimer's writing; we have followed her work into the depths of an historical "unconscious." We have seen how broader social and historical codes are embedded in her novels, and how her novels in turn illuminate these codes. Through fiction we have traced major shifts, and shifts of consciousness, in South African history. The focus of this study has deliberately been kept narrow in the belief that much may be learned from a relatively small area of investigation if that area is well enough defined. But it is to be hoped that we have discovered here something of what constitutes an historical consciousness, and how it is implanted in fiction; and that the abiding role of fiction in history as embodying its deeper codes of transformation may again be seen afresh.

<div align="right">

Stephen Clingman. *The Novels of Nadine Gordimer: History from the Inside* (London: Allen & Unwin, 1986), pp. 223–25

</div>

Nadine Gordimer's life has been lived mainly in South Africa. In this she shares with prominent white novelists Alan Paton and J. M. Coetzee an insistence on her rooted Africanness but differs from so many other white, English-speaking writers who have chosen to leave South Africa. Together with her decision to live on in Johannesburg comes her life-long scrutiny of the roles open to whites in her apartheid-ridden home.

As the political scene has changed since the late forties, so has altered her own position. From a starting point at which she analyzed white complicity in the injustices of the regime, whatever the good intentions of her more or less well-meaning, "decent" white protagonists, she moved on to investigate the failure of liberal hopes and policies (from whites who opposed the regime) in the late fifties and early sixties. In the mid-sixties and seventies she turned to an evocation of the dead end of white "occupation" and possession, with a new interest in the psychology of her characters, whether of the occupying class or of the class who tried—with varying degrees of integrity—to alter things. With the publication of *Burger's Daughter* in 1979, she introduced a new demand for action and commitment into her analysis of the complexities of white involvement in apartheid politics. That insistence has grown stronger in her later depictions of both the present, now-violent struggle and her vision of revolutionary conflict to come. In these later works the

impetus for change is in the hands of blacks, and her investigation focuses on how whites can (and do) adapt to a situation in which their role in "liberation" is secondary but nonetheless demanding.

Gordimer's later work shows an increasingly confident use of fictional form. Not only does her political emphasis become more radical from the seventies on, but her controlled variations of point of view and narrative voice also combine with structural leitmotifs in language, image, and metaphor to give her later novels extraordinary depth and resonance.

Throughout her career Gordimer has insisted on the "truth," or at least truthfulness, of her fiction. In a celebrated public address, she argued: "I remain a writer, not a public speaker; nothing I say here will be as true as my fiction." The consequence of this conviction is that she attempts in all her work to present the many-sidedness of the social and political situations she examines. Judgments by the reader emerge from the often-neutral presentation of events by the narrative voice. All sides of the case have to be presented or at least alluded to. The inappropriateness of some attitudes, beliefs, or behavior informs the judgments implicit in the text, but seldom are the appropriate reactions spelled out by the author. In Gordimer's view, it is in the accuracy of her presentation and in the depth of her imaginative grasp of the events portrayed that the fictional "truth" is to be found. Propaganda and polemic are, to her, the concerns of nonfictional prose, not of imaginative writing.

Gordimer does not always live up to this conviction. She does make ex-cathedra statements from time to time in her fiction, particularly of the summational kind, in the form of choric closing comments on the action. But generally her approach is to preserve a neutral narrative stance herself, allowing the characters or events to speak for themselves. It is up to the reader to draw the inference from the drama enacted or the comments made. This technique has resulted in Gordimer's having been criticized for coldness in her early career. Her apparent detachment from her subject has been taken as a sign of her "frozen" sensibility, a product of her white observer status in the depiction of the compromises and collusions of bourgeois conscience in apartheid South Africa.

Rowland Smith. In Robert L. Ross, ed.
*International Literature in English: Essays
on the Major Writers* (New York: Garland,
1991), pp. 172–73

GORDON, CAROLINE (UNITED STATES) 1895–1981

Penhally is the triumphant tragedy of a house and the vindication of a mode of life. It is an achievement at once of erudition and of sombre and smoulder-

ing passion. It is distinguished by the afterglow of the Greek-Roman-Anglo-Saxon classicism that marked the Old South off from all other lands. . . .

Penhally differs from other historical works which are written from the outside and are at best *tours de force*—more or less re-constitutions. It unites itself to the living school of autobiographic writers in that it is a piece of autobiography. Mrs. Tate [Caroline Gordon] has from her earliest days so lived herself into the past of her race and region that her whole being is compact of the passions, the follies, the exaggerations, the classicisms, the excesses, the gallantries and the leadings of forlorn hopes that brought the Old South to its end. She does not have to document herself in order to evoke Morgan's cavalry raids or conditions of life amongst the slaves in the be-hollyhocked Quarters. She has so lived in the past that it is from her own experience that she distils these things.

So *Penhally* is a chronicle of reality. . . . Her characters have none of the historic over-emphasis that distinguishes the usual romance of escape. Her Southern girls are not over-dimited, her gallants not over-spurred, her great proprietors not over-lavish. They are in short everyday people—but people of an everyday that is not today. That is a great literary achievement—and a great service to the republic the chief of whose needs is to know how life is constituted.

Ford Madox Ford. *The Bookman*.
December, 1931, pp. 374–76

None Shall Look Back fills out by a . . . discursive method the fortunes of the family in the midst of a war which destroys the social basis of its way of life. *The Garden of Adonis* has for scene the country community about the time of the last depression, when the full effects of defeat have had time to show their marks. *Aleck Maury, Sportsman* is not outside [Caroline Gordon's] subject but treats it in a very special way; and her most recent novel, *The Women on the Porch,* shifts the location to the city, the full-blown symbol of the western progression, or more specifically in American mythology, the end of pioneering. The heroine, the first to marry outside the connection (and this is significant), in her flight from the City with no intention of returning to the family seat instinctively finds her way back, but this time to a place of ghosts and sibyls. But the startling disclosure of the book is the crystallization of what has been gradually emerging, the theme of prevailing interest. To isolate such a theme . . . is an act of violence and distortion to the work as a whole. Briefly, this theme is what Life, the sly deceiver, does to woman-kind but particularly to the woman of great passion and sensibility. It is not that men do not come in for their share of sorrows and disappointments; it is rather, that Life, represented in the only possible hierarchy of institutional and organized society, has a masculine determination. Very subtly the White Goddess reasserts herself as Miss Gordon's Muse. The young girl in "The Brilliant Leaves," the various heroines of *Penhally* (Alice Blair, the dark sister), Lucy of *None Shall Look Back,* and most eloquently the wife of Aleck

Maury, are all the same woman. Very few of the male characters—Forrest, Nicholas, Mister Ben the possible exceptions—are able to measure up to the requirements of what the heroine thinks a man should be.

<div align="right">Andrew Lytle. Sewanee Review. Autumn,
1949, p. 578</div>

[Caroline Gordon] has not accommodated the austerities of her method to that cultivation of violence and oddity for its own sake, whether in subject-matter or style, which is one of the more distressing infantilisms of an otherwise vital and growing Southern expression in literature. And while there is nostalgia and backward glancing in her early novels of the old South, she sternly reminds herself in the title of one of them that "None shall look back." Thus she loses out, as well, at the popular romancing level of Southern fiction, for she has not gone with the wind.

Caroline Gordon, whose prose is perhaps the most unaffected and uniformly accomplished that is being written by any American woman today, should be seen as the conservator in contemporary Southern fiction of the great classical tradition of the nineteenth century novel as formulated by Stendhal, Flaubert and somewhat later, Henry James. . . .

Miss Gordon's allegiances are clearly formulated [in the preface to the anthology *The House of Fiction*] and in her last novel, *The Strange Children,* her fidelity to the tradition of "naturalism" as she has defined it emerges with a mature authority. It is in this finely thoughtful work that her real service to the realm of Southern letters as the conservator of the heritage of "naturalism" and thus of the mainstream of the great fiction of the western world is most powerfully demonstrated.

<div align="right">Vivienne Koch. In Louis D. Rubin, Jr., and
Robert D. Jacobs, eds. Southern
Renascence: The Literature of the Modern
South (Baltimore: Johns Hopkins University
Press, 1953), pp. 325–27</div>

The Malefactors marks a new departure in Miss Gordon's fiction. Yet it does have a connection with four novels which precede it. It also illustrates strikingly a change in outlook which these novels represent. *Penhally* and *None Shall Look Back* are full of regret for the vanished order of the Old South where men and women knew their place in the social hierarchy and could depend all their lives on values which their ordered society taught and supported. With *The Garden of Adonis* Miss Gordon moved into the modern Southern world, which has lost its connections with the old order. Her men and women must now struggle through the crises of their lives helped only by a sense of decency and the necessity of reconciliation to forestall disaster. There is no way back, not even through nostalgia and grief for a vanished order.

In *The Strange Children* a new note is faintly sounded. . . . This muted emphasis on a religious theme prepares us for its full development in *The Malefactors*. Among the wastrels of talent whom we meet at the fête of the prize bull only Tom and Vera discover the way up and are reborn. Will this, then, be the pattern in Miss Gordon's fiction hereafter? As the South has faded from her novels, religion has taken its place, and the way is up.

Willard Thorp. *Bucknell Review*. December, 1956, pp. 14–15

Most of the critics who have written about Miss Gordon have discussed her as a Southern writer—and of course she is. Some of her characters are deracinated Southerners or Middle Westerners, usually intellectuals who have left home. They are invariably unhappy; trouble and disorder trail along their foreign paths and remain with them when they occasionally return home. Miss Gordon has also written many passages, even whole novels, about the land and its healing moral power, which gives one a sense of belonging. She especially likes land that has not given up its fruits and rewards too easily; one appreciates what one has sweated to achieve.

Is Miss Gordon's preoccupation with Art also Southern? Perhaps, but her style is closer to Willa Cather's than it is to Southern rhetoric, even the quiet rhetoric of Katherine Anne Porter. Respect for form is in part Southern—for example, in manners, which cover and control personal likes, dislikes, drives, and ambitions; possibly too in a fairly general disregard for scientific principles and a preference for the arts that bear on personal relationships; and in a more open respect and liking for "elegance." But change comes on apace, and the Southern world of Miss Gordon's youth is no longer what it was. North and South grow more, not less, alike, and at least one . . . of her novels seems to acknowledge that this is so.

William Van O'Connor. In Louis D. Rubin, Jr., and Robert D. Jacobs. *South: Modern Southern Literature in Its Cultural Setting* (Garden City, New York: Doubleday, 1961), p. 321

Most of Miss Gordon's fiction belongs close to the heart of the new tradition; in fact, she and her husband [Allen Tate] are responsible for the term, symbolic naturalism, and for its definition. Miss Gordon conspicuously lacks the spontaneity and originality of the more widely read artists in the mode, but she has been one of the most conscientious students of technique and has constantly sought to broaden the range of her subject matter and philosophic understanding. Committed, like her husband, to the conservative agrarian ideal and opposed to modern "progress," she turned immediately to a fictional examination of her heritage, which centers in a rural district on the Kentucky–Tennessee line, adjacent to that of Robert Penn Warren. Only

gradually, after an excursion back into Virginia beginnings, did she work her way into the modern era.

Miss Gordon's instinct is for pattern; she works most effectively, therefore, with the historical movement, the family group, the typical, rather than the individual, character. Not until her later novels does she attempt any deep penetration into her protagonists' minds or psychological processes and seldom then does she enter into them with any strongly participative warmth. Her quality as an artist depends upon objective observation and analysis, on a sure control of technique and symbolic extension, rather than upon the arousal of an empathic response to her characters. Perhaps largely for this reason, she has never achieved great popular success, though her work has stood high in critical esteem.

> John M. Bradbury. *Renaissance in the South: A Critical History of the Literature, 1920–1960* (Chapel Hill: University of North Carolina Press, 1963), pp. 57–58

In 1953 Caroline Gordon remarked that a trend toward orthodoxy in religion was apparent among fiction writers as it was in the world at large. . . . It is no more surprising that in her quest for the universal myth she should have come to Catholicism than that she should have found, before her conversion, the touchstones of her being in the southern past. She [was] not, in the 1940s, a Catholic writer. But the entire, combined force of her need—for order, for tradition, for piety, for absolution and grace, for a shaping world view that would take the place of the shapeless chaos of the world—forced her inevitably and logically toward the Roman Church; and at the end of the decade, in 1951 to be precise, she published her first overtly Catholic novel. She had made the open commitment augured in all her predispositions. The wonder is that writers like Faulkner and Warren, who, for the same reasons, seemed to press toward the same end, had not yet entered the Church a decade later.

Before the Church there were the South and the Past. The elegiac tone Caroline Gordon adopted toward the past derived from her conviction that a total conception of life, life as good, stable, and continuous, had disappeared or been destroyed. A pervasive sense of cultural loss flows through her work. The fragmented lives of her characters are a reflection of this destruction of a whole and coherent cultural pattern that might define life. No force appears in the secular world to act as anchor for man, since neither the cosmopolitanism of urban culture nor the intellectualism that flourishes there provides a satisfactory center for human existence. Nor is the world of nature in itself sufficient. The urgent pessimism of her fiction is the result of her conviction that man's hope and his fate are equally blasted.

> Chester E. Eisinger. *Fiction of the Forties* (Chicago: University of Chicago Press, 1963), p. 186

It is the strength of Miss Gordon's work to suggest continually new facets of significance as one lives through the books in his mind. The characters and the incidents form new configurations with the result that the significance of any one of her books enlarges constantly as one reviews it. Her purpose has been from the beginning to suggest that reality is spiritual as well as empiric, immaterial as well as material. Accordingly, she has presented the experience of her characters in time and then again as it reaches beyond time. The ineffable dimensions of her materials she suggests through a discerning use of myth; and in her later books Christianity reinforces their universal implications. . . . As a writer Miss Gordon is the inquiring moralist even before she is the religious writer. Because of her passionate concern with the way life should be, her books are rooted in social realities even as they look toward the visionary. Intelligence, compassion, psychological insight, depth of vision, and stylistic distinction inform a canon of work that impresses always by its comprehensiveness and strength.

Frederick P. W. McDowell. *Caroline Gordon*
(Minneapolis: University of Minnesota
Press, 1966), p. 45

[Caroline Gordon's] fiction dramatizes the myth of the South, as Cooper's does that of the Western migration, James's of Old and New World culture, Proust's of French social change at the end of the nineteenth century. Beginning, in thematic order, with *Green Centuries* and ending with *The Malefactors,* Miss Gordon's fiction shows the movement from loss to acquisition, from rootlessness to stability, from chaos to order, from matter to spirit. In *Green Centuries* the antagonistic natural world drives the exile to certain destruction as he escapes his past (finally, himself) in the pursuit of the unknown. This theme of the natural world as opponent reappears later in *The Garden of Adonis* and particularly in *The Women on the Porch,* as does the central concept of the failure of love between man and woman, in part the result of destroyed cultures or man's warped view of new and different economic systems.

James E. Rocks. *Mississippi Quarterly.*
Winter, 1967–68, p. 10

Penhally is a completely "rendered" novel, as [Ford Madox] Ford would have said. Its method of presentation—the shifting post of observation in the line of succession among the Llewellyns—allows a remarkable degree of control for such a large subject. Its author has seldom written better. But she was not content with the perfection of a method, and her subsequent books have realized her subject by a variety of means. Her second novel, *Aleck Maury, Sportsman* (1934), for instance, is based on the convention of the old-fashioned memoir. Aleck Maury is the only one of her major characters whom Miss Gordon has granted the privilege of telling his own story, and she thus departs from what with her is a virtual principle. This, the most popular of

her novels, can stand by itself, but it gains something from those written after it, as though it were cutting across a territory whose outlines are more fully revealed later on.

Ashley Brown. *Southern Humanities Review*. Summer, 1968, p. 283

No more than a handful of modern writers have produced short stories which are both technically sound and rich in fictional values.

Such a writer is Caroline Gordon, whose artistic discipline has always been adequate to control the wide range of vision she brings to her fiction. Indeed she tends to crowd into her stories more than their formal limitations would seem to permit: the total experience of a region's history, the hero's archetypal struggle, the complexity of modern aesthetics. In every instance, however, she succeeds in bringing the broad scope of her narrative into focus and in creating the ideal fictional moment, when form and subject are at war and the outcome hangs forever in the balance.

Yet there is a classic simplicity in most of her short stories, an unusual economy of incident and detail which decorously masks their essential thematic complexity. Even the prose is, for the most part, spare in its diction and syntax, particularly in the first-person narratives, dominated by a tone that is quiet and conversational, the intimate language of the piazza on a warm summer evening.

And it is in this quality that one finds a clue to the origins of Miss Gordon's narrative virtue. For she is still in touch with the oral tradition which in her formative years was a vital element of family life. Like William Faulkner and Katherine Anne Porter, with whom she has much in common, her experience of the nature of being begins in the family, with its concrete relationships, its sense of wholeness, its collective memory.

Thomas H. Landess. In Thomas H. Landess, ed. *The Short Fiction of Caroline Gordon: A Critical Symposium* (Dallas: University of Dallas Press, 1972), p. 1

The Glory of Hera is a matchless book—a peak, I think, in the career of a writer devoted to a too familiar, and often belittled, vocation. The uniqueness of the book consists in this: that its author stretches the capacities of the novel so that it can operate authentically in the protean land of ancient Greek myth. It can take on the shapes and assume the colors that make it resemble a luminous mosaic depicting the exploits which were attributed to the god-engendered hero, Heracles. Beginning with Homer's account of the burly bowman, the myth, though revealed piecemeal in many arts, remained the special property of the poets, so astonishing was it, so unbounded, ranging as it did from Heaven to Hell and over all of the perilous borderlands of Earth. The ancients would argue that whatever else might occur, this ineffable stuff could never be captured by a writer of mere prose, by which they

would have meant, of course, a chronicler or encyclopedist of some sort. That Caroline Gordon has captured it—indeed she has delivered it quivering and alive from the monstrous darkness of the past—is a triumph for the modern art of prose fiction as well as for the far from modern arts of revivifying immemorial legends.

<div align="right">

Howard Baker. *Southern Review.* Summer, 1973, pp. 523–24

</div>

Almost all of Gordon's work up until 1940—which includes her novels *Penhally* (1931); *Aleck Maury, Sportsman* (1934); *None Shall Look Back* (1937); and *The Garden of Adonis* (1937), along with a number of memorable stories, including all but one of those about Aleck Maury—depicts heroic characters struggling to assert order and meaning in an unstable world. At the heart of these solitary stands against death and disintegration lie a Stoic acceptance of man's depraved condition and a desire to forge a code of valor and dignity. In *Penhally,* several generations of the Llewellyn family strive to maintain family order as the social order around them collapses; in *The Garden of Adonis,* Ben Allard and his tenant Ote Mortimer, embodiments of agrarian virtue, defy all odds in attempting to transform stubborn clay into fields of abundance; and in *None Shall Look Back,* Rives and Lucy Allard hold their marriage as a bulwark to stem the dark flood of the Civil War. But indomitable as Gordon's heroes seem, disaster awaits them all: the dark forces of life destroy the heroes and—we finally see—their fragile edifices of order. *Penhally* ends with a fratricide and the family irrevocably split; *The Garden of Adonis* with Ote murdering Mr. Allard; *None Shall Look Back* with Rives dead and Lucy wrapped in a mantle of bitterness and despair.

The general picture is bleak. Yet Gordon's fiction is not merely a series of shrill cries against life's unfairness; rather, it is a profound exploration of heroic endeavor, which remains honorable even though it is doomed. Her work achieves such depth primarily because of Gordon's own deeply felt admiration and sympathy for her heroes. By standing their ground, by holding their heads high, these doomed figures act out the only heroism that Gordon at this point saw available to modern man—a private assertion of dignity. The bond of sympathy she felt with her heroes (derived in large part from the example of her father and from her extensive early education in the classics) allowed her to maintain a healthy tension between her dark vision of existence and her need to assert some vestige of meaning amidst life's pain and suffering. This tension vitalized her imagination and led to the creation of a number of profound novels and stories.

<div align="right">

Robert H. Brinkmeyer, Jr. *Three Catholic Writers of the Modern South* (Jackson: University Press of Mississippi, 1985), pp. 80–81

</div>

Henry James once said that, in writing about fiction, "one speaks best from one's own taste, and I may therefore venture to say that the air of reality (solidity of specification) seems to me the supreme virtue of a novel—the merit on which its other merits helplessly and submissively depend." Though James here refers to the novel, what he says would inevitably apply to the short story and may serve as our golden text in an introduction to the short stories of Caroline Gordon. Her stories show to a superlative degree "solidity of specification," even if the land she knows so well lies thousand of miles and hundreds of years from the great country houses, shaven lawns, family-portrait galleries, and Sèvres which so enchanted James. . . .

The stories gathered in *The Collected Stories of Caroline Gordon* are more than admirable examples of the "solidity of specification." They are dramatic examples of man in contact with man, and man in contact with nature; of living sympathy; of a disciplined style as unpretentious and clear as running water, but shot through with glints of wit, humor, pity, and poetry. Caroline Gordon belongs in that group of Southern women who have been enriching our literature uniquely in this century—all so different in spirit, attitude, and method, but all with the rare gift of the teller of the tale.

> Robert Penn Warren. Introduction to
> Caroline Gordon. *Collected Stories of*
> *Caroline Gordon* (Baton Rouge: Louisiana
> State University Press, 1990), pp. vii, xi

GORDON, MARY (UNITED STATES) 1949–

Felicitas Maria Taylor, Mary Gordon tells us in the first line of *The Company of Women,* is christened after "the one virgin martyr whose name contained some hope for ordinary human happiness." She yearns for the happiness her name represents. So does Isabel Moore, the heroine of *Final Payments,* Gordon's earlier novel. But both heroines find ordinary happiness extraordinarily difficult to attain. Their separate searches determine the plots of the novels and give rise to some of Gordon's most important themes.

Because they give us heroines caught in webs of conflicting values, each trying to disentangle an old and strong affiliation with the Catholic Church from her desire to establish herself as a free, modern woman, it is tempting to view the two novels as discussions of Catholicism. In part, they are. But the novels finally assert and illustrate three themes which cut across the lines of religious denomination. First, they affirm that self-assertive, intelligent young women must rebel against or at least reevaluate their allegiance to any code to which they are wont to give unthinking loyalty. Second, they suggest that the fathers of such young women are often dominant influences in their lives and that their growing-up process must involve a rebellion, replacement,

and reconciliation with the father as well as a reevaluation of ties to old authorities. And third, they illustrate that the Catholic Church, and by extension any other institution founded on patriarchal values, offers little hope to modern women. The world is in need, the novels imply, of a new system of values. And they offer an alternative which enables Isabel and Felicitas, at least, a chance to discover some of the "ordinary" happiness they seek. . . .

This playing out of the father-daughter conflict and resolution forces us to see that accepting the good as well as the bad in fathers and in men in general is part of the "ordinary" happiness both heroines seek. Felicitas talks to, although she does not fully love, Cyprian at the end of *The Company of Women;* Isabel finally cries over the death of her father at the end of *Final Payments.* Accepting the notion of one's own sexuality as non-sinful is another. Both heroines are ready to make presumably happy sexual commitments at the ends of the novels. Even Cyprian, though he does not understand it, approves Felicitas's upcoming marriage. At the end of *The Company of Women,* Felicitas tells us: "Now I will be married; I will do this ordinary thing." These words most clearly articulate the notion implicit in both novels that a heterosexual union is part of the ordinary way to happiness for most women.

But the novels do more than simply assert that the mindless allegiance to authority stifles the individuality of intelligent women and that the process of growth for women includes the separation from [and] the correct assessment of one's relationship with one's father. They contrast male and female value systems and suggest that women must live by their own, even though they may lie counter to the "higher" values of men. Gordon introduces this idea by building male and female value systems, exactly counter in every tenet, into each novel. . . .

Thus, Gordon implies, for modern young women like Isabel and Felicitas, feminine values hold the most hope. But Isabel's and Felicitas's alignment with the feminine is, at best, qualified. They will never embrace the secondary role of women within the Catholic Church. They will never yield unthinkingly to men or to authority of any kind. They will never be the kind of women society wholeheartedly embraces.

This last, too, is a part of Gordon's point. Isabel and Felicitas are part of a new breed of women who discard the bad and extract the good from old values. They fashion new codes, applicable to themselves and the moment in which they live. Their struggles will not end with the ending of the novels. The struggles of such women, trying to find their places in "ordinary" society, very rarely end.

<div style="text-align: right">

Susan Ward. In Alice Kessler-Harris and William McBrien, eds. *Faith of a (Woman) Writer* (Westport, Connecticut: Greenwood Press, 1988), pp. 303–8

</div>

Mary Gordon's third novel, *Men and Angels* (1985), introduces, for the first time in her fiction, a family in the ordinary sense of the word. Also for the

first time, she eschews the Irish Catholic subculture that permeates her earlier novels, *Final Payments* (1978) and *The Company of Women* (1980). Despite this change in focus, Gordon seeks in all her work to explore how people love, or fail to love, each other in a world where belief in God is either a memory or an inconceivability. While the conventional family unit occupies the center of *Men and Angels,* Gordon's real concern extends beyond Anne and Michael Foster and their children to the wider human community outside their comfortable home.

In the first two novels, Gordon portrays communities where the traditional nuclear family plays little part. *Final Payments* opens on the day that Isabel's father is buried. Feeling responsible for her father's stroke eleven years before, she has devoted her life to nursing him. Ultimately, the novel is about coming to terms with death and accepting life with all its risks. It is only near the end that Isabel really mourns her father and begins to move beyond her guilt and self hatred. . . .

Mary Gordon uses various strategies to explore how people live and relate to each other in the late twentieth century. In *Final Payments* and *The Company of Women,* she studies the Catholic subculture in disarray as certainties fade; shelter is offered by extended families, earthly echoes of the Mystical Body. But these families are flawed, even that of Father Cyprian, whose "company of women" is insular and isolated. There is no sense here of the universal community predicated by St. Paul or the Canon of the Mass. The third novel, *Men and Angels,* shifts the focus to an "average" American family. But the shelter offered here, in an a-religious environment, is so fragile that it cannot include the troubled Laura.

"Nobody wants to write about yuppies," Gordon herself has remarked. "It's much more interesting to write about a close . . . slightly secret, marginal group." This preference explains the first two novels, some of the short stories, and the work in progress, a treatment of the Irish immigrant experience. Yet *Men and Angels* is her "yuppy novel." As such it dramatizes forcefully the dilemma of our culture, which has left God and Church behind but not yet found a satisfactory substitute—the best it can offer is a Foster family.

John W. Mahon. In Mickey Pearlman, ed.
American Women Writing Fiction
(Lexington: University Press of Kentucky,
1989), pp. 47, 59–60

When asked whether she considers herself a feminist writer, Mary Gordon answered: "Sure. What is terribly important to me, deeply important—and this is where I feel a sense of vocation—is to write about issues that are central to women's lives, to write about them beautifully and in high style." She has said that her "subject as a writer has far more to do with family happiness than with the music of the spheres," that she values and wishes to preserve "daily rhythms." But her novels *Final Payments* (1978), *The Company of Women* (1980), *Men and Angels* (1985), and *The Other Side* (1989)

offer a fuller, deeper view of those issues, a richer sense of those rhythms, than many contemporary novels by their portrayal of a religious dimension to the protagonists' quests.

In that the protagonist of Gordon's first novel escapes with two female friends from a life of service, the central figure of her second rejects a religious role and settles in a community of women whose priest is dying, the protagonist of her third confronts a religious fanatic who kills herself, and the matriarch of her fourth leaves the Church behind when she leaves Ireland, one could argue that religious and feminist concerns are at odds in Gordon's fiction and that all the novels move away from the former toward the latter. Susan Ward, for example, emphasizes the necessary rebellion of "self-assertive, intelligent young women" against the codes of the Church. Observing the same behavior but with a jaundiced eye, Carol Iannone claims that Gordon's books "are about the monumental self-centeredness released by the collapse of orthodoxy, the agitated emptiness that finds an expression in movements like feminism." But focusing solely on the rebellion can obscure Gordon's suggestion of the ongoing importance of the religious inheritance. And the assertion that feminism simply replaces religious orthodoxy does not ring true to the complexity of the novels, whose problems admit of no easy, self-centered resolution. As Margaret Drabble puts it, Gordon "asks questions rather than provides answers." Gordon's religious concerns enrich her feminist vision, even as her feminist concerns deepen her religious vision. . . .

Gordon, like Flannery O'Connor, one of her favorite writers, portrays characters who believe they are acting according to their religion but whose limitations of vision range from pathetic to monstrous. Gordon has noted the contrast between O'Connor's professed belief in the Incarnation as "the central mystery that shaped her life" and the kinds of characters she creates. Between Gordon's own belief in the importance of the Incarnation and the twisted Laura or Theresa one sees a similar contrast. In both writers' works, in the face of the characters' perversions of Christianity, the reader senses the reality of that which has been perverted, a possible living tradition the characters have misunderstood.

Meanwhile, many of Gordon's other characters do not have all the answers but ask the important questions. Gordon's women protagonists may find "temporary shelter," the title of Gordon's 1987 collection of short stories, at the ends of the novels but have not finally resolved their struggles. And Gordon places them within the context of many other characters' related struggles, for example those of Cyprian, Vincent, and Dan, on which this essay has had no time to dwell. She repeatedly focuses us on enduring questions of faith, hope, and charity.

We have seen in Gordon's works one apparently failed female Messiah figure (Felicitas) and two misguided crucifixions (Isabel and Laura) as well as several failed Marys. The women protagonists are all without belief in God, yet the power of the religious tradition remains. Certainly one of Gordon's key

achievements has been her portrayal of our denying our religious heritage at the same time that its questions and imperatives continue to surround and often pull on us.

Marcia Bundy Seabury. *Christianity and Literature.* 40, 1990, pp. 37, 53

GORODISCHER, ANGÉLICA (ARGENTINA) 1928–

In the collection of short stories entitled *Trafalgar,* Argentine writer Angélica Gorodischer relates the adventures of Trafalgar Medrano, an intergalactic salesman who recounts his experiences to his friends in Rosario, Argentina. The extraterrestrial frame serves as a device which enhances the "willing suspension of disbelief"; the reader accepts as fantasy the events described and neither expects nor receives scientific or rational explanations for most of Trafalgar's adventures. Nor is his ability to travel through space questioned or explained by the unnamed first-person narrator of most of the stories. What interests both her and Trafalgar is what happens on those visits, not the visits themselves. By placing the events on other planets, Gorodischer expands her possibilities in terms of character and action to include psychological and physical elements which, although often somewhat familiar to the reader, are nevertheless altered to a degree not encountered in the "real" world of Earth.

The two stories I shall examine, . . . "El señor Caos" and "Sensatez del círculo," center on the psychology of beings Trafalgar meets. The character for whom the first story is named and all of the native inhabitants of the planet of the second story display an altered state of consciousness which may be termed transcendent. While transcendent consciousness is not unknown on Earth, Gorodischer's presentation of it in aliens allows her to express its manifestation in unique ways. In "El señor Caos," the central character's consciousness is diametrically opposed to the exaggeratedly ordered psyches of the rest of the population of his world. The characters in "Sensatez del círculo" have advanced beyond the external trappings of "civilization" and remain in an internal world of perfect communication between themselves and the cosmos. . . .

While both stories center on the transcendent experience, Trafalgar's comprehension of that experience on each planet demonstrates the contrast between those manifestations, in "El señor Caos," only one character reveals an altered state of consciousness. Trafalgar's role in describing that consciousness is dual: he contrasts el señor Caos with the other inhabitants, and his participation in the conversation enables both the narrator/listener and the reader to arrive at an understanding of el señor Caos' consciousness. Trafalgar completely lacks that ability to communicate, on any level, with

the inhabitants of Anandaha-A. He is reduced to the role of spectator of the natives' dance and of Veri Halabi's transformation. Language is not a manifestation of the transcendent state; it serves only as a symbol which must be deciphered from the texts. Even with the translation of the texts, Trafalgar is at a loss without Simónides' explication of their symbolic language. Trafalgar's confusion in his encounter with this symbolic world is itself significant in that it focuses on the advanced nature of transcendence on the planet. The natives' consciousness cannot be understood by people who have not shared it; at most, its outward manifestations can be witnessed and the decoded texts can be used to explain it symbolically.

<div style="text-align: right;">M. Patricia Mosier. Chasqui. 12, 1983,
pp. 63–64, 70</div>

Angélica Gorodischer is an Argentine writer noted primarily for her science fiction short-story collections, which include *Bajo las jubeas en flor* (1973), *Casta luna electrónica* (1977), and *Trafalgar* (1979). With *Kalpa Imperial,* a two-book series of stories published in 1983 and 1984, Gorodischer turns from science fiction to fantasy to describe "el más vasto y más poderoso [imperio] que ha conocido el hombre" ("the most vast and most powerful (empire) known to man") in stories about the lives of many of the Empire's rulers.

In her previous works, the science fiction frame serves as a means to suspend the reader's disbelief rather than as a motivation or explanation of the stories' events. Her treatment of fantasy is similar to her treatment of science fiction: Inexplicable phenomena are not the impetus of the stories and do not even appear in many of them. The Empire is fantastic only in its vast physical proportions and its millennia of existence. The narrated events seem to exist outside of time, as the rulers portrayed are members of dynasties that endure for centuries. The chronology of the Empire's history is less important than the realistically depicted style and deeds of the ruler under consideration. Each ruler exemplifies an approach to the use of power, and the unifying thread of the stories—the rulers' ascensions to power and their use of that power—is a view of politics as real as the politics of any place or time. In *Kalpa Imperial,* what differentiates "good" rulers from "bad" is universally applicable: Good rulers do not place personal ambition before their primary duty of enhancing the welfare of the people.

The stories are narrated by prestigious "contadores de cuentos," storytellers who sit in public parks and relate orally the history of the Empire to its subjects. The first book, subtitled "La casa del poder" ("The house of power") focuses on the lives of Emperors and Empresses. The second, "El imperio más vasto" ("The wider empire,") while still concerned with the power structure, includes narrations about commoners. The Empire is centered in the cold North of the kingdom, an area of cities and commerce in which social and economic conditions do not differ radically from most past or present cultures: A strict class structure defines one's social role; war and

political intrigue are common; and women are limited in their possibilities by the patriarchal social structure. The often rebellious South, in contrast, is a warm, fertile area whose people live in small towns and work the land. Although only one story focusses on this part of the Empire, it is clear that Southern society is more egalitarian; its social and political structures allow for the expression of more humanistic values than do those found in the North.

M. Patricia Mosier. In Donald Palumbo, ed.
*Spectrum of the Fantastic: Selected Essays
from the Sixth International Conference on
the Fantastic in Literature* (Westport,
Connecticut: Greenwood Press, 1985),
pp. 153–54

Floreros de alabastro, alfombras de Bokhara (Alabaster vases, Bokhara rugs), by Angelica Gorodischer won the publisher Emece's 1984–85 prize unanimously. The Argentine writer . . . had already published about a dozen books when *Floreros de alabastro* appeared. . . . As Angela Dellepiani says, hers is an oeuvre with a "wide literary range." A noticeable fact is that she is the only Argentinean—not to say Latin American—woman writer who writes science fiction, the best example of which is her 1977 collection of short stories *Casta luna electronica* (Chaste electronic Moon). . . .

Gorodischer's resourceful expressiveness is immediately obvious when you begin to read *Floreros de alabastro*. This is the story of an adventure whose hero is a Buenos Aires widow, mature and energetic, who narrates the events with remarkable originality. Her endless commentaries on everything around her are a source of constant hilarity and frequent surprise.

The citation of the first two stanzas of a sonnet by Maria Eugenia Vaz Ferreira, "Yo era la invulnerable que por su ruta avanza," (I was the invulnerable woman who marches forward on her way), anticipates the novel's strongly feminist dimension, as does the central character's unusual personality. Furthermore, given the roguish humor of Gorodischer's later work, the inclusion of this poem, in which the Uruguayan woman poet describes herself as an indomitable Amazon who ends up surrendering to the kisses of the beloved, echoes the radio soap opera, which the novelist obviously has captured and makes use of to establish the playful tone that prevails in the novel. . . .

At first sight, this novel looks like a thriller. However, the author only uses detective fiction technique in its broad outlines. Curiously enough, her first literary effort was a detective story published in 1964 . . . which won second prize in the contest sponsored by the magazine *Vea y Lea*. Paradoxically, she then claimed that she was unable to subject herself to the internal logic of the detective story. Angela Dellepiani observes that the success of this story is due to the way Gorodischer ingeniously gives a turn of the screw to the basic detective scenario. By means of the detective plot, the writer

creates a tension between the text and the reader that motivates the reading and at the same time forces the protagonist to see her life from a new perspective. . . .

The central character's feminism in *Floreros de alabastro* is a feminism rooted in basic principles upheld by everything meaningful in human life. The widow is always ready to exercise her rights, but never sacrifices her femininity or her powerful maternal instinct for a minute. . . .

Maria Esther Vasquez perceptively describes the relationship between Gorodischer and her literary work. In her opinion, the narrator transforms the creation into a total ludic activity, taking her characters into unexpected situations, without losing sight of the vital material of which they are made. *Floreros de alabastro, alfombras de Bokhara* is no exception. The succession of extraordinary events build up to an equally amazing denouement, because the reader conditioned to the unexpected has no predisposition to a reasonable conclusion. The Argentinean novelist, once more rejecting literary conventions, offers us a human work, overflowing with humor and imagination that brings together certain Spanish American themes and contributes in a highly original way to the narrative panorama of the twentieth century.

<div align="right">Corina S. Mathieu. <i>Letras Femeninas.</i> 17,
1991, pp. 113–14, 118–19</div>

GOTŌ MIYOKO (JAPAN) 1898–1978

The history of tanka does . . . contain great stretches of monotony. The patient delver into the courtly anthologies must surely wish from time to time, whatever his patience, that a few of the poems about cherry blossoms could instead be about dandelions, a few of those about maple leaves might rather be about poison oak.

Yet tanka poets went on finding variations. An even greater wonder is that from time to time there have been bursts of great vitality. It still proves possible to make thirty-one-syllable statements that not only avoid repetition but speak to us with power and urgency. Our own century has been such a time. Tanka poets have preserved the thirty-one-syllable form and in varying degree adhered to the conventional subject matter, and yet managed to speak with voices and to convey experiences and emotions that could only be of our time.

Mrs. Gotō was among the major poets in this modern renaissance. She sometimes chose themes and subjects that had not much been used before. Probably the most famous and popular of her poems are on motherhood, inspired chiefly by the tragic death of her older daughter. Sometimes she brought new life to old and much-used themes (over-used, we might be tempted to say). For me the most remarkable of her poems are about cherry

trees. She did not use the image, as so many earlier poets did, to signify evanescence or something of the sort. Rather she sought to convey the immediate experience of a cherry tree; and she succeeded. It is a remarkable achievement, among the notable ones of our time. A theme so old and worn that one might have thought it on the point of expiration is made to live once more.

<div style="text-align: right">

Edward Seidensticker. Preface to Gotō
Miyoko. *I Am Alive: The Tanka Poems of
Gotō Miyoko, 1898–1978* (Oakland,
Michigan: Katydid, 1988), pp. 11–12

</div>

Written over some sixty years Miyoko's tanka reflect in microcosm Japan's struggle for identity as a modern nation. Here is a mirror in which one catches sharp glimpses of a woman full of the fascinating paradoxes that could be found in almost any Japanese who underwent the transformation of the first three decades of the twentieth century. Miyoko was traditional and inhibited, yet at the same time progressive and liberated; though shy and cautious, she was a strongly independent woman of powerful passions. . . .

Combining conservatism and modernism helped Miyoko rediscover and revitalize the tanka tradition, an achievement best exemplified in her tanka on *The Tale of Genji* and in her efforts to bring back through contacts with proletarian and amateur poets the vigor and freshness tanka once possessed before the long process of conventionalization. Having to work from a tradition at least twelve hundred years old Miyoko became a masterful practitioner who never hesitated to violate formal rigidity and abandon the narrowness of simple refinement in her effort to treat new topics demanded by her modern perception and international experiences. Even her most private poems share this expansiveness which illuminates a whole range of human relationships between four generations of women—her mother, Miyoko herself, Miyoko's daughters and her only granddaughter—all of them typically, but not only, Japanese. Miyoko's deeply involved and involving experiences of love, anger, hatred, anxiety and joy achieve an extraordinary intensity. . . .

Some critics, uneasy with Miyoko's openness about her private life, have called her poetry "ego-centric" and accused her of insensitivity to those she exposed to the public eye. Others, while recognizing the powerful integrity of her work, wish for a broader social and historical outlook. It seems to me, however, that Miyoko's poetry is able to transcend her private experiences precisely because it is so firmly grounded in them. Her integrity permitted her to go beyond petty conformity to social niceties, but she was sometimes disturbed that her poetry might possibly harm others. Still, she was unable to avoid becoming "the demon of tanka."

<div style="text-align: right">

Reiko Tsukimura. Introduction to Gotō
Miyoko. *I Am Alive: The Tanka Poems of
Gotō Miyoko, 1898–1978* (Oakland,
Michigan: Katydid, 1988), pp. 13–14, 17

</div>

With the abrupt and dramatic modernization of Japan, traditional forms of literature—as well as traditions in other spheres of life—were attacked, defended, refined, expanded; some survived. Gotō Miyoko participated in the renovation of *tanka* ("short poem"; or *waka*, "Japanese poem"), the thirty-one-syllable construct that had been a basic poetic form for over a millennium. She both challenged and supported the tradition. The challenge was with proletarian poems that depicted nontraditional subjects, used colloquial rather than classical language, and stretched the traditional five-line structure: "A haggard mother runs to the factory, / her child racing after her, no time to wipe his nose" . . . "At last the baby sucks firmly, but the afternoon work-/ siren snatches away the breast." She supported the tradition, however, by using its structure and nuance in poems both subtle and startling and is best known for the psychological intensity of her poems about motherhood. . . .

I Am Alive has many fine translations of exciting poems, and it is a pleasure to meet with them: "Potatoes / the large ones silent / the small speaking aloud". . . . The organization of the book, however, is rather cumbersome for such a slim volume: there is a brief preface by Edward Seidensticker; an introduction, chronology, commentary (divided chronologically), and notes by Reiko Tsukimura; and the Japanese texts of the poems (as well as a bibliographic note and an index of first lines). The division of discussion about the poet and her times among those parts makes the information seem repetitive and superficial. The death of the poet's daughter and her estrangement from her granddaughter in particular are subjects which demand greater analysis and subsequent insight: otherwise they are best left to the poetry to express. The poems themselves are, in Tsukimura's translations, alive and enlivening. They are a gift to the reader of discovery and satisfaction.

Amy Vladeck Heinrich. *World Literature Today*. 64, 1990, p. 364

Gotō Miyoko . . . belongs to the generation of *tanka* poets after Saitō Mokichi. She was a highly respected poet, but in contrast to the many works about Mokichi and the over 50 volumes of his complete works, as yet, according to Tsukimura's Bibliographical Note, no full-length study of Gotō Miyoko's work has appeared in Japanese, and the definitive edition of her poetry is but a single volume. The situation may have changed since 1988, the year this book was published, but the fact remains that *I Am Alive* is the first full-length work on Gotō Miyoko in any language.

Tsukimura has translated 246 poems, most of them *tanka*, a few *chōka*. Edward Seidensticker has contributed a preface on the *tanka* tradition. Tsukimura's introduction and extensive commentary set the poet's work beautifully in context, and her notes explain essential details.

Tsukimura suggests that Gotō Miyoko's poems, especially those about relationships with the members of her family, "can be read as an autobiography in the form of the traditional tanka." The poet's interests were not exclu-

sively personal, however. She was deeply involved in the proletarian *tanka* movement in 1929–30 and later, by selecting *tanka* for the *Asahi shimbun* *tanka* column for 22 years, maintained contact with thousands of amateur poets of all ages and occupations. She was also the *tanka* instructor for the present empress when she was still Crown Princess Michiko.

In Tsukimura's view, Gotō Miyoko's work takes to an extreme the human, narrative elements of *tanka*. To illustrate her point, Tsukimura compares Bashō's famous *haiku*

> In the same inn
> prostitutes also sleep—
> Bush clover and moon [I have changed Tsukimura's punctuation
> to clarify the meaning]

with one by Miyoko, also on prostitutes:

> Casting
> envious glances
> at my child
> prostitutes roam the streets,
> lipstick bright.

The *haiku,* writes Tsukimura, focuses on nature, while the "humans fade into the background, harmonizing with it." "The tanka," in contrast, "involves itself." Or, as the poet herself put it, "Tanka looks for the dust."

Two of Gotō Miyoko's central themes were her children (she had two daughters) and cherry blossoms. Like most good poets, she also wrote meta-poems about writing poems. Here are poems on two of these topics:

> On the ground
> the shadow of my child
> darkens;
> I trace the shape of her ears,
> and feel my love.

> When a poem
> is born, life seems
> whittled away;
> I know such moments
> and secretly fear them.

The simplicity of Tsukimura's translations reflects the originals; nothing has been added, nothing taken away. Quite often, as in the poems above, something has been created that is also poetry in English.

Janice Beechin. *Journal of Japanese Studies.* 18, 1992, pp. 197–98

GRAU, SHIRLEY ANN (UNITED STATES) 1929–

Most of these stories center around Negroes in Louisiana. . . . These "colored" stories are quite definitely the best of her work. The reader may be occasionally mildly troubled by Miss Grau's tendency to blur or confuse her own point of view with that of her focal characters as she does in the rather unsuccessful story "Miss Yellow Eyes"; for the most part, though, she writes with considerable control and skill. More important, she sees and hears well; most important, she understands what she sees and hears. To an uninitiated ear her dialect is for the most part effective; her people are almost always convincing. Miss Grau, further, displays considerable variety and flexibility; whether she works in the border-region of myth and folklore, as she does in the effective title story of Stanley "the Black Prince" . . . or in the more traditional medium of the realistic "The Way of a Man," she avoids sensationalism, violence, and whimsy for their own sakes. She writes out of neither sentimental love nor tear-filled despair. Hers is not a namby-pamby world of dreams, or a darkened alley in which animals die meaningless deaths. Frustration and violence and death are present in her world, but so also are serenity and achievement and life.

<div align="right">William Peden. <i>Saturday Review of
Literature.</i> January 29, 1955, p. 16</div>

Her basic approach in the stories was one of careful atmospheric setting. She has used the same technique in the novel [*The Hard Blue Sky*], painstakingly describing the coast, the islands, the desolate sweep of marshes, birds, oaks and palms, the packs of wild dogs that overrun the Isle aux Chiens—her island world, a terrain outlined minutely and enclosed by water and the hot summer sky. . . . Miss Grau writes wonderfully well about people—there isn't a character on the island who doesn't come alive, and no two, even though everyone on the island seems to be more or less vaguely related, who are alike. Her handling of the relations between men and women is particularly perceptive, but again it is her knowledge of and interest in character that reveals so much about these relations. . . . Above all, Miss Grau is a natural story-teller, and her novel has a kind of casual looseness that makes room for many stories, tales which, far from destroying the unity of the book, tighten the fabric of the world she constructs.

<div align="right">Elizabeth Bartelme. <i>Commonweal.</i> July 11,
1958, p. 380</div>

[*The Hard Blue Sky*] belongs in the category of novels which are essentially evocations of a little-known region or place—in this case a small, primitive, storm-swept island off the Louisiana Coast on the edge of a dangerous swamp. The people on the Isle aux Chiens are of mixed French and Spanish descent, and their curious speech is peppered with eroded bits of French. . . . Miss

Grau recreates in all its dimensions the singular life of an inbred, almost isolated little world. She is a fine artist, but she has stretched her material too far; it could have been handled more effectively within the compass of a novelette.

Charles Rolo. *The Atlantic Monthly.* August,
1958, p. 84

The Hard Blue Sky, to the extent that it needs to be classified, belongs to the old-fashioned school of regionalism. *The House on Coliseum Street* could be Gothic but isn't: . . . it is not even specifically Southern. It is full of the sights and sounds and smells of New Orleans and the surrounding country; that is the kind of writer Miss Grau is. But its essential action could take place anywhere.

To me *The House on Coliseum Street* is not so exciting as *The Hard Blue Sky,* but it is a good book for Miss Grau to have written at this point in her career. Her control is perfect, and there isn't a scene that doesn't count. Her senses are acute, and, as I have said, they make their contribution to the texture of the novel, but there are no descriptions for the sake of description. The writing, as always, is wonderfully firm. Miss Grau is not exploring new territory, as she was in some of her stories and in *The Hard Blue Sky,* but she has done admirably what she wanted to do, and she has left us with a picture of a young woman that it will be hard to forget.

Granville Hicks. *Saturday Review of
Literature.* June 17, 1961, p. 20

The most effective aspect of Miss Grau's work here [*The House on Coliseum Street*], to my reading, is the conveyed awareness of loss and emptiness following the abortion. . . . Joan is haunted by "that first ghost child Ghost child, lost child" and in her imagination it takes on the aspect of a bit of seaweed, "my seaweed child."

This, in what seems to me the novel's furthest imaginative grasp, becomes the ultimate loneliness, the lost "heart ticking away inside. . . . The soft floating seaweed bones."

But there are only occasional and faint flashes of such imaginative and verbal magic here, magic which lit up page upon page of Miss Grau's memorable first book, *The Black Prince and Other Stories.*

Coleman Rosenberger. *New York Herald
Tribune.* June 23, 1961, p. 6

Shirley Ann Grau has been demonstrating her gifts as a sensitive observer of human development and growth for some time now. With a few words she can establish a mood, mixing man's emotions with appropriate reflections of them in landscape. . . . She knows the people, knows the ambiguities of race relations, the devices, pretenses, ironies, absurdities and incredible frustrations. . . . Most significantly, she writes at a time when she can know some

answers too. For this is a novel [*The Keepers of the House*] which in its own sudden and firm way has a statement to make . . . She gathers herself together and ends her story by insisting that deceptions exposed are ultimately if painfully better than compromises and falsehoods endured.

Robert Coles. *New Republic*. April 18, 1964,
pp. 17–19

Shirley Ann Grau is a Southerner who writes about the Deep South with a word choice as fastidious as Willa Cather's and with a passion aroused by the turbulence in her home country. Her new novel, *The Keepers of the House* . . . , a beautifully designed, beautifully written book, is a story told in two moods. The first half is the evocation of the William Howland plantation. . . . The tone of the telling changes after [William's granddaughter] Abigail's marriage to handsome John Tolliver. She suspects that he married her for her money, and he did; and she suspects that he is a philanderer, which he is. But she knows that he is a hard worker in his law office, and she loves him; she bears their children and works for his political career, until they are flung apart by the scandal over Old Will's miscegenation. The bitter vengeance that follows is hard to take.

Edward Weeks. *The Atlantic Monthly*. May,
1964, p. 135

There is no denying the fact that Grau's career has moved in several distinctly different directions since she began to write professionally. Like so many younger authors, she suffered from hyperbolic overpraise for her first published fiction. The critical commonplace that her early work is her best remains true, and it is this early work that seems in retrospect to have prompted the most wildly inappropriate acclaim, as critics outdid each other in finding authors with whom to compare Grau. . . . One can conclude quite easily that this collected (and premature) acclaim was simply too immense a load for a young writer to carry.

For with such enthusiastic praise as she received for her early books, there was simply no way for anyone short of a Faulkner to continue the pace. And Grau, though a writer with decidedly well-developed talent, is simply not so consistently in the same league as some of those with whom she has been compared. Consequently, when she changed subjects, techniques, or locales, the inevitable revisionist thinking set in, with critics trying to balance their earlier excessive praise with excessive reproach that was fully as hyperbolic.

A more balanced initial reception, in retrospect, would no doubt have been preferable to the acclaim, for it is undeniable that much of what Grau does is craftsmanlike, perceptive, and enduring, just as it is true that much is unconvincing, stereotyped, and curiously thin; what she does well she does very well indeed, but when she falters, the result can be embarrassing. Among the things she does best are handling regional characters, settings,

and issues; probing into the manipulations of those seeking power, wealth, and influence; and depicting primitive, even primordial, forces in conflict. Among the things she seems to handle less well are creating urban (as opposed to rural) people involved in their humdrum daily pace, probing deeply into character motivation, and demonstrating any overriding philosophical perspective governing her fiction.

As a regional novelist, for example, Grau is particularly effective in delineating the manner in which her characters—particularly blacks and primitives—move easily through settings which in other hands would be merely picturesque or romantic. As one critic noted persuasively, "nature is her vision, the focal point of her best fiction," with "nature" in this case implying the pervasive sense of animal and plant references and imagery that in themselves constitute, for this critic, a "vision" of indifference and impartiality. Indeed, Grau's objective handling of her characters' lives is often cited as one of her special strengths. Her sense of "place" is strong, and Grau's best work is that growing out of her lifelong experience with the hot, humid Gulf Coast below New Orleans.

One can see, again in retrospect, that much of her fiction in concerned with various kinds of love and power, as well as with the manipulations of others that so often is a part of craving such love or power. Not surprisingly, most of her characters seem incapable of a mature acceptance of either of these two forces in life, for both readers and writers find accounts of depravity, evil, hatred, and power-hunger more persuasive as fictional subjects than the seemingly naive celebration of pure love, mature handling of power, and rejection of evil in one's life would be. . . .

On more formal grounds, one can see that Grau's strength is more as a stylist than as a constructor; that is, she is better at creating a sense of mystery or an atmosphere laden with exotic sensory stimuli than she is in creating plots that end conclusively. A good deal of her fiction simply ends, as with the protagonist's death, or in other ways equally unsatisfying; and all too often her characters simply fall into a fetal position at moments of crisis, evidently a hysterical reaction to the problem requiring resolution in their lives. Simply as a storyteller, Grau is excellent, even if these stories sometimes are offered at the expense of "message" or thesis. As has often been noted, Grau has observed that she has "no cause and no message," a candid but disarming admission. For even without writing heavily thesis-laden works, works that clearly are written primarily to support one conviction or other, she surely could have suggested a greater commitment in her characters' lives. As it is, though, we sometimes simply do not get "inside" her characters sufficiently to be able to say what it is that motivates them or that causes them to respond to others as they do. Objectivity, then, is fine up to a point, but the reader often wishes for more of a sense of engagement in the characters' actions and responses.

In this respect, one should note Grau's effective, objective use of violence; through a simple, usually direct style, her uncomplicated characters

enter into violent situations as often because of circumstances as because of deeply flawed personalities. The term "documentary" has been used to discuss this aspect of Grau's work, to indicate her tendency to record rather than to interpret. For since Grau works "without a dominant theme or an explicit philosophical view," even her use of violence is less an example of grotesquerie in her characters than it is their sole means of reacting against injustice, hatred, or whatever; it is simply their reaction against "anxiety, frustration, and insecurity."

Grau, therefore, is a fine example of the regional novelist whose best work surpasses mere regionalism, whose other work is always interesting even when deeply flawed, and whose overall career, despite the early extremes of praise accorded it, has been a steady, sure development of one who sees that the many forms of love, evil, and power possible in human life are best personified in the lives of ordinary people from the region she knows— and loves—the best. All in all, this is no small achievement, and one cannot omit the possibility that her future career as a writer will take even more changes of direction as she continues to explore the machinations of evil in human life.

Paul Schlueter. *Shirley Ann Grau* (Boston: Twayne, 1981), pp. 140–43

For those who find in houses evocative symbols, "house-holders," . . . few other human symbols are so significant. Bachelard observes that, "Without it [a house] man would be a dispersed being. It maintains him through the storms of the heavens and through those of life. It is body and soul . . . the human being's first world. Life begins well, it begins enclosed, protected, all warm in the bosom of the house." An integrating force, a house holds the promise of physical and psychological well-being; it promises safety and respite from trouble.

Exploring the history or decor of Shirley Ann Grau's fictional houses is less productive than exploring her use of the spatial value of a house and her examination of that missing narcissistic sense that a house reflects none other than oneself. For Grau, the house is center and substance of each fictional world. Relying upon spatial values, she succeeds in gathering characters and readers about an ancient symbol of sheltering places and spaces. Her houses can represent the final hope of those struggling against the outer dark like Mamere Terrebone in *The Hard Blue Sky* and Abigail Mason Tolliver in *The Keepers of the House*. More often they represent an often-destructive shelter from which to escape. Annie Landry in *The Hard Blue Sky*, Joan Mitchell in *The House on Coliseum Street,* the young Margaret Carmichael in *The Keeper of the House,* the child-suicide Anthony and Stanley in *The Condor Passes,* Edward Henley and his son Stephen with his Florida retirement home: all forsake the walls of a house because they are not mirrored in them. Finding not gratification but threat therein and torn by the life they find, they look elsewhere.

From *The Black Prince,* her first book, to *Nine Women,* her most recent, Shirley Ann Grau has found resonance and meaning in the image and symbol of houses and in the motif of the character displaced from them. Her comprehensive house-consciousness—her using interior places and spaces, heights, and the disordered impersonal world just beyond the threshold—all suggest a writer deeply aware of the symbolic nature of houses in her own and her characters' lives. Her fictional houses have provided her work with a unifying symbol and incident, an organizing pattern which critics of her work have failed to notice. Her readers share the human core both of those who must build inward in order to survive and of those who must leave such inwardly leaning or inclining walls to go outward.

<div align="right">Anthony Bukoski. Critique. 28, 1987, p. 191</div>

GREGORY, LADY [AUGUSTA] (IRELAND) 1859–1932

Lady Gregory's "translations" [*Cuchulain of Muirthemne, Gods and Fighting Men*] are not to be judged for what that term implies. They are not so much translations as folk-versions of the old saga, adapted to literature. . . . Lady Gregory is the first and only writer of the Revival to employ the peasant idiom in narrative prose. . . . It was a fine literary instinct that guided her in making this innovation, for, stripped of their language, her stories of Cuchulain and the Fianne would have been lost in the anonymous mass of similar popularization. As it is, she has been saluted by many as an Irish Malory, and her work has shared in the general admiration for the beauties of an idiom illustrated shortly afterwards by the genius of J. M. Synge. The young writers of a generation unfamiliar with the emotion aroused by O'Grady, in the distant days when his rehandling of the bardic material was a revelation, may derive from Lady Gregory's pages that enthusiasm for heroic beauty which inspired the first movement of the Revival.

<div align="right">Ernest A. Boyd. Ireland's Literary
Renaissance (New York: Knopf, 1916),
pp. 396–97</div>

It was Mr. Bernard Shaw who, in commenting on the rowdy reception of the Irish players in some American theaters, spoke of Lady Gregory as "the greatest living Irishwoman." She is certainly a remarkable enough writer to put a generous critic a little off his balance. Equal mistress in comedy and tragedy, essayist, gatherer of the humors of folk-lore, imaginative translator of heroic literature, venturesome translator of Molière, she has contributed a greater variety of grotesque and beautiful things to Anglo-Irish literature than any of her contemporaries. . . . She is one of the discoverers of Ireland. Her genius, like Synge's, opened its eyes one day and saw spread below it

the immense sea of Irish common speech, with its color, its laughter, and its music. It is a sort of second birth which many Irish men and women of the last generation or so have experienced. The beggar on the road, the piper at the door, the old people in the workhouse, are henceforth accepted as a sort of aristocracy in exile.

Lady Gregory obviously sought out their company as the heirs to a great inheritance—an inheritance of imaginative and humorous speech. . . . Her sentences are steeped and dyed in life, even when her situations are as mad as hatters.

Some one has said that every great writer invents a new language. Lady Gregory, whom it would be unfair to praise as a great writer, has at least qualified as one by inventing a new language out of her knowledge of Irish peasant speech. This, perhaps, is her chief literary peril. Having discovered the beautiful dialect of the Kiltartan peasantry, she was not content to leave it a peasant dialect—as we find in her best dramatic work, *Seven Short Plays*—but she set about transforming it into a tongue into which all literature and emotion might apparently be translated. Thus, she gave us Molière in Kiltartan—a ridiculously successful piece of work—and she gave us Finn and Cuchulain in modified Kiltartan, and this, too, was successful, sometimes beautifully so. Here, however, she had masterpieces to begin with. In *Irish Folk History Plays,* on the other hand, we find her embarking, not upon translation, but upon original heroic drama, in the Kiltartan language. The result is unreality as unreal as if Meredith had made a farm laborer talk like Diana of the Crossways. . . . It is because the characters in the comic plays in the book are nearer the peasantry in stature and in outlook that she is so much more successful with them than with the heroes and heroines of the tragedies.

<div align="right">Robert Lynd. Old and New Masters
(London: T. Fisher Unwin, 1919), pp. 178–81</div>

Lady Gregory has written thirty-one original plays, of which all but two have been produced at the Abbey Theatre. She has been writing plays for twenty-five years, in addition to her splendid work as a Director of the Theatre, a biographer, historian, and folk-lorist. Her industry and enthusiasm are amazing, resembling somewhat those Spanish dramatists at whose versatility Northern Europe stands aghast. Most of her work can be studied on the printed page as it has nearly all been published. Her first volume of plays, *Seven Short Plays*, 1909, contains her most popular and much of her typical work. Some of these plays have been referred to already, they are farcical comedies with a strong undercurrent of satire. In *The Workhouse Ward*, 1908, is satirized that tendency to quarrel about nothing which is marked in (though not peculiar to) Irish people. It is possible that a political satire was intended, and perhaps the play says more about Irish politics than the politicians have yet learned. The political interest is stronger in *The Rising of the Moon*, 1907, in which those who appear to be against the Irish struggle for political liberty

are shown not to be so in fact. A conflict between sympathy and duty rages about the police sergeant who is the central figure in the play. The sergeant's choice is difficult, and the artistry by which Lady Gregory enables the ballad-singer to arouse his latent patriotism is a masterpiece of dramatic technique. Another of these short plays, *The Gaol Gate,* 1906, has all the tragic intensity of *Riders to the Sea,* reaching a climax in the triumphant *caoin* of grief and joy with which the mother greets the news of her son's fidelity till death. All the elements of doubt and uncertainty, pity and helplessness, are combined in this little play to make it one of the great tragic experiences of the modern theater. . . .

Grania is Lady Gregory's highest achievement in historical tragedy, and here she is superior to the Ibsen of *The Vikings at Helgeland,* the Strindberg of *Gustavus Vasa,* or the Hauptmann of *Florian Geyer.* In emotional content and poetic intensity *Grania* can bear the comparison with Synge's *Deirdre* to which it has been subjected. Deirdre has had her admirers in plenty, almost every Irish poet is included in the number, but Grania has had, if the result of the Moore-Yeats collaboration be ignored, only Lady Gregory. . . . "I think," says Lady Gregory, "I turned to Grania because so many have written about sad, lovely Deirdre, who when overtaken by sorrow made no good battle to the last. Grania had more power of will, and for good or evil twice took the shaping of her life into her own hands." In this three-act tragedy of love and jealousy there are only three persons, but in falling under the spell and "fascination of things difficult," Lady Gregory achieved her masterpiece in tragedy. It is generally considered that she is at her best in the one-act play, and it is true that she has failed more often in her long than in her short pieces, but the success of this three-act play in characterization, dialogue, and construction is a standing refutation of the statement.

<div style="text-align:right">

Andrew E. Malone. *The Irish Drama*
(London: Constable, 1929), pp. 158–61

</div>

She started to write comedy because the Abbey was short of comedies, and she was craftsman enough to shape what she had to the theater's needs. *Spreading the News* came to her as an idea with possibly tragic connotations: she "kept seeing" an image of a girl going to market, "gay and fearless," but coming home in the evening with her head hanging and avoided by the crowd because of a story that had arisen from a chance word. It might have made a serious play, but comedy was needed at that time for the Abbey, and Lady Gregory made it her quickest comedy. Quickness and spareness are her assets. Her tragedy has them too. If she had only a limited range of things to say, as least she knew better than to say more. Yeats regarded himself as a sparer, quicker, concise developer of stage situations, yet whereas he and Moore had made a *Grania* traffic-blocked with characters, she astonished him by making a *Grania* out of three characters and with those three eliciting from the traditional story the Irish father-son problem and her private problem of the appeal of a strong woman.

It is both a limitation and an excellence of her theater that the allusions depend on her intimacy with the audience. Think of her as a writer thinking of her audience, and you see that she chooses every word with warmth and purpose. In her first draft for a play, *Coleman and Guaire,* she conceived herself as providing material for Kiltartan schoolchildren to play to Kiltartan people. Later, even in the most ambitious work, the conception was similar. She hoped that her histories would be played in the schools of Ireland to inform and inspire Irish children. The texts crackle with topical allusion, with instruction and exhortation. . . . Lady Gregory works entirely on the basis of that consent between author and audience to discuss—even if to quarrel— Ireland and Irish issues: actually, she herself never challenges a quarrel; she never gives less than a whole-hearted treatment of the issues, she never is unorthodox on them, she never goes outside them to use the enriching terms of other interests and other literatures.

<div style="text-align:right">

Herbert Howarth. *The Irish Writers: 1880–1940* (New York: Hill & Wang, 1958), pp. 100–101

</div>

The base to Lady Gregory's personal theater was the little community of Kiltartan, where through restricted dialect and characterization she managed to express her universal comic vision. Closer examination reveals two basic themes which are both universal and persistent: the idealist and his shattered dream. As all who knew her attest, and as can readily be observed from her writings, Lady Gregory had a deep sympathy with the "image maker," the rebel who must stand alone, apart from his community and yet bound to it by his dream. "To think like a wise man, but to express oneself like the common people" was her favorite quotation from Aristotle; perhaps she too felt the inevitable loneliness of the leader who must take his own way. For as Yeats has said, "always her wise man was heroic man."

It is not surprising to discover in her first folk-histories, therefore, an emphasis far more personal than historical in her examination of three "strong people of the world": the tragic heroines of Irish history, Gormleith, Dervorgilla, and Grania. . . .

It is perhaps inevitable that the celebration of the rebellious individual should appear under the mantle of tragedy, for in Lady Gregory's universe, as in Yeats's, such is the fate of those who take destiny into their own hands. But as one observes in Yeats's heroic fool, clearly the struggle is worth it, for only in controversy against inevitable Fate or overwhelming odds does he realize his full strength. This is the message of Grania, Gormleith, the penitent Dervorgilla; it is the message of Ireland's history. And when we turn from the tragic "tragi-comedies" to the "pure" tragedies, *MacDonough's Wife* and *The Gaol Gate,* we find the same stirring call to inner strength and the independent spirit.

The world in which Lady Gregory's plays have reality is very much a people world, inhabited by characters who are all gifted with loquacity and

infinite capacity to believe, their individuality a result of fertile imagination. Consequently she rarely scales the heights of heroic tragedy, for as Yeats pointed out, the spirit of laughter is a great deflater, and once Lady Gregory allows her little people to take on their wayward personalities, she is no longer in control.

<div align="right">

Ann Saddlemyer. *In Defence of Lady Gregory, Playwright* (Dublin: Dolmen, 1966), pp. 63, 72

</div>

Lady Gregory's use of character in her comedies is far from romantic, it is classical. She would subscribe to the Aristotelian view that character is present for the purpose of the action. In some ultimate sense, however, for her the action is there to present the static image of a world. One imagines that with the conclusion of one of her actions and with, say, the next morning's opening of the shops in Cloon Square, all things and all people will be at the places appointed them in the original stage directions. This is obvious in such shorter plays as *The Workhouse Ward* and *Coats,* least obvious but equally true in *Spreading the News,* where at the play's end certain things remain to be cleared up among the characters before the original situation is restored.

The Workhouse Ward (1908) has the quality of a tableau that is for a little while interrupted by a minor crisis resolved ironically. It invites a brief meditation on its scene—two old paupers endlessly wrangling in their separate beds. It is not surprising that Lady Gregory herself meditated upon the scene and observed, "I sometimes think the two scolding paupers are a symbol of ourselves in Ireland—"It is better to be quarrelling than to be lonesome.'" *Coats* (1910) offers the picture of two rival newspaper editors lunching at the Royal Hotel, Cloonmore. The action of the play is a confused argument between them over their respective obituary notices. It breaks the quiet of their lives, but is resolved. One imagines them sitting there again at the next noon, the next argument on another subject, but again resolved.

Lady Gregory's plays are very Irish, but they arise out of a conception that life is everywhere fundamentally the same and that the fundamentals do not change from age to age. This is the attitude of the folklorist and of one who is conscious of a tradition and seeking to preserve or restore it. Finally, it is one of an artist observing a society that has been conservative, isolated, and jealous of its privacy, suspicious of the invader.

<div align="right">

Hazard Adams. *Lady Gregory* (Lewisburg, Pennsylvania: Bucknell University Press. 1973), pp. 73–74

</div>

The false image of Lady Gregory's personality and capacities painted by Joyce, Gogarty, and Moore has survived almost to the present day; for even her recent critics have tended to ignore the extent to which her plays, translations, and organized powers were respected in the early years of the twentieth century. Moreover, what these three satirists left unscathed, the august pres-

ence of Yeats tended to obscure. Lady Gregory throughout her lifetime, how-
ever, was as much a rebel as any one of her detractors. Her muted but
dedicated refusal to accept the status quo began in her desire to break away
from the repressive surroundings of Roxborough. . . .

A few years later her rebelliousness and her objectivity were evinced by
her abandonment of a short-sighted and restrictive Nationalism in favor of a
consideration of the individual. Her synthesizing ability resulted in her per-
ception of the magic behind everyday country experiences, in her eye for
the key anecdote that reveals the human being behind the political mask, in
her surprise with and fulfillment in the resuscitating Gaelic movement, and
in her power of remaining distant from the more esoteric philosophizing of
Yeats. On a few occasions, Lady Gregory's exuberance led her to judge
falsely; but these instances occur primarily in her "wonder works," the magic
and fantastic collections which, by implication, she finds equal in importance
to the eloquent and noble *Cuchulain of Muirthemne*. In the totality of her
work in Irish myth, however, she succeeded in sending Irish culture abroad,
even though she paid little attention to historicity. . . .

In her final years, Lady Gregory emphasized a strain of mystical thinking
that had been present from the start in her works. Its two embodiments,
fantasy and spirituality, were objectified by the political horrors of the years
after 1916, by her disappointment over the theft of Hugh Lane's pictures, by
the growing importance of Realism in the theater, and by the necessity, after
so many years, of capitulating to a governmental censor. The fantasies, such
as *The Dragon* and *Aristotle's Bellows*, are notable for their blend of bur-
lesque and pathos. The mystical works, especially *Dave*, have their share of
literary permanence.

In short, Lady Gregory's career was a rich and full one. She participated
in all the central movements of an interesting and vital age, and she shaped
the energies of the principals and added her own blend of humor and magic
to the more dour moments of Irish Renaissance literary polemics and politics.
With a personality that was a combination of deep-rooted tradition and lofty
idealism, Lady Gregory seemed to know always just what was needed and
how to go about accomplishing her design. At all times, her great wish was
to create what was worthwhile and artistically truthful, in spite of nationalis-
tic and religious pressures, and to provide a forum for others capable and
willing to add dignity to Ireland.

<div style="text-align: right">

Edward A. Kopper, Jr., *Lady Isabella
Persse Gregory* (Boston: Twayne, 1976),
pp. 138, 140–41

</div>

[*Cuchulain of Muirthemne,* 1902] and *Gods and Fighting Men* (1904), a retell-
ing of Irish mythology and the stories of the Fianna, became basic source
books of Irish legend for many writers who could not read the tales in their
Gaelic originals. Both books, and others which followed, showed that Lady
Gregory was very skillful in adapting the work of scholars to the style, point

of view, and idiom of native storytelling; she was, in fact, the best popularizer of legend and folklore the Irish Renaissance produced. . . .

She was a very productive writer during a career which began when she was almost fifty and only ended with her death at eighty, producing several books of legend and folklore, more than twenty original plays plus almost as many collaborations and translations, books on the Irish theater, and autobiographies. All this was the product of constant hard work, hard work which also attended to years of day-to-day management at the Abbey, an enormous correspondence, the upkeep and supervision of Coole, and constant attention to her family and to younger writers. Those who knew her often describe her strength and purposefulness, and she must have been a rather daunting figure at times. Yet there is a controlled twinkle in the eye in her best photographs; control of herself and amusement at the world's foibles were two of the secrets of her career. A third secret was her passionate love for Ireland, the Ireland of Coole with its beautiful house and deep woods, but love also for the Ireland of dull little Gort, the Ireland of urgent nationalism, and the Ireland which the Abbey embodied. She was a persistent and courageous woman, fearless in defending her friends, the theater company she nurtured and sustained, and the ideals she came to believe in. One night during the Anglo-Irish War, when she was in her late sixties, she was waiting for a tram with the secretary of the Abbey after the night's performance. Shots rattled in the street, and she was begged to lie down on the pavement. "Never!" she answered as she shouted out encouragement to the rebels. That courage carried her through "the troubles" in Ireland, the death of her son in World War I, and the eventual sale of Coole. She was herself a great rebel against her background and her class, a fighter determined to do all she could for Ireland and Irish drama, a rebel who knew that every cause worth fighting for has its funny side. Only a person of great courage and great humanity could write as she did toward the end of her life, "Loneliness made me rich— 'full' as Bacon says."

<div style="text-align: right;">

Richard Fallis. *The Irish Renaissance*
(Syracuse: Syracuse University Press, 1977),
pp. 99–101

</div>

Lady Gregory published in 1912 two volumes of what she called *Irish Folk History Plays—First Series* and *Second Series.* The *First Series,* "concerning strong people of the world," as she says in her dedication to Theodore Roosevelt, "one of the world's strong men," is labeled "Tragedies," the *Second Series,* "Tragic-Comedies." While she unabashedly places her play *Grania* as the first of the "tragedies," however, critics have since been reluctant to see it as a real tragedy. That is, they concede tragic elements within the play, but imply that the real tragedy is associated with external personal matters that generated the play to begin with. . . .

There is no question . . . about Grania's strength. But we [see] a very real reluctance to confer upon her story the distinction of tragedy. While she

does not physically die in the end, however, we cannot say that she goes off to marry the king and live happily ever after. Dying, in fact, might have been the easier course, and it is only her extraordinary strength that allows her to reject it. But in a sense Grania does die in the last act, because through the process of selection and emphasis in her work with the myth, Lady Gregory has defined Grania's character and her very being as that of the lover, even to the extent of having her love endowed by fatalistic powers beyond the realm of human intercourse: the exposure of Diarmuid's love spot corresponds to Juliet's crossed star, to Iseult's love potion, and to the prophecy about Deirdre and the sons of Usna, and so is removed from an ordinary human love that is kept impure by life's other motives and instincts. The Grania who is this lover is certainly dead at the end of the play, killed by a tragic vision brought about through the sequence of events that close in upon her. Her last gesture may be to open the door and with a look of fierce nobility put a sudden stop to the derisive laughter, but that look itself has behind it the bitterness of a terrible cynicism, as revealed in her final line, when she says that "there is not since an hour ago any sound would matter at all, or be more to me than the squeaking of bats in the rafters, or the screaming of wild geese overhead!" Finn's new queen cannot participate in human affairs even as do other queens, because she has really lost her humanity with her love in playing out her tragic role. This is Lady Gregory's embellishment, or contribution to the myth—to answer the "riddle" that Grania's behavior "asks us through the ages." The ambivalence that many critics have found in Grania's role as a tragic lover does exist in the myth; it does not exist in Lady Gregory's play.

Finally, as to the other two characters in the drama. Finn is more or less enlightened in the end, but enlightenment, instead of inspiring him to heroic action, subdues him, and the man who was once a giant and hero is led off by his new queen a broken old man—one could say timid and doddering, even, if it weren't for the bit of strength with which Grania infuses him, and which allows him to face the crowd at the very end with his arm around her. He is a figure, certainly, of pathos rather than tragedy. Both Finn and Diarmuid had been treated more generously by Yeats and George Moore, who had, while making some departures, generally kept more closely to the myth that Lady Gregory had prepared for them. Motives are considerably muddled in the 1901 *Diarmuid and Grania,* but Grania is more aggressive in luring Diarmuid into the woods (the love spot is not mentioned), Diarmuid generally carries more of his own weight in the love affair afterwards, and Grania's love for Diarmuid is compromised by an ambivalent attraction she feels for the great Finn after the seven years in the country. In the end Diarmuid, consistent with the myth, is killed by the wild boar as had been foretold, and the play closes with eulogies of him by Grania, her father King Cormac, Finn, and other members of the Fianna. Only in the last lines does the usually troublesome Conan the Bald say that "Grania makes great mourning for Diarmuid, but her welcome to Finn shall be greater." The implication here is

that Grania is simply the fickle lover, which, indeed, is consistent with her reputation as it has come down through the ages in the myths. In Lady Gregory's version Diarmuid, after rushing out like a raging beast to kill the King of Foreign, dies in a delirium, mocking his lover and proclaiming an endless loyalty to his lord. But this occurs several pages before the end of the play, the final pages devoted to the ultimate development of Grania's tragic stature. This play's title, after all, bears only Grania's name.

Joseph Ronsley. *Canadian Journal of Irish Studies*. Spring, 1977, pp. 41, 55–57

The circumstances of her childhood, the teaching of family, church, and class all told her that her role as a female was to serve others. She believed it; duty was the lifeline from which she hung all her actions and achievements. Her life is dazzlingly instructive in the utility of those drab virtues within command of the will: self-restraint, tenacity, hard work, devotion. But she also had fairy gifts: a great, long-term vitality, a soldier's courage, and a detachment that—taking away from love—brought laughter. . . .

First she served her brothers as junior nursemaid and later as house-keeper. She served the poor on her family's estate far in the west of Ireland. There was not much future in it. Then when she was twenty-seven she captured the catch of the Irish marriage market, sixty-three-year-old Sir William Gregory, master of neighboring Coole Park, a former colonial governor of Ceylon, a delightful and cultured gentleman who moved in the highest social circles in Ireland and England. She was, she wrote, "happy in the thought of being with him, of serving him." At his death when she was forty, she put on mourning and continued to wear it, long after her sorrow was gone, for the remaining forty years of her life. It was the appropriate costume for her role as a dutiful woman. She edited several books about her husband's family, she collected folklore for Ireland, and she again captured the one man in Ireland who could do her the most good, the thirty-one-year-old poet William Butler Yeats, poor, overworked, and ready for all the good she could do him.

She looked after him at Coole Park, she loaned him money, bought furniture for his flat in London, sympathized with his hopeless love for Maud Gonne, collected folklore for his collections, wrote pleasant dialogue for his plays, founded the Irish theater with him. . . . Their relationship, as complex, rewarding, and limiting as a marriage, was the masterstroke of her life—and immensely important to his. As he wrote, "I doubt I should have done much with my life but for her firmness and care." And, as she wrote him on her deathbed, "I have had a full life & except for grief of parting with those who have gone, a happy one. I do think I have been of use to the country, & for that in great part I thank you." Serving him, founding the Abbey Theatre with him, she found at last the broadest, most congenial and rewarding objects of service: Ireland and literature.

But there was a break in the continuity of her service. When she was fifty, in the middle of a renaissance, when she was busier and happier than

she had ever been, in the service of Yeats, the Irish theater, Ireland, and literature, she set out to write plays. Unlike Yeats, who was continually making the night sea-journey through his soul, she was suddenly dunked into her subconscious—and discovered her creativity. She came up gasping, "*Sinn fein,* 'we ourselves'—is well enough for the day's bread, but is not *Mise Fein*—'I myself'—the last word in Art?"

Her short comedies are explosions of laughter. Her patriotic plays touch immediately a deep tribal identification with the Irish people united against an oppressor. All her plays provide a satisfying, touching demonstration of the power of the psyche to balance itself, to supply in one form the love and freedom denied in another. Many of her plays were very popular. She never stood centerstage at the Abbey, spread her arms, and exulted, "I made it!" But she did smile and bow.

<div style="text-align:right">

Mary Lou Kohfeldt. *Lady Gregory: The Woman Behind the Irish Renaissance* (New York: Atheneum, 1985), pp. 5–7

</div>

GUIDACCI, MARGHERITA (ITALY) 1921–

Guidacci's literary career started early: her first book of poetry, *La sabbia e l'angelo* (Sand and the angel), appeared in 1946 and was immediately greeted not as a promise but as a fully mature achievement remarkable for the strength and originality which distinguished it from the poetic fashion of the time. The same independence, accompanied by a complete lack of concern for the mundane aspects of literary life, has marked the poet's path throughout her career making of her an isolated figure whose importance has nonetheless been widely acknowledged. Her work comprises a dozen books of poetry in addition to *Sand and the Angel,* the most important of which are *Neurosuite* (1970), *Il vuoto e le forme* (1977; The void and the forms); *L'orologio di Bologna* (1981; The clock of Bologna), and *Inno alla gioia* (1983; Hymn to joy). In reviewing the collection *Taccuino slavo* (1976; Slavic notebook). . . . Wallace Craft wrote: "The factors which chiefly distinguish Guidacci from other poets of postwar Italy are resistance to abstraction and responsiveness to the physical world—i.e., to the mystery and marvel of life itself. Such exceptional sensitivity and openness to life ultimately account for her art's validity and universal appeal." Writing on *Inno alla gioia* Thomas Bergin noted: "Unlike her colleagues, [Guidacci] sings not of despair but of joy. . . . Sincerity of sentiment and deftness of artistry combine to make 'Hymn to Joy' not only a joyous work but a truly original one as well. Her graceful and persuasive lines make us feel with her the positive effects that love, freely given and faithfully reciprocated, can create: reassurance, confidence, unselfish dedication, and a recurrent sense of wonder."

Guidacci is also the author of two books of criticism—a 1975 monograph on T. S. Eliot and a 1978 collection of studies on American poets and novelists—and an active and highly regarded translator, principally of English and American authors such as Eliot, Beerbohm, Conrad, Bishop, Pound, Hawthorne, Donne, Blake, and Dickinson. Her poetry has earned her such accolades as the Carducci Prize (1957), the Cervia Prize (1965), and the Biella Prize (1978), and her renditions of Elizabeth Bishop received the 1983 Piombino Prize for the best Italian verse translations published during that year.

William Riggan. *World Literature Today.* 60, 1986 p. 36

Ruth Feldman has aptly translated an interesting volume of poetry [*A Book of Sibyls*] by Margherita Guidacci, among the leading poets of Italy today. . . . The titles of the short poems are taken from various types of sibyls of antiquity who speak to give advice: Persian, Cumaean, Delphic, Libyan, and others. The author points out that as mysterious figures they represented a primitive form of cult, bound to the earth. Their divinations are rendered in appropriate nature settings such as the cave, the forest, and the spring, in an atmosphere of smoke and attended by sacred animals such as the python and the male goat.

Guidacci's poems are written in a free-verse form, musical, clear, and beautiful; Feldman has managed to render them literally but has achieved a poetic beauty of her own. Philosophical remarks are distinctly quoted: truth awaits people in midlife encounters, and it is these which mark them the deepest; at the end we find the optimistic note to take heart amid "the burden of anxiety, misery, and temptation." In the sibyls an instinctive religiosity appears to be exposed. Feldman clarifies numerous learned references for the modern reader by providing general and specific notes at the conclusion of the volume. The Italian originals are given on the lefthand page, with the English on the right. In both cases we are aware of a fluid, easy-flowing poetic line. We become conscious of feelings of hatred and pain in the world; hence the need for advice. Figures of speech and picturesque imagery are found in both versions, as in the following example: "I watched the luminous stars hang from the dark branches of the sky, the moon ripen to a silver fruit, then shrink to a shadow fruit." Contrast frequently highlights emotional responses, yet on the whole the verses contain a mystery and a stillness, a kind of peace.

Patricia M. Gathercole. *World Literature Today.* 64, 1990, p. 295

There is an extraordinary unity of tone in the three parts into which the latest collection of poems [*Il buio e lo splendore.* (The mud and the splendor)] by Margherita Guidacci . . . is divided, a tone given by the continual reference to ancient myths, revived by the poetic voice with unmistakably modern tinge yet pervaded by the serenity of past epochs.

The first part, "Sibyllae" (Sybils), is dedicated to and inspired by the ancient figures whom Guidacci terms "expressions of a primitive religiosity, tied to the earth and its vital forces": feminine voices lost in the darkness of time and emerging with the splendor of their mystery and their wisdom in the poems' fragmented, intense visions. These voices encompass the destinies of humanity, whether they be the passing of Persian and Greek armies or the grief or regret of a single individual, violence and love, judgment and compassion, dead generations and future ones. All this temporal and spatial universe is rendered in a beautiful language flowing in an almost narrative rhythm, rich with images of leaves and caves, waves and roots—the appropriate, poetic expressions of Guidacci's own world view.

Part 2, "Rileggendo Ovidio" (Rereading Ovid), is a delightful rendering of the story of Baucis and Philemon, the poor and simple peasant couple made guardians of a temple and then transformed into trees by the gods as a reward for their goodness: a story of nature, serenity, death and immortality, told from Baucis's viewpoint as a subdued yet strong affirmation of love. Love is also the theme that runs through the last part of the collection, "Il porgitore di stelle" (The hander—or pointer—of stars), titled after an ancient Etruscan legend; the exotic, beautiful names of the stars accompany and emblematize various aspects of human destiny. So the darkness of night is the necessary backdrop for the splendor of the stars, just as the darkness of Mother Earth sometimes revealed the splendor of the Sybils' responses. *Il buio* and *lo splendore* are indeed the two poles of Margherita Guidacci's splendid poems.

<div align="right">Gian-Paolo Biasin. World Literature Today.
64, 1990, p. 89</div>

In any case, Guidacci refused to write in ways that would smack of "sophistication," wanted to keep her words as simple and plain as possible, and wanted her poetry to be as natural as it could be—that is, she wanted to write a "poetry of experience" based on signifieds and not on the play of signifiers and always sought to find and render in her poetic language the adherence of words to things, the *adequatio rei et intellectus.* Two general corollaries derive from these premises. First, her poems seem to be (and to a certain extent are) easier to read and understand than many avant-garde texts played almost entirely on formal qualities. Second, her poems are mostly based on a free or blank verse that is close to narration (with the notable exception of her Italian haiku texts, modeled after the Japanese genre and published under the title *Una breve misura,* [A brief measure]).

But the seeming naturalness and simplicity of Guidacci's poetry should not be taken lightly; it should not be oversimplified or overnaturalized. Her poetry is imbued with a religiosity and compassion that transcend her personal self (even when she talks about herself and the terrifying experience of a psychic sickness, as in her collection *Neurosuite,* for example, or of a

loss of a beloved person as in *A Farewell*) and point to a very high conception of poetry and its function.

For Guidacci, poetry is the human voice that witnesses human destiny in its broadest manifestations (history and nature) as well as in its innermost nuances (love or fear, beauty or disgust). In its witnessing, poetry discovers the traces of the divine in all the cracks and voids of the world, and it relies on the maternal, earthy solidity of its origin, shrouded in darkness, to achieve light. The light, indeed the splendor, of Guidacci's poetry is the revelation at the same time of infinity—a religious feeling—and the limitation of language to express such an infinity—pathos, a poetical feeling. . . . If the theme of death. . . . should be considered fundamental in the very organization of Guidacci's poetry, the theme of life is equally basic, and a third concern becomes immediately thematized as well: "the voice of the poets," the nature of poetry. Guidacci is quite conscious of her poetic voice and never tires of highlighting it with a self-referential attitude, which is, however, unfettered by intellectualistic preoccupations and is developed in beautiful images. Finally, the "high divide" and the "valleys" of the initial line of the poem point out another fundamental aspect of Guidacci's poetry: her interest in the landscape—a landscape that is both physical and metaphysical, as it is here, or one that is both natural and historical, inhabited by generations of men and women who have left their traces on it before disappearing: precisely a "landscape with ruins," as stated in the beautiful title Feldman has chosen for this volume.

> Gian-Paolo Biasin. Introduction to
> Margherita Guidacci. *Landscape with Ruins:*
> *Selected Poetry of Margherita Guidacci*
> (Detroit: Wayne State University Press,
> 1992), pp. 17–18, 20

GUIDO, BEATRIZ (ARGENTINA) 1924–88

The most distinguished female figure of the "angry" group, Beatriz Guido, has acquired her reputation on the basis of four novels and her screenplays, as well as a collection of short stories. She has succeeded in reaching a considerable popularity with the mass audience. . . .

Less "angry" than other contemporaries, she brings to her fiction the same concern to bear witness; she photographs the decadence of the Argentinean haute bourgeoisie and wants to show its disintegration and alienation with respect to Argentine historical process. Beatriz Guido, in exposing this social stratum, makes an oblique criticism. . . . She documents but offers no solutions. She shows the wounds of a social class at a given moment in history, exposes them and nothing more. There is a certain veracity in her

descriptions of the social ambience, albeit with the limitations we shall indicate. There is power in her situations . . . not enough in the characters, marionettes moved about by strings that are too visible and that are not operated with sufficient dexterity. . . . Formally, Beatriz Guido makes use of and combines the characteristic techniques of the modern novel, but, more than an interest in form for its own sake, we believe there is a desire to increase a sort of special complexity in her books. Her language is "popular and alive." . . . Perhaps this novelist's greatest value lies in her powerful inventive gift. . . .

Guido could be considered the novelist of adolescents and their crises, except that combined with this is her concern with the national mood or temper. *La casa del angel* (The angel's house) is the gilded prison of a teenage girl in the process of becoming a woman. . . . The whole mental and psychological problem of the young girl is described in terms that try to be poetic but succeed only in being affected. . . .

In *La Caída* (The collapse) Beatriz Guido remains faithful to her style and the social groups that interest her, with emphasis on the emotional viewpoint of this novel of manners. . . .

Fin de Fiesta (End of the party) is without a doubt the best of Beatriz Guido's work and, together with *El incendio y las visperas* (Fire and Vespers) represents a worthwhile attempt to recreate Argentinean political-social history in a period that goes from the 1930s until just before the fall of Perón, although her characteristic adolescent conflicts also play a part in the novels.

<div align="right">Angela B. Dellepiane. Revista
Iberoamericana. 34, 1968, pp. 259–62</div>

In the short work, *La mano en la trampa* [Hand in the trap, Guido] . . . insists on the use of her recurring themes and she presents, with the intensity of a confession made by the heroine, the violent reaction of the youths who will not be kept away from what is forbidden or mysterious, even if the price to be paid for such knowledge may prove to be self-destruction. Repression and violence are the two extremes which determine the drama within a traditional provincial middle-class family which lives [in] its memories of past generations and shuts its eyes to reality.

Nevertheless her [next two] novels are more significant because the writer, without any reticence, faces the reality of political life in Argentina since the coming of power of Peronismo in 1945, showing the disintegration of two families belonging to the oligarchy under the influence of characters and political facts taken from real life.

In *El incendio y las visperas* the plot sequence moves along a linear development with the exception of one flashback, and chronologically covers the period from October 17, 1952, to April 15, 1953. Both dates appear on the subtitle and correspond to two historical facts: the first one commemorates the action taken by the masses which, in 1945, liberated Juan Domingo Perón from his prison on the island of Martín García; the second one marks

the night when the mobs burnt down the Jockey Club, which was exclusively for the gentlemen of the upper middle class of Buenos Aires. The ending of the novel thus acquires a symbolic characteristic.

The third reality is the expropriation, decreed by the Peronista government, of the homestead and the parkland of the finest and largest "estancia" in the Province of Buenos Aires which belonged to the Pereyra Iraola family. The grounds were renamed "The Park for the Rights of the Aged" and opened up for the recreation of the "justicialista" workers during their vacations, in memory of the dead Eva Perón.

In the novel the expropriation of this land is what triggers the drama of the aristocratic Pradere family. They try to save the "estancia" [country place] (named "Bagatelle" in the novel) because they have inherited it from their ancestors, even though in order to do that they have to come to terms with the "judicialista" régime which they hate.

"Bagatelle"—with its name suggesting a French mistress—and the Carrara marbles that adorn the parkland, and the collection of paintings and sculptures in the Jockey Club, all obsess Alejandro Pradere, the father, a book-lover who is passionately fond of beauty and art; all this is what he lives for and all this justifies his surrender before the demands of the régime as he accepts the position of ambassador to Uruguay; that is, as the representative "de un gobierno que desprecia" (of a government which he despises). Months go by. The night when the Jockey Club is burnt down, Ambassador Pradere, who has come over to Buenos Aires for a few days in order to enjoy his books and works of art, commits suicide in the face of the crimes which are being perpetrated against art and culture. The decree for the expropriation of "Bagatelle" is signed two days later. Sofía and her children come to the mansion in the "estancia" for the last time and then calmly walk out, leaving behind them all its treasures with the exception of the father's favorite night-table clock, to the amazement of the government officials who have been sent there to arrange for the moving of the furniture.

The mother goes off to exile in Paris; José Luis and Inés, together with Pablo, go on struggling in the resistance movement. As the Pradere family disintegrates, there rises the love of Pablo and Inés overcoming all barriers: social, ideological and even physical, because as the result of another political activity Pablo has been imprisoned and tortured by the police, and José Luis has had to resort to his money and his influence in order to save his life after Pablo has undergone horrible mutilations.

Beatriz Guido's last work during this decade is *Escándalos y soledades* (Scandals and solitudes) a novel in which she breaks away from the traditional form of the narrative which she had never done before. She makes a "collage" in which the accumulation of diverse materials is no obstacle to the development of the plot which the reader reconstructs and thus fulfills the function of a collaborator which is assigned to him in the modern novel. The writer insists on the theme of political facts and characters, this time within a family of men. . . .

Beatriz Guido . . . delves deeply into the dramatic consequences which the complex political situation that has been troubling the life of Argentina since the early forties have had upon the Argentinean family.

<div align="right">Yvette E. Miller and Charles M. Tatum,
eds. Latin American Women Writers
(Pittsburgh: University of Pittsburgh Press,
1977), pp. 63–65, 67</div>

Beatriz Guido belongs to the "angry generation" of Argentina during the years of 1950–1965. She depicts, from the point of view of the oligarchy, the disintegration of the upper classes and the social changes that take place with the advent of Peron.

The author uncovers the special world of women during this historical period. In *La casa del ángel,* Ana, the daughter of an important politician, is raped in her own house by one of her father's good friends. In *Fin de fiesta* women appear living out decisions made for them by men. The author shows clearly the great influence that the education of the sexes will have in their future activities: aggressive or passive roles in society are enforced by men to the extent that women are always treated as weak people incapable of making important decisions.

<div align="right">Lucía Fox-Lockert. Women Novelists of
Spain and Spanish America. (Metuchen,
New Jersey: Scarecrow, 1979), p. 20</div>

Beatriz Guido was born in the provinces, but has lived in and was educated in the city. She traveled in Europe and studied in Paris and Rome. Her influence has crossed national borders since her marriage to the film director Leopoldo Torre Nilsson, a great power in the Argentinean celluloid world, with whom she has collaborated on the adaptation of her own work for the screen. These films, well received at the major film festivals of the Western world, have given Beatriz Guido a well-earned audience not only nationally, but internationally.

Beatriz Guido entered the literary scene twenty years ago with a novel, *La casa del ángel.* . . . This novel was not only a remarkable success in the marketplace, but also was awarded the Emece Prize, given for the first time on this occasion, and today one of the most prestigious and coveted Argentinean literary honors. The first novel was followed by another, in 1956, entitled *La caída* and, in 1961, by *La mano en la trampa,* a collection of ten short stories preceded by a novella that provides the title for the book. In 1976, Beatriz Guido published her second collection of short stories, *Piedra libre* (Free stone) and this year, 1979, her latest novel, *La invitación* (The invitation). These five volumes were important in her readers' consciousness because in them—especially in three of the novels—the author gives us a tender and at the same time implacable vision of the inner working of the female adolescent soul, the secret fantasies that inhabit her heroines' world.

What is more, Beatriz Guido is not only the first colonizer of this hitherto almost unexplored human territory, but also, along with many other Latin American novelists, an engaged writer. In 1958, she moved toward material that no Argentinean narrator can ignore. Having experienced the era of the Peronist lie as well as the period of lies that followed it, Beatriz Guido began her work of bearing witness to the national disintegration caused by the country's political vicissitudes, starting with the first years of the 1940s with her novel *Fin de Fiesta,* where she uncovers the sordid dealings of an absentee leader. *Fin de Fiesta* was followed in 1964 by *El incendio y la visperas,* a novel that recreates a year in the lives of her characters, from October 17, 1952, to April 15, 1953, the latter being the dread date in Argentinean history when a maddened mob set fire to the aristocratic Jockey Club, the cultural center and social headquarters of the oldest and most corrupt Buenos Aires families. In the novel, the burning of the Jockey Club acquires a symbolic quality. Guido's eyewitness series culminates in 1970 with *Escandalos y soledades* where, freeing herself from all formal bonds, she puts together an extraordinary work of collage in order to indict bungling and ineffective government. However, she also offers hope when she expresses confidence— although only half-aloud—in the country's future recovery.

<div align="right">Nora de Marval de McNair. <i>Círculo.</i> 10, 1981, pp. 29–30</div>

GUIDUCCI, ARMANDA (ITALY) 1923–

Both confessions included in Armanda Guiducci's *Due donne da buttare* (two disposable women) openly flaunt the circular, repetitive, detailed nature criticized in women's personal narratives. Guiducci's frustrated housewife immerses the reader in descriptions of her endless and repetitive duties as housekeeper, wife, and mother to which society assigns no productive value. The remarks of the housewife about the incapacity of household appliances ("*elettrodomestici*") to save time reflect topical protests of feminists against a powerful consumerism that reinforced images of the traditional housewife and that of the superior male provider. These and other criticisms of society judiciously reinforce the presentation of an intelligent and lucid self that has somehow remained intact despite banal adversity. The housewife is careful to separate herself from other more obsessive acquaintances who frantically swallow hormones to defeat the aging process, or who have allowed the tedium of their lives to drive them into insane asylums. Women, she explains, are innately rational beings, endowed with a "senso pratico," as opposed to men who think in theoretical and abstract terms. However, her much vaunted common sense leads her to isolate herself from feminist groups such as the *Comitato delle Arrabbiate* [Committee of Angry Women], which she de-

nounces as being too unrealistic in their demands. Thus, her need to achieve a rational presentation of self creates a paradox which critic Elissa Gelfand notes in many women's confessions: having confronted the difficulty of her situation, the narrator adopts survival mechanisms such as withdrawal, isolation, and establishment of personal boundaries instead of directly contesting these difficulties.

<div style="text-align: right">

Carol Lazzaro-Weis. *Italica.* 65, 1988,
pp. 296–97

</div>

Written in the charged atmosphere of the 1970s, Armanda Guiducci's feminist books address the issues facing women in a traditional patriarchy, where being female is tantamount to being invisible. Guiducci's protagonists are not angry protestors who scream their rage at an unjust sexist society and shout war cries at the male-dominated world, but are instead the truly silent majority, conditioned to resignation and relegated to the shadows of history and culture. The writer intends to give voice to these women of silence, allowing them to emerge from obscurity and speak themselves into visibility. Intentionally created to function as both distinctive narrators and universal prototypes, Guiducci's emblematic protagonists represent the female situation understood as a cycle repeated from generation to generation, since the beginning of time. The title of Guiducci's first fictional work, *La mela e il serpente* (The apple and the serpent; 1974), is connotative: it is about one woman, as indicated in the subtitle (Self-analysis of a woman), but it is also about Eve, the first woman and the symbol of everywoman. In this work, the first-person narrator delves into both the conscious and the unconscious self, seeking to understand her continued adherence to a tradition of oppression and conditioning, concluding that a woman's struggle for self-affirmation is as much personal as it is societal. This protagonist explores herself and her roles, coming face-to-face with the obstacles to self-fulfillment presented by the environment and by history itself. For Armanda Guiducci, the female condition in society is inherently inferior.

Women's status as a second sex is clearly demonstrated in the two companion pieces, *Due donne da buttare* (Two disposable women; 1976) and *La donna non è gente* (Women are not people; 1977). Conceived as instruments for the affirmation of the profound humanity of the dispossessed women of Italian society, these testimonies of pain and invisibility speak to the universality of each individual experience. Guiducci's narrative strategy manipulates the confessional genre by presenting unpolished and unsequential monologues that reflect women's unfamiliarity with self-expression, thereby giving speech to silence. Muted words and unheard lives find a voice in Guiducci's first-person narratives, which are both fiction and biography and represent untrained, nonliterary voices appropriate to women who have been traditionally excluded from power, position, and expression. . . .

Within the context of European feminism, Armanda Guiducci reinforces the belief that the individual self is indeed political. The soliloquies of *Due*

donne da buttare are concurrently personal and universal expressions of the female condition in the patriarchy, a condition that is simultaneously temporal (the presence of urban industrialized Italy) and atemporal (the crossgenerational repetition of activities and attitudes). Guiducci's critique is directed, in part, at the contemporary oppression of women advanced by bourgeois materialism but also at the ceaseless feminine servitude of marriage, which results in the subordination of women's bodies to the desires and exigencies of men. Although grounded in European Leftist feminism, the author goes beyond its concerns with the hegemonic middle class in her exploration of the archetypal figures of Madonna and whore. By deconstructing these male-formulated configurations and reconstructing them in feminist terms from the inside, Guiducci "has come to repudiate an interclass perspective in order to specify, first on the theoretical level, and then within the area of narrative expression, the profound dichotomies existing within the feminine role." The tales of private woe and psychic cleavage recounted by the housewife and the prostitute support the view that each woman is an everywoman whose individual experiences reflect and register the collective lives of her sisters. Women are joined in gender and Guiducci's use of female imagery reinforces the truth of this connection. In the conversational patterns, broken ungrammatical sentences, fragmentary phrasing, and obsessive imagery of these confessions, Armanda Guiducci creates a female discourse, giving voice to the silence of centuries. If men "have the money have a handle on the world," women can escape total oblivion through expression, giving voice to silence and words to the previously unspoken. To quote the housewife, "it's necessary to dream isn't it I'm not ready to throw away yet like this I'm not in my coffin yet."

<div style="text-align:right">

Fiora A. Bassanese. In Santo L. Aricó, ed.
*Contemporary Women Writers of Italy:
A Modern Renaissance* (Amherst:
University of Massachusetts Press, 1990),
pp. 153–54, 167

</div>

GURÓ, ELENA (RUSSIA) 1877–1913

In his reminiscence about Elena Guró, Vasilij Kamenskij links Guró's poetry with a tragic event in her life, the loss of her only child. Unable to come to terms with her son's death, Guró, in Kamenskij's recollection, went on imagining her son was alive and continued to buy toys for him, maintain his room, draw his portraits, and write stories and poems for him. Although both the emphasis on biographical roots of a poet's imagination in general and Kamenskij's reminiscences in particular have to be taken *cum grano salis,* it is striking that as both a poet and a painter Guró was almost obsessively preoc-

cupied with the world of the child. As a poetic persona, she frequently identifies with children or at least expresses her strong empathy with them by assuming a maternal stance toward life. She further confounds the issue of her parentage when she states in one of the prose sketches in *Baby Camels in the Sky* (Nebesnye verbljužata): "You see, I have no children, maybe that's why I love so unbearably everything that is alive. Sometimes it seems to me that I am a mother to everything." While there is uncertainty with respect to Guró's status as a parent, it is a noteworthy detail of her family background that her grandfather on her mother's side was the well-known pedagogue Čistjakov, who both wrote stories for children and was the publisher of *A Children's Journal* (Žurnal dlja detej) in the years 1851–1865. But whatever the specifics of their ostensible biographical underpinnings, Guró's creative interests were also clearly grounded in some of the most important trends and assumptions which gained momentum in the late nineteenth to early twentieth century, the period that nurtured Guró's literary and artistic sensibilities. One such trend was primitivism which, at the time Guró entered the literary scene in Russia, fostered an idealization of childhood and sought to legitimize its world not only in literature but also in art, psychology, philosophy, political thought, and the law. . . . Giving literary and artistic expression to her interest in the infantile world, Guró made a multifaceted contribution to what was a specifically modern version of primitivism, the growing cult of childhood. This cult gained its forcefulness from the belief that childhood exemplified not only the most desirable human state but also the ideal artistic condition. Perceiving a fundamental similarity between the child and the artist, Guró viewed childhood as encapsulating the natural artistry of mankind. Her identification of childhood with genuine artistry was not unlike that of Rainer Maria Rilke who wrote, shortly before his two influential trips to Russia, that the essence of artistry lay in childlike naiveté, unselfconsciousness, openness to and instinctive trust in life.

For Guró, as for Rilke, emulation of the artistic sensibility of the child was not a mere return to the romantic ideal of the noble savage who had been praised for both his intuitive wisdom and keen sensitivity to beauty. Children in her eyes are born artists, endowed with unique perceptions in both life and art and with a predisposition for playfulness which she considers to be at the source of all creativity. Childhood for Guró epitomizes that stage in human development in which reality is not yet divided into fixed categories or ordered by the principle of causality. The child is a symbol of wholeness, free to connect outwardly unrelated phenomena and to intermix reality with fantasy. Fascinated with the world of childhood, Guró dedicated her oeuvre to exploring it from several perspectives. The child's vision not only colors the feelings and ideas conveyed in her works but also informs the techniques and devices that shape the presentation of their thematic material. Exploiting children's language and imagery, Guró captured both the symbolizational mechanism and the freshness and immediacy of their experiences. In the

process, she illuminated not only the rich fabric of the natural artistry of children but also aspects of creativity in the making.

<div align="right">Vera Kalina-Levine. Slavic & East European
Journal. 25, 1981, pp. 30–32</div>

A trained painter as well as poet, Elena Guró puts great emphasis on visual effects in her prose and poetry. The window is one of the commonest as well as most striking images in Guró's writings and paintings; it evolves into a unique device. Functioning not only as a visual image, the window becomes a compositional device, a physical frame, a theatrical stage, and the frame of a painting. Guró's drawings of windows help us understand the windows in her writings and the difference between the two. The "artistic" windows of the paintings imply a picture which, for the most part, shows movement in only one direction, from inside outside; her "literary" windows follow the point of view of a reader as well as of a poetic persona and allow motion in both directions, from the inside to the outside and from the outside in.

The window in Guró's literary works is seen as an opening through which the smells, sounds, visual impressions, light and air can penetrate the inner world of city rooms. The interaction between the outer and inner worlds helps create a picture of the city. The frame of the window, its glass, the window-sill, are part of the composition. One can observe the street through the window without going outside, and one can be observed from the outside. Depending on whether the curtains are drawn, or whether it is raining or the glass is dirty, the picture can change. Likewise, an open window can allow the outside world to penetrate the inner space of the room. . . .

Since windows are conceived as eyes open to the city, the room therefore becomes an image of the inner mood of the poetic persona. The poetic persona does not merely look out. The outside world, symbolized by the street, thrusts itself into the world of the room. As a result of this movement out/in and in/out, the room or the street becomes transformed according to the perceiver's frame of mind and self-awareness. The objects both within the room and on the street are altered as they reflect changes in the person observing them. Disparate images and fleeting perceptions of concrete reality, sensations and emotions are juxtaposed to create a picture, convey a state of mind, or merely suggest an impression. The projection of the poetic persona's emotions gives an added dimension and depth to the seemingly fragmentary world, so characteristic of Guró's writing as a whole. . . .

The life that the reader senses through Guró's images is filled with typical urban problems: loneliness, alienation, prostitution, poverty, dust and dirt, crowds, noise, etc. There is a continuous movement out/in and in/out. The window in Guró's poetic world can be perceived as an object drawn from everyday life, which gives the reader both a concrete sense of the world and simultaneously the poet's own subjective insight into and experience of that world and the objects that exist in it. Details of the external world and the various objects that are used as a part of the picture help the reader under-

stand the subjective world of the poetic persona. In selecting the objects to be framed, and in her description of them, Guró presents both a subjective view of reality and a concrete illustration of the inner states of her narrative persona. By juxtaposing elements of reality and of imagination, Guró is able to depict in concrete terms her own and her characters' perception of the interaction between the inner world and outer reality. Careful use of the window as a frame or "stage" of a seemingly incongruous and arbitrary mixture of impressions, images, events, moods, thoughts and acoustic perceptions, enabled Guró to interpret, together with the reader, the rhythm, the language and the spirit of the world that surrounded her.

<div style="text-align: right;">

Milicia Banjamin. In Josip Matešić and
Erwin Wedel, eds. *Festschrift für Nikola R.*
Pribić (Munich: Hieronymous Verlag
Neuvied, 1983), pp. 5, 6, 15

</div>

Although Guró did not characterize creative work as "feminine," she admitted that it seemed to her that women possessed a "special richness of light" and certain life-bearing qualities which they were able to personify in their work. For example, Nel'ka was not necessarily conceived of as a prostitute, but as a symbol of "a woman of a city street." As we saw earlier, a similar portrayal of the submission of women is given in "The Street." Another curious expression of Guró's attitude toward women can be found in her undated drawing in black pencil "Hysteria" (Isterija), which depicts a naked woman before a devil who, having ripped open her abdomen, pulls out her entrails while she smiles at him voluptuously. The woman's pose is provocative—as if she were enjoying what was happening to her. In a comment in one of his notebooks, Matjušin explains the drawing as a protest against a typical male attitude of spitting on a woman's personality after taking everything from her. According to Matjušin, the drawing expressed Guró's protest against the humiliation of the woman.

The everyday language of prose gives freshness to Guró's perception of the city. The same child-like wonder and awe can be found in her prose and poetry devoted to nature. Urbanism and the worship of nature coexist in Guró's works. The world of Petersburg, although barely named, is present with its dissonant noise, its shops, signs, crowds, and loneliness. Guró touched on many aspects of city life in terms of color, smell, and sounds. But by 1910 the city ceased to hold her attention, except in her diary. Nature presented a quieter environment in which she gave free rein to her vivid imagination and in which she communed with trees, animals, and flowers.

<div style="text-align: right;">

Milicia Banjamin. *Slavic & East European*
Journal. 30, 1986, pp. 241–42

</div>

The book [*Elena Guró: Selected Prose and Poetry*] makes available some materials by the Russian futurist Elena Guró which were previously unpublished or which appeared in ephemeral miscellanies. The first piece consists

of selections from a writer's diary kept by Guró from 1908 until her death in 1913. These entries were selected and prepared for publication by her husband, the composer Mixail Matjušin, in 1915. The brief entries bear a strong resemblance to the prose poems that appear beside the more conventional poetry in both *Šarmanka* and *Nebesnye verbljužata*. Like those prose poems these entries reflect her sentimental attachment to nature and to whatever may be termed child-like. Their style is impressionistic and intensely personal. The diary entries are, however, often dated and mention is made in them of actual people. In many entries she imagines, and even addresses, her fantasy son, Vilja. She speaks of having in progress a long work, presumably the "Bednyj rycar'" which appears later in this book. As in her published pieces she delights in her own capacity to see the world in a child-like way.

The diary is followed by a number of short pieces, in prose and poetry, which appeared in miscellanies published between 1905 and 1920, and which are now rare. These miscellanies include the following futurist collections: *Sadok sudej* (1910), *Sadok sudej 2* (1913), *Sojuz molodeži 3* (1913), and *Troe* (1913). Some pieces are devoted to such fantasy subjects as the "touch-me-not" (*Nedotroga*), giants, centaurs, and ghosts. As in much of her work, Guró portrays the Karelian landscape at the dacha where she and Matjušin lived and worked in the summers. In some places she also tried to capture a "Finnish" mentality.

The last of the unpublished documents is "Bednyj rycar'," an impressionistic prose tale at which she worked from 1910 until her death. Its posthumous publication was several times anticipated but not realized until now. The work is devoted primarily to the thoughts of a Gospoža Èl'za, who is the mother of a young boy. He lives through fantasy adventures, such as his capture by "Satana." He is eventually identified both with Don Quixote and with Christ. The final section, entitled "Iz poučenij svetloj gornicy," consists of precepts that can be variously described as Christian, philosophical, or merely personal. The ending of the piece is solemn in tone and leads the reader to suppose that the author was preoccupied with thoughts of her own death.

The book has a general introduction describing the place of these unpublished or rare pieces in the oeuvre of Guró. Each of the three sections also has its own introduction and careful scholarly apparatus, either in the form of footnotes or of bibliographical information. The book is a welcome new source for specialists in the Russian avant-garde. It further documents the pastoral current in Russian futurism and illuminates Guró's personal relationships with the writers and artists who were her contemporaries. It also suggests some Scandinavian sources of inspiration not only for Guró, but for some other Russian futurists as well.

Evelyn Bristol. *Slavic & East European Journal.* 53, 1989, p. 460

HALL, (MARGUERITE) RADCLYFFE (GREAT BRITAIN)
1886–1943

It seems startling at first sight, but those who locked up copies of *Jane Eyre* were prompted by the same feelings as those who now have just banned *The Well of Loneliness*. They wished that *Jane Eyre* should not be read because it made people, especially young people, aware that women existed whose experience of love is passionate. . . . In the case of *The Well of Loneliness* the passion described is abnormal; it is the story of a woman who falls in love with another woman. That there is a very small percentage of human beings of both sexes whose love-life is centered on members of their own sex is a fact about human nature which is well known; why should it not be generally known? What harm can a book do which deals with the unfortunate complications which result from such aberrations? Here and there it might suddenly reveal a reader to herself. It might again suddenly explain to a reader of another kind the behavior of some one else towards her. Why should this be bad for them? Is there not, on the contrary, a possibility that such a book may be of service, helping them to recognize traits in themselves and in others, and so know more surely where they are? . . . The fear that if such novels are not at once suppressed the book-market will be flooded with them, is empty. A curiosity sale is soon over. In my youth, when the tone of the times was stricter both in conversation and in print, *Moll Flanders* and translations of Maupassant and Flaubert were purchased and read furtively for the sake of the suggestions a few passages might carry to an eager curiosity. Now those books are read, as they ought to be, for their merits. The same thing would happen in the case of such books as *The Well of Loneliness*. History shows that only those communities have flourished in which men were allowed to pool their experience and comment freely on life, and that the suppression of freedom is a graver risk to civilization than the circulation of any particular book to morality.

Desmond MacCarthy. *Life and Letters.*
October, 1928, pp. 340–41

The most ludicrous interference with an English book of recent years was the suppression of *The Well of Loneliness* by Radclyffe Hall, the theme of which was homosexuality among women. When the editor of a well-known Sunday newspaper had a screaming fit, and by his screams alarmed the Home Office, a prosecution was instituted, the result of which was that thousands of people, who had not been aware that there was such a thing as homosexuality among women and never would have been aware of it but for the advertise-

ment it received at the hands of the Law, were not happy until they had managed to read *The Well of Loneliness* under the impression that they would find out the details of such odd behavior. It is hardly necessary to add that many novels on the same subject have appeared since without interference and without making the public much wiser about homosexuality among women.

<div align="right">

Compton Mackenzie. *Literature in My Time.*
(1933; Freeport, New York: Books for
Libraries, 1967), pp. 208–9

</div>

The work of Radclyffe Hall is serious, profound and beautiful work, in no way doctrinaire, yet thoroughly indoctrinated. Her emotion is still yet deep. She is like a quiet pool of great depth. She is ageless. It is work that might have come out of Greece. It is work that might have come from India. It seems to have nothing to do with the modern Western world and the flair of that world for the nonchalant, the bizarre and the funny. It has nothing to do with Victorian sentiment. It has nothing to do with Elizabethan delight in living; neither has it anything to do with eighteenth-century sophistication; nor yet anything to do with the romance that belongs to all centuries. She is preoccupied with the mysteries, as the priestesses were, and she pities the human race as it passes them by for things that can be added up and multiplied and subtracted and divided.

<div align="right">

Margaret Lawrence. *The School of
Femininity* (New York: Frederick A. Stokes,
1936), pp. 329–30

</div>

If there is any single pervasive theme in Radclyffe Hall's fiction, it is that of quest, or of the struggle of the characters to attune themselves simultaneously to their inner needs and to the demands the world makes upon them. Radclyffe Hall's attitude toward this struggle is always compassionate because, for all her specificity, she sees each drama *sub specie aeternitatis,* under the aspect of eternity. It is this perspective which finally justifies Margaret Lawrence's term "priestess." When a priestess writes fiction, according to Lawrence, "the drama of human effort and failure takes possession of the soul, and all the little inconsequential things of life begin to unfold themselves in pleasure and pain before the eye of the watcher. And the form of expression moves on to the narrative. Men and women set down in their impermanency against the strange permanency of the universe." A pervasive sense of mystery brought close, inexplicable mystery manifesting itself through the lives of real people in real situations, is the keynote of Radclyffe Hall's fiction, and it is responsible for the unique resonance of all her work, whether the predominant tone is comic, psychological, social, or spiritual.

Radclyffe Hall's style is for the most part traditional, and she tended to accept the standard Victorian and Edwardian formula for the novel, complete with omniscient narrators and chronological time sequences. . . .

If one wishes to classify Radclyffe Hall's fiction, she surely belongs to the school of psychological novelists, although she never thought of herself as part of a particular movement in her writing. Familiar with some of the works of Freud and Jung and fairly widely, though sporadically, read in available books on psychology, she was too clever to "apply" these ideas in such a way as to turn them into mathematical proofs. Rather, she was interested in psychology in the broadest sense: the nuances of self-deception, the subtleties of familial inter-relationships, the dynamics of personality formation. The psychological premises of *The Unlit Lamp*, were the novel published today, would not seem outdated, although the dramatization of the sexual undercurrents between mother and daughter sometimes seems naïve in its blatancy. The early chapters of *The Well of Loneliness*, if the causes of Stephen's homosexuality are put aside for a moment, reveal a wonderfully subtle analysis of a child's reaction to a parental conflict which is beyond her comprehension. In *Miss Ogilvy Finds Herself*, the regressive personality of the fifty-year-old "Fräulein Schwartz," the process of sublimation leading to a fanatical appreciation of art in "The Lover of Things," and the mental disintegration of a failed business man in "The Rest Cure—1932," are all portrayed with a touch of genius. In her other works too, to a greater or lesser extent, she displays an acute insight into the workings of the human mind, an insight which is universal and certainly worthy of modern attention.

<div align="right">

Claudia Stillman Franks. *Beyond the Well of Loneliness: The Fiction of Radclyffe Hall* (Avebury, England: Avebury Press, 1982), pp. 6, 8

</div>

Of the crop of novels about homosexual love produced after the First World War—Rosamund Lehmann's *Dusty Answer,* MacKenzie's *Extraordinary Women,* Bowen's *The Hotel,* Woolf's *Orlando* and Radclyffe Hall's *The Well of Loneliness*—it was Hall's novel which became and has remained by far the most popular. For whether one defines the popular as noncanonical, or oppositional, or simply as that kind of writing which attempts to popularize more specialized forms of discourse, *The Well of Loneliness* can claim to fulfill all these conditions. The reasons for its popularity are themselves worth considering.

First, the novel was *designed* and written to reach a wide audience. . . . The second, most potent, reason for its popularity concerns the circumstances of its production. The Obscenity trial which followed its appearance in 1928 gave *The Well* a notoriety which in one sense is still active . . . if the author's own project was to break "the tyranny of silence" surrounding homosexual love, it was the state's intervention (via the Director of Public Prosecutions) which amplified that voice and gave the novel its home among the liberalizing discourses of the 1920s.

But, third, its readership since 1928 to the present depends on the fact that the protest-plea for homosexuality is still one that needs to be made . . .

Although the ideological, social and political conditions governing sexuality *have* changed, there is enough cultural continuity between the England of 1928 and the England of fifty or more years later to give this narrative of lesbianism [*The Well of Loneliness*] a continuing relevance. The readings now made are different, but it is read as a story for lesbians as well as a story for those who wish to understand more about women's sexuality.

This brings me to . . . in my view, [the] most important reason for its continuing popularity: that the very mixed and contradictory discourses on sexuality in play in this novel (medical, psychoanalytic and religious) are still in play and still unresolved in today's discussions. If *The Well* remains—as Jane Rule claims—"*the* lesbian novel," this is partly because no "metalanguage" about homosexuality (or sexuality) has been produced since. When we read *The Well of Loneliness* now, we do so not simply to examine a set of archaic and superseded discourses about sexuality, but *from within* a set of equally problematic debates on the social, psychic or biological determinants of sexuality and object-choice. For though much has been written in the last fifteen years, particularly from the American and European women's movements, on the question of women's sexuality, little has been resolved, I would argue. And though feminist critics have challenged *The Well's* religiosity, its defeatism, its endorsement (in some sense) of a conventional patriarchal notion of sexual difference, its rejection of a lesbian subculture in favor of role-playing coupledom, it remains nevertheless a doubly significant text: for what it tells us about sexual ideologies in the 1920s, and for the way it speaks to contemporary sexual ideologies. The fascination of *The Well*, for me, read in this way, is that it alerts us to the discontinuities and the continuities in the way we tell stories about human sexuality. It can tell us more about what we can no longer say and what we continue to try to say because—as Foucault puts it—we are within the same archive.

Jean Radford. In Jean Radford, ed. *The Progress of Romance: The Politics of Popular Fiction* (London: Routledge, 1986), pp. 98–99

Because the homosexual relations described in the novel approximate to those of the heterosexual world, *The Well of Loneliness* is appealing on conventional romantic terms. Even so, the idea that Stephen and Mary's relationship could be a conventional romance is constantly undermined throughout the novel. . . .

Apart from the specter of sterility, the passion between Stephen and Mary is shown to be untenable for largely social reasons. What would have counted as a satisfactory *dénouement* in a conventional romantic work here contains the seeds of its own destruction. For Stephen and Mary as a couple, there is social opprobrium from the world at large. . . .

In fact the only society in which Stephen and Mary can find a niche is the lesbian ghetto which has started to emerge in Paris. Stephen's attitude to this group is extremely ambiguous and contradictory. She is prepared to mix with them because Mary needs friends, but refers to them as a "miserable army" of inverts, the dregs of society. . . .

It is something to be allowed to live as an invert accepted by this group but such ghettoized existence is not enough for Stephen whose vision stretches "out beyond to the day when happier folk would accept her." The world of the Paris inverts is a bohemian milieu and Stephen views it from a definite class position in the world at large. . . . [T]his wider social world in which Stephen grows up and with which the lesbian subculture is contrasted, is indelibly upper-class.

The particular way in which Stephen grows up "masculine" is in fact saturated with class. What she grows up to be is a "perfect gentleman." From an early age she is instinctively gallant and protective to her mother and by extension to all women; she has a strict sense of honor and speaks of doing "the decent, clean thing"; she lays on a generous wedding for her servants. The final proof of her moral excellence comes when she gives up the unwitting Mary to Martin, her own old beau, having decided that Mary is too weak and womanly to withstand life without a husband, children and a place in respectable society. These class-bound manifestations of *noblesse oblige* are read back into Stephen's nature just as much as her "inversion" is. Ellis's suggestion that inverts are rescued by general superiority of character is given a very classbound interpretation by Hall and one which was felt at the book's trial to make the lesbian character dangerously attractive. . . .

Hall's contribution should be seen as the start of a reverse discourse, a process by which a category of lesbianism derived from a medical discourse is first adopted and then eventually transformed by those defined by it. This implies a degree of political self-consciousness on the part of lesbians, if they are to speak for themselves as a unified group. It is clear that Hall's intervention can be seen as contributing to the formation of the political self-consciousness; later generations of lesbians were to follow her model of public identification even if they repudiated her particular views. What may be less clear is that her intervention in itself was both an adoption of Ellis's category of inversion and an initial step towards transforming it. . . . Inversion was shown as a problem for society to face and not just a moral dilemma for inverted individuals. The conflicting ways that *The Well of Loneliness* was received by commentators were in fact organized around two dominant discourses: the rearguard moralizing discourse of sin or sickness, which was now challenged by a new, liberal discourse on inversion as a social problem backed up by medical opinion. A variant of the moralizing commentary was a rather satirical strand, addressing the quality of Hall's book primarily as a work of fiction and criticizing it in terms of literary merit, in a way which

ostensibly side-stepped her views on lesbianism as such. It is within these competing discourses that a battle over the definition of lesbianism was waged.

Sonja Ruehl. In R. Brant and C. Rowan,
eds. *Feminism, Culture, and Politics*
(London: Lawrence and Wishart, 1982),
pp. 23–28

HANSBERRY, LORRAINE (UNITED STATES) 1930–65

The supreme virtue of *A Raisin in the Sun* . . . is its proud, joyous proximity to its source, which is life as the dramatist has lived it. I will not pretend to be impervious to the facts; this is the first Broadway production of a work by a colored authoress and it is also the first Broadway production to have been staged by a colored director. . . . I do not see why these facts should be ignored, for a play is not an entity in itself, it is a part of history, and I have no doubt that the knowledge of the historical context predisposed me to like *A Raisin in the Sun* long before the house lights dimmed. Within ten minutes, however, liking had matured into absorption.

Kenneth Tynan. *The New Yorker.* March 21,
1959, p. 100

If *A Raisin in the Sun* had been written by a white instead of a colored woman and if it had been written about a white family, it would have done well to recover its investment. As it is, it has received praises from all sides and the public is flocking to see it. As a piece of dramatic writing it is old-fashioned. As something near to the conscience of a nation troubled by injustice to Negroes, it is emotionally powerful. Much of its success is due to our sentimentality over the "Negro question."

Miss Hansberry has had the good sense to write about a Negro family with vices as well as virtues, and has spared us one of those well-scrubbed, light-skinned families who often appear in propaganda pieces about discrimination. If she avoids the over-worked formulas of the "Negro" play, however, she does not avoid those of the "domestic" play. . . .

It may have been Miss Hansberry's objective to show that the stage stereotypes will fit Negroes as well as white people, to which my own reply must be that I never doubted it. They will fit anybody. Rather, anybody can be made to fit them. The play is moving as a theatrical experience, but the emotions it engenders are not relevant to the social and political realities.

Tom F. Driver. *The New Republic.* April 13,
1959, p. 21

It is a sound rule in the theatre that excellence is inversely proportional to tears shed; that is, the bigger the catch in your throat as the curtain comes down the more suspect the play will seem half-an-hour later. On this account *A Raisin in the Sun* is highly questionable. At the end of it the handkerchiefs were out in force and the audience, though they elbowed each other as savagely as usual through the doors, were speechless. True enough, Miss Lorraine Hansberry's play has most of the ingredients of the classic tear-jerker: a poor but honest family on the wrong side of the tracks; a benevolent despot of an Old Mum; her aging son who is eating his and his wife's heart out for lack of an opportunity in life; his pert kid sister who goes to medical school and has a couple of admirers in tow, one intellectual, one rich. There is also a large insurance check, most of which the son is promptly conned out of. More than that, the dialogue is occasionally as predictable as the situations: the mother hands the cash over to her son with the words, "It isn't very much, but it's all I got in the world." He, presumably, passed it on to the con man murmuring, "Take it, it was my mother's."

Yet, although *A Raisin in the Sun* occasionally slips over into triteness, it makes an extraordinarily compelling evening's theater—which shows once again, I suppose, the degree to which drama is an extra-literary activity. As a play it may be patchy, but as a vehicle for the actors it is superb. One reason is that a powerful rhetoric comes naturally to Miss Hansberry. This puts her in a rather small club of writers, most of the other members of which are Celts. But with a difference: the rhetoric of a talented Negro writer always gives you the impression that it is about something, which is certainly not true of the Irish or the Welsh. Miss Hansberry has more than a gift of the gab; she also has a great deal to say on questions that deeply concern her. So her rhetoric is not just colorful; it has a natural dignity, which presumably has something to do with the fact that the rhythms and diction of passionate Negro speech come straight from the Bible. The language is felt and meant to a degree where it can afford to be simple. Finally, Miss Hansberry's characters continually talk about the subjects which concern all Negroes: the jobs they can get, the areas they can live in, the strategies by which their pride is preserved or undermined, the problem of assimilation and racial independence. This means that the otherwise nice, rather sentimental family life, with its humdrum quarrels, ambitions and pieties, is continually strengthened by outside loyalties and outside hatreds.

<div align="right">

A. Alvarez. *The New Statesman*. August 15,
1959, p. 190

</div>

There is a sort of inverted miracle in the way Miss Hansberry [in *The Sign in Sidney Brustein's Window*] manages to distort so many things—taste, intelligence, craft—and be simultaneously perverse as dramatist, social commentator, political oracle, and moral visionary. A further miracle is her union of bitchiness with sentimentality. But it is borrowed bitchery, for in her incredibly awkward drama, in which scene stolidly follows scene like a row of

packing cases and character talks to character like droning telephone poles, Miss Hansberry plunders from every playwright around, most thoroughly, Edward Albee.

The play can be said to be about the editor of a weekly New York newspaper who joins a local political crusade, is disillusioned, then revived by the knowledge that "love is sweet, flowers smell good, and people want to be better." But Miss Hansberry is a master of changing the subject, so that there is a plethora of entirely separate plots: a domestic drama; an interracial one; the tragedies, respectively, of a good-hearted whore, a fainthearted queer, and a lily-livered liberal; the melodrama of a blackhearted dope pusher, and the tragi-comedy of a cheated-on wife.

Yet none of this suggests the uses to which Miss Hansberry puts her dragooned themes. They serve exclusively as containers for her venomous anger: she hates homosexuals, liberals, abstract artists, non-realistic playwrights, white people unwilling to commit suicide, Albert Camus, Jean-Paul Sartre, Samuel Beckett, William Golding, and, especially, poor, plundered Edward Albee. Miss Hansberry ostensibly wants to attack sham and hypocrisy, but her lack of charity chokes the play and becomes itself an intellectual vice which, ironically, stings her with its backlash. Her attack on "success" name-drops furiously, and her savage assault on intellectuality brandishes every intellectual catchword that can be snatched from the *Zeitgeist*.

Richard Gilman. *Newsweek*. October 26, 1964, p. 101

One of the biggest selling points about *A Raisin in the Sun*—filling the grapevine, riding the word-of-mouth, laying the foundation for its wide, wide acceptance—was how much the Younger family was just like any other American family. Some people were ecstatic to find that "it didn't really have to be about Negroes at all!" It was, rather, a walking, talking, living demonstration of our mythic conviction that, underneath, all of us Americans, *color-ain't-got-nothing-to-do-with-it,* are pretty much alike. People are just people whoever they are; and all they want is a chance to be like other people. This uncritical assumption, sentimentally held by the audience, powerfully fixed in the character of the powerful mother with whom everybody could identify immediately and completely, made any other questions about the Youngers, and what living in the slums of Southside Chicago had done to them, not only irrelevant and impertinent, but also disloyal: *A Raisin in the Sun* was a great American play, and Lorraine was a great American playwright because everybody who walked into the theatre saw in Lena Younger—especially as she was portrayed by Claudia McNeil—his own great American Mama. And that was decisive. . . .

It was good that people of all colors, strata, faiths and persuasions could identify so completely with Lena Younger, and her family, and their desire to better themselves in the American way. But that's not what the play was about! The play was about Walter Lee, Lena's son, and what happened to

him as a result of having his dream, his life's ambition, endlessly frustrated by poverty, and its attendant social and personal degradation. Walter Lee's dreams of "being somebody," of "making it," like everybody else, were not respectable to Mama, and not very important to us. He wanted a liquor store which would enable him to exploit the misery of his fellow slum dwellers like they were exploited by everybody else. Walter Lee is corrupted by the materialistic aspirations at the heart of Western civilization, and his corruption is bodied forth in his petty, little dream. But it was his dream, *and it was all he had!* And that made it a matter of life or death to him, revolutionary, dangerous in its implications. For it could explode if frustrated; it could destroy people, it could kill, if frustrated! That's what Lorraine was warning us about. But we would only listen to Mama, and Mama did not ever fully understand Walter Lee!

<div style="text-align:right">Ossie Davis. Freedomways. Summer, 1965,
pp. 399–400</div>

The Sign in Sidney Brustein's Window is a good play. It just misses being great. Miss Hansberry tried to sum up in the personality structure and the private conflicts of a single character all the social anxieties, the cultural confusion and the emotional debris that litter and torment our days. The remarkable thing is that Miss Hansberry nearly succeeded.

Sidney Brustein is modern man in confrontation with a world he never made and which he must remake to conform to the definition of himself. But this definition of himself is buried under layers of casual, cynical collaboration with expediency and the code of the disengaged, the uncommitted, and it begins to come clear to him only as these layers are stripped away by successive encounters with aspects of stone-hard truth. His wife, Iris, represents one aspect of it, her sister Mavis, another, and her sister Gloria, a third. Then there are the men: Alton, the Negro; David, the homosexual playwright; and Wally, the negotiator, who strips away the last layer, and Sidney discovers himself to be one ". . . who believes that death is waste and love is sweet and that the earth turns and men change every day and that rivers run and that people wanna be better than they are and that . . . tomorrow, we shall make something strong of this sorrow." Given all the characters and all the situations, and given especially the character of Sidney Brustein, this hymn of affirmation is the right ending for the play.

<div style="text-align:right">Saunders Redding. The Crisis. March, 1966,
p. 175</div>

Lorraine Hansberry's greatest achievement lies in her ability to avoid what Saunders Redding has called "The obligations imposed by race on the average . . . talented Negro." The obligation to limit one's scope to the immediate but parochial injustices of racial intolerance has for long sapped the creative energy of the Negro writer. Having paid her debt to this tradition with the poor *A Raisin in the Sun,* however, Hansberry achieves a significant break-

through with *The Sign in Sidney Brustein's Window,* which is clearly in the mainstream of contemporary drama. The Negro is no longer seen as the victim of a savage social situation but becomes an endemic part of a society desperately searching for a valid response to the human condition. Lorraine Hansberry's death at the age of thirty-four has robbed the theater of the one Negro dramatist who has demonstrated her ability to transcend parochialism and social bitterness. . . .

Lorraine Hansberry's commitment . . . transcends the merely parochial for her rebellion is directed less against intransigent racialism than against the sterility of the absurd and the inconsequence of a theater founded on distraction.

C. W. E. Bigsby. *Confrontation and
Commitment: A Study of Contemporary
American Drama 1959–66* (Columbia:
University of Missouri Press, 1967),
pp. 172–73

When *A Raisin in the Sun* burst on the scene with a Negro star, a Negro director plus a young Negro woman playwright everybody on Broadway was startled and very apprehensive about what this play might say. What obviously elated the drama critics was the very relieving discovery that, what the publicity buildup actually heralded was not the arrival of belligerent forces from across the color line to settle some long-standing racial accounts on stage, but a good old-fashioned, home-spun saga of some good working-class folk in pursuit of the American Dream—in their fashion. And what could possibly be thematically objectionable about that? And very well written also. We shall give it an award (A for effort), and so they did, amidst a patronizing critical exuberance I would have thought impossible in the crassly commercial institution of Broadway. Not a dissenting critical note was to be heard from Broadway critics, and thus the Negro made theater history with the most cleverly written piece of glorified soap opera I, personally, have ever seen on a stage. Only because it was about *Negroes* was this play acceptable, and this is the sobering fact that the aspiring Negro playwright *must* live with it. If this play—which is so "American" that many whites did *not* consider it a "Negro play"—had ever been staged by *white actors* it would be judged second-rate—which was what the British called it, and what the French said of the film version.

Harold Cruse. *The Crisis of the Negro
Intellectual* (New York: William Morrow,
1967), p. 278

Black people ignored the theater because the theater had always ignored them. But, in *A Raisin in the Sun,* black people recognized that house and all the people in it—the mother, the son, the daughter and the daughter-in-law—and supplied the play with an interpretative element which could not

be present in the minds of white people: a kind of claustrophobic terror, created not only by their knowledge of the house but by their knowledge of the streets. And when the curtain came down [after one of the early performances], Lorraine and I found ourselves in the backstage alley, where she was immediately mobbed. I produced a pen and Lorraine handed me her handbag and began signing autographs. "It only happens once," she said. I stood there and watched. I watched the people, who loved Lorraine for what she had brought to them; and watched Lorraine, who loved the people for what they brought to *her*. It was not, for her, a matter of being admired. She was being corroborated and confirmed.

James Baldwin. Preface to Lorraine
Hansberry. *To Be Young, Gifted and Black*
(Englewood Cliffs, New Jersey: Prentice-
Hall, 1969), pp. x–xi

Structurally, Lorraine Hansberry remains essentially within the bounds of the conventional realistic well-made play, something almost anachronistic amidst the styles of the 1960s. The term "well-made" can be misleading because of its unfortunate connotations with the emptiness of nineteenth century tradition, but we need only look at the plays of a modern dramatist such as Lillian Hellman to recognize that orderly development of plot and a neatly planned series of expository scenes, complications, and climaxes can greatly assist in thematic and character development of a superior nature. Plot in Miss Hansberry's plays is of secondary importance, for it is not her main dramatic purpose. Nonetheless, because the audience has considerable interest in *what* is happening as well as *to whom*, both *A Raisin in the Sun* and *The Sign in Sidney Brustein's Window* are thoroughly enhanced by well-ordered revelation of the events which are so important in the lives of the characters. The straightforward telling of a story remains a thoroughly honorable literary accomplishment, and Miss Hansberry has practiced this ancient dramatic art with eminent respectability. Moreover, the scene, incident, and dialogue are almost Ibsenesque, avoiding overt stylization for its own sake and performed within the standard "box" set that progressively becomes more rare.

Jordan Y. Miller. In C. W. E. Bigsby, ed.
The Black American Writer, vol. 2 (New
York: Penguin, 1969), p. 161

Ed Bullins occupies much the position in today's vanguard of black writers that Lorraine Hansberry did ten years ago. The differences between their generations—as well as some surprising similarities—were highlighted this season by an evening compiled from Miss Hansberry's work, entitled *To Be Young, Gifted, and Black*. The differences are matters more of content than form. Some of Miss Hansberry's attitudes (though not all) are decidedly out of fashion with black playwrights now. For example, the self-portrait she draws of herself as a young coed is far closer to the heroine of any standard

McCall's serial about life in a white college dorm than to the experiences of today's black collegians. And her love of country ("I walk in my American streets again"), hedged with whatever doubts and increasingly superseded in the last years of her life by concern for her fellow blacks, would be unthinkable for a Bullins or a LeRoi Jones—as would her ambivalence about whether she considered herself a revolutionary.

<div align="right">Martin Duberman. <i>Partisan Review.</i> No. 3,
1969, p. 490</div>

[Hansberry] knew that *naturalism* began in *determinism,* and she wanted no part of that. For her, for her play, human possibility was what counted. She wanted, as her remarks on Sean O'Casey in *To Be Young, Gifted, and Black* indicate, to create the life of the Chicago she knew, but more than that she wanted to organize her creation so that her play and her hero could opt for what was best and most spirited in that life, not give in to all that was destructive. Her second play, *The Sign in Sidney Brustein's Window,* was primarily an attack on a particular kind of fashionable determinism, the assumption that nothing can be done about the evils of the world and the resulting "great sad withdrawal from the affairs of men," as one of the characters puts it.

<div align="right">Gerald Weales. <i>Commonweal.</i> September 5,
1969, p. 542</div>

I commend *Les Blancs* to your immediate attention, not so much as a great piece of theater (which it may or may not be) but, more significantly, as an incredibly moving experience. Or, perhaps, as an extended moment in one's life not easily forgotten or regularly discovered in a commercial theater that takes such pains to protect us from knowing who and what and where we are in 20th-century America. . . .

The play divides people into sectors inhabited on the one hand by those who recognize clearly that a struggle exists in the world today that is about the liberation of oppressed peoples, a struggle to be supported at all costs. In the other camp live those who still accept as real the soothing mythology that oppression can be dealt with reasonably—particularly by Black people— if Blacks will just bear in mind the value of polite, calm and continuing use of the democratic process. . . .

The play is flawed—what play not completed by its original author would not be? Yet, beyond the imperfection of its ragged perimeters, or its frequently awkward transitional sections and fitfully episodic construction, there is a persistent glow, an illumination. Somewhere, past performance, staging and written speech, resides that brilliant, anguished consciousness of Lorraine Hansberry, at work in the long nights of troubled times, struggling to make sense out of an insane situation, aware—way ahead of the rest of us— that there is no compromise with evil, there is only the fight for decency. If

even Uncle Sam must die toward that end, *Les Blancs* implies, then send *him* to the wall.

<div align="right">

Clayton Riley. *The New York Times.*
November 19, 1970, p. 3

</div>

Lorraine Hansberry was no "black panther," but an intelligent, compassionate human being with a gift for lucid dramatic writing which, when well acted as was the case of Sidney Poitier in *A Raisin in the Sun* and as now in a new kind of characterization by James Earl Jones [in *Les Blancs*], commands attention and inspires respect. To wave aside *Les Blancs,* a more mature play than *A Raisin in the Sun,* as old-fashioned and obvious—it may be "old-fashioned," obvious it is not—is an evasion which I am inclined to ascribe to bad faith, especially in view of what certain folk call "good theater."

<div align="right">

Harold Clurman. *The Nation.* December 7,
1970, p. 606

</div>

The Drinking Gourd, a three-act drama well suited for television presentation, is what may be called in television jargon a documentary of American plantation slavery. It is a compact yet comprehensive, authentic, and vivid portrayal of the "peculiar institution," correctly called the sum of all villainies, as it was especially in the cotton kingdom on the eve of the Civil War. The action in the drama is framed between a long prologue and a brief epilogue both of which are spoken by a soldier "perhaps Lincolnesque" in appearance. The prologue kaleidoscopically reviews the history of American slavery from its beginning to the middle of the nineteenth century. The epilogue avows that by that time the Civil War had become necessary to keep slavery from destroying the United States. . . .

Imaginative, unified, easily documentable, and intensely interesting story that it is, and being good theater as well as good dramatic literature, *The Drinking Gourd* is in the best tradition of historical dramas—much more so than *Les Blancs,* which is also an historical drama. In both of these works, nevertheless, as in the drama which first won her acclaim as a playwright, Miss Hansberry skillfully used original and vivid dialogue to reveal character and develop action. In *Les Blancs* she wrote all of the dialogue in standard informal spoken English, having no reason to use any other kind. In *The Drinking Gourd* she used the same kind of English to represent the speech of semiliterate and illiterate people. This she did convincingly without resorting to mutilated English, which has so often been perpetrated as "dialect," whereas it represents nobody's actual speech.

<div align="right">

W. Edward Farrison. *CLA.* December, 1972,
pp. 193, 196

</div>

My God, how we need [Lorraine Hansberry] today! She knew that politics was not ideology, but caring. Politics is that quality of becoming more and more human, of persuading, cajoling, begging, and loving others to get them

to go with you on that journey to be human—and defending yourself against those who seek to prevent that journey.

Perhaps the greatest irony is that so much humanity should have come from the life and work of a black woman. Then again, it is quite logical. She had been tempered by the fire and emerged briefly to let her own light shine. She knew that blackness was the basis for her existence, not the totality, and that if it becomes the whole, one can only become consumed by the fires of one's own rage and frustration. Lorraine Hansberry is the black artist who lived beyond anger, which is not to say that she wasn't angry. Her plays are an expression of rage against the outrages perpetrated against humanity. Anger did not define her art, but motivated and informed it. The quality which pervades her plays is compassion, the kind of compassion which can slap a face as easily as it can tease. She didn't make the mistake of hating white people. She hated what people did to each other.

> Julius Lester. Introduction to Lorraine
> Hansberry. *Les Blancs* (New York: Random
> House, 1973), pp. 31–32

The untimely death in 1965 of Lorraine Hansberry, one of the most poetic voices in the American theater today, deprived us of one of our most gifted dramatists and of one of our best authors, but she left a legacy for the newer black dramatists in that she pointed the way to a new direction, a newness in content and attitude, and a purpose for Black theater. "Positive and un-flinching, deadly serious" [Loften Mitchell], she won the 1959 New York Drama Critics Circle Award for her first play, *A Raisin in the Sun,* which was monumental in commitment.

The anger of the play is somewhat tempered when compared with the anger of later, more notably "black" dramatists, such as Baraka and Baldwin. But her play is a well-crafted one, reflecting the world of blacks on two levels of awareness. One is the daily struggle for existence shown in Mama's relentless desire to endure in the face of her son's and daughter's "modern" objections to their lot in life, and the other is the illusionary world of dreams. The dreams center on the money Mama is to receive from her husband's life insurance, which creates new hopes in a family almost without hope. . . .

The play indeed strikes an awareness of the changing attitudes of the black man. As the play ends, Mama's world seems to be a thing of the past, while the family, it is hoped, is on its way. They all agree to move into a house in a white neighborhood, against the whites' judgment, and we notice how Mama's dormant fear of equality has been replaced with a new-found optimism and self-reliance. . . .

Miss Hansberry's *A Raisin in the Sun* brought something new and honest to the New York stage, but it also brought with it a warning. The Chicago of the Negro, with all its frustrations, anger, and small hope of the late 1940s, and early 1950s, was re-created for New York and the American theater. The

black theater of protest had its inception. Others would take up, with more anger and less sentimentality, what Lorraine Hansberry had begun.

Robert J. Willis. *Negro American Literature Forum.* Summer, 1974, pp. 213–14

"One cannot live with sighted eyes and feeling heart and not know and react to the miseries which afflict this world."

These words, from a speech Lorraine Hansberry made to a black writers' conference in New York City in 1959, could easily have been those of friends, others I know and work with or even my own. What is most familiar is the sense of disbelief at what we, as humanity, will do to each other, in the name of that same humanity.

These words provide a welcome opportunity to rediscover the depth and breadth of Hansberry's social and political concerns and to see how they are manifest in her work. I say rediscover because today one only need say *Raisin* and the world of her play, *A Raisin in the Sun,* springs fully realized to our minds. It is now easily recalled that she was the first black woman playwright to be produced on Broadway and the youngest ever to win the New York Critics Circle Award. These are statistical triumphs. But in 1959, we more clearly saw the political ramifications of every public black accomplishment. Today Hansberry has entered our consciousness and in some ways that casual acceptance of her success diminishes the social impact of those achievements and their lasting influence on our lives today.

I say rediscover because she was proud of being "young, gifted and black" at a time when black women were stereotyped as merely long-suffering matriarchs with sharp tongues. Hansberry's redefinition of black women as active and responsible participants in our political future was surprising in 1959 and remains so to some as we enter the 1990s. It is her pride and the scope of her vision that is the key to her uncommon consciousness. . . .

Hansberry took that naturalistic style and deliberately infused it with an array of ideas, which other writers were consciously not doing. Beyond the message that black is normal and good, there was no other dimension to the political and social concepts of black drama. Hansberry was an intensely political person.

Once proclaimed the reigning queen of black drama, Hansberry did not let up. In her next play, *The Sign in Sidney Brustein's Window,* she had the audacity to make the central characters white! The play's production met scorn from both white and black critics. This in spite of the fact that white people had been describing and defining black people for centuries, not only on paper but in real life. The play also included a gay male character, but people were not interested in talking about him at all, much less demanding Hansberry's qualifications to describe him.

Lorraine Hansberry had many stories to tell. She did not feel the need to justify any one of them. . . .

Hansberry had considered all of these political issues and taken a solid position that their resolutions were interdependent. She would have been invaluable in the great divisive debate about whether or not black women need feminism. . . .

Etched on the marble stone of her grave are these words from her play, *The Sign in Sidney Brustein's Window:* "I care. I care about it all. It takes too much energy not to care . . . The why of why we are here is an intrigue for adolescents; the how is what must command the living. Which is why I have lately become an insurgent again."

She has lately become an insurgent again, inside of me. I felt her moving me to action as I prepared this work. But she predicted that, too.

> Jewelle L. Gomez. In Henry Louis Gates,
> Jr., ed. *Reading Black, Reading Feminist*
> (New York: Meridian-Penguin, 1990),
> pp. 307–8, 312, 315–16

It is odd that when Philip Rose wanted to produce Lorraine Hansberry's *A Raisin in the Sun* and made the rounds with the script, he was told the play was not what Broadway wanted. Yet *Raisin* is a quintessentially commercial Broadway drama. It is old-fashioned: Brooks Atkinson called it a "Negro *The Cherry Orchard*," and Tom Driver said that "the effect that it produces is comparable to that which would be had in a concert hall if a composer of today were to write a concerto in the manner of Tchaikovsky." It is safe: it is Clifford Odets or Arthur Miller in blackface in a conventionally naturalistic and well-made drama about people who could be of any racial minority, what Atkinson identified as "human beings who want, on the one hand, to preserve their family pride and, on the other hand, to break out of the poverty that seems to be their fate." It is relevant without being radical and sweet without being saccharine, uplifting and not too disturbing. C. W. E. Bigsby put his finger precisely on the play's commercial appeal when he wrote:

> For all its sympathy, humor and humanity. . . . [*Raisin*] remains
> disappointing. . . . Its weakness is essentially that of much of
> Broadway naturalism. It is an unhappy crossbreed of social pro-
> test and re-assuring resolution. Trying to escape the bitterness
> of Wright, Hansberry betrays herself into radical simplification
> and ill-defined affirmation.

Raisin in the Sun is not a great play, but for various reasons it has an enduring place in American theater history, like *The Contrast* or *The Fantasticks* or other milestones. It will remain and draw interest to itself as a period piece and record-breaker, but it also will help our theater to remember what it was like to be a young, moderately gifted, more than usually successful black women playwright at a time when that meant pioneering on two fronts at least. Hansberry did notably more in her work than Mrs. Scales, the black

domestic mentioned in a strong speech in *The Sign in Sidney Brustein's Window*, who brought home leftovers from the white family's table to feed her black children.

<div style="text-align: right;">

Leonard R. N. Ashley. In June Schlueter,
ed. *Modern American Drama: The Female
Canon* (Teaneck, New Jersey: Fairleigh
Dickinson University Press, 1990),
pp. 151, 158

</div>

HAREVEN, SHULAMIT (ISRAEL) n.d.

The use of biblical narrative as a scaffold for interpretation and further elaboration was very common in nineteenth-century Hebrew writing but has diminished with time. Shulamit Hareven's incursion is therefore of interest, especially since she is a versatile writer in several genres. In her biblical miniatures, the genre to which *HaNavi* (The Prophet) belongs, she no more intends to be historical than did August Strindberg in his well-known historical miniatures.

First came "Miracle Maker" (1987), a work in which the reader finds himself with the Israelites before and after their exodus from Egypt. Bayta, who had raised the orphan Esh-har and had hidden him from the slavemasters, is taken from the boy to be married off. Esh-har demands justice of the elders, but Joshua bars his way: "We do miracles; justice is not our province." An outcast and an outsider, Esh-har comes to reject Moses, the miracle maker. He is the first to view the Promised Land beyond the endless mountains, however, and reconciliation comes when Dina bears him a son. Later he too becomes part of the host that marches on Jericho.

In "The Prophet" we are in Gibeon. The biblical story is well known. With the Israelites encamped close by, the city is all hustle and bustle, with shepherds driving their bleating herds through the city gate. Although walled, Gibeon is not a city of warriors like its neighbor Ai, vanquished by Joshua. "What will be?" the inhabitants ask Hivai the prophet, but unlike earlier days, he has no answer now. Perhaps he senses the truth, however, but simply cannot utter it, for he joins the four elders who leave the city by night to seek the enemy. Leaving them, he joins the Hebrews and becomes a "hewer of wood and drawer of water." After seven years, he is sent away by his master, according to the Law of Moses. He leaves a wiser man, knowing he is not a prophet but a seer. Moses, who brought the Law, is the true prophet. Stopping at a roadside inn, he finally learns of Gibeon's fate: the traitors were executed by the king along with a "big traitor," a prophet. So, Hivai is "dead," left without a people, without a city, without God. He ultimately finds a retreat in the Jordan River valley opposite the Land of Moab, where

a tongueless little fellow who communicates via a flute befriends him and some slight gift for prophecy returns to him.

The implications of the two novels are many and entrancing. Motifs of solitude and prophecy run through both. Like Elijah, Havai flees to the wilderness, where he finds peace and truth, but it is human contact which brings reconciliation. Artistically, Hareven adheres to a pure, unadorned style without modernisms. She occasionally makes use of long-forgotten words which sound as if they were lying in wait for her in the desert, and the proper names she employs are also unusual and ancient.

<div align="right">Dov Vardi. World Literature Today. 64,
1990, pp. 189–90</div>

In these remarkable stories [*Twilight and Other Stories*] Shulamith Hareven evokes the deep estrangement and melancholy of individual life. Families, friends, husbands, children: these exist, but must always be recalled from their typical locale on the periphery somewhere beyond the foregrounded narrative. In the absence of these comforting and supportive relationships, the solitary self is defenseless against the intrusion of the immediate present as it dramatically assaults the protagonists' inner sanctuaries, threatening personal security, peace, or sanity. The stricken landscape of the tales is Jerusalem and its environs, and although Hareven only indirectly draws the reader's attention to this determining fact, one realizes that the characters are already burdened by a past that casts a shadow over their barely reconstructed lives. In most cases the memory of a European past is indelible, rendered in the gesture, accents, and dreams of the characters—or their nightmares, as the title story brilliantly conveys. Each story is masterfully translated from the Hebrew, thus making available to the English reader this impressively mature writer.

<div align="right">M. Butovsky. Choice. 30, 1992, p. 124</div>

The characters in this slender collection of seven stories [*Twilight and Other Stories*] live fragmented lives in contemporary Jerusalem, although their memories, longings and regrets often inhabit other times and places. The title story is one of the briefest and most powerful: in it a woman describes her nightlong year in "the city of sorrow," where she was born. Her surrealistic narrative conveys how a dream can enable a Holocaust survivor to separate herself from the past. In "My Straw Chairs," a woman who is nearly 50 explains that the beauty she looks for in a man "should be like the beauty of this country in which I live—this country that I love with an undivided love, it is all that I have. What I miss in people is a kind of starkness; there is so much superfluity about them." In these short stories, the Israeli writer Hareven (*The Miracle Maker*) succeeds in communicating both starkness and love. Occasionally, the storytelling is so spare that the dramatic meaning of the tales eludes the reader. But when the connection is made, it is a lasting one.

<div align="right">Penny Kaganoff. Publishers Weekly.
January 13, 1992, p. 51</div>

Shulamith Hareven is a well-known Israeli writer who has published poetry, novels, stories, essays, even a thriller. Known for her ironic humor and her subversion of Jewish myth, she is the first woman member of the Academy of the Hebrew language. *Twilight and Other Stories* is the fourth of her books to be translated into English. . . .

[In these] seven stories . . . passive, dissociated, middle-aged Israeli women float above their lives like figures in a Chagall painting. Hareven's anti-heroines are mostly European refugees who seem never to have taken root or flourished in Israeli soil. They face aging, change, betrayal by men, divorce, retirement and death, steeped in depressive feelings—fear, anxiety, guilt. . . .

Rootlessness, emptiness, fear, lack of self-esteem, are certainly subjects worthy of investigation. And the book's epigraph, from Montaigne's essay "Of Solitariness," prepares us for a compassionate treatment of the bleak material that follows: "Oh Lord," prays Paulinus, Bishop of Nola when that city is invaded by barbarians, "deliver me from the feeling of this losse; for Thou knowest as yet they have touched nothing that is mine."

But instead of sympathetic inquiry into what it might mean to try reconstructing a home and a lost self, Hareven undermines her material and short-circuits our sympathy. . . . Why does Hareven seem to feel only irritation for these pathetic characters? Why, for a harmless feminine vanity, only disdain?

Hareven grew up in Jerusalem, was a teenager in the Hagana underground, a combat medic, an Army officer and front-line war correspondent, a peace activist who spent time in Arab refugee camps during the Intifada, all while writing thirteen books and having two children. She is everything her women characters aren't. Which leads one to wonder what she's up to here. Why spend time on such vulnerable and disenfranchised characters if only to attack them?

Perplexingly, the only sympathetic treatment given to a woman of this refugee generation is in "A Matter of Identity," and this protagonist isn't a Jew but a Russian Orthodox peasant who has followed her Jewish lover to Israel. He deserts her, but in her earthy sensuality she triumphs over all difficulties. She even breathes life into two depressed, repressed Jewish men, her jaundiced ex-lover (she locates him after fifteen years) and the uptight bachelor-lawyer she consults about her daughter's identity papers. You wonder: is it only a goyishe peasant refugee who can resurrect these timid, joyless European Jews? And do only Jewish refugees lose their life force once they've left Europe?

Although Hareven has finely honed powers of observation and narrative technique, at the end of this book I felt cheated. I didn't feel I had really met these women of Jerusalem, felt the heat on their skin, smelt their streets, or breathed their dusty air. Like the dreamer in "Twilight," I felt nothing.

<div align="right">

Barbara Shortt. *Women's Review of Books.*
9, July, 1992, p. 27

</div>

HARJO, JOY (UNITED STATES) 1951–

Joy Harjo divides *In Mad Love and War* into two sections, "The Wars" and "Mad Love." The "war" poems are in one way or another political—Nicaragua, American racial injustice—but all are linked to the "love" poems by the last entry in the first section, "The Real Revolution Is Love."

The most powerful of the "war" poems is concerned with the case of Anna Mae Pictou Aquash, the victim of an unknown killer at Wounded Knee; her hands, in an incredible moment of official barbarism, were hacked off and sent to Washington for fingerprinting. Harjo relates Aquash to the Wounded Knee ghost-dancers, who were assumed by journalists and politicians to be preparing for a new "outbreak" when in fact they were only engaged in a profound, if doomed, spiritual exercise. This poem, it seems to me, is the best kind of "protest" poem, because its meanings rise from the outrage against Aquash to become a larger statement about the way all martyrs ennoble the thought of those who are able to remember and honor them.

All the "love" poems are of a high order, but several stand out. "Death Is a Woman" is a powerful lyric about the self-destructive life of the poet's father. "Rainy Dawn" is an almost unbearably beautiful evocation of the memory of her daughter's birth, that miraculous event when the child, "unfolding like a butterfly newly born from the chrysalis of my body," took its first breath "to take it on like the rest of us, this immense journey, for love, for rain."

"Transformations" is a key work in the book. Its title refers to the process by which poems are transformed into the things they are about, but also, more significantly, about the way "hatred can be turned into something else, if you have the right words." Harjo explained the poem in an essay in Swann and Krupat's *I Tell You Now* . . . in terms of our need to recognize our submerged self. If it is true that no good poem can be merely political, it is also true that, in a sense, *all* poems are political, because they are means by which conflicting elements in a society can be reconciled to one another. What makes this process possible is our own "transformation," our reconciliation to the deep self which we must acknowledge if we are to achieve reconciliation with others.

In an interview in Joseph Bruchac's *Survival This Way* Harjo said that all of us are originally tribal and that "civilization" is the process of losing our tribal consciousness, which she defined as the recognition of the interrelatedness of everything and of everybody. She might better have said that only those who have achieved that consciousness can really claim to *be* civilized. In any case, that achievement will be easier for those who experience the "transformations" in her poems; they possess the ultimate political power to change us and thus to change the way we deal with one another.

<div align="right">Robert L. Berner. World Literature Today.
65, 1991, p. 167</div>

Joy Harjo is a Creek Indian poet whose work has steadily matured since her debut with the chapbook *The Last Song* in 1975. Since then, three full-length collections—*What Moon Drove Me to This?* (1979), *She Had Some Horses* (1983), and *In Mad Love and War* (1990). . . . —have established her as a major American Indian woman writer. The present volume, though not of the caliber of her previous books, should nevertheless add to her growing reputation as a major Indian writer, regardless of gender, especially since she appears to be working now in a new medium, the "prose poem."

The cover of *Secrets from the Center of the World* credits both Harjo and Stephen Strom. However, Strom is not a coauthor; he is rather the contributing photographer for the text. . . .

More than halfway through *In Mad Love and War*, her most recent work, the poems become prose poems, as if to signal the poet's fascination with the form; in the present volume all thirty poems are prose poems. These are occasionally reminiscent of the Saint-John Perse of *Anabasis* (another worker in the prose-poem pattern), particularly as Harjo, like the Antillean-born French poet, calls up images taken from the desert landscape: "This land is a poem of ochre and burnt sand I could never write, unless paper were the sacrament of sky, and ink the broken line of wild horses staggering the horizon several miles away." Again reminiscent of Perse: "To describe anything in winter whether it occurs in the past or the future requires a denser language, one thick with the promise of new lambs, heavy with the weight of corn milk."

Harjo is not merely re-creating Persean images, however; she discovers her own in the beauty of Navajoland: "In a misty dawn at the center of the world is the morning star, tending cattle at the other side of the fence." She also utilizes the traditional Navajo holy colors of red-black-yellow-white ("an earth house made of scarlet, of jet, of ochre, of white shell"), showing the relationship of these essences to the four cardinal points of prayer and, in all, making it uniquely hers. There are some overly cute passages that are too arch and jar the otherwise stately prose poetry: the famous lines of a well-known Indian "49" song "When the dance is over, sweetheart / I will take you home / in my one-eyed Ford"—is answered with "Did we ever make it home?"

Overall, *Secrets from the Center of the Earth*, though alternating between stateliness, beauty, and reverence on the one hand and archness, occasional strained imagery, and garish photography on the other, is an impressive collection. Joy Harjo is indeed well on her way toward becoming a major poet.

Geary Hobson. *World Literature Today.*
65, 1991, p. 168

Joy Harjo speaks, as she has in her previous work, with great sureness of spirit and the mercurial, expansive imagination of a conjurer in this third collection, *In Mad Love and War*. Nearly all these poems seem written in a moment of urgency, fed by deeply rooted memory or longing, sometimes by

defiance, and always by a warriorlike compassion that sees through the split between people and their histories, people and their hearts, people and the natural world.

These poems reflect her heritage as a Creek Indian, both in their evocation of emblems such as deer, laughing birds, and "the language of lizards and storms," and also in their identification with people whose dreams have been thwarted by dull circumstance or outright violence. . . .

Harjo stands squarely in these poems as "one born of a blood who wrestled the whites for freedom," but her stance is not so much that of a representative of a culture as it is the more generative one of a storyteller whose stories resurrect memory, myth, and private struggles that have been overlooked, and who thus restores vitality to the culture at large. As a storyteller, Harjo steps into herself as a passionate individual living on the edge, at once goaded and strengthened by a heightened sensitivity to the natural order of things and to the ways history has violated that order. This sensitivity, a gift of her heritage, becomes her gift to the readers of her poems. . . .

Like a true magician, Harjo draws power from overwhelming circumstance and emotion by submitting to them, celebrating them, letting her voice and vision move in harmony with the ultimate laws of paradox and continual change.

<div align="right">Leslie Ullman. Kenyon Review. n.s. 13,
Spring, 1991, pp. 180, 182</div>

It is difficult not to use the word "magic" when thinking of Joy Harjo's poetry—on the page, words enter another dimension; the cadences of her stunning readings stay with the listener for days; and even the television or video screen is only a scrim easily slipped through by this poet accustomed to easing beyond the barriers of time and structured thought.

In Mad Love and War continues this exploration of the beyond: "I know there is something larger than the memory of a dispossessed people. We have seen it," and the attempt to translate memory, time and passion into the inadequacies of first, language itself, second, into the language of the white people, a tongue already suffering the loss of much of its own integrity. "In this language there are no words for how the real world collapses." With this collection, Harjo moves ever closer to making this language expand to bear the awful burden of poetry, even while acknowledging the ultimate paradox: "All poets / understand the final uselessness of words."

But words as components of music, "chords to / other chords to other chords, if we're lucky, to melody," can be a method of understanding other worlds, if not actually entering them. . . .

In Mad Love and War has the power and beauty of prophecy and all the hope of love poised at its passionate beginning. It allows us to enter the place "we haven't imagined" and allows us to imagine what we will do when we are there.

<div align="right">Kathleene West. Prairie Schooner. 66, 1992,
pp. 128, 130</div>

Joy Harjo is clearly a highly political and feminist native American, but she is even more the poet of myth and the subconscious; her images and landscapes owe as much to the vast stretches of our hidden mind as they do to her native Southwest. This is one reason why her *Secrets from the Center of the World* is such a continually intriguing book. Ostensibly, the setting is a landscape known to all (with the Stephen Strom photographs giving that part of the country an appropriate surreality to which all of us can truly respond), but Harjo's prose poems give us a *vision* of the land for the first time, as this seer takes us below the surface of the literal world for visions and images we recognize as simultaneously new and timeless. . . .

Harjo's most recent volume of poetry, *In Mad Love and War,* shows the poet becoming more personal in her concerns. These poems also bring us to and from other worlds and invite us to hear recurring echoes of Native American ways of thinking. It is this double sense of landscape, the sharp reality that is so clear to the Native American seer and the ruined earthly paradise that is such a source of pain and bewilderment to the rest of the population, that is examined so ruthlessly and lovingly in the book's first poem, "Deer Dancer." . . .

Harjo's range of emotion and imagery in this volume is truly remarkable. She achieves intimacy and power in ways that send a reader to every part of the poetic spectrum for comparisons and for some frame of reference. . . .

Harjo, as much as Yeats, is able to survive in the larger culture while still breathing deeply of her native air. In a hostile place that has denied her dreams and often done its best to destroy the dreamer, she has responded by giving back to the larger culture values and insights it never realized it had lost.

John Scarry. *World Literature Today.* 66,
1992, pp. 288–91

Poetry combines with camera work . . . in Harjo and Strom's *Secrets from the Center of the World,* another book carefully produced. It consists of well-crafted epigrams and facing color photos in a three-way merger of language, photography, and bookmaking. In pages again clay-coated, the prints are all framed by a well-etched border, adding a depth remarkably underscored by the way they and the facing texts refer back and forth. For example, the passage on page 20 together with its accompanying photograph suggests that the branches in a thicket of tamaracks resemble crows "leaning over the edge of the world, tasting the wind." The statement prompts a second look at the print, with its interplay of curving branches in autumn. Thus invited, the eye moves deeper into the photo where the trees indeed assume a posture that implies cosmic limits.

Paul G. Zolbrod. *American Indian
Quarterly.* 16, 1992, p. 53

Contemporary Native American poet Joy Harjo expresses and reflects patterns of ongoing, multilayered and multivocal memories within the narratives of her poems. These memories flow and interweave on a continuum within a metaphysical world that begins deep within her personal psyche and simultaneously moves back into past memories of her Creek (Muskogee) heritage, as well as forward into current pan-tribal experiences and the assimilationist, Anglo-dominated world of much contemporary Native American life. Harjo's poetic memories may be personal stories, family and tribal histories, myths, recent pan-tribal experiences, or spiritual icons of an ancient culture and history. And, while Harjo writes using both an "alien" language, English, and within expected structural and narrative formats of contemporary poetry, her poems also frequently resonate with the distinctive chanting rhythms and pause breaks associated with traditional Native American oralities. As with other contemporary Native American women poets such as Paula Gunn Allen (Laguna Pueblo/Sioux), Linda Hogan (Chickasaw), and Wendy Rose (Hopi/Chowchilla Miwok), Harjo's past memories and present experiences seamlessly fuse together within individual poems; and when read together as a group, her poems construct in the reader's mind a single consistent, cohesive, and unified poetic utterance.

The importance of memory to Harjo's poetry best reveals itself through a survey and examination of one of her most important ongoing tropes, the contemporary American city. Within her varied urban landscapes, Harjo's poetry most clearly illustrates the multivoiced nature of any marginalized poetry, and of Native American women's poetry in particular. . . .

What sustains Harjo's contemporary speakers in such an alien environment are memories—memories of ancestral lands, family and tribal life, traditional spirituality, and a pan-tribal heritage. In Harjo's poems the multi-voiced city experiences of Native Americans living within indifferent and often hostile urban landscapes offer a strikingly different reading from contemporary Anglo experience of the American city, and thus they make an important statement about current American societies. Moreover, we can also trace a distinct growth in the richness, complexity, and tone of Harjo's city trope from her earliest to her most recent poetic texts. . . .

Whereas Harjo's early city poems are usually set physically in bars, apartments, or automobiles and often describe aimless and alienated drifting, her later poems tend to be set in the mind and its memories of an urban experience, and to describe both a clear-eyed acceptance of life as it is and a quiet but fiercely unwavering commitment to the Native American belief in the inherent spirituality within all life forms.

Thus memory, what Paula Gunn Allen refers to as "that undying arabesque," underlies all of Harjo's poetry. While all Native American cultures value the powers of memory, the contemporary urban pulse-beats and incidents recorded in Joy Harjo's poems bring memory most fully and dramatically into the non-Native . . . [experience. As she] poses her Native American memories of the earth against present-day urban life experiences,

Harjo creates a uniquely surreal, yet frighteningly accurate and familiar picture of modern American cities and their alienated citizenry. As Harjo explains memory, one has no authentic voice without memory; and without an authentic voice, one is speechless, hardly human, and unable to survive for very long. Thus, Harjo's braided strands of multilayered memory and poetic voice intertwine into the very warp and woof of her poetic creation.

<div align="right">Nancy Lang. MELUS. 18:3, 1993,
pp. 41–42, 48–49</div>

HARROWER, ELIZABETH (AUSTRALIA) 1928–

At the center of all Harrower's novels is an intense psychological drama, a struggle between the strong (as far as position is concerned) and the weak, although the nature and the terms of the struggle vary widely. She has a keen understanding of the motivating forces of selfishness, envy, ignorance, malice, pride, pity and fear and of the way these forces can work within a small, familiar group to produce misery for the innocent or defenseless. At a deeper level, her fiction tentatively and searchingly explores the ambivalent problems of responsibility and freedom, guilt and innocence, naivety and experience. *Down in the City* traces the disillusionment of an upper-class woman, Esther Prescott, with the working-class businessman Stan Peterson, whom she marries after an acquaintanceship of two weeks. Apparently easygoing and fun-loving, Stan turns out to be a racketeer and a paranoid bully. A weak man, unable to abandon either old habits or his old mistress, he finds in Esther a new object on which to vent his grudge against the system. *The Long Prospect* is a more complex exploration of the banality of evil. Here the adult world, seen partly through the consciousness of a child, Emily, reveals itself as both seedy and dangerous, vulgar and destructive. In her progression to a finer moral awareness and a new condition of isolation, Emily is typical of Harrower's heroines. *The Catherine Wheel,* a subtle study of an exceptional and complicated relationship, is her least popular novel. Set in London, it traces the struggle between a young Australian girl, Clemency James, and a penniless, handsome, enigmatic young man, Christian Roland. Christian's self-indulgence, unpredictable moods, manufactured charm and exhibitionism are convincingly presented but the struggle between Clem's passive integrity and his uncompromising selfishness becomes somewhat unequal. *The Watch Tower* is a darker exploration of anarchic evil, made more compelling by the novel's ordinary suburban setting. Felix Shaw, a domestic tyrant who lives only to gratify his need for power, is chillingly presented, as is the gradual collusion of his chief victim, his wife Laura. For Clare, Laura's sister, suffering is morally rewarding, however, an illuminating experience

both of the enfeebling force of pity and the indomitable power of the self to resist appropriation.

William H. Wilde, et al., eds. *Oxford
Companion to Australian Literature*
(Melbourne: Oxford University Press, 1985),
pp. 321–22

Harrower's voice emanates from the female subculture and echoes many of its concerns—social, sexual, cultural—and, as such, it is a political and ideological statement, concerned not only with the creation of literature but also with the evocation of the situation of women in Australian and Western society. It is, as Robyn Claremont pointed out, the sociological and psychological factors inherent in the novels that make it difficult for the reader to confront them. The distinctively female view that directs the works may be one of the reasons why Harrower has been neglected by a predominantly male Australian literary critical establishment.

The Watch Tower, like the earlier work, *The Long Prospect,* is concerned with the isolation and mental and emotional impoverishment of women in a specific (but in some ways culturally universal) situation. *The Long Prospect* details Emily Lawrence's neglect by her family in the depressingly familiar Australian industrial town of Ballowra. . . .

In both *The Long Prospect* and *The Watch Tower* the female characters derive their initial suffering and abandonment from their female elders: the grandmother and the mother. As with other female fiction, the older woman conspires with the dominant male culture to enslave the younger girl and make her aware of her subordination. *The Watch Tower* continues the blighted history of female-procuring-female through the depiction of Laura's attempts to enslave Clare to Felix. . . .

Although both men and women are seen by Harrower as rendered less than human by our society, she leaves the reader in no doubt that, for her, woman are archetypal victims. . . .

Each time violence erupts in the household, the reader is excluded, either directly by the author in that she stops the action and gives only the aftermath, or in that the violence is reported by the neighbors in their desultory and self-congratulatory conversations. By such means, the Gothic overtones of the work are intensified, a Gothicism which is the more sinister in that the setting and people of the novel are mundane, suburban, seemingly without threat.

It is at this point that we should ask whether Harrower is a feminist writer. Certainly in her depiction of the plight of women within the Australian context she can be seen to be feminist, showing as she does the degradation, isolation, and emotional impoverishment of females within this culture. Yet at another level, Harrower is concerned also with the plight of the special individual, the spiritually enlightened one, be it male or female, who has to cope with what Harrower sees as the desert of Australian society. An image

that recurs throughout the novel is that of the Pacific as at once a boundary and a means of escape. Harrower thus reflects much of the 1960s dilemma of Australian writers in their desire for a national awakening and at the same time the penchant for seeing enlightenment, civilization, and intellectual amelioration beyond the shores of Australia. Many of Harrower's concerns, both in *The Watch Tower* and in her other novels and short stories, are those of a group of writers, including Stow, Koch, and White, writers whose works display an ambivalence, a loathing/loving attitude towards Australian society, and who tend to deal with this through the creation of enlightened individuals such as Clare Vaizey, rather than proposing more general and radical social reforms. The fact that this individual happens to be a female in Harrower's works displays the author's perception of the special individual within the female subculture, and her own place in this category, and should in no way confine her work to a narrowly prescriptive category of feminist.

This is not to deny that Harrower writes from what we may term a female perspective; her images, themes, and subject matter are drawn always from the tradition of the female subculture and echo and reinforce many female writers both in Australia and abroad.

<div style="text-align: right">

Frances McInherny. In Carole Ferrier, ed.
*Gender, Politics and Fiction: Twentieth-
Century Australian Women's Novels* (St.
Lucia, Australia: University of Queensland
Press, 1985), pp. 152–53, 160–61

</div>

The Watch Tower is unlike all the others in that here it is not a matter of attraction towards but revulsion from. In her early teens, Clare is taken to live in the harborview house of Felix Shaw when he marries her older sister Laura, some thirty years his junior. She watches with puzzlement, suspicion, and, finally, quiet horror as he reduces Laura to the status of mechanically responsive house slave. The interesting thing is that Clare's aversion from her brother-in-law leads her into the same close, obsessed survey which the female keeps upon the male in the other novels from motives of love or attraction.

In each case the female maintains a close, continuing surveillance of the male, with the feeling and out of a conviction that he means more than just himself. . . .

No . . . concluding comfort is available to Clemency in *The Catherine Wheel*. She discovers the most fearsome contradiction in the same heartland. What is most true and what is most completely simulated cannot be separated there—as with fire, so with humankind. In the person of beautiful, beautifully spoken Christian, destructive force and sheer brightness run together. Her intellect, finely honed from prolonged abrasive contact with him, becomes an instrument of self-defense as well as discovery. Her situation, at the last, is the reverse of Esther's in the opening chapters of *Down in the City*. Esther must be rescued from the quiet, comfortable and appalling apartness into

which circumstances have carried her. She is readier than she knows for the supportive force of sheer contradiction which arrives in her life with Stan Peterson's sudden crunching presence. She learns, through a sequence of brutal lessons, that his abruptness is, in the context of their marriage, a sort of positive.

Clare, in *The Watch Tower,* is rather closer in tendency to her repulsive brother-in-law than she can see. At least she takes on the view that seems to be his, of existence as flatly objective, as a field where the familiar and the foreign are all one, as are kindness and calculation. So, when she sheds it, her whole world picture tilts right over, comes to seem suddenly charged with value. This, however, is only to suggest something of the complex realizations to which Elizabeth Harrower's heroines come. Her splendidly explorative fiction forces matters back beyond any area of easy social surmise into one where her characters see and feel and think what can hardly be said.

D. R. Burns. *Meanjin.* 45, 1986, pp. 347, 353

Elizabeth Harrower is not unknown in Australian literary circles. Several published short stories and two novels (*The Long Prospect* and *The Watchtower*) have earned her a reasonable amount of critical attention in the past two decades. Her two other published novels, *Down in the City* and *The Catherine Wheel,* have not fared so well. *Down in the City* was Harrower's first novel (1957) and provides a unique insight into the life of Sydney in the post-World War II years while also highlighting the author's interest in the human psyche and manipulation of the mind. However, the novel has been all but ignored in recent years.

While her contemporaries, such as Patrick White and Christina Stead, have enjoyed continuing attention, both in Australia and internationally, for two decades, interest in Harrower's novels has been selective, in spite of the fact that many common preoccupations link these authors together. Harrower and White have a mutual interest in what they portray as the philistinism of Australian society and the effect this can have on the sensitive individual out of place in this culture. Harrower and Stead are similar in the intensity of the psychological concerns which are explored in their novels.

The reason for the relative lack of interest in Harrower's fiction is difficult to ascertain. Part of the problem is that Harrower has not published a new novel since 1966, whereas many of her contemporaries are still writing or at least are still having their books published. The difficulty of obtaining some of Harrower's novels is also a factor. In the case of *Down in the City,* in particular, it seems that a vicious circle has developed where lack of interest is coupled with unavailability. . . .

Harrower's love of Sydney has inspired her to create [in *Down in the City*] a novel which is concerned with each character it presents, no matter how minor or how briefly. In none of her later novels is this sense of the complexity of urban society so evident. Rather, they move in settings where little of the outside world interrupts the intense, enclosed situations. While

Harrower's interest in intimate psychological warfare is developed in the novels which followed *Down in the City* none provides such a vivid picture of a city brimming with vitality and a complex multitude of humanity.

Rosie Yeo. *Southerly.* 50, 1990,
pp. 491, 497–98

HARWOOD, GWEN (AUSTRALIA) 1923–

Those who study Australian poetry don't agree on much, but they would all agree that Gwen Harwood is exceptionally adept at masking. Even those who have only read one or two of her poems know, of course, that she has written acrostics adroit enough not to be recognized as such by the fragile skills of editors. A little more acquaintance teaches us that she has written, under pen names such as "Miriam Stone" and "Francis Geyer," poems that have excited many a talent spotter with the conviction that they have just discovered a coruscating new Austpoet. It is not much farther to the recognition that she is capable of bold and subtle ventriloquisms, pastiches and parodies of other poets—a few have even noticed her cool and incisive parodies of herself. These more or less obvious phenomena seem to me, however, simply the outward signs of a pervasive and crucial masking that is characteristic of the best poems in her first two books. By "masking" I mean the conscious and significant selection of a voice and a way of experiencing which is not autobiographically necessitated. Obviously, some of the poems in both books are autobiographically based, and others, such as the beautiful art poems to Larry Sitsky ("The New Music") and A. D. Hope ("To A. D. Hope") exist at a heightened level where the issue of just who is speaking has been left behind. In other words, in these poems (and analogous though less successful ones) the pervasive irony of perspective and reaction has been integrated into the celebration of art as a texturing *sprachspiel,* leaving questions of personality behind—or, more accurately, offering answers rather than questions.

In the Eisenbart and Kröte groups (I doubt whether they are truly sequential in the sense that poem 3 must be read before poem 4) the range of masking seems to me to be at its widest. Not only are both protagonists utterly convincing monsters of evasiveness about their own characteristics and situations, but also they inhabit a world where problems of judgment and perception are endemic. The verbal and cultural equipment of the poems, though invariably detached in tone from any simple identification of observer with protagonist, is constantly being shifted away from objectivity in the direction of a recognition of the way the protagonist feels, or how he "sees the world."

Norman Talbot. *Australian Literary Studies.*
7, 1976, pp. 241–42

The capacity to surprise and delight is the mark of any good poet, I suppose, but Gwen Harwood has it to a higher degree than most. Hers is indeed a fire-talented tongue; and one of the ways in which her fiery talent manifests itself is in the sudden juxtaposition—grotesque, absurd, violent, beautiful, disturbing, or simply funny—of the quotidian, the ordinary routine suburban reality in which most of us have to spend our days, with the completely unexpected. . . .

Gwen Harwood is clearly a protean and complex personality, and her poetry is similarly various, brilliant and puzzling. For this reason, perhaps, there has so far been little extended critical discussion of her work, although there has been a fairly general recognition of its quality and stature. . . .

Yet it does not seem at all inappropriate that her third volume should be her *Selected Poems,* that mark of a poet's elevation into the ranks of the establishment. For it has been apparent from the beginning that her work bears the mark of permanence. Her first book is remarkable not only for the audacity and originality of certain individual pieces and sequences—notably the Eisenbart poems—but also for its general air of assurance, confidence and maturity. It is in fact one of the most powerful and dazzling opening performances ever staged by an Australian poet: it carried her at one stride into the front rank of contemporary writing. It should not surprise us then that in some ways there should appear to have been relatively little development in her work—although this appearance is possibly deceptive. Her more recent poetry certainly displays a greater formal easiness, a certain air of relaxation and freedom; and she has also become more frankly and confidently personal in some of her statements—and if anywhere there has been development it is probably in this area. But substantially, her style, her themes, her poetic world are present and established from the outset—like Athena she sprang fully armed into the public gaze; although unlike that formidable goddess Gwen Harwood when she made her debut was forty-three, married, and the mother of four children. . . .

It would be silly, of course, to attempt to label Gwen Harwood as a Freudian poet—or, for that matter any other sort of poet: she is too much her own woman to fit comfortably under any label. But it is interesting to find what Freud called the primal scene—the witnessing by the child of the primary act of betrayal, the sexual intercourse of his parents—figuring so prominently . . . ; interesting if for no other reason than that, according to Freud, this is the scene which, having witnessed, we then thoroughly repress. And it is significant in the context of the poems we have been looking at to find the words "gross" and "dark"—and "violence"—associated with it. It suggests that beneath all the erotic images, situations and statements in the poetry there is a persistent core of profound and possibly conflicting and not fully understood feelings. It suggests too that the control exhibited by the poetry is more than merely formal: it is not merely the anarchy of language that the poet has to master but the anarchy of her own psyche.

This to a degree is true of any poet. But for Gwen Harwood the conflict between restraint and freedom, control and spontaneity, is a central and abiding preoccupation, and one which has been and continues to be the source of many of her most forceful and idiosyncratic poems. . . .

Indeed the whole corpus of Gwen Harwood's work can in some ways be seen as a sequence of love poems, even the most satirically savage of them. They celebrate the world and man in a spirit of rational love, and they have grown out of that loving wrestle with the language that is the subject of the poem I discussed earlier: her poems are the work of one who has indeed learned to write as one makes love. And their strength rests in the confident belief that all art at its purest is the expression and embodiment of a love that is at least human and is possibly divine.

R. F. Brissenden. *Southerly.* 38, 1978,
pp. 3–5, 10–11, 20

If Dobson offers a personal and lyrical version of the cultural European consciousness, Harwood achieves her most vivid poems by locating as dramatically in the figures of Kröte and Professor Eisenbart, the middle-aged intellectual whose intellect cannot exempt him from the realities of the flesh, lust and death. The humiliating and terrifying revenges of flesh and spirit upon the presumptuous intellect which we find in the Eisenbart poems again share thematic concerns with White, but the combination of socio-intellectual comedy and a nightmarish, apocalyptic leaping of experience upon the protagonist that we find in "Panther and Peacock" also has affinities with a strain in the poetry of [A. D.] Hope. . . . Harwood's dramatic poems, with their energy and particularity, their delight in precise observation of details of human behavior, and their capacity to imbue particularity with general intelligible significance, are different in tone from her meditative lyrics, but the underlying preoccupations are often the same.

For her, the wonder of art is twofold. That defined in "New Music" is the creative voicing of the unknown—not so much a crossing of the frontier as a breaking of the barrier of the "living sleep" of established modes of perception. In the fine early poem "Giorgio Morandi" she writes of a different power in art—that of re-validating the familiar, and of giving it a sacramental value which can still the deep, the rooted fears of the heart. She has spoken of trying in her poetry to "shape a sense of joy in the flux of time"; that joy can only be gained by going through the terrors of a creature existing in time, of mortal flesh destined for the gross darkness of death, and of spirit suffering that other form of gross darkness, the wasting and betraying of the light of ideas.

Jennifer Strauss. *Meanjin.* 38, 1979,
pp. 344–45

Harwood is a poet who chooses to retain power by sidestepping many of the claims of modernism. Like Hope, another such sidestepper, she developed

late, publishing her first book at the age of forty-three. Her lyrics are full of romantic intensities; full of such words as "ghost," "vibrates," "dark brilliance," "dazzle," "terror," "radiant presences," "a fragment of passion / savoured and sucked"; full, if we may say it, of things lost, whether they be images of her youth, or lovers, or dreams which had offered brief illumination. Her regular stanzas keep calling out "Remember me" or uttering strong cries of loss:

> How can this body past
> childbearing lapse and rage,
>
> spirit's fury at last
> quicken, and wreck the cage
> of absence, so I stare
> across wastes of frozen air?
>
> ("Night Flight")

Like the new "an-aesthetic" poets, she celebrates Wittgenstein, but unlike theirs her diction has learned nothing from this influence. Frequently invoked, Wittgenstein figures in her verse as magus, as mystic, as a benevolent cross between Merlin and Eros.

Mimetically, Harwood takes for her province the clear, cool, unsmutched landscapes of Tasmania, along with the grim history of genocide which attended its original inhabitants; the natives of this island are another of her plangent losses, but their environment remains, to be haunted by them:

> Dreams drip to stone. Barracks and salt marsh blaze
> opal beneath a crackling glaze of frost.
> Boot-black, in graceless Christian rags, a lost
> race breathes out cold. Parting the milky haze
> on mudflats, seabirds, clean and separate, wade.
>
> ("Oyster Cove")

It is striking that Harwood mourns the Aborigines as dead and gone whereas Murray seeks to join them as living compatriots: this is not merely a point about the history of Tasmania and New South Wales, but also reveals different habits of the heart.

It is through the deployment of traditional, largely iambic meters, then, and of square-hewn stanzas, as well as by the administration of a pre-Wittgensteinian discursiveness of language, that Harwood earns her Trilling intensities. She makes loss or absence into a continuous present rhetoric; despite her recurrent wit, the provisionality of language games fails to subvert the ways in which she orchestrates erotic yearning.

Chris Wallace-Crabbe. *Journal of Commonwealth Literature.* 19, 1984, pp. 5–6

Harwood lives in Hobart, Tasmania, and has for nearly thirty years written poetry that engages the work of Blake, Heine, and Wittgenstein, that ponders music and quantum physics, without relinquishing a precise and local eye and ear. As much a familiar figure at the Hobart Public Library, scanning the latest issue of *Mind,* as in her dinghy, watching for the twitch on her fishing line, she has produced a body of work governed by the desire at once to analyze and integrate a complex dialectic of passion and intellect, loss and salvage, parish and globe.

A series of renunciations brought Gwen Harwood at last to poetry. By the time she came to writing as an active vocation (though with roots that stretch back to earliest childhood love for lyric, hymn, and rhyme) she had already absorbed or relinquished a number of lives: a concert career, the heady intellectual excitement of the late 1930s, the tropical landscape and climate of Brisbane. Perhaps many others could offer a similar tale of that time, but for Gwen Harwood these dislocations seem to have formed a pattern of echoing loss and recompense that has organized much of her poetry. But though drawn to the elegiac mode, by both history and temperament, Harwood has always chastened elegy from sentimentality through the very strength of the hunger for recovery that first set it in motion. "Recovery" here must be understood to contain two equal vectors, often in tension with one another: the return of the lost through some figurative translation (into dream, memory, talisman, or haunting), and the repair of the elegist. But since recovery in the former sense is very likely the occasion of relapse in the latter, a continuous dialectic or cycle is sketched out. . . .

It was not until around 1960 that Harwood's work began to appear regularly in Australian journals. Andrew Taylor has described her appearance at this time on the scene of Australian poetry as "a period of excitement and also of bewilderment." The latter response stems from Harwood's use of several pseudonyms, both then and later, so that tracking her work became something of a puzzle for readers: Was this a single poet, or a remarkable new school "of virtuoso technical accomplishment, wit and insight?" Some of these pseudonyms were tactical—her work was at one point banned from *The Bulletin,* because of an acrostic poem of which the editors, when they noticed it too late, disapproved. Jennifer Strauss has suggested that the various names were used "in order to get an unprejudiced hearing," though there is no evidence that this was a motive. But in fact Harwood's use of pen names predates these incidents, which only served to reinforce an impulse towards shape-shifting already in play. Rather the pseudonyms are a ludic device by which the poet projects divisions from within her work onto the level of authorial ascription. The pen name "Miriam Stone" offers an example of this impulse to mask: Stone's poems treat especially the frustration and despair of women locked in domesticity to the stagnation of their other needs. Clearly a version of Harwood's experience in Hobart haunts such poems as "Suburban Sonnet" or "Burning Sappho," but their ascription to the emblematic "Miriam Stone" allows bitterness to emerge as one aspect of a composite

poetic sensibility, elements of which can be distinguished by giving them separate names. The impulse to follow out and analyze the tensions within an image or situation, as in "Fire-Scarred Hillside," reappears at another level. The use of pseudonyms is in this way consistent with Harwood's method elsewhere in her earlier poems, and it should not be surprising, in retrospect, that a poet as committed to dialectical tension as Harwood should experiment in this way with alter egos. Indeed the opening poem of her first book carries this very title, "Alter Ego," and imagines, through the structure of Mozart's music, the possibility of multiple historical selves being subsumed synchronically "beyond / Time's desolating drift" if only the right light or mode of consciousness could be found to glimpse them in.

T. G. Bishop. In Robert L. Ross, ed.
International Literature in English: Essays on the Major Writers (New York: Garland, 1991), pp. 622–23

HAYASHI FUMIKO (JAPAN) 1904–51

Hayashi Fumiko, born in 1904, was the daughter of an impecunious peddler and from her early childhood she moved from one part of the country to another with her parents. As soon as she had finished school, she launched out on her own in a desperate effort to support herself. She tried innumerable ways of making a living—as a maid, a clerk in a stockbroker's office, a worker in a celluloid factory, an assistant in a maternity hospital, a waitress in a German café, a street-stall vendor, to name only a few of her occupations. She was in constant poverty and often on the verge of starving or of taking to the streets; on at least one occasion she attempted suicide. All these experiences are realistically described in her first well-known work, *A Roving Record* (Hōrōki, 1922–27).

Hayashi Fumiko's devotion to literature started at an early age and continued during the course of her unsettled and esurient life. In her brief spare time she wrote poems, short stories, and children's tales, and gradually these began to attract attention. She went through a period of left-wing writing, but in describing poverty and social injustice her approach was always very different from that of the tough-minded authors of the proletarian school.

It was not until after the war that Hayashi Fumiko's literary reputation became established. By the time of her death in 1951 she was undoubtedly the most popular woman writer in Japan.

In her stories and novels Hayashi Fumiko portrays with realism and compassion the hardships of the Tokyo lower classes, with which she was so intimately acquainted from her own youth. She shows us a world of degeneration, humiliation, and instability in which men tyrannize over women and

women themselves are, all too often, merely apathetic. Yet, tough as this world is, Miss Hayashi suggests that there is a surprising degree of cheerfulness and hope in the lives of the members of the lower stratum that she describes. Her principal women characters are of the humble, yet undaunted, type. As in the present story, their impulses of despair are almost always balanced by a strong will to live and a faith in the future. Given its dominant subject and approach, it is inevitable that Hayashi Fumiko's writing should frequently verge on the sentimental; yet there is a simple, poetic quality about her language and a directness about her telling method that save her work from ever becoming maudlin.

<div style="text-align: right">

Ivan Morris. Introduction to *Modern Japanese Stories* (Rutland, Vermont: Charles Tuttle), 1962, pp. 349–50

</div>

Floating Cloud is the story of a young secretary, chased by lustful and selfish men, who, like her, suffer from living lonely lives without friends, money, work, or source of support. Yukiko's lover looks for her but then leaves her, not even knowing if he loves her. He hurts his wife with his infidelity. Attached to his home and at the same time unsatisfied with his sad, insipid married life, he is himself uncertain and lost. . . .

The atmosphere of poverty, sadness, and human abandonment prevails in this story, showing the author's great capacity for kindness as well as her unusual skill to describe the feelings of a feminine heart most subtly. There is an echo of the deep humanity of some characters of Gorki. Hayashi's destitute heroes can attain a rare feeling of happiness through mutual devotion and selflessness.

In her short story "Tokyo," a tea peddler called Ryo is portrayed with truth and tenderness in her poverty. Hayashi herself had made her living as a streetstall peddler at one time. The woman in the novel has not heard from her husband, a prisoner in Siberia, for six years and she is caring for her six-year-old son. She possesses nothing, not even a room to sleep in, and still she can generously give love without asking for love in return. Of the same human generosity is the worker with whom she falls in love; he is unexpectedly killed in a lorry accident. He fought in war, survived the hardships of a prisoner camp in Siberia to die in an accident when coming back from work. Ryo accepts the loss without despair or romanticism. She continues to sell her tea. Then one day a woman asks her "How much does it cost?" Seeing the peddler's rucksack she adds, "Come in and rest a while, if you like. I'll see how much money we've got left. We may have enough for tea." [The text continues:] "Ryo went in and put down her rucksack. In the small room four serving-women were sitting on the floor around an oil stove, working on a heap of shirts and socks. They were women like herself, thought Ryo, as she watched their busy needles moving in and out of the material. A feeling of warmth came over her."

It is this human warmth that gives the stories of this writer such a deep human quality. She has an extraordinary gift for developing a tight plot and creating a living atmosphere.

There is no romantic banality, even when risking a difficult subject, as in *Hone* (Bones). In it a young war widow, Michiko, has her first experience as a prostitute. She had to get money to feed the selfish family consisting of her senile father and young brother dying of tuberculosis:

> She could not help feeling terribly guilty. Staring blankly at the frosted glass which had brightened to blue-green, she felt like asking some god if this was human fate.

It is curious to note that this short story opens with a quotation from the Bible and ends with Michiko and her daughter carrying the casket with the ashes and bones of the young brother, while the child sings "Jesus Loves Me." At that moment Michiko only wonders when her father will die. What is most admirable about Hayashi is that unlike most proletarian writers, she wrote not with ideological tirades or theories, but with understanding for real people. . . .

The Western tragic sense of life has not impressed Japanese literature except for two authors, Osamu Dazai and mainly Fumiko Hayashi—again a Japanese woman exceeds Japanese men in the building of a world of deep human emotions.

<div style="text-align: right">

Armando Martins Janiera. *Japanese and
Western Literature: A Comparative Study*
(Rutland, Vermont: Charles Tuttle, 1970),
pp. 172–74, 268

</div>

Uno Chiyo and Hayashi Fumiko were contemporaries: the former is still writing in her mature years, and the latter died in 1951 at the age of forty-eight. They represent good examples of women writers for whom writing and the choice of life-styles were inseparable. They loved and wrote, and many of their major works are autobiographical. Hayashi Fumiko was born in a lower-class family with a peddler as a father and a mother who was even more unconventional in her relations with men than Fumiko herself. Her works are often distinguished by their autobiographical portrayal of a woman equipped with a free spirit and great vitality. Her later short stories, however, including "Narcissus" which appears here, are pure fiction finished with artistic mastery. Uno Chiyo's life was also untraditional in her personal relations, which form materials on which she draws heavily in her works. Yet her treatment of them brings her works close to the phenomenological study of state of mind rather than the involved scrutiny of the self.

<div style="text-align: right">

Noriko Mizuta Lippitt and Kyoko Iriye
Selden. Introduction to *Stories by
Contemporary Japanese Women Writers*
(Armonk, New York: M. E. Sharpe, 1982),
p. xix

</div>

Between her jobs and love affairs she found time to write poetry and children's stories. She also kept a diary, excerpts of which were serialized in the women's literary magazine *Nyonin geijutsu,* in 1928, under the title *Hōrōki* (Journal of a vagabond). When *Hōrōki* was published in book form in 1930 it immediately attained tremendous popularity. It depicts a young heroine who manages to live with impressive honesty and cheerfulness in the lowest stratum of society. It is candidly narrated, devoid of pessimism and sentimentality. The montagelike sequence of diary entries creates a natural time flow of events, and Hayashi's style is compellingly vivid and intensely lyrical.

The success of *Hōrōki* put an end to Hayashi's precarious mode of life; she was able to travel to China and, in 1931, to Europe. She spent much time in Paris frequenting museums, concert halls, and theaters. Returning home in 1932, she wrote a number of short stories that gradually established her place in literary circles.

In 1935 Hayashi wrote her first novel, *Inazuma* (Lightning), whose characters were modeled on the members of her own family. During the Second Sino-Japanese War (1937–45), she was dispatched to China as a special correspondent by the newspaper *Mainichi.* She also served as a member of the Japanese wartime press corps in the South Pacific in 1942. These experiences gave further scope and depth to her later writings. During the remainder of the war she lived in the country and concentrated on writing children's stories.

In 1948 Hayashi published on of her finest stories, "Bangiku" ("Late Chrysanthemum," 1960). It delineates with consummate skill the subtle, shifting moods of a retired geisha who is visited by a former lover. But on arrival the man confides that the purpose of his visit is to solicit financial assistance. Struggling to hold onto her receding romance, she receives a second blow on learning that the money is for extricating him from a tangled affair with a young woman.

Ukigumo (1951; *Floating Cloud,* 1957) was acclaimed as Hayashi's major work. The heroine Yukiko leaves for Indochina, trying to forget a rape incident. There she falls in love with Tomioka, and together they return to Japan. Spurned by him, she vainly tries to revive Tomioka's affection and gradually degenerates to the point of prostitution. Tomioka, having failed in business, leaves for Yaku Island. Enfeebled with tuberculosis, Yukiko follows him to the island only to die while he is away in the mountains. Just before her death Yukiko abandons herself to beautiful memories of their days in Indochina. A dark pessimism prevails in this work, but Hayashi's controlled detachment and penetrating insight into the fallen, wandering Yukiko generate a genuine pathos and an added dimension to the world of Hayashi's hobo protagonists.

Few of her contemporaries can rival Hayashi's skill in vividly evoking a particular atmosphere. Perhaps more important, she felt and understood the loneliness of displaced women, creating female characters, alienated but always alive, who speak with a universal voice that transcends their milieu and their homeland.

<div style="text-align: right">

Kinya Tsurata. In Leonard S. Klein, ed.
Far Eastern Literatures in the 20th Century
(New York: Ungar Publishing, 1986),
pp. 96–97

</div>

To eat and to write are the two reasons for living, Hayashi Fumiko once said. Until the time she established herself as a successful writer, the life of Fumiko followed a pattern similar to that of Hirabayashi Taiko and Uno Chiyo: an ambitious young woman, she went to Tokyo seeking better opportunities and spent several years working in poverty, barely surviving from day to day. Though her life was considerably shorter, Fumiko achieved greater fame as a writer than either Taiko or Chiyo. She was the first woman fiction writer in modern Japan who enjoyed both popular success and critical recognition; she was able to compete effectively with men and fared well in male-dominated literary circles. During her twenty-year career she produced an enormous amount of work, including poems, short stories, and novels, many of which were important for their fine artistic quality as well as for their immense popularity. *Vagabond's Song* (*Hōrō-ki*), a novel that established her reputation as a writer, sold over 600,000 copies and inspired three films; nine of her other novels also became films. Fumiko continued to write with remarkable intensity until the day of her death at age forty-eight. Her prodigious output totaled some 30,000 pages, which she left behind in two hundred and seventy-eight books. . . .

Fumiko started writing poetry and found it a natural and spontaneous way of expressing herself. Eventually she found a woman friend who also wrote poetry, and with twenty yen from an anarchist student acquaintance (who happened to be from a rich family), they published a tabloid entitled *Two of Us* (*Futari*). The publication of Fumiko's first book, a collection of poems entitled *I Saw a Blue Horse* (*Sōma o Mitari*, 1929), was also financed by a donation from a friend. . . .

The novel [*Vagabond's Song*] is both a collection of sketches of daily incidents, in the manner of impressionist watercolors, and a journal of a young woman, who is poor but full of dreams and the courage to resist the drudgery of a non-creative life. Clearly autobiographical, the story describes the cafés and other places where Fumiko had worked; the streets, the women with whom she had shared small rooms, the men who had caused her pain, and her mother, portrayed as living in a remote southern town but always present in the mind of the narrator. The writing is characterized by a free-flowing, poetic sensibility that many readers had not seen before in fiction written by women, and its readability contributed to the book's great popularity. The novel was also unique in that it depicted café life from the point of view of the women who worked there. The café had become a vital part of city life in Japan in the 1920s; like the geisha houses decades earlier, cafés—along with dance halls and bars—sprang up in the large cities, symbols of developing mass culture amidst spreading economic hardship. The vagabond narrator of Fumiko's novel was an appealing character and readers empathized with her struggles to overcome her bleak existence. Fumiko later acknowledged the key role Knut Hamsun's book, *Hunger*, had played in the conception of *Vagabond's Song*. Like the narrator of *Hunger*, the protagonist of Fumiko's novel transcends despair, turning misery into aspiration.

The commercial success of *Vagabond's Song* established Hayashi Fumiko as a highly marketable author in the minds of publishers, but she also achieved critical recognition. At the end of the following year, 1931, she wrote a short piece, entitled "The Poor" (*Seihin no Sho*), describing life with Ryokutoshi. This work received rave notices from the critics and gained her membership among the writers of so-called pure literature. Fumiko was greatly encouraged by this but realized that she could not limit her creative writing to the portrayal of poverty and its victims. Although many of her stories are autobiographical, Fumiko proved she also could create characters and situations for which she had no living model. "The Oyster" (*Kaki*, 1935) is about a feeble-minded and neurotic craftsman who is slowly going mad. "The Crested Ibis" (*Toki*, 1935) portrays a diligent and kind-hearted young woman who feels she will not be able to marry because of a birthmark on her face. . . .

Her masterpiece novel, *The Floating Cloud* (*Ukigumo*, 1949–50, tr. 1965), is based on her travels to Southeast Asia during the war years and is the story of a young woman and a man who have both been spiritually devastated by the war. *The Floating Cloud* is the best among the very few works of fiction that portray the confusion, apathy and moral despair suffered by the Japanese people in the post-war period. Fumiko's friend and rival, Hirabayashi Taiko, remarked that even had she written nothing else, Fumiko's name would be imprinted in modern Japanese literature as the author of *The Floating Cloud*. The novel demonstrated that Fumiko was capable of writing a full-length novel with complex characterization, sustained plot development and large social perspectives, an achievement only one or two Japanese women writers had accomplished before her. . . .

Fumiko was among the first writers to respond to the needs of modern Japan's widened audience. Her writing never lost the down-to-earth sensibility and sense of immediacy that won so many new readers, and her vivid style and probing themes make her fiction among the most significant and lasting in modern Japanese literature.

<div style="text-align: right">

Yukiko Tanaka. *To Live and to Write: Selections by Japanese Women Writers 1913–1938* (Seattle: Seal Press, 1987), pp. 99–104

</div>

Hayashi is most concerned with depicting her characters when and as long as they remain outside the boundaries of convention. Clearly, then, when she thematizes the woman's experience, Hayashi is not generally inclined to pose one woman against another in alternative roles. Rather, she explores the context of a given woman's life in terms of needs that she sees as present in all women. From Chiyoko to Kin, her protagonists are seeking to combine their desires for security and love. As we shall see in the special case of *Chairo no me,* she is perfectly capable of portrayals of the "respectable lady," but her compassion lies elsewhere—with the rootless, the unprotected, the

physically, financially, or emotionally needy, who must act outside the limits of what is "proper" in order to hold on to life.

In a literature that has a marked abundance of passive and reflective main characters, Hayashi's women have passion and energy. They go on living as best they can, taking life as it comes, but wanting more. They have fully articulated (but not consistent) personalities. Consistency, after all, is the outward sign of the already formulated symbol—the stereotype.

Hayashi's protagonists are perceived more directly, if not more distinctly, than those of most Japanese male writers. . . .

When the consciousness of the feminine is filtered through a woman's perspective, the sharpness and certainty of objectification are yielded up to the more intricate balancing of identification. The reader, reading a text that depicts a woman's perspective as a woman projects it—and perhaps most especially if the reader, too, is a woman—is beyond the reification of Otherness and behind the eyes of the Same. Experienced as it were from within, Hayashi's women are not aesthetically pleasing. They are not aesthetically imaged; they are not images (except through the eyes of men or in the totally cold blood of "Late Chrysanthemum"). They fall between "wife" and "mistress," Osan and Koharu, sometimes closer to one pole than the other, but always in some way outside the safety of tradition and the dichotomizing eye which sees Otherness as objectified.

<div style="text-align: right">

Victoria V. Vernon. *Daughters of the Moon: Wish, Will, and Social Constraint in Fiction by Modern Japanese Women* (Berkeley: Institute for East Asian Studies, 1988), pp. 155–56

</div>

HAZZARD, SHIRLEY (AUSTRALIA) 1931–

In Shirley Hazzard's *The Transit of Venus,* a dispassionate narrator remarks of a perceptive but willfully impassive minor character: "Around Mrs. Charmian Thrale . . . impressions passed in ritual rather than confusion . . . welling together in a flow of time that only some godlike grammar—some unknown, aoristic tense—might describe and reconcile." Significantly, the events of Hazzard's novel unfold for the characters in a kind of aoristic tense, an indefinite past tense in the Greek language that does not clarify whether an action is completed, continued, or repeated. Hazzard's novel raises ultimate questions about order and meaning in the lives of people who can gain only such limited, aoristic perspectives upon their own experience. Stranded within the even more unformulated, indefinite present tense of consciousness, these characters sometimes tragically, sometimes pathetically struggle

through the agencies of memory, will, language, and art to discover or create meaning and order in a universe of "havoc.". . .

Hazzard's novels evoke readers' memories of the fiction of Henry James, Charlotte Brontë, and Thomas Hardy, among several others (including poets). In *The Transit of Venus,* for instance, Ted Tice is introduced as "young and poor and [as having] the highest references—like a governess in an old story, who marries into the noble family"; and throughout the end of the novel, he is a modified Jane Eyre figure whose affection for Caro approaches consummation only after Caro, like Mr. Rochester in Brontë's novel, experiences a sort of blindness. The ghostly presence of this and other fictional classics in Hazzard's work imparts a sense of tradition, the heritage of the traditional novel to which her own writings belong even as they considerably revise their literary precursors. Among these ghostly echoes also appear vestiges of Hazzard's own work. In fact, each of her novels successively revises its immediate predecessor. For example, a plane crash is one of many significant images in *The Transit of Venus;* the novel expands the implications of this same image in *The Bay of Noon,* which advances the function of this image in *The Evening of the Holiday,* which recalls the image in *Cliffs of Fall.* This same chain of progression informs Hazzard's characters, who share certain similar attributes from novel to novel; for example, the encounter between Valda Fenchurch and Mr. Leadbetter in *The Transit of Venus* calls up the reader's memory of *People in Glass Houses.*

Catherine Rainwater and William J. Scheick.
Texas Studies in Literature and Language.
25, 1983, pp. 181–83

Writers and critics of present-day fiction tend to fall into one of two camps: traditional or innovative. The traditional writers persist in creating narratives with distinct, coherent characters and recognizable settings; they cling to the referential function of language; and their narrative voices, however artful or literary, continue to efface themselves in the service of effective storytelling. To many contemporary critics and authors, these habits appear mechanical and naive, capable of producing only outworn fiction. Modernist and post-modernist theoretical schools alike—despite certain differences in their assumptions—unite to call into question the seriousness of the contemporary traditional author.

Shirley Hazzard's fiction—above all her 1980 price-winning novel, *The Transit of Venus*—clearly evinces the strictures of such criticism and the sorts of fiction it prohibits and authorizes. Her success suggests that when a contemporary "old-fashioned" novel fails artistically it does so not because of its commitment to tradition but because that commitment is shallow or thoughtless. Over time her work has increasingly become infused with textual self-awareness and has increasingly become a vindication of the traditional literary convictions which it embodies. Literary art, her work implies, has always stood in a complex and fragile relation to the world. It has always

followed rules of its own, rules different from the rules of life (if, indeed, life has any rules), and hence has never corresponded to life in a simple replicative sense. As a creation of the will, it has always been in essence a fiction which resists life even while remaining grounded in and rising from real experience. "The Transit of Venus" does not merely tend to fall into the camp of the traditionalists: it is dedicated to tradition as a creed. Its conspicuous passion for literary art makes it as serious and self-aware as the most radical experimental novel—makes it, in some extraordinary fashion, a radical experiment itself. . . .

As she fully assumes the burdens and challenges of fiction for the first time in *The Bay of Noon,* Shirley Hazzard defines fiction in its classical, neo-Aristotelian sense as an imitation of an action; with a beginning, middle, and end, the whole is mediated by a narrator who is responsible for the artistic arrangement of incidents—for the plot, which is the soul of fiction. We recall that Hazzard began her literary career as a short-story writer who found the highest form of literature to be the lyric. In quoting from lyrics and alluding to them, her work seemed to remind us that there was something superior to the kind of thing she was doing. Now, the entire work of fiction, the completed action, the closed structure, seems to have become for her the equal of the lyric poem. Fiction has no need to apologize or to draw on higher literary forms. . . .

From the crisp opening sentences of *Cliffs of Fall,* we could not have predicted *The Transit of Venus,* although now that we see the outcome we can construct a narrative. In this narrative Shirley Hazzard's fixed commitment to traditional literature produces increasingly ambitious and successful traditional structures, in both mimetic scope and assertion of artifice. *The Transit of Venus* is a satisfying and beautiful work of art, a triumph for the old-fashioned novel.

<div align="right">

Nina Baym. *Texas Studies in Literature and Language.* 25, 1983, pp. 222, 238, 247

</div>

Until recently Shirley Hazzard was not nearly as well known as she deserved to be. But the publication of her fourth novel *The Transit of Venus* in 1980 changed all that. It was awarded the National Book Critics Circle Prize in America and reached the top of the best-seller list in several countries. As relatively little has been written about her work, I want to place her major achievement in *The Transit of Venus* in the context of her life and other works and so offer a general introduction to this Australian disciple of Flaubert and the other masters of European fiction. . . .

A brief glance at Shirley Hazzard's early life will throw considerable light on her later choice of themes: of the spiritual quest, the ironies of fate, the poignancy of loss and the consolations of memory. It will also further illuminate her brilliant evocation of an Australian childhood in her latest novel through the early lives of Caro and Grace Bell, a childhood chiefly characterized by the disturbing irrelevance of their European-oriented educa-

tion and the sense of cultural displacement. The author herself was born in Sydney in 1931, was educated at Queenwood School, Sydney; and, like Caro Bell in *The Transit of Venus,* had her first experience of Italy when she saw Italian prisoners of war in the Blue Mountains when her school was briefly evacuated there. Later, Italy was to provide the initial inspiration for her early short stories *Cliffs of Fall* (1963) and her two brief novels *The Evening of the Holiday* (1966) and *The Bay of Noon* (1970). In Italy her characters fall in love and learn the language of the senses. . . .

Few modern novelists have combined such complex public and private themes in a novel [*The Transit of Venus*] that is so beautifully structured and written in a style that, as I have suggested, combines George Eliot's moral seriousness and Henry James's wit and irony. More thoroughly than most feminist writers she exposes the power structures and forms of language that maintain male dominance, but she does this as a natural part of her ironic scrutiny of personal relations and not to make propaganda for a cause.

John Colmer. *Journal of Commonwealth
Literature.* 19, 1984, pp. 10, 21

In an interview transcribed in *The Bulletin,* Shirley Hazzard is reported as saying:

> men often find it hard to go through with the private occasions of life, or with independent beliefs. And perhaps the very fact of allowing—or enabling—other men to launch you into wholesale slaughter is a way of announcing, "What does it all mean? Let's cry havoc and let rip with our primitive passions."

These remarks, in part, echo some lines given to the seemingly stable and conventional Grace Bell in *The Transit of Venus* and they allude to the war motif which is central to any consideration of the novel, linking, as it does, its public and private realms. Just after her affair with Dr. Dance has ended, a relationship for which she was prepared "to relinquish" her marriage and to become, as she puts it "an honest woman," Grace speaks to her sister, Caro, of men and women. "Women have to go through with things. Birth, for instance, or hopeless love. Men can evade forever." Grace, we are told, "had learned to shrug": she "had discovered that men prefer not to go through with things. When the opposite occurred, it made history: Something you'll remember always." . . .

It is the notion of men and women going, or not going, through with things, and what Miss Hazzard terms the masculine tendency to "let rip with . . . the primitive passions" that form the focus of this essay, but it should be made clear from the outset that Miss Hazzard does not attempt to depict her male or female characters as either exclusively evil or virtuous. They all participate in a "difficult humanity," some with distinction, some without; but there are no absolutes. What does distinguish one character from another

in the novel is the willingness or reluctance to signal a difference from the established power elite. Miss Hazzard suggests that, no less than women and the poor or underprivileged, middle-class men face the choice that to realize themselves they may have to question or work outside the certain certainties of the male-dominated social formula. . . .

It is . . . what Tice terms "conscious act[s] of independent humanity that *The Transit of Venus* celebrates. It endorses those characters who side with Venus, not Mars; who endorse reciprocal love over manmade violence; who recover greatness of the earth and who, in accomplishing things, do not, as Paul freely admits to having done, relinquish their "immortal soul." In a century of "jagged devastations," Shirley Hazzard's point is that the great heroism is in living, in having the imagination and the moral courage to go through with "the private occasions of life. . . . But this "life" is not easy, and "living" means having the integrity to be individuals in what Grace Bell, in despair, calls the "mass society."

<div align="right">John Wieland. Commonwealth Novel in
English. 3, 1984, pp. 1–3</div>

In *Transit,* Hazzard clearly wants improved conditions for women and is concerned to show the effects of prevailing conditions on (bourgeois) women. Nevertheless, she fails to argue against the mystified notions linking women, art, love, and the private sphere that are central to bourgeois theories of art and culture and which assist in the continuation of the present structures. For example, Caro Bell is frequently compared to works of art, paintings or sculpture, in ways that concur with such narcissistic associations. In the long run, this will achieve little for Caro and even less for working-class women, a group to which she plainly does not belong. In Hazzard's work, then, there appears to be a crucial connection between her bourgeois political ideology and her essentially traditional aesthetic values.

An examination of any similar contradictions in the work of other successful women writers would provide fuller information about the construction of women writers in reviews. For this discussion of *Transit's* reception, it is sufficient to say that such features have been read by the establishment in ways that subscribe to hegemonic values. The connections between politics, aesthetics, and questions of literary value, and between women writers, their works, and the publishing and reviewing institutions, whether of "high" or "popular" culture, are subtle and complex. They need to be considered in feminist socialist accounts of women's writing as well as the influence of social issues like gender, class, and race.

Thus, when book reviewers suggest that *Transit* is a novel of "frigid excellence [that] cleanses in a world poisoned by junk," their comments are less interesting for the implication that Shirley Hazzard has written a "good" novel than for the light shed on the attitudes about literature current among some writers and some critics. The difficulties and ambiguities raised by a scrutiny of the reception of *The Transit of Venus* suggest that it is not enough

to be grateful that a woman writer (and an Australian) has achieved critical acclaim in the review columns. It is not only that the processes of constructing her "success" may result in certain misreadings of her work. More seriously, her success may expose many of the aesthetic and political affiliations of some reviewers and some (women) writers that are, in the final analysis, counterposed to the aims of those who read women's writing from a feminist socialist viewpoint. We shall need to argue vigorously against the literary orthodoxies for some time to come, and this will involve not only the definitions of writing by women but also the definitions and political functions of writing—or literature—itself.

> Bronwen Levy. In Carole Ferrier, ed.
> *Gender, Politics and Fiction: Twentieth-Century Australian Women's Novels* (St. Lucia, Australia: University of Queensland Press, 1985), pp. 198–99

HEAD, BESSIE (SOUTH AFRICA) 1937–86

I think we can begin to talk of a new category of South African novel, which, in theme at least, may be termed the South African Novel of Africa, concerned certainly with the viciousnesses of South Africa's political kingdom, but seeing them in meaningful relation to South Africa's future, by means of present models for that future at hand for close observation in the independent countries of Africa. The first of these novels was Peter Abraham's *A Wreath for Udomo,* which appeared as long ago as 1956. But it was Nadine Gordimer's *A Guest of Honour* (1970), with its extraordinarily fine political perceptions, that made such a subdivision of the South African novel seem a possibility, and it was soon followed by Ezekiel Mphahlele's *The Wanderers* (1971). And then one looked with fresh eyes at Bessie Head's novels and, within the past year especially, at *A Question of Power.* Her novels strike a special chord for the South African diaspora, though this does not imply that it is the only level at which they work or produce an impact as novels.

They are strange, ambiguous, deeply personal books which initially do not seem to be "political" in any ordinary sense of the word. On the contrary, any reader with either Marxist or Pan-Africanist political affinities is likely to be irritated by the seeming emphasis on the quest for personal contentment, the abdication of political kingship—metaphorically in *When Rain Clouds Gather,* literally in *Maru,* and one might say wholesale in *A Question of Power.* The novelist's preoccupations would seem to suggest a steady progression from the first novel to the third into ever murkier depths of alienation from the currents of South African, and African, matters of politics and power—indeed in *A Question of Power* we are taken nightmarishly into the

central character's process of mental breakdown, through lurid cascades of hallucination and a pathological blurring of the frontiers between insanity and any kind of normalcy. . . .

There are two major clues to the overall homogeneity of Bessie Head's novels. It is impossible to avoid noticing how frequently the words "control" and "prison" (and phrases and images of equivalent value) occur in all three novels, in many different ways certainly, and probably not as an altogether conscious patterning. "Control" occurs in contexts tending towards the idea of control over appetites felt as detonators that set off the explosions in individual lives, no less than in the affairs of mankind, which leave those broken trails of blasted humanity that are a peculiar mark of our times. "Prison" occurs in more varied uses, but most often related to a voluntary shutting of oneself away from what goes on around one. Sometimes it may be straight escapism or alienation, but more often it suggests a willed control over a naturally outgoing personality, an imprisonment not for stagnation but for recollection and renewal—a severely practical self-imposed isolation which is part of natural growth. Like the silk-worm's cocoon, it is made for shelter, while strengths are gathered for outbreak and a fresh continuance. . . .

Bessie Head's most recent novel, *A Question of Power,* is clearly more ambitious than its two predecessors, and less immediately accessible, and altogether a more risky undertaking. The movement here is even deeper (and more disturbingly so) into the vast caverns of interior personal experience. The setting is closer to that of *When Rain Clouds Gather,* a remote Botswana village with a medley of exiles and foreign-aid helpers showing the Batswana how to make semidesert sands more fertile. There are two prime exile figures, the visionary, dynamic white Afrikaner who has escaped the other prison of apartheid, and the central character, Elizabeth, whose mental stresses and breakdown take her into ultimate isolation and absolute exile. In addition she is a colored South African exile in Botswana. . . .

I do not believe that Bessie Head's novels are offering anything as facile as universal brotherhood and love for a political blueprint for either South Africa or all of Africa. In *Maru* common sense is described as the next best thing to changing the world on the basis of love of mankind. What the three novels do say very clearly is that whoever exercises political power, however laudable his aims, will trample upon the faces and limbs of ordinary people, and will lust in that trampling. That horrible obscenity mankind must recognize in its collective interior soul. The corollary is not liberal abstention from action, but rather modest action in very practical terms, and with individual hearts flushed and cleansed for collective purpose. The divinity that she acknowledges is a new, less arrogant kind of humanism, a remorseless God who demands that iron integrity in personal conduct should inform political action too. . . .

In the development of the South African novel, this disturbing toughness of Bessie Head's creative imagination returns to us that gesture of belonging

with which *A Question of Power* ends. All three novels are fraught with the loneliness and despair of exile, but the resilience of the exile characters is even more remarkable. Bessie Head refuses to look for the deceiving gleam that draws one to expect the dawn of liberation in the South, but accepts what the meagre, even parched, present offers.

<div align="right">

Arthur Ravenscroft. In Christopher
Heywood, ed. *Aspects of South African
Literature* (London: Heinemann, 1976),
pp. 174–75, 183, 185–86

</div>

Female novelists are rare in Africa. Bessie Head is even a rarer commodity, coming as she does from South Africa, where writers of any type are in short supply. With four books—three novels and a collection of short stories—and several uncollected sketches to her credit, Miss Head deserves attention. But there are more important reasons for considering her writing. She fits into a pattern which is now familiar to the whole world—the writer in exile; and like other writers in exile she has carried with her the mental stresses and strains of her home country, even while describing the landscape and people of her adopted country.

Miss Head is remarkable among South African writers living in exile. Intensely urbanized, practically all of them—the best known among them are Peter Abrahams, Ezekiel Mphahlele, Dennis Brutus, Lewis Nkosi, and Alex LaGuma—have settled in the cities of America and Western Europe. But Miss Head has settled in Botswana where she has participated fully in an experiment in rural self-sufficiency. Her fierce determination to take root and grow in this unfamiliar terrain accounts for her distinctive vision of alienation. . . .

Miss Head is not a Hegelian. But her writings make it clear that while she, like other South African exiles, rejects the religious, social and intellectual order of her home country, she also rejects as completely the political visions which other African writers have posited as alternatives. Her alienation from the prevailing political perspectives both of South Africa and the Pan-African movement naturally did much to color Miss Head's picture of her own selfhood—and ultimately of her role as a writer. . . .

Miss Head's uniqueness derives from her combining an intense awareness of alienation with a commitment to issues larger than personal interests. The clue lies in her life, which made alienation not an endless discovery demanding expression, but merely the initial premise. Alienation was the initial premise because Miss Head was, to begin with, by birth trapped in the color situation in her country: "In South Africa she had been rigidly classified Colored. There was no escape from it to the simple joy of being a human being with a personality. There wasn't any escape like that for anyone in South Africa. They were races, not people." Adolescence brought further estrangements: an unsuccessful marriage, and her decision to emigrate.

But when Miss Head settled down in Botswana, the premise of total alienation began to be undermined. As her autobiographical novel, *A Question of Power,* clearly indicates, her anguished—but ultimately successful—struggle to move from an alien to a citizen has given her a sense of the unexpected possibilities and rewards of individual participation in the ordinary life of a community. Bessie Head's first years in Botswana were everything to her career as a writer, not only because they gave her a subject, but because to the earlier perspective of every kind of alienation there was added a foreground of immediate experience which featured a series of the most direct personal and social commitments—to her career, to her adopted country, to humanity at large. These commitments have had the most far-reaching effects on her attitude to her role as a writer, and on her understanding of human life.

Kolawole Ogungbesan. *Journal of African Studies.* 6, 1979, pp. 206–7

Bessie Head's fictional solutions are not reassuring ones, to be sure. Still rejected at home, stateless abroad, she herself, like her heroines, has achieved a tenuous, uncertain, and unrecognized status in the country of her would-be adoption. Only as a writer has she achieved acceptance and international recognition. "Restless in a distant land," she does speak out, through her fiction, of her frustration and her turmoil, her insistence on being ordinary. "Africa had nothing, and yet, tentatively, she had been introduced to one of the most complete statements for the future a people could ever make—Be ordinary. . . . She did not realize it then, but the possibilities of massive suffering were being worked out in her." It is ironic that the intensity of her reactions and her sensitivity to the hostile environment of Africa produce not only fine novels but also suspicion and rejection there when she seeks security and refuge. Labeled as minority or colored in a black society, exiled from South Africa, a woman alone, she lives today on sufferance in a hostile, male-dominated world.

Bessie Head faces a question of power, a challenge to will. The inner power she seeks—the intellectual power achieved by an articulate and brilliant intellectual—makes her own protest unavailing. Her artist's sensitivity to the world around her is evident in her portraits of children, her sketches of bird and thornbush, her identification with those ostracized. It also reveals her vulnerability. The very intensity of her reactions may produce discomfort in those around her. Turbulence may rock the boat. Her frank avowal of the autobiographical element in her fiction puts off hypocrisy or avoidance of issues as fictional only. So the qualities which make her outstanding as an artist also make her unacceptable in exile, at least for now. Just as Elizabeth's last uncertain hope is for a new wind to blow through the chaos of the world, so may the inner power to write and to endure support Bessie Head. May the "fine wind" blow a "new direction"; may she find peace and belonging

as the outcome of her sufferings in exile, not the division, violence and alien-
ation of tears.

<div style="text-align: right">

Charlotte H. Bruner. In Carolyn A. Parker
and Stephen H. Arnold, eds. *When the
Drumbeat Changes* (Colorado Springs:
Three Continents, 1981), pp. 274–75

</div>

Bessie Head chose the novel as a medium, she tells us in "Some Notes on
Novel Writing," because this form was "like a large rag-bag into which one
(could) stuff anything—all one's philosophical, social and romantic specula-
tions." It was not, however, until she had left South Africa that she could
marshal her thoughts and feelings into producing long fiction. In Botswana
she found an environment where she derived a feeling of security from the
people around her, who lived "in a kind of social order, shaped from centuries
past, by the ancestors of the tribe.". . .

Bessie Head feels that an ideal world can be brought about. Eventually,
she says, the "world wide awareness of struggle and suffering cannot help
but lead to a sense of idealism in those who rule." A reviewer of *Rain Clouds,*
Olive Warner of the *Spectator,* quoted by the publishers of *Maru* on the
cover, speaks of her "radiant optimism." Yet in her more sober moments she
is less naïve. "It is preferable to change the world on the basis of love of
mankind. But if that quality is too rare, then common sense seems the next
best thing," she says wryly in *Maru,* when speaking of Margaret Cadmore,
wife of a missionary, who took in the young Masarwa girl and gave her her
own name as well as a reliable grounding in life. In a *A Question of Power,*
the optimism at first seems to falter. Again, Head's own experiences are
relevant. She had not been granted citizenship in Botswana, her status still
being that of a refugee under the protection of the United Nations. Her years
in South Africa had made her feel dehumanized, and the vital human link to
her new home was still tenuous.

Alienation means having no roots within the community. Without that,
as Sello says at the beginning of *A Question of Power,* "I am just anyone," a
statement which Head describes as one of the most perfect, and a very
African one. Belonging also means having one's roots firmly planted in the
land. In her grasp of the significance of land in Africa, both as a symbol and
a fact, Bessie Head is perhaps nearest to the Kenyan writer Ngugi wa Thi-
ong'o. In the first novel, it is the land in the community of Golema Mmidi
around which the action centers. The villagers, newly independent, try to
cope with drought amid agricultural ignorance. Makhaya, the refugee who
comes from a South African urban area and Gilbert, a British agriculturist,
join forces in helping the community restore the land, hampered by reaction-
ary chiefs and self-seeking politicians. Through their success the land pro-
vides their own peace of mind. In *Maru,* it is the antagonistic forces among the
Botswana, rather than Margaret, who are alienated. Margaret has a prophetic
dream, which she puts into three of her pictures. In them a pulsating glow

of yellow light emanates from a field of daisies and dominates a pitch-black house. There is an embracing couple in the picture who do not want anyone near them. A strong wind, however, blows Margaret, the dreamer, in their direction; when she tries to grab hold of the daisies to save herself, she awakes. At the end of the story the couple in their black house will have to accept the dreamer whom the wind of freedom has blown into their midst. Elizabeth in *A Question of Power* finds her sense of belonging by joining a land project which, through its physical reality and international co-operation, keeps her nightmares at bay.

> Ursula A. Barnett. *A Vision of Order: A Study of Black South African Literature in English (1914–1980)* (London: Sinclair Browne/Amherst: University of Massachusetts Press, 1983), pp. 119, 122–23

Bessie Head's reputation as a writer rests on three novels, a collection of stories and a book on Serowe village. The three novels—*When Rain Clouds Gather, Maru* and *A Question of Power*—form something like a trilogy. In each of them the novelist exhibits strong disapproval for the misuse of power by any individual or group. This dislike is evident in the way she dramatizes the process of the abdication of power which gets more complex from the first novel to the last. By the time the reader gets to the end of the third novel the novelist's message is clear: the naked display of power by the racists in South Africa or any other bigots elsewhere can only lead to disaster. There is no way of avoiding the rewards of oppression whether it is of blacks by whites, whites by blacks, whites by fellow whites or blacks by fellow blacks. The wise thing to do is to conceive of power in a progressive evolutionary manner. But, given man's insatiable lust for power, this is hardly possible. The novelist considers at length the psychological basis of power and finds that this has been largely eroded in a world dominated by conflict and the desire for political ascendancy. It is because of this stated position that Bessie Head is, for example, said to express "an indiscriminate repugnance for *all* political aspirations in *all* races."

The collection of stories, *The Collector of Treasures*, affords the author a chance to display her mastery of the art of storytelling. She understandably concentrates on the position of women and takes every opportunity to project a feminist point of view. She needs all the artistic talents displayed in her previous works to succeed with *Serowe: Village of the Rain Wind*. Here she combines imaginative writing with the fruits of a year's research study to produce work of great distinction. She succeeds magnificently in her reconstruction of the village life of Serowe. The daily occupations, hopes and fears of the ordinary people of the village come alive in the reader's mind mainly because of the opportunity given the inhabitants to tell their own stories. The conception of history here is edifying—history is made out of the preoccupations of the common man, not out of the lofty ideals, cruelty or benevolence

of the wealthy and powerful. This reflects the concern for the underprivileged and oppressed masses of the people which is easily discernible in Bessie Head's writings.

Oladele Taiwo. *Female Novelists of Modern Africa* (New York: St. Martin's, 1984), pp. 185–86

Bessie Head's novel *A Question of Power* raises the problem of how one can write about inner chaos without the work itself becoming chaotic. (There are similar difficulties in, for example, writing about tedium without becoming tedious; about meaninglessness without losing meaning.) One is reminded of Mary Turner in Doris Lessing's *The Grass is Singing*; of Oskar in Günter Grass's *The Tin Drum (Die Blechtrommel);* of Malcolm Lowry's *Under the Volcano*; of Saul Bellow's *Herzog,* and, closer in time and distance, of Zimbabwe's Dambudzo Marechera and his *Black Sunlight.* Both Marechera and Head write about the cruelty done to individuals and the damage they consequently suffer. They are hunted and haunted writers whose works are an attempt to understand and come to terms; a wrestle to win through, out and above. Pauline Smith wrote that human beings sometimes have to endure the unendurable: Bessie Head writes of the human "capacity to endure the excruciating." Appropriately, the novel is set in a village called Motabeng, "the place of sand." Motabeng suggests a lack of certainty and firmness. Like life and the world, all is loose, shifting and changing. Yet we search for little rocks and patches of firm ground in the sand; for permanence within the wider impermanence; for value within the ultimate valuelessness.

Charles Ponnuthurai Sarvan. In Eldred Durosini Jones et al., eds. *Women in African Literature Today* (London: James Currey/ Trenton, New Jersey: Africa World Press, 1987), p. 82

The figure of the story-teller imparting wisdom to an audience around an open fire or in the daily round of work (see Benjamin) bears an interesting relation to the stories of Bessie Head. Her stories describe a society steeped in an oral tradition but they do not themselves emerge from that tradition nor do they re-enter it—at least, not in any simple way. Her audience is not the people she describes. Her role in Serowe (the Botswanan village in which she lived in exile) is not that of story-teller. She is not typical of Serowe and could not participate as an equal partner in the round tales and folklore that constitute its ancient oral tradition. Her stories are discontinuous with the flow of village life by virtue of their dependence on the written word.

Bessie Head straddles two cultures, and her work draws upon two traditions. She grew up on the peripheries of South African cities, completed a teacher's diploma and worked for a while as a journalist. Her South African cultural heritage, then, was a largely "literate" one. Her subsequent entry

into a predominantly oral society governed by pretechnological necessities was also an entry into the cultural matrix of the story form: "the art of telling stories, since it originates by the primitive campfires of unread people far back in time, is an oral and not a written one."

Bessie Head describes a society with an ancient oral tradition where storytelling, the recollections of old men recounted around an open fire, tales told of ancient tribal migration, and village gossip, all combine to define the community. . . .

These "stories of human action," the stuff of the narrative tale, are the principal constituents of *The Collector of Treasures.* Each of the tales in the collection focuses on individual life stories; each draws upon a real outside world, or one re-evoked in the memories of old men, and reconstructs in the mode of the narrative tale a segment of the life of the whole village.

Bessie Head draws a complete portrait of the village, each story being a part of the composite whole, and giving the impression of overlapping with others around it. Her story-telling encompasses the minute, the particular, the details of an event in a particular person's life, as well as an awareness of the greater social context. . . .

Bessie Head's stories are apprehended in just such an environment. They partake of the same life force as village history, gossip and tales. Deeply sympathetic and understanding, and at the same time possessing an astute ability to analyze, she is able, as Berger puts it, to "see how events fit together." *The Collector of Treasures* shows Bessie Head to have the very quality that she attributes to one of her characters: "the unerring heart of a good story-teller."

> Craig Mackenzie. *World Literature Written in English.* 29, 1989, pp. 140–41, 143, 147

Bessie Head's novels are intensely private, remarkable works. They are charged with an honesty and power that arise from deep experience with the issues explored. One of their most intriguing features is their idiosyncratic divergence from other African novels in terms of treatment of theme and authorial perspective. In *When Rain Clouds Gather,* which deals with the conflict between modernity and tradition (the stock-in-trade of much African fiction since the appearance of Achebe's classic *Things Fall Apart* in 1958), Head inverts the customary story line of this genre, which in Southern Africa typically focuses on the passage of the protagonist from his rural village to the bright lights of the city (as in Peter Abrahams's 1946 novel, *Mine Boy*), and eschews a simplistic paradigm of racial conflict by constructing, in fictional terms, the possibility of interracial cooperation and friendship. Her second novel, *Maru,* further establishes her uniqueness in Africa by its incisive probing into the racism that exists in traditional African societies and by its dramatic inversion of the social pyramid in Botswana: A despised Masarwa (bushman) woman, considered the lowest of the low, marries a future paramount chief of the dominant tribe of the region and with this single

act throws time-honored prejudices into disarray. And, finally, in her concern with women and madness in *A Question of Power,* claims one critic, Head "has almost single-handedly brought about the inward turning of the African novel."

The above examples should serve to illustrate Head's unique status in the field of African literature. Her novels have gained her an international reputation: Their "inclusivity," their insistence on universal human values and concerns, and, in *A Question of Power* particularly, their desire to break out of narrow traditionalistic modes of perception to embrace diverse religious and mythological systems have made Head accessible to an international readership. . . .

Bessie Head's novels show an increasing interiority of perspective. This interiority culminates in the cathartic *A Question of Power,* which signals an end to an "inwardly directed" phase in the author's life. *The Collector of Treasures* goes on to explore in a more outward reaching way the life of Head's adoptive village. The short story as a genre—particularly in Head's use of it—seems singularly able to cope with the material yielded by the author's more objective interest in episodes of village life. It is a genre, moreover, that is appropriate to a new phase in the author's life. *Serowe: Village of the Rain Wind* naturally has different dimensions to the collection of stories but is nevertheless a companion volume, and part of the same community-directed project. Both volumes are, in their different ways, remarkably well suited to the author's new intentions, and they evince a symmetry and balance absent in the novels. *A Bewitched Crossroad* represents in some ways a return to the novel genre, and yet its importance—and, indeed, area of competence—is more impressively demonstrated in its reinterpretation of Southern African history. In different ways Head's last three works show a capacity to explore the lives of the Botswanan people. The new direction she takes in these works involves a surmounting of the problems of isolation and alienation that characterized her earlier phase and a new commitment to Botswana and, particularly, the people of Serowe. For it was in Botswana, in the quiet rhythm of its daily life and, most important, its continuity with the past, that Bessie Head was able to carve out a spiritual as well as physical home and work out in creative terms political alternatives for a more hopeful African future.

<div style="text-align: right">

Craig Mackenzie. In Robert L. Ross, ed.
International Literature in English: Essays on the Major Writers (New York: Garland, 1991), pp. 558, 566–67

</div>

HÉBERT, ANNE (CANADA) 1916–

Anne Hébert's short stories in the volume entitled *Le torrent* bring us again into the tragic atmosphere we found in *La fin des songes* by R. Elie, whose instruments of thought are similar. Miss Hébert is essentially a poet and these stories are distinguished from poetry only by their form; the poetic experience, resulting from the duality of the poetic personality, expresses itself here less abstractly, as symbolic characters who incarnate the two opposing forces which create the anguish. A poet, who is aware of his life as a surge of impulses within him, is irked by routine, every-day existence, which appears stagnant, paralyzing, and seeks to free himself from it. If he cannot free himself physically he frees himself imaginatively and this separation of dream from reality is tragic.

On the one hand, "house"—as it does in "La maison de l'esplanade"—might come to symbolize the bondage of tradition and custom; on the other, "water" symbolically expresses the essential life of the poet, his super-reality. First there is a torrent, a rush and roar of falling water. François comes to it by looking into himself. And, as his mother had forbidden him to look into himself, he saw a raging gulf and heard accusing voices. His fate, the poet's fate, is to become one with the torrent, to lose himself in his lonely, frightful, rich adventure. This story is notable for its luminous examination of the poet's consciousness of his fate.

One of her most beautiful creations. "L'ange de Dominique," is the story of an invalid who is visited—when her aunt is not about—by a cabinboy who charms her with his dancing, for he is the dancing spirit of the sea. In the end Dominique's spirit, a dancing spirit, dances into the water. The exquisite beauty of Miss Hébert's tragic irony is created by the play of her intelligence on these structural symbols.

W. E. Collin. *University of Toronto Quarterly.* July, 1951, pp. 397–98

The writing of Anne Hébert records an intense interior drama of poetic and spiritual evolution, though in volume her poetic output has been quite small: *Les songes en équilibre, Le tombeau des rois,* and *Poèmes.*

Miss Hébert's first volume of poetry, *Les songes en équilibre,* reveals to us a young girl in the first stages of physical, artistic and spiritual evolution. The style likewise is as yet unformed; on the whole it is thin and frail, but occasionally it gives a foretaste of the clearcut, unadorned styled of Miss Hébert's more mature poetry. . . . *Les songes en équilibre* has traced the path of the poet into solitude; the poems of *Le tombeau des rois* are songs of this solitude—its sweet sadness and its unbearable anguish.

Late in 1960 Anne Hébert published her *Poèmes,* which contains the whole of *Le tombeau des rois* plus a collection of new poems, most of which appeared in periodicals between 1953 and 1960. In the preface to these later

poems, Miss Hébert describes the function of poetry as a breaking of solitude. This provides a clue to the difference between *Le tombeau des rois* and the poems that follow it. The period of solitude necessary for poetic and spiritual formation has been broken by the act of poetic creation, and now the poet is united in a real way with all men.

Thus the main difference between the poems of *Le tombeau des rois* and the later poems is that the latter are written on a much broader scale. They express not only the anguish of the poet but that of entire cities and countries. In the later poems Miss Hébert participates in French-Canadian literature's growing revolt against long-standing restriction. . . . Poetry not only breaks solitude but brings joy, and the liberation promised in the closing lines of *Le tombeau des rois* has proved a reality. The oppressed refuse to submit to the stagnation imposed on them. Their tunic of unhappiness becomes so tight that overnight it splits from top to bottom, and they awaken naked and alone, exposed to the beauty of the day ("Trop à l'étroit").

The images in these poems are those of the earlier volumes—the bird, the salt, the brilliant sunlight and dark night, the sea, the closed room, the house and the doorstep—but all appear in new and significant contexts, singing of boldness and hope and a new joy. . . . In these poems, poetic and spiritual experience are still as closely related as in *Les songes en équilibre* and *Le tombeau des rois*. Now Miss Hébert, like Claudel, sees the poet as spokesman between men and God. To the poets of the ages, intensely loving and sensitive, has been entrusted the "passion of the world." Theirs is a Christlike mission, working with Him toward the world's redemption. . . .

The three volumes of Anne Hébert's poems, then, record her evolution from carefree childhood through an agonizing solitude of poetic and spiritual formation to a freedom in which she embraces her French-Canadian people and all humanity—a triumphant development of thought through poetry.

Patricia Purcell. *Canadian Literature*.
Autumn, 1961, pp. 51, 54, 59–61

[*The Tomb of the Kings*] is a book closely unified by its constant introspection, by its atmosphere of profound melancholy, by its recurrent themes of a dead childhood, a living death cut off from love and beauty, suicide, the theme of introspection itself. Such a book would seem to be of more interest clinically than poetically, but the miracle occurs and these materials are transmuted by the remarkable force of Mlle. Hébert's imagery, the simplicity and directness of her diction, and the restrained lyric sound of her *vers libre*. . . .

When these poems are weak, it is because the imagery becomes too elaborate, turns into machinery, and begins to echo that naturalized French citizen, Edgar Poe. The title poem has this fault (although the similarity of the title to Mallarmé's is, I think, accidental), as do a few others, but they are far outnumbered by the poems in which this most difficult subject is given the strange grace of art.

Samuel Moon. *Poetry*. June, 1968, p. 201

"The Mystery of the Word" is a title whose meaning is derived from liturgy; this meaning is confirmed by a poetic language whose hieratic nature has often been stressed by critics in Quebec. This language is nevertheless one of total communication. Its hieratic nature, which should be a property of all poetic expression, is not sufficient to define the full significance of Anne Hébert's work. This "mystery of the word," which enters into the world of man, has the power to enable man to regain possession of his wealth and his own identity—gifts of which he has been dispossessed. . . .

"The Mystery of the Word" situates poetic expression in a spiritual and social climate in which the word permits the exiled man to return to the world, and his return is like a new creation of the world. Poetic language has powers that are organized by the poet, powers whose nature the poet alone has determined, but powers whose action the poet does not control; in the reader's consciousness poetic language provokes shocks and illuminations that modify, enrich, and unsettle his personal universe. . . .

I need not insist on the fact that Hébert's inspiration, which moves me very deeply, has its sources in life in Quebec. More fundamentally than any other work, "The Mystery of the Word" helps us understand the soul and the life of a people from whom we have been separated not only by the distance of an ocean but much more by our illusion that their origin and language ought to make them altogether similar to us.

René Lacôte. *Anne Hébert* (Paris: Éditions Seghers, 1969), pp. 84, 86–87

Whereas English-Canadian literature tends to be haunted by the sterility of a materially abundant but overly mechanical order imposed upon life, French-Canadian tends to be haunted by the sterility of an overly ascetic order resulting from a complete withdrawal from life. Such a withdrawal is evident in French-Canadian poetry from Octave Crémazie through Émile Nelligan, Alain Grandbois, and Saint-Denys-Garneau to the early Anne Hébert. The disillusionment of the individual in his personal life, the French-Canadian in his national life, and the spiritual man in his worldly life, all lead to a withdrawal from the actual world of the present into a world of the ideal. . . .

Anne Hébert moves through the rooms of her "Vie de chateaux" which are empty except for the mirrors from which specters of the past emerge to embrace her in a barren shiver imitating love. The garrison mentality leads here from a closed garden to a closed room to the narrow world of the grave, where the only communion is the communion of saints, or of shades. The more recent work of Anne Hébert and of a generation of younger writers rejects this mentality, moving outward toward the world and toward action. It takes up anew the attitude of Louis Fréchette that would affirm life and celebrate the world whatever its imperfections or threats. These writers too insist that the voice that now needs to be heard must be the voice of the land

and that the new pioneer must stock his log houseboat with all the animals, even the wolves.

D. G. Jones, *Butterfly on Rock* (Toronto:
University of Toronto Press, 1970), pp. 9–10

In a recent article in the French *Magazine littéraire* Yves Berger examined the problems of the French-Canadian writer and came to some gloomy conclusions. . . . Many French-Canadian intellectuals feel that their language has become too different from the French of France, that it has lost its purity, become a patois, and is being increasingly menaced by English and "franglais."

None of this despair or lack of confidence is apparent in *Kamouraska* though; and it is far from being a mediocre novel. A romantic tale set in 1839, it is based on fact. Élisabeth Rolland, faithful wife and mother of many children, is dutifully watching over her husband's deathbed. She flashes herself back some twenty years to the time when she was married to the brutal Antoine Tassy, Seigneur of Kamouraska in the frozen Canadian north, who, with her approval, was murdered by her lover, the young American doctor George Nelson. This is all there is to the story. It is somewhat over-long, perhaps, but it gives a clear picture of the stifling life and conventions of provincial nineteenth-century Canada, and of a woman who is aware that she has no other path in life but marriage.

Kamouraska is continually, and fashionably, jumping back and forth in time, and is written in elegant French with only an occasional anglicism or unusual turn of phrase. But what is wrong with that? English readers take seriously the English of a Samuel Selvon or an Amos Tutuola, and appreciate it as a renewal of their language. Why should French-Canadians feel inferior to the French-French, and feel they have to imitate the way they write? At this point of history there must be many readers who would appreciate it if Canadian authors would write in their own way about their own problems.

(London) *Times Literary Supplement*.
April 2, 1971, p. 402

In *Kamouraska,* Anne Hébert succeeds remarkably well in exploiting the ceaseless conflict between the self and society, the dichotomy between appearance and reality and, to a lesser extent, the contrast between the main character's past and present. Yet, *Kamouraska* can be called neither a historical novel nor a social novel, for the author provides barely enough information to render comprehensible Elizabeth's private hell. . . .

In unexpected ways, Anne Hébert takes us beyond the stultifying world of nineteenth-century French Canada, and perhaps even outside it altogether. Her portrayal of the little girl appealing desperately and vainly for an explanation of sex transcends the Jansenistic refusal to acknowledge the existence of sex: it rings like an admission of the inadequacy of all our knowledge about the matter. Indeed, there is another aspect of Elisabeth's education which

makes us wonder whether the world of the novel is French Canada at all, and that is the family's curious tolerance of Elisabeth's unorthodox behavior, and their persistence in referring to her as "La Petite," even after she is married. . . .

That in *Kamouraska* Quebec's past has been indicted, judged and condemned will doubtless be the conclusion of most readers, but this particular condemnation is in itself a redemptive act. One might be tempted to regret the unrelenting bleakness of the novel—the overemphasis placed on human isolation, the virtual impossibility of communication, the complete estrangement of human beings from one another, even in their own native land. But at least the problems have been stated, in universal terms, but also in terms specifically French-Canadian, notably in regard to that very delicate balance between control and eruptiveness which is an important part of the Québecois's Gallic heritage. In that vast northern darkness of fear, superstition, passivity, candles are being lit, candles of inquiry regarding the nature of that "real life" which each one of us must seek and find for himself. In this endeavor, Anne Hébert is clearly a spiritual leader of the highest order.

<div align="right">Armand Chartier. The Association for
Canadian Studies in the United States
Newsletter. Autumn, 1972, pp. 66–67, 74</div>

[*Kamouraska*] is striking and holds one's attention. This is not an ephemeral work, dependent on fashions, a slave to circumstances—but a profound and enduring achievement. *Kamouraska,* whose density of language is astonishing, opens onto the mysteries of the heart and the body: one can see the frenzy of possession and abandonment appear and grow in intensity. We are firmly placed in a universe in which reason has abdicated some of its constricting powers, in which despair seizes on living tissue and bites down hard on it, in which love is lacerating, and in which time and dreams are joined together. This novel is a dazzling descent into man's darkness, with fantastic images that work perfectly. . . .

The value of such a book is clearly separate from the story it tells. This book is the work of a poet. . . . The inspiration for *Kamouraska* was a real event, a "news item" that took place in Canada toward the middle of the nineteenth century: a story of love and murder, set against a background of blood and snow. Naturally, if a writer of Hébert's quality selects such an episode, we can assume that her choice of material is meaningful. But what does it mean? Perhaps the story was one she had heard, undoubtedly with a shudder of fear, during her childhood. And this story could have later become, in the course of many days and nights, a dream—or more precisely, an instrument for building dreams. The organization of dreams is such, we know, that real people who find a place in dreams are altered, metamorphosed, freed of their dross, and in the end transformed into creatures totally

imaginary in nature. This osmosis between the world and the active dreamer is one of the novel's essential sources.

Hubert Juin. *Les lettres françaises.*
September 30–October 6, 1970, p. 5

The Mother image in French-Canadian literature embodies more than a symbol for the individual Conscious. In "The Torrent" the Mother represents a collectivity and an established order of life. Because of the importance of this figure in the literary history of French Canada and its relatively dominant position in the major portion of our literature in French, the Mother cannot perforce be a limited symbol. Indeed, if she is archetypal in Quebec, all the ambiguities of such a portent must be taken into account. Claudine, therefore, is not solely François's external world but also a disruptive part of his inner world. She is part of the Self, conscious and unconscious. She represents land, duty, religion, country, culture, the past and the present.

If the same mother-figure symbolizes for Émile Nelligan a protective barrier against a threatening real world, for Anne Hébert she symbolizes a protective barrier that threatens self-annihilation. And the poet is aware of this.

F. M. Macri. *Canadian Literature.*
Autumn, 1973, p. 11

Anne Hébert's creative works show a remarkable diversity of form and range. But within this broad variety of forms there is evident a certain development in artistic temperament. In her earliest work the dominant tendency is to explore the sensibility of the individual artist, or, as in "Le Torrent," of a single character whose inner world is thus re-created. The culmination of this mode of artistic expression is found in *Le Tombeau des rois,* where the poet plumbs the depths of one individual persona's sense of alienation. Although contemporary critics immediately saw that her poetry also expressed a collective sense of alienation, Anne Hébert will in future be remembered not primarily as a Quebec poet, but as a poet. Her reputation will rest on the strength of her poetry, rather than on the aptness of her poetry's expression of the particular social context from which it sprang.

The artist's examination of society is also evident in Anne Hébert's early work, but she did not immediately gain mastery of forms that adequately express the complexity of a whole society or period. Apart from the success of the story "Le Torrent," the early stories remain slight, although effective, and the early plays are overly dense and allegorical. In the pieces dating from the end of the 1950s and the early 1960s, the artist is increasingly concerned with the external social world, particularly in her two plays, and to some extent in *Mystère de la parole* as well. Her first novel, however, pays more attention to the interior world of the small group of characters than to their social environment.

It is her two major novels, *Kamouraska* and *Les Enfants du sabbat,* which confirm Anne Hébert's talent in re-creating a richly varied social world in which the reader finds many of the dominant themes of her *oeuvre.* The physical substance of recaptured times and places is added to the intensity of feeling found in her best poetry. Paradoxically, it is by making the Quebec social context explicit that these works place the universal qualities of human experience in the foreground. . . .

Anne Hébert sees herself as an artist in the Jungian sense of the word, that is as a vehicle to express the unconscious truths of the artist's particular society. In this we concur with Albert LeGrand (among other critics), who states that Anne Hébert's *oeuvre* has always been an expression of the collective Quebec psyche. Nevertheless it is finally her merit as a writer dealing with the nature of man that we have attempted to demonstrate, and it is, in the last analysis, the art of her writing which commands our admiration.

> Delbert W. Russell. *Anne Hébert*
> (Boston: Twayne, 1983), pp. 113–15

It is discomfiting to read the poetry of Anne Hébert. Though the reading of poetry is not guaranteed to be a reassuring experience, it is nonetheless difficult to set oneself the task of reading the poems of a *québécois* writer who dismantles the plausible myths making natural storms, man-made wars, loving procreation, and humiliating genocide understandable to us. Yet, estrangement from the kinds of experiences we have come to accept as common brings certain rewards. Hébert may destroy traditional notions of order, but, in exchange, her poetry expands the range of experience over which we are to impose a greater order.

The assertion that Hébert is concerned with reforming our vision contradicts common critical wisdom, which has weighted Hébert's commitment to the real world and found it inadequate. When *Le Tombeau des rois* was published in 1953, Roger Duhamel wrote that this second volume of Hébert's poetry employed a language of "arid peaks," exquisite, but remote. Sensitive to the same transcendent quality of language in the collection, André Rousseaux referred to Hébert's poetry as "music."

The verbal distance between the poet and her readers has been interpreted by later critics as a withdrawal from the outside world into a private, defensive one. In his exhaustive study of the relationship between oneirism and Hébert's poetic themes, Guy Robert observed that the poet "being first and foremost a poet, her works cannot be dissociated from her most secret, most real personality." This seclusion is seen as an escape from real problems in the analysis of Jean Ethier-Blais, who called Hébert's work "waiting literature . . . a literature which adheres to the reality of a people hesitant to define themselves as a nation."

The assumption behind these assessments of Hébert's poetry—that literature has to do with reality only when it deals with contemporary situations—translates Hébert's use of prehistoric myths, events in the past, or

traditions transplanted in Quebec from metropolitan France, into expressions of nostalgia, fear of reality, and a reluctance to face the future. . . .

The contradiction between the two theories of culture is an important factor in the accurate reading of poets who, like Hébert, emerge from politically volatile cultures. Theories like Negritude and ethnopoetics force us to make a clear distinction between minority writers, who are participants in a political struggle between old and new powers, and marginal writers, who are engaged in a literary struggle between old and new perceptions. . . .

The poet's purpose is not merely one of revelation. She aligns the forces of the two realities to erase the conflicts which dull our perception of the common world. Hébert wants us to reject the world as we have been taught to see it, identifying objects and segregating them into familiar and alien camps. Poetry should reconcile us with that which is alien; otherwise, we remain prisoners of the past, afraid to explore reality beyond the distinctions separating objects. When we overcome our fear of reality, when we reject ideas received from the past, we use that past to enhance our perception of reality.

The use of the past in the interest of the best possible future is the basis for Hébert's counter-traditions. But if her counter-traditions serve a protective and conservative function, they also perform the task of revolution. Hébert's mystery of words is a theory of deep change, for words operate like traditions, constantly expanding their significance, broadening our apprehension and experience of objective reality. Hébert's words change our world.

The female poet who exerts pressure on words to alter their significance and our perception advances on the outer limits of meaning, on the signifying edge of words. This edge separates sense from nonsense, that which is already known from that which is yet to be understood. This is the margin on which Hébert writes. But her acute awareness of reality and her drive to see beyond superficial distinctions do not permit her to err on the side of universalism, where those distinctions are denied. Hébert does not assume that objects share some universal, essential bond. She creates that bond through her poetry.

<div style="text-align: right">

Susan L. Rosenstreich. In Paula Gilbert
Lewis, ed. *Traditionalism, Nationalism, and
Feminism: Women Writers of Québec*
(Westport, Connecticut: Greenwood Press,
1985), pp. 63–64, 68

</div>

Anne Hébert's haunting and powerful novel *Kamouraska*, which is surely destined to endure as a masterpiece of *le roman québécois*, brilliantly reconstructs a notorious real-life scandal which had shocked the inhabitants of Quebec in 1839. In a bold prefatory note which served the novel as epigraph, the author firmly staked out her own position on the issue of the relationship between fact and fiction which she knew would be raised by her work. . . .

In the most carefully precise language, Anne Hébert's epigraph asserts that her reconstruction of the nineteenth-century story owes little to the known facts and everything of real consequence to her own creative imagination. The justification for so sweeping a claim lies in the text of *Kamouraska* itself, which indeed gives scant narrative space to the scandalous raw material of the real-life source: adultery, the brutal murder of the husband by the lover, and the lover's subsequent flight from justice, leaving the widow to stand trial alone for complicity in the murder. The raw material sketches a lurid adventure of lust and crime in which Anne Hébert obviously had little interest, since *Kamouraska* is not at all that kind of novel. Her interest was rather in character, in motivation, in feelings, and in the apparent link between Quebec's rugged landscape and the human passions bred there. As the concluding sentence of the epigraph seems to imply, the real-life actors in the Kamouraska drama had long occupied her imagination, not as a matter of prurient interest, but because she saw in their story an actual example of the way the Quebec environment can affect individuals; and in the course of the *"lent cheminement intérieur"* of which she speaks, those actors had gradually become assimilated in her imagination to other creatures of her own invention by means of whom she had sought, throughout her career and in various literary forms, to articulate the same themes. The ultimate implication of the epigraph, indeed, appears to be that, however different from her previous compositions *Kamouraska* may, on the surface, appear to be—and she was mindful of the fact that she had never before used a historical happening as a source of inspiration, nor told a story so explicitly rooted in time and place—it was nevertheless not a new thematic departure for her, but simply a continuation, by other means, of her pursuit of the artistic objectives she had always had. *Kamouraska,* in short, had its real origins not in a newspaper *fait divers,* but in the first halting steps of her own literary career. . . .

The tragedy that is central to *Kamouraska* is most often female in scope, but is ultimately portrayed as a human tragedy, visited upon individuals of both sexes, by social, cultural, and environmental forces as much as by innate characteristics.

The most conspicuous emblem of this concept is the title which Anne Hébert chose for her novel: *Kamouraska*. It is an old Indian name, given to a village between Quebec City and the Gaspé, on the rock-bound banks of the St. Lawrence River. Now it is a fact that too little of the action of the novel takes place in Kamouraska to make that place name the inevitable choice for the book's title. One must suppose, therefore, that Anne Hébert saw something essential to the novel's meaning in the name itself, to have insisted on its use as the title. She might, to begin with, have counted on the harsh and alien sounds of the name to evoke for her readers a wild and rugged landscape as setting for the drama of primitive passions she would recount. She might even have intended that the barbaric-sounding syllables of Kamouraska would convey the *québécois* character of her book. . . .

Did it perhaps occur to Anne Hébert that, buried inside the savage sylla-bles of the Algonquin name Kamouraska, there lurks, almost unnoticed, the fragile French word *amour*? Whether or not the author consciously intended it so, the title surely expresses symbolically one of the controlling concepts in the novel, namely that in Kamouraska, love is swallowed whole, and thus denatured, rendering man's—and, even more, woman's—destiny there inevi-tably tragic.

Murray Sachs. In Paula Gilbert Lewis, ed.
*Traditionalism, Nationalism, and Feminism:
Women Writers of Québec* (Westport,
Connecticut: Greenwood Press, 1985),
pp. 109–10, 119, 121

HELLMAN, LILLIAN (UNITED STATES) 1905–84

Here is a play to wring the heart and fire respect, an adult, steadfast play so conspicuously fine and intelligent that, beside it, much of the theater's present crop becomes shoddy and futile. This is the first play of this erratic season in which power, intellect, and a glowing sense for theater combine for a terrifying and ennobling experience. The new play is *The Children's Hour,* a first play by Miss Lillian Hellman, and overnight, by the force of its own stature, it has become the most important play in New York.

Here is a play that shines with integrity. It is, definitely, the first play of the season in which for two whole, consuming acts the First Audience sat completely silent, held taut by the richness and reality of the tragedy which it describes.

In *The Children's Hour* there is conspicuous and magic correlation be-tween the author, the producer, and the cast. It is evident that each contrib-uted a positive majesty of sincerity to it and that all three together determined to make this a play to command the appreciation of its audiences.

Literary Digest. December 1, 1934, p. 20

Miss Hellman is not a specialist in abnormal psychology and not a specialist in the Marxian interpretation of society. She is a specialist in hate and frustra-tion, a student of helpless rage, an articulator of inarticulate loathings. Ibsen and also Chekhov have been mentioned in connection with her plays. Strind-berg would be nearer, though perhaps still far enough from the mark. . . . She is fascinated by her own hatred of something.

Joseph Wood Krutch. *The Nation.*
December 26, 1936, pp. 769–70

Watch on the Rhine . . . binds the attention of the audience to the stage, and very often binds it tight. A great deal of this is due to the expert stage

craft of the melodrama itself. But a great deal, also, come from the author's remarkable gift for character, the way in which she can lay out a group of characters that are not crudely differentiated one from another or hammered at in the writing or thrown at each other's heads for the sake of contrasts and variety. They are observed with much pains as to the exact kind of detail that will convince us of their actual existence and difference, relationships and mutual reactions to each other, and that will brighten our eyes and ears to note them pointedly with pleasure. . . .

As an indictment of Nazism, *Watch on the Rhine* will seem more or less pointed and forceful according to the spectator. You may say quite plausibly that the play would get pretty much the same results if the hero's enemy were almost any sort of men and things that he was at odds with, that he had fought bravely against and been persecuted by, and that make his return to save a friend highly dangerous, and his whole resolution heroic and appealing. In sum it is the story and characters that really carry us along with the play, however much or little the anti-Nazi connotations may stick in our minds. Any way you take it, *Watch on the Rhine* is infinitely better than the propaganda plays we are used to in the theatre.

Stark Young. *The New Republic*.
April 14, 1941, p. 499

That *The Searching Wind* is neither so appealing nor so wholly satisfactory as *The Little Foxes* or *Watch on the Rhine,* that its means of achieving revelation are somewhat awkward, and that its implications are not entirely convincing—this is not very important: the play relies to a remarkable extent on the characterization and not on the story, on the dialogue and not on the plot; it needs no violence other than the violence precipitated by the impact of person on person, idea upon idea. Most notable, however, is the author's own attitude toward the problem she wants to set forth. She is no longer the special pleader for this or that type of reform, and she is evidently not ridden by the notion that all you have to do to win the Good Life is to eradicate the evil men and substitute the good. "I love this place," says Sam, and Sam speaks for the author, "and I don't want any more fancy fooling around with it." This place is, of course, our country, or perhaps all those countries in which our way of life is held to be the best.

Lillian Hellman has been writing plays for only a little over a decade; she has pretty well mastered the tools that every dramatist must use in order to gain the attention of the public; she is conscious of the limitations of the drama medium, and she has found out at moments how to make the best of them. She is still unwilling to use her talent except directly in the service of humanity. It is possible, I am convinced, for her to speak just as eloquently on behalf of the oppressed and the blind if she is willing to forget the immediate good to be won by this reform or that and to concentrate on the far more difficult and rewarding task of illuminating the world she knows *as she sees it,* through the power of her imagination, without insisting too much on guid-

ing and instructing it. It is questionable whether the preacher ever did anything as effectively as the poet.

Barrett H. Clark. *College English*.
December, 1944, p. 133

In many ways *The Autumn Garden* is unlike any of Lillian Hellman's previous works. The same muscularity of mind, the same command of authentic dialogue, the same willingness to face unpleasant people as they are, and the same instinctive awareness of the theatre's needs which have always animated her writing are present. But the mood, the tone, the flavor, the point of view and hence the means employed are so different from those of *The Children's Hour, The Little Foxes, Watch on the Rhine,* and *Another Part of the Forest* that it is no overstatement to say a new Miss Hellman has emerged.

For the first time in her distinguished career she has, so to speak, turned her back on Ibsen and moved into the camp of Chekhov. To the casual reader such a shift in allegiance may seem unimportant. To the theatre-minded, however, it represents a change in attitude, method, and purpose of the utmost significance. . . .

Even in her most loyal Ibsenite days Miss Hellman was never a copyist. Far from it. She had found her own way of making her own comment upon the American scene. She was a progressive who was old-fashioned only in the sense that in a period of slovenly workmanship she continued to write "well-made plays." Her pride as a craftsman was clear. She excelled at contrivances, at big scenes, and sulphurous melodramatics. Although sometimes misled into overcomplicating her plots, she wrote with fervor as a person to whom ideas and causes came naturally. The protest in her voice was strong. It was as characteristic of her as the energy of her attack or the neatness of her planning.

John Mason Brown. *Saturday Review of
Literature.* March 31, 1951, p. 27

The author is just with her characters; she sees them with a certain smiling asperity, an astringent, almost cruel, clarity. But she is unable to reveal in their weakness that which makes them part of what is blessed and great in life. The blunderers in Chekhov are brothers in our nobility even as in our abjectness. The characters in *The Autumn Garden* are our equals only in what we do not respect about ourselves. Miss Hellman refuses to be "metaphysical," poetic or soft. She will not embrace her people; she does not believe they deserve her (or our) love. Love is present only through the ache of its absence. Miss Hellman is a fine artist; she will be a finer one when she melts.

Harold Clurman. *The New Republic.*
March 26, 1951, p. 21

It is the measure of Lillian Hellman's superiority to most American play-wrights that nine years after *The Autumn Garden* she could return to Broad-way with an original play that gave no sign of diminished energy. *Toys in the Attic,* which opened on Broadway toward the close of the 1959–60 season, proved to be one of her most hard-driving plays. Among her earlier works only *The Little Foxes,* her masterpiece of the strenuous Thirties, had pos-sessed as much penetration and dramatic vitality, and rarely before had Miss Hellman written dialogue with such vigor and virtuosity. It was possible to realize at the end of the decade that at least one American playwright had kept her sword of judgment—or rather her "knife of truth," as the neurotic child-wife of the play would have said—unblunted in the damp mental climate.

She had brought to the task of adapting Emmanuel Roblès' *Montserrat* earlier in the decade an existentialist concern with decisions that test men's stamina; and in adapting Anouilh's Joan of Arc drama, *The Lark,* she had invigorated the play by counteracting the French author's rather facile skepti-cism. If a loss of dramatic voltage was apparent in *The Autumn Garden* at the beginning of the decade it could be attributed to her experimentation with a relatively loose form of dramaturgy for the purpose of securing amplitude of characterization and giving a rueful account of enervation and failure in society.

In *Toys in the Attic* Miss Hellman picked up the sword of judgment many playwrights of the Fifties had laid aside and wielded it with renewed vigor. But this time, compassion guided her hand so that she performed surgery on her characters instead of summarily decapitating them.

<div style="text-align:right">

John Gassner. *Theatre at the Crossroads*
(New York: Holt, Rinehart & Winston,
1960), p. 137

</div>

Since she is a playwright of the thirties, she has sometimes been taken simply as a social playwright. Although there is implicit anticapitalism in *The Little Foxes* and explicit antifascism in *Watch on the Rhine,* Miss Hellman has always been most concerned with personal morality, although, as both *The Little Foxes* and *Watch on the Rhine* indicate, personal action has public consequences. Any social content in the recent plays is far below the surface. One of General Griggs's speeches in *The Autumn Garden* suggests that the characters are failures because they belong to specific families, the decaying end of the post-Civil War money-makers, but the implication is not diagnostic; Miss Hellman makes quite clear that the problem is personal, not social, determinism. Something might be made once again of the Hubbards as bud-ding capitalists, but in *Another Part of the Forest,* greed spreads to every character in the play (except perhaps Lavinia and Coralee) and the Hubbards have here become grotesques, their nastiness almost biological. If a character in any of these plays may be said to suggest social criticism it is the off-stage Cyrus Warkins in *Toys in the Attic,* the respectable businessman who uses

thugs to beat up Julian Berniers and Mrs. Warkins, although even Cyrus's motivation may mix jealousy with outrage at being bested in a business deal. Despite her obvious concern with social evil, Miss Hellman more often seems preoccupied with abstract evil, even to the point of caricature, as in *Another Part of the Forest,* or she goes out of her way to provide acres of psychological motivation, as in *Toys in the Attic.* For Miss Hellman, however, psychological determinism, as *The Autumn Garden* shows, is never an excuse. Always the moralist, the playwright is usually intent on pointing a critical finger not only at the eaters of the earth, but at those who, in Addie's words from *The Little Foxes,* "stand and watch them do it."

> Gerald Weales. *American Drama since World War II* (New York: Harcourt, Brace & World, 1962), pp. 89–90

It is far too soon, of course, to know whether *Toys in the Attic* has anything of the stature of [Chekhov's] *The Three Sisters,* even though it has unusual magnitude. But it is revealing that this is the first of Miss Hellman's firmly-plotted plays of which such a question can be raised without absurdity. Miss Hellman's plays have always been dramatically powerful and she has always displayed the virtues of vivid characterization, credible motivation, and an unusually clear and convincing dialogue style; but her work was always too limited in theme and attitude for general or permanent value. In *The Autumn Garden* she displayed something of the qualities she had lacked, but the play misses her characteristic force. In *Toys in the Attic,* with bows to Chekhov and the great fabulists, she has written her first play to combine all her earlier virtues with compassion, truth detachment, and tremendous dramatic power.

> Jacob H. Adler. *Educational Theatre Journal.* May, 1963, p. 117

In many ways *The Autumn Garden* marks a new stage in Lillian Hellman's writing. For the first time she renounced the presentation of her favorite topic—social criticism in one form or another—and concerned herself with a human problem that is not bound to social conditions. The problem of facing old age, the summing up at the middle of one's life, is the main theme of this drama. The play closed after 102 performances. Critics have divided opinions on this drama, which in my view, suffers greatly from the fact that its main theme is presented in too many cases and thus tends toward a statistical account rather than toward the depiction of an individual tragic fate. Controversial as it may be, *The Autumn Garden* has similar importance for the artistic development of Lillian Hellman as had *Days to Come,* though in quite another respect. *The Autumn Garden* marks Chekhov's influence on Lillian Hellman at its closest, indicated by the play's title, which is reminiscent of the Russian dramatist's *The Cherry Orchard.* How intense Lillian Hellman's

interest in Chekhov is can be judged in the introduction of the selected Chek-hov letters which she edited.

Manfred Triesch. *The Lillian Hellman Collection at the University of Texas* (Austin: Harry Ransom Humanities Research Center, University of Texas, 1966), pp. 51–52

The dramatic quality [in *Pentimento*] is everywhere evident, not only in the background of social intrigue before which many of these lives are enacted; but rather more importantly in the author's sense of timing, a kind of poised power over the units of scene that few writers of fiction possess. But there is also the extraordinary gift for the precise detail which is a fictional quality, and then again, for the often comically explicit detail. . . . She seems always to find precisely the right word, the right combination. . . .

She has called herself an unfinished woman, and she concluded the book of that title with what is probably the most open-ended sentence in literature: "However." Open to the rest of her experience in life, as she has been to it in the past, is the only sense in which we can accept the word "unfinished." But be that as it may, she writes what seems to me a prose as brilliantly finished as any that we have in these years.

Mark Schorer. *The New York Times.* September 23, 1973, pp. 1–2

[Hellman's] instinct for careful work has paid off in prestige as well as cur-rency. Authoring only 14 plays, two of them adaptations, she has found a place among the foremost dramatists of the century. *An Unfinished Woman,* her autobiography, won a National Book Award and *Pentimento* should widen her reputation as a storyteller. The earlier book covered sizable areas of her life with seven-league boots. In *Pentimento* she returns to some of those areas and does profiles of obscure people she knew (permitting herself a solitary exception in her chapter on "Theatre"), even throwing in a sketch of a reptilian hero who clung to life with a fury that would do credit to a two-legged hero.

Writing of men and women she loved and who have in nearly all instances died, she tries to see them in perspective. Hence her title: an artist's term for a painting that was reworked but whose original details emerge as the paint thins out. The profiles don't go deep; cautious in her art, Hellman is wary about attributing motives or dabbling in conjectures. One character stands forth sharply from her pages however—L. H. herself. In short, apart from its readability, *Pentimento* is valuable as a picture of a woman and writer in the making.

James Walt. *The New Republic.* October 20, 1973. pp. 27–28

Scoundrel Time bring[s] back, with extraordinary pain, the sorrow and disorder of those years when, under similar circumstances, thousands of Americans suddenly found themselves on planes, buses, and trains, wandering the streets of strange cities, with a voice inside screaming "What am I doing here? How did I get here? What is *happening?*"

What is, of course, distinctive about *Scoundrel Time* is the voice behind the words—that voice we first heard with such startled pleasure in *An Unfinished Woman,* then with deepening gratification in *Pentimento,* and now with moving intensity in this third volume of Hellman memoirs. It is the voice of a writer who seeks to describe in measured sentences as precisely as possible the imprecise flow of life as it has moved through her and all around her. It is the voice of a writer who reveals great courage of spirit because that voice, quite plainly, says: Make no mistake, there is much about myself I do not know, much that remains a dark and painful mystery I cannot face unflinchingly because if I do I will lose control and fall apart all over these pages, and that I'm damned if I'll do. But much that seems painful is often merely difficult. I know the difference between pressure and pain, and pressure I can take. I will force my pen, my actions, my life down on those pressure points to the utmost of my ability—even unto the point of pain.

It is this quality that makes Lillian Hellman the remarkable writer she is. The measured gravity of her sentences coupled always with the sudden, earthy directness reveals a steadiness and independence of mind, heart, and spirit that induce nothing but uncritical admiration: a welling-up of warmth and gratitude in the face of such a civilized intelligence. . . .

Scoundrel Time is a valuable piece of work. The kind of work that stands alone, untouched, in the midst of foolish criticism and foolish praise alike.

Vivian Gornick. *Ms.* August, 1976,
pp. 46–47

Such a value system as Hellman's, whether in the plays or the memoirs, with its clearcut criteria of good and evil, has a reassuring emotional appeal; it makes us nostalgic for a child's world (where the worst crime is to tattle on your friends) and for the make-believe world of fiction and drama, of despoilers and bystanders, where such a system flourishes. But the adult realm of politics and history demands complexities of knowledge and fact, in which value judgments are painfully arrived at. We must do more than ask Sophronia.

Lillian Hellman's insight is sharpest when it is most personal and specific. If some of her plays seem dated now it is probably because of their "well-made," realistic mode and their two-dimensional, good-or-evil characterizations. But three plays (and perhaps others) have had current repertory revivals—*The Autumn Garden, Toys in the Attic,* and *The Children's Hour.* These are the less structured ones, more concerned with psychology than plot, and with moral ambiguity rather than moral definition.

As a memoirist, Hellman was able to present her materials dramatically, without the limitations imposed by the stage. The memoir form allowed, too, for subtlety in the exploration of character; for unanswered questions, and for a certain mysterious quality that evoked a response from readers who knew that mystery for their own.

The personal, the ambiguous, were not appropriate, however, to the politics of *Scoundrel Time,* and Hellman has taken some punishment for that mistake. But she formulated her philosophy of survival when she was fourteen: "If you are willing to take the punishment, you are halfway through the battle."

Lillian Hellman is still producing, still battling, still surviving, still performing. Whatever we may think of her politics or temperament, we must rejoice in the energy, ingenuity, and skill of the performance.

Doris V. Falk. *Lillian Hellman*
(New York: Frederick Ungar, 1978),
pp. 156–57

Any final judgment must include a perception of Hellman as ironist, with a way of seeing, and seeing again. This is not to say that such an awareness will necessarily cause a reader to prefer Hellman to other major American playwrights. But it should prevent one's judging her by inapplicable criteria. To "rank" Hellman in a Williams-Miller-Odets-whoever list is, as she might put it, "a losing game." In the modern American theater Lillian Hellman is *sui generis,* and a careful reading of her plays reveals that those generally considered her best (*The Little Foxes, The Autumn Garden, Toys in the Attic*—to which might be added *Watch on the Rhine* and *Another Part of the Forest*) are the most fully ironic (and novelistic). By the same criteria, *Pentimento,* in which Hellman most completely employs fictional techniques and a controlling ironic voice, is the superior memoir.

D. C. Muecke [in *The Compass of Irony,* 1969] has described irony as "intellectual rather than musical, nearer to the mind than to the senses, reflective and self-conscious rather than lyrical and self-absorbed," having the qualities of "fine prose rather than . . . lyric poetry." Readers and audiences with no predilection for irony will perhaps prefer Arthur Miller's pathos of the common man, or perhaps Tennessee Williams' poetry of the sensitive, bruised soul. There will always be those, however, who will turn to Lillian Hellman for a view of life trenchantly expressed, often moving, frequently funny, uncomfortably accurate in its ironic vision of the fools met in the forest—and the fools *those* fools meet. In judging Lillian Hellman's work, critics might abandon the automatic genre labeling and examine her way of seeing and her appraisal of things seen, remembering that there is more than one valid way of looking at a blackbird. And a writer.

Katherine Lederer. *Lillian Hellman*
(Boston: Twayne, 1979), pp. 138–39

The central figure of this strange short memoir [*Maybe: A Memoir*] (if it can be called such) is not its ostensible subject, Sarah Cameron, nor the memoirist, Lillian Hellman, but the elusive, mutilated, often reeling character of memory itself. Again and again Miss Hellman tries to corner memory, forcing it to reveal the truth about the people and events she is trying to make sense of. Important epistemological questions are suggested: How valid is what we know—or think we know—about the people who dropped in and out of our lives in the past? How can we tell where memory blends into fantasy, producing a composite that takes on different shapes at different times, according to our needs? At the end of Miss Hellman's struggle with these questions, we have to settle for some very dusty answers; meanwhile we have been entertained, dismayed and, above all tantalized. . . .

I prefer to accept Miss Hellman's word that she is trying to get at the truth—and assume that the truth she has in mind is not of some novelistic of symbolic variety. Even if it were intended as fiction or as fictionalized memoir, the Sarah-story still would not add up to anything significant. Facts and dates do not constitute the "truth," but they are useful in anchoring an otherwise free-floating subjectivity. By surrendering prematurely to the impossibility of getting things straight—or at least straighter—Lillian Hellman has, I think, lost a chance to make *Maybe* the fascinating encounter with memory and time that it might have been. Despite the subtleties of its voice, its strong period quality and its brave forays into the self, the book remains, disappointingly, less a memoir than a shaggy-dog story.

Robert Towers. *The New York Times.*
June 1, 1980, pp. 3, 36

Lillian Hellman's plays redeem the impediment of a social role of passivity as a calculated artistic choice in a curious, perhaps unlikely, way. It is less Hellman's theme of passivity than her structural *reworking* of the quality within each drama that reclaims these plays from labels of infectious villainy or triumphant duplicity. For it is no longer illuminating to see her characters in the simple categories of initiators of evil, the "despoilers" who execute their destructive aims on the one hand, or the "by-standers" who, because of naiveté or lack of self-knowledge, suggest evil as the "negative failure of good." Rather, passivity redefined to include aspects of deception and moral disguise is both thematically and structurally crucial to any reevaluation of Hellman as a significant contemporary playwright. As Addie in *The Little Foxes* (1939) says: "Well, there are people who eat the earth and eat all the people on it like in the Bible with the locusts. And other people who stand around and watch them eat it. Sometimes I think it ain't right to stand and watch them eat it." . . . The socially negligible female characters, the ones who "stand around and watch them [the locusts] eat," actually control the more brutishly powerful, but often in indirect, unobtrusive ways. As General Griggs (*The Autumn Garden* [1951]) might say of their passive behavior, it is simply a way "to remain in training while you wait" for the big moments, the

turning points in life. The minor female characters—Lavinia, Birdie Hubbard, Sophie, Lily Prine and Lily Mortar—candidly, if unwittingly, reveal dramatic "truth" in certain situations. By their revelations they catalyze the outcome of dramatic action. Thus the socially negligible become the dramatically invaluable. . . .

Lillian Hellman plays passivity in her minor female characters the way a jazz musician ranges over musical notes. She improvises variations on a chordal progression that vibrates from Lily Mortar to Lily Prine; from inadvertent truth-telling to conscious moral restitution and shrewd self-awareness; from moral disguise (Lily in *The Children's Hour*) to physical escape (Sophie in *The Autumn Garden*). Close examination of the negligible women in each of the five plays suggests that Hellman is a consummate trickster both in characterization and in theme—a role for this contemporary dramatist only broached by current criticism. She never appears to be the drum banging melodramatist that critics of her work have insisted. As if to defy what she calls the "pretence of representation" in the theatre, its claptrap as well as its "tight, unbending, unfluid, meagre" form, Hellman cleverly tailors a socially assigned role—passivity—into variegated moral and dramatic authority. And the artistic as well as the moral clout of passive characters has grown increasingly complex as Hellman's playwriting has matured over a quarter of a century. Sophie is surely a more wry, sophisticated blackmailer than Mary Tilford; Mrs. Ellis, more consciously skilled than Lavinia in reversing family events; Lily Prine, a more thorough "undoer" than Lily Mortar. And in the case of Regina's wiles or Mary Tilford's theatrics, Hellman tricks up a counterpoint to the authentic truth-tellers, those who clutch their own word with stubborn personal integrity.

By a painful arithmetic of craft, Lillian Hellman reexamines language, theatrical convention, and the calculated effects of acting and staging, as well as passivity. Shunning "labels and isms," she formally realizes the hazards of moral, verbal, and theatrical absolutes in the effect of these minor characters on the dramatic outcome. Her "spit-in-the-eye" rebelliousness proclaims that the just and the worthy are never adequately credited by social labels, no more than her dismissible women are justly summed up by the inelastic social appearance of passivity. The writer's skill prevails, Hellman insists, not society's foibles: "The manuscript, the words on the page, was what you started with and what you have left . . . the pages are the only wall against which to throw the future or measure the past." Hellman's words—but especially the words and actions of the passive women in five major plays— suggest not only new possibilities for moral being, a new range of expression for female behavior, but also a new approach to reevaluating Lillian Hellman's playwriting skills.

Mary Lynn Broe. *Southern Quarterly.*
19, 1981, 27–28, 41

Lillian Hellman's *Watch on the Rhine* (1941) serves as a good example of a realist play that omits a gendered analysis in its representation of a historical

crisis. In response to the urgent threat of fascism, Hellman sought to infuse anti-fascist polemic into the ahistorical structures of a naturalized and nostalgic version of gender relations. To do this, the "unpatriotic" text of *Pentimento*'s Julia, who "prematurely" fights fascism in Europe, is repatriated in *Watch on the Rhine*'s portrayal of the heroic, but depoliticized, European, Kurt. The plot of an imperiled family in America literally familiarizes the play, and naturalizes an asymmetric relation between the sexes within marriage and family. The spectator is offered the seduction of the seeming logic, acceptability, and inescapability of female subservience. The play exemplifies a general trend, deliberate or unconscious, towards gendered inequality in response to any perceived "ungendered" historical crisis, denigrating opposition to patriarchy by rationalizing regressive fictions about gender on the basis of this "larger" crisis. A common patriarchal fiction of ideological neutrality is that, especially in the face of a "large" crisis, gender (as well as race, class and ethnicity) are not determinants of history. By contrast, when gender is historicized as a product of alterable structures in history, the spectator is given a perspective on gender to consider and evaluate against their own gendered history. To quote Elin Diamond, "When spectators 'see' gender they are seeing (and reproducing) the cultural signs of gender, and by implication, the gender ideology of a culture."

My choice of Hellman's *Watch on the Rhine* rests in part on its "datedness" as a "relic," on the melodramatic contrivances which allow the play to be dismissed more easily, less a part of the respected Hellman canon. The very obviousness of the play's message-laden rhetoric and didacticism obscures the sophistication and seductiveness of its use of the structures of realism, a form which gains much of its power from its seeming transparency. Unless one simply assumes that anti-fascist plays were, by definition, appealing to audiences in the forties, the powerful response to this one needs theorizing by the critic in the eighties. . . .

Watch on the Rhine capitalizes on the nostalgia for sexual inequality just at the edge of the historical moment when so many real women would shift into active industrial participation for the war effort. In one sense, then, the devolutionary women's line slides over the forties, erasing the competent, self-supporting image of Rosie the Riveter to anticipate the more restricted position of women in the fifties. But perhaps American responses to the war and its aftermath contained the seeds of the fifties with its suburban reproductions of "chickenhouse playrooms," just as the portrayals of women in this play do. That Hellman's 1943 film script *The North Star* included portrayals of gun-wielding, torture-resisting Russian women and girls responding to invasion by the Nazis reinforces by contrast that even when staged within the illusion of invasion of America, there was still no space in the form, content, or ideology of *Watch on the Rhine* for female resistance. In support of a formal declaration of war and acceptance for the archetypal departure of the soldier, the text sacrifices gender equality, so for the female

spectator the play must create a situation so pressing, a mission so holy, that any role in it is glorified. . . .

I want . . . to establish an intertextual relationship between *Watch on the Rhine* and the "Julia" section of *Pentimento,* to exemplify the way a text can historicize another by the same author. . . .

Instead of enfolding resistance to fascism within the confines of the symbolic ideological units of marriage and family, "Julia" presents an anonymous network of women and men "of Catholic, Communist, many beliefs," in which politically committed, ordinary women taking grave risks are foregrounded. The notion that the foundation for anti-fascism is to be found in various, specific systems of belief replaces the individual moral dilemmas of *Watch on the Rhine,* which suggested that context, even history itself, did not change people's values. And if *Watch on the Rhine* posits fascism as an evil based on its opposition to the nuclear family, "Julia" repoliticizes the struggle against fascism by reconfiguring those whom fascism most directly threatens, and who must be rescued by the underground as "Jews . . . And political people. Socialists, Communists, plain old Catholic dissenters." . . .

In response to her own historical dilemma, Hellman tried to explode the insularity of the family by familiarizing what was outside it, tried to internationalize political concerns and social relations by relocating them all within the United States and American democratic ideology. The result conveyed an aggregate national identity based on individual acts that appropriates history and politics as the province of the normal, the acceptable, the inescapable, and ultimately ahistorical structure of the family. And, as a pro-war play of the forties, *Watch on the Rhine* doesn't explore the question of what we do, how we live, how we resist fascism if we don't use war. Not tied to a war ideology, the retrospective presentation of Julia's anti-fascism may serve as more of a model for political action, including the fuller gendered historicizing the text accomplishes. If, in *Watch on the Rhine,* Hellman opposes one set of fixed ideological metaphors to another set implied by fascism, in "Julia" Hellman destablilizes the most traditional tropes of configuration, given her network of female resistance to fascism outside of the family structure. This suggests the instability of sexual identity, of male and female, as products of culture and subject to redefinition. Transgressive structures operate on both the "personal" and "political" level of "Julia" so that class and gender issues are more fully integrated into this work's anti-fascist ideology. An action of the plot of *Watch on the Rhine* is to conceal the dead body of Teck; the body buried, so to speak, in this realistic American family plot is the body of women as, for example, political resisters, close companions, and transgressors of the injunction to legitimize children through marriage. In its rejection of hierarchizing, of fixed identities enclosed in a thematics, and of naturalizing myths of origin that erase history, the text of "Julia" and not just the character Julia operates as a resistance to fascism, a disruptive

expression of female desire not corralled into legitimacy or erased by dominant ideology.

Vivian M. Petraka. *Modern Drama*.
32, 1989, pp. 128–29, 138–39, 142

The contentions of her most antagonistic critics that Hellman is, at best, a tricky and disingenuous simplifier, at worst, a fraudulent liar should be addressed with the understanding that her four autobiographical works are literary documents, works of art that combine a variety of life-writing's forms (autobiography, biography, memoir, and diary). The major charges against her autobiographies can be summarized: she obscures her life by chronological discontinuity and a tendency toward reticence; she lies by omission because of her elliptical style and her too-meticulous attention to surface finish; she is falsely modest and naive, manipulating her position in history so that her political faults are diminished, her personal heroism augmented; she misrepresents her historical position before the House Committee on Un-American Activities and the split between anticommunists and anti-anticommunists; and most damning, she makes herself look heroic by claiming to aid "Julia" when actually she took the idea for "Julia" from another person's life. Although there are times in her autobiographies when Hellman is less than forthcoming, misleading, annoyingly moralistic and exasperatingly mean spirited, ultimately her autobiographies are exceptionally authentic portraits of America's greatest woman playwright, a woman whose life story has significance far beyond its literal events.

Because her major adverse critics have been political analysts, writing with a historian's approach, rather than literary critics well versed in contemporary autobiographical theory, her autobiographical writing has generally been misinterpreted, primarily because those who have criticized her have misunderstood her tone, failed to consider her four books as one unit, and overlooked the subtitles of her autobiographical performances. Those who have written favorably of Hellman's memoirs are primarily novelists and playwrights like Marsha Norman, who said of Hellman, "I am not interested in the degree to which she told the literal truth. The literal truth is, for writers, only half the story."

Timothy Dow Adams. In Mark W. Estrin,
ed. *Critical Essays on Lillian Hellman*
(Boston: G. K. Hall, 1989), p. 198

American theaters in the late 1920s and early 1930s presented several more or less controversial plays exploring the dangerous attraction of lesbianism, particularly to young women in all-female environments. Between 1926 and 1933, for example, New York saw productions of *The Captive* (1926), *Winter Bound* (1928), and *Girls in Uniform* (1933). Certainly the best known of such works is Lillian Hellman's *The Children's Hour* (1934). Hellman's play, like

the other explorations of lesbianism, both reflects and participates in the cultural revision of women's sexuality that occurred in the early twentieth century. Read in historical and biographical contexts, *The Children's Hour* emerges as a crucial document, for it not only provides insight into Lillian Hellman's complex response to contemporary sexual ideology, it also illuminates the struggles of her female contemporaries. . . .

Hellman's choice resembles that of a very different female predecessor, Willa Cather. Like Cather, Hellman accepted traditional views of gender despite their hostility to her independence and her profession. Both women denigrated the feminine and celebrated masculine aggression. Both expressed condescension toward women's art. Hellman's statements in a 1968 interview are perhaps the most damning: "I don't think many women write with the vigor of men, whether they are novelists or playwrights or poets. . . . It's just too bad that we all thought that women would be equal and they are not equal. Why and how this is I don't know. Perhaps it's even biological." The desire for "aesthetic potency" through identification with the masculine has been aptly described by Gilbert and Gubar as a "masculinity complex." Hellman finds masculinity so desirable that *An Unfinished Woman* recounts with pride Hemingway's praise: "So you have *cojones,* after all. I didn't think so upstairs. But you have *cojones,* after all." At least fleetingly, testicles seem a fine acquisition, testifying to her ability to compete with men on equal footing. Unlike Willa Cather, Hellman did not locate most of her emotional life in relationships with women, and as her notes for *The Children's Hour* reveal, early in her career she clearly feared difference, particularly sexual, both in herself and in others.

Lillian Hellman's first play sought to settle all of these contradictions. Its young and ambitious author refused from the start to act the lady. As Hellman proudly recounts in *Pentimento,* during rehearsals she sat back in the theater with her feet propped on the seatback before her, ignoring the protests of the theater's owner. Her unconventional posture asserts her entrance into male space on equal terms: she defies all convention. Yet her play labors to show that despite such unconventionality she remains a loyal heterosexual; it hopes to lay all fears to rest, including those of its author. Although the play appropriates Shakespeare in its opening lines, it does so while mocking feminine readings of his text. If her play itself is intrusive— a woman's work in traditionally male space—it seeks to reconfirm the status quo, presenting imaginative women as dangerous and sexual difference as socially disruptive. At the close of *The Children's Hour* three "abnormal" women are silenced: one is under permanent observation, the other exiled, and the self-confessed lesbian is dead. Contemporary sexual ideology has been soundly endorsed.

Or has it? As with the end of "Julia," matters feel unresolved. The "(W)right," who has survived the death of her lesbian counterpart, half-heartedly promises that she will "write" again, if she ever has "anything to say." Hellman coyly hints that her first play may not be her last. The coyness

of this farewell only momentarily brightens the play's rather solemn and accusatory close. Karen speaks her last word—"good-by"—alone on the stage, simultaneously dismissing Mrs. Tilford and the audience. The connection between the two is suggestive: both Mrs. Tilford and the audience are responsible for the corpse in the wings (Martha's body lies just offstage), and both will leave the "wright"—Karen and her creator—alone with it. The society outside the play, as much as the society within, has accused the "wright" of lesbianism. If in the play that society, mustered by Mrs. Tilford, brought on Martha Dobie's suicide, outside the play another society forced the playwright to murder the lesbian in her text, and perhaps in herself. In both worlds the result is the same: isolation and grief, not a renewed, happily heterosexual social order.

<div style="text-align: right;">Mary Titus. Tulsa Studies in Women's Literature. 10, 1991, pp. 215, 228–29</div>

HENLEY, BETH (UNITED STATES) 1952–

From time to time a play comes along that restores one's faith in our theater, that justifies endless evenings spent, like some unfortunate Beckett character, chin-deep in trash. This time it is the Manhattan Theatre Club's *Crimes of the Heart,* by Beth Henley, a new playwright of charm, warmth, style, unpretentiousness, and authentically individual vision.

We are dealing here with the reunion in Hazlehurst, Mississippi, of the three MaGrath sisters (note that even in her names Miss Henley always hits the right ludicrous note). Lenny, the eldest, is a patient Christian sufferer: monstrously accident-prone, shuttling between gentle hopefulness and slightly comic hysteria, a martyr to her sexual insecurity and a grandfather who takes most of her energies and an unconscionable time dying. Babe Botrelle, the youngest and zaniest sister, has just shot her husband in the stomach because, as she puts it, she didn't like the way he looked. Babe (who would like to be a saxophonist) is in serious trouble: She needs the best lawyer in town, but that happens to be the husband she shot. Meg, the middle sister, has had a modest singing career that culminated in Biloxi. In Los Angeles, where she now lives, she has been reduced to a menial job. She is moody and promiscuous, and has ruined, before leaving home, the chances of "Doc" Porter to go to medical school. She made him spend a night with her in a house that lay in the path of Hurricane Camille; the roof collapsed, leaving Doc with a bad leg and, soon thereafter, no Meg.

The time of the play is "Five years after Hurricane Camille," but in Hazlehurst there are always disasters, be they ever so humble. Today, for instance, it is Lenny's thirtieth birthday, and everyone has forgotten it, except pushy and obnoxious Cousin Chick, who has brought a crummy present.

God certainly forgot, because he has allowed Lenny's beloved old horse to be struck dead by lightning the night before, even though there was hardly a storm. Crazy things happen in Hazlehurst: Pa MaGrath ran out on his family; Ma MaGrath hanged her cat and then hanged herself next to it, thus earning nationwide publicity. Babe rates only local headlines. She will be defended by an eager recent graduate of Ole Miss Law School whose name is Barnette Lloyd. (Names have a way of being transsexual in Hazlehurst.) Barnette harbors an epic grudge against the crooked and beastly Botrelle as well as a nascent love for Babe. But enough of this plot-recounting—though, God knows, there is so much plot here that I can't begin to give it away. And all of it is demented, funny, and, unbelievable as this may sound, totally believable.

The three sisters are wonderful creations: Lenny out of Chekhov, Babe out of Flannery O'Connor, and Meg out of Tennessee Williams in one of his more benign moods. But "out of" must not be taken to mean imitation; it is just a legitimate literary genealogy. Ultimately, the sisters belong only to Miss Henley and to themselves. Their lives are lavish with incident—their idiosyncrasies insidiously compelling, their mutual loyalty and help (though often frazzled) able to break toward heart-lift. . . .

The play is in three fully packed old-fashioned acts . . . none repetitious, drily predictable. But the author's most precious gift is the ability to . . . [create] characters between heady poetry and stalwart prose, between grotesque heightening and compelling recognizability—between absurdism and naturalism. If she errs in any way, it is in slightly artificial resolutions, whether happy or sad. . . .

I have only one fear—that this clearly autobiographical play may be stocked with the riches of youthful memories that many playwrights cannot duplicate in subsequent works. I hope this is not the case with Beth Henley; be that as it may, *Crimes of the Heart* bursts with energy, merriment, sagacity, and, best of all, a generosity toward people and life that many good writers achieve only in their most mature offerings if at all.

John Simon. *New York*. January 12, 1981,
pp. 42, 44

In April of 1981, Beth Henley, a little-known young playwright from Jackson, Mississippi, received the Pulitzer Prize for Drama for her first full-length play *Crimes of the Heart.* She has written two other full-length plays as well, *The Miss Firecracker Contest* and *The Wake of Jamey Foster.* In its reviews, *Crimes* has been characterized as a comedy, and the other two plays have equally strong comic overtones. In all three the elements of comedy abound: slapstick, as when Lenny in *Crimes* chases her nosy cousin up a tree with a broom; word play, as in characters' names like Collard (affectionately called Collard Greens at times) in *The Wake* and Popeye Jackson in *Miss Firecracker;* bizarre, hilarious characters such as the slow-witted but innocent Leon in *The Wake;* and laughter-evoking situations, as when Brocker Slade

in *The Wake* picks up and eats a piece of ham which has fallen from Collard's sandwich onto the corpse of Jamey Foster.

Yet Henley's plays are more than amusing comedies, for they present us with a tragicomic vision of human experience and human nature. The dual quality of her drama has been indicated by critic William Raidy, who calls *Crimes* "a rather zany comedy, with dark shadows." Henley herself, in commenting on the influence of Chekhov on her work, has noted, "I also like how he doesn't judge people as much as just shows . . . the comic and tragic parts of [them]." Further, she has described *Crimes* as "*sort of* a comedy" [italics mine], and her comments on *The Wake* clearly underscore its double nature: "It just comes out like comedy. A friend of mine just told me that he thought *The Wake of Jamey Foster* was the funniest thing I've written. And I found it to be the saddest thing to put down." In many ways the vision is bleak indeed, portraying a chaotic and sterile world characterized by cruelty, suffering, and futility. The human beings, often either failures or victims, hurt one another and degrade themselves. Yet, as dominant as this negative view seems at first to be, there is also a strong positive element in each play, particularly in the closing scene. First, the powerful force of human solidarity is clearly communicated, for, although the characters may criticize and hurt one another, they also are able to support and sustain each other, so that perhaps the dominant theme of her drama ultimately is the value of love, with family love providing this support more often than romantic love. Further, although they are flawed human beings, the major characters learn something valuable about themselves or their world in the process of the drama, and they reveal a certain strength or stoicism in managing to endure in difficult, often meaningless, lives. The view of humanity that Henley offers us both in plot and in theme is a mature and complex one; like the later drama of T. S. Eliot, her works are essentially serious, although they are presented in the comic mode. . . .

The vision of humanity and of human experience presented in Henley's drama is, then, essentially a tragicomic one, revealing both the despicable and the admirable elements of human nature as well as the duality of the universe which inflicts pain and suffering on man but occasionally allows a moment of joy or grace. Ultimately, however, it is the human beings themselves who must wrest what small significance, what small success or victory, they can from a bleak existence. The force most capable of furnishing significance and support to them is that of familial and, more rarely, romantic love. That each play ends with two or more characters joined together in a bond of human solidarity and with fireworks or a golden glimmer or even a simple tune in the background suggests an affirmation of humanity's ability to persevere and to endure, if not to achieve some kind of victory or success. Her portrayal of the human condition seems to me realistic, painfully honest, and yet consistently compassionate. For so young a playwright, Henley's dra-

matic vision is indeed a complex and mature one, thought-provoking, often depressing, but ultimately cheering and sustaining.

Nancy D. Hargrove. *Southern Quarterly*.
22, 1984, pp. 54–55, 69

In 1981, Beth Henley's *Crimes of the Heart* became the first drama to receive the Pulitzer Prize prior to its Broadway opening, and she, the first woman playwright to receive the award in twenty-three years. The play's enthusiastic reception on Broadway late in the year of the drama's prestigious award brought Henley quickly into the theatrical mainstream; it also opened theatre doors across the nation to the production of her plays, particularly *Crimes of the Heart,* and thrust the dramatist into a commercial prominence long denied more experienced women writers. . . .

Crimes of the Heart is about lost American ideals in the larger tradition of native dramatists from Eugene O'Neill to Sam Shepard, who have explored America's shift from a stable, rural tradition of self-reliance and moral certitude to transient instability, materialistic prosperity and spiritual bankruptcy; from family and community solidarity, trust and resourcefulness to fragmentation, incommunicativeness and sterility.

In Henley's play, as in works of Marsha Norman, Sam Shepard and other contemporary dramatists, characters consume food to numb the pain of loneliness, familial disintegration and spiritual emptiness. Old Granddaddy's well-stocked kitchen, which serves as the single setting for *Crimes of the Heart,* emphasizes the dominance of food as opiate in the sisters' lives. Indeed, Henley's metaphoric use of food and drink as narcotics pervades the play. Food is devoured not for sustenance, but as compensation for grievances of the heart; it has no relationship to the ideal tradition of family gatherings, a sharing with others or meal-time communion. While food permeates the play, no family meal is ever served. Rather, each of the sisters forages for herself, as she has come habitually to do in life since childhood, trying to relieve her emotional losses through bodily indulgences: cokes, candy, nuts, cookies, lemonade, bourbon, vodka and cake litter the sisters' traumatic landscape. . . .

In all of her plays, Henley takes up themes related to the disintegration of traditional ideals, such as the breakup of families, the quest for emotional and spiritual fulfillment, and the repressive social forces within a small southern community. The author's success in finding fresh explorations of these ideas in the works following *Crimes of the Heart* has been limited by the narrow range of her material. Since Henley's special concern is with the world of the "walking wounded," her later characters, intellectually and emotionally impoverished, possess little potential for change, for retrieving themselves from hopeless resignation. Unnurtured by family or peers, they reach adulthood hungering for bonds of affection, longing to connect with family, home and siblings. Trapped within their own limitations and eccentricities, they have few resources for positive action and remain essentially passive

victims. Henley's modern South is a world of estrangement, spiritual longing and grotesquerie, made all the more remarkable by the calm acceptance of the bizarre as perfectly ordinary.

Billy J. Harbin. *Southern Quarterly*.
25, 1987, pp. 82–83, 85, 93

The quality that most sets Henley and Marsha Norman apart from their peers is their narrative technique, particularly that aspect of it which focuses on the storytelling of characters in the play. In interviews Henley emphasizes that her storytelling ability is deeply rooted in the southern oral tradition—that "stories" make up a major part of life in the South, including her hometown of Jackson, Mississippi: "I get off the plane, and the stories are just incredible. All sorts of bizarre things are going on. It's in the air. Oh, Lord, the stories I hear about just who has died in town. There are dope fiends living next door. Hermits live over here. The police are out after people breaking windows. Somebody's drowned, and somebody's just shot themselves. [She pauses.] And that's just the houses on my block."

Henley's plays abound with just such stories, serving multiple functions: delineating character, propelling the plot forward, providing comic relief, creating moments of pathos. The literal density and wide-ranging variety of these stories in Henley's plays can be demonstrated by skimming virtually any scene in her canon. . . .

In Henley's *Crimes of the Heart, The Miss Firecracker Contest* and *The Wake of Jamey Foster,* relatives frequently gossip about one another, sometimes lecture one another, and have definite ideas about how family members should be living their lives, but such interference is usually benign (as in *Crimes of the Heart* when Meg, Lenny and Babe talk about each other's problems and secrets in groups of two) and at worst an annoying nuisance (as when Chick tries to "improve" the MaGrath sisters). Henley's plays maintain that no matter how much your family may irritate you, it is always a source of love and strength.

Lisa J. McDonnell. *Southern Quarterly*.
26, 1987, pp. 96, 101–2

HERBST, JOSEPHINE (UNITED STATES) 1897(?)–1969

This is the second book of a trilogy dealing with the disintegration of our society—with what happens to people caught in the web of contemporary events. *The Executioner Waits* is a better book than its predecessor, *Pity Is Not Enough.* It continues the saga of the Trexler Wendel family, adding to it the history of another family, the Chances.

Why anyone should speak of the racy prose of such a book as dry, I cannot understand. Miss Herbst is laconic because of the lavishness of her material. She has so much to say she can waste no words. But I know of no writing where the exact cadence of daily speech has been more accurately registered—not only the speech, but the exact turn of people's thoughts. It is a rich and tender and terrible book, violent in its pity for those who, like Rosamund and Jerry, are frustrated by the inevitable forces of our society; and in it Miss Herbst comes into her full powers.

She has not only an underlying philosophy to get over, but also the clear and beautiful pattern of the two families. Her canvas is as wide as the land and depicts the lives of three generations. It tells a story of the crumbling of ambitions that, in a reasonable society, would have been fruitful; it shows the sterility in the lives of those who, if trained for anything but money-making, might have been rich in something beside their material possessions. . . .

The book is packed with scenes, ironic, hilarious, heartrending, each one an interpretation of a facet of American life—wartime America and pre-war America; the reaction on the community when the I.W.W. holds a convention there; Seattle during the general strike. Take the little chapter, "The Clock Goes Back," in which there is the whole story of a man's defeat. Take the story of Anne Wendel's death when she has to be permitted to go. And then there is a whole gallery of contemporary portraits—the Blums, the Vinitskis, the University set, Ed Caseman.

The piling up of these people and events, the clarification of Vicky's mind toward their meaning, is so sure and inevitable that *The Executioner Waits* becomes a tremendous experience in reading. And it should be read, for there no doubt of its being one of the most important documents of American social life that has yet appeared.

Mary Heaton Vorse. *The New Republic.*
December 12, 1934, pp. 145–46

In the articles Josie [Herbst] wrote from Cuba, what she called the "implications" of the Cuban struggle were never entirely absent. Beneath the despair of the Cubans lay the hope of revolution on every page. Yet Josie's articles are more than political. They are beautiful. As natural and intimate as her letters, they people the landscape with individuals so definite they are given weight, historicity, by her accounts. The struggle for the "Soviet" in Cuba was a small moment in Cuba's history, lost as a mere incident in the post-Machado blur, lost even in the major texts, and to what extent it has been reclaimed even since Castro I do not know, but years later the people of "Realengo 18" are as alive in Josie's articles as any heroes of history, a direct light of determination linking the 1935 Cuban revolution that could not possibly have happened with the 1959 revolution that did. The *New Masses* made fanfare out of what was a major journalistic achievement. "Cuba on the Barricades," the series was called, and it began with a dramatic cover, "Eyewitness Account: The SOVIET in the Interior of CUBA," featuring Josie's

name. That there was a "SOVIET" in CUBA was certainly what her audience wanted to believe. But far from simply asserting a position, Josie had demonstrated it. She had gotten below the politics of Havana to the movement of the people beneath, and beneath that she had gotten to a profounder question still: *Why* the people moved. . . .

If *Pity Is Not Enough* is "about" capitalism and *The Executioner Waits* is "about" the rise of resistance to capitalism, *Rope of Gold* is "about" a period of flourishing of the revolutionary movement. Continuing the stories of Victoria and Jonathan Chance at approximately the point they were left in the previous novel, the third volume opens with a long, painful, confrontation with Jonathan's relatives in his father's comfortable living room—a scene that will feel familiar to radicals of any generation who have suffered political estrangement from their families—and it follows them across what readers of this biography will recognize, with qualifications, as an essentially autobiographical terrain. Jonathan's difficulties in sticking to his writing, his self-doubt, his identification with the local farmers' protest, his elevation into a responsible position with the Communist Party, his dissatisfaction with being made into a fund-raising "Front." Victoria's obsessions with her past sorrows, her isolation in the country, her gradual development of a career as a reporter, her rising identification with the international revolutionary movement, particularly during a visit to Cuba, her increasing dedication to her work. What happens between them—: the recriminations that are a product of their poverty and disappointments, the complications of their conflicting schedules, their sexual and emotional infidelities, the long slow dissolution of their mutual trust and hope until their eventual, inevitable, separation. . . .

It is in the contrast between the commitment of the radical characters and the outcome of their actions that the meaning of the novel is ultimately found. The book is more than the sum of its characters. Despite their desire for a new social order, despite their need, the book as a whole does not believe with them that therefore change will come about. There is a tension between what people want and what happens to them. Neither in personal nor in political life does justice necessarily win. In effect, despite the existence of the revolutionary movement, the destinies of individuals are as limited by external forces as they were in the periods of the earlier volumes, and radicals, despite believing otherwise, are no exceptions. If the passion of the book is in its people, the dispassion is in its design: both the forceful rhythmic alternation of scenes so that no one set of characters is ever allowed to represent the whole, and the use of italicized inserts which here carry the settings beyond the boundaries of the story in both space and time to indicate the ever-growing terrors, particularly in Europe, that the revolutionary movement must face. The principal action, including the story of Victoria and Jonathan, is set in the early 1930s and is marked by its spirit of hope. The inserts are set in the later 1930s and are marked by its spirit of doubt. The section of the book about Victoria's involvement in Cuba is preceded by an insert showing radical defeats in Italy and Germany. The climax of the text

shows Steve Carson scaling a wall to join the strikers in an auto plant, but the climactic insert which precedes it is about the crushing of the popular armies in Spain. Throughout the novel there are two lines being developed at once, the subjective and the objective, and at its conclusion they are, at best, at a standoff. This is hardly the simple novel that its "proletarian" label suggests. In fact it is something like Brecht. Granted that the wishes of the author, like the wishes of the characters, plainly cry out for change, the judgment of the author—unlike the judgment of the characters—is another matter. Within its radical framework there is an authorial impartiality for which Josie has never been recognized. If emotional logic suggested revolution, political logic did not, and she shaped her fiction to history, rather than the other way around.

Elinor Langer. *Josephine Herbst*
(Boston: Atlantic–Little, Brown, 1984),
pp. 176, 236–38

In a biographical profile of Herbst that appeared in *Mother Jones* in 1981, Elinor Langer observed:

> If anyone has captured the pattern of American history from the 1860s to the 1930s as well as she has in her trilogy, I have not read it; in no other memoirs that I know of are the political and literary dilemmas of the 1920s and 1930s more artfully portrayed.

As [Harvey] Swados and Langer suggest, Herbst's reputation will probably always remain tied to the Depression decade and to its immediate prelude and aftermath. In those years she produced her major work of fiction, the trilogy about the Trexler-Wendel family, and offered in her sociopolitical articles fine examples of documentary reportage, the special kind of journalism developed by the Left in that period. Moreover, the problems and challenges facing committed writers between 1926 and 1942 figure prominently in her memoirs. Yet it should not be forgotten that her career spanned half a century, evolving organically out of her personal and social preoccupations even as it reflected some representative intellectual and artistic trends. . . .

The start of the 1940s marked the end of an era in social and political history and the beginning of the decline of a literary generation, especially of those writers like John Dos Passos and James T. Farrell, who had directed their efforts toward social fiction. Herbst's career in the 1940s reflects these trends. Her novels from that period are existentially oriented, emphasizing problems relating to the inner being. *Satan's Sergeants* focuses explicitly on the effects of private guilt; in *Somewhere the Tempest Fell* the social and political crises discussed are less absorbing than the author's investigation of the fragmented selves of her characters. Whether out of specific autobiographical motives or a generally grave outlook on human nature, each of

these novels expresses bitter poignancy at losses never to be recovered. Finally, both books are less successful artistically than her 1930s trilogy, for reasons that include an inability to make her habitually numerous story lines cohere around a well-defined interpretation of society.

Instead of continuing to grapple with the immense difficulties involved in creating a new form of social fiction, in the 1950s Herbst channeled a revitalized narrative skill into a gracefully written novella with few social overtones and discussed American society in a book of nonfiction. In the novella "Hunter of Doves" she provides another vision, less despairing than in her earlier work, of individuals striving to break through to life and achieve their human potentiality; blending a newly complex poetic style with expertise in working with the short fiction form acquired during several decades of writing short stories, she reestablishes herself as a thoughtful and talented artist. . . .

The memoirs Herbst published in the 1960s are distinguished for their literary power and wise sociopolitical insight. The product of intense dedication to her craft and of patient blending of observations and reflections accumulated over the decades, these memoirs offer an informed, subjective vision of some important aspects of the years between 1926 and 1942, representing them as they appeared to and were experienced by her and as they exist in her memory. . . .

Individually, Herbst's novels, stories, essays, biography, and memoirs can be read as chronicles of her times, each an attempt to come to an understanding of a particular moment in the development of modern society and of the state of human consciousness. Considered as a whole, these works chart the responses of one sensitive and intelligent observer to her world and record her continuous effort to communicate the meaning of human experience as she had discovered it to be.

Winifred Farrant Bevilacqua. *Josephine Herbst* (Boston: Twayne), 1985 pp. 112–13

Now, decades after portions first appeared in small magazines, we have Josephine Herbst's memoirs, printed under the title of one section, *The Starched Blue Sky of Spain.* Or, rather, we have a fragment, for at her death in 1969 Herbst left uncompleted a lengthier manuscript. Edited by Ted Solotaroff and with an introduction by Diane Johnson, this brief volume gathers three essays focused on the twenties and thirties that appeared during Herbst's lifetime, plus a hitherto unpublished memoir of her Iowa childhood.

This is a continuation of a modest Herbst renaissance that began with Elinor Langer's excellent 1984 biography and the concurrent reissue of three autobiographical novels, the so-called Trexler trilogy. Those events brought back to public view the radical novelist and journalist who had been eclipsed after World War II, as Herbst struggled with minor-league McCarthyite persecutions, economic woes and emotional disappointments. This lovely book

is the measure of an equivocal victory over those and larger impediments to her writing.

Perhaps both gender and her provincial origins had something to do with the ways in which she was most at home in the role of outsider, even as, inflamed by literature that to her "*was* life, as authentic as bread and salt," she trod a determined path from Sioux City to the intellectual centers of two continents. It was the daughter of a mother accustomed to reading and writing in the kitchen, a batch of jelly bubbling on the stove, who crashed the International Congress of Revolutionary Writers in Russia in 1930 and felt that the arrival of the official delegations rather spoiled things. In besieged Madrid she fretted, with a symbolic frugality worthy of Emily Dickinson, over the shame of eating food that might have gone to the combatants, meanwhile noting how her friend Ernest Hemingway flaunted delicacies scrounged by his entourage.

Herbst conveys all this in prose as spare and nuanced as poetry, a sauce she'd simmered over decades. (The view of the "boys" on the Jarama front in Spain, "stemlike" bodies weirdly vulnerable beneath healthily tanned bodies, echoes the portrait of an ailing farmer from her 1939 novel, *Rope of Gold.*) The dense sensory imagery and the ingenious use of "mooing" in this description of an afternoon's sailing (on Sacco and Vanzetti's execution day, not at all by coincidence) are typical of her style:

> As the sails were so languid, barely moving, the breeze so light, we tacked back and forth with the patience of a spider stitching a fine web. The lazy needlelike movement sometimes lulled me to sleep, but only for a moment. Waking was always the same. You were inside some vast cocoon, and it was sticky with a wetness that soaked the skin. It clung to your hair like damp bees. We might have been alone, except for the sound of the foghorns mooing in the distance of watery pastures.

However, a reader's relish of gorgeous prose is dealt a rebuke by Herbst's own youthful world view: "'The lovely and the beautiful' became for our generation a term of contempt; the grounds for complacency held by the parents, despised." Complacent Herbst hardly is, but in recalling the sprawling depictions of ideological strife and emotional confusion that she dared in her fiction, one begins to notice what she sacrificed for these studied distillations. In *Rope of Gold,* a character makes the still valid point that "sincerity without a program isn't going to make a social revolution." Here she renounces all abstraction: "I don't know anything really about Spain except what came through me and my skin." . . .

Despite all the elisions, enough of the truth about the historical motivations and human texture of the political life is available in *The Starched Blue Sky of Spain* to make it a radical document, not just well-wrought reminiscence. Whether it will be understood as such in the present atmosphere is

an interesting question. Diane Johnson's introduction doesn't bode well in this regard; she quotes Hilton Kramer's predictable diagnosis that Herbst was "a Stalinist," which she scarcely mitigates with her condescending view that Herbst's "Marxism seems to have been temperamental, based more on her nature than on social philosophy." Herbst's avoidance of left ideology, as well as her sexual reticence, makes it all too easy to enjoy her stunning prose and her cast of famous literati while ignoring how subversive she really was.

Muriel Rukeyser—also profoundly affected by her brief time under Spain's sky—wrote in a poem about Käthe Kollwitz that if a woman told the truth about her life, "the world would split open." That statement stands for one ideal of art, provoked by the tumult of the world's contending voices, the interplay of levels of experience, the grandeur in chaotic history intersecting private meanings. It was an ideal Herbst pursued in her fiction, but by the time she wrote her memoirs she was after a different truth, an almost spiritual unity glimpsed in emblematic moments like the "celestial" evening she spent with Spanish villagers and soldiers of the International Brigade, remembered as "a kind of enchanted world, which was being kept suspended, like the colors in a soap bubble that may burst all too soon." The irony is that a full response to this vision of paradise depends on our appreciation of the complex emotional and ideological currents she had banished from the enchanted bubble of her art.

Jan Clausen. *The Nation*. November 11, 1991, pp. 594–95

HERNÁNDEZ, LUISA JOSEFINA (MEXICO) 1928–

While still very young, Luisa Josefina Hernández has succeeded in producing a rich and mature oeuvre which already contains a goodly number of titles: *Aguardiente de caña* (Sugarcane brandy), *Los sordomudos* (The deaf-mutes), *Botica Modelo* (Model Drugstore), (*El Nacional* Prize for 1953), *Los Duendes* (The spirits), *La llave del cielo* (The key to heaven), and what was without a doubt the best dramatic work to debut in 1957: *Los frutos caídos* (The fallen fruits). Her name is already inseparable from the best of our theater and her work is among the most important of that "best."

Los huéspedes reales (The royal guests) reflects an evolution in the author's concept of structure. The division into scenes gives her the opportunity to be more selective in her realism and at the same time provides a greater flexibility to the outline and greater richness in the characters' developmental features.

The story itself is simple and the characters are familiar to us. We meet a Mexican family: a young woman student, her parents, her female friend, the fiancé she is going to marry. Yet an old and frightful echo begins to

resound in the voices that were so familiar to us; we are going straight to the roots of her guilt and the figure of Electra shines through the skin of the protagonist. From the beginning, the tone has an unusual dignity. The dialogue is free of all triviality, it is rigorous, elegant, falls like a rain of arrows. . . .

The style is a very refined realism in which the author selects only what is most essential, advancing toward a pure and terrible nakedness, toward leaving only what is most violent and significant in the characters and the story. The beauty and the elegance of the dialogue are, for this reason, a natural consequence and not the result of contrived ornamental effects (as is so often the case in our theater).

The impression is created that this is a drama that culminates an entire stage in its author's oeuvre and begins another. And this makes us see that in Luisa Josefina Hernández we have the finest material for the creation of a drama with genuine world-class resonance, one that will, in the fullness of time, easily become our country's best and highest.

Emilio Carballido. *La palabra y el hombre.*
8, 1958, pp. 478–79

La cólera secreta (Secret anger), Luisa Josefina Hernández's most recent novel, is a simple, traditional novel (if we understand as traditional the most direct means of expression), but a surprising one. Luisa Josefina Hernández is a serious professional writer. Her already extensive bibliography allows us to trace the full development of her talent: *El lugar donde crece la hierba* (The place where the grass grows), . . . already indicated a path of psychological analysis and, at the same time, certain desires to use poetic language and the uncommon phrase to underscore subjective environments. Luisa Josefina Hernández has, over time, reined in her tendencies to subjectivity. *La cólera secreta* gives us a . . . world that at no time ever loses sight of its origins in reality. All the characters are made of flesh and bone and two of them, Miguel and Ana, have a relationship that is the axis around which a series of mysteries appear and disappear that end by explaining, describing, and justifying themselves fully. The plot of *El lugar donde crece la hierba* originated in an essentially detective-story format, and the events, the majority of the pages, lie submerged inside a sad ambience. The forms of expression in this first novel by Luisa Josefina Hernández were at the service of fantasmic atmosphere . . . while the language used in *La cólera secreta* is precise, and the places in which the action unfolds are limited and expressively congruent: an office, telephone booth, second-class apartments. . . .

The essential quality of *La cólera secreta* has its roots in the success of an almost perfect combination in the development of the fictional form: the simplicity of the form and the deepening of the content. The story never ceases to be narrated through a literary language and yet this language is comprehensible without ceasing to be profound. . . .

The mystery that we may encounter in *La cólera secreta* (which in the contemporary novel constitutes the only accepted and legitimate mystery) is that created by the psychological movement of the characters. . . .

In this novel, Luisa Josefina Hernández has succeeded in doing what she did not succeed in with her earlier novels or in her dramatic works: telling, impartially and with literary excellence, an attractive story of feelings and rejections, of limitations and fears overcome.

<div style="text-align: right">Alberto Dallal. *Revista de Bellas Artes.*
1, 1965, pp. 94–95</div>

La primera batalla (The first battle) interweaves the story of its protagonist Lorenzo from the prerevolutionary Mexico of Porfirio Díaz to our own day, with the simultaneously public and intimate story of the Cuban people in revolution. The novel—and we call it that following the definition that the novel includes anything—develops these two themes in counterpoint, which in turn contains many other themes conceived in a contrapuntal fashion. The part that corresponds to Mexico is narrated as a fable; the chapters that connect to Cuba are in a style that oscillates between stage monologue, press reportage, and prose poem. In the former case, it is evocation that predominates, in the second, invocation.

From the beginning, the principal themes of the novel are identified: . . . the Mexican Revolution; the ancestral desire for Mexican justice, specifically, justice for the Indian masses, and the lack of understanding on the part of some Latin Americans for the Cuban Revolution.

As with the majority of Mexican writers of the past fifty years, there is present in Luisa Josefina Hernández what we might call "nostalgia for the Mexican Revolution." . . . The dominant motif of the chapters about Cuba is that of the foreigner, specifically certain Spanish Americans who can no longer live in their own country or in the one they have chosen. . . . Together with this "leit-motiv" other Cuban motifs appear throughout the book: cane-cutting, the sun, santería, the family estate, the bus, the dormitories, the manatee, the mania. . . .

Beneath the thematic surface there moves a world of symbols that at times links the author very securely to the Mexican part of the narrative. . . .

The two faces of *La primera batalla*—the Mexican and the Cuban—do not come together and we are left with the feeling that we have just read two books, two narratives, two stories linked together with excessive schematization, with too much rigorous symmetry.

Although as the first Latin American novel about the Cuban Revolution. . . . *La primera batalla* holds greater interest for us, we must admit that the other recent work of Luisa Josefina Hernández, *El valle que elegimos* (The valley that we chose), is a generally more successful achievement.

In it, the author moves into a world that she is more familiar with, the world of the Mexican theater, through which she leads us with a sure hand,

making use for this purpose of almost all the modern narrative means and techniques. . . .

Across the individual lives of each of the actors recurs the principal drama, which is collective, an idea that makes itself felt throughout the book, little by little, without stridency, without the sometimes didactic tone or the clearly political intention of *La primera batalla,* and this contributes to the greater emotion of *La valle que elegimos,* which places Luisa Josefina Hernández in a rank in no way secondary within the contemporary Mexican novel, with the specific and not always common quality that her works are the product of an essential literary honesty.

Leonardo Acosta. *Casa de las Americas.*
7, 1967, pp. 139–41

In 1955, Hernández finished her early masterpiece, *Los frutos caídos.* This work benefits from the earlier exercises, for none of the prior deficiencies appear. Hernández weaves theme and character into a whole and orchestrates the separate parts together toward a climax that is altogether a fitting conclusion to the sparse exposition. The predominant theme remains basically the same as that of her prior efforts: in spite of the characters' desire to overcome their isolation one from another, the unhappy destiny suggested at the beginning of the work is met. Half-truths are the watchword. Each individual feeds on the other's needs and weaknesses. Finally, they are led to understand that their lives cannot be changed although they find their present existence intolerable. Their despair is unalleviated when the work closes; clearly, Hernández wished to indicate her view that middle-class life in Mexico was empty and futile. The audience comprehends that view.

Los frutos caídos is the culmination not only of the thematic concerns established in this initial stage in Hernández's development but also of her final mastering of this dramatic form. . . .

Freudian psychology is the second major influence that forged Hernández's point of view in her early works. Her interest in it tends to manifest itself in prototypal behavior based upon complexes. *Los huéspedes reales* considers the consequences of an Electra complex in contemporary dress. It also underscores her frank admiration for Eugene O'Neill's *Mourning Becomes Electra.* Her *La hija del rey* (1965, "The king's daughter"), a little-known but extremely complicated monologue, is the dramatization of an idea reflected in this quote from the author: "I wanted to see the behavior, the dissimulation of a weak woman in the situation of Electra." It is not a pleasant thing to watch—Hernández is very severe in her treatment of the character. . .—but the psychological overlapping of the character, based on feigned humility, fear, and self-conscious justification, is extremely effective.

The concept of sublimation supplies the key to her two farces, *Los duendes* and *Arpas blancas, conejos dorados* (1963, "White harps, golden rabbits"). *Los duendes,* for example, is almost unintelligible—which is not to say chaotic or nonsensical, for the instincts, if left to follow the intricacies

of the farce, do "understand" what is happening—unless one begins to "read" the *behavior* of the people rather than their superficial identities. In this way the grandmother is a small child playing as a witch, the granddaughter is the mother, the sister-in-law is the ugly duckling on one level (a witch on another), and love is the all-conquering agent, reconciling the apparently disparate parts into one beautiful unit. . . .

The tragedy *Los huéspedes reales* is a case in point. The dramatic problem is the converse of *La hija del rey:* a daughter who grows in strength during the play, an Electra who perverts the normal family relationships by challenging a powerful, jealous mother and nearly seducing an ineffectual, emotionally impotent father. The figure who supplies us with the sample of extremely harsh character treatment is the father, Ernesto. He is a good man in many ways, but strangely unworldly and innocent. A kind of blindness toward potential deviate behavior in members of his family prevents him from exorcising dangerous traits when they initially appear. Although he has governed his life according to the best of intentions, he almost accepts his daughter's incestuous love. He has desired nothing of life other than to grow old gracefully and with dignity, but his wife has ensnared him and rendered him impotent. When he finally realizes the repercussions of the general deviate behavior and his complicity resulting from this blindness, it is too late. Suicide is the only solution available to him in order to obviate the women's deleterious dominance. . . .

In addition to this broadening scope of the dramatist's concern, Hernández also learned the limits of realism and found it wanting for her new dramatic needs. As a result, in the 1950s and early 1960s, she moved on to new forms and new content with apparent ease. Of the forms that most attracted her, the theater of commitment was dominant. The major works in this form are three: *La paz ficticia* (1960, The fictitious peace), *La historia de un anillo* (1961, The story of a ring), and *La fiesta del mulato* (1966, The mulatto's festival). All were written under commission for school groups, as was her first tragicomedy, *Popol Vuh* (1966, Popol Vuh).

Hernández's great strength is her ability to handle structure. These nonrealistic pieces give free reign to this strength, with the result that the stage becomes in part the message. Astute use of space, light, music, and dramatic juxtaposition gives these works great vitality and symbolic quality. These dramas of commitment are, in addition, compelling, thought provoking, and sharply critical, slashing at the political and religious establishment. Her ire has not abated. . . .

Hernández's nonrealistic theater . . . challenges the primacy of form over content in Mexico. From *La paz ficticia* through *La historia de un anillo* to *La fiesta del mulato,* Hernández repeatedly demonstrates the bankruptcy of *la mano dura, caciquismo,* and the Establishment. Even though the characters are not psychologically developed, there is great audience identification with the values they represent. When arbitrary power is unleashed and the

audience sees the destruction carried out in the name of progress, we feel with the author that form selectively and consistently destroys the individual.

With the exception of *Quetzalcoatl* (1968), an unproduced drama addressing itself to yet another important moment of transition in Mexican history, Hernández has of late dedicated herself to the novel and to teaching. She appears now to be returning to the theater, however, and there is every reason to expect that this sensitive and highly intelligent dramatist will offer us new and rewarding works.

> John K. Knowles. In Leon F. Lyday and George W. Woodyard, eds. *Dramatists in Revolt: The New Latin American Theater* (Austin: University of Texas Press, 1976), pp. 135–37, 140–41, 143–44

Most of Hernández's . . . characters are emotionally wounded, drained, in need of affection, of human contact. Some learn to express that need and go on to try and fulfill it (as in *Los frutos caídos* and *Arpas blancas, conejos dorados*), often directly challenging the established order. Others never learn how to reach out and end up alone *(Los sordomudos),* or chose the "wrong people" to love *(Los frutos caídos),* or find themselves face to face with societal taboos (like the father in *Los huéspedes reales*) and commit suicide. Most come to terms with the essentially frustrating nature of life and love, and in particular with the deadening effects of life in the rural provinces of Mexico. Her portrayal of people in a small town situation, with their petty likes and dislikes, their routines and their intrigues reminds us of Agustín Yáñez's *Al filo de agua* (The edge of the storm), as well as the closed, suffocating world of Galdos's *Doña Perfecta* (Miss perfect).

Hernández creates tortured female protagonists, resolute and determined in their personalities, who try to solve their inner conflicts but are eventually thwarted by the circumstances of which they are a part. Hernández portrays love as essentially unattainable, with obstacles to happiness often imposed by the characters themselves. There is also a distinctly cynical attitude about marriage and human relationships in general (particularly in *Arpas blancas, conejos dorados* and *Los huéspedes reales*).

Hernández's plays challenge numerous norms for Latin American society. She is challenging the society around her by presenting dissident voices, by giving life to situations that *do* exist and that are uncomfortable, such as hostility between mothers and daughters, "dark passions" between fathers and daughters, and the double standard of sexual morality for men and women. Her female characters see themselves first as women, and are therefore conscious of the roles that society expects them to fulfill. . . .

In *Los duendes* (The spirits), with the help of absurdist techniques, and her acute sense of humor, Hernández pits the increasingly mechanized, systematic, rational world of the male characters against the more spontaneous, unexpected and richer reality of her female characters. In the tradition of

Ionesco and Albee, Hernández shows us how life is much more absurd, strange and illogical than we know, in protest against people's acting as if life were predictable and mundane. Is it gratuitous that in this play the men represent the "watch keepers," the "schedule keepers," the self-conscious principle, and the women, the curious, experimental, out-reaching principle? Hardly. As we can see from this brief examination of her works, her point of view is consistent. Her women figures are in conflict with the aspirations that the society at large has for them and they assert themselves in different ways. They generally do not succeed in fulfilling themselves though. This doesn't imply negative aspirations for women on Hernández's part, as much as it does imply her negative assessment of the way reality unfolds for women in Latin America.

<div style="text-align: right">

Gloria Feiman Waldman. In Yvette E.
Miller and Charles T. Tatum, eds.
Latin American Women Writers (Pittsburgh:
University of Pittsburgh Press, 1977),
pp. 76, 79

</div>

Luisa Josefina Hernández is one of the most important figures of contemporary Mexican theater. She has received grants, honors and prizes and has traveled a great deal. Recently her novels have begun to attract the attention of the critics. She analyzes the frustrations of the individual who has to confront the truth. When asked why she wrote *La primera batalla,* a book that brought sorrow to many, she answered "because I did not wish to continue hiding—as do many Mexicans—the defects of my country."

In her novels women are the ones who try to break the tenuous net of hypocrisy. In *Los frutos caídos* and in *Agonía* the protagonists are divorced women that must face up to their families and friends. Hernández's novels show a desire to unmask hypocritical patterns of behavior. One critic has said:

> Her ire is especially aroused when it deals with the human propensity for protective cover, when that cover becomes a license and justification for deceit or just plain weakness. When her characters demonstrate those traits or are simply naive, she is uncompromisingly rough on them. And she makes them work back towards the essence of their being—its limits, its energies, its general nature—they are made to feel that each day, each parting, each encounter is but a hint of things to come. This knowledge is searing and personal; it is also unavoidable and we share it with them.

For the author, the pessimism of a rupture with the past may also bring hopes for the future. Love is the moving force that can bring hope to frustrated lives. Love appears also as a destructive force. As a result, there are several

levels on which love can induce people to act: the redeeming love in *La cólera secreta* and *La plaza de Puerto Santo,* the unattainable love of *El lugar donde crece la hierba,* the vengeful love of *Los palacios desiertos,* the evasive love of *Arpas blancas, conejos dorados* and *Los sordomudos;* altruistic love in *La primera batalla,* the sick love of *La noche exquisita* and *El valle que elegimos,* and rejecting love in *La memoria de Amadís.*

<div align="right">Lucía Fox-Lockert. Women Novelists of Spain and Spanish America (Metuchen, New Jersey: Scarecrow, 1979), pp. 21–22</div>

HILL, SUSAN (GREAT BRITAIN) 1942–

Susan Hill's fictional output has been substantial and has been well received by the English literary establishment. Between 1961 and 1976, she published nine novels, two short story anthologies, one collection of radio plays, and received recognition with the Somerset Maugham Award in 1971, the Whitbread Literary Award in 1972, and the Rhys Memorial Prize in 1972. Her success enabled her to be financially independent as a writer from 1963 onwards. Unlike many of her contemporaries, Susan Hill does not seem to be primarily concerned with the subject, or the subjection, of women. A female consciousness rarely forms the center of her tales, and questions of women's social position appear merely as vague shadows hovering on the edges of her writing. Yet, in spite of this subordination of women, a close reading of Hill's work seems to vindicate a feminist approach. For her victims, her peculiar cast of artists, idiots, children, lonely and dying men and women, are all romantic figures who have given up the struggle to live in an adult, "masculine" world. They are enclosed within their fears of engagement with a difficult, demanding actuality. They withdraw into passive, dependent situations, feeling that they do not know how to "live." Hill seems to pose their problems in metaphysical terms—as to whether life is worth living at all—but behind these there are considerable economic and emotional factors which have determined their senses of "failure." As her fiction develops, a resolution slowly emerges, but it is achieved at a considerable price, and it shows that the real issues behind her work are related to problems of female survival. . . .

[Hill's] body of writing . . . shows considerable unity: from *The Enclosure* (1961) to *The Land of Lost Content* (1976), the same preoccupations appear in it. Plots, themes, and motifs recur with a striking similarity in different texts, as they move toward a resolution of a basic desire to enter life. Perhaps the most powerful of Hill's images, and the most central, is the one which is found in her work time after time, of a cold, frozen country, of ice, snow, still water, frost, winter. A tension between apprehending ice/win-

ter/sterility and longing for warmth/summer/fertility is constant in her fiction. It is graphically expressed in two identical dream images, found in the openings of *Strange Meeting* (1971) and *The Bird of Night* (1972). These haunting images, primarily oneiric scenes which are not readily translated from visual into verbal discourse, can be regarded as the imaginative center of Hill's fiction. . . .

Not surprisingly, in terms of the opposition that Hill constructed between "art" and "life," the resolution of that feeling of being enclosed in an inhuman aestheticism involves her in a complete repudiation of fiction. Randal reminds James in *Strip Jack Naked* that outside his perfect grey world, everything is chaotic. "Life is disorganized and messy. . . . Outside the door of this room. There are loose ends, questions, various answers and sometimes . . . no answers. A series of choices, awkward events . . . accidents. Distress." In the name of engagement with these external contingencies, a cold country of art is renounced altogether. Susan Hill abandoned fiction in the late 1960s in a gesture towards a less etiolated, less enclosed, activity—and a more respectable female role—maternity. In doing so, she made explicit certain assumptions which had been present throughout her writing. Instead of clarifying or confronting difficult ideological issues, about the role of the artist within contemporary culture, and the problem of women's oppression within patriarchy, Susan Hill's work evades them. Her art is trapped within a tradition of humanism—and its essentially realistic mode (made slightly expressionistic by grotesque images and a filtering of experience through non-adult minds). Her women are trapped in their ignorance of the political roots of their misery. Attempts to resolve these questions on an apolitical, metaphysical level prove both unsatisfactory and, as Hill's fiction illustrates, impossible. It is no accident that Susan Hill's work has been so well received by a liberal literary tradition, for it ends by silencing its own timorous interrogation of some of the fatal and crippling effects of a patriarchal, "male" culture and retreats into a familiar "female" enclosure of defeatism.

Hill's images of the female role within patriarchal culture are unequivocally bleak ones of wasted lives. She silences women's utterance of quiet anguish in a familiar and traditional manner. Woman's "voice [is] stilled," her "body [made] mute, always foreign to the social order"—for in Kristeva's words, "in the entire history of patrilineal or class-stratified societies, it is the lot of the feminine to assume the role of *waste*."

<div align="right">

Rosemary Jackson. In Thomas F. Staley, ed.
Twentieth Century Women Novelists
(Totowa, New Jersey: Barnes and Noble,
1982), pp. 81–82, 102–3

</div>

Susan Hill's novels were not bestsellers when they were published in the early 1970s, nor would they be today, for they are short, have no complex plots, and do not exploit the sensual or bizarre. But each novel is a masterful probe into human emotions and needs. Her characters come alive not be-

cause of what they do but how they feel and react to others and to their environment. Hill's style is clear and the structure of her work is simple. Her novels are a paradox, easy to read yet profound in exploring our complex behavior and the universal problems we encounter—death, war, seclusion, even madness. Hill never exploits human tragedy. Suffering and grief illustrate the importance of human relationships and reaching out. . . .

The ultimate test for many of Hill's characters is a confrontation with death. . . .

Unlike *In the Springtime of the Year* where a single death resounds throughout an entire town, death is rampant in *Strange Meeting*. Through junior officer Barton, the atrocities the British encounter during World War I dramatically unfold. But the power of the novel lies not in facing death but in our need for human compassion and communication that is Hill's trademark.

Barton expresses his feelings in letters to his family. His charm endears him to his comrades, and a certain mystique makes him enigmatically refreshing to fellow officer Hilliard who feels stifled by the dull reserve of his upper-class British family. Hilliard's ironic revelation is that he would rather fight alongside Barton than endure his sterile home where truths and emotions are camouflaged in silence.

Barton's letters explicitly expose his attitudes in a vivid commentary of the war from the cafes with "bad beer and comfortable chairs" to the bloody chaos of combat. He describes the "litters of armies" and "the sweet rotten trench smell of soil and chlorine and blood and the mustard gas like garlic." More important, he describes his feelings about death and his personal responsibility about the war. The accidental death of a young private provoked this reaction: "I thought of it all, how he'd been born and had a family. I thought of everything that had gone into making him and it wasn't that I was afraid . . . I just wanted him alive again."

How does Barton resolve death? To be unfeeling. Yet this is not his character. Barton's real conflict is not in coming to terms with death. He is plagued with altruistic guilt, for he is helpless to stop the fighting. He feels guilt for ravishing the earth, uprooting and disturbing all nature. He briefly risks his life to rescue a hedgehog.

When his death occurs, it does not trigger torment within Hilliard as Ruth endured in *In the Springtime of the Year*. Because of their "strange meeting," Hilliard's emotional renaissance had such a profound, everlasting effect that even the death of his dear friend could not shatter his newfound freedom. Ironically, Hill demonstrates that amid death people can be resurrected to learn to love.

Our need to reach out is never so present as in *The Bird of Night*. In this virtually plotless novel, Harvey exemplifies a total giving of self as he resigns from the British Museum to devote the next twenty years caring for a poetic genius who simultaneously endures fame and madness. *The Bird of Night* is Hill's most difficult novel because of Francis's progressive madness

and the incessant shifting in time from Harvey's narration to the interjection of Francis's journal, his documented stream of consciousness.

Why does a man relinquish his life to assume caring for another? Harvey answers, "Because I had glimpsed into the heart of his despair, because I had shared it a little . . . that I understood why I must stay with him."

Because of his progressive madness, Francis is erratic in his allegiance to man and nature. He tries to kill his brother for having shot a bird, yet he had no affinity for nature. He fears animals and confesses that "all stars have sharpened points." Hill's imagery reflects his inner torment in his "blood-filled" nightmares where he sees his flesh "putrefy and rot" and fall away from his bones. He is not at rest with himself and certainly not in harmony with nature. Unlike Ruth in *In the Springtime of the Year*, Francis can derive no strength from nature. Unlike Barton in *Strange Meeting*, he has no compassion for the wild, natural world people destroy. And it is this inherent alienation, this total "inwardness" that justifies his madness and explicates Hill's recurrent theme—everyone's need for human compassion. He is as Hill writes in *In the Springtime of the Year*, "absolutely alone." He has fallen beyond the depths of loneliness to madness.

In Harvey in *The Bird of Night*, Ruth in *In the Springtime of the Year*, and Barton in *Strange Meeting*, we witness the positive effects of reaching out to others and experience a compassion and understanding for those hurting. Hill never needs to define or eulogize this awareness, for she examines and understands the human spirit. There is no place for morbid absurdity in these stories.

<div style="text-align: right">

Mary Jane Reed. *English Journal*. April,
1983, pp. 75–76

</div>

It is almost a decade since Susan Hill's last novel appeared. Similar to E. M. Forster in one respect at least, that of having written a handful of mature novels before giving up the form, she paradoxically invites, by her novelistic silence, a retrospective consideration of her work. Much-read but little analyzed, her work has a fluency and economy soon taken for granted, a simplicity of surface that is deceptive. *In the Springtime of the Year* (1974), her sixth and arguably most accomplished novel, received critical acclaim when it was published, but in the absence of any academic attention, certain features of the book's narrative structure have gone unnoticed. One feature especially, that of interior duplication or *mise en abyme*, makes an unobtrusive but carefully judged appearance, testifying to her subtle overall control and effective presentation of material.

Auden's description of Rilke as the "Santa Claus of loneliness" is one that might be adopted, with some modification, for Susan Hill. All her novels, it has been observed, focus on "the same kind of lonely, dislocated experience. The characters are always somehow unaccommodated, outside ordinary intercourse; there is always the pathos of an excited, complex sensibility that has to stay closed-off and inarticulate." Each novel explores a particular

set of relationships, ranging from possessiveness and jealousy (*Gentleman and Ladies*, 1968, *A Change for the Better*, 1969), cruelty (*I'm the King of the Castle*, 1970), fear and intimacy (*Strange Meeting*, 1971), to madness (*The Bird of Night*, 1972) and grief (*In the Springtime of the Year*, 1974). Living "at the edge" in terms of mental stability, the central characters of these novels vary in age and sex from elderly spinsters and retired people to schoolboys, from a soldier and a poet to a young widow. They share a sense of guilt and responsibility exploited by family and kin, and a spiritual or geographical isolation making them vulnerable to events, so that, not surprisingly, death frequently intrudes. Two novels actually culminate in suicide, and the sixth and final novel only narrowly escapes, to close on a note of qualified hope.

In the Springtime of the Year is a study of the effects on a 19-year-old woman of the sudden death of her husband, a forester, killed while felling timber. Although Ben Bryce's family lives nearby, it has long shown resentment and lack of sympathy towards Ruth, and she now suffers in virtual solitude, tended only by her 14-year-old brother-in-law Jo. The novel traces the course of Ruth's emotional responses to Ben's death, from an initial terror and numbness, through despair interrupted by brief moments of vision, to an ultimately precarious sense of consolation based upon altruism. By dividing the narrative into three unequal parts, such that the first and third are temporally sequential and spatially subordinate to the central "embedded" section, Susan Hill skirts the danger of monotony inherent in a straightforward linear presentation of the material. Thus, the first part is set six months after Ben's death, while the second part opens on the day before that event in February and closes with the Easter weekend, leaving the third part to continue from August into December. For Ruth, sunk in depression, the approach of Easter represents "suffering and death and resurrection . . . despair and hope and certainty," but a scene which occurs before its arrival and is located at the very center of the novel seems in many ways more decisive. It is also a scene best conceived of in terms of the *mise en abyme*. . . .

Whatever the value of using the triptych as an approach, the analogy underscores the value of considering structural as well as thematic features, and of relating each to other. Serious shortcomings in any area obviously can not be redeemed by mere felicities of structure, but the latter, on the other hand, can reinforce already existing strengths. Critics of *Springtime* have usually pointed to a certain simplemindedness or indulgence, a lack of vulgarity, a trend towards quietism or melodrama, and an overliterate inner consciousness. Others, more favorably disposed, have commented on a lack of sentimentality, a delicate rendition of the countryside which blends inner and outer weather, a fastening on moments of genuine feeling and vision, an unfashionable concentration on the fundamentals of life. This intensity of concentration, Susan Hill's particular strength, whereby the private concerns of characters viewed in their isolation reach an obsessional level, results too from a classical purity of narrative marked by an absence of subplots, ideol-

ogies or panoramic ambitions, which could distract from or counterbalance the prime thrust.

K. R. Ireland. *Journal of Narrative Technique.* 13, 1983, pp. 172–73, 179

HIRABAYASHI TAEKO (JAPAN) 1905–71

While still in the upper grades of elementary school she became an avid reader of Russian literature and the works of the socialist critic Sakai Toshihiko. Determined to become a writer and an active member of the socialist movement, she went to Tokyo, where she supported herself by working at various jobs such as waitress and telephone switchboard operator. She became acquainted with members of the anarchist group and for a time wandered about Korea and Manchuria, living with one or another of the male members of the group. She also came to know the writers Hayashi Fumiko and Tsuboi Shigeharu and his wife Sakae. In 1927 a story of hers entitled *Azakeru* was selected for publication in the Osaka *Asahi Shimbun,* and the same year she joined the proletarian literature movement that centered around the magazine *Bungei Sensen.* She married Kobori Jinji, a leader of the movement, and with the publication of her story entitled *Seryōshitsu ni te* she became recognized as an important new writer of proletarian literature. In 1937 she and her husband were arrested for their involvement in the Front Populaire incident, and the years that followed saw her engaged in a desperate battle with poverty and sickness, from which she did not emerge until 1943. After the war she was among those chosen for the First Women Writers' Award. Her postwar works such as *Kōyū onna* (1946) and *Hitori yuku* show her to be less interested in the class struggle than in the basic human will to live and the passionate battle for survival that it so often entails. Many of these works, which have a special flavor of their own, are semipopular in nature. Her lengthy autobiography, entitled *Sabaku no hana* and published in 1957, attracted considerable attention because of the frankness with which she wrote of the experiences of her early years.

Sen'ichi Hisamatsu. *Biographical Dictionary of Japanese Literature* (New York: Kodansha, 1976), p. 266

Hirabayashi Taiko, Miyamoto Yuriko, and Sata Ineko were a vital part of Japan's prewar leftist movements, movements which fought against Japan's invasion of Asian countries and domestic class oppression. . . .

Unlike Miyamoto, who experienced fully the censorship and political oppression of writers by being arrested many times yet heroically resisted the pressure for conversion, Hirabayashi was more an anarchist in tempera-

ment, and her relation to the movement and Communist Party was indirect, coming through her husband. Nonetheless, she too lived fully in an age of turmoil as a woman and independent thinker who would not be silenced or intimidated by the tenor of the age and the authorities who expressed it. "Blind Chinese Soldiers," because of its controlled realism, is a moving short protest against war; the work depicts not only the atrocities committed against the Chinese but also the victimization of common Japanese people who were thrown into a state of confusion and rendered unable to control their lives. Like Miyamoto, whose sequential autobiographical novels secure her position in modern literary history, Hirabayashi addressed herself more fully after the war to the autobiographical portrayal of her own life.

Noriko Mizuta Lippitt and Kyoko Iriye Selden, eds. *Stories by Contemporary Japanese Women Writers* (Armonk, New York: M. E. Sharpe, 1982), pp. xix–xx

In "The Goddess of Children" (*Kishimojin*, 1946; trans. 1952) Hirabayashi Taiko (1905–72) has her heroine say: "I have lived the whole breadth of a woman's life. From now on, I will apply that same energy to plumbing its depths." The comment could well be applied to the author's own life. Although Hirabayashi was born into a well-respected rural family, she moved to Tokyo on the day of her graduation from high school and embarked on a flamboyant life both as a woman and as a left-wing activist, eventually marrying one of her comrades. She made her literary debut in 1926 with an autobiographical piece that was among the prize-winners in a short story contest. Her career as a proletarian writer came to an abrupt end in 1937, when she and her husband were arrested and imprisoned for alleged unpatriotic activities. After a few months of life in prison, she contracted tuberculosis and had to spend the next eight years trying to recover from it. With the end of the war she resumed writing, but this time her thematic focus was on the liberation of the suppressed humanity within the individual rather than on the liberation of a particular social class. Reflecting her personal experience, her postwar stories often portrayed prisoners and hospital patients who show a strong will to live, and to live as fully as possible. "I Mean to Live" (*Watakushi wa ikiru*, 1947; trans. 1963) and "A Man's Life" (*Hito no inochi*, 1950; trans. 1961) are representative of such stories. Various illnesses hampered her creative activities in her later years. With great persistence, however, she continued to write stimulating stories, including "Secret" (*Himitsu*, 1967), which won her the Women's Literature Prize in 1968.

Many of Hirabayashi's postwar stories that feature women can be said to represent the author's attempt to "plumb the depths of womanhood." The most famous among them is "The Goddess of Children," which studies female sexuality in a small child. "A Woman to Call Mother" (*Haha to iu onna*, 1966) treats the same theme, except that the subject is an aged, dying woman.

Makata Ueda, ed. *The Mother of Dreams and Other Short Stories: Portrayals of Women in Modern Japanese Fiction* (New York: Kodansha, 1986), p. 210

While working as a waitress, Taiko wrote detective stories and juvenile fiction, which she was able to sell readily. Her talent as a story teller was evident and a few editors encouraged her to write more of this popular fiction in order to establish her place in the genre. Taiko felt, however, that her real calling was serious literature. The wide range of her experiences, most of which would have been simply unthinkable for women of previous generations, gave her a unique chance to study the people around her and was a source of inspiration for her more developed writing. In 1927 Taiko won first prize in the New Writer's Award contest for her story, "Self-Mockery" *(Azakeru),* and this was a major breakthrough—she received 200 yen in prize money, enough for a couple to live on for several months. A largely autobiographical story, "Self-Mockery" conveys a strange mixture of despair and nonchalant bravado, a sense of rebellion both idealistic and cynical. The young woman protagonist wants to believe that the poor are incorruptible and that she will never surrender to the social mores which have kept women unenlightened. She despises middle-class values and is contemptuous of social conventions, yet she recognizes her own muddled life is equally a target of mockery.

"In the Charity Ward" *(Seryōshitus nite),* another prize-winning piece written in 1927, is based on Taiko's Manchurian experience. The protagonist, a self-proclaimed socialist, has been arrested as an accomplice to a political crime, but she is placed in a hospital rather than a prison because she is about to deliver her baby. Because she is a charity patient, however, the hospital authorities refuse to supply her with cow's milk, even though she is afflicted with beriberi. Her baby dies while she is breast-feeding him. The story is an attack on bureaucratic rigidity and the inhumane treatment of the poor at an institution run by Christians. It was published in the left-wing literary journal *Literary Front (Bungei Sensen)* and established her reputation as a proletarian writer.

Taiko also wrote stories about women factory workers on strike and about the peasants' struggles against landowners. "Diary of Members of the Opposition Faction" *(Hi-kambu-ha no Nikki,* 1927) tells about a couple of poor, uneducated socialists, who cannot go along with the formal teachings of a Marxist group. They are skeptical of what they hear at study sessions and what they see in prison; they distrust the leaders who seem to be satisfied with merely the rhetoric of class struggle. Taiko shared this skepticism, which she particularly felt toward the more radical faction of the leftist leaders, which included several writers. The proletarian school of writing advocated the theory that political ideology had to override personal sentiments. Taiko could not swallow this dogma and twice left the leftist writers group over disagreements on views of literature. Keenly interested in the complexity of human nature as well as in the relationship between the individual and society, Taiko put these interests above ideological concerns. . . .

For ten long years, beginning when she was thirty-two, Taiko endured continual illnesses and police interrogations because of her political beliefs. For all conscientious writers refusing to cooperate with the military state,

these were years of silence. In 1946 her voice was restored with the publication of "This Kind of Woman" *(Kōiu Onna)*, a story for which she was honored with the prestigious Women's Literary Award. In this work, which stood out amidst the devastated post-World War II literary scene, Taiko succeeds in creating a fully developed character whose strength is measured in terms of her self-awareness and her ability to share. herself with her loved ones. The year the story was published, Taiko adopted her husband's niece. From this year until her death from breast cancer at the age of sixty-three, Taiko was extremely productive. She expanded her repertoire to include non-political writings that reached a wide audience and she established herself as an important and well-known literary and social critic. . . .

Her autobiographical novel, *A Flower in the Desert (Sabaku no Hana)*, was published in 1957 and here Taiko reveals her life in its full range—her early struggles for independence and her series of destructive relationships with men, the pain and joy of creative and political activity, and, most impressively, her endurance and unfailing trust in herself as a woman and an artist.

Throughout her life, the central topic in Taiko's fiction was the condition of women, and her stories are filled with strong and determined women characters. Taiko's fierce and uncompromising independence, her vitality and resilient spirit set her apart from the women writers of the previous generation and from many of her contemporaries. As much as any writer of the 1920s and 1930s, she represented the radical spirit that became an important voice in modern Japanese literature.

Yukiko Tanaka, ed. *To Live and to Write:
Selections by Japanese Women Writers
1913–1938* (Seattle: Seal Press, 1987),
pp. 70–73

HODGE, MERLE (TRINIDAD) 1944–

In Merle Hodge's *Crick Crack Monkey* the heroine is Tee (Cynthia). . . . The story, told through the consciousness of Tee, is the sensitive treatment of a young girl who spends her first eleven years in a rural village. She and her younger brother, Toddam (Codrington), live either at the home of their paternal aunt, Tantie, or their paternal grandmother, Ma. When Tee wins a scholarship that entitles her to attend one of the best high schools in Port of Spain, she enters a new and frightening world.

Living with her maternal middle-class Aunt Beatrice and her light-skinned cousins, Tee is ostracized both at home by her cousins and at school by her teachers for her black skin and her rural background. But even as Tee comes to recognize the artificiality and meaninglessness of the social

and moral values of her new environment, she begins to become alienated from her former life and to long for acceptance in this new world. . . .

Tee's entrance in the middle class society of Trinidad is forced and painful. At home she is resented and ignored by her cousins, and made to feel an intruder. At school she is not welcomed by the teachers or the other girls in any of the extracurricular activities. Aunt Beatrice is the only one who attempts to make Tee (who now becomes Cynthia) a part of this new world. But Aunt Beatrice's generosity is tinged with a great deal of bitterness. For Cynthia learns about the disgrace her light-skinned, middle-class mother has brought on her family by marrying Tantie's black-skinned, lower-class brother. It is through Cynthia's consciousness that Hodge records the young girl's utter isolation and unhappiness in her new environment.

<div align="right">

Leota S. Lawrence. *CLA Journal.*
21, 1977, pp. 246–47

</div>

[That] women are the main purveyors of cultural values and role expectations for their daughters and women-children in general is a given. Yet women in modern societies exist within various classes as all people do. This fact renders a particular problem for Tee, the central character of *Crick Crack Monkey*, who spends part of her formative existence with her feisty paternal aunt, Tantie, who is from the Trinidadian urban poor, and part with her maternal aunt, Beatrice, a dilettante and member of the rising middle class. The clash of values and world view which Tee must reconcile as a result of living with these two different women is an emotional and psychological torment which she tries to solve by choosing sides. Her choice damages her own developing self-concept and is clearly an eventual link to the type of woman she will be in the future.

Tee and Tantie's relationship is one of nurturance. Tantie serves as mother and provider for Tee and her younger brother Toddan after their mother dies in childbirth. Tantie provides the tangible basics: food, clothing and shelter. But she also provides an education in the basics for human survival among the urban poor of Trinidad: love, rage, "fight-back spirit" and pride. Tantie's sense of order and world view result from her life experiences as a Black woman who is unmarried, head of a household and poor. She survives by her resourcefulness and "gifts" from her various men friends who are "uncles" to Tee and Toddan.

Even though she establishes financially dependent relationships with her men friends, Tantie is independent in behavior and spirit. She raises an adopted son, Mikey, from the time he is a toddler, when she took him from his impoverished mother who had several other young children. She manages to fight effectively the more financially stable Beatrice for the legal guardianship of the children. After the victory she tells the children:

> Well she know big-shot, yu know, big-shot in all kinda government office. Father-priest and thing—so she get this paper.

But we wipe we backside with she paper—we send the chirren
to get some town-breeze, an' in that time I get a statement from
Selwyn—yu shoulda see the bitch face in the Courthouse! Eh!
she face look like if she panty fall down! . . . Eh! but that is the
end of that bitch, matter fix, yu livin by yu Tantie, yu father
self could go to Hell—wha yu say, allyu aint't even have no use
for he!

Tantie's role as mother and nurturer is all important to her. And the fierce
and bitter struggle of the two aunts for guardianship demonstrates a cultural
role that Tee and all women children in her community learn: motherhood is
an imperative goal for women.

While living with Tantie, Tee develops a sense of family security. Tantie
treats her as a child, using the traditional methods and attitudes of parent-
child relationships, which is why Tee records no long or involved conversa-
tions between them even as she passes to the upper primary grades.

However, Tantie does begin to prepare Tee for a more mature role by
sending her on minor errands and trips to the local Chinese grocer. This
helps Tee's developing self-confidence and independence. A trip to the grocer
alone at the age of seven or eight is something Tee's middle-class aunt Bea-
trice would never allow. Of course, Tantie's perception of the responsibilities
of a womanchild is different. Tee's successful execution of her small missions,
coupled with the pride gained from her passing to First Standard, indicate
that she is moving progressively toward the development of a positive self-
image while she resides with Tantie.

Tee's feeling of unity which gives her a sense of security and her new-
found independence are two of the most significant aspects of her developing
selfhood. A third aspect, equally significant, is her achievement in education.
Ironically, Tantie's wish for the best possible education necessitates de-
livering Tee to "The Bitch," Aunt Beatrice.

The relationship between Tee and her Aunt Beatrice is never complete,
secure or wholesome. Aunt Beatrice lives and breathes all the biases, rules
and affectations of the African-Trinidadian petitbourgeoisie by rote. She
heaps these prejudices upon Tee's consciousness. They are reinforced by the
snobbery and bias of the teachers of St. Ann's and the cruelty and ostracism
perpetrated by Beatrice's selfish daughters. The psychological impact of this
social setting upon Tee is dramatic and destructive. She withdraws into her-
self, having no friends or outlet for solace.

Beatrice wants her relationship with Tee to be the mother-daughter bond
that she does not share with her own insensitive children. She sees the arrival
of Tee as a second chance at mothering. However, she also sees that she will
have to destroy the Tee that Tantie has trained and refashion Tee into a proper
middle-class child. All her motives lack any understanding or sensitivity
to Tee's psycho-social development. As Beatrice usurps most of Tee's free
time, combs Tee's hair every morning, insists that she sit by her at each meal

and tucks her into bed each night, Tee's once developing sense of independence and maturity dissolves. Since Beatrice's family is either openly hostile or coldly ignoring of Tee, her once strong feeling of family security disappears also.

Although Tee is never secure at St. Ann's or in Beatrice's home, the weightiness of the prejudice and the overwhelming force and advantage of the pettibourgeois lifestyle make Tee opt for the values and worldview it presents. However, this acceptance robs her of self-worth, making the attitudes and most values gained in Tantie's household null.

Tee's conscious and self-destructive decision to turn her back on her "low class" family prompts Tantie to write her brother in England urging him to send for his children, which he does. Tee reflects while visiting Tantie before the trip to England:

> Everything was changing, unrecognizable, pushing me out. This was as it should be, since I had moved up and no longer had any place here.

Tee's acceptance of a different class perspective and of her aunt's prejudices are the forces "pushing" her out of the circle of Tantie's world. She thinks that she has moved up the social ladder, yet she has only changed class allegiance; she has consciously aligned herself with a narrow-minded outlook which she feels befits her rising social position. Her real position in the world as the daughter of Trinidadian working-class parents remains the same.

Even the false alliance between Tee and Beatrice is destroyed by the time Tee leaves for England. The tenuous bond ends when Beatrice's family vacations at the beach and at a crab hunt in which her daughters are participating. Tee allows her true revulsion for her aunt to show. "It was when a boy sprang forward to take it that the hand took hold of mine and I savagely slapped the hand away and recoiled and turning sharply I was staring helplessly into Auntie Beatrice's face." The sheer power of the physical rejection is too much for Beatrice. After the incident, she leaves Tee alone and allows her true regard for Tee's lack of middle-class cultural indoctrination to vent. In effect, Beatrice begins to treat Tee as her daughters and others in their social milieu treat her—with derision and ostracism.

Therefore, as Tee prepares to leave Trinidad, she has no close relationship with either aunt. Her education and her relationship with Beatrice have given her a choice in the perception of the world, but it has also seriously damaged the positive self-image she was developing while she resided with Tantie.

<div align="right">Yakini Kemp. SAGE. 2, 1985, pp. 24–25</div>

Merle Hodge, whose novel *Crick Crack Monkey* marks a crucial transition from nationalist discourse to postcolonial writing in the Caribbean, has written on how colonial education, by presenting the lived experiences of the Caribbean people as invalid, negated the very subjectivity of the colonized

by taking them away from their "own reality": "We never saw ourselves in a book, so we didn't exist in a kind of way and our culture and our environment, our climate, the plants around us did not seem real, did not seem to be of any importance—we overlooked them entirely. The real world was what was in books." If existence and significance are defined by the texts we write and read, as Hodge seems to suggest here, then the absence of female texts in the Caribbean canon meant that political independence had not restored speech to the Caribbean female subject. If independence represented the triumph of modernist forms, it had legitimized a situation in which the lives of Caribbean women were still surrounded by a veil of silence perpetuated by a male-dominated discourse. For this reason, the current outpouring of Caribbean women's writing can clearly be seen as the first major challenge to the project of modernity initiated by the colonizer. . . .

In a sense, for postcolonial Caribbean women writers to reconfigurate modernist discourse, and to unmask its function as an instrument of male domination, they invent strategies of representation which reject the notion of a subject that is defined, and fixed by, the dominant patriarchal culture. As I will show in my reading of Hodge's *Crick Crack Monkey,* Caribbean women writers are concerned with a subject that is defined by what de Lauretis calls "a multiple, shifting, and often self-contradictory identity, a subject that is not divided in, but rather at odds with, language." . . .

Merle Hodge's *Crick Crack Monkey* was the first major novel by a post-colonial West Indian woman writer to problematize and foreground questions of difference and the quest for a voice in a social context that denied social expression to the colonized self and hence cut it off from the liberating forms of self-expression which define the Caribbean narrative. For Hodge, this emphasis on voice as a precondition for black subjectivity in a colonial situation was necessitated by both ideological and technical reasons. First of all, in the plantation societies of the Caribbean, the voices of the oppressed and dominated slaves and indentured labourers survived against the modes of silence engendered by the master class. For these slaves and laborers, then, the preservation and inscription of a distinctive voice would signify the site of their own cultural difference and identity. Second, the voice was, in radically contrasting ways, an instrument of struggle and a depository of African values in a world in which the slaves' traditions were denigrated and their self-hoods repressed. In terms of narrative, the recovery of voice becomes one way through which unspoken and repressed experiences can be represented.

In Merle Hodge's novel, then, the voice is a synecdoche of the unwritten culture of the colonized, the culture of Aunt Tantie and Ma, and its privileging in the text signifies an epistemological shift from the hegemony of the written forms; alternatively, the negation of the spoken utterance through education and assimilation is a mark of deep alienation. When Tee opens her retrospective view of her childhood at the beginning of *Crick Crack,* she discovers that the past cannot be narrated without a cognizance of the voices that defined it. The voice is shown to be both central to the subject's conception

of her past and as a paradigm that defines the context in which her multiple selves were produced. . . .

In a sense . . . Hodge's narrative develops along what appear to be contradictory lines: the subject is privileged in the discourse, but this privilege is undercut by her function as the reporter of other's speech, or by her limited perspective. This is an important strategy for showing not only how the subject develops in multiple and contradictory ways, but also the extent to which a unique sense of self is often produced by a painful struggle with the discourse of others. We have moved away from trying to invent a new language of self to a recognition of Bakhtin's famous assertion that "language, for the individual consciousness, lies on the borderline between oneself and the other. The World in language is half someone else's." . . .

Tee is structured by a set of oppositions, none of which offer her true identity: her Creole world is makeshift and marginal; her desired colonial universe is artificial. When she recognizes the sources of marginality and the nature of artifice, then she will outgrow Helen "in the way that a baby ceases to be taken up with his fingers and toes." Herein lies the value of narration in the postcolonial moment: as the adult narrator of her own experiences and subjectivity, Tee will not need external mediators molded in the image of the colonizer; having discovered that idealized images are unreal and that the colonial subject cannot adopt the colonizer's discourse for her new identity, the narrator will write about her past to exorcise the ghost of colonialism and to challenge the assumption—often sustained by the neo-colonial élite—that independence is the native's way of appropriating the modernity project initiated by the colonizer.

<div style="text-align: right">

Simon Gikandi. *Ariel.* 20, 1989,
pp. 18–22, 28–29

</div>

In *Crick Crack Monkey*, Trinidadian Merle Hodge presents a young protagonist, Tee, who is caught between the warm, rural, traditional world of her Tantie and the cool, middle-class, assimilated existence of her Aunt Beatrice. The further she moves into the world of Aunt Beatrice with its mulatto, middle-class pretensions, the more self-hate she feels. She is ashamed, embarrassed by Tantie's family, even by her grandmother, Ma, the market-woman who gave her sustenance and told her the Anancy stories which travelled the middle passage with her ancestors.

Even though some of the women, like Aunt Beatrice, identify with the colonial culture, the role of women as central to the family, as prime educators, as storytellers, reflects a matrifocal African heritage. As in many African cultures, the term mother is loosely used to include grandmother and other female relatives. Hodge's protagonist Tee has no mother; raised by her Tantie, she and the other children call the grandmother "Ma." Consanguinal lines are often stronger than conjugal lines. As in an African village compound, the women become communal mothers to the children around them. The structure of polygamy is gone, but the women remain mates. . . .

The title of Hodge's child narrative comes from the storytelling term, "Crick Crack." In the novel, it is Ma, the grandmother, whose Anancy stories conjure up a culture carried to the Americas by their African ancestors; yet revealingly, the assimilated Tee loses the ancestral name that Ma offers to her on her deathbed. Tee does not return to Ma at her death, and her Tantie, caught up in her niece's change, "hadn't even bothered to remember it." These [new Caribbean women] writers understand that they will lose the names, the songs, and the stories, if they do not pass them on to the next generation as they have been passed on to them. The use of folklore, legends, values, and traditions are all part of the herstory that these young narrators learn.

> Gay Wilentz. *College English.*
> 54, 1992, pp. 396–97

HOLTBY, WINIFRED (GREAT BRITAIN) 1898–1935

It is the merit, and it is a great merit, of *South Riding,* not that it is a picture of Local Government at work (all that should have been cut out) but that it has defined, in the most clear-minded way, the modern Fate. That Miss Holtby did not choose to be content with doing that, but wrote, also, a novel about social workers, and unsocial workers, in Yorkshire, so that one is so exhilarated by her enthusiasm that one wants, under the influence of that part of the book, to throw all his books out of the window and go and do things, is the measure of the greatness of her heart; and of her limitations as an artist. For it means that because of entirely subsidiary material we are distracted, as she was deflected, from the significance of the individual human tragedy. . . . She wrote in *South Riding* a book that is a grand picture of the life of our times, and created, incidentally, in Sarah Burton, a figure who must be one of the minor masterpieces of fiction. To have done that is to have accomplished a great deal.

> Sean O'Faolain. *London Mercury.*
> April, 1936, pp. 643–44

Winifred Holtby had one positive fault—the only one that the most exacting of her friends could find in her—and even that was a defect of the most conspicuous of her splendid qualities. She was so accessible to ideas, so generously eager to dash out and rescue them before they perished from contempt or indifference, to "try all notions for their gold" as her friend Hilda Reid has put it, that she was an erratic and unreliable critic. It was not that she praised, out of kindness, that which she did not believe to be good. The gay and gallant figure that stands out luminously in the mind from the confused and chilling background of the post-war scene, was utterly sincere,

bone-honest. But she liked too much. She praised too often and too quickly. And then, life seeming (as it proved) so short, and there being so much to do, chiefly for other people, she hurried on to the next thing, seldom allowing herself time to reverse or confirm her judgments. It was on contemporary values that she went astray. She was as sound as the best on permanent literature. So that anyone editing, for instance, her letters [*Letters to a Friend*], does her no service by not editing them enough, or by giving her impulsive lightning views the solemn air of conclusions.

Violet Scott-James. *London Mercury.*
May, 1937, p. 82

The success of *South Riding* and its international fame make it a book which cannot be treated as merely one event among others in Winifred's complicated life. Her only novel that comes near to it in stature is *Mandoa, Mandoa!* but except for those who know its hidden springs the earlier story belongs to a more intellectual and less broadly human category, and has therefore a less universal appeal. From the moment that *South Riding* appeared, critics and public alike acclaimed it as a masterpiece, a classic, a picture of England which, as the novelist Helen Simpson suggested in her broadcast review, may well stand as Winifred's monument. By the time that Winifred had finished this last and greatest novel, she knew her own work too well to be wholly unaware of her achievement. But her innate skepticism about her ability to capture a large public prevented her from counting upon even one of the many triumphs, won by the book, which came too late to reward her. *South Riding* was the choice of the English Book Society in the month of its publication, March 1936. Of the original 8/s English edition over forty thousand copies were sold; of the American between ten and twenty thousand. The following year Edinburgh University awarded the book its annual James Tait Black Memorial Prize for the best novel of 1936. Soon after its publication it was issued in the Albatross Continental edition, and has already been translated into Dutch, Danish, Swedish and Czech. . . .

South Riding was the work—and probably the first typical work—of Winifred's maturity. Amongst her writings it represents both an end and a beginning. It is an end in the sense that, when compared with her first novel, *Anderby Wold,* it gives an uncanny appearance of completion to her literary cycle. It is a beginning because it clearly indicates what she could and would have done had she survived for another decade. From its pages we can estimate the real measure of her quality.

For those who can read it, Winifred wrote her autobiography in *South Riding* as clearly as she had once written it in *Anderby Wold,* and far more profoundly. Her book is not only an achievement of the mind; it is a triumph of personality, a testament of its author's undaunted philosophy. Suffering and resolution, endurance beyond calculation, the brave gaiety of the unconquered spirit, held Winifred back from the grave and went to its making. Seed-time and harvest, love and birth, decay and resurrection are the imme-

morial stuff of which it has been created. In it lie both the intuitive and the conscious knowledge of imminent death. Its lovely country scenes go back to the earliest memories of the Yorkshire child who, only thirteen years before she died, had come as a brilliant Oxford graduate to London. Her unconcealed passion for the fields and wolds of her childhood suggests that she returned with relief to her beginning because she knew that, beyond the brave struggle for life and for time, the inevitable end was near.

Vera Brittain. *Testament of Friendship*
(London: Macmillan, 1944),
pp. 408–10, 418–19

Winifred Holtby's *Mandoa, Mandoa!* is in intention a left-wing *Black Mischief,* written a year or two after Waugh's book came out; which fails not so much because she was less talented than he as because his sensibility and his form were incorruptibly one, and his sensibility was incorruptibly upper middle class. You can't put lower-class sympathies into that kind of work. And her *South Riding,* a respectable piece of work, built entirely on her "decent" values, with two categorically lower-middle-class heroines, a school-mistress and a woman alderman, is topped off with a romantic, reactionary, wounded, brooding, ineffectual, upper-middle-class hero. The hegemony was too much for her. For a hero she had to have a gentleman. Because *her* sensibility, *her* themes, had no contemporary forms.

Martin Green. *A Mirror for Anglo-Saxons*
(New York: Harper, 1950), p. 116

In the case of [Vera] Brittain and Holtby, perhaps even more than with other writers, the written word is evidence of their interaction. Almost always they responded only to each other's completed work; any attempt to influence the process was seen as a form of oppression, a stifling of the individual creative act. . . .

For Brittain and Holtby, dealing with life through literature involved two major activities: writing as a form of catharsis and writing as a means of self-definition. In *On Being an Author* Brittain devotes several pages to quoting other writers on the subject of writing as catharsis. She describes her own coming to terms with the personal tragedies of World War I through writing *Testament of Youth.* The author, she claims, "is one of the few men and women who can set himself free from fear and sorrow. He can, if he chooses, write these scourges of the spirit out of his system." Similarly, Holtby describes writing her first novel, *Anderby Wold,* as a way of curing the heartbreak she felt when her father sold the family farm. . . .

One way of describing the process between Brittain and Holtby is to see it as the mutual creation of acceptable fictions. These fictions are versions of each other and the other's world compatible with images of the self that each is able to live with. As Patrocinio Schweickart says, women "are most concerned in their dealings with others to negotiate between opposing needs

so that the relationship can be maintained." Women also authorize each other in a third way, then, by making authors of each other. Brittain and Holtby did this in a literal sense, of course, since they encouraged each other to write. Their conversation, their attempt to reach consensus, took place on the page; they defined themselves through their written texts. This female friendship is thus not merely paradigmatic of the reading process but a literal illustration of it.

> Jean Kennard. *Vera Brittain and Winifred Holtby: A Working Partnership* (Hanover, New Hampshire: University Press of New England, 1989), pp. 11–12, 17

HOPKINS, PAULINE ELIZABETH (UNITED STATES)
1875–1930

Despite her prolific writing career, Hopkins has been omitted from the canon of American literature. We might conjecture that her race and gender are somewhat responsible for her omission, in that white male writers, by and large, receive critical attention from white male critics. Furthermore, male critical judgments have categorically established the canon of Afro-American literature and literary criticism. Thus, it is not surprising to find that Ann Allen Shockley's 1972 *Phylon* article, entitled "Pauline Elizabeth Hopkins: A Biographical Excursion into Obscurity," is the only critical piece that gives Hopkins more than a passing nod. In fact, when surveying Hopkins's critical reception, it is much simpler to cite the few works in which she is mentioned than to refer to the many which fail to mention her at all. In this regard, we find Hopkins's work discussed in Vernon Loggins's *The Negro Author: His Development in America* (1931), Hugh Glouster's *Negro Voices in American Fiction* (1948), Robert Bone's *The Negro Novel in America* (1965), and Judith Berzon's *Neither White nor Black: The Mulatto Character in American Fiction* (1978). But these sources only treat *Contending Forces,* thereby further neglecting the full body of Hopkins's published work.

According to Loggins, *Contending Forces* is a complicated work of exaggerated injustice, cruelty, and brutality. He compares Hopkins's novel only to that written by Frances Harper, as if the novels of William Wells Brown, Martin Delaney, Sutton Griggs, or Charles Chesnutt were somehow different in their basic themes, plot structures, and authorial intentions. That Loggins placed Hopkins's work into an artificial context, isolated from her male contemporaries, was not an unusual critical practice. This type of gender segregation was the rule rather than the exception.

Glouster, her next critic, reports that Hopkins was motivated to do all that she could "in a humble way to raise the stigma of degradation from her

race." Like Loggins, Glouster focuses on Hopkins's preface in order to explain her motive for writing. Also like Loggins, Glouster seems to subscribe to gender segregation in that he places Hopkins solely in the company of her female contemporaries, Frances Harper and J. McHenry Jones.

Bone, her third critic, mentions Hopkins as an early Negro novelist, who had adopted the stance of strict moral piety in her work in order to promote the social advancement of Afro-Americans. He also contends that she was a subscriber to the myth of Anglo-Saxon superiority and guilty of stereotyping her minor characters. All of these comments are undisputed characteristics of the fiction of Hopkins and her contemporaries, writers who staunchly believed in moral piety and personal industry and who used the tragic mulatto as a vehicle for racial protest.

Finally, Berzon remarks that "Hopkins's ideology is . . . distinctly Du-Boisean. . . . Sappho, Hopkins's beautiful golden-haired black heroine, is opposed to industrial education exclusively." Berzon continues to quote Sappho as a means of giving expression to Hopkins's DuBoisean conviction that black Americans must have full political rights in order to ensure their social advancement. Although Berzon makes particular reference to Hopkins's dramatization of the DuBois-Washington controversy, Berzon seems more concerned with using Hopkins's work to mark an appearance of the mulatto character in American literature than with placing her work in the literary tradition of her day.

Pauline Hopkins was an important writer who deserves serious attention because, in being both black and female, she documents the cross section of the literary concerns of two major groups of American writers: turn-of-the-century black writers, who primarily dramatized themes of racial injustice, and mid-to late-nineteenth-century white women writers, some of whom wrote sentimental and domestic novels that acclaimed Christian virtue. In some of these novels, a young girl is deprived of the family assistance she had depended on to sustain her throughout her life. The popular success of white women in depicting their heroines' necessity of making their own way in the world despite injustice provided a ready and fertile context within which black women writers might also place their fair-haired black heroines and dramatize racial protest. For many black women writers embellished the plot line of their white predecessors and contemporaries. They include Amelia Johnson, Sarah Allen, Emma Kelley, Ruth Todd, Marie Burgess Ware, Frances Harper, and J. McHenry Jones. In their work we find that the youth is black and may be male but is more often female. She believes herself to be white, obviously having no knowledge of her African ancestry. This knowledge is withheld so that she can enjoy the privileged life afforded her by her white father. Circumstances lead to his death, and as a result the child and her mother are subjected to the horrors of slavery. Both are abused by cruel slave masters, despite the fact that they are as white and as noble as any one of their former caste and more handsome than most. The child survives and eventually marries well, thereby concluding the tragedy of her

plight. This marriage is not only based on love but forms a partnership for continued work in racial advancement and, thus, gives the union a high and noble purpose. But practically every one of these writers has been lost in out-of-print books and periodicals which have long ceased to be available. Their work must be retrieved in order to correct the now longstanding misconception that Phillis Wheatley and Frances Harper were the lone literary women of the eighteenth and nineteenth centuries, who all by themselves brought forth the generation of black women writers of the Harlem Renaissance.

<div style="text-align: right">

Claudia Tate. In Marjorie Pryse and Hortense J. Spillers, eds. *Conjuring: Black Women, Fiction, and Literary Tradition* (Bloomington: Indiana University Press, 1985), pp. 54–56

</div>

Pauline Hopkins was a black intellectual whose writing was part of, not separate from, the politics of oppression. In an article called "Heroes and Heroines in Black," she appealed to her readers to exhibit a "wild courage." Fiction, she thought, needed to be of "cathartic virtue" to stimulate political resistance, and we can now read this collection as her cathartic response to black oppression. . . .

As can be seen in her first novel, *Contending Forces,* Hopkins created histories that rewrote definitions of American culture. Questions of heritage and inheritance shape the political direction of all her stories. The actions and destinies of Hopkins's characters are related to the ways in which their ancestors acted upon their own social conditions; the contemporary moments of the tales are shaped and determined by the history of the social relations between white and black.

In her preface to *Contending Forces,* Hopkins stated that she wanted the novel to "raise the stigma of degradation from my race." She believed that writing fiction was an especially effective means of intervening politically in the social order. It is the "simple, homely tale, unassumingly told," she argued, "which cements the bond of brotherhood among all classes and all complexions." Her pedagogic and political intent was that her fiction enter "these days of mob violence" and "lynch-law" and inspire her readers to political action. To a contemporary readership, which is cynical about the possibilities of narrative contributions to social change, it is important to stress Hopkins's belief in the historical and political significance of fiction. She considered fiction to be "of great value to any people as a preserver of manners and customs—religious, political and social" and to be a "record of growth and development from generation to generation." Black intellectuals had a crucial role to play as writers, for only they, Hopkins thought, could *"faithfully portray the inmost thoughts and feelings of the Negro with all the fire and romance which lie dormant in our history"* (italics in original).

Hopkins's fictional histories provide her readers with an understanding of the source of contemporary forms of oppression. "Mob-law is nothing new," she argued in *Contending Forces*. "Southern sentiment has not been changed. . . . acts committed one hundred years ago are duplicated today, when slavery is supposed no longer to exist." What she feared most was that mob-rule and lynch-law would become acceptable practices throughout all the states. Hopkins saw the black inhabitants of the North as the inheritors of a New England tradition of liberty, and as a Northern black intellectual she thought the culture that she could produce could contribute to, if not create, a political climate of agitation, a new abolitionist fervor.

Although Hopkins's *Contending Forces* gives considerable insight into her construction of fictional histories, there are significant differences between this novel and her magazine fiction. Within the pages of the *Colored American Magazine*, Hopkins made a decision to incorporate some of the narrative formulas of the sensational fiction of dime novels and story papers. Consequently, her magazine fiction shows an increased emphasis on such narrative elements as suspense, action, adventure, complex plotting, multiple and false identities, and the use of disguise. The representation of social and intellectual conflict is more frequently accompanied by physical action and confrontation. Hopkins's didactic intent remains but is shaped by the attempt to combine these elements of a popular fiction with stories of political and social critique. In *Hagar's Daughter,* which she wrote under the pseudonym of Sarah A. Allen, the physical action includes murder, kidnappings, and escapes, if not actual fights, and concludes with a spectacle, a confrontation in open court that brings together the entire community of the novel. The use of more popular fictional formulas in all three of Hopkins's magazine novels was also a consequence of the demands of serial publication, as can be seen in each novel's episodic structure. Each episode ends in a state of suspense that is not relieved until the next issue, which in turn ends in suspense. Fictional resolutions to the overall narrative structure and history occur only in the concluding episodes to each of the novels.

Hopkins's magazine fiction also differs from *Contending Forces* in terms of setting; the serialized novels are situated within a white rather than a black social order, although the conclusion in *Of One Blood* does assert a Pan-African history. In *Contending Forces,* a black family's boarding house and the black church are the central focus of the consequences of Hopkins's fictional history, and the representation of the black community is as a fairly autonomous locus of alternative possibilities for American culture. White society is represented indirectly, as a systemic set of social forces, through accounts of the experiences of Hopkins's black characters. But in *Hagar's Daughter* and *Winona,* the white world is represented directly through white villains as individual figures of greed who symbolize the power of white society to oppress. *Hagar's Daughter* contains three black female characters who

exist within the context of a white community and are believed to be white; for each, blackness is a secret and a means of their victimization.

> Hazel Carby. Introduction to Pauline
> Hopkins. *The Magazine Novels of Pauline
> Hopkins* (New York: Oxford University
> Press, 1988), pp. xlviii, xxxv–xxxvii

The second tactic of inscribing the father's absence decenters the nuclear family, diminishes the importance of excessive patriarchal demands for feminine piety, purity, and propriety, as well as mitigates feminine prescriptives for absolute deference to male authority. This revised family discourse shifts narrative hegemony from racial protest to domestic ideality. Hence, ideal families evolve in the absence of what is conventionally known, in patriarchal societies, as the father's law. *Contending Forces* stands at the crossroads of this hegemonic shift because although this novel inscribes both the racial and domestic discourses, the former becomes increasingly reticent here, while the latter, which inscribes what I call the mother's law, is dominant. The mother's law centers a black gynocentric morality that metes out reward and punishment in direct proportion to the moral character of one's deeds and serves as the basis for redefining a virtuous woman.

> Claudia Tate. In Cheryl Wall, ed. *Changing
> Our Own Words* (New Brunswick: Rutgers
> University Press, 1989, p. 121

Pauline Hopkins was among the most ambitious black writers in early twentieth century America. She was, primarily, a novelist who can be placed in the familiar category of sentimental protest writers. Nevertheless, working within the confines of essentially romantic plot lines, Hopkins developed stories and characterizations that gave added dimension to black literature as it was developing in her day.

At the time Hopkins was doing her most important work, she was literary editor of the *Colored American Magazine,* from 1900 to 1904. During this period, she produced four novels—two of them serialized in *Colored American* (one under the pen name Sarah A. Allen)—and a number of articles and short stories. She also published, in 1905, a little book entitled *A Primer of Facts Pertaining to the Early Greatness of the African Race and the Possibility of Restoration by Its Descendants,* a question-and-answer book on the ancient Egyptian background of African and American blacks. Fired from *Colored American* when it was taken over by Booker T. Washington, she began to do some writing for *Voice of the Negro.* After about 1905, her writing career came to an abrupt, unexplained end. . . .

Hopkins also did some writing as part of her activities with her theatrical company, creating dramatic sketches for the troupe to perform.

As Hopkins moved out of the theatrical world and into literary life, she helped mold the ambiguous literary consciousness of early twentieth century black American writers. As literary editor of *Colored American,* she pushed that leading secular magazine toward publishing an eclectic range of literature, including dialect writing, sentimental stories, and protest. Although Hopkins's role on the magazine cannot be precisely documented, some estimate may be drawn from the relative paucity of literary material in *Colored American* following her firing.

Hopkins's encouragement of a wide range of work by black writers is important, because it helps provide a perspective on the rather narrow focus of her own writing. Although she did do some experimental writing on unusual subjects, such as spiritualism, and even did one work about a Washington street urchin, the bulk of her fiction was overwhelmingly dominated by protest, framed by stories about interracial love and racial mixture. The few critics who have written about Hopkins' work have tended to treat it as offering little more than a variation on the theme of the tragic mulatto. Such a reading is not without foundation, since Hopkins did draw heavily on that theme in several of her works. Still, she tended to treat the familiar subject of racial mixture in unfamiliar ways.

Hopkins's use of racial mixture as her key focus emphasizes some of the ambiguities in black literature during this period. Some of her writing looks back to the tradition established by *Iola Leroy,* stressing the importance of racial identity. Her 1902 short story "A Test of Manhood," published under the pen name Sarah Allen, is the tale of a young man, successfully passing, whose plans are disrupted when his mother appears and he is unable to reject his race if it means disavowing his love for her. But far more revealing of Hopkins's usual focus is her rather long story published that same year. "Talma Gordon," a tale of murder and false accusations centering around the proposition that "amalgamation" must occur when two races exist in close proximity to each other—a proposition dramatized by the interracial marriage of the story's protagonists. Identity is thus subordinated to profoundly assimilationist goals, which are symbolized by the belief that all racial barriers, even those prohibiting interracial love and marriage, will fall in a truly integrated society. This is the point of view that dominates Hopkins's work.

The depth of Hopkins's assimilationism and its relation to literary trends are shown most fully in her novel-length works. The earliest, and the one published in book form, is *Contending Forces,* which appeared in 1900. Hopkins set forth her purposes as a writer in a four-page introduction, where she described herself as motivated "in an humble way to raise the stigma of degradation from my race." Fiction, she believed, was a peculiarly good way to do this; she wrote, "It is the simple, homely tale, unassumingly told, which cements the bond of brotherhood among all classes and all complexions." And she asserted beyond this, a special role for the black writer. Fiction could capture the manners and morals of any community, and black writers had the responsibility to tell the truth about their people. "No one will do

this for us," Hopkins claimed. "We must ourselves faithfully portray the inmost thoughts and feelings of the Negro with all the fire and romance which lie dormant in our history, and, as yet, unrecognized by writers of the Anglo-Saxon race." But as her story makes clear, her call for a black literature was one that took very seriously her own assimilationist ideals. . . .

The revised view of the world [in *Of One Blood*] and the ancient African setting, taken with the novel's rather ambiguous ending, indicates that, by the end of her literary career, Hopkins was beginning to see problems in the wholehearted assimilationism of her earlier works. In its evocation of ancient Africa, *Of One Blood,* along with the later *Primer,* shows a writer moving toward an appreciation of black distinctiveness, even if ancient Africa was the most assimilationist theme in the rhetoric of distinctiveness. The relatively ambiguous ending works the same way. Reuel comes out all right, but he is unable to protect Dianthe—not to mention his brother—from the corruption of a racist society. *Of One Blood* is the obverse of Hopkins's earlier novels, an indication of her awareness that her effort to escape the ambivalences of American society by turning to fantasies of interracial kinship and marriage could not be wholly effective.

Still, Hopkins was an important figure in the development of black writing in the early twentieth century. Certainly, her work helps illuminate the underlying aspiration of assimilationist goals by showing the kinds of relationships that must exist between black and white Americans in a decently ordered society, especially in a society built on genteel virtues. Hopkins was, in her first three novels, willing to say the unsayable, although she couched her words in a romantic sentimentalism that made them more hopeful than threatening.

Dickson D. Bruce, Jr. *Black American
Writing from the Nadir: Evolution of a
Literary Tradition, 1877–1915* (Baton Rouge:
Louisiana State University Press, 1989),
pp. 144–47, 155

HOWARD, ELIZABETH JANE (GREAT BRITAIN) 1923–

Bettina von Arnim, the subject of this biographical portrait, was a splendid specimen of the romantic temperament at its most engaging, and lucky enough to be thrown among kindred spirits in the age of sensibility, when romance was all the fashion. Born in 1785, a Brentano, of mixed German and Italian parentage, at the age of fifteen she read Goethe's *Wilhelm Meister* and forthwith decided that the character of Mignon was the one for her to impersonate. She accordingly climbed onto roofs and up apple trees, adopted wayward, unpredictable habits and occasionally dressed the part. . . .

About half this book *[Bettina]* consists of delightful excerpts from Bettina's writings and those of her friends. One wishes there were many more of these, for the authors' joint contribution [E. J. Howard and Arthur Helps] is often sadly at sea. In the course of providing the necessary biographical information they are exasperatingly discursive. Occasionally they introduce acute and well-timed comment, but too often they are tempted to air their views on the Teutonic mentality and road to Hitler. And what have Palmerston, *Punch,* Elinor Glyn, Home Chat and the Welfare State to do with their chosen subject? Moreover the index is ramshackle, and in the text it is difficult to tell where the misprints end and the mistranslations begin. Still, one must be duly grateful to them for bringing Bettina to England.

Ralph Partridge. *The New Statesman.*
September 21, 1957, p. 358

One of the trials of becoming an "important" novelist is that critics start to make hay with influences and trends. Miss Howard has already won a high reputation with her two earlier novels, and *The Sea Change* confirms her place among the important women novelists now writing. Though it would be a mistake to saddle her already with high-flown comparisons or influences— particularly since one is much aware of her potentialities and of the quiet confidence with which she is developing along her own lines—it may be worth quoting a remark of Henry James, who was similarly preoccupied with variations in technique. He says: "Really, universally, relations stop nowhere, and the exquisite problem of the artist is eternally but to draw, by a geometry of his own, the circle within which they shall happily *appear* to do so." This is Miss Howard's constant theme, the flux of relationships at a level of intimacy which demands the most delicate investigation if we are to discover truth, and the most intricate selection of situations that will appear both complete and natural.

The Sea Change is told through each of the four characters in turn, and this gives the reader the illusion of being at the center of the circle of events, although it means the sacrifice of the surprise element and occasionally appears self-conscious because of the need to distinguish in style between the narrators.

(London) *Times Literary Supplement.*
November 20, 1959, p. 673

[After Julius] is Elizabeth Jane Howard's fourth novel—time to ask where one of England's most talented writers is going. Miss Howard has been called "promising" so often the word must make her shudder. She has also been pinned as a "lady novelist"—fit companion for such quivering styles as Rosamond Lehmann.

I suspect Miss Howard does not accept this description of herself. *After Julius* has a mother named Esme who rereads Jane Austen constantly—and a sweet, simple daughter named Emma, who has a complex, bitchy, older

sister named Cressida. Is Miss Howard tired of being hailed for her exquisite sensibility? Does she want us to notice that she also has quite a bit of sense in her books?

At bottom, all the characters in *After Julius* are working out a dilemma that has muddled middle-class lives in England and America for generations—how the do-good tradition of loving "humanity" in the large permits people (especially men) to fink out on loving people individually. Women, of course, are the inevitable victims of this masculine malaise. . . .

Miss Howard handles this story pretty much in the manner of her previous books—shifting points of view between the major characters. The style is superb, as always. The sensibility still casts a glow. Beautiful Cressida, endlessly analyzing her failures at love is a fascinating, totally believable character.

However, the same jarring artificiality remains. Asking us to believe Esme and Felix have remained in emotional limbo for twenty years while waiting for their confrontation is a bit creaky. The proletarian poet is just a little too simple. And at the end, when twenty-seven-year-old Emma decides to marry him, her uncle informs her—for the first time—that there is a legacy of £3,000 to keep them alive. Jane Austen could get away with it—but you have too much sense, Miss Howard.

<div align="right">Thomas J. Fleming. The New York Times.
January 9, 1966, p. 36</div>

There is a moment halfway through Elizabeth Jane Howard's new novel *[Odd Girl Out]* when Edmund Cornhill, predictable, inhibited, dependable, and dull, longs to provoke a nasty scene. He is even ready to wallow in "every cliché about the *ménage à trois* that every *ménage à trois* has been through" in order to communicate. But although, on the final page, his wife Anne feels that the air has cleared, it is hard to believe that Miss Howard expects us to accept their experience as cathartic. Rather, we are left—perhaps deliberately—wryly observing how very little these characters have dared, how little they have learnt or suffered, how little difference the events she describes have made to their lives. Except to one life, a fringe casualty, abandoned in despair and unnoticed, merely another piece in Miss Howard's ironical jigsaw of relationships.

<div align="right">(London) Times Literary Supplement.
March 24, 1972, p. 326</div>

The Long View by Elizabeth Jane Howard (1956) is . . . most radical in form. It dissects a marriage spanning the years 1926–50 by beginning at the moment of its breakup and working backward to the first meeting of Antonia and Conrad Fleming. The novel's startling retrospective plotting dramatizes a view of history as determined and depressing. Written years after the war, the novel suggests that women are necessary and exploited during war but barely relevant afterward. At the same time, however, the perspective cre-

ated by the narrative structure shows a persistent resistance on the part of these women.

The Long View incorporates the social changes of its time span in the consciousness of Antonia, but because we see her awareness emerging at the beginning of the novel—at the moment when it may be too late to change the direction of her life—we share her entrapment. We are forced to watch her fated development without hope of any literary or social surprises. When it begins, in 1950, the novel depicts a woman's futile efforts to discover and sustain what little sense of self she has grafted from her upper-middle-class life. Looking ahead to her next twenty-five years, she realizes that she has no "violent facile conviction to support her . . . no god-like creature brimming with objective love and wisdom to whom she could turn." This melancholy view of a woman caught in the stasis which her world takes for stability becomes a challenge to the reader. As we review her life for the past twenty-five years, we also review the social and literary forces which seemed, in the twenties, to promise women self-determination. In the narrative space of Antonia's life, we see how these promises left women wiser but still trapped in domestic space. For the contemporary reader, from the perspective of new promises for women's liberation and of new feminist perspectives on women's writing, Howard's novel is a sobering experience.

The Long View shows the interaction of social and literary experiment with women's psychological, social and literary imprisonment in domestic scenes of the fifties. When the novel begins, the Flemings' marriage has reached the end of a protracted stalemate. When the novel ends by retrospectively returning to 1926, we are thus aware of the doomed nature of Antonia's youthful innocence and open-ended dreams of self-definition. This long and critical retrospective view shows how the curious mixture of idealism and cynicism of the twenties created a bind for female character: whatever highs and lows the world endured, the fates of women in the domestic novel remained bound to the care and feeding of family establishments.

In the time warp of *The Long View,* all emotional and social modulations are dramatized in terms of domestic conflict. The opening scene, wherein Antonia Fleming views her dinner party as "the kind of unoriginal thought expected of her," makes it clear that the domestic power which enabled Mrs. Ramsey and Mrs. Dalloway to create a moment of harmony has atrophied. Over the long and disastrous course of the Flemings' marriage, woman's domain functions not only as a battleground, but as the sacred fount on which women are worshiped and discarded. They cannot but fulfill and disappoint male fantasies of ageless and infinitely fascinating grace and beauty while they serve as the emotional and social barometer of the hearth. The following exchange between Antonia and her first disappointed and disappointing lover prefigures the categorical distinctions in which a patriarchal ideology has caged the female. When he asserts, "Domestic creatures never have any choice, you see—not like the wild ones," she questions whether it is possible to "divide people up like that," into "Wild, or domestic." Only during World

War II, an episode at the formal and thematic center of the novel, is there a possibility for Antonia to define her own responsibilities and thus other categories for female experience. . . .

Howard's tale, . . . like her circular staircase, curls back to a beginning which signifies that the prince's rescue, the "beginning" of his tale, is not a journey to happily ever after. If Antonia makes her own destiny by offering her hand, the backward movement of the novel shows how the mixed messages of her traditional background make this inevitable. Even as the wartime experience fostered women's independence, by 1950, when this novel begins, it is clear, as Karen Anderson points out, that the war also "generated confusion, insecurity, and anxiety," out of which grew an "ambivalence" which is no more surprising than "the attempt to reconcile conflicting values and behavior with the strident certitudes of the postwar 'feminine mystique.'"

Phyllis Lassner. *Mosaic.* 23, 1990, pp. 90–92

HOYOS, ANGELA DE (UNITED STATES) 1940–

Two discrete tendencies are apparent in the work of Angela de Hoyos; one is made up of the Chicano/a poems and it is where the author takes on the task of bearing witness, denouncing, and didacticizing, motivated by an imperative of social demands that, given its reality, is inescapable. This first (we say first for reasons of method, although, as we shall see, Angela de Hoyos is responsive at one and the same time to the other imperative that shapes her work) tendency that we might call "engaged," to use a cliché (meaningful enough, although ridiculed by many), adopts a stance common to all (or almost all) creators of Chicano literature; thus, speechifying, direct and linear communication and conviction that the artist (the poet, in this case) should make him or herself into a spokesperson for the disinherited (dis-inheritance of voice, education, and economic dignity) is established in this first tendency.

The other side of the poetic coin, in terms of themes, is made up of those poems in which the author comes face to face with herself and with the world that surrounds her. An intimist, personal poetry that serves to call "private ghosts" into question and tries to exorcise them somehow. The poems of the "I" or "personal poems" are as numerous as the others and, at times, draw on similar sources and form; but, in our opinion, the elements that divide them are more significant than those that unite them. . . . It should be made clear that we are not speaking of polar tendencies but rather of a bifurcation based on the same principle: the adjacent reality that surrounds her as an individual, and the reality that surrounds the human group with which she identifies; yet, in both situations, it is manifested as a chaotic, incongruent, and unjust reality.

This dichotomy is beautifully illustrated in the three books that make up Angela de Hoyos's oeuvre; the first of them, *Chicano Poems: For the Barrio,* is an inventory (a roll call?) of the Chicano problematic; it is, as well, a set of formulas for alternatives and methods of struggle. . . . *Chicano Poems* is an engaged book with a very specific audience (Chicanos) and with a very well defined goal (integration). . . .

The intimist naturalness that predominates in the second tendency within Angela de Hoyos's work could be described as antiheroic in that it contrasts with the heroic "we" on the other side of her poetics. This side, the West side, describes the little limited and soporific world of a petty bourgeois home. . . .

From this narrow world (from the garden to the kitchen; from the living room to the bedroom), the poet draws her themes, injecting into them a bitter irony, and lays them out for us in short lines, where the "I," the main character, encompasses all the people who read them, because anyone who identifies or recalls or seems him/herself reflected is immediately transformed into this antiheroic "I," venal and modest, who appears in the majority of Angela de Hoyos's poems. . . . The heroic, collective "we" of the Chicano poems is opposed to the individual and discouraged voice of the antiheroic "I"; a contradiction that can subsist only in the chaotic and ordered universe of art.

<div align="right">Luis Arturo Ramos. Angela de Hoyos: A Critical Look/Lo Heroico y Lo Antiheroico en su poesía (Albuquerque: Pajarito), 1979, pp. 10–11, 27–28</div>

Arise, Chicano! is testimonial poetry that denounces the social injustices done to the Chicano, and reflects his/her downtrodden and exploited circumstances. "Arise, Chicano!", "Brindis: for the Barrio," and "The Final Laugh" reflect the circumstances that have produced the mental, physical and spiritual suffering inherent in the loss of their heritage and economic dignity. In effect, de Hoyos's first book of poetry is a call to action. Not only does the poet chastise and condemn the dominant culture, but she prods the Chicano to recognize and do something about his/her circumstances.

The poet's major intent in "Arise, Chicano!" is to teach and to inform. For this reason, the poem tends to have pessimistic overtones. The reality of the Chicano is not a pleasant one. The truth that the poet projects reflects mainly negative aspects. Her attitude, however, is not negative; instead, she exhorts the Chicano[s] to be [their] own savior[s]. . . .

Stress is on ethnic differences, rather than cultural dominance. Pessimism is more apparent, while racial discrimination is seen as the primary cause of the marginalization and alienation of the Chicano. Assimilation into mainstream America does not seem possible, and the ethnic question is offered as a dilemma for which no solution exists.

The author of *Arise, Chicano!* consistently employs new creative techniques. As a rule, de Hoyos creates a series of graphic images. The conventional noun-adjective juxtaposition with compounded adjectives contributes

to the visual quality of her poems and creates a montage-like effect. One image following upon other works to impart an idea or create a tone. As in a montage, an image—which can be considered an idea of varied elements—is juxtaposed to another without comment or transition. The process is a function of complementary and contrastive relationships. The compounding of images directs the reader to focus on each element as a part of a whole, permitting the poem to be experienced both emotionally and intellectually. As such, "Arise, Chicano!", "Brindis: for the Barrio," and "The Final Laugh" achieve complexity through striking metaphors that possess bisemic and trisemic symbolic significance. Equally important is an expert use of puns and irony that often attains levels of black humor.

Arise, Chicano! is an example of Angela de Hoyos's conscious projection of the Chicano interlingual and intercultural reality. This world, like her poetry, exists in antithetic tension. It is not separated, as it were, into two neat spheres but is the fusion of two cultures.

The poet's language—the best gauge of cultural antithesis and tension—contains several linguistic devices which are used to create foregrounding. Varied linguistic dimensions are elicited in English and Spanish—or in their mixture—that cannot be found in the poetry of a monolingual English or Spanish writer. De Hoyos's most important linguistic devices are the Hispanicization of English and the creation of a slanted vernacular in both languages. The many poems analyzed in here reflect Spanish influence in one way or another.

Perhaps the most notable and consistent characteristic of Angela de Hoyos's poetry is the use of English clichés to criticize the dominant culture. As a result, the English language is revitalized. Often, a well-known saying of the dominant culture is made to convey a sense of Chicano poverty and concreteness. This phenomenon is not only apparent in the use of language, but also in the way that themes are treated. An adage or human value is hybridized to fit new poetic needs. These linguistic innovations make de Hoyos's Chicano poetry refreshingly unique and creatively original.

Not unexpectedly, de Hoyos's second book, Selected Poems/Selecciones, reveals many of the same stylistic and linguistic devices employed in Arise, Chicano! Thematically, Selected Poems reflects a deeper concern for the universal themes of life and death. Through humor, de Hoyos unfolds both her view of life and her recognition of mortality. . . .

Selected Poems/Selecciones and Arise, Chicano! contain vocabulary, concepts, images, and symbols that acquire multiple levels of significance. Factors that contribute to this richness are: (1) the continuous use of puns; (2) the tendency to underplay the seriousness of theme; (3) the incorporation of technical devices that create antithetical tension; and, perhaps most important, (4) the poet's command of language and clichés.

In Chicano Poems: For the Barrio, de Hoyos returns to social-political themes. There is concern for such matters as race and the loss of language and traditions. Moreover, Chicano Poems is different stylistically. The most

notable stylistic trait is code-switching. In "Hermano," the code-switching is controlled; Spanish is used to refer to the poet's culture and English to refer to the dominant culture. In "Small Comfort," the code-switching is "willy-nilly", that is, there doesn't seem to be any pattern. In "Blues in the Barrio," the code-switching is organized: the poem begins and ends in Spanish, and the dialogue—in Spanish—contributes to the authenticity of the poet's ethnic background. . . .

Yo Mujer, Gata Poems, and Goodby to Silence are three forthcoming books by Angela de Hoyos. In these works we see Angela de Hoyos occupying herself more and more with the feminine. While Gata Poems pokes fun at middle class women, Yo, Mujer projects the poet's voice to other women. In Gata Poems, code-switching is predominant, and in Yo, Mujer the entire range of language alternatives—Spanish, English and code-switching—is used. Goodbye to Silence, her most recent creation, stems from de Hoyos's personal experience of having lived in a world of silence. This poetry, thus far, is bilingual in nature; that is, English and Spanish versions are included. . . .

Another innovation is the incorporation of pachuquismos in the poem "Abran paso, gentes." In this poem, the English version turns out to be a literal translation from Spanish, except where appropriate idiomatic expressions are unavoidable; then the poet re-does the line or word in order to create a similar effect.

De Hoyos's trajectory crosses several thematic and stylistic planes: from a political stance to a philosophical position, and back again; from poetry written predominantly in English to code-switching. De Hoyos continues to explore the linguistic and cultural reality peculiar to the Chicano of the Southwest. Spanish, Spanish vernacular, pachuquismos, English, and English vernacular combine, contrast and mesh to create richly textured poetry.

<div style="text-align: right">

Marcella Aguilar-Henson. The Multi-Faceted
Poetic World of Angela de Hoyos (Austin,
Texas: Relampago, 1982), pp. 71–78

</div>

In the voice of Angela de Hoyos, we encounter a wide range of attitudes with darker and lighter areas that takes us along with it to where the sky might just surround the hand . . . or where death is lying in wait for us. . . .

This is poetry that offers us the intimate biography of common and universal experiences that makes us brothers in all latitudes, giving us a feeling of intemporality. Constant truths that, shared as they are, cannot be unknown to each of us and that inexorably mark our fate. . . . Sorrow, illness, failure of communication accompanied by loneliness and silence, the struggle between life and death with which each of them asserts itself at the expense of the other, these are the tragic themes that move us in some of her poems. For Angela de Hoyos, the word redeems, transforms itself into an orderer of chaos and of the emotions that constantly attack us and that in the poem are transformed into this courageous stammering . . . that unveils to us, with

images and metaphors, those unexplored zones of reality that lie before us like new lands where other generations are passing.

Thus, Angela de Hoyos appears to us in her work as one of the Chicana poets of the highest intensity and maturity in the early period of the development of contemporary Chicana literature and of the female presence within it. The quality of her poems shows, once again, that political and social engagement is not in conflict with poetry of great inspiration, in which individual and collective experiences are fully realized in art.

<div style="text-align: right">

Maria Eugenia Gaona. In Aralia López-
Gonzalez, et al. *Mujer y Literatura
Mexicana y Chicana,* vol. 2 (Tijuana:
Colegio de la Frontera Norte, 1990), p. 271

</div>

HUCH, RICARDA (GERMANY) 1864–1947

She is so extremely German. She writes novels you sing in the twilight, overpowered by memories. . . . Her art, in the proper sense of the word, is not great. Her characters are not personally interesting, especially from the realistic point of view. Neither does she move her figures on the chess-board of life according to a hidden rule which you feel compelled to recognize as such in the end. Of problems she knows only one: the suffering of passion which is kept in chains by the constraints of the world. . . . Ricarda Huch is more than a novelist—she is a poetess.

<div style="text-align: right">

Levin Ludwig Schücking. *English Review.*
1909, pp. 166–67

</div>

The distinctive quality of her world view . . . might perhaps be said to lie in this: that she stood outside reality and at the same time strived passionately for reality. Accordingly, the theme of almost all her works is constituted of the two extremes—that of not living and that of life's supreme intensification. Love and death—the gates by which life enters and by which it leaves— are the constant subjects of her dramatic, epic, and lyrical work. . . . These components of the action are reflected in the two differing human types into which the large, highly articulated cast of characters seems to divide itself again and again. There are on the one hand those who are deeply rooted in life, who follow their instincts with an almost somnambulistic sureness, those in whom nature works directly, without mediation, removed from all reflection, detachment, and self awareness. . . . These are the characters in whom the author means to embody the very object of her longing—life itself, and she endows these personifications of life with all the awesome, demoniacal, and irresistible attraction that life holds for her.

While one of her two human types thus embodies the object of her long-
ing, the other type gives shape and substance to that longing itself. These are
the characters who . . . flee the treacherous currents of a bottomless and
shoreless sea and seek refuge in a cloister; those who do not live, the men
of reflection who consciously take a position above, outside of life; those to
whom the life represented by the other type is a matter of wistful tenderness,
something to be watched over with superiority and renunciation. . . .

The confrontation of the two human types bears a close relation to cer-
tain peculiarities of form in Ricarda Huch's work. The man of reflection is
at once the mirror in which the nature of the man of life is reflected—of this
nature the man of life himself cannot be conscious—and the one who puts it
into words. This formal principle is often raised to such a pitch that the entire
narrative is cast in the form of memories from the lips of the man of reflection.
It follows directly that the first-person novel here is wholly different from
what it normally would be: the story of the narrator's own development. That
development is at most touched upon only in passing. . . . The intentional
sharp separation of reflection and action, of thought and life . . . wholly
excludes any unification such as would be necessary to live life and simulta-
neously mirror it in consciousness. Such a "harmonious man of the future"—
to use our author's own expression—hardly ever appears in any of her works.

Elfriede Gottlieb. *Ricarda Huch* (Leipzig:
Teubner, 1914), pp. 52, 54–55, 60

In her own time, Ricarda Huch is an isolated phenomenon. . . . In an age
that is intent on all that is singular and subjective, an age that focuses upon
the unique aura and bloom of the individual human soul, she struggles to
achieve the typical, the impersonal. She is concerned not with the rousing
melody but with the solid, firm architectonic structure. She rejects the
churning agitation of the gothic and baroque and yearns for the clear, soothing
lines of the buildings of antiquity. Her aim is not the throb and heat of life,
but—to an ever larger degree—a harmonic stillness and peace. What draws
and attracts her is not the singularity of wholly individual emotion but the
harmonious man, the man who has conquered—who has conquered himself
most of all.

. . . The conquests she achieved within herself through her poetic work
are the subject matter of her poetry . . . we might also say that she gives
objective form to subjectivity.

She bases herself on her own experiences. . . . Her lyric poetry gives
us an intimation of how strongly she was drawn to the personal, the negative
statement; for, to Ricarda Huch, the lyric is the poetic form of the personal
statement. Thus she composes poems in which the "I" possesses a self-
awareness such as can be achieved only by an "I" that has looked into the
mirror and seen itself.

Oskar Walzel. *Ricarda Huch* (Leipzig: Insel,
1916), pp. 112–14

Zeitalter der Glaubensspaltung (The age of religious schism). This portrait of the religious struggles which distracted the fifteenth and sixteenth centuries is both revealing and, in some way, reassuring. Ricarda Huch's vision is as true of past centuries as it is of our own time. The mere facts of these struggles of four hundred years ago will bring home to the reader the greatness of religious conflict throughout the centuries and stress the eternal force to be found in convictions based on conscience. . . .

Ricarda Huch's book stands midway between an historical study and a work of fiction.

> F. W. Pick. *German Life and Letters.*
> 1938–39, pp. 55–56

Ricarda Huch had begun with romanticism . . . in her first novels—*Erinnerungen von Ludolf Ursleu, dem Jüngeren* (Memoirs of Ludolf Ursleu the younger) and *Triumphgasse* (Lane of triumph)—in the novel *Vita somnium breve,* and in her great literary work portraying the inner history of romanticism [*Die Romantik,* 2 vols.]. . . . By its thorough mastery alone of so vast a body of material, with its hundreds of themes and characters, this two-volume work represents a tremendous achievement for a woman in her 30s. . . . But, far beyond that, it is one of the few books on a problem continuously alive in German literature, a problem that can be picked up with profit again and again. . . . But these volumes have still another meaning for Ricarda Huch. By a kind of catharsis, she cured herself by writing them. By giving expression and form to the problems of those affected by that sickness—for romanticism is a sickness, indeed, and proud of being sick—she healed her own heart. . . . Other readers . . . will be touched by still other statements and formulations in the rich and rewarding pages of this work—a work that will not lose its substantiality for a long time.

For the fitting, striking expression was Ricarda's forte—and we do not mean the light, deft, boldly tossed-off aphorism, which is so often noncommittal and can't be so easily wiped off the slate. We mean the slow and steady swell of evidence and proof channeling its theme like a musical composition, to bring it to its climax in the right and tightly-built phrase of rigorous style.

> Richard Friedenthal. *Neue Rundschau.*
> 1948, pp. 294–95

Ricarda Huch's own personality has found its purest and fullest expression in her love poems. The unity that such poetry demands, a unity of feeling and self-revelatory formulation, of living situation and the way in which the mind grasps and shapes that situation, reveals her nature most completely. Only on rare occasions do the words interpose themselves and obscure life. For, since the choice of both remains her own and within herself, the realm of the subjective spirit, that unity triumphs much as it does in Rilke; the feminine emotion remains in control of the masculine form as well, and thus

it ultimately achieves suprapersonal stature. In Ricarda Huch's verse, even more than in the great narratives that her work includes, we encounter the living presence of the spiritual universe of those women of the turn of the century who became the first martyrs of the romantic faith in their own superiority over the object-bound world of the male—a superiority that had been proclaimed as early as Cato.

Paul Fechter. *Gate*. March/May, 1948, p. 12

Huch's powerful hunger for life, for struggle, and for knowledge is poured into masterful form, a sign of the fact that her seemingly limitless subjectivity will not have the last word. Even the novel *Aus der Triumphgasse* (1902 [Lane of triumph]), which puts figures and destinies from the Trieste slums together to form a darkly growing mosaic, reveals the need to make her fellow man no longer merely a vessel to contain her own emotions, but to see and recognize him as a creature in his own right.

Her breaking out of the egocentric sphere is revealed even more clearly in the fact that history, which even in her student days claimed her main attention, now becomes the object of her creative activity. It offered Ricarda Huch a subject that challenged her form-giving power by knowledgeably ordering the abundance of happenings and by embodying the motivating forces in representative characters. She was interested in the tumultuous periods of conflict in which opposites clash and in which the old disappears and the new comes into being.

Elsbeth Merz. In Hermann Kunisch, ed.
*Handbuch der deutschen
Gegenwartsliteratur* (München:
Nymphenburger, 1965), p. 300

In Trieste . . . Ricarda was inspired to compose her best novel, *Aus der Triumphgasse* (Lane of triumph), which . . . is named ironically for a triumphal arch, which, in time past, separated the alley from the rest of the world. This image is a symbol of the transitory nature of the glories of life.

The sensitive hero of the story wavers between his attachment to the world of the *Triumphgasse,* a world of human beings struggling blindly for existence, and his love for Isabella, the representative of a world of convention and comfort into which the narrator too was born. At the end of the novel, the vision of a ship, from whose slippery deck he gazes down at his drowning fellow-passengers, looms ever larger in his consciousness.

Ricarda Huch's language is characterized by a musical and rhythmic quality; another feature of her style is the occasional pathos in the words spoken by the narrator.

Henry M. Rosenwald. *Jahrhundertwende.*
(New York: Harcourt, Brace & World,
1968), p. 137

HULME, KERI (NEW ZEALAND) 1947–

Great excitement has attended the publication of this novel in New Zealand. So far, nothing I have seen written about *The Bone People* could be described as "critical." It has been received with acclamation. The *New Zealand Listener* gave it not one review but two—both by women, one Maori, one Pakeha (European). As far as I can recall both were direct addresses to the author. They told her she had spoken for us all, or for all women, or all Maoris; but it was impossible to guess what kind of novel was being reviewed. . . .

Criticism is always a dialogue. One seldom has the chance to speak first, and what the critic says is always partly in answer to what has been said already. In the case of Keri Hulme's novel "what has been said" is largely a babble of excited voices in public places. *The Bone People* touches a number of currently, or fashionably, sensitive nerves. . . .

The Bone People, I would be inclined to argue, is a novel by a Pakeha which has won an award intended for a Maori. The fault is not Keri Hulme's. It is in the conception of such an award, which is thoroughly confused, and is in any case patronizing, suggesting that Maori writers can't compete openly with Europeans. It doesn't surprise me that Witi Ihimaera refused to enter his work for the Pegasus award. . . .

I have never doubted that [Hulme] has a powerful and original literary talent. I have admired some of her stories published in *Islands.* And I was sure Auckland University Press made the right decision when it accepted her collection of poems, *Moeraka Conversations,* for publication. Her talent is abundantly clear in *The Bone People.* But all the indications are that, for reasons which are not strictly literary, the achievement of this novel is going to be inflated beyond its worth. I'm glad *The Bone People* has been written and published. I'm sorry it wasn't revised, decently copy-edited, and presented to better advantage. I'm sure its author will go on to better things. But I have to admit that when I stand back from the novel and reflect on it there is, in addition to the sense of its power, which I have acknowledged, and which is probably the most important thing to be said about it, a bitter aftertaste, something black and negative deeply ingrained in its imaginative fabric, which no amount of revision or editing could have eliminated, and which, for this reader at least, qualifies the feeling that the publication of this book is an occasion for celebration.

<div align="right">C. K. Stead. Ariel. 16:4, 1985,
pp. 101–2, 104, 107</div>

Keri Hulme's Booker prize winning novel for 1985, *The Bone People,* meshes events, mysticism and dreams in such a tight net that the author leads us to speculate on the importance of total experience in the search for meaning. Over four hundred pages span the events that take place within a short time, possibly little more than six months. By commenting only briefly on those

past events that continue to influence the lives of the main characters, Hulme forces us to concentrate on the shaping present which the main characters often misunderstand.

If we untangle the plot from the psychic drives of the characters a quotidian microcosm emerges. A woman artist, Kerewin, encounters the child-mute Simon, through whom she meets his Maori stepfather, Joe. Joe's child-bashing causes partial deafness to Simon and the temporary separation of the three. All unite at Christmas: Joe returns from his gaol sentence for Simon's mutilation; Kerewin extricates herself from an exile of guilt and mysterious illness; and Simon, through Kerewin's fostering, escapes welfare custody. While the events seem common enough, the characters charge them with so much emotional intensity that the mystical forces generated, direct their lives.

In some sections of the novel Hulme seems to distance herself from those spiritual forces and strange visitors that Joe and Kerewin allow to influence them. Sometimes, the novel's innovative artistry and patterns tempt us to search for structural developments in plot, when Hulme stresses only the characters' psychological reactions to events. There were also occasions when Hulme demonstrates that mystical insights condition the characters' responses to immediate events when the meaning extends beyond their understanding.

<div style="text-align: right">Carmel Gaffney. Southerly. 46, 1986, p. 293</div>

Does a Booker Prize ensure wide and critical attention for the winner's subsequent publication? Expecting to satisfy a "pent-up demand," retailers in New Zealand "ordered up heavily" when 1985 recipient Keri Hulme smartly released a volume of short fiction, *Te Kaihau/The Windeater,* in 1986. However, as one area book manager has said, her company "took a big punt" with *Te Kaihau* and "just did a nose dive." *Te Kaihau* has been a publishing non-event; the book has not sold well and no one has much to say about the stories. The fiction elicits only brief and oblique mention in Ian Wedde's review which focuses on the prefatory poetry. Was Wedde off on a linguistic tangent close to his own heart, or did he consciously avoid engaging with the actual fiction? Much of *Te Kaihau* was written contemporaneously with *The Bone People;* stylistically and thematically the two books have much in common. Why then has one book attracted wide acclaim while the second has received relatively little attention despite the propitious circumstances of its publication?

The tensions in *The Bone People* inspire diametrically opposed readings. One critic praises Hulme's skill in rendering the protagonist a "living, realistic woman," while another argues conversely that Kerewin is "too omnicompetent to be believable in fiction." Similarly, *The Bone People* divides readers on the symbolic as well as the realistic level. The novel succeeds as a model for post-colonial harmony because Kerewin's "sexual neutrality" suggests that "bonds need not be biological," a point which relates "overtly to individuals" but could be seen as an "optimistic blueprint for future race relations."

This same model fails, however, because the "last quarter of the novel" extends itself "too far," and the "characters cannot stand up under the mythic burden placed on them." If the model does not work for individuals, it cannot work for the community. . . .

The Pegasus Award for Maori Literature meant to Hulme that "regardless of how mongrel you are" the work was "accepted as a Maori thing." *Pakeha* critics, however, deny the novel's Maori elements. C. K. Stead argues that Joe's quest to recover his Maori spirituality, "read as Maori lore or fiction," is "almost totally spurious." Prentice sees the novel as the "balancing of positions within the post-colonial society" and agrees with Stead; reading the novel as Maori is "inherent ludicrousness." However, the commensal vision depends upon accepting Maori spirituality in *The Bone People*. If Joe's quest is "spurious," the novel collapses. Perhaps it is opting for the easy response, but as a *pakeha* inevitably outside Maori spirituality, I cannot criticize the novel as mythicized self-projection. A Maori critic, writing from inside, may justify such a response, but imposing *pakeha* value judgments on the novel feels too much like racism.

I have, however, become uneasy with the commensal vision. By whatever means Kerewin may "win a home" in *The Bone People,* she is the exception rather than the rule in Hulme's work. Questers abound in Hulme's short fiction. The characters are similar to Kerewin in ways I shall suggest, but no other character, as yet, completes the heroic journey to return to a new-found community. These endings in *Te Kaihau* may be more "believable" in the light of the real world in which we think we live and, therefore, more convincing to readers like Stead; they also point to Hulme's resistance against the possibility of commensalism or community. Simply, images of alienation dominate over community in Hulme's oeuvre. . . .

[T]he Maori myths which fuel *The Bone People* also fuel "Te Kaihau/ The Windeater." Where Hulme "made a hook" with *The Bone People* to raise the characters to face the "bright broad daylight" of "home," she has "made a sinker" with the "Windeater" persona who, "in another second," will "be gone." Where Kerewin is the spider and ultimately sees herself "weaving webs" of future events, the windeater's life is "an old spiderweb" with the remains of "past feasts." What is missing, however, "what is needed to make sense of it all, is the spider." Kerewin, as "spider," makes "sense" of her world; the "windeater" cannot find the spider and comments on the impossibility of making sense." . . .

Perhaps it is to Hulme's poetry we must turn for a synthesis. The final poem in *The Silences Between,* "Moeraki Conversations 6," seems to incorporate the simultaneous ascent and descent of the double spiral. The poet says, "*we* are full of talk and singing, sprawled/in a ring round the fire." In the course of the night, "one, by one, two by two, *we* drift away to bed." The poet says, "there is only *us*." The reader is drawn into the poem because the poet, writing as "we," includes the reader as the subject and object, implicating the reader in the writing. At the same time, the plural pronouns seem to

integrate the poet into the group which the now familiar image of the solitary poet "waiting in the dark" contradicts. "We" may drift away, but the poet remains. Just as Hulme can hide gender with the pronoun "I," she can hide an essentially isolationist vision with the pronoun "we." What Hulme gives the reader is the 'self" constantly on the move, shifting ground to prevent the reader from latching onto the poet. The poet is both visible and invisible. Thus, I find that the poem's ideas and structures "work against each other" and "unsettle" the "stability of one another." The use of "we" obscures the fundamental separateness of the "I" speaker. . . .

Ultimately, because Hulme believes the Maori "we" can no longer work, it is the *Te Kaihau* vision which dominates. I am more terrified by the violence, menace, and doom in *Te Kaihau* than I am heartened by the vision of the "bone people" as instruments of future change. And so, I believe, is Keri Hulme.

<div align="right">Susan Ash. World Literature Written in English. 29, 1989, pp. 123, 127–29, 133–34</div>

The plot of Keri Hulme's *The Bone People* is implausible, even melodramatic. A straightforward account of events would lurch from those typical of the marvelous—a strange child found after a shipwreck becomes the catalyst for a relationship that, it is implied, will change a whole nation, to those of soap opera—his foster father beats him viciously, eventually leaving him in a coma but is finally forgiven—then to those of myth, in which man, woman, and child together prove to be the fulfillment of prophecy. The story is not told straightforwardly, however, but in dense, witty, and often poetic language laid out in a highly purposeful and sophisticated structure. The story cannot, ultimately, be told straightforwardly because the text is attempting to rework the old stories that govern the way New Zealanders—both Maori (indigenous New Zealanders) and Pakeha (New Zealanders of European origin)—think about their country. The new story set in its place is of the bone people who incorporate a variegated ancestry, and who may, in turn, become the spiritual ancestors of a transformed land.

A shifting series of narrative frames is established by allusions to a range of literary works from *Robinson Crusoe* to *The Lord of the Rings* and to a range of popular narrative conventions. At the simplest level, the function of these frames is to keep the reader reading. The desire to discover more about Simon's mysterious origins, for example, drives one to read on as Kerewin undertakes a case reminiscent of a Sherlock Holmes story. But the expected neat unfolding of the solution never occurs although most of its parts are available, because Simon's past proves irrelevant either to his survival or to the future. Hulme lays out the openings to some of the most powerful fantasies, or "master narratives," of Western culture, not just to entice readers but to undermine these narratives' pervasive power, usually by dropping, reshaping, or awkwardly rushing their conclusions. Among the most powerful of these narratives are the fantasies of self-sufficient individual, of empire, of

limitless riches, of the transforming power of heterosexual romance, and of superhuman strength. . . .

The Bone People is part of a postcolonial discursive formation evolving worldwide to counter not only the "truths" that drive the imperialism of nineteenth-century but also those that drive the centers of power in the twentieth. The literary texts in this formation are worked out separately, in different corners of the world, by writers familiar, perhaps all too familiar, with American popular culture and the British literary canon but unfamiliar with each other's political or cultural context. It will reward much careful study, preferably of the sort that, while comparing it to other works sharing its concerns, refuses to ignore the differences that mark it as written by a part-Maori woman from New Zealand in the late twentieth century.

<div align="right">

Margery Fee. In Robert L. Ross, ed.
International Literature in English: Essays on the Major Writers (New York: Garland, 1991), pp. 53–54, 60

</div>

Unlike [Leslie Murman Silko's] *Ceremony, The Bone People* does not include traditional myths and stories that challenge realism's codes. Rich in physical and psychological detail, the novel's dialogue and indirect discourse employ a pungent New Zealand vernacular interspersed with Maori phrases, which are translated in an appendix. With considerable vividness and plenitude of detail, there is a strong impression of verisimilitude. The ruptures in realism occur in other ways.

The first is an issue that should in some ways reinforce rather than subvert the novel's claim of mimesis. The name "Kerewin Holmes" bears obvious similarity to that of the author Keri Hulme. We suspect that Joe, Simon, and other characters have living counterparts as well, and we are thus encouraged to read the text both as novel and as autobiography. Thus the novel may contain traces of an implied autobiographical text or texts. Tempted to deconstruct the text as we read it, we search for autobiographical clues that may or may not be present in a narrative that in other ways proclaims its fictionality. This double reading does subvert realism.

Traces of still other texts abound in *The Bone People*. The lonely woman living in a stone tower by the sea, visited by a mute child, a changeling who himself came from the sea—the plot is redolent of fairy tale, of Celtic romance. Further, since Kerewin is both eclectically well-read and verbally histrionic, her voice, which dominates the text, is filled with allusions and echoes. And finally, the technical influence of James Joyce is ubiquitous.

These intertextual elements, leading the reader to an encounter with the materiality of the text itself, comprise ruptures in realism. As in *Ceremony*, the linear flow of the narrative is altered through the introduction of a controlling metaphor or hermeneutic trope—not the spider web of Thought Woman's design, but the spiral, a design element in Maori art that has special meaning to Kerewin and ultimately to the narrative itself, which will move not only

linearly but in a spiralling, concentric pattern, as Kerewin and Joe confront their innermost fears and desires. Like *Ceremony,* realism here is ruptured irrevocably by the introduction of the supernatural that accompanies the reawakening of the traditional gods.

Thomas E. Benediktsson. *Critique.* 32, 1992,
pp. 125–26

HURSTON, ZORA NEALE (UNITED STATES) 1901–60

One can readily see why Miss Hurston's first novel, *Jonah's Gourd Vine,* was received with small enthusiasm from certain quarters of the Negro race. With a grasp of her material that has seldom been equaled by a writer of her race, she had every opportunity of creating a masterpiece of the age. But she failed. She failed not from lack of skill but from lack of vision.

The hero, John Buddy, who rose from an outcast bastard of an Alabama tenant farm to a man of wealth and influence, could have been another Ben Hur, bursting the unjust shackles that had bound him to a rotten social order and winning the applause even of his enemies. But unfortunately, his rise to religious prominence and financial ease is but a millstone about his neck. He is held back by some unseen cord which seems to be tethered to his racial heritage. Life crushes him almost to death, but he comes out of the mills with no greater insight into the deep mysteries which surround him. Such a phenomenon, although not intended by Miss Hurston as a type of all Negro manhood, is seized upon by thoughtless readers of other races as a happy confirmation of what they already faintly believe: namely, that the Negro is incapable of profiting by experience or of understanding the deeper mysteries of life.

Nick Aaron Ford. *The Contemporary Negro
Novel* (Boston: Meador, 1936), pp. 99–100

Filling out Janie's story [in *Their Eyes Were Watching God*] are sketches of Eatonville and farming down "on the muck" in the Everglades. On the porch of the mayor's store "big old lies" and comic-serious debates, with the tallest of metaphors, while away the evenings. The dedication of the town's first lamp and the community burial of an old mule are rich in humor but they are not cartoons. Many incidents are unusual, and there are narrative gaps in need of building up. Miss Hurston's forte is the recording and the creation of folk-speech. Her devotion to these people has rewarded her; *Their Eyes Were Watching God* is chock-full of earthy and touching poetry. . . .

Though inclined to violence and not strictly conventional, her people are not naïve primitives. About human needs and frailties they have the unabashed shrewdness of the Blues. . . . Living in an all-colored town, these

people escape the worst pressures of class and caste. There is little harshness; there is enough money and work to go around. The author does not dwell upon the "people ugly from ignorance and broken from being poor" who swarm upon the "muck" for short-time jobs. But there is bitterness, sometimes oblique, in the enforced folk manner, and sometimes forthright.

Sterling A. Brown. *The Nation.* October 16, 1937, pp. 409–10

Only to reach a wider audience, need [Zora Neale Hurston] ever write books—because she is a perfect book of entertainment in herself. In her youth she was always getting scholarships and things from wealthy white people, some of whom simply paid her just to sit around and represent the Negro race for them, she did it in such a racy fashion. She was full of side-splitting anecdotes, humorous tales, and tragicomic stories, remembered out of her life in the South as a daughter of a travelling minister of God. She could make you laugh one minute and cry the next. To many of her white friends, no doubt, she was a perfect "darkie," in the nice meaning they give the term—that is a naïve, childlike, sweet, humorous, and highly colored Negro.

But Miss Hurston was clever, too—a student who didn't let college give her a broad *a* and who had great scorn for all pretensions, academic or otherwise. That is why she was such a fine folk-lore collector, able to go among the people and never act as if she had been to school at all. Almost nobody else could stop the average Harlemite on Lenox Avenue and measure his head with a strange-looking, anthropological device and not get bawled out for the attempt, except Zora, who used to stop anyone whose head looked interesting, and measure it.

Langston Hughes. *The Big Sea* (New York: Alfred A. Knopf, 1940), pp. 238–39

Out of her abundant stores of vitality Zora Hurston fashions an autobiography [*Dust Tracks on a Road*] which shoots off bright sparks of personality. . . . A woman of courage and action, she would scorn any academic retreat from the touch and feel of ordinary life. Not only is there nothing of the recluse in her nature, but there is, to state it positively, a preference for the jostling of the crowd. She feels a challenge to elbow her way along her traffic-jammed road with a roving eye for adventure. Tracks she leaves behind her in the dust, witnesses of her presence which only she among all those people can make. Mixing with others only enhances her individuality. . . .

Free of many routine moral obligations, Zora Hurston busies herself with unwrapping the happiness contained in each moment. She engenders an atmosphere of surprises both for herself and others who know her. Shrinking from the dullness of dogmatism, she blossoms out with an originality of thought and conduct. Although the author can hardly inform us that this originality is the secret of her charm, we can quickly detect it on each page

of her autobiography. Even her literary style shows an out-of-the-ordinary quality, a concrete and earthy imagery, an uneven rhythm which reflect imagination, warmth, and impulsiveness. It is a safe guess that few people were bored in her presence. Angered sometimes, amused often, at least they must have responded positively to the unexpected course of her behavior. Sustained by her unflagging spirit, Zora Hurston is enabled to present a strong case for the doctrine of individuality in her own person.

Rebecca Chalmers Barton. *Witnesses for Freedom* (New York: Harper, 1948), pp. 101, 114

The style of [*Jonah's Gourd Vine*] is impressive enough. Zora Neale Hurston, whom Langston Hughes has described as a rare *raconteuse,* draws freely on the verbal ingenuity of the folk. Her vivid, metaphorical style is based primarily on the Negro preacher's graphic ability to present abstractions to his flock. . . .

The genesis of a work of art may be of no moment to literary criticism but it is sometimes crucial in literary history. It may, for example, account for the rare occasion when an author outclasses himself. *Their Eyes Were Watching God* is a case in point. The novel was written in Haiti in just seven weeks, under the emotional pressure of a recent love affair. "The plot was far from the circumstances," Miss Hurston writes in her autobiography, "but I tried to embalm all the tenderness of my passion for him in *Their Eyes Were Watching God.*" Ordinarily the prognosis for such a novel would be dismal enough. One might expect immediacy and intensity, but not distance, or control, or universality. Yet oddly, or perhaps not so oddly, it is Miss Hurston's best novel, and possibly the best novel of the period, excepting [Richard Wright's] *Native Son.*

Robert A. Bone. *The Negro Novel in America* (New Haven: Yale University Press, 1958), pp. 127–28

Despite the psychological limitations which color her works, her novels deserve more recognition than they have received. While publishing more books than any Afro-American woman before her—four novels, two collections of folklore, and an autobiography—she was one of the few Southern-born Afro-American writers who have consistently mined literary materials from Southern soil. Gifted with an ear for dialect, an appreciation of the folktale, a lively imagination, and an understanding of feminine psychology, she interwove these materials in deceptively simple stories which exhibit increasing artistic consciousness and her awareness of the shifting tastes in the American literary market. . . .

Her relative anonymity may be blamed on two causes. First, during her most productive period—the 1930s—widespread poverty limited the sale of books. Second, her tales of common people form a seemingly quiet meadow

overshadowed by commanding, storm-swept hills on either side. To the rear, in the twenties, stands the exoticism of the Harlem Renaissance—Claude McKay's lurid depictions of Harlem, Wallace Thurman's satirical invective, Langston Hughes's jazz rhythms, and Countee Cullen's melodious chauvinism. On the other side, in the forties, stands the lusty violence of Richard Wright, Frank Yerby, Ann Petry, and Willard Motley. Most of Zora Neale Hurston's stories, in contrast, seem to be quiet quests for self-realization. . . .

Because of her simple style, humor, and folklore, Zora Neale Hurston deserves more recognition than she ever earned. But, superficial and shallow in her artistic and social judgments, she became neither an impeccable raconteur nor a scholar. Always, she remained a wandering minstrel. It was eccentric but perhaps appropriate for her to return to Florida to take a job as a cook and maid for a white family and to die in poverty. She had not ended her days as she once had hoped—a farmer among the growing things she loved. Instead she had returned to the level of life which she proposed for her people.

> Darwin T. Turner. *Zora Neale Hurston: The*
> *Wandering Minstrel* (Carbondale: Southern
> Illinois University Press, 1971),
> pp. 98–99, 120

Miss Hurston's most accomplished achievement in fiction is *Moses, Man of the Mountain,* which provided a format in which she could best utilize her talents for writing satire, irony, and dialect. . . . If she had written nothing else, Miss Hurston would deserve recognition for this book. For once, her material and her talent fused perfectly. Her narrative deficiencies are insignificant, for the reader knows the story. Her ridicule, caricature, and farce are appropriate. The monstrous Hattie of *Jonah's Gourd Vine* and Mrs. Turner of *Their Eyes Were Watching God* reappear aptly in the jealous, accursed Miriam, who actually becomes a sympathetic figure after she has been cursed with leprosy. Finally, attuned to folk psychology, Miss Hurston gave the Hebrew slaves an authenticity that they lack in the solemn Biblical story. . . .

In her final novel, *Seraph on the Suwanee,* Miss Hurston for the first time focused upon white protagonists, in a work so stylistically different from her earlier efforts that it reveals her conscious adjustment to the tastes of a new generation of readers. Although *Seraph on the Suwanee* is Hurston's most ambitious novel and her most artistically competent, its prolonged somberness causes many readers to yearn for the alleviating farce and carefree gaiety of the earlier works.

> Darwin T. Turner. *In a Minor Chord: Three*
> *Afro-American Writers and Their Search for*
> *Identity* (Carbondale: Southern Illinois
> University Press, 1971), pp. 109–111

Despite structural and formal defects, *Jonah's Gourd Vine* is most important for its depiction of the character of the black woman. Lucy is far from being completely developed as a character. She does, however, contain elements seldom seen in fiction by men which feature black women. Moreover, Miss Hurston, in her portrayal of Lucy, has begun early to deal with the conflict between black men and women, which receives fuller explication in Chester Himes's *Lonely Crusade* and John Williams's *Sissie* later in the century. The conflict centers around two victims of the same oppressive society. Take John and Lucy as metaphors of black men and women. . . .

John, the metaphor of black men, remains, for Miss Hurston, essentially a creature of appetite, insatiable even though offered such a delectable morsel as Lucy Pearson. Her loyalty, perseverance, and love border upon the messianic. What her husband lacks in courage, strength, and initiative, she more than compensates for. The conflicts, therefore, given such personalities, can be resolved only when black men correct the defects in character. That this was the author's implicit commentary upon black men might be attributable to her distorted conception of them. The chances are, however, that she was less interested in John Pearson than in Lucy, less interested in the men of her novels than in the women, who receive more multidimensional treatment.

In *Jonah's Gourd Vine* and *Their Eyes Were Watching God,* she views them as modern women, patterned upon paradigms of the past, those of the courage and strength of Harriet Tubman and Sojourner Truth. Far from being images of old, the willing copartners of white men in the castration of black men, her women are, instead, the foundation of a new order, the leavening rods of change, from whose loins will eventually come the new man. Past stereotypes aside, therefore, her women need only search for greater liberation, move even beyond the stoiclike devotion of a Lucy Pearson, move toward greater independence and freedom. Put another way, black liberation meant burying the old images and symbols that had circumscribed black women along with black men. What is needed, McKay had argued in *Banjo,* is "Women that can understand us as human beings and not as wild, oversexed savages." In the context of *Jonah's Gourd Vine* and *Their Eyes Were Watching God,* this meant that both sexes must move collectively outside of American history and definitions.

<div style="text-align: right;">

Addison Gayle, Jr. *The Way of the New World* (Garden City, New York: Doubleday, 1975), pp. 143–44

</div>

To herself, she was a failure. Fortunately, no critic wholly supports this view. While a few lampoon her for what they consider her lack of social consciousness, her tendency to transcend racism and prejudices by disallowing them a major role in her works, and for technical and narrative deficiencies in her fiction, most praise her for her ability to tell a good story well, for her vivid and unforgettable figurative language, for her staunch individualism, and for the sense of "racial health" that permeates her fiction. . . .

What really made her premature, however, was all the beauty and struggle of *Their Eyes Were Watching God* where marriage is largely defined in sexual terms; where one mate must remain petal open and honest for the other; where mere sex may take place without consummation of the marriage since consummation only takes place when the right dust-bearing bee comes along; where the quality of one's life counts more than the quantity of it; where poetry is more essential than prose, love more essential than money, sharing paramount to dominating; where one's dream is the horizon and one must "go there to know there." All that and more made Hurston extraordinary; all that makes the beauty of *Their Eyes Were Watching God* almost unbearable today, makes one wonder if even today the world is ready for Zora Neale Hurston.

Her works are important because they affirm blackness (while not denying whiteness) in a black-denying society. They present characters who are not all lovable but who are undeniably and realistically human. They record the history, the life, of a place and time which are remarkably like other places and times, though perhaps a bit more honest in the rendering. They offer some light for those who "ain't ne'er seen de light at all."

Lillie P. Howard. *Zora Neale Hurston*
(Boston: Twayne, 1980), pp. 170, 174–75

The devil is not the terror that he is in European folklore. He is a powerful trickster who often competes successfully with God. There is a strong suspicion that the devil is an extension of the story-makers while God is the supposedly impregnable white masters, who are nevertheless defeated by the negroes.

Zora Neale Hurston

In *Their Eyes Were Watching God,* Zora Neale Hurston takes the supposition quoted above from the glossary of her anthropological study, *Mules and Men,* and weaves a larger folktale of the white man as a false "god" who must eventually be defeated. The novel is about Janie, an independent black woman, who does not, as her community does, watch God; she is looking elsewhere. Janie fights her way out of the constricting conventions of the dominant culture and, through her quest for self-determination, comes to find her own values in life. These spiritual values are paramount to Janie's growth and well-being, unlike the materialistic, middle-class values imposed on a group which by color alone cannot realize the "ideal." At each stage of Janie's development, certain characters pressure her to deify the white culture. First there is her grandmother Nanny's materialism; later, her husband Jody's bourgeois aspirations; and finally, Mrs. Turner's worship of white features. As the pressure of this imposing white culture increases, the ability of each character involved to exert influence over Janie decreases as she progresses towards what is real. What is *real* in this novel are Janie's self-determination, her love for [her third husband] Tea Cake, and the folk culture.

Hurston has received criticism, from both black and white critics, for ignoring racial issues in her novels. It is true that she does not document the tragic history of social injustice as did Richard Wright (who compared Hurston to Jane Austen and said she did not look at race or class struggles). Yet by the very absence of explicit racial conflict, the pressure of the dominant culture on the thoughts and actions of the all-black community of Eatonville as well as blacks as a whole, is detailed throughout the novel. Robert Hemenway, in his biography of Hurston, states that Hurston "triumphs over the racist environment without political propaganda but by turning inward and turning around the folktale." By breaking away from the racist atmosphere in which she was brought up, Janie loses a false god and finds herself. And Hurston, through the medium of the folk culture, creates a world in which Janie defeats the oppressor.

> Gay Wilentz. In Alice Kessler-Harris and
> William McBrien, eds. *Faith of a (Woman)*
> *Writer* (1984; Westport, Connecticut:
> Greenwood Press, 1988), pp. 285–86

I would like now to turn to the work of an author acutely conscious of, and superbly skilled in, the seductiveness and complexity of metaphor as privileged trope and trope of privilege. Zora Neale Hurston, novelist, folklorist, essayist, anthropologist, and Harlem Renaissance personality, cut her teeth on figurative language during the tale-telling or "lying" sessions that took place on a store porch in the all-black town of Eatonville, Florida, where she was born around 1901. She devoted her life to the task of recording, preserving, novelizing, and analyzing the patterns of speech and thought of the rural black South and related cultures. At the same time, she deplored the appropriation, dilution, and commodification of black culture (through spirituals, jazz, etc.) by the predepression white world, and she constantly tried to explain the difference between a reified "art" and a living culture in which the distinctions between spectator and spectacle, rehearsal and performance, experience and representation, are not fixed. "Folklore," she wrote, "is the arts of the people before they find out that there is such a thing as art."

> Folklore does not belong to any special area, time, nor people. It is a world and an ageless thing, so let us look at it from that viewpoint. It is the boiled down juice of human living and when one phase of it passes another begins which shall in turn give way before a successor.
> Culture is a forced march on the near and the obvious. . . . The intelligent mind uses up a great part of its lifespan trying to awaken its consciousness sufficiently to comprehend that which is plainly there before it. Every generation or so some individual with extra keen perception grasps something of the obvious about us and hitches the human race forward slightly

by a new "law." Millions of things had been falling on men for
thousands of years before the falling apple hit Newton on the
head and he saw the law of gravity.

Through this strategic description of the folkloric heart of scientific law, Hur-
ston dramatizes the predicament not only of the anthropologist but also of
the novelist: both are caught between the (metaphorical) urge to universalize
or totalize and the knowledge that it is precisely "the neat and the obvious"
that will never be grasped once and for all but only (metonymically) named
and renamed as different things successively strike different heads.

> Barbara Johnson. In Mary Ann Caws, ed.
> *Textual Analysis: Some Readers Reading*
> (New York: Modern Language Association,
> 1986), p. 235

Zora Neale Hurston remains one of the most enigmatic and elusive figures
in black American literary history. The author of four novels (*Jonah's Gourd
Vine* in 1934, *Their Eyes Were Watching God* in 1937, *Moses, Man of the
Mountain* in 1939, and *Seraph on the Suwanee* in 1948), two book-length
anthropological studies (*Mules and Men* in 1935 and *Tell My Horse* in 1938),
the autobiography *Dust Tracks on a Road* in 1942, and numerous articles,
poems, and plays, Hurston was often at the center of controversy, the object
of resentment by her peers. Hurston, a native of Eatonville, Florida, was the
only one of the Renaissance writers of the 1920s who was really "of the folk."
She alone had been raised in the rural South amid the folk culture and oral
traditions that formed the basis of the spiritual and cultural flowering that
attracted otherwise mostly middle-class writers to Washington, D.C., Har-
lem, and other urban cultural centers.

As the critic E. Edward Farrison wrote in his 1943 review of Hurston's
Dust Tracks on a Road, "This is not a great autobiography, but it is a worth-
while book." While *Dust Tracks* fails to sustain the spontaneous "creative
imagination of childhood," there are momentary glimmers of what Edith
Cobb would call "individual genius" experiencing "a sense of discontinuity,
an awareness of [her] own unique separateness and identity and also a conti-
nuity." Part of this "renewal of a relationship with nature as a process" is
exhibited in Zora's sitting in the chinaberry tree, her contemplation of the
horizon, and her childhood race with the moon. . . .

Richard Wright, Alain Locke, Sterling Brown, and others have criticized
Hurston for not depicting racial oppression and interracial conflict, for not
"telling the whole story," but she felt justified in her chosen view. For as
Robert Hemenway has observed, "As a dedicated Harlem Renaissance artist
Zora Neale Hurston searched hard for a way to transfer the life of the people,
the folk ethos, into the accepted modes of formalized fiction. She knew the
folkloric content better than any of her contemporaries and this led to a

personal style that many did not understand." She was, in Hemenway's estimation, "struggling with two concepts of culture."

Dust Tracks reveals these inner conflicts; like many other women autobiographers, Hurston affects a tone of conciliation in her autobiography, and she is not sufficiently concerned with narrative development and proportion. . . . She does not reveal too much; that is, she does not open herself to criticism or love for the fear of losing her hard-won self. The comment "ladies don't kiss and tell" is a way of thumbing her nose at reader expectations with a glib self-defense reminiscent of her mother's sass. It is also a tipoff that she has made some decisions about what she wants to keep private. Such self-imposed constraints help explain the discontinuity of form and voice in *Dust Tracks*.

Unfortunately, Hurston also makes concessions to her publisher that effectively shatter the text's narrative proportion and development and undercut her subversive racial humor. Robert Hemenway describes the editorial process *Dust Tracks* was subjected to at the publishing firm of Lippincott, which deleted many of Hurston's views on race and international politics, especially her criticism of American foreign policy in Japan and Mexico: "The completed manuscript (now in the James Weldon Johnson Collection at Yale University) carries with it a note in Zora's own hand: 'Parts of this manuscript were not used for publisher's reasons.'" One of the greatest contributions of the 1984 edition prepared by Hemenway is an appendix that restores much of the original manuscript and provides "a better feeling for Hurston the writer, who obviously did not feel that her international opinions were 'irrelevant' to her autobiography . . . or that her views on her people needed to be filtered through an editorial process." The Hemenway edition includes three chapters either omitted from the 1942 edition or published in a much altered form: the manuscript version of the chapter that became "My People! My People!" in the first edition, along with "The Inside Light—Being a Salute to Friendship" and "Seeing the World as It Is," both of which were omitted from the 1942 edition.

> Joanne Braxton. *Black Women Writing
> Autobiography: A Tradition within a
> Tradition* (Philadelphia: Temple University
> Press, 1989), pp. 146–47, 150–51

Hurston's position as initiator of an Afro-American woman's tradition in novels can be seen in subsequent Afro-American women writers' refigurations of Hurston's complex delineation of black female unity in *Their Eyes Were Watching God* in their novels' content and form. Hurston's thematic focus and narrative strategies are consistent with her refiguration of Du Bois's double consciousness code in the content of her novel and represent most elaborately her response to the formulations of the esteemed black male writer and her *denigration* of the genre of the novel.

Janie's double consciousness results from her husband Joe Starks's insistence on her silent subservience. She is able to merge her dual selves, her "inside" and "outside," only through an immersion in the wisdom of Black culture. While the text confirms unquestionably that Janie has gained a cultural voice and is quite capable of narrating her story, such a narration, despite Janie's announcement to Pheoby that she will tell her own tale, does not occur in the text. . . .

The figure of a common (female) tongue, of a shared Afro-American woman's authorial voice, serves as an appropriate metaphor not only for Janie and Pheoby's cooperative textual relationship, but also for the Afro-American women novelists' textual system. . . .

Though essays focused on Janie's storytelling as a key to her self-definition are richly suggestive, such essays uniformly fail to acknowledge that despite an undeniable emphasis in the novel on the importance of the protagonist's achievement of voice, she does not seem at all enamored of her oratorical skills when she makes her final return to Eatonville. When Pheoby tells her that the female porch sitters are discussing her return and suggests that she "better make haste and tell 'em 'bout you and Tea Cake," Janie answers: "Ah don't mean to bother wid tellin' 'em nothin', Pheoby. 'Tain't worth de trouble." She, thus, seems uninterested in becoming a public spokesperson sharing the wisdom of hard-won cultural experience with the group. . . . Not only does Janie appear to dislike the obvious malevolence of the porch critics, she also seems to issue a general condemnation of verbal performances that are not (and *cannot be*) supported by appropriate action. In other words, she claims to dislike talk for talk's sake. . . .

Perhaps the best evidence of her transformed perspective is the narration of Hurston's novel. First introduced by an omniscient narrator, Janie insists that she will serve in the role of storyteller in order to relate to Pheoby the important incidents of her life. These incidents will include, apparently, not only her sojourn with Tea Cake during the preceding year and a half, but also enough information about her entire history to provide Pheoby, a "kissin'-friend" of twenty years, with "de understandin' to go 'long wid" her depiction of her life with Tea Cake. In a text which concentrates so intensely on the question of Janie's establishment of a powerful black cultural voice, one feels that such a concentration should be complemented by action. Janie, indeed, should narrate her own story in the novel. Because she expresses such a strong perspective on action and voice and, yet, fails to emerge as the exclusive—or even the primary—narrator of her story, *Their Eyes Were Watching God* seems flawed (as numerous critics . . . have claimed) in ways that diminish the overall effectiveness of Hurston's novel. . . . Hurston's narrative strategies demonstrate not a failure of the novelist's art, but her stunning success in *denigrating* the genre of the novel. To show how the author accomplishes her task, it is necessary first to discuss narrative events in *Their Eyes Were Watching God*. In the novel, there exists an observable tension

between saying (words) and doing (acting upon those words)—between voice and action.

Michael Awkward. *Inspiring Influences: Tradition, Revolt, and Afro-American Women's Novels* (New York: Columbia University Press, 1989), pp. 12–13, 16–17

HYVRARD, JEANNE (FRANCE) n.d.

Jeanne Hyvrard's choice of alienation over saneness in an alienating, capitalist, consuming society is loudly proclaimed in the following attack which may well be directed at Marie Cardinal, referred to anonymously as "that one": "That one tells how she was mad. That one tells how she was cured. That one tells how she wrote a book. That one tells how she became normal again. . . . She thanks the doctors who made her normal. . . . They got her. They turned her into the nonliving. . . . I am ashamed. . . . This shame which falls back upon us all."

No biographical summary can be made of the self-definition of the feminine *I* which speaks in Hyvrard's texts out of total alienation from an exploitative, destructive, phallocentric, capitalist, and colonialist society. The interlocutors of the *I* are above all the Mother and the collective *they* or *one* representing the negative, oppressive forces to whom may ultimately be traced woman's paralysis and the earth's sterility. Hyvrard's language is rarely conciliatory. It denounces, rebels, suffers, appeals; but love, when it appears, is mostly the memory of a lost paradise which we may read as a variation of the mother's womb. . . .

The return to the womb or to Africa is also symbolic of a search for an original language, for an original *locus* from which an authentic woman's speech could evolve: "A very ancient language in the depths of my body. A language whose words also mean their opposites. A language with three moods. The real. The imaginary. The fusional. (Le fusionnel)." The metaphor of her search for a word which would liberate her and which might be *identity* or that feminine version of the masculine *pouvoir* (power) which is *puissance,* serves to underline what Irigaray called woman's absence from language: "They have chosen forms which expulse us, and they say we don't know how to speak." This expulsion of women from language is paralleled by the slaves' deportation from the Motherland: "Mother Africa, I was you. But the whites came and tore me away from you. Then I entered death. For a thousand years."

The female body in Hyvrard's sometimes surrealistic representation assumes cosmic dimensions, integrating within itself identification with personified, allegorical figures of Earth, Death, and Time: it is the latter image which perhaps best serves to express woman's difficult quest for herself, both as

mythological and historical subject: "Mother, . . . You are Time. Without beginning or end. The inner time absent from our conjugations."

The feminine subject's struggle and search for identity in Hyvrard's works, while not triumphant, is resistant. Her identification with the dispossessed, with all women, nourishes her defiance of psychiatric normalization and readaptation to life. What others call life is actually for her the nonlife that she is fleeing from into madness: "I survive. The essential does not give in. The essential still has no name." One word stands out in *Mère la mort,* and that is the word "Refusion" combining, as it does, the *semes* for refusal and fusion, and summarizing, it seems, the fundamental life and death impulses governing the unconscious.

The value of Hyvard's journey into the feminine unconscious is, on the one hand, that it recaptures the poetic truth of fundamental instincts, and on the other, that the feminine unconscious accedes here to one possible representation of itself by means of a renewed language. To escape categorization, nomination, the speaking subject adopts fleeting, multiple identities as victim and essentially Other, as the concrete embodiment of Time or allegorical incarnation of Death—the supremely *Other.* She proclaims herself as the Unnameable, in a quest for the liberating return to an ancient Paradise, her Motherland.

<div style="text-align: right">Marguerite le Clézio. Stanford French Review. 5, 1981, pp. 386–89</div>

As anyone who reads Jeanne Hyvrard knows, when she wrote *Les Prunes de Cythère,* she thought she was writing an economic report on the results of colonialism in Martinique whereas the critics thought they were reading the fictional autobiography of a new black writer. As Hyvrard herself expressed it in a recent lecture: "[La critique parisienne] diagnostiqua une rupture d'identité qu'elle analysait en termes de folie. Il s'agissait en fait d'une identité planétaire transnationale en voie de constitution dans l'économie-monde" The distinction is an important one. For the critics, the fragmentation they perceived was that of the disintegration of a previously unified entity: the female protagonist, whereas the writer was in the first stages of exploring a world whose form she has already recognized and used to structure her text in 1975 but which she does not name until 1985 in *Le Canal de la Toussaint. . . .*

The parallel between the world and the women is [made] quite evident . . . and we see how the multipolarized protagonist of *Les Prunes,* identified with the voices and experiences of herself, her mother, her grandmother, the servant, and certain heroes of uprisings against the colonial regime, was for Hyvrard a metaphor of the economic and political climate of Martinique. Jeanne, the narrator, expresses herself through her body and that body is the body politic. . . .

Both *Le Cercan* and *Les Prunes de Cythère* are extended examples of the concept of "contrairation." The accepted social view of Jeanne-la-folle and of the cancer patients, as it is shown within the texts, is parallel: they

are in a state of incapacity and must be restored to "normal" life within the social and linguistic order or failing that they must be separated from it. In opposition to that is the view of the narrators: they see themselves as active participants in their situation, having chosen it and taking responsibility for it. Thus all major concepts are transformed. Just as in *Les Prunes* where all the key words had multiple meanings according to the situations in which they were used, so in *Le Cercan* the words transform and have a transformational power.

The "Cercan" offers a shift in attitude to cancer and the world is turned over as states become actions: "cancereux/cancerant." Fragmentary understanding can no longer be perceived as a sign of disintegration but is rather a coming together in a new creation. Disorder is no longer lack of a known order but rather a sign of a new and more inclusive order, just as the irrational is not the state of any lack of reason but the more inclusive process of thinking the chaos (or disorder) before reason.

In this world of ever expanding concepts, illness takes on a new significance. If cancer and madness are signs of growth towards a new order in a changing context, then dis-ease is the sign of health and activity and "normality" becomes the passive state of sickness.

Jennifer Waelti-Walters. *Dalhousie French
Studies*. 13, 1987, pp. 71, 74–75

Jeanne Hyvrard is one of the strongest feminist voices to emerge in France in recent years, and *Mother Death* is among the most richly poetic and provocatively imaginative texts of its kind. Hyvrard was born in Paris and is an economist by profession. Her books include *Les Prunes de Cythère* (1975), *Mère la mort* (1976), *La Meurtritude* (1977), *Les Doigts du figuier* (1977), *Le Corps défunt de la comédie: Traité d'économie politique* (1982), *Le Silence et l'obscurité, Requiem littoral pour corps polonais, 13–28 décembre 1981* (1982), *Auditions musicales certains soirs d'éte* (1984), *La Baisure, Que se partagent encore les eaux* (1985), and *Canal de la Toussaint* (1986). Although elements in her writing have led some critics to characterize her as a representative of Caribbean literature, Jean Hyvrard is, in fact, French: "French, hexagonal, and white like all my ancestors."

Set within the confines of an insane asylum, the "action" of *Mother Death* consists of the memories, observations, and imagination of the unnamed heroine as she gives voice to her own experience, creates her own logic, and simultaneously escapes the repressive nature of "their language" by retreating into silence and, ultimately, into "mother death." Before she enters mother death, however, she offers us, on the one hand, glimpses into a powerfully creative, imaginative, different mode of being and, on the other, an eloquent critique of patriarchal culture and the complex intersection of cultural, linguistic, philosophical, and psychological codes of power and authority that have dominated the Western world. . . .

This appropriation of language is perhaps the most crucial issue explored in *Mother Death,* since it is ultimately through language that society operates, cultural values are inscribed, and expression takes place. How can a woman speak herself if she must use a male discourse? How can the *I* of the text speak herself if she is forced to speak the language of the invaders? Very much aware that their language is not her language, Hyvrard's heroine struggles to resist their indoctrination and their desire to normalize her.

<div align="right">
Laurie Edson. Afterword to Jeanne
Hyvrard. *Mother Death* (Lincoln: University
of Nebraska Press, 1988), pp. 111–13
</div>

Jeanne Hyvrard is intent on preserving her anonymity. She has chosen to reveal only a name and a written trace, the inscription of her voice. No face, no habits, no places, no friends, and no opinions will be associated with her other than the ones she expressly puts on paper, for she scornfully rejects the "biographical" for the sole benefit of the textual matter. "I live outside of myself," she says straightaway, anxious to designate with a quasi-oxymoronic formula the *atopia* from which she writes, a symbol of all the differences she plays on and claims as a woman, as a Creole, and as a madwoman (ill, she was once considered mad).

In 1975, Jeanne Hyvrard published her first novel, *Les Prunes de Cythère.* Accumulating the usual descriptive terms, critics said that the book was "upsetting," "embarrassing," "truthful." These were the many ways for them to assimilate the new into the known and to reduce the event to the news item. Hyvrard repeats her offense a little later with *Mère la mort* and with a two-part work: a "roman" entitled *La Meurtritude,* followed by *Les Doigts du figuier,* a text defined by her as "parole." This strange gesture can hardly be identified with any existing literary posture: poetry mingled with prose, or to be more exact, the metaphoric demands of her prose, subject to the convulsions of rebellion, naturally seems to give "birth" to a second language. This decanted language would reiterate the same violence, would resume the same imperious narrative, but differently. In fact, one cannot read one version without the other. "Parole" and "roman" stick together like the two sides of a page. In 1982, Hyvrard published *Le Corps défunt de la comédie,* called simply "littérature." This text, a kind of poeticopolitical essay, assembles the tragic record of all the "follies," "horrors," and forms of oppression, in daily life as well as in peoples' destiny. Since then the author has primarily written poetic prose, both in the form of "short stories" and "novels," pursuing the model itinerary she set for herself.

In the beginning, Hyvrard says in most of her texts, was oppression. Let us not be deceived by the familiarity of the word: it is not the author's intention to take up again the well-known notion, duly defined in political terms and contained in its geographical and social limits, which has found a place—a way to neutralize its effects—in the various epistemological discourses. There is more, the author says from the outset, much more. There

is an even more radical form of oppression, a constituent and original oppression which resides in the flesh and mind, unthinkable, unnameable, and unlivable. In the beginning, and from the furthest reaches of memory, is this *ill-being,* a symbol of all the others. If, in this context, writing appears to be a "duty" (one which consists in expressing this ill-being, in giving voice to it), that is to say responsibility, it is in order to *witness,* to remind everyone, to contribute to the construction of a certain understanding of the world. How? . . .

If Jeanne Hyvrard's writing beckons to Hélène Cixous's, Catherine Clément's, Monique Wittig's, Viviane Forrester's and many other women of her generation, it also contains the anguished lucidity and the painful resplendence one finds in Nerval, Rimbaud, and Artaud. The radicality of Jeanne Hyvrard's questions, asked in a very original language, makes her one of the great writers of our time.

<div style="text-align: right">

Martine Reid. *Yale French Studies.* 1988,
pp. 317–18, 320

</div>

IBARBOUROU, JUANA DE (URUGUAY) 1895–1979

In the Uruguayan, Juana de Ibarbourou (a Basque name) and in the Argentine, Alfonsina Storni, there is little or nothing of the glacial Francisca da Silva. Neopaganism may blow hot as well as cold. When, some six years ago, the poet and philosopher, Miguel de Unamuno, extended his hand across the sea to her of the Basque patronymic, he but confirmed a reputation that was already in the ascendant. This professor of Greek knew his Sappho, he knew that the chaste unveiling of her soul was a braver thing than the mere unveiling of her body. In Juana de Ibarbourou he was surprised to find the chaste spiritual nudity which, he had thought, had gone out of letters.

Since that day the poetess has grown in spiritual depth and in poetic directness. She has essayed also, as in *The Fresh Jug,* a poetic prose that does not, even at its best, wholly escape the evils of bastardy. Yet even here she displays, amidst much that lacks depth and originality, a rare nature that is stirred by stimuli to which most persons are altogether anaesthetic. Of a quiet life she has made an exciting succession of important trivialities. She has a pretty fancifulness and plays with pantheism. Yet one has but to compare her lines to water with the symphonic strophes, "Sister Water," of Amado Nervo, to realize how little she has made of an infinite theme. . . .

This is a paganism that is as young and as old as Nature. She does not imitate the classical poets; in herself flows the blood that wrote those ancient lines. In a word, the paganism of Juana de Ibarbourou is autochthonic, American. She speaks, not in terms of Francisca Julia da Silva's centaurs, but in terms of her own Uruguay and of her own days and nights. Señor Breñes Mesén thinks her a precursor [of the future] in no fewer than three ways. In the first place, she has thrown aside the masculine convention; her vision of the world is freely feminine. In the second, she proceeds without a conscious thought of the schools; her sight, in a sense, is thus virginal, and little conditioned by the work of other writers. Finally, "she is the precursor of that paganism which during this century will extend across the American continent."

<div align="right">Isaac Goldberg. The American Mercury. 7,
April, 1926, pp. 451–52</div>

Miguel de Unamuno has stressed in an evaluation of Juana de Ibarbourou that the pessimistic, somber part of her works seems artificial to him, somewhat false, and in any event something completely literary. He considers the sincere and natural in her to be the simple joy of living and loving that she expresses in other poems. Nevertheless, with all due respect, the great

Basque writer has perhaps fallen into psychological error, into a simplification, when he believes that the coexistence of the two sentiments, the sentiments of life and death, is contradictory and incompatible in the same poetic consciousness. Paradoxically, nothing is more logical and natural than that apparent contradiction. The idea of death accompanies the joy of living as the shadow accompanies the body. At least for individuals of fine sensitivity, for most people live with the philosophical unawareness of the animal in them and they do not see beyond their immediate reality.

When one most loves life, death inspires that much more terror, and that much more does its shadow obsess one's thoughts. All silence between two bursts of laughter, all rest between two dances, is filled by the presence of death. Like water, it fills all the empty spaces and the gaps in our hours. Only a belief in the immortality of the soul can overcome the horror of death. Only religious hope for a beyond can make the thoughts of our ephemeral condition less shadowy. The joy of life in one who only believes in and loves the sensory and the corporeal—and such is the case with a great part of humanity today— is similar to a merrymaking party on a sinking ship. Far from being forced, artificial, and merely literary, the pessimism and death is, in this poet of naturalism, precisely her most natural and most sincere quality.

Indeed, a poetry in which there was only joy would be forced, literary, and conventional. . . . Moreover, a totally happy poetry would be, if it were sincere, a foolish poetry. . . . The shadowy background in which graceful dancing figures move gives aesthetic value and profound meaning to poetry. Without tragic sensitivity there is no art, and tragedy in naturalistic poetry [such as Juana de Ibarbourou's] is to be found in that sense of ephemeral mortality.

<div style="text-align:right">

Alberto Zum Felde. *Proceso intelectual del Uruguay: Crítica de su literatura,* vol. 3 (Montevideo: Ediciones del Nuevo Mundo, 1967), pp. 60–61

</div>

People believe Juana de Ibarbourou to be successful and lucky, but she is really a captive of life, of circumstances, of her timidity. She could have gone to Paris, to preside there as queen of poetry and of the "moment," which is the most brilliant kind of reign. She could have gone around the world by ship, lionized with triumphal trumpets. Yet she never traveled even to Brazil, which was right next door, or to Paraguay, where she was adored. When she did go to Buenos Aires, after receiving an invitation accompanied by many honors, she had to return home a few hours later because of a family illness. . . .

Juana died spiritually because of her frustrated desire to travel—to cross the sea and to cross frontiers, to hear herself called a foreigner, to see unknown horizons and to hear new sounds. And it was not because she wanted romantic freedom or had high-flown fantasies. She would probably have wanted to travel with her own people, with those who made up her beloved

home. But they all had roots sunk deep into the hard soil while she was the one with blue wings on warm shoulders.

And her poems changed, not because of new literary sensitivities but because of the impossibility of continuing to raise the burning host of hopes and dreams over her shoulders. The cry of the young and strong impassioned woman . . . has become hoarse by having struck, year after year, against the black stones of dull and heavy routine. And the inspired woman who, little by little, has let her rebellious arms fall, abandoning the sweet fruits and the red flowers, now continues to play by containing her bitter despair within the salty stones of the hostile beaches that will not let her pass.

<div style="text-align: right">Mercedes Pinto. Revista cubana. 4,
October–December, 1935, pp. 49–50</div>

It is indeed a striking circumstance that Uruguay should have produced some of the most renowned women poets of its continent in the twentieth century. This distinction is not limited alone to its women literary artists, for Uruguay, the smallest country in South America, has also produced a galaxy of important writers, male and female, in other fields of literature. There are at least three women poets who are worth knowing intimately: María Eugenia Vaz Ferreira, Delmira Agustini and Juana de Ibarbourou. The tragic spirit of Vaz Ferreira moves us to compassion; Agustini is a melancholy dreamer; Ibarbourou, by contrast with the other two, shows a happy and exuberant nature.

The influence of these women has been great, particularly in their own country. Luisa Luisi and others of the new generation have followed the example of their predecessors but especially the inspiration of their contemporary, Juana de Ibarbourou. Juana de Ibarbourou, as well as Vaz Ferreira and Agustini, felt the current of the Modernist Movement in poetry, but instead of imitating very closely other poets of this period they wrote verses which are more individual and intimate and offer a distinct form as to content and themes. The form was free and did not conform to traditional moulds except in the case of an occasional sonnet. . . .

The first three volumes of her work . . . will probably live on and make her name immortal. In them is found the most sincere, intimate and charming part of her personality. A certain exuberance, freshness, and simplicity is apparent in them which is not found later. She expresses many of the qualities of youth: a joy, a desire to love and to be loved, and an overflowing delight in life and nature.

The work of the last period lacks the spontaneity and pleasantness of the previous poems. She has become more vague and intellectual. She is not inspired by the world which surrounds her nor does she reflect her intimate emotions and sentiments. The omission of this human element is characteristic of a great deal of modern art and poetry.

<div style="text-align: right">Consuelo B. Babigian. Modern Language
Forum. 25, March, 1940, pp. 9–11</div>

Nature is the mirror that reflects [Ibarbourou's] thoughts, her emotions, her moods, her manner of expression. It is difficult, therefore, to isolate her themes and attempt to define them singly; for not only are they all interrelated as regards nature, but there is a deep inner unity of thought and concept— not necessarily premeditated—that makes each an indispensable part of the other. The thought of love, for instance, immediately evokes the desire for life, the fear of death, the pleasure she finds in offering to the lover her sun-browned, elastic, fragrant body; the thought of life summons up appetizing feasts of love, as she proffers her tempting beauty with a joy marred only by the haunting thought that youth, alas!, is not everlasting, and that death will one day extinguish the starry gaze in her eyes, will pale the bloom of her cheek, will reduce arms that embrace and lips that burn to lifeless ashes; the thought of death steals short-lived joy from what might otherwise have been cloudless hours of love, it awakens the desire for endless life as part of nature, for ever-verdant beauty; the thought of herself, fragrant with nards, and proud of her youth, her beauty, her desirability, calls up visions of the lover waiting to pluck the flowers and the fruits of love, while life still lends them fragrance and flavor—before death wilts and robs them of their power to lure. . . .

Set against a background of nature, each one of these themes is presented simply—one might almost say naïvely—without great depth of thought, without philosophical implications, but with a freshness and spontaneity which only poetry of this type can possess. For her ideas upon life, upon death, upon love, are not transcendental, but the direct, basic ones of a person who does not seek to comprehend what there is, or may be, beyond that which meets the eye. She bases her ideas of love upon her feelings and desires; those of life upon what she sees of nature; those of death upon what she knows of life. She does not attempt to pry or indagate into the unknown— or to deduce the why and the wherefore of things; for she is as simple and elemental and direct in her thoughts and in her emotions, as the flowers, the fruits, the trees and the other creatures of nature that fill her verses and with which more than once she identifies and compares herself.

<div style="text-align: right">

Sidonia Carmen Rosenbaum. *Modern Women Poets of Spanish America* (New York: Hispanic Institute in the United States, 1945), pp. 239–40

</div>

One element that is either absent or appears only slightly [in Ibarbourou's early poems] becomes mores insistent as [she moves toward] the dramatic late poems. I am referring to the sadness caused by the passing of life, the end of dreams, and the presentiment of death. The love for life nurtures the fear of death, and Juana experiences the decline with great pain. . . . The certainty of the finiteness of being inspires her to write words charged with melancholy and nostalgia for the past; these true elegies contrast with her earlier poems, which are filled with optimism and enthusiasm for life. . . . It is painful for her to accept her own destruction and difficult to foresee the

pleasures of the spirit, free from bodily restraints, and to understand abstract concepts. She can only *suffer* the loss of the bodily raiment in which the soul finds itself oppressed; she does not long for the soul's emancipation, for its "setting out for the first origin," as the mystics say. . . .

[Juana's] positivism separates her from those romantics who saw in death only a repose from earthly torments, from the mystics who desired death to draw closer to God, from those Christians who accept it because of their religious convictions, and from the Greeks, who embellished its meaning. Juana speaks of death with horror, and her beliefs in returns and in future transformations [are inspired more by] poetic convention than by any authentic belief. Despite her words, her idea of death is that of someone who cannot conceive or accept it because she embraces a sensitive corporeal life.

<div align="right">Maruja González Villegas. USF. 41,
July–September, 1959, pp. 174–75</div>

Azor [Goshawk], formally very rich, with complex images, in the first part, "Divino Amor" (Divine love), as well as in the second, "Amor Divino," (Love divine,) in which she bears witness anew to her Catholic spirituality, reflects the poet's mastery and her constant search for new means of expression. But *Mensajes del Escriba* (Messages from the scribe) 1953, which reappeared considerably expanded under the title "Oro y Tormento" (Gold and torment), reintroduces us to her level and flexible voice, which appears unconcerned with artistic effort. . . .

We are in the period whose latest stage is embodied in the very recent book *La Pasajera* (The passenger), from 1967. Two sections in verse and fifteen texts in lyrical prose bear witness to creative persistence, continuing ductility, faithfulness to her subjects, and ability authentically to adopt new trends, with which Juana de Ibarbourou fulfills her early promise.

<div align="right">Ida Vitale. Capitulo Oriental. 20, 1968, n.p.</div>

Our anthology offers the novelty of a selection of poetry by subject. It shows the great essential themes of Juana's poetry, making it possible to trace the evolution of her feelings from early youth to the age of eighty. . . . Like any organization of this type, it is not absolute; love poems may touch on the themes of loneliness or death, nature poems be infused with the preoccupation with the passage of time. But we wanted to underline the dominant note, which groups under a common sign compositions identified by the same problematics, across time. This makes it possible to evaluate how the focus varies chronologically, how feelings and ideas become denser and deeper with the passage of years. In the love poems, for example, we witness the expectant love of adolescence . . . passing through youthful illusion and disillusion, the fear of losing the fragile joy, the nostalgia of having lost it, that make up the great sentimental novel of every women, culminating, in Juana's poetry, in her poem "Inmensidad" (Immensity), perhaps the deepest, most harmonious, and most successful of all her love lyrics. Later come dusk,

absence, and death, and nothing sums them up better than the book *Elegía* (Elegy), of recent date. . . . At the opposite pole from love, the theme of death runs through the poetic cycle from the adolescent challenge to Charon, when Spring exulted in her, to the serene poems of the present that speak without anguish of a "calendar with few dates left," marked by a curiously detached and testamentary tone. We have added other important aspects: the poems of motherhood and those that are inspired by the ardent concern for peace and rejection of war.

> Dora Isella Russell. Foreword to Juana de
> Ibarbourou. *Antología Poética* (Madrid:
> Cultura Hispánica, 1970), pp. 9–10

The themes that Juana de Ibarbourou pursued were, of course, those of other great lyric poets. . . . In his study of metaphor . . . Jorge Luis Borges considers the multiple examples of an identical theme that may run through a universal literature. He took as an example, the rose. . . .

Juana de Ibarbourou also frequently referred to the fragrant roses in her poems and her stories. However, very differently from Borges's examples. She situates them, like Borges, among her best loved flower, but identifying them as a part of that vegetal world to which she herself would like to belong. We should consider it as part of the theme of Nature, a basic one in her work, along with Love and Life, which leads to the theme of Death.

In order to capture the details of the surrounding medium, Juana de Ibarbourou makes use of all the senses. Some stimuli interest her more than others; thus, aroma, color, and tastes over and above sound, shapes, and textures.

> Jorge Oscar Pickenhayn. *Vida y obra de
> Juana de Ibarbourou* (Buenos Aires: Plus
> Ultra, 1980), pp. 98–99

Juana de Ibarbourou the chaste, "permeated by the Franciscan love for things," the nature-lover who enjoys, in the country, "drops of pure blood, daily absorption of water and sun, with a tenderness for birds and flowers," distances herself ironically from the stereotypes of criticism and subverts the feminine values with which that criticism attempts to imprison her words.

Despite the apparent acceptance of several traditional models of womanhood and love, in *Lenguas de diamante* (Diamond tongues) (1919), its author performs a transition that changes them and, with it, inscribes herself in a new way within the literary tradition. The spontaneity and the absence of effort, underlined by the critics, are seen to be false judgments ignoring the poet's ironic reworking of the themes of earlier erotic poetry.

From that book, for example, we may cite "El fuerto lazo" (The strong bond), a poem in which the themes of offering and sacrifice, inherent in the woman's stereotype, are presented from an innovative and ironic perspective; "La hora" (The hour), which is inscribed within the secular topos of *carpe*

diem in order to alter it profoundly; and "La espera" (Hope), which recuper-
ates the archetypes of the journey and return as perceived from the situation
of the woman who awaits her beloved.

Margarita Rojas and Flora Ovares. *Las*
poetas de buen amor (Caracas: Monte Avila,
1991), p. 109

IDSTRÖM, ANNIKA (FINLAND) n.d.

Annika Idström is a remarkable writer, with three earlier novels to her credit,
two of which have been honored with distinguished literary prizes and the
third translated into a variety of languages. She has figured as a candidate in
demanding competitions and is considered one of Finland's more important
authors. Her books belong to the general category known as literature of
horror.

What, one may ask, accounts for the success of Idström's books, which
are actually painful to read? Their language is of persuasive power. Every
word is carefully chosen and hits the reader's consciousness with the full
impact of its meaning and of the associations it calls forth. Her descriptions
are sparse but of a visible and palpable accuracy that makes one live in the
places of which she speaks and either enjoy them or be devastated by them.
The psychological structure of her unusual and at times abstruse characters
is convincing throughout. Still, all this does not account for the impression
made by her books. The questions they raise and the effects they produce
reach levels beyond intellectual analysis.

Kirjeitä Trinidadiin (Letters to Trinidad) is perhaps Idström's deepest
and most provocative work. It tells the story of a couple and their fourteen-
year-old daughter as they undertake a vacation trip to Israel. The husband,
Seppo Sirén, is a civil servant with the Internal Revenue Department. A quiet
man who considers life basically tragic, he is neither happy nor unhappy and
contents himself with being helpful to his clients. His wife Elisabet grows up
as the only child of a small-town cantor and has neither occupation nor special
interests. Their daughter Ursula is stricken with symptoms of mental and
physical retardation, combined, however, with flashes of intellectual and spir-
itual lucidity that usually go unnoticed.

As the story unfolds, Seppo turns out to be a sex-obsessed masochist
and Elisabet an equally sex-hungry sadist. The tortures they inflict upon each
other and upon themselves are worked into a travel log, in the center of
which stands the tourist guide Vainikainen, who had renounced a career as
a clergyman and become a guide to Israel so as to be able to tell again and
again the events recounted in the Gospels and allow voyagers to relive the
life of Jesus. This easily overlooked statement offers a key to the otherwise

enigmatic novel. The experiences undergone by Seppo and Elisabet are of tragic and shocking cruelty, culminating in a psychotic episode that Seppo endures as the result of a sunstroke. However, almost imperceptible hints arise from the horrors and evoke deep, meaningful associations. Seppo may be seen as Adam, falling into every kind of temptation but, in doing so, taking on traits of Adam reborn, of Jesus, the man of sorrows who bears the sins of the world. In nightmares and long inner monologues Seppo recognizes the lies and deceptions, the exploitation of the weak and the disdain of people that taint even his seemingly well-intended actions.

As Seppo undergoes the descent into his own inner hell and Elisabet succumbs to other temptations, the final act of death and resurrection is left to Ursula, the child, who is poor in spirit. As she stands at the edge of the springboard from which she will, unwittingly, jump to her death in an attempt to make her father proud of his skillful daughter, he sees her as an angel, crowned by a halo of light. In a dream he hears her urging him to rise from his bed of sins and walk to the door of freedom; when he claims that he is unable to do so, she answers, "You can, if you believe." In a letter he reads only after her death she tells of being a bird that longs to leave for Trinidad (the Trinity!), a place whose whereabouts she does not know yet one where, in the end, she and her father will meet. The tale ends with Seppo's helpful response to his wife's agonized expression of need—humanity crying from the abyss of its sins and given answer.

Anne Fried. *World Literature Today*. 64, 1990, p. 673

The first novel by Finnish writer Idström to be translated into English [*My Brother Sebastian*] unfortunately does not make readers wish for more. From page one, the voice of Antti, the 11-year-old-narrator, supplies insights into human nature that might be appropriate to a very intelligent and sensitive adult. Thirty pages into the novel, the sadomasochistic pranks of the school children are no longer believable either. A highly charged erotic narrative that dangles madly in time and space, the book offers an interesting structure as it attempts to superimpose horrors at school with the collapse of Antti's life alone with his mother when she veers off into madness. Perhaps the novel worked well in the original Finnish, but this cumbersome translation cannot handle experimentalism, bogging down even with simple English colloquialism. Complicating matters further are typos and misspellings as well as incorrectly used homonyms. The variant themes begin to draw sensibly together in the third and final section, but by that time most readers will have given up.

Penny Kaganoff. *Publishers Weekly*. August 3, 1992, p. 65

JACKSON, SHIRLEY (UNITED STATES) 1919–65

The middle-class emotion of embarrassment has been substituted for many of the human passions and passion itself is very often treated in such a way that the reader is only embarrassed by it. The mixture of the macabre and the familiar—hell yawning beneath the commonplaces of life—and especially the combination of cruelty and the childlike is a standard theme, which Miss Jackson treats, not as a source of macabre humor, as Saki treated it, but as a source of macabre embarrassment.

<div align="right">Donald Barr. The New York Times.
April 17, 1949, p. 4</div>

She sees life, in her own style, as devastatingly as Dali paints it, and like Dali also, she has a sound technique in her own art. There is a beguilingness in the way she leads her readers to the precise point at which the crucial shock can be administered.

The stories are of varying length and quality, but there is in nearly all of them a single note of alarm which reminds one of the elemental terrors of childhood—as when the pages of a book are unsuspectingly turned upon a frightening picture, or a shadow moves into sudden shape upon a wall.

<div align="right">James Hilton. New York Herald Tribune.
May 1, 1949, p. 4</div>

The short stories of Shirley Jackson . . . seem to fall into three groups. There are the slight sketches like *genre* paintings, dealing with episodes which by means of her precise, sensitive, and sharply focussed style become luminous with meaning. . . . In these she is completely successful. . . . The second group comprise her social-problem sketches. . . . Here she has, in addition to an enlightened point of view, a penetrating understanding of the subtle ways . . . prejudices operate. . . . Her final group deals with fantasy ranging from humorous whimsy to horrifying shock. Her method is to establish with meticulous detail a concretely realistic setting, and then to allow the story to crumble . . . into unreality.

<div align="right">Robert Halsband. Saturday Review of
Literature. May 7, 1949, p. 19</div>

Magic is the word that has been woven around the literary personality of Shirley Jackson, the latest to join the select corps of triumphant women short-story writers who apparently flourish in America. Of the stories that make up her surprisingly high-selling collection—entitled *The Lottery*—

[many feature] the supernatural and some sort of devil worship. . . . True, Miss Jackson believes in magic. She says it works for her, both the black and white varieties. But she also says it's a silly thing to talk about. Obviously, Miss Jackson was able to be natural even about the supernatural.

<div align="right">

Harvey Breit. *The New York Times.*
June 26, 1949, p. 15

</div>

There is, throughout *The Lottery,* a ghostly teasing resemblance to the work of people like Aubrey Beardsley and Algernon Blackwood—there is the same air of the fantastic, the improbable, the cruel and the evil, all overlaid by a veneer of the commonplace, but the final impression is that even this surface shines, not with the sheen of polish, but with the iridescence of decay, so that one is left believing that even the commonplace is fantastic. This is, of course, the modern romantic belief that nothing is ever right or happy or genuine.

<div align="right">

E. G. Langdale. *Canadian Forum.*
July, 1949, p. 94

</div>

The collected short stories, *The Lottery* . . . left little doubt anywhere of the distinctive order of Shirley Jackson's talent. Even so, it is a rarity when a novel by a writer as young Miss Jackson (she is just 30) turns out to be a work of artistic maturity; a novel within its own brief, but not shallow limits, of courage, integrity and persuasion. Such, happily, is the case with *Hangsaman.*

The language of *Hangsaman* . . . is alive, complex and clear. Its perceptions are piercing beyond the ordinary. The characters are true to themselves (and to life) with every breath they draw; the situations are true to the characters and, in turn, subtly affect and alter them. One cannot doubt a word Miss Jackson writes.

<div align="right">

Alice S. Morris. *The New York Times.*
April 22, 1951, p. 5

</div>

Having delighted untold thousands with her recent account of life among the savages in Bennington, Vermont, Shirley Jackson the housewife and mother has once more yielded to Shirley Jackson the literary necromancer, who writes novels not much like any others since the form was invented. . . . Sinister, sardonic, and satirical by turns *The Bird's Nest* is what one might expect from the author of those frightening stories in *The Lottery.* And yet, as the book races from one astonishment to the next, we come to feel that the other Miss Jackson must have had a hand in it, too. The drama repeatedly turns into farcical comedy, and under the comedy lies pathos. . . . And the climax of the story and its conclusions are curiously moving.

<div align="right">

Dan Wickenden. *New York Herald Tribune.*
June 20, 1954, p. 1

</div>

Miss Jackson shocks her readers into instant attention by the effective juxta-position of startling incident and unusual characters. . . . In addition to being a first-class story-teller, she has always been concerned with the conflict between good and evil in a world deplorably deficient in common sense, kindness, and magnanimity in the Aristotelian sense.

William Peden. *Saturday Review of Literature.* March 8, 1958, p. 18

It is the preeminent virtue of Miss Jackson's story [*The Haunting of Hill House*] that she is never didactic, never even explicit. The real tragedy of Eleanor's helpless liaison with Hill House is only shown, dramatized from page to page, as her fantasies usurp more and more of her sense of reality. At the end she is totally "possessed" by the house, and can even hear "the duet drifting gently in the attic, the wood aging" in the walls. It is a goose-pimple horror story, and a good one; it is also a pathetic portrait of a needful creature on the edge of the unknown, crying out to belong and be loved.

Roger Becket. *New York Herald Tribune.* October 25, 1959, p. 14

Perhaps the best thing one can say of this author is that she offers an alterna-tive to the canonical view of "seriousness" in literature. Like the late Isak Dinesen, she is a meticulous storyteller who can evoke the reality of the times without invoking its current cloying clichés. Her work moves on the invisible shadow line between fantasy and verisimilitude; it also hovers be-tween innocence and dark knowledge. Above all, her work never averts itself from the human thing, which it quickens with chilly laughter or fabulous imaginings. . . . The effect depends on her ability to specify a real world which is at once more sane and more mad than the world we see.

Ihab Hassan. *The New York Times.* September 23, 1962, p. 5

Despite a fair degree of popularity—reviews of her books were generally enthusiastic, reprints and foreign publications were numerous, and her last two novels, *The Haunting of Hill House* and *We Have Always Lived in the Castle,* became modest best sellers—her work has been very little under-stood. Her fierce visions of dissociation and madness, of alienation and with-drawal, of cruelty and terror, have been taken to be personal, even neurotic, fantasies. Quite the reverse: they are a sensitive and faithful anatomy of our times, fitting symbols for our distressing world of the concentration camp and The Bomb. She was always proud that the Union of South Africa banned *The Lottery,* and she felt that they, at least, understood the story.

Stanley Edgar Hyman. Introduction to Shirley Jackson. *The Magic of Shirley Jackson* (New York: Farrar, 1966), p. viii

Because few close, meaningful relationships exist among her fictional people, her characters experience no deep emotions except those of fear and anxiety; no strong love, no strong anger, jealousy, or hate. The most violent moments of hatred are found in *The Bird's Nest* when two of the multiple personalities of Elizabeth battle in one scene to dominate each other and in *We Have Always Lived in the Castle* in which Merricat has in the past hated her family and now vaguely (in a psychotic state) hates the villagers, who are on the periphery of the scene. She hates and fears Charles, but the moment that the object of her hatred is removed, she is in a euphoric state, knowing that she is safe, that no outside forces will take Constance away from her. Her relationship with Constance is closer than that of any other characters; and, because they feel secure in each other, Constance and Merricat are prepared to withstand the terrors of the outside world. The vague hatred that other characters feel appears often in the form of prejudice, like that of the villagers for the Blackwoods or of the Pepper Street families for the one Jewish family on the block. This hatred is a chronic illness in a society in which there is more hate than love.

Miss Jackson avoids ugliness or grisly realistic details of unpleasantness. When death occurs, which is seldom, it happens offstage as in *Road Through the Wall,* or is disposed of in a sentence or two as in *The Haunting of Hill House* when Eleanor crashes into the tree and as in *The Sundial* when Orianna Halloran is found lying at the bottom of the stairs. The body is carried off to rest beside the sundial on the lawn, but no unpleasant details are given. At the end of "The Lottery," the reader discovers with horror what is about to happen; but the story ends with the casting of the first stones. Miss Jackson prefers to leave the sordid details to the reader's imagination. . . .

Miss Jackson is not, however, a major writer; and the reason she will not be considered one is that she saw herself primarily as an entertainer, as an expert storyteller and craftsman. She has insights to share with her readers; but her handling of the material—the surprise twists, the preoccupation with mystery and fantasy, her avoidance of strong passions, her versatility, and her sense of sheer fun—may not be the attributes of the more serious writer who wishes to come to grips with the strong passions of ordinary people in a workaday world, who prefers to deal directly with the essential problems of love, death, war, disease, poverty, and insanity in its most ugly aspects. Even with "The Lottery" one wonders if Miss Jackson may have chosen the situation for its shock value. The message is, nevertheless, effective; and the story is superb, regardless of the intent of the author. Despite the lack of critical attention, her books continue to be popular with those people who are sensitive, imaginative, and fun-loving; and perhaps, in the long run, that popularity will be what counts.

<div style="text-align: right">Lenemaja Friedman. Shirley Jackson (New
York: Twayne, 1975), pp. 157–61</div>

To the extent that she is remembered at all, Jackson is remembered for her gothic fiction or psychological thrillers, and one might well contend that

writers of gothic fiction have rarely held a secure place in literary history. Worse for Jackson, she was a humorist as well; one of the distinguishing features of her work is a delicate balancing of humor and horror that is bound to make the reader uneasy. In *The Road through the Wall* (1948), for example, when the comically portrayed thirteen-year-old neighborhood outcast hangs himself, our shock is compounded by our previous guilty participation in laughter at his expense. We may even feel betrayed because the author induced us to laugh at a character she knew to be tragically doomed. A similar situation occurs in *The Haunting of Hill House* (1959), in which the narrative's gentle mockery of the main character does not prepare us for her suicide at the end. Jackson's habit of mocking the doomed must have seemed to many traditional readers decidedly unfeminine. . . .

Increasingly, in the past decade, feminist scholars have challenged accusations of insignificance directed at women writers by traditional critics, and have made a new place in literary history for women of varied experiences and talents. Because feminist criticism recognizes the divided self that lies at the heart of the female experience in a patriarchal society, it has explored the variety of means by which women writers express multiple selves in their writing, reviving interest, for example in Louisa May Alcott's thrillers, Emily Dickinson's letters, and Ellen Glasgow's and Edith Wharton's ghost stories. In such company, Shirley Jackson appears perfectly normal. Moreover, feminist critics have recently begun to take a closer look at housewife humor, a mode Judith Wilt has labled "matriarchal comedy."

If, as Wilt argues, matriarchal comics elect the safest way to express the frustrations of the female role in a sexist society, Jackson's uniqueness lies in her use of other more dangerous means as well. In fiction, she writes most often about women. The typical Jackson protagonist is a lonely young woman struggling toward maturity. She is a social misfit, not beautiful enough, charming enough, or articulate enough to get along well with other people, too introverted and awkward. In short, she does not fit any of the feminine stereotypes available to her. She is Harriet Merriam in *The Road Through the Wall* (1948), an overweight teenager who thinks to herself, "You'll always be fat, . . . never pretty, never charming, never dainty," and who may have been the one to murder pink and white, doll-like Caroline Desmond because the little girl was everything Harriet was not. She is Natalie Waite in *Hangsaman* (1951), whose feelings of isolation and alienation during her first few months away at college generate a fantasy other, an imaginary friend. She is Elizabeth Richmond in *The Bird's Nest* (1954), whose adolescent confusion about her mother and her mother's lover splits her at last into a tangle of discrete personalities. She is Eleanor Vance in *The Haunting of Hill House* (1959), whose feelings of rejection and social displacement ultimately lead her to suicide. She is Mary Katherine Blackwood in *We Have Always Lived in the Castle* (1962), who lives with her sister in a state of siege, barricaded against a town's hostility. She is Mrs. Angela Motorman in "Come Along with Me" (unfinished, 1965), whose world has always been peopled by creatures no one

else can see. She is even Aunt Fanny in *The Sundial* (1958), whose life of uselessness as a maiden aunt is vindicated by a vision of doomsday.

> Lynette Carpenter. In Alice Kessler-Harris
> and William McBrien, eds. *Faith of a*
> *(Woman) Writer* (1984; Westport,
> Connecticut: Greenwood Press, 1988),
> pp. 143–45

JAMESON, STORM (GREAT BRITAIN) 1897–1986

England has again an art-critic, and that phenomenon is a woman. . . . She is robustiously free from sex astigmatism, or type; indeed, there is no bias of sex in her judgments, unless it be found in a (perhaps feminine)) weakness for Oscar Wilde and the author of *Peter Pan,* whereby she seems to betray the motherly instinct. . . . These are the two critical weaknesses in a book [*The Modern Drama in Europe*] which must be accounted a brilliantly sane estimate of the life forces which created the Modern Realist Drama wallowing in the commercial anarchy and art degradation of the present day. The author is epicenely stern. Her judgments are derived from right concepts. Her adjectives are few, and she is never deflected. She has the virility to see that Strindberg and Ibsen were the two dominant intellects of the age, and, on the whole, her instinct is sound. . . . Not only does she understand Nietzsche, she declines to misunderstand Bernard Shaw. . . . M. Storm Jameson is either a portent or an apparition, yet in any case a beacon. Her book reminds me of the first airplane over London. We look up.

> S. O. *English Review.* January, 1921,
> pp. 57–58, 62

Miss Jameson's novel [*Love in Winter*] is far above the average, for to skill, variety of interest, and verisimilitude she can add the study of a rich emotional nature as familiar to us as an old friend, as true to life as a human instinct. Many widely acclaimed novels will seem crude after the simplicity of this careful portrait.

> Osbert Burdett. *English Review.* May, 1935,
> p. 626

The Road from the Monument is a comfortable, well-padded novel set in the 1950s but written within the conventions of 50 years ago: . . . the characters are solid and subtly drawn, the story stuffed full of moral conundrums for them to solve. . . .

It's quite possible to find this compulsively readable and an artful fake, which of course it is. Miss Jameson pretends to a criticism of human vanities,

but really offers complicity in a daydream. . . . and here we are back where Galsworthy left us, with a bunch of noble sentiments and a fast-weakening grasp of reality.

<div align="right">Robert Taubman. New Statesman. January
26, 1962, pp. 133–34</div>

[In her novel, *In the Second Year*] Jameson uses several strategies to make her point about British society. Contemporary British intellectuals are mentioned in the novel; Stephen Spender has disappeared without trace, E. M. Forster is in exile. Fascist bullies murder a Jewish poet who has ridiculed the leader, but anti-Semitism is of a covert, decent British kind, "hungry Eastenders smashing up little shops in Whitechapel are usually sternly reproved by the Magistrates." Jameson had visited Berlin in 1932, and through her involvement in international PEN was in close contact with exiles from many European countries throughout the 1930s. Her translation of the horror of the rise of Nazism to a British context works effectively because of her familiarity with British politics and character, and her knowledge of events in Europe. Although a member of the Labour Party, she depicts its disarray and the economic disaster faced by the MacDonald government and its subsequent collapse, and describes a varied response by Labour politicians and union leaders to the rise of the dictator, some changing sides, some quietly disappearing into privacy, others, staunch in their beliefs, confined to the labor camps. Jameson writes that *In the Second Year* was "a disappointment to my friends on the far Left, who expected a direct attack on Fascism, with a Communist hero, and the rest of it." Although sympathetic with the Left, Jameson's refusal to write this kind of novel springs from her distaste for the excesses of power, whether in the hands of the right or the left. Her narrator describes Hillier having "for the common people . . . the face of the Messiah. . . . Serve them right for being deceived. Serve them right if they die of him. They chose him and they deserve him." Rather than suggest that salvation might lie in the hands of another political leader, she locates it in the north of England, particularly her native Yorkshire, and in Norway, where she wrote the novel. It is thence that her narrator returns at the conclusion, refusing the opportunity to join an underground Communist movement. His final words are "I believe that England will be saved in her own way, and it won't be yours." The harsh landscape of the north, and the dour, insistent individualism of the northerners, are repositories of the symbolic spirit which will triumph over tyranny, rather than an opposed but potentially dangerous ideology. The outspoken Jameson was to publish another anti-Fascist dystopia in 1942, and an anti-Communist novel in 1948.

<div align="right">Nan Bowmen Albinski. In Gorman
Beauchamp, et al., eds. Utopian Studies
(Lanham, Maryland: University Press of
America, 1987), p. 21</div>

At the time of her death in 1986, Storm Jameson was a neglected and ignored writer. Since the beginning of her long career—her first book was published in 1919—she has remained a disregarded author, the victim and darling of no one except the book reviewers. Our time is one of persistent and often interesting scholarship and criticism; books outline the careers of obscure authors and writers may be noticed early and have reams written about them while they are still in mid-career. But no one has thought to write a book, or even an extended article, about this writer. She is hardly known in academic circles, and her novels do not appear on reading lists for the twentieth century British novel courses that I have seen. Her books have, for the most part, gone out of print, without much likelihood of reprints. . . .

The firmest impression one gets of her work is that she is a formidable writer, possessing a sense of craft and a thoughtful stubbornness of attitude. In a time that has included much literary experimentation, she has not been an experimenter. Her novels are conservative in their structure, shapely, well-expressed, careful to stay within their limits. By writing as she does, she follows consistently her long-held and carefully considered critical opinions about the novel. Reflecting upon her critical dicta, a *Times Literary Supplement* reviewer, admitting to unkindness, summed them up as a question: "Why doesn't anyone write nineteenth-century novels anymore?" The unkind question has point. She doesn't care, quite emphatically, for *Finnegan's Wake* and so invites the neglect of those who do. Still, reading her books for the pleasures that they afford, one is still surprised by the ingenious ways we have discovered to ignore her.

<div style="text-align: right">

Douglas Robillard. *Essays in Arts and Science.* 17, 1988, pp. 63–64

</div>

JANSSON, TOVE (FINLAND) 1914–

When contemporary Scandinavian literature is discussed by nonspecialists in other parts of the world a dozen or more names are usually mentioned. But the Scandinavian author whose works have the largest number of foreign readers and followers is apt to be overlooked, is even largely unknown. Still, the adventures of Tove Jansson's Moomin family, their friends and their enemies, have been published in many languages, on several continents and are being read by hundreds of thousands daily.

Someone who is not acquainted with Tove Jansson's works may assume that they are not worthy of the attention of literary connoisseurs. This view could be rooted in the conventional attitude towards children's books and comic strips. Tove Jansson feels that many people are embarrassed to admit that they enjoy reading about a friendly world, where security is never boring and danger is never really dangerous. Tove Jansson believes that some people

read detective stories to give vent to certain emotions while others choose children's books as an outlet for a sort of "forbidden kindness." . . .

Moominland Midwinter differed considerably from Tove Jansson's earlier works and was probably her most mature book. In this story friendly Moomin Valley was transformed into an alien and frightening winter world of loneliness and darkness, which was "not made for Moomins to live in."

In many ways, *Moominland Midwinter,* is the most Nordic of Tove Jansson's books: it conveys moods that are very important to the people in Scandinavia: the seemingly endless wait for the sun, warmth and the re-awakening of nature.

<div style="text-align: right">

Frederic and Boel Fleisher. *American Scandinavian Review.* 51, 1963, pp. 47, 53–54

</div>

The line of development of Tove Jansson's work seems to be determined by the conflict between the demands placed on her from outside, as a successful children's author and cartoonist, and her own need to communicate, as an artist, on a different level. Even in the earliest of the children's books, it is possible to discern ideas and associations that may not immediately be of interest to children. They were not noticed by adults at first, and it is only with the hindsight acquired by reading a large number of her books that these themes can be seen in her early work.

As the Moomin series proceeds, the overtones become more obvious, until it is the poetry and the overtones that dominate in the final books in the series, while the fantasy characters are no longer childlike and simple but increasingly adult and complex. As this change in concept takes place, it becomes clear that the children's book is no longer a sufficient medium for the writer. She is changing, has changed, and she needs a means of expression less inhibited by the need to appeal to children. One of the consequences is an increasing preoccupation with the problems of art and inspiration, the question of artistic integrity and the role of the artist. It also may well be that she was feeling frustrated by the sheer success of her cartoon series with its constant demands for fresh inventiveness. She was, in fact, whether she liked it or not, living in a kind of Moomin world from which she had to break out. It was at this stage that she made her first move toward purely adult literature in *The Sculptor's Daughter.*

In this and the slightly later *Summer Book,* Tove Jansson still does not stray very far from the children's book. Her Moomin world is behind her, but she still writes simply, in a manner reminiscent of stories told for children, though the overtones place these books in the adult category. New themes begin to assert themselves, and in *The Summer Book,* old age assumes a new and important role. It is well known that children and old people often find things in common, and here Tove Jansson explores that area, seeking to define how much they share and where the limits in one particular grandmother-

grandchild relationship lie. In its turn, this leads to the consideration of old age itself and the changes that affect people as they age.

These themes are again present in *The Listener,* in which the author's penchant for the short story takes a new turn, and they dominate in *Sun City,* her most ambitious examination of old age and the effects of ageing. If Miss Peabody from this novel is considered along with Sniff from the Moomin books, the implication seems to be that characteristic already present in children assert themselves in a new and uncompromising form in old people. *The Doll's House* then examines the intermediate stage, when personal idiosyncrasies in some people acquire a strength of their own and lead to abnormal behavior. The author now moves firmly into the area of mental disturbance, which has been close to the surface as far back as some of the stories in the Moomin books. . . .

Not only does Tove Jansson observe and understand the characters she draws, but she evinces great sympathy and forbearance toward them all, even the most difficult and apparently unattractive of them. It would be difficult if not impossible to find any of them depicted in a critical or negative light. Many of them are superficially uncomplicated beings, but often they have unplumbed depths. Signs of unexpected complications behind a placid or simple facade can be found in the later Moomin books, and the tendency becomes more pronounced in *Summer Book* and *Sun City.* To talk of the simplicity of the characters in *The Doll's House* would be a gross exaggeration; the central figures are almost all portrayed as complicated. They are often on the borderline between normality and abnormality, and some of them have crossed it.

Tove Jansson's work is not yet finished, but *The Doll's House* seems to constitute a major breakthrough in which the tensions apparent in the earlier books have been worked out and to some extent resolved. It thus comes to stand as the culmination of Tove Jansson's work so far, and perhaps points the way to yet another phase in her production.

W. Glyn Jones. *Tove Jansson* (Boston:
Twayne, 1984), pp. 163, 165–66

The characters that populate Tove Jansson's books for children are known and loved in many parts of the world. Since they first began appearing in 1946, her Moomin books, for example, have been translated into twenty-four languages and have carried her fame far beyond the borders of her native Finland. She reached a point in her literary development, however, when she simply could no longer write exclusively for children. The fiction written since that time, therefore is addressed to adults and is gradually beginning to receive both popular appreciation and critical acclaim. . . .

Stenakern, Jansson's most recent novel, relates the story of Jonas, an aging journalist who has agreed to write the biography of a man he despises while visiting his daughters, whom he knows only in the most superficial way, at their vacation cottage. Within this context, Jansson explores the rela-

tionship of truth to language, the possibility of writing truthfully, and complex familial relationships that need to change and require a greater degree of truth than ever before. Jansson also returns here to two themes that have been central to earlier works such as, most notably, perhaps, *Solstaden:* loneliness and the problem of aging. Neither is to be understood in a thoroughly negative sense but rather as a complicated human problem worthy of careful study and investigation.

<div style="text-align:right">

Steven P. Sondrup. *World Literature Today.*
59, 1985, p. 608

</div>

Tove Jansson's earlier books of short stories, *Lyssnerskan* (1971) and *Dockskåpet* (1978), were by and large impressive; a tale such as "Ekorren" remains unforgotten. Her third collection [*Resa med läft bagage*] shows perhaps the need for an editor's hard and selective eye. The feigned letters from a thirteen-year-old Japanese admirer of Jansson's work ("Korrespondensen") are simply cloying and self-congratulatory; the conversations between the young artist couple and the very Finland-Swedish grandmother in the first part of "Åttiårsdag" (as well as the subsequent chatter in the second part, *post festum,* with three raffish middle-aged men) provide, one supposes, some shafts of illumination for the girl-narrator, lighting up both her mind-set and her boyfriend's. Nevertheless, as can be the case with stories in the *New Yorker,* the reader wonders if he is missing something.

"Sommarbarnet" is about a child unable to keep his foot out of his mouth; at long last the relationship with his summer host family becomes better, and there is a happy and altogether predictable end. "Främmande stad," about an elderly lady's unnerving experiences between planes, is short and awakens the hope that Jansson's gift for calling up the uncanny in a few sentences will work its magic. It almost does. The same hope, again only slightly disappointed, returns with the title story about sharing a ship's cabin with an importunate stranger. The item that, in the book's structure, separates these two satisfactory travel tales is "Kvinnan som lånade minnen." . . . Vanda, who resides in Stella's former apartment, has pretty well taken over Stella's former life, and Stella—who can blame her?—becomes eager to escape from her sometime abode, which she has just visited. The long "Lustgården," about more or less well-heeled visitors in Spain and their small frictions, seems flaccid. The longer the story, the less the intensity. This rough-and-ready rule of thumb's converse is illustrated by the brief "Shopping," a view of life after a not-altogether-total nuclear disaster, and by the still briefer "Skogen," in which an older boy reads to his little brother from Edgar Rice Burroughs's jungle classic *Tarzan of the Apes,* managing to scare both himself and his sibling and to turn himself somehow into an undependable father figure.

"Gymnastikärarens död" starts with a report of a gym teacher's suicide; Henri and Flo—the setting, for no apparent reason, is Belgium, not Finland—decide not to go to the funeral but to accept a dinner invitation to the country

instead. The host, Michel, is detained; in the uncomfortable conversations à trois between the couple and Michel's wife Nicole, Flo's emotional disturbance becomes more and more evident, as does the lonely Nicole's, more quietly. The talk centers on the suicide, which took place because the teacher could not learn to climb a rope. Flo admires the teacher's deed, but Nicole does not; on the way home Henri thinks to himself; "A splendid woman. Probably easy to live with. I have a difficult woman. Everything's fine." It is not, of course. Domestic unhappiness continues in "Måsarna," as wife and husband grow all too concerned with watching and feeding the sea birds that come to their summer island. The husband kills what he believes is the wife's pet gull, Kasimir, and inadvertently blurts out, "Else, I'm killing you." He is wrong; his victim was not Kasimir but a more rapacious bird. Nevertheless, Else decides not to tell him about his mistake, realizing at the same time that Kasimir "would never come back." Finally, in "Växthuset" the odd couple consists not of man and wife but of two old men, Uncle and one Josephson, who first get on each other's nerves during their daily visits to the greenhouse in the botanical gardens and then become friends despite their differences: "It doesn't seem as though we'll be able to convince each other. But is that really necessary?" Although it is nice that *Resa med lätt bagage,* begun with sugar and spice by the lavishly grateful Tamiko in far-off Japan, can end on a sweet note of reconciliation, the bitter little slices of evil tucked away here and there in the book's interior are more piquant and more memorable.

George C. Schoolfield. *World Literature Today.* 62, 1988, pp. 672–73

Tove Jansson's later Moomin books, *Moominpappa at Sea* (1965) and *Moominvalley in November* (1970) mark her transition into writing for adults, though some child readers have enjoyed the entire series. Her Moomin books probe the isolation of the individual without entirely abandoning the celebration of community. Moominpappa's journey into self begins with his ennui in August. His spirit is becalmed because "it seemed everything there was to be done had already been done or was being done by somebody else." Pappa's usual consolation, the crystal ball where he projects his own image into the lives of the family, betrays him when light from Moominmamma's new lamp fills the sphere. Stunned that he can no longer contemplate an ongoing life of protecting the family, Pappa journeys to what, for Moomins, is the source of light. There, in the remote lighthouse, each family member confronts limitation, finality, and blankness in a series of images redeemed from terror only by the Moomins' rootedness in nature.

Nancy Huse. *The Lion and the Unicorn.* 12:1, 1988, pp. 32–33

The first Moomin book, *Smaatrollen och den Stora Oversvamningen (The Small Troll and the Big Flood),* appeared in 1942, when Jansson was twenty-eight. From the episodic adventure structure of the first few novels (there

are nine novels and a collection of stories in the series), the books evolved into complex psychological fantasy, with accompanying shifts in illustration style from romantic to surreal. A story collection, published in Swedish as *Det Osynliga Barnet* (*The Invisible Child*, 1963) and in English as *Tales from Moominvalley*, was followed by two additional novels, *Moominpappa at Sea* (1965) and *Moominvalley in November* (1971), exploring adult-child relationships and the aging process. . . .

Across the manuscript of her first short story for adults, "The Listener" (1971), Jansson scrawled *"Inte for barn!"* (not for children); her theme in this and later fiction is the power of language, a "mind-game called Words That Kill—." Despite her wish to keep children at a distance from such themes, to avoid projecting her own needs onto them over a long process of accepting and articulating a lesbian identity, many child readers have traced themes of alienation, doubt, artistic isolation, and maturation in the Moomin series books which precede Jansson's conscious attempt to write only for adults. The children's letters, and Jansson's replies to them, suggest how Jansson's creative process depends on the links to her own childhood that the Moomins represent. . . .

Though Jansson's lesbian orientation has remained hidden from them, child readers have recognized and empathized with her shifting existential beliefs, the yearning of the artist for solitude and of the person for affection, and the questioning of the nature of reality and illusion.

Nancy Huse. *Children's Literature*. 19, 1991,
pp. 150–52

For her new volume of thirteen short stories, *Brev från Klara* (Letters from Klara), Jansson's only illustration is the wistful and autumnal painting on the cover. It shows sophisticated adults picnicking in a fantastic park. The landscape is reminiscent of the Moomin world, complete with lake, mountain, and rainbow. The participants are arranged as in Manet's *Dejeuner sur l'herbe*, but this is no sensuous feast. These picnickers seem remote from one another, hardly within talking distance.

The Moomintrolls live in a protected sphere where catastrophes like floods and earthquakes turn into festive, communal occasions which lead to friendships with odd new acquaintances. In "Letters from Klara" odd characters also appear. There is the lonely art student who mails each classmate a formal letter severing their relationship; the grown man who happens to meet a once secretly adored older schoolmate on a long train ride, only to hear that his worship was noticed and that it repelled the recipient; the aged mother who wants to be addressed as "Big Squirrel" by her middle-aged "Little Squirrel" son.

The characters in *Brev från Klara* are treated with humor and understanding, but some of the stories are vague and unconnected, like the covering painting. None is more so than "Emmelina," about an incorporeal

beautiful blond nineteen-year-old facilitator of death and suicide: death for the old and frail, suicide for the young and unhappy.

A few of Klara's letters have an autobiographical flavor and, with that, a Moomin touch of gaiety and strength. The Moomin world is clearly flavored by the author's childhood, described in her 1968 autobiography *The Sculptor's Daughter.* In the story "In August" two old sisters quarrel over whether their eighty-year-old mother had fun or was deranged when she painted a bathroom ceiling late one night, fell, and broke her neck. In the volume's final selection, "Journey to Barcelona," a daughter accompanies her indomitable eighty-year-old artist mother to the Catalonian capital in order to admire Gaudi's free-spirited architecture for one day. They continue to Juan les Pins, where they manage to live within their means on what the mother longed for as the real Riviera. A midnight tour in a "borrowed" dinghy, with the mother serving as captain and rowing, highlights their penny-pinching weeks.

"Letters from Klara" is a slight book. Its author is approaching the age of the extraordinary mother figure. Perhaps next time either the fictional Klara or Tove herself (b. 1914) will write at length about growing old in today's Finland and about being a beloved artist and writer.

<div align="right">Margareta Mattsson. World Literature Today. 66, 1992, p. 534</div>

Tove Jansson, the creator of Moomintroll, is probably the best-known writer in Finland—not only for her children's books, but for her fine stories and novels for adults, one of which, *Sun City,* is set in an upmarket retirement home in Florida. She is also a successful artist who illustrates her own work with deceptively simple line drawings. . . .

Tove Jansson's characters, like Milne's, are highly individual creatures, part human and part animal and part pure invention, living in a remote and peaceful rural world. Jansson's simple language, comic gift, and down-to-earth relation of odd events all remind one of Milne; so does her love of the countryside and the high value she places on affection and good manners. Like Milne, she is a humanist; and like him, though she writes for children, she deals with universal issues. . . .

One of Tove Jansson's most remarkable creations is her gallery of strange and eccentric characters, many of whom, in spite of their odd appearance, are familiar human types. . . .

[Also] remarkable . . . about Tove Jansson is her ability to feel sympathy for these rather unlikable characters. In *Moominvalley in November* (1971), the last and most complex of the series, a Hemulen and a Fillyjonk move into the Moomin family's deserted house while they are away on the island. The Hemulen tries to play the part of Moominpappa, with limited success, especially when he insists on teaching everyone to ski. The Fillyjonk, who doesn't really like children, attempts to replace Moominmamma. Though Jansson makes fun of the Hemulen and the Fillyjonk, she also pities them and even seems to respect their clumsy efforts.

By the end of the series, Jansson has got to the point where she can sympathize even with her most difficult and frightening creation. This is the Groke, a strange large dark long-haired mound-shaped creature with huge staring eyes, who seems to represent depression and despair.

Alison Lurie. *New York Review of Books.*
December 17, 1992, pp. 16, 19–20

Her debut as a writer came in 1945, with *Småtrollen och den stora översvämningen* (the little trolls and the great flood); out of this rather simple beginning, there developed the realm of the Moomintrolls, with their generosity and tolerance, their inventiveness and powers of imagination (which reflect salient qualities of their creator), their dislike of sternness and pedantic order, and their close if somewhat haphazard family life. As a rule, the Moomintrolls have none of the malice attributed to the trolls of Nordic myth; instead, they resemble cheerful miniature hippopotami who walk, or waddle, upright. They are inveterate if nervous adventurers, but prefer not to wander far from Moominvalley. . . .

A darkening is perceptible in the later volumes; the inhabitants' growing fear of natural catastrophe becomes more and more apparent, and an atmosphere of loneliness seems gradually to get the upper hand over the happy spirit of community that had prevailed at the start.

With the Moomin books Jansson offers an equivalent to the "moral messages" of her distant predecessor in Finland's literature for children, Zachris Topelius (1818–1898), whose tales preached patriotism, a sense of duty, and industry. Jausson, however, inculcates a set of softer virtues, among them kindness, the ability to laugh at one's self, and a love of life's small pleasures.

As the Moomin series was drawing to its close, Jansson began to write directly for a mature public. She has produced three books of short stories— *Bildhuggarens dotter* (1968; *The Sculptor's Daughter,* 1976), the very title of which gives the collection an air of autobiography; *Lyssnerskan* (1971; the woman who hearkens); and *Dockskåpet, och andra berättelser* (1978; the doll's house, and other stories)—and two novels—*Sommarboken* (1972; *The Summer Book,* 1977), composed of views, happy and sad, of a child and its grandmother in the Finnish skerries, and *Solstaden* (1974; *Sun City,* 1977), an unsentimental description of an old-people's home in St. Petersburg, Florida. In the children's books, the idyll, often threatened, is never destroyed; in the narratives for adults, the idyll is frequently artificial, or it undergoes a terrifying metamorphosis, as in "Ekorren" (the squirrel), the finale of *Lyssnerskan.*

George C. Schoolfield. In Leonard S. Klein,
ed. *Encyclopedia of World Literature in the
20th Century* (New York: Frederick Ungar,
1982), p. 493

JELLICOE, ANN (GREAT BRITAIN) 1925–

The Sport of My Mad Mother . . . recently in repertory at the Royal Court, shared the third prize in the *Observer* play competition and is the first of the prize-winners to be produced. Here one feels the atmosphere of a drama school "original." The play presents a group of teddy boys and girls, led by a not very persuasive Life Force with a long red wig and full womb, an Australian girl named Greta. Into this group's alley hangout wanders a young American with dark-rimmed spectacles and a need to understand whatever he encounters. Tension grows between the American's feeble but persistent Mind and the Life Force's cruel, unpredictable vigor. ("All creation is the sport of my mad mother Kali," says the program, quoting a Hindu hymn.)

What makes this play interesting is not its stock of ideas, needless to say, but rather its use of techniques of formalization. The treatment of language, except for some rather witless lyricism at intervals, may recall Eliot's jazz refrains in *Sweeney Agonistes* (this is the suggestion of Kenneth Tynan, and it seems just). For Miss Jellicoe, too, tries to present the current ills of our world, this time through the symbols of frightened, fidgety, aggressive adolescents. And she uses their East London idiom and their gawky but busy gestures as devices for catching the uneasy excitement of all of us. These characters are ready at every moment to bring overcharged nerves to playing with a home permanent kit (chanting the instructions in a jazz tempo and falling into a dance as they do) or to carrying on a suddenly terrifying interrogation of the strange American in their midst. Three of the adolescents were beautifully played, and there seemed to be at least a dazzling one-act drama lost in this rather pretentious and directionless full-length play. By the time Greta is delivered of the Future, or what you will, the audience is cringing too hard to listen to the Theme.

Martin Price. *Modern Drama*. May, 1958,
pp. 58–59

Whole sections of the text [of *The Knack*] make no noticeable sense in themselves, because it is always what is going on, and what the audience apprehends from participating in what is going on, that counts. Often the dialogue is simply a series of disjointed non sequiturs or uncomprehending repetitions, and in one key scene, where Colin and Tom gradually draw Nancy into their fantasy that the bed in the room is actually a piano, of "pings" and "plongs" variously distributed and extending virtually uninterrupted over some three pages of the script. The most remarkable quality of the play, in fact, is the sheer drive of the action, physical and emotional, right through its three acts in one unbroken movement; in the theater not only does the play not demand rationalization on the part of its audience but, unlike *The Sport of My Mad Mother,* which is by comparison sometimes uncertain and immature (the last act in particular fails to cap the previous two conclusively), it positively

forbids it: the spectator is carried along irresistibly by the verve and ebullience of the play, and at the end, even if he does not know what, stage by stage, it means, he certainly knows vividly what it is about.

In the five years between *The Sport of My Mad Mother* and *The Knack* Ann Jellicoe has matured and developed extraordinarily as a dramatist while continuing obstinately to plow her solitary furrow (her translation, during that time, of two Ibsen plays *Rosmersholm* and *The Lady from the Sea,* has had no noticeable effect on her writing). Her plays are quite unlike anyone else's, and even in a generation of dramatists distinguished above all else for their sure grasp of practical theater her work stands out by virtue of its complete command of theatrical effect. Her plays are difficult to stage, undeniably, since they depend so completely on their theatrical qualities and the sensitivity and accuracy with which the director can cover the bare framework of mere words with the intricately organized architecture fully drawn out in the creator's head. But once staged, and staged well, they infinitely repay the trouble.

John Russell Taylor. *The Angry Theatre*
(New York: Hill and Wang, 1962), p. 71

Shelley is in his room at Oxford, his furniture madly collected into the middle of the room in the shape of perhaps a boat. His desk is attached to the ceiling by a rope which passes through a tinder box, which later explodes. Upon the bridge stands "Mad Shelley." "I'm making an experiment," he cries to his friend Hogg. Dimly the necessary symbolism shimmers: rearrangement of established dogmas, intellectual dependence on religious doubt for inspiration, the break, the boat-life.

Once the spoonful of castor oil has been got down, a straight enough reconstruction follows of Shelley's brief downhill run into exile and death. It is done by a skillful tableaux montage, with only the faintest shading here and there to betray an author's hand as distinctive as Ann Jellicoe's. It might almost have been written as a fast after the indulgencies of *The Knack.*

The subject seems to have been taken on as a Bible story might be, "because it is there," rather than for any sympathy the author may have had for Shelley's beliefs as listed in the programme. Subject and treatment would seem aimed at the film men, were it not for the unheroic, deadpan allegiance to the facts of Shelley's life. Facts which no director could afford to take seriously.

Shelley has long been the god-head of youthful poetic genius overwhelmed by personal tragedy. At first glance he is the easiest character to identify with in moments of romantic self-pity. When we hear he was called "Mad Shelley" at Eton, we are up there beside him in madness. Not so Ann Jellicoe. She is down among the commentators in the cold light of day. Here is a Shelley who could lay down the pompous "Declaration of Rights," yet here too is a Shelley noble enough to stand by them—not till death, for he forgoes them before then, but until social ridicule and hate force him out of

the country. It is a Shelley at once too boring and too wonderful to suit our need.

The play goes diligently ahead with its molding. Anyone who could take himself so seriously, "A man has not only a right to express his thoughts but it is his duty to do so," must surely be humorless, it reasons. But that is not human nature. Shelley's humorlessness is too consistent. It is not until the end of the play, when disillusionment has arrived and he starts to twist his ideals to salve his conscience, that a human being emerges. . . .

The emphasis of the play is on historical fact, not characterization. The characters are depicted, as everyone dreads their own will be, by what they have done, rather than what they were like. In a life-story so complete there was no time for fancy. The actors play the parts of chessmen on a board. They have little to disguise themselves with, so their own personalities are inclined to show through like bare skin. As each of them plays several parts, this is unfortunate. One sometimes can't tell one from another.

Hugh Williams. *London Magazine*. January, 1966, pp. 66–67

The Knack is about three boys and the girl whom two of them are trying to seduce. The most likely to succeed is Tolen, a ladies' man who claims to have mastered the art of seduction and, if he is to be believed, is in constant practice of that mastery. The least likely is Colin, a meek, awkward and gallopingly nervous school teacher. While Tolen is sexual in a crudely esoteric way ("There is little charm and no subtlety in the three-minute make"), Colin is a novice at casual (or any) erotica. Mediating between them is Tom, a very bright, very articulate boy with a sensitivity to shapes, movement, colors and size. . . .

Their victim-bait-test tube is Nancy, lately from the provinces and swept into the trap on her way to the YWCA. Whether she is really seeking a Tolen, whether she is really seeking a Colin, whether she is too willing a seducee or whether she is merely an innocent at the mercy of circumstance is one matter of the play. But there were more things on Miss Jellicoe's mind. For *The Knack* was as much about international politics as it was about interpersonal relationships, although the author rightly considered neither matter of greater importance than the other. . . .

Jellicoe will not restrict herself to a temporal political situation. The behavior of nations is analogous to the behavior of individuals and humans have always attempted to get control of other human beings. The situation of Colin, Tolen, Tom and Nancy remains human and pitifully illogical. Force is force and is always terrible. Weakness is eternally ineffectual. Decency is inevitably trapped in the middle and is without even the victim's sympathy.

Martin Gottfried. *A Theater Divided* (Boston: Little, Brown, 1967), pp. 219, 221

JENNINGS, ELIZABETH (GREAT BRITAIN) 1926–

Her great virtue is that of tone: in almost every page she has written she has preserved that gentle and modest tone in which she questions patiently her own powers of observation. Her subjects are admirably expressed by the title of her last two books: *A Way of Looking* and *A Sense of the World*. . . . Not only her style is a questioning, but her subject-matter as well. But her poems (and I suppose her temperament) are such that she will not admit of the fixity of answers. . . . If she could get down to giving us a landscape, a particular one, she would surely have something new to say about it, and her questions might imply answers that are more precise.

Thom Gunn. *The Yale Review.* Summer, 1959, pp. 620–21

Robert Conquest's anthology, *New Lines,* in 1956 brought together the "Movement" (the label was not his, but the invention earlier of some journalist on the *Spectator*) rather as *New Signatures* had represented "the new movement" of the 1930s. This led to a great deal of publicity, little of which was critically useful. What in fact, *was* the Movement? The poets who appeared in Conquest's anthology—Conquest himself, Elizabeth Jennings, Kingsley Amis, John Holloway, Thom Gunn, Philip Larkin, John Wain, Donald Davie—did not obviously share a common set of beliefs about life or principles about what poetry should be. What they do seem to me, in retrospect, to have shared is a new attitude to their audience. They were no longer writing for a "poetry-loving" audience, or for a set of kindred spirits, or for the ideal reader, or for the Muse. They were not acting as spokesmen of beliefs or causes. Nor had they, though this is a more tricky question, a common "class" voice. Some were of working-class or *petit bourgeois* origin . . . but all of them had been to Oxford or Cambridge and represented a young, alert, professional middle-class attitude, not revolutionary, but certainly not reactionary, and on the whole rather indifferent to politics. A critic of their own generation, Alfred Alvarez, was to condemn them for being "genteel." Their poems have the tone of being addressed, with sometimes slightly conscious unaffectedness, to an ideal "plain reader." . . .

The Movement poets shared a common attitude, modest and craftsmanlike, to the craft of verse itself. Many of them thought, like the American critic Professor Yvor Winters, of the idea poem as the expository poem: a situation is clearly presented, a judgment is made upon it, the reader is invited to agree with the poet's judgment. . . .

Yet these generalizations, though useful, have little to do with the poems of the Movement that one finds oneself remembering and still admiring: like the beautiful short early poem, "Winter Love," by Elizabeth Jennings. Only the rhyme "hurry" and "weary" and perhaps the tension of stresses which rhyme again forces on the word "snowflake" would enable a reader to date

that as a modern poem. Its substance would be at home in the Greek anthology or in a volume of Elizabethan or Caroline short lyrics. . . . I think the best poems of the Movement, like that one, . . . are poems which, even if starting from the topical, explore perennial situations.

G. S. Fraser. *The Modern Writer and His World* (London: Penguin Books, 1964), pp. 346–50

The Mind Has Mountains (the title is from a poem by Gerard Manley Hopkins) is an unusual and disturbing book. It consists of a series of poems which Elizabeth Jennings wrote as the result of mental breakdown, and while she was recovering in hospital. Most of them deal with her mental condition, with suicides, illusions, derangements, and hysteria, and all are written with the same kind of understatement usually associated with her work.

For all their grim subject matter, they are the poems of a quietist, of one struggling for the light of reason, and for some kind of release, in brilliant moments of lucidity. They have not the frustration of Clare, the high electrical passion of Hölderlin, or the torment and splintered coherence of Ivor Gurney, all of whom were touched by madness in one form or another. Their feet are on firmer ground, they are more analytical and less protesting, the people and the happenings they mention are minutely observed and assimilated. But they are very painful poems to read, largely because they do not concentrate on self-pity but rather on resignation and acceptance. Yet, for all their restraint, they are very self-conscious and may well mark a state in Elizabeth Jennings's development. Since they are poems of recovery they represent her triumph over adversity, but, in the end, she may well discard many of them for some lack the inner tension of her former work, and others read as drably as the unhappy condition they describe.

Leonard Clark. *Poetry Review.* Spring, 1967, p. 52

Looking at the whole collection [*Collected Poems*], there are immediately available qualities: the dedication of the craftsmanship, the serious, uncompromising honesty, the refusal of cheapness (although, on occasions, at the risk of preciousness). Miss Jennings has written over the years a severely limited poetry, sometimes pressing a stiflingly orthodox form to the limits of its suppleness and intelligence, but remaining on the whole within its conventions, with both creative and damaging consequences. Her mind works in exact congruence with the poetic structure she uses, so that this pared, precise, aesthetic yet morally sensitive structure seems to reproduce the structure of her thinking and feeling.

It is this exact congruence which is both her strength and weakness: in her best poems, the marriage of form and substance is compelling, but elsewhere the absence of *tension* between the two results in a passive, abstract and energyless verse. Since she seems deliberately to inhibit her feeling, the

tension which can't be got from a conflict of substance and technique can't come, either, from the structure itself: instead, she strips down its elements to create a cool, pure space, within which the idea moves like a dance, always coaxed through with precise fidelity, allowed to emerge logically and as it were inexorably through the balanced working-out of rhythm, in a process which can never be quickened or short-circuited.

Again, this has a strength and weakness simultaneously. The poetic structure stays strikingly faithful to the experience it negotiates, but only at the expense of a drastic limitation of range and feeling, of a kind of monotonously aesthetic arrangement of small items into ironic apposition, paradox and aptness so that wistful "truths" may mutedly emerge.

Terry Eagleton. *Stand.* 3, 1968, p. 69

[Elizabeth Jennings's] central preoccupation [in *Collected Poems*] is not, then, with technique—something she takes for granted and uses skillfully. Nor does she worry much about "what poetry is"—she recognizes that it is essential to her, and it would be solipsistic in her to tease out the reasons for this urgent necessity. If anything, poetry is a mode—perhaps the only mode—she has of reaching beyond her individual isolation and discovering relationship. When her poems are aesthetic in preoccupation, she is usually exploring the applicability of art to experience, or its vital relationship with experience. Most often her preoccupation is with suffering of various sorts, with loss, and occasionally fine celebrations of love. She is a poet . . . who is still developing, within her chosen formal confines, towards a new clarity. She began as a love poet and has developed into the poet of complex relationships. Her best poems are not descriptive but exploratory of relationships. She seems at present to be putting aside rather than losing her earlier, more complex language, her aesthetic frame of reference, and her for a time obsessive mental hospital themes for direct confrontation with relationships. Some of the recent poems strike one as sentimental: simplifications rather than lucidities. But the best of them are her finest work to date, rediscovering meaning in apparently overused words, finding a linguistic spareness and clarity which render the poems direct and to the heart. The stylistic transition is almost complete.

Love, shadows, the mind, silence—all these are basic themes in her work. Time, too, obsesses her, and time rather than space is the poet's plane, through which she moves. Her images from nature are usually explicated, allegorized. . . . The experiences of loss, the uncertainty of continuous identity, unfulfilled or frustrated longing, the ephemerality of landmarks and time-marks, a failure to find roots and security, to establish permanent relationships with nature or with human beings, have become the burning concerns of Miss Jennings's poetry. "It is acceptance she arranges," one of the recent poems says—perhaps this is the almost sacramental function of her art, expressed earlier in "Visit to an Artist." There the host and wine,

the offering—which the experience underlies, validates, sanctifies—are most real and impart an ultimate validity to the poetic act.

"It was by negatives I learned my place." Without ever having been a genuinely confessional poet, Elizabeth Jennings has explored more territory in more depth than most poets writing today. Her recent work continues with the preoccupations of the earlier, but moves always closer and closer to bedrock. It is strange for a poet, at the outset of a career, to foresee intellectually most of the problems which will become realities for her later on. To have kept course and cut always deeper as she went and goes is a remarkable achievement.

> Margaret Byers. In Michael Schmidt and
> Grevel Lindop, eds. *British Poetry since
> 1960: A Critical Survey* (South Hinksey:
> Oxford, Carcanet Press, 1972), pp. 82–84

Despite [its] declarations, the Movement had less success in the 1960s [than in the 1950s] in upholding reason and commonsense. This was particularly noticeable in the case of Elizabeth Jennings, who, notwithstanding the occasional reflection that her Movement stance might be too cozy and evasive ("Big questions bruised my mind but still I let/Small answers be a bulwark to my fear" as she self-accusingly puts it in the 1955 poem "Answers"), had for much of the 1950s fitted neatly into a program for order, lucidity and reason. The opening, title poem of *Song for a Birth or a Death* (1961) made clear that she had changed, and was now about to allow violent and disturbing visions into her works:

> Last night I saw the savage world
> And heard the blood beat up the stair;
> The fox's bark, the owl's shrewd pounce,
> The crying creatures—all were there.
> And men in bed with love and fear.
>
> The slit moon only emphasized
> How blood must flow and teeth must grip.

It was personal experience, as well as susceptibility to the work of Hughes, Plath and even American Beat poets like Ginsberg, which brought about the changes in Jennings's work in the 1960s. Many of the poems in *Recoveries* (1964) and *The Mind Has Mountains* (1966) describe the ordeal of a nervous breakdown in the early 1960s. "Pain," the first poem from a "Sequence in Hospital," is typical of the confessional mode in which Jennings relates this experience:

> At my wits' end,
> And all resources gone, I lie here,

> All of my body tense to the touch of fear,
> And my mind,
>
> Muffled now as if the nerves
> Refused any longer to let thoughts form,
> Is no longer a safe retreat, a tidy home.

Other Movement poets have also found that the mind is not "a safe retreat, a tidy home," and that reason lacks the power to deal with the full range of human experience.

> Blake Morrison. *The Movement: English
> Poetry and Fiction of the 1950s* (New York:
> Oxford University Press, 1980), pp. 279–80

It is customary, at least as far as Elizabeth Jennings's early career is concerned, to group her along with those poets of the 1950s who, since 1956, have generally been classified collectively as *The Movement,* or *the Movement poets.* There is no doubt that during her studies at St. Anne's College in Oxford in the years 1945–49 Elizabeth Jennings got to know Kingsley Amis and also came into contact with Philip Larkin and John Wain. The convictions that this Oxford-educated representative of the Movement shared with the group are expressed in her poem "Modern Poets," which Kingsley Amis published in 1949 in the anthology *Oxford Poetry.* There she declared:

> This is no moment now for the fine phrases,
> The inflated sentence, words cunningly spun,
> For the floriate image, or the relaxing pun
> Or the sentimental answer that most pleases.

Elizabeth Jennings, who is the only woman in the Movement, and is furthermore a practicing Catholic . . . wanted to write on topics that did not interest the others. When John Press asked her in 1966 whether her customary inclusion among the Movement poets had been "helpful" or "justified," she replied: "At the time I think it was positively unhelpful, because I tended to be grouped and criticized rather than be grouped and praised." In this interview she stressed that while there were affinities between the various members of the group, this unity, as far as it existed, was "not a contrived one." . . .

Maybe Elizabeth Jennings found her own poetic voice and her own thematic earlier than the other Movement poets of the 1950s, although she concedes that they also developed their own individual style. In any event, her individual poetic voice is to be found in her first collected volume of poetry, entitled just *Poems*

This poet from the island kingdom, who at the age of thirteen was spellbound—"elevated in wonder"—in the contemplation of the stars in the night

sky, has been inspired to write a poetry of that creative energy, which is embraced in the warmth of love, that, as one might say, comes down from heaven, and which is likewise contained in the roar of the sea and the moan of the winds—a poetry that is true in the smallest details as well as in its depiction of the great phenomena of Nature, the wonders of the Cosmos, for she fell under the "Spell of the Elements."

Through the range and the universality of her themes Elizabeth Jennings has realized her dictum that "Poetry" is "the long finger of time." She offers us not only a picture of the contemporary world, but has also increasingly occupied herself with the past, devoting herself more and more to myth, as her poems "Orpheus" and "Persephone" and others show, while facing the future, "a wanderer still among those stars," with quiet confidence.

<div style="text-align: right">

Erwin A. Storzl. In James Hogg, ed. *On
Poets and Poetry,* 5th series (Salzburg:
Institut für Anglistik und Amerikanistik,
1980), pp. 62–63, 96

</div>

JEWETT, SARAH ORNE (UNITED STATES) 1849–1909

Miss Jewett's character, and her purpose, which, of course, is an expression of her character, may be reasonably regarded as having also influenced, more perhaps than she knows, her choice of material. A woman of refined tastes, she naturally feels strongly the usual feminine distaste for crude tragedy and sordid detail. A writer anxious to win respect and liking for a special class in the community, she naturally chooses for emphasis the scenes in which it appears to the best advantage. There must, of course, be shade as well as light in the picture, but the reader is made to feel that if any of her people are hard-hearted and selfish,—they are seldom worse than that,—they are to be pitied as victims of hard conditions rather than blamed.

<div style="text-align: right">

Charles Miner Thompson. *The Atlantic
Monthly.* October, 1904, p. 494

</div>

It was precisely this union of what was at once so clearly American and so clearly universal that distinguished her stories, in the eyes of both editor and reader, as the best—so often—in any magazine that contained them.

Her constant demand upon herself was for the best. There were no compromises with mediocrity, either in her tastes or in her achievements. It was the best aspect of New England character and tradition on which her vision steadily dwelt. She was satisfied with nothing short of the best in her interpretation of New England life.

<div style="text-align: right">

M. A. DeWolfe Howe. *The Atlantic Monthly.*
August, 1909, p. 280

</div>

This intimacy with her material—an intimacy that sometimes approaches identity in the Wordsworthian manner—is shown at once as the reader looks out through Miss Jewett's eyes upon the face of the country. She never bores us with more description for description's sake; nor does she seem to care very much about imparting information concerning New Hampshire hamlets and the coast of Maine. Least of all does she deem it necessary to catalogue beast, bird, and flower in its appropriate season. These things are all there. New Hampshire hillsides and Maine islands with their appropriate flora and fauna are as clear to see as though one had lived among them; but the grace of Miss Jewett's art appears in the fact that her references to them come to the reader almost as reminders of past experience. Instead of bald description, she chooses the gentler ways of reminiscence.

<div style="text-align:right">Edward M. Chapman. The Yale Review.
October, 1913, p. 161</div>

Miss Jewett's stories are always stories of character. Plots hardly exist in her work; she had little interest in creating suspense or in weaving threads of varied interests. She presents people through mild desultory action, in situations seldom dramatically striking. The people interpreted live simple, inconspicuous lives, without great tragedy attending them, but made significant through the little things which, by reiterated irritation and pain, tax the spirit of endurance and shape character. The wisdom won from slow pondering of life is found on the lips of her men and women. And these persons speak the very thoughts and the very language of their region; thoughts expressed in a shrewd, picturesque, colloquial fashion, in a dialect directly true to life, not a romantic make-believe. But the best part, perhaps, of her delineation of these people is in her record of their silences.

<div style="text-align:right">Martha H. Shackford. Sewanee Review.
January, 1922, p. 23</div>

There is a stark New England Sarah Jewett does not show, sordid, bleak, and mean of spirit. She looked at nature in its milder moods, and at mankind in its more subdued states of tenderness and resignation. But she did not live in an unreal paradise. She was aware of all these aspects, she simply did not emphasize them. If the Almiry Todd you generally see is the humorous figure sitting heavily in the stern of a dory, you are not allowed to forget that forty years before her young heart had been filled with an impossible love; and although she had since been handled with the commonplace marriage and death of her fisherman husband, it has not dimmed her memory.

Miss Jewett does not generally deal with the central facts of existence. You do not remember her characters as you do the atmosphere that seems to detact from their rusty corduroys and the folds of their gingham dresses. Her township was on the decline, and to her eyes it was a place where emotion was recollected in tranquility.

<div style="text-align:right">F. O. Matthiessen. Sarah Orne Jewett
(Boston: Houghton, 1929), p. 149</div>

With this equipment—the close, sensitive knowledge of the people she wrote about, and the awareness of a larger world of culture and refinement—she went tranquilly about her work, carefully selecting whatever served her personal needs and her literary purposes. "Écrire la vie ordinaire comme on écrit l'histoire," she copied out of Flaubert and pinned on her secretary. That is what she tried to do. But to write about ordinary lives as if one were describing the great pageant of history one must see in ordinary lives something of the grandeur and significance of historical events. That gift, so far as a certain limited kind of ordinary life was concerned, Miss Jewett had. . . . *The Country of the Pointed Firs,* a kind of miracle in pastel shades, varying between a delicate humor and a delicate pathos, is, within its limits, the finest American achievement in its *genre* and a work of which we can be permanently proud.

> Granville Hicks. *The Great Tradition* (New
> York: Macmillan, 1935), pp. 102–3

Much of Miss Jewett's delightful humour comes from her delicate and tactful handling of this native language of the waterside and countryside, never overdone, never pushed a shade too far; from this, and from her own fine attitude toward her subject-matter. This attitude in itself, though unspoken, is everywhere felt, and constitutes one of the most potent elements of grace and charm in her stories. She had with her own stories and her own characters a very charming relation; spirited, gay, tactful, noble in its essence and a little arch in its expression. In this particular relationship many of our most gifted writers are unfortunate. If a writer's attitude toward his characters and his scene is as vulgar as a showman's, as mercenary as an auctioneer's, vulgar and meretricious will his product for ever remain.

> Willa Cather. *Not under Forty* (New York:
> Knopf, 1936), p. 84

The conventional judgment of Miss Jewett's fiction places her short stories on a higher plane than her novels. But the characters that make the deepest impression come from the longer narratives, for the obvious reason that she has had more time to establish them. As a matter of fact, her significance must be judged in terms of quality, not quantity. In both her short and her long narratives her achievement was to paint imperishably the decaying grandeur of New England, symbolized in the towns, once great seaports, which live on memories of former splendor. As is natural, her characters are largely feminine, members of families whose men have died or gone away. In the cities they are content to live on quietly, existing on narrowed incomes, cheered by the homage of other women who cherish them as the representatives of a more virile civilization. In the country, they have a harder struggle with the menace of the poorhouse ever present. This harder aspect of life is not so often stressed as it was later, but Miss Jewett did not shirk its presenta-

tion. She felt, however, that misery or lack of breeding was not necessarily of supreme importance in fiction.

<div style="text-align: right">

Arthur Hobson Quinn. *American Fiction*
(New York: Appleton-Century, 1936),
pp. 329–30

</div>

This little corner of Maine, with the islands northward, was Sarah Orne Jewett's peculiar realm. She travelled early and late,—as a girl to Wisconsin, and three or four times abroad, as far as Athens,—but she always returned to Berwick and the house and garden where she had lived as a child and where she died. . . . In this "country of the pointed firs," with its long frost-whitened ledges and its barren slopes where flocks of sheep moved slowly, she found the Dunnet shepherdess and Mrs. Todd, the herbalist, and many of the scenes and persons of her finest stories,—stories, or sketches, rather, light as smoke or wisps of sea-fog, charged with the odours of mint, wild roses and balsam.

<div style="text-align: right">

Van Wyck Brooks. *New England: Indian
Summer* (New York: Dutton, 1940),
pp. 352–53

</div>

At the university Willa Cather had accepted the principles and admired the methods of Henry James, who seemed to her to do flawlessly what she wanted to aim at. In 1907, when she met Sarah Orne Jewett and her friends in Boston, the young plainswoman felt that she, "an American of the Apache period and territory," might come among them "to inherit a Colonial past." That past was all round them, throwing across them the shadows of memorable events. Though only the echoes of New England's heroic days were to be heard in Sarah Orne Jewett's stories, they were clear and fresh and simple in their versions of the actual life of the present which lay under that past. Miss Jewett's advice had more effect on Willa Cather than the example of Henry James. The elder woman knew from the first that the younger would sooner or later write about her own country. She must write about the life of the plains as it was, and make a way of her own in which to write. Willa Cather later found her way, in *O Pioneers!* (1913), by trying to tell the story of her characters as if she were talking about them to Miss Jewett.

<div style="text-align: right">

Carl Van Doren. *The American Novel,
1789–1939* (New York: Macmillan, 1940),
pp. 282–83

</div>

As a rule, Miss Jewett artistically avoided all extremes. Her New Englanders are neither saints nor sinners: they are pleasantly human, with their worst fault a slight avariciousness. Many find it much "easier to understand one another through silence than through speech"; if they go beyond this sensitivity, they merely revert pathetically to their childhood or seek refuge in soli-

tude. The farm-women endure grinding poverty and hard work, but the unpleasant details of their existence are glossed over.

Babette May Levy. *The New England Quarterly.* September, 1946, pp. 351–52

Her major interest . . . was centered in the misunderstood people of her countryside. The growth of the railway had gradually forced the small shipping villages into decay, and the young and the energetic had left for the West or for the manufacturing cities. Life for the remaining few was dull and inactive. Miss Jewett saw the decline in progress and the lives of the old people slowly ebbing away. . . . Thus, she was well aware that many of the summer residents held in contempt the elderly inhabitants of the little seaside villages and inland farms and regarded their lives as inconsequential, if not queer. To Miss Jewett their lives appeared otherwise. Her keen perception of human qualities penetrated beneath the oddity in dress and manner of these secluded folks and perceived the sterling qualities of character that were hidden from the casual observer.

Eleanor M. Smith. *The New England Quarterly.* December, 1956, pp. 474–75

It is in these stories-within-the story that the major themes of the book [*The Country of the Pointed Firs*] are most fully registered; the narrator's part is simply to describe the teller and the situation, to provide the occasion, to give notice of the passing of time—and, at the beginning and end of the book, to lead the reader sympathetically into the legended world of Dunnet Landing and safely, if equivocally, out again when the time comes. Jewett, it might be said, solved her inability to master a Jamesian art of the short story by abandoning it.

Or she apprehended at last that what she had to tell was one story and one story only, one that all the earlier ones lead up to or provide analogies for. Another way of describing the achievement of *Pointed Firs* is to say, in these terms, that she had finally discovered within her materials—anecdotes, incidents, scenes, special cases—the essential legend that was there for her to tell, and found for it an appropriate form.

Warner Berthoff. *The New England Quarterly.* March, 1959, p. 36

Given her temperament, and also the time and the place in which she was born, Sarah Jewett's literary bearing is inescapable. She stands on the fringe of an era whose codes and rituals enthrall her, regrets its air of spiritual depletion, and determines to bring back to life—as far as pen and ink can— the simplicity and the strength that once underlay its daily existence. To this resolve she adds the aim of correcting the ludicrous misimpressions that cityfolk have of countryfolk. These gigantic tasks of revival and interpretation she takes upon herself out of devout love. Steeped in the ethos of her native

past and present, she sees no need to distort or embroider. "Real life's interestin' enough for me," she has Abby Harran say in "A Native of Winby." So she paints no extravagant pictures, nor does she interject grotesques for their own sakes.

Meticulously and without ado, Miss Jewett, with an art perhaps too serene to appeal to the uninformed city audiences she had in mind, superimposes upon each other two worlds—one lost and one misunderstood. The most frequent criticism of her rendition is that she screens out of it all the coarse and contemptible actualities of life in favor of a too pervasive charm and refinement. . . . A close examination of Sarah Jewett's world will reveal that none of these criticisms is entirely justified. She does not uniformly dulcify her scenes, nor do her people invariably demonstrate redeemable virtues. She knows the ugly underside of nature as minutely as its happier facets, and she seldom shrinks from presenting the despicable in human motives or behavior.

> Richard Cary. *Sarah Orne Jewett* (New
> York: Twayne, 1962), pp. 30–31

Yet out of the rhythm of her life there emerged the pattern of a larger order which became a primary fable for the revelation of her country world in its totality, a fable in its essence of the impact of experience upon the receiving mind, relating the individual to the community in which he lived, the village to the world beyond. This narrative design was that of the outsider who makes a visit to a village or country locale and has a series of brief experiences. This visit pattern, present in many of the stories and in all of the longer fiction except *The Tory Lover,* made its earliest important appearance in *Deephaven* (1877); evolving slowly for many years, it received its most commanding, definitive statement in *The Country of the Pointed Firs* (1896). The time limitations imposed by the visit fitted the modest dimensions of her personal experiences, and the presence of an outside observer provided additional justification for the practice of defining character in terms of external circumstances.

> Paul John Eakin. *American Literature.*
> January, 1967, pp. 518–19

The central dilemma in Sarah Orne Jewett's life and in her fiction during the early 1880s continued to be the conflicting attractions of rural and of urban life. . . . By mid-decade, she seems to have arrived, therefore, at a practical solution to the conflict. Her personal integration of the conflicting worlds of the country and the city is reflected in the ending of *A Country Doctor* (1884). In that work, Nan Prince, the protagonist, is also able to achieve a creative integration of her urban, professional self and her rural identity. The question is also a central issue in Jewett's other novel of the period, *A Marsh Island* (1885). The rural-urban conflict culminates in her classic story, "A White Heron," where it found its most complex and moving expression. . . .

Sarah Orne Jewett's masterpiece, *The Country of the Pointed Firs* (1896), was completed at the height of her career. It is a consummation of the thematic and formal concerns that had shaped her work since *Deephaven*. In her preface to the 1925 edition, Willa Cather ranked it as one of three American works destined for literary immortality, the other two of which were *The Scarlet Letter* and *Huckleberry Finn*.

The work is structurally innovative. More unified than a collection of sketches, yet looser than the traditional novel, it is difficult to classify by genre. Its "plot," like that of *Deephaven*, is held together by a unique structural device: the presence of two women at a series of events and the growth of their relationship with one another. Unlike *Deephaven*, however, *The Country of the Pointed Firs* does not suffer from clashes of mood between the women and their environment. On the contrary, a correspondence exists between the moral and physical landscapes in the work that at times takes on symbolic significance.

Aesthetic control is maintained throughout. There is consistency in imagery and clear thematic counterpoint. All of this contributes to the work's remarkable effect of aesthetic integrity, one important reason for its claim to the honor of "masterpiece."

Themes that emerged as central in earlier works are important here as well: the tensions between rural and urban, and among independence, isolation and community. But in this work they assume greater significance. In *The Country of the Pointed Firs* they are expressed as an underlying conflict between time passing—both of history and of personal relationships—and time transcended. The narrator seems to be seeking some meaning beyond the fleetingness and fragility of human bonds. The seacoast area of Maine is for her an example of a community that transcends individual barriers. This model of transcendence is the most important moral idea presented in the work; it brings to final synthesis Jewett's continuing theme of isolation and community.

At the same time and on another plane, Dunnet Landing, the remote hamlet the narrator visits, seems to be a town on the edge of historical time. Mrs. Todd, the town herbalist, practices rites that belong to lost ages. Other characters hearken back to timeless states; one speaks of a land that exists between the living and the dead, between time and eternity. Mrs. Todd and her ancient craft—indeed the entire "country of the pointed firs"—provide an alternative that transcends the powers of Western industrial "progress" that Jewett has seen encroaching on her pastoral sanctuary.

While in earlier works Jewett's tone was optimistic, in *The Country of the Pointed Firs* it is elegiac. The preindustrial, matriarchal community of Dunnet Landing is dying, and in what is undoubtedly her greatest work Sarah Orne Jewett grieves its passing as an historical entity, but celebrates its eternity as a way of being.

Josephine Donovan. *Sarah Orne Jewett* (New York: Frederick Ungar, 1980), pp. 49, 99–100

A chief source of the enduring appeal of Sarah Orne Jewett's *The Country of the Pointed Firs* is its presentation of a world which seems to us touchingly coherent. Unlike the fragmented, incongruous worlds we find in modern literature (and in our own experience), in this work Jewett presents a world which seems mythic in its stability, integration, and consequent warmth. However, the book does not seem sentimental, because of Jewett's unflinching presentation of decay, loss, and imminent death in the coastal Maine town she calls Dunnet Landing. Numerous characters remark that things have been going down-hill there in recent years; Captain Littlepage calls it "a low-water mark here in Dunnet" since the port lost its commercial significance. Irritation, thwarted potential, unresolved grief, eccentricity bordering on madness, are all explicitly part of the book's emotional atmosphere. Nonetheless, the book achieves a poignant elegiac quality while preserving a social and natural world which Jewett plainly felt was lost to her, as certainly we feel it is lost to us.

<div align="right">

Marcia McClintock Folsom. *Colby Library Quarterly.* 18, 1982, p. 66

</div>

Sarah Orne Jewett incorporated the perceptions of women's literary realism developed by her predecessors in the local color school to produce an authentically female-identified vision of her own that moved beyond their limits. Hers is a woman's vision of transcendence, but it is no longer one of naive optimism as seen in Stowe or in the early Phelps. There is in Jewett a recognition of the troubles that concern the late Phelps and Freeman—anxiety over an encroaching male dominion, the "burglars in paradise." With Jewett, neither the anxieties nor the burglars prevail. The encroachment is resisted, the female sanctuary preserved.

But Cooke's intuition that evil and alienation may exist even in this country setting is incorporated in Jewett's final synthesis. Jewett adds to the gallery of strong and authentic female characters developed by the local colorists. But their optimistic doctrine of salvation by works is tempered in the late Jewett by a growing sense of the fragility of any human endeavor. We have seen where Elizabeth Stuart Phelps's hopes for women's fulfillment were blocked in the 1880s. Jewett was able to transcend this impasse by establishing a vision of a supportive community of women, sustained by a kind of matriarchal Christianity, and by traditions of women's lore and culture.

Yet Jewett's was not an escapist Utopia. She did not leave stubborn and painful realities behind. It is indeed the tension between the "fallen," alienated world of real experience and the transcending vision of a supportive, fulfilling community that gives power to her greatest work. The sense of elegy which so many have remarked in Jewett's work is a lamentation for the tentative nature of human accomplishment—and especially for the artificially limited possibilities of emotional and intellectual development afforded women—but at the same time there is a celebration of the transfiguring

moments in which the human community—again sustained primarily by women—coheres. . . .

Sarah Orne Jewett created a symbolic universe which expressed the longing of late-nineteenth-century women that the matriarchal world of the mothers be sustained. By her use of "imaginative realism" she carried the themes of the earlier local colorists to a powerful and complex conclusion.

Josephine Donovan. *New England Local Color Literature: A Women's Tradition* (New York: Frederick Ungar, 1983), pp. 99–100, 118

The reputation of Sarah Orne Jewett is in bad straits. Since her death in 1909 she has been shabbily served in all three of the retrospective categories: F. O. Matthiessen's biography is gravely derelict in quotidian detail, in literary evolvement and appraisal; Annie Fields's volume of collected letters is malformed and undocumented; and Clara and Carl Weber's bibliography is a construct flawed by imprecision and omission. These books have reigned unquestioned as the standards of scholarship on Jewett's life and works from as long ago as 1911 until as recently as 1978 when Gwen and James Nagel ably rectified and updated the Webers' section on secondary studies. It is deplorable that only in short analytical and interpretative essays can one find saving grace, pointedly those by Charles Miner Thompson, Edward M. Chapman, A. M. Buchan, Warner Berthoff, Hyatt Waggoner, and Paul John Eakin. It is deplorable because, in the eighth decennium after her death, Sarah Orne Jewett still stands paramount among prose expositors of the Maine scene, its people, and their ways. That may sound a prodigal judgment until one tries calling up any single novel about Maine that can be placed beside *The Country of the Pointed Firs* as a full-fledged peer. Few will disavow Jewett's text as the acme of its kind.

Richard Cary. *Critical Essay on Sarah Orne Jewett* (Boston: G. K. Hall, 1984), p. 198

JHABVALA, RUTH PRAWER (POLAND–GREAT BRITAIN–INDIA) 1927–

Prawer Jhabvala is a Pole, who was educated in England and is now married to a Parsi architect, living in Delhi. She has already published three novels—*To Whom She Will, The Nature of Passion* and *Esmond in India*. Khuswant Singh, in his article "After the Raj," written for the *New Statesman* review of *Commonwealth Literature,* has included her (along with R. K. Narayan) as among the two outstanding novelists of India. They both write in the same comic-ironical vein, calling up a picture of middle-class life.

She does not write only about the nouveau riche as Khuswant Singh says, but also about the lower middle class, as in *To Whom She Will,* and her latest novel, *The Householder.* . . . Mrs. Jhabvala has not been long in India, but she has an extraordinary insight into middle-class life, and gives graphic, detailed, and intimate pictures of ordinary domestic and family life. She is best when mildly satirical.

Maya Jamil. *Venture.* March, 1961,
pp. 84–85

Lois Hartley has reported that R. Prawer Jhabvala told her in 1964 that her next novel would have more Europeans in it than any of her previous works, that in fact Europeans would be the main characters. *A Backward Place* has now appeared, the seventh of Mrs. Jhabvala's books to be published in the United States. It is natural that Mrs. Jhabvala, born in Germany of Polish parents and retaining her British citizenship in Delhi, would come at last to present the urban Indian world which she and other Europeans inhabit.

It is natural too that many of these Europeans and some Indians also should regard India as a "backward" nation. . . . But backwardness, like so many other human qualities—or, more precisely, human judgments of qualities—is relative. Because Mrs. Jhabvala understands this so well and because her art is equally free of sentimentality and sarcasm, she produces satire that is distinguished by intelligence, accuracy, and compassion. She knows that the Indian character is flawed by ignorance, superstition, vanity, and occasional crudity and cruelty. But the incursion of Western "cosmopolitanism" into Indian urban centers has produced a hybrid society marked by European forms of coarseness, selfishness, sterility, meanness, and meaninglessness. Her characters, Westerner and Indian alike, experience love at some level, real pain, moments of triumph or exultation, moods of despair; they practice deceit and deception: they are aware of hunger, humiliation, the terror of aging; they struggle back from illness and lonely defeats. Each is centered on his own private desires and ambitions, but occasionally one is capable of listening to another out of a sense of the other's deep feelings. Though they contradict each other in their mutual estimates of one another, everything each says is true because all things are true of India—as of mankind generally.

Carl D. Bennett. *Literature East & West.*
Spring–Summer, 1966, pp. 164–65

Ruth Prawer Jhabvala's novels of the contemporary Indian scene have for some time now been earning her a considerable reputation in England. The case has been different in America. Whether it is that India can never be quite the subject of interest to America it seems, eternally, to be to the English or whether it is that the leisurely play of character and observation native to this sort of sensibility falls on resisting ears here (I do not for the

moment believe it), or some other thing, it is hard to tell, but she is much less known in this country. . . .

Given a hint of its background and of its Anglo-Indian theme, it is easy to mistake *Travelers* for a sociologically weighty book. It is a weighty book all right, in the way that psychological richness is always weighty. As for the sociology, there is no trace of it, except for the sort that comes naturally and implicitly to any novel worthy of the name. Mrs. Jhabvala's art is high comedy, woven in the most sober fashion into the characters of her protagonists. That comedy is in their very nerve and bones, but the lives they are aware of, the lives they have, are another matter: the life they know, each of them, is full of a terrible seriousness. . . .

Mrs. Jhabvala's power as a novelist is compounded of an extraordinary mixture of sympathy, economy, and a wit whose effects are of the cruelest sort: the sort that appears to proceed not from any malice of the novelist, but from the objects of her scrutiny. . . .

The reader who takes [*Travelers*] up will encounter for himself the wit and grace of mind that lies at the core of it.

<div style="text-align:right">Dorothy Rabinowitz. The New York Times.
July 8, 1973, pp. 6–7</div>

It must be about two years since I first came across a book of R. Prawer Jhabvala's short stories, *An Experience of India,* and made my own personal discovery of her. She has of course been widely and deservedly noticed for years. Perhaps inevitably, those who wish to praise her bracket her with Forster; but her virtues spring from a very different cultural tradition. Ruth Jhabvala is Polish. Her sensitive observations concern behavior that is coarse, often grotesque; and the flesh of her people has juice in it. And she deals with several of the themes Angus Wilson handles in *As if by Magic.* She understands the precise nature of a Guru's hold upon his followers. . . .

Ruth Jhabvala gives us the texture of India itself; on a clear day, for instance, in a boat when all the squalors of the city—stale puddles, rotting vegetables, and people waiting to die on the sidewalks—are suddenly purified and washed away. Without reservation, *A New Dominion* is a magnificent novel.

<div style="text-align:right">Elaine Feinstein. London.
August–September, 1973, pp. 149–50</div>

[*Heat and Dust*] is a short novel but an extraordinarily rich one. Surprisingly, in such an economical and well-planned work, it proliferates with minor characters, of whom the most delightful is the collapsed-blanc-mange-like Harry, an Englishman trapped in the service of a native state. The social comedy is as funny and as sympathetic as it is in Mrs. Jhabvala's earlier novels, even though she has departed from her more usual theme of middle-class Indian life. Here we are insiders in two worlds at once. So deep in Mrs. Jhabvala's knowledge of India and so sharp her imagery that we seem to see, with eyes which are both English and Indian, into two societies which coexisted but

were virtually invisible to one another. They are linked by the account of the pilgrimage, begun by Olivia and completed for her by the narrator, into a life of isolation in the mountains. The area which they reach lies above and beyond the conventional India and is one in which most of their compatriots would be unable to penetrate.

<div style="text-align: right">Brigid Allen. (London) Times Literary Supplement. November 7, 1975, p. 1325</div>

The achievement of Ruth Prawer Jhabvala as a literary artist is distinctive and rather limited at the same time. It is distinctive because she has cultivated and demonstrated the qualities of a literary artist which are her own and which naturally emerge from a social and cultural milieu peculiar to herself. However, her distinction is modified and narrowed down by the rather limited quality of her literary achievement, which is, in part, the inevitable result of her choice and, in part, the artistic outcome of her creativity. This peculiar paradox of her attainment as an artist is, in a way, rooted in the environs of her literary effort, and is also coextensive with the range and quality of her fiction.

Ruth Prawer Jhabvala has sometimes been described as an "inside-outsider," and other times as an "outside-insider." These apparently contrary expressions are more meaningful than mere high-sounding literary labels since they impinge on her special personal and literary situation. She is essentially a European writer who has lived, and continues to live, in India and who has given to her experience of life and society in India an artistic expression. From the European literary vantage point she may seem an "outside-insider," while from the Indian artistic view-point she seems an "inside-outsider." Both these positions show a basic change of perspective, though one of the two is inherent in her literary situation. . . .

The theme of East-West encounter in Jhabvala's fiction has social, cultural and spiritual dimensions. In the social context Indians and Europeans meet, fall in love, get married, and face either mutual dissonance or familial friction. In the cultural context they face the problems of adjustment of diverse backgrounds. Jhabvala is, of course, very much concerned with the problems of European men and women trying to get adjusted to Indian society and its mores. In the spiritual context she portrays Europeans who are fascinated by gurus, the torch-bearers of India's ancient spiritual heritage. The spiritual element in these gurus may be bizarre or genuine, yet the charm they hold for Europeans is unmistakable. The relationship between Indians and Europeans is thus varied; it has at least three prominently portrayed dimensions in Jhabvala's fictional world. Jhabvala as an artist in the realms of fiction thus seeks three kinds of reality, the social reality, the cultural reality, and the spiritual reality. She is pre-eminently a novelist of domestic life, its joys and sorrows, its harmony and friction, its fulfillment and frustration. Since she is concerned with a money-civilization in its domestic setting, she seeks to present the material reality which is significant in the metaphysic

of her art. However, this metaphysic in her cosmos has also a spiritual dimension partly revealed in the charm that Europeans feel about the gurus, the inheritors of India's spiritual glory. In this way Jhabvala's quest for the material reality is supplemented by, and harmonized with, her search for a spiritual reality. This dual quest finally leads to the basic unity of her art in which the real and the ideal, the material and the spiritual are harmonized into a unified vision of her art.

Vasant A. Shahane. *Ruth Prawer Jhabvala*
(London: Arnold-Heinemann, 1976),
pp. 11–12, 30–31

It is interesting to trace Jhabvala's complex relationship with India from its beginnings to its end, to arrive at some idea of its intensity, and to study the process by which, in eight novels and numerous short stories, Jhabvala had transmuted her difficulties with India into art. Her move from India to America, and her present way of life—traveling every year in a circle that links her with members of her family in Britain, India, and the United States—are factors that set up an altogether different set of problems and literary concerns for readers of her work. For one thing, she no longer writes as a European isolated in India but as a European who has found herself a home in a Western city of immigrants, many of whom have undergone experiences similar to her own. While still leading by choice a professional life of comparative isolation and quiet, her work in cinema has widened her experience of people and of places. She is no longer the inexperienced young writer who went to India in 1951 but a mature and skilled author who has developed theories and perfected techniques for the pursuit of her art. . . .

A method of approaching Jhabvala's American fiction could certainly be found through a study of her models: the practitioners of the novel whom she regards as masters of the art of fiction. Jhabvala's literary models, recognizable in her early work as including Jane Austen and Henry James, also include European masters of the novel and the short story. Her borrowings are, however, so skillfully submerged in the imaginative creations of her later years that they are virtually unrecognizable as themselves. The part played by Henry James in shaping her responses to America may well have similarities with that played by E. M. Forster in relation to Jhabvala's Indian novels and stories. In *Heat and Dust,* the single novel in which she treats British rule in India, Jhabvala takes Forster as her principal guide, evoking a British Raj of the 1920s and an Indian Raj of the 1970s that are equally destructive of human personality, hypocritical, restrictive, and false. In *A New Dominion,* a novel in which she examines the workings of an Indian chauvinism in independent India, she writes in the shadow and in the spirit of E. M. Forster's *A Passage to India.*

Equally valid in attempting to understand her aims and assess her achievement would be a study of the early novels and stories through which she first "got to know" India. For example, a study of her novel *A New*

Dominion, and especially of its characterization of the sinister, smiling "Swa-miji" (the most memorable of Jhabvala's portraits of Indian holy men) illumi-nates the character of Leon Kellermann, the anti-hero of *The Search of Love and Beauty.* Similarly, a study of Jhabvala's fictional methods could not pass over her skilled presentations of unreliable narrators, especially Lee in *A New Dominion* and the unnamed woman narrator of *Heat and Dust:* charac-ters who, interesting in themselves, can now be seen also as preliminary sketches for the full-length portrait of Harriet Wishwell, the naive narrator of *Three Continents.*

A careful consideration of Jhabvala's work as a whole also shows that from 1960 onward, when she wrote her first screenplay for James Ivory and Ismail Merchant, her best work in both genres has sprung from a fusion of fictional and filmic elements. In addition to her European, Indian, and Ameri-can experience, she draws today in writing her novels and short stories on a dazzling repertoire of cinematic techniques, learned in the process of trans-lating her own fictions and those of other outstanding writers to the screen.

A chronological reading of her novels and stories highlights the extraor-dinarily comprehensive way in which Jhabvala's writing—of which her "American" fiction forms as yet only a very small part—could be said to represent and exemplify the social and artistic concerns of the twentieth century. Between 1951 and 1976 she provided an example of the displaced expatriate writers who have been so much part of the postwar international scene. She now illustrates that contemporary phenomenon, the unhoused itinerant author who writes out of a "free" and unhoused state.

<div align="right">

Yasmine Gooneratne. In Robert L. Ross, ed.
International Literature in English: Essays on the Major Writers (New York: Garland, 1991), pp. 387, 389–90

</div>

The parallel lives of Ruth Prawer Jhabvala are unique in achievement among contemporary authors. As a writer of fiction, she has published a stream of well-regarded novels and story collections, including *Three Continents, Out of India* and the Booker Prize-winning *Heat and Dust.* In a more public sphere, she has transformed classic novels—*A Room with a View* and *How-ards End,* among others—into intelligent screenplays (for James Ivory and Ismail Merchant) that routinely are nominated for and sometimes win Acad-emy Awards.

Jhabvala's fiction, often set in India, where she spent much of her adult life, has been compared to the subtle literary explorations of a Jane Austen or Henry James. Her latest novel, *Poet and Dancer,* however, is set in today's Manhattan and seem more akin to the work of I. B. Singer, a blend of the ethereal and the earthy. It is a slender novella-length work made to seem longer by large typeface and lots of white space. The style is simple and unadorned, as though anything more ripe would overwhelm Jhabvala's

briskly told cautionary tale of innocence and experience, passion and paralysis. . . .

The author, it must be said, seems less willing to create nuanced male characters than she does female characters. And her subplot . . . tapering off into irrelevance, turns out to be more of a tease than an integral part of the . . . story.

But *Poet and Dancer* easily rises above such minor failings because of its insight into character. Peter's plea that "you can't blame a person for his nature" is merely the self-serving version of a minor character's more trenchant insistence that "there are good people trying to do all right, and there are bad ones that pull them down and win."

Jhabvala herself resists such easy moralizing. She is too aware of the frailty in everyone for that. At the heart of *Poet and Dancer* is the vague yearning for fulfillment that shapes all her characters.

> Dan Cryer. *Newsday.* rpt. *Austin American-*
> *Statesman,* March 21, 1993, p. E7

JOHNSON, PAMELA HANSFORD (GREAT BRITAIN) 1912–81

Pamela Hansford Johnson is one of those several respected and respectable English novelists today whose position could almost be charted with a slide-rule, midway between literature and the insubstantial best-seller, high thinking in very plain words, the perturbing presence of saints and sinners encased reassuringly in a daily world that all of us in the quasi-intelligentsia can recognize, everything terrible made nonchalantly readable and nothing much resolved. Her new novel, *An Error of Judgment,* stretches the resources of this genre pretty far. . . . Miss Hansford Johnson was so talented when she confined herself to what might roughly be called conjugal problems. It is her new pre-occupation with the cosmic ones that does not become her.

> Anne Duchene. *The Manchester Guardian*
> *Weekly.* July 26, 1962, p. 11

A petite and puckish Englishwoman, Pamela Hansford Johnson, like her husband C. P. Snow, has earned a considerable writer's reputation on both sides of the Atlantic. Her latest work [*Night and Silence—Who is Here?*], also petite and puckish, is an academic novel in which Lady Snow undertakes a merry lampoon of the donnish dilemmas and moral stratagems which have occupied Sir Charles in such famous fictions as *The Masters* and *The Affair.*

The basis of her story, as in so many of his, is the politics of academic preferment. But what a difference! . . .If the locale is American, the comedy itself is distinctly British, in the Dickensian tradition of broad caricature with interludes of farce. . . . These, one and all, are people whose predicaments

can be enjoyed without our feeling the slightest compulsion to believe in their actuality. It is likely, nevertheless, that Lady Snow will be said to have written a roman à clef. She and her husband recently enjoyed a term as joint Visiting Fellows at Wesleyan University.

<div align="right">Carlos Baker. The New York Times. July 28, 1963, p. 4</div>

The novels of Pamela Hansford Johnson are the basic material of the publisher looking for a well-made, intelligent novel that stands the chance of a book club selection and will go well with a public that wants its fiction neither light nor heavy. It is the kind of fiction that keeps the novel going in between the valleys and the peaks. It handles ideas in terms of the people involved; it rarely aims at abstractions, and the conflicts themselves are those one encounters in daily life. Emotions are of course played down; there are few powerful climaxes, few dramatic intensities that would weight the novel unduly. In brief, the novelist makes no attempt to exceed the tight, well-controlled world over which he or she is a master. [1963]

<div align="right">Frederick R. Karl. A Reader's Guide to the Contemporary English Novel (revised ed. New York: Farrar, Straus and Giroux, 1972), p. 275</div>

Miss Hansford Johnson is a novelist of varied method and versatile talent. The most impressive of her earlier works, The Humbler Creation, dealt seriously with the problems of an English clergyman and his abominable wife. In later books she has turned to comedy, commenting directly upon sorrow and silliness rather than depicting them plain.

Her latest book, Cork Street, Next to the Hatter's, contains, as all good comedies should, a portion of pathos and of the materials of tragedy. It also contains a much larger portion of commentary on society and morals. Morality is the author's chief concern, and her position is one that might be described (and is indeed described by her more odious characters) as reactionary. She espouses with spirit views at present unfashionable, at least among novelists.

For one thing, she believes that vice and crime are boring and that sinners are generally commonplace people, and to prove the point she produces a marvelously wicked and marvelously insipid murderer. But while sin is dull, she believes that the incessant portrayal of depravity in books, plays and films can make the public depraved. The main part of her story concerns a play, unspeakably disgusting, obscene and blasphemous, written by one of her good characters in an unsuccessful effort to prove to himself that there is some limit to the amount of repulsiveness the public will swallow. . . .

She is not merely wholesome, she is didactic. And her conservatism is irascible; she might with exactitude be called an Angry Middle-aged Woman. But her weapons are up to date. She writes with superb urbanity, and her

wit reeks of sulfur. *Cork Street, Next to the Hatter's,* the reader may feel, is very much what might happen if Mary McCarthy were suddenly to embrace the *Weltanschauung* of Louisa May Alcott.

It is a novel of flashing juxtapositions, contemporary depravity displayed against timeless virtue.

<div align="right">

Laurence Lafore. *The New York Times.*
November 14, 1965, p. 61

</div>

Pamela Hansford Johnson is untypical in that she deals with situations that are untypical, "unfictional" in the sense that they have not the neat, ready-made air of so many chosen by novelists. Her lovers, for instance, are not necessarily young or attractive; people of many varied ages can love, depend on one another, desperately need one another; good people may need bad ones, worthy people be infatuated with wastrels (from Sid in *The Trojan Brothers* to Helena or Charmian in the trilogy, the decent person obsessed with the indecent, with the totally unworthy object of love, is a recurrent figure in her novels). Even in the first novels, when almost inevitably it was a case of boy meeting girl, there were no conclusions, solutions, or happy endings. Even when she was still at an age to be moulded by it herself, Miss Hansford Johnson could stand outside the ideas of her time and background, criticize the sort of education (or lack of it) that made a girl totally unready for marriage.

The ability to "belong," atmospherically, to a particular place, class or age-group never means that she is confined to the standards of that particular group: time and distance become integral parts of the action, so that, while one has a vivid sense of a particular moment, one has an equally strong sense of a later judgment, a distancing and re-living of what happened then. Even in the earliest books everything was seen as fluid with possibilities, the present opening into the future; life was never a series of compartments, fixed and sealed by a particular situation. Things were always relative, becoming unfinished, open to every sort of possibility.

<div align="right">

Isabel Quigly. *Pamela Hansford Johnson*
(London: BC/Longmans, 1968), p. 8

</div>

Miss Hansford Johnson's latest novel [*The Survival of the Fittest*] is, paradoxically, vaguer in outline and more naked in feeling than her earlier books. It is a deliberate attempt at a large novel—408 pages of the emotional lives of a large group of people, in detail, from the 1930s to the 1960s. . . . Pamela Hansford Johnson is one of the very few living (or indeed dead) women novelists who is able to describe sexual happiness in women with interest or conviction. . . .

Miss Hansford Johnson does seem a novelist of whom it is meaningful to say that she is creative. Not particularly inventive—her invention often flags, and the much-praised comic novels seem to me often put together with effort rather than glee. But in the trilogy, and the patient, serious novels of

the Fifties—*An Impossible Marriage, The Last Resort, The Humbler Creation*—she seemed able to create solid dramatic life, independent of her own circumstances. She seemed to write out of an emotion which appeared then one of her own primary responses to life—a greedy curiosity, detached yet sympathetic, about other people's passions. As the novelist-narrator of *The Last Resort,* her most finished and immediately passionate book, said of herself, she is aware of the automatic slight sexual tensions by which almost anyone relates, or refuses to relate, to almost anyone else at any given moment, and can construct from these clues a complete image of their needs, drives and fates. She specializes . . . in odd loves—a rich spinster's marriage to an ageing homosexual, a vicar's sister-in-law's physical passion for a drunken journalist, a 70-year-old's passion for an amorphously subservient young man. She also specializes in the quiet creation of real pain—and both love and pain are made sympathetic and solid through the ability to recreate the basic obsessions which produce them.

As a primary impulse, curiosity, rather than confession, is a great advantage to a novelist, but it follows that to be intensely personal about the non-autobiographical is easier than to confront or recreate one's own world. *The Last Resort* is so good partly because the sexually happy novelist and the created heroine in pain are both real, and the novelist's curiosity is part of the plot and focus for it. In *The Survival of the Fittest* attention is dissipated, not concentrated, by movements of memory, shifts of point-of-view between several characters, all partial. The book is slightly shy. On the other hand, the sense one occasionally had in the past that art was laboring to cover the effect of artifice, that a character was converted by pure will from a grotesque to a person, is missing. . . . The book as a whole, if without urgency and solidity, has gained in ease and certainty. Miss Hansford Johnson is still a finished and unassuming artist.

<div align="right">A. S. Byatt. *The New Statesman.* May 17,
1968, pp. 654–55</div>

Any critic faced with the task of defining the nature of Pamela Hansford Johnson's novels finds that, like many of her characters, it belongs to a class that is extremely difficult to label—too good to belong to the middle range but not good enough to belong among the really great. Yet, if, as Iris Murdoch firmly maintains, "it is the function of the writer to write the best book he knows how to write," there can be little doubt that Pamela Hansford Johnson has more than fulfilled her function as a writer. Throughout her long career as a novelist she has demonstrated the seriousness of her commitment to her art and explored those aspects of life that touch upon the experience of most readers with a great deal of lucidity and humaneness.

Looking back over her production it is possible to see how she began writing with a great deal of interest in social problems and the interaction that takes place between people in a small community. Gradually her interests seem to have developed from the general toward the particular, and in the

novels that she wrote during the 1940s she analyzes man's romantic nature and his tendency to fall in love with an unobtainable dream. In the novels of the 1950s she becomes more preoccupied with the workings-out of an enduring relationship and turns her attention to the circumstances that cause it to disintegrate. Truly successful relationships are rare in her fiction and suggested rather by a promise of their being so than by their actual attainment. *Catherine Carter* and *The Honors Board* are the only two novels in which she describes a successful union between her major characters. In general her real gift lies in her ability to analyze pain and loss. *The Humbler Creation* is an example of how well she is able to convey such emotion and relate it to moral necessity. The novels of the 1960s seem to be characterized by a preoccupation with the problems of good and evil. Ironically enough, two of the novels where she is most clearly concerned with the evil in man are ostensibly comic in mode. Her most recent novels are her most assorted since they seem to represent a return to forms and ideas she has tackled before and wishes to approach once more in depth and with maturity. Thus *The Survival of the Fittest* is a mature version of the early panoramic novel; *The Honors Board,* a well-balanced study of the personal relationships in a closed community; and *The Holiday Friend,* an exploration of the individual's ability to suffer through passion. *The Good Listener* is reminiscent of *The Unspeakable Skipton,* with its cadging hero, and it also indicts the society that permits such people to flourish.

Ishrat Lindblad. *Pamela Hansford Johnson*
(Boston: Twayne, 1982), pp. 175–76

JOHNSTON, JENNIFER (IRELAND) 1930–

The most balanced view of [the Big Houses] is to be found, not surprisingly, in fiction rather than in history books, and though it is not, I presume, the author's direct intention, the novels of Jennifer Johnston can act, if not as defense counsel, then as mitigation pleader, in chronicling the latter days of the unceltic twilight. Somerville and Ross had recorded seismographically early tremors, especially in *The Real Charlotte,* but they could not bring themselves to face the end of their world directly. Miss Johnston, with the knowledge that their ideals while not specifically concerned with the good of an independent Ireland were real (and, as it turned out, helpful to the raw self-conscious country), can present their case without special pleading and do it skillfully so that even the most rabid Nationalist is left with a sense of compassion at their eclipse and relief that some of their achievements survived. . . .

[Miss Johnston's] most recent novel, *How Many Miles to Babylon?,* deals with the last full-bloom of the Big House rose. It is the personal narrative of

Alexander Moore, whose career as an officer on the Western Front is about to be ended rather unusually with his execution for the murder of a private soldier. "Because I am an officer and a gentleman they have not taken away my bootlaces or my pen." His memories range over his childhood—the largest part of his short life—and we recognize it as the childhood of MacMahon and Prendergast: private education in a gracious house in a landscaped demesne, a mother happily trapped in upper-class aspic, and a father, wise, gentle and weak. Also, the solitary son of the Big House makes his only friend in Jerry Crowe the stable boy and there is some nice comedy as each influences the other; Jerry's pleasant coarseness is smoothed down while Alec learns of Granuaile and the Sean-Bhean Bhoct. In spite of rancorous opposition from the mother the friendship continues until each is driven to enlist. Alec by his mother's insistent need for sacrifice and Jerry so that he may learn to be a soldier for Ireland in the coming struggle.

It is here that Miss Johnston's writing takes a great leap forward. Her description of the recruits' leavetaking, the botched suicide attempts, the ultimate madness of the trenches is a miraculous piece of imaginative reconstruction. Her writing about the war is as good as Graves's and Remarque's though in a quite different way. One set-piece which, without being obtrusive is screaming to be anthologized, is a hilarious account of a fox-hunt in Flanders with Jerry, Alec and another expendable youngster, Lt. Bennett. Jerry leaves the line to find his missing father, establishes that he has been killed (necessary this for his mother's pension) and on his return is sentenced as a deserter. Alec in a last act of friendship shoots him while in his mind dance the words of "The Croppy Boy," surely the most haunting of the '98 ballads and one that he originally learned from Jerry. At least one Anglo-Irishman did something to even the score and in death was not divided. The novel reads like the tying-up of the last threads of a tapestry. It is a statement of reconciliation—the closing of an account besides being an expression of fine anger at gross wastage.

It is likely that Miss Johnston will fare further now; she never staked out a claim on the Anglo-Irish territory. Her technical ability, her handling of dialogue, her tact when writing about youth and age, her detachment, her humor, her quality of imagination, above all, her economy—the longest of her books is only 117 pages—all mark her out as a writer who may someday become great. She is perhaps lucky that it is in their gothic decay that the Big Houses are most attractive. . . . She has helped to define the past they played in the Ireland of their time and their effects now. . . . I will be surprised if Miss Johnston continues to work this theme, but if she does, since harking back is *le vice Irlandaise,* her work will still have relevance and of course delight.

Sean McMahon. *Irish Press.* February 22, 1975, p. 32

Jennifer Johnston's third novel *[Shadows on Our Skin]* is a sophisticated account of a family in Northern Ireland during the present troubles. Seen

through the eyes of a schoolboy, the novel focuses primarily on his relationship with his family: a cranky, ex-Republican father, a fussy, protective mother, an elder brother home from England with the confused and dangerous notion that he will carry on in the "Movement" and emulate his father's "heroic" past. The boy is also drawn to a girl teacher from Wicklow whose own loneliness in Derry causes her to befriend him and then, to his dismay, to have a brief relationship with his brother, ending for her in a beating by his "friends." In the background of these relationships lie the troubles of Derry: gunfire, soldiers in the street, ambushes, house searches and arrests. It is one of the book's achievements, and an indication of its skill, that public distress and private stress impinge on each other, the one an extension and a definition of the other.

The novel's taut narrative portrays the world of self and family, conflict within and without in a compelling manner. Jennifer Johnston has a good eye for detail, for the accurate depiction of concrete reality that gives grit to the novel and gives the reader confidence in her work. There are several moments of fine realized writing capturing, for example, the tensions of the boy's home or the warm delicacy of his feelings for the schoolteacher, and there is the release and powerful evocative picnic to the old fort of Grianan that lifts mythically above the whole surrounding landscape of Derry and from which they look down at the fortified city.

Projecting her vision of things through the consciousness of the boy, the novelist accepts the limitations that follow as the story reveals his progress through innocence into experience; events grind at his innocence, even as he deals bravely with them and tries to capture some of the experience in words. This novel of adolescence is mercifully free from the familiar traumas of Irish Catholic youth. In a quite brilliant and contemporary way Jennifer Johnston frees herself and her characters from intrusive social, religious and political contexts, from the nightmare of history, although they too belong to the shadows that are present.

Maurice Harmon. *Irish University Review.*
Autumn, 1977, pp. 298–99

[In *The Old Jest*] Jennifer Johnston treads easily and gracefully through the Ireland of the 1920 "troubles," avoiding all pitfalls of Irish caricature and period charm. Nancy is just 18, an orphan living with her Aunt Mary and her grandfather, old General Dwyer, on the coast about half an hour's train-ride south from Dublin. Although in love with 26-year-old Harry, she is intelligent enough and realistic enough to know that he is unsuitable and in any case is in love with someone else. She teases Harry unmercifully—about his job as a stockbroker, about his conventional clothes, about his lack of experience with girls. When she goads him into admitting his virginity, he calls her "a dreadful little brat" and she retorts. "I'll tell you one thing. I'll have done it by the time I'm twenty-six." Nevertheless, she remains potty about him,

wishing she could "see how his body looks when he is naked, coming stark out of the sea, shining with wetness."

Nancy's unsatisfied romantic longings are focused on a mysterious stranger whom she meets one day on a lonely stretch of beach. She wonders if he could be her father, who perhaps had not died in India after all. After several meetings, during which she learns that he is an active revolutionary, a republican idealist who believes that it is necessary to kill for the cause, she falls under his spell and agrees to deliver a message for him in Dublin. Unwittingly, she has a hand in the murder of some British soldiers at the Curragh—and in her hero's death when a party of British soldiers finds the two of them together on the beach.

The Old Jest is a quite delightful novel about growing up. While the old General sits in his wheelchair scanning the railway line with his binoculars and singing snatches of hymns like "Swift to its close ebbs out life's little day," Nancy experiences unrequited love and witnesses violent death. Aunt Mary, who comes back from a race meeting one evening "gaily intoxicated by several wins, several drinks and the undemanding good humor of her friends," talks seriously for once to Nancy: "I've been happy, calm and useless most of the time. The great thing to remember is that there is nothing to be afraid of. You learn that as you get older. We live in a state of perpetual fear. All the horrible things we do to each other, all our misunderstandings, are because of fear." What Nancy learns, as she grows older during the events of August 1920, seeing her admired revolutionary shot and killed after he'd thrown down his own weapon, hearing that her "beautiful" Harry is going to get engaged to the tiresome girl whose father is going to "develop" the village, is that "you can always choose, and then . . . you've no one to blame but yourself." The strength of *The Old Jest* lies in its delicacy, in its restraint, untypically Irish qualities which make Jennifer Johnston's books so satisfying: no lip-service here to "My Dark Rosaleen."

John Mellors. *London Magazine*. December,
1979, pp. 131–32

"Profoundly moving," "magnificent," "totally absorbing," "marvelous," "noble"—I read these quotes from British reviews of *The Christmas Tree* and I thought well, perhaps it won't be so bad. And I was right, Jennifer Johnston is a polished and talented writer, but in her latest novel she hasn't shown us a surprise, a quirk, a style all her own, a moment that sticks in the mind, or anything else that deserves those encomiums.

Constance Keating leaves Ireland when she is about 20 years old to go to London and try to be a novelist. After producing three novels, she is told by an editor that though she has some talent she doesn't want or need or love writing enough to produce a good book. She believes him, although she is a virgin in her 40's who has given up everything else in order to write.

On a holiday in Italy she meets Jacob Weinberg, a Polish Jew who has had his fingers broken by the Nazis so that he could not play the piano like

his father. As Jacob puts it, he plays the typewriter instead. He writes funny books—a funny occupation for a man with his history.

Except for the fact that he calls Constance "Irish woman" and inclines toward what someone described as "cafe weltschmerz," Jacob is all right. I like him for saying to Constance after their first night together: "We won't set the world on fire. For a little while we will struggle to be a little content."

Mostly, people in *The Christmas Tree* say the expected things. Constance's mother says of her father, "He gave me everything I wanted and left me alone." She says that he was one of those men who "need women, but don't like them." Constance's father is, of course, remote, abstract in utterance, a bit bored and a bit at a loss in the role. Are there any other kinds of fathers in novels now?

Without Jacob's knowledge, Constance gets herself pregnant—an idea that is no better in a novel than in life. But no sooner does she deliver the baby, at the age of forty-four, than she discovers that she is dying of leukemia.

Now Miss Johnston's troubles start. While it is impossible to write about death without sentimentality—it is the one inevitable moment of sentimentality in our lives—this sentimentality must have weight, be drastic. Whatever originality there may be in a character who is dying in a novel, the author has to find it. It is depressing to write routinely about death: it puts everything in doubt if even *this* can't stir up something strong. To make death new might be said to be one of the obligations of fiction. . . .

Though we can't expect everyone in real life to die with powerful imagery, we do expect it in a novel. Death is the strongest image we've got, even stronger than love or hate, and if an author can't conjure with it, she ought to leave it alone. Please do not litter death.

Constance says she would like to "see the pattern" of her life, or in life. She makes quite a fuss about a Christmas tree with blue lights. Well, as Hemingway said, death might come on a bicycle, so I suppose it can come on a Christmas tree with blue lights too. It is one of those images, though, like the fog coming on little cat feet, that is too diminutive, too endearing.

<div align="right">Anatole Broyard. The New York Times.
March 31, 1982, p. 21</div>

The self-contained world that Johnston's fiction describes, the sealed spaces where the storyteller plots his fictions and maps his battle plans, is a world that bears significant resemblance to the separate, isolated, enclosed spaces that have so meticulously been described by women novelists writing about women: a similar atmosphere of exclusion and seclusion has been portrayed with clinical precision by Doris Lessing, Margaret Drabble, Susan Hill, Edna O'Brien, Barbara Pym, Jean Rhys and Elizabeth Bowen. The "woman's novel" predicates itself on the notion that social separateness is an *a priori* condition of the woman in contemporary society. Johnston's work seems to suggest that such exclusive status is not necessarily peculiar to women: the title of this essay ["The Masculine World of Jennifer Johnston"], then, is entirely inappropriate to her subject as I have described it: this world is not

masculine, not open, accessible, social, a world of action, but rather specifically feminine: closed, suffocated, lonely, and inward-turning. The apparent suggestion of these novels is that the *male* world is secret, sealed off, plotted by means of battle lines and codes, cut off by arbitrary divisions, checkpoints, military demarcations, that life is perceived to be a series of strategies and diversionary tactics to keep the enemy at bay and that privacy is a retreat to the "comparative safety of the trenches," while the more social, open stance submits the ego to constant scrutiny and observation. The metaphorical terms delineating this world are certainly masculine, but the world itself— and the condition of those who inhabit it—shares more with Virginia Woolf than with Anthony Powell. While the component elements of her world are certainly drawn from the little-boy games of playing war, which turn out to be the grown-up games of making war, it is not at all clear that the essential subject of this fiction has anything to do with masculinity or maleness. The metaphor of trench warfare, of warfare under conditions where one's loyalties are unclear and one's ultimate goal is held in question, of tracking the enemy through field glasses down the railway line, seems to hold as a kind of statement about the survival of human beings in general and of the literary artist in particular. Against the myth of Irish storytellers, the ebullient, social beings, at home amidst the hard-drinking and long-talking pub patrons, Johnston posits another kind of Irish voice—one that is not clearly even Irish but rather transplanted and misplaced, one that is neither male nor female (there is little difference in tone or style, even in subject matter, between Minnie MacMahon and Nancy Gulliver's tales and Alexander Moore's or between Joe Logan's poetry and Diarmid's battle plans), one that is distinctly separate from and aligned against its origins and impetus. In short, these do not seem to be stories that are told "naturally," that arise from shared assumptions between speaker and audience as to the efficacy of or the motivations for storytelling; rather, they seem to be bred in spite of the impetus to stop them, against the tactics of the enemy (the larger social intrusion) which would force these to be stories of another kind, to be tales of community rather than the lonely individual, stories of success rather than of stalemate, stories that are shared rather than kept secret. Instead, these narratives are told outside the time frame they delineate, are told from the perspective of an isolation that has been enforced (*How Many Miles to Babylon?* and *Shadows on Our Skin*) or by one that has been violated (*The Captains and the Kings, The Gates, The Old Jest*). They exist on a plotted space between the entrenched encampments of the enemy, in a figurative no man's land to which the reader has gained access by being an accomplice to the intrusion these stories resist, but to which they bear testament. That the common denominator of these fictions should be the activity of war suggests that they serve to explicate the further reaches of artistic alienation.

Shari Benstock. In Thomas F. Staley, ed. *Twentieth-Century Women Novelists* (Totowa, New Jersey: Barnes & Noble, 1982), pp. 215–17

The six short novels published by Jennifer Johnston since 1974 contain many popular culture and literary allusions important to the development of her characters. Most of these allusions are from the Irish tradition and define the psychology and stance of the major characters. This paper selects *How Many Miles to Babylon?* (1974), *Shadows on Our Skin* (1977) and *The Old Jest* (1980) for the purpose of examining the author's approach to characterization structured on various lyrics and legends integral to character development. In each novel the controlling lyric or legend is analyzed as a narrative device that gives depth to character through tradition, myth and other spiritual considerations.

Johnston writes what is traditionally considered the novella with emphasis upon specific portions of the major characters' lives. To this mode of fiction she weaves in the material of particular lyrics whose scope lends themselves to the sparse details, limited character presentation, and restricted content matter of the novella. In addition, the lyric frequently includes legendary material appropriate to the timeless themes and events that constitute and define a culture. The result of Johnston's various techniques and content matter is a short novel centered on character or characters of greater depth and scope than the novella usually assumes. . . .

In an age characterized by electronic media and instant information, the fiction of Jennifer Johnston seems an anomaly. The careful crafting of scene and character has a quality associated with the past, another life. The careful reader can cherish the images and textures of her portraits that compose the restricted world of which she writes. The reader becomes an intimate of these people who convey their lives through memoirs, songs and legends. The technique of the first person narrator in control of every detail lends to the trust and trustfulness Jennifer Johnston instills in her readers. As the author conveys her understanding of the segment of the world she portrays, the reader grows to appreciate the faces and individuals of her fiction whose presence in the popular media is reduced to either a sensational headline or cliché.

<div align="right">Joseph Connelly. Éire-Ireland. 21, Fall, 1986,
pp. 119, 124</div>

Without exception Jennifer Johnston's works are, in one sense or another, concerned with "the Irish question," with the colonial heritage that divides the island to this very day. Some of Johnston's novels, especially *Shadows on Our Skin* and to a lesser extent *The Railway Station Man,* concern themselves directly with the present-day conflict in Northern Ireland. But her best books focus on the period just before or during the Troubles of the early 1920s (which led to the present partition of Ireland), to the extent that "as Jennifer Johnston plays and replays the refrain of ancient wrongs and haunted legacies, some critics have complained that the needle has stuck in the groove." In her variations on the same theme, however, and by mediating history

through myth, Johnston manages to create a vision that goes beyond the divided Ireland she depicts in her novels.

The past is important in all of Johnston's novels; its importance may be related to an awareness that the present divisions in (Northern) Ireland would not be so wide if people could liberate themselves from the past, and that the persistence of past experiences ("remember 1690" and all that) is at the root of the present problem. But for Johnston the past is fascinating as a notion in itself, and many of her characters find themselves disturbed by ghosts from the past. . . .

In spite of their historical interest, Jennifer Johnston's eight novels to date, and especially the later ones, should be read not only, and perhaps not first and foremost, as realistic novels. Her extensive reworking of Biblical and Shakespearian motifs indicates a very strong dimension of religious and secular myth in her works, and if anything her novels should be approached along those lines. This profound element in her works has the effect, not only of lifting the Irish historical experience onto the level of myth or legend, giving it a universal human significance outside of its limited naturalistic context, but more especially of turning the Irish problem itself into an extended metaphor which embraces all human relations. As such her novels present a sustained vision of individuals struggling against hope and against all odds in an uncaring world.

José Lanters. *Dutch Quarterly of Anglo-American Letters.* 18:3, 1988, pp. 229, 241

JOLLEY, ELIZABETH (AUSTRALIA) 1923–

Jolley operates with an inspired thrift. She returns unabashed to what she finds evocative and rich and not yet properly understood or exorcised. It's not just a matter of recurring characters, though that's part of it. Certain images, phrases, whole sentences, whole paragraphs, whole trains of events emerge again and again, in a manner which at first unnerves, like a half-remembered dream or a flicker of déjà vu, but which finally produces an unusual cumulative effect. She will take a situation, a relationship, a moment of insight, a particular longing, and work on it in half a dozen different versions, making the characters older or younger, changing their gender or their class, jailing or releasing a father, adding or subtracting a murder or a suicide; and these repetitions and re-usings, conscious but not to the point of being orchestrated, set up a pattern of echoes which unifies the world, and is most seductive and comforting.

What are these images, so industrious but never threadbare? The timbered valley, the rooster which has just lost a cockfight and is too ashamed to peck at its food, the old man who designs his wine labels before he has

even bought the land, the brick path made by the nine-year-old boy, unexpected rain coming into an open shed, the ribbed pattern of a vineyard, the old man whose "freshly combed white hair looked like a bandage," the child's mouth "all square with crying," the dream-like "lawns made of water," "the great ship with a knowledge not entirely her own," the half-eaten pizzas discarded in the laundry after a party, the person who crushes herbs in the palm of one hand and sniffs at them, the pile of firewood that the old husband lovingly maintains so that the housewife "only had to reach out an arm for it," the father who, when his small daughter writes a sentence, "kissed the page," the observation that "water is the last thing to get dark." These things are some of Jolley's icons.

Her characters, too, are part of this strange net of familiarity, and are held in it: that weird trio, always in paroxysms of laughter or rage; the mother who cleans houses for a living to support her feckless son and her anxious daughter—the daughter as often as not the narrator; mother and landlady or vice versa; pairs of sisters; pairs of lesbians, one much older than the older; migrants humiliating themselves to earn a living as salesmen; crazed European aunts who sob with homesickness and knit "wild cardigans"; harmless imposters, simpletons and idiots; couples ill-matched intellectually; savage nurses with vast bosoms and shameful pasts. And running through all six books is the strong connecting tissue of land, land, land: the obsession with the ownership of land, the toiling and the self-denial and the saving for it with such passion that denial itself becomes the pleasure; land that people bargain for and marry for and swindle for; land with strings attached; land to be deprived of which can drive people mad; land that flourishes, land that is sour and barren; land that is stolen from aging parents by children and sold; land with healing properties; land without which life has neither meaning nor purpose. "All land," say her characters over and over, "is somebody's land."

But how can I have got this far without mentioning that Elizabeth Jolley is a very *funny* writer? The novel *Palomino* is the only one of the six books which is devoid of her weird humor, and this is one of the reasons for its failure. Her humor is not cruel, though some people have used this word to describe the novel *Mr. Scobie's Riddle.* The bottom line, for Jolley, is love. What makes us laugh in her books is the friction between humor and pathos. She is droll, sly, often delicate; not averse to the throwaway line.

<div align="right">Helen Garner. Meanjin. 42, 1983, pp. 154–55</div>

If the message of [Thea Astley's] *A Kindness Cup* is that what is true cannot be written, the message of *Miss Peabody's Inheritance* is that what is written becomes true: the art of writing itself is at the heart of the plot, and the cause from which all effects spring. In this novel the act of "narration" is itself the main event of the "story"; it's a novel which tells the story of a novelist who tells a story to someone who, in the end becomes a novelist who will go on telling the story—and in that sense it is, like *A Kindness Cup,* a "feminine" text, open-minded, ambiguous, linguistically unstable, ironic

about its own authority and equivocal about the authority of writing in general. Like *A Kindness Cup*, *Miss Peabody's Inheritance* contains within itself another text (Diana's letters) which, like Astley's transcript-style court report, is demonstrated to be itself unreliable: Diana turns out to be, not a splendid and powerful and independent farmer, but a woman crippled and confined: to have been telling Dorothy not one "story," but two. . . .

Miss Peabody, at the end, is given her own chance to "crash through the barriers of the real." The late Mrs. Peabody and the late Diana Hopewell have "written" Miss Peabody into existence—her mother first by creating her physically and afterwards by determining and circumscribing the conditions of her life; Diana by literally writing *to* her and "creating" her on another level, as any writer creates a reader by positing his or her existence as a given in the act of writing at all (even if, as with diaries and shopping lists, the only "real" reader envisioned is the writer's later self). Diana also "writes" Dorothy by forcing her to summon a personality of sorts, simply in order to be able to answer the letters, to have something to say about clothes, or gifts, or love. But on the deaths of her two creators, her two writers, Miss Peabody comes into her inheritance; she moves from the position of the written to that of the writer, from that of the object to that of the subject, from narratee to narrator, from reader to author.

Kerryn Goldsworthy. *Australian Literary Studies*. 12, 1986, pp. 477, 481

"Readers," the tutor-writer Miss Alma Porch tells her Summer School group, "can piece things together in rapid [order]. Imagination in the reader must not be overlooked as endless pictures can fill the reader's mind from what the writer offers." And readers of Elizabeth Jolley's *Foxybaby* will do well to remember that expectation. A lot of the information they need is dextrously encoded, and there's scarcely a line in the book which isn't capable of two interpretations.

Foxybaby is the most philosophically intricate and coherent of Elizabeth Jolley's books. It is also profoundly funny, a mixture of ironies, verbal wit, send-up and slapstick.

Alma Porch has been appointed tutor to the school's Drama Group, whose members, all unskilled, are to mime the readings of her novel *Foxybaby* while it is video recorded, accompanied by percussion sticks and double bass in addition to the punk rock Alma wants. What she wants is of little importance since the school's principal, Miss Peycroft (significantly Alma first believed her name was Pencraft), has taken over both direction and interpretation. . . .

The Principal believes that "Miss Porch has conceived and is producing a drama which integrates conceptual performance, art, contemporary music and the theory of human communication through a series of statements created through the co-ordinated efforts of the participants." Miss Porch believes that she is possibly going to be very ill, or is going mad, and that they

are making nonsense of her work with their stupid mime; but she tells them that "The story will come together from these fragments. This is how a story is made, from little scenes and the thoughts and feelings of people."

Alma's work becomes a play within a play, the story of a touching, dreadful and enigmatic relationship between a father and his drug-addicted daughter and her drug-affected baby. This girl is the Foxybaby—one of them. There are three: the girl, Alma's novel, Elizabeth Jolley's novel. The characters in Alma's drama begin to affect the characters enacting them, and beyond and beneath all this the book becomes a brilliant examination of the creative process—the ways in which the initial theme has to be illustrated and enlarged (and inevitably damaged in the process) by the addition of scene and character and dialogue and exegesis. At this level of *Foxybaby* we see both the satisfactions and the miseries of the writer's trade—the convictions of worthlessness, the little peaks of arrogant self-satisfaction, the miserable jealousy of writers who are younger, cleverer, handsomer. And at the end of it all there's a sudden movement into a new dimension, a twist that brings it into the realm of the surreal and sends you straight back to the beginning—if not to read it again at least to make certain that you haven't been cheated. You haven't.

Elizabeth Jolley's triumph is that she can think deeply and report her thought mockingly in a tone that is intrinsically female and noticeably feminist. . . .

Alma Porch makes a statement about her own writing which we may reasonably take to be a statement about Elizabeth Jolley's. She says, "My course is entirely literary, concerned only with the drama of human conflict and the resolution of conflict and it has no commercial or political overtones. I am entirely ignorant of what is taking place in the markets of the world. And where I have written about a man hurting another man unnecessarily and deliberately, it has nothing whatsoever to do with homosexuals, politicians, governments, shire councils, education departments or the health scheme."

Barbara Jefferis. *Overland.* 103, 1986,
pp. 65–66

Institutions, schools, hospitals, and prisons are the most important locations in Jolley's novels and stories. In such places individuals find themselves in situations where they cannot escape the consequences of proximity and isolation. They are cut off from the outside world by physical distance—as in the bizarre summer school for creative writing in *Foxybaby*—or, as in the case of the elderly inhabitants of St. Christopher and St. Jude in *Mr. Scobie's Riddle,* by senility and incontinence. In *Milk and Honey* and in the isolated farmhouses of *Palomino* and *The Well* the restrictions are self-imposed, the products of diffidence, fear, of an irresistible need to exclude the confusing and menacing world of "ordinary" reality. Within these confines the characters may ignore all conventions, engage in practices that the "normal" world would frown upon, or, as in the case of the Heimbachs in *Milk and Honey,*

indulge their fantasies of being different, set aside, even special, with at times terrible consequences. Much of Jolley's fictional world is claustrophobic, its "reality" often that of a nightmare. Her characters are compounded of shrewd, acute observations of the quirks and foibles of human behavior and of a stylized artifice, suggesting to some readers the presence of an allegorical intention. Only in these somewhat abnormal settings—the school, the hospital, the prison, the farmhouse, the suburban dwelling tightly quarantined from quotidian reality—is Jolley's singular fictional world capable of existing. Even where such enclosures are not formally established by way of a particular setting, as for instance in Edwin Page's suburban house in *The Sugar Mother,* where there are no physical or psychological barriers, the tendency is, nevertheless, to isolate the characters against intruders, against anything that might impinge on their private, often fantasy-ridden existence.

My Father's Moon provides, in its boarding school and in its hospital, some clues about what experiences and environments contributed to the fashioning of Jolley's fictional world. . . .

Even though most of the novels and a number of the stories are experimental in shape and mode, the experimentation confines itself to fairly conventional and traditional bounds. For one thing, there is usually a firm sense of location and of characters within such locations, even when both prove to be the products of fantasy or hallucination. But within these boundaries there remains room for considerable structural ingenuity. For example, *Miss Peabody's Inheritance* and *Foxybaby* both contain sizable portions of a novel allegedly written by one of the characters. In *Foxybaby* there is the suggestion that the whole of the novel occurs within Miss Porch's dream when she falls into a light sleep aboard the airless bus bearing her to Miss Peycroft's establishment. *My Father's Moon* emerges as the most radical of the novels in its treatment of time and place. While the bulk of the action takes place during World War II in an English hospital, the narrative also reveals Veronica's experiences at boarding school, her unhappy attempts to bring up her illegitimate daughter without financial support from her family, and a vaguely specified and much later time that she may have spent in Australia.

One can argue that Jolley displays a keen interest in the question of the novel, a preoccupation of most contemporary fiction writers. But her experiments—if that is what they are—with the possibilities of the postmodernist novel are prompted by a characteristic of her writing that inevitably puts considerable difficulties in the way of longer structures. For Jolley is essentially a miniaturist. The most memorable aspects of her novels and stories come about when individuals find themselves in characteristic and telling situations, those where a world of possibilities and implications reveals itself by a significant glance or gesture. Even in a generally unsatisfactory work like *My Father's Moon,* there appear any number of these vignettes— a nurse chasing cockroaches with a knitting needle, the formidable matron surrounded by the trimmings of her office, and, best of all, a diminutive refugee from Hitler's Austria clicking around her English hosts' floors on

impossible high heels, leaving behind drops of her uncontrollable *monats-fluss*. Nevertheless, the very sharpness and immediacy of these images, their ability to sum up and to evoke economically and vividly a complex of possibilities and experiences, means that the novelist encounters considerable difficulties in achieving those linkages necessary in an extended narrative structure. Yet each of her works, even the least satisfactory, bears the stamp of an imagination both vivid and concrete, and most manage to find a fine accommodation between the commonplace and the macabre—the location of her individual voice.

<div style="text-align: right">

A. P. Riemer. In Robert L. Ross, ed.
*International Literature in English: Essays
on the Major Writers* (New York: Garland,
1991), pp. 373, 379–80

</div>

JONG, ERICA (UNITED STATES) 1942–

Erica Jong's first novel, *Fear of Flying,* feels like a winner. It has class and sass, brightness and bite. Containing all the cracked eggs of the feminist litany, her soufflé rises with a poet's afflatus. She sprinkles on the four-letter words as if women had invented them; her cheerful sexual frankness brings a new flavor to female prose. Mrs. Jong's heroine, Isadora Wing, surveying the "shy, shrinking, schizoid" array of women writers in English, asks "Where was the female Chaucer?," and the Wife of Bath, were she young and gorgeous, neurotic and Jewish, urban and contemporary, might have written like this. *Fear of Flying* not only stands as a notably luxuriant and glowing bloom in the sometimes thistly garden of "raised" feminine consciousness but belongs to, and hilariously extends, the tradition of *Catcher in the Rye* and *Portnoy's Complaint*—that of the New York voice on the couch, the smart kid's lament. Though Isadora Wing, as shamelessly and obsessively as Alexander Portnoy, rubs the reader's nose in the fantasies and phobias and family slapstick of growing up, she avoids the solipsism that turns Roth's hero unwittingly cruel; nor does she, like Holden Caulfield, though no less sensitive to phoniness, make of innocence an ideal. She remains alert to this world. . . .

Isadora Wing should be recognized as a privileged case, with no substantial economic barriers between her and liberation, and—by her own choice—no children, either. Edna Pontellier, the heroine of Kate Chopin's elegiac novel of female revolt, *The Awakening,* was a mother as well as a wife, and drowned herself to escape the impasse between her personal, artistic identity and her maternal obligations. Childless, with an American Express card as escort on her pilgrimage and with a professional forgiver as a husband, Isadora Wing, for all her terrors, is the heroine of a comedy. . . .

The novel is so full, indeed, that one wonders whether the author has enough leftover life for another novel. Fearless and fresh, tender and exact, Mrs. Jong has arrived non-stop at the point of being a literary personality; may she now travel on toward Canterbury.

John Updike. *The New Yorker.* December 17, 1973, pp. 149–50, 153

Erica Jong's first book of poems, *Fruits & Vegetables,* was one of those things rare in poetry: a new experience. I read these poems the way you watch a trapeze act, with held breath, marvelling at the agility, the lightness of touch, the brilliant demonstration of the difficult made to look easy. The poems were brief, swift, sure of themselves; they combined a cool eighteenth-century detached wit and a talent for epigram with a virtuoso handling of that favourite seventeenth-century figure of speech, the conceit, with body as fruit as body, poem as food as poem, man as Muse, Muse as Man. They did not pose as straight-from-the-soul confessions; rather they posed as artifacts, beautifully *made:* china figurines which were really Iron Maidens, the spikes hidden beneath the painted foliage. They were literate without being literary. They toyed with the reader, refusing to reveal the extent of their seriousness—whether they *meant* it. . . .

In *Half-Lives* the tongue is out of the cheek, at least part of the time. This book's cover is not lush pink but stark black. The wit is still there, but it's less like a flirtation than a duel. There's less fun, more pain. . . .

Jong's poetry is sometimes tricky, like a well-performed conjuring trick; the props show only occasionally. But a good magician's best trick is to leave some doubt in the minds of the audience: perhaps the magic is real, perhaps the magic *power* is real. And in Jong's best poems, it *is* real. We may find the fool more entertaining, but the magician is, finally, more impressive.

Margaret Atwood. *Parnassus.* Spring/ Summer, 1974, pp. 98, 104

Flying as a theme both introduces and ends the novel. Isadora Wing begins her "mock memoirs" by announcing her fear of flying; after treatment by six of the 117 psychoanalysts aboard the flight to Vienna, she remains "more scared of flying than when I began my analytic adventures some thirteen years earlier." In contrast, at the end of the novel, when Isadora sits in the bathtub in her husband's hotel room admiring her body and hugging herself, she realizes "It was my fear that was missing. The cold stone I had worn inside my chest for twenty-nine years was gone. Not suddenly. And maybe not for good. But it was gone." The novel, then, traces the stages necessary to progress from a fear of "flying"—literally and apparently figuratively, judging from this last quotation—to its elimination and subsequent replacement with a love of self. Isadora's last name, "Wing," underscores the significance of the novel's major theme and symbol.

Flying, for Jong, denotes literal flying but connotes creativity ("in the way that the word 'fire' was used by poets like Alexander Pope to mean sexual heat, creativity, inspiration, passion"), sexuality, and independence. Indeed, during the novel Isadora manifests, confronts, and rids herself of each of the three fears of flying. First, in her marriage to her second husband, Bennett, she overcomes the fear of creativity (and the habit of artistic dishonesty) so that she can fly, or explore the world of herself through poetry: "My writing is the submarine or *spaceship* which takes me to the unknown worlds within my head. And the adventure is endless and inexhaustible. If I learn to build the right vehicle, then I can discover even more territories. And each new poem is a new vehicle, designed to delve a little deeper (or *fly a little higher*) than the one before" (my italics). In her relationships with all of her men, especially with Adrian, she encounters the second fear of flying, consisting of those social or sexual inhibitions that prevent her from realizing her fantasy of the archetypal casual sexual union during which bodies flow together and zippers melt away. . . . Only with Adrian does she overcome her fear sufficiently to brave convention, bolstered by thoughts of "D. H. Lawrence running off with his tutor's wife, of Romeo and Juliet dying for love, of Aschenbach pursuing Tadzio through plaguey Venice, of all the real and imaginary people who had picked up and burned their bridges and *taken off into the wild blue yonder*. I was one of *them!* No scared housewife, I. I was flying" (my italics). Finally, in her relationship with herself, the most important relationship of the three, she fears confronting and being herself, living independently of men, without their approval. Thus when Adrian abandons her in Paris, he forces her to survive alone, to "fly." Terrified, Isadora describes the experience as "teetering on the edge of the Grand Canyon and hoping you'd learn to fly before you hit bottom."

Jong strengthens the theme and symbol of flying by conjoining it with myth—the classical myth of flight, the myth of Daedalus and Icarus. . . . The myth of Icarus similarly provided a structure for James Joyce's *Portrait of the Artist as a Young Man,* in which Stephen Daedalus became an artist like the "old artificer," the father he preferred to his real one, his priestly one, his national one. But Jong interprets the myth from the woman's point of view: Isadora Icarus spurns the "old artificer"—her real rather, her psychiatric fathers, her sexual and intellectual ones, refusing those borrowed wings or strings, refusing to be governed by old myths. She returns to the minotaur begotten by her two mothers and unites her divided self so that she can fly away from the labyrinth on her own wings.

Both the novel and its author have been misunderstood. Whereas Jong intended her work to "challenge the notion that intellectual women must be heads without bodies," instead her intellectual Isadora has been viewed, at least by one critic, as entirely body, "a mammoth pudenda, as roomy as the Carlsbad Caverns, luring amorous spelunkers to confusion in her plunging grottoes. . . ." Similarly, the intellectual author has herself been castigated because of Isadora's adventures. "To a lot of men," she admits, "a woman

who writes about sex is basically a whore. This assumption is not made about men who write about sex." Yet Isadora has heroically reconciled her formerly divided selves of mind and body, artist and woman. So the novel itself, as this study has attempted to reveal, weds its humorous and erotic content to a carefully controlled form—achieved through the myth of Daedalus and Icarus and the theme and symbol of flying.

<div style="text-align: right;">

Jane Chance Nitzsche. *Rice University
Studies.* 64, Winter, 1978, pp. 90–91, 99–100

</div>

In striking contrast to the fears of the body expressed in the fiction of Joyce Carol Oates, both novels by Erica Jong—*Fear of Flying* and *How to Save Your Own Life*—end with a kind of symbolic ritual baptism in celebration of the female body. . . .

As with all patterns of language, the writer after a while is imprisoned with a rigid enclosure of words in which, as in *How to . . .,* love is reduced to cunt and cock. We don't have a man and woman experiencing a warmly human relationship in which ultimately there is a sense of rebirth and a feeling of unity with the living universe (as that post-sexual love dialogue between Isadora and Josh would have us believe). There is only an impression of disembodied gentalia in which dripping cunt meets hard cock. . . .

In using this kind of sexual vocabulary, there is a sense of the writer beggared for expression and falling back on a vocabulary of male street usage. Woman needs a sexual vocabulary of her own—not one borrowed from men's street language. Such language is always self-limiting because it is more geared to voicing frustrations than fulfillment. . . .

The world of *Fear of Flying* and its sequel *How to . . .* offers us a heroine who appears to be far more intrepid and confident than any of Oates's women. Yet, ultimately, we see that Jong's Isadora Wing is as helpless as the most timid of Oates's women characters—in the common avowal that man has the power. True, Isadora's discovery comes out of sexual need and not fear, but her conclusion is basically the same as the one affirmed in book after book by Oates. Woman is helpless. Man is powerful.

<div style="text-align: right;">

Anne Z. Mickelson. *Reaching Out:
Sensitivity and Order in Recent American
Fiction by Women* (Metuchen, New Jersey:
Scarecrow, 1979), pp. 35, 46–48

</div>

Erica Jong is too fine a writer to care much about the accidental categories of the activists, categories that are a product of crippled imaginations. If Ms. Jong wrote a novel with a male protagonist-narrator, I would pick it up with respect and in the expectation of entertainment and even of enlightenment. If she said, in effect, "Men are like this," I would know her to be right. I trust her insight and her imagination. So far, in *Fear of Flying* and *How to Save Your Own Life,* to say nothing of her poems, she has presented the pains and occasional elations of the Modern American Female. With the confidence

in the exterior validity of introspection that marks the true poet (Keats for instance), she has extrapolated from her own life and her own fear an archetype that has had immense appeal, not only with the MAF, but also with the Modern European Woman.

In her new novel, Erica Jong has refused to capitalize on an outlook and an ambience that a less scrupulous writer could have exploited forever. She has gone to the British 18th century and contrived an authentic picaresque novel with a female protagonist. Her title *Fanny,* as well as the afterword, acknowledges a measure of indebtedness to John Cleland's erotic masterpiece, *Fanny Hill,* but the book is neither a pastiche nor a parody. It is, despite its allegiance to an antique genre, a genuinely original creation.

This brings me to an aspect of Ms. Jong's work rarely considered by her admirers or her detracters—its stylistic distinction. Style, indeed, must be regarded not as an aspect of a book but its totality: The intention, or pretension, to produce literature—as opposed to the book of a possible film—depends on verbal competence more than knowledge of "life," whatever that is. Ms. Jong's first two books are highly literate. They show mastery, or mistressy, of language; they depend for their effects on verbal exactitude and the disposition of rhythm. Subject matter apart, they are models of what orthodox, as opposed to experimental, fiction ought to be in this final phase of the century.

Ms. Jong's concern with language has led her to a genuine experiment— the composition of a full-length novel in a mode of English no longer in use, though still capable of expressing a modern sensibility. She has gone further than Joyce, who merely, in the "Oxen of the Sun" chapter of *Ulysses,* played brief passages in ancient style. Her eighteenth-century English is not a matter of restoring the second person singular, using tags like *prithee,* or slavishly following old orthography (*musick, logick,* capital initials for nouns). It is a matter of vocabulary, and also of rhythm. . . .

The female liberationists are going to be angry with Ms. Jong because she has not repeated what she has already done so well. Instead, Ms. Jong, who is a literary scholar and a specialist in the eighteenth century, has transmuted her learning into literature, a very laudable thing to do.

A few critics will condemn what she has done because the writing of eighteenth-century literature is the task of eighteenth-century men and possibly women, and there is nothing to add to what, by its nature, has already been completed. There are answers to that. The romantic movement began with a pastiche of the past—the Rowley and Macpherson fabrications—but also with "The Ancient Mariner," which used the vocabulary and metric of the old ballads. Most of our best-selling novelists write, because they know no better, in a calcified Victorian style. But Bernard Malamud, with *The Fixer,* wrote a nineteenth-century Russian novel that literature needed, and Ms. Jong may be said to have filled a gap in the great tradition of the picaresque novel. *Fanny: Being the True History of the Adventures of Fanny Hackabout-*

Jones had to be written, and Erica Jong was the right hermaphrodite to write or endite it. I am delighted to belong to her sex.

<div align="right">Anthony Burgess. Saturday Review. August,
1980, pp. 54–55</div>

Fanny focuses on the mother in the mother-daughter relationship. Writing her memoirs for the enlightenment of her daughter Belinda, now seventeen, the same age Fanny had been when forced into the world, Fanny vows to tell the whole truth. Much of her lore involves the traditional mother-daughter communication abut sexuality. Fanny neither abhors sex nor is reticent about it. From her earliest sexual experience—rape by her foster-father—she is able to distinguish between violence and true sexuality, between her love for her raper in his fatherly role and her despair at his brutality. Thus Fanny starts with knowledge that separates her from the stereotype of sexual woman as masochistic and insatiable, an image emphasized in the famous 18th-century pornographic novel *Fanny Hill,* which Jong's *Fanny* parodies. Unlike Fanny Hill, Fanny endures brutality and sadism only because she must in order to survive and to rescue her infant daughter who has been kidnapped. Unlike Fanny Hill, Fanny does more than repeat experience: she learns from it. Although Fanny's sexual adventures are as wild as any in picaresque novels, they are not told for their own sake; *Fanny* is a novel of development, like *Tom Jones.* Fanny learns about and rejects the 18th-century philosophies of optimism and rationalism as male views which would accept human brutality as part of "the best of all possible worlds." At the end of the novel, having like Tom Jones come into her patrimony, Fanny has also profited from specifically female wisdom in learning her mother's story. Because of this wisdom, she is ready to change the world; Jong's novel implies that if Tom Jones had been female, the world of our time would have been different. *Fanny* is truly comic in the novelistic tradition of belief in individual development as a means of integrating and improving society; its hero is saved from 20th-century cynicism only because of her female development. . . .

Jong's book with its unequivocally happy ending—a heterosexual woman happily married and with a child, able to initiate a life of usefulness in accordance with her own ideals—differs from the other books whose happy ending is at best implied. This difference stems from Jong's emphasis that women will succeed as women only in a world which values female wisdom. Her vision is of a new society achieved through the opportunity for full female development. Although Fanny achieves wealth and position as do male heroes, what she learns through her adventures is not how to achieve wealth and position; she learns the truth about human motivation and relationships, about the inextricable mixture of good and evil in the world. Fanny grows in moral perception as do the best of heroes; freed from the Oedipal struggle which Freud thought of as leaving women too weak for true moral develop-

ment, Fanny has the energy to achieve ethical adulthood. She learns *because* of being female, not in spite of it.

Mary Anne Ferguson. *Denver Quarterly.*
17:4, 1983, pp. 68–69, 73

The most complete celebration of open motion in recent women's fiction is Erica Jong's *Fear of Flying,* a novel which is in the main tradition of American picaresque fiction because it so strongly endorses both its heroine's suspicion of anything which would fix her in time and place and her quest for a life of "flying" into new forms of open space which liberate the self. Isadora Wing often feels confined by the social roles which her past experiences have imposed upon her and wants to "break loose" and "hit the open road." Resentful of her mother, to whom she feels tied by "a little golden chain," she marries Brian Stollerman, a person "always in motion." Eventually disillusioned with this marriage, she divorces Brian and marries Bennett Wing, who takes her on a wide assortment of travels to Texas, Heidelberg, Paris, and Vienna. Five years into this second marriage, she feels that she is at a "crucial time" in her life where she has to decide between a secure existence of being a wife and a mother or divorcing and resuming a radically unstable life of "musical beds." . . .

Fear of Flying, like most American journey books . . . boldly equates life with motion and stasis with death. Isadora Wing is moving toward selfhood because she has remained true to her last name and has overcome the fear of what her first name implies. Unlike Isadora Duncan, who was strangled when her scarf caught in the rear wheel of the speeding convertible she was riding in, Isadora Wing can travel without fear. No longer flying on borrowed wings, she can move toward the same protean world which has liberated Natty Bumppo, Huck Finn, Ishmael and scores of other American picaresque heroes. Finally cleansed of her past and floating "lightly in the deep tub," she has indeed learned how to "fly."

Robert J. Butler. *Centennial Review.* 31,
1987, pp. 312–13, 329

JORDAN, JUNE (UNITED STATES) 1936–

Those who come to June Jordan's poetry because of her reputation as a strictly political poet will be surprised at the large number of love poems and of her constant recourse to this genre. Setting aside political concerns, the poet indulges her erotic longing: "I can use no historic no national no family bliss / I need an absolutely one to one a seven-day kiss" ("Alla Tha's All Right, but," *Passion*). What is here a raucous assertion and celebration of sexual need has earlier—more often than not—been an expression of intense

vulnerability in love. Jordan's first collection of poetry, *Some Changes* (1971), is divided into four untitled sections, the implicit rationale for section two being love. This second section, arguably the richest in the volume, has an important long-term effect on Jordan's overall poetic development. . . .

If "Fragments from a Parable" is the dividing line between Jordan's early and later poetry, the crucible through which she had to pass to go from one to the other, then the outcome of this process can be briefly summarized by "Poem Toward the Bottom Line." The title itself proudly and punningly announces the poem's artifice—the interest in formal delight and structural control. The poem is a tightly-knit verbal web in which linguistic difficulty is counterpoised by artistic command. The poem as a whole is shaped by a movement from chaos ("we began here / where no road existed"), then "unpredictable around the corner / of this sweet occasion" to the climactic final line: "tenderly enough." The poem "enacts a wild event," while keeping the wildness firmly under artistic control and while reconciling erotic "disturbance" and "derangement" with "tenderness." In the context of *Passion* as a whole, "Poem Toward the Bottom Line" helps to provide an important contrast with the poems concerned with rape "Case in Point," "Rape Is Not a Poem," and "Poem About My Rights"). The theme of rape is not new; it goes back to the mother's rape in "Fragments of a Parable": "They made their rabid inquiry and left her." In *Passion,* Jordan needs a distinction between erotic force and rape. She must be able artfully to enter the sexual labyrinth and find that the bottom line is tenderness: "the body of your trusting me."

The achievement of trust is particularly powerful when seen from the perspective of the early love poetry where much trust, though ardently sought, was unobtainable. The overall shift in Jordan's poetic development from a negative image of love as desolation to a positive version of love as affirmation thus provides an indispensable context in which to read individual poems. The exploration of love is not an end in itself since it becomes a resource for a larger political vision. But the political rhetoric is the stronger for being grounded in Jordan's sustained, intimate engagement with love's anarchy. To use the final phase of the poem "From Sea to Shining Sea" in Jordan's most recent volume *Living Room,* the energy to overcome despair and to imagine political change, which turns the poem around, issues from the celebration of love as "a natural disorder."

<div style="text-align: right">Peter Erickson. *Callaloo.* 9, 1986,
pp. 223–24, 233</div>

June Jordan, like [Maxine] Kumin, opens herself to a different kind of order, one that will lead her beyond despair. The issue of reordering priorities forms the subject of one of Jordan's best-known poems, "From Sea to Shining Sea." The poem opens with the proclamation (promise or warning?) that "Natural order is being restored." One of the "signs" of this order, as Jordan meticulously informs her readers, is a pyramid of 104 pomegranates priced at eighty-

nine cents each. She later elaborates on some of the far-reaching extensions of this order:

> Designer jeans will be replaced by the designer
> of the jeans.
> Music will be replaced by reproduction
> of the music.
> Food will be replaced by information.
> Above all the flag is being replaced by the flag.

Implicitly she warns that symbol is replacing substance, that the ad man appeal to surface and style is driving out the real essence of the commodity. Old cultural connections with the sacred—costume, music, food, national symbols—have been distorted and emptied of meaning by the technicians and image makers. As a result, both the real value and the symbolic meaning of these items are severely diminished.

"Natural order" comes to mean in this poem anything that is contrived and set up to serve some purpose beyond its own essence. It is "not a good time" to be against the natural order, Jordan tells us. In fact, it is a "bad time" to be black, to be gay, to be a child, to be old, to be a woman—or even to live in Arkansas where

> Occasional explosions caused by mystery
> nuclear missiles have been cited
> as cause for local alarm, among
> other things.

Jordan continues to catalog in her poem the injustices and disparities as well as the economic and racial provocations to social equality and equanimity. In a manner reminiscent of Whitman, she almost derails her poem in despair. She pulls herself up, though, with the same abrupt decisiveness as the earlier New York poet and says, simply, "Wait a minute." The turning point comes when Jordan summons up the lusciousness of the pomegranate, its succulence exploding in her mouth with "voluptuous disintegration." In that recollection, she announces:

> This is a good time
> This is the best time
> This is the only time to come together

> Fractious
> Kicking
> Spilling
> Burly
> Whirling

Raucous
Messy

Free
Exploding like the seeds of a natural disorder.

Louise Kawada. *Papers on Language and
Literature.* 26, 1990, pp. 125–26

June Jordan's *Naming Our Destiny* spans more than thirty years of writing
and includes some fifty new poems. She is a wise, passionate, compelling
poet at work in the real business of poetry—the business of transformation,
the business of naming names. In "Poem from Taped Testimony in the Tradi-
tion of Bernhard Goetz," she comes to meet the poem head-on. . . .

This poem, which runs several pages, is a tour de force underscoring
the power of the idiomatic, the power of the colloquial, showing the reader
just what might pass through a mind like that of a Bernhard Goetz, but from
a Black woman's perspective. There are a number of truly extraordinary
poets writing in colloquial speech now: Hayden Carruth, Etheridge Knight,
and David Lee have been pushing at those boundaries in narrative poems
for many years; Lucille Clifton and Judy Grahn write a spoken voice most
forcefully. June Jordan is in the forefront [of], but not limited by, that oral
tradition.

Too much poetry of recent years has been bogged down in reflective,
reflexive meditations of isolated dreamers in air-built castles. Elsewhere, the
world over, governments are falling and democracy growing *because of the
work of writers.* Jordan's poetry is deeply engaged, as she is, in daily history.
She reminds poets of their authentic duties. In her hands, history is not a
passive entertainment, but the immediate product of our daily lives. It is
consequential.

In a response to Yeats's "Leda and the Swan," she offers "The Female
and the Silence of a Man," . . . her Leda, with lacerated breast and clawed
heart. . . . The poem is lovely in its formal dress, and as "true" and as power-
ful as any written by those who profess adherence to a "formalist" credo.

Jordan's passionate commitment to a search for justice and for compas-
sion is everywhere evident within these pages, never more powerfully than
in the closing autobiographical poem "War and Memory." . . . This poem
makes use of what in others is so often a weakness—from the first person
pronoun to the choice of "telling" over showing—but finding a music to carry
the poem song-like on the expansive voice of its speaker, she gets away with
it, makes it work. The poem is packed with cultural icons and historical
snippets like Afros, the Viet Nam War, the "War on Poverty" that we must
also have lost, Victory Rations, and more. The poet remembers calling the
police to ask them "to beat my father up for beating me / so bad / but no one
listened." Hers is a poetry that thrives on memory and commitment and an

oral tradition with roots in "giving testimony" whether in affirmation or before the Inquisition.

June Jordan returns us to the real work of poetry. She refuses to indulge in the easy question. Here is a poetry of passionate courage and enormous compassion, a poetry that speaks on behalf of the world's oppressed and dispossessed and disenfranchised, and does so with great clarity, without the pandering to propaganda and cheap emotional tactics that too often mar the work of lesser poets.

<div style="text-align: right">

Sam Hamill. *American Poetry Review.* 20,
March–April, 1991, pp. 35–37

</div>

Jordan is obviously devoted to the poetics of politics and judgment; she's a poetry activist. Her aesthetic includes, not only the casual or democratic sensibilities of free verse, but also the bald, repetitive, encantatory powers of oratory; hers is persistently spoken poetry, whose closest contact with song is the chant. . . . June Jordan reminds us that, while these two aesthetics have comprised the dichotomy of Western philosophy and literature for thousands of years, they are incomplete in expressing the more various cultural heritages of this country. Jordan's prosody may derive primarily from the free verse liberties of Romanticism, and her decidedly nontranscendental, socially aware sympathies may align in intriguing ways with Neoclassical worldliness; still, Jordan's most immediate tradition and her most notable accomplishment correspond with her development of a distinctly African-American poetry. Much of her power stems from her antagonisms—intended or not—with the two more predominant forces in our poetry. That's why I said earlier that, though her interests do not seem to reside wholly in poetry, I find that stance to be critically valuable. For Jordan, to adopt the techniques of a Western aesthetic is to risk forgetting the history of an African past—and an importantly African present. . . .

"Test of Atlanta 1979" exemplifies the sternest and most blunt qualities of Jordan's poetry. It is expressly unpoetic, ungarnished; it is virtually prose in lines. Yet the power of its testimonial rhetoric, the plain and undeniable fact-making embedded in the poem, produces a voice capable of moving beyond mere shock, blame, or stupor into an accumulating indignation leading toward action. Jordan's well-chosen title to this volume [*Naming Our Destiny*] reiterates one of her most urgent tasks: to name names, in order to rehearse the details of one's past; to identify the face of one's oppressor; and actively to take part in the creation of one's future. . . .

There are names abounding in *Naming Our Destiny:* in titles ("A Richland County Lyric for Elizabeth Asleep"), in dedications (to her son Christopher, to Jane Creighton, to Adrienne Rich, or in "commemoration of the 40,000 women and children who . . . presented themselves in bodily protest . . . at The United Nations, August 9, 1978"), and in the characterizations within virtually every poem. The nominal and spiritual transformation of Saul to Paul provides, in Jordan's important "Fragments from a Parable," a

paradigm for another crucial naming: the naming or recreating of oneself. As if directly to confront the paradox of an artist—the desire to be original while employing the received technique and traditions of one's art form—Jordan opens her poem in purposefully tentative fashion:

> The worst is not knowing if I do take somebody's
> word on it means I don't know and you have to believe
> if you just don't know. How do I dare to stand as
> still as I am still standing? . . .
> Always there is not knowing, not knowing everything
> of myself and having to take whoever you are at your
> word. About me.

Elsewhere in *Naming Our Destiny,* the trope of nomination produces a push toward responsibility and duty, as well as a sense of kinship or sympathy; in "Fragments from a Parable," the drive to name participates in the fundamental process of self-identity. The speaker must invent herself, must give birth to herself, not only as artist, but as person. . . .

Jordan's variety of poetic stances enacts her drive to connect and represent, for in addition to her principal mode of delivery—the poet talking directly to an audience—she also speaks through a number of other characters in persona poems, giving sympathetic articulation to lives, idioms, and concerns beyond her own. Like Carl Sandburg, she makes public art out of public occasion and the available word, and she does so with confidence and conviction. . . .

Jordan's work is a reminder that poetry might yet be a viable and persuasive form of social corrective, that its more oratorical modes may have the capability to mobilize as well as inspire. Her project is especially whelming, given her ethnic as well as artistic fidelities: she requires of herself, and invites us, to review some of the most basic assumptions about myth, identity and influence.

<div align="right">David Baker. Kenyon Review. 14, 1992,
pp. 152–57</div>

Technical Difficulties is a book about America—subtitled, as it is, "The State of the Union." This is America observed and found both noble and nurturing, brutal and malformed—often at the same time—by a brilliant and mature African American scholar who has looked at our country with her own unique clarity of vision and focus. Her subjects include affectionate tributes to her own Jamaican heritage ("For My American Family") and that of those other immigrants, not the Poles, Russians, Irish, or Germans but the too-often invisible and darker-skinned newcomers whose journeys through New York harbor, past the Statue of Liberty and Ellis Island, have been largely overlooked in our romantic imaging of the American melting-pot.

Although these less chronicled voyagers harbored dreams much like those of America's white immigrants, they came not from the *shtetls* of Eastern Europe, but rather from places like "Clonmel, a delicate dot of a mountain village in Jamaica." They settled their families down in black communities such as Brooklyn's Bedford-Stuyvesant that sociologists in the 1950s characterized as "breeding grounds for despair," where teachers taught Jordan "all about white history and white literature." Yet there, in her parents' "culturally deprived" home, she "became an American poet." In her essays Jordan combines love and respect with scorn and mistrust for this America where her parents—her "faithful American family"—created a new life and nurtured this "barbarian" of a writer.

In another essay, "Waking Up in the Middle of Some American Dreams," Jordan directs her attention to an analysis of her own deliberate self-isolation and the intrusions upon it by a lifetime of memories, a single ring of the telephone, and then, violently, by a rapist. She inserts this brutal assault into her narrative with just three words, but those words carry the potency of a drop of paint splashed into a bucket of water—spreading out to infuse the entire pail with its livid pigment. Questioning "American illusions of autonomy, American delusions of individuality," she had created her own "willful loneliness," designed to nurture her own creative process. She had sought and found an isolated spot where she could ask herself such questions as "what besides race and sex and class could block me from becoming a clearly successful American, a Great White Man," only to have her illusions of Eden-like solitude shattered by violence. Her conclusion, "I do not believe that I am living alone in America," is countered by the fearful question, "Am I?"

"Don't you talk about My Momma" and "No Chocolates for Breakfast" both traverse Jordan's familiar home ground—the lives of African American women. With wit and steel, she lashes out at men such as Daniel Patrick Moynihan who would endlessly analyze and put down her "Momma." "If · Black women disappeared tomorrow," she argues persuasively, "a huge retinue of self-appointed and *New York Times*-appointed 'experts' would have to hit the street looking for new jobs." . . .

June Jordan has a prolific intellect and a vast reservoir of extraordinary and broad-based knowledge, yet her writing maintains its solid grounding in everyday experience. (The frustrating disempowerment of black women, for example, is captured in the impossibility of getting a taxi on a rainy afternoon.) The luminous accessibility of these essays keeps them well clear of the murky pits of obfuscation that trap those scholars who write for the purpose of garnering accolades from others in the academy. Jordan's is an intricate and often jarring patchwork collage of Americans and American life. Attempting in her "Alternative Commencement Address at Dartmouth College" to define this "American," puzzling over how to characterize that slippery and complex essence, Jordan observes that "*He* was not supposed to be an Indian. *He* was not supposed to be a *she*. He was not supposed to

be Black or the African-American descendant of slaves. And yet, here we are, at our own indomitable insistence, here we are, the peoples of America."
 Adele Logan Alexander. *Women's Review of*
 Books. 10, April, 1993, p. 6

JORGE, LÍDIA (PORTUGAL) 1946–

The novel *A Costa dos Murmúrios* represents a type of historical fiction that goes beyond a detailed reconstruction of past events to bring out and analyze broader themes of history and the historical process. . . .

The text of the novel is divided into two parts. The first takes the form of a short story entitled "Os Gafanhotos," which in a very "literary," symbolic, metaphorical manner describes an event from the Portuguese colonial war in Mozambique. The second part, a longer one, forms a dialogue between the author of "Os Gafanhotos" and the main protagonist of the events he describes, Eva Lopo. In fact, it is not really a dialogue but a monologue in which Eva Lopo relives the past and fills the empty spaces left in the record by the less direct and more allusive text of the short story. At the same time, her own text, injected with subjectivity, challenges and subverts the discourse established by the short story. A dialogue is established, therefore, not between the author of "Os Gafanhotos" and Eva Lopo but between the two texts, two discourses corresponding to the two parts of the novel. The dual structure sustains a polemic view of history dependent on the subject who constructs it, the prevalent ideology, and the type of narration. . . .

Whereas the short story "Os Gafanhotos" has a symbolic and indirect character that leaves the reader with a vague notion of historical ambience rather then a detailed account of what really happened, the second part of the novel—the monologue of Eva Lopo—further develops narrative plots that were only alluded to in the previous story. At the same time, it introduces a new perspective and metatextually comments on the manner in which the story was written. At first, the difference between "Os Gafanhotos" and the narration of Eva Lopo consists of a change in the narrative voice. Eva Lopo presents us with a very personal description of the events, written in the first person singular and filtered through the subjectivity of her emotions. The perspective she adopts contrasts with that of the narrator in "Os Gafanhotos" who, even though he tries to objectify his telling of the events by narrating them in the third person, restricts himself to the point of view of the group of white (and mostly male) Portuguese. Eva Lopo, to the contrary, in order to find an explanation or a "truth" of the events, places herself on the side of the colonized and on a less ideological but more concrete side of the war itself. This essential difference places Eva Lopo on the other side of the story and, also, on the other side of history. The division of the novel reflects a

fragmented concept of history that suddenly becomes dependent on the subject. Both versions of events are subjective, but while Eva Lopo openly explores the possibilities of her own subjectivity, the narrator in "Os Gafanhotos" uses literary discourse to make his version more "objective." In spite of Eva Lopo's being white and Portuguese, her discourse is constructed from the beginning as the discourse of the Other. It is a voice of a woman that metaphorically as well as literarily identifies itself with the marginal and the minor amidst all the symbology of war, virility, and power that pertains to men in both parts of the novel.

The vision of history presented by Eva Lopo can be placed, above all, in opposition to the official historical discourse of the Estado Novo. She attempts to deconstruct, demythify, and expose the ideological compromises of a history that chooses as its defining principle the desire to justify the existence of the colonies and an imperialist war to control them. By stressing the relativism of the historical process, its literary dependence on written records, and the unavoidable influence of rhetoric, ideology, and the subjective bias, Eva Lopo shows that any version of history has its limits. Her commentary may appear cynical but it is constructive as well. Through the violent revelation of certain facts and events and by focusing on a different side of the story in contrast to the version presented in "Os Gafanhotos," Eva Lopo's historical account challenges the "discourse of forgetting" that the short story adopts. Some of Eva Lopo's observations and advice directed to its author should be, in my opinion, read as ironic. . . .

A Costa dos Murmúrios is the most recent novel of Lídia Jorge but, according to its historical chronology, it might have been the first. This novel confronts openly and sometimes bitterly the questions of a past that ended with the Revolution of the 25th of April, choosing, among many aspects of that past, the most difficult one—the colonial war. As historical fiction, A Costa dos Murmúrios offers the reader more than a simple, honest reconstruction of past events. Its focus seems to be on the historical process itself, contemplating the question of whether an objective history is at all possible and in what way it could exist. Through an originally introduced division of the text in two parts, Lídia Jorge is able to contrast two different accounts of the same historical event: the short story's discourse of "forgetting" and Eva Lopo's discourse of "recuperation." Each helps to bring out different aspects of history: its symbology, its ideological compromise, its dependence on the subject, its simultaneous incorporation of witnesses' accounts and their interpretation, and finally, its relative incapacity to represent reality objectively. This "incapacity" does not necessarily mean a deviation from "truth" but rather a very specific version of it. Most important, however, is to see how different people or incidents coexist to enrich the complex texture of history.

Helena Kaufman. Luso-Brazilian Review. 29,
1992, pp. 41–43, 46–47

In an interview presenting her novel *A costa dos murmúrios* (1988), Lídia Jorge . . . denounced the symptomatic absence of a history of the colonial war, attributing it to the fact that the Portuguese were unwilling to talk about a painful and shameful event. By 1988, however, several literary accounts of the colonial war had already been published. Just to mention two well known novels, *Os cus de Judas* (1979) by António Lobo Antunes and *Autópsia de um mar em ruínas* (1984) by João de Melo document the war in its crudest and most pathetic details, from the experience of the frontline to the psychological turmoil of the returned soldier. In fact, João de Melo's two volume anthology *Os anos da guerra, 1961–1975*, also published in 1988 by the same editor as Lídia Jorge's novel, Dom Quixote, gives proof of all the voices that had attempted to apprehend and fictionalize the "real" of the colonial war. One cannot but wonder, then, why Lídia Jorge not only chose to ignore these works but, moreover, felt compelled to point out the inexistence of a history of the colonial war.

Aside from a simple marketing strategy, the author's disavowing gesture might provide a clue to the critical-theoretical aims of *A costa dos murmúrios*. It is evident that it partakes of the postmodernist historical revisionist trend which Linda Hutcheon has described as "historiographic metafiction": the novel flaunts a "theoretical self-awareness of history and fiction as human constructs"; and, notwithstanding its metafictional status, it "speak[s] to us powerfully about real political and historical realities." Lídia Jorge's novel contests then those narratives, such as Lobo Antunes's *Os cus de Judas,* which are written as though the real is knowable, as though language is transparent, and as though they can contribute towards man's emancipatory project in History. Because they do not avow—much less problematize—the aesthetic, ideological and philosophical assumptions on which their claims to "truth" are grounded, existing accounts of the colonial war reproduce the same masked, secretive, irrational violence that they wish to denounce.

It is therefore not surprising that Lídia Jorge deliberately avoids associating her own novel [with] the literature on the subject of the colonial war, preferring that it be seen as "maybe a book about the violence, the last convulsions of an epoch." Set in the late sixties, *A costa dos murmúrios* announces, for sure, the impending end of the Portuguese colonial war; but, more than that, it present the era that paved the way for the future breakdown of humanist beliefs regarding truth, subjectivity, knowledge, language and historical progress. While reflecting upon the Portuguese colonial war from a post-colonial, postmodernist perspective, Lídia Jorge explodes the myths that have sustained the violence of all forms of colonial wars, including those waged against women's bodies.

A costa dos murmúrios deconstructs, theorizes and rewrites the traditional war narrative, positing the conditions under which literature can retrieve the past without engaging in what Nancy Armstrong and Leonard Tennenhouse, following Foucault, have termed as "the violence of representation." . . .

Lídia Jorge begins and ends *A costa dos murmúrios* with the laughter of a female dismantler of myths, particularly those that represent woman. [The bride] Evita's potentially transgressive laughter, at the beginning of "Os gafanhotos," is recuperated by Eva Lopo's own laughter at the closing of her critical observations. Thanks to the character's distanced position vis-à-vis the text of the wedding reception, she is able to laugh at its creators—the makers of colonial history, her husband among them. Twenty years later, in the late eighties, the literary critic Eva Lopo does indeed the same thing by distancing herself from, challenging and, ultimately, annuling her interlocutor's ambition to (historical) authorship *and* authority.

<div align="right">

Ana Paula Ferreira. *Revista Hispánica*
Moderna. 15, 1992, pp. 268–69, 271

</div>

Her first novel, *O dia dos prodígios* (1980; The day of the prodigious events), acclaimed by an eminent Portuguese scholar as one of the key works of the Portuguese revolution of 1974, was an immediate success. It revealed already most of the characteristics that were to define her as a novelist: formal experiment, an idiosyncratic style marked by a pronounced orality, an inclination toward magic realism, a fascination with her historical moment. Many novels were written about the 1974 revolution in the years immediately following it, but none of them records its failure as brilliantly as does Jorge's. The author figures her commentary in the juxtaposition of two prodigious events: the revolution itself and the sudden appearance and equally sudden disappearance in the rural village of Vilamaninhos of a mysterious winged snake. For the villagers, the former is a remote "prodígio," far less real and far less fascinating than their own prodigious snake. By depicting these villagers as an insular, culturally deprived community, implicitly like many others throughout the country, Jorge questions the viability of a political program as sophisticated as the one espoused by the makers of the revolution. On a secondary level, the novel is as much about the art of narration as it is about the inability of political reform to penetrate the remote corners of Portugal. Early in the novel, Jorge reveals an interest in the dynamics of group storytelling. The task she sets for herself is not merely to describe the process but to reproduce it, to transpose the oral experience of simultaneous narration (essentially temporal) to the medium of writing (primarily spatial). For this novel, she won the Ricardo Malheiros Prize (1980).

Jorge's second novel, *O cais das merendas* (1982; The snack wharf), is again a response to social change. Here the issue is an insidious colonization: the tourist invasion of the Algarve. The author exposes its devastating consequences for the inhabitants of a small rural village, lured by the perceived sophistication and economic promise of rededicating their lives to service at a thriving resort hotel. The price is the sacrifice of cultural identity and of selfhood in new roles that require Jorge's characters to be no longer members of a culturally valid community but simply functionaries in the world of the tourist, a world that appropriates their time and space but systematically

excludes them from full participation. Jorge's artistic medium is again a brilliant use of language and form: shifting narrators and temporal planes, symbolic and allegorical detail, a touch of magic realism. Most impressive is her depiction of language itself in the process of being colonized, her revelation of the cultural charge that words carry, and the cultural and psychological ramifications of replacing one word with another.

Colonization of a more traditional, though no less devastating, kind is the subject of Jorge's fourth novel, *A costa dos murmúrios* (1988; The coast of murmurs). As in the second novel, the setting is a hotel, this time one that houses the wives of military personnel in war-ravaged Mozambique during the final throes of the colonial enterprise. The author's primary intention is to expose the brutality of the war, but, as in the other two novels, there is a secondary, one might say literary, concern as well. This book is in reality two novels in one. The first is an account of a tragic war-related episode that once occurred at the hotel. The second, a telling of the "true story" of that event by a participant who twenty years later has just finished reading the account. The author's intention here is to explore the relationship of truth, reality, and history (history as the way in which reality is interpreted, recorded, and remembered). She intends not simply to question the events and the rationale of the colonial war but to challenge the way contemporary Portuguese society is processing the "memory" of that war. Again the novel is enriched by the oral style, the numerous and varied discourses of that African experience.

While all of these novels have met with a highly favorable reception, there is one group of readers that has been less than enthusiastic about Jorge's work: the radical feminists. Jorge gives a prominent place to women in each of the works, but she does not privilege them, undoubtedly because it was the broader national picture that absorbed her. Her third novel, *Notícia da cidade silvestre* (1984; Word from the sylvan city), focuses on two female characters through the first-person confessional narrative of one of them. The narrative appears at first to be the story of women's friendship, but it soon becomes evident that it is something quite different: an examination of the power struggles and the subliminal forces that inform human relationships whether they be with women, with men, or even with children. All are at issue in the novel, which in that sense continues to have a broader social theme. This work breaks with the others not only in dealing with more intimate, subjective material but in doing so in a more straightforward manner, shorn of the allegorical and magic realist cast that characterizes them. Orality alone continues. For this work Jorge received the City of Lisbon Fiction Award (1984). Since the publication of these novels, Jorge has written a play dealing with the early twentieth-century feminist and medical doctor Adelaide Cabete; plans for a stage production are under way.

In the scant decade since she began publishing, Jorge has become one of the central figures on the Portuguese literary scene. She is much sought-after in academic as well as literary circles not only in her own country but

in Brazil and even in the U.S. She is one of the most imaginative and linguistically gifted of her contemporaries, and she is clearly a writer with a social mission.

> Alice R. Clemente. In Steven R. Serafin and
> Walter D. Glanze, eds. *Encyclopedia of*
> *World Literature in the 20th Century,* (New
> York: Continuum, 1993),
> pp. 340–41

JOUBERT, ELSA (SOUTH AFRICA) 1922–

The first edition of this remarkable narrative, *(Die swerfjare van Poppie Nongena;* (The long journey of Poppie Nongena)] sold out in a matter of weeks. It was then serialized by the Afrikaans newspaper *Rapport,* won three literary awards in South Africa and occasioned dispute between Afrikaner academics. One of them, J. J. Degenaar, contends that *Swerfjare* exposes "the structural violence" of the laws pertaining to Africans, and that Afrikaners can no longer claim ignorance of the effect these laws are having on the lives of blacks. This book—arguably not a novel but a brilliant piece of New Journalism resulting from careful documentation—portrays the life of an extended family of Xhosa people, focusing mostly on Poppie Nongena, her husband and children.

We follow in close detail Poppie's own account of her life from childhood to middle age, an account which is rendered cohesive by the interpolations of an omniscient narrator who maintains the quality and rhythm of Poppie's speech. At first Poppie uses a northwest Cape Afrikaans which in time changes to one with greater Xhosa inflections and then changes again as her vocabulary is affected by the Cape Coloured people. Poppie's speech, her preoccupations and her emotions change with her various forced moves to different locations. Joubert's reconstruction of Poppie's day-by-day struggle with poverty, her frustrating efforts over ten years to obtain documents to remain with her husband, and her will to rebuild her life each time the authorities move her, has a cumulative and shocking effect on the reader.

The style is generally terse and objective, but because the story is told from the inside out we grow to know Poppie and are deeply moved by the tragedy that is her life. Elsa Joubert has transformed what might have been merely a sociological study into a work of art.

> Sheila Roberts. *World Literature Today.* 53,
> 1979, p. 735

After Elsa Joubert's exciting, widely hailed and translated book *Die swerfjare van Poppie Nongena* . . . [her new novel, *Die laaste Sondag*] does not disap-

point. Instead of following the proven successful path of her earlier book, that of a semidocumentary narration of black sufferings, she boldly strikes out in a different direction altogether and depicts the obsessions and claustrophobic trappings of the ruling white caste, this time somewhere on the northern borders of South Africa.

Terrorist bomb attacks against white farmers have become fairly common, while nearby, the antiterrorist military operations of the government are raging. The situation is therefore feverish and tense. The scattered white farm community is closely knit and aloof from the teeming blacks in their huts and hutches. The leader, the dominee or minister of the Dutch Reformed Church, while on a brief monthly stint as an army chaplain, is confronted with an experience that deeply shakes and unnerves him: a horrified, delirious soldier shows him the clothing of a brutally murdered family of six and propounds that Christ must be "bought" through the death of thirty innocent victims, in the same way as He had been sold for thirty pieces of silver, so that the Old Testament law of an eye for [an] eye can be reinvoked.

The dominee, at first stunned, becomes obsessed with the idea. He puts the bloodstained clothing in a chest in the church, around which he has a high fence erected after discovering a couple of black boys exploring the inside of the church. This fence, dazzlingly bright, is an affront and a challenge to the blacks, and tensions mount in both the black and the white communities until the inevitable explosion comes with the thirtieth victim on the eponymous last Sunday.

The premise on which the story is built, that of "buying out" Christ, is not so hard to believe as it might seem, given the dour, Old Testament nature of this white community. The individual characters are clearly drawn and, because they are so distinct, so clearly involved in their petty activities and caught in their loveless race situation, are entirely believable. The heresy propounded by the dominee can be accepted by them as well as by the reader.

Die laaste Sondag is a sincere accusation against the Afrikaans churches for their loveless and patriarchal relationship toward blacks. In an enlightening detail, the dominee slaps a black juvenile when the latter enters the church: one is harshly reminded that the Dutch Reformed Church is for whites only.

To my mind, there is a weakness in the story, a flaw that makes it somewhat unbelievable: namely, that while the dominee dominates the first half of the book, he is offstage, so to speak, in the second and most important half because he is taking his Sunday after-dinner nap. When he wakes up, his change of insight is just too sudden, therefore, however much he may be horrified by the results of his concepts. Nevertheless, *Die laaste Sondag* is a deeply disturbing novel and should be read as a dire warning to white South Africa to change its racial attitudes.

Barend J. Toerien. *World Literature Today.*
58, 1984, p. 654

Poppie is the true story of a Black woman's life in contemporary South Africa as told by Poppie herself and by members of her family to the writer, Elsa Joubert. The novel therefore is of a documentary kind. In his review André Brink calls it an example of the American genre of "faction." But Brink's formulation is dubious, since "faction," as composed by its creators, Norman Mailer and others, is a mixture (as the name suggests) of "fact" and "fiction," whereas *Poppie* does not depart from "truth" (as defined by Poppie's rendition) at any stage. Recent directions taken by social historians who are attempting to rewrite South Africa's history "from below" show an interesting affinity with the method used by Joubert in the composition of *Poppie*. The construction of a social history from interviews conducted with the common, or representative "people," is a crucial aspect of the new South African historiography, and is an approach which was anticipated, several years in advance, by Elsa Joubert in 1978. The closeness of the relation between the novelist and the social historian, both of whom face similar problems in the construction of narrative, is powerfully demonstrated in Joubert's novel, which departs radically from anything else written in this country in fictional form. . . .

The writer has, . . . with immaculate judgment, chosen to emphasize Poppie's individuality at a moment when she describes an event (her removal to a homeland) which makes her most representative of her people, her race, her gender, according to this country's legislation. When she is denied a permit to live in Cape Town and is forced to remove to the Ciskei because that is her husband's birthplace, Poppie suffers the fate of millions of South African Black women. The author conveys a sense of this suffering to the reader, not by stressing Poppie's collective humanity, but, on the contrary, by foregrounding the particular, individual qualities of her personality. . . .

Poppie is remarkable for several reasons. It is the only book written by a South African author that one could regard as a true epic, that is, a narrative account where the content is so powerful that the reader is swept along with it from beginning to end and where the writing itself seems secondary, natural and inevitable. Secondly, the book dispels once and for all the fashionable critical cliché which says that the situation in South Africa makes it impossible for a White to write with any authenticity about Blacks, or, for that matter, for Blacks to write about Whites. Here is a book about a Black life, several Black lives, in contemporary South Africa written by a White woman living in a White suburb. Thirdly, Elsa Joubert's method in this remarkable work anticipates, by at least three years, the now fertile production of the new historiographers, neo-Marxist social historians who are re-creating the history of the country "from below" and often through detailed interviews with the people most affected by the state's legislation and institutions: migrant workers, domestic workers, farm laborers, trade unionists, people affected by resettlement, unemployment, or demolition.

Jean Marquard. *English Studies in Africa.*
28, 1985, pp. 137–40

Elsa Joubert refuses to be pegged down. After an international success with *Poppie Nongena* . . . a feat which should not have been too hard for her to repeat, she approached the turbulent racial situation in South Africa from another angle and form in her novel *Die laaste Sondag* in which the unloving actions of a dour Calvinist minister are related. Her new novel, *Missionary,* is a painstaking fictional biography of Aart van der Lingen, an early Dutch missionary at the Cape from 1800 to 1818. On second thought, her subject matter has not really shifted; it remains that of the impact of Europe on Africa and above all, of the validity of the Christian religion.

Van der Lingen is a physically and emotionally weak character who finds the task of converting the native tribes well beyond his abilities, but he nevertheless perseveres. He has much to contend with: he is saddled with a hunchback, has no knowledge of or gift for the indigenous languages, is out of contact with the directors of his missionary society, and is constantly out of funds. The conditions he must cope with are indeed severe: the rough trails over the mountain ranges; the hostile tribes in the north (Tswanas), that did not even want to hear him; the marauding Xhosas on the eastern front. There are also the San (Hottentots), at that time already detribalized, continually pilfering and begging for tobacco. He comes across a frightening sight—a girl stricken with smallpox has been tied down on an anthill—and flees the scene. There is also the distinct group calling themselves "Basters" (half-castes), descendants of whites, runaway slaves, and native women who still remain in Namibia (and are often erroneously called "Bastards" in journalism). On the whole, the missionaries were not popular with the white settlers, who were still slaveholders at the time and often held the view that the indigenous people "have no souls."

Joubert is constantly questioning Van der Lingen's actions, thereby interrupting the story. I found this irksome. Her narrative is also alternated with that of Van der Lingen's diary and passages in his own voice, presumably from the beyond. After a slow start, however, the book becomes fascinating, especially when more forceful personalities are introduced, such as the controversial missionary Van der Kemp. Joubert has thoroughly researched her subject, perhaps too much so. She interlards the text with copious extracts from Van der Lingen's diary and letters, and as these are in Dutch, an Afrikaans reader is bound to find the approach tiresome. In translation this matter will fall away, as will Joubert's unsure hovering between the familiar and the respectful second-person-singular forms of address. The issues raised in the book are still very acute in the South Africa of today, and *Missionaris* deserves a foreign readership.

<div align="right">Barend J. Toerien. *World Literature Today.*
63, 1989, pp. 730–31</div>

Poppie, Elsa Joubert's award-winning novel of a black servant woman, caused uproar among whites on publication in South Africa, and was said to make hardened government ministers change their outlook (if not their policies).

In *The Last Sunday,* originally published in Afrikaans in 1983, she focuses on a remote border community of Boer farmers, and portrays a tense, fragile lifestyle smoldering on the fires of racial segregation.

Dominie Falk, the local pastor, is a Christian fundamentalist with messianic delusions. When he is called to comfort the shocked witness of border violence, who is subsequently killed, Falk is convinced that if he collects bloody clothing from thirty such victims, he can buy back the Lord, not with pieces of silver, but with lives: "An eye for an eye, a tooth for a tooth . . . then we'll be free to take revenge."

Naive fanaticism and blind justification are siblings of apartheid. When the pastor beats up an innocent black boy who ventured out of curiosity into the white man's church, he defends his actions to the distressed black minister as protecting his daughter from "gangsters". When he insists that seven-foot fencing is mounted around the church, he ignores the advice of Duvenhage, an enlightened farmer, who warns that pressures behind the fence will surely build "like water behind a dam wall."

Racists and their language are portrayed unflinchingly, as are their frailties, and fears. At times the translation seemed blunt, its bitter simplicity lacking any emotional let-up. Yet whether she is describing a simple social ritual or a father grappling with the awareness that his son played a part in his own death, Elsa Joubert's uncompromising deftness is gripping, in a gloomy, doomed, way.

<div style="text-align:right">

Julia Hobsbawm. *New Statesman and Society.* December 22–29, 1989, p. 44

</div>

In many respects *Poppie Nongena* is a scandalous book. Nothing like it had ever appeared in South Africa. Firstly, it is a political scandal, for it speaks of the life of a very poor black woman: her childhood shuttling from shanty-town to shanty-town, child-labor in a white fish-factory, reluctant marriage, the births and miscarriages of her children in wind and sand, the bad infinity of work for white families, her husband's health broken by poverty and fatigue, the domestic violence of despairing men wedded to drink, the tightening of the influx and pass laws for women, the police raids and evictions, the refusals to leave, the ignominies and ordeals at the pass offices, forced removal to the desolation of the Ciskei bantustan, the forbidden returns, the dogged perseverance, the family loyalties and survivals—and then finally the nationwide rebellion of 1976, "the revolt of the children."

If the book is a political scandal, it is also a literary scandal. All stories of genesis are stories of political power and all publication involves a delegation of authority. Edward Said points out that the word author itself springs from the same etymological roots as authority and is attended by potent notions of engendering, mastery and property. The entry into autobiography, particularly, is seen to be the entry into the political authority of self-representation. The narrative of a very poor black woman taking possession of her history in the privileged male sanctum of the South African publishing

world was a scandal in itself. At the same time, the book tramples underfoot any number of aesthetic expectations. At once autobiography, biography, novel and oral history, the narrative is also none of these; it is a generic anomaly. Moreover, as the doubled-tongued collaboration of two women, it flouts the western notion of the individual engendering of narrative. Finally, it is a female collaboration across the forbidden boundary of race, if a decidedly problematic one. So the book's unruly political substance, its birth in the violent crucible of the uprising, its doubled and contradictory female authorship, its violation of racial, gender, class and aesthetic boundaries, all amounted to a flagrant challenge to a number of white male certainties.

Yet the book was met by a standing ovation in the white community. Within a week it won three major literary awards, was reprinted three times in six months, and was soon translated into English, French, Spanish and German—an astonishing welcome for any book in Afrikaans, let alone a book by two women. *Rapport,* an Afrikaans Sunday paper, serialized the entire narrative, as did some white English women's magazines. Conservative cabinet ministers read it, business leaders read it, housewives and schoolteachers read it. Well over a hundred reviews, articles, and reports debated, discussed and analyzed it. It has never been banned.

Most black readers and critics have applauded it. Yet for the most part the white left has ignored it. What is the meaning of this paradox?

The most striking feature of the articles and reviews that flooded the newspapers and magazines was the unanimous stridency with which the book was declared to be *apolitical.* . . . "Joubert's book is *never* political," roundly declared the *Cape Times.* "[I]ts honesty is apolitical," approved the *Eastern Province Herald.* "The book is furthermore no political accusation," Audrey Blignaut hastened to assure his readers. "Politics do not enter in," agreed . . . *The Star.* Other examples abound. . . .

[It is necessary to] refute the national whitewash of the narrative as apolitical by exploring the contradictory politics of the book's reception and the ambiguous politics of female collaboration across the boundaries of race and class difference.

Anne McClintock. *Social Text.* 25, 1990, pp. 197–98

KAHANA-CARMON, AMALIA (ISRAEL) 1930–

Amalia Kahana-Carmon's story, "To Build a House in the Land of Shinar" provides a neatly complementary opposite to Kaniuk's fable of the moving house. Her model Israeli household in a new town, visited by a foreign home economist, is a quietly claustrophobic setting of stale domesticity, and the ironic epic overtones of the title—no national symbolism is intended—alluding to the builders of the tower of Babel in Genesis, intimate that this is not a house which will stand.

<div style="text-align: right">

Robert Alter. *Defense of the Imagination:*
Jewish Writers and Modern Historical Crisis
(Philadelphia: Jewish Publication Society,
1977), p. 256

</div>

While there seems to be a critical consensus about the technical and stylistic innovativeness of Amalia Kahana-Carmon, the most highly respected woman author in Israel, it is not difficult to detect some reservation about the importance of her work. It is no coincidence that the decision to grant her the 1985 Brenner Prize (third in rank after the Bialik and the Israel Prize for belles lettres) was mostly based on a recognition of her "sensitivity to the word, the rigor, the precision, the scrupulousness in the choice of the word: the word in its widest narrative meaning," rather than on an appreciation for the "word's" meaning or significance. The laudatory emphasis on *how* she writes evokes ever so subtly the critical reticence about *what* she writes. Even in this most unlikely context, Kahana-Carmon is declared to have the ability to create pretty rather than important fiction. . . .

This is not to say that Kahana-Carmon's work is not concerned with the anatomy of human encounters, the desire to be at the top, the search for transcendence, or the relationship between life and art. My argument is that these motifs can and ought to be seen as thematic extensions of the female predicament Kahana-Carmon describes. The allegorization of that predicament posits a substitutional and hierarchical relationship between the female and the human condition which implies that the latter is not only different from the former, but more important. . . .

The alleged triviality of Kahana-Carmon's subject matter is the product of a male-centered value system which devalues women's writing, women as fictional characters, and women's real or imagined concerns. My argument is that there is no need to dignify Kahana-Carmon's work by resorting to convoluted allegorical interpretations. There is no need to justify her inclusion in the canon by "universalizing" her stories. The critical "rehabilitation"

of Kahana-Carmon by her defenders discloses their agreement with their apparent opponents that female characters are not as universal as male characters and that women's traditional concerns are not as significant as men's concerns. . . .

[H]er work moves from the romantic antiromantic stories of *Under One Roof* (1966), through a sensitive depiction of the double bind of a married woman in *And Moon in the Valley of Ajalon* (1971), to a tentative and partial exploration of the image of the independent woman in *Magnetic Fields* (1977). One could argue that by portraying most of her heroines as dependent on males and as victimized by them (Wendy in *Magnetic Fields* is a secondary character), Kahana-Carmon risks idealizing the image and state of the female victim. When the female's rehabilitation requires a sympathetic vision, the combination of female heroism and victimization becomes problematic. A careful reading of Kahana-Carmon's work can demonstrate, however, that the valorization of the female Other often results in a critique of the repressive conditions that lead to her victimization. The more sympathetic the heroine's treatment, the more objectionable her oppression.

For Amalia Kahana-Carmon is not only struggling with the female Other as a literary image, but also with her self-image as Other in a male-dominated canon. As the first (and thus far only) woman author to gain partial access to the Hebrew literary canon, she is facing a tough struggle against a literary establishment that often identifies creativity with masculinity. . . .

It should come as no surprise that Kahana-Carmon's gynography, despite her ability to articulate so well the contradictions and problems entailed in female writing, manifests the residual impacts of androcentric thinking.

<div style="text-align:right">

Esther Fuchs. *Israeli Mythogynies: Women in Contemporary Hebrew Fiction* (Albany: State University of New York Press, 1987), pp. 87–89, 93–94

</div>

Amalia Kahana-Carmon is one of the very few Israeli women writers to date, who has a clearly defined poetics. In an ongoing dialogue with three of her protagonists, Mr. Laszlo in "First Axioms" (1966), Mr. Hiram in *And Moon in the Valley of Ayalon* (1971), and Zevulun Leipzig in *Magnetic Fields* (1977), Kahana-Carmon grapples with the problem central to her fiction, namely, "what it means to be a writer." More recently, she has brought her concern into sharper focus with the specific problem of "what it means to be a woman writer." . . .

The main difference between protagonist and author may be seen in the way each perceives the world, hence the double discourse and use of masks in the text, which confounds the reader as to who is the protagonist and who the author. Socialized for centuries in the domestic sphere, the woman has developed a "trained sense of perception," which enables her to focus on so-called "insignificant details" with a startling accuracy and precision, as though viewed through the lens of "a telescope." Things that a male would

probably consider trite or banal inform her world, for example: the finely pointed stitchery in the embroidered initials on a pillowcase hanging on the washing line, the clump of fine hairs escaping from an elegant coiffure, or the angle of a brooch on a bosom. These details, depicted with a ready facility, and wrested from the core of her experience and being, constitute the building blocks of her art, as she transforms the "domestic into the artistic." This bears out Woolf's contention that the essential difference between male and female writing is revealed precisely in the way "that each sex describes itself."

Out of the woman writer's deep sense of loneliness and alienation as she stands on the periphery of the male dominated literary tradition, comes a sudden illumination, a newly discovered sense of awareness, which bear her to a "port of departure for a wondrous journey towards a moment of revelation" so that she will now speak in her own authentic voice, out of her own space—albeit the "wilderness."

"First Axioms" has been read by Israeli critics such as Shaked and Rattok, as a story that deals with the attempts of a protagonist, Mr. Laszlo, to create "the form" and "means of articulation" for his artistic endeavors, and whose poetics are close to that of the author. . . .

From a feminist viewpoint, "First Axioms" is a key to the understanding of Kahana-Carmon's work at large, and may be seen in particular to mirror the author's own struggle to find a place for herself in a largely male-dominated literary tradition. On Kahana-Carmon's own testimony, the collection *Under One Roof* was rejected by the editor of a leading Israeli publishing house, A. Ukhmani, who said: "What's this? . . . First mobilize your energies in the right channels, then come to me with your stories." The subtlety of the polemical nature of a story such as "First Axioms," which deals with the nexus between genre and gender—was lost on him, and is still largely lost on contemporary Israeli literary circles, for they lack a strong theoretical "feminist" critical background.

In her latest articles with the catching titles "To Be a Woman Writer," "Brenner's Wife Rides Again," and "To Waste One's Self on Trivia," we can see that Kahana-Carmon is still one of the few lone voices raised in protest against the marginalization of the woman writer in contemporary Israeli letters.

Sonia Grober. *Modern Hebrew Literature.*
13, 1988, pp. 10, 13–14

KASCHNITZ, MARIE LUISE (GERMANY) 1901–74

Das Haus der Kindheit (The house of childhood). . . . The reminiscences told in this book are hardly of an individual nature. They are, one might say, the collective property of all the more reasonable representatives of a certain

generation; and being such, they are so utterly typical that they frequently degenerate into cliché. But these reminiscences represent neither the purpose nor the true concern of the tale, whose uniqueness resides rather in a technique of self-critical alienation often employed in a virtuoso manner: the power of the book resides in the distance that Marie Luise Kaschnitz creates between herself and her first-person narrator, which she maintains throughout the book. The book's weakness is the less critical because of the emotion-charged distance between the fictional narrator and her childhood.

Das Haus der Kindheit . . . is not a museum of objects and appurtenances. It serves to conjure up individual vistas of childhood, and scenes and persons long forgotten, long subliminated: hallucinations of the most concrete kind that are enacted, compellingly, overpoweringly, on the floors and in attics, in the rooms, gardens, and landscapes of childhood. They totally spellbind the visitor, demanding that he use all his sensory faculties to the full, for their effect is optical, acoustical, and olfactory; thus they require his complete surrender, often even his active participation.

Here our narrator may—and must—relive childhood impressions, expose herself to a confrontation with the key figures of the world that was then adult, yet without ever losing the selfawareness or the differentiating powers of one who herself has outgrown that childhood.

<div style="text-align:right">Wolfgang Hildesheimer. Merkur. 1957,
pp. 86, 87–88</div>

Lange Schatten [Long shadows]. Twenty-one stories are brought together in this book, stories full of warmth and charm and charged with genuine pathos, capturing the "overwhelming fullness of the world." The authoress, a virtuoso of the short form, highlights the important elements; she shakes the reader, moves him to his depth, then lets him smile and in the end grants him the liberty to reflect and make his own decisions. All of the stories have in common an organic harmony of matter and style, of narrative rhythm and emotional shadings—a harmony that is the matchless mark of Marie Kaschnitz's work.

<div style="text-align:right">Herta Holzhauer. Welt und Wort. 1961,
p. 220</div>

A comparison of Marie Luise Kaschnitz's new poems with her earlier lyrical compositions, for instance with the *Gedichte* [Poems] that appeared fifteen years ago, unmistakably reveals a growing spiritualization. Those earlier texts still contained images that seemed rather accidental, lines whose rhythm was not yet compelling, whole stanzas reminiscent of what we had seen before. None of this can be said of the *Neue Gedichte* [New poems], published in 1957, and still less of the volume now before us, *Dein Schweigen—Meine Stimme* [Your silence—my voice]. The volume receives its characteristic stamp from Marie Luise Kaschnitz's effort to give a more or less precise description of specific objects. Even metaphors have no primary importance

for her. . . . This does not mean that these poems merely formulate things that could be said equally well in other ways, in meditative prose. But they are so clearly guided by suffering life and consciousness that they at no time lose contact with the subject that wants to be communicated. Thus these poems strike us as terse—even when they, occasionally and purely on the surface, extend to greater lengths. We are dealing here with signals, with allusions communicating that feeling of solidarity in suffering that alone makes poetry significant.

> Walter Helmut Fritz. *Neue deutsche Hefte.*
> January–February 1963, p. 110

Read your way into the nearly unsurpassable dialogue-model play "The Alien Voice" [*Die fremde Stimme*]: here Marie Luise Kaschnitz unfolds before us, in brief, parabolic passages, the sorrowful, ineluctible fate of woman's love. These are examples that allow us to understand what a radio play truly is. All its action has been reabsorbed into the word that pronounces fate, into the playful conflict between alien and yet familiar voices.

> Dieter Hasselblatt. *Neue deutsche Hefte.*
> January–February, 1963, p. 110

Wohin denn ich (Whither I). These notes carry more than one meaning. Those who esteem Marie Luise Kaschnitz are reassured here that after long silence, imposed by her husband's death, a new beginning is being made. But those to whom such autobiographical matters are of little interest in themselves are here confronted with a theme of a greater magnitude, the new beginning of an aging human being. . . .

The slim volume . . . [is] a diary. Besides observations of nature, it contains comments on everyday events, city sketches, reflections, the remarks of a woman of the world, a German whose sphere of life embraces the fully realized world of classicism. But it contains also the summation of a marriage communion, the recognition—given sadly but willingly—that one received one's companion for life "from eternity" and returns him to eternity.

> Ilse Leitenberger. *Welt und Wort.* 1964, p. 72

Marie Luise Kaschnitz once said that death would always be one of her main themes. It is the subject not only of her first major postwar work, a dramatic poem entitled "Totentanz" (Dance of death) . . . but also of many of her stories, including "Gespenster" (Ghost story). In "Totentanz" the dead, violently cut down by war before they could experience the fulfillment of life, are lost souls condemned for all eternity to a limbolike realm where they can find no peace. They have not really lived, and therefore they cannot really die. In death they restlessly seek the life they never knew on earth and never will know. "Gespenster" also deals with this problem. Like many of this writer's narratives, it begins with an account of events rooted in everyday reality; but the story gradually takes on an aura of mystery and finally defies

rational explanation. So plausibly is the whole sequence of events presented, so skillful is the fusion of the real with the unreal, that the suggestion of supernational manifestations compels belief.

<div align="right">

Ian C. Loram and Leland R. Phelps, eds.
Aus unserer Zeit (New York: W. W. Norton,
1956, 1965), p. 163

</div>

For a long time Marie Luise Kaschnitz was considered a purely lyric poet, and her short prose pieces and essays were appreciated only as attempts at exploring and testing the terrain beyond the poetic. Her collection of twenty-one stories, *Lange Schatten* (1960; Long shadows), proved that her prose has polish and compactness and an unmistakable narrative rhythm. The basic attitude of this narrative prose, as of the radio plays, is lyrical; and not least because of that does she like to choose her subject matter from the realm of poetry, the world of Greek mythology. Over and above all variation among the themes, Marie Luise Kaschnitz tries again and again to raise the random event to a formula of existence. Almost all of her stories, somewhat like the stories of . . . Blixen, have a second, profounder basis where the enigmatic, the mysterious, the inexplicable lives to which only the imagination has access.

<div align="right">

Horst Bienek. In Hermann Kunisch, ed.
*Handbuch der deutschen
Gegenwartsliteratur* (München:
Nymphenburger, 1965), p. 336

</div>

Ferngespräche (Telephone conversations). . . . The lives of all her characters in this collection are marked by tragedy, a silent tragedy, however, which is performed behind the lowered curtain of insignificant, everyday existence. In some stories, the actors of the leading parts do not even realize—or do not want to realize—the tragic roles they are playing. . . .

She conveys her message without loud pathos or sensationalism. What happens to the narrator in "Vogel Rock" could happen to anyone, it seems, and indeed, perhaps does. Her humor, however, shines through in several stories, notably in that about an Italian wedding anniversary ("Silberne Mandeln" [Silver almonds]) which testifies to the author's deep human understanding. Her language resembles a steadily flowing stream; sometimes a willful syntax signifies rapids, indicating the hidden currents in the ordinary lives of very ordinary people.

<div align="right">

Sigrid Bauschinger. *Books Abroad.* 1967,
pp. 187–88

</div>

Ein Fort weiter (A further word). Every new volume of her verse . . . shows Marie Luise Kaschnitz as one of the few poets today who can say of themselves that they have learned to make existence tolerable by writing poetry.

She is, in many ways, a traditional poet. Her voice is clear, her technique subtle and some of the poems, such as "Geheim" (Secret), are unforgettable.

R. E. *Books Abroad.* 1967, p. 322

Beschreibung eines Dorfes (Descriptions of a village). In simple, clear words the thinker suggests how she might evoke the way a beloved village was and is in her mind and heart. Daily presenting a new facet, she feels she could, in three weeks, give a picture. One day she would tell of people in the village, another day she would present trees, and then perhaps odors. And lo, she has suddenly yet gently and indeed refulgently succeeded. The result is a coruscating cameo. This is lyric prose conjuring up inner and outer images artfully and hauntingly with the loving sensitivity of a perceptive poet.

Wayne Wonderley. *Books Abroad.* 1968,
p. 120

Tage, Tage, Jahre (Days, days, years). . . . The latest book by this author presents in diary form her experiences and reminiscences set down between the spring of 1966 and December 1968. Alternating between autobiographical reflections, political discourse, and extensive social commentary, the diary's entries provide a serious look at contemporary Germany through the mind of a truly remarkable woman. An impending urban renewal project, which is threatening her apartment building, poses the inevitable questions: What will remain? and What can I take with me? Salvable tangibles give way to thoughts of the more important intangibles, as a sick woman attempts to preserve that which perhaps in reality cannot be preserved: an exceedingly full and worthwhile existence. The diary alone must stand as a monument, a record of rich and happy times which otherwise would be shattered and lost forever under the cruel assault of the wrecking ball.

Thomas Hajewski. *Books Abroad.* 1969,
pp. 596–97

Walter Benjamin divides the caste of preliterate anonymous storytellers into two tribes: returning voyagers and stay-at-homes. The long literary career of Marie Luise Kaschnitz, which produced poetry, novels, short stories, and essays, combines both strains. She was born Marie Luise von Holzing-Berstett in Karlsruhe in 1901, died in Rome in 1974, closing her life in the city where she had met and married the archeologist Guido von Kaschnitz-Weinberg, with whom she traveled the classical Mediterranean world until the beginning of World War II. Landlocked throughout the war in Frankfurt, that "altered city / which blossomed burned and fell into ashes," she fused her schooling in the German poetic tradition of privacy and *einsamkeit* with the political and moral expedient of "internal emigration," the invisible compound of outer submission, inner resistance which characterized not only that central episode in her life, but the content of her late, best work: the watchful eye through the chink in the shutters, the inert treasonous impulse

in the censor's shadow. She retrieves from the earlier trauma of sorrowful inaction a mirror for old age itself, noting the ripening of judgment blent by silence into detachment, conserving her strength for the delayed response, the slow-winding circumnavigation of the familiar, the long way home.

The well, the potted fig tree, the spiral stair: these items of nameless domestic architecture served her better than marble or monuments of princes. They lead her, as does the vineyard in "In Meinem Weinberg" which becomes (in German) a crypt for the name of her dead husband, without hesitation straight to her deepest associations. They are crossing-points between inner and outer worlds. Kaschnitz contains her dark meanings in an unduplicitous speech, fastidiously shorn of much of the *double-entendre* in which German poetry so easily rejoices. Although her complete poems comprise an anthology of rhetoric, she allows only one tongue for introspection, settles on the plainest of dialects for the inner life. She abjured the sublime in her later work and lived and wrote long enough to mock her own exhortative, declamatory voice. Lettered in classical scholarship, she learned Gunter Eich's lesson late: that ". . . remembering is a form of forgetting. . . ." Holding fast to the *"dur desir de durer"* she wrote a few poems as permanent, as accomplished, as Casper David Freidrich's solitary tree. If I seem to damn a great many of these poems with faint praise, I am nonetheless grateful for their occasional striking gifts: the unaccountable explosions of the adequate into the astonishing. Her most severe limitation is in the undesigning language she chose to express her "hardest, most painful inner reality." It yielded poems of the first rank only through the most forceful conjunction of circumstance, feeling, and memory, through delayed access to the forgotten details of the imagined journey, cold harvest of the winter night.

<div align="right">Katharine Washburn. <i>Parnassus.</i> 10, 1982,
pp. 140–41, 151–52</div>

The . . . "struggle for languages" could be said to crystallize Kaschnitz's lifelong affirmative stance on the conflict of poetic articulation. It forcefully denotes a reluctance to submit fatalistically to a kind of permanent verbal asceticism, or, as a more drastic outlet, to abandon the writer's métier entirely. . . .

From the evidence presented it is clear that Kaschnitz chose to steer a middle course between verbosity and silence, exhibiting in her verse relatively few outbursts of extreme laconicism. Taciturnity in the immediate postwar climate naturally sprang from that distrust of the ideological basis of language common to all "denazified" writers. It equally safeguarded mental composure. . . . But there was also a simple literary-historical rationale behind the formalistic principles of abbreviation and reduction in Kaschnitz's oeuvre, namely that they represented (as they did for Christine Busta, Hilde Domin and Karl Krolow at particular stages in their literary development) an avenue for surmounting "die Künstlerische Problematik des lyrischen Traditionalismus" [the artistic problematics of Lyrical traditionalism]. Kasch-

nitz's subsequent commitment to post-1945 modernism was such that even in her futuristically most imaginative of moods she remained securely within the perimeters of established linguistic practice.

Alan Corkhill. *Colloquia Germanica.* 17,
1984, pp. 108–9

Aside from sharing a first name, Marieluise Fleisser and Marie Luise Kaschnitz seem in many other ways to have been uncannily alike. They were both born in 1901, both died in 1974; they spent most of their lives, including the dark years from 1933 to 1945, in Germany, yet they were neither Nazis nor Nazi sympathizers. As so-called inner exiles, they belonged to that loosely defined group of writers who retreated into inner worlds as protest against the chaos and inhumanity around them. They concentrated as writers on particular genres in which they became well-known and respected. . . . Kaschnitz's personal and intense lyric poetry and short prose have become the subject of considerable discussion since the 1950s. . . .

Another habit shared by Fleisser and Kaschnitz involved the writing of autobiographical prose works—diaries, essays, and short stories heavily colored by personal detail—that appeared in great abundance in the later years of their lives. The personal politics these works display is neither overt nor obvious, but rather an effort to define a world in highly subjective fashion; the result is not only a collection of valuable source materials for the history of German women, but also a vivid look into the psyche of women whose role in that history was often uncertain and ambivalent. Born after the heyday of the radical feminists active at the end of the previous century and dying at the onset of the new feminism of the 1970s, Fleisser and Kaschnitz represent a vulnerable transitional generation. While logically it should have carried on in the progressive tradition that it had inherited, it often seemed bewildered and dislocated. The autobiographical writings of both women offer insight into a group that spent much of its energy trying just to stay alive: these records of survival seem appropriate introductions to two representative personalities whose importance should not be confined by barriers of language to a limited geographical sphere. . . .

The uncommitted and hesitant character of their generation is immediately apparent in their reactions to the more radical women of an earlier time. As Kaschnitz remarks in her last major autobiographical work, the 1973 *Orte* (Places) "I was not interested in the women's movement, whose great forerunners were already old by then, by the time of the First World War; I belonged instead to that group of women who recognized their accomplishments, but reneged on the inheritance." . . .

Kaschnitz, whose gentility does not prevent her from being straightforward, never presents the image of lesser woman cowed by male power that one finds in Fleisser's writing. . . . Kaschnitz does not glorify the so-called inner emigrants among whom she was counted, and tries instead to analyze

their role, to give it form and meaning without any sort of ameliorating embellishment. . . .

Yet despite the fragility, despite the essentially gloomy portrait of vulnerable, often helpless women in a chaotic era that frequently did violence to them not only in physical, direct ways, there is an underlying current of power and optimism that becomes evident primarily through the telling of their lives. Kaschnitz claims that writers are born with an urge to express themselves autobiographically; she lends credence to such expression by making it representative of the many who, for reasons of hesitancy, tact, and inability to speak, or shame, cannot share of themselves as she is able to do. The personal writings of both Kaschnitz and Fleisser depict weakness in the face of oppression, but they expose a sense of durability as well. Both women were clearly diminished by the men who surrounded, indeed engulfed them, and by the world events that on occasion threatened to bury them. But by simultaneously exposing—and being exposed by—their accounts of a life in a difficult era, they have become representative of a generation caught in turmoil. The fact that they managed to write openly and with passionate involvement assures their survival and is a victory, however muted. Indeed, in their will to live on and to provide words that acknowledge and underline their existence, they serve as a bridge over the silent abyss that Germany has symbolized during much of this century: Kaschnitz, through an eloquent honesty that lent to her personal struggle to survive a larger relevance and importance for the twentieth-century German woman who has often needed a particular strength to go on. . . .

With the onset of age, Kaschnitz in particular became more confident and assertive and seemed to have found some optimism to temper her often dark view of her world, to have gained an independence of thought and action. In *Orte,* for example, there are passages . . . that offer evidence of new strength. . . .

Finally, a joyful and positive element that emerged in Kaschnitz's later autobiographical work was her effort to describe and define even the smallest, most basic parts that make up her being. There is an intense reconfirmation of her self in such descriptions, an affirmation of one who has found value and purpose in her existence.

Ruth-Ellen B. Joeres. In Alice Kessler-
Harris and William McBrien, eds.
Faith of a (Woman) Writer (1984; Westport,
Connecticut: Greenwood Press, 1988),
pp. 151–54

KAYE-SMITH, SHEILA (GREAT BRITAIN) 1887–1956

It is to Thomas Hardy and Maurice Hewlett that the English farmer is indebted for his high place in literature. . . . To the company of Hardy and Hewlett must be added Sheila Kaye-Smith. What they have done for the rural folk of Dorset, Devon and Wiltshire, she has done for the farming folk of Sussex. Her love for her country and its folk does not soar as does that of Hilaire Belloc: it goes deep down into the soil, and into the minds and hearts of the people. In the series of novels which began in 1908, and now includes thirteen volumes, Miss Kaye-Smith has portrayed the Sussex folk of the past and the present. . . . She is often brutally frank, in speech as in description, sparing no details of the dung and sweat of the farmyard. . . . Miss Kaye-Smith is as realistic in method as she is romantic in temperament.

Sussex Gorse was . . . hailed by the most competent critics as one of the most remarkable novels of the time. But it was with *Tamarisk Town* that Miss Kaye-Smith first achieved the large circle of readers which is called popularity. The publication of this novel in 1919 also differentiated her sharply from the other considerable women novelists of her time. It is again the story of a man told from a man's viewpoint and with a man's outlook. . . .

Green Apple Harvest seems to have been somewhat of a respite precedent to the triumph of *Joanna Godden,* 1921. This is the life story of a woman, but a woman with a man's outlook and a man's occupation. She is, of course, a farmer. . . .

Miss Kaye-Smith's latest novels, *The End of the House of Alard,* and *The George and the Crown,* do not, unfortunately, sustain her previous triumph. *The End* is cramped and mechanical, with little of that vitality which gave such charm and power to even her very early work. . . .Its preoccupation with a thesis brings John Galsworthy to the mind of the reader rather than Sheila Kaye-Smith. It is the most popular of her books; it was one of the "best-sellers" of its year, about fifty thousand copies being sold within a few months of publication.

<div align="right">

Andrew E. Malone. *Fortnightly Review.*
August, 1926, pp. 201–3, 206–8

</div>

Nothing is more characteristic of the modern novel in its abundance and variety than the existence of a book like this [*Susan Spray*], largely traditional in style and spirit, which is an excellent story and, if not quite "literature," is, at any rate what Mr. Priestley has called "a full-time job." Reviewers tend to accept writers like Miss Kaye-Smith and Mr. [Joseph] Hergesheimer as novelists of genius, whereas seen in the perspective of literature they are, of course, nowhere. So far as genius goes, Sir Hall Caine has as much as either. They have the common habit of adopting a country or an island, of romanticizing the common life, and exploring it through a series of books in extraordinary detail. It is like filling in the corners of a large canvas. There is no

new canvas or fresh vision; the same picture becomes more and more complete. Miss Kaye-Smith is not interested in the modern world, not even to Mr. Chesterton's extent of exploding fireworks in it. She has chosen Sussex as a rambling ground because the life is old-flavored and literary associations are strong.

<div align="right">

Fortnightly Review. May, 1931, pp. 707–8

</div>

There is not much of accentuated femininity about Sheila Kaye-Smith. Her pages seldom rustle like the silk petticoats of once upon a time. Indeed, she seemed to enter the English novel in rather the same spirit as that in which land girls took up agriculture during the war, and she was one of the first women to assert her right to masculine objectivity without at the same time assuming the name George in order to do so.

<div align="right">

Compton Mackenzie. *Literature in My Time*
(London: Rich and Cowan, 1933), p. 215

</div>

The early books were slight, a young girl's dreams of romance in dingles and upon the Downs; but the later ones, as the author's touch grew more sure, show an increase in confidence and power, as well as in bulk and solidity. *Little England* and *Joanna Godden,* the more ambitious *Tamarisk Town* and *The End of the House of Alard,* and their companions, have brought Sheila Kaye-Smith in the quarter-century of her literary activity to a high place among her male and female professional contemporaries; and in one respect she is, I believe, superior to all the other equally industrious traditional novelists of about her own age.

That respect is an important one in the craft of fiction, although it is often undervalued by amateurs. Sheila Kaye-Smith's novels, which at first took a rather conventionally unconventional view of love, grew steadily in that substance which comes of care in building. They told sober and progressive stories, into which one was slowly inducted and in which one never— the point is two-edged, and yet I must make it—wholly lost oneself. And above all they were models of construction.

<div align="right">

Frank Swinnerton. *The Georgian Scene*
(New York: Farrar and Rinehart, 1934),
p. 289

</div>

Perhaps the life work of Sheila Kaye-Smith might best be summed up by the remark of Hugh Walpole that "it has been Sheila Kaye-Smith's virtue . . . to make her novels timeless." Because she probes the psychological depths of human needs, she presents characters who appear as real people, caught up in forces which either aid or hinder them in their growth toward human maturity. The human needs which form these forces do not change with changes in a societal view. The need for acceptance as an individual, the need for freedom to reach one's potentiality, the need for community with one's fellow human beings—all these reside deep within human nature. By showing the

basis for these human needs and by picturing the constructive or destructive use to which they are put, Sheila Kaye-Smith provides insight into the core of life—human relationships.

Ample evidence exists that her novels were extremely popular in their time. Unfortunately, other techniques and other visions supplanted the solid, expert, professional technique wedded to a hopeful vision that remained central to the talent of Sheila Kaye-Smith. But copies of her books are still available in libraries, and apparently they are read. Many should be reprinted, and not only because they are good stories, but because they provide insight into this time and every time.

Sheila Kaye-Smith always tells a good story. From the time she was a tiny girl, stories were part of her. Her imagination pulled together memories, observations, and intuitions, resulting in artistry. Her stories contain well-plotted action as well as expertly motivated characters. The effect is to draw the reader into the circle of which she writes, so that the characters step from the printed page into the reader's consciousness.

As was pointed out, Miss Kaye-Smith's critical acclaim rests on her use of Sussex as locale, her conversion to Roman Catholicism, and her supposed ability to write like a man. But each novel can be taken as an entity. The locale, the religion, the objectivity, the power, the breadth of vision—all serve to point to a vision which sees life in a certain way. This way is based in part on the tragic vision, in which each individual brings about his or her own destruction through a tragic error. Added to this is the Judeo-Christian tenet, in which love of self and love of neighbor must be manifest before maturity as a human being can be reached, plus an existential view of existence in which action precedes essence, so that her protagonists become by doing. . . .

There is paradox in her characterizations as there is in life. She has no easy answers to the problem of existence. But, then, Sheila Kaye-Smith does not attempt to write religious tracts. She presents stories based on human need, and she succeeds in making this need understandable to her readers.

Dorothea Walker. *Sheila Kaye-Smith*
(Boston: Twayne, 1980), pp. 152–53

KEANE, MOLLY (M. J. FARRELL) (IRELAND) 1905–?

[*Mad Puppetstown*] follows a more or less familiar pattern, but it is written with so much beauty and freshness that it seems, while one is reading it, to be alone of its kind. It is primarily a novel of locale, and nothing in it is so important as the feeling of a particular place that it conveys—the atmosphere, the color and activity, the sights and sounds of an Irish home. The considerations of plot and character are secondary—though the plot, what there is of

it, is quite adequate, and the characters are ably and unmistakably drawn. Puppetstown, the seat of the Chevingtons, dominates the book.

In those mellow and prosperous years before the war and before the turbulent outbreak of the Irish rebellion, Puppetstown had been the center of life for the Chevingtons—a beautiful old house, with its parks and paddocks and bridle paths, with its flower gardens, where Aunt Dicksie was perpetually occupied with shears and trowel, with its ponds and trout streams where the children played, with its brooding guardian mountains, Mandoran, Mooncoln, and the Black Stair. It was a place of easy and gracious hospitality, with its stables filled with good horses and its cellars with fine wines, with sporting prints on its walls and a fire of ash or laurel on its broad hearth. Above all, Puppetstown was Irish to the core—there was something that set it apart from a similar country place in England, a hint of savagery or romantic wildness that responded perfectly to the romantic wildness in the blood of the Irish Chevingtons.

M. J. Farrell succeeds admirably in evoking this characteristic atmosphere as it grew into the consciousness of three children—Easter Chevington and her two cousins, Basil and Evelyn—who were bred with the spirit of Puppetstown and the love of racing and hunting in their blood. Then comes a break in their lives. Easter's father is killed in the war and the children are removed to relatives in England because the countryside round Puppetstown is being ravaged by the Sinn Feiners. In the leaner years that followed the great war and the little, bitter forgotten war in Ireland, there remained to them only a few golden memories of Puppetstown, where Aunt Dicksie stayed on, growing madder and more miserly with the passing years. Then Easter attains her majority and the ownership of Puppetstown passes to her. Basil and Evelyn have finished at Oxford and Evelyn engages himself to a girl of adequate fortune and irreproachable antecedents and succumbs to English respectability. But in Basil and Easter there is a lingering homesickness, a sense of being strangers in a strange land. "England," said Basil, "she's too crowded. We want a littler, wilder sort of place. We're half English, both of us, Easter, but we haven't got the settled, stable drop of blood that goes down with the English."

So Basil and Easter return to Puppetstown—but to a Puppetstown that is changed, to a house fallen into decay from neglect and disuse under the jealous and miserly care of Aunt Dicksie . There is a double tragedy in the conflict of their homecoming—tragedy on the part of the young people who find the place spiritually closed against them and on the part of Aunt Dicksie, who sees it about to be taken from her. . . .

To reveal the fashion of the tragedy's resolving would do as much injustice to the beauty of Miss Farrell's writing, as to the tact and appropriateness of her conception. Suffice it to say that *Mad Puppetstown* is a novel superb in its kind, and that there will be few who can read it unsympathetically.

New York Times Book Review.
June 19, 1932, p. 7

The title of this new novel [*The Rising Tide*] by Miss Farrell covers the mystery of one more "Big House." In Garonlea the rule of Lady Charlotte McGrath brought not only gloom but rebellion. The revolt of the children against the rule of parents is now too hackneyed to be interesting; but Miss Farrell brings a novel type of rebel into her story. As in *The Silver Cord*, [Sidney] Howard's play, it is a daughter-in-law who starts the whole business.

The Victorian atmosphere, which had survived the death of the Queen, was dispelled, although the seeds of revolt remain. They sprout anew in the offspring of Cynthia, bringing about a rebellion against the tyranny of the mother who would have her children live the kind of life she had chosen for herself and them. When her husband is killed in the Great War Cynthia pursues the gay life with even greater avidity, plunging from the open-air sporting world into a boisterous whirl of love and alcohol. She is the "Merry Widow" in a new guise, and when she goes down against the rising tide she leaves behind her a trail of sympathy and admiration. The characters are all drawn with Miss Farrell's customary skill, and the novel will be found thoroughly entertaining.

Irish Times. October 25, 1937, p. 7

M. J. Farrell is feminine and Irish and fanciful, but she does not belong to the peaty school. The plot of *The Enchanting Witch* is a gay exaggeration of how people in love behave. The setting is precisely right for what is to come— an "absurd" Victorian Gothic dwelling on the south coast of Ireland, perched on a cliff overlooking an inlet of the Atlantic. With its flying bastions, prepos- terously mullioned windows and elegant but cluttered interior, it suited its poised and willful, willowy châtelaine—a beautiful widow of forty-seven who "held her chin so high against the flying years that it gave her a silly look sometimes." Her son and daughter called her Angel, and so did Oliver, who managed the estate admirably and courted her lightly, being the only person in her orbit who saw through her. The rest of the ménage comprised shy Tiddley, a niece who adored Angel and received cast-off finery and crumbs of thanks for her devotion; Miss Birdie, the cook, who saw love in the cards, and Finn Barr, a young ex-poacher who helped in the kitchen and the garden.

All the troubles in this household have one origin: Angel rushes in and fears to tread on no one's life. Masked as affection and superior wisdom, her motives are selfish in every instance. Birdie has missed out on a husband, more than once, thanks to Angel who enjoys the intoxication of power—and wants to hang on to a good cook.

When the curtain rises—*The Enchanting Witch* has the tight construc- tion of a play, with most of the action within a twenty-four-hour span—Angel is up to her uptilted chin in two projects. She is strewing misunderstanding between her daughter, Slaney, and a neighbor boy madly in love with her and a good match besides. And she has everything in readiness to welcome her son after three years in the war. What the adoring mother does not know is that Julian is bringing home from the Tyrol an American divorcee who helped

him through shock and has promised to marry him. Sally Wood has been an actress and knocked about considerably; she knows the Angels of the world and quickly takes the measure of this one. The antagonists are well matched, however, and they purr before they scratch.

The witches' brew has some added ingredients that are quite delicious. Sally has a worshipful manservant, her ex-husband's valet, who can whip up a toque, a drink or an omelet with equal speed and skill. He is the answer to Miss Birdie's dream and the cards. Poor Tiddley, as you probably surmise, has always been secretly in love with Julian, and Oliver, the farseeing overseer, happens to be an old flame of Julian's fiancée. The issue is joined at the tea table, in the pantry, in the flower garden and up in Angel's room.

The Enchanting Witch is by no means a romantic soufflé: it has scenes as sharp as vinegar. The climax is comedy—a well-kept secret we shall not unguard here.

<div style="text-align:right">Lisle Bell. New York Herald Tribune.
October 14, 1951, p. 21</div>

The story behind *Good Behaviour* has been widely publicized, as part of a promotion campaign for the book. As "M. J. Farrell," the author was a successful novelist and dramatist who ceased writing fiction in the 1950s and plays in the early 1960s. The reason given is that sudden widowhood "broke the springs of her creative energy." In 1980, Farrell was, in literary terms, dead. None of her books were in print; encyclopedias like *Contemporary Novelists* did not mention her. At midsummer 1981, *Good Behaviour* was published *in propria persona* and became a best-seller in America and Ireland. In early autumn the novel was published in Britain, and Molly Keane joined six others on this year's somewhat extended list of Booker Prize candidates.

One might suspect hype in reports of this extraordinary come-back story. But in fact *Good Behaviour* is as successful a novel as Deutsch's hand-outs claim it to be. It opens with a scene which cunningly draws the reader into false sympathy. A spinster daughter forces rabbit on a bedridden mother for whom the meat is revolting. The mother chokes and dies, and the daughter is upbraided by a faithful servant for her sadistic bullying: "We're all killed from you and it's a pity it's not yourself lying there and your toes cocked for the grave and not a word more about you, God damn you!" As if to challenge this, the remainder of the novel flashes back to an earlier generation, and the daughter's victimization by her mother, then a woman well-bred to the pitch of domestic monstrosity: "She had had us and she longed to forget the horror of it once and for all. She engaged nannie after nannie with excellent references, and if they could not be trusted to look after us, she was even less able to compete. She didn't really like children; she didn't like dogs either, and she had no enjoyment of food, for she ate almost nothing."

The setting is Irish, and the novel exploits an Irish comic situation which goes back at least as far as Thackeray: gentility's struggle to preserve itself

against invading shabbiness. The St. Charles family is first discovered living a pre-war, prosperous "leisured life." 1914 brings catastrophe and gradual decline. The heroine's dashing father loses a leg in the Great War and survives a whiskey-sodden philanderer. The family's only son is killed in a motoring accident. Debts accumulate. The father has a stroke and dies leaving the two St. Charles women destitute, except for the house, Temple Alice. To everyone's surprise, this is left to the fat, unwanted pathetic daughter; she has no marriage chances, but she can devote the rest of her life to a filial revenge of the violence of which she is clearly unaware. Hence the distasteful rabbit of the first scene.

The charm of *Good Behaviour* is in its telling. Aroon's narrative (it may be a journal, or interior monologue—we're not told) is marked by total recall, habitual impercipience and odd flashes of eloquence. "Good behavior" is shown to be her guiding principle, and it preserves her in the various crises of her life. When her brother's friend comes to her bed (in fact, he is using her as a decoy, to hide a homosexual involvement with the brother) it is good behavior that keeps her virginity and her consoling romantic illusions intact. When the scheming lawyer makes advances to her (he knows the terms of the will), it is not penetration of his motives but the instinct of good behavior that saves her: "One of Mummie's phrases came to me and I spoke it, in her voice: 'You must be out of your mind,' I said, and I knocked his hand away. In spite of my heartbreak and tears, I was, after all, Aroon St. Charles."

I hope *Good Behaviour* wins its prize. But it will have to combat the fact that its author's literary resurrection happened in America, and caught on here.

<div align="right">

John Sutherland. *London Review of Books.*
October 15, 1981, p. 16

</div>

In *Time after Time* . . . Molly Keane has written a novel of locked lives, of four people imprisoned in age and habit. Living together in a decaying Irish mansion, Jasper Swift and his three sisters suffer from what Ronald Blythe in *The View in Winter,* his study of old people, called "the destruction of progressive movement."

Jasper, a bachelor who is 74 years old, lives for his cooking and his garden. April, the eldest of the three sisters, is widowed and deaf. She lives for her elegant clothes and the remnants of her beauty. May, who never married because of a deformed hand, devotes herself to handicrafts in order to forestall the world's pity. June, the baby sister at age 64, is a barely literate dyslexic, an upperclass peasant who cares only about the farm attached to the house.

As if they had triangulated the major possibilities of personality, the three sisters dislike one another. Jasper, the inspired cook, despises the poverty of their ingredients. He laughs at them as he laughs at the absurd recipes of the woman's page in the newspaper. While their lives are hollow dramas, his is a thin comedy.

So they might have remained, if Leda, their cousin, had not returned to Durraghglass, as the house is called, for a visit. She is Jasper's age and he had loved her when he was 7 years old and she lived with them. Leda left the house in her teens, surrounded by scandal and suggestions of an affair with their father. After more than 50 years, Jasper and his sisters had assumed that she was dead.

Leda is blind, as if Miss Keane had set herself the task of exploring every kind of disablement. "Since she could not see Durraghglass in its cold decay, or her cousins in their proper ages, timeless grace was given to them in her assumption that they looked as though all the years between were empty myths," Miss Keane writes. "Because they knew themselves so imagined, their youth was present to them, a mirage trembling in her flattery as air trembles close on the surface of summer roads." . . .

Blindness, Leda says, is "an adventure" for her. It shields her, she believes, from the vulgarity of the visual. She maintains that she gets to know people better, that she approaches them through the superior channels of the spirit. The sisters, who all have dogs instead of friends, respond to Leda as if she were the only surviving human being in their world. . . .

As Montaigne said, "We are always beginning again to live," and this is the underlying theme of *Time after Time*. When Yeats asked, "Why should not old men be mad?" he might have spoken for women as well. In Miss Keane's novel, madness is only the beginning of sanity for her characters. She's a drastic woman, Miss Keane is, which is just what a novelist should be. She, too, went through an interesting rebirth. After establishing herself in the 1930s as one of Ireland's most interesting novelists, she fell silent for several decades. In 1981, in her 70's, she reappeared with a novel called *Good Behaviour,* which seems to have delighted everyone who reviewed it. Now, with *Time after Time,* Miss Keane continues her "progressive movement."

<div style="text-align: right">

Anatole Broyard. *The New York Times.*
January 11, 1984, p. 622

</div>

Through writers as various as Aldous Huxley, Evelyn Waugh, D. H. Lawrence, Elizabeth Bowen, Dorothy Sayers, we have been exposed to a group of people who responded to the disintegration of the First World War with a brittle determination to cut themselves off from the world that had been too real for them. The novels and plays about these people would lead us to believe that there had been no General Strike in 1926, and that the poor existed to be invisible and perfect servants and a source of Cockney jokes. One wouldn't have thought the same thing was going on across the sea in Ireland, but two early novels by M. J. Farrell assure us that it was. *Devoted Ladies* was first published in 1934 and *The Rising Tide* followed three years later. They are now made available by Penguin Books, which has taken on distribution in this country of the splendid books of the British Virago Press,

which is reissuing works by 19th–and 20th-century women that we otherwise would not have known.

M. J. Farrell's novels are brilliant evocations of a world that strained to combine, to its peril, the old way of life that centered on hunting and the foreign modern influences of cocktails, homosexuality, adultery and inappropriate fur coats. We are pulled up short remembering that the Ireland M. J. Farrell (the pseudonym used by Molly Keane in her early books) is describing had just been torn by a murderous and suicidal civil war; politics has no corner in these rich people's world. There are hardly even any Catholics.

What strange and vivid books they are, these two, their timbre female in some sexually stinging way: unloving mothers hiding and demanding in the background and cruel beauties exacting obeisance from the unfortunate, the plain, the merely lovesick. Miss Farrell is Anglo-Irish, but she shares the native Irish female tendency to assume that real life is lived by women; the men in these two books are handsome, stupid, amiable, ineffectual and balked. These are the heterosexuals; the homosexual men are as vicious and rapacious as the women, and their vision is as comprehending and as sure. . . .

Miss Farrell's genius lies in her remorselessness. Cruelty, she suggests, is the dominant feature of any human landscape the eye can fall upon. One chooses merely one's mode, which differs with the age. The Victorians and Edwardians were smothering and dishonest; moderns are heedless and anonymous. The poison is the same; only the vessels change. . . . She has in all her work taken her countryman W. B. Yeats's advice to "cast a cold eye," and we are chastened and refreshed by her singular vision.

Mary Gordon. *New York Times Book Review*. September 29, 1985, p. 43

For all the modernity of Molly Keane's two recent novels and for all their popularity with ahistorical contemporary critics, filmmakers, and readers, *Good Behaviour* (1981) and *Time after Time* (1983) exist within a major tradition of Anglo-Irish fiction. By placing them within this historical pattern, I am not only suggesting the persistence of the Anglo-Irish Big House novel in a Catholic Ireland, but also emphasizing how the existence of a traditional literary form releases the potential for innovation, how a successful novelist recreates and reinvents a form.

Published when Keane was in her late seventies, after almost a three-decade hiatus in the appearance of her fiction, *Good Behaviour* and *Time after Time* represent an extraordinary achievement in her long career. Under the pseudonym of M. J. Farrell, Molly Keane has been writing about Anglo-Irish society since 1928. In several of her novels published in the mid- and late 1930s, most impressively in *The Rising Tide* (1937), she begins to perceive the Big House darkly and to emphasize those themes which control her masterpieces, *Good Behaviour* and *Time after Time*. These novels pick up thematic strands found in the best of her earlier fiction, but represent a new

and fiercely corrosive dissection of a society she could evoke with some elegiac glamour in several of the early novels.

With age, Keane has achieved a chilling distance from her Anglo-Irish heritage, a distance which allows her to cast a cold eye on life and to view it with comic detachment. In her last two novels, Keane indicates what her nineteenth-century predecessors barely implied: that the ever-receding ideal of the cultivated Big House at the center of an organic community is based on a fictive rather than historical vision of the past. This ideal of a harmonious and morally ascendant ruling class, suggests Keane in *Good Behaviour* and *Time after Time,* rests on carefully constructed patterns of delusion, on willfully misinterpreting the past in order to construct self-protecting visions of stability.

Perhaps Keane's major achievement in these novels is to push the Big House form to its breaking point, to provide, through her controlling themes a final blow to her own culture. Both *Good Behaviour* and *Time after Time* portray characters who survive through their capacity to create self-serving illusions about their past. In examining and exposing these illusions, her novels implicitly move beyond character analysis into the larger enterprise of a cultural analysis of twentieth-century Anglo-Ireland. . . .

Writing *Time after Time* in her seventies, using and recreating the patterns of a traditional form, Molly Keane faces the decline of her culture and the accompanying aging of her childless characters with a wry admonition which is missing from the darker and more brutal vision of the Anglo-Ireland she presents in *Good Behaviour.* Although amused and sometimes appalled by the Swifts, Keane never allows herself to hate or pity them. The awful Swifts remember the passions of their youth; they tolerate each other and survive. In this survival, their toughminded creator finds some unlimited affirmation of their—and of her own—Anglo-Irish heritage. The Swift family line will end with their deaths, but their refusal to succumb to self-pity, their extraordinary capacity to plot and plan for the future, to scramble greedily for life, suggests that even in its defeat, the Big House asserts its life. Why indeed should not old men be mad?

Vera Kreilkamp. *Massachusetts Review.* 28, 1987, pp. 453–54, 460

KENNEDY, MARGARET (GREAT BRITAIN) 1896–1967

Sometimes a very successful book proves a handicap to the writer. *The Constant Nymph* has made it hard for Miss Kennedy to get a hearing for her other books. . . . But she does deserve a fair hearing (without comparisons)

for her other books. *A Long Time Ago* is not another *Constant Nymph*. Although it has a similar charm, it is another book altogether.

Helen Moran. *London Mercury.*
December, 1932, p. 171

[*The Constant Nymph*] did enjoy an epidemic success. I can testify from personal experience that in reading it I was not infected by the germ of American influenza. Naturally prejudiced against best-sellers I avoided reading it when it was first published; but when I did read it a few months later I fell a victim to it like everybody else. . . . *The Constant Nymph* appealed chiefly to men over forty and young women. During the epidemic it was read by everybody; but I heard much censoriousness about it from women of taste and experience.

Compton Mackenzie. *Literature in My Time*
(London: Rich and Cowan, 1933), p. 225

It is Miss Kennedy's tendency to put a little more into the popular novel than it will bear or a little less into the serious one than it requires. She is a perceptive writer who seems afraid to allow her perceptions full play. . . . In general, the novel [*The Oracles*] is agreeable light entertainment modified by the pathos of Miss Kennedy's always lifelike children and the resignation of a disappointed man.

(London) *Times Literary Supplement.*
June 24, 1955, p. 345

When Margaret Kennedy died on July 31st, 1967, she left as her monument sixteen novels and a number of plays, together with two valuable critical works and a quantity of uncollected short stories. Two of the plays had had creditable runs on both sides of the Atlantic, but it was her second novel, *The Constant Nymph,* which gave her an international reputation, and led directly to stage successes. From this peak moment the graph of her popularity may, to some extent, have gone down, but until the Second World War Margaret Kennedy's novels and plays were received as those of an author whose name needed no introduction.

When I began this study I was familiar with the pre-war novels, but less so with those which were written after a break of twelve years, 1938 to 1950, a break for which war had been responsible. It was in reading the later books that I became aware how early success had eventually mitigated against a proper appreciation of Margaret Kennedy's remarkable gifts.

To assess the qualities of her post-war novels is not, of course, to rescue them from oblivion. One was a Book Society Choice, another received the James Tait Black Memorial Prize, but *The Times* obituary notice made it clear that Miss Kennedy had been stranded on the sandbank of an earlier literary generation. The obituary notice spoke of her qualities as a writer, "hardness, gaiety and firm moral stamina," but confused the productions of

her dramatized novels in a manner that brought a correction from her co-author, the producer Sir Basil Dean. . . .

[By the time her post-war novels appeared, although they] were reviewed regularly in England and in the United States, where she never failed to find a publisher, . . . she had become a writer whose name needed explanation to those too young to be cognizant of the wild success of *The Constant Nymph*. . . .

I hope I have not failed to convey the pleasure I have enjoyed from her novels, and my admiration for their artistry. Additionally, I hope that this study may lead to a renewed appreciation of Margaret Kennedy as an author whose works are rich in examples of technical skill and creative imagination. She said herself that she came to recognize a kind of glow in her senses when she experienced something about which she was going to write. Not least of her gifts was the power to convey this glow to her readers.

<div style="text-align: right">

Violet Powell. *The Constant Novelist*
(London: Heinemann, 1983), pp. 11–12

</div>

KEUN, IRMGARD (GERMANY) 1905–82

In *Gilgi—One of Us* there are many similarities to Fallada's *Little Man—What Now?*, but the reality presented by Keun is a much more threatening one. In her novel, the economic situation is seen to have an impact on even the most intimate aspects of life. Both novels deal with the social and material suffering of the white-collar worker, but in Keun's novel there is no room for idealization. Her critical description of the era is consistent and gives lie to the idealized final scene in Fallada's novel. Keun, in a way that is appropriate both artistically and socio-historically, postpones the utopian vision of personal happiness for the future. For even when a woman internalizes the male-created dichotomy of femininity as mother or whore, something remains that is neither. It is this remaining part of the self that Hertha reveals in her confession to Gilgi. But Fallada's Lammchen, in that she always plays the mother-comforter role in healing her wounded hero, is an idealized, utopian figure, a character-type who has been created in a way which has never reflected the real experiences of women but who nonetheless has a well-established place in the literary and artistic traditions of the Western world. But in order to do justice to Fallada one can categorize Lammchen as a traditional stereotype who is consistent with the imagined concept of femininity. The same is true of Cornelia in Kastner's *Fabian*. Countless women in the novel are whores and she is one of them. She prostitutes herself for the sake of money and success even though she loves Fabian. The entire novel is a showpiece of the previously mentioned dichotomy in the imagined concept of femininity, since the only woman character who is not greedy for sex

or money is the hero's pure, mild, concerned mother, a constant source of comfort to her son.

Keun, however, bestows upon her female character so much determination to preserve her own identity that she leaves the man she loves rather than allow herself to be taken over by him. The reader is in no way under the illusion that this decision is an easy one or its consequences trivial. On the contrary. The woman suffers and struggles with herself before she takes this step and the reader is left with no doubt that the next phase of the heroine's life, although it is not described by the author, will be difficult. . . .

The social criticism in *Gilgi—One of Us* is more complex and radical than that of *Little Man—What Now* and *Fabian*. It contains illuminating observations about the misery of the white-collar workers as it permeates the most intimate of relationships but does not attribute this misery exclusively to the economic crisis which only highlights the contradictions. It is also shown that women are sacrificed twofold by the prevailing social system, the patriarchal basis of which rejects equality of the sexes as a threat to the system. Although Russia was a country with a new beginning, [Alexandra] Kollontai's concept of women's total emancipation from the oppressive mechanisms of the past was welcome for only a short time. It was not long before the revolutionaries of yesterday could be recognized as defenders of their privileges in a socialist patriarchy. Without the efforts of the more recent American and German women's movement to re-evaluate the achievements of women, the works of Keun and Kollontai would have remained shamefully buried.

> Livia Z. Wittman. In Alice Kessler-Harris
> and William McBrien, eds. *Faith of a*
> *(Woman) Writer* (1984; Westport,
> Connecticut: Greenwood Press, 1988),
> pp. 100, 102

How the cinema during its checkered beginnings radically altered the ways in which literary works were produced and read constitutes a major unanswered question about modern literature. Particularly in Germany, the strictly drawn distinction between art and popular entertainment caused a rigorous debate on the aesthetic value of film and its status vis-à-vis literature and the arts. Toward the end of the 1920s, however, the overwhelming commercialization of the film industry and the advent of the talking film had all but obviated the intellectual reasons for sustaining such a controversy. The cinema had relinquished the aesthetic innovation of a silent film language, become an integral part of German social life and begun to generate a popular mythology of great suggestive power. Perhaps more complexly than any other novel published in the last years of the Weimar Republic, Irmgard Keun's *Das kunstseidene Mädchen* (1932) reflects this critical juncture in the history of the interrelationship between film and literature.

The cinematic suitability of Keun's writing attracted attention from the outset. In 1932 Paramount promptly filmed *Gilgi, Eine von uns* (1931), her first and very successful novel, with a cast that included Brigitte Helm, the famous star from *Metropolis,* and the prominent leftist actor Ernst Busch. Such an expeditious transference of the novel onto the screen did not meet with universal approval. In a review written for the *Linkskurve* and pointedly titled "Keine von uns," Bernard von Brentano accused Keun of producing a literary *Wunschtraum* that derived from celluloid oversimplifications to begin with and hence lent itself readily to cinematic adaptation by the UFA's American partner.

By the spring of 1933, a film based on *Das kunstseidene Mädchen* would have constituted a political liability. Included on preliminary blacklists which supplied guidelines for the so-called "Säuberung" of public libraries, the novel was confiscated and destroyed before the end of the year. In any case, it is doubtful whether this work would have satisfied the restrictive narrative codes implicit in a large studio production. *Das kunstseidene Mädchen* can in fact be read as a text which consistently undermines the ideological messages conveyed by popular films. If, as Brentano insisted, a cinematically superficial sense of life pervades *Gilgi,* then it is also true that this source of the main character's values remains concealed and unquestioned within the novel. This is not the case with *Das kunstseidene Mädchen,* in which Keun dispenses with the third-person, sometimes annoyingly omniscient narrator of the previous work, adopting instead an autobiographical form to present a woman obviously conditioned by the films she has seen. . . .

With [her] treatment of *Mädchen in Uniform,* Keun focuses on the reception of a major film to an extent scarcely matched in other novels of the period. Perhaps the only comparable treatment occurs in Lion Feuchtwanger's *Erfolg* (1930), where the Bavarian minister Klenk is shown watching *Battleship Potemkin* in a Berlin movie theater. Both of these exemplary depictions of how historically important films affect individuals and condition their social and political behavior deserve further attention for what they reveal about the sociology of the cinema. But while Feuchtwanger portrays the passing effect of an avant-garde political film on a calculating reactionary mind, Keun shows how the sexual subtext of a more conventional, socially critical film increases the understanding of a naive sensibility. Keun's choice of this particular film underlines the medium's emancipatory potential, for Doris articulates the subversive message of lesbian sexuality with a matter-of-fact frankness that eluded most contemporary critics. The novel's recognition of this theme jibes with the present perception of *Mädchen in Uniform* as a film whose rediscovery has been essential "to establishing a history of lesbian cinema." Keun herself was later to regard female homosexuality as a possible form of protest against the obnoxious cult of male superiority she witnessed under the Nazis.

As the novel ends, Doris is alone again, headed for the waiting room at the Zoo train station but very uncertain about what to do next. The unre-

solved conclusion is brightened somewhat by her final tentative concession: "Auf den Glanz kommt es nämlich vielleicht gar nicht so furchtbar an." Through Doris's reluctant rejection of a life dominated by the false glitter of cinematic dreams, Keun implies that she has not entirely missed the ethical and political message of *Mädchen in Uniform*. By revealing the powers of the cinema to deceive and at the same time drawing on its communicative energy, *Das kunstseidene Mädchen* points in the direction that a new, cinematically schooled literature might have taken.

<div style="text-align: right">Leo A. Lensing. Germanic Review.
60, 1985, pp. 129, 133</div>

Like her near-contemporary Ödön von Horváth, the novelist Irmgard Keun was very much "a child of her time." She had some literary success towards the end of Weimar, left Nazi Germany, and was then largely forgotten until a renaissance in the 1970s. Unlike Horváth, she lived to experience this renewed interest; she died in 1982. She did not, however, write much during the later part of her life.

Her emigration was not spent in what Frank Thiess later chose to call "Logen und Parterreplätzen," unless this is an apt description of a small hotel in Ostend where she spent one summer. During this time, she also formally separated from her husband, the writer Johannes Tralow, who had stayed in Germany and was, in her view, compromising with the Nazis. When he asked her to return, she and her new companion Joseph Roth composed a telegram which must amount to one of the finest snubs ever: "Schlafe mit Juden und Negern. Laß dich endlich scheiden. Irmgard!" She was in Amsterdam when the German troops entered and was thought by many fellow exiles to have committed suicide. In fact, she persuaded a German officer to give her false papers and returned to Germany, one case surely when even the sternest detractors of the term would accept that it is possible to speak of "internal emigration."

The volume *Ich lebe in einem wilden Wirbel* consists of Irmgard Keun's letters to her sometime lover Arnold Strauss, a doctor of Jewish extraction, who emigrated first within Europe and then to the United States. The letters, with one exception, span the period 1933 to 1940. After the war, Strauss, who had married in 1941, sent a Care-parcel but did not reply to Keun's letter of acknowledgment. In fact, the sending of gifts or requests for gifts, especially of money, take up a large part of the whole correspondence. Her life was far from easy as she struggled with financial, personal, political, and professional problems. Many of these, it must be admitted, were of her own making; one must also doubt whether, for all her protestations, she ever intended to settle down with Strauss. This was certainly the view of his parents.

What emerges from the letters is the picture of an archetypal Bohemian who paid a high price for her talent (drink was a major problem) and made those close to her suffer too. This is the view of Gabriele Kreis, who selected

about half of the available letters for publication. She comments on their contents in an appendix and between individual letters. One wonders if it would not have been better to let these speak largely for themselves and for value-judgments to have been restricted to the appendix. Nevertheless, this is a fascinating volume for the insights it provides both into the literary life of émigrés in general and into the work and character of Irmgard Keun in particular. Clearly, she deserves to be better known. A first step towards this would be an authoritative editing of her work. These letters, for instance, cast into doubt previous ideas and her own autobiographical writing on the question of the dates of her emigration, although it now seems clear that her real date of birth was 1905; not 1910, as she herself claimed and as stated in certain older reference works.

Stuart Parkes. *Modern Language Review.*
84, 1989, pp. 804–5

KILPI, EEVA (FINLAND) 1928–

It would be nearly impossible to distinguish between Eeva Kilpi the writer and Eeva Kilpi the woman. Both her writing and her life are products of personal circumstance. She is a woman's writer nonetheless. Her output is a deliberate investigation of the progression of a woman's life—*her* life. The men in her books, with a few possible exceptions, are incidental and flatly drawn. Her women, on the other hand, are alive—alive to the very painful essence of their existence, independent, respectful of creativity and emotion, close and distant, open and contemplative simultaneously, even as the author seems to be. . . .

A catalogue of her books is like a systematic examination of her own life; it is an investigation into life itself. Her oeuvre can be divided into four chronological phases. The first deals with childhood, adolescence and the establishment and dissolution of a family. The next phase scrutinizes the ordeals and tentative successes of a woman on her own, of any middle-aged single woman. Phase three consists primarily of poetry, of experience and emotion crystallized into expression. The final and current phase is a detailed investigation into the intangible links that bind family pasts and our own. . . .

Eeva Kilpi's life has been traumatic, entailing the unforeseen circumstances of evacuation from her home province of Karelia, as well as those of a divorced and single woman. As the epigraph in *Elämä edestakakaisin* says, her "world is turned topsy-turvy and life is turned back to front." She has transformed life into a matter of internalized experience expressed in some of the most persistent language of her nation. Her writing, like her life, has of necessity been a matter of emotional rather than rational experience. Although Kilpi works primarily with the limited elements of immediate experi-

ence, she applies these to the universal problems of existence. She is an exceptional writer, able to examine the innermost aspects of life without destroying it, to analyze what is painful yet not find life hopeless.

<div align="right">

Kathleen Osgood Dana. *World Literature Today*. 59, 1985, pp. 354, 357

</div>

The Time of the Winter War: A Childhood Memoir casts a net of reality over the constant themes Kilpi has worked and reworked in her more imaginative writing. The pivotal events of her childhood—the Winter War of 1939 and the consequent evacuation of her family from their home in Karelia—constitute the stuff of both her life and her imagination. *Talvisodan aika* covers in great specificity the events and memories of the 1939–40 winter, making the reader wonder if a future volume of memoirs covering the arduous Continuation War will be forthcoming.

Citations from war records kept in Raivattala by an anonymous officer lend the memoirs a feel of historical veracity; but it is Kilpi's close attention to the nature of memory that gives her writing its real authenticity, for emotion too is memory. Every event or turn of phrase or image that she recalls is scrutinized for its context and truth, and Kilpi does much to examine the foibles of memory. She writes: "Memories prove fickle when they are approached. At first they seem firm and clear, but the moment they are touched, they suddenly become frail and breakable, like plants in an old herbarium. Parts fall off, they become as transparent as ghosts, and one refracts another, making them hard to locate in time and place. . . . Which details belong to which memory? What closes these memories off from me?"

Kilpi reminds us that we do not say important things at important times, for the events speak for themselves. So she wrestles with the difficulty of finding words to convey the emotional and eventful days that marked the close of her childhood and the loss of her home. She speaks of a recurring nightmare wherein war catches her helpless, at the crossroads in her home village of Hiitola. As a child she was immobilized in the nightmare, unable to flee, but as an adult she has gained the knowledge that, despite her immobility, all she must do is survive and endure: "I have remembered this dream throughout my life, and in every subsequent nightmare the same emotion has ruled in one way or another. Just recently the helplessness of my terror has been replaced by a secret knowledge that I will survive, all I have to do is survive."

The author mourns the premature loss of her childhood as much as she does the loss of her home and homeland. During their evacuations she longs to be home, just to observe a certain patch of flowers through their growing season. She pines for the pleasures of quiet contemplation. At the same time she relishes the sudden flash of knowledge and understanding she gleans in the tiny segment of absolute freedom between the innocence of childhood and the burgeoning pressures of adolescence. With total objectivity she observes her mother and sister, aunt and grandmother in their makeshift refugee

homes. Her aunt becomes slovenly, letting a rip in her only dress grow larger, until news of her husband's forthcoming leave brings her back to reality and a needle and thread to repair the rip.

When the Winter War ends and her father brings the family to a remote homestead on the still-precarious Savo-Karelia border, young Kilpi rejoices to be once more in her own forest and determines to make the best of it. In short, she has learned to survive.

Kathleen Osgood Dana. *World Literature Today.* 65, 1991, p. 154

Her second volume of memoirs, which appeared last year, is equally compelling, but *Välirauha, ikävöinnin aika (Between the Wars: A Time of Sorrow and Sickness)* is marked by the hard-edged urgency of adolescence and the distressing reality of being uprooted by war, economics, and school. Although there are flashbacks and flashforwards in both volumes (usually precipitated by the memory of a meal or a garment or a piece of furniture), the second volume follows a stricter time frame: from the summer of 1940 to the spring of 1941, the period circumscribed by the brief interlude between the Winter War and Finland's reentry into World War II as an ally of Germany. *Välirauha* follows young Eeva to her family's resettlement on a wilderness farm near the new Soviet border in the summer of 1940, to a compensatory school session in Lappeenranta, to her resettled grandmother's new home in Kerava to attend high school, and then to a new home in the village of Vuoksenniska, only to be uprooted once more by the resurgence of war in the spring of 1941. Without the immediacy of war to supply an exact chronology of events, the volume is organized more by *place* of memory than by *time* of memory.

Perhaps the examination of memory itself is the most fascinating and illuminating feature of Kilpi's memoir. As in much of her prior work, she seems uniquely qualified to speak on the nature of deeply rooted but unvoiced intuitions about the human condition. She writes that memory seems "to reverberate regardless of chronology. It is as if temporal succession is the least restrictive of all of memory's characteristics. Continuity seems to be composed of quite different factors, whose real nature remains a secret." Throughout her writing she poses fundamental, philosophical questions. When she asks, "Where do I belong?" the problem of "Where is home?" recurs time and again. Boarding with relatives in Lappeenranta, she is plagued by a homesickness that is always accompanied by real sickness, blurring the borders between emotional and physical well-being. A child of the forests, she finds her life unduly limited by streets and cityscapes, lamenting "I long always for the forests." She seems to have heaved a sigh of relief when Finland called its Karelians "evacuees" for the first time as they were relocated from the Soviet border. No longer buoyed up by her heritage as a Karelian, she finds satisfaction in once again knowing what to call herself, even if the new name is only "evacuee."

Musing on the problems of survival, Kilpi finds in the behavior of animals the ability simply to endure quietly; in the landscape near their border farm a jumble of caves forms a metaphor for survival. Her father takes her and her young sister to explore some of the caves, which are just big enough for them to squeeze through on their stomachs. When she emerges on the other side, she thinks about how they had all just "squeezed through" the ordeal of the Winter War and their first evacuation. At the same border farm, she kills an endangered snake and is horrified at her action. That horror is internalized and becomes a strong voice echoing in the defense of all animals in much of her subsequent work. Kilpi's is a woman's voice on a par with those of the very best writers in the world, and *Välirauha, ikävöinnin aika* is a profound and rewarding memoir, a work which makes us hope for more memories to follow.

<div align="right">

Kathleen Osgood Dana. *World Literature Today.* 65, 1991, pp. 739–40

</div>

When Kilpi was twelve years old, the family had to leave their Carelian hometown of Hiitola as a result of the Finnish Winter War in 1940. This experience, the topic of Kilpi's two long novels *Elämä edestakaisin* (1964; Life back and forth) and *Elämän evakkona* (1983; Refugees of life) as well as of her two memoir books, *Talvisodan aika* (1989; Time of Winter War) and *Välirauha* (1990; Provisionary peace), shaped Kilpi's outlook on life. As the theme of loss and pain or separation it structures much of Kilpi's production.

Kilpi's first collection of short stories, *Noidanlukko* (1959), the name of a flower that never blooms, dealt with idyllic childhood experiences, which, however, were cut short by the war. In the autobiographical series of books, starting with *Talvisodan aika,* she returned to her childhood Carelia, but now in the documentary mode, focusing not only on the loss of the land itself but on what it meant for a girl to grow up in the midst of the family's many moves and the whole nation's attempts to come to terms with its new truncated existence. Ibsen's words "Kun det tapte evig eies" ("Only what is lost, is forever owned") describe admirably Kilpi's attitude to the lost province of Carelia. For Kilpi's and her parents' generation, Carelia functioned as the seat of authentic values; its shared loss gave the former Carelians a sense of togetherness, and the shared memories bestowed their lives with meaning. Realizing that with the demise of her fathers and mothers disappeared also the values of the era they represented. Kilpi has felt compelled to record her own Carelian experiences based on diaries, old letters, and other documentary sources.

Women as creators and centers of creativity but also as the deprived ones, whose lives consist of a series of losses, are the protagonists of many of Kilpi's novels and short stories. The lost childhood experience of unity with one's environment can be recaptured through love and the sexual experience. But for a woman even love leads to losses, of lovers, of a husband, and, for the mother, of her sons. Finally, she has to face the increasing signs

of physical deterioration, the augurs of old age and death. It is particularly this perspective of a middle-aged woman, rather scantily treated in literature, that gains prominence in Kilpi's works. More openly than perhaps any other Finnish woman writer of her generation Kilpi has dealt with female sexuality. At times her attitude approaches the traditional male one where a one-night stand serves to validate the aging woman's self-worth and prowess. But more often, like in the erotic novel *Tamara* (1972; *Tamara*, 1978) and the fictional diary *Naisen Päiväkirja* (1978; A woman's diary), the sex act is the one experience that at least momentarily reestablishes a feeling of lost unity by erasing all alienating boundaries between male and female, body and soul, life and death. Identification with nature and its cycles of life and death, from trees to insects, offers a similar experience of almost pantheistic oneness with the universe. Stylistically Kilpi's detailed descriptions of nature are superb in their sensitivity and beauty.

While a male critic's retort that Kilpi's meticulous reporting of the female's bodily functions leaves readers cold greatly misjudged the sociological makeup of the readership, it did accurately reveal how Kilpi's works address women in particular. Both in her psychological analysis of the different phases in a woman's life and her openly confessional treatment of female sexuality, she has been the forerunner of the many women writers of the 1980s who have been both bolder and stylistically more experimental in their depictions of today's Finnish women. Also in her attunement and deference to nature Kilpi anticipated the ecological consciousness of the 1990s. A good indication of the exceptionally warm reception Kilpi has enjoyed among readers in Sweden are the numerous and almost instantaneous Swedish translations of her works.

Virpi Zuck. In Steven R. Serafin and Walter
D. Glanze, eds. *Encyclopedia of World
Literature in the 20th Century* (New York:
Continuum, 1993), pp. 359–60

KINCAID, JAMAICA (ANTIGUA–UNITED STATES) 1949–

Jamaica Kincaid made an immediate impact on the literary scene when she first appeared in the early 1980s. Her two works so far are *At the Bottom of the River,* published in 1983, followed by *Annie John* in 1985. *Annie John* is a semi-autobiographical novel dealing with her experience of growing up in Antigua. *At the Bottom of the River* is a collection of pieces combining reflection and memories of that early experience. The two works are in fact companion pieces, the one in straightforward prose, the other poetic and intuitional in style. The substance of the experience in *Annie John* reappears in the images of *At the Bottom of the River.*

The reader is immediately struck by the originality of Kincaid's work, an originality that comes both from the peculiar character of the experience she recalls as from her singular rendering of it. In the more accessible *Annie John,* she re-creates a vivid picture of the Antiguan setting in which she grew up. It is the typical small-island environment before urban times. . . .

The preoccupation with childhood lies at the core of Kincaid's work and represents a very special achievement. In exploring it, she renews our understanding of the meaning of innocence and the value and possibilities of our first world. . . . One must look closely at what she recognizes in this innocence. It is not a state free from stain and imperfection. Growing up in *Annie John* involves an openness and receptivity to all manner of emotions and impulses, creative and destructive—love, dawning cruelty, generosity, possessiveness, instincts of hubris. In other words, the child is fully in touch with the complex motions of her own nature and being. It is also the freedom of the child's natural curiosity, the intentness with which it relates to the world around it, animate and inanimate forms alike. In Kincaid's testimony, the mother comes to contain and embody the world because of the totality with which the child lived that first relationship with her; and the struggle to be reconciled with her mother contained in embryo the struggle to be reconciled with life itself. In another piece entitled "Blackness," Kincaid intimates the possibilities and depths of remaining in touch with these sources as she, now a mother, looks through the prism of her own child. . . .

And what has all this to do with Kincaid's roots in the Caribbean? Derek Walcott, in an early response to Kincaid's work, has this to say: "Genius has many surprises, and one of them is geography." Kincaid grew up in an environment which helped give her a firm grounding in human relationships and their tenacity, an uncluttered landscape which kept her imagination in touch with primal realities. Her own work is proof of the power of that landscape. In reclaiming these roots she makes an explicit disavowal of the universe according to the twentieth-century view—a system that can be calculated, programmed and mastered, where the human spirit is left very little space to breathe. She puts it thus as she looks through the vision reflected at the bottom of the river: "the sun was The Sun, a creation of Benevolence and Purpose and not a star among many stars, with a predictable cycle and a predictable end. . . ." In the global scheme of things, Kincaid's native Caribbean, despite the brutalities of its past, is yet close to the state of childhood, and has the capacity to bring this message.

<div style="text-align:right">

Patricia Ismond. *World Literature Written in English.* 28, 1988, pp. 336–37, 340–41

</div>

"Now I am a girl, but one day I will marry a woman—a red-skin woman with black bramblebush hair and brown eyes, who wears skirts that are so big I can easily bury my head in them. I would like to marry this woman and live with her in a mud hut near the sea." The magic of *At the Bottom of the River* (1983) comes from its language. It is as rhythmic and riddlesome as poetry.

Lovely though the words are, they often read like a coded message or a foreign language. Throughout *At the Bottom of the River* the reader is left wondering how to decipher this writing. The decoder comes in the form of Jamaica Kincaid's novel *Annie John. Annie John* was published in 1985, two years after *At the Bottom of the River.* Its chapters had all appeared as individual stories in the *New Yorker. Annie John* tells the same story as *At the Bottom of the River,* that of a girl coming of age in Antigua, but uses straightforward novel talk and presents few comprehension barriers to the reader. *Annie John* is a kind of personification of *At the Bottom of the River.* It fleshes out the fantasy and the philosophy of *At the Bottom of the River's* poetry, and between the two books there exists a dialogue of questions and answers. They ultimately read as companion pieces or sister texts. . . .

At the Bottom of the River has been billed as "Caribbean fiction" portraying "a childhood in the Caribbean" that is "partly remembered, partly divined" (back cover, Aventura edition), but the most obvious alternative reading of Kincaid's collection of stories interprets it as being not so much about growing up on the islands as about growing up female. Every sentence of Kincaid's writing breathes this feminine sensibility. . . .

At the Bottom of the River is so strange and new that it often reads like not only a foreign language, but an entirely new kind of writing that could specifically be called a woman's writing. The name filling up her mouth is not only "Annie John" and not only "Jamaica Kincaid." The name is also "woman."

<div align="right">Wendy Dutton. World Literature Today.
63, 1989, pp. 406–7, 410</div>

The works of Jamaica Kincaid, with their forthright acceptance of Caribbean identity (and of course the fact that she has legally renamed herself "Jamaica") present an explicit identification. Kincaid's works therefore begin at a different point on the identity/heritage continuum. Having already accepted Caribbean identity, she can then pursue the meaning of her woman self as she does in "Girl"; her inner personal self as she does in "Wingless" and "Blackness," which is a clear redefinition of the concept of "racial" blackness; her relationship to the landscape and folklore, as she does in "In the Night" and "Holidays"; and all of these in the title story "At the Bottom of the River." Both *At the Bottom of the River* and *Annie John* explore the female self in the context of landscape and Caribbean folk culture. Central to both books also is perhaps the best presentation in literature so far of the conflicted mother-daughter relationship.

Heritage and identity are intrinsic to the narrative and have as much significance as the gender issues with which she begins *At the Bottom of the River.* "Girl" begins with a catalogue of rules of conduct for the growing Caribbean girl/woman. These merge into surrealistic images of the Caribbean supernatural world but conclude with her woman-to-woman motif which recurs throughout both texts. . . .

Annie John is a *bildungsroman* marking the girl's growth from childhood to womanhood and only at the end of the work, close to the point of her departure from the island do we learn that she and her mother share the name Annie John. . . .

In the surreal landscape of *At the Bottom of the River* it is easy to see the maternal image merge with the image of woman love, for the imaginary female love she creates combines her Red Girl friend and her mother. The differentiation that is forced in *Annie John* with its solid autobiographical realism is allowed free poetic exploration into emotions and self in *River.* . . . In the haunting world of *At the Bottom of the River* where landscape collides gently with people, there is an Edenic quality to relationships and place and woman-to-woman identification is strong.

<div style="text-align: right;">

Carole Boyce Davies. In Carole Boyce
Davies and Elaine Savory Fido, eds. *Out of
the Kumbla: Caribbean Women and
Literature* (Trenton, New Jersey: Africa
World Press, 1990), pp. 64–67

</div>

Derrida in *Positions* speaks of the necessity of ridding oneself of a metaphysical concept of history, that is linear and systematic. His claim is for a new logic of repetition and *trace,* for a monumental, contradictory, multileveled history in which the *différance* that produces many differences is not effaced. Jamaica Kincaid's *At the Bottom of the River* and *Annie John* represent examples of writing that break through the objective, metaphysical linearity of the tradition. At the same time, her voice manages to speak up for her specificity without—in so doing—reproducing in the negative the modes of classical white patriarchal tradition. Kincaid's voice is that of a woman and an Afro-Caribbean/American and a post-modern at the same time. This combination is therefore not only disruptive of the institutional order, but also revolutionary in its continuous self-criticism and its rejection of all labels. Perhaps we could say that it is a voice coming *after* the struggles of the women's movement first for recognition and then for separation; the voice of the third "new generation of woman" as Kristeva defines it: an effort to keep a polyphonic movement in process in the attempt to be always already questioning and dismantling a fixed metaphysical order, together with a determination to enter history. Her narrative, in fact, is a continuous attempt to turn away from any definitive statement *and* to utter radical statements. . . .

The theme of colonialism is treated by deconstructing the Master-Slave dialectics upon which it rests: After mocking the English who didn't wash often enough—"Have you ever noticed how they smell as if they had been bottled up in a fish?"; after having the English girl wear the dunce cap in class; after stressing that "our ancestors"—the "slaves"—"had done nothing wrong except sit somewhere, defenseless," she refuses to appropriate the Western conception of nation in order to express her anti-colonialism. . . .

Just like the imagery of death which pervades the "paradise" of the first chapters and dissolves as the problems rise in the central part of the book, everything is looked at in its multiple aspects. Grounded on personal experience, Jamaica Kincaid's writing nonetheless defies a realistic interpretation of her voice; it challenges any possibility of deciphering a single meaning by emphasizing multiplicity in what Roland Barthes would call,

> an anti-theological activity, an activity that is truly revolutionary since to refuse to fix meaning is, in the end, to refuse God and his hypostases—reason, science, law.

But for Jamaica Kincaid it certainly does not mean to refuse love as we can know it.

> When I write I don't have any politics. I am political in the sense that I exist. When I write, I am concerned with the human condition as I know it.
>
> Giovanni Covi. In Carole Boyce Davies and
> Elaine Savory Fido, eds. *Out of the
> Kumbla: Caribbean Women and Literature*
> (Trenton, New Jersey: Africa World Press,
> 1990), pp. 345–46, 352–53

One of the most intricate questions dealt with by the Caribbean writer in recent years has been that of identity. The issue of subjectivity, beset with problems such as recognition of self and other and oedipal conflict under the most conventional circumstances, is complicated further here given the additional factors of colonialism and pluralism which continue to mark Caribbean society and culture. One recent work which tackles such questions is Jamaica Kincaid's *Annie John*. Set in the Antigua of the 1950s, this autobiographical novel recounts a succession of experiences which culminate in the protagonist's almost palpable hatred for her mother. Underlying its apparent linearity, however, are various tropes and figures which trace Annie's desire to establish an individual identity within the complexities of Caribbean social structure. The specific psychoanalytical concepts which bear upon and explicate her wish for separation will be shown at several points to be impacted not only by the exigencies of Caribbean history, but by its racial pluralities as well.

The quest for identity in which the protagonist engages in this novel is mediated primarily by the Lacanian paradigm of the alienated subject. Lacan himself posits this alienation by delineating clearly the split inherent in subjectivity: "Identity is realized as disjunctive of the subject . . . since it is the subject who introduces division into the individual, as well as into the collectivity that is his equivalent." In her exemplary work entitled *Jacques Lacan*, Anika Lemaire says of this split subject that "the truth about himself,

which language fails to provide him with, will be sought in images of others with whom he will identify." In this case the protagonist, unable to achieve assonance with the world around her, identifies with the image of the other in the form of her mother in an effort to establish a coherent self. This symbiotic relationship appears to function until the falseness of its premise is exposed to her, an event which is specifically precipitated by a primal scene. This, in turn, gives rise to a new perception of the mother as being both racially and culturally different. The mother's creole Dominican past becomes opposed to Annie's Antiguan cultural formation, so that the mother's cultural separateness and "foreignness" are interpreted as a form of racial difference. This idea of racial difference as a subset of "foreignness" thus initially terminates the primary stage in which Annie seeks her identity through the (m)other. In conjunction with the primal scene, it also gives rise to Annie's perception of her mother's abdication of authority, precipitating her rejection of that unique sense of unity that had bound them together.

<div align="right">H. Adlai Murdoch. Callaloo. 13, 1990, p. 325</div>

With *Lucy* Jamaica Kincaid continues a story of West Indian female development. Whereas the earlier bildungsroman-style works *At the Bottom of the River* (1983) and *Annie John* (1985) dealt with the adolescent years of a girl in the Caribbean, the new book presents a single learning year—the nineteenth—in the life of a character called Lucy, in the new setting of the United States. Lucy is an immigrant engaged to work as an au pair for a wealthy white couple and their four young daughters. Her year is complexly lived with its attendant difficult times, but it provides Lucy with learning experiences that enable her to manage the cultural change and her passage. By the end of this year she can appreciate the commitment of sisterhood (with her employer, for instance), has negotiated a social world of friends and lovers, and has embarked on an independent life provided for by a job as a photographer's helper. She has, moreover, survived the separation from her West Indian mother and upbringing, tasting an independence she has craved for many years. However, the persistence of unreconciled ambivalence toward her mother, guilt about her recently deceased father, and fears concerning her uncharted future becloud this newly gained freedom. The end of the work thus suggests a problematic future, though the fact that Lucy identifies herself as a writer—the act of inscribing her name, Lucy Josephine Potter, across the top of a journal notebook signifies this—indicates a self-authenticating, defining, and authorizing gesture of significance.

Compared to the earlier works, *Lucy* engages a thicker web of conflicts. Coming-of-age dilemmas in the preceding works involved the more limited parameters of home and small-island environment. Thus, conflicts were essentially the result of the circumstances of family (with the mother considered the most central aspect of "oppression"), of the social world of peers and adults, of the adolescent's anxieties of physical maturation and sexuality. The later work complicates these conflicts, introducing cultural and geographic

change and displacement as new factors in the life experiences of the young girl. Lucy finds that she must negotiate an identity in a culture that is for all practical purposes an unknown to her, and one with operant discourses of race, class, and gender that she must quickly decipher. She focuses her alien's hostility to this culture upon Mariah, her employer. She is often enraged by the confidence of this all-American woman (whom she eventually comes to love, however), as for example in her need to wish to proclaim in great self-confidence, "I have Indian blood." Lucy considers such racial acknowledgment as transgressive; it serves to deny history. She feels that "victor and vanquished" are historically separate events of being. Contemplating her own Indian heritage—she is part Carib—Lucy tells herself that to claim Carib status would be to totemize it.

As an immigrant, Lucy bears comparison with other immigrants. Similarly, she feels threatened in the U.S. (she is, she well knows, part of an economic underclass); similarly, she is heartened by the prospects of freedom and choice there. When she first arrives, Lucy is the disappointed immigrant; the U.S. is "ordinary" and "dirty." Unusually perceptive and sensitive, however, she forgoes superficial knowledge of the culture and instead engages in a dialogic confrontation with it. Not victimlike, she expresses rather than suppresses her differences and individuality.

Lucy also makes a strong statement about the difficult terms of living under colonialism. A good example of this comes in the first chapter, when Lucy is being pressed to show admiration for daffodils. As she vehemently protests, these flowers are for her a symbol of cultural imperialism. They bring back memories of her school days in the West Indies, when she had been expected to memorize a poem about daffodils—flowers, she reminds her employer, that are not native to the islands. That foreign material (in all respects) should have been dominant in the education she received, and native material made superfluous to education, evidenced for Lucy the cultural oppression that she had endured. Negative reinforcements were the patriotic songs, such as "Rule Britannia," that tried to indoctrinate the West Indian into the discourse of European superiority and native inferiority. This past, too, Lucy seeks to escape.

The work ends with Lucy's statements, "One day I was a child and then I was not" and "Your past is the person you no longer are." The fact that Lucy gives the appearance of believing this is indication, of course, that she is barely twenty years old.

Evelyn J. Hawthorne. *World Literature Today.* 66, 1992, p. 185

KINGSTON, MAXINE HONG (UNITED STATES) 1940—

In my view, Kingston's reaction to female experience is centered in simultaneously claiming new possibilities and integrating a knowledge of actual lived reality—claiming fantasy not as a separate inner world of the imagination but as a powerful tool for reshaping lived experience beyond the repressions of personal daily life. For it seems to me that the power of *The Woman Warrior* lies not in the invisible force of fantasy as distinct from reality but in the powerful interaction of fantasy with reality—without refusing to differentiate—in determining new possibilities for female selfhood. Through this interaction, the narrative process, then, enables Kingston to develop a strong female identity, grounded—as is narrative itself—in the capacity to choose and to interpret and in the ability to act in a social context.

The most immediate reality in Kingston's childhood is extremely oppressive: not only the isolation of a bi-cultural context in which she can claim neither Chinese identity nor American identity but also the immediate misogyny of much of that context. Kingston grows up haunted by a vague fear of being sold into slavery or wifehood and a more immediate awareness that her brothers are more valued than she and her sisters, as is clearly evident in the rituals and celebrations of their lives. She knows fully the traditions of feet-binding and the capacity of the language to reinforce self-hatred. . . .

The attempts to reject her own femaleness imply a kind of self-hatred, which is even more evident in a story of factual reality from her childhood, told in the final section of the autobiography. Following the portrayal of her own shrouded childhood silence in American public schools, she tells of her physical and psychological abuse of another Chinese American girl with whom Kingston herself obviously identifies, for the "quiet one" shares Kingston's own earlier refusal to speak aloud in public and her inability to participate in American life. But Kingston is also making every effort to differentiate herself from this girl by claiming her own hatred of neatness and pastel colors, her own desire to be tough rather than soft. The actual abuse is clearly an effort to expunge those parts of her Chinese-female identity which she abhors and to mark out her own possibilities for strength in resisting that identity. The experience is followed by a "mysterious illness" and with it an eighteen-month period of social isolation, after which she must relearn "how to talk" and come to recognize that the other girl has different ways of surviving, different protections than are available to Kingston. The painful retelling of the abuse and of her subsequent healing solitude becomes the attempt now to reinterpret her own past, to free herself from both the silence and the aggression, to alleviate the evident guilt she feels, and to understand the sources of the person she has become, somehow straddling Chinese and American realities and accepting her female identity.

But this effort cannot succeed through simple documentation of either the repressive reality or her attempts to resist it. Rather she must claim her

female identity by shaping her narrative interpretation of self through the interpenetration of fantasy with reality. The dominant fantasy in the autobiography is, of course, that of the woman warrior

> Joanne S. Frye. In Alice Kessler-Harris and
> William McBrien, eds. *Faith of a (Woman)*
> *Writer* (1984; Westport, Connecticut:
> Greenwood Press, 1988), pp. 294–95

In *China Men*, the narrator, who is again the daughter, is less involved with the characters and far less concerned with relating how she feels about them; Kingston says that *The Woman Warrior* was a "selfish book" in that she was always "imposing my viewpoint in the stories" through the narrator. In *China Men*, on the other hand, "the person who 'talks story' is not so intrusive. I bring myself in and out of the stories, but in effect, I'm more distant."

Like *The Woman Warrior*, *China Men* expresses the Chinese American experience through family history combined with talk-story, memory, legend, and imaginative projection. But while *The Woman Warrior* portrays the paradoxical nature of the Chinese American experience through the eyes of an American-born Chinese, *China Men* is a chronicle of Chinese American history less particular and less personal. The distance between the narrator and the characters in *China Men* might be attributed to the fact that Kingston heard the men's stories from women's talk-story: "[W]ithout the female storyteller, I couldn't have gotten into some of the stories. . . . [M]any of the men's stories were ones I originally heard from women." . . .

Despite what some Chinese American male critics of Kingston have alleged, *China Men* is not anti-male; on the contrary, it is the portrait of men of diverse generations and experiences, heroes who lay claim on America for Chinese Americans and who refuse to be silenced or victimized. They are strong and vocal men who love and care for each other. *China Men* is also about the reconciliation of the contemporary Chinese American and his immigrant forefathers, nourished by their common roots, strong and deep, in American soil. Kingston's men and women are survivors. The reconciliation between the sexes is not complete, but Kingston demonstrates that Asian American writers can depict with compassion and skill the experiences of both sexes. The men and women of *China Men* and *The Woman Warrior* are vivid and concrete refutations of racist and sexist stereotypes. The complexity and diversity of the Chinese American experience as presented in these books make continued acceptance of unidimensional views of Chinese Americans difficult: for every No-Name Woman, there is a Fa Mu Lan; for every Great Grandfather of the Sandalwood Mountains, there is a Brother in Vietnam. And for each perspective set forth by Maxine Hong Kingston, there is a myriad of other Chinese American viewpoints.

> Elaine H. Kim. *Asian American Literature:*
> *An Introduction to the Writings and Their*
> *Social Context* (Philadelphia: Temple
> University Press, 1982), pp. 208, 211–12

In *The Woman Warrior: Memoirs of a Girlhood among Ghosts,* Kingston recreates the Chinese-American heritage that provided the tissue for her adult fantasies. Stories from a mythical China, where females were traditionally denigrated and girl babies often murdered at birth, prey upon her psyche and weave their shapes into phantasmagoric fables. Like the obsessive images of babies in *The Bell Jar,* Kingston's inner turmoil finds its objective correlatives in "nightmare babies" who proliferate among a host of ghosts and crazy women. There are the Mainland China ghosts carried to America by her mother; the brother and sister "who died while they were still cuddly," defective babies left to die in outhouses, girl babies smothered in boxes of ashes, "the ghosts, the were-people, the apes, . . . the nagging once-people. . . . My mother saw them come out of cervixes." Most of these phantasms are transmitted to Maxine through her mother's midwifery tales, thus establishing a ghoulish connection in the daughter's mind between the mysteries of birth and death. . . .

It is not surprising to find in Kingston's world blatant images of crazy women coexisting alongside ubiquitous ghost forms. There is the crazy lady stoned to death by the villagers for trying to signal Japanese planes with her mirrored headdress; Crazy Mary left behind in China for twenty years and forever beyond the pale of sanity when she arrives in America; the witch-woman Pee-A-Nah, "the village idiot, the public one"; Aunt Moon Orchid, who goes insane in California after her arrival from Mainland China; the speechless girl who refuses to be pinched into speech—all are alter egos for the author herself, who lived her girlhood on the edge between the threat of ghosts and the temptation of madness. "I thought every house had to have its crazy woman or crazy girl, every village its idiot. Who would be It at our house? Probably me."

Kingston structures her autobiography around the figures of five central women who incarnate various negative and positive possibilities leading either to craziness and/or suicide, or to escape into more fortuitous forms of self-expression. . . .

The final strategy [of *The Woman Warrior*], like much of the book, is nothing less than brilliant. "Here is a story my mother told me, not when I was young, but recently, when I told her I also talk-story. The beginning is hers, the ending, mine." Resolution takes place between the mother's oral tradition and the daughter's written craft, between the Chinese and the American, and ultimately between mother and daughter. Maxine Hong Kingston, American offspring of a foreign-born mother who does not speak or read English, finds her voice by taking up where her mother's leaves off. By consciously situating herself within the heritage of maternal "talk-story," she learns to loosen her own tongue, which will be the guarantor of her sanity. Like [Marie] Cardinal, Kingston offers the model of a writer who talked her way out of madness.

<div style="text-align:right">

Marilyn Yalom. *Maternity, Mortality, and the Literature of Madness* (University Park: Pennsylvania State University Press, 1985), pp. 96–97, 99–100

</div>

We won't get much of anywhere with *Tripmaster Monkey* unless we understand that Maxine Hong Kingston is playing around like a Nabokov with the two cultures in her head. In *Ada,* by deciding that certain wars, which were lost, should have been won, Nabokov rearranged history to suit himself. There were Russians all over North America, making trilingual puns. This odd world was a parody of Russian novels. In *Tripmaster Monkey,* America in the 1960s is looked at through the lens of a half-dozen Chinese novels, most of them sixteenth century. I will fall on this sword in a minute.

First, a disabusing. What everybody seems to have wanted from Kingston, after a decade of silence, is another dreambook, like *The Woman Warrior.* Or another history lesson, like *China Men.* Anyway: more magic, ghosts, dragonboats, flute music from the savage lands. Never mind that she's earned the right to write about whatever she chooses, and if she chooses to write about looking for Buddha in the wild, wild West, we'd better pay attention because she's smarter than we are. Nevertheless, the reviewers are demanding more memoir. Where's the female avenger?

Instead of the female avenger, we get Wittman Ah Sing, a 23-year-old fifth-generation Chinese-American male, Cal English major, playwright and draft dodger. This Wittman, singing himself in Berkeley and San Francisco in the early 1960s, in the parenthesis between the countercultures of beat and hippie, will lose a job in the toy section of a department store and apply for unemployment; read Rilke aloud to startled passengers on a bus and look in the woods for his abandoned grandmother; act up and act out. He wants to be an authentic American, but America won't let him. Racist jokes enrage him, but he also worries that a rapprochement of black and white might still exclude his very own yellow, which color determines his wardrobe, his slick performance. . . .

Wittman is a "tripmaster," a guide to the stoned in their travels through acid-time. But he's also, and this is where it gets tricky, an incarnation of the Monkey King in Wu Ch'eng-en's sixteenth-century *Journey to the West,* a kind of Chinese *Pilgrim's Progress.* He's the rebel/mischief-maker who helped bring back Buddha's Sutras from India; the shape-changer (falcon, koi fish, cormorant) who annoyed Lao-tse by eating the peaches of the Immortals, even though he hadn't been invited to their party. The weeklong play this Monkey stages to finish off Wittman's "fake book" is nothing less than a reenactment of *Romance of the Three Kingdoms,* a kind of Chinese *Terry and the Pirates.* And the actors he press-gangs into service for that play—everybody he knows in California, including his Flora Dora showgirl mother, his "aunties" and a kung fu gang—are nothing less than symbolic stand-ins for the 108 bandit-heroes of *Water Margin,* a kind of Chinese Robin Hood—enemies of a corrupt social order, hiding out in a wetlands Sherwood Forest, like Chairman Mao in misty Chingkangshan or the caves of Yenan. . . .

A word here about language. What so excited readers of *The Woman Warrior* and *China Men* was that shiver of the exotic, the Other's static cling. It was as if we'd eavesdropped on a red dwarf and picked up these alien

signals, this legend stuff, from an ancestor culture that despised its female children, that bound their feet and threw them down wishing wells and killed their names. Kingston achieved such a shiver by a sneaky art—disappearing into people who couldn't think in English, and translating for them. She had to invent an American language commensurate with their Chinese meanings. In the way that Toni Morrison arrived at all the transcendence of *Beloved* by stringing together little words *just so*, rubbing up their warmth into a combustion, Kingston dazzled us by pictographs, by engrams. . . .

The result in *Tripmaster* is less charming but more exuberant. Instead of falling into pattern or turning on wheel—there's something inevitable about everything in *The Woman Warrior* and *China Men*, something fated—this language bounces, caroms and collides; abrades and inflames. Instead of Mozart, Wittman's rock and roll. . . .

Wittman's too easily wowed. He's a one-man *I Ching*—"a book and also a person dressed in yellow," jumping from "reality to reality like quantum physics." He needs watching. And a female narrator—usually affectionate, always ironic, occasionally annoyed—looks down on him. Don't ask me how I know the narrator's female. I just do. She's as old as China, and remembers what happened in five dynasties and three religions. She's also foreseen the future: America will lose the war in Vietnam, which Wittman's dodging; the 1960s will be sadder than he hopes; feminism's in the works.

You can stop looking for the Novel of the Sixties. It took 3,000 years on its journey to the West. But here are the peaches and the Sutras.

<div style="text-align: right">

John Leonard. *The Nation.* June 5, 1989,
pp. 768–70, 772

</div>

In *The Woman Warrior,* not only does Maxine Hong Kingston use the first person freely, but she ranges widely through the polyglossia and images of her multicultural upbringing, from male locker room talk—"I hope the man my aunt loved wasn't just a tits and ass man" to allusions to Virginia Woolf—"by giving women what they wanted: a job and a room of their own" — to Chinese myth—"As the water shook, then settled, the colors and lights shimmered into a picture, not reflecting anything I could see around me. There at the bottom of the gourd were my mother and father scanning the sky, which was where I was"—to open tirades against her mother: "You lie with your stories. You won't tell me a story and then say, 'This is a true story,' or, 'This is just a story.' I can't tell the difference. I don't even know what your real names are. I can't tell what's real and what you make up. Ha! You can't stop me from talking. You tried to cut off my tongue, but it didn't work." This polyglossia is a verbal portrait of the Chinese American girl Maxine, who "being young is still creating herself." Maxine is American-bold in protesting the misogyny of traditional Chinese culture and the tyrannical methods her mother used to impose her will on her family. Kingston is poetic and imaginative in creating dramas that she did not witness: the No Name aunt's adultery and punishment, Fa Mulan's mystical training, Brave Orchid's

exorcising of the sitting ghost. In fact, the line between fantasy and reality, in Kingston's book as in her mother's stories, is never strictly maintained and the narrative frequently crosses the border. . . .

The Woman Warrior is a brilliantly developed exposition of the between-world condition from the very first line, in which Kingston breaks her mother's injunction to silence by telling the story of the adulterous aunt that she is told never to tell, to the last story of Ts'ai Yen. The American daughter needs to gain independence from family traditions, seen in the No Name aunt's story as constraint to the point of annihilation, while the Chinese mother's purpose in passing on family stories and custom is to mold the next generation into conformity with time-honored tradition. The dutiful mother tells the story to her daughter as a cautionary tale, but the rebellious daughter calls this aunt "my forerunner" and admires her for defying conventions, breaking taboos, and being her own person, regardless of the cost. The mother wants the daughter to participate in the family's punishment by never speaking of this aunt, but the daughter begins her book by making public the aunt's story and even embroidering on it with her own poetic speculations as to why and how the woman committed adultery and suicide. Out of a victim, one whom the villagers punished by raiding her family's house and destroying or taking all their stores, and whom her family punishes by never speaking her name, Kingston creates a victor, of sorts, and a threat: the No Name aunt killed herself and her child as she was expected to do, but she did it by jumping into the family's drinking well, thus polluting the water and getting her revenge. Furthermore, as a spite suicide, she does not even mean Maxine well, but "weeping ghost, wet hair hanging and skin bloated, [she] waits silently by the water to pull down a substitute."

Though seemingly disconnected, the episodes in The Woman Warrior are carefully structured and organized to illuminate the themes of woman as victim and woman as victor. Each theme is manifested primarily in one story at a time, and these stories alternate and balance one another throughout the text: the No Name aunt is followed by the warrior Fa Mulan; the indomitable Brave Orchid's feats by the tragedy of her pale, weak sister Moon Orchid; the crazy women who have only one story that they repeat over and over; by Maxine herself, who has a list of more than 200 items that she finally gives voice to. . . .

China Men begins and ends with parables about the treatment of Chinese men in the United States. The opening chapter, "On Discovery," adapts an episode from a nineteenth-century Chinese novel, Flowers in the Mirror, by Li Ju-chen, in which a man sails by chance into a country of women and is forced to endure all the tortures that generations of Chinese women have endured for the sake of beauty: pierced ears, plucked eyebrows and fore-heads, and bound feet. He is at last transformed into a "pretty" servant fit for the empress. A dialogism informs this parable. On the one hand, as a woman, Kingston seems to take a feminist delight in inverting the gender roles and in giving men a taste of medicine they have forced their women to

drink. On the other hand, as a person of Chinese ancestry, in suggesting that the Women's Land is in North America she sides with the men in implying that Chinese men have been metaphorically castrated in the United States. They have been "allowed" to serve the white master through the demeaning work usually relegated to women: cooking, washing, and ironing.

Apart from this first chapter, however, Kingston does not concentrate on the emasculation of Chinese men in the United States. Instead, she focuses her epic narrative on their rebellious acts, on their heroic feats, their achievements against enormous odds, accomplishments requiring great physical strength, intellectual ingenuity, and spiritual endurance. . . .

Without doubt, the novel [*Tripmaster Monkey*] is brilliant, the puns witty, and the wealth of allusions from Shakespeare to Rogers and Hammerstein and Hollywood films, from *The Romance of the Three Kingdoms* to *Orlando*, from Rilke to Whitman to Bulosan, from Chang and Eng to the Eaton sisters, from phrases in Chinese to expressions in French—this massive compendium—is fun, dizzying, and impressive, reminiscent of the style of the mature James Joyce. In fact, the interweaving of the sixteenth-century Chinese classic *Monkey* or *Journey to the West* recalls the intricate interweaving of Homer's *Odyssey* into Joyce's *Ulysses*. The use of an earlier mythic source to give substance and shape to a particularized contemporary experience was the method Kingston used to good effect in *Woman Warrior*, and which she employs again with equal success in *Tripmaster Monkey*. The 1960s, with its counter-culture of "flower children" and "hippies" protesting the Viet Nam war, was a period particularly well suited to a resurrection of the iconoclastic Monkey King. . . .

Tripmaster Monkey is, for the most part, written in the spirit of play and fun. Kingston said, explaining the genesis of this book, "I would like us to have come here for a wonderful reason—we came to have fun. After I had that vision, I set out to do research to back it up." She discovered that playing in the form of putting on plays was one of the reasons the earliest Chinese came to the United States. "We came to play . . . We played for a hundred years plays that went on for five hours a night, continuing the next night, the same long play going on for a week with no repeats, like ancient languages with no breaks between words, theatre for a century, then dark. Nothing left but beauty contests."

Though full of rollicking humor, *Tripmaster Monkey*, however, has tragic undertones, for both Wittman and Shutung are disillusioned idealists and unfulfilled artists. "We all had, everyone of us, some rare and secret, splendid dream. All of us were trying to make it come to life, but it never did," says Shutung, who is constantly having to compromise and is invariably disappointed. In defense of Wittman, the sympathetic narrator explains, "Wittman's not crazy and he's not lazy. The reason he doesn't have right livelihood is that our theatre is dead." Like Shutung, he was born at the wrong time and in the wrong place. Both Wittman's bitterness and anger and Shutung's frustration and withdrawal are the result of the discrepancy be-

tween things as they are and things as they should be. For both Wittman and Shutung, there should be brotherly love without racial discrimination and a respectable means of living for the readers and writers of this world.

Though Kingston's are stories of frustration, bitterness, and suffering, to a large extent, the texts she shapes out of her material are triumphant works of art. Their poetry is transcendent, their passion ennobling, their imagination breathtaking. The critical accolades she has received in the United States, the National Book Critics' Circle Award, her designation as a "Living Treasure of Hawaii" by Honolulu Buddhists, and the favorable notice given her in the Peoples' Republic of China would indicate that she has accomplished the goal she thought impossible: "conquered and united both North America and Asia." [H]er writing is not focused exclusively on women but she gives equal attention and space to the men. Among our writers, Kingston is probably the one most consciously and outspokenly feminist, and yet her sympathies are large. She may protest misogynist tendencies in her ancestral culture but she also protests racist tendencies in the dominant culture. Injustice is wrong whatever its source and one is duty-bound to right/write it.

> Amy Ling. *Between Worlds: Women Writers of Chinese Ancestry* (New York: Pergamon, 1990), pp. 125, 144–45, 150–51, 156–57, 163

To say that Hong Kingston discloses—for her feminist and mainstream white audience—the legalized humiliation and degradation suffered by China Men at the hands of the dominant race is not to say, however, that she wishes simply to recuperate and valorize the traditional Chinese culture, with its base in patriarchal Confucianism, that was undermined by America's exclusionary immigration laws. This is a point that two critics writing on this topic seem to have missed. Linda Ching Sledge, in a valuable early article, points out: "The inversion of sexual roles [in *China Men*] . . . illuminates the internal tensions accumulating in [sojourner] families as a result of the erosion of sex differentiation in the household. The strain on husband, wife, and children as a result of the father's 'emasculation' or failure as provider is clear." She goes on to conclude, however, that Hong Kingston, in the final analysis, gives

> an overwhelmingly heroic account of sojourner family life. . . . Throughout *China Men,* the continuing hold of certain fundamental aspects of the primordial Confucian ideal of family unity, economic interdependence, and mutual help is maintained. . . . Rather than undermining the ancient notion of family accord, the scenes show that faith in the patriarchal family system . . . remains the ideal against which the daughter's [Maxine's] more modern definitions are measured.

Alfred Wang also discusses the triumph of Hong Kingston's male protagonists over legalized discrimination and implicitly praises the survival of traditional Chinese culture by linking her *"Men Warriors par excellence"* to "Guan Goong, Liu Pei, and Chang Fei," the military heroes of patriarchal Chinese literature and legend.

The impulse to champion the survival of Chinese American family life in the face of repeated, conscious attempts to destroy it is both understandable and admirable; but Sledge and Wang have fallen victim, I believe, to thinking in binary oppositions: if Hong Kingston lambastes—as she does—the white racist for their behavior and attitudes, then, in her sympathy for the hero-victims, she must be supportive of the traditional family structures that have come under fire. This kind of thinking is anathema to Hong Kingston's feminist argument, which critiques all systems that establish social relationships as hierarchies of power and which is perfectly capable of a both/and approach instead of an either/or one. Hong Kingston can both deplore the emasculation of China Men by mainstream America *and* critique the Confucian patriarchy of traditional family life, as King-Kok Cheung has recognized. Of the Tang Ao story, Cheung writes: "I cannot but see this legend as double-edged, pointing not only to the mortification of Chinese men in the new world but also to the subjugation of women both in old China and in America. . . . The opening myth suggests that the author objects as strenuously to the patriarchal practices of her ancestral culture as to the racist treatment of her forefathers in their adopted country." [T]his [is a] double-edged antiracist, antisexist sword, wielded by the narrator. . . .

I have said that *China Men* is to some extent an act of revenge on the father; but it is also an act of attempted reconciliation between daughter and father, just as *The Woman Warrior* was an act of reconciliation between daughter and mother. Unfortunately, it cannot match the competing dialogue between mother and daughter that the earlier fiction attained, for the father has no voice; therefore, it must be a pure gift, an act of restoring something he lacks. It is the restoration, though, not of the phallus he feels he lacks in white America but of the imagination America has robbed him of by "defeating" his dreams and by excluding him from its history. In a sense, he does not need a restoration of phallic power: the filial attendance of his children and the attentions of Brave Orchid demonstrate his "masculinity." Furthermore, he has the traditional Confucian solution to securing a place in history: procreation, family endurance, "the making of more Americans." What he needs to be a complete being is his-story, the very gift Maxine tries to give him in this text of her fantasies, her imaginings, her fabulations.

<div style="text-align: right">

Donald C. Goellnicht. In Shirley Geok-lim
Lin and Amy Ling, eds. *Reading the
Literatures of Asian America* (Philadelphia:
Temple University Press, 1992),
pp. 193–94, 205

</div>

On the cover jacket of *Tripmaster Monkey* we are discreetly told in small print that the work is a "novel" and on the inside flap the publishers announce that "this is Maxine Hong Kingston's first work of fiction." As with *The Woman Warrior* the rush to delineate Kingston's new work within recognizable formal boundaries threatens to minimize some critically important aspects of *Tripmaster Monkey*. More significantly, the failure to recognize *Tripmaster Monkey* as something both more and less than a novel deprives the work of a place among the representative voices of the postmodern era. Furthermore, the narrow definition assigned to Kingston's most recent work detracts attention from the crucial recognition that ethnic Americans, by virtue of their hybridized experiences as identified by critics of postmodernism such as Baudrillard, Jameson, and Lyotard, in a sense have always carried the essential germ of the postmodern. . . .

Specifically, their experiences identify them as persons at the intersections of contested cultural codes and discourses who are uniquely positioned and empowered to undertake what new anthropology terms the task of the "indigenous ethnographer" . . . a condition that challenges us with its contradictions, discontinuities, repetitions, and complexities. Correspondingly, the ethnographic enterprise is the reflexive attempt to talk about the inconsistencies of life in the latter third of the twentieth century.

> Patricia Lin. In Shirley Geok-lim Lin and
> Amy Ling, eds. *Reading the Literatures of
> Asian America* (Philadelphia: Temple
> University Press, 1992), pp. 335–36

KIRSCH, SARAH (GERMANY) 1935–

While [Helga] Novak consistently writes out of socialist convictions, Kirsch has repeatedly emphasized that her poetry is not written to support any party platform, and, while Novak has had her phase of doctrinaire feminism, Kirsch has insisted time and again that what counts is the quality of the writing and not the sex of the author. Novak is strong but uneven in her poetry but exciting and powerful in her prose, whereas Kirsch writes weak and uninteresting prose but has a magnificent ear for the poetic line. Novak is resolutely attached to the details of day-to-day existence, and in this respect has something of Böll's pragmatic affections, but Kirsch, though not unrealistic, is amply willing for her texts to suggest rather than state, to seem late-Romantic and even symbolic rather than exact. . . .

A fine example, and one which . . . touches on Kirsch's continuing affection for the GDR, is the poem 'Der Rest des Fadens' from *Drachensteigen* (1979):

Drachensteigen. Spiel
Für große Ebnen ohne Baum und Wasser. Im offenen Himmel
Steight auf
Der Stern aus Papier, unhaltbar
Ins Licht gerissen, höher, aus allen Augen
Und weiter, weiter

Uns gehört der Rest des Fadens, und daß wir dich kannten.

(Flying kites. A game for vast plains without trees or water.
The paper star climbs, the open sky, unstoppably pulled to the
light, higher, where eyes cannot see, and on, on / We are left
with the line that remains, and having known you.)

A note in *Drachensteigen* tells us that this was the first poem to be written
in West Berlin after Kirsch's crossing. Knowing this, we find a political sym-
bolism lies readily recognizable in the poem: the kite is the egalitarian dream
on which a socialist state was founded, and, in striving towards the dazzling
realm of the ideal, it is removed further and further from the ken of the
people, and loses contact with everyday reality. In the final line, Kirsch seems
to look back wistfully on her GDR past, knowing that the sharing of a utopian
dream was an experience that will remain a significant part of her. After all,
the symbol of the star is not accidentally chosen; that the kite is star-shaped
underlines the presence of a vibrant hope in socialist ideals, and Kirsch ac-
knowledges that hope is always a human good. Equally, of course, "Der Rest
des Fadens" is a leave-taking and a finality: unspoken behind the speedy
desertion of the airborne kite is a sense of betrayal.

<div align="right">Michael Hulse. Antigonish Review. 62–63,
1985, pp. 224, 229–30</div>

Sarah Kirsch's poem "Death Valley" from *Erdreich* (1982) recounts the de-
scent of its narrator into the unexpectedly treacherous desert and her reemer-
gence after a cathartic encounter with wild, powerful nature. . . .

These three elements—memory, identification, and discriminating pos-
session (which also involves forgetting part of an experience) are essential to
the writing process. By asserting their importance, Kirsch privileges mental
journeys over physical ones, for as we learn in the poem, it is all the diverse
activity of the mind responding to the world, not just sensory apprehension
of it, that nourishes the poet. As Kirsch writes in "Reisezehrung," the com-
panion poem to "Death Valley" from *Erdreich,* "Ich kann in Palermo sitzen /
Und doch durch Mecklenburgs Felder gehn." The Alice persona of "Death
Valley" must learn to remember and forget selectively, to give herself at times
over to subjective, irrational, or immediate experiences, and at other times
to return to the rational, mundane world of her writing desk, that is, to

integrate various feminine roles. Only in this way can the writer, and particularly the woman writer, achieve full poetic expression.

"Death Valley" ends precariously, a poem, much like the tiny box in its own final stanza, that hardly seems to have the capacity to contain all the elements Kirsch presses into it. Interestingly, it was one of the works from *Erdreich* that Kirsch did not choose to include in the collection *Landwege* (1985), though it would be too bold to construe this as an assessment of the poem's quality by the author. Whatever its extravagances or weaknesses, "Death Valley," with its intricate references to Kirsch's own work and her position as a writer, is a pivotal poem in the volume *Erdreich*. In mapping one sort of border crossing, from life into death and back again, it prepares the reader for the imaginative passage into the GDR that Kirsch accomplishes in the later poem "Reisezehrung." Thus "Death Valley" begins the gradual thematic transition Kirsch makes in *Erdreich* to a more domestic realm, a world which subsequently provides the substance for her poems in *Katzenleben* (1984) and *Irrstern* (1986).

<div align="right">

Charlotte Melin. *Germanic Review*. 62, 1987,
pp. 199, 203

</div>

The spectrum of the dozens of recent German *Dichtung-und-Wahrheit* memoirs is broad indeed, ranging from largely documentary chronicles to fanciful collages in which factual reports are difficult to identify with any degree of certainty. In terms of content, Sarah Kirsch's *Allerlei-Rauh* probably falls somewhere in the middle. Its style, however, definitely crowds the fanciful extreme. The motto is programmatic: "Alles ist frei / erfunden und jeder Name / wurde verwechselt." How many different meanings could be found for these nine words? The first word of the text is no less significant: *bunt*. The narration is "colorful" and "varied," but—another subtlety—by no means "gaudy." The first ten words playfully form a dactylic hexameter (is Hermann or Dorothea lurking over the next hill?), and the first paragraph, a soaring introduction to a description of the North German landscape Kirsch calls home, concludes with a phrase that captures the essence of the work as a whole: "nichts Besonderes, nur unvergeßlich."

The book has no sections, chapters, or other divisions. The narration flows smoothly, so smoothly that the reader is not always immediately aware that the perspective has shifted from the (rural) North German present to the (rural or urban) East German past, or from North (Germany) to South (Greece), or from people (Christa [Wolf,] the friend) to poetry (Christa [Wolf,] the author of *Kassandra*), or from reality to the fairy tale of the title. The style, however, is another matter. Here the shifts are unmistakable, as when the usual descriptive or reflective poetical language is broken by long parodies of classical or romantic style.

<div align="right">

Jerry Glenn. *World Literature Today*. 63,
1989, pp. 97–98

</div>

Sarah Kirsch's work has always acknowledged the attractiveness of idyll, whether in the natural world or in human relationships, but the threat of disruption has never been far distant. One of her earliest poems, whilst extolling the East German countryside in the changing seasons, also observed that in places it was "rußschwarz und mehlig" and in others was discoloured by "Geriesel vom Kalkwerk." The concern was prescient, although the blemishes noted seem trivial in the light of what is now known about toxic pollution in the GDR. But this too pales into insignificance beside the nuclear accident in 1986 at Chernobyl, an event which took place while Sarah Kirsch was working on *Allerlei-Rauh*. Chernobyl is not mentioned there by name, but even if the reference to "das schwarze Frühjahr zuletzt" were insufficient clue, the influence of the disaster within the text is very apparent. Apart from the Mecklenburg scenes, the work is set mostly in rural Schleswig-Holstein, where Kirsch has lived since 1983 and whose atmosphere she evokes with immense fondness. The beauty of the landscape, however, cannot disguise its extreme fragility, nor the transience of humankind, before the heightened dangers now facing the planet. The effect upon the narrator is to create within her a sense of isolation, even despair, of an intensity that is new in Sarah Kirsch's work and for which the closing paean to nature's steady rhythms seems inadequate consolation.

Peter Graves. *German Life and Letters*. 44,
1991, pp. 272–73

KOBYLYANSKA, OLGA (UKRAINE) 1865–1942

The more significant works of our recent literature portray women of universal ideas who strive for greater enlightenment and desire to become useful independent members of society. Such depiction of women we find in Kobylyans'ka's *Tsarivna* [The princess].

Kobylyans'ka has created a heroine who, like herself, has a poetic temperament and is very sensitive to the beauty of life, as well as to its difficulties. The diary form itself of the novel indicates that there is no real action in it. The author simply reveals to us . . . the soul of a young girl. The princess, to be sure, is not the usual everyday person. She is a deeply original thinker with a somewhat sarcastic view of her soulless surroundings. She has a clear understanding of her own situation and of women in general. She adheres to high ideals, for which she is willing to suffer, and she even attempts to write literary works. Her tender and . . . extremely sensitive temperament and the aristocracy of her soul render her incapable of doing positive work among the people she scorns. Because of this, the heroine, instead of raising those surrounding her to the level of her thinking, instead of influencing them by the strength of her convictions, withdraws into herself and only occasionally

voices her feelings in nebulous phrases . . . and then falls into silence and thought.

But in spite of her passive role in society, Kobylyans'ka's heroine, Natalka, is a new type of woman in our literature. She is new because she thinks about beauty, about lofty things, and she desires beauty. Yet she is unable to function because of her sensitivity and the lack of real people around her. . . . Kobylyans'ka's heroine, despite her struggle, is doomed to remain an emancipated woman only in spirit. . . . [1899]

> Vira Lebedova. In *Ol'ha Kobylyans'ka v krytytsi ta spohadakh* (Kiev: Derzhavne vydavnytstvo, 1963), pp. 71–73

Beautiful lyrical, romantic passages alternate in [Kobylyans'ka's] works with realistically written scenes, reflecting real life. Her works, such as *Tsarivna* can be considered psychological studies. They reflect her extensive reading in recent works of various foreign literature, the wealth of her well-thought-out reflections, and her great sensitivity. Her favorite character is the poor unmarried woman, a victim of circumstances rendered hopelessly defenseless by the cruelties of life. Kobylyans'ka is the defender and champion of this type of woman. . . . She may be unable to solve her problems, but she shows a sincere compassion for her plight.

Kobylyans'ka reaches into the arsenal of her heart for the most suitable weapon to defend these innocent downtrodden human beings, and with it she conquers the most formidable of opponents. Her writings reveal . . . the need to admit women into professions that would give them a goal in life and provide a means of subsistence to those who have not married. They show the necessity for a woman's liberation from the bondage of primitive, traditional laws.

From the artistic point of view, Kobylyans'ka's short stories are superior to *Tsarivna*. Her descriptions of nature are especially noteworthy. They reveal a lyrical talent, a poet possessing a great gift for observation, sensitivity, and artistic taste. . . . [1899]

> Osyp Makovey. In *Ol'ha Kobylyans'ka v krytytsi ta spohadakh* (Kiev: Derzhavne vydavnytstvo, 1963), p. 67

Certain critics have reproached Olga Kobylianska with having failed to digest the influence of German romanticism and German idealistic philosophy and, by way of a concrete example, quote her "Nietzsche-ism." It is true that the authoress was directly influenced by German literature and also wrote her earliest works—though these were never published—in German. . . .

Those Soviet critics who affirm that Olga Kobylianska has paid homage to personal individualism in certain works and glorified the "qualities of superman," have obviously overlooked the passage in which the authoress says so very aptly: "There is one God above us all and we are all his chil-

dren—whites and gypsies alike.". . . If all men are equal in God's sight, then there is no room for supermen, but there is however room for those persons who vigorously strive upwards, not for selfish gain but because they are prompted by the noble desire to perfect themselves and "constantly to strive upwards."

Those who draw the conclusion, after having read the various critics on Olga Kobylianska, that she set herself the aim of developing from a symbolistic (Yefremov) visionary and adherent of Nietzsche, who paid homage to "superman" and individualism, into a progressive and democratic authoress (Bilecky) in the sense of socialist realism, should take into account the fact that all these trends run parallel to each other, or to be more exact, result from each other, through her entire life.

<div style="text-align:right">

Karl Siehs. <i>The Ukranian Review.</i> Fall,
1964, pp. 63–65

</div>

The novel <i>Zemlya</i> [The Soil] is a highly artistic . . . document about the recent past. It is a work which excites us even today and which contains a message and a warning. . . . Even if Ol'ha Kobylyans'ka had not written anything else . . . she would have to be considered an independent, original cultural phenomenon in Ukrainian and in world literature.

She was a person of a warm, sincere heart, a humanist who responded with all her soul to the pain and suffering of others. As a woman, she acutely felt the inequality and subjugation of her sisters and fought tirelessly for the liquidation of this inequality. She fiercely hated everything petty and philistine, and in the name of the complete freedom of the human person, she constantly exposed the dirty world of egoism. She deeply loved and understood her people . . . and became the bard of their sorrows and joys. She also had a great love for other nations and saw in every nationality primarily the human being. She was most sensitive to the beauty of the human soul, to the natural beauty of her country, and to music, and she reacted against everything that worked against this beauty. She was a great psychologist. . . .

Her marvelous language carries in it the smell, the color, and the sound of the beautiful, haunting natural world of Bukovina. her works reveal the soul, the feelings, and the aspirations of the Ukrainian people.

<div style="text-align:right">

Yevhen P. Kyryluk. <i>Radyans'ke
literaturoznavstvo.</i> June, 1965, p. 53

</div>

Olga Kobylyanska's novels and numerous short stories are centered on the hard lot of the Bukovina peasants, and on women's right to work and to civic independence. Her first work, the story <i>Man</i> was written in 1886–1891 and published in 1894. Her most merited stories are: <i>Tsarevna</i> (1888–1895), <i>He and She</i> (1892), <i>Impromptu Phantasie</i> (1894), <i>Village Bank</i> (1895), <i>In the Fields</i> (1898), and <i>Across the Foot-bridge</i> (1911). Her novel <i>Land</i> (1901, published in 1902) is considered one of the best books about land and peasants in Ukrainian literature. Her psychological novel, inspired by a popular folk

motif, *"On Sunday Morning She Gathered Herbs. . . ."* (1908), was widely
acclaimed. In 1915–1923, Olga Kobylyanska wrote a cycle of anti-war stories,
then the story *She-Wolf* (1923), the novel *Apostle of the Rabble* (1923), and
also a great number of short stories from the life of the peasantry.

> n.a. *Written in the Book of Life: Works by*
> *19th and 20th Century Ukrainian Writers*
> (Moscow: Progress, 1982), p. 324

KOGAWA, JOY (CANADA) 1935–

Obasan voices not the affirming experience of self and others represented, for
example, by the diverse Canadian literary renaissance itself, but the horrific
experience of ostracism.

The history of one extended family, the Kato/Nakane clan, reflects the
history of the Japanese-Canadian experience during and after the Second
World War. Kogawa intertwines historical fact and often rhapsodic fiction to
show how one little girl, Naomi Nakane, becomes aware of being an outsider,
an enemy, an outcast in her homeland. A forbidding metaphor introduces
Obasan: "The word is stone." Kogawa writes about what has been silenced;
she writes with the meticulous purpose of one acutely aware that such stone
must bloom: "Unless the stone burst with the telling, unless the seed flower
with speech, there is in my life no living word" (Introduction). This introduc-
tory passage has the force and metaphorical intensity of Thomas Wolfe's
opening to *Look Homeward, Angel*. Her introduction, like his, establishes
the major themes: connections between the living and the dead, the tension
between true and false memory, the tension between telling and silencing.

To find that "living word," the reluctant narrator, Naomi Nakane, must
solve the riddles surrounding the dispersion and, in fact, destruction of her
family. *Obasan* opens on August 9, 1972; the war is a disquieting memory
for the thirty-six year old school teacher. Naomi Nakane returns to Alberta,
a place of Japanese-Canadian exile, to bury her Uncle Isamu, who raised her
and her brother Stephen after the dissolution of her immediate family. Her
journey to bury the dead leads her into the treacherous territory of memory.
She must move through this mine field as she attends Obasan Avako, Uncle
Sam's widow who embodies the old, Japanese virtue of silent forbearance.
Naomi muses that "Everywhere the old woman stands as the true and rightful
owner of the earth. She is the bearer of keys to unknown doorways and to a
network of astonishing tunnels. She is the possessor of life's infinite personal
details." But Obasan Avako guards the doors and tunnels; she wants the facts
of the Japanese-Canadian experience, in general, and of the Kato-Nakane
clan, in particular, kept silent.

Pitted against this tyrannical silence of Obasan Avako stands the other Obasan, the thoroughly modern, thoroughly Canadian, not-to-be-silenced Aunt Emily. Naomi is the battleground upon which the war between the silence and speech is waged. According to Aunt Emily, the edict to remain silent "kodomo no tame"—for the sake of the children—has justified for too long Naomi's ignorance about her mother's being caught in the atomic blast in Japan, about her musician father's death in a prison hospital, about her people's unwilling diaspora into the farthest reaches of the Canadian vastness. . . .

From Aunt Emily, Naomi reluctantly accepts a box of facts: newspaper clippings, editorials, letters from exiled Nisei, headlines from World War II on the domestic front. She finds this Pandora's box filled with hatred and historical woe which offers, paradoxically, her only hope. This inclusion of precise documents and speeches—from Stanley Knowles's address opposing disenfranchisement of Japanese-Canadians to details of the Japanese Repatriation Program—underscore how completely the stone of silence has covered those victimized by racial misunderstandings. Kogawa presents the fictional Kato-Nakane clan to stand nobly against the official, often malicious social memory: history.

That history often silences the oppressed and glorifies its collective social memory is a stony fact, in and of itself. As the train full of Japanese-Canadians moves unwillingly into the Canadian interior, each disenfranchised citizen feels this stone of silence: "We are the silences that speak from stones. We are the despised rendered voiceless, stripped of car, radio, camera, and every means of communication, a trainload of eyes covered in mud and spittle." Silenced by society, on the one hand, and by the Japanese tradition of forbearance on the other, Naomi Nakane becomes, nevertheless, the knower and the teller.

The narrator knows, too, that the treatment of the Japanese-Canadians parallels other injustices. In a beautiful passage, Naomi recalls walking with Uncle Isamu every year through the prairie grasses of Alberta. To an old man whose family has lived along the coast of British Columbia since 1893, these grasslands provide some small sense of flow: "Umi no vo," Uncle says, pointing to the grass. "It's like the sea." Resting near an old Indian buffalo jump, the niece thinks of Chief Sitting Bull, another man displaced by war and racial hatred. Thus Kogawa bridges other times and other cultures decimated by historical facts of difference, uniting the red and yellow-skinned peoples of Canada through their mutual love of the land, their silence, and their will to survive.

Naomi Nakane—through the lyricism and the unyielding strength of the writer Joy Kogawa—does triumph. The "living word" does shatter the stone of silence about the Japanese-Canadian experiences. The unspoken contention of *Obasan* addresses a concern wider than a single child or a clan or a culture group. The contention is this: to remain silent in the face of elaborate social injustice is to will some other people—at some inevitable future time

and for equally compilable facts—to suffer a similar fate: dispersal, denigration, dehumanization. To those of us interested in revisionist history, in ethical literature, and in cultural psychology *Obasan* proves to be mandatory reading.

B. A. St. Andrews. *International Fiction Review*. 13, 1986, pp. 30–31

Joy Kogawa's *Obasan* is an extremely quiet, slow moving book that yields its secret of exceptional power and intensity only gradually. It takes time to pick up the rich reverberations beneath the calm, controlled narrative voice, as we become aware that in returning to her past, the narrator, Naomi, undertakes a spiritual journey; she is urged by an inner need to find answers to a series of compelling questions: Is there a meaning to the persecution and suffering endured by the Japanese Canadians during and after World War II? Can the victim overcome the paralyzing effect of personal hurt and humiliation? Can a human being ever come to terms with the experience of evil on the psychological, the political, the universal level?

The novel sets up these multi-dimensional questions as puzzles arranged in a concentric pattern—container hidden within container within container—creating a sense of mystery and tension. The deliberate visibility of the concentric structure compels the reader to search for a central meaning at the core of the multi-layered texture of Naomi's narrative. To enter the psychological, political, and universal dimensions of Naomi's dilemma, the novel provides three openings, three distinct, yet interrelated landscapes. . . .

Obasan is a book about silence. The narrator is an extraordinarily quiet child whose relatives often wonder if she is in fact not mute. But this muteness is a deliberate withdrawal into silence. It is a child's resentful response to a world which has wounded her anonymously, impersonally, inexplicably. The most poignant contribution of this highly poetic book is the experience in which the little girl, who in the course of the novel has grown into a lonely and unhappy adult, is compelled to transform the silence of shame, hurt, and abandonment into words. Alerted by the symbolic landscapes, we witness an almost breathless quality as the narrative unfolds; silence on the verge of turning into sound. Silence speaks many tongues in this novel. For Obasan, silence is the language of service to the family, the language of her prayers. Uncle's silence is that of old Japanese Canadians who feel that the injustice and discrimination of a whole decade should be kept quiet. "In the world there is no better place. . . . There is food. There is medicine. There is pension money. Gratitude. Gratitude.". . .

Since the entire book is a document of silence turning into sound, we become intensely aware of the burden carried by language in this invocation of the consciousness of a silent people. To say that Joy Kogawa has a language of her own is not sufficient. Many good poets or writers do achieve that. But in Naomi's narration one often has the feeling that the writer is virtually reinventing language. Unmistakably, the style is the result of extensive lin-

guistic experimentation, presenting us with the special flavor of Japanese Canadian speech patterns and their underlying sensibilities. The writer translates Japanese expressions, often including the Japanese turn of thought. Occasionally she mixes English words with Japanese. . . .

There is no doubt that Kogawa's description of Naomi's spiritual journey comes alive through natural symbols, and that without these symbols we would be at a loss for the significance of the human drama. In terms of this drama, Aunt Emily's testament was the dead stone, containing a record of bitterness and anger against injustice. Mother's message from the past is the vital insight which allows Naomi to come alive emotionally, to accept the transcendental reality of love which flows through the roots at the very gravesides. Once she received this message, the seed will flower with speech, and Naomi's own testament will become the "white stone" with the "new name," the "living word." Ultimately, it is the message of love, which breaking the several seals of Aunt Emily's documents, will "overcome" the conflagration of the Apocalypse. Once Naomi is able to "admit" this message in the innermost circle, the personal-psychological landscape, the currents of the vital emotion will inevitably overflow and bring to life the landscape in the second and third circles, that is, in the political and cosmic dimensions. The combination of the narrative devices—the three openings, the riddle in each, the interpenetration of the three landscapes, the task imposed on the reader to puzzle out nuances in the natural landscape as they become key elements in the human drama—results in a sophisticated game of hide and go seek, established at the start and resolved only at the end of the novel. . . .

In addition to and complementary to the spider's web is the ball of twine and string Obasan had collected from bits and pieces saved over the years. Powerful in her silence, Obasan is indeed in charge of "life's infinite details," as if the ball of string accumulated over the years would have somehow absorbed the wisdom and experience of those years themselves. As Naomi had anticipated, both the centerpiece and the end of the string—both the central secret and the key to its unravelling in the appropriate moment—have been in Obasan's hands all along. Struggling to overcome Obasan's silence, yet also inspired by its depth, Naomi has grappled with her task faithfully, unraveling her yarn in all its intricate patterns, yet also in full control of the tight-knit unity of its concentric, globe-within-globe-within-globe structure. And although it has taken Naomi less than three days between Uncle's death and the gathering of the family for the funeral to accomplish her elaborate journey back and forth in time, within this interval she succeeded in solving a lifetime of accumulated puzzles. She has also made the silence speak: *Obasan* is a testimony to that hard-won miracle of creativity which alone has the power to turn silence into sound.

<div align="right">Erika Gottlieb. Canadian Literature. 109,
1986, pp. 34, 37, 39, 51–52</div>

Obasan presents a very different view of Canadianness from any of the other novels discussed, for Joy Kogawa is a Japanese-Canadian born in Vancouver

into two cultures utterly different from each other in customs, language and frames of reference. This is a novel which questions the benevolent Canadian social myth of multiculturalism by suggesting that dual inheritance may be a split inheritance rather than a double one, at least for those whose citizenship is Canadian and whose race is Japanese. It is a historical novel written nearly forty years after the events it reports; it is also a woman's fictive autobiography where she writes about the experience of being an "other" in Canada. Through language she struggles with the conflicting intermingled voices within herself in an attempt to rehabilitate herself as a speaking subject in a slow progress from alienation to belonging. Written by a woman, told by a female narrator, the title referring to a Japanese woman's domestic role as Aunt, the novel is about the lives of girls and women. These are stories about the narrator Naomi Nakane born in Vancouver to a second-generation Japanese family and raised a Christian who grows up to be a prairie school teacher, about her Japanese-Canadian mother who died in Japan after the Nagasaki bombings in 1945, about her two aunts Emily and Obasan, who maintains a home in western Canada for Naomi and her brother through all the troubles of the war and who is still living there at the time this story is told in 1972. All the themes of women's fiction are here—marginality, lack of political power, patterns of submission, enforced silence, but the story Kogawa tells necessitates a very different treatment for these themes are all transposed beyond individual experience to include that of a racial community, the Japanese-Canadians of British Columbia at the time of the Second World War. In the telling a very different image of Canada emerges, as a place where it is not nature which is indifferent and hostile but the white society of wartime Canada where for some Canadian citizens one's native land becomes alien territory.

Obasan is very much part of the late twentieth-century Canadian effort to revise and rewrite the official history of the nation, to fill in some of the gaps in the documentary record by making known other versions of historical events told not from the point of view of the authorities but from that of the people whose lives and deaths were directly involved. . . . In Obasan there are the records of real historical events in the evidence of newspaper clippings and Acts of Parliament, public and private letters, photos and personal diaries. All this material is shaped by the narrative imagination which transforms the chaos of fact into art and creates new possibilities for the future. T. S. Eliot's question in "Gerontion," "After such knowledge, what forgiveness?" is turned inside out here for Obasan asks a subtly different question, "After such knowledge, what else except forgiveness?" The novel insists on mutual forgiveness which can only be achieved after knowledge as a possible way forward out of the past. . . .

It is with words that I am concerned in this last section, for much of the novel's power lies not in its historical indictment nor in the story of Naomi's private quest but in the lyric intensity of its vision. This is an invented world of art whose surface of daily living is often chaotic but under that surface is

an intricately structured web of interconnecting threads binding together the present and the past, the living and the dead by feeling, intuition and dream. Joy Kogawa is a poet who has also written this one novel so she is acutely aware of the multiple possibilities within language, of its power to distort and lie which is matched only by its power to create texts of subtly interwoven images which shadow the life of the psyche. . . .

A strong indictment of women's silence and the silence of two cultures, the novel insists that forgiveness and hope for the future depend on speech, on the telling of suffering and injustice as the only way to heal wounds in the psyche. The novel reaches a point of optimism when the story of private and communal suffering has been told, in a characteristically elegiac movement away from grief towards transcendence of loss and back into life.

Coral Ann Howells. *Private and Fictional Worlds: Canadian Women Novelists of the 1970s and 1980s* (London: Methuen, 1987), pp. 119–20, 125–26, 128

In 1981, Joy Kogawa's *Obasan* appeared, the first novel on the internment of Canada's Japanese residents during the second world war. The political significance of the book's publication may be what strikes us first: the novel appeared at a time when the question of reparation to Japanese Canadians was beginning to receive exposure in the press; and since the newly elected Prime Minister Mulroney's promise of reparation in 1984, the issue has become "hard news" and receives continuing media attention. But *Obasan's* political significance alone does not explain why the novel won the 1981 *Books in Canada* First Novel Award and the Canadian Authors' Association 1982 Book of the Year Award. Nor does it explain why the novel was successful enough to be reprinted in paperback by Penguin Books in 1983. *Obasan* is a moving and original novel, expressive of a sensibility that wishes to define, in relation to each other, Japanese and Canadian ways of seeing, and even to combine these divergent perceptions in an integrated and distinctive vision. . . .

Kogawa began as a poet, publishing three volumes of lyric verse before her novel; in the novel there is an accession of imaginative power that is connected with her adoption of narrative. Often the poems express feelings that emerge from a narrative context that is only partly defined. In a sequence called "Poems for My Enemies" in her third collection, *Jericho Road,* it is not clear who the woman's enemies may be or why, for example, she at one point imagines (in a striking surrealistic image) that her washing machine contains "buckets of mud":

> how can the wash get clean
> if the water is not clear
> if there are buckets of mud
> in the washing machine.

In *Obasan,* Naomi at one point finds a note on which her Aunt Emily has handwritten a quotation from the Book of Habakkuk in the Old Testament: "Write the vision and make it plain." Reading the note, Naomi thinks: "She's the one with the vision The truth for me is more murky, shadowy and gray." But in *Obasan* Kogawa has written the vision and made it plain: the book is an imaginative triumph over the forces that militate against expression of our inmost feelings.

<div style="text-align: right">Gary Willis. Studies in Canadian Literature.
12, 1987, pp. 239, 249</div>

All the reviews I have seen praise Kogawa's poetic style, which establishes truth as more than mere facts, but then go on to thank Kogawa for correcting history, for revealing what "really" happened, for resurrecting a piece of Canada's heritage, for setting the record straight. This type of criticism remains staunchly mimetic and humanistic in [Claudia] Tate's sense: it views the novel as being realistic (representational of the empirical world) and didactic (a tool to correct our knowledge of history). Such an approach implicitly accepts language as transparently referential and treats as unproblematic the notion that language can reconstruct past events, thus providing us with history. In the process, it misses a major point of Kogawa's fiction: that her text problematizes the very act of reconstructing history by comparing it to the process of writing fiction. The interpenetration of traditional source material for the writing of history (diaries, letters, news accounts) with an obvious fictional narrative produces not an organically whole, seamless, realistic novel, but a disruptive, or polyphonous, genetic mixture that Linda Hutcheon has ingeniously labeled "historiographic metafiction."

In examining the issues that surround the transformation of empirical events into historical text—an act of textualization—and complicating these issues by drawing parallels between how history and fiction are made, Kogawa's novel opens a Pandora's box of questions that prove especially relevant to those "silent / silenced" minority groups that have all too often been shut out from the textual production of either history or fiction. In this regard, *Obasan* is doubly revealing because its narrative position is that of a doubly marginalized subject: a Japanese Canadian woman. . . .

We as readers share this text's awareness that its truth cannot be absolute, but just as Emily's narrative enkindles Naomi's thought and action and assists her to find her identity, Kogawa's historiographic metafiction enkindles our thought and action and helps us as a nation to come to terms with our identity. The fiction is didactic not in the traditional way of teaching a product, but in teaching an epistemological process, a way of knowing through telling and reading, and an existential process, a way of forming identity through discourse. Kogawa has replaced simple mimetic and humanistic realism with a complex work of historiographic metafiction that itself enters the dialogical

fray surrounding the "silenced" subject of racism in Canada as a powerful, but self-conscious, "word warrior."

Donald C. Goellnicht. *Tulsa Studies in Women's Literature.* 8, 1989, pp. 287–88, 302

In *Nisei Daughter* and *Obasan,* issues of race and gender intersect in self-consciously literary ways. Both show an interest in prose experimentalism; mixing genres; crossing the boundaries of prose and poetry; combining the work of memory and history, fact, reverie, and fiction; the discourse of myth and legend (both Eastern and Western), and the discourse of bureaucracy and law. *Nisei Daughter* is an autobiography of Kazuko Itoi, a second-generation Japanese American woman who struggles through the internal, familial, and racial conflicts of finding her identity. Kazuko Itoi, anglicized as the author Monica Sone, portrays the internment traumas of Japanese Americans after the outbreak of World War II and her "development" from childhood in her family, left behind in the internment camp of Minidoka, to her assimilation into a white American mainstream. Kogawa's book, *Obasan,* is the fictional-ized life story of Naomi, separated from her mother at five when her mother visits Japan and is prevented by the outbreak of the Pacific War from re-turning to Canada. The novel traces her family's disintegration as they and other Japanese Canadians are exiled to the Canadian interior and recounts Naomi's persistent mystification at the numerous hardships and prejudices encountered as her relatives seek to protect her through their silent submis-sion. Her mystification, Naomi learns later, derives from her Japanese Ameri-can community's silent submission to Canadian racism. Although *Obasan* is a novel, it coincides with Kogawa's life story of internment in Canada on many points. In *Obasan,* especially, instabilities in the text correspond to the themes of instabilities of race and gender identification. Kogawa's novel deliberately rewrites a body of communal stories (the infamous history of Japanese Canadian wartime detention and nuclear [destruction of Japanese cities]). . . .

The interest of Sone's and Kogawa's books for us lies not only or chiefly in their discourse as social history, especially as the blurring of boundaries between fact and fiction, history and myth, poetry and prose casts doubt on their identification with social history, but also in their insistent claims to a "writerly" status. Their "life stories" demand to be read within and against a tradition (history) of written texts as much as a specific ethnopolitical his-tory. Their achievement, the means by which they achieve their effects, their construction as texts, rest on their manifold interweavings of personal and family history, political and legal documents, myth, legend, talk-story and poetry. Their significance as social documentation cannot be separated from their significance as language. . . .

Obasan begins where *Nisei Daughter* ends, with a Japanese Canadian daughter in search of a silenced, lost, and forgotten Japanese mother, and traces the daughter's reconstruction of this absent racial/maternal figure.

Countering the repressions of *Nisei Daughter, Obasan,* written three decades later, insists on the interrelations between the subject of the "I" and the language through which that subject is expressed and bases the thematics of recuperation of a lost mother in the thematics of the recuperative powers of language itself. In *Obasan,* the writing project is inseparable from the reconstruction of the maternal. The figure of the daughter is also the figure of the writer figuring her self. . . .

The novel presents itself on one level as a mystery story, a historical and psychological riddle. Seeking to unravel the mystery of her mother's disappearance at the beginning of the Pacific War, Naomi must also unravel the mystery of the disappearance of a whole community of Japanese Canadians who uncomplainingly accepted the Government's Orders-in-Council to exile them from their West coast homes to the Canadian interior, the story of "the Issei and the Nisei and the Sansei, the Japanese Canadians. We disappear into the future undemanding as dew." The lost mother is also the figure for displacement of an entire people.

<div style="text-align: right">Shirley Geok-lin Lim. Feminist Studies. 16,
1990, pp. 291–92, 301–2</div>

The remarkable success of Joy Kogawa's documentary novel in weaving historical fact and subjective experience into a coherent whole is partly due to its ability to co-ordinate several layers of time around a single event: the internment and dispersal of the Japanese Canadians during and after the Second World War. The most obvious purpose of the novel is to reconstruct a suppressed chapter in Canadian history—this is Aunt Emily's special project. In counterpoint to Emily's facts and documents stands the intense personal history of Naomi's narrative, which reveals the damage inflicted on a child by the destruction of her community. As the narrative unfolds we become aware of another layer of history: that of the succeeding generations through which an immigrant community adjusts to a new culture, and the disruption of the relation between these generations by the dispersal of the Japanese Canadian community. Aunt Emily provides the essential facts, and Naomi's record of inner experience invites the reader to a strong emotional involvement in the narrative, but it is the history of the generations, as represented by the Kato and Nakane families, which binds together the various time-layers of the novel. Here I will stress the close connection between historical and psychological aspects of the novel by beginning with a discussion of the relation between generations, and then showing how this provides the basis for Naomi's relation to her two aunts and her absent mother, and also for some central imagery in which Naomi expresses both the fragmentation of her world and her final sense of resolution. . . .

The remarkable fusion of historical and psychological time in *Obasan* is facilitated by a clear distinction between the attitudes of the different generations towards the past, the public world, and the role of woman. Thus the history of the community is implicit in the various kinds of discourse with

which the characters signify these attitudes. Uncle and Obasan are entirely oriented towards an idealized past, while Emily represents her generation's orientation towards a delayed future, only now she demands that the future acknowledge the unjust past which thwarted the aspirations of the Nisei. Uncle and Obasan represent conventional acceptance, Emily the revolt against tradition of the activists of her generation. If the Issei idealize their homeland, or family life in Vancouver before the internment, she is still looking for the ideal Canada which the Nisei longed to join. The image of the circling airplane suggests that since leaving Vancouver she has never found a new community. In her initial arguments with Aunt Emily, Naomi claims to have no interest in the past, but the images of the ideal mother with which her memories begin show that she is far more attached than Emily to the past and its values. This can be an advantage as well as a vulnerability, because once she deals with her own past Naomi will be in a position to appreciate the strengths of both generations.

Naomi begins with an apparent acceptance of her present world and a professed lack of interest in her past as a Japanese Canadian. In fact, however, she is ill at ease with herself in the present while, in her resistance to Emily, remaining loyal to the most conservative values of her former community. Her ideally communal childhood, repressed from conscious memory because of its contrast to later experience, continues to influence her identity, blocking acknowledgment of the pain and anger caused by her brutal separation from it. A period of intense recall enables Naomi to relive her past while retaining an adult perspective informed by Emily's documents and advice. While much of the past returns readily, the emotional impact of her most painful and ambivalent experiences finds expression only in symbolic terms; to complete her task she must confront a layer of grotesque images involving inner wounding, dismemberment, conflict between inner and outer reality, and between ideal togetherness and self-mutilating separation. The final transformation of these into images of a growing forest suggests a new sense of rootedness in that hostile outer world which Emily has forced her to acknowledge, but where Emily herself never seems to have found a landing place.

Since Naomi has experienced the full impact of the internment and dispersal in her formative years, she can render in personal detail a period which Emily—aside from her diary—presents in moral abstractions; thus Naomi reinforces Emily's argument by showing that the psychological consequences of this experience extend into the present. The depth and convincingness with which Naomi's inner conflicts are presented provide the basis for an intensely personal narrative which can assimilate the objective, historical elements presented by Emily. The novel emphasizes a fracture between inner and outer worlds as a central problem for Naomi and her community, but also suggests a resolution in the very effectiveness with which it combines historical and subjective reality.

The difference in discourse between Emily and Naomi also suggests a conflict between the literary and political consciousness. Naomi's awareness

of the connotative value of words, which makes possible the poetic aspects of the novel, also provides a part of the motivation for her resistance to Emily and the purely political world her discourse implies. Emily's rapid-fire, exhortatory and rather indiscriminate use of language suggests a lack of sensitivity to the subjective self: "she never stays still long enough to hear the sound of her own voice. . . . from the moment we met, I was caught in the rush-hour traffic jam of her non-stop conference talk." As she begins to appreciate Emily's values, however, Naomi moves towards a vision where the public and private life—political activism and poetic sensibility—are no longer irrelevant to each other. Naomi remains sceptical of the effectiveness of her aunt's activities, but in her painful sense of growing from Canadian soil she affirms Emily's assertion that "We are the country."

<div style="text-align: right">Mason Harris. Canadan Literature. 127,
1990, pp. 41, 53, 54–55</div>

On the surface *Obasan* is the story told by a woman about her childhood as a Japanese Canadian during World War II, a time when the Japanese living in Canada were singled out by the Canadian Government as a threat to National Defense and were subsequently, through a series of edicts, removed from the West Coast and sent to Japan, or dispersed throughout the British Columbia interior and eventually through the Prairies. Naomi Nakane tells of the forced fragmentation of her family and community, and in doing so discloses a quest for the M/mother and an understanding of herself, both accomplished through reunification, purification, and the spirit of survival.

Surprisingly, below the surface, this story is the tale of a totem, a tribe, and the sacrificial victims—and the dialectic is one of abjection. The tribal totem is the Canadian ethos, while the high priests are figured as the various levels of government, its (pseudo and authentic) representatives of the people, and the documents by which it perpetuates its power. The tribe in the novel's context is made up of the Canadian people/s, while the Japanese Canadians, during World War II and after, can be viewed as the sacrificial victims. The continued current of abjection is based on the mystery of the absent mother and the need for a strong father, needs that do not become satisfied. In the novel, the mother or matriarchal powers are suppressed so much that abjection surfaces in her place. The abject is prefigured in masculinist power structures; that is, those structures that form the foundation of law and order, such as religion, politics, and family/community.

<div style="text-align: right">Robin Potter. Studies in Canadian
Literature. 15, 1990, p. 117</div>

In one of the closing chapters of Joy Kogawa's *Obasan* (1981), its narrator, Naomi, questions, as she has throughout the novel, her origins in both personal history and the communal history of Japanese-Canadians: "Where do we come from Obasan?" she asks. Her own answer—"We come from cemeteries full of skeletons with wild roses in their grinning teeth. We come from

our untold tales that wait for their telling"—makes it clear that the telling of tales is in *Obasan* no insignificant act. It is, rather, a strategic act of signification that conditions both individual and collective history and subjectivity. Narrative, in other words, is where we come from. . . .

Obasan, an example of the category of writing that Linda Hutcheon (1988) labels "historiographic metafiction," addresses precisely the issues Rimmon-Kenan raises. In a typically postmodern gesture, the novel invites us to consider it as a simultaneously literary, historical, and theoretical work. According to Hutcheon's definition, historiographic metafiction's "theoretical self-awareness of history and fiction as human constructs (historiographic metafiction) is made the grounds for its rethinking and reworking of the forms and contents of the past." Kogawa's novel radically revises . . . the concept of "documentary history." . . . The novel enacts a kind of paradox: it is its own wake, the celebration of a story that is both lost and found. The "freeing word" that it seeks is, on one level, "mother," not as a biological entity, but as the mark both of release from narrative and textual closure and the persistent desire for it: the mark, one might say, of an "absent relation."

> Manina Jones. In Martin Kreiswith and
> Mark A. Cheetham, eds. *Theory between*
> *the Disciplines: Authority/Vision/Politics*
> (Ann Arbor: University of Michigan Press,
> 1990), pp. 213–14, 228

KOLB, ANNETTE (GERMANY) 1875–1967

The three prose works through which this writer over the past few years has come to be known by a wider audience—despite considerable differences in their formal execution and complete independence from each other in their subject matter—are steeped in a uniform atmosphere, resound with a unifying verbal melody, and, above all, strive for a single goal: the portrayal of man, for whom the powers of unredeemed nature and antiquity become fate—but over whose species, like "an alien yet special light," beams the Church's promise that he should find peace.

> Karl Thieme. *Hochland.* 1933–34, p. 255

Die Schaukel [The swing] appeared in 1934. More than twenty years separate it from *Das Exemplar* [The paragon], and—if I may be allowed this bold comparison—its relationship to the latter is what the eruptive energy of Goethe's *Ur-Meister* is to the clear, filtered worldly wisdom of *Die Wahlverwandtschaften (Elective Affinities)*. If "autobiographical writing" means to impart to poeticized figures the sum total of one's own existential experiences and to settle them in the experienced and unforgettable world of our child-

hood years, then *Die Schaukel* is autobiographical in the best sense. . . . It is the most personal and, consequently, the most private confession of the writer. . . . Here, too, as in *Daphne Herbst,* which preceded it, a family; here too, three daughters and a son. But in this book death is more merciful; he tears only—and how bitter even this "only" is—the oldest daughter . . . away much too soon. . . . The mellowness of age—and the twenty years between the first two novels and the mere six between the second and the third nevertheless carry equal weight as signs of this writer's inner development. And let me repeat: especially now, when the city has been transformed into a hopeless ruin, Munich lives on in these two novels by Annette Kolb, portrayed by a pen that has at its disposal the variety of a painter's palette and, equally effective, the firm command of a sculptor's chisel.

Rudolf Burkhardt. *Gate.* 3–4, 1948, p. 24

Against the background of darkening time the self-portrait—willful, amazing, attractive, and repellent—stands in a series of books, of confessions increasingly more profound—a kind of monologue novel. And *Das Exemplar* [The Paragon], the story about the impossibility of an encounter, is, after all, a monologue. We might suppose that all this is the spell of the past, the intermission at a *Residenztheater* on a summer evening, or the leaves of a tree rustling outside the window. . . .

The elegy has its justification, and so does irony, which revenges itself for unspeakable wounds. Many an album leaf is a projectile. Could she, always alone and with the "tragic feature" in her face veiled by the suggestions and follies of fashion, have made her way without weapons? This is what is so impressive—that she did go her own way, suffering from herself as we all do but to a higher degree, and then free again, always at her word, always in the presence of her terrible misgivings and her even stronger hope. It makes no sense to call her a writer or poet, although that would be appropriate: the personality is everything, but personality subject to a great goal.

Reinhold Schneider. *Neue Rundschau.* 1955,
pp. 314–15

Blätter in den Wind [Leaves into the wind]. Under this clever and skeptical heading the octogenarian German-French writer gathers together, with the noticeably careless and at the same time charming gestures of a creator, all the various reminiscences, cultural observations, and critical reminders in essayistic prose, and she wishes them to be considered as a loose unity. . . .

Accompanying these "leaves," written in Kolb's high-spirited German, is something consciously composed in French: the great character portrait of the statesman Camille Barrère. . . . Not by chance are such broad observations separated by two more specific ones: discussion of the Jewish problem and the heavily cultish Catholic mass. It is in these very studies that a first-rate European professes world-wide tolerance on the one hand and preservation of the most inherent occidental forms on the other. In these studies she

once again shows the great curve of her intellectual being, which in language and form, in themes and intentions, contains both attack and agreement simultaneously. This above all, is what gives these "leaves" their literary value.

Inge Meidinger-Geise. *Welt und Wort.*
1955, p. 132

She is bilingual and her culture is half French. . . . Herself of royal descent, she moved in the circles of the high aristocracy which she so easefully describes, not only of Munich—in her autobiographically tinged novel *König Ludwig der Zweite und Richard Wagner* (1947) . . . but also of London, where the heroine of her first novel *Das Exemplar* (1913 [The Paragon]), whose heart to all appearances is closed to love, goes to find the man, now married, whom she once loved. Rilke was fascinated by the story and Thomas Mann's valuation of the authoress emerges from the fact that she is known to be the Jeannette Schierl of his *Doktor Faustus.*

Jethro Bithell. *Modern German Literature*
1880–1950 (London: Methuen, 1959), p. 491

Memento. Properly considered this "remembrance," condensed into the most compact space, is no autobiography but an autobiographical extract by the writer who is by now eighty-five years old but apparently still youthfully proud. It presents in briefly illuminated scenes the flight from Hitler and from the false spirit of tyranny—but it is at bottom only the flight into her own individual self and leads to the recognition of her task of mediating between German and French modes of being. Annette Kolb's slim volume is an admonition to us all to be always mindful of what is necessary in the European situation.

Alexander Baldus. *Welt und Wort.*
1961, p. 93

. . . She was already famous as a result of her first novel, *Das Exemplar* [The Paragon], a love story that grows in value every year. In one particular instance in it, she portrays what she saw taking place everywhere after the thrust of war: obtaining freedom from a man. She describes the stay of a young woman in England . . . and after the exposition of the beginning, she never lets go of the theme, which she works densely and forcibly into the structure. She carries it through with the strength that comes from surmounted torment: a farewell forever, without a word about it . . . separation with wounds. . . . With genuine stylistic understatement, the novel achieves the level of great literature. The Goethean theme of renunciation is realized here. The closing scene of separation calls to mind the great protypal novel of passion and renunciation, *La Princesse de Clèves.* Little of our narrative fiction during the last hundred years . . . captures something of the severe and suprapersonal necessity that breaks the human heart as does this novel *Das Exemplar.* In it the heroine's and the authoress's law of life rises above

all too personal involvement in one's own happiness and toward a vital will for achievement that adjusts itself to universals. Blessings came upon it.

Max Rychner. *Merkur*. 1964, pp. 825–26

Most people's impulse when they meet Annette Kolb is a great fear that a strong gust of wind might blow away that tiny woman. But there is no such danger to her writing which is still popular on both sides of the Rhine. She has been called "Tochter zweier Vaterländer [the daughter of two homelands], because she writes as fluently in French as she does in German. She has been awarded most of the major German prizes for literature.

John Michalski. *Books Abroad*.
1965, p. 281

Startled by the "vile German" in one of Hitler's radio broadcasts, Annette Kolb left Germany as one of the first voluntary emigrants. Already in 1933 she had written a provoking article against fascism: *Alle Männer in Europa haben versagt!! Ein paar Ausrufungszeichen von A.K.* [All Men in Europe Have Failed!! A Few Exclamation Marks by A. K.] Most of her reflective articles and essays were intended for . . . Germany and France, the two countries between which, according to her heritage, she saw herself positioned. Over and over she attempted to bring the culture and politics of both countries to a common denominator under the sovereign banner of humanitarianism and pacificism: *Sieben Studien* (L'ame aux deux patries, 1906 [Seven Studies]); *Wege und Umwege* (1914 [Ways and Detours]); and a collection of earlier essays, *Briefe einer Deutsch-Französin* (1916 [Letters of a German-French Woman]), in which she comes out against every kind of chauvinism.

Gertraude Wilhelm. In Hermann Kunisch,
ed. *Handbuch der deutschen
Gegenwartsliteratur* (München:
Nymphenburger, 1965), p. 353

In some notes that can be found among his manuscripts, Joseph Roth calls Annette Kolb "our literature's only female knight—she fences when she writes," and by writing and publishing her courageous, candid books, she renounces her powerlessness.

A born cynic, Annette Kolb herself views the success of her life's work with pessimism. She will have lived in vain if the learning process she underwent has not served in the instruction of others *(Zarastro)*. "Though it succeeded, time and again, that dialogue atop the bridge—still no one considered it a navigating bridge—, the wind carried away the echo of the words, the shores of the river caught them up, it flowed off in that direction" *(Versuch Über Briand)*. This she wrote in the year 1929. Then, and still today, she is oppressed by the thought of the futility of her work. And yet my acquaintance with Annette Kolb leads me to another conviction, for in her we find confir-

mation of the truth that quality and impact cannot be measured according to the external standard of popularity.

Annette Kolb's art and the mission she has chosen for herself as a writer cannot be separated from her personal life. That is why the literary merit of her books is intimately connected to their human content, and the critic must rely on both aspects if he wants to evaluate her contribution to literary history in the twentieth century. If I have succeeded in making clear the value of Annette Kolb's fiction, the reader will understand my introductory assertion that the important thing is not that she wrote, but rather that she lived. She was never the center of public attention; her books will probably only seldom be read. Although she reached a wider circle through her novels than through her essays, the latter, though bound to the period in which they were written, are just as significant and characteristic of Annette Kolb's *oeuvre* as are her narrative works. They reveal the soul of a woman who deeply perceived the poetry as well as the sorrows of our times and poetically put them into words.

Doris Rauenhorst. *Annette Kolb: Ihr Leben und Ihr Werk* (Freiburg: Universitätsverlag, 1969), pp. 162–63

KOLLONTAI, ALEXANDRA (RUSSIA) 1872–1952

Red Love is a sensational title—not, we understand, the title which the Soviet Ambassador to Mexico gave the book in her own language. "Red Love" sounds like bait for the least intelligent kind of American interest in Russia. And for that sort of fish, there is indeed something here to nibble at. But there is a lot else as well, packed into a small space. The love story, a simple, moving tangle, is also the story of the new woman all over the world, the problem of work vs. love. Then there is a glimpse of the deep, narrow, utterly selfless will, which, implanted in a few hundred thousands, has made Russia's and much of Europe's history for the last ten years. But the characters of the book, and its peculiar intimate struggle, belong to a later period, the let-down in revolutionary ideals, the infection of communists themselves with the views of life which mushroomed with the "New Economic Policy." The contrast between the harried, heroic, puritanical Vasya and her easy-going, successful, result-getting, tainted lover—communists both of them—is symbolical of a real change and a real problem in revolutionary circles. As a document, *Red Love* is enormously interesting. As a novel, it is uneven, and often unreal, with the thesis too boldly peeking out from between its lean ribs. It has not the sweet, heroic unreality of so much revolutionary fiction, Stepniak's, for instance. It is harsh, brave, searching, blind, desperate,

shrewd, and not a little disillusioned. But that may be only the weariness of those who spend their days cutting off hydra heads.

The New Republic. April 13, 1927,
pp. 230–31

Mme. Kollontay's novel [*Red Love*] is an argument, in story form, for more looseness in marriage bonds. Neither as fiction nor as theory is it impressive.

A young woman Communist, who has already had liaisons with several men, finds that her latest lover is dividing his attentions between herself and another woman. There follows a period of jealousy, of quarrels and reconciliations, concluding with the discovery, on the young woman's part, that she doesn't "need" the man, and is happier running her own show and working for the Party. Implicit, rather than narrative, is Mme. Kollontay's contention that "purity," in the "bourgeois" sense of the word, is an outgrown notion, and that women in the future will be judged less by their "spotlessness" than by their usefulness to their class and country and to humanity as a whole.

As an expression of the aesthetic side of the present Soviet Ambassadress to Mexico, *Red Love* has, naturally, a certain "news interest." The force of arguments involving moral changes so profound as those suggested here depends, naturally, a good deal on the source from which they come. An Ellen Key, for example, would be a more persuasive advocate than one who, as in this case, might appear merely to be rationalizing her own adventures.

Saturday Review of Literature.
June 4, 1927, p. 874

[*Red Love*] is the eternal tragedy of the triangle with a Soviet Russian dressing. The modern Bolshevik background with the emerging new woman against it adds interest to what might otherwise have been only another novel. . . .

This is all very good, but I don't get the point. Judged as a literary production, *Red Love* surpasses expectations. There is some really fine writing in it which the translation has not spoiled. But why did Kollantai print such a thing? The most revolutionary doctrine she preaches is that of voluntarily giving up one's partner in marriage when love has disappeared. Of course, Kollontai has a philosophy of sexual relations which comes better to view in the original Russian *Love of Working Bees,* where one finds the present story with two shorter ones. This philosophy is brought out somewhat too generally in a foreword—actually a postscript sent in from Mexico City. Love and family, Kollontai argues—and as one of Europe's leading feminists she merits as much attention as any suffragette—are sideshows in a man's life. He is judged by his job. The ambassadress advocates the same measuring-rod for women. A woman ought to be considered "good" or "bad" not because she does or does not conform to a certain set of bourgeois morals but according to whether she serves humanity and society. There is a life for women outside the kitchen and nursery and beyond love. Fine. But Kollontai

has presented a bad illustration, for Vasya loves less the more she works. It need not be so.

<div align="right">Louis Fischer. The Nation.
June 22, 1927, p. 700</div>

In her autobiography Kollontai is reticent about her theories of morality and sexuality and even her references to women's liberation are guarded and unemphatic. On the first page, she states as an aim of her life, the "setting in bold relief that which concerns the women's liberation struggle and further the social significance which it has," but this is deleted to emphasizing "that which has an importance for the solution of the social problems of our time, and which also includes the problem of complete women's liberation." The inertness of her phraseology may not be entirely attributed to the vicissitudes of translation, for one is struck throughout her biography with the turgidity of her style compared to the rhapsodic writing of *The New Woman,* written in more optimistic times. The most massive elisions in her brief text relate to the double standard of morality and conventional marriage, to love and to criticism of the Party's attitude to such things. She was moved to write of her impressions in 1905, "I realized for the first time how little our Party concerned itself with the fate of the women of the working class and how meager was its interest in women's liberation," but her ruthless blue pencil strikes it through.

Again, truth bade her write, "For our Soviet marriage law, separated from the church to be sure, is not essentially more progressive than the same laws which after all exist in other progressive democratic countries," and loyalty prompted her to erase it.

<div align="right">Germaine Greer. Foreword to Alexandra
Kollontai. Autobiography of a Sexually
Emancipated Woman (rpt. London: Orbach
and Chambers, 1972), pp. xi–xii</div>

In these moving love stories Kollontai pursues themes from her non-fiction writing—particularly those from *Communism and the Family* and *The New Morality and the Working Class.* She was concerned with the complicated connections between personal life and political ideas, and was convinced that relations between the sexes must be freed from the restraints imposed by women's economic dependence on men.

Yet she tried always to examine the gap between the official surface of things and the actuality within—and would not rest content with the easy formula that changes in the mode of production and the external structures of work relations under communism would automatically create a new freedom and equality between the sexes.

Though completely opposed to those feminists who thought there could be women's emancipation within capitalism, she also fought continually inside the Bolshevik Party against the kind of complacency which failed to take

sexual relations and the positive creation of a new culture of daily life seriously. She wanted complete equality between the sexes, realizing that this necessitated big changes in the structure of the family, the organization of domestic work and the economic position of women.

Convinced of the need for all these changes, she also indicates in her non-fiction writing that she hoped for an inner transformation—for a "new eros under communism," a love which extended throughout humanity. Kollontai is more optimistic about emotional love between men and women. Indeed, the conflict between passion and freedom appears in her writing almost as a natural tension. And in addition Kollontai realized that there was the immediate—and difficult—present. The past haunted this present, and the peculiar circumstances of "socialism in one country." Civil war, scarcity and reconstruction restricted the emergence of the new culture of which she conceived. . . .

Kollontai shows how the state of the Soviet economy in the New Economic Policy period helped maintain old-style relationships between men and women. Free unions became a cover for male irresponsibility, and women were left with the children. Communal housing turned into overcrowded barracks. The material problems facing the country fed the conservatism of the vast majority of women—for them, new freedom also meant insecurity, and perhaps better the devil you knew . . . It is clear in these stories how much Kollontai felt it necessary to struggle against this conservatism. . . .

At the time *Love of Worker Bees* was written, sexuality was a subject of great controversy in many countries. The conservative elements saw the feminist movements, easier divorce, freer relationships between the sexes as part of a process of disintegration; for liberals these events represented an evolution towards progress. Marxists frequently dismissed sexuality as peripheral, seeing it as subject simply to changes in the external structures of social relations.

Kollontai was conscious always of a more complex dialectic. In her stories she describes economic and social circumstances *and* inner patterns of feelings. She was aware of an unevenness in the relation between new social forms and sexual passion—an unevenness which bore the weight of centuries of oppression. Here Kollontai is straining towards an alternative culture of communism, which would transform all human relationships. Though the context for such a culture has completely changed, and we face a very different political situation, the problems that Alexandra Kollontai so intensely describes persist. If the setting and some of the assumptions seem strange to us, *Love of Worker Bees* still has an immediate relevance.

<div align="right">Sheila Rowbotham. Afterword to Alexandra
Kollontai. Love of Worker Bees (Chicago:
Academy, 1978), pp. 223–25</div>

Through her fiction Kollontai's ideas on erotic love spread around the world, becoming known by the end of the twenties even in China. This was unfortu-

nate, because the stories do not contain as full a statement of her views as articles such as "Make Way for the Winged Eros!" A reader unaware that Kollontai disapproved of promiscuity could see Zhenia as a model, and even young, middle-class Chinese cited Kollontai as advocating casual sex. In Soviet Russia, her name was widely identified with "the glass of water theory," a defense of promiscuity on the ground that one should satisfy the sex drive as simply as one satisfies thirst. Kollontai did not originate or even favor "the glass of water theory," but one could draw that conclusion from reading only "The Love of Three Generations."

Kollontai's fiction is thus an incomplete guide to her views on erotic love. It is also bad literature. It lacks the strength of her sometimes overwritten but generally lucid and well-organized nonfiction. The characters are one-dimensional, the females all saintly, maternal, and committed to the cause and to other women, the men childish, demanding, selfish, and not a little stupid. The men are also easily corrupted by the NEP, while the women remain untarnished, unless they are bourgeois in origin. The prose is florid, and the ideas are hammered home with a lack of subtlety suited more to an agitational harangue than to fiction. Kollontai made major points—that women were still having to choose between love and work, that they still had to contend with economic insecurity, unsympathetic husbands, and pregnancy, that Soviet society should permit a variety of relationships between women and men. When she discussed the same issues in nonfiction, she produced work which suffered less from her didactic tendencies and which presented her ideas in more complete form.

<div style="text-align:right">

Barbara Evans Clements. *Bolshevik Feminist: The Life of Alexandra Kollontai* (Bloomington: Indiana University Press, 1979), pp. 230–31

</div>

Kollontai's "Letters to Working Youth" prophesied a new kind of relationship between men and women. Her novels, on the other hand, reflected ambivalence toward any emotional relationship with men. Revolutionary women tended to avoid elaboration of their personal lives. Kollontai was the exception. In *Vasilisa Malygina*, Kollontai wrote a fictional but thinly disguised account of the end of her marriage to Dybenko. *Vasilisa Malygina* is the story of Vasia, a young working-class woman and Communist Party member who falls in love with Volodia, a fellow Communist with anarchist leanings. Vasia and Volodia begin living together during the Civil War. Eventually he becomes a successful NEP entrepreneur who succumbs to bourgeois pleasures, one of which is a love affair with a member of the former bourgeoisie, a powdered and pampered *Nepmansha,* Nina, a young woman who is looking for a man to take care of her. . . .

Vasilisa Malygina was no stilted Soviet novel with its stereotyped woman—the kind of novel that within a few years would become the norm in Soviet literature. It was a feminist novel in that it emphasized the twin

concepts of female self-realization and sisterhood. It was also a departure from Kollontai's earlier writing, for at some point Vasia begins to feel compassion for Nina, the *Nepmansha*. This suggests that Kollontai now accepted a doctrine she had always fought against prior to the Revolution: that between women bonds existed transcending those of class. In a remarkable passage, Vasia explains her feelings toward Nina: "I sympathized with her as a sister, for she had known a woman's pain, and had suffered as much as I." That the *"Nepka"* Nina and the Communist Vasia both lived in a working-class state did not make Kollontai's "feminism" less irritating to Bolsheviks.

<div style="text-align:right">

Beatrice Farnsworth. *Alexandra Kollontai: Socialism, Feminism, and the Bolshevik Revolution* (Stanford: Stanford University Press, 1980), pp. 326, 329

</div>

There [in Norway] she immersed herself in writing her novella and two short stories, and adjusted to her new life. *Love of Worker Bees* came out in Russia the following year in a small edition as part of the series *Revolution in Feeling and Morality,* and was followed by her second fictional trilogy, *Woman At the Threshold: Some Psychological Studies.*

Writing these, her first published works of fiction, with a candid and moving simplicity which she hoped would make her insights accessible to working women who might not otherwise read novels, Alexandra described the changes in women's sexual feelings, their confusions and their new strength, throughout the years of the revolution and the early period of the NEP. In fiction she could examine more openly than in political writings the connection between the economic pressures of female unemployment, dwindling creches and mounting prostitution, which were driving women back into the confines of monogamous marriage and solitary housework, and the more insidious psychological pressures which were so deeply rooted in the NEP. Through her three main women protagonists in *Love of Worker Bees*—Vasilisa Malygina (the central character in the novella of that name), Olga Sergeevna (the narrator of "Three Generations") and the narrator of "Sisters"—she explored the ways in which women were struggling to understand these pressures and offering each other solidarity and sympathy in the process. . . .

The most engaging work in her collection of short stories entitled *Woman at the Threshold* was "A Great Love," which went into a second edition in September 1927. It dealt with some of the complex and conflicting demands of sexual passion and revolutionary dedication, and drew its inspiration from three passionate intellectuals and revolutionaries—Lenin, Nadezhda Krupskaya and Inessa Armand—in whom she had seen these conflicts embodied in her years in exile and just before the revolution.

<div style="text-align:right">

Cathy Porter. *Alexandra Kollontai: A Biography* (London: Virago), 1980, pp. 405–7

</div>

At the time [Kollontai's *The Social Basis of the Woman Question,* 1908,] was only the second book, following the publication in 1901 of the pamphlet entitled *The Woman Worker* by Sablina (the pseudonym of Nadezhda Konstantinovna Krupskaya), to examine this issue from a Marxist position. Written in a lively and imaginative style and with an acutely polemic content, this book was accorded a sympathetic reception within the workers' movement and helped the Bolshevik Party to counter bourgeois influence on working women. A condensed version of this well-documented account of the history of the women's movement in Russia from the end of the 19th century up to the 1905 revolution is contained in Kollontai's pamphlet *On the History of the Movement of Women Workers in Russia.* . . .

[At t]he women's international socialist conferences held in Stuttgart (1907) and Copenhagen (1910) . . . she spoke on behalf of Russia's women socialists and fired all present, as one Danish newspaper reported, with her moving pathos, boundless energy and inexhaustible passion. . . .

The pamphlet *The Woman Worker and Peasant in Soviet Russia,* reproduced here in abbreviated form, tells of the enormous role played by women in defending the gains of the first workers' republic against the internal and external enemies of the proletarian state.

> I. Dazhina. Introduction to Alexandra Kollontai. *Alexandra Kollontai: Selected Articles and Speeches* (New York: International Publishers, 1984), pp. 11, 13

Unpossessed, she had no interest in possession. Reminiscent of Emma Goldman's essays on love and jealousy, Kollontai wrote that disinterest in love as possession freed the new women to be comrades, to feel "a collectivity of comradeship in love." No longer jealous, she was free to fulfill herself, her own needs for work and creativity. "The woman of the past had been raised by her lord and master to adopt a negligent attitude toward herself, to accept a petty, wretched existence as a natural fate." But it was now clear that "Every woman who exercises a profession, who serves any cause or idea needs independence and personal freedom." For the New Woman, in service to the social idea, science, or creativity, love cannot become servitude. In this she separated herself from the past when the dignity of women was measured only by standards of "property-based bourgeois morality," of "sexual purity." In the past (the very recent and rigid Russian past of arranged marriages) a woman who "sinned against the sexual moral code was never forgiven." But today the wife no longer stands beneath the shadow of the husband. Before us stands today "the personality, the woman as human being." This, Kollontai insisted, was one of the great tasks before the revolutionary working class and its Party: "to create healthier and more joyous relations between the sexes." "History has never seen such a variety of personal relationships." The Revolution required "a basic transformation" of the human

psyche so that people will be able to "achieve relationships based on the unfamiliar ideas of complete freedom, equality and genuine friendship."

For Kollontai the Revolution was about emancipation, freedom, workers' control, fulfillment. It was about happiness. She believed in the power of love, the energy of love. And she believed in community, work, and purpose. . . . She insisted on a new respect for different love relationships among society's many differing people, who would be free to choose. Free love did not mean women on demand. For Kollontai it meant, very specifically, choice, options, understanding, and "respect for the right of the other's personality." This, like her other work, was egregiously distorted to give rise to the "glass of water theory," the theory that sex should be as easy and uncomplicated as drinking a glass of water.

> Blanche Wiesen Cook. In Judith Friedlander et al., eds. *Women in Culture and Politics: A Century of Change* (Bloomington: Indiana University Press, 1986), pp. 371–72

For the sake of argument, we might distinguish three stages in Kollontai's work. The first found expression in her earliest book on women, *Social Foundations of Women's Issues,* which she wrote in 1909. Recognized in its day as the most important study on the subject ever made by a Russian woman, the book relied heavily on the approaches of the German Social Democratic movement. . . .

In *The Social Foundations of Women's Issues,* Kollontai analyzed the crisis of the family which, as a result of the development of capitalism, was no longer performing its old functions. The problems of marriage and prostitution were treated as social phenomena that had to be transformed by working women who would take control of their own situation. . . .

In the second stage, Kollontai's work centered on her social and political role which, after October 1917, was no longer confined to propaganda activities. For five months (October 1917 to March 1918) she held the post of People's Commissar for Social Welfare. During this time, the first Family Code of the Soviet Union was adopted (1918). And it was Kollontai who was primarily responsible for legalizing marriage by civil ceremony, divorce upon demand, and free abortion, among other things. But these measures, each having a different impact, were simply not in line with the prevailing ideology and mentality of a country in which serfdom had been abolished only in 1861.

The third stage began after Kollontai's "ministerial" duties had been fulfilled. Now her writings were characterized by an all-encompassing, deep-rooted desire for innovation on a grand scale. They described a society, utopian in its capacity to generate new social units, yet they did not underestimate the radical nature of the proposed transformations. Most of the following discussion will focus on this third stage.

The twenty-five pages of *The Family and the Communist State* (1919) are devoted to clearing up the remaining ambiguities in the analysis of that

outmoded institution the family. Taking up Engels's theory that the realloca-
tion of the means of production entails a radical change in the status of
women, Alexandra Kollontai banished from the field all those irrational ele-
ments which militate against the coming of the new society, such as class
prejudice and uncertainty about how to apply the new forms of social
organization. . . .

The New Morality and the Working Class (1919) takes literary examples
as the basis for an analysis of the behavior of the New Woman. The "model"
is not really literary, however: the new living conditions are its source. Single,
no longer enslaved by her emotions, the New Woman channels all her crea-
tive forces into work to benefit society. The importance women traditionally
attach to their love lives had been displaced, and social action becomes their
main means of self-expression. In defining this new life-style, Kollontai
stresses the novelty of behavior in which the external expression of private
life ultimately mingles with the work of society. She explains the abolition of
individual self-expression by analogy with the control of the means of produc-
tion by individuals, the sexual possession of women by men, and the image
of love relations which women then form in imitation of the initial
usurpation. . . .

"Literature itself is a force which can be used in propaganda." Does
not Alexandra Kollontai's work bear out these words of the prematurely
silenced nihilist?

<div style="text-align: right">

Christine Fauré. In Judith Friedlander et al.,
eds. *Women in Culture and Politics: A
Century of Change* (Bloomington: Indiana
University Press, 1986), pp. 378–80, 382, 384

</div>

A few commentators have noted that Kollontai uses her fiction to criticize
the officially sanctioned NEP, but her broad system of politically charged
domestic objects has remained unidentified. Indeed, Kollontai's real concern
was not simply the NEP, but, as she made abundantly clear during her partici-
pation in the Workers' Opposition at the Tenth Party Congress in 1921,
the all-pervasive, ever-threatening bourgeois disease in general. Two of
Kollontai's four best-known fictional works, the novel *Bol'shaia liubov'*
and the short story "Liubov' trekh pokolenii" which are set largely in pre-
revolutionary times, expose the same bourgeois vulgarity in "practical every-
day life," through a similar if not so elaborate domestic symbolism, as do
Vasilisa Malygina and "Sestry" with their more persistently materialistic
NEP background. In the first lines of *Bol'shaia liubov'*, the narrator empha-
sizes the parallel: "All of this happened long ago . . . in the years of the
[post–1905] reaction. Over there, abroad. In exile. This is how it was then. But
it is this way now, too." Yet despite her firm belief that the NEP represented a
"new threat" to old communist principles and to the healthy development of
her country, Kollontai curtailed her public criticism after the summer of 1922
and made a cleaner break with the opposition than most of her comrades. . . .

To lament Kollontai's political bias and artistic simplicity is to forget that balance, whether intellectual or literary, was not what she sought. The purpose of her fiction was instead frankly didactic: to instruct the general public on what in her opinion was the most important issue in socialist life, namely "the struggle with bourgeois morality for the emancipation of women." As an avid reader of popular literature herself, Kollontai knew it as a useful conduit of both factual information and political propaganda and was also aware of the linguistic and philosophical considerations facing writers who address themselves to the poorly educated, newly literate reader.

Birgitta Ingemanson. *Slavic Review.* 48,
1989, pp. 73–74

In Kollontai's proletarian state the new working-class morality recognizes love as both a psychological and social force, a new eros uniting humans both in production and reproduction. In order for this life-force to succeed, it must acquire new inner qualities "necessary to the builders of a new culture—sensitivity, responsiveness and the desire to help others . . ." In the development of proletarian love-comradeship these qualities should, however, conform to three basic ideological principles: (1) to end masculine egoism and the suppression of female personality, so that equality in relationships could be achieved; (2) to abandon the principle of property in sexual relationships and recognize the couple's individuality; and (3) to maintain a "comradely sensitivity" and the ability to listen to and understand one another, a requirement demanded only of the woman in bourgeois society.

The ultimate goal is thus to overcome individualism by subordinating the personal and subjective eros to the "more powerful emotion of love-duty to the collective" in order to enhance cohesion and happiness among the people. At the same time the "winged eros" should provide a new socialist identity for both men and women.

László Kürti. *Anthropological Quarterly.*
64, 1991, p. 57

KOLMAR, GERTRUD (GERMANY) 1894–1943

A wealth of kaleidoscopic imagery fills the variety of her forms, always moving toward clearness, always expressed in a language that deepens and belongs to life. She can strike the light, atmospheric key and the sweeping, resonant chord. These poems have survived as the harvest of her great creative power, the somber offspring of the tragedy that rent a woman's soul.

Fritz Martini. *Deutsche Literaturgeschichte*
(Stuttgart: Kröner, 1958), p. 597

Not until the appearance of the complete edition of her poems . . . was the dimension and richness of her lyrical work revealed. These verses resemble stratified rocks; their music is metallic, not light and catchy, and then again it is tender, moving, and feminine. Seldom is there a smile in these poems— a heavy seriousness always prevails. The form of the poems is loose and simple; often they are free rhythms with a pervading melody. We do not find, as we do in the age of expressionism, screams and emotional outbursts in these poems. . . .

Her prophetic power is boundless. The most diverse subjects pass into her very being and become poetry: women, nations, countrysides and cities, Judaism and history, animals and flowers, clothes and rooms. They are drawn into the rhythm of a language that lets stillness and dreams speak as they almost never did before in German poetry.

Rudolf Kayser. *German Quarterly.*
1960, pp. 2–3

The few poems published during Gertrud Kolmar's lifetime did not attract much attention. . . . The extreme withdrawal of her individual being allowed a lyrical poetry of inexhaustible imaginative richness to develop "below ground," a completely self-contained body of work in all its multiplicity of forms and subject matter. . . . Her ability to design and build artfully tends strongly toward the cyclical structure, and this is revealed as well in the formal strictness of the single poem, whether it makes use of classical models or finds its own proper rhythmical verse of unprecedented compactness. Great mythical and visionary hymns stand next to the poems of homage of the Rose cycle, and next to the somewhat weaker historical cycles about Napoleon and Robespierre and to folk-songlike stanzas.

Eberhard Horst. *Neue Deutsche Hefte.*
July–August, 1961, pp. 130–31

Das lyrische Werk [The lyrical works]. . . . It is an unbelievably rich treasure of poems, distinguished by formal metrical severity and the renunciation of all verbal experimentation, and yet the content of these poems allots her a legitimate place between Annette von Droste-Hülshoff and Elisabeth Langgässer. If the cycles about Napoleon and Countess Walewska or about Robespierre hardly go beyond historical portraiture, the fifty-four "Alte Stadtwappen" [Old municipal coats of arms], verses dedicated to the Prussian provinces, manifest the tragic relationship with her homeland and reveal a much profounder fascination of the poetess than the emblems' simple formulas lead one to suppose at first glance. . . . The names of so many of these towns have been forgotten—and no reading book in any Prussian school contains the poems of this woman, whose country perished with her.

Ilse Leitenberger. *Wort und Wahrheit.*
1961, p. 388

Together with Elisabeth Langgässer, Gertrud Kolmar has explored the higher and nether regions of childhood. There are moments when the reader of her verses is wondering whether she is not the girl Proserpina of whom Elisabeth Langgässer wrote, whether she is not the young Sichelchen of *The Quest* (*Märkische Argonautenfahrt*). The rhyme is handled masterfully, the images grow luxuriantly, and almost all poems abound with that great incantatory breath which greets the reader in the very first poem. . . . Her call is very audible. We can only stand amazed that this woman in whose poems the German language lives splendidly and unforgettably was forced into hard manual labor, deported, and probably murdered in Germany.

Richard Exner. *Books Abroad.* 1962, p. 54

One well-known thing about Gertrud Kolmar is that she, though not a member of any religious group, also wrote poems in Hebrew, which are, however, now lost. Already as a young girl she was attached to Zionism. Although Judaism is actually not one of her central themes—these are concerned with woman in her manifold external roles, with children, for whom she longed in vain her whole life long, and with the creatural world in general—her magic bond to the people of her heritage and her belief becomes evident in certain single poems.

Jürgen P. Wallmann. *Merkur.* 1966, p. 1191

Gertrud Kolmar died in Auschwitz at age forty-eight; she was given time to become herself, though no time for her name to grow; until this moment, she must be considered unknown. She was published and reviewed barely eight weeks before *Kristallnacht,* that infamous country-wide pogrom called the Night of the Breaking Glass—after which her external precincts narrowed and narrowed toward death. Not so the open cage of her spirit: she felt herself "free in the midst of . . . subjugation." A forced laborer in a Berlin factory, she continued to make poetry and fiction. Ghettoized in a tenement, she began to study Hebrew, and her last—lost—poems were written, most remarkably, defiantly, and symbolically, in the language of the house of Israel.

What has been recovered is not the record of the harrowings—though there is this besides—but the whole blazing body of her poetry, unconsumed. The American poet she is most likely to remind us of is Emily Dickinson—and not so much for her stoic singleness, the heroism of a loneliness teeming with phantasmagorical seeing, but for the daring pressure she puts on language in order to force a crack in the side of the planet, letting out strange figures and fires: she is a mythologist. To fathom this, one must turn finally to the Blake of the *Four Zoas,* or perhaps merely to German folklore: Kolmar too invents fables and their terrible new creatures, intent on tearing out of the earth of the Dark Continent of Europe its controlling demons.

On and on the furnaces of destruction burn; nothing can make them go out, as long as there are you and I to remember who lit them, and why. But now and then a congeries of letters plunges up out of the sparks to give us

back a child; a man who meditates on Spinoza in the slave-factory (it was to him Gertrud Kolmar talked of freedom in subjugation); a woman who fabricated original powers in a life beaten out of isolation, sans event until the last cataclysm—and who flies up alive from the cataclysm on the sinewy flanks of these poems.

As if the ash were to speak:

Amazed, I clothe myself.

Cynthia Ozick. Foreword to Gertrud Kolmar. *Dark Soliloquy: The Selected Poems of Gertrud Kolmar* (New York: Seabury, 1975), pp. viii–ix

Kolmar's first published poetry appeared in 1917 after which the writing and publication of various poem cycles followed at infrequent intervals. The . . . collection, which is as close as possible to what can be considered her "Gesamtwerk," came into print in 1960. Her published prose works are few: a short novel *Eine Mutter* (1930–31), an historical essay *Das Bildnis Robespierres* (1933) and a short story "Susanna" (1940). Of no less interest are her letters to her sister Hilde in Switzerland. This relatively small body of poetry, prose and letters constitutes her total *oeuvre.* . . .

The author's poetry is a moving composition of prophetic, defiant verse. Moreover, it became increasingly vociferous with her increasing allegiance to her Jewish roots and with her intuitive sense of the imminent horror about to befall the Jews. . . .

Her major cycles—*Weibliches Bildnis, Kind, Tierträume,* written between the years 1928 and 1937—with their forceful sexuality and sensuality, affectionately detailed animal poems, themes which concern the primal image of woman, are never without a tone of foreboding. In Judith the prophecy is strikingly evident. . . . Yet the whole poem is a testimony to the fearless Judith who, although she sleeps with Holofernes, must then kill him in order to save the people of the town. Implicit in this warning to the Jews is a virtual call to arms, a scream of rage against the brutality of Holofernes's armies and the expression of anxiety at the persecution of the Jews in the thirties.

Kolmar's letters represent a growing personal affirmation of the author's self-assurance under most difficult physical circumstances. The daily discomforts of living appear to be easily outweighed by a philosophical and spiritual confidence and security. The gradual retreat into an inner self provides a sanctum against the realities of Berlin during the last years of her life. Kolmar, in her letters, becomes a quietly defiant Judith who, in self-imposed solitude, disarms the oppressive forces from without by virtue of a personal strength and resilience and a commitment to her poetry. Her own example is not unlike the portrayals of the heroines in [her works of fiction,] *Eine Mutter* and "Susanna." Three Jewish women bear the burden of their fate. While

each pursues a solitary course, each has nevertheless understood the source of ultimate consolation. . . .

The penultimate letter quoted (15.12.42) could most appropriately serve to commemorate Gertrud Kolmar. Her death, to come but a few weeks later, was awaited with peaceful expectancy. Yet her complete *oeuvre* reflects anything but a tone of defeat or hopeless resignation. The strident scream and voice of defiance against the evils of the oppressor lash out from poetry and prose. In actual life, however, the author was a quiet Judith who, through her work, stepped forth bearing the head of Holofernes.

<div align="right">Michael C. Eben. German Life and Letters.
37, 1984, pp. 197–98, 206, 209</div>

KÖNIGSDORF, HELGA (GERMANY) 1938–

"Die geschlossenen Türen am Abend" is the title of one of the eleven short prose narratives that make up Helga Königsdorf's latest collection [under that title]. In most of the stories the protagonists are women in their late forties. They have jobs, husbands and children, houses to take care of, yet feel like outsiders. They have come to a point in their lives where they can no longer cope with the indifference and selfishness around them and therefore go to pieces in various ways. In "Unterbrechung" the "interruption" refers to the interruption of pregnancy and the total lack of emotional support for her "rational" decision. In "Kirchgang" a woman cannot bear to continue an indifferent Christmas evening with her family and, not knowing where she should go, finds herself in a church. In "Gewitter" the woman has become an alcoholic. Since all these women are "reasonable," they usually side with the world against themselves; they feel they are making demands by simply existing and then are beset by guilt for imposing those demands. This is particularly clear in "Rummelplatz," where the protagonist is dying in a hospital. She notices her daughter stealthily looking at her watch and feels guilty that the daughter is there visiting when she should be at home taking care of her husband and children.

Sometimes the author suggests that her women characters are still traumatized from childhood experiences during the war, and sometimes a grandmother seems to provide understanding. This is particularly the case in "Wenn ich groß bin, werde ich Bergsteiger"; in "Rummelplatz" the woman dies as she imagines her grandmother taking her to a fair. Königsdorf, who lives and writes in the Democratic Republic (where in 1985 she received the Heinrich Mann Award), occasionally peppers her portrayal of these women and the men's grandiloquent self-righteousness with satire. In "Die Himmelfahrt des Philosophen Bleibetreu" a woman's exploitation is contrasted with the pompous musings and mismanagements of men. Königsdorf is not mili-

tant, however; she portrays with a cool voice, and to the end she believes in the persuasiveness of reason.

<div align="right">Ernestine Schlant. World Literature Today.
64, 1990, p. 96</div>

Helga Königsdorf has received considerable attention recently, perhaps more as an outspoken and controversial figure in the political arena than as an innovative writer. *Innovative* may not be the correct term to apply to her latest literary effort. "Revival of a once popular form" would probably be a more apt description of her short novel *Ungelegener Befund* (Inconvenient findings). The work is an epistolary novel in the tradition of *Werther,* told entirely through letters exchanged by the protagonist with friends and colleagues. In due course there surfaces another pack of letters apparently written by the protagonist's father just prior to and during World War II.

Königsdorf's narrative does not seek the close ties to Goethe's *Werther* found in Ulrich Plenzdorf's *Neue Leiden des jungen W.* (1973), though she too has a young man in crisis write letters to express what ails him. The crisis is precipitated by events involving conflicts both in a homosexual relationship and with his responsibilities toward a restrictive yet forceful society. Dieter Jhanz, a biologist interested in gene research, is in love with one of his students, a brilliant but somewhat immature young man for whom Jhanz is a mere interlude on the way to an important career. The student's name is Felix, symbolic of happiness. While preparing the festivities to memorialize his recently deceased father, Jhanz discovers that the highly regarded elder Dr. Jhanz may have been involved in the Nazi mania for *Rassenforschung.* All this, however, remains shadowy and serves primarily to show that young Jhanz is at a crossroad. Much as his gifted father had to conceal his fascist past, so the equally gifted son must hide his homosexuality in order to advance in the suffocatingly narrow-minded academic community of the GDR. He cannot fully condemn his father and remains indecisive about his own career and future.

Despite the interesting premise of a homosexual young Werther created by a female writer, Königsdorf's novel leaves something to be desired. Perhaps a dose of Freudian psychology would have helped. As it is, the protagonist's florid outbursts in unmailed letters to an imaginary Felix, who little resembles his lover, transform Jhanz into a caricature rather than revealing anything resembling an interesting, complex personality, and all the other characters remain without substance. The novel's political overtones smack of the socialist-realist tradition. Altogether *Ungelegener Befund* is a story as "dated" as the recent past to which it relates.

<div align="right">Rita Terras. World Literature Today. 65,
1991, p. 113</div>

Like Christa Wolf's *Störfall* (1987; Accident), with which it has various parallels, *Respektloser Umgang* (Disrespectful relations) addresses the threat of

nuclear destruction and calls for action to remove this danger. That this concern, though not GDR-specific, is increasingly common in recent GDR literature bespeaks a mature nation and literature interested in issues of world importance, rather than in solely internal matters. . . .

While the narrator seems to represent the future and her hallucinated conversation partner, the early nuclear physics great Lise Meitner, the past, each actually reflects aspects of both past and future. . . .

The narrator of *Respektloser Umgang* tries to come to terms with herself and her fate of an untimely death due to an unspecified terminal illness. She seeks a "greater continuity" by extending her life into the past and the future. The process of establishing bonds to her professional and biological "Vorfahren" by her dialogues with Meitner enables her to draw on the past as the source of a mission that will give meaning to her life. Her change of focus from personal to world concerns leads her to abandon introspection for active engagement to preserve the future of humankind from nuclear destruction. Thus, she becomes an advocate for the future in league with the past. . . .

By conceiving and writing *Respektloser Umgang* despite her own illness, Königsdorf demonstrates her commitment to the narrator's mission. She could focus solely on a straightforward warning about the nuclear threat, but instead develops her theme by a complex interweaving of past and future in regard to the Nazi past, the narrator's illness, and the science and technology issue. I think she has several reasons for doing so. This method enables her to portray Meitner, who has long interested her, and to utilize for her literary work her hard-won insights on the meaning of a life cut short by illness. She recognizes that the need for resistance and responsibility in the future can be illustrated most effectively by comparison with past circumstances which required these virtues. Her method implicitly reflects a belief in Santayana's dictum that "those who cannot remember the past are condemned to repeat it." Thus, she emphasizes the interdependence of past and future to undergird her urgent message that we must make science and technology serve the needs of humanity lest our future be doomed by our failure to learn the lessons of the past.

<div style="text-align: right">

Nancy A. Lauckner. In Margy Gerber et al.,
eds. *Studies in GDR Culture and Society*
(Lanham, Maryland: University Press of
America, 1991), pp. 151–52, 162–63

</div>

In the last two decades many feminist writers and scholars have (re)discovered forgotten achievements of women from the past. Besides the rather straightforward aim of correcting the historical record—confirming the active presence of women throughout history—such research has often been motivated by the assumption or hope that women's lives may hold special lessons for the future. In the GDR, this motivation is especially evident in the writings of Irmtraud Morgner and Christa Wolf, although it can be found in other

literary works and a wave of recently published biographies of women as well. . . .

Most . . . feminist assumptions . . . are challenged in Helga Königsdorf's *Respektloser Umgang*. . . . For example, Königsdorf's decision to write about atomic physicist Lise Meitner (1878–1968) seems calculated to call into question the idea that women had no part in producing destructive forces; Meitner's role in the discovery of nuclear fission is after all well-established, even if not widely known. Königsdorf approaches the question of special knowledge or insight available only to the "marginalized half of humanity" by re-examining and to some extent re-imagining Meitner's life, poking at what she did, what she might have done, and why. Königsdorf also personalizes and concretizes her questioning by linking Meitner's experiences to those of the narrator, a woman scientist modelled closely on the author herself. This is a way to bridge the gap between the hypothetical (what could/should have been done?) and the here and now (what can/will I do?). . .

The narrator's perspective is . . . relativized to some extent by the Meitner character's persistent challenges to her. For example, taking an interest in the status of women in the GDR, the fictionalized Meitner demands to know how many women Nobel Prize winners the GDR has, what steps are being taken to produce more prize-winning scientists, and whether women professionals have household help. The narrator loses patience and refuses to answer; the questions belong to a different tradition and a value system that is alien to her, but seems perfectly appropriate to Meitner. The fictionalized Meitner also repeatedly challenges the narrator to rethink her relationship to her personal history, raising questions which the narrator presumably would not have asked herself, especially about her father's possible resistance to or collaboration with the Nazis. . . .

The narrator, like Meitner an insider and outsider, both victimized in some ways and able to make choices, looks not to "the marginalized half" but all of humanity for her solution.

> Jeanette Clausen. In Margy Gerber et al.,
> eds. *Studies in GDR Culture and Society*
> (Lanham, Maryland: University Press of
> America, 1991), pp. 165–66, 175, 180

KOROLEVA, NATALENA (UKRAINE) 1888–1966

Koroleva's novel *1313* . . . is about the invention of gun powder during the Middle Ages. The novel is artistically sound, and quite positive in its ethics and ideology. Nonetheless, it unexpectedly provoked heated criticism . . . which accused the author of an anti-Catholic stand and of lack of knowledge of the Middle Ages. These attacks were unsupported by reality; Koroleva

knew and understood the Middle Ages quite well, and she never opposed Catholic morality. . . . *1313* displays her characteristic tendency to portray the mysterious in human life, that is, the supernatural. She introduces the Devil into the novel, but does it, so to speak "naturally," without destroying the verisimilitude of the work. The same can be said of the figure of the naïve Abel, who "senses the Devil," and of others.

These supernatural features are even more striking in Koroleva's next novel, *Predok* [The ancestor]. . . . In it she traces the course of a mysterious curse placed on two Spanish families, which, incidentally, contained the writer's ancestors. It is never quite clear why the innocent descendants of those two ancient families are made to suffer, but this does not detract from the overall value of the novel. The highlights of the work (the portrayal of the insane queen, the sketch of monastic life in the desert) are literary gems of great artistic quality.

In dealing with the Middle Ages Koroleva is greatly aided by her . . . fertile imagination, which enables her to create scenes not rooted in her life. In this respect, there are very few writers who can equal her, not only in Ukrainian literature but in world literature in general.

Teofil Kostruba. *Zhyttya i slovo.* Winter, 1948–Spring, 1949, p. 240

Because of her style, Natalena Koroleva occupies a special place in our literature. Her style is most unusual, one could say archeological. It is quite flexible, at times even marvelously ornate, and it always conveys the spirit of antiquity. This is clearly seen in *Legendy starokyyivs'ki* [Old Kievan legends]. Koroleva re-creates scenes from the ancient world with very accurate historical and sociological details. Her literary work also reflects her talents as a painter and as a singer. . . .

To a reader not used to her themes and style, her works often appear dull. . . . In all fairness, however, it must be stated that the reason for this is not the writer's inability to capture the reader but rather the unpreparedness of the reader to deal with works that contain no superfluous phrases. . . . In spite of all difficulties and "misunderstandings," it must be stated that Koroleva is a great creative artist. She has an excellent command of the Ukrainian language, for which she has developed new poetic forms. Her great and noble work has earned her a place of honor in Ukrainian literature.

Dmytro Buchyns'kyy. *Nashe zhyttya.* December, 1958, p. 3

[Koroleva] writes about life in antiquity and during the Middle Ages in the Ukraine and beyond its borders. Against this background she poses and solves ethical problems, which often lead her to touch on supernatural and mystic aspects of human existence. All this gives her works a religious character, which makes them akin to those of the Christian symbolists of Western European literature.

One of her historical novels is *Quid est veritas*. She collected documentary data for this work over a period of many years. . . . This novel, however, could also be viewed as a legend, for it is based not only on archeological findings and documents from various archives but also on a "spiritual archaeology": it includes the ancient oral tradition, old legends, myths and tales, which regardless of their fantastic character developed from a . . . grain of objective truth. This is why the novel contains many scattered legendary motifs, making it at times read like a fairy tale. Yet one must keep in mind that these fantastic elements reflect, like a magic mirror, the spirit of an age when "gods walked the earth." They also reproduce the world view of the man of antiquity, for whom a world filled with magic and marvellous events was a reality. However, the essence of her work is not obscured by her manner of writing, her mysticism and symbolism, nor by her wealth of literary devices.

The focal points of the novel are the human soul's search for truth; man's responsbility for his deeds, voluntary and involuntary; and their evaluation from the point of view of divine justice.

> Roman Zavadovych. Introduction to
> Natalena Koroleva. *Quid est veritas*.
> (Chicago: Mykola Denysiuk Publishing Co.,
> 1961), pp. 8–9

In Koroleva's works two worlds—the visible and invisible—are woven into one colorful and rich fabric. Both exist alongside each other in people and events. The subject matter of her works alone leads us into the spiritual world.

The sketches in *Vo dny ony* [At that time] deal with events from the time of Jesus Christ and express extratemporal and extraspatial elements. Like the Sacred Scriptures, they are a source of interpretation of God's kingdom on earth. The author wrote that these sketches are frames for the stories of the Gospels rather than independent works. At the same time, they are without a doubt beautiful works of art, profoundly symbolic and bathed in the reflection of eternity. They reveal to our eyes the kingdom of God, which the glorified figure of Jesus Christ invites us to enter. This kingdom, however, is not located in unattainable heights but here among people, both rich and poor, in crowded marketplaces or in quiet churches. It is the Kingdom of God in the human soul.

> Oleksandra Kopach. *Natalena Koroleva*
> (Winnipeg: Ukrainian Free Academy of
> Sciences, 1962), p. 18

KOSSAK, ZOFIA (POLAND) 1890–1968

In her historical novels, Zofia Kossak gives a vivid account of men's struggle for power; but she is also concerned with their normal predicament. Her saints, warriors and common people come to life against the background of a superbly drawn tapestry that stretches from Europe to the Middle East and Asia.

In such novels as *The Golden Freedom*, Kossak explores politics, patriotism and religious problems while she portrays the exuberance of eighteenth-century Polish life. Her treatment of history is metaphorical. She does not draw social conclusions in her narratives, but she stresses the evolutionary values of human existence. The old and the new are linked imperceptibly by a subtle use of rhetoric and the skill with which she humanizes the anonymous reality of history. Zofia Kossak depicts the religious movements of the sixteenth and the seventeenth centuries, their origins, development and results; but she is primarily interested in the impact those movements had on the minds of contemporaries. Her historical novels thus turn into psychological studies of the human personality, and the defeated protagonists are often portrayed as the true victors. This method of psychological analysis enables the author to combine religious problems with political ones, and the private lives of her heroes with the story of Poland's statehood.

<div style="text-align: right">

Adam Gillon and Ludwik Kryzanouski.
Modern Polish Literature (New York:
Twayne, 1964), p. 170

</div>

The twenty years between the two world wars was marked for a qualitative and quantitative stagnation in the domain of historical novels, although to all appearances this was not so. In 1928, for instance, Wincenty Lutoslawski, then already much advanced in years, loudly proclaimed to the world with a roll of drums that Poland had a new Sienkiewicz, this time a member of the fair sex, the authoress of the novel *Golden Freedom (Złota wolność)* Zofia Kossak (1890–1968), who then used her married name with her maiden name (Kossak-Szczucka, later Kossak-Szatkowska). She was the granddaughter of the famous painter Juliusz Kossak and already had quite a considerable achievement to her credit in the literary field, to mention her first book *Conflagration (Pożoga,* 1922), which was a literary presentation of her war reminiscences, and the prospect of a brilliant rise to fame before her in Sienkiewicz's domain, that is, in the field of the historical novel. The first of them *Angels in the Dust (Krzyżowcy,* 1935) was given an enthusiastic reception and those that followed had a wide reading public, although the critics made ever fewer references to her being a new Sienkiewicz. This was the case with her later books of the cycle devoted to the Crusades *The Leper King (Król trędowaty,* 1937) and *Blessed Are the Meek (Bez oręża,* 1937), and with *Gift of Nessus (Suknia Dejaniry,* 1939) and others. All these novels

had as their source of inspiration the religious and historical interests of the authoress, which also formed the basis of shorter novels like *The Battlefield of Legnica (Legnickie pole)* and *Beatum scelus,* and her short stories published in the volume *The Divine Fanatics (Szaleńcy boży,* 1929). So her sensational debut with *Golden Freedom* dealt with the Polish Arians and their role in the rebellion led by Mikołaj Zebrzydowski, her book *Angels in the Dust* was an extensive account of the first Crusades, and her *Gift of Nessus* was a novel based on the legend of Kazimierz Korsak, taken from the medieval work *Life of St. Alexis.* As regards her shorter works, the above-mentioned *Beatum scelus* (a later edition bore the title *A Sin Blessed—Błogosławiona wina*) brings the history of the miraculous picture, The Kodeń Madonna, stolen by a magnate whose desire to possess it was too strong for him to resist, and *The Divine Fanatics* is a beautifully written series of lives of the saints. This specific bent of the authoress was to have a rather unfavorable effect on her historical novels, particularly as her weak knowledge of history did not enable her to direct a beam of light into the dark ages in search of truth. For instance, her views about the Polish Arians were just as far from the truth as the exaggerated exaltation of the admirers and followers of the "Polish brethren" and their political attitude. Her presentation of the cause of the Crusades did not rise above the clericalized presentation of the question in school textbooks. The works of the authoress of *Gift of Nessus* are thus an example of the lamentably low intellectual level of Polish Catholic milieus. . . . If it were not for the fact that this would sound like paltry malice—one might see in her a modern Deotima, without all her pretentious coquetry it is true, but—like her—unable to subject her flights of imagination to rigorous intellectual control and criticism based on a scientific knowledge of the past.

Julian Kryzanowski. *A History of Polish Literature* (Warsaw: PWN-Polish Scientific Publications, 1978), pp. 637–38

While living in England, Kossak wrote her memoirs about Auschwitz, *Z otchłani: Wspomnienia z lagru* (1946; From the abyss: memoirs from the camp). This book, so different in subject and character from her other works, has a stark and piercing vividness. While her historical novels could be compared to panoramic oil paintings, full of color and large in scale, her memoirs from the camp resemble black and white, brutally direct sketches. Their narrative is halting, unlike the flowing narrative of her historical novels; and a great sense of pain and of probing into the limits of human endurance is evident. . . .

The steady and consistent decline in critics' favorable response to Kossak's novels and tales was caused by what they uniformly regarded as Kossak's shallow knowledge of history and her limited familiarity with philosophy and theology. Kossak's knowledge of Catholic doctrine was considered minimal and her treatment of history often more fantastic than factual. Never-

theless, no critic ever found her wanting in narrative talent or in vivid imagination. Kossak demonstrated considerable literary skills, and her knowledge and love of the visual arts is evident in all of her writings. The panoramic quality of her historical novels, the appeal of colors, the richness of detail, and the likability of her characters account for her considerable popularity among readers. The wealth of factual material assembled by Kossak in her historical novels and the faithful rendition of the language of a given historical period she described balance the shortcomings in Kossak's interpretation of history and in her understanding of philosophy and theology. Kossak is neither a critic's nor a scholar's writer, but her works fare extremely well with her readers, and the passing of time does not diminish their popularity.

<div style="text-align:right">

Malgorzata Pruska-Carroll. In Steven R. Serafin and Walter D. Glanze, eds. *Encyclopedia of World Literature in the 20th Century* (New York: Continuum, 1993), pp. 603–4

</div>

KOSTENKO, LINA (UKRAINE) 1930–

The literary work of Lina Kostenko, one of the most gifted of our young women poets, has not been analyzed much by the critics. Readers display a variety of attitudes toward her poetry. Some are enthusiastic; others look upon it with both favor and some reservations. Frankly, I am impressed with the sensible manner of this poet, whose works compel us to recall the poetry of Tyutchev and that of the undeservedly forgotten Yevhen Pluzhnyk. . . .

Kostenko herself has very aptly described the nature of her talent: "I write anxious poems." Indeed, the word "anxiety" is often encountered in her poetry. . . . Her muse is anxious, disturbed, one could even say nervous. There is nothing wrong with this. Poetry is born in the depths of the human soul, and serenity does not always reign there. To be sure, Kostenko at times poses. She indulges in emotional upheavals and painful thoughts; she over-emphasizes dramatic moments; she seems to play up her loneliness, her unstable personal situation, her life's sorrows. More frequently, however, she gives birth to poetic lines filled with authentic unremitting pain and inner anxiety. . . .

The true strength of Kostenko lies in her reflections, her passionate thoughts about the contradictions and conflicts of life, about man's destiny, and about what is considered happiness on earth. . . . In her poem "Smikh" [Laughter] she reveals her perception and her view of the world. She is for truth and sincerity and against opportunism, affectation, and spiritual hypocrisy. . . . We too are for sincerity. But the world is not all veiled in

sorrow, and life consists not only of losing but also of finding, not only of partings but also of encounters. The latter elements seem to be lacking in Lina Kostenko's muse.

<div align="right">

Yosyp Kysel'ov. *Vitchyzna*. November, 1961,
pp. 190–91

</div>

The publication of Lina Kostenko's first collection of poems was an event unprecedented in Soviet Ukrainian poetry, at least since the latter part of the 1920s. Her great literary talent revealed itself from the very beginning . . . in completely mature poems characterized by a sincere lyricism and a perfection of form. All this contrasted most refreshingly with the constant repetitions of Malyshko and Sosyura, the lyric poetry of the apparently creatively spent Ryl's'kyy, the work of Tychyna . . . and of Pavlychko, who adhered to the Party line. . . .

The older poets were unable to come to terms with the heavy burden of the past. The pioneering word had to come from a member of the new generation of poets. This role was assumed by Lina Kostenko. Her first two collections . . . promised much, not only in themselves, but as examples which could be followed by others. . . .

However, a literary bureaucrat . . . immediately attacked the young poet with a tried weapon—the accusation of formalism. . . . All the accusations made against her were unfounded. As to form, Kostenko employs almost the same rhythmic structures as any other Soviet poet. She offers perhaps a greater degree of variety and an occasional experiment in stanzas, but she uses nothing that could not be used by a Malyshko or a Sosyura. Admittedly, at times she writes in blank verse, which is still a rare thing in Soviet Ukrainian poetry. . . .

Inasmuch as the Soviet critics consider Kostenko's poetry too modernist and formalist, assuming that they are sincere in their opinion, the explanation of this could be as follows: the critics were simply so overwhelmed by the originality of her poetic imagery that they understood it as formalism.

<div align="right">

Ivan Koshelivets'. *Suchasna literatura v
URSR* (New York: Prolog Assn., 1964),
pp. 282–84

</div>

In [Kostenko's] early poems formalistic elements and a symbolic mode of expression dominated. Her most beautiful early poem . . . "Paporot'" [The fern], deals with green birds, which congregate late at night on a freshly cleared area in the forest, where the round, sawed-off tree trunks gleam like the full moon. The invocation—"Green birds,/What more do you want?/You have the moon,/You have the sky."—is followed by the surprising ending: when in the golden light of dawn the birds attempt to fly off into the sky, they are unable to do so; they get caught in the mass of fluttering wings.

After being chastised by the official critics for "formalism, linguistic trickery, and a pessimism unworthy of a Soviet poet," Lina Kostenko became

silent for three years. The critics sharply charged . . . that her poems express "despair, hopelessness, and doom" and that they are "removed from the optimistic view of life and the noble sentiment of collectivity that fills every Soviet human being." Her next collection of poetry did not appear until 1961. . . . It is characterized by a more mature language and a poetic style of her own. Two of the poems in it can be considered as a confession of the young generation of poets. . . . In the poem "Kobzarevi" [To the Kobzar] . . . Lina Kostenko attacks all those crippled souls who have strayed into literature and who live from it. . . . In the poem "Estafety" [The Estafette] . . . she condemns the pettiness and glory-seeking of those Soviet litterateurs who serve only their own comfort.

The very same critics who in 1958 accused Lina Kostenko of formalism became enthusiastic over her work in 1961 and praised her ability to express the complicated and elusive moments of man's spiritual life.

<div style="text-align: right">

Anna Halya Horbatsch. *Ukraine in der Vergangenheit und Gegenwart*. Winter, 1965, pp. 159–60

</div>

The problems raised in ["Mandrivky sertsya" (The Problems of the Heart)] reflect the search for spiritual-humanistic dimensions in the literature of the new epoch. The themes of the poem are the conquering of spiritual emptiness through social action and the joy of an active struggle for the happiness of all mankind.

Like other of her poems . . . the work has the form of an allegorical fairy tale. The subject is developed through the journeys of a human being with an "extraordinarily big heart," who is dissatisfied with the ease of life and the weightlessness of the "immense emptiness" of the soul. During his travels the lord "of the big heart" is exposed to a series of symbolic visions of both the . . . tragedies and the achievements of contemporary mankind. . . .

Having fathomed the depths of human suffering, the hero of the poem is filled with the undaunted spirit of battle. . . . The ideal of Kostenko is a human being who is able to face the stern black nemesis, a human being who is made "strong by the strength of goodness."

The recurring theme of the work is a fiery call for enkindling activism in the human spirit, for brotherhood and unity in the battle against the contemporary forces of reaction. . . .

The poem, as well as the entire collection *Mandrivky sertsya,* was a major success for the poet, at the same time that some of her poems were provoking justified charges by the critics, inasmuch as those works contained a potpourri of ideas and a one-sided, pessimistic view of reality.

<div style="text-align: right">

Istoriya ukrayins'koyi literatury u vos'my tomakh, vol. 8 (Kiev: Akademiya nauk ukrayins'koyi RSR, 1971), pp. 299–300

</div>

Of the sixty or more poets from the new ranks the most eminent and durable work belongs to Lina Kostenko, whose latest collection entitled *Garden of Unmelting Sculptures,* published in the latter part of 1987, attests to the continued high quality of her poetry, and to Vasyl Symonenko, whose premature death in 1963 at the age of 28 cut short his work as one of the foremost members of the group.

Of the seven books of poetry published so far by Lina Kostenko only three belong to the period of the thaw which lasted roughly from mid-1956 to March 1963: *The Earth's Rays* (1957), *Sails* (1958) and *Wandering Heart* (1961).

The other four collections of poetry were greeted with great enthusiasm by the reading public when they appeared, the first quite unexpectedly after a relative silence of more than 15 years. Its title is *On the Banks of the Eternal River* and it was published in 1977. 1980 saw the appearance of two outstanding books—one a historical novel in verse relating to the tragic semi-legendary figure of the same name as the title, *Marusia Churai,* and the other a collection of poems entitled *Non-recurrence.*

In a part of the world where "real" poetry had rarely been seen since 1934 in other than a clandestine form and, apart from a break during the years of the thaw, the population had been fed a diet of boring and insincere rhymes within the precepts of socialist realism, it is perhaps not too astonishing to discover that when this last book went on sale in Kiev 3,000 copies were sold in one bookshop alone in the space of three hours. The fourth in this group is the collection mentioned above—*Garden of Unmelting Sculptures.* It is the most recent and has generated excitement around the Ukrainian-speaking world. . . .

Kostenko's invariant theme is made up of at least four *invariant motifs.* Zholkovsky defines the term *invariant motif* as "a portion of the author's favorite messages. . . . A poetic world is a complete set of the messages that are included by the author, in one or another combination, into any text and in this sense 'built into' his code."

Stated very simply, the four invariant motifs which emerge from Kostenko's poetry are the following:

1. Life and literature are a continual battle of good against evil.

2. An artist has a moral responsibility to be sincere and honest; the artist's work is worthy of promotion as a theme in itself.

3. Pain cleanses and heals, therefore painful thoughts should not be pushed aside.

4. Satire, which is intended to bring the foolish to their senses, should be combined with a sense of optimism. . . .

The four invariant motifs of Kostenko's invariant theme would be strong candidates for such universals. These universals are constructs which have to a large degree been conceptualized by means of the terminology of the poetics of expressiveness.

The disenchantment with society does not, as might be expected, lead to a feeling of alienation, nor to a slow and cautious warming to the more relaxed conditions. Quite the reverse is true—there is forcefulness of expression and intensity of involvement. The battle of good against evil in its various guises is waged with great sincerity and moral conviction. There is a sense of delight in the rediscovered feelings of anguish and suffering, accompanied by the belief that they will lead to a healing and a restructuring, for both society and the individual. The freedom of spirit and compelling need to be completely honest, at times even satirical, is laced with a sense of optimism.

Most encouraging of all is the knowledge that the achievements of each thaw are not erased by subsequent tightening of controls. They live on through their influence on the work of later generations.

<div style="text-align:right">

Halyna Koscharsky. *Australian Slavonic and East European Studies.* 2, 1988, pp. 69–70, 75

</div>

The poetry of Lina Kostenko is essentially the poetry of experience. Her life forms the subject matter of her verse, from the seemingly humdrum events of daily existence in which she finds higher truths to the deeply felt and personal emotions of love found and love lost. Like her fellow countrywoman Anna Akhmatova (real name Horenko), who wrote in Russian rather than in Ukrainian, Kostenko often presents a slice of life in her poetry, a scene from her personal lyrical diary, from which she shares both the experience and what she has learned from it. The Western scholar John Fizer acutely observes that this aspect of her verse is classically Aristotelian, with plot the central component of her poetics.

While she tends to be elegiac, Kostenko always strikes a final life-affirming note. Her immense popularity can be explained by her accessibility, by the bond of shared intimacy that she immediately creates with her reader. Her poetry is neither purely intellectual nor opaque, as has become typical in much modernist verse, but rather is grounded always in reality, in specificity. Her persona is that of an impressively educated, articulate, and aesthetically inclined individual. She is a Renaissance woman, who is intimately at home with the works of Western and Russian literature, the Bible, the Greek and Roman classics, and her own native Ukrainian literature. Her poetic voice is rooted in a fusion of the literary with the experiential, with an admixture of folk wisdom and the omnipresent sense of belonging to the larger entity of society. Her poetry does not pontificate from an ivory tower; it affects the reader directly from the heart and soul of the poet.

The language of Kostenko's poetry is laconic, natural, and free of linguistic experimentation. Reading it gives one the experience of genuineness and beauty, the very kind of aesthetic experience that the poet seeks in her life and in her poetry. Kostenko comes from the long line of poets who believe in the sacred nature of the poet's task, in the equation of poetry with truth. It is no surprise then that images of the sea, of vessels, of journey abound

in the early poetry. The poet tests herself in the world in neo-romantic terms: she seeks spiritual freedom, she seeks herself, she seeks love. If we use her own typically romantic metaphor, she is a tiny individual (the sailboat) in a vast and sometimes overwhelming universe (the sea). Yet she never deals with the vast cosmos on its own terms; instead, the lessons of personal life shape her philosophical outlook. . . .

The very titles of Kostenko's collections convey the central metaphors that appear throughout her poetry. Rays of earth illuminate, with spirituality having its source in the earthly realm. Sails give the poet metaphorical wings for her journeys. The poet's heart wanders in search of someone to share her quest. And the metaphorical sculptures from one of her most recent collections provide the link between the historical past and the present that helps both an individual and a society to define themselves. Nature provides the other central source for the poet's quest for spiritual truth. Kostenko's nature lyrics are word-paintings, verbalized landscapes that capture the quintessence of the scene described in all its bustling life. They are minimalist miniatures that invoke intense visual and aural imagery. While the poet often seeks peace and serenity in a sylvan mountain scene or in a seascape in order to meditate creatively, she also searches for storms to inspire her muse. Her storm lyrics are among the most vivid to be found in twentieth-century literature.

Kostenko's interest in history is typical for a contemporary Soviet Ukrainian society that defines itself by examining its past. . . . Just as she learns from her personal experiences, she learns from the lessons of history, for both have their source in a common wellspring—life. . . .

Kostenko now has been one of the leading voices of Soviet Ukrainian poetry for some thirty years. It is only poetic justice that official appreciation of her work has caught up with the high reputation and popularity that she has always enjoyed among her readership. Her works like *Marusia Churai* and her verse dramas are now being performed in theatrical versions in the Ukrainian SSR and abroad. Her public readings have become more popular than ever. And she continues to write in her native Kiev. Hopefully, the relaxed political climate in her homeland will continue to allow her to flourish as a poet.

Michael M. Naydan. Afterword to Lina
Kostenko. *Selected Poetry: Wanderings of
the Heart* (New York: Garland, 1991),
pp. 146–49

Kostenko takes two avenues when she explores recollected emotion. In one type of poem, she re-experiences the more distant past of her childhood. Much like a psychiatrist delving into childhood through psychoanalysis, Kostenko reaches back to a time she considers paradisal. In that past she finds the formative sources of her adult self. Anamnesis in these poems results in a psychological state of well-being, in a sense of immortality and inner

strength. In the other strain of poems based on recollected emotion, the poet deals with more recent adult experiences—with the theme of love lost, or in other words, the loss of a paradisal state of bliss. This second type of lyric by its very nature is elegiac. Since it reconstructs sorrowful emotion and a sense of loss, the poet runs a certain emotional risk. When the mental probing ends, she can be left with the intensely powerful sorrow of her loss. On the other hand, the process can also be therapeutic: by catharsis, the poet can purge herself of the high-pitched emotions that have become all too real as a result of her mental exploration. . . .

[A] namnesis for Kostenko is essentially a restorative technique that she uses to reinvigorate her spirit. The mental return to childhood always recreates an inner paradise, while the restoration of a sense of loss can have an emotionally devastating effect. In the first type of memory poem the poet exercises a certain amount of control over her rational mind and the mental journey has a predetermined therapeutic goal. In the second, the poet delves into the irrational. Prolonging emotional suffering can lead to even greater suffering. This is a lesson that confessional poets like Sylvia Plath and Marina Tsvetaeva learned all too well. Their prolonged psychic experimentation for the sake of their art led to psychic catastrophe. In Kostenko's poetry, there seems to be a certain balance between the two types of memory lyrics. While the poet knows that she can tap into these psychic energies for the sake of her art, she also seems to intuitively understand the limits to her mnemonic experimentation.

<div align="right">

Michael M. Naydan. *Canadian Slavonic Papers*. 32, 1990, pp. 120, 132

</div>

In the Ukraine, as in much of Eastern Europe, poets often serve as spokesmen for the nation and as such are closely scrutinized by the authorities. This has most certainly been the fate of Lina Kostenko, an outstanding Ukrainian poetess of the twentieth century. Her first collections—*Prominnja zemli* (1957; Earthly rays), *Vitryla* (1958; Sails), and *Mandrivky sercja* (1961; Wanderings of the heart)—were a rediscovery of the lyrical *I* and a reaction to the declarative and officially sanctioned panegyrical poetry of the postwar period. It was not long before the backlash to the thaw, however, led to increasingly harsh criticism of her poetry for its purported spirit of pessimism, and the publication of two of her collections, *Zorjanyj intehral* (1963; The integral of stars) and *Knjaža hora* (1972; The king's hill) was halted. *Marusja Čuraj,* her historical novel in verse, fared no better; submitted in 1973, it was initially rejected by the state publishing houses and only appeared years later after the political situation had improved. Although Kostenko was not arrested in the 1968 crackdown on Ukrainian writers and cultural figures, she did not publish again until 1977. Since then a number of her poetic works have appeared: *Nad berehamy vičnoji riky* (1977; At the shores of the eternal river); *Marusja Čuraj* (1979); *Nepovtornist'* (1980; Originality); *Skyfs'ka baba* (1981; The Scythian idol) a translation from Serbo-Croatian; *Sad netanučyx*

skul'ptur (1987; The garden of unthawed sculptures); and *Buzynovyj car'* (1987; The king of lilacs) a collection of poems for children.

Vybrane contains poems from all of the collections mentioned above (including the two unpublished ones) and poems that did not appear in any collections, as well as her most recent work entitled "Incrustations." It is the first volume compiled according to the author's wishes with no interference from the censors. The poems do not follow in chronological order nor are any dates provided, hence the volume does not offer a retrospective view of her work. Instead the volume is divided into ten sections: six sections of poems grouped more or less thematically, three containing the long poems "Skifs'ka odisseja" (Scythian odyssey), "Snih u Florenciji (The snow in Florence), and "Duma pro brativ neazovs'kyx (A Duma about the Non-Azov Brothers) and the last section, "Incrustations." Some collections are represented more completely than others. *Sad netanučyx skul'ptur,* which contains the three long poems mentioned above, appears almost in its entirety, while only a few poems from *Buzynovyj car'* are included. *Vybrane,* with a print run of 60,000 copies, is intended for the general public, but has no introductory essay, no biographical nor bibliographical information, which would have been useful for a reader unfamiliar with Kostenko's life and work.

From the very first Kostenko's work has been marked by its strongly personal nature, not as a private world that the reader must struggle to penetrate but as an expression of Kostenko's experience as a women and a poetess, and as a voice for her people. Her determination to preserve her integrity in personal relations and in regard to her art, and her support of humanistic ideals figure prominently in her poetry. The restrained emotion, the measured tone, the aphoristic closures, and an absence of ornateness and of experimentation with form produce a deceptively simple lyricism. But in Kostenko's poetry the realia of everyday life and nature (an important source of her imagery) acquire deeper significance and raise eternal questions about existence and fate. This is evident in her pronounced interest in historical characters and periods. Kostenko focuses on shared moral issues and emotions to illustrate the immediacy of the past for the present. Her examination of Ukrainian history, particularly the tragic struggle for freedom, becomes a means for understanding herself and for commenting on her society. As a poetess she has forged a voice of courage and intimacy that preserves a balance between human dignity and femininity. And, as she has urged contemporary women to do, she has gone "beyond the boundaries of a narrow internal world into the great and complex world." Her uncompromising search for the truth (also found in her intimate love lyrics) has drawn comparisons to the poetry of Lesja Ukrajinka and has endeared her to her public and made her a formidable force in Ukrainian literary and cultural life.

Selected Poetry: Wanderings of the Heart contains translations of ninety-five poems, most from Kostenko's first three collections and others (written between 1956 and 1969) that were not originally published in collections. . . .

The selection of poems gives an unfamiliar reader an accurate sense of Kostenko's themes, her style, and her poetic voice. The selection also aptly conveys the changes in Kostenko's relationship to her reader—from coaxing the reader in her first collection, to exhorting him in the second, to a less didactic and more self-assured tone found in *Wanderings of the Heart*. While the volume may spark disagreement over some of the selections, it contains such excellent poems as "The Artist," "The Passage of the Storm," and her programmatic poem "O Bard," as well as less impressive poems such as "Laughter." . . .

Hopefully these two volumes will stir interest in Kostenko and lead to scholarly studies of her work. The political climate is most certainly right.

George Mihaychuk. *Slavic and East European Journal.* 35, 1991, pp. 587–88

This collection [*Vybrane*] by the premiere Soviet Ukrainian poet Lina Kostenko represents a major event in Soviet Ukrainian literature and functions as a bellwether for the Ukrainian redaction of glasnost. While editions of selected works normally comprise the best of previously published material, this volume includes more than one hundred poems that have never before appeared in print in the Soviet Union. These poems, marked by an asterisk in the table of contents, mostly come from two collections that had been scheduled for publication but were never released: "Zorianyi integral" (1963) and "Kniazha hora" (1972). Kostenko garnered a vast cult following in the early 1960s, yet authorities impeded her from publishing from 1963 to 1977. During her period out of the mainstream of officially sanctioned Ukrainian cultural life, she never resorted to samizdat or tamizdat publication but still continued to write and to gather materials for future projects. Even after she was published again, she staunchly reacted against attempts to censor her works and, at one point, initiated a hunger strike to maintain the integrity of her soon-to-be published collection *Nad berehamy vichnoi riki* (1977). Back then she won the battle and has since apparently won the war. . . .

Her strengths lie in the intimate lyric, especially in love and nature poems. The poem "Zatinok, sutinok, den' zolotyi" is a masterpiece of the parting elegy. (For an English translation see the journal *Nimrod* [Spring/Summer 1990].) Within the Slavic literary tradition, we might add her historical and long poems as areas in which she can be placed among the best of the Slavic narrative poets.

Besides giving a cross-section of Kostenko's variegated traditional poetry, this collection marks a new stylistic stage in her poetic oeuvre: shorter verse forms. Most of these stylistically condensed poems attack various targets: Chernobyl, philistines, political hacks. One of my favorites in this vein contains the lines: "Even if you lift a vulgarian with a tire jack / he won't become a democrat." Many of these brief poems exhibit extraordinary cleverness and border on being political haiku. This, of course, is the most primitive of poetries—akin to the iambics written by Archilochus to smite his enemies.

While providing a clear message for the reading masses and exorcizing many years of pent-up bile, this kind of poetry has one major drawback: It goes against the grain of Kostenko's strengths as a poet. Her deep lyricism for the most part becomes lost in these poems, except for a few notable exceptions.

Michael M. Naydan. *Slavic Review.* 50, 1991, pp. 729–30

Some of Kostenko's verses are miniatures that invoke the reader's imagery. In their essence the poems reflect her inner self, her immense sincerity. For example, we read: "And I gaze and mull over poems. / When they are sad— let them be sad. / Only let them not laugh falsely." This attitude of inner freedom and sincerity was impermissible in official Soviet literary circles. Consequently, Kostenko was harshly criticized and, as a result, retreated into silence for protracted periods of time. Her works reappeared in print only during the short periods of "thaw."

Through her poetry Kostenko is able to link dynamically the past of the Ukrainian nation with its future, despite insurmountable obstacles and the threat of annihilation. This is reflected not only in her epic poems but also in her lyric works. Naydan refers to her as a Renaissance woman who has studied Western literature and the Greek and Roman classics. She turns to the nineteenth-century Ukrainian poet Taras Shevchenko as a source of truth in art, asking him for advice in "O Bard." This poem exemplifies her esthetics, essentially a search for inner truth and beauty for herself and for her generation.

As a neoromantic in style, Kostenko seeks spiritual freedom of expression. The highlights of her poetry, rich in metaphors, are reminiscent of her own life, which has become a well of wisdom, for everything that has happened is deeply rooted in the eternity of cosmic space. Lines from her poems are like murmurings of the heart wandering through the immense steppes. They may sound elegiac, but they are actually affirmations of her life. Her love of nature and humanity in its midst is striking to the reader for its sincerity. Some of her most profound values lie in her intimate love poems. The quest for true eternal love penetrates her at times laconic verses. Despite the simplicity of her style, she succeeds in producing a verbal symphony of the human heart. What emerges from her poetry is a quest for truth, beauty, and love. The aphoristic poetic phaseology reveals eternal values and wisdom about life.

Naydan's task [as translator] was to create an artistic reflection of Kostenko's poetic works and her lyric heroes. He restricts himself somewhat in his translations, not applying, for example, Kostenko's metrical schemes and rhyme, which, he contends, may sound artificial to the English literary ear. By retaining the organic rhythm, however, or at least trying to approximate it and by harmonizing some of Kostenko's alliterations, he manages to re-create in English Kostenko's poetic style and images. His translations, em-

phasizing the intellectual content and the adequacy of the images in Kostenko's poetry, will enable the English reader to experience her work fully.

Natalia Pazuniak. *World Literature Today.*
66, 1992, p. 167

KOZIOL, URSZULA (POLAND) 1931–

The modern poet depends on a sensitive if not to say loving reader. The concentrated language of poetry, its unfamiliar imagery, and its non-everyday idiom make increased demands on the reader's patience and on the broadest possible range of his intellectual preparation. A certain preparation and intellectual maturity are indeed prerequisites for an appreciation of Urszula Kozioł's *Poems,* an excellent collection from one of Poland's finest contemporary woman poets.

An optimal appreciation of Kozioł's poems would require a knowledge of the Polish language. The bilingual edition from Host Publications in Austin, Texas, provides that opportunity, yet in the absence of a knowledge of the original language the faithful English translation will have to do. Regina Grol-Prokopczyk's versions furnish the lover of modern poetry with new esthetic experiences, with moments of surprise and delight through the acquaintance with the author's poetic imagination. The slim volume offers specimens from the great variety of poetic forms she employs, including the beautiful paean to her native region of Giłgoraj, "Inwokacja" (Invocation), rich in the use of language native to that corner of Poland. Elsewhere we find lovely poems on natural phenomena such as rain and snow, on the seasonal changes, on the experience of love, on life as a journey, and on the need for humility in all life's situations. One such poem on humility is "Lekcja z polskiego (Do młodego człowieka)" (A lesson of Polish, addressed to a young man), and it is illuminating that Kozioł should choose the Polish language as an image for this introspective piece. What the choice indicates is the importance of her native tongue for her work. One could quibble about the translation here: perhaps the title should have been "A Lesson in Polish." The way the poet makes use of Polish words is central to her art, and the translator points to this feature in her informative introduction: "Kozioł taps on the full range of resources in Polish. The poet relies with relish on archaisms, colloquialisms and regionalisms."

The full range of Kozioł's poetic art as presented in *Poems* cannot be illustrated in a short review, but her introspective, reflective lyrics, some as brief as an aphoristic statement, are certainly among her finest. The difficulties of translation are often apparent, especially where grammar and poetry

are intimately linked and provide an idea, an idea which becomes blurred in the translation.

Joachim T. Baer. *World Literature Today.*
64, 1990, pp. 490–91

Urszula Kozioł was born in 1931 near Biłgoraj in eastern Poland. This is noteworthy, since one of the poems ("The Biłgoraj Region Years After") in her latest collection recounts memories of her birthplace. She has received many awards, including honors from the city of Wrocław and the Ministry of Culture. Her first collection of verse, *In the Rhythm of Roots* (1963), was followed by a succession of works which included not only poetry but also novels and dramas. Her *Selected Poems* appeared six years later (1969). Of her novel *Stations of Memory* Czesław Miłosz wrote in his *History of Polish Literature* that it acquired an epic breadth. In the monthly *Odra,* moreover, the author has a feature column, "From the Waiting Room." Thus we can call Kozioł not only a poet but also a novelist, a playwright, and an essayist.

Żalnik means literally "Laments." The volume consists of some fifty short poems. In "About Myself to the Next Generations" Kozioł tells us that she suffered hunger and saw the horrors of war. She learned to bring her lofty ambitions in tune with reality. In "Self-Criticism" she complains about her mind which cannot concentrate, her eye which fails to see, her ear which refuses to hear, her tongue, her hand, her heart, et cetera. Her main complaint, however, is that her word has lost its balance and refuses to stand in its proper place. In "To Myself on My Birthday" she ponders her own death. When she dies, the memory of her will also die. In the above mentioned poem on Biłgoraj the poet notes with sadness that the house in which she was born has been condemned and marked for demolition, that there is now no smith in the smithy, the mill stands idle, no one comes to the well for water, and the stork looks in vain for a thatched roof. "Farewell to My Friend" and a separate untitled poem describing the pain after the loss of a dear one both deal with bereavement.

Another theme that finds expression in Kozioł's most recent verse derives from the Polish romantic tradition. Historically, the poet has played a special role in Poland, a role that has been virtually a mission. When Poland was wiped off the map of Europe, the poet stood guard to save the soul of the nation. Miłosz wrote in "You Who Have Injured," "A poet remembers / Kill him—a new poet will be born." Listen to Kozioł in "More about the Same": "But when the others sleep / he [the poet] stands guard." The poet watches judges in their robes, records all acts of injustice, et cetera.

Kozioł's verse is in the tradition of the avant-garde. The first eight lines of "More about the Same" (to take only one instance) sound more like poetic prose than verse. Still, the poet's words possess power, and her lines are haunting. Despite her fears, there is every indication that she will be remembered.

Jerzy J. Maciuszko. *World Literature Today.*
64, 1990, p. 491

Contemporary Polish literature can boast of so many extraordinary poets whose work has found an international readership (e.g., Miłosz, Herbert, Szymborska, Różewicz, Zagajewski), that it is not at all surprising that some interesting poets whose works are admired in Poland have been virtually ignored by scholars and translators abroad. Urzula Kozioł is one such poet, and Regina Grol-Prokopczyk has set out to rectify this omission. To this reviewer at least, Grol-Prokopczyk's handsomely produced bilingual collection of Kozioł's poetry [*Poems*] (illustrated with six black-and-white photographs that harmonize with the poems) does not fully support her enthusiastic championing of Kozioł as "a poet of soaring introspection" whose work is marked by "compelling artistry and . . . autonomous reflection." Nonetheless, the volume makes an important contribution, if only because it is misleading to know and judge a literature solely by the achievements of its greatest representatives.

Grol-Prokopczyk has selected forty-four poems from two of Kozioł's published editions: the retrospective *Wybór wierszy* (1976) and the most recent collection, *Żalnik* (1989). They are arranged thematically rather than in the more usual chronological order. Given this editorial decision, the translator should have supplied dates for the individual poems. On the whole, the thematic arrangement works well, although for some of the poems it suggests a narrower range of meanings than is warranted. Grol-Prokopczyk has wisely minimized this problem by not grouping the poems into subsections or imposing her own thematic labels on them.

The translations strike a judicious balance between literal faithfulness to the original and an attempt to make "real" poetry in English. There are occasional lapses in which the English has too much of a Polish flavor. But there is only one poem that just does not work in English: "Inwokacja"/ "Invocation." Its insistent, hypnotic trochaic beat disappears in translation and all the poetry of this invocation vanishes with it.

Madeline G. Levine. *Slavic and East European Journal.* 35, 1991, pp. 165–66

KUNEWICZ, MARIA (POLAND) 1899–

Maria Kuncewicz, a talented new writer . . . is an extremely interesting phenomenon, and not only in terms of literature. Perhaps this is the first time in Polish literature that a woman's "naked soul" has spoken out and has done so with a shout—or, perhaps one should say, with the shriek of someone in birth pangs. At the same time this cry is more than merely a personal voice; it is, all things considered, the voice of a generation. It is very characteristic that the courage to speak out is displayed by a woman, and courage it is considering how thoroughly her generation is saturated with hypocrisy. *Przy-*

mierze z dzieckiem [Covenant with a child], a book about malicious, consuming love and about hatred, is a very repellent, indeed, a wonderfully shameless book!

I do not know of any other book written by a woman that is so devoid of coyness and so brutal as *Przymierze z dzieckiem*. The writer's thoroughly physiological approach is fully reflected in her style. It is an expressionistic style (I mean the Polish brand) . . . whose main characteristics are hyperbole, affectation . . . almost unbearable bad taste, and considerable naïveté. On the other hand, there are passages in the book rich in verbal texture and poetic quality; what a pity the author often spoils them by stylizing the grotesque.

<div align="right">Stefan Napierski. Wiadomości literackie.
April 14, 1927, p. 4</div>

Kuncewicz's new book is a work of mature talent. This is obvious from the careful and intricate construction of the novel.

Cudzoziemka (The stranger) is quite a dynamic novel, a feat not easy to achieve considering that the central plot is developed within a single day. In the space of several hours the writer fills in the perspective of four generations. . . . Not only has she pitted two different worlds against each other . . . not only has she depicted two different Warsaws . . . but she has spun all those images out of a single character. . . .

Róża, the "stranger" of the novel, is a woman over sixty who in the last hours of her life reexperiences all the previous phases of her unhappy fate until she is finally liberated from her burdens almost on the threshold of death. The tragedy of this remarkable woman—who keeps captivating us to the very end with her strangeness, her lyricism, her tense emotions of love and hatred, her morbid desire for revenge and her pursuit of chimeras—is underlined by the emphasis Kuncewicz places on her erotic and artistic frustrations. . . .

The last hours of her life are shown with a gospel-like brevity and simplicity. She undergoes a complete transformation, becomes filled with love, tolerance, friendship, and forgiveness. And when she dies, she dies reconciled to life, people, and the world. The psychoanalytical intermezzo [responsible for this change] . . . is the only flaw in an otherwise excellent characterization. Róża is too conscious of her behavior, thoughts, and motives to have allowed her love for Michal to sink into the subconscious and to weigh so heavily on her life. . . . This minor qualification notwithstanding, the novel must be considered one of the best and most interesting psychological novels ever written in Poland.

<div align="right">Emil Breiter. Wiadomości literackie.
January 26, 1936, p. 4</div>

Miss Kuncewiczowa is a prize-winning novelist and her book, *The Stranger,* does a great deal to reduce our cynicism about prize-winning writers, in other

countries at least, for she is indeed a novelist. One means a real novelist, capable of an imaginative recreation of experience which achieves complete autonomy. . . .

The Stranger, written sometime before 1939, was translated at once into several languages but it is now presented in English for the first time. Its subject is "the major frustrations of a minor character," and its theme is the psychology of exile. It studies the life and relationships of a woman named Rose, whose childhood, happy and secure, was spent in Russia, where her parents had been exiled after the insurrection of 1863. To save Rose from being Russianized, her patriotic Aunt Louisa brings her back to Poland. Ever after, she shuttles back and forth between the two, at home in neither.

Perhaps the main result of exile is a necessary turning inward, an intense preoccupation with one's self and with one's immediate family circle in the absence of allegiance to a larger circle. The structure of The Stranger expresses the process of this development. On the day of her death, Rose is in the house of her daughter, Martie, and while awaiting her, she summons her own husband, Adam, to her, and in the scene which follows their whole tortured past is revealed. Rose falls ill, and Adam calls her son and daughter-in-law, and through a series of flashbacks their intricate relationship becomes clear. When Martie appears, the web of Rose's life is completely rewoven. In the final scene, Rose attempts to make amends for her mistakes, and she dies with a measure of satisfaction as her family achieves a measure of freedom.

The flashback method in this novel has one serious shortcoming, which is that important motivations, sometimes summarized in a paragraph, are blurred. Rose's life is founded on hate, and this passion, in itself, Miss Kuncewiczowa penetrates with amazing insight. Its root in Rose's life is the betrayal of a first love, a plausible motive if it were knit into a larger psychological context, but this eager yielding and brutal ending is tucked alone into a paragraph, and it remains abstract and unlikely. The result is that all details and recurring themes pegged onto it have a falseness and triteness about them which are utterly out of keeping with the whole.

For The Stranger is a genuinely witty book, even a gay one, comic in essence. These are qualities which come from a deeply ironic imagination. Besides being beautiful and incalculable, Rose is witty, but Maria Kuncewiczowa is wittier than she, and while Rose reveals herself, the author's style and tone test her revelation. This is perhaps the surest sign of a real novelist.

Ruth Page. *The New York Times.*
August 5, 1945, p. 26

In *The Conspiracy of the Absent (Zmowa nieobecnych)* Maria Kuncewicz, Polish novelist in exile, writes a story of the beleaguered hearts of our times which, from every viewpoint, is exceptional. It has beauty as well as violence, and its nightmare reality is tempered with fine dreams.

Beginning about midway in the second world war, the novel shuttles back and forth between Nazi-occupied Poland and bombed-out London. Its theme is the split between past and present, between conquered and free, between friends, families and lovers. For most of the characters, whether at home or in exile, the only way to cross the gap in time and distance is by the bridge of memory, a bridge often too tenuous to use, but in rare moments as indestructible as steel. Only two of the people in the book actually travel from the one world to the other; an aviator who parachutes into Poland and an underground leader who flies to London. . . .

Both in London and in Poland, in the free world and the world enslaved, the scenes Madame Kuncewicz describes have a dreamlike, synthesized quality unlike any other war-time book. With the brush of a Toulouse-Lautrec, she paints the hectic refugee circles in London, where suspicion, defiance, doubt and soul-sickness consume the sorry folk who are powerless to change history and powerless to face it. Again, on the other side of the world in occupied Poland, with the same brush she paints the guerrilla patriots, united in battle against their oppressors, but ready, in the intervals between plot and shot, to leap at one another's throats over why they are fighting, whether for nationalism, the old order, the proletariat, the rights of man, or God.

Here then is a new and different viewpoint on the tragedy to which a world at war is consigned, told by a writer with an ear for poetry, a mind for irony, a stomach for terror and a spirit unwilling to relinquish essential truths.

Virgilia Peterson. *New York Herald Tribune.*
December 17, 1950, p. 6

The Forester (Leśnik) is . . . a convincing reconstruction of an alien world. The scene is Lithuania in the middle of the nineteenth century, a meeting place of conflicting patriotisms; and the hero, in spite of all temptations to belong to other nations, decides at first that he will be a Pole. His German speaking grandfather, employed as forester by the Russian proprietor of a Lithuanian domain, sums up the family: "The great-grandmother's a Lithuanian miller's wife; the grandmother's married to a German, the mother to a Pole. So how about the *kind*? What will he be, poor child?"

Casimir finds that though in Lithuania he is regarded as a Pole, one of the oppressor gentry who stand between the Orthodox peasantry and their Orthodox Tsar, in Warsaw he is a suspect foreigner; and when family influence gets him into a high school chiefly reserved for Russians his position becomes very difficult. The picture of Polish hostility to Russia in occupied Warsaw is drawn with fidelity, including the mutual suspicions of treason that are endemic among really stout patriots. In the end Casimir goes home to the forest, tired of the noble Polish part of his ancestry and when asked who he is he gives the stock peasant answer, that he "comes from these parts." A slightly depressing tale, whose moral seems to be that nothing is worth fighting for; but an excellent picture of life, not quickly forgotten.

(London) *Times Literary Supplement.*
January 29, 1954, p. 69

The question is: Can a contemporary novel, constructed on principles so unlike those of nineteenth-century epic fiction, serve the purposes of historicism? . . . It would seem that the narrative form of *Leśnik* is hardly suitable to a historical novel. The narrative gives the impression of having been entirely objectivized. But its objectivism is, in fact, very incomplete. It embraces only those parts of the novel that deal with external circumstances, that is, the broad framework of the narrative.

This is, then, the first principle of *Leśnik*'s structure. But there is another, much more important, principle involved. The story is told from the point of view of the characters as they come to the forefront of action. The narrator, preserving the appearance of objectivity, is in reality showing us the world of the novel through the prism of the protagonists' consciousness, behaving like the chairman of a meeting, so that the characters are given the floor according to the requirements of the novel's situation. . . . The use of stylistic devices typical of the modern psychological novel thus has far-reaching consequences. In a psychological novel the distance between the narrator and the faithfully and dynamically reproduced sequences of experience need not be preserved. It does, however, seem necessary in an historical novel, in which the narrator operates under an entirely different set of concepts, and his experiences are, so to say, different from those of his characters. Kuncewicz, in using psychological narrative techniques, deprives herself of those means of construction that could directly serve the purposes of historical interpretation. We thus see history as the protagonists see it, and the protagonists, incidentally, are seldom furnished with sophisticated minds. This makes the novel intellectually weak and gives a facile air to many of its problems and solutions. . . .

Nevertheless, *Leśnik,* a work of triumphant eclecticism, is an astonishing novel. It is not often that we encounter on the pages of a single book such disparate literary creations as the cheap Countess and the vividly drawn Aunt Regina, who reminds us that Kuncewicz created a remarkable heroine in the novel *Cudzoziemka.*

<div align="right">Michał Głowiński. Twórczość.
December, 1957, pp. 145–47</div>

In the autumn of 1953 a French peasant patriarch was tried for the murder of a titled English family that had camped overnight on his soil the previous year. Convicted, he was ultimately pardoned because the falsehoods told by the witnesses, in accordance with far older laws of that rocky, remote land, had kept the truth a family secret. On the stand old Gaston Dominici said, "One would have to have black blood to commit such a crime." He referred to the killing of Elizabeth Drummond, aged ten, who had died after hours of agony, lying by the roadside with her skull crushed by the butt of an American Army rifle.

Little Pat Monroe is spared that final horror in *The Olive Grove (Gaj oliwny),* a novel otherwise faithful to the facts of the case. This is understand-

able, since Maria Kuncewicz based the character of the girl on another English child she knew and loved, whose inner life seemed as vivid as the one recorded in Elizabeth Drummond's diary almost to the hour of her death. Shocked that such an imagination could be so brutally blotted out, Mme. Kuncewicz felt impelled to try by recreating the events to explain them.

She has built the plot of her novel around the rumors current during the trial that Sir Jack Drummond's camping trip had really been an investigation of certain crimes committed during the war under cover of the Resistance movement. Thus she has been able to link her English Monroes and her French Variolis in a history that gives believable reasons for the otherwise unmotivated murder. This network of past bitterness and betrayal, like Pat's family situation, sometimes seems too complex. It is only when these plot chores have been disposed of that the novel becomes as fascinating as its material.

A child's fantasies are hard for an adult writer to report without seeming fatuous. And the early chapters are not without this fault, but halfway through, as the story approaches its climax, Pat's intense relationship with the Varioli grandson is recounted with an unsentimental precision that rings tragically true.

Among the grownups there is the same psychological momentum. The scene in which old Varioli, half crazed and wholly drunk, wanders over his moonlit hillside and blunders into the trap set for him by fate comes close to explaining the inexplicable. It is almost possible to believe that by some dark chemistry a man's blood could, in one night, blacken in his veins.

<div align="right">Hope Hale. Saturday Review of Literature.
June 22, 1963, pp. 39–40</div>

Tristan 1946 [Tristan 1946] fulfills perfectly the requirements for a best-seller. Discreetly modern, it does not shock the traditionalists. Traditional in a good sense, it is not anachronistic. It is a love story in the full meaning of the term, that is, it speaks of the timeless problem of human emotions but at the same time it emphasizes what is most characteristic in twentieth-century mentality. In this novel love is above all a form of escape from the contemporary malaise of loneliness.

Moreover, the story itself is a fine transposition of an old Celtic myth, and this enhances the book's attractiveness in an age in which mythology is very much in fashion. Kuncewicz has not limited herself merely to alluding to the myth in the title of her novel. In shaping the story of the love of a young Pole and an Irish girl she has faithfully recreated the characters and situations of the medieval romance, even using the same landscape. Only the accessories are modernized: instead of the medieval love potion we have a symphony by Franck; instead of the use of the black sail to symbolize bad news we have the word "black" in a cable. The ending of the story is different, too, since we no longer live in an age in which people die of love. The entire

mythic structure of the book is interpreted and commented upon by the writer in the process of unfolding it. . . .

[The book] is definitely one of the important novels of the past year.

Anna Bukowska. *Miesięcznik literacki.*
January, 1968, pp. 119–20

LACROSIL, MICHÈLE (GUADELOUPE) 1915–

Thanks to Fanon's high visibility, [Mayotte] Capécia [whom he attacked] was remembered long after she should have been forgotten and served as pretext for Michèle Lacrosil's own texts. Suggested by an editor who wanted to capitalize on the successful Capécia's formula . . . *Sapotille* (1959) and *Cajou* (1960) succeeded, instead, in dismantling the paradigm: The bitter conclusion to the tragic mulatto convention was its own destruction.

It is a black husband who beats her up savagely and causes her to miscarry, not a faithless white man, that Sapotille flees, hoping, like Capécia's heroine, for the freedom of the French shore. This first novel ends, semi-optimistically, with her arrival. The second picks up where the first one ended and finishes it off. Cajou has lived in France a while and is now engaged to a man of integrity. Her tragedy has less to do with French racism than with Caribbean pathology. Fanon had shown that skin gradations lose ontological status in France where everyone is "just a nigger". Obsessed with such gradations, Cajou . . . cannot believe that the white man by whom she is with child wants to marry her. Rather than confront the possibility that she is wrong, she commits suicide. . . . For the tragic mulatto of the '50s, race is self. Take it away and there's nothing.

Demain, Jab-Herma was written against her editor's wishes and it suffered accordingly. A virtual recluse and shy by temperament, Lacrosil could never deliver the verbal pyrotechnics that imposed the younger Condé on fickle Parisians. Its originality was overlooked. Unlike Chauvet's *Volcan* which used data from the Haitian revolution as backdrop only, *Jab-Herma* was after far more ambitious results: To inscribe an altogether blank text.

Guadeloupe makes an interesting case because its self-birthing is missing from the official record. . . . Caliban's island stands at the center of the symbolic web. Its emplotment in a Caribbean text closes Hegel's epistemological circle for the first time in the western discourse. *Jab-Herma* locates itself in the '50s, in the midst of impending African independences, an increasingly problematic platform for *Négritude;* and, on this particular island, sugar riots met with a ferocity that Napoleon's mercenaries would have envied. At the nadir of insular history, collective imagination feeds on what glorious moments from the past can be retrieved. But can such memories be trusted? *Jab-Herma* poses frontally the question that Condé will only gingerly raise ten years later in her first novel: What happens to history when the Father is a fake.

The surface story is simple, its political dimension obvious. Young Philippe arrives on the island to take control of a failing sugar operation owned

by a European cartel but run by Constant, former owner of the surrounding plantation, a Prospero fallen from power. New Ferdinand on the blessed isle, Philippe will eventually level Constant's magnificently dilapidated mansion to replace it with a cost efficient factory; throwing out of doors and out of work the army of plantation hands whom Constant kept on the payroll because they had always been at the service of his family.

The subterranean plot is less predictable. First, Lacrosil stands on its sexist head the tragic mulatto paradigm, changing Capécia's configuration to a homoerotic one. The switch underlines the Hegelian structure of interdependence upon which the master-slave relationship is predicated. Not the wish to be LIKE the master, ever imperfect approximation, but the desire to BE the master. (Those who recognize famous Sartrean premises will be glad to know the novel was dedicated to Sartre and Beauvoir.) Mesmerized by Philippe's blue-eyed beauty, Cragget, a mulatto who despises his own color, commits a series of murders culminating in his own suicide.

Next, Lacrosil uses intercrossing pairs to bring out the dialectical content of the topos. As white Philippe (the outsider from without) is to the mulatto (outsider from within); so is black Jab-Herma (the voodoo priest) to white Constant (the planters' scion), the young master with whom he was raised. Constant's need for Jab-Herma has the same neurotic intensity as that of Cragget's for Philippe. It leads to the same suicidal temptation, under the sign of the Ancestor: Delgrès, the man "who knew how to choose his own death."

Setting off these two homoerotic pairs in binary opposition, the text poses the question of history as a search for legitimacy. . . . But, from the outset, the legend (and the folk tale which recounts it and therefore represents the collective interpretation thereof) made it quite clear; the treasure must be collectively searched and collectively found: "On se le partagerait." History can only be that which can be shared. That he should seek to steal the hidden powers of the black ancestor (Delgrès) in order to become the white man (Philippe) is the sign of his condition: Claiming the wrong ontology and, therefore, the wrong history. This use of history as the single most important narrative device raises the question of historical discourse: Writing as rewriting. It puts Lacrosil ahead of her times, in line with current feminist theories of decentering, fragmenting the image of the Father in order to question his legitimacy.

Clarisse Zimra. In Carole Boyce Davies and Elaine Savory Fido, eds. *Out of the Kumbla: Caribbean Women and Literature* (Trenton, New Jersey: Africa World Press, 1990), pp. 150–52

Francophone Caribbean women writers depict women in their societies as being haunted by this same sense of alienation. Whether she is in the Caribbean, in France, or in Africa, the situation of the black *Antillaise* woman is

portrayed as one of confinement and frustration. Her life is depicted as tragically limited and her efforts at resistance doomed to failure. This predicament is expressed metaphorically in terms of clearly delineated and closed spaces: a boat, a cabin, windows, mirrors, rooms, houses, prisons—structures which isolate and alienate the woman from herself and from others. She is an island, cut off, stranded with no life-lines. The journeys she undertakes become a "*voyage d'évasion,*" an attempt to escape, but also, like Césaire's voyage, a journey within, to self-awareness. Both images are dual (double and contradictory) in nature. Thus the Nausicaa, a transatlantic ship in Michèle Lacrosil's first novel, *Sapotille et le serin d'argile, (Sapotille and the Clay Canary)* (1960) is both a prison and a refuge. The heroine is confined to her cabin, both the ship and cabin being a metaphor for the woman's condition. The space in the novel is restricted, compartmentalized and stratified. The boat is traveling between the Antilles and France, cut off from both. The decks on board ship mirror the divisions in Caribbean society. The heroine, Sapotille, is on her way to France because she is seeking to flee from her suffocating island society with its prejudices of race and color and false, alienating values. But the reader soon becomes aware that the journey is futile. The boat is not a means of escape but a temporary shelter and a prison—the class structure Sapotille hopes to escape is reproduced, and class divisions are even more strictly enforced in the tiny microcosm of the ship. The heroine's naïve expectations of a classless society in her new, unknown, "*patrie*" [mother/fatherland] point to a voyage which is doomed from the start. She is locked in by her neuroses and prejudices, as she is confined within her cabin, in the world of the ship. As Sapotille recognises at the very outset: "Mon voyage est pourri" (My trip is ruined). Indeed, Sapotille is forced to share her cabin with a childhood companion, the light-skinned daughter of a *député,* a sort of alter-ego, symbolic of all she is trying to flee. Her prison is within.

<div style="text-align: right;">

Elizabeth Wilson. In Carole Boyce Davies
and Elaine Savory Fido, eds. *Out of the
Kumbla: Caribbean Women and Literature*
(Trenton, New Jersey: Africa World Press,
1990), p. 47

</div>

At the core of the quest for identity . . . is the mulatto woman's inability to identify with a particular group and place. Hence the preoccupation with the colored woman's place in Caribbean societies, explored particularly through the characters' perceptions of their exclusion from both black and white social groups. The disintegrating sense of self of the protagonist of Lacrosil's *Cajou,* for example, evidences the disastrous impact of the self's inability to root itself in a particular group. Living with her white mother in a neighborhood removed from the black world of her father, Cajou feels cut off from a vital part of herself. . . .

Cajou voices the historical plight of the Caribbean mulatto, adrift between a sea of black peasants and the longed-for shore of acceptance into the world of whites. In Capécia's *La Négresse blanche,* Isaure articulates a similar dilemma, underscoring the very social isolation which will prompt her to leave for France at the conclusion of the novel: "Serait-elle toujours seule, ni noire ni blanche, haïe pour les uns, méprisée pour les autres?" (Would she be always alone, neither black nor white, hated by one group, despised by the other?)

The particular poignancy of the mulatto woman's position as depicted in these texts, however, derives as much from the characters' internalization of feelings of racial inadequacy characteristic of colonial societies, as from their being in flux between the peasant/working-class world of their parental background and the bourgeois, *beké* (white creole) world to which they aspire to belong. . . .

Cajou's first sexual encounter with Germain, her white colleague and lover, reveals the extremes that male coveting of the mulatto female body can lead to in these texts. The description she offers is closer to that of a rape. . . .

Sapotille gives further evidence of women's objectification through the protagonist's descriptions of her husband's threats of physical violence and of the actual beatings she receives at his hand. A peculiarly telling scene finds her husband calling upon misogynist African traditions—in the person of his servant Mambo—to aid him in controlling his wife: "Prends garde, je te dis. Pour Mambo, une femme ne compte pas. Si je le lui ordonnais, il t'abattrait sans hésiter" (Watch out, I'm telling you. Women are not of any consequence to Mambo. If I ordered him to, he would [kill] you without hesitation). Sapotille's unwillingness to submit, her inability, as she puts it, to respect Benoît's efforts to "rétablir ces valeurs sûres: le courage, le prestige du mâle" (re-establish those tried-and-true values: the courage, the prestige of the male), leads to repeated beatings at whose core is her resistance to be molded into the perfect model of bourgeois domesticity. . . . Sapotille's departure for France at the end of the novel—where she plans to stay "jusqu' à que je suis guérie" (until I have healed)—symbolizes a repossession of her battered body, an effort to be "for herself" for the first time. Although her departure has been interpreted by critics most frequently as an escape which fails to solve her racial dilemma and precludes, perhaps permanently, her integration into Guadeloupan society, it can be seen, from the perspective of her repossession of her body as a triumph over Benoît's frequently stated claim to ownership of her body. Her revolutionary behavior is acknowledged by her friend and fellow traveler's manifestation of surprise at her divorce, since, after all, "*personne* ne divorce pour quelques coups" (*no one* gets divorced over a few blows.) . . .

Sapotille's reaction to her miscarriage—the result of a beating from her husband provoked by his sexual jealousy—links Benoît's violence against women to the oppression of black males, underscoring the connections be-

tween her society's inability to promote racial equality and the resulting prob-
lems in gender relationships.

Lizabeth Paravisini-Gébert. *Callaloo*. 15,
1992, pp. 66–69, 72

In Michèle Lacrosil's novel, *Sapotille et le Serin d'argile* [*Sapotille and the
Clay Canary*] (1960), the heroine at one point has a miscarriage which, to the
great scandal of those around her, she receives happily. Here is how she
records the memory of her sentiments a short while later in her written
journal:

> Comment leur faire approuver ma joie? Non, cet enfant ne vi-
> vrait pas. Non, je ne voulais pas de petite fille qui lirait dans
> son livre d'histoire: "Nos aïeux les Gaulois portaient 'la braie
> et la saie'" et qui ouvrirait ensuite les yeux sur un monde par-
> tagé, races, castes ennemies!

> (How could they ever understand my joy? No, that child could
> not live. I did not want a little girl who would read in her history
> book: 'Our ancestors the Gauls wore pants and skirts' and who
> would then open her eyes to a world divided by race and
> caste enemies!)

The fact that this denunciation of the hegemonic and universalizing discourse
of French schooling is tied to such a personal event as the loss of a child
gives these lines an uncommon force and a tragic dimension. The private
and the public, the personal and the political are interwoven at the deepest
levels of Sapotille's feminine body and subjectivity. . . .

There is no reassuring grandmotherly presence here [at school] nor any
sense of purpose or resolve which can nurture Sapotille's development in a
hostile environment. The grandmother's convictions about the benefits of
education are belied and betrayed by the actual conditions Sapotille faces at
Saint-Denis. It is in school that we find the beginnings of the exclusionary
logics which she will later encounter. The continued deferment of the tango
which Dr. Pottriès promises to dance with her appropriately symbolizes her
vanishing hope of integration among the circle of light-skinned, well-off mulat-
toes to which she would like to belong. Only on the ship, significantly called
Nausicaa, will the roles be reversed and the young woman finally move to
the *center* of a group of Guadeloupean passengers who used to shun her. At
every level, Sapotille's Caribbean society is fractured along sexual, color,
economic and prestige lines.

Madeleine Cottenet-Huge and Kevin
Meehan. *Callaloo*. 15, 1992, pp. 75, 82

LAFORET, CARMEN (SPAIN) 1921–

Constantly going from surprise to surprise, from amazement to amazement, [Laforet] looks into the abyss along with her protagonist Andrea [in *Nothingness*] until she meets, at every turn, nothingness. Never before has Spanish literature known such absolute desperation, such radical nihilism; one could say that the civil war has consumed the last hope and along with it any sense of human existence. And what makes this vision of the world more desolating is that it does not appear to be twisted or forced toward any purpose: the novel is not wrapped in a thesis, nor does it respond to an aesthetic, political, or philosophical doctrine; nor, likewise, does it reflect an influence of any particular model; in it a clean, fresh, and bold vision passes through a confused, febrile, broken, viscous milieu—it limits itself to bearing witness.

Before this lucid emptiness, before this testimony of nothingness, one must stop to tremble; for it is pure desperation in excellent souls like our protagonist's still to have the courage to bear witness. And one must also stop to tremble because the *nothingness* that the author condensed in the title of her novel coincides with the nothingness that, in many ways, the most characteristic literary outpourings of other countries continue to proclaim. Ingenuously, Carmen Laforet includes in the title the spiritual attitude of existentialism, . . . which has become a narrative device in France used by writers who wish to be completely in vogue.

What Jean-Paul Sartre, for example, achieves on a philosophic level and with a very refined artistic consciousness, can already be seen, in the same profound meaning, contained in this early work, written in a direct form and without any slips of the pen, by a girl, twenty-two years old, who was expressing her immediate experiences in life when the world war was still undecided and France was still occupied by invading forces.

Which is evidence of terrible meaning.

Francisco Ayala. *Realidad.*
January–February, 1947, pp. 131–32

I want to point out to you [Carmen Laforet] that what I consider most fulfilling about your novel *Nothingness* is that extraordinary chapter 4, with its perfectly natural and revealing dialogue between the grandmother and Gloria; chapter 15, is indeed, a sublime story, as are many of the other chapters. It seems to me that your book is not a novel in the most usual sense of the word—I say this because of the plot—nor is it in that other, more special sense that is characteristic of an "art" novel, but it is rather a series of quite lovely stories—some of them like those of Gorky, Eça de Queiroz, Unamuno, or Hemingway; and I believe this so much that for me *Nothingness* slips a bit in chapter 19, that is, when a continuous novelistic plot becomes noticeable. I have not read that chapter in its entirety; it was repulsive to me; and I tarried some time in finishing the rest of the book because that chapter

caused me to feel a kind of knot like that of a colic attack that had the power to take away the vitality from the rest of the work. Because you really are a novelist who writes subjectless novels, as one is a poet who writes poems without subjects. And here lies the most difficult part of writing a novel or a poem. . . .

Let us see if we can interest some American publisher in your book, so that it can be translated and published here [in the United States]. For this I will need two or three copies of *Nothingness*. It seems to me that it would really be appreciated, because *Nothingness*, like everything that is authentic, also has a place here; it is of today and will belong to tomorrow; it has a place in any part of the world, as it belongs to yesterday and to everyone. That is what this kind of accessible and committed writing that you do has. I was very happy to see at the front of your novel an excerpt of a ballad of mine, also a reaction against something ugly, the nothingness of life.

Well, Carmen Laforet, let us see how you are going to capture that troubled Madrid in another one of your novels without a subject. I am very sorry not to be able to speak with you, but it is clear to me that I am a friend of yours, and I will be a reader of yours if you send me whatever you happen to write.

Juan Ramón Jiménez. *Ínsula.*
January 15, 1948, p.1

Perhaps [Laforet's] work [*Nothingness*] should be considered merely an exercise in graphic recording, a kind of *tour de force* aimed at producing the impression of a nightmare in personal relations. Her dynamic style insures the attainment of such a goal and in large degree accounts for the novel's readability. But the treatment of character and situation, together with certain purposive remarks, confirms our belief that Carmen Laforet at least toyed with the idea of a diabolical, mechanistic universe symbolized by the small locale whose center is the house on Aribau Street. Here the cruelty of cosmic law declares itself in distorted lives, misguided energy, and uncontrollable impulses. The author knows that one immediate cause of her characters' desperation is their imprisonment in themselves. . . . But instead of treating psychologically the subject of enslavement to self and its effects in human association, the author chooses to poetize the inharmonious aspects of the latter. At the same time she links the discordance with a vague, suprahuman force. . . .

Now, Carmen Laforet joins imaginatively in the generalizations of her central character, combining a philosophical overtone with structural form and a physiological view of personality. She thus leaves a concrete demonstration of mechanistic forces fatefully operating within a specific set of relationships. She does so, however, purely as a literary diversion, allured no doubt by a materialistic vision of human experience as being appropriate subject matter in the present age. For a brief moment of concentrated literary effort, she plunges into the vision in company with Andrea and with her

retires to a comfortable position after an exciting venture. The result of her venture is a vivid image of human beings tossed to and fro as though impelled by a law of mechanics. The tersely wrought structural form, which we have described as an oscillatory movement of animated objects (people), stamps the narrative with uniqueness. The novel may in time be remembered only as a curious experimentation in method and technique. But in so far as the cultivation of a decisive literary manner is concerned, Carmen Laforet has set an example which other contemporary Spanish novelists would do well to follow.

Sherman Eoff. *Hispania.*
May, 1952, pp. 210–11

The Island and the Demons has a slow and painstaking plot full of small relevations and surprises that very soon form an entire universe of sharp and tremulous sensations. The personality of Marta and the force of her temperament are revealed by means of warm and fine descriptions of all the sensations that are present in the world of the slightly wild adolescent, who senses in herself a paternal inheritance of an uncontrollable desire for doing nothing and for living a bohemian life. Her world continues to be enriched as she goes on pruning her life of illusions; she remains alone and naked with the unencumbered truth of her existence, taking risks in life and without commitment to any kind of code or convention. José and Quino form the prison of punishment, in which Marta's surly character gains strength, and her domestic quarrels have an intense energy for fighting to keep up the physical plant of the estate. Pablo is a lively and imposing portrait, and the contrast between the sublime and ridiculous qualities of this character is marvelously realized.

The novel is written with simplicity and exactness, and with delightful elegance. No effort whatsoever is noticed in the achievement of this prose filled with clarity and precision. In *The Island and the Demons* Carmen Laforet acquires even more grace in her style than in *Nothingness,* and the forcefulness of the narrative is more skillfully accomplished. The descriptions that the author gives us of Grand Canary Island and trips through the mountains and the nearby islands are impressionistic scenes of an intimate and poetic realism; they are powerful canvases that breathe like slices of life.

Carmen Laforet has achieved another success, her second one [the first being *Nothingness*]. She appears fully capable of telling a story and of creativity; if it is certain that everything she narrates is a product of her inner, intimate life, it is not any less to her credit that she knows how to take delight in these mental states and in all these transpositions of the most difficult complexities with a power of penetration and with an uncommon ease.

J. Castillo Puche. *Cuadernos
Hispanoamericanos.* June, 1952, pp. 385–86

After reading [*The New Woman*] one asks in what country on this earth can Carmen Laforet possibly live? The argument of her novel can have validity in many places, by conceding, which already is a lot to concede, that a woman can believe for fourteen years that she is married without being so. But that it is in Spain, which is precisely where the action takes place, makes it completely inadequate. And do not think that this woman is an ordinary one without any credentials. Paulina—that is her name—besides being facilely intelligent and pedantic, has a college degree in the sciences and knows how to take care of herself. It is that the literary models that Carmen Laforet follows count for too much in this novel, and, therefore, originality slips away through some unexpected trap door. . . .

The episodes of the narrative are always confused and digressive, without any purposeful relation to the principal subject. The Spanish that she uses is deficient, lacking nuances and flexibility. And the novel lacks "tempo" as the various biographical phases in confused repetitions are superimposed without clear discrimination and appropriate sequences. But the principal defect of the work is secondary to these small details of style and originates precisely from the exposition of the psychological conflict. The conversion of Paulina is transmitted from character to reader in such a lifeless way, so full of worn-out commonplaces and so conventional, that in the culminating moment, by breaking the mood that was set—that is to say, that was intended to be set—with the thunderous arrival of salvation, the "I" of the novelist breaks into the narrative so infelicitously . . . that the little poetic charm that she had realized comes crashing down to earth, diminishing the emotion before the writer's prosaic and analytic presence.

J. Villa Pastur. *Archivum*. May–December,
1955, pp. 455–56

The appearance of *The Island and the Demons* . . . proved that the writer had simply been developing. [Laforet's] new book contains the life of Marta, another adolescent, in Las Palmas of the Canary Islands. Marta is, one might say, Andrea [in *Nothingness*] before going to Barcelona. However, there are scarcely any autobiographical elements in this book, or else they are so transformed as to be unrecognizable. Nevertheless, we cannot deny that the young girl goes on being, fundamentally, the same spirit full of pure inclinations that clash with brutal reality. It is noteworthy to what point the author has been true to herself. Also in *The Island and the Demons* we find a familiar group of persons who border on the psychopathic, but the story is in the third person, which indicates a change in narrative technique and a greater difficulty for the author. There is more landscape in these pages than in *Nothingness* and a more complicated plot. The style has become more conscious although keeping indelibly its personal mark. The sentiments and the characters have been analyzed more deeply. Marta could be Andrea at fifteen or sixteen, but the two books are not continuous. That is to say, *Nothingness* is not a continuation of *The Island and the Demons*. The demons of this

novel "are everywhere in the world. They get into the hearts of men. They are the seven cardinal sins."

The Island and the Demons follows the author's previous line: literature of the smiling disillusioned. In spite of that reference to sins, there is no religious finality in the presentation of the emotional problems and their consequences. If the meanness and moral filth that Marta witnesses disgust her, it is only because of her good taste and ethics, just as the superficialities of stupid people bore her. She sets a high standard for herself. For that reason, those "conversations about life, people and love affairs provoke her to a rare little laugh. They were insufferable."

The best of this novel is the most objective aspect of it, the story of a servant of the house and her daughters. Carmen Laforet begins there to describe from the adult point of view the lives of others, and achieves an extraordinary and expressive vigor.

<div align="right">Rafael Vásquez Zamora. Books Abroad.
Autumn, 1956, p. 395</div>

Nothingness is more than a novel of contemporary Spain; it is a work that captures the anxieties, hopes, and frustrations of our time. It takes place in Barcelona two years after the end of the Civil War. There are no ruins, no bombed buildings, but the grim struggle of a postwar society is there. Even the parties, dances, and student gatherings it describes have a hollow gaiety. Everywhere memories of a bitter experience cluster to form the backdrop for the scene.

The house on Aribau Street, where the heroine Andrea arrives one rainy night, is the center of the world created by the novelist. Strange and fascinating characters inhabit it. It is a house full of dark corners, doors that slam violently, windows that are forever shut. The air is filled with human sounds, monotonous quarrels, piercing screams, a child's weeping.

The characters create infernos for one another. They are pursued by a spiritual isolation that makes each of them a haunted, tortured soul. In this world of frustration and fear, objects and things take on a new dimension. We follow the author, like a camera pausing to observe a mangy cat, catching the frozen image of a distorted face, moving in for a "close-up" of a claw-like hand.

The heroine, young and sensitive, struggles to free herself of this nightmare. She roams the streets of the city, searches for new ties and a sense of security. But always she must return to the house on Aribau Street and its inhabitants, for they fascinate her as they inevitably do the reader. This is because in the nebulous outlines of these people she finds a mystery that seems to say much of the human condition. She is moved by their yearnings and frustrations and often hypnotized by their evil. In this the work is strongly reminiscent of the Russian novelists of the nineteenth century, particularly of Dostoevski, for whom the author has often expressed admiration.

The novel moves swiftly. It has the suspense of a mystery story, the ever-changing perspective of a movie. It is written, one critic puts it, as if the author wanted to free herself of some burden. Carmen Laforet herself admits to a certain abandon in her style, to an inability to rewrite and polish. She even finds it difficult, she explains, to make corrections of detail, so concerned is she with the drama of her characters, the interior action of her plot. . . .

Carmen Laforet here gives expression to the anguished confusion of youth confronted by chaos and seeking a meaning to existence. The heroine well personifies this state of mind, its groping, its fears, and its confusion as she endeavors to comprehend the new world in which she finds herself—a world which had promised so much and seems to offer so little. . . .

Seen superficially *Nothingness* is in some ways a naïve work. Yet its breathless pace, cries, and silences, although they say little, convey much. *Nothingness* has many artistic merits, but it is truly impressive because it strikes us as real, real with passionate honesty, simplicity, and directness of youth.

<div style="text-align:right">

Edward R. Mulvihill and Roberto G.
Sánchez. Introduction to Carmen Laforet.
Nada (New York: Oxford University Press,
1958), p. xii–xv

</div>

[In *Sunstroke*] the characters are human and not very far removed from ordinary social situations. They are beings who pulsate with life. As in a faithfully reproduced miniature, the entire reality of a person with the total system of his motivations and his idea of the world, which is made transparent in each meaningful act, becomes conspicuous. Carlos and Anita help with this. These beings who share their lives in an important moment constitute the plot of the work, which achieves full structural coherence by means of these personal relationships.

Outside of the three children [Martín being the third], the rest of the characters are simple people whose actions lack complexity. They lead relatively well-ordered lives, free of abstractions and intellectualisms, lives that are repetitive, unchanging, and predictable. . . .

Circus people constitute part of the theme of this work. Unexpectedly, it seems that there is more fantasy now in Laforet's novelizing, since she is not conveying an actual, strong, or easily imaginable existence. But then it has to be taken into account that the reality of circuses is also real, that the men and women of the tightrope act within their own lives, that behind the life that they reflect on the trapeze there is their real one that can give nourishment, like all life, to a created reality. As José Marra-López has said, "*Sunstroke* is a marvelous novel with its characters of flesh and blood. All possess a deep human reality that is alive and meaningful."

<div style="text-align:right">

Graciela Illanes Adaro. *La novelística de
Carmen Laforet* (Madrid: Gredos, 1971),
pp. 188–89

</div>

[*Nothingness*] contains in its very essence the lesson which Román appears best to understand. Yet Andrea, as protagonist, is allowed to take her leave of the house in Barcelona and of her readers in a way which seems to undercut this overbearing sense of time and of art's failure to save life from decay. The ending appears happy. Rather than traveling alone, rather than missing the train as she did in her trip of the year before, when the novel closes Andrea is in a moment of hopeful escape. . . .

When we consider the various hints built into the novel, it becomes clear that the author's careful structuring of the work and even its richly sensuous descriptions form part of a studied art created not out of simple recollection, but out of an effort to disengage life from time through art. The disabused author Andrea, controlling the action from the beginning, has moved away from the world view of the Andrea of the story, who only partially develops. The character Andrea is capable of illusion at the end, despite her experiences and despite her knowledge of Ena's character, just as she was at the beginning. . . .

The novel engages in bad faith on two levels. The character Andrea, who refuses the lessons Ena and Pons have taught her, and the examples of Juan and Gloria and of Román—of all of her family—continues to be as Román has said, "a child . . . good, bad, what I like, whatever I want to do. . . ." She remains incapable of perceiving the underlying qualities of corruption and decay that render all such categories of existence invalid. The second level of bad faith is offered by Andrea as author. As author, she is conscious now of the overpowering truths contained in the house on Aribau Street, aware that these truths reduce to nothingness everything that is not the house on Aribau Street. She nonetheless allows the novel to end happily. The happy ending and the illusioned Andrea join to produce an effect inconsistent with the basic themes of the novel. This level of bad faith suggests that writing, like living, is always threatened with inauthenticity. Survival depends upon the maintenance of a delicate balance between hope and disillusionment. The artist tries to beguile the forces of time and death, knowing nonetheless that the effort is hopeless. Andrea, the protagonist, like Andrea, the author, participates in a more or less conscious effort at self-deception in order to hold off the desperation whose victim Román became.

<div style="text-align: right">Ruth El Saffar. Symposium. Summer, 1974,
pp. 126–28</div>

It must be recognized that when seen in its entirety, the work of Carmen Laforet represents no important advance in the area of structural and linguistic experimentation; it is alarmingly removed from the novelists of this century, and in particular from those of the last decade. Nevertheless, her work brings a subtle and deep exploration of the conflict—so adolescent, so feminine, but also so symptomatic of postwar Spain—between the necessity of enthusiasm and the substantiation of disenchantment. The souls that Carmen Laforet sketches or those in which her own portrait is seen indirectly are

souls hungry for authenticity, who verify their search for values in a world of reverberating violence, routine, and daily need. In this sense, Carmen Laforet's work must be put in the line of the existential realism that prevailed in Spain during the 1940s. *Nothingness* is not merely a lucky novel that owes its widespread sales to outside circumstances. If it aroused such great and lasting notice, it was, doubtlessly, because it correctly discovered aspects of the present reality that had remained outside the first novels written after the war: the hopeful attitude of the young generation, the material and psychic ravages of war suffered by the average family, the imbalance between hope and daily existence, hunger, poverty, moral disorder. . . .

The fundamental theme in Carmen Laforet is disenchantment: a world that seems susceptible to being transfigured magically by a fresh vision, but which reveals itself as deficient, inferior, unworthy. This theme is developed in *Nothingness, The Island and the Demons,* and *Sunstroke* by going from more to less, or going from apparent being to latent nothingness. In *The New Woman* the process follows an altogether inverse procedure: from disenchantment about everything to a supernatural enchantment of faith, which makes Paulina Goya see all the spaces of the world in the summit of a distant instant, far from "that ardent, vulgar, petty intrigue that was life."

> Gonzalo Sobejano. *Novela española de
> nuestro tiempo* (Madrid: Prensa Española,
> 1975), pp. 159–60

The principal theme of *The Island and the Devils* [*Demons*], imagination and fantasy, the heart of artistic creation, is a natural adjunct of the island setting. The island, with its unreal ambience, brilliant seascapes, volcanic irregularities, profuse and colorful vegetation, and openness of spirit manifest in the native folklore, legends, and songs, fosters the imagination. Too, the island suggests the distance necessary to creation. The backdrop of terrible events occurring on the mainland and the physical remoteness of the Canaries (Matilde is constantly repeating the refrain, "One would hardly know a war was going on") reminds us that spatial as well as temporal distances are important to art. *Nothingness* relied upon the temporal dimension; in *The Island and the Devils* geography is more important. There is a tacit suggestion that the peninsula is reality while the island is fantasy, unreality.

The Island and the Devils contains yet another symbolic dimension in the enclosure motif. Unfulfilled aspirations are related to incarceration as Pino, and later Marta, are closed up in the country house by José, and Teresa is literally imprisoned there. . . . The island becomes a place from which to escape for Marta; she claims she will never return. Thus a dialectic of closed/open, house/sea, island/peninsula imagery is constructed to underscore hindrances to and means by which growth may take place. Fantasy, when it serves to deny reality, is a kind of personal enclosure. In the end Marta will have to leave the island, symbol of her entrapment in a life of unreality.

> Roberta Johnson. *Carmen Laforet*
> (Boston: Twayne, 1981), pp. 73–74

La insolación (1963), Carmen Laforet's last published novel, has been un-justly ignored by criticism of post-Civil War Spanish fiction. It is a complex work that explores the problems of growing up in the early years of the Franco regime (1940–42), and it contains a harsh criticism of the moral hypoc-risy inherent in the conservative pro-Franco elements of Spanish society in that period. Laforet masks her criticism by focusing her story on the lives of three adolescents (two boys and a girl) engaged in seemingly frivolous summertime play, but she manages to subtly raise the moral issues of interest to her: men's and women's roles, homosexuality, and political deviance in a traditional, militaristic, Catholic society. Laforet diffuses any possible censor-ship of her acerbic look at Franco's Spain in two ways: 1) Her depiction of the children's moral formation, the central issue in the novel, is detailed and accurate in a universal sense as can be demonstrated by reference to recent research by social scientists. 2) She embeds her criticism in an artistic frame-work that carries the narrative beyond the realm of social commentary. To highlight the complex moral choices the children must make in their restric-tive society, Laforet borrows the technique of light and shade from the painter's craft. The protagonist Martín, whose mother is dead, lives most of the year with grandparents in Alicante while attending art school. But the novel centers on three summers (1940, 41, 42) that he spends at the seaside resort town Beniteca where his father, a military officer, is stationed. Martín's school months in Alicante are summarized in several pages between parts one and two, and two and three. The grandparents are liberal, having sided with the republicans during the recent Civil War, while the military father, who fought in Franco's army, represents traditional, Catholic Spain. Thus by focusing on the summers in the father's house, Laforet shows us the developing adolescent male consciousness confronting the barriers, limitations and moral hypocrisy of the most traditional elements of post-War Spanish society.

Roberta Johnson. *Letras Femeninas.* 12,
1986, pp. 94–95

Novels written in the 1950s are understandably more muted in tone [than those written since the end of Fascism in Spain.] Nevertheless, Laforet's *La isla y los demonios* is a surprisingly outspoken statement on women's rights. Marta, Teresa's adolescent daughter, is the epitome of the actively noncon-formist heroine. Like Natália, she is prepared to abandon her mother; she intends to run away rather than allow her halfbrother José to imprison her along with Teresa and his wife Pino.

Although Teresa's inner exile is not equated with the political situation in Spain as is Judit's in *La hora violeta, La isla y los demonios,* set as it is against the background of the Civil War years, does deal directly with exile on political as well as personal levels. Physically separating and enclosing its residents, the island is at once a place of refuge for Marta's relatives who have fled from the wartorn peninsula and a symbol of their physical exile. Tía Matilde, eager to return to the mainland at the end of the war, declares

that she has been "encerrada en una isla." In spite of being a native of Las Palmas, Marta, too, shares the feeling of enclosure and wishes to escape.

Laforet does not limit herself to one symbol of exile but rather presents layers of enclosure and separation, including Teresa's country home where José insists that the family live and the room where Teresa has remained for ten years. Teresa's madness and confinement is the extreme of inner exile: immobile and silent, locked up within a room in an isolated house on an island. Teresa's entrapment—an extension of her inexplicable marriage to José's father, a somewhat brutish man twice her age who apparently married the beautiful, charming, sensitive young woman strictly for her money—is mirrored in the lives of the other women in the novel. Pino feels herself exiled in the country and resents having to care for Teresa. Matilde, deprived of freedom in her own marriage, empathizes with Pino. When José wishes to protect the family honor by locking Marta in her room and isolating her from the outside world, she, too, learns to understand imposed exile.

As Sara E. Schyfter has noted, confinement to her room is the traditional punishment for a girl, as opposed to the corporal punishment meted out to boys. Similarly, while geographical exile or banishment has an historical basis as a form of punishment for men, inner exile, as defined by enclosure within one's own house, repeats a traditional form of punishment for women. Voluntary isolation and immobility therefore may function as self-castigation, but a self-castigation that ironically extends the woman's loss of freedom in traditional marriage.

José is the antagonist in Marta's fight for liberation. Ostensibly he is the defender of the family honor; he punishes Marta because she has been seen out swimming and boating with a young man. His role as devoted stepson justifies her intention of exiling Marta, as well as Pino, to care for Teresa. His strongest motivation, however, is Teresa's wealth. To control the family fortune, he must control Teresa and Marta, her heir. Under the facade of the traditional moral and family values that keep women in their place in patriarchal society is the crassest form of materialism.

Phyllis Zatlin. *Letras Femeninas.*
14, 1988, pp. 6–7

LAGERLÖF, SELMA (SWEDEN) 1858–1940

If the world is ever to know peace, life must come to be invested with the same sacredness we now accord to death. If men are to cease from strife, they must come to abhor the taking of life even more than they do the thought of desecrating the dead. This fundamental necessity, which is all too little realized, is the gospel of *The Outcast,* and Selma Lagerlöf would seem peculiarly adapted to drive it home. Her power, her sincerity, her dramatic realism

are splendid tools for the service of weaning the world from the lure of war and dispelling the illusions of its glory, and she uses them with a depth and sincerity of purpose that all her other work would lead us to expect. But for all this, she has failed to achieve a great book in *The Outcast*, a failure poignantly regrettable from the urgent necessity and greatness of its message. . . .

In the person of the Outcast, Selma Lagerlöf has drawn a character which, banned for a supposed sin against the dead, becomes, not bitter and perverse, but infinitely gentle and humble under the affliction. As his mother says of him: "To my mind, the boy's like one of the stones that lie down on the shore, and always being rolled about by the waves. He's got worn and smooth from all the hard knocks he's got, till there's not a sharp edge nor a corner anywhere." The hardness and brutality of the individuals who go to make up a self-respecting small community, the heavy punishment their sense of righteousness continuously inflicts on one whom they shun and abhor as beneath contempt, are very much the same the world over. Sven Elversson's mother sums them up well. "Full to the brim with faith and righteousness, till there's no room for a drop of mercy in them." Ultimately, the grim tragedy of the war pressing in closely on their lives stirs their hearts, brings to fruition the seeds of good sown by the Outcast, and leads them to a truer perspective.

Into the making of this story go the forces of love jealousy, mysticism, and a surpassing charity. . . . Many shrewd notes of insight into character and motivation are touched in with a delicacy that yet accords with the rough-hewn character of the whole. And the book is further beautified by those occasional descriptive passages in which Selma Lagerlof always makes us look through her eyes at land and sea, and feel the Swedish atmosphere about us. It is not a war story; its appeal might be more compelling if it was. As it is, the final chapters on the tragedy the sea reveals are too extraneous to the story to be as effective as they might be, coming as they do when the emotional climax has been reached. . . . Yet aside from criticism of their relation to the novel, these final chapters are memorable in themselves.

<div align="right">

B. U. Burke. *The Nation.* December 21,
1921, pp. 724–25

</div>

American readers of foreign literature may consider it a fortunate circumstance when, as in the instance of Selma Lagerlöf's *Mårbacka,* the translator has succeeded in rendering the soul of the narrative with such faithful regard for the original Swedish text. Indeed, Velma Swanston Howard is no newcomer with respect to Lagerlöf books in their English translation. Beginning with *Jerusalem* and including *Mårbacka,* Miss Howard has no less than nine of this Swedish writer's novels to her credit as translator.

To call *Mårbacka* an autobiography of the soul of Selma Lagerlöf, as the jacket of the book will have it, takes no account of what her emotional experiences were after she grew up. For, in fact, this book is reminiscent only of her childhood's days, and written, as it is, in the third person, has

the fairy-story touch throughout. In many other of her books Miss Lagerlöf registers impressions even more autobiographical than what she has to tell about the family life at Mårbacka, the ancestral home. For all that, what pictures she here paints of her idolized father, Lieutenant Eric Gustaf Lagerlöf; of her mother, whose economic domesticity stood at strange contrast to the carefree head of the house; of sister Anna and brother John; of the austere Mamselle Lovisa, the aunt; and then Back-Kaisa, the nursemaid! They are unforgettable glimpses behind the scenes of a well-to-do Swedish homestead where love dwelt secure and childish fancies roamed within their own circumscribed world. . . .

American readers who make their first acquaintance with Selma Lagerlöf in *Mårbacka,* the simplicity of which is its outstanding characteristic, have a surprise in store when turning to such red-blooded books as the *Story of Gösta Berling,* for instance. Where gentleness encompasses everything having to do with Mårbacka and its environs, in a number of her other works the passions and worldliness hold sway. And yet, idyllic as it is, the reminiscent aspect of this, Miss Lagerlöf's latest book, fits in perfectly with all that has gone before. It is little to be wondered at, therefore, that this writer holds the great love and esteem of her countrymen. It is not unlikely further that *Mårbacka* may be the means of gaining for Selma Lagerlöf an even larger audience than before, and a word of commendation must go to the American publishers for their enterprise in making one more of her fascinating books available in English.

<div style="text-align: right">

Julius Moritzen. *Saturday Review of Literature.* October 11, 1924, pp. 179–80

</div>

[In *Liliecrona's Home*] Selma Lagerlöf takes one bodily to the mountain districts of the north, to pine-girt lakes swept by storm winds, to lonely parishes which struggle for their existence against the snows. And then, with an exquisite and deceptive simplicity, she spins a fairy tale of a forlorn maiden, a cruel stepmother, accounted a witch, and the dark, elusive Liliecrona who wanders in from the night. Her story is haunted with a northern sadness. It is nourished on the brooding superstitions of peasants and infused with wild poetry. Undoubtedly there are those who can see nothing in Selma Lagerlöf, who cavil at her naive phrasing and her atmosphere of extravagant romance. Of such critics one can only say that they have lost their contact with the world's youth. One cannot compare the Swedish novelist with the psychologists and realists who hold the field at the moment. Hers is a different voice, powerful and primitive. That voice has a magic tone which creeps through the barrier of language in this new translation as in previous ones.

<div style="text-align: right">

E.D.W. *The New Republic.* April 20, 1927, p. 257

</div>

Selma Lagerlöf's art is an art rooted in a tradition. Back of the simple audacity in character portrayal lies the author's assurance that these types are

familiar to her readers, that a certain homogeneity of feeling concerning the old aristocratic families and their legendary backgrounds persists. For the American novelist every background presented is sectional, and any culture is a veneer upon the changing surface of cultures in this country. Nothing, therefore, may be taken for granted here, no values, no history. But in Sweden there is a literary history and a well-established folk tradition. The romantic and heroic sagas are not lost to the knowledge of the race; they are merely translated into more modern versions. Therefore it is with the greatest economy that Selma Lagerlöf is able to present her story and its character types, all of whom are individualized, each of whom moves within the definition of a certain social rank and attitude.

The Ring of the Löwenskölds is a trilogy: *The General's Ring, Charlotte Löwensköld,* and *Anna Svard.* The first part would seem to be a ghost story only, did it not serve to introduce the curse fallen upon the Löwensköld family. The avaricious ghost is laid, but the curse persists. The two following books indicate how this curse worked upon the characters of the story and, in particular, upon Karl Arthur, the religious fanatic, and his female counterpart, Thea.

The reader is, however, likely to forget the curse entirely, for it is unnecessary to the motivation of such fully analyzed characters as the author now presents. These are men and women controlled not by the supernatural, but by human passion. Here is a study of religious fanaticism which is unforgettable. Karl Arthur, upon whom the curse rests, is a perfectly understandable egocentric and melancholic young boy who must find some outlet for his vanity. This outlet comes when he accepts a "faith" and comes to believe himself "like Christ." He is engaged at this time to Charlotte, his cousin, whose essential sanity might save him, since it is in every way the antithesis of his own passion. But he resents this sanity and flees from her to take, as wife, the first woman who may cross his path. He marries the peasant girl, Anna Svard, because over her his pride and egotism may triumph. Poverty and self-torture have become the necessary outward signs now of his religious power. But Anna is better able to endure poverty than he is, and again he finds himself the less important person in a situation. This he cannot endure, so he joins himself to the fanatical Thea, and they go out together to preach on the streets. Karl Arthur's madness grows. He is selfish and cruel to everyone, and all in the name of Christ. Finally he who began by preaching love ends by denouncing all mankind in a kind of frenzy. Gradually this man's fanaticism destroys all whom he might have loved, and the curse is carried out.

As in *The Story of Gösta Berling,* Selma Lagerlöf is interested here in the psychology of religious fanaticism, and not in the influence of any so-called curse upon a family. The folk superstition is used and to advantage, but the novel is a powerful study of the disintegration of a character whose powers overleap themselves.

Eda Lou Walton. *The Nation.*
February 11, 1931, pp. 157–58

Superficially regarded, the work of Selma Lagerlöf is very similar to that of the great Danish story-teller Hans Christian Andersen (1805–73). . . .

Such superficial comparisons are, however, a trap for the unwary. From the *Fairy Tales* alone we can show with a few strokes of the pen how different their methods are. Andersen took only a small number of stories from oral tradition; among them "The Fireworks," "Big Klaus and Little Klaus," "The Princess on the Pea," "The Wild Swans," "The Traveling Companion," "The Swine-herd"—the stories one thinks of first when one mentions his name. They can be distinguished from his own creations by their clearly defined, well-knit action, whereas it was this mastery of action which Selma Lagerlöf adopted into her own creations. Nor does Andersen make his stories into allegories expressive of his faith as the Swedish author does. He brings in here or there a little of his own thought, and occasionally makes it the subject of a story, but his spiritual thinking does not run like a network of connected purpose through all his work.

Andersen's thought lacks the firmness and clarity of Dr. Lagerlöf's, and he has none of the deep pathos which in her holds humor in check. He is softer hearted, merrier, more childlike. But above all his imagination is not so controlled, not so subdued to his purpose; it is playful and inconsequential, like the thoughts of a child or the figures of a dream. His attitude to folk-lore is therefore wholly different from that of Selma Lagerlöf; the world of magic is valuable to him simply for the free play it gives his restless imagination. These traits are very marked in "The Traveling Companion." Imaginative descriptions and passages of irresistible humor alternate with scenes of piled-up horror. In the whole range of Selma Lagerlöf's work there is nothing parallel to this, for such sheer play of fancy is wholly foreign to her. . . .

Selma Lagerlöf's creative work has striking resemblances to that of Goethe, whose poetic gifts were, in even higher degree than hers, devoted to the service of universal humanity. . . . In comparison with Goethe, Selma Lagerlöf was a more exact and detailed observer of movement, thanks in part to the calm certainty of her religious faith. Goethe is a great listener rather than a great observer, as one can tell from his style. He finds the most wonderful means of expression for his emotions in the rhythm and melody of his verse, and reveals himself most intimately in lyrics. His greatest contribution to the language of feeling is the abundant wealth of new rhythms and melodies through which his inspiration found utterance. In earlier days poetry was chanted, later it was declaimed. As a follower of Klopstock Goethe turned the musical values of declamation into a vehicle of thought, and so opened new paths for the lyric poetry of our age. This wedding of thought to musical language is foreign to Selma Lagerlöf's nature. Her imaginative conceptions are more plastic, one might say more solid than Goethe's, her work contains more tersely depicted, intense action than his, but her style is less sensuous, less varied and less rich in sound.

Selma Lagerlöf is akin to Goethe in the even balance of her powers. In his works far greater forces have play, but like her he is ever striving towards

inner harmony, and however great the agitation of his mind, calm returns at last. His yearning for a repose and a security which will lift him beyond the power of restless emotion culminates in piety, a solemn elevation of thought towards everlasting rest in God, the Lord.

> Walter A. Berendsohn. *Selma Lagerlöf: Her Life and Work* (Port Washington, New York: Kennikat, 1968), pp. 128–31

Lagerlöf maintained the traditional focus of the saga, centering either on a specific place or on a specific clan. Thus, for example, *Gösta Berling Saga* examines life in one province and is duly considered "the epic of Varmland." Her two-volume classic, *Jerusalem* (1901–02)—which is also translated as *The Holy City*—is considered the epic of the Swedish peasant because it focuses on the Ingermarssen clan. It is *Jerusalem* which won Lagerlöf accolades as "the incomparably greatest novelist who has written in Swedish." Even after decades of scrupulous criticism, *Jerusalem* is still considered "a monumental study of the clash between an ancient conservative peasant traditionalism and modern religious sectarianism," all achieved with what Alrik Gustafson calls "that sovereign narrative skill" so characteristic of Lagerlöf's opus.

The balanced portrayal of tradition and modernity earned Lagerlöf a reputation as "a modern of Moderns." . . . Lagerlöf's works focus on problems facing her contemporaries; as she exclaimed: "Everything that concerned education, peace, temperance, the woman question, and the care of the poor riveted my attention." These issues provided the moral dilemmas of her day, and the saga, it must be remembered, is a didactic form of literature.

In Lagerlöf's works, the lively, common, solid men and women of daily life face the ethical dilemmas. They receive knowledge, willingly or unwillingly. They act; they accept responsibility for knowledge of good and evil. As always in modern literature, the temptation *not* to decide, *not* to assume responsibility lures her protagonists. As with some Existential heroes of more recent times, procrastination sometimes poses as deliberation; negation of individual effectiveness sometimes excuses inaction.

This moral tension in Lagerlöf's writings proclaims her modernity; yet as a composer of highly didactic sagas, Lagerlöf confronts ethical issues unflinchingly.

> Bonnie St. Andrews. *Forbidden Fruit: On the Relationship between Women and Knowledge in Doris Lessing, Selma Lagerlöf, Kate Chopin, Margaret Atwood* (Troy, New York: Whitston, 1986), pp. 61–62

At the time of publication in book form in the year 1904, Selma Lagerlöf's short story "Herr Arnes penningar" was praised for its tightly knit structure. The author was pleased about the reception, although . . . she had intended

an ending different from the one in the Swedish edition. In a letter to her publisher . . . Selma Lagerlof discussed the difficulty of replacing the first ending with the revised one, since Albert Edelfelt had already completed illustrations for the text. Selma Lagerlof was particularly fond of his depiction of the last scene, and it was for this illustration that Edelfelt was to receive special acclaim. The German translation of the text, however, did not include Edelfelt's drawings and was therefore free to use the revised ending. And so it came about that in 1904 two versions of "Herr Arnes penningar" were published.

The two endings are actually similar. Only one detail distinguishes them from each other, but this detail changes the narrative focus and consequently the reading of the text. The Swedish version concludes with a group of women of Marstrand walking out to the ice-bound ship to retrieve the body of Elsalil. In the German version, the ghosts of Herr Arne and his household members come to fetch Elsalil. Both versions emphasize the power of nature to keep the ship ice-bound until order has been restored, that is to say, until the murderers have been caught and Elsalil has been brought back to land. The captain expresses no surprise at seeing either group approach his ship. The reader's identification of the ghosts in the German ending is made through the skipper's eyes, but without registration of anything extraordinary. As the group returns to land, the skipper notes a young girl bending over Elsalil's body in greeting. . . .

Considering the nature and function of the supernatural in "Herr Arnes penningar," why did Selma Lagerlöf rewrite the ending? For this point of investigation Tzvetan Todorov's model of the fantastic as a genre is helpful. Its emphasis on the fleeting borderline between the real and the imaginary alerts us to a gradual shift in the narrative focus of Lagerlöf's text. The two endings will be seen to reflect different levels of concern communicated by the implicit narrator. . . .

In the Swedish ending, Elsalil is the center of attention. She is the heroic individual, who has sacrificed her life so that justice be restored. The women praise her moral uprightness and lament her loss of the man she loved. This ending is aesthetically pleasing; one is comforted to know that Elsalil's struggle has not gone without recognition. It can be seen as an epitaph, in which a congregation of sisterhood makes certain that her name and deed will be preserved among the living. . . .

The German ending, in contrast, draws the consequences of the dynamic movement in the narrative. The causality of the other world is no longer hidden; the supernatural is accepted. The German ending intensifies the extra dimension: the implicit narrator's concern with death as a form of life. Elsalil's death loses its individually heroic status and becomes instead an act of service to a continuation of life in a new form. Most important, the German ending relies on the narrator-reader communication, which has all along pursued the question of the supernatural as an intervening force in the fictional world. Selma Lagerlöf's own hesitation in prompting this ending is then evi-

dent. When the ghosts come out on the ice to fetch Elsalil, the very framework of the fictional world is threatened. The world of the supernatural, which has emerged mainly in the extra-fictional narrator-reader communication is allowed to take over.

"Herr Arnes penningar" may not be a fantastic text according to Todorov's definition, since its hesitation is not directed at the existence of the supernatural, but through the model the text can be seen to grow out of a different kind of hesitation—one concerning an experiment with the supernatural in fictional and metafictional worlds.

<div style="text-align: right">Monica Setterwall. Scandinavian Studies.
55, 1983, pp. 123–24, 131–32</div>

The role of the narrator and the narrative perspective varies in Lagerlöf's works. In some, the narrator plays a major role, introducing and commenting on the story. The first-person narrator in *Gösta Berling's Saga,* for example, creates a special mood, with his passionate outcries and lyrically accented commentary. In other works, the narrator tells the story in a more intimate style, playing the role of cultural intermediary, as, for example, in The *Ring of the Löwenskölds.* Occasionally, there is no explicit narrator. Certain stories are told simply and directly; others are based primarily on insight into the thoughts of the characters. . . .

In certain stories, Lagerlöf adds an observer, a sort of *raisonneur,* who comments on the action. Torarin, the fishmonger in *The Treasure,* is such a figure, as is Lilljänta in *Liliecrona's Home,* the little girl who tries to interpret the tragic events at Lövdala. These characters play a similar role to that of the reader, but since their interpretation of what happens is naive and incomplete, the reader himself is also challenged to work intensively with problems in the text. Although the role of the reader in Lagerlöf's fiction is definitely very important, no attention has, as yet, been paid to it.

Characteristic of Lagerlöf's narrative method is her manner of allowing for various perspectives and ways of interpreting a story and then leaving it up to her readers to take a position regarding the questions presented. Her characters represent not only different standpoints. Frequently they also come from different social classes and speak different kinds of language. . . .

Another feature of Lagerlöf's art that is beginning to attract attention is the often strong discrepancy between what is on the surface and what lies beneath it in her works. On the surface, the stories can appear artless and simple, but upon closer scrutiny they reveal a complicated structure. The question is whether the similarities with the popular narrative extend deeper than the superficial level of the action. The correspondence between the qualities of popular naive literature and the literature of high culture gives Lagerlöf's work its distinctive stamp. Her method is to turn a simple folk motif into a narrative with many different psychological dimensions. One can also assert, however, that psychological developments are shaped into concrete stories patterned after the dramatic structure of folk literature.

To the complex and artistic qualities of Lagerlöf's works belongs also her symbolic language. In an allegorical way, she uses nature myths and other popular tales as images of the powers of existence. As it has been pointed out, in *Gösta Berling's Saga* there is a wealth of personification of various feelings and attitudes, from "the spirit with the icy eyes" to the Dovre witch. The symbolic figure who etches herself most strongly in the reader's memory is, however, Lady Sorrow in *The Tale of a Manor,* the woman with wings made of leather patches, a dream figure, created in a moment of strong inspiration.

On the whole, the ability to mythify existence pervades Lagerlöf's narrative practice. While her characters have distinct social roots, they are, nevertheless, ultimately representatives of various attitudes toward life. Since people have, as a rule, applied the demands of naturalism to Lagerlöf's art, they often have been blind to her method of using a complex interplay of roles, related to each other, to cultivate and analyze humanity in all its forms—from the most wild and uncivilized to the ethereally pure and saintlike. . . .

With her unique mythical imagination and narrative talent, Lagerlöf cannot easily be placed into any literary-historical category. She is both a realist and a romantic. Perhaps she should be regarded primarily as a symbolist, for her work is—far more than people usually recognize—permeated with symbols. Often entire stories are illustrations of myths. Life is even "transformed into myth." Nature and landscape, which in themselves are presented concretely, become the bearers of human problems and function as a parallel to them. Nature becomes identical with man, and man becomes identical with nature. This creates an interesting complexity in Lagerlöf's literary works, which, on the whole, also contain a good deal of direct conflict.

Lagerlöf's role as a storyteller has widely overshadowed her importance as a writer with humor, psychological insight, and sharp-sightedness in delineating her characters. She has created a gallery of living characters—well-rounded, believable figures. Here, too, an acute sense of human confusion and vulnerability informs her vision. Lagerlöf, who often felt herself to be cold, empty, and introverted, had the ability to hold her public spellbound with her art.

Lagerlöf's narratives, her literary language, and her mythic landscapes came to be of tremendous importance for the then impoverished Swedish prose tradition. She herself was aware of her contribution to Swedish letters. Generations of writers after her have honored her and called her their mother. Some, however, have tried to revolt against her influence, but, for the most part, they have failed. Her foremost heir in the field of prose writing is Hjalmar Bergman, who gained acclaim during the first decade of the twentieth century and, supposedly, in turn, stimulated her writing. Traces of Lagerlöf can still be seen in the wave of narratives, chronicles, and depiction of provincial life that mark Swedish literature around 1980.

<div style="text-align: right">

Vivi Edstrom. *Selma Lagerlöf* (Boston: Twayne, 1984), pp. 124–26, 134

</div>

LAGORIO, GINA (ITALY) 1930–

From the point of view of narrative structure, what is immediately striking in the novels of Gina Lagorio is the polyphonic dislocation of the voices and hence the absence of hierarchy in relations among the characters. In this sense, there is no protagonist, even when the novel is centered on a principal figure who is the pivot of the action. It is rather interesting that Geno Pampaloni, outside of any narratological intention, says à propos of *Approssimato per difetto* (By default) (1971), that it is difficult "to name the real protagonist" of the novel, and that we confront "an unusually large series of possibilities." . . . Pampaloni, veering from structure to content, which is, moreover, his real critical interest, ends by identifying love as the actual protagonist of the work. . . . But what for Pampaloni bears the aspect of a conclusion, a solution, becomes a point of departure for us: will it not perhaps prove that this absolute love, about whose centrality in this and in all the other novels there cannot be the slightest doubt, has something to do with the polycentric structure of this narrative? . . .

But absence of hierarchical dependency relations among the characters also means a lack of dependency between the characters and their author; yes, this is the great Pirandellian discovery, which Bakhtin, who, however, did not know Pirandello and drew on Dostoyevsky, the brilliant precursor of all contemporary narrative, theorized in his overrated and overused propositions on the "polyphonic" and on the "Carnavalesque." Gina Lagorio, who fortunately suffers from a fertile sense of guilt but at times ends up feeling guilty, as well, for her very nature as a writer of feelings and characters . . . has felt acutely the problem of the relations between herself and the protagonists of the narrative events that she establishes. Who is she for her characters? And her characters for her? . . . In Lagorio's latest novel, *Tosca dei gatti* (Tosca of the cats) (1983), the dilemma is deliberately thematized. From the third-person narrative of the woman who has just been presented as the protagonist, in a whole omniscient-novel framework, all of a sudden the "I" of the author of those pages, pops out; this is the writer-journalist Gigi, who tells Tosca's story as far as he knows it, but is tormented by the dilemma of which it is said: "I wonder if it is still legitimate to write a novel or if the presumption is no longer sustainable. Basically, the question of the first or the third person is only a euphemism: the first person is humble, it speaks itself, it does not arrogate to itself, does not patronize; the third person exhibits the arrogance of a profession." . . .

Basically, Lagorio is saying that the writer is not quite sure if his or her character belongs to external reality or is a projection of his or her own being, and not for the obvious enough reason that, being an artist, he or she tends to render the temporal world according to his or her own view rather than adapt that view to the world, but for the deeper reason that the writer is not in a position to distinguish the first from the third person, Tosca being within

him as a potentiality and modality of the I or he within Tosca as the authorized possessor of another's sensibility.

Elio Gioanola. *Letteratura Italiana Contemporanea*. 5, 1985, pp. 215–18

Most would agree that the difference between autobiography and fiction is problematic and any attempt to define this difference is often unsatisfactory. Nonetheless, everyone seems to agree on the fact that the most passionate writing always has its origin in our experience. How this is transformed into words, however, depends on the writer. In Gina Lagorio's case, one could say that the autobiographical observations that slip into her fiction originate in the profound intensity with which the writer perceives the problem of the relationships between herself and her characters. As Elio Gioanola asks: "Whom does she represent for her characters? And her characters for her? Do they represent her and how do they do so?" We all agree on the fact that Lagorio has sensed this kind of dilemma since her earliest work as a novelist. . . .

[The] very intense relationship between writer and characters and between literature and life is also in perfect harmony with a setting already familiar to both the writer and the characters. As often happens in Pavese, the existential conflict is buffered by the mythical sense that the landscape instills in its viewers. In much the same way, the pages of Lagorio's text attain at moments tones and rhythms of a formal and exquisite beauty, internalizing the external element of the setting as music and thus accompanying the undulations of the spirit and calming its restlessness. As for the literary formation of Gina Lagorio—as has been pointed out many times before—there are also two main areas of geographical influence: Piedmont and Liguria, "the universes of her native surroundings," as Ferdinando Albertazzi says. . . .

[B]eside the models and influences available in Barile, Sbarbaro, Pavese, and Fenoglio, Gina Lagorio's vocation as a writer unfolds autonomously; she expresses herself in her own personal way, in all her peculiarly feminine sensibilities. Certain characters remain innately feminine, even when their delicate profile gives way to a very well-defined and forceful character.

Pietro Frassica. *Italica*. 15, 1988, pp. 329, 331–33

Since the publication of *Il polline* (Pollen) in 1966, Gina Lagorio has focused on the theme of women's moral superiority as a central factor in social history. Inspired by what she has seen of the political world, she writes that women possess a "courage for truth," which their male counterparts have lost in the struggle for power. She points out that such an affirmation would have evoked irony and pity a few years ago, when female characters in literature were customarily treated as objects of weakness and ambiguity. In rebellion against this bias, Lagorio has chosen to adopt the theme of feminine

indomitability as the central tenet of her oeuvre. As she has written, focusing on the courage of women is a new way to reconsider certain private stories, if not history. . . .

In an article entitled "Donna e fatica" (Women and labor), Lagorio honors the peasant women of the Langhe. She writes of how these tenacious women would work the land beside the men and then also do the domestic work that a house and family necessitated. In describing Fenoglio's effective depiction of his female characters which was also inspired by the women of the Langhe, Lagorio underlines the ethical parameters that remain a constant of women protagonists in her own writings: "Poor wives who gather the scraps, deformed by labor and maternity, distrustful of what is new, but firm in their heart and arms when defending their roof and land." She offers examples from Fenoglio's short novel *La malora* (Misery), which capture the essence of the "geographical courage" Lagorio often emphasizes when writing about Piedmont. . . .

When asked if she was a feminist, Lagorio replied that she did not care for slogans. She recalled the pity and strength of the women that both she and Fenoglio had described, and she believes that women will be at the center of the future—not against men but beside them, responsibly sharing rights and duties. The writer recalls that women were the pillars of the peasant society from which she came. "My grandmother . . . could have commanded an army and I thought back to the women of the Langhe who had been able to close the door in the face of the Germans when there was the need to save a hidden partisan."

Lagorio's less than enthusiastic reaction to feminist slogans is similar to that of another of her favorite writers, Anna Banti. Like Banti, however, Lagorio incorporates the feminine condition as a dominant theme of her work. Banti's collection of short stories written in the 1940s and entitled *Il coraggio delle donne* (The courage of woman) is particularly significant to Lagorio, who writes that the title of the collection carries the central theme of both Banti's and her own writing: "I thought that her [Banti's] theme was precisely the courage of women, and this theme is, I believe, also my own." . . .

The courage of women has proved to be the backbone of Lagorio's poetics. The author has succeeded in transforming the private stories of Angela, Elena, and Tosca, women caught in a harsh environment, into truthful and exemplary editions of social history. The women of the Langhe in Piedmont, a fierce attachment to the land of her origins and the poetic values of Liguria, her aesthetic indebtedness to Fenoglio, Banti, Pavese, Montale, and Sbarbaro provide a life-affirming background for Lagorio's continued fascination with women's unique courage.

Mark F. Pietralunga. In Santo L. Aricò, ed.
*Contemporary Women Writers in Italy: A
Modern Renaissance* (Amherst: University
of Massachusetts Press, 1990), pp. 77–79, 87

LANGGÄSSER, ELISABETH (GERMANY) 1899–1950

In her *Tierkreisgedichte* (1935; Poems of the zodiac) she has attempted in a curious way to bring the ancient world back to life. . . . Elisabeth Langgässer, pious Catholic, sees the living legacy of ancient Greece in the late Hellenistic mystery religions, in which the Greek spirit penetrates the Christian church. The old nature gods of the mythical religions have been tamed by the church. The Christian church has taken over the lawful inheritance of the ancient world. . . . This way of experiencing the ancient world, with its starting point in the Christian religion, finds its expression in Elisabeth Langgässer's poems, in which the signs of the zodiac are represented as motive forces in nature. For example her poem about Jupiter represents him not only as the supreme god of ancient mythology but also as the "ruler" in the sign of the zodiac Sagittarius. . . . The poems, therefore, bring together the Greek world of gods and spirits, beliefs prominent in Christianity, and the idea of an all-pervading nature religion.

> Werner Milch. *German Life and Letters.*
> 1937–38, pp. 137–38

E. Langgässer cannot be separated from the period she lived in. She displays all its characteristics but tries, like almost no other poet of her sex, to transcend the period, to anchor it in the past—in memory, as well as in the future—in prophetic vision. She took as her life's goal the task of defining those features of our transitional epoch that would be decisive in giving the world the form of a totality—in space and time and even beyond them.

The poet carries. . . demons within her, both white and black, and thanks to her these demons become articulate: strange, outrageously new voices that contradict themselves, interrupt each other, and reverse themselves, since the logic of demons does not correspond to the logic of "common sense." Ideas and feelings never united before are squeezed into the same sentence and, as if it were completely natural, welded into a new statement. The language of imagery becomes the indispensable spokesman of content. For the first time parts of the inorganic and organic enter into relationship and reveal their kinship. She invents a mystical language with borrowings from Greek mythology with its many names, from the Orient and Thule, and from Byzantine and Roman Christianity. There is not a single person who fully understands all these voices. It is doubtful whether the poet herself could have brought this host of voices to clarity: she does not speak, the voices speak through her. She listens, groups them, creates poetic and prose works, crystallizes what has been unconsciously assimilated in consciously formed novels.

> Johannes M. Fischer. *Wirkendes Wort.*
> 1950–51, p. 110

Das unauslöschliche Siegel (The Indelible Seal). . . . Taking into account Elisabeth Langgässer's romantic and neoromantic predecessors and considering that contemporary German narration has already branched out into the realm of the myth and of utopia in such masterpieces as Herman Hesse's *Glasperlenspiel* or Franz Werfel's *Stern der Ungeborenen,* one will not be able to ignore the radicalism and the consistency with which Elisabeth Langgässer has given her mystical experience a suprarealistic framework and a metapsychological foundation hitherto unknown in the history of the German novel. . . .

Indeed, the quest of mercy and call from the realm of the supranatural find an adequate form in a composition which, deliberately, defies any rational analysis. It is left to the individual reader whether he wants to open himself to a religious experience in the extreme shape Elisabeth Langgässer has given to it. Frank Kafka once said about his own writings: "All these parables really set out to say that the incomprehensible is incomprehensible. . . ." As such a parable of the incomprehensible *The Indelible Seal* occupies a place of distinction among the German novels of our time.

Heinz Politzer. *Germanic Review.*
1952, pp. 208–9

There are points in common between Graham Greene and Elisabeth Langgässer—their common faith, their portrayal of the innocence and corruptibility of childhood, their preoccupation with sex and sin, with violence and crime; but the two novelists are poles apart in their narrative method, and Elisabeth Langgässer's complex prose style and unusual vocabulary are much more ornate than Graham Greene's manner. In her sultry and sometimes incoherent vision of humanity caught up in the toils of irrational evil but vouchsafed awareness of the reality of God, Elisabeth Langgässer has perhaps been more influenced by Bernanos than by any other Roman Catholic writer.

H. M. Waidson. *German Life and Letters.*
1953–54, p. 115

The reader of Elisabeth Langgässer's books is faced with no easy task. None of her books makes straightforward reading and many are baffling at first. The difficulty lies not so much with the language, although Elisabeth Langgässer commands a very large vocabulary and is not afraid of falling back on her native dialect if this suits her requirements. But even her long sentence constructions seem lucid as compared with the elaborate style of Thomas Mann, for example. The real difficulty lies in the wealth of meaning that is packed into each sentence. It is rare that the full impact of a phrase is understood at once, for its meaning always goes far beyond the incident to which it refers, and points almost invariably to a metaphysical plane. . . .

Elisabeth Langgässer was fully aware of these difficulties, and in her essay *Muß Dichtung schwer sein?* [Must Poetry Be Difficult?] she argues that the sense of the modern reader has become so blunt by the stereotyped

language of newspapers and pamphlets that he is no longer able to grasp the full sense beyond the duplicity of the word.

W. Neuschaffer. *Modern Languages.*
December, 1954, p. 19

Das unauslöschliche Siegel. . . . Whether this poet was "theologically" right or wrong in criticizing the Christian charism of baptismal grace is beside the point. What is crucial is that she did so in harmony with our new consciousness of time and existence, and new linguistic and stylistic means necessitated by the fundamentally new consciousness. The rich, intricate counterpoint of the composition, together with the renunciation of chronologically charted action, psychological keys to character, and a causal explanation of events, were preconditions for outlining on an epic scale archetypal images of time and Christian man in the shadow of God's struggle with Satan. Thus despite or because of its absolute Christian outlook, this important twentieth-century novel is essentially closer to the non-Christian works of Kafka, Musil, or Broch than to novels and stories that are Christian in spirit but faithful in traditional form.

Bernhard Rang. In Hermann Friedmann and
Otto Mann, eds. *Deutsche Literatur im
zwanzigsten Jahrhundert* (Heidelberg:
Wolfgang Rothe, 1954), p. 205

The prose of *Das unauslöschliche Siegel* . . . no longer has the immediacy of ingenious, spasmodic, and syncopated formulations. The wild growth of language has been cropped, and with an enormous will for expression the word material has been grouped, aligned, and set in motion, grammar employed, the articulated emphasized. It is a literary prose of the highest order: incandescent and ethereal, earthly and winged, sensuous and spirit-borne. The cadences are carefully calculated, the punctuation functions like a remote control relay system. Melodic and rhythmic values are expanded significantly both at the top and bottom of the language scale.

Of course, a prose as delicate and greatly compressed as this is not always immune to aestheticizing temptations. Elizabeth Langgässer occasionally records impressions that dissolve into beautiful nothingness when their mystical veils are swept aside. . . .

Her language is free of high-spirited modernity and burlesque effects; it is an uninterrupted flow of metaphors in which past and present mingle intimately. The outer becomes inner, meaning and being magically change places. The writer always has a firm grip on her epic material. Her command of language enables her to find the precise word with the confidence of a sleepwalker. The most contradictory ideas and feelings ring true in her prose because in body and soul she is a creative person.

Heinz Piontek. *Welt und Wort.* 1954, p. 300

E. Langgässer's style develops individual motifs and symbols interestingly out of a relatively thin layer of reality. . . .

In her vision the building stones are thrown into disarray and enriched, lined up together and developed separately, carried forward in associative sequences whose individual links are interchangeable. Many critics have rejected this technique that seizes symbols, names, and then quickly drops them without having fully presented the real qualities of each. However, we believe the technique of free association with volatilized ideas is justified by the spiritual disorder of the protagonists. It provides the author with a very effective compositional means, capable of creating poetic junctures between the plane of reality in the foreground and the surreal, poetic world.

Aside from the interchangeability of themes and symbols as an instrument of style, E. Langgässer was convinced that "everything that happens has a real coherence on the symbolic plane."

<div style="text-align: right">

Eva Augsberger. *Elisabeth Langgässer*
(Nürnberg: Hans Carl, 1962), pp. 37–38

</div>

The lyrical structure of her work, so evident in a novel such as *Märkische Argonautenfahrt (The Quest)*, can be easily demonstrated. She composed, basically, poems, whenever she wrote. The cyclical composition, a matter of poetic conviction to her, greatly enhances each individual story. . . . Much of what she tells has its background in catastrophe, World War I, the aftermath of the war and the occupation, the inflation, World War II. She never sees such a catastrophe as an isolated incident but as a part of a vast pattern. . . . Behind it all there is the hand that bids the waters rise and fall. . . . Against the theological background there is loving attention to detail, a realism so human and intense as to point beyond the mere facts it lists. . . . They are the exact description of certain geographically identifiable places . . . they are also, when they become absorbed in the reader's imagination, symbolical and mythical.

<div style="text-align: right">

Richard Exner. *Books Abroad*. 1965, p. 187

</div>

The metaphysical restlessness of the transitional moment emerges most intensely from Elisabeth Langgässer's *Märkische Argonautenfahrt*, 1950 (Argonauts of the Mark Brandenburg) / *The Quest*, 1960. In a novel full of shifting time sequences and interpolated meditations, seven persons, all deeply scarred by traumatic experiences, set out on a hot August day in 1945 from Berlin, still rank with rotting corpses and black flies, to rediscover the lost meaning of their lives at Anastasiendorf, a Benedictine monastery in a remote corner of the Mark. Almost instinctively, they join in the quest for personal salvation—a baptized Jewish couple, too eager to begin again as if little had happened; a young architect burdened with guilt; his sister, who is obsessed by sexual memories of her missing husband; a returning soldier; a bored actor; and a girl who has been imprisoned for her part in the resistance. But Elisabeth Langgässer (who has learned a good deal from Virginia Woolf)

does not offer explicit solutions: the ineffable is merely touched upon in a concluding story about hungry children and black marketeers hiding out in the Berlin sewers, and the fate of the seven seekers is left in suggestive abeyance. I think it was symptomatic that the difficult works of Elisabeth Langgässer, who was persecuted by the National Socialists, attracted wider attention only for a brief moment. Her fellow Catholics she offended by using sultry images of vegetative sex, and her leftist readers anxious for earthbound relevance, by revealing the white heat of her mystical passions. Today she is read only by the happy few.

<div align="right">

Peter Demetz. *Postwar German Literature:*
A Critical Introduction (New York: Pegasus,
1970), pp. 51–52

</div>

LARSEN, MARIANNE (DENMARK) 1951–

En skønne dag (One fine day) is a collection of rather puzzling yet intriguing prose poems covering a wide variety of sensations and sentiments, reveries and remembrances: "welfare—and other conditions," as Marianne Larsen succinctly puts it in her introductory remarks. The poet begins her collection with a personal and rather ambivalent address. We catch a glimpse of an individual and her relationship to another before the perspective changes, the individual poems or sections of the work properly begin, and the poet assumes the role of narrator. The initial prose poems imply contact, sharing, mutual connection, which are foreign to the lonely protagonist of the remainder of the collection.

In the course of *En skønne dag* the poet traces the actions, recollections, and thoughts of her protagonist. The individual poems of the work curiously blend fantasy and rather painful reality, the woman's dreams and wishful imaginings, her hopes, feelings of futility, her plans and planless existence, and the prosaic events and occurrences around her. The poet's blend of reality, a past dream world, and the world of others seems confusing and fascinating. At one point, for instance, she describes "a fortune spider living on in her shirt, silently, motionlessly waiting, passing time, considering the threads, the pattern. The web hangs there and remains whole, although her breathing regularly disturbs it." The unnamed protagonist becomes secondary in importance to an imagined spider of good fortune, living on in her apparel. At other points, the protagonist engages in ordinary, routine activities, such as visits to offices, supermarkets, shopping centers, and laundries; yet even these prosaic undertakings seem more imaginary than real, more dream than actual experience, for the protagonist never enters into contact with those who are always (it seems) at a distant remove from her: "People outside the walls seem near. She opens the window most widely. But then

they're already far away and can hardly be distinguished from the rose haze over the sidewalks." The protagonist's ordinary engagement in prosaic life seems wholly unreal, perhaps because of her isolation and disconnection from others whenever she searches for a link.

En skønne dag depicts the solitary dreams and reality of an individual who inexplicably, curiously, lacks contact and connection to others and to the ordinary world around her. The poet conveys a mood of despondency, loneliness, and solitude, describing one who "does not know with whom she will be when she falls asleep . . . but [who] imagines friends, friends, friends." In her prose poems Larsen depicts an individual who seeks in dreams, illusions, and imaginings what she cannot realize in a daily life marked by impersonality, habitual duty, and imposed isolation.

<div align="right">

Lanae H. Isaacson. *World Literature Today.*
63, 1989, p. 689

</div>

[W]ithin [Danish] poetry there is a development away from progammatic feminism. The early 1970s were dominated by poetry collections that in many cases can only claim to be poetry by being printed in the form of shorter lines, which earned them the derogatory label of "broken prose." Granted, the poetry of Marianne Larsen also deals with gender roles and sex discrimination. But it is removed from the intimate sphere of the majority of the works of "broken prose" in her advocacy of the liberation of the abandoned individual within the framework of political liberation, of a dream of community as expressed in the title of *Der er et håb i mit hoved* (1981; There is a hope in my head). Larsen's latest collections, *Hvor du er* (1987; Where you are) and *I timerne og udenfor* (1987; In hours and outside), do mark a stronger orientation toward the personal realm in line with the general trend of the 1980s.

<div align="right">

Sven Hakon Rossel. In Steven R. Serafin
and Walter D. Glanze, eds. *Encyclopedia of
World Literature in the 20th Century*
(New York: Continuum, 1993), p. 160

</div>

Larsen is one of the foremost representatives of Danish vanguard prose and poetry in the 1970s. Born in a provincial district of Zealand, she studied Chinese at the University of Copenhagen and later translated a selection of Lu Xun's poetry into Danish. Her own debut, with a collection of texts called *Koncentrationer* (1972; Concentrations), dates back to her first year at the university.

This volume, along with the following collection *Overstregslyd* (1972; Crossed-out sound), marks an authoritative body of experimental prose and poetry in which dreamlike abstraction and surrealism come across in a language defiant of normal grammar and logic. Repressive orderly circumstances and societal norms are subjected to linguistic disruption, and the crossing of visual and auditory boundaries, as in "crossed-out sound," indicates a

confrontational poetic strategy aimed at creating new and freer connections and identities.

In *Ravage* (1973; Havoc) this exclusive scheme applies more directly to societal conditions as it unmasks the conflict between victims and perpetrators of political oppression. It affords an insight into revolution, love, and poetry that is indispensable for the underdogs to counter the havoc inflicted by the powers that be. *Cinderella* (1974) is a specific, gender-political deployment of these experiences.

In *Billedtekster* (1974; Pictorial texts), with the subtitle "Un-calligraphy," and *Sætninger* (1974; Sentences), textual and scripture-thematic underpinnings still provide a balance for Larsen's sociopolitical rejection of the entire society of commercial exploitation; her location of disorders remains a matter of combining political analysis with sensitive reflections of human loneliness. Larsen wishes to liberate the abandoned individual, but for the effort to take effect, she concurrently must redefine societal frames. Increasingly concrete, her texts incorporate her abstractions and leave the reader with a synthesis of political criticism and political utopianism.

In *Modsætninger* (1975; Contrasts) the political analysis of societal conflicts gets the upper hand while in *Fællesprog* (1975; Common language) a reborn and purified sociolinguistic synthesis is proclaimed. An attempt to further simplify these social teachings is apparent in *Det må siges enkelt* (1976: It must be said in simple terms) and in the bold political poems of *Handlinger* (1976; Actions). *Hvem er fjenden?* (1977; Who is the enemy?) makes no bones about the implications: This is "class poetry," as the subtitle reads, and it is unambiguous class poetry to boot.

Not abandoning the victims of technocracy and male domination, Larsen succeeds in reopening her political agenda for poetic inquiry. *Under jordskælvet i Argentina* (1978; During the earthquake in Argentina) is a collage of photos and texts with discernible references to clashes between military rulers and rebelling masses, yet it shows few geographical restraints. In *Jeg spørger bare* (1982; I am only asking) the questioning referenced in the title is the guiding principle in the opening part of the book—before predictable left-wing answers follow at the end. In the meantime a series of sober examples, written in different poetic and narrative modes, gives compelling testimony to the typical hardships of society's little people, especially its children.

De andre, den anden (1986; The others, the other) recalls the dichotomy between collective situations and individual attachments. Myriads of outer sensations collide with notions of intimate love. This is not individualism, though. The "other" is a figment of one's imagination—until the others offer fulfillment. *En skønne dag* (1989; One fine day) may promise precisely that; but it may also be a bittersweet indulgence in wishful thinking.

A similar ambiguity adheres to Larsen's two novels. *Fremmed lykke* (1990; Alien happiness) submits that human progress comes with development and the recognition of otherness, but also that otherness is always alien and out of reach. It makes a formally compelling case for both possibilities.

Spanning from almost trivial verisimilitude to impenetrable abstractions, Larsen's pivotal point is nothingness. Her language blueprints a universe that is moving, touching, and indicative of *Lysende kaos* (1990; Shining chaos), "open texts—registrations of transition," written with Pernille Tønnesen (b. 1957). Plain wonder is a challenge to the unnatural boundaries behind which we live because it is nothing, really. But its volatility is captivating, and so is the author when she allows poetry to be her political dimension and to complicate her more gullible political pronouncements, so typical of the 1970s.

> Poul Houe. In Steven R. Serafin and Walter
> D. Glanze, eds. *Encyclopedia of World
> Literature in the 20th Century* (New York:
> Continuum, 1993), pp. 380–81

LARSEN, NELLA (UNITED STATES) 1893–1963

Negro writers seldom possess a sense of form comparable to that of Miss Nella Larsen. Her new novel, *Passing,* is classically pure in outline, single in theme and in impression, and for these reasons—if for no others—powerful in its catastrophe. The whole tragedy is prepared and consummated in less than fifty thousand words, without the clutter of incident and talk which impede the progress of most novels, and without a single descent, so far as this reviewer could perceive, into sentimentality. The sharpness and definition of the author's mind (even when her characters are awash in indecision) are qualities for which any novel reader should be grateful.

Passing tells the story of the life and death of Clare Kendry, who was white "with a touch of the tar-brush." Clare Kendry married a man who did not know she had Negro blood. She could have lived her life through placidly on the assurance of her husband's ignorance if she had not felt herself disturbed and fascinated by the race she had abandoned. She went back to her own people furtively, in spite of the danger which she always recognized; and one night in Harlem, at a party, her white husband found her. In the scene which followed she leaned (or was pushed) backward from a window. Her lifeless body in its red, shining dress was picked up by the Negroes in the courtyard six floors below.

Miss Larsen prefers to tell Clare Kendry's story through another character, that of an old schoolmate who was Clare's link between the white and Negro worlds. Sometimes this character is opaque enough to irritate us by hiding the figure of Clare, the shimmering centre of the tragedy. Particularly is this true in the last section of the book, when it becomes apparent that Clare has consummated her career of betrayal by falling in love with Brian, the Negro husband of her old schoolmate. In this final passage the old schoolmate (whose name is Irene Redfield) wearies us a little with her suffering.

As a matter of technique, Miss Larsen should either have told us the story of Clare Kendry directly, without the device of an intervening personality, or else have made the device-character interesting enough to mean something to us. As it is, we are impatient with Irene Redfield's tortures because they cut off our view of Clare.

It is in the creation of that character, not always perfectly realized but always strongly felt, that Miss Larsen's best achievement lies. Form alone could not do this. Clare Kendry, as intrepid and lovely as the most romantic of heroines, has made her declaration:

> Spicy grove, cinnamon tree,
> What is Africa to me?

She has built her life on it, but Africa is not so easily dismissed from the blood and bone. In describing the gradual surrender of Clare to the fascination of the Negro, her final return and death, Miss Larsen has made an unusually powerful appeal to the sensibilities and imaginations of her readers.

In some other respects the author has not been so successful. Although the writing is of good quality in general, it does occasionally lapse into the sort of jargon we call "literary." There is no reason, for example, for Miss Larsen to say "the rich amber fluid" when she means tea. Or to say "thanking him smilingly as well as in a more substantial manner for his kind helpfulness and understanding," when she means that the lady tipped the taxi-driver. These occasional elaborations are disconcerting in a work which otherwise seems so clear and chaste. Similarly, one wonders whether the author does not slightly exaggerate the wit and elegance of the salons of Harlem. Such wit and tone as Miss Larsen describes ("brilliant, crystal-clear and sparkling," with "nonsensical shining things" being thrown into "the pool of talk") have not been common this side the water, or indeed anywhere else since the eighteenth Century. And when examples of this esprit are given ("you're as sober as a judge," is the first of them) one wonders what Madame du Deffand would have had to say about them.

These occasional evidences of self-consciousness are undoubtedly due to the fact that Miss Larsen, like most other Negro writers, is aware of a mixed audience; a large proportion of her readers must be white people, which is to say, either uncomprehending or hostile. But there is a great deal less of this self-consciousness in Miss Larsen than in most writers of her race. She has produced a work so fine, sensitive, and distinguished that it rises above race categories and becomes that rare object, a good novel.

W. B. Seabrook. *Saturday Review of Literature.* May 18, 1929, pp. 1017–18

Drawing upon much the same material as Jessie Fauset, Nella Larsen was more successful in infusing it with dramatic form. Even her less important novel, *Passing* (1929), is probably the best treatment of the subject in Negro

fiction. The novel contrasts the lives of two colored women, both fair enough to pass. The one, desiring safety and security, marries a Negro professional man; the other, crossing the line, "lives on the edge of danger." Unfortunately, a false and shoddy denouement prevents the novel from rising above mediocrity. *Quicksand* (1928), on the other hand, is tightly written; its subtleties become fully apparent only after a second reading. The narrative structure of the novel is derived from a central, unifying metaphor; its characterization is psychologically sound; and its main dramatic tension is developed unobtrusively but with great power.

The protagonist of *Quicksand* is Helga Crane, a neurotic young woman of mixed parentage, who is unable to make a satisfactory adjustment in either race. Educated by a white uncle after the death of her parents, she embarks on a teaching career at Naxos, a Southern Negro college. Quickly disillusioned by the realities of Negro education in the South, and disappointed by a loveless romance with a smug instructor, she leaves the campus for points north. Harlem provides a temporary refuge, but a growing resentment with her lot as a Negro drives her to Denmark and her mother's people. In Copenhagen, a romantic involvement with a famous portrait painter poses the problem of mixed marriage—a prospect which she is unwilling to contemplate because of the tragic effect of miscegenation on her own life.

Helga returns to America with the problem of her identity still unsolved. Back in Harlem, she learns of the marriage of her best friend to Dr. Anderson, a former Naxos administrator of exceptional self-confidence and maturity. Strongly attracted to Dr. Anderson, she prepares herself for an extramarital affair, but the object of her passion refuses to cooperate. More insecure than ever, she takes refuge from a rainstorm in a revival meeting and impulsively submits to the pastor, who has comforted her in a helpless moment. Subsequently, she marries the Reverend Green, accompanying him to a small town in Alabama, where she sinks inexorably into a morass of child-bearing and domestic drudgery. . . .

On one level, *Quicksand* is an authentic case study which yields readily to psychoanalytic interpretation. Each of the major episodes in Helga's life is a recapitulation of the same psychological pattern: temporary enthusiasm; boredom, followed by disgust; and finally a stifling sense of entrapment. Then escape into a new situation, until escape is no longer possible. Race is functional in this pattern, for it has to do with Helga's initial rejection and therefore with her neurotic withdrawal pattern. Her tendency to withdraw from any situation which threatens to become permanent indicates that she is basically incapable of love or happiness. No matter how often she alters her situation, she carries her problems with her. . . . Helga's tragedy, in Larsen's eyes, is that she allows herself to be declassed by her own sexuality. The tone of reproach is unmistakable. It is this underlying moralism which differentiates *Quicksand* from the novels of the Harlem School. It is manifested not in Helga's behavior, which is "naturalistic" and well motivated, even inevitable, but in the symbols of luxury which are counterposed to the bog,

in the author's prudish attitude toward sex, and in her simple equation of "nice things" with the pursuit of beauty. . . .

A comparison of Larsen's best novel with the best work of Claude McKay may help to sharpen the contrast. Objectively, Helga Crane's fate is not much different from that of Bita in *Banana Bottom*. Bita, too, having been educated for something "higher," returns to a folk existence in the end. That one author interprets this event as a tragedy and the other as a natural expression of cultural dualism is a measure of their respective attitudes toward bourgeois society. Two normative judgments are involved: an evaluation of "nice things" and an evaluation of the folk culture. Nella Larsen sees beauty only in "gracious living," and to her the folk culture is a threatening swamp. Yet within the limits of her values she has organized one aspect of Negro life into a complex aesthetic design. *Quicksand,* for this reason, is a better novel than *Banana Bottom,* although its structure is reared on a narrower ideological base.

<div align="right">
Robert A. Bone. *The Negro Novel in America* (New Haven: Yale University Press, rev. 1965), pp. 102–6
</div>

The importance of Henry James's *The Portrait of a Lady* (1881) as a source for Nella Larsen's *Quicksand* (1928) has been noted in print (Lay), but another source—one closer to home—is Sinclair Lewis's *Main Street* (1920). The influence of *Main Street* is apparent throughout Larsen's novel, especially in the particulars of the protagonist's character and appearance, but it plays its most important part in the last thirty pages, where it provides Larsen with a model for the bitter ending of her work.

Helga [Crane's] story ends tragically, reflecting the fact that black Southern women had fewer alternatives than white Northerners. The ending of *Quicksand* shows quite clearly that even though Larsen used Carol as a model for her protagonist, her intention in the novel differed greatly from that of Lewis, who forced the reader to recognize that characters other than Carol [Kennicot] have their sympathetic qualities. In contrast, Larsen viewed Helga as a victim not only of the limitations set by white America but of those set by the black community as well. . . .

Nella Larsen's quarrel with the America of her time was somewhat different from that of Sinclair Lewis. Although Lewis felt the limitations imposed on any citizen of a small town and sympathized with the additional restrictions placed on a woman's freedom, Larsen added to Lewis' criticisms the barriers America erected in the way of black people and the burdens black society places on its own women. Yet when it came to finding a model for her story of Helga Crane, Larsen chose wisely when she emulated *Main Street,* the book that had startled middle America out of its complacency at the beginning of the decade.

<div align="right">
Robert E. Fleming. *Modern Fiction Studies.* 31, 1985, pp. 547, 552–53
</div>

At the height of the Harlem Renaissance, Nella Larsen published two novels, *Quicksand* (1928) and *Passing* (1929). They were widely and favorably reviewed. Applauded by the critics, Larsen was heralded as a rising star in the black artistic firmament. In 1930 she became the first Afro-American woman to receive a Guggenheim Fellowship for Creative Writing. Her star then faded as quickly as it had risen, and by 1934 Nella Larsen had disappeared from Harlem and from literature. The novels she left behind prove that at least some of her promise was realized. Among the best written of the time, her books comment incisively on issues of marginality and cultural dualism that engaged Larsen's contemporaries, such as Jean Toomer and Claude McKay, but the bourgeois ethos of her novels has unfortunately obscured the similarities. However, Larsen's most striking insights are into psychic dilemmas confronting certain black women. To dramatize these, Larsen draws characters who are, by virtue of their appearance, education, and social class, atypical in the extreme. Swiftly viewed, they resemble the tragic mulattoes of literary convention. On closer examination, they become the means through which the author demonstrates the psychological costs of racism and sexism.

For Larsen, the tragic mulatto was the only formulation historically available to portray educated middle-class black women in fiction. But her protagonists subvert the convention consistently. They are neither noble nor long-suffering; their plights are not used to symbolize the oppression of blacks, the irrationality of prejudice, or the absurdity of concepts of race generally. Larsen's deviations from these traditional strategies signal that her concerns lie elsewhere, but only in the past decade have critics begun to decode her major themes. Both *Quicksand* and *Passing* contemplate the inextricability of the racism and sexism which confront the black woman in her quest for a wholly integrated identity. As they navigate between racial and cultural polarities, Larsen's protagonists attempt to fashion a sense of self free of both suffocating restrictions of ladyhood and fantasies of the exotic female Other. They fail. The tragedy for these mulattoes is the impossibility of self-definition. Larsen's protagonists assume false identities that ensure social survival but result in psychological suicide. In one way or another, they all "pass." Passing for white, Larsen's novels remind us, is only one way this game is played. . . .

Nathan Huggins has observed that of the Harlem Renaissance writers "Nella Larsen came as close as any to treating human motivation with complexity and sophistication. But she could not wrestle free of the mulatto condition that her main characters had been given." I would argue that Larsen achieves a good measure of complexity and sophistication, yet Huggins's point has merit, especially in regard to *Passing*. Much more than *Quicksand*, this novel adheres to the pattern: the victim caught forever betwixt and between until she finds in death the only freedom she can know. The inevitable melodrama weakens the credibility of the narrative and diverts attention from the author's real concerns. Still, the plot reveals something of the predica-

ment of the middle-class black woman, and the book itself illuminates problems facing the black woman novelist.

Among the images of black women presented in fiction before the Harlem Renaissance, the tragic mulatto character was the least degrading and the most attractive, which partly explains its prominence in Jessie Fauset's novels and in those of her predecessors, dating back to Harriet Wilson and Frances Watkins Harper. Nella Larsen's personal history doubtless increased the character's appeal for her, as the reality behind the image was her own story. Besides, depicting the tragic mulatto was the surest way for a black woman fiction writer to gain a hearing. It was also an effective mask. In a sense Nella Larsen chose to "pass" as a novelist; not surprisingly, readers who knew what they were seeing—that is, reading—missed the point.

<div style="text-align: right">Cheryl A. Wall. Black American Literature
Forum. 20, 1986, pp. 97–98, 109–110</div>

Larsen's *Quicksand* records the picaresque movements of Helga Crane as she seeks a clearer understanding of self and sustained happiness. The novel records this journey toward self which, in spite of her physical movements—from Naxos (in the South) to Chicago to New York to Copenhagen back to New York, then to the Deep South—spins Helga round and round in the same spot until she is virtually bogged down inside of herself. As William Bedford Clark points out, Helga "flees from the imperative of self-knowledge, seeking to allay the dissatisfactions which arise from within her with a change of scene and society. Her refusal to face the reality about herself in turn distorts her perception of the reality around her, finally breeding tragic consequences." By the end of the novel, not even physical movement is possible. The pain the reader is made to feel at the end of the novel is for the death of Helga's search and thus the death of Helga. Crane, who always seemed on the verge of meaningful discovery but who lacked the necessary mettle for real insight and for change, has, by the end of the novel, taken her last feeble stand against herself . . . and she has lost. . . .

Helga, whose dilemma is so acute because she cannot reconcile herself to the reality of her race, or her sexuality, is driven toward a materialism which masks the essence of herself, and lacks the basic capacity to accept herself as she is and to move forward from this knowledge. At key points in Helga's life as she quests for happiness, she replaces one obsession with another until having explored and exhausted all obsessions she can name, nothing remains except the nameless. As Mary M. Lay has discovered, each turning point is accompanied by a contemplation scene which rivals that of Isabel Archer in Henry James's *Portrait of a Lady*. For Helga, however, each contemplation is a new exploration of the same question. Family is replaced with materialism, with sexuality, with race. The same question, at least in terms Helga can accept, remains answerless.

<div style="text-align: right">Lillie P. Howard. In Victor A. Kramer, ed.
The Harlem Renaissance Re-examined
(New York: AMS, 1987), pp. 226–27</div>

Nella Larsen's *Quicksand* is a meditation on color: gowns of shivering apricot; sunsets of pink and mauve light; the turquoise eyes of fellow travelers; and "gradations within [an] oppressed race . . . sooty black, shiny black, taupe, mahogany, bronze, copper, gold, orange, yellow, peach, ivory, pinky white, pastry white." Helga Crane, the protagonist, perceives reality in terms of color. For her, light on the surfaces of things constitutes fine distinctions of texture, tone, and hue. Her attention is arrested by details of clothing and textiles, objets d'art, and interior decor. Her preoccupations are reflected in Larsen's narrative. Even nature is described as fabric: clouds are like shreds of incredibly delicate cotton; water is akin to silk.

In *Quicksand* the emphasis on color advances a thematics of race. The novel tells the story of a woman who perceives herself as the consequence of passion, an unwanted product of a temporary union between her white Danish mother and a black jazz musician, the father she has never known. Embodied in the character of Helga Crane is the tension between black and white construed as opposites in American culture. Hers is an extreme case, separating race from ethnicity, from community: her only family connections are white; she has never known a single black person whom she could call family. Her hatred for "the race problem" barely masks the agony of facing color as division rather than as fruitful multiplicity. Through her love of color Helga attempts to create a spectrum rather than an opposition, a palette that will unify her life rather than leave it divided.

Themes of race merge with concerns of gender, for Helga's destiny is shaped as much by her sex as by the problematics of race. The fascination with clothing and color that marks her character is an attempt to construct a female identity, to use her attractiveness as power. The object of desire, she fails repeatedly to come to terms with her own desires. Hazel Carby calls Helga Crane "the first truly sexual black female protagonist in Afro-American fiction" and notes that "the representation of black female sexuality meant risking its definition as primitive and exotic within a racist society.". . .

Among African American novelists writing before Zora Hurston, Larsen is innovative not only in her treatment of female sexuality but also in her experimentation with narrative style. In *Quicksand* the story's emphasis on aesthetics focuses on overlapping concerns of race, gender, and artistic creation. Larsen makes readers pause and question whether skin color is merely a surface that encases the self or whether surfaces in fact create the self. How is the self conceived in a particular cultural construction? To what degree are race and gender shaped by biological inheritance and to what degree by cultural categories? What finally emerges in this fictional meditation on race and gender is a complex representation of the world in which there is no such thing as blackness, whiteness, masculinity, femininity, or art in and of itself.

Quicksand suggests an alternative strain of African American women's writing, one that deals with problems of cultural identity and assimilation,

drawing on the materials of urban life rather than on a rural landscape or an oral tradition.

Larsen's idiom differs from Hurston's in its focus on aesthetics—in its attempt to create a stylistic surface of spare refinement. The narrative surface of *Quicksand* is richly encrusted with symbols chosen from the object world of haute-bourgeois culture; black folk culture is significantly absent. In fact, the text is iconic of Helga's dilemma: Helga *is* the text—an aesthetic experiment, an isolated gem on the margins of the African American literary heritage. As such, her character illustrates the contradictions of an aesthetic that judges a work of art to be significant inasmuch as it transcends—or can be read and interpreted independently of—the context in which it was created and the society that it reflects. Thus Helga Crane's self-imposed isolation and her imprisonment by constructions of race and gender (both those of her society and those that she has internalized) direct the reader outside the work to reexamine the social practices of racial and sexual discrimination that the text represents and that an aesthetic of "art for art's sake" tends to perpetuate. *Quicksand* thus deserves serious critical consideration not only as a bold and innovative novel about race and gender but also as a searching metaphor for the experiences of many Americans trapped by narrow definitions of race, caught in cultural transition, and alienated from the traditional anchors of family or ethnic tradition.

Ann E. Hostetler. *PMLA*. 105, 1990,
pp. 35–36, 45

Nella Larsen's heroines are emotional nomads, women whose intelligence and genius for rebellion make them ill suited for the proscribed existence ordained by whites for blacks in 1920s and '30s segregated America. No tragic mulattoes here. These prim, proper colored ladies bristle with discontent and yearning. But, most important, they are driven by the impulse to shape their lives rather than suffer them, even when their grasp is unsure and they are careening full tilt towards disaster.

In Helga Crane and Clare Kendry, Nella Larsen has created two characters that are rich, complex, and contradictory. *Quicksand* and *Passing* launch each woman on a quest for self that predicts the themes of much of the most important writing in American literature of the last twenty years. Inevitably, any writer whose female protagonists resist the expected, the traditional, the "correct," is dialoguing with the literary legacy of Nella Larsen.

The tension between the individual and society, the yoke-like manner in which society encroaches, and the courage Larsen's women find to resist predict writers as diverse as Ellison, Wright, Shange, and Walker. While the social milieu that Larsen explores is fairly insular, the black bourgeois, a thin sliver of 1920s black America, her vision is broad. The political and social debates of the period, the texture of the Harlem Renaissance, the specific fabric of Negro life, be it urban or rural, are captured with an eye for detail that is nearly surgical. While always delicate and often poetic, Larsen is

tough-minded and withering in her critique of black bourgeois manners and obsessions.

The geography of the soul, the rocky, rich terrain of dreams, is in reality the setting for *Quicksand* and *Passing*. Helga Crane and Clare Kendry are women of enormous energy, talent, and sensitivity who find no release for or realization of those gifts in either black or white society. The real tragedy for both women is that there is literally no place for them to be somebody except in the arms of a man. Marriage is their only legitimate option. The worlds that created and confined them were neither large enough nor good enough for them. For these restless, spirited souls were hampered as much by the failure of imagination of those around them as by their own weaknesses. Both women could imagine themselves free from racial prejudice and, by extension, from sexual oppression—unfettered, whole; they just couldn't make themselves that way.

> Marita Golden. Foreword to Nella Larsen.
> *An Intimation of Things Distant: The*
> *Collected Fiction of Nella Larsen* (Garden
> City, New York: Doubleday, 1992), pp. vii–ix

Quicksand is the story of an educated black woman's inability to find her niche in the contemporary world. The scope of Helga Crane's search is international (America and Europe) and is exacerbated by the fact that she is not only middle-class but mulatto. What separates Larsen's novel from earlier works concerned with the plight of the tragic mulatto (Frances Harper's *Iola Leroy,* 1892, or Charles Chesnutt's *The House Behind the Cedars,* 1900, for example) is the depth of her characterization, as well as her superior narrative technique. Helga Crane is the most fully realized and convincing black woman depicted in American fiction to that date. Above all, hers is a portrait of loneliness and pain, despair and sorrow—qualities which bind her to the heroines of any number of later works by black women writers: Zora Neale Hurston, Ann Petry, Toni Morrison, Gayl Jones, Alice Walker, Gloria Naylor. . . .

Passing, published the following year, was equally despairing in its depiction of the lives of middle-class black women. The story has frequently been misconstrued as Clare Kendry's tragedy, since she is the character who has crossed over the color line, concealed her racial origins, and whose past is eventually discovered by her bigoted white husband. Larsen's superior craft added new meaning to the subject implied by her title. No passing novel can be regarded as anything other than a strong indictment of American life; people are driven to such drastic measures because of American racism and the need for economic survival. When Irene first muses over Clare's boldness, Larsen states, "She wished to find out about this hazardous business of 'passing,' this breaking away from all that was familiar and friendly to take one's chance in another environment, not entirely strange, perhaps, but certainly not entirely friendly. What, for example, one did about background, how one

accounted for oneself. And how one felt when one came into contact with other Negroes." Yet the central story—for all of the realities of Clare's unhappy life—is what happens to her childhood friend, Irene.

After several encounters between the two women, Irene Redfield's almost morbid fascination with Clare Kendry's fate becomes the novel's main focus. It is Irene who cannot control her curiosity and thrusts her hand into the tar baby (Clare) and thereby finds herself trapped in a situation she never foresaw. Thus, the primary theme is not race (as has usually been interpreted) but marital stability. *Passing* describes Irene's attempts to keep her marriage intact in the face of her husband's possible adultery with Clare. In many ways, Larsen has written an old-fashioned tale of jealousy, infidelity, and marital disintegration. Although at the end Irene may believe that her "sudden moment of action" has released her from the threat of losing her husband, one cannot help pondering about Brian's absence in the final pages of the novel. In a strange transference of conditions, Irene has inherited Clare's life of duplicity and isolation.

> Charles R. Larson. Introduction to Nella
> Larsen. *An Intimation of Things Distant:*
> *The Collected Fiction of Nella Larsen*
> (Garden City, New York: Doubleday,
> 1992), pp. xiv–xv

LASKER-SCHÜLER, ELSE (GERMANY) 1876–1945

[H]er being puts the human heart in the center of all her work and in the center of all values; characteristically, her first novel is called *Mein Herz* (My heart, 1939). This, her being, is new-fashioned, but that is not true of all her works, many of which bear impressionistic features. Thanks to her being, there is hardly a significant review in which her pieces do not appear next to those of the very youngest. . . . Amidst the appeals and the exclamations of the young her art stands out—a colorful, fairy-talelike, fiery idyll. But in the larger works her art is effective not for its unity and form but for an abundance of beautiful detail.

> Albert Soergel. *Dichtung und Dichter der*
> *Zeit,* II (Leipzig: Voigtländer, 1925), p. 440

More than almost any other poet, she was voice and nothing but voice: with a candor bordering on sadism, she expressed what . . . she herself, as she said, often did not understand. If ever a poet has embodied in his work C. G. Jung's concept of the collective unconscious—the sum of the experience of our fathers that lies dormant in the mind of the individual—it was Else Lasker-Schüler.

When she was honest, her wisdom was that of a child, emerging suddenly, in strange forms. At such times her love was also the love of a child, recognizing no limit or barrier, an endless yearning for tenderness and requited trust. The best among the poems of Else Lasker-Schüler will endure.

<div align="right">

Heinz Politzer. *Commentary.* April, 1950,
pp. 336–37, 344

</div>

The precarious nature of the Expressionist poet's dream of grandeur is a prominent aspect of the work of one of the movement's most delicate lyric talents, that of Else Lasker-Schüler.

Else Lasker-Schüler created a make-believe world for herself and tried desperately to integrate it into her life. She was alternately Tino, poetess-princess of fabulous Baghdad, and Jussuf, Prince of Thebes. She addressed her fellow Bohemians as kings and princes and was happy when she was hailed in return as a fantastic and exalted personage. . . .

But only a thin line divided the isolated outcast's proud daydream from the nightmare. The tension between dream and reality gave rise to the grotesque self-irony which distinguished her work from Neo-Romanticism. . . .

Some of her most tragic self-revelations are clothed in that witty grotesque idiom which, while begging for human sympathy, cannot take itself seriously. There is flirtation in her melancholy and sadness in her exuberance. Her romantic aloofness . . . lacked the robustness that comes from belief in one's own exceptional status. She stayed in an obvious make-believe world, indulging in a childlike and melancholy masquerade. . . . Then the curtain painted with her royal dreams was suddenly rent to reveal an almost Biblical despair.

<div align="right">

Walter H. Sokel. *The Writer in Extremis*
(Stanford: Stanford University Press, 1959),
pp. 70–72

</div>

As if she could believe in the new condensation of a world dissolving into infinite space whenever a person turns his face to her, Else Lasker-Schüler constantly keeps people in front of her and thinks of them in terms of the great, pure, and all-encompassing. Her poetic portraits are woven legends. Their colors are basic tones. . . .

Else Lasker-Schüler's pathos is devotion rising out of being lost, homesickness due to homelessness, vision produced by blindness. This theme runs through all her poems. The unquenchable yearning purifies itself from purple to silver-grey. The desperate jubilation of gold becomes pious blue. The figures of biblical history take their places besides people whom she transfigures in the name of love. But where is she herself? . . . She cleared a space around herself that can only be overcome by those friends who are dead—Sanna Hoy and Franz Marc.

<div align="right">

Karl August Horst. *Wort und Wahrheit.*
1960, p. 565–66

</div>

Gedichte 1902–1943 (Poems 1902–1943). . . . [T]hese collected poems prove once again that the extremely uneven output of this minor poet is best enjoyed in a rigorous selection; Else Lasker-Schüler is no serious rival to Droste-Hülshoff's claim as Germany's greatest woman poet. Yet she is important as one of the numerous "forerunners" of expressionism—an evidently growing, curious group of authors that should finally cause critics to ponder the correctness of the accepted birth date, 1910—for this vital movement. . . . About three of Lasker-Schüler's poems belong firmly in every truly representative anthology of German verse, not more.

<div style="text-align: right">Ivar Ivask. Books Abroad. 1961, p. 264</div>

Lasker-Schüler combines self-expression with continuation, and thus her poetry is valid at the particular as at the universal level. Hers is a lyric which does not employ rhyme or word-music as ends in themselves. Whether she writes in free verse, as she generally does in poems addressed to particular persons, or in rhyme, in poems containing moments of revelation—a revelation of the state of the world, of her position in the world, or of transcendence—her poems are always carried by a rhythm adequate to their meaning.

<div style="text-align: right">G. Guder. Modern Languages.
June, 1962, p. 60</div>

. . . The poetry of Else Lasker-Schüler is the inner confession and revelation of a soul wandering far, far away. The sober and pitiless everyday world becomes for her a magic kingdom filled with Arabian perfumes. It is a realm into which she introduces, under self-invented names, her large circle of friends—she was universally loved, and there is not one contemporary poet whose essence she failed to catch in a few wonderful verses.

<div style="text-align: right">Wilhelm Duwe. Deutsche Dichtung des 20.
Jahrhunderts, I (Zurich: Orell-Füssli,
1962), p. 158</div>

Else Lasker-Schüler was called "the Jewish nightingale." The name is more than a romantic metaphor. It is a comparative, explanatory image helpful in understanding this great and dark figure, the reality of this poet of the contemporary West. The name . . . evokes the millennium-old origin of the blood throbbing in her songs, the melodious sound of her poetic language, the hot, summer night bower of her sonorous voice. It also brings to mind the dark ground and overwhelming pleasure of her harmonies. The lightness, indeed weightlessness, of the bird voice is united with the magic and weight of the yearning for messianic hopes that go back to the beginning of human history.

Stars and night are recurrent signs and symbols of Else Lasker-Schüler's lyric poetry. They are present in her childlike, fairy-tale songs of the stars and in her womanly, truly maternal night songs, which await, implore, and

finally learn from the starry light about the son of truth, the meaning of his journey, and the birth of mankind's reconciliation.

Walther Huder. *Welt und Wort*. 1965, p. 293

Her creative development can be traced most easily in the formal aspects of her poetry. Blocklike forms and irregular rhyme techniques predominate in Lasker-Schüler's first collection of poetry, *Styx* (1902). The poems of the middle phase, represented in the *Gesammelte Gedichte* (1917 [Collected Poems]), consist mainly of two three-line stanzas without rhyme. The late poetry, *Mein blaues Klavier* (1943 [My Blue Piano]), has strict rhyme structures in which one and the same rhyming vowel frequently runs through an entire poem. The early lyrics are primarily poems of passion, the middle and late lyrics religious and love poems, with both themes frequently merging.

The fate of émigrés, loneliness, poverty, and old age, provide the background of the late poetry and the posthumously published play, *Ich und Ich* [I and I]. Flight, weariness, death, and the experience of God's remoteness are the subjects of these poems. But their scope extends beyond the personal to embrace the religious existence of modern man in general. Doubt and certainty of God's existence are closely juxtaposed throughout all her work, which is defined by a restless yearning for security.

Margarete Kupper. In Hermann Kunisch, ed. *Handbuch der deutschen Gegenwartsliteratur* (München: Nymphenburger, 1965), pp. 383–84

In her poetry Else Lasker-Schüler created an entirely personal myth, integrating elements from the most diverse religions and cultures. It also served her as a dreamland into which she withdrew from the assaults of reality. But as a Jew her own religion always remained crucial, and she turned to it again after the death of her adored son (1927).

She took her themes from the Jewish mystics, cabalistic writings, and, above all, from the Hassidic legends. On the other hand, she often willfully reinterpreted biblical stories as though they had not been taken from the scriptures but had arisen as archetypal images from the poet's unconscious.

Jürgen P. Wallmann. *Merkur*. 1966, p. 1192

Explosions of feeling destroy words and lead to babbling. However, Else Lasker-Schüler was firmly rooted in language, and even when she defied customary usage she was right on a higher level. Before her, we never heard of "star" as a color; but in "black and star," a brilliance of color flashes, striking and affirmative. It may be feminine devotion to the spirit of language, a talent for loving to the point of self-dissolution that reconciles words to new and happy marriages in her writing. . . . This explains the incomparable glow her poems radiate, the mixture of the primordial and immediate, of folk

song and expressive stringency of speech . . . of what is most mysterious and exotic, of what is most profoundly German in its naiveté.

There is a sweetness and an unappeasable grief in her poems—and even in the unsuccessful ones a verse or phrase sparkles fascinatingly in a manner unheard of before in German poetry. She was a soul suffering from a dead world and could not soar up to God, her consolation. The sorrow to which she was defenselessly exposed rang out in her, dark Lorelei, as a song of redemption fleeing this world.

> Georges Schlocker. In Otto Mann and
> Wolfgang Rothe, eds. *Deutsche Literatur im*
> *20. Jahrhundert,* I (Bern: Francke, 1967),
> p. 357

Lieber gestreifter Tiger [Beloved striped tiger]. Numerous letters in this volume commemorating the hundredth birthday of the poet whom Gottfried Benn called "die grösste Lyrikerin, die Deutschland je hatte," attest to her tenacious fight to preserve her childlike being and to the tragedy of its loss, which—though of long process—became irreversible only when the Nazis forced her from her German homeland.

These letters, often tender, frequently bitter . . . always fascinating and singularly, if also eccentrically, human, bear witness to the life struggle out of which Else Lasker-Schüler wrought her unmatchable offerings to the store of German lyric poetry.

> Sidney Rosenfeld. *Books Abroad.*
> 1970, p. 478

The poetry of Else Lasker-Schüler is distinguished by its rich and deceptively simple imagery and by the fact that almost all of it consists of love poems. Her poetic acts of love are at once ritual, entertainment, artistry, riddle-making, doctrine, persuasion, sorcery, soothsaying, prophecy, and competition: in short—play. . . .

Else Lasker-Schüler's game of love is her grand design for life. Her playful verse, a product of what Hermann Hesse in *Das Glasperlenspiel* terms "die freispielende Plastizität der Spielsprache" [the free-acting plasticity of the language of the game], attempts to restore lost vigor to sterile reality, warmth and charm to a language which has become a mass of clichés, and love to depersonalized human relationships. Her game-world recalls childhood; it is her vision of paradise; it is her world of freedom. The rules of the game define the limits of her world and the specific spheres of influence for each of her protagonists. They guarantee her loved ones protection from life's harm and exclude from the protective circle of her private world those who have transgressed the rules.

> Bernhardt G. Blumenthal. *German*
> *Quarterly.* 43, 1970, pp. 571, 575

The poetess's eye is the pinnacle of time. Its radiance kisses the hem of God's robe.

In this poem, "Mein stilles Lied," as elsewhere in her lyric work the *eye* for Lasker-Schüler stands as a center of consciousness, a meeting place of the soul and the visible world, more manifest than the former, more self-aware than the latter. But in this particular context, unusual for her, the eye is universalized, so that the poetess experiences her being as the very focal point of time and beyond that, as a transcendent radiation into the presence of God. The eye of the speaker, her awareness of the world, extends beyond *vision* to the *visionary*, a not uncommon metaphorical expansion. Although Else Lasker-Schüler indeed saw the poet's role as one of revelation and an almost priestly calling to praise and lamentation, "Mein stilles Lied" is almost unique in the assertion of this claim.

Yet something of the centrality, the limitless radiance, mystery and beauty of this gleaming eye is retained among the many occurrences of the image in her poetry. To judge by the poems, she was exquisitely sensitive to the expressive quality of human eyes both in others and in herself. She seemed constantly to be in voluntary or involuntary communication with them, receiving their messages of love and anger. She made frequent poetic note of them in her friends and acquaintances—Georg Trakl, as she records in a poem dedicated to him, had eyes that *standen ganz fern,* transfixed undoubtedly by the silent calm or chilling melancholy which suggested to Trakl in his own lyrics the numerous *monden* and *steinern* eyes. Gottfried Benn's *Tigeraugen* became sweet in the sun. (Revealing him as a paper tiger in perhaps more ways than one.) The *Mandelauge* of Franz Marc, painter of blue horses, is consoling and quieting, a virtue she loved in this much admired friend, whereas Georg Groß's are *äschern* and in them brightly colored tears are sometimes seen to play. In a letter, she once describes to Trakl the eyes of an acquaintance in Munich as *blaue Augen wie Flüsse—ich ertrink so gern darin,* here using a metaphor of "liquid flow" that she sometimes ascribed to eyes, one incidentally that is hardly to be found in other poets, save in the literal context of tears. . . .

Undoubtedly there are many unresolved problems of critical evaluation which await resolution for Else Lasker-Schüler's work. Despite some exquisitely finished poems, she leans to stylistic carelessness and is not immune to rashes of saccharine sentimentality. No one would claim that all her poems are guided by a coherent logic (but, then, what about Trakl and Benn?). Nevertheless, a good deal of her imagery is original and symbolically well-founded, and many of her poems dynamically cohere through verbal and psychological association, in a way unrecognized by hasty and condescending critics. In particular, her visual imagination—which is emotionally driven, concrete and often subtle in its correspondences—has very fruitfully, and more fully than other poets, exploited some traditional aspects of the age-old symbolism of the *eye*—namely its *power*—and has expanded in the symbolic mode of eye = *spirit* (as opposed to *knowledge* or *light*) the German

language's metaphoric scope, far beyond what any previous poet has accomplished. In this and other respects Lasker-Schüler's poetic gift deserves to be treated with greater attention and seriousness should we not be inclined to approach it thus already because of the jewel-like brilliance of rhythm and epigrammatic phrase which is attained in many of her best poems.

<div style="text-align: right;">Robert P. Newton. <i>MLN.</i> 97, 1982,
pp. 694–95, 711–12</div>

LAURENCE, MARGARET (CANADA) 1926–87

What *is* it about the African sun that its touch should so often flame writing into literature? *This Side Jordan* is a really excellent novel set in the Gold Coast just before it became Ghana. Its chief character, a most haunting, interesting un-hero, is Nathaniel Amegbe, schoolteacher; shabby, unimpressive, conscience-ridden; a divided man, torn between the pull of the old, tribal ways he has managed to half-educate himself out of, and the Christian-commercial life of the city. Accra, incidentally, and its inhabitants could hardly I imagine be better drawn. Miss Laurence has a natural instinct for proportion; her detail is exactly enough to bring place and people most vividly to all one's senses. . . . Were it not for a suspiciously sunny conclusion I would have said this book had an almost Forsterian quality of understanding.

<div style="text-align: right;">Gerda Charles. <i>New Statesman.</i>
November 19, 1960, p. 800</div>

[*The Stone Angel* and *The Tomorrow-Tamer*] would be impressive each on its own, but taken together they announce beyond any doubt an important arrival. In them Mrs. Laurence reveals herself as a writer of high degree, for they display the versatility and the richness of resource that go with major talent. The first is a novel of sustained power with a Canadian background and the second a collection of ten stories, sad, comic, weird or horrifying, set in the Africa of nationalism and independence. The author appears to be as much at ease in the one form as in the other, and as much at home in African surroundings as in the land of her birth.

The theme of *The Stone Angel* is old age, and for a woman of the author's years to have explored it so deeply and sensitively is a further sign of her quality. . . .

Darkness is gradually closing in on the old woman as the tale proceeds. She becomes more terrified, angry and confused with every day. But the author manages the flow of her narrative so well that we feel no jarring sense of dislocation as it wanders forward and back in time, and this effect is further helped by the consistency of character and unity of mood. It is her admirable achievement to strike, with an equally sure touch, the peculiar note and the

universal: she gives us a portrait of a remarkable character and at the same time the picture of old age itself, with the pain, the weariness, the terror, the impotent angers and physical mishaps, the realization that others are waiting and wishing for the end. Once or twice her own love of nature shows in descriptive passages that are over-lyrical, since it is Hagar [the protagonist] who is supposed to be talking; but this small criticism is the only one I have to make.

Honor Tracy. *The New Republic.*
June 20, 1964, p. 19

The stories [in *The Tomorrow-Tamer*] are set in an unspecified new African nation and concern the first tentative efforts of Africans to move out of their tribal pieties and embrace the new gods that come to them from the West in bewildering combination—Christ, freedom, and technology.

These stories look like sound and enlightened reporting, but some of them are weak fiction, because the gap between the Africans and the Westerners is too great, the ironies are too obvious. The story about a fundamentalist missionary who finds Africa too complicated for him is a set piece, for instance; the reader expects to see him seduced by Miss Sadie Thompson before he clears out. The enterprising young African who attempts to get his respectable family to put on a show of primitive savagery to ensnare a rich young Englishman of anthropological tastes is funny enough, but it is *Charlie's Aunt* in blackface.

The best of the stories—the most moving and the least contrived—confine themselves to the African point of view. It is impossible to assess the accuracy of Mrs. Laurence's attempt to penetrate and portray the minds of these "emerging" people, the young Africans who go to work on construction crews or enlist in westernized armies, but the stories bear the mark of an imaginative tact that is certainly genuine.

Paul Pickrel. *Harper's.* July, 1964, p. 100

It's odd that when one's eye encounters clichés such as "sex-starved spinster" and "painfully self-conscious," it glides on as if they didn't mean anything; whereas they've become clichés because they mean something, because they express something we all know and have seen. That "something" can be brought to life again in our imaginations by a writer who is gifted in finding fresh words and fresh insights. And those are exactly what Margaret Laurence finds in *A Jest of God.* Miss Laurence writes about a thirty-seven-year-old spinster whose sexual life has been devoid of fleshly experience. A Grade School teacher in a small Manitoban town, she lives with her widowed mother, vulnerable to the blackmail of her mother's heart-attacks. She is far from ill-looking, intelligent, cultivated. Why has she not found a man? She is self-conscious to the point of desperation.

But then a man comes along who is partly careless of her self-consciousness, partly careless of *her,* it turns out. He is a vigorous Ukrainian,

born on the wrong side of the small town's tracks, who has come back from the city, Winnipeg, to see his parents. He seduces her, and she discovers, overwhelmingly, the nature of fleshly experience. He goes back to the city and his family, but her existence—here comes another cliché—is never the same again. The change seems to me exactly credible: she remains a spinster, but she takes a new command of her own life, gets a job in a different place and shakes off her mother's blackmail.

I have used the phrase "fleshly experience" out of tactful admiration for Miss Laurence's gifts as a novelist; for I have to admit that while reading the book I wondered how far she, too, had been affected by current fashion, for whose main focus I normally use the cruder phrase "genital experience." But the aim of the book is serious, and Miss Laurence has written it with realism, sympathy and distinction.

<div align="right">William Cooper. The Listener.
August 25, 1966, p. 283</div>

In [Margaret Laurence's] Canadian-based short stories and novels, which at this point in her career outnumber her other works of fiction, the small western town of Manawaka is the setting for her world of imaginative truth, the thoroughly persuasive communication of its physical reality, her point of departure, as the spiritual reality of its characters is her goal and point of return. Manawaka is not Neepawa, but its trees and its grain elevators, its cemetery, Tabernacle, Chinese café, the attitudes of its people to one another and to the outside world, depend as much on Margaret Laurence's experience of Neepawa, her ability, both to store and to transmit what she knew and what she felt of it, as on her assimilation of all her experience into a created fictional world of art. Obviously, she has always been "one of those people on whom nothing is lost," one who simply possessed the faculty of storing experience and impression even before she was aware of her writer's vocation. . . .

This town and its people say the things about Canadian experience "that everybody knows but doesn't say," the truth that Margaret Laurence wishes to *show* more than to say and that, by extension and their deepest level, are true for all experience everywhere. Manawaka is fictionally real, with the hard surfaces and sharp outlines of a place in time and space, furnished with a density of sense-gratifying detail fitting to its place, its times and its seasons. Beyond that, it is timeless in its reference. . . .

Her commitment to the writing of fiction, the characters her imagination forms and shapes will undoubtedly demand new patterns and different techniques from her as time goes by. Whatever they may be and wherever they may lead her, they will certainly show us more about what it is to be Canadians, to be exiles, and to be all men, forever blundering towards an elusive homeland which must, always and finally, be that hard-fought and dearly won core of peace, somewhere within ourselves.

<div align="right">Clara Thomas. Margaret Laurence (Toronto:
McClelland and Stewart, 1969), pp. 6, 57, 59</div>

Long Drums and Cannons is welcome, because it looks at African literature basically from the outside. Most of the criticism of African, and particularly Nigerian, writers has so far come from writers who have lived in Nigeria and been closely involved with the writers and the cultural life of Nigeria. Miss Laurence sees many things with a refreshingly new eye, and she interprets these writers with sympathy and sensitivity. She clearly responds most strongly to Soyinka's writing and her long essay on him is the best in the collection. She curiously overrates Cyprian Ekwensi and her essay on Tutuola is the least original: it adds little to Gerald Moore's now classic piece on Tutuola in *Seven African Writers*.

Miss Laurence also tries to fill in a great deal of background information about Yoruba gods, popular theater and so on, but her information is sometimes inaccurate. . . .

Miss Laurence has restricted her essays to drama and the novel. "Principally," she says, "these essays are an attempt to show that Nigerian prose writing in English has now reached a point where it must be recognized as a significant part of world literature." The omission of poetry was perhaps a mistake: some of the authors she discusses are *primarily* poets, like Gabriel Okara and J. P. Clark; and some of Soyinka's plays, like *A Dance of the Forest* and *The Road* are hardly prose.

Nevertheless she eminently succeeds in her aim: even those who have had little knowledge of Nigerian writers before reading her book will be convinced by her perceptive analysis, that this is indeed now a significant part of world literature.

(London) *Times Literary Supplement.*
January 2, 1969, p. 8

In *A Bird in the House* [Margaret Laurence] recreates the small-town Canadian scene with its middle-class life-ways and by now predictable family characters: the crotchety old grandfather, opinionated, obdurate and often mean, recalled later in tenderness; the long-suffering family and the patient mother; the old-maid aunt who later married; and the sensitive grandchild— Vanessa, the narrator of these stories—in whom traits of the grandfather unconsciously appear. Despite their "reality," the stories and their somewhat condescending rich-white attitudes are reminiscent of the *Life with Father* type of melodrama, whose clichés are by now nearly exhausted. In reading these partly sentimentalized memoirs one gets the feeling that there is nothing new—the Canadian frontier achievement is no different from ours.

The patronizing tone is evident in "The Leons," in which Piquette, a sickly half-Indian girl from a family of outcasts, is invited by Vanessa's father, a doctor, to spend the summer in their vacation cottage. The attitude of Vanessa, who scarcely talks to the girl during the summer, is capsuled in this line: "She [Piquette] existed for me only as a vaguely embarrassing presence, with her hoarse voice and her clumsy limping walk and her grimy cotton dresses that were always miles too long." Four years later Vanessa meets

Piquette in a juke-box café. Rouged and dowdy, she is now an animated girl, proud of the young man she is engaged to marry. But—as one would have guessed—Piquette comes to a sorry end. These poor folk from the other side of the tracks *always* do!

<div align="right">Curt Leviant. <i>Saturday Review of Literature.</i>
September 5, 1970, p. 27</div>

[The] phenomenon of sudden change is described in detail by Margaret Laurence in *The Prophet's Camel Bell*. For Laurence, the harshness of the Sudan, where human decay was both prevalent and rapid, suggested a fundamental weakness in the theory of a benevolent deity. During her prolonged stay in Somaliland, the street beggars she repeatedly encountered, the child prostitute, and the families dying of hunger and thirst during the Jilal became more than merely a reproach. As the full implications of the things she had seen began to penetrate, Laurence came to recognize the threat posed by them. . . .

In her fictional writings Margaret Laurence would return to this vision of the crowded, dust ridden streets of Africa, where the European is faced with a throng of beggars and forced to recognize his helplessness before them. Thus, in "The Merchant of Heaven," Mr. Lemon's determination to ease the lives of the poor shatters quickly. . . .

The suddenness and prevalence of death, made so evident by her experiences in Somaliland, continued to preoccupy Margaret Laurence. Even when the setting of her novels changed from Africa to Canada, the images of death and decay persisted.

<div align="right">Frank Pesando. <i>Journal of Canadian
Fiction.</i> Winter, 1973, pp. 53–54</div>

Margaret Laurence, the writer, and Morag Gunn, the central figure in her new novel [*The Diviners*] are literary diviners. Once again, this year, Margaret Laurence's divinations have taken her back to Manawaka, Manitoba, that fertile town of her imagination and recollection where she set part or all of four earlier books. *The Diviners* is a cathartic sequel to those stories, a culmination in her series of female journeys to self-discovery. It is the semi-autobiographical story of a forty-seven-year-old Scots Presbyterian prairie woman who finds herself in her writing. It is also a resolution between mortality and instinct, the chronicle of a woman coming to terms with her own strength. . . .

In one sense, *The Diviners* is a cultural catharsis. Morag's personal alienation parallels the broader dispossession of the Scots and the Métis. Morag goes further than [Laurence's earlier protagonists] Hagar, Rachel, Stacey or Vanessa in resolving the tension between pride and love, between the duty of the past and the instincts of the present. In fact, characters from the other novels are introduced and traced against Morag's development. The

fire which kills Piquette Tonnerre must haunt Margaret Laurence because she describes it for the third time in this novel. She shows Niall Cameron, father of Rachel and Stacey and the local undertaker, assuming a communal sense of Scots guilt for the death of the young Métis woman. . . .

Perhaps the strongest statement in *The Diviners* is Morag's growing autonomy as a woman, the discovery of her strength. Margaret Laurence is a vehement supporter of feminism. Like many women who found themselves before "The Movement" existed, her approach is less than rhetorical. Her writing assumes the necessary subtlety of fiction. Nevertheless, issues like physical exploitation, abortion, roleplaying are drawn in intricate detail in all the Manawaka novels, climaxing in Morag's self-definition.

Valerie Miner. *Saturday Night.*
May, 1974, pp. 17, 19, 20

Five books are the product of Laurence's seven years in Africa and her continuing interest in that continent. Her Manawaka books also number five. A book for children and a collection of essays bring the total to twelve. Laurence's African writing and her Canadian-based fiction are closely related. Together they represent a seamless fabric, a steady growth and maturation of a way of seeing which was first formed in Neepawa, Manitoba. The Canadian prairie where her world began is both harsh and beautiful: a land of extremes, of testing, of dignity in the face of defeat. This environment, together with the fact that Canadians have never been an imperial power and have emerged relatively recently from their own experience of being colonized, helped to prepare for Laurence's sympathetic understanding of Somaliland and Ghana in the 1950s. At the same time, the prevailing liberalism of Canadian culture bred a naiveté in the young Laurence which the African experience cauterized.

Laurence's first published work was a labor of love. Her translations, *A Tree for Poverty: Somali Poetry and Prose,* are the first written expression of this ancient oral literature. Laurence had never experienced a foreign culture before Somaliland. Her Preface to the 1970 Canadian reprint apologizes for "unwitting condescending, in the manner of white liberals, out of pure ignorance." Both the 1952 Introduction and the later Preface stress the significance of human differences, cultural and individual. In commenting on the folk tales, Laurence writes of the pride, courage, and humor of the ordinary Somali herdsman, in a land where independence is necessary to survival.

The rigors of desert survival evoked a deep response in the woman from the Canadian prairie who had been raised amid drought and depression. Laurence describes her grandparents' generation as people who had inhabited a wilderness and made it fruitful, people whom she loved and valued because they were great survivors. She also admired the Somalis for their toughness,

their ability to eke out life, their refusal to die easily. The desert sun, she writes in *The Prophet's Camel Bell* (1963), exposed the heart as well as the land. Her descriptions of the harsh and exotic beauty of the desert are often moving, but the most interesting portions of the travel narrative deal with her encounters with people—the Somalis, the expatriates, and, most of all, herself. The travel narrative uses fictional techniques and is essential to our understanding of its author. It is one of her major works.

Laurence's African fiction, a novel and a collection of ten short stories, dramatizes fear and hope, but the resolutions are clearly optimistic. The themes are Laurence's typical ones of freedom and communication. *This Side Jordan* portrays two social groups (white colonial administrators and Africans) co-existing in Ghana in the 1950s as the country moved towards political independence. The British expatriates, managers of a well-established textile company, are threatened by the planned changeover to African management. The difficulty for Laurence was to be fair to the colonial managers and their families. In rewriting the novel, she attempted to make this group more sympathetic, and in retrospect she feels that she has been more successful in probing their mentality than that of the Africans. Most reviewers, including Africans, disagree. Like the stories in *The Tomorrow-Tamer,* the novel is a sensitive portrait of social change in West Africa and the pressures it exerts on individuals and groups.

There is nothing sentimental in the handling of her themes. Man is rarely free, and no one knows this better than Laurence. The other side of the coin is bondage, entrapment, alienation. Some of the bonds are forged by her characters for themselves; some are imposed from without, through various ironies of circumstances beyond their control. Alienation and exile are seen as forms of bondage or psychic slavery. In African and Canadian stories alike, Laurence depicts an often agonizing struggle to break these bonds, to overcome alienation, to achieve an integration both personal and social which is imaged as a freedom to love and accept love, to share, to meet, to touch. Such a state, Laurence implies, is our spiritual home, the human goal, the grail. In stories where the mode is primarily ironic and tragic, the focus is upon the forces that block movement towards this goal. In stories where the structure is comic, the characters are engaged, difficulties notwithstanding, in the long trek home.

Patricia Morley. *Margaret Laurence*
(Boston: Twayne, 1981), pp. 33–35

There is in Canadian literature today a preponderance of women writing about women, among whom Margaret Laurence is both the pioneer as well as, in many ways, the writer of greatest stature. In the light of this study, one way of accounting for this situation is in terms of the archetypal quality of her fiction—in the extent to which it articulates responses which have their origin in the collective unconscious. Laurence expresses what for many has been inexpressible: the growing need to reconnect with ancient feminine principles. These values, some of them implicit but neglected in our patriar-

chal inheritance, some of them long lost in pre-history, are increasingly emer-
gent in modern life. This is especially true in modern Canadian life, where a
people that specialize in the compromise and comprehensiveness of a non-
heroic but mosaically diverse culture are particularly suited to the rediscov-
ery of lost causes, including the "lost cause" of the feminine world-view.
Thus for men and women of all types in our culture Laurence speaks not so
much from personal and topical experience but with "antique authority."

Helen M. Buss. *Mother and Daughter
Relationships in the Manawaka Works of
Margaret Laurence* (Victoria: University of
Victoria Press, 1985), p. 78

There is a touch of irony in the fact that the theme of survival which Laurence
herself recognized as emerging naturally from *The Stone Angel* became the
dominating idea and provided the title for one of the leading works of thematic
criticism during that period—Margaret Atwood's *Survival.*

Thus for many reasons *The Stone Angel* stands as an influential book in
the development of a true Canadian literature during the 1960s and subse-
quent decades, and will continue to interest future cultural historians. It is
also likely to interest social historians for the way it portrays several genera-
tions of farming life on the prairie, and middle-class life on the Pacific coast,
and perhaps especially for the way Laurence uses her characters' speech
patterns as indicators of class and generation.

But the final test of a work of literature is whether it retains the interest
of readers who are not literary or historical specialists. We talk of writers
surviving, of books continuing to live, and by this we mean that they find
readers, generation after generation, who feel that they are entering not only
the minds of the characters but also the fictional world they inhabit. Critics
and literary historians have often argued about the reasons why some books
continue to be read a hundred years after they were written, and others,
popular at the time of publication, are quickly forgotten. I suggest that the
secret lies in a combination of universality and uniqueness. The characters
must be presented, through their thoughts, action, and speech, in such a way
that readers from other cultures can continue to identify with them. But no
character can exist in a timeless vacuum. The environment, the fictional
world that the novelist creates for them to live in, must be unique and self-
consistent, so that it continues to exist in a kind of time capsule that inhabit-
ants of other ages and places can enter through their identification with the
characters.

I believe *The Stone Angel* will survive because it fulfills both these re-
quirements. Hagar Shipley, its heroine, is a universal personification of the
urge to survive, and it is no accident that, as Laurence once remarked, North
American readers accepted her as everybody's grandmother. Yet at the same
time she is fiercely independent as a character in her own right, a whole
personality. In the same way, by creating her fictional town of Manawaka,

Margaret Laurence has on one level epitomized the characteristics of all small prairie towns; indeed, of all rural towns everywhere. Yet Manawaka as we experience it in *The Stone Angel* is unique, a self-contained world of the imagination that will survive in the mind long after the actual prairie communities of which it reminds one have passed away.

George Woodcock. *Introducing Margaret Laurence's The Stone Angel: A Reader's Guide* (Toronto: ECW Press, 1989), pp. 17–18

Statistics indicate that in real life the number of women who are enacting what was traditionally women's role—that of homecentered wife and mother—is diminishing rapidly, and it is the same in fiction. In fiction, as in real life, the external characteristics of the role are changing radically, but the recurrent appearance of a maternal figure in the contemporary fiction of women writers such as Margaret Atwood, Margaret Drabble, Doris Lessing, Iris Murdoch, Alice Munro and Margaret Laurence testifies to the continuing power of the archetype as distinct from its societal and time-conditioned image. In *The Fire-Dwellers,* in Stacey MacAindra, the only protagonist in Laurence's Manawaka novels enacting the traditional role, Laurence creates a remarkable portrait of the life of a middle-aged mother-of-four with all its horrors, its impossibilities—and its absolute centrality to feminine experience. A sensitive and challenging definition of the maternal emerges that renews the concept for modern times and yet links it with the biblical woman whose children rise up and call her blessed. Laurence's focus encompasses not only an external, forceful and easily recognized social reality, but also a rich and sensitive internal perspective that often corresponds to and illuminates work done by Eric Neumann, Joseph Campbell and other followers of Carl Jung in the study of archetypes. . . .

Such a woman as Stacey has the potential to break what [Adrienne] Rich calls the cycle of women's lives "lived too long in both depression and fantasy while our active energies have been trained and absorbed into caring for others." Laurence's portrayal of what Rich calls "courageous mothering" is a remarkable achievement of characterization. Never does the universal psychological validity of the character intrude upon the vitality, individuality and spontaneity of the particularized protagonist, and yet never is the accuracy of the psychological realism betrayed. The colloquial, comic and ironic understatement of the narrative voice does not relieve the reader of an obligation to enter into an often painful yet liberating comprehension of what the experience of being both a mother and a woman entails.

Nancy Bailey. In Colin Nicholson, ed. *Critical Approaches to the Fiction of Margaret Laurence* (Vancouver: University of British Columbia Press, 1990), pp. 107, 117

Margaret Laurence's *The Diviners* is a novel of attentive social consciousness examining the interaction of the individual and the constructions of Canadian society in the mid-twentieth century. Unusually for its time, the novel presents a relentless refusal to be heroic or to search for determinist patterns. Yet rather than the bleak canvas of modernist writing or the brightly colored juggling collage of the postmodern, Laurence draws a picture of necessary action, for her an action of articulation, in the midst of social and political structures that work by repressing articulation because it exposes the points of contradiction in their agenda. The exposure of contradiction is part of the humanist resistance to a determinist/liberal tyranny, that shuttles between fixed structure and positionless flux breeding both complacency and fear, grabbing at tradition or heritage or genealogy in the face of change that appears to bring community breakdown.

The world of Morag Gunn is a set of structured consolations in which the complicity in relationships of social order and power is shown to be supportive and comforting. Within this world there is a necessity for an articulation of the consolation, a speaking out that reveals the hidden or evaded or oppressed/repressed and gets to the point of contradiction in people's lives. The issues are many, but the focus is upon women and men, children and adults, minority and powerful, pivoting around history and writing both as means of articulation but also as topics in themselves.

The Diviners presents history initially as legend, something that provides a pattern and an inevitability because it has happened, is in the past and is possible to recount. But a substantial part of Morag's life is concerned with recognising the shifts in the re-telling of legend, and learning the techniques and strategies needed to construct and make history which does not purely console: in the context of the re-telling each person has to find the points of difficulty, the parts that do not work smoothly in her life, at the same time as resisting the urge to fabricate a version of events where all things do work smoothly, effortlessly fitting in and creating yet another consolation. The techniques and strategies to be learned are intimately part of the skills of oral and written communication; and Laurence tells us that the need to practice that communication is "strong and friendly. But merciless." There is an energy of need yet the work is not God-given but learned.

The narrative of the novel is an explicit illustration of the issues both as topics and as actions. There is a tentative split between the articulation of the construction of gender in the re-telling of Morag's past, interleaved with the articulation of the familial, the child/adult relationship in the telling of the present interaction between Morag and Pique. Yet the story of the re-telling gives the reader Morag as a child, then Morag the adult defined as a child by Brooke, followed by her rites of passage into defining herself as an adult, and superimposes this past on the present.

Lynette Hunter. In Colin Nicholson, ed.
*Critical Approaches to the Fiction of
Margaret Laurence* (Vancouver: University
of British Columbia Press, 1990), pp. 132–33

Margaret Laurence is usually regarded as a "regional" writer concerned with Canadian history and myth. It is true that her writing gives voice to what she has called Canada's "cultural being," "roots," and "myths," and *The Diviners,* the last novel of the five-volume Manawaka series which occupied a decade (1964–74) of her career, associates personal quest with the search for Canadian past. But in *The Diviners* Laurence writes against wider and older traditions, reworking epic quest and Shakespearian romance in a revision of a central myth of our culture, that of the "fortunate fall," and proposing an alternative conception of "paradise" and "the artist." Laurence also defines herself against Modernists James Joyce and T. S. Eliot, drawing on *A Portrait of the Artist as a Young Man* for her portrait of the artist as a young woman, and on *The Wasteland,* which similarly draws on Shakespeare's *Tempest* (and for the same reasons Laurence does) for its concern with the uses of the past. . . .

The image Laurence uses to suggest the interdependence of past, present and future is that of the river that flows both ways. This figure suggests time in both its subjective and objective aspects: time that is subjective—memory—moves backward, time that is objective moves forward; and the novel concludes with the paradoxical injunction, *"Look ahead into the past, and back into the future."* This backward and forward movement implies that past influences present, but it also suggests that the present influences the past, that we *can* change the past: and indeed within the present episodes of the novel, Morag does change the past. By imaginatively reconstructing it, conjuring it with memory and language, she wrests what is valuable from it and transforms bondage to freedom, bequeathing a more hopeful legacy to the future.

The "use" of memory, then, is liberation. So also is the use of the literary tradition, "for liberation." On the simplest level, Laurence gives her female protagonist the male part, allowing her to act as epic hero who founds a new order and assumes the powers of Prospero—artist, magician and Shakespeare's figure for himself. Actor, writer and director of her "plot," she attains an authority and authorship which enables her to transmit something of value to the future. But the power of the artist is a resignation to the *limits* of power, a relinquishing of characteristically "masculine" attributes of rationality and control and an attainment of a difficult humility that comes from involvement with others. Laurence reworks the idea of the artist and paradise to a contemporary feminist perspective: and it is a reworking as significant as Milton's adaptation of classical epic [to] Christian values, Wordsworth's adaptation of Milton's *Paradise Lost* to his autobiographical *Prelude,* or Joyce's adaptation of *The Odyssey* to his epic of modern life, *Ulysses.* Unfortunately, however, the parallels with *The Tempest* also suggest the sense of finality which Laurence expressed elsewhere, a "second sight" that turned out to be all too true, since this was her last novel.

<div style="text-align: right;">

Gayle Greene. In Colin Nicholson, ed.
*Critical Approaches to the Fiction of
Margaret Laurence* (Vancouver:
University of British Columbia
Press, 1990), pp. 179, 200–201

</div>

Margaret Laurence has afforded readers of *The Stone Angel* significant insight into Hagar Shipley's character through various allusions to literary archetypes embedded in the narrative. The biblical story of Hagar has garnered the bulk of critical attention for obvious reasons, although Shakespeare's *King Lear*, Coleridge's Ancient Mariner, Keats's Meg Merrilies, and Joyce Cary's Sara Monday have also received prominent consideration. Nevertheless, whereas each of these analogues illuminates one or more key aspects of Hagar's predicament, none can be said in itself to embrace the whole. For this, I believe, we must turn to Milton's *Paradise Lost,* one of the most influential books in Laurence's background. Clara Thomas records that Laurence kept and treasured her mother's calfbound copy of the poem, which she reread "repeatedly, before and during the composition of every novel," and that among the author's papers at York University is "a sheaf of pages folded over and labeled 'Morag's Notes on *Paradise Lost*.' These are notes in Morag's voice, not Margaret's, on each book of *Paradise Lost*." Not only does Morag study Milton's epic while boarding at the Crawleys', but she also marries a Milton scholar and titles one of her novels *Shadow of Eden,* all of which indicates how thoroughly the great work had been assimilated into Laurence's creative imagination. It is not surprising, therefore, that she should have turned to Milton's Satan as the prototype for her own proud, rebellious angel. Indeed, within the context of the Manawaka Cycle, *The Stone Angel* represents Margaret Laurence's vision of Hell, with Hagar Shipley manifesting the characteristics of the most notorious fallen angel. . . .

The extent to which Hagar Shipley repeatedly subverts life-enhancing impulses in herself and others marks the extent to which she personifies evil in the Manawaka world. Indeed, her dominant characteristics—pride, envy, anger, selfishness, bigotry, among others—are the very ones Rachel, Stacey, Vanessa, and Morag battle against with varying degrees of success. This is not to suggest that Laurence either affirms through Hagar the formal constraints of Milton's religious philosophy or subscribes to the Puritan doctrine of predestination. Rather, I believe the creation of Hagar represents her humanistic and artistic response to the tragic irony of the Satanic predicament: the potential of self-deluding pride to strike inward and outward simultaneously, for proof of which she needed to look no further than her own grandfather. Moreover, the introduction of classic vampire imagery effectively takes Hagar's dilemma out of a strictly religious context by placing it in a modern Gothic construct. To be sure, there is grace and the promise of redemption in Laurence's vision, but Hagar eschews them even at the last and knowingly defeats herself in accordance with the provisions of free will: "I'll drink from this glass, or spill it, just as I choose." I believe the wonderfully ambiguous "And then—" that concludes the novel implies that Hagar does in fact spill the water, rendering her final grasp for independence as futile as her escape to Shadow Point. Like Satan, she can traverse the miles to alter her estate, and she can distort language to mollify her guilty pride, but she cannot escape the Hell within.

<div align="right">

Paul Comeau. *Canadian Literature*. 128,
1991, pp. 11, 21

</div>

Most critics of Margaret Laurence who have focused on the spiritual quest in her fiction have stressed the Biblical references which support an orthodox religious interpretation of her search for transcendence, in an attempt to reconcile her writing with the Judeo-Christian vision. One states the case like this: "How can [Laurence's] pejorative view of the institutional church be made to tally with a clearly Christian pattern of providential action which marks her novels?" But *is* it clearly Christian? Laurence refused to be pigeonholed on her religious beliefs, stating, "I don't have a traditional religion, but I believe there's a mystery at the core of life." "I don't think we can define God, but if there is a conscious will aside from man, I think it leaves us a free will. It is up to us to save the planet." The "us" she refers to here is, I would suggest, women. In response to one query made toward the end of her life about whether her work implied that we should look toward a female principle for spiritual guidance, Laurence responded very emotionally that she had long hoped this trend would be observed in her work. She called *The Diviners* her spiritual autobiography, and it represents the apotheosis of her quest. To Margaret Atwood she confessed, "I don't think I'll ever write another novel." . . .

In tracing Laurence's shift in consciousness from androcentric orthodox religion to "gynolatric," or "woman-reverencing," spirituality in the Manawaka novels, I want to stress the predominance of fat goddess and grotesque mother images. Laurence also emphasizes the themes of birth, pregnancy, and mortality. Each novel represents the four elements central to ancient goddess worship: earth, air, fire, and water. Where she does use Biblical imagery, it is generally subverted, in an attempt to break way from the dualistic philosophy which has characterized Western theology, or to give precedence to the immanent which has historically been denigrated at the expense of the transcendent. Laurence wants us to see that spiritual freedom is not a question of either/or, but instead an acceptance of the possibilities of both/and.

The iconoclastic nature of each heroine's rebellion as she struggles against orthodox religious structures is marked by confrontation with such issues as motherhood, suffering, fate, generational conflict, and social withdrawal, all seen from a woman's perspective. Each woman embarks on her own journey involving a "dark night of the soul" and finds herself an outcast. Marginalization thus becomes a position of power, a way of knowing, a way of seeing differently. On one hand, Laurence regrets the tragic loss of community when strong individuals are alienated by stratified institutions which create the loss of genuine spiritual vitality and lead to the polarization of the individual and society. On the other hand, it is clear that Laurence herself was becoming increasingly disillusioned with and losing faith in patriarchal monotheism.

Elizabeth Potrin. *Canadian Literature.* 128, 1991, pp. 25, 27

LAVANT, CHRISTINE (AUSTRIA) 1915–73

Das Kind (1948; The child), *Das Krüglein* (1949; The little jug), and *Die Rosenkugel* (1953; The rose ball) are collections of stories in which childhood experiences are depicted with great and authentic originality. The most remarkable quality of these pieces is probably the writer's accuracy (not in the least calculated) in giving shape, from the roots up so to speak, of the child's world with its demonic features. The author does not actually "empathize" herself into a child's mind but almost unconsciously participates in its confused fears, fantasies, and the things that happen to it.

Rudolf Hartung. *Neue deutsche Hefte.*
September, 1956, p. 397

Christine Levant's new volume, *Spindel im Mond* (Spindle in the moon), picks up where *Die Bettlerschale* (The beggar's cup), left off. It is as if here the second part of a diary had been placed in front of us. . . . There is the play of free association with a repetition of the same words and themes. The effect could have been monotonous and tiresome, and it speaks in favor of Lavant's poetic power that we will continue to return to the book in order to listen to the same or another poem. We are rewarded by wonderful discoveries.

Wieland Schmied. *Wort und Wahrheit.*
1960, p. 212

[S]he earns her living by crocheting and she has published her verse and gained recognition and prizes under the pseudonym Christine Lavant. Her verse collections—*Die unvollendete Liebe* (1949; Unfinished love), *Die Bettlerschale* (1956), and *Spindel im Mond* (1959)—mark the point where the restoration of modern German literature meets with the genuine tradition of its creative genius, and the uneasiness of a contemporary soul is redeemed by its acceptance of primeval images like the bread, the wine, and the dove.

Heinz Politzer. *Germanic Quarterly.*
1960, p. 124

The present fashionable climate which prefers the irrational, the obscure, the incomprehensible, myth and mysticism, gloom and despair has certainly favored the recognition which was given to Christine Lavant's verse. . . .

The world of Christine Lavant is unsophisticated, unpretentious, naive like the sphere of the fairy tale, full of enchantment, anxiety and terror, in spite of the difficulty of some of her images. . . . Her world of hallucinations and somnambulism indicated in the very title of this volume of verse (*Spindel im Mond*) is conjured by a childlike voice whose night-

mares are mitigated and consoled by the comfort and glory of a baroque Catholicism, native to the Austrian culture landscape.

Ernst Waldinger. *Books Abroad.* 1961, p. 366

The title, *Spindel im Mond,* may surprise the reader, but the strange image is the product of a style with a language that wishes to be heard. *Spindel im Mond* reminds us of a tool of the Norns who capriciously decide man's fate. . . .

At first the reader is inclined to regard such metaphoric language as outdated. As the title indicates, the image of the moon appears in many poems. Since, in addition, the poems are rhymed, the casual reader might assume they should rightly be relegated to the period of Brentano or Eichendorff. But this is not a romantic, a sentimental moon—it is not even the prop for a romantic setting! And it is capable of symbolizing the essential meaning of our bitter contemporary period.

Tradition is continued and at the same time new lyrical territory is entered in Christine Lavant's poetry. Beyond all the energetic manipulation of modern poetic trappings, beyond her obvious general imitativeness, it is possible to hear her own artistic voice, which is not merely highly individual but also genuinely relevant to our times.

Dieter Arendt. *Welt und Wort.* 1961, pp. 274–75

Lavant is at home in the enchanted regions, in the border forests of the mythical; that is, those places where many poets claim to dwell today although only their intellect undertakes the wishful journeys to artificial paradises and equally artificial hells. . . .

Nowhere does the impression arise of the remote, the hermetic, since the veil of estrangement is cast over the world not for the sake of a fashion or whim, but because no other possibility exists: and this is accomplished with a good deal of artistic delight in playfulness. These poems are a witch's spell spun out endlessly, as well as the powerful confession of a tormented soul.

Gerhard Fritsch. *Welt und Wort.* 1965, p. 228

After the appearance of the first volume of lyrics, Miss Lavant published nothing for seven years. During this period she succeeded in overcoming domination by Rilke, transforming this experience into an integral part of her own verse. Of the rose, borrowed in the beginning from Rilke, she fashioned her own poetic symbol. The reader familiar with the poetry of Georg Trakl will quickly identify this further influence during Miss Lavant's formative years.

Obscurity in lyric poetry is hardly a negative quality; Miss Lavant's obscurity, however, is of a lucidity which often makes it truly dumbfounding. A phrase or a line frequently offers an obvious meaning, which then fails entirely when introduced into the poem as a whole. A masterkey to this poetry is not offered. . . . even when the poetess fashions a symbol, as she

has done in the rose, it is of so many and varied facets, that its true meaning must be established anew in each poem. . . .

One would not know from this world of poetry that there had been a major global conflict during the lifetime of the poetess. Social and economic conditions are likewise lacking. The sphere from which this poetry arose is personal and individual. . . .

She runs a dangerous course in her writing; few modern poets would be tempted to speak of bread and wine, the dove or daily bread in verse. Christine Lavant does this, however, making these symbols meaningful, often in both their original context and the new environment which she gives them.

W. V. Blomster. *Symposium*. 1965, pp. 35–36

Despair assumes a hundred faces in Christine Lavant's poems. It can speak out in all the roles the self assigns to itself or in which the self wrestles with God and devil, earth and heaven. Despair can appear gentle and exhausted in the attitude of subjugation or violent and direct in the language of a madman dancing like a stag at bay.

Grete Lübbe-Grothues. *Zeitschrift für deutsche Philologie*. 1968, p. 622

Nell. Four novelettes . . . make up this collection. Not many contemporary writers have seen and reported the unceasing assaults on the human spirit as Miss Lavant has seen and reported them. . . . But whether she describes the profound pain of the wife and mother who bargains with God, the supreme mortification of the lonesome spinster or the orphan girl who are scorned by the world, or the deep spiritual distress of the schoolboy whose loyalty is divided between two female teachers, human hurt is always mixed with inner hope, is never naked, unalloyed despair. The common leitmotif in these stories is the bitterness of the human condition and the forlornness of unloved people, but also the arcane and inspired communication that in the end God is the only refuge.

Robert Schwarz. *Books Abroad*. 1970, p. 305

Ever since she was recognized as a major postwar poet in 1956 Christine Lavant has not quite fit into any literary school. She has been called a religious mystic, but her God is too often a cruel and demonic tyrant who takes rather than gives life. She has been called a post-expressionist poet, a surrealist, a nature poet, and a *Rilke-epigone;* the baroque quality of her poetry as a typically Austrian heritage has been pointed out as well as the mannerism in style and the tensions in subject matter. Yet all of these attempts to put her into a frame of reference have left parts of her poetry unexplained and the puzzle of her uniqueness unsolved. . . .

In her poetry death and guilt are invariably bound up with images of female barrenness; isolation is hubris or sinful pride. . . . Lavant's work mirrors the ambivalence she felt toward her creativity. She does not minimize

the pull, the need for the traditional familial ties. After all, they offer compensations. But through circumstance and choice that became a way of life she renounced those ties for the sake of her art. The price of loneliness and isolation that she paid for her freedom runs through her poetry as a thread of suffering. Stepping outside the traditional social pattern made her feel singled out and at times defiantly proud of her isolation, which gave her the courage to challenge the personifications of those social and implicitly religious demands—the overpowering father-figure of God or vaguely defined potentially destructive male figure, occasionally addressed as an absent lover. But quite as often she is overwhelmed by guilt, longing, humility, and a feeling of loneliness. Both attitudes are closely linked; they are the flip sides of one coin, and in the context of personal and social emancipation their inextricable simultaneity marks the transitional phase of development, in which problems and basic injustices are experienced on an unconscious emotional level rather than verbalized, put into perspective, and rationalized.

Lavant's poetry shows hardly any awareness of what went on in the world around her. If most of her poetry deals with pain and suffering, it is always her own personal suffering, physical and metaphysical at the same time. And yet her poetry is highly political in the sense that it is a poetry of alienation, a poetry in which the "I" is seen as the other, the outsider battling against a closed social, religious, and linguistic system in which not even the most familiar concepts and definitions coincide. . . .

Lavant's alienation from any social group as well as from the hierarchical society in which she lived, is total. It affects her relationship to religion and more specifically to the dogmatic God of Catholicism. It determines her attitude toward society at large, which, if focused upon at all, is a brute and anonymous otherness insensitive to the sufferings of the self and in league with a cruel God. What society and religion offer and what Lavant demands in her poetry do not correspond. Society and religion do not speak her language. This is one reason why her poetry is considered impenetrably hermetic. . . .

What makes Lavant interesting in a feminist context is her transitional position in women's poetry, where rebellion is carried out less on a level of ideas and rational argument than on an unconscious level. Yet rebellion on this nonargumentative level turns language itself into a tool of subversion. Neither in her life nor on the surface level of her poetry—themes, ideas, content—was Lavant an iconoclast. Her only rebellion was withdrawal and a refusal to conform to fashionable trends on the contemporary literary scene. In her life as well as in her poetry she followed her own vision with a single-mindedness that suggests a strength and self-confidence one might not suspect. . . . Like most women artists caught in the transition between acceptance of the system and a new awareness, she herself, body and soul, becomes the battlefield of the two worlds. The demands of society and, in Lavant's case, of religion are too deeply internalized not to cause intense guilt-feelings and self-hatred at their being challenged. As a result we encounter the am-

bivalence between self-abnegation, a feeling of inferiority that has often been called masochistic, and rebellion. Each step toward autonomy and freedom is purchased at the high price of isolation, guilt, imagined or real punishment, and self-doubt.

Waltraud Mitgutsch. *Modern Austrian Literature*. 17, 1989, pp. 79, 81–82, 102–3

LAVIN, MARY (IRELAND) 1912–

To me [Mary Lavin] seems reminiscent of the Russians more than of any other school of writers and, with the exception of the gigantic Tolstoy, her searching insight into the human heart and vivid appreciation of the beauty of the fields are worthy in my opinion to be mentioned beside their work. Often, as I read one of her tales, I find myself using superlatives, and then wondering if such praise must not necessarily be mistaken, when applied to the work of a young and quite unknown writer. And yet are not such doubts as these utterly wrong-minded? For if there is no intrinsic thing in any art whatever, irrespective of its date or the name or age of the writer, how then can there be anything in good work at all? How, if we cannot recognize great work when we come across it unexpectedly, have we any right to say that even Shelley or Keats wrote well? Should we not rather say in that case: "I have been told that they wrote well"? I know people who can never tell a beautiful piece of silver-work or furniture until they have first found out the date of it. If it is over a hundred years old they think it is bound to be good, and if it is made in this century they think it is bound to be bad. Often they are right in both cases, but they have no judgment whatever and, though they are quick to find out the date of a Chippendale chair or the hallmark on a piece of old silver, and will praise their beauty immediately after doing so, nevertheless the emotions that should respond to beauty can only be awakened in them by the aid of a catalogue. That is a very sorry state to be in.

Let us therefore always praise intrinsic beauty whenever we see it, without concerning ourselves with irrelevancies, such as the age or name of Mary Lavin or how on earth she came by her astonishing insight.

Lord Dunsany. Preface to Mary Lavin. *Tales from Bective Bridge* (Boston: Little, Brown, 1942), pp. ix–x

Don't let anybody tell you that Mrs. Lavin, who was born in Massachusetts, looks upon the Irish scene with alien eyes. With this distinguished novel [*The House in Clewe Street*] she takes her place among the best writers Ireland has produced in a hundred years. . . .

As a novel, *Clewe Street* is probably too long; it runs to 530 pages. But tragedies told briefly are six for five cents in your daily newspaper. Again, time passes slowly in Trim, and how else than by a piling up of detail is a novelist to convey the sense of slowly passing days? How else, indeed, can one give power—as Mrs. Lavin certainly succeeds in doing—to what must otherwise have been a rather trivial story?. . .

I must pay tribute to Mrs. Lavin's quite exceptional talent; here is some of the finest writing that has come out of Ireland in many a year, and though there is great and laudable honesty, there is no vulgarity in this book. Other reviewers, I am aware, have thought the characters wooden, but that, I think, is a very wrong idea. I have not in years come across a portrait so appealingly true as that of Aunt Theresa. It is the case however, that the lyrical note is strong in Mrs. Lavin's prose; and her characters, though sharply and firmly conceived, are infused with a kind of poetic intensity that carries them, I suppose, to the point of verging on abstractions; so that you can, perhaps, forget at one moment how real these people were the moment before. But you won't have any trouble of this sort, be sure of it, if you happen to have any Irish relations of your own.

<div align="right">David Marshall. Commonweal. July 20,
1945, pp. 340–41</div>

Miss Lavin's novel [*The House in Clewe Street*] was partially published in serial form in America as *Gabriel Galloway:* the change of title points to the weakness of the book. If the central subject is the boy his fortunes do not really begin to unfold until about a third of the way through—on page 149 he is not yet quite seven: if the theme is the fortunes of the house then that drops out of the picture not much under a third from the end. This frailty in forming the central concept, the "What-is-this-I-am-at-exactly?" also affects our pleasure in Miss Lavin's stories which equally charm us by their delicacy and puzzle by their dissipation.

This may be purely a matter of a technique that is not as yet quite surefooted, and the timing all through *The House in Clewe Street* is possibly mainly responsible for it. Thus the death of the child's father is given a slow treatment, although Miss Lavin agrees that the boy will hear of this past only in gossip about lives before his own "that will not provide any depository of experience from which he can supplement his own inexperience": whereas the death of the grandfather occurs in a flash, although of the boy's consideration on death *that* night she says: "Leaf by leaf, petal by petal, our impressions are laid down": and just before that he has had a slowly-told day in the fields with a poor neighbor's children—ending, it is true, in a graphically pictured mimicry about what dead people look like, but, surely taking a disproportionate time to get to that point, if that is the point?

The pleasure of the book, as by corollary, is that it contains a great many separate delights; whether she is describing a girl letting out the tucks of her dress; or swans on the river—"one had to glance at the banks along which

they passed in order to perceive that they were in motion; nothing about their compact, calm demeanor suggested the furious activity of webbed feet that propelled them forward": or a girl opening her umbrella—"such gestures at once familiar and unfamiliar pierce the heart like a shaft."

She is, however, herself alone responsible for our impatience with her faults, natural in a first novel. Hers is a quality that demands to be judged by the highest standards: she is, obviously, the most promising young Irish writer of our time.

<div style="text-align: right">

Sean O'Faolain. *The Bell.* April, 1946,
pp. 81–82

</div>

[*Mary O'Grady*] is a novel of motherhood which tells the story of Mary O'Grady from the time she leaves her native Tullamore to marry a Dublin man to the day of her death some forty years later.

Miss Lavin, a talented Irish writer with a fine knowledge of the human heart, succeeds in making Mary O'Grady a character of depth and dimension, yet paradoxically she fails to make this somber chronicle of a mother come fully to life. Where Mary O'Grady's story should be moving it is often monotonous, where it should be simple it frequently seems contrived, and where it should ring with rich Irish laughter it is, alas, strangely lacking in humor. Furthermore, while Mary O'Grady and, to a lesser degree, her three daughters are well realized, the men, including Tom, the husband, and the two sons, Patrick and Larry, seem blurred and fuzzy. . . .

Disappointed in her hopes for her children Mary, alone in her shabby and disordered home, finally finds peace in her memory of the love she has known and given and in her dreams of meeting her husband and children in the next world. Miss Lavin's portrait of an Irish mother has warmth, loyalty, understanding and pride. But somehow the feeling aroused by the series of tragedies which befall Mary O'Grady is one of mere sadness rather than deep compassion.

<div style="text-align: right">

Richard Harrity. *New York Herald Tribune.*
January 29, 1950, p. 10

</div>

Miss Lavin's novel [*Mary O'Grady*] is the story of Mary O'Grady, the country girl from Tullamore, who loves and marries a Dublin tram driver: it is the simple life of a woman whose love dictates her days, love for her husband and for the children that are soon born to them—and for the first thirty pages or so it is exquisite. Truly and surely, with that gift which Miss Lavin has for understanding what life means to the simple, that gift of illumining the commonplace and making touching the ordinary, she moves over Mary's married life in Dublin, with its babies coming like the seasons, and the young woman's instinct for beauty fastening itself upon the grass of a vacant building lot. Miss Lavin's rich and poetic powers of writing are well seen in what she makes of that grass.

But this enchanting prelude, at once momentarily satisfying us and sending our expectation questing ahead for its development, is not followed by a body of work equal to it. I do not mean to suggest that the level of the writing does not rise through the book to the standard of the opening. All through there are passages of great beauty and grace—it would hardly be Miss Lavin's, if this could not be said of it. But the development of the theme does not equal as a whole the opening; still less does it swell out from it, and the reader ends baffled and disappointed.

What happens is that into the closed, warm and loving world of Mary O'Grady, whose only weapon against Fate itself is unquestioning affection, disaster on disaster crowds. Death, madness, illness, estrangement stalk in, as in an Elizabethan play. Tragedy supplants idyll and lyric, or rather, what should be tragedy, but remains only inexplicable calamity, supplants early happiness. . . .

Mary O'Grady, therefore, full of evidence as it is of the writer's talent, is yet a disappointing book. It is disappointing because this extraordinary talent, which no one doubts, has as yet not found its appropriate outlet in the novel. It is a talent highly poetic, sensitive and subtle in many directions, which to use Coleridge's words of Wordsworth has the power to throw the coloring of the ideal world over the ordinary things of life, and yet which has not refined itself of much dross, which still lies fitful and gleaming, embedded in a mass of the arbitrary, the ludicrous and the inexplicable. If Miss Lavin could cut away these needs, there would shine a jewel indeed.

Lorna Reynolds. *Dublin Magazine.* April,
1951, pp. 58–59

Miss Lavin is much more of a novelist in her stories than O'Flaherty, O'Faolain, or Joyce, and her technique verges—sometimes dangerously—on the novelist's technique. That has its advantages of course. In her later stories there is an authenticity and solidity that makes the work of most Irish writers seem shadowy; not the life of the mind interrupted by occasional yells from the kitchen, but the life of the kitchen suddenly shattered by mental images of extraordinary vividness which the author tries frantically to capture before the yells begin again. The only story in which she deliberately eschews the physical world is the fable of "The Becker Wives," which she sets in a capital city that might be either Dublin or London, and among merchants whose names might be Irish or English, and, for all its brilliance and lucidity it seems to me only the ghost of a story, a Henry James fable without the excuse of James's sexual peculiarities. She has the novelist's preoccupation with logic, the logic of Time past and Time future, not so much the real short-story teller's obsession with Time present—the height from which past and present are presumed to be equally visible. Sometimes she begins her stories too far back, sometimes she carries them too far forward, rarely by more than page or two, but already in that space the light begins to fade into the calm gray even light of the novelist.

She fascinates me more than any other of the Irish writers of my genera-
tion because more than any of them her work reveals the fact that she has
not said all she has to say.

<div style="text-align: right;">

Frank O'Connor. *The Lonely Voice*
(Cleveland: World, 1963), pp. 211–12
</div>

It is a truth not universally acknowledged, that the short story is so subtle
an art form, and at the same time so independent of its surroundings, that a
reviewer does violence to any collection if he reads it straight through, as he
would a novel. Only frail, meagerly developed stories profit from such an
approach; the accumulative momentum, then, provides assurance from story
to story that the author has really constructed a world for us. The richer and
more demanding the story, the more it forces us to participate in its imagina-
tive drama; to read too swiftly a number of stories that require us to think
and feel—like Mary Lavin's superbly artistic stories—would result in exhaus-
tion that might wrongly be attributed to the stories.

A Memory is Mary Lavin's fifteenth book, and her thirteenth collection
of short stories. She has long been recognized as one of the finest living
short-story writers. Uninterested in formal experimentation, she has concen-
trated her genius upon certain archetypal or transpersonal experiences as
they touch—sometimes with violence—fairly ordinary people. The five sto-
ries in this collection emphasize the universality of certain experiences—
love, self-sacrifice, the need to relinquish the world to those who follow us—
but never at the expense of the particular. Mary Lavin's ability to transcribe
the physical world, especially the green damp world of rural Ireland where
many of her stories are set, is as remarkable as ever. She rarely strains for
metaphors, yet her prose is "poetic" in the best sense of that word; if her
people talk perhaps more beautifully than might seem credible, that is what
art is all about.

<div style="text-align: right;">

Joyce Carol Oates. *The New York Times*.
November 25, 1973, p. 7
</div>

[*The Becker Wives*] embraces the normal narrative point of view for Lavin,
selective omniscience. This narrative pattern is most obvious in Lavin's char-
acter vignettes. Many of her stories seek solely to present a character trait
or portrait through an action which will enhance its development. In doing
so Lavin has created a remarkable catalogue of characters such as Miss
Holland, the Inspector's Wife, the Nun's Mother, the butlers of "A Joy Ride,"
the young nun of "Chamois Gloves," Pidgie, and the widow of "In a Café."
In all of these cases the narrative point of view reflects the new mind of the
protagonist and in several stories approaches stream of consciousness.

Deviations from a third-person narrative pattern are comparatively few,
and often these are stories which are so obviously autobiographical that
Lavin drops the third person distancing for a more natural first-person narra-
tive. "Tom," a story which recounts a little girl's relations to her parents,

particularly her father, is a prime example. There is still the element of fiction even in those stories which seem purely autobiographical, but the emotions, if not the facts, have their counterpart in the author's life. "Story with a Pattern" . . . and "Say Could That Lad Be I?" are further examples of Lavin's involvement in her own stories: first, because they concern the nature of her art; and second, because the narrative point of view differs so remarkably from her normal perspective. The latter, "Say Could That Lad Be I?" is a first-person narration by the author remembering the voice of her father, who in turn recollects his boyish adventures with his dog. There is about the story the amorality of elders' tales of youthful derring-do, not the kind that Lavin herself would normally write. It is a father's story, and, as such, presumably holds a place in the author's heart sufficient to publish it along with her own more sophisticated fiction. . . .

There are few experiments in structure in the Lavin canon. Many of her stories are character vignettes in which the action is a mere vehicle for character revelation. Others, in which plot plays a more paramount role, often begin *in medias res,* with the ultimate details of the action informing the meaning of the characters who participate as well as the plot itself. An example of this is one of the most popular of Lavins' stories, "The Great Wave." The exciting details of the tragedy appear in a flashback in the mind of a bishop revisiting the island on which he and another youngster were the only survivors of the great wave. The story carries with it, because of this distancing of time, the attitude that the disaster may have been the work of divine providence. The realistic details of the frame and the disclosure of the identity of the bishop at the end lend both a sense of reality and a perspective of distance at the same time, putting the disaster in an historical context but preserving its immediacy.

<div style="text-align: right;">

Zack Bowen. *Mary Lavin* (Lewisburg,
Pennsylvania: Bucknell University Press,
1975), pp. 54–56

</div>

Each of Mary Lavin's stories appears linear in structure, supporting the first impression of simplicity. Between beginning and end, however, stretch particles of life, held by forces that both repel and attract, vibrating with unseen energy like the famous line that Marcel Duchamps perceived and tried to paint. Applied to the fiction of Mary Lavin, such metaphor and analogy are appropriate, because they introduce ideas that affect her work: as an artist conscious of and curious about the creative process, she is intrigued by all concepts and perceptions that challenge the human mind. Techniques and theories of other forms of art are, to her, applicable to literary art: she herself tries consciously to see with the eyes of a painter or sculptor, to hear with the ears of a composer or musician. But she is intensely interested also in those developments in the social and natural sciences that affect human understanding of the world in which she, we, and her characters live. The observations and speculations about the nature of the human species

that these offer are refracted for her by the prism of human personality in response to questions that, attempting to understand these observations and speculations, she asks herself. What kind of person would think or feel that way? Under what circumstances would that kind of person think or feel that way? What kind of person never would think or feel that way? How would that kind of person think or feel under those same circumstances?

Such probing of personality, sometimes painful and relentless in its intensity, invites comparison with the work of Virginia Woolf. At the same time, the author's awareness of the self-protective limitations to human understanding seems similar to that of Henry James. And her evolution of a range of personality types, particularized in different roles and different situations, with different identities and different social and intellectual backgrounds, is not unlike Gertrude Stein's attempts to present "bottom nature." But this focus on character is never separate from consideration of milieu. Accidents of birth and environment are presented by Mary Lavin as forces that play on universal sensibility. Thus she exhibits also, for those seeking her literary antecedents, if not the English, something of the French naturalists.

Janet Egleson Dunleavy. *Irish University Review*. Autumn, 1977, pp. 222–23

The key narrative event in Lavin's "A Cup of Tea" is deliberately and deceptively simple and insignificant—a mother and daughter fall into a heated argument over whether or not boiled milk spoils the taste of tea. The truth of "A Cup of Tea" exists in the emotional undercurrents in the family which briefly come to the surface during the incident of the boiled milk. The unspoken antagonism between Sophy and her mother, because of the mother's empty life with her husband and Sophy's desire to escape the emotional circle of her mother's failure, flares out into the open for a brief moment in spite of their efforts to avoid a confrontation. The fact that the daughter has been away at the university and has just returned home for a visit aggravates and intensifies the emotional conflict and sets the stage for any minor incident, even boiled milk, to provoke an outburst of pent-up emotions.

"A Cup of Tea" is told from the third person limited perspective of the mother and shifts to Sophy's perspective only in the last moments of the story. The narrative, then, focuses on the mother's desperate and futile efforts to keep her feelings of frustration and loneliness under control, while she tries to enjoy her daughter's visit. Her need for her daughter's affection and approval, however, is so strong that it is only a matter of the time it takes the milk to boil until mother and daughter release their mutual resentment and hostility. When Sophy is finally alone, she comes up with a simple solution to her family's emotional problems that, unfortunately, reveals only her own inexperience and her fragile hope that she will escape the mistakes of her father and mother: "People would all have to become alike. They would have to look alike and speak alike and feel and talk and think alike. It was so simple. It was so clear! She was surprised that no one had thought of it before."

One of Mary Lavin's finest stories, "A Cup of Tea," also has the basic characteristics of her fiction, the eternal conflict between individuals with naturally opposed interests and sensibilities and the brief revelation of one individual's lonely and bitter life when faced with a disturbing confrontation with its opposite self. Other early stories like "At Sallygap" and "A Happy Death," are carefully designed studies of the breakdown of the emotional relationship between husband and wife. In each story, Lavin skillfully uses a shifting perspective to expose the secret loneliness and buried hostility and frustration that have been festering over the years. Later in her career, after her brief and temporary interest in the story with a pattern, she converted her basic theme, primarily because of the tragic loss of her first husband, William Walsh, into the widow's painful and frightening search for self-identity. "In the Middle of the Fields," "In a Café," and "The Cuckoo-spit" are not only symbolic of her recovery from her own grief and despair; they also signal a return to the form of her early stories after a phase in which she gave her critics what they wanted. Each of her widow stories, narrated from the perspective of the widow, marks a phase in a long and difficult struggle to understand the relationship between past memories and the emotional pain of the present in finding a new life and identity.

<div style="text-align: right">Richard Peterson. <i>Modern Fiction Studies.</i>
Autumn, 1978, pp. 392–93</div>

Lavin is not a feminist in the contemporary sense; she is a "quiet rebel" who prefers to take an ironic stance, like Jane Austen, directing her detached gaze upon the foibles of men and women alike. Her vision has little in common with that of Doris Lessing, or of Sylvia Plath, or even Virginia Woolf, whose work and life inspired her own first attempt at writing fiction. Yet the treatment of women in Lavin's stories, particularly her treatment of the woman as artist, is at least as central to an understanding of her work as her treatment of the Irish character. One should remember, however, that "there is no such thing as *the* female genius, or *the* female sensibility." If Lavin's treatment of the relationship between femininity and creativity differs in important ways from the treatment of similar themes in the work of more fashionable writers, that is all the more reason to enrich our understanding of "the female sensibility" by paying close attention to her work. . . .

The world from which her mysterious women-artists retreat, on the other hand, is a real world, and its flawed actuality is reported with zest by a witty, ironic voice, the instrument of a shaping and controlling imagination. Like the widow of the story, "In a Café," the artist as writer of short fiction organizes her experience by scrutinizing the world outside herself closely and compassionately but from an ironic distance. To conquer loneliness and isolation, she confronts them directly but keeps them contained within a small frame. The mysteries of creativity she refuses to look at directly, except through the veil of myth. Faced with conflicting demands upon her time and energy, the woman-artist steadies her wrists, as it were, like the old watch-

maker, and concentrates all her craft upon the small but complex object before her. Perhaps the work most revelatory of Lavin's attitude toward her own life and art is the fine story, "Happiness." It tells of the death of Vera Traske, who suffers a stroke while cultivating her garden, from the point of view of her daughter, who recognizes that her mother's belief in and pursuit of "happiness" has been a conscious commitment requiring great courage and control. That control, manifested as craftsmanship, is the essence of Mary Lavin's image of the artist.

Patricia K. Meszaros. *Critique*. 24, 1982,
pp. 39–40, 52

LEDUC, VIOLETTE (FRANCE) 1907–72

Why does Simone de Beauvoir want at any cost to make us acknowledge the "moral earnestness" of this touching sixty-year old [Leduc]? I am afraid that Beauvoir is succumbing to a fondness for moralizing, to a need for idealization that is even more suspect than the annoying inclination of puritans to point the finger at a scandal. This error undoubtedly arises from the belief shared by a number of contemporary novelists, especially women novelists, that audacity lies in the use of certain words and the description of certain acts. But true audacity is that of ideas. . . .

The testimony of Leduc [in *The Illegitimate Girl*] is meant to be cruel and overpowering—a savage cry against society. It is true that Mme. Leduc has not led a dull life. An aggressive and abandoned mother, a strange and unsuccessful marriage, a friendship with Maurice Sachs. But what primarily gives the book its terrifying strength is Leduc's sense, justified or not, of her physical ugliness. A revelation like this is not made to reconcile her with the world.

How can anyone not be touched by the despair of the narrator when, walking with Hermine, she hears this remark thrown in her face: "If *I* looked like that, I'd kill myself!" We would then expect a complaint that would awaken in us some healthy revolt against the world of appearances and false values. But Leduc consoles herself on the bosom of Hermine in such a manner that she runs the risk of dismaying tender souls.

Naturally, this writer will have scornful critics who will accuse her of vulgarity, indecency, conformity to ugliness, and who knows what else. I consider *The Illegitimate Girl* the most moral book I have read in a very long time, because it is the most likely to discredit the "anti-physicals" (as they said very nicely in the seventeenth century), the most appropriate to turn young people away from old women who hold out poisoned candy, the best calculated to bring us back to virtue.

Gilbert Ganne. *La revue de Paris*.
December, 1964, p. 104

This collection of three novellas [*The Woman with the Little Fox*] (her novels remain unpublished here), confirms an impression of her autobiography [*The Illegitimate Girl*] as an uneven, perfervid letter to the world in which she struggled to find the communion denied her in her life and writing. She was defeated. To the reasons adduced above, we must add her own artistic failure. The extraordinary intensity of her recall of childhood betrayal coerced her memoirs, as it had her existence, into a continuous howling reenactment. One longed for the imposition of some distance, her release as well as ours, from the "frightful quantity of I's and me's," which Stendhal correctly foresaw could render the writer tiresome.

The fictional process has brought respite from Mlle. Leduc's self-indulgent trancelike stare at her mirrored reflection. She has shifted her eyes, as it were, to look over her shoulder. Pursuing herself from this changed perspective, backward and forward in time, she wrests from her overwhelming early experience a set of alternate possibilities. With these stories of three women, she moves us with minor, wholly original art.

The Illegitimate Girl exasperated: the novellas are agitating. We waver between mystification and blood recognition; so, one imagines, it must be to witness primitive rites. Bits of objective information—a packet of instant pudding, typists' fingers, gift-wrap ribbon—tell us the events are of our day. But the evidence is irrelevant; we are floating in existential time. An intractable lens twists the familiar world into strange shapes which reason rejects but to which our instinct responds.

> Muriel Haynes. *The Nation.* January 23,
> 1967, pp. 118–119

Violette Leduc may be described as Simone de Beauvoir's answer to Genet, so earnestly sponsored by Jean-Paul Sartre. Her novel, *The Illegitimate Girl,* is supposed to be largely autobiographical, and describes a life of petty crime, perversion, wretchedness and despair. *Thérèse and Isabelle* is about a "love" affair between two schoolgirls at a French boarding school, and describes in salacious detail all their exercises in mutual masturbation in the school lavatory, in a classroom, in the dormitory and in a hired room in a nearby town. It is the kind of book which used to be considered pornographic and sold under the counter; nowadays it is described by its reputable publisher as "a classic account of an all-too-familiar, yet unknown event . . . a powerful, touching and sometimes shocking book . . . hailed in Europe as a masterpiece. . . ."

Needless to say the book is unrelieved by any gleam of humor or true imagination; it is just about two little greedy animals tearing at one another's bodies in search of some sort of appeasement of their clamant appetites. No doubt it will provide the aging and the impotent with a quick flicker of interest; it might even induce young girls who stumbled upon it to try out the practices described, though this, I am happy to think, is more questionable.

Otherwise, it is difficult to see the point of it, except perhaps to relieve Mlle. Leduc's feelings and to excite the admiration of Mme. de Beauvoir.

As will be gathered, I do not share the view that *Thérèse and Isabelle* is a masterpiece, nor that Mlle. Leduc is a considerable writer. If the book, instead of being about little girls masturbating, had been about, say, playing basketball, no one would have paid the slightest attention to it. It represents the last scavenging for sensations in a disintegrating materialist society whose bad dreams have become its art.

<div align="right">Malcolm Muggeridge. Esquire.
September, 1967, pp. 14–16</div>

Madness in the Head is [Leduc's] second volume of autobiography, taking up where *The Illegitimate Girl* (published in English in 1965) left off. *The Illegitimate Girl* brought Violette Leduc the public attention which her novels, though critically esteemed, have never had. . . . All her novels were in any case fragments of a disguised autobiography, and perhaps their logical outcome was explicit autobiography. *Madness in the Head* tells of the creation of these novels, of how, already nearing the age of 40, she became a writer.

If *The Illegitimate Girl* describes the weight of a malediction—the stigmata of her birth, rejection by her mother, guilt and will to self-annihilation, narcissism and first homosexual loves—*Madness in the Head* is a story of this malediction redeemed and forged into a vocation. In Simone de Beauvoir's terms, it is an example of a destiny taken in hand by a liberty: transformed by the choice of freedom. The book is in part the story of a salvation through writing, through assumption of the risks of confession and the effort to fix one's perception of the world on paper, the daily struggle with pen and notebook to render exactly what has been seen. This is the interior "madness" referred to in the title. . . . She chooses imprisonment—in the "black den" of her room, in the solitary labor of writing—in order to escape the inner prison.

A phrase runs through the book like a leitmotif: Simone de Beauvoir's question, "Have you been working?" By working she means writing. At the start of the book, we are in Paris after the Liberation, and everyone seems to be writing: Sartre, Camus, Nathalie Sarraute, Jean Genet, Arthur Adamov, Simone de Beauvoir herself. Pages are being filled at the tables of the Café de Flore and the Deux Magots. One has the impression of a whole nation writing madly, attempting to bear witness to the time and the place, trying to save itself through writing. . . . [But] it would be a mistake to give the impression that *Madness in the Head* is primarily a picture of the literary scene in Paris between 1945 and 1949. It is the story of an utterly personal literary vocation, assumed in despair and never quite believed in.

<div align="right">Peter Brooks. The New York Times.
October 3, 1971, pp. 4, 41</div>

For Violette Leduc, and for the long French tradition of which she represents the thin, dwindling end . . . reality is inert until it is cast into language, celebrated in a literate consciousness. Mme. Leduc can thus admit that words often kill what they are meant to frame. . . . She can recognize that there are all kinds of human occasions that just won't go into language . . . but still write on, torrentially, undeterred.

Where language for Beckett, say, is a poisoned gift, a set of vicious circles, the possibility of infinite lies, for Mme. Leduc, as for Genet, it is freedom. You are and you can have whatever you can name. By a kind of magical nominalism, you possess whatever you can think of in language. . . .

The point [in *The Taxi*], I take it, beyond the trickery and dainty pornography (incest thrown in for those who like their vicarious kicks lightly spiced), is a gamble with language: you speak the unspeakable, you have two characters talk when what they are up to is seemingly beyond talk. Indeed, the book is *all* talk. The children lapse into significant silences now and then, while they get down to other things, but they are out of them like lightning. There is something desperate here, which Mme. Leduc's technical virtuosity releases but cannot hold. Language is being used not only to quicken an otherwise dead reality, and not only to suggest how incapable we are of silence, but to make do somehow in reality's total absence.

Here and in other works, Mme. Leduc suggests that mediocre lives can have their intensities, their fine moments which will not die on them. We can even organize our intensities, in the way that the children in *The Taxi* set up their day as a glory to remember, a provision to see them through a tedious normal life to come. We have to make demands on life, claim our due of passion, as the lady in *The Woman with the Little Fox* fails to do—she is so old and so little worn, we read, that even beauty seems moth-eaten by the side of her. . . . But a glance at some of Mme. Leduc's early books . . . and her later work suggests that life for her is less a record of lived passions than a substitute for them, a literary insistence on something that has no life outside literature. We hear the sound of an echoing solipsism, the voice of a person alone in a prison of exciting words, and again we think of Genet.

Michael Wood. *New York Review of Books.*
August 10, 1972, pp. 15–16

In Violette Leduc there was a striking contrast between her imaginary life, filled with hallucinations and obsessions, and her attitude towards reality. She dreaded death: at the least shiver, the least feeling of illness, it seemed to her that life was running out of her. Yet she underwent the two operations required by the most terrible of diseases with an astonishing serenity. . . . Her unconscious was determinedly sanguine; it did not believe in old age nor in death nor in the hallucinations she invented for herself. When she went into hospital at Avignon in the spring of 1972 she was convinced that she was merely suffering from an upset liver. When she left she wrote and told me

how happy she was to be home again and to know that her illness had not been at all serious. A little later I was told on the telephone that she had just sunk into a coma: the doctors had let her leave the hospital because there was nothing more they could do for her. She died without having recovered consciousness, without suffering and apparently without anxiety. She was buried, as she wished, in the graveyard of her village.

At Faucon she had drafted the end of her autobiography. I think it will soon be possible to publish some passages from it. I hope so, because in her case it is impossible to separate the books and the flesh-and-blood woman who wrote them. She turned her life into the raw material of her works, and that gave her life a meaning. [1972]

Simone de Beauvoir. *All Said and Done.*
(New York: G. P. Putnam's Sons, 1974),
pp. 51–52

For Violette Leduc the bond with mother was all the more powerful because there was no father. Illegitimate daughter of a houseservant made pregnant by *le fils de famille,* Violette was brought up by two women—her mother and grandmother. Her childhood attachment to mother was, by clinical standards, excessive, "neurotic," "abnormal," contributing, as in the case of Proust, to adult forms of sexuality deemed deviant by the culture in which she lived. For our purposes we view her devotion as a magnified form of motherlove— a paradigm of passion that we all once knew.

In strangely beautiful passages of poetic prose, Leduc evokes a sense of oneness with her mother deriving from their initial physical union. . . .

In returning to an embryonic stage of life through the vehicle of imaginative autobiography, Leduc reminds us of a central fact of existence: that we are all, as in the title of Adrienne Rich's ground-breaking book, "of woman born," and that the attachment to mother is the first fact of life. Separation from the mother's body is the second. Projecting herself back to the foetal mind, the author relives the trauma of birth. Whether or not this trauma remained alive in her unconscious since that time, as Otto Rank believed, the feelings of pain and fear are recaptured in writing and reclaimed by the adult in search of her origins. . . .

In this respect, the case of Violette Leduc is both characteristic and atypical of the female experience. Birth bestowed not only the common wounds of humanity and womanhood, but also the shame of illegitimacy and the seeds of a deep mistrust for men. Mother let it be known that men are, at worst, heartless swine; at best, distant gods to be courted with caution. Their favor is fundamentally irrational: it confers legitimacy and illegitimacy. You can never be sure.

Marilyn Yalom. *Essays on Literature.*
8, 1981, pp. 74–75

Each [of Leduc's primarily autobiographical works] is, in fact, a fresh attempt to organize her life along the lines of fiction and to create a unity. In *La Bâtarde,* the attempt becomes a struggle as the narrative structure collapses into a series of episodes, and the sentences—short, dry and almost brusque—maintain their separateness.

Indeed, this lack of continuity is apparent through the work. Each time the narrator successfully establishes a "ligne directrice," each time unity seems possible, gaps appear and the continuity is destroyed. The narrator's construct betrays itself. This pattern is particularly significant in the structural role played by Violette's guilt. Since guilt dominates *La Bâtarde,* it constitutes a "ligne directrice." It transforms the work into a chronicle of illegitimacy in which the protagonist's anguish centers around her birth and in which references to the circumstances of that birth, as well as to the physical and emotional pain it caused her mother and to the financial difficulties it entailed, recur obsessively. Guilt, in fact, determines the structure of *La Bâtarde,* for the metamorphosis of that guilt is therein replayed. A solid core forms around the protagonist's birth, diffuses over her sickly childhood, and is finally transformed into feelings of artistic, intellectual and physical inferiority. The narrator thus establishes guilt as a unifying force.

The nature of Violette's guilt, however, contradicts its structural role, for its psychic effect can only be debilitating. Indeed, applying psychoanalytic tools reveals that guilt actually promotes psychic disintegration. Investigating the sources of that guilt shows how the superficial unity described above is continually being subverted. The psychoanalytic perspective itself serves both to characterize that continual subversion and to highlight the resulting oscillation between deep structure and surface structure. . . .

More generally, writing does not serve as a unifying force. Not only are its results temporary, but it is also incapable of creating an entity where none exists. What it does, instead, is allow the narrator to acknowledge the presence of the incorporated other and to come to terms with her own fragmentation. It allows her to accept her byline as a collection of individual letters, rather than as a sign of inner unity. In fact, she stresses the separateness of its parts. . . . Finally, writing allows her to pause in her frantic search and embrace—if only briefly—both the statue formed in the Imaginary state and its obligatory silence.

Jean Snitzer Schoenfeld. *French Forum.*
7, 1982, pp. 261–62, 267

Unlike most authors, Violette Leduc did not write her autobiography after becoming a well-known writer; rather she became a well-known writer through her autobiography. She did not write to recount her success but to lament the lack of it. Paradoxically, by recounting failure she achieved success. Unlike Simone de Beauvoir and Clara Malraux, the major French female autobiographers of the same period whose narratives combined personal issues with historical, political and intellectual discussion, Leduc

drew exclusively from her intimate experiences and wrote only about the chaos of her inner world. . . .

It is true that Leduc frequently apologizes for daring to call herself a writer, and that she often interrupts her work to confess to her readers how difficult it is for her to take her writing seriously. But this distrust stemmed from her background as well as from her insecurities as a woman. She was raised in a social class that considers manual work more useful than the abstract scribblings of intellectuals—especially if, as in Leduc's case, these are neither acclaimed nor remunerated. In this respect, Leduc presents the uncommon example of a writer whose works reflect the consciousness of both class and sex.

But despite her ambivalence toward the writing enterprise, her difficulty in justifying its validity, and her fear that her literary pretensions are misplaced, Leduc never compensates by adopting strategies of conformity, modesty, timidity, or by seeking to "please" readers in the stereotypically "feminine" style to which Beauvoir was referring in 1949. Not only is Violette Leduc totally unafraid "to disarrange, to investigate, to explode," but her entire work rests on the defiant affirmation of precisely such subversions. Her texts read like a stream of violent and richly imaged self-accusations interrupted by moments of tenderness and joyful lyricism. Leduc was the first woman writer in France whose works were published precisely because their originality lay in honest, brutal self-confessions, and in the transformation of psychological desire, shame, and hallucinatory visions into literature. She broke the code of silence by revealing truths that, up to that point, had been off limits to women.

Finding herself in the triple role of misfit woman, anguished human being, and visionary poet, Leduc learned how to give personal chaos meaningful artistic form. But the "unflinching sincerity" applauded by Beauvoir, the "enterprise of masochism, heroism and poetry" admired by François Nourissier, exacted a heavy toll in terms both of Leduc's lifelong social isolation and of the ambivalent response to her publications. The appreciation by some readers of Leduc's "weird mixture of burning, naïve, lucid, and unadorned sincerity . . . and of poetic inner monologue" was coupled by others' wariness toward the exhausting demands her writing made on them. The ambiguous status of Leduc's books, which has persisted since her death, is due partly to the fact that her publisher, Gallimard, has done nothing to generate renewed interest in her oeuvre. Besides a handful of fiercely devoted friends who have not forgotten her endearing eccentricity, and a growing number of scholars who continue to discover "treasures for the asking" in her writing, the larger reading public remains aloof from both Violette the character and Leduc the writer.

<div style="text-align: right;">

Isabelle de Courtivron. *Violette Leduc*
(Boston: Twayne, 1983), pp. 117–19

</div>

Encouraged by her friend the writer Maurice Sachs, she published her first book, *L'Asphyxie,* in 1946. It was a slim autobiographical work that described

one short period of her life. In 1948 and 1955 Leduc published two more books, *L'Affamée* and *Ravages,* in which she again wrote about discrete episodes in her life.

It was not until 1964, with the publication of *La Bâtarde,* that Violette Leduc, at age fifty-seven, produced the first autobiographical work that purported to give a complete chronological account of her life. Or almost complete, for *La Bâtarde* ends with the end of the war, on the eve of the publication of her first book, *L'Asphyxie.* This ending with the author's coming to writing recursively structures the book as a kind of artist's novel. Not only is the author of *La Bâtarde* a bastard child, but the book is a bastard of another kind: a mongrel genre, a cross between an autobiography and a *Künstlerroman.* This crossing of genres in *La Bâtarde* highlights one of the main issues presented both in and by the book: the relationship of life and writing.

For Violette Leduc, this interval of difference, as minimal as it may be, at first imposes the sense of radical incompatibilities between her life and her autobiography. The writing seems to cancel out the very validity of the life whose meaning it is to complete. In a significant analogical shift, she expresses this sense of incompatibility and devaluation as a difference in gender. Not unsurprisingly, she associates biological birth and life with her female gender, while writing becomes a masculine enterprise. Autobiography appears, then, to be a male affair: a paternal supplement to the maternal process of giving birth. The very act of writing by which Leduc asserts her claim to identity simultaneously invalidates her as a woman. Her wish to authorize herself by her writing entails for Leduc the paradoxical and painful necessity of self-repudiation. . . .

Given the fact that what was initially in question for Leduc was her worthiness as a woman, it is not surprising that she should visualize another woman as her muse. The asymmetries of the male and female relations to writing and literary tradition are perhaps nowhere clearer than in the personae of this allegory. While the male writer extends himself by desiring his writing as an other, the female writer, in order to avoid canceling herself by identifying with the male pen, must desire her writing as her self. . . .

La Bâtarde ends with the beginning of a book—not itself, but another book, *L'Asphyxie.* Unlike so many *Künstlerromane, La Bâtarde* does not explain itself, is not recursive. The structure of this autobiography reproduces, rather, the spiral of its own thematic waltz, in its syncopation paradoxically remaining constant to its own fierce but fragile vision. The ending, which defers its own beginning for another sixteen years, opens a free space where, repeating and transforming each other, Leduc's writing and our reading can come (in)to play. At once excrescence and emptiness, generosity and lack, this space is the painful and glorious zone of bastardy where women and their words can re-create (a) life.

<div style="text-align: right">

Martha Noel Evans. *Masks of Tradition:
Women and the Politics of Writing in
Twentieth-Century France* (Ithaca: Cornell
University Press, 1987), pp. 102–4, 120, 122

</div>

The oscillation between love and hate for the mother is felt throughout Leduc's texts, from her early book *L'Asphyxie* (1945) to her last autobiographical volume, *La Chasse à l'amour* (1973). Indeed, it is this tension which produces her texts. Whether they are called short stories (like *L'Asphyxie, L'Affamée,* or *Ravages*) or are true autobiographies (like *La Bâtarde, La Folie en tête,* and *La Chasse à l'amour*) one is struck by the resemblance between all of Leduc's texts, as if they constituted endless variations on a single theme: the story of a loss (the separation from the mother) and the utopic quest for absolute love. But this quest carries its own seeds of destruction. Unable to achieve unity and fearing rejection, Leduc turns against the beloved object and destroys it, thus repeating the initial drama of the separation between mother and daughter.

The texts, *L'Asphyxie* and *La Bâtarde* written sixteen years apart and recalling the narrator's early years, are particularly revealing of this pattern, for they focus primarily on the daughter/mother relationship. *L'Asphyxie,* Leduc's first book, written in 1945, is the matrix around which her creative universe articulates itself. As she recalls in *La Bâtarde,* Leduc "gives birth" to her book in an attempt to free herself from a mother she feels is responsible for her past and present unhappiness. The maternal figure who emerges from this text is that of a harsh, egocentric woman, who inspires nevertheless fascination within her daughter. Leduc unleashes unabashedly her hate for a mother who "never held her hand" and abandoned her, as she sees it, in a boarding school after her marriage. Still close emotionally to the burning memories of her childhood, she produces a text dripping with hate and violence, using short sentences with a staccato rhythm. Writing becomes a cathartic experience during which the mother is immolated.

> Colette Hall. In Michel Guggenheim, ed.
> *Women in French Literature* (Saratoga,
> California: Anma Libri, 1988), pp. 232–33

LEE, VERNON (pseud. VIOLET PAGET) (GREAT BRITAIN) 1856–1935

I have always disliked—quite of course *pour le beau motif*—this author's writings. I have got out of their way whenever I could; they seem to offer me a sterilized atmosphere like that to be found in the work called *John Inglesant* or in the writings of the late Walter Pater. There is nothing that so much irritates and frightens me. This of course is no condemnation. . . . It simply means that this type of literature does not ring my poor old bell; or rather, that it evokes from that instrument of communication overtones that make my poor old head ache.

But I can perfectly well see the adroitness of the workmanship. I can also perfectly well see the culture of mind, the erudition of the historic still-

life; I can perfectly realize that hours and hours must have been spent in meditation before such a novel as *Louis Norbert* could have been produced. To read it is like watching a player of another school playing a game that I do not like. I can admire the deft turn of wrist and the precise evolutions, but they seem to me—a hostile spectator—to be things that evoke no real warmth and an enthusiasm purely intellectual. . . . And it is all admirably done and almost too admirably engineered. There is so much restraint that it would appear as if Vernon Lee were incapable of passion. There are pictures here and there throughout the book—the picture of the English manorhouse, the picture of the birth and smuggling away of the monarch's son; the picture of the Italian household, with the old marchese slumbering on a sofa, the young people poring over documents, the guests reading novels and illustrated papers. Yes, at precisely the right moment Vernon Lee turns on reflections; at precisely the right moment a description of a document, a remark about Mr. Cunninghame Graham, about Mr. Henry James, or about the *Roi Soleil.*

Ford Madox Hueffer. *Outlook.*
June 13, 1914, pp. 815–16

Dr. Vernon Lee has . . . produced some travel sketches [*The Golden Keys*]. They are very slight. . . . On the other hand it must be recorded that Dr. Lee has a tenderness uniquely her own, that her style is fluent and lucid as spring water, and that her culture, though a later age will find it *dates,* is amusingly presented. Dr. Lee talks pacifism, but she is really a reactionary. The Italy she loves is a picturesque ruin, and the Germany a medieval fairy tale. Her resentments are directed less against war, the estranger of nations, than against facts, those destroyers of dreams. It is no secret that she is no longer a young woman, but every reader of *The Golden Keys* will congratulate himself that its author survives to represent a calmer and—be it whispered— more inquisitive age than his own.

Milton Waldman. *The London Mercury.*
August, 1925, p. 437

Most adults these days cannot read Poe; our world seems to us full of evil men and good and evil ideas, and we do not have the moral leisure to be titillated by those vague emotional outrages, all effects, all wrath, remorse and terror, and never a meaning. Poor Poe, ever the victim of responsibility (his own, of course) could not portray goodness and knew nothing about evil except the name of it. But the Englishwoman who called herself Vernon Lee knew a great deal about it. Beauty without goodness (which had fascinated Browning, upset Ruskin and spoiled Pater) made her both see and think. Brilliantly specific and frighteningly controlled are these tales [*The Snake Lady*] of ghosts and appetites, obsessions and revenge.

It is hard to imagine them coming from the straight little gray woman, the pro-German propagandist, with her powerful, orderly, suspicious intelligence,

whom Frank Swinnerton met in 1916. It is hard to think of them being written by the scholarly girl who at fifteen began gathering material for a big historical treatise and published it at twenty-five. The author of a technical work on psychological esthetics; the metaphysician; the popular travel-book writer, the French-born, Italian-reared daughter of an eccentric British gentlewoman—each is an improbable author for these tales.

Yet all of them together were "Vernon Lee" who was really Violet Paget and who died at 79, totally forgotten in 1935. And all of them together produced these tales, which are the products, but not the by-products, of her studies of her esthetic sense acting on history. No other literary revival so interesting as this is likely to happen soon.

<div align="right">

Donald Barr. *The New York Times.*
March 21, 1954, p. 24

</div>

Violet Paget chose the pseudonym "Vernon Lee" because she believed that the public would scorn serious writing from a woman. Such reticence seemed uncharacteristic of a woman who never indicated the slightest hesitancy in pronouncing categorical judgments, who lectured H. G. Wells on his sexual irregularities, and who alienated good friends like Henry James by making them satirical butts in her novels. . . .

In her severe masculine garb, her habit of referring to men by their surnames, and her argumentative manner, no one better exemplified the "New Woman." Most of her life was spent in Italy, a situation which provided her with a defiantly independent attitude in her frequent forays on the English literary scene. Her cosmopolitanism was also responsible for her outspoken pacifism during the first world war.

<div align="right">

Phyllis Grosskurth. *London Daily Telegraph.*
July 23, 1964, p. 18

</div>

Ariadne in Mantua was perhaps the most widely known of Vernon Lee's works, with the exception of the *Genius Loci* essays. It went into three English editions; in America T. B. Mosher first published it in *The Bibelot* in January and February 1906, then in book form in the same year, and a second edition in 1912. Further, it was translated into the most important European languages. It does not appear that Vernon Lee wrote *Ariadne* for the stage. In April 1903, Edith Wharton, who had been asked her opinion of it, pointed out its dramatic defects. "Certainly the idea is dramatic; but even for a play read in the closet it seems to me to lack movement and clash of emotions. . . . The whole romance lives in my memory like a more delicate, a paler, Pinturicchio." Sarah Orne Jewett was [one] of its warmest American admirers. In England it found favor especially in literary circles. Edmund Gosse thought it a "jewel"; Maurice Baring, Magdalen Ponsonby and Ethel Smyth (to whom it was dedicated, with a request for music) too, were full of its praises, and sought to have it produced on the stage. . . . Vernon Lee [wrote] in a friendly letter to Mrs. Granville Barker: "I have never believed

much in the possibility of performing *Ariadne* (I called it on the title-page not a play but a *romance in five acts*); and knowing that I would never consent to alter a word of it, I have never attempted to get it performed: it was intended for reading, not for the stage." However, it was later performed in England, and at a time when Vernon Lee was out of favor with the public, by reason of her pacifist views. In May 1916, the Countess Lytton produced *Ariadne* at the Gaiety Theatre, with Viola Tree as Diego-Magdalen. . . .

It was with her *Genius Loci* type of travel essay that Vernon Lee reached her widest public—in fact, later she rather resented that the public should have preferred what she considered was her minor work to her more serious contributions to aesthetics and sociology. These little essays on travel and places appeared, for the most part, weekly in the *Westminster Gazette*. In all, she published seven volumes of such notes, beginning with *Limbo* (1897). . . . Besides these, she published two further volumes of essays during this period: *Hortus Vitae* (1904) and *Laurus Nobilis* (1909). . . . These little personal essays on various subjects are in the tradition of Hazlitt and Charles Lamb. They are addressed to cultivated, traveled people with time on their hands: nothing separates us from this period so much as the realization that few of us today have the type of cultivated, discriminating taste which would allow us fully to catch their particular savor. . . .

She became in time a tireless observer, with a practiced "eye" for texture, line movement, and with the subtlest discrimination of fleeting shades and tones, whether of landscape, water or buildings. And as an adjunct to this visual sensibility went her profound knowledge of European art, literature and history.

Maurice Baring has written how incomparably rich an experience it was to stroll with Vernon Lee through the streets of Rome or in the Italian countryside. . . .

The travel sketches are mostly of scenes in Italy, Switzerland, Germany and France—of a world, that is, which has almost completely passed away. For the true traveler, the "sentimental" one, in the old sense, these essays call up a poignant nostalgia; but, for the reason that there are few such travelers today, the essays are not likely now to be widely read. Two wars have ravaged much of the countries and rendered callous our spirit.

Peter Gunn. *Vernon Lee* (London: Oxford
University Press, 1964), pp. 179–83

Vernon Lee's writings on what may be called the "poetics" of fiction—after she had written variously on Italy, the Rennissance, and art and literature in general, largely under the influence of Walter Pater and the aesthetic movement, and had also written several novels and stories—belong to that significant period of English theory of fiction which began with James, Stevenson, and George Moore in the 1880s. Yet while she is usually thought of only as a critic of the 1890s, it should be noticed that the more important of her theoretical writings, collected together as ten chapters in a volume of 1923

(The Handling of Words), cover a wider range of time. As far as I have been able to ascertain, the dates of some of these writings are in the mid-1890s, of some others the turn of the century, and of yet some others, say, *circa* 1920–22. This broad time spectrum, however, does not indicate any very remarkable growth of her thoughts; they remain more or less the same, although some faint development might just be traced. The fact is that, spanning the whole literary period that we associate with the names of James, I. A. Richards, and Eliot, Vernon Lee proliferates in the second decade of this century the sharply revolutionary ideas which she introduced in the nineties and thereby showed that she wrote ahead of her time.

One all-pervasive theoretical stance runs throughout Vernon Lee's writings on fiction; that is her concern with the craft of fiction, to which she gives the name "literary construction"—although by "construction" we mean something else:

> The craft of the Writer consists . . . in manipulating the contents of the Reader's mind . . . in construction by his skillful selection of words and sentences.

Thus Vernon Lee gives her own interpretation to the craft of fiction—although to my mind technique would perhaps be a better word for what she means: it is the organization of the novelist's as well as the reader's experiences. Obviously, by giving a psychological orientation to the idea of craft and involving the writer-audience relationship in it, the attitude implies the necessity of the verbal organization of responses to life as one of the central features of prose, especially of prose fiction.

<div align="right">

Amitbha Sinha. *Journal of the Department of English, Calcutta University.* 17, 1981–82, pp. 75–76

</div>

LE FORT, GERTRUD VON (GERMANY) 1876–1971

Hymns to the Church (Hymnen an die Kirche) is poetry in its greatest sublimity. The authentic mysticism, shown in all Gertrud von Le Fort's other writings, is given the full range of soaring wings. Nothing that more completely transcends the mundane has even been written, nothing that remains to haunt the reader with its great organ music of soft diminuendos, sonorous middle octaves and its triumphant fortissimos.

<div align="right">

J. G. Brunini. *Commonweal.* February 4, 1938, p. 27

</div>

The Wreath of the Angels (Der Kranz der Engel) is certainly a masterpiece and unique of its kind, because the spiritual problems of our time are here

interwoven in a humble love story, which reveals, however, the full depths of the Christian word and the best-concealed dangers of modern paganism. The most subtle theological intuitions and psychological insights are involved in the simple form of a novel, but behind it the enormity of the metaphysical struggle between the realm of grace and the realm of darkness becomes apparent. It is the first attempt at an artistic interpretation of the national-socialist phenomenon and of the crisis of the West from a Catholic point of view. It is a milestone in the history of modern Christian art, and is interesting even for the non-German reader just for its typical German character. Probably no other country would have been able to produce such a work, especially in this time. The escape into the pure world of thought, this diving into purely spiritual life, and the utter disregard of all material misery and social problems—this is a particular strength of the Germans.

A book, however, whose plot results less from will and action than from feeling and reflection, a book which is essentially allegorical, will always be difficult for the non-German to comprehend, and even more so for a non-Catholic.

Eva-Maria Jung. *Monatshefte.* 1950, p. 12

Some literary critics have tried to differentiate between Gertrud von Le Fort's works by having them focus on three different centers of interest: *Reich, Kirche, Frau.* Such a distinction seems artificial. In none of her writings will the reader forget her Catholic-Christian attitude, nor her profound interest in women and in the past and present of her fatherland. The only book centering exclusively on the Church is the small collection of *Hymnen an die Kirche* (Hymns to the church); her only work focused on the glamour and misery of her country is the collection *Hymnen an Deutschland* (Hymns to Germany). The latter manifest her ardent love of Germany, her pride in its past, her deep concern with the country's affliction resulting from the First World War, and her hopes for a better future. Here, too, as in her fiction, she interprets suffering as the one way to God, earthly defeat as a means to moral victory, destitution and powerlessness as a lesson to acquire the inner, the genuine power. . . . In the face of such poetry, the author's disappointment in Germany during the period of Hitler's false glory becomes understandable. . . . As she suffered for those who were wronged by the German people and their leaders, her compassion now embraces Germany itself, which she considers purified through judgment and punishment.

Eva C. Wunderlich. *Germanic Review.*
1952, pp. 311–12

One of the principal themes of Gertrud von Le Fort's writing has been the conflict between loyalty to the Church and the temptations of worldly life, especially of the state. *Das Schweißtuch der Veronika* (The veil of Veronica) is her major work. . . . With detailed analysis, though always with logical clarity of exposition, the heroine's girlhood in pre-1914 Rome is presented,

revolving round the problem of faith. The second section of the novel reflects the struggle between religious faith and nationalism in the hearts of the heroine and the man she is to marry.

H. M. Waidson. *German Life and Letters.*
1953–54, p. 242

Gertrud von Le Fort's work is based on the conviction that Christianity must pervade life in all its forms, i.e., not only the life of the Church, but also that of the state and that of the individual. The moment Christianity is allowed to form the centre of life everything falls into shape. The moment its absolute power is questioned decay sets in. . . .

What attitude must the Christian take up in this world of unbelief? Two solutions are offered. The one is that of the Dean in *Der Kranz der Engel* (The wreath of the angels), who insists upon stiff resistance and self-preservation, the avoidance of any contact with the contaminated; the other is that of Pater Angelicus, who sees solution in the sacrifice and the utmost venture of life. The whole trend of Le Fort's work is towards the second solution. It is the one arrived at by all her great characters . . . they all choose the way of sacrifice, for this is the way of love that wins its ultimate victory in the moment of utter defeat. . . . The secret of Christian strength is weakness, such is the message Gertrud von Le Fort has to impart and this weakness carries the seeds of victory in itself.

In linking the individual and the Reich to the Church, Gertrud von Le Fort succeeds in giving man once more roots in the universe; she attains what seems to be more than ever removed from most of us at a time when the foundations of western civilization are tumbling.

W. Neuschaffer. *German Life and Letters.*
1954–55, pp. 30, 36

Of the numerous women writers whose works have appeared in Germany during the last twenty years, Gertrud von Le Fort is probably the one who enjoys the greatest popularity both at home and abroad. . . .

The central position in Gertrud von Le Fort's work is held by the two volumes of *Das Schweißtuch der Veronika.* . . . Both volumes, which contain much that is autobiographical, deal with the relationship between the individual and the church, which seem gradually to have drifted away from each other beginning with the age of classicism when the self-sufficiency of the individual was first proclaimed. . . . The novel shows sharp insights into the causes that have led to Nazism and the tragedy of the second world war. Man has sacrificed love for will, and the will has ended by making man its slave. Man has renounced his humanity, and having become inhuman, he must ultimately put an end to the existence of man on earth.

Apart from her great novel, Gertrud von Le Fort has published a number of short stories which rank among the best in contemporary German literature. They are Novellen in the true sense of the word, being accounts of

unusual events with a turning point, that is, a point where the action suddenly begins to move in an unsuspected direction. What is new is the introduction of a mystical element. . . . Le Fort's importance in German literature is not that of a pioneer, for her work is of a conservative nature. She does not experiment, but preserves the old forms in their purity. Her language, free alike from mannerism and slovenliness, flows naturally and yet is forceful enough to break through to the essence of things and to reveal their hidden symbolism. Her message is one of love without which there can only be destruction; and if, by her style, she should numbered among the foremost German prose writers of our time, by her message she rightly deserves a place among the great humanitarians.

W. Neuschaffer. *Modern Languages.*
March, 1955, pp. 63, 64

The creative power and formal artistry of this poet with the not accidentally Romance name become even more manifest in her stories and novellas. . . . Here are works that are played before an historical background and present new variations on the attitude of the individual toward church and God. . . . Here is a style-conscious, highly intellectual prose art of unusual compositional strength, austere in form and with such consistent grasp of its subject matter that the idea of women's literature is inadequate to encompass it.

K. U. *Welt and Wort.* 1956, p. 336

Gertrud von Le Fort's writings are animated by a powerful and profound gift of symbolic language, have their source in her religious consciousness, and are focused on the timeless-lawful. The Divine Will shines through the caprices of the world and even Evil serves Him—as the "impotence of the Good"—until it collapses as the latter regains its strength. . . . Gertrud von Le Fort's importance is not due solely to the vigorous revival of Catholic faith; it is also a consequence of her ability to transform historical narrative. She transcends chronology and the psychology of history by elevating the historical to the symbolic and mythologizing ordinary facts through the prism of poetic language. Perhaps one may conjecture that expressionism is still bearing fruit in the spiritual turbulence of her prose.

Fritz Martini. *Deutsche Literaturgeschichte*
(Stuttgart: Alfred Kröner, 1958), pp. 583–84

Die Letzte am Schafott (The song at the scaffold) is a "Rahmenerzählung." Its central events are presented within the framework of a letter, written in 1794 by a French nobleman . . . to an aristocratic lady-friend of pre-revolutionary days, now an émigrée. . . .

The themes of *Die Letzte am Schafott,* the perennial problems of Grace, of Evil and of "Angst" are very much in the literary and artistic consciousness of modern German Catholic authors such as Werner Bergengruen and Elisabeth Langgässer. Le Fort, like these writers, has obviously been primar-

ily concerned with the problems as such rather than with the historical background against which they are deployed, and the relevance of the themes of the Novelle to the present day is readily apparent. Le Fort's approach to these themes is basically determined by her religious beliefs, yet she does not force her interpretation of events on her reader, and makes no attempt to suppress the possible rational explanation of the happenings described. By allowing the two characters of the framework to hold divergent views she enables the reader to hover in neutral territory and to decide for himself the significance of the story of Blanche and the nuns. . . . She arouses a direct response to her story in the reader by throwing the onus of decision on to him and the Novelle characteristically ends with the words "Sie haben das Wort." *Tua res agitur!*

<div style="text-align: right">Ita O'Boyle. <i>German Life and Letters.</i>
1962–63, pp. 98, 103–4</div>

Gertrud von Le Fort is a master of the historical novel as it develops out of her triad of themes—*die Kirche, die Frau, das Reich*—not only because her sympathies enable her to reconstruct the past so faithfully and warmly in the spirit but equally because this very historical past, beneath the skillful reproduction of costume and setting serves indirectly to throw a baleful light on physical horrors and mental confusions of recent times. . . . We hear much in our time of the *deus absconditus* in existing literature, and Le Fort's novella *Am Tor des Himmels* (The gate of heaven) for all its weakness of character drawing and contrived situations (due in large measure to the baroque landscaping of her story) is a forthright, honest commentary on the urgency of this timely theme.

<div style="text-align: right">Frank Wood. In Carl Hammer, ed. <i>Studies
in German Literature</i> (Baton Rouge:
Louisiana State University, 1963), p. 141</div>

Gertrud von Le Fort's soft voice seems to drown in that uproar of politicians whom everybody knows today and nobody misses tomorrow. The producers of best-sellers cook up a storm with the same persistence, storming through the day but not surviving it. Such illusion deceives as the large editions of Gertrud von Le Fort's stories and novellas, which continue to be published, prove. There still exist quiet people in the country who listen to the voice of eternity when indirectly or directly it proclaims the great mystery. And since, as always, it is the fateful questions that confront our generation, they find their steadfast and pious answers in the work of this writer.

The reader approaching Gertrud von Le Fort's work less for its creative form than for the answers it offers—although the one is really entwined with the other—will recognize the correctness of our argument. This work contains the pious answers to every existential question that preoccupies our age.

<div style="text-align: right">Theoderich Kampmann. <i>Hochland.</i>
1964–65, p. 34</div>

Le Fort is one of the few engaged writers in Germany today who has success-fully combined a deep personal commitment with a high degree of literary skill and she seems to be chiefly important as an exponent of ideas. . . .

Le Fort's basic theme is the question of man's relationship to God. She has viewed this problem in a variety of settings and against many different historical backgrounds, yet in each work the central issue is fundamentally the same: no matter in what period or environment man is placed, he must cope with and work out for himself what for le Fort is the crucial problem of all existence—his position *vis-à-vis* his Creator. The second theme fundamental to her prose work is that of human relationships. On a very broad basis this theme might be said to be that of almost any novelist, but under the pen of le Fort it has taken on a new significance. As we have indicated, all le Fort's work is conditioned by her background and by her ideological commitment. She accordingly ap-proaches the theme of human relationships from an unusual angle and views it in the context of the *corpus Christi mysticum*. As members of this mystical body all men are intimately bound together: no man is an island and each must bear a measure of responsibility for others. Thus le Fort never views human actions in isolation, but is constantly concerned to communicate her own acute consciousness of their endless repercussions. . . .

No survey, however brief, of le Fort's work would be complete without mention of her concept of the role of woman. Although this is not exactly a major theme of her writing, it is fundamental to her thought and has influ-enced her in all her portraits of female characters. Le Fort is by no means a feminist or an advocate of woman's playing an important role in public affairs; on the contrary, she sees woman essentially as the giver and protector of life, dedicated to the welfare of mankind, but by preference striving after perfection in the seclusion of her home. Woman's life is to le Fort essentially one of self-effacement and humility in the service of others. Her special prerogative is *giving*. . . .

Many other themes occur with greater or lesser degrees of frequency in le Fort's writings; we will mention only two of these which have a particular relevance to the present-day situation, namely, the question of Christian unity and that of the difficulties presented by the advancement of science. . . .

The predominant impression conveyed by a study of le Fort's work is that of a pervading unity of thought and theme and of a consistency in out-look. Her concentration on a limited number of themes increases the overall effect of strength and vigor which the work imparts. It is true that Catholic thought frequently supplies the source of her inspiration, yet her work em-braces wider horizons. Her art lies in her ability to view human life and endeavor with understanding compassion and to raise her theme above its immediate context to a level where it has a universal significance. At its best, her presentation of theme is powerful, urgent and assured, and in these qualities lie her great strength and her importance as a literary figure.

<div style="text-align: right">

Ita O'Boyle. *Gertrud von Le Fort: An*
Introduction to the Prose Works (New York:
Fordham University Press, 1964),
pp. 99–101, 104

</div>

Her stories are marked by their quiet tone and sometimes seem lightweight. One looks in vain for close attention to detail and bite in her writings. Gertrud von Le Fort tends to sketch in with a few light touches here and there the few details she feels necessary for the completion of a background to a story and the result is generally satisfactory; witness, for example, the fading bitter-sweet summer atmosphere of the First World War in *Das fremde Kind* (The strange child). And for all their being lightweight, the stories do not lack effectiveness. Alongside the directness and simplicity of language, there exists an almost hermetic atmosphere in *Die letzte Begegnung* (The last encounter) to increase the element of tension; *Das fremde Kind* has an economy of form and material that is admirable. Critics of her work might argue that there is a tendency to oversimplification.

> Ian Hilton. *German Life and Letters.*
> 1966–67, pp. 117–18

[For] Gertrud von Le Fort, the feminist movement had a "tragic" motivation. Catholic authors of recently published books in the "eternal feminine" tradition continue to oppose the idea of women having authority or becoming "too intellectualized" on the grounds that they then become "defeminized." Criticism of this sort is always directed toward those who fail to conform; never is it directed to the assumptions of the ideology itself.

A striking effect of the "eternal feminine" ideology . . . is insensitivity to injustice. The dehumanizing effects of exclusive male headship are passed over. So too, the effects of inferior education and opportunity are ignored, while energy is expended in describing the imagined evils of equality. It is particularly ironic, therefore, that the Church, which should be leading the way in matters of social justice, should be perpetuating this pattern of thinking and consequent behavior.

The complexity of the problem is indicated by the fact that many women themselves seem to justify insensitivity to the "feminine problem." Some of them have been ardent promoters of the "eternal feminine" (Gertrud von Le Fort [and others]).

> Mary Daly. In Robin Morgan, ed. *Sisterhood
> Is Powerful: An Anthology of Writings from
> the Women's Liberation Movement*
> (New York: Random House, 1970),
> pp. 127–28

In 1965, at the age of eighty-nine, Gertrud von Le Fort published an autobiographical volume entitled *Hälfte des Lebens,* in which she attempted to digest the first half of her life through memory, that sort of "stomach for the mind" as St. Augustine termed it. Despite a disclaimer in the introduction to the work, that it was not her intention to subject her personal life to the scrutiny of literary critics, le Fort nevertheless proceeded to write down her recollections of the era extending from 1876 to 1923. The introduction ends with the declaration that these recollections are "a quiet accounting, which I set down

for myself in the waning years of life, in order to permit the long sequence of experience to pass again in review. They are not actually memoirs, they are recollections, which I have written down for myself and my friends." It is significant that le Fort employs the term *Erinnerungen* in the German, since the process of internalizing experience in order to savor it, contemplate it, and thus see oneself again [is] inherent in the word itself. . . .

Hälfte des Lebens is uniquely suited to provide a personal perspective of Imperial Germany, since the first half of Le Fort's life . . . very nearly corresponds to the era of the German *Kaiserreich* (1871–1918). As a member of the Prussian aristocracy and a *Bismarckkind*, le Fort sketches vignettes of upper-class life in a variety of settings. Understandably, the view of Imperial Germany thus derived is a filtered one. Its character is not that of a ponderous social history, augmented by statistical evidence and awash with minutiae, but a gaze into the shadowy mirror of a remembered past, a conjuring of atmosphere and locale, which is necessarily somewhat faded and yet fascinatingly misted by the veil of time. . . .

A second characteristic of *Hälfte des Lebens* is the importance for its author of a sense of place. In this context, place is to be understood in its broadest meaning as a combination of geographic locale, personal identity, and social position. . . .

The security of knowing oneself as defined by one's place in society surfaces repeatedly in Le Fort's descriptions of everyday life during the Imperial era. . . . As a member of the landed Prussian aristocracy, Le Fort deftly depicts the mores and social customs of this dying class through her recollections.

<div align="right">

Kristine A. Thorsen. In Volker Dürr, ed.
Imperial Germany (Madison: University of
Wisconsin Press, 1985), pp. 182–85

</div>

LE GUIN, URSULA K. (UNITED STATES) 1929–

The Lathe of Heaven . . . is really a very neat performance, accomplishing what science fiction is supposed to do. The time is 2002, the hero a passive man who discovers that his dreams are out of control. George's dreams change reality. Whatever George dreams comes true as he dreams it; moreover, his dreams cover their tracks, changing the past and what people remember as well. Naturally people are reluctant to believe George's story—but George is terrified. His "effective" dreams, as he calls them, began in a small way—a relative killed, a picture changed—but in time he dreams of the alteration of the world and history. The earth's population is decimated; its wars intensified and then halted; an alien planet attacks . . . and all because George dreamed it. An ambitious psychiatrist discovers that under

hypnosis George will dream what he is told and so the psychiatrist can play God, advancing both his own career and history as he wishes—except that, as we know from Freud, dreams like to play tricks.

Ursula Le Guin is extremely inventive. She shifts her continuum of the world and its past every few pages, playing expertly on alternative suggestions as to what we may expect from violence, war and overpopulation. She has a nice sense of irony, too: for all his tremendous power, George remains virtually a prisoner; for all the horror of his dreams, the world actually seems to improve. Science fiction is rarely able to offer a sustained view of an interesting alternative to the world we know, and Mrs. Le Guin does not attempt to do so; instead, she provides the brief glimpses, the partial speculations that I have suggested are essential to a story of this kind. Even her moral—that we cannot stand outside the world and direct it but must be content to be part of the whole—is gracefully developed. It is, after all, what the ecologists are still trying to tell us.

Peter S. Prescott. *Newsweek.*
November 29, 1971, p. 106

Her fiction is closer to fantasy than naturalism, but it is just as grounded in ethical concerns as [John] Brunner's work, despite its apparent distance from present actualities. Though some would argue that her political novel, *The Dispossessed* (1974), is her best work, and others might favor her ecological romance, *The Word for World is Forest* (1972, 1976), or her young people's fantasy, *A Wizard of Earthsea* (1968), today's critical consensus is still that her best single work is *The Left Hand of Darkness* (1969).

In *The Left Hand of Darkness* Le Guin moves far from our world in time and space, to give us a planet where life has evolved on different lines from our own. This world, which happens to be in a period of high glaciation, has evolved political institutions in two adjoining countries that resemble feudalism on the one hand, and bureaucracy on the other. But the most important difference between this world and our own is that its human inhabitants are different from us in their physical sexuality. All beings on the planet Gethen have both male and female sexual organs. In a periodic cycle like estrus in animals, Gethenians become sexually aroused—but only one set of sexual organs is activated at this time. These people are potentially hermaphroditic. Most of the time they are neuter, but then they may briefly become a man or a woman, and in that time beget a child or conceive one. Thus the same person may experience both fatherhood and motherhood at different times. . . . The major effect of Le Guin's imagining such a fictional world is to force us to examine how sexual stereotyping dominates actual human concepts of personality and influences all human relationships. . . .

Ursula Le Guin has been attacked by radical feminists for not going far enough, for using male protagonists, as she does even in *The Left Hand of Darkness*, and for putting other issues, both political and environmental, ahead of feminism. In fact, it is probably wrong to think of her as a feminist.

But I know of no single book likely to raise consciences about sexism more thoroughly and convincingly than this one. And that this is done gently, in a book which manages also to be a fine tale of adventure and a tender story of love and friendship, makes the achievement all the more remarkable. There are few writers in the United States who offer fiction as pleasurable and thoughtful as Ursula Le Guin's. It is time for her to be recognized beyond the special province of fantasy and science fiction or feminism as simply one of our best writers.

<div style="text-align: right">Robert Scholes. The New Republic.
October 30, 1976, pp. 39–40</div>

The Dispossessed . . . has both implicit and explicit connections with anarchism and utopian tradition. Its very title recalls the English title of Dostoevsky's controversial satire *(The Possessed)* on Nechayev and his nihilist gangsterism, a movement related to anarchism through its influence on Bakunin. In its more obvious sense, though, "dispossessed" refers to the freedom from property that is central to anarchism and which is actualized in Odonian society. Indeed, elsewhere Le Guin has indicated her partiality for anarchism as a political ideal, stating that the thematic motivation of *The Dispossessed* was to accomplish for the first time the embodiment of that ideal in a novel. Similarly, the novel's subtitle ("An Ambiguous Utopia") indicates that it is to be read as a contribution to the utopian tradition, while its structure, which alternates chapters narrating Shevek's experiences on Urras with episodes from his life on Anarres, conveys the dialectic of old world and new world that is central to utopian satire and vision.

<div style="text-align: right">John P. Brennan and Michael C. Downs.
In Joseph D. Olander and Martin Harry
Greenberg, eds. Ursula K. Le Guin
(New York: Taplinger, 1979), p. 117</div>

It is not uncommon, as a literary technique, to employ a critical individual who narrates as the action unfolds. Ursula Le Guin takes this device one step further, making of her protagonists participant-observers; in short, she transforms them into anthropologists. Her heroes all seem to have characteristics that separate them from the worlds in which they find themselves: they are either off-worlders whose job may be explicitly that of an ethnographer, such as Rocannon *(Rocannon's World)* or Genly Ai *(The Left Hand of Darkness),* or they are the skeptics and freethinkers in their native society, as in the cases of Selver and Lyubov *(The Word for World Is Forest)* and Shevek *(The Dispossessed).* Because they are outsiders with the outsider's critical viewpoint, they are cast in the mold of anthropologists, with the perspective and unique dilemmas of the discipline. Repeatedly in her fiction we confront individuals who are of society and yet not quite a part of it. The outsider, the alien, the marginal man, adopts a vantage point with rather serious existential and philosophical implications. For Le Guin this marginal-

ity becomes a metaphor whose potency is fulfilled in a critical assessment of society. . . .

Le Guin squarely confronts the isolation and loneliness of her protagonists. Themes such as xenophobia, a suspicion and mistrust of all that is different, are developed in all her work, but reach a clear culmination in 1972 in *The Word for World Is Forest*. Here there is an explicit presentation of the heroes (Lyubov and Selver) as anthropologists in their roles as outsiders and translators. Consistently her portrayal is pessimistic. Such individuals suffer heartily. Abandoned, misread, and psychologically disoriented, they often sacrifice themselves or are sacrificed for their understanding. Yet often they represent the only hope.

Le Guin has, essentially, two modes for presenting her protagonists as outsiders: either they are true aliens (for example, Rocannon, Lyubov, Genly Ai, and Falk-Ramarren [*City of Illusions*]) or they are natives of a society, yet their perception of social life nevertheless sets them apart (for example, Shevek, Selver, Estraven [*The Left Hand of Darkness*], Jakob Agat [*Planet of Exile*], and George Orr [*The Lathe of Heaven*]). In either case, their problems, and more importantly their solutions, are of a similar nature. Their apartness precludes their complete membership in, or commitment to, any particular society. Yet their critical viewpoint gives them an insight into the nature of social relations that eludes their fellows. . . .

In the final analysis, however, Le Guin's anthropologist-outsiders have the edge over their fellows. For all their solitariness, their convictions are strengthened by their ordeals. They are no longer mystified by differences. They can grant humanity to others because they cease to glorify or stigmatize that which is not immediately comprehensible. The irony is that in their realization that opposition does not necessarily imply impenetrable boundaries, they erect barriers between themselves and their society. Because they recognize that the task of understanding is not impossible, they contribute to their own isolation. Their perception of balance is an appreciation of differences. And it is here that the paradox ultimately resides; for if there is an aloneness in the chaos of social life, there is even greater solitariness once order is achieved.

<div style="text-align: right">

Karen Sinclair. In Joe De Bolt, ed. *Ursula K. Le Guin: Voyager to Inner Lands and to Outer Space* (Port Washington, New York: Kennikat, 1979), pp. 50–52, 64–65

</div>

In the nine novels and numerous short works which she has written between 1962 and 1976, the exploration of imaginary worlds has provided a framework for an exploration of the varieties of physical life, social organizations, and personal development open to human beings. At the same time, this richness and variety suggest the ethical concept underlying her work: a celebration of life itself, through a joyful acceptance of its patterns. This concept is expressed not only in the works themselves, but in her vision of the artistic

process which brought them forth. . . . In general, her characters are engaged in a quest, both a physical journey to an unknown goal which proves to be their home, and an inward search for knowledge of the one true act they must perform. The development of the plot, then, takes on a deeper significance than is usual is science fiction, with its emphasis on action for the sake of entertainment. The Le Guin character often initiates actions which have personal and social consequences. . . . More important than the pattern of plot, however, is each character's movement to an understanding of this pattern: to an acceptance both of the integrity of each individual life, and of the place of each individual within the overall pattern of life. . . .

Le Guin's weakness is a paradoxical tendency to impose moral and ethical patterns on her work, so that form and content work against her philosophy. This didacticism is most evident in "The Word for World Is Forest" (1972), "The Ones Who Walk Away from Omelas" (1972), and passages of *The Dispossessed*. The author's statement of values precludes their discovery, in contrast to the process, most notable in the Earthsea books, whereby the reader shares naturally in the characters' growing awareness of the right direction of their lives. Such a tendency is inevitable, however, given Le Guin's serious concern with human experience and conduct. It is this concern, usually embodied convincingly in individuals' actions and perceptions, which has made her one of the most notable writers to choose science fiction as a framework for discovery.

Ursula Le Guin's work, then, is mature art: rich and varied in content, skillful in presentation, joyous in its celebration of life, and, above all, thoughtful in approach, rooted in and developing a significant personal philosophy. The maturity is literal as well as literary.

<div style="text-align: right">

Susan Wood. In Thomas D. Clareson, ed.
*Voices for the Future: Essays on Major
Science Fiction Writers,* vol. 2 (Bowling
Green: Popular Press, 1979), pp. 154–56

</div>

Surely one sign of the serious artist is the willingness to subordinate the part to the whole. Somehow, through her faithfulness to the controlling conception of the work, the artist hopes to create a whole that transcends the sum of its parts. I think Le Guin has done this in *The Left Hand of Darkness,* but that is not all of her accomplishment. The artist's desire for coherence can lead to dogmatism; in this case, unity can easily become sterility. Freud observed that life resists order, that perfect order is synonymous with death. This observation is germane to *Left Hand,* not only because the dualism it implies is thematically relevant to Le Guin's holistic vision but because the book offers us both the satisfaction of artistic unity and the richness of a complex diversity. For almost every statement she gives us, Le Guin supplies a counterstatement. No truth is allowed to stand as the entire truth; every insight is presented as partial, subject to revision and another perspective. . . .

Such subtle but pervasive insistence that every truth is a partial truth is, of course, wholly consistent with Le Guin's controlling vision for this book, since if she allowed any truth to stand as *the* truth, the sense that wholeness emerges from a tension between dualities would be lost. The delicate balance of conflicting possibilities that Le Guin posits means, for one thing, that the book is rarely in danger of becoming dogma. It also means that, for a complete expression of Le Guin's holistic vision, nothing less than the entire structure of the book will suffice. The final whole that emerges is the book itself. And this kind of unity, which encompasses within itself all manner of diversity, makes *The Left Hand of Darkness* itself an example of the creative fecundity that is possible when differences are not suppressed but used to create a new whole. For all these reasons, *The Left Hand of Darkness* is one of Lee Guin's finest books, and an enduring literary achievement.

N. B. Hayles. In Joseph D. Olander and
Martin Harry Greenberg, eds. *Ursula K.
Le Guin* (New York: Taplinger, 1979),
pp. 113–15

The importance of Ursula Le Guin's contribution to science fiction lies in her ability to use a distinctly Western art form to communicate the essence that is Tao. In many of her novels, Tao is the universal base upon which societies and individual characters act. The fact that Tao exists not in rational systems but in life and the imaginative construct of life that we call art makes the critic's task of revealing the methods and materials of Le Guin's imaginative integration a very difficult one. . . . The Taoist mythos . . . permeates the three novels—*City of Illusions, The Left Hand of Darkness,* and *The Dispossessed*—which I think best communicate it. . . .

Le Guin is a deliberate, conscientious writer who not only creates fully developed cultures in each of her novels, but who has woven them together into an entire cosmogony, giving, in the course of all her novels and stories, a history of the spread of civilization from Hain-Davenant to the Ekumen of eighty worlds, of which Terra is a part. She weaves social and political commentary into her cultural presentation, as in the conflicts between Karhide and Orgoreyn in *The Left Hand of Darkness,* or Anarres and Urras in *The Dispossessed,* always set within the larger scale of humanity as an integral part of the balance of the cosmos. Finally, her style mirrors the balance of her themes. Her writing moves gently but inexorably. To use another analogy from Lao Tzu, it is like a deep pool of water, seemingly inactive, but actually teeming with life. She, too, like the Sage, influences by actionless activity. The value of her work lies in the combination of all these elements, and others, into a complete overview of what it means to be human, no matter on what world, in what cultural subdivision, humans find themselves.

Dena C. Bain. *Extrapolation.*
Fall, 1980, pp. 209, 221

Le Guin is a seeker who uses her imagination. If she returns again and again to fantasy and science fiction, it is not only because these genres are traditionally ones that make use of journeys and marvels. It is also because they offer great scope to the creative mind. Le Guin is convinced as she explains in her essay, "Why Are Americans Afraid of Dragons?", that we must use imagination, as long as it is disciplined by art, for our minds to be fully alive and well.

She says this in defense of fantasy. But what is true of fantasy is, for her, also true of science fiction. She recognizes that they are different forms and, after her early novels, she has tried not to mix them. But, all the same, she feels that there is a similarity between them. . . .

Le Guin is a romantic, and as a romantic she values love, nature, adventure, marvels, dreams, the imagination, and the unconscious. Like the romantics, she is aware of the dark side of things and is attracted by it, even when she prefers the light. She values the individual and his or her struggle for personal liberation. And she expresses that struggle in a language that, while straightforward, makes use of poetic metaphor. But like the Brontës, she manages to be romantic and realistic at the same time. Her early apprenticeship to the description of people's daily lives, even if those lives were led in a country that cannot be found on any map, taught her skill in handling specific detail. She uses that skill to good effect in her fantasy and science fiction.

However, it is hardly surprising that she did not find a publisher for her first novels. Romantics are not welcome nowadays in mainstream literature. It is in fantasy and science fiction that such an unfashionable attitude can find a home, since these genres offer a great deal of liberty to the writer. Certain conventions have to be observed, but within these conventions there is scope for the widest variety of outlook, approach, and style. Because of her love of personal freedom, Ursula K. Le Guin has chosen the genre that affords the greatest freedom to her mind, for which we can well be grateful.

<div style="text-align: right">

Barbara J. Bucknall. *Ursula K. Le Guin*
(New York: Frederick Ungar, 1981),
pp. 153–54
</div>

Le Guin's earliest difficulties in achieving publication were caused by the genre problem. Her first stories were set in the imaginary country of Orsinia, but were neither fantasy, nor science fiction, nor realism. As a result they were repeatedly rejected. She learned that in order to be published in this country, one has to write pieces which are easily categorized. When she aimed deliberately to write a clearly definable science-fiction story, she found a ready market for it.

Although the publications continued steadily once they had started, the genre problem returned to plague Le Guin in a different way at the height of her success. The problem afflicted even her greatest triumphs, that is, the Earthsea trilogy, *The Left Hand of Darkness,* and *The Dispossessed.* The

Earthsea trilogy was labeled not only fantasy, which in this country was not regarded seriously in the late 1960s, but also children's literature. As a result it did not receive proper critical attention. The special issue of *Science-Fiction Studies,* for example, neglects the trilogy altogether. The case of *The Left Hand of Darkness* and *The Dispossessed* was not a matter of neglect because of genre but of misinterpretation based on genre. While their recognition as science fiction novels gained her both awards and an international reputation, it also narrowly categorized her as a science fiction writer. Much of the negative commentary that met both of these novels was based on generic assumptions. Rather than extending the definition of science fiction to include her richly innovative techniques, several commentators attacked the novels for not adhering to an accepted narrow definition of science fiction. What is especially significant about both of these novels is that they have in fact extended the limits of science fiction. . . .

What are the distinctive traits of this versatile and gifted writer? First and foremost is her myth-making ability. As reflected in the title of one of her early interviews—"Meet Ursula: She Can Shape You A Universe"—she has the ability to create a completely coherent and convincing secondary world, with authenticating details on language, history, myth, climate, geography, calendar, flora, and fauna. The authenticity is confirmed by much more than superficial details of landscape. Drawing on her anthropological background, Le Guin is able to create cultural concepts for her imaginary societies. . . .

Le Guin's mythopoetic imagination is gracefully fulfilled and embodied in her elegantly precise style. In her hands language is a flexible instrument, and she is equally adept at humor, vivid description, straightforward suspenseful narrative, stream-of-consciousness, and nuances of dialogue. . . . Neither flat nor static, Le Guin's characters experience both internal conflict and moral growth. To do justice to either Ged or Shevek, to cite just two examples, one would have to recite their development in full, for they mature through experience. As a result many of her characters are convincingly contradictory: courageous and fearful, humble and proud, lonely and gregarious. In short, they are real.

Narrative structure is also a distinctive feature in Le Guin's fiction. Almost none of her novels falls into a pattern of simple linear plot. Even in her early fiction, she experiments with the circular journey as structure as well as theme. She later tries basing structure on point of view (e. g., *The Left Hand of Darkness*), and she creates parallel and double structures (*The Dispossessed* and "The New Atlantis"). All of these structural experiments involve to some extent manipulating point of view, and all are at the same time exact manifestations of theme. Never simplistic, Le Guin's fiction aims at an organic interweaving of plot, theme, character, and structure. . . .

Still another striking feature in her fiction is Le Guin's use of imagery, both verbal and nonverbal. The verbal imagery is, of course, a molecular unit

of her writing style. The nonverbal images, however, tend to resonate in the reader's memory long after finishing the novel.

Charlotte Spivack. *Ursula K. Le Guin*
(Boston: Twayne, 1983), pp. 154–55, 159–61

Le Guin's conception of heroism . . . is—like the ubiquity of human values in her cosmos—admirably enlightened yet somehow also fundamentally optimistic, denying the ineluctable difference of the truly alien by making the central feature in heroic behavior a refusal to *be* alien-ated. Le Guin's heroes insist on the negotiable status of difference; the plots both of *The Dispossessed* and *The Left Hand of Darkness* involve successful negotiation. Le Guin's Hainish cosmos is thus tailored to demonstrate the power of individual heroes, the altruism of their heroic impulse, the advancement of society through violation of its laws, and the persistence of humane values despite often unfavorable cultural conditions. (Genly Ai, imprisoned in totalitarian Orgoreyn and moved by the special treatment given him by fellow-prisoners, muses: "It is a terrible thing, this kindness that human beings do not lose.")

Above all, Le Guin's cosmos is ethical, designed to provide a setting for the drama of human choice. Fredric Jameson has called her procedure "world reduction," but it also involves an inflation of individual human agents.

Carol McGuirk. In Harold Bloom, ed.
Ursula K. Le Guin: Modern Critical Views
(New York: Chelsea House, 1986), p. 245

One of today's most praised and read science fiction authors has incorporated wholesale the question of defining humanity as a dominant theme in her work. Ursula K. Le Guin, in her several major novels, brings into conflict beings that by appearances and behavior could be human though there is some factor present that creates doubt or, on the other hand, misguided certainty. Earlier, when I used the term "other," I was borrowing from Le Guin, who defines "other" as "the being who is different from yourself." When she uses the term regarding her own work, however, Le Guin means something apart from the usual robot-alien-telepath-superhuman. Her others tend to be less different from us than those of most writers and deliberately suggest conventional humanity. Generally, in Le Guin's work important other-human differences give way to important similarities. . . .

Two Le Guin novels of unquestionably high standing, even among readers who generally do not care for science fiction, are *The Left Hand of Darkness* and *The Dispossessed*. In these novels Le Guin continues the practice she describes in her Introduction to *Rocannon's World*, where she describes herself as writing science fiction based on "social science, psychology, anthropology, [and] history," presumably instead of on mathematics, the physical and biological sciences, or engineering. . . . The result, too infrequent in science fiction, is an emphasis on culture, with barely enough hard science to justify the alien circumstances in which Le Guin's characters find

themselves. Perhaps because of this cultural emphasis Le Guin's questions about humanness are as profound as any in science fiction.

<div style="text-align: right">Keith N. Hall. Modern Fiction Studies. 22
(1986), pp. 68–69</div>

Although they appreciate her style and reputation, many feminists have been disturbed by the public statements of Ursula K. Le Guin and have criticized her for writing too much about men and for ending too many love relations with marriage or its science-fiction or fantasy equivalent. Except for Rolery in *Planet of Exile,* the priestess Arha in *The Tombs of Atuan* and Luz in *The Eye of the Heron,* the protagonists in Le Guin's major works are male, and these males are generally decent loving men who care for those about them. Similarly, when asked about the constant theme of her works, her reply was "Marriage," just as *The Left Hand of Darkness* is dedicated to her husband. Though Le Guin does not "see how [one] could be a thinking woman and not be a feminist," she cannot accept as a premise that "the root of all injustice, exploitation, and blind aggression is sexual injustice." . . .

Just as [Martin Luther] King sought to convert whites to the cause of racial equality, so Le Guin is arguing for sexual equality but with male fans and science-fiction writers. Thus her "flip statement" to the question of "Why are your protagonists generally men?" is "Because I like to write about aliens." More stridently, in "American SF and the Other," her 1973 contribution to a panel on women in science fiction, she protested: "I think it's time SF writers—and their readers!—stopped daydreaming about a return to the age of Queen Victoria, and started thinking about the future. I would like to see the Baboon Ideal replaced by a little human idealism, and some serious consideration of such deeply radical, futuristic concepts as Liberty, Equality, and Fraternity. And remember that about 53 percent of the Brotherhood of Man is the Sisterhood of Woman."

<div style="text-align: right">Craig and Diann Barrow. Mosaic. 20, 1987,
pp. 83–84</div>

The term "utopia," of course, notoriously embodies a pun: Sir Thomas More's coinage is deliberately ambiguous in its derivation. Its root may be taken either as *ou-topos*—"no place," or *eu-topos*—"the good place." Almost by definition, therefore, utopia is both a good place, an ideal society, yet at the same time one which does not exist. In utopian fiction this is normally reflected in its location, almost invariably remote or well-insulated from the real world to which it proposes an alternative. More and Bacon place the ideal societies on islands: Campanella's City of the Sun is rendered impregnable by its sevenfold walls (on which are inscribed the sum total of human knowl-edge—the city itself is a form of book), while more recent authors have set their utopias in the future, on other planets, or both. Only the scope of utopia has changed with the passage of time: where early utopias were conceived of as isolated bastions of sanity in the midst of a world of chaos and unreason,

their more recent counterparts have become all-embracing, the Wellsian world state being a case in point. And while there are exceptions to this rule (such as Huxley's *Island*), the overall trend appears to be toward utopian fictions where the ideal society, instead of cutting itself off from the real world, seeks rather to replace it. In Marge Piercy's feminist utopia *Woman on the Edge of Time,* the forces of sexism and technocracy have been marginalized to the arctic regions and outer space, while in Ursula Le Guin's anarchist vision, *The Dispossessed,* utopia and the real world are twin planets circling one another in mutual suspicion and hostility. . . .

Le Guin's utopian society represents an even more radical departure from the traditional pattern than does Piercy's. Far from being a static system of perfection, her utopia is shown as the product of unceasing human effort, created, not once and for all, but rather perpetually recreated—its very precariousness being one of the features that give it life. Shevek, growing up on Anarres, is shown as being faced by problems and contradictions just as pressing as those he encounters on Urras. In addition, LeGuin provides a telling commentary on the nature of the relationship between the real and ideal societies. It is Urras, for example, her parallel to our own reality, which is the richer and more fertile, a scene of far worse cruelty and oppression, certainly, but also allowing for a far greater variety and intensity of experience. Anarres, by contrast, is an arid, barren world, devoid of any life forms other than vegetation and the humans who have colonized it. There are no land animals on Anarres—like any utopia, it is purely a human creation—and in its inhabitants' unceasing struggle to make fertile their barren world, we find a richly suggestive metaphor for the process of trying to breathe life into and give substance to apolitical abstraction. Like any ideal, LeGuin's utopia can only be made real by human participation. By contrast, Urras, the real world, is pregnant, for all its fertility, with death: it needs the ideal of Anarres to give shape and direction to its processes, just as Anarres needs the life-giving variety and vigour which Urras embodies (and from which its own inhabitants originally came). The two, real and ideal, are indissolubly linked: this is a utopia which neither isolates itself from the real world, nor replaces it. Instead, reality and utopia are linked in a symbiotic relationship, each giving the other what it lacks. . . .

Utopia is a future, but again one that constantly changes in response to both past and present, while at the same time changing their nature too: like Piercy, LeGuin realizes what Wells only talks of—a utopia that is not static, but kinetic.

Chris Ferns. *English Studies in Canada.*
14, 1988, pp. 453, 464–65

LEHMANN, ROSAMOND (GREAT BRITAIN) 1903–

It is not surprising that *Dusty Answer* should be widely read and discussed. The novel is thought by the elderly to throw light on the young generation; its merits appeared to me to lie not in being a picture of a particular generation, but in giving a vivid account of youthful emotions. The story has fervor; the author is sincerely interested in all she narrates and describes, and without these elementary questions (it is extraordinary how rare they are in fiction) no love story can hold the attention of a reader worth having. . . .

The author of *Dusty Answer* struck me as remembering passion well and understanding it; and since the story she has to tell is, as the title suggests, one of disillusionment, it is not unnatural that she should have been driven to understand the nature of emotions which produced such exaltation and withering pain. . . .

The new frankness between the sexes does not prevent the old muddles, for each continues to interpret the feelings of the other to meet their own wishes. *Dusty Answer* is far above the average novel, but its merits are not those which make one confident that the author will write a better one.

Affable Hawk [Desmond MacCarthy].
The New Statesman. August 6, 1927, p. 539

Miss Lehmann's widely heralded opus [*Dusty Answer*], dealing with a group of young people in England, does not possess even . . . solidity. Her style and outlook suffer from the same melancholy anemia which is the keynote of her character. She is so sadly aware that her young people are decadent and rotted at the core. Here we have a group of young men and women in whom the subconscious acceptance of a failing national destiny is so strong as to make them wearily impervious to all experiences save one—romantic love. . . . They . . . are a refined end-product . . . the decayed remnant of an agricultural aristocracy whose sentimental ethos is becoming more and more irrelevant to a mechanized universe.

Clifton P. Fadiman. *The Nation.*
November 23, 1927, p. 576

Miss Rosamond Lehmann's *Invitation to the Waltz* . . . is concerned with Olivia's first dance, the preparations for it, and its aftermath. Miss Lehmann ruthlessly analyzes the thoughts and reactions of the introspective Olivia, but does not convince the reader either that this was worth doing or that there was any real compulsion behind the doing of it; the result is a mildly amusing but disappointing book.

Brian Roberts. *Life and Letters.*
December, 1932, p. 480

The Ballad and the Source is a long book, written mainly in dialogue, full of subtle and often beautiful detail. Miss Lehmann's virtuosity is impressive; one is compelled to admire her fluency and her technical skill: and, apart from the interest of the actual narrative, this novel throws an intriguing sidelight on an odd aspect of the English character.

Mrs. Jardine, the heroine of the book, defines the word "convention" as another name for the habits of society. . . . Her admirers thrill in their sure and sanctified haven, vicariously enjoying her escapades. Individualism, even of the imitation variety, is to the tradition-worshipping Englishman the modern sin at which he peeps from afar in horrified fascination.

Miss Lehmann brings all this out very clearly in the composite picture of her heroine. But Mrs. Jardine is a sensation-seeker more than an individual; she is experimenting with life instead of living it fully: her experiences, being psychologically unexplained, appear uncoordinated, spasmodic, and lacking in natural rhythm. Some essential element has been omitted, without which the personality picture cannot be brought to life. The picture obstinately stays a picture right to the end. And because Mrs. Jardine never quite becomes a real person, her disjointed history is also without real emotional significance. In spite of the technical excellence of its construction, *The Ballad and the Source* fails, ultimately, to stimulate and engage the deeper attention.

<div align="right">Anna Kavan. Horizon (London).
February, 1945, p. 145</div>

Some people besides writing prose fiction, or poetry, or narrative, or biography, also write magic. This has nothing to do with what they are writing about, neither their characters nor, in a larger sense, their theme. It is rather an ability to communicate emotion, to move the reader into a created world that is experienced with an immediacy, a totality of apprehension, similar to that with which one lives in one's own world. Rosamond Lehmann's books, particularly this new one [*The Echoing Grove*]—happen as completely and mysteriously as living happens. Twenty-five years ago *Dusty Answer,* her first novel, was felt by a whole generation of young people in England and America as a personal experience, and this has been true to some extent of all her books. What happens is less important than the vibration of emotion which accompanies it and is more truly the happening than the event itself.

<div align="right">Elizabeth Janeway. The New York Times.
May 10, 1953, p. 1</div>

Miss Lehmann's new novel [*The Echoing Grove*], her first since 1945, again proves what an exciting writer she is, not only because of what she writes and how, but on a third count as well: she has that infrequent and curious capacity which enables a writer to communicate to us at least a partial perception of what the creative act is. We finish her book with a sense of having been taken to the center of things. . . .

The people in Miss Lehmann's world are governed not by social dicta but by the laws of emotional supply and demand. For her the external milieu matters very little. The role that the war plays in *The Echoing Grove* is significant—it is simply one of the conditions of life, like the lack of money or the loss of health. It is not this, but the given moment of any given day, the moment when two people may be together or must be apart, that is momentous.

Adrienne Foulke. *Commonweal.*
May 22, 1953, pp. 183–84

Despite . . . popularity and critical praise Rosmond Lehmann's reputation has definitely declined in the last two decades. It is certainly symptomatic of this situation that David Daiches decided to leave out his reference to Rosamond Lehmann from the 1960 edition of *The Novel and the Modern World.* One of the reasons may be that Rosamond Lehmann has been silent as a novelist since 1953 and critics no longer can view her as a promising writer of whom it was even said—after the first three novels—that "in one sense, Miss Lehmann has accomplished more than her contemporaries and has as great a promise as any of them" and that she "could take a major place in modern British fiction." Even though her appeal to the reading public has evidently also decreased, and the novels lost some of the attraction that a depiction of a contemporary scene usually confers on fiction, it is my conviction that they remain worth reading and interesting if only because they exemplify some significant trends present in much modern literature. I use the word "modern" as defined by Leon Edel: a novel is modern "in that it reflects the deeper and more searching *inwardness* of our century." This inwardness is in turn closely related to what I call the "subjective vision of the world," which is the central concept throughout my discussion of the novels. . . .

The scope of experience presented in the novels is perhaps restricted, but Rosamond Lehmann is aware of her limitations and stays within her range. One might define her fiction as a subjective exploration into the true nature of experience, in which there emerges no complete vision of life but rather a convincing picture of how life is felt by a handful of characters. Therein lies her claim to distinction, as well as in the organic unity of the form and themes of her novels. . . .

Rosamond Lehmann encounters the modern dilemma as a creator of characters who is conscious of the present lack of a common frame of reference. How then is a novelist to create a convincing and "lovable" character? . . .

Rosamond Lehmann's solution seems to be a limitation of her range of characters to those she "knows everything about." It is characteristic that she chooses to present almost exclusively the experience of young girls and women. She writes about an essentially feminine world and the "femininity" of her art is of such an order that, in the words of a fellow novelist, William

Plomer, "one can think of no higher praise." It is just because Rosamond Lehmann does not venture beyond what she knows perfectly well, that it is possible to say about *The Weather in the Streets:* "As a picture of certain aspects of contemporary life it could scarcely be better, for Miss Lehmann knows, as they say, her stuff, and knows it through and through. She is just as strong on family life as on the circumstances surrounding adultery and abortion."

> Wiktoria Durosz. *Subjective Vision and*
> *Human Relationships in the Novels of*
> *Rosamond Lehman* (Uppsala, Sweden:
> University of Uppsala Press, 1975),
> pp. 10–11, 133–34

The novels have sold well—though none as spectacularly as the first, *Dusty Answer,* which so caught the feeling of the times. Both it and *The Echoing Grove* are published now by Penguin: the two books represent different poles of her achievement but (as she herself remarked) are to some extent complementary. *The Echoing Grove,* indeed, has been in Penguin for a good many years, and its presence on academic reading lists has been one of the ways in which Rosamond Lehmann has surfaced again into public visibility. The other novels are all now currently available as Virago reprints. Of these, *Invitation to the Waltz* and *The Weather in the Streets* have sold the best, as they no doubt deserve to.

Rosamond Lehmann's literary revival is still under way, and although she is in some respects a survivor from another era, enjoying the unusual experience of basking in a renown that seems posthumous in character if not in fact, it is still too early to make any pronouncement of the niche she will eventually occupy in the English Literature of the twentieth century. In addition, the fact is that she *is* still alive, and still intensely interested in life and literature, inevitably makes my task one to which no proper "Conclusion" can be written. The "finished portrait" (to employ the phrase she employed in her valedictory passage on Rickie Masters in *The Echoing Grove*) comes only with extinction. (Not that "extinct" is the word she would now use, but it is the one used in that context.) The corpus of her work is as it is: it is unlikely now that much will be added to it. But it is not impossible—and in any case a writer's books, considered as a function of her life, are not in themselves entirely "finished portraits" but are to some extent still volatile. It may yet be that further developments in Rosamond's own life, or aspects of that life which can only be adequately revealed and discussed after her death or the deaths of others, will shed further and different light on her novels. Till that time, the present book should be looked on as something in the nature of an interim report—and one which has had the peculiar advantage of having been read by the subject herself.

Meantime, she has contributed something in the nature of an interim report herself, in her memoir *The Swan in the Evening,* which is sub-titled "Fragments of an Inner life." I have quoted a number of passages from this book, mainly in order to support and amplify my thesis about the interrelation between her life and work: I have not till now considered the memoir as a shaped and constructed artifact in its own right. It may be objected that a memoir is an attempt to tell "the truth" whereas a novel is "fiction." Yes, but fiction is simply another way of putting truths down on paper, and *The Swan in the Evening,* in selection of themes and construction, is certainly as carefully and deliberately shaped as any novel.

<div align="right">

Gillian Tindall. *Rosamond Lehman:*
An Appreciation (London: Chatto and
Windus/Hogarth, 1985), pp. 197–98

</div>

L'ENGLE, MADELEINE (UNITED STATES) 1918–

[Madeleine] L'Engle . . . attempts the conflict of good versus evil inherent in most major contemporary fantasies, but her pseudometaphysics and doctrinaire messages have neither the urgency of sociological science fiction nor the grandeur of the best fantasy. Without its space-opera costume, *A Wrinkle in Time* would simply be uninspired fantasy.

Both the plot and the characters of *A Wrinkle in Time* are strained. Meg and her five-year-old brother Charles William can communicate mentally with one another and in a vague location in space they battle for the survival of civilization itself, fighting for genius, individualism, and human excellence in the face of an antihuman brain, which unfortunately rings too many bells with Dorothy's confrontation with the bogus great brain in *The Wizard of Oz.*

This kind of American pop history continues in the latent imperialism of L'Engle's subsequent book, *A Swiftly Tilting Plant* (1978). In this sequel to *A Wrinkle in Time,* Charles William, now fifteen years old, travels, in his mind, on a unicorn through time and space, entering other people's minds and bodies in an effort to alter human destiny and free human will in a noncredible attempt to save world peace. Crammed with characters from different periods, the narrative is difficult to follow. One can only hold on to the thread that the president of a small South American state may or may not loose an atomic bomb upon the world because of the color of his eyes. They have to be blue!

Tampering with free will and history have been generally considered antithetical to the tradition of dramatic conflict. Unfortunately L'Engle ignores this canon. . . .

L'Engle's strained writing and imagination falters even more when she moves outside of the domestic lives of her scientist family, as, for instance, when she has the mother making a meal on her Bunsen burner.

Sheila A. Egoff. *Thursday's Child: Trends and Patterns in Contemporary Children's Literature* (Chicago: American Library Association, 1981), pp. 148–49

Certainly the zeal with which *A Wrinkle in Time* tackles ethical (and thus inevitably, psychological) issues distinguishes it from many other works of fantasy and science fiction written for children; and its moral earnestness has done much to secure its favorable reception by critics and the book-buying public. (The novel won the Newbery Award for its year, and evoked two sequels, *A Wind in the Door* (1973) and *A Swiftly Tilting Planet* (1978). The novel's heroine is Meg Murry, a young teen-age girl whose father, a research scientist interested in time travel, disappeared without a trace while on a mission for the government. Because of her anxiety about her father, Meg is something of a trial to her family and her teachers, and it is not until she meets Mrs. Who, Mrs. Which, and Mrs. Whatsit—three creatures who materialize on earth as old women, but who can take any shape their ancient wisdom chooses—that Meg begins to develop a firm sense of her own identity. Meg learns from the three Mrs. W.'s that time travel is indeed a reality, and that she has the opportunity to go in search of her father. So, accompanied by a friend, and by Charles Wallace, her younger brother (mistaken as a simpleton by most people), Meg finds her father held captive on Camazotz, a planet ruled by IT, a disembodied brain, and all of whose inhabitants are automata, cells in the body politic who live only to do IT's will. Meg and her father and friend manage to escape, but Charles Wallace succumbs to IT and remains on Camazotz. To Meg falls the task of returning to Camazotz—alone, this time—to rescue her brother. Having been possessed by IT, Charles Wallace attempts to convince Meg of the rightness of IT's goals and methods—no one on Camazotz suffers, after all,—and only Meg's love for her brother (love being the one human power stronger than IT) enables her to defeat IT and restore Charles Wallace to himself. In the process, she shows great courage, and her struggles with IT teach her that to be different from others is not necessarily wrong.

Because of its complexity of plot, character, and theme, *A Wrinkle in Time* merits the attention it has received. Meg's quest is perfectly suited to her character, and the novel artfully uses the traditional journey-to-the-Otherworld of fantasy to enrich its equally-traditional motif of the child's quest for the lost parent, a fruitful theme in children's literature since Telemachus' search for his lost father at the opening of *The Odyssey*. *A Wrinkle in Time* is, in short, a remarkably ambitious novel, a novel which attempts to achieve at least three things, and which, in the opinion of many of its readers, achieves them very well.

First of all, it is a novel about self-discovery, a novel about an alienated teenager who finds within herself the resources to overcome that alienation. Those familiar with the contemporary adolescent novel will recognize this, or some trivial variation thereon, as the creaking mainstay of that genre. Suffice it to say that *A Wrinkle in Time* is superior to most of its plethora of imitators in its handling of this subject.

Second, the novel is a story of time travel and of journeys to other worlds; the flexibility of space and time provide circumstances in which Meg's growth can be accentuated and clearly understood; character and situation are mutually illuminating.

Finally, the novel attempts an anatomy of evil; in rescuing her father and Charles Wallace, Meg faces an evil power which not only threatens her personally, but is also presented as a power cosmic in its ambitions and operations. (Meg watches as a mysterious black shadow absorbs a star, and later sees it ravening for our own planet, which it encircles). It is in the matter of the presentation of evil that *A Wrinkle in Time* shows its greatest ambition—and its greatest weakness. In this, for all its virtues, it amply demonstrates the wisdom of another student of human misery, Lao-Tse, who once observed that "It is difficult to use the Master Carpenter's tools without cutting one's fingers." . . .

Finally, however the moral confusions of *A Wrinkle in Time* are a great part of what is fascinating about it. The novel is a touchstone even though it finally does fail, for the sources of its failure reveal much about children's literature and its relationship to the moral education of children.

<div style="text-align: right">

William Blackburn. In Perry Nodelman, ed.
*Touchstones: Reflections on the Best in
Children's Literature* (West Lafayette,
Indiana: Children's Literature Association,
1985), pp. 124–25, 130–31

</div>

Admittedly, *A Ring of Endless Light* by Madeleine L'Engle is splendidly written, with well-developed characters and intrinsic interest for the older reader, particularly female, because of the many romantic triangles involved. Admittedly, too, the book required much thoughtful research and contains many perceptive ideas. Its major drawback is that death permeates it from beginning to end.

The novel starts at a funeral. Vicki Austin is attending the funeral of a dear friend of her family's, Commander Rodney. He has suffered a fatal heart attack after rescuing a would-be suicide from the ocean. Vicki knows the would-be suicide, Zachary, and soon becomes deeply involved with him. She wants to help him, even though his impulsive and dangerous streak frightens her and he is far more advanced sexually than she.

In the meantime, Vicki and her family must also face the impending death of her grandfather, who has leukemia. Zachary's mother, too, has died in the previous year, perhaps triggering his suicide attempt. Another young

man, Adam, who eventually captures Vicki's heart, has faced the death of a good friend because a girl Adam was involved with was actually a spy after scientific research. As a result of Adam's blind love for her, he trusted her; now he feels guilty over his friend's death. Adam's boss, Jeb, has also lost his wife and child the previous year in a tragic automobile accident. Later in the book, a motorcyclist hits Jeb, and he lies close to death. Near the end of the book, Vicki becomes acquainted with a small child, Binney, at the hospital. Eventually, Binney dies in Vicki's arms. And throughout, we are aware of the atrocities around the world—mass murderers and fishermen killing hordes of dolphins. The family is even worried about a family of swallows nesting about their front door; because the nest is so shallow, they fear the birds will fall to their death.

Interwoven among all of these gruesome events are numerous discussions among the various characters that touch upon many aspects of death: cryonics (a process by which a dead body is frozen in hopes that in the future we may have the knowledge to revive the person); the traditional view of heaven; the morality of keeping people on life-support systems; the ethics involved in withholding medical care for religious reasons. In addition, several of the characters give their own particular views on death. These conversations are a bit hard to swallow (normal, everyday people are not usually that articulate or philosophical), and Vicki, not yet sixteen, is unusually perceptive for a girl her age.

Nevertheless, the book will give the more mature reader much to ponder, and it does, in the end, offer affirmation. Adam, in his scientific work with dolphins, enlists Vicki's aid. She has a peculiar knack of communicating with these animals. Not only do they offer fascination, but they are able to take her mind off her troubles, and when she seems unable to recover from the many shocks of the summer, it is the dolphins who comfort her and bring her back to the magical world of the living.

Marian S. Pyle. *Death and Dying in*
Children's and Young People's Literature
(Jeffrey, North Carolina: McFarland, 1988),
pp. 84–85

For this time-slip novel [*An Acceptable Time*] L'Engle again reaches into her bag of weird and wonderful knowledge, blending snippets of tantalizing information from a variety of disciplines—history, natural history, physics and Christian metaphysics, to name a few—into a rich and heady brew. Red-haired Polly O'Keefe (last seen in *A House Like a Lotus*) arrives at her grandparents' farm in Connecticut for some private tutoring. There, in a landscape familiar to L'Engle fans (who will be pleased to know that the Nobel Prize-winning Mrs. Murry still cooks over a Bunsen burner), Polly slips back 3000 years into a different time "spiral." She meets Anaral, a Native American girl; Karralys, a druid banished from Britain for his progressive thinking; and Tav, a handsome warrior who accompanied the druid to their new land.

Polly travels back and forth between the two worlds, and eventually her purpose becomes clear: with the aid of her new friends she forges peace between two clashing tribes, and helps Zachary Gray (also from *A House Like a Lotus*), a self-centered but very ill young man. The story is laced together with L'Engle's now-familiar theme of the transcendant importance of love. This fine fantasy, firmly rooted in reality, is the kind of thoughtful story at which L'Engle excels.

Sybil Steinberg. *Publishers Weekly.*
November 10, 1989, pp. 61–62

When it was first published in 1962, Madeleine L'Engle's *A Wrinkle in Time* presented a view of women which was ahead of its time. The now classic fantasy novel features a female protagonist, Meg, who is a math and science whiz with a sharp and unabashed tongue, and her mother, Mrs. Murry, who is herself a whiz at juggling the roles of mother, faithful wife, and brilliant chemist. In the early 1960s, such success in the male sphere of science was the stuff of fantasy for most young women. L'Engle's portrayal of women was truly progressive for the era, foreshadowing the women's liberation movement, which would not explode with its full force until the later years of that decade.

Today, people talk of "postfeminism," of goals achieved and doors opened. However, even as some cry triumph and close the book on feminism, others, most of them working women, are crying foul. While the Women's Movement has largely succeeded in paving women's path into the "man's world" of business, science, and the like, it has failed to release them from the moral and practical imperatives of "femininity": the roles of primary caregiver, housekeeper, and keeper of the moral flame of the family are expected to be filled by the woman in the family, regardless of and in addition to the less traditional goals and ideas she may cherish and pursue.

The problems facing women in the 1990s are much subtler, and all the more insidious for their subtlety, then were those of the 1960s and 1970s. At this juncture, it is imperative that we scrutinize the "progressive" ideals and icons of feminism's early days with a critical eye, searching for ways of thinking which may serve to perpetuate the dangerous ideals of the so-called "Superwoman" and the archaic, yet incredibly tenacious, moral mother, the sole repository of love and justice in the family. As a children's classic of enduring value, *A Wrinkle in Time* is an important and deserving target for such a critical reexamination. We grew up with this book, and gleaned much from its pages. Today, a rereading of *A Wrinkle in Time* is a lesson in the power of hindsight: trumpeting the breakthrough ideals of feminism in the 1960s, L'Engle could not see the dangers inherent in the realization of the seemingly simple dream. . . .

Meg's deed is highly praised by all, and it is truly a noble one. However, after two hundred pages in which she was criticized much of the time for her lack of femininity, this praise smacks disturbingly of a vindication. Meg is

portrayed as in her element, her "happiest medium" as it were, when she is operating in the traditionally feminine sphere of maternal love as redeeming force. The final message is that a girl becomes a woman only when she voluntarily takes on the role of moral leader and keeper of love, subordinating her other interests and capabilities to this one. The seeming inevitability of Meg's transformation and its quality of revelation imply a lack of freedom for a young woman like Meg to choose her own path; it is simply woman's destiny and duty to care for the moral health of others.

<div align="right">Katherine Schneebaum. The Lion and the
Unicorn. 14, 1991, pp. 30–31, 36</div>

LESSING, DORIS (ZIMBABWE–GREAT BRITAIN) 1919–

The plot of *The Grass Is Singing* might have served for a polished, unpleasant and effective short story in the manner of Mr. Somerset Maugham; Miss Lessing treats it in a different way. She starts with a denouement, purposely sacrificing the elements of suspense and surprise, and then reconstructs the events leading up to it slowly and in detail. The result is that her novel is rather less exciting than it might have been, considering its dramatic theme, but is impressively serious, solid and convincing. The author evidently has a deep knowledge of a certain aspect of South African life, and of the type of woman from which her heroine is drawn.

Mary Turner is a shallow, harmless creature with pretensions to refinement, who has married a farmer in order to secure a husband before it is too late. Turner is a failure as a farmer, and during the years Mary spends as a poor white on his isolated, uncomfortable farm, her emotional and social frustrations find an outlet in a neurotic hatred of the natives who work for her husband. Later she becomes involved in a morbid relationship with a Negro houseboy whom she had once brutally ill-treated, and eventually she is murdered. Mary is an unsympathetic but a pitiful character, and her mental and moral breakdown is described ruthlessly, without false sensationalism: her story is also of value as an indirect and angry comment on racial intolerance in South Africa.

<div align="right">Francis Wyndham. The Observer.
March 12, 1950, p. 7</div>

Miss Lessing's ten short stories [*This Was the Old Chief's Country*] are so essentially readable and entertaining that it is hard to realize that they are only her second published book. All of them have a vivid background of South African farm life, but Miss Lessing avoids monotony by focusing attention sometimes on the natives and sometimes on the Dutch and English settlers. She appreciates the dignity of the natives without overestimating

their intelligence, and appears to prefer some Englishmen to most Afrikaners. Her descriptive writing is vivid and unforced and she is also very shrewd about social relationships. In the longest and best story, "Old John's Place," she gives a subtle portrait of a thirteen-year-old girl battling with uncertainties of adolescence in a world of well-meaning but not very edifying grown-ups. Miss Lessing, in short, appears to be a versatile and talented writer.

(London) *Times Literary Supplement.*
May 11, 1951, p. 289

Too often Miss Lessing's fiction is dissolved in a long sociological or journal-istic insertion, like the accounts of communistic tactics and wrangles in *A Ripple from the Storm* or the long, dull, clinical study of discovering that one is pregnant which takes up about seventy pages of *A Proper Marriage.* Her politics are one-sided, her characters are limited in conception, and her world revolves in a simple pattern. . . .

Doris Lessing's intense feeling of political and social responsibility is carefully worked into specific historical situations. But the positive convic-tions can become heavy-handed, and the specific situations journalistic, while the strict allegiance to time and place can limit the range of perception about human beings. Miss Lessing's kind of intensity is simultaneously her greatest distinction and her principal defect. She produces an enormously lucid socio-logical journalism, honest and committed, but in much of her work she lacks a multiple awareness, a sense of comedy, a perception that parts of human experience cannot be categorized or precisely located, a human and intellec-tual depth. Intense commitment can cut off a whole dimension of human experience.

James Gindin. *Postwar British Fiction*
(Berkeley: University of California Press,
1962), pp. 85–86

What on earth are library-goers going to make of Doris Lessing's formidable multi-level note? Without the author's note (printed on the jacket, but not in [*The Golden Notebook*] itself) Mrs. Lessing's purpose will be hard to discern. She says the book is about artist's block: "In describing the reason for the block, I would also be making the criticisms I wanted to make about our society. I would be describing a disgust and self-division which afflicts people now, and not only artists." The novel is also "about what Marxists call alien-ation" and "an attempt to break a form; to break certain forms of conscious-ness and go beyond them." Quite a lot for one novel, in fact, even if it is 568 pages long.

A woman writer called Anna Wulf (*née* Freeman—and if that puts you in mind of the heroine of a play called *Play with a Tiger* I'd say you were right the first time) keeps four notebooks: a black one, which is an autobio-graphical novel about Anna's Northern Rhodesian Communist friends during the war; a red one, dealing with her experiences with the British Communist

Party during the 1950s; her writer's journal (yellow) and her diary (blue). These are led off and interrupted by a story called "Free Women" about Anna and her friend Molly and Molly's son Tommy, who blinds himself trying to commit suicide. Near the end of the book comes "The Golden Notebook," about thirty pages describing a desperate affair between Anna and an American, and if *that* reminds you of a play called

When a novelist writes a novel about a novelist writing what we know the real novelist has written, we have a right, I think, to object. Not having read all of Mrs. Lessing's work, I don't know how much of *The Golden Notebook* is self-parody, but I know some of it is. The self-division never for a moment disguises the self: each part of the book repeats the other parts without really adding to them. Using different kinds of type does not disguise this fact. The novel is a ponderous bore. Yet it shouldn't be: Mrs. Lessing has attempted something big and important, a portrait in depth of the loneliness of the "free" woman (liable to have that "free" misunderstood, needless to say) who has the courage to reject the bourgeois hypocrisies only to have her own self-deceptions and failures rejected by her child.

<div style="text-align: right">

Julian Mitchell. *The Spectator.*
April 20, 1962, p. 518

</div>

It is a particular distinction of *The Golden Notebook,* a long and ambitious novel by the gifted English writer Doris Lessing, that while dealing with some of the materials favored by novelists of sensibility, it escapes their constrictions of tone and outlook. Both Miss Lessing and her characters are deeply caught up with the cult of "personal relations," yet she is able to keep some critical distance from her material and to look upon it as merely the latest turn in the confusion of modern history. She yields her sympathies to those of her characters who fall back upon "personal relations" in order to get through their days, but she tries not to settle for the limitations of experience they must accept. She understands that the idea of "personal relations" has been shaped by the catastrophes of our time and, in the form we know it, is not to be taken as an absolute or uncontaminated value.

It is a further distinction of Miss Lessing's novel that its action is carried mainly by that rarity in modern fiction: a heroine, Anna Wulf, who is a mature intellectual woman. A writer with a sophisticated mind, sharp tongue and an abundance of emotional troubles, Anna Wulf is sufficiently representative of a certain kind of modern woman to persuade us that her troubles have a relevance beyond their immediate setting; she is also an intelligence keen enough to support the public combativeness and personal introspectiveness that Miss Lessing has given her. At the very least, Anna Wulf is someone who has measured the price for being what she chooses to be—"a free woman," she would say with pride and irony—and who is prepared, no matter how much she groans, to pay it.

Miss Lessing has a voice and a mind of her own. She is radically different from other women writers who have dealt with the problems of their sex,

first in that she grasps the connection between Anna Wulf's neuroses and the public disorders of the day, and second in that she has no use either for the quaverings of the feminist writers or the aggressions of those female novelists whose every sentence leads a charge in the war of the sexes. The feminine element in *The Golden Notebook* does not become a self-contained universe of being, as in some of Virginia Woolf's novels, nor is the narrative voice established through the minute gradations of the writer's sensibility, as in some of Elizabeth Bowen's. And Miss Lessing is far too serious for those displays of virtuoso bitchiness which are the blood and joy of certain American lady writers.

<div align="right">Irving Howe. The New Republic.
December 15, 1962, p. 17</div>

Mrs. Doris Lessing is a novelist in her forties, whose first book, set in Africa, was a best-seller, but who has written no other best-sellers. She is a *divorcée*, and lives alone; she has one child. She has lived in Africa. Politically she is of the Left. She has written a novel, *The Golden Notebook,* of which the heroine is Anna, a novelist in her forties, who has written one best-selling novel, set in Africa, and can write no more novels. . . .

Towards the end of *The Golden Notebook,* Anna, who is having a short and most turbulent affair with a young American writer, says to herself "I must write a play about Anna and Saul and a tiger." Mrs. Lessing's *Play with a Tiger,* about an unattached woman in her forties, Anna, who is having a turbulent affair with a younger American, is running at the Comedy Theatre. The puritan reviewer holds up his hands in horror and cries, "Can self-indulgence go further?" The workaday journalist holds up his hands in admiration and cries "What economy of material!"

You'll have read other reviews of this book and you'll know that it's very long (568 pages), and that it is made up of a third-person running narrative about Anna and her friend, Molly, an actress, and Molly's son, Tommy. Between the patches of narrative are long extracts from the four notebooks Anna keeps. . . .

I'll end by suggesting that *The Golden Notebook* is neither self-indulgent or over-economical. The re-use of the same material is the point of it, because every use is different. Mrs. Lessing even allows herself pieces of pastiche and sketches of the way in which material might be treated in the cinema or television. There is a section at the end where an account of the affair with Saul has cross-references to stories for which aspects of the affair might be used. I don't think that *The Golden Notebook* is a particularly interesting book for anyone who is not interested in the *process* of imaginative writing, but for anyone who is, it's a very interesting book indeed.

<div align="right">John Bowen. Punch. May 9, 1962, p. 733</div>

[*The Golden Notebook*] moves in four main cycles, and each cycle contains one section called "Free Women" followed by four notebooks: "The Black

Notebook," "The Red Notebook," "The Yellow Notebook," "The Blue Note-book." The final cycle has two appendages, "The Golden Notebook" and a final "Free Women" section. The "Free Women"" sections, written in normal third person narrative from the viewpoint of Anna Wulf (though the view shifts occasionally), examine the problems Anna and her friend Molly face as they attempt to preserve their identities as independent, radical, emotionally complete women. . . .

In the nightmare near the end of the short section called, "The Golden Notebook," where Anna is close to resolution of her destructive impulses, a movie projectionist with Saul's voice runs a film of Anna's past as she has perceived and ordered it. That film, obvious and literal as a dream, covers all the material in the notebooks, and Anna realizes how false, how partial, it all is. A few nights later, the same dream, and the same film, reoccur, except that the ordering viewpoint is changed, and closer to the precise truths of character and action beyond Anna's ordering distortions. Thus all the notebook material is finally judged by the serene Anna of "The Golden Note-book," and it is hardly accidental that in "The Golden Notebook" Saul gives Anna the sentence which is to begin Anna's new novel, the same sentence which opens the first "Free Women" section of *The Golden Notebook*. Were it not for those "Free Women" sections, Miss Lessing's book could be read as a series of partial attempts at fictional order expanding into a cohesive and embracing vision, with the final section of unity of viewpoint bearing the same title as the entire book. Yet "Free Women" insists not only on a view-point which can not be included within any of the notebooks, but also on several facts and events (Tommy's blindness, the minor affair with Nelson, the six days with Milt) which the notebooks contradict. So finally there are not only a multiplicity of viewpoints directed on Anna, which become one unified perception, but a separate viewpoint which is never integrated; a dry, ironically distanced account of the attempt to live as a free woman. Why Miss Lessing has split the two viewpoints beyond any possibility of unity, thereby hopelessly dividing an already complex form, remains unclear, but the choice determines the failure of *The Golden Notebook* to cohere. Given Miss Lessing's compelling integrity, it may be that the fracture is deliberate, a refusal to admit formal unity where the experiences, and the alternative viewpoints, are still separate. A unity of form might mean a resolution of the discontinuity and anguish Miss Lessing analyzes, which she may not find possible within her own, or any, society. Nevertheless, the final failure of *The Golden Notebook* occurs on an ultimate level of form and complexity few contemporary novels ever reach.

Norman Fruchter. *Studies on the Left.*
Spring, 1964, pp. 124, 126–27

One of the best first novels of our time was Doris Lessing's *The Grass is Singing*. The story of a town girl married to a farmer in Africa, and of her behavior towards her Negro servants, behavior reflecting her own inner un-

certainty and in the end with fatal consequences to herself, it satisfies both as a novel and as a parable on the nature of relations between black and white in Africa. It heralds one of Doris Lessing's two main themes, the relationship between the races in Africa. The other is the problem of being a woman in what is largely a man's world. Both themes come together in her work in progress, *Children of Violence,* of which so far *Martha Quest, A Proper Marriage* and *A Ripple from the Storm* have appeared. The sequence traces the life of Martha Quest from her childhood and adolescence on a farm in what seems to be Rhodesia to the break-up of her marriage in the country's capital during the war and her involvement in left-wing political activities at the time. . . .

How the work will continue it is difficult to say. In *A Ripple from the Storm* Martha Quest seems no longer the channel through which the action flows. She has become smaller, overshadowed by the events described, lost in the minute political detail of the book, which relates the break-down during the war of a raw provincial society, in which the color problem can still be seen in terms of crude, white and black, under the impact of invasion from the outside, by Jewish refugees from Nazis and by class- and politically conscious airmen of the Royal Air Force. What had begun as a full-length portrait of a young woman has become a study of a society in a process of disintegration.

In her most recent novel *The Golden Notebook,* the African theme is subsidiary to that of being a woman in a man's world. . . . The novel consists largely of the notebooks Anna keeps, so that we have something like a series of novels within a novel. As a work of art, *The Golden Notebook* seems to me to fail. The structure is clumsy, complicated rather than complex. But all the same it is most impressive in its honesty and integrity, and unique, it seems to me, as an exposition of the emotional problems that face an intelligent woman who wishes to live in the kind of freedom a man may take for granted. The comparison commonly made by English reviewers was Simone de Beauvoir's *The Second Sex:* the comparison indicates its merit, the nature of its interest and also, perhaps, its limitations as a novel. Its main interest seems to be sociological; but that said, it must also be said that it is essential reading for anyone interested in our times. . . .

<div style="text-align: right;">

Walter Allen. *The Modern Novel in Britain
and the United States* (New York: E. P.
Dutton, 1965), pp. 276–77

</div>

Doris Lessing, who grew up in Southern Rhodesia between the two wars, has been a witness of the late glories of Empire and has observed at first hand the drama of racial antagonism which increasingly fills our minds. She is both a former member of the Communist party and a political exile from the country which is her home. She is also, as they say, "alienated," living among the old complexities of Britain in her characteristically ambiguous role of one who is at once inside and outside the group, both English and not English. From her fiction it appears likely that the facts of her personal life

have matched, in their contemporary quality, those of her public one. All in all she seems well fitted to speak for the times. . . .

The high estimate of Mrs. Lessing's importance which has been current in Britain for some time, and which is becoming so in the United States, seems to suggest that the largeness of what she deals in has been matched by a correspondingly large achievement. One recalls, for example, with what seriousness the task of exegesis was taken up on the appearance two or three years ago of her most obviously heavyweight book to date, *The Golden Notebook.* . . .

It seems to me that one of the tasks of a "colonial" writer is to respond to a rudimentary society in a way which is not itself rudimentary, and, in defining its absence of density and forms, to help create them. There are several Commonwealth writers—one thinks of the Trinidad novels of V. S. Naipaul or the South African ones of Dan Jacobson—who have attended to the true theme of the colonial experience with sustained precision. In the work of Mrs. Lessing, the incoherences which lie in the texture and quality of White Rhodesian life are present but not dealt with. It is true that the surfaces she records for us reveal that life as raw, new, and insipid. But it is also true that its constricting and provincial quality is reflected in a vision which is itself constricted and crude. Jacobson and Naipaul speak out of the particularities of their own estrangement to that of all of us, and leave us in the end with a deepened sense of the needs of any society. In Mrs. Lessing's work her own imagination is touched by the thinness and superficiality of the life it presents.

<div align="right">Roger Owen. Commentary.
April, 1965, pp. 79–80</div>

The form of *The Golden Notebook* was itself a paradigm of Mrs. Lessing's complex sensibility, and ought to be borne in mind in reading her new volume of *African Stories.* . . .

Most of the tales collected in this very ample volume of *African Stories* observe a more traditional form than that of *The Golden Notebook,* but beneath their smooth surfaces and familiar shapes (which confirm Mrs. Lessing as a literary craftsman of the first order) one discovers many of the same insistent themes. Foremost among them is the situation of women emotionally isolated, at times all but imprisoned, in a man's world, their dependence all the greater for the passion and loyalty that are denied a style of life in which to flower. The prevailing feeling of these stories may be summed up in a line from a story—"The Trinket Box"—otherwise quite uncharacteristic of Mrs. Lessing's style: "And slowly, slowly, in each of us, an emotion hardens which is painful because it can never be released."

This somber epitaph of life denied is everywhere echoed in this volume, but it stands for something more than the individual attrition of the heart— and thus clearly marks Mrs. Lessing's gifts as having a range far beyond that of the familiar "feminine" sensibility, all sensitivity and nuance and fine hurt

feelings, to which many of us have become inured, if not totally indifferent. She is that rare thing in fiction nowadays: a social observer of really keen powers. Moreover, she has long had in hand—the earliest of the stories date from the early '50s—a subject that is a fictionist's dream: the world of British Africa in the twilight of a once glorious imperium. Mrs. Lessing herself grew up in Southern Rhodesia, the daughter of British parents, and to that circumstance, no doubt, owes not only her subject but her special success in writing about this demoralized colonial remnant from the inside and with the kind of harsh, unforgiving intimacy—by no means devoid of sympathy or warmth—that only deep familial attachments can yield a writer of her persuasion. The result is a sustained fictional vision that makes us feel the withering of emotion and the decay of individual conscience as, virtually, the crux of the colonial experience itself in all its ramifications.

Within that vision the most private encounters implicate an entire system of values that is intrinsically inhuman and historically moribund. The most commonplace dreams harbor monstrous and disabling guilts. Anecdote loses its innocence, for human action on any level—even the most humane—is trapped in the net of a dying and death-dealing society. A love affair refracts a social pyramid of sheer madness; a child's coming of age throws open a door on the moral void. Here, too, history and private consciousness are significantly joined, and fiction once again engages life at its exact center rather than at the periphery. . . .

Mrs. Lessing's Africa is both an historical reality, very closely observed, and something more: a vast metaphor for the death of feeling, for the atrophy of whatever emotion is required to sustain the values of liberal civilization in circumstances that permit their dissolution. To be a woman in the Africa of these stories is already, it seems, to find oneself suspended between the values of the civilization and those of the barbarism that has displaced it.

Hilton Kramer. *New Leader.*
October 25, 1965, pp. 21–22

Lessing's examination of the psychoanalytic experience is significant, because it is an evaluation of one of the ways through which reality is structured. By this I mean human life is explained by psychoanalytic knowledge claims, claims in which the concept of the self and self-knowledge is of utmost importance. Thus, for modern man, the quintessential individual experience is psychoanalytic. Suggesting that this explanation is insufficient, Lessing makes an important epistemologic claim transcending the bounds of fiction. More narrowly, within the context of her own works, her repudiation of analysis is a rejection of the individual as the center of meaning. In *The Golden Notebook,* psychoanalysis barely helps stave off further individual fragmentation; it flatly fails to increase the connections between individuals.

Lessing denies Marx as roundly as Jung. The study of communism in the red notebook parallels that of analysis in the blue. Thus Lessing examines the other major explanatory system of our time, that of man as a member of

the collective. She concludes that structuring reality solely in terms of the collective fails as surely as does its antithesis. Anna's experiences offer the best evidence for this statement. The Communist Party group she is part of in Africa is beset with quarreling and accomplishes little. The soul searching which follows the anti-Stalinist purge culminates in Anna's resignation from the Party. . . .

While Lessing seems to say that what one sees when one sees steadily and whole is fragmentation, *The Golden Notebook* is far different from the "golden notebook." Lessing's work is an aesthetic whole uniting all the fragments. Equally important, while the characters are rendered as "split" and aware of that division, they try desperately to heal themselves. The image of a world in which neither sex is divided, in which both right personal and right collective relationships are possible, is the implicit background against which the novel must be seen.

<div align="right">Selma R. Burkom. Critique. 11:1, 1968,
pp. 55–56</div>

The Four-Gated City is bulkier by far than any one of the four preceding novels in the series knows as *Children of Violence (Martha Quest,* 1952; *A Proper Marriage,* 1954; *A Ripple from the Storm,* 1958; *Landlocked,* 1965). Like them, it is a chronicle of change, a *Bildungsroman* of character and history. Unlike them, it charts not only a decade and a half of the recent past (the previous four volumes together cover about two earlier decades) but moves on to view the apocalyptic years that will conclude this century. It is thus not only narrative and history but a stab at prophecy as well. For that reason and one other, *The Four-Gated City* is more important than its four predecessors.

The other reason has to do with turning a corner into mostly uncharted regions. Here, the concluding novel reminds me of *The Golden Notebook,* published in 1962 and generally considered to be the best of Lessing. As in that book, the immediate scene is England in the fifties. In both novels, the heroines move toward a descent into madness and then release from it, though the terms and values of the experiences differ significantly.

As in *The Golden Notebook,* mental breakdowns of all kinds are, in part, a response to the politics of the West, the bureaucratization, the incipient fascism, the irrational violence, and to the dehumanized, propaganda- and drug-addicted culture we live in. But for Mrs. Lessing in 1969, madness is not merely a debilitating affliction or an escape, or even a novelist's tool. Developing particular forms of what Western man calls "madness" may be the only way out of his afflicted culture. Can anything—any persons or organizations—Mrs. Lessing asks in this novel, call halt to the inevitable destruction to come, given the growth and movement about the earth of mad machines, on the one hand, and the lack of internal human commonsensical and moral controls, on the other? Her answer is unequivocally No. Our dulled apathy to the condition of daily life and to the cries of war signals what Robert

Bly has called "the deep longing for death," a suicidal rush to annihilation, as though the half-drugged of us were longing for total immolation, for the relief of the end. Mrs. Lessing, on the contrary, envisions a struggle toward life, through the use of extraordinary sensory powers by intelligence and a moral consciousness.

<div align="right">

Florence Howe. *The Nation.*
August 11, 1969, pp. 116–17

</div>

To read a great deal of Doris Lessing over a short span of time is to feel that the original hound of heaven has commandeered the attic. She holds the mind's other guests in ardent contempt. She appears for meals only to dismiss the household's own preoccupations with writing well as decadent. For more than twenty years now she has been registering, in a torrent of fiction that increasingly seems conceived in a stubborn rage against the very idea of fiction, every tremor along her emotional fault system, every slippage in her self-education. *Look here,* she is forever demanding, a missionary devoid of any but the most didactic irony: *the Communist party is not the answer. There is a life beyond vaginal orgasm. St. John of the Cross was not as dotty as certain Anglicans would have had you believe.* She comes hard to ideas, and, once she has collared one, worries it with Victorian doggedness.

That she is a writer of considerable native power, a "natural" writer in the Dreiserian mold, someone who can close her eyes and "give" a situation by the sheer force of her emotional energy, seems almost a stain on her conscience. She views her real gift for fiction much as she views her own biology, another trick to entrap her. She does not want to "write well." Her leaden disregard for even the simplest rhythms of language, her arrogantly bad ear for dialogue—all of that is beside her own point. More and more Mrs. Lessing writes exclusively in the service of immediate cosmic reform: she wants to write, as the writer Anna in *The Golden Notebook* wanted to write, only to "create a new way of looking at life."

Her new novel, *Briefing for a Descent into Hell,* is entirely a novel of "ideas," not a novel about the play of ideas in the lives of certain characters but a novel in which the characters exist only as markers in the presentation of an idea. . . .

So pronounced is [the protagonist Charles Watkins's] acumen about the inner reality of those around him that much of the time *Briefing for a Descent into Hell* reads like a selective case study from an R. D. Laing book. The reality Charles Watkins describes is familiar to anyone who has ever had a high fever, or been exhausted to the point of breaking, or is just on the whole only marginally engaged in the dailiness of life. He experiences the loss of ego, the apprehension of the cellular nature of all matter, the "oneness" of things that seems always to lie just past the edge of controlled conscious thought. He hallucinates, or "remembers," the nature of the universe. He "remembers"—or is on the verge of remembering, before electro-shock oblit-

erates the memory and returns him to "sanity"—something very like a "briefing" for life on earth.

The details of this briefing are filled in by Mrs. Lessing, only too relieved to abandon the strain of creating character and slip into her own rather more exhortative voice.

Joan Didion. *The New York Times*.
March 14, 1971, p. 1

The most considerable single work by an English author in the 1960s has been done by Doris Lessing, in *The Golden Notebook* (1962). It is a carefully organized but verbose, almost clumsily written novel, and if we were to view it solely as an aesthetic experience, we might lose most of its force. The book's strength lies not in its arrangement of the several notebooks which make up its narrative and certainly not in the purely literary quality of the writing, but in the wide range of Mrs. Lessing's interests, and, more specifically, in her attempt to write honestly about women. To be honest about women in the 1960s is, for Mrs. Lessing, tantamount to a severe moral commitment, indeed almost a religious function, in some ways a corollary of her political fervor in the 1950s.

While the English novel has not lacked female novelists, few indeed—including Virginia Woolf—have tried to indicate what it is like to be a woman: that is, the sense of being an object or thing even in societies whose values are relatively gentle. For her portraits, Mrs. Lessing has adopted, indirectly, the rather unlikely form of the descent into hell, a mythical pattern characterized by her female protagonists in their relationships with men, an excellent metaphor for dislocation and fragmentation in the sixties. Like Persephone, her women emerge periodically from the underworld to tell us what went awry—and it is usually sex. Within each woman who tries to survive beyond the traditional protection of housewife and mother, there exists a bomb which explodes whenever she tries to live without men, as well as when she attempts to live with them. Her dilemma is her personal bomb.

Frederick R. Karl. *Contemporary Literature*. Winter, 1972, p. 15

Doris Lessing is a prophet who prophesies the end of the world. She is much read but not perhaps much heeded, for there is very little that can be done, in her view, to avert catastrophe. Why, then, does she continue to write for a posterity that does not exist? Because, she says, we must continue to write and live *as if.* She is used by now to living on the edge of destruction, though her conception of it has changed over the years: now she foresees a world polluted and ruined by nerve gas and fallout, with England "poisoned, looking like a dead mouse in a corner, injected with a deathly glittering dew," whereas she used to foresee revolution. One of her characters, contemplating her miserable marriage in the war years, comforts herself in these terms: "I'm caught for life, she thought: but the words, 'for life,' released her from anxiety.

They all of them saw the future as something short and violent. Somewhere just before them was dark gulf or chasm, into which they must all disappear. A communist is a dead man on leave, she thought." And that is how she continues to write, though no longer a communist: a dead man on leave.

If her prophecies are listened to, it is with helplessness. Her literary prestige in England could not be higher, though she cares little for the literary world. She also has real readers. She is the kind of writer who changes people's lives: her novel *The Golden Notebook* has been described as "the Bible of the young," and although I don't think she'd care much for the portentousness of the phrase, it certainly catches the feeling of converted emotion that she arouses.

Margaret Drabble. *Ramparts.*
February, 1972, p. 50

One of the great rewards of reading Doris Lessing's novels has always been a sense of sharing with the writer herself the experience of growing older, of discovering new ideas and questioning old values. This is not merely to say that, in her best-known and most substantial books (the Martha Quest series and *The Golden Notebook*) Mrs. Lessing has given us an unforgettable account of her generation's involvement in world violence and a good deal of insight into her own writing experience; it is her peculiar gift to write with the kind of honesty and generosity that suggest to the reader he is privileged to be a friend, to feel he knows something of the true ideals, the private agonies and delights, that have inspired her writing. And, like any real friendship, this appreciation is more acute where those ideals are shared and the brave spirit of inquiry and challenge that Mrs. Lessing's work always shows seems to the reader in itself a wholly admirable thing.

Although a collection of short stories is not normally the form in which one finds integrated self-revelation, Mrs. Lessing's new volume [*The Story of a Non-Marrying Man*] is quintessentially part of her sharing of experience, a marvelous scrapbook of old and new memories and discoveries. Whether she is simply describing, in three short vignettes of solitary walks round Regent's Park, how a moorhen's nesting or the falling leaves seemed heavy with meaning and the images infinitely precious; or chronicling the bizarre chance that led a Rhodesian post-office clerk of thirty years ago into political prominence; or accompanying old Hetty Pennefather and her cat with their pramful of rags to a derelict's death in Hampstead; or imagining the reactions of interplanetary reconnaissance officers to a pop group in Cornwall—without obtruding, she leaves us in no doubt what, for her, gave a particular experience its paradoxical, often bitter, significance.

(London) *Times Literary Supplement.*
September 22, 1972, p. 1087

Doris Lessing's relation to the women's movement, especially in America, has been an awkward one. After reading her novels, many radical feminists

wanted to appoint her their wise-woman, but she has resisted this honor. The serious, intense crowds who welcomed Mrs. Lessing on her last trip to New York were disappointed and even angry to hear her say that *The Golden Notebook* was not about or in favor of war between the sexes. In fact, she also explained later in print, "the essence of the book" was "that we must not divide things off, must not compartmentalize." Moreover, though she supported Women's Liberation, she didn't believe it would have much effect. . . . Yet while making such discouraging, even patronizing, statements, Doris Lessing goes on writing novels and stories that seem to speak directly to and about women's liberation, at least in the lower-case sense. . . .

The intelligent middle-class housewife whose children have grown up and whose husband is tired of her is a staple of recent fiction (and life), but she has never been described better than in *The Summer before the Dark*. The movement of the book takes Kate Brown, age forty-five, from a last moment of domestic security, or blindness—afternoon tea on a suburban lawn—through a series of changes and crises that alter her perception of herself and the world. . . .

The Summer before the Dark, part of which has already appeared in *Ms.,* is sure to be read by liberated and slave women all over the world. And to judge by the attitudes of my own not very radical rap group, which is already lining up for my copy, they will read it like a prophetic book, to find out, first, How it really is, and second, What to do about it. If Doris Lessing tells them that nothing can be done, the slaves will be sourly satisfied; the rest, bitterly disappointed.

<div align="right">Alison Lurie. New York Review of Books.
June 14, 1973, pp. 18–19</div>

Doris Lessing, whose position as one of the major women writers of the twentieth century would now seem assured, stands quite apart from the feminine tradition of sensibility. Her fiction is tough, clumsy, rational, concerned with social roles, collective action and conscience, and unconcerned with niceties of style and subtlety of feeling for its own sake. She is, nevertheless, fully aware of the bifurcation between sense and sensibility and the meaning it presents to women, and it is with an awareness of the terms that she makes her choice. In the preface to *African Stories* she writes, "'The Pig' and 'The Trinket Box' are two of my earliest. I see them as two forks of a road. The second—intense, careful, self-conscious, mannered—could have led to a kind of writing usually described as 'feminine.' The style of 'The Pig' is straight, broad, direct; is much less beguiling, but is the highway to the kind of writing that has the freedom to develop as it likes." The latter part of this statement is ambiguous enough; suffice it to mean that Lessing finds her freedom in a realm apart from the traditional feminine resource of sensibility.

<div align="right">Lynn Sukenick. Contemporary Literature.
Autumn, 1973, p. 516</div>

Strung throughout the events of Kate's journey of separation and return [in *The Summer before the Dark*] is a series of striking dreams in which she obsessively carries a wounded seal northwards, finally slipping her dream burden into the sea just before her actual return home at the end of the summer.

Though Doris Lessing's [novel] has been hailed as both a beacon towering above the dense landscape of feminist literature and a fine rendering of the universal human dilemma of aging, a number of reviewers expressed disappointment with the ending in particular. . . . From a feminist's viewpoint, is the author of *The Golden Notebook,* the first major literary perspective on "free" womanhood, and the creator of Martha Quest, one of the few serious female pilgrims since Jane Eyre, now turned bitterly pessimistic regarding female options? In wider terms, is Lessing suggesting that resignation to a life of memory, regret, and mundane limitations is the best one can hope for once having crossed the meridian into middle age? Perhaps so. Yet the significance of Kate's return to Blackheath needs to be examined not only in relation to her conscious gestures, but in terms of the underlying processes contained within the dream cycle; we must look not only at the surface events, but at the strands woven into their reverse side, both their specific essence and the pattern they set up with the overt narrative events. . . .

At best . . . Kate attains a negative freedom: unconsciously, she has become aware that she must abandon her past illusion which forced her to confuse subjective being with an object as helpless and lowly as an injured seal, but she is unable to replace that illusion with something more viable, either in her dream life or her sphere of action. Indeed, the latter is crucial. Given the limited horizons of her conscious, active life, how can Kate hope to reach a new and more authentic imaginative grasp on her existence? The imagination does not thrive in a void, and without new experience, new metaphors can be of no value or distinction. Lacking new options, Kate remains at the end caught in a kind of experiential lag: her imagination has outrun the realistic possibilities of her life to the point where she is two separate beings: the Kate who returns to the limiting life of Blackheath and the Kate who has, on an imaginative level, repudiated the false self demanded by that very life. The first Kate has merely enacted a version of the myth of separation and return, a pattern that allows for very little transcendence. . . . The other Kate has enacted a very different myth, one which involves the exorcism of a self-projection that is alien and destructive; her final gesture is roughly analogous to the beast-slaying found in the legends of Hercules and Beowulf, among others.

<div align="right">Barbara F. Lefcowitz. *Critique.* December,
1975, pp. 107–8, 118–19</div>

The most brilliantly experimental performance soon becomes heavy-footed if there is no real substance to the plot or respect for the importance of sustained tension.

A case in point is *The Memoirs of a Survivor*. Doris Lessing is justly acclaimed as one of the leading novelists of our time. Earlier novels, such as *The Grass is Singing* and *The Summer before the Dark,* were both memorable for a searing insight into emotional states of mind as well as being first-class examples of ultra-modern fiction in their own right. Thus it is disappointing to find her falling for the prevalent fashion of speculating about life in the not so distant future, although this could have been rewarding if she had provided an original slant on the Brave New World. Alas, her predictions are in line with almost every other science fiction fantasy about the kind of existence we may one day be obliged to endure: a universal deterioration of moral standards and public hygiene, with scrounging nomads roaming the street. We have heard it all so often before and the only wonder is why a projection on the next century is always portrayed as regression rather than progress.

As would be expected from Doris Lessing, the effects of the squalor and deprivation are immediately related to an unusual group of human beings, among others a precocious adolescent girl named Emily and an older woman who adopts her. Tentative efforts to break down the girl's hostility are impeded by the presence of Emily's "familiar," a huge "cat-dog" named Hugo, a creature straight out of *Grimm's Fairy Tales,* who worships Emily and accepts any indignity in order to remain by her side. Predictably, Emily soon eludes both Hugo and her foster-mother and joins in sex and horse-play with the rabble. Flashbacks to the more stable past supply some useful clues, but are often jerky and confused and do not appreciably assist either the fantasy or the realism. What compensates are Doris Lessing's evocative word pictures of an unchanged country landscape beyond the littered streets and spasmodic, penetrating comments about Emily and her guardian, but these commutations are few and far between.

<div style="text-align: right">

Rosalind Wade. *Contemporary Review.*
April, 1975, p. 213

</div>

Few people can read Doris Lessing and then just forget about her; she affects lives—the way people view themselves and their world. Too many of us can find ourselves somewhere among Lessing's characters—with Jack Orkney, Charles Watkins, or Kate Brown—beginning to perceive the superficiality of what they had considered exemplary lives; with Anna Wulf and Martha Quest struggling against the mental entrapment of traditional female roles; with the many characters who have been violated by an insane society. I know people who, having glimpsed themselves here, are then unable to remain fixed by the patterns of life and thought that Lessing exposes so artfully.

Yet to explicate Lessing's fiction would seem to do it violence; such an endeavor is of course reductive, and Lessing continually strikes out against the mental divisions that she believes distort the human spirit. Nevertheless, at the same time she does wish to be understood. This fact is clear, both in her novels and in the comments she makes about them in essays and interviews. Quite simply, she believes (with many others) that our civilization is

slipping ever-faster toward the precipice. Almost from the beginning, her work has explored what in human nature is causing this catastrophe and what, if anything, can be done about it. I believe that no novelist writing today has treated these crucial issues with her art, perception, and persuasiveness.

Lessing's attention is always turned toward humanity's destructive weaknesses and potential strength, and it is essentially these that I have called the two *cities* and the *veld*. For Lessing, the African veld is the unconscious, physical world of nature that nourishes mankind with its unity but also inflicts its own mindless repetition and, in human terms, cruelty and indifference. The city is half-evolved consciousness, the destructive fragmentation of partial awareness. The ideal City is a hope for the future: the unified individual in a harmonious society. . . .

Lessing lays bare the really important problems that face us today: survival, and beyond that, the potential of the human spirit. And while one can encounter ideas similar to hers in other places, she does what only the novelist can do—dramatize them and imbue them with the special reality of the artistic imagination. In doing so, her hope surely is to effect the kind of understanding that leads to movement instead of just discussion.

<div style="text-align: right">

Mary Ann Singleton. *The City and the Veld:
The Fiction of Doris Lessing* (Lewisburg,
Pennsylvania: Bucknell University Press,
1977), pp. 9–11

</div>

As the final volume of *Children of Violence, The Four-Gated City* is the most comprehensive synthesis of the ideas and narrative techniques that have steadily evolved in Doris Lessing's fiction. Since the series as a whole traces Martha Quest's evolution through the various stages of her life from youth through adolescence, womanhood, maturity, and death—and since it was written and published during a time period embracing two decades—it is not surprising that the theme itself evolved from its original premises. In 1957, when only the first two volumes had appeared, Lessing described the series as "a study of the individual conscience in its relations with the collective"; its modulation in the final volume might be paraphrased as a study of the individual consciousness in its relations with the collective consciousness. The realization that both life itself and its symbolic transformation into fiction are organic, evolutionary processes is the shaping structure as well as the visionary theme of *The Four-Gated City*. Concurrently the series as a whole, framed by acts of collective violence, suggests more pessimistically that even the highly developed individual consciousness cannot finally influence the self-destructive potentiality and the inertia of the collective.

A number of other ideas in Lessing's fiction . . . are also assimilated into the larger spectrum of *The Four-Gated City*: the forms of relationships (between men and women, women and women, parents and children, private and public selves, artists and society); the functions of politics, the arts, institutions (psychiatry, government, journalism), and others. In its scope the

novel goes far beyond the traditional *Bildungsroman* convention that Lessing has identified as the form in which the series is cast. Martha Quest matures beyond the young adult's first strong claim on his/her identity to embrace a more collective and transpersonal sense of her own being. At the same time the final volume of *Children of Violence* asserts most clearly the Hegelian underpinnings of the form: Martha not only mirrors the education and progress of consciousness, directed by reason, toward a spiritual plane, but also embodies the assumption that "the individual, child of [her] time, possesses within [herself] the whole substance of the spirit of that time. [She] needs only to appropriate it to [herself], make it present to [herself] again."

Structurally, this concluding volume of the series bears the same relationship to the earlier four that the "Golden notebook" section bears to the novel of the same name: that of encompassing, reconciling, and transforming the spectrum of ideas that lead up to it—like the white light that results from the fusion of the colors of the spectrum. Moreover, the structural organization of fourness which Jung and others have identified as the image of rational wholeness and completion functions in the shape of *The Four-Gated City* itself. Like *The Golden Notebook* with its structure of repeating fours, there are four major sections of the novel, each of which contains four chapters. The Appendix, analogous to the Golden notebook, is a separate section that forms a synthesizing conclusion and returns the open-ended ambiguity of the whole.

Roberta Rubenstein. *The Novelistic Vision of Doris Lessing* (Urbana: University of Illinois Press, 1979), pp. 125–127

Lessing prefaces the third volume of her *Canopus in Argos: Archives* [*The Sirian Experiments: The Report of Ambien II, of the Five*] with comments on her intentions and expectations. Her central concern is one she shares with this novel's protagonist: "ideas must flow through humanity like tides. Where do they come from?" Her wish, as an imaginative writer, is that "reviewers and readers could see this series . . . as a framework that enables me to tell (I hope) a beguiling tale or two; to put questions, both to myself and to others; to explore ideas and sociological possibilities." As in the Sufi tradition that has influenced her, she (a living "sage") seeks to enlighten by means of teaching-stories whose inner meaning transcends literal interpretations to which familiar elements may tempt the reader.

The form of this installment is an illustrative memoir, composed in exile by Ambien II, a disgraced high colonial administrator and social scientist of the Empire Sirius. She finds herself writing, uncharacteristically, "a history of the heart, rather than of events"—in effect a narrative of the soul's search for perfection. She shows how her colonial work of social engineering, controlling and conditioning the satellites of the Sirian Empire, had turned under the mysterious compulsion of her encounters with representatives of a higher system, that of Canopus, into a quest for the ultimate meaning and source of what Sirius "compassionately," yet mechanically, does. Ambien II is well

equipped as omniscient narrator to embody Lessing's aims. She is virtually immortal: "we of the superior Sirian mother-stock . . . do not expect to die except from accident or a rare disease." Through Ambien's timeless perception, as both actor and observer, Lessing allows herself the utmost freedom to pursue her manifold quest.

Lessing's quasi-allegorical fictive cosmology embraces world history—legendary, pre- or factual—myths and beliefs about good and evil, and an eclectic range of social and political ideas. The action centers upon Shikasta (in Sirian parlance Rohanda) and leads up to that of her first volume, Shikasta's Last Days. "Good" (Canopus) and "evil" (Puttiora/Shammat) come more fully into focus, yet constantly, tantalizingly—and too vaguely, it will be complained—beyond their struggle for ascendancy in Shikasta hovers the mysterious Canopean recognition of the hidden "Necessity" (a Sufi concept) that governs all. Earth-visiting "gods," immaculate conceptions, UFOs, talismanic magic, Wellsian echoes, combine with freely shuffled episodes from our world's history—Aztecs and conquistadores, Mongol invasions, the modern global wars—to form an imagined whole whose metaphysical direction remains open, and intriguing, to the end. However, as in *Shikasta* (but not *The Marriages between Zones Three, Four, and Five*) meaning and message often smother those fictional elements that should illuminate them: too seldom are teller and tale "beguiling" enough to teach by indirection.

Michael Thorpe. *British Book News.*
August, 1981, p. 504

While there are those who tie their evaluation of Lessing's novels to her choice of technique—some reserve their praise for the earlier, "realistic" novels, while others claim that only the "visionary" novels succeed artistically—it seems to me that the telling factor is not *which* technical choices Lessing made in each work, but how bold and distinctive those choices are. For example, the choice of a tragic structure for *The Grass Is Singing,* a novel based on a Marxist understanding of history, is an aggressive, a contentious, and ultimately, a liberating fictional strategy. The tragic form channels the action and feeling of the novel in such a way as to reveal aspects of Lessing's theme to which a more conventional socialist realist format would not give scope. Similarly, the highly crafted architectonics of *The Golden Notebook* condition—in a sense, create—Lessing's reading of the epistemological issues that dominate that work. Finally, the creative tension of the science fiction and scriptural codes of *Shikasta* and the wonderfully effective anachronism of the medieval romance format of *Marriages* are assertive, even defiant choices that give great vitality to these first volumes of *Canopus in Argos.* The novels that fade into the background while these masterpieces take precedence, are those which are crafted in a conventional, predictable way or those in which the technique is muddied. The middle books of the *Children of Violence* series, for example, constitute the drabbest portions of Lessing's oeuvre, precisely because in them the tandem development of the

Bildingsroman pattern and the socialist realism is so very predictable. On the other extreme, the attempted amalgam of realism and fantasy in *The Memoirs of a Survivor* fails in effect because the two genres are made neither to cohere nor to clash significantly; there is instead a simplistic division in the text.

A well-defined and arresting structure—no matter how complex or simple—liberates the energy inherent in the matter on which it impinges. When Lessing succeeds in finding such a structure, she empowers herself to write, in the words of Anna Wulf, "the only kind of novel which interests me: a book powered with an intellectual or moral passion strong enough to create order, to create a new way of looking at life." It is a tribute to Lessing's intellectual, moral, and artistic passion that in her career of thirty years she has written such varied and such powerful examples of the kind of novel that she has set as her own ideal. *The Grass Is Singing, The Four-Gated City, The Golden Notebook, Canopus in Argos*—these at least will stand as novels that "create a new way of looking at life" precisely because they "talk through the way [they are] shaped," channeling, intensifying, and realizing the power of consciousness, which is their constant subject.

<div style="text-align:right">

Betsy Draine. *Substance under Pressure: Artistic Coherence and Evolving Force in the Novels of Doris Lessing* (Madison: University of Wisconsin Press, 1983), pp. 185–86

</div>

The Good Terrorist has to be taken seriously because it comes from the same hand as *The Golden Notebook,* which—written before her capitulation to Sufism, when, being of the world as well as in it, she encompassed so much of the world—crowns the period ending (ominously, in retrospect) with *The Four-Gated City.* How far Lessing has traveled since that period, *The Good Terrorist,* in its wholesale negation of the large humane intelligence, the honesty of mind and feeling, which informed her engagement then with what she called the great debates of our time, bears sorry witness. But that is not to say she has trodden a downward path all the way in the years between. Though no work she has produced in these years approaches the stature of *The Golden Notebook,* or of *The Four-Gated City* for that matter, her power to confront and render in her fiction the seismic shocks of our time, to enlarge and intensify our consciousness of them, has still made itself felt intermittently. She can still turn out a book—*The Diary of a Good Neighbor* is the most recent example—free of cant (amazingly so, given the deluge of it in the Canopus series). Perhaps *The Good Terrorist* is not, after all, the death rattle of the writer in Lessing, much as it sounds like it.

<div style="text-align:right">

Dierdre Levinson. *The Nation.* November 23, 1985, p. 559

</div>

A while ago Doris Lessing seemed to have given up realistic fiction in favor of a high-flown and involved futuristic fantasy. Five volumes of *Canopus in Argos* had appeared; though they were praised by some critics, many of her most devoted readers found them impenetrable and profoundly discouraging. For years Lessing had been their guide through the mazes of racism, Marxism, South African politics, feminism, Jungian and Laingian psychology, and Near Eastern mysticism. Now, struggling alone with political and sexual backlash, they felt abandoned in the hour of their greatest need.

Then, late last year, it was revealed that Doris Lessing had in fact recently published, under a pseudonym, two modest but very well-written naturalistic novels. They had been reviewed equally modestly or not at all, and soon disappeared from the bookshops. Reissued under her own name as *The Diaries of Jane Somers*, they were news everywhere; such is the effect of the literary celebrity system.

Considered in combination, however, *The Diary of Jane Somers* and *Canopus in Argos* were disturbing. They suggested that the creative high-tension in Doris Lessing between wild, imaginative energy and practical realism had finally snapped, splitting her into manic and depressive selves who produced, respectively, cloudy, optimistic fantasy and pessimistic tales of modern life. . . .

In her new and far more ambitious novel, *The Good Terrorist*, published under her own name, the two Doris Lessings are happily reunited. She continues to cast a cold eye on contemporary Britain. She asks questions of the sort that must have occurred to many people there in the past few years. How could their ordinary fellow citizens—not hysterical foreigners or obvious crazies—have planned and carried out the bombings of stores and offices that have killed and injured so many? Who could set out to do such a thing, and why? Whether her answers are right or not, Lessing has succeeded in writing one of the best novels in English I have read about the terrorist mentality and the inner life of a revolutionary group since Conrad's *The Secret Agent*. . . .

If Alice is, in a sense, England today, the prospect is bleak. By the end of *The Good Terrorist* all her good impulses have come to nothing or worse. The ruined house she has transformed into a comfortable home will be turned into expensive flats, and its inhabitants scattered; the waifs and strays she has befriended are lost or dead or in despair. Her parents' refusal to cut themselves off from her has ruined or nearly ruined their lives: her father's firm is close to bankruptcy and her mother has become an embittered alcoholic. In its conclusions, this is a deeply pessimistic book; but its energy, invention, and originality cannot help but make me optimistic about Doris Lessing's future work.

> Alison Lurie. *New York Review of Books.*
> December 19, 1985, p. 8

The book [*Prisons We Choose to Live Inside*] consists of a slender collection of brief essays, which turn out, as a note informs us, to be transcriptions of

a series of five lectures given by Doris Lessing in 1985 under the auspices of the Canadian Broadcasting Corporation. Perhaps the constraints of the radio talk as a form account for the author's brevity, tone and simplifications. Perhaps she felt that the general public shouldn't be bombarded with over-sophisticated and possibly mystifying concepts, that the main thing was to get some general points across. I think, if that was the case, that she may have underestimated her audience. . . .

Perhaps I'm making an unfair reading. Perhaps I've misunderstood. In any case, the author would probably be impatient with my naiveté; she has lived through more wars and social upheavals than I have. Yet, if she wants us to understand her views, she should explain herself more fully and perhaps be prepared to admit that the problem is a complicated one. As she herself says, wise people have been bothered about it for a very long time.

In a sense this book develops ideas already present in Lessing's novel series *Children of Violence*. . . . Political solutions are pronounced inade-quate, tainted by human imperfection and irrationality, the corrupting capac-ity of power. Confronted by this impasse, Lessing swerved off for a while (e.g. in *Briefing for a Descent into Hell*) to explore Laingian ideas of the truths uttered by those our culture labels deviant and schizophrenic. After detaching herself from the Laingians (as she formerly detached herself from the Communists, the Marxists and the Christians) she has increasingly opted for wry, dry, sibylline utterances, as in her sequence *Canopus in Argos,* and for the sort of omniscient narrative strategy that goes with nineteenth-century views of the author's relationship to the world. Perhaps to break out of the sibylline mold she wrote two novels under the pseudonym of Jane Somers. . . . *Diary of a Good Neighbor* and *If the Old Could.* It's a shame Jane Somers doesn't give radio talks as well as write novels; she dwells in the valley of human messiness rather than austerely on the mountain top and knows a lot about the human heart and its desires.

Perhaps *because* Doris Lessing was, for so many of my generation (com-ing up to forty), a prophet and wise mother who wrote brilliantly and percep-tively about our struggles to make sense of sex 'n' god 'n' politics, it's all the easier peevishly to reproach her for having gone beyond our petty concerns and no longer writing what we want to read. Mother's gone away and we complain? Certainly Lessing has recorded her irritation with this response. Yes, she is a major figure in 20th-century literature; yes, her labors and prodi-gious output have helped to change the way we see ourselves. But I wonder how much she really likes other human beings.

<div align="right">Michèle Roberts. The New Statesman.
September 25, 1987, pp. 29–30</div>

Like Rhys and Stead, Lessing alternates in her fiction between self-expression and attempting to capture the other, most simply at first by writing vignettes shaded with local color. These early works assume that a vivid mimesis will insure the reader's duplication of the author's attitudes—often

attitudes of rejection toward her subjects. Domination and empathy, the values of "market" and of "home" or of empire and colony, of sophisticated city and of pastoral retreat—and often of men and women—struggle with each other throughout Lessing's work. Domination and empathy may work to cross purposes when the narrative dominates its subject matter in such a way as to break the empathic identification between reader and characters, often by turning the tables on a dominating person and so exposing the social order that person represents. Lessing's narratives, in turn, struggle against both domination and empathy, seeking the autonomy of an individual identity, which is also the desire for a story of one's own, a story within a meaningful history.

> Judith Kegan Gardiner. *Rhys, Stead, Lessing and the Politics of Empathy* (Bloomington: Indiana University Press, 1989), p. 85

The Golden Notebook remains "alive and potent and fructifying" because each time one reads it, it yields something new. It provides "a new way of looking at life" and "expand[s] one's limits beyond what has been possible," and its structural innovations affirm the possibility of psychic and political transformation by enacting change formally. Lessing writes not only beyond romantic endings, but also beyond the idea of the ending, with its inevitable nostalgia, and beyond those fictions by women who refuse their protagonists powers equivalent to their own. "A woman if she is to write must have a room of her own," said Virginia Woolf, and Lessing gives Anna "Wulf" not only a room of her own but the literary and critical gifts neither Woolf nor Austen, nor the Brontës, nor Eliot ever lavished on their protagonists, and then demonstrates that this is not enough, for the room in which Anna and Saul break down becomes a place where new possibilities are forged, terrible and marvelous: "the floor . . . bulging and heaving. The walls seemed to bulge inwards, then float out and away into space. . . . I stood in space, the walls gone." *The Golden Notebook* represents more than an "act of imagination" that "keeps the dream alive." It has been for many of us a "lurch forward" into new possibilities; it is what Margaret Drabble calls "territory gained forever."

> Gayle Greene. *Changing the Story: Feminist Fiction and the Tradition* (Bloomington: Indiana University Press, 1991), p. 129

LE SUEUR, MERIDEL (UNITED STATES) 1900–

The spare prose of [Meridel Le Sueur's] early stories from the thirties, collected in *Salute to Spring* (1940), has a leanness more akin to Katherine

Mansfield's delicate artistry than to socialist realism. In 1940, *The New Yorker* praised the collection as "twelve distinguished short stories about what we used to call the [American] proletariat. People on strike; people on relief; people waiting for Sacco and Vanzetti to die; a young girl, pregnant, hungry and yet somehow assuaged by the pear tree outside her window. Le Sueur describes them all with a passionate and convincing partisanship."

While she was writing the luminous short stories of lives lived in poverty and obscurity which gave her a national reputation, she was also reporting on the strikes, unemployment struggles, breadlines, and the plight of farmers in the Dakotas. She was on the staff of the *New Masses* and wrote for *The Daily Worker, The American Mercury, The Partisan Review, The Nation, Scribner's Magazine, The Anvil,* and other journals.

In "I Am Marching" [reprinted in *Salute to Spring*], probably her most famous piece of reportage—about the bloody 1934 Minneapolis truckers' strike—she described the central spiritual conversion of her life: her rejection of middle-class values for a life as an artist of the working people. "I am putting down exactly how I felt," she writes, "because I believe others of my class feel the same. . . . The truth is I was afraid [during the strike]. Not of the physical danger at all, but an awful fright of mixing, of losing myself, of being unknown. . . . I felt I excelled in competing with others and I knew instantly these people were *not* competing at all, that they were acting in a strange, powerful trance of movement together."

<div align="right">Patricia Hampl. Ms. August, 1975, p. 63</div>

The body of Le Sueur's work is impressive, both for its quantity and diversity. Since 1928, when her first short story was published in the *Dial,* her writings have appeared in many journals: *American Mercury, Scribner's, Partisan Review, New Masses, Daily Worker, Anvil,* and many small, now defunct journals devoted to short fiction. She has worked in many genres: the short story, interpretive reporting, history, children's books, novellas, the novel, poetry, and personal journal writing. Her subject matter, too, has been wide ranging: from politics to intensely personal introspection.

Writing was always Meridel's primary political activity, and her style reflects a unique interweaving of politics-history-poetry. Many of Le Sueur's stories recount specific political actions between the thirties and the fifties. Even in her later poetry, she was moved to write to the women of Vietnam via a long poem integrating feminism, pacifism, and Marxism entitled "Doan Ket." "What Happens in a Strike," a story about the 1934 trucker's strike in Minneapolis; "A Hungry Intellectual," a devastating description of a man unable to make a commitment, although he was "intellectually" aware of the conflicts within the culture during the Depression; "I Was Marching!" perhaps her best known and most powerful political statement of human solidarity and collective political action; "Murder in Minneapolis," an angry eulogy for strikers killed at the Flour City Architectural Metals company in Minne-

apolis; and "Minneapolis Counts Its Victims" are a few examples of her interpretive reporting of events.

In other articles, she documented direct exploitation and murder. "Iron Country" was an exposé of the mining companies of the Mesabi Range who fired workers they found suffering from lung diseases; "The Derned Crick's Rose" illuminated Marx's theory of the alienation of workers from the means of production; and "The Dead in Steel" showed the courage of union organizers and their families. Other short stories and articles detailed the devastation of the land and people during the drought of the 1930s in the Midwest: "Cows and Horses are Hungry," "Tonight Is Part of the Struggle," "Salute to Spring," "The Farmers Face a Crisis," and "How Drought Relief Works." Except for her support of America's entry into World War II, Meridel has maintained a consistent pacifism in her writings, and in several short stories she examines the impact of war on victims and families: "Song for My Time," "Breathe upon These Slain," and "The Way It Seems." . . .

In all her writings the images of the land as the great circle of the prairie interfuse with her imagery of politics, philosophy, and sexuality. The earth is the woman of joy and abundance, of giving, of life. The earth is the woman raped; the raped woman is the earth. The exploited land is the worker exploited, the woman abused. She returns again and again to the land, creating new images and symbols, redefining a true relationship with the earth.

The relationship of the feminine to the earth has been a dominant theme in Meridel's writings. From her earlier references to Demeter and Persephone to her later incorporation of the American Indian attitude toward the land, she has opened new insights into our understanding of nature and our place in, or with, the earth. Understanding the earth as feminine requires that we look "inside" to the inner experience and feel ourselves as we are in that place, within the body, within the curve of the prairie circle, within the midwestern village. . . .

For Meridel Le Sueur, the prairie is that space in which she has centered her entire world view. Her vision of a global consciousness is an image born directly from the great open spaces of the Midwest. Perhaps the experience of the land does have a different feeling in the Midwest, creating a broader vision of expansiveness and spaciousness. Meridel has succeeded in translating that sense of wholeness and circularity and all-inclusiveness that bridges the religion of the prairie tribes and the early pioneer sense of awe for the great land spaces. Emerging from the little space on the prairie, expanding to the large universal space, Meridel completes her circle of life.

Neala J. Y. Schleuning. *Books at Iowa*. 33,
1980, pp. 27, 32, 38

Meridel Le Sueur is to the American conscience what Romain Rolland was to France or Käthe Kollwitz to pre-Hitler Germany. Her work, just beginning to receive adequate attention, looms on the literary spectrum for its recording of what she has seen and known. . . .

The Great Depression: that bland stupidity of the Coolidge era. Two world wars and their ultimate spinoff of the Vietnam war. The civil rights struggle, whose gains are now so threatened. The long lines of unemployed men and women outside personnel offices. The cynical demagogy of politicians and the daily searing lives of women selling themselves to pay room rent. All these things Meridel has described with her penchant pen flowing as eloquently now in her eighties as it did during her twenties and thirties. . . .

As a Southern regional writer, I was deeply impressed with the way Meridel interpreted her own region—the Midwest—that area which had given our country Clarence Darrow, John P. Altgeldt, Edgar Lee Masters, Sherwood Anderson, Carl Sandburg, and so many other great writers of the people. I was especially appreciative of Meridel's book-length classic, *North Star Country,* published in the '40s, for inside its covers one caught the authentic flow of life and history in her marvelous Midwest.

Inside *North Star Country* one could feel the majesty of the great rivers, the large fields of corn and wheat, the power of the blizzards that swooped down from Canada. But more importantly, one could learn of the torrential political movements, such as the Non-Partisan League, the Farmer Labor Party, and the Populists scaring hell out of both the Democratic and Republican oligarchies. This is Meridel's turf. She knows how to define it, and best of all how to portray and speak for its peoples—not glorified thieves like Jim Hill and Jim Fisk, antisocial like the rest of their odious kind, but the masses of hard-working citizens from all the region's ethnic groups. The Scandinavians breaking soil for their industrious settlements, the Germans and the Irish, the Native Americans, and those conglomerate Americans of so many threads known as Anglo-Saxons.

In *North Star Country* one also reads of the varied worker categories: the railroaders, the miners, the lumberjacks, the boatmen, the migrant workers and hobos, men and women longing for "work that is real" (to quote Marge Piercy). In the more than 30 years since it has been available to the American reading public, this book still is the finest historical and cultural work on the Midwest ever written.

Harold Preece. In Mary McAnally, ed. *We Sing Our Struggle: A Tribute to Us All* (Tulsa: Cardinal, 1982), n.p.

The book is in essence conflict (not always opposition), not only because change and process are conflict but because Meridel Le Sueur's *The Girl,* written in 1939, is still not settled into any comfortable *stasis* within the literary tradition. The true classics never do, or never remain there long. *The Girl* is not a classic. An unknown classic is a contradiction of the language. That it will become a classic is in doubt only if our literature is in doubt.

The question is not will we fail to recognize the worth of this novel but whether we fail to establish that larger tradition within which this novel will find a place of worth. It will not become a classic because of any critical

attention (this essay is not propaganda for it). But because of its influence on readers and writers and because of their influence on the culture that has up until recently effectively kept it hidden, it is classic.

In other words, the novel has the chance of being accepted within the tradition if the tradition is recovered and seen anew. But this larger conflict is not my immediate concern, even though it cannot be ignored that the past critical betrayal of *The Girl* is an indictment of the literary establishment— meaning the critics and reviewers not all of whom are academics but who have distorted the aesthetic judgment so that any work is pronounced flawed that has the possibility of altering the society's *status quo.*

I am intrigued by *The Girl* for several reasons, but the main one—the one that draws me back to successive re-readings—is the story. It is the story that has been denied us until now. *The Girl* helps rescue from oblivion a significant portion of our language. This story, like all true stories, continues to inform us now. This is one reason why Le Sueur is a heroine to a large and growing number of female readers. But considering gender as the issue does not reveal the main significance of the story, nor is it primarily developed along class lines. The story is significant now because the way it was told—how form and content are not separable—becomes a model for a renewed literature that puts the lie to the prevailing aesthetic prejudice that an art of the people is necessarily simplistic.

It is the internal complexities of *The Girl* that reveal the worth of the characters because of the novel being true—in a way very few novels that attempt realism have ever been true—to the story of those characters. In the afterword to the West End Press edition of *The Girl* Le Sueur explains how various essential parts of the story were given her by her friends who lived them. The story is a collective, then, instead of solely the artist's imposition of the tyranny of the imagination. It is her being faithful to the dynamics of the people's stories that has kept process and conflict integral to the artistry—and hence recognizable—and hence true.

<div align="right">

Joseph Napora. In Mary McAnally, ed. *We Sing Our Struggle: A Tribute to Us All* (Tulsa: Cardinal, 1982), n.p.

</div>

As a general pattern Le Sueur's work is increasingly polemical with each decade. Stories from the 1920's such as "Persephone," "The Laundress," "Holiday," or "Corn Village" are the least self-conscious in pressing an ideological critique. Le Sueur told me that the Party recommended she write leaflets to become more disciplined and that she found it a way "to escape being vague." In the 1930's Le Sueur published a mix of fiction and journalism which often embodies straightforwardly a political point. *New Masses* published "Women on the Breadlines" and "I Was Marching," and *American Mercury* published "Cows and Horses Are Hungry" and "What Happens in a Strike." The fiction often featured union organizers or members of the Workers' Alliance. The most persistent themes in the stories from the thirties

through the fifties are the disaffection from the capitalist system and the joy and wholeness found by joining in the communal group. Stories such as the 1934 "No Wine in His Cart" feature the wife whose working-class loyalties lead to the rejection of her bourgeois husband when his opposition to the union reveals their true differences. Even "The Horse" (*Story Magazine* 1939), which is to my mind the most politically oblique of her major stories, may be read as a critique of the corruption of the individualist who isolates self from the communal group. The stories and essays in *Masses and Mainstream* in the late 1940s and 1950s are usually openly critical of the destructiveness of capitalism in terms of human relations and our relation to the land, or they are commentaries on the "dark of the time" of McCarthyism.

Feminist readers have seen in Le Sueur's treatment of working-class women a portrayal of lives seldom represented in literature, and in her treatment of male-female relations, a picture of sexual oppression. We should note, however, that the oppressive men in her work, such as the husband in "No Wine in His Cart" or Bac and Butch in *I Hear Men Talking* and *The Girl,* are not among the comrades. The husband in "No Wine" is an owner, and the tension between him and his wife is one of class conflict. Bac in *I Hear Men Talking* has sold out the striking farmers to the sheriff before he attempts to rape Penelope. Male characters such as Lowell, the organizer in *I Hear Men Talking,* or Steve, the friend from the Lincoln Brigade who served in Spain in "Song for My Time," are instrumental in helping the female characters recognize their true identity as members of the communal group. Le Sueur's focus on the woman's experience in pursuit of a communal identity is cast in a political context but parallels what Carol Gilligan describes as the result of women's different experience of social reality. . . .

Though Le Sueur's current reputation rests mainly on her portraits of women, her writing, especially after the mid-1930s, also gives us a powerful anatomy of the American radical experience. Her radical characters, male and female, capture the yearning that moves people to join the communal group and to stay with it through troubled times. Her quasi-journalistic accounts of America during the "dark times" of McCarthyism evoke the anger and grief in those who had dedicated themselves in the thirties and forties to the goals of justice, freedom, and equality.

<div align="right">Linda Ray Pratt. Women's Studies. 14, 1988,
pp. 257–58, 262</div>

Le Sueur is known for her reportage, especially "Women on the Breadlines" and "I Was Marching," which I categorize as "official" proletarian literature. However, "Our Fathers" is one text in which an "unofficial" Le Sueur emerges. She has described "Our Fathers," which is somewhat autobiographical, as "one of the few [of my] stories that's not covered up. . . . It [is] really a naked cry" (interview). Through the fictional characters, she confronts her grandmother's, her mother's, and her own emotional deformation. Adolescent Penelope, the story's protagonist, rebels as Le Sueur did against

ascetic Protestantism. Penelope insists on knowing and feeling what her mother and grandmother have repressed, forgotten, denied. . . .

"Annunciation" departs even more than "Our Fathers" from typical proletarian literature. The title alludes to the angel Gabriel's announcement to Mary that she will give birth to the Son of God (Luke 1:26–38), and Le Sueur originally wrote the story in 1928 to her first unborn child. Set in the Depression, this narrative prose poem represents a pregnant woman's dreamlike state of mind, imposing a theme of fertility and regeneration upon a secondary theme of contrasting deprivation.

Like "Annunciation," "Corn Village" has little in common with orthodox proletarian realism or reportage. In writing about Midwest farmers, Le Sueur was not writing about workers considered by the Party during the Third Period to be the key to revolution; the Party gave priority in this period to organizing efforts among workers in basic industry because of its assumed importance to the economy. In "Corn Village" Le Sueur has consciously or unconsciously almost wholly discarded the Party discourse. "Official optimism" and its corollary, what I term "official certainty" ("we know that not pessimism, but revolutionary élan will sweep this mess out of the world forever") are noticeably absent from the text. . . .

"Corn Village" is not constrained by the limited-understanding ideology that characterizes much of proletarian realism and reportage. For example, in Le Sueur's "I Was Marching," ideology is seen as merely a superstructure produced by an economic base, a fallen consciousness obscuring society's "real" structures. In contrast, ideology pervades "Corn Village," prefiguring the more current understanding of ideology as the way in which we actively but unconsciously perform our roles within the social totality. The story supports Gramsci's notion of dominance and subordination as a "whole lived social process" saturating even the most private areas of our lives and consciousness. If we accept Wendell Berry's definition of regionalism as "local life aware of itself," "Corn Village" qualifies as an extraordinary piece of regionalist writing precisely *because* Le Sueur adopts the double consciousness and the oscillation between complicity and critique that "The Fetish of Being Outside" condemns as neither possible nor desirable for the radical writer. Le Sueur resides at once within the corn village culture and outside it, negotiating difference and sameness with divided loyalty and consciousness.

Constance Coiner. In Lennard J. Davis and
M. Bella Mirabella, eds. *Left Politics and
the Literary Profession* (New York:
Columbia University Press, 1990),
pp. 168–71

In Meridel Le Sueur's *The Girl,* a nameless Girl, the novel's heroine and narrator, undergoes an extraordinary metamorphosis—or more precisely, a series of metamorphoses that change a scared and silent country girl into a woman. At first naive and virginal, she learns the ways of her sex and class,

and assumes the responsibilities of her knowledge. She becomes the bearer of woman's secret, the partisan of oppressed people and the mother of a beatific child—a mythic Mother. Her ultimate transformation, easily overlooked but striking, is from silent witness to storyteller. Like Le Sueur, she retells stories told to her by poor, dispossessed, and mad women whose voices are not usually heard in the world and whose lives, unrecorded in official histories, would be forgotten if not for her words. These words are my central concern. I hope to trace them to their sources within the text and show how, through a process of appropriation and subversion, the Girl acquires a language she finds empowering. At the same time I wish to point out limitations in this language that the Girl does not see but that, I believe, Le Sueur recognizes and tries to overcome by strategies that make her writing linguistically exciting and confused. Confusion, in its etymological sense of melting or pouring together, represents an ideal of unity she attempts to realize by amalgamating discrete and incompatible discourses. The idea is in itself an amalgam of her utopian dreams of a classless society, of a sexual identity shared by women and men as mothering figures, and of a literature accessible to common people—a poetic language created from proletarian speech.

Ironically, Le Sueur's vision of a reconciliation of difference appears in a text characterized by conflict. Its style is conflicted, its various discourses remaining dissonant despite Le Sueur's attempts to conflate the rhetoric of proletarian politics with the language of fertility myths, urban working-class vernaculars (male and female), hieratic incantations, and biblical prophecy. The result is a rich stylistic confusion that makes *The Girl* a complicated text to analyze, though it seems superficially simple in plot. On close examination, however, even its plot moves in different directions: in a linear progression that marks the stages of the Girl's growth to womanhood and social consciousness; and in the circular pattern of loss and recovery of resurrection myths. The result is a confusion of genres, for *The Girl* is a novel of radical social protest that contains within its form a feminist jeremiad, a woman's bildungsroman, and a fertility myth that simultaneously inscribes and denies sexual difference. The history of its episodic production may account in part for both the overdetermination and the indecisiveness of the text. Almost four decades intervened between its conception as a record of the lives of urban working women caught in the Great Depression and its revision and publication. In this interim, Le Sueur accommodated to and yet resisted the cultural changes she saw taking place. Unlike many leftist writers of the thirties, she never repudiated the radicalism of her youth; rather, she sought to consolidate Marxist doctrine with other ideologies committed to social change—with, for example, the feminism that had reemerged as a social force while she was revising *The Girl*. Feminism and radical politics had always been intertwined in Le Sueur's writing, and as she tried to make them indissoluble in her novel, she produced a unique text that is both dated, expressive of an aesthetic sensibility of the thirties, and proleptic, anticipating a call for a generic woman's novel—for a bildungsroman—and for a woman's language.

Since traces of erasures made in the early manuscript are visible beneath its revisions, *The Girl* may also be defined as a palimpsest, a text in which, feminist critics claim, women writers subversively assert their authority.

<div style="text-align: right;">

Blanche Gelfant. In Florence Howe, ed.
Tradition and the Talents of Women
(Urbana: University of Illinois Press, 1991),
pp. 183–84

</div>

LEUTENEGGER, GERTRUD (SWITZERLAND) 1948–

In 1980, there appeared a three-part dramatic poem by Gertrud Leutenegger, who had held a position as assistant theater director in Hamburg as recently as 1978. The author named it *Farewell, Have a Good Trip,* in cryptic reference to a song that had brought success to the "Comedian Harmonists" in the 1920s—that is, in the age of the gradual expansion of tyranny in Germany. It engages her in an analysis of power and its victims, and forces her to come to terms with the past. Yet what is unique about this work is its depiction at the same time of the conflict between men and women, which is an absolutely central component of the historical theme. Leutenegger's argument is neither sociological nor political, although her representations do have societal relevance. . . . Time and again—most recently in the novel *Governor* . . . she succeeds in condensing reflective thoughts into language in such a way that they lose their abstract character and achieve poetic autonomy. . . . Hitherto, each of Leutenegger's works has demonstrated the triumph of the imagination over intellectual abstraction. Without a doubt, this poetic tour-de-force emerges as a distinguishing feature of her determined style.

Processions and demonstrations, Carnival and theater played a decisive role from the beginning in the literary creativity of Gertrud Leutenegger. And so, too, in *Farewell, Have a Good Trip,* she makes use of the greatest of her childhood experiences, that of the Carnival, and of her studies in directing, each of which she brings up to date in terms of content and form. Smoothly, she inserts the confrontation with the man and his cravings for power—a theme pursued further in the novel *Governor*—into the context of the Carnival game of masquerade in which the stakes are life and death. Meanwhile, the eternal return of the song by the "Comedian Harmonists" (this, by the way, is also to be taken literally as an expression of Leutenegger's dramaturgy) estranges us from the mythological theater, serving as a reminder of the staging of a deadly reign of terror. Crucial aspects of this "dramatic poem" appear to verify key traits of a specifically feminine sensibility. . . .

Leutenegger configures the identity of man and woman as eternally separate entities by citations from the Bible and mythology; for these, too, represent for her an origin, a native home, a "mountain range." In all her works

to the present, she has succeeded in depicting the tensions between the sexes, but also the possibility of a loving identification between them. . . . It would be unfair to her to recognize in this new communion between the sexes merely a poetic myth. Mythology, including that of the Bible (cf. Jonah, Noah, Lot's wife), represents nothing more than a reflection on native cultural origins. If there is to be a journey into the future, then it becomes—for the man and the woman alike—a "journey of death" on into "eternity," and back to that which connects us, rather than divides us. That is why, despite all the irony inherent in the dramatic poem's title *(Farewell, Have a Good Trip)*, it demands to be taken seriously. It too is at once play and meaning, sign and spirit. Although the work's sociopolitical appellation absolutely cannot be ignored, it distinguishes itself in that it never succumbs to the one-dimensionality of everyday politics. Women's literature—and not it alone—has in Gertrud Leutenegger one of today's greatest artists of language.

<div style="text-align: right">

Manfred Jurgensen. *Frauenliteratur:*
Autorinnen—Perspektiven—Konzepte
(Bern and Frankfurt: Lang, 1983),
pp. 215–16, 229–30

</div>

Gertrud Leutenegger . . . is undoubtedly one of Switzerland's most prominent contemporary writers. Her tightly structured, dense prose narratives frequently circle around a traumatic, deeply repressed event which nevertheless informs all the protagonist's thoughts, movements, and perceptions. The eponymous "Meduse" of her newest work is a huge jellyfish. A young, nameless woman, the I-narrator, sees the jellyfish as she walks on the beach. Memories emerge of a summer spent in a nearly deserted mountain village with her lover Fabrizio. (But is he merely her lover? Why does she know so much so intimately about his childhood, which somehow they seem to share?) Fabrizio's uncle (called only "Uncle") and the latter's sister Giuditta (why is she never referred to as Fabrizio's aunt?) are the only year-round inhabitants of the village. What is their relation to each other? Why did neither of them ever marry?

Intricate chains of associations weave from the round body of the jellyfish with its long, dangling arms, to a child's head with its hair, to the earth with its trees, and encompass practically everything spherical. Other chains radiate from white milk, white snow, white linen, to dark spaces of seclusion. Structures of separation such as skin, walls, tissues, even shadows, stand in vivid contrast to the boundlessness of the ocean, while images of rupture and violation . . .

The mythological references are carefully integrated yet, like palimpsests, provide only discontinuous bits of information. (For example, the transparent plastic sandals, protection against the stings of the jellyfish, are Perseus' "winged sandals," worn when he severed Medusa's head. Giuditta/ Judith likewise decapitates, but who is her Holofernes?) Throwing away the

protective sandals, the narrator walks into the ocean and, following the "Med-
use," becomes what she had contemplated.

Ernestine Schlant. *World Literature Today.*
63, 1989, pp. 92–93

Leutenegger is one of the most outspokenly feminist and politically leftist
novelists of the postwar generation in Switzerland. Her most important con-
tributions are in the areas of drama and the novel, which are characterized
by a combination of a highly lyrical style, autobiographical elements, and
political allegory. She initially published short stories and poetry. Leuteneg-
ger was the daughter of a civil servant and was educated in Swiss schools as
well as a French boarding school. She also lived in Florence, England, and
Berlin, then specialized in early-childhood education, but also worked in a
women's psychiatric clinic as well as being for a time the custodian of the
Nietzsche House in Sils Maria. These diverse working and living experiences
made her critical of Swiss society's self-perception as a well-regulated micro-
cosm, with its unrelenting insistence on tradition and order. Leutenegger
protests against deeply entrenched structures of order, normalcy, and same-
ness, which marginalize women, foreigners, especially the Italian working-
class population in Switzerland, the mentally ill, and those with communist
or socialist political leanings.

Her first novel, *Vorabend* (1975; The evening before), invokes the apoca-
lyptic atmosphere on the eve of a political demonstration. The isolated female
narrator feels alienated from her surroundings but chronicles her feelings of
dread and rebellion in realistic detail on a walk through Zurich, remembering
on the eve of a big protest march, which she wants to join, sudden and violent
disruptions of the daily routine—a worker killed by electric current in the
town square, an awakening lesbian relationship to a girlfriend in high school
with the ridicule that went along with it, being a nurse in a women's psychiat-
ric ward, where the old and the ill are kept medicated but no effort is made
to reintegrate them into society or even treat them as human beings. Leuten-
egger voices her hope for a less hierarchical, more caring society, but her
appeal is tempered by skepticism. In her second novel, *Ninive* (1977; Ni-
neveh), Leutenegger frames her plea for social innovation in a more biblical
and allegorical vein. The narrative begins with a visitation, an embalmed
whale is exhibited to the people of Leutenegger's hometown, and ends with
the whale's destruction. This narrative contains the childhood friendship and
later love-story of two communist inhabitants whose vision of a better society
survives the repression of state institutions, which the whale symbolizes.

In 1977 Leutenegger began taking classes in directing for the stage at the
Zurich Academy of Theater and the Arts, and interned with the noted director
Jürgen Flimm in Hamburg in 1978. This experience led to the publication of a
play, *Lebewohl, gute Reise* (1980; Farewell, have a good trip), which deals with
the struggle between Gilgamesh and Enkidu for control of the world. Their bru-
tality is opposed but not overcome by two marginalized and abused female pro-

tagonists. The play incorporates many fantastical and surrealist elements, which tend to dominate in Leutenegger's next novel, *Gouverneur* (1981; Governor), an allegory of a Nietzschean construction project on a mountain plateau in Switzerland, far from the cities yet subject to periodic checks by teams of hostile state inspectors. The narrator wishes to find or remember the governor (God), who planned the project originally. The governor does return unexpectedly in the guise of a knife seller at the end when most of the other protagonists have been killed or victimized, and the dramatic ending leaves it open whether he has returned to help or to kill the narrator.

Two of Leutenegger's more recent works, *Komm ins Schiff* (1983; Come onboard) and *Meduse* (1985; Medusa), demonstrate her mastery of evocative, lyrical language. While the political dimension of Leutenegger's earlier writing is less foregrounded in these texts, they blend philosophy, fantasy, and autobiographical detail with a critique of male-female relationships in so far as they reproduce social inequalities. Leutenegger is most compelling in her ability to blend social critique and writing about everyday life in Switzerland with a richly poetic language.

> Helga Druxes. In Steven R. Serafin and
> Walter D. Glanze, eds. *Encyclopedia of
> World Literature in the 20th Century* (New
> York: Continuum, 1993), pp. 383–84

LEVERTOV, DENISE (UNITED STATES) 1923–

Nothing could be harder, more irreducible, than these poems [*Here and Now*]. Like the eggs and birds of Brancusi, they are bezoars shaped and polished in the vitals of a powerful creative sensibility. No seminar will break their creative wholeness, their presentational immediacy. No snobbery will dissolve their intense personal integrity. However irrefrangible as objects of art, it is *that,* their personalism, that makes them such perfect poetic utterances. Denise may not ever have pushed a pram in a Cambridge, Mass. supermarket, but these are woman poems, wife poems, mother poems, differing only in quality of sensibility from thousands of other expressions of universal experience. Experience is not dodged, the sensibility is not defrauded, with any ambiguity, of seven types or seventy. One meets the other head on, without compromise. This, I was taught in school, many years ago, in a better day, is what makes great poetry great. And the rhythms. The *schwarmerei* and lassitude are gone. Their place has been taken by a kind of animal grace of the word, a pulse like the footfalls of a cat or the wing-beats of a gull. It is the intense aliveness of an alert domestic love—the wedding of form and content in poems which themselves celebrate a kind of perpetual wedding of two persons always realized as two responsible sensibilities. What

more do you want of poetry? You can't ask much more. Certainly you seldom get a tenth as much.

<div align="right">Kenneth Rexroth. Poetry. November, 1957
pp. 122–23</div>

Also emerging [in modern poetry] is an ultimately . . . serious body of non-traditional verse represented by the work of Charles Olson, Denise Levertov, Paul Blackburn, Robert Duncan, and Robert Creeley. Their poetry shows the same intransigence as that of [Allen] Ginsberg and [Lawrence] Ferlinghetti, the same fundamental assumption that the crack-up of values prophesied by an older generation has completed itself. Indeed, these qualities are at the heart of almost all the more impressive new work, traditional or not. . . . In the Olson group, a renewed emphasis on the feel of specific moments of awareness, as if they were totally detachable from the rest of life, is indispensable to the reordering of sensibility.

Denise Levertov . . . [is among] the most "open" and sensuous writers in this group. Miss Levertov may begin a poem ("The Flight") with a quite sophisticated proposition. . . . But that is just the bending of the bow. When the conception here stated in so cramped and paradoxical a way is embodied in an anecdote about a trapped bird, the poem flies as an arrow of insight into an important subjective reality. "The Hands" does the same sort of thing in reverse, beginning almost sensually. . . . The dreaming movement into ecstasy is then translated into abstract esthetic dimensions, a pattern of tensions like that set up by actors rehearsing "on a bare stage." In such pieces Miss Levertov gives us a world of awakened, contemplative self-awareness, in which sympathy with other selves may appear, but completely independent of social expectations. Even the poems which come closest to explicit statement of the toughened intransigence I have mentioned—poems like "The Dogwood" and "Something"—seem to regard the civilization against which they react as a sort of cobweb brushing the face, something alien and strangely cold, almost unreal.

<div align="right">M. L. Rosenthal. The Modern Poets (New
York: Oxford University Press, 1960),
pp. 268–69</div>

In presenting us with particularities, Miss Levertov is constantly trying to break down categories and dismiss them from our minds: she implies that if we are to feel sympathy with the flux of life (such sympathy is the dominant emotion of the book) we must disregard the classifications into which we have come to divide the constituents of the world and regard each thing and process as special, unique. The purpose of her very metaphor is often to get rid of our preconceptions. . . . She has abandoned the slightly tenuous fancifulness around which some of the early poems are organized, for a solid acceptance of the solid. It is not a glib acceptance, either, merely borrowed from the nineteenth-century romantics, but one which surely reflects (as any

good poetry must) a manner of living, a personal discipline, in this case the discipline of tolerance.

Thom Gunn. *The Yale Review.*
Autumn, 1962, p. 130

In *O Taste and See,* Denise Levertov demonstrates herself the true and worthy heir of William Carlos Williams. It is not only that she employs a free verse which at its most successful is more like his than like anyone else's, nor is it that she too writes poems that sound, as many of his did, like fragments of experience. More than these remembrances, her spirit is like his, the female to his male, both of them praising and full of the power to live. No one of her poems in this book is as full and as marvelously satisfying as some of his late poems were; she has not yet the amplitude for such singing; but she is getting there. And she has a spiritual quality that matters more than any technical consideration in a verse this loose: sureness.

George P. Elliott. *Hudson Review.*
Autumn, 1964, p. 461

The hard, clear form of Levertov's poetry since coming to America and until her most recent work was possible because she possessed a sense of self denied to many poets born and raised in the younger culture. In the fifties, Kenneth Rexroth found her poetry superior to that of Duncan, Olson, Creeley, Ginsberg, Cid Corman, and other "avant-garde" poets because "she is more civilized. One thing she has that they lack conspicuously is what Ezra Pound calls culture—and which he is himself utterly without. She is securely humane in a way very few people are any more." Intending it, I suppose, as Matthew Arnold intended it in his criticism of the Romantic poets, Rexroth asserts that Levertov is a superior poet because she "*knows more than her colleagues*" (my italics). His seems a just appraisal: "securely humane" is an excellent description of Levertov's work in the volumes published between 1955 and 1965. She brought with her to the American experience a self-assurance and stability that kept her humanity strong and natural. The poetry offers no doubt that she is in control, moving attentively and perceptively through experience with a confidence more common to poets before the First World War. Not a naïve or romantic poetry, but a poetry of a healthy psyche, it is unlike much poetry written in the 1950s and 1960s. Either because severe self-doubt did not exist or was kept outside of the poetry, the work before 1965 is able to devote its attention to the balanced seeing and savoring of life. Intensely personal . . . "poetry of the immediate" drawn directly from experience, it is yet a poetry in which the ever-present "I" is remarkably unobtrusive. The four volumes from *Here and Now* (1957) to *O Taste and See* (1964) are, in fact, admirable examples of Levertov's "negative capability." Because of the Vietnam War the same cannot be said

of *The Sorrow Dance* (1967), *Relearning the Alphabet* (1968), and *To Stay Alive* (1971).

James F. Mersmann. *Out of the Vietnam Vortex: A Study of Poets and Poetry against the War* (Lawrence: University Press of Kansas, 1973), pp. 182–83

Levertov's poetry derives most directly from the masculine tradition that dominates modern poetry, although both its recurrent ambivalence and frequent flashes of vibrant strength seem to me to arise out of an engagement with her feminine experience. . . .

Levertov . . . occupies a significant and transitional position in the history of poetry by women because her work contains elements of both the dominant masculine and the emerging feminine traditions. She seems to see herself as poet, not as woman poet. Over the twenty-five years of her poetic career, her work has grown in skill and refinement, but there has been little change in either her aesthetic theories or the forms in which they are rendered. Writing closely within a mainstream of modern poetry—"imagistic," "organic"—she also brings to her work a spiritual, religious element and particular kind of personalism (that of her feminine experience). Sometimes these elements work together in harmony; at other times they struggle with one another, affecting the unity of a given poem. A need to abstract and to generalize upon the greater significance of an experience (a distancing movement found in both the poetic and the spiritual traditions in which she works) is sometimes at odds with an involvement and an immediacy that arise most strongly in poems that deal with intense personal experience (in particular, the feminine and the political). . . .

Levertov's poetry constantly explores the relation between the inner world of dream and the outer world of action precisely because this dynamic is the very source of poetry itself. . . .

Because she is a woman, the experience that her poems require for their existence is feminine experience. The dominant qualities of those experiences of nature, art, people, and politics that make up her poems are their personal and private nature and their circumscribed boundaries. Such qualities have come to be associated with women's experience, so on that level Levertov's poetry seems very feminine. Even when her poetry becomes more public in its involvement with political issues, such as the Vietnam war, it continues to explore these problems in relation to everyday and private life.

Suzanne Juhasz. *Naked and Fiery Forms: Modern American Poetry by Women—A New Tradition* (New York: Octagon Books, 1976), pp. 58–61

[Levertov's] poems have been an important part of the contemporary literary scene for twenty years. When the formalist 1950s relaxed to accept Allen

Ginsberg's *Howl* and Robert Creeley's short-lined love poems, Levertov's work offered a kind of middle ground: poems in which rich sound patterns balanced "natural speech"; poems in which a humanistic credo—and the need to express it—overshadowed the mere presentation of an image. From the first, Levertov had insisted that a poet had to use all language resources available. She had also declared that every poet had firm social responsibilities. . . .

The tone of many of the poems in *The Freeing of the Dust* is quieter, more satisfied—not with the physical or social circumstances of life, but with a human being's ability to cope with those circumstances. There is much emphasis here on exploring the fullest ranges of consciousness and psyche, and I was reminded of her 1972 essay on Ezra Pound in which she praised his writing because "He stirs me into a sharper realization of my own sensibility. I learn to desire not to know what he knows but to know what I know: to emulate, not to imitate." Poems here echo with this completion of earlier promise, with the sense of Levertov as person knowing herself, being, and becoming, through both life and poetry. *The Freeing of the Dust* is an amazingly rich book, giving us the image of Levertov as fully realized poet, humanist, seer and—not the least—as woman. In the process of complete engagement, a poet who is also a woman must, finally, speak with a woman's voice: any denial of that primary identity would play havoc with the self-determination of the poem. There are perhaps too many women who use the crutch of sexual identity to make bad poems effective, but when Levertov creates the feminine identity, as in the evocative "Canción," its use is powerful. . . .

In countless other ways, this 1975 collection re-states Levertov's strengths as poet. It impresses with its versatility: there are seven groups of poems, ranging from the political commentaries to poems about love and divorce; from masterful sequences to the single-image poems that reach further than any image poems have any right to. Not a collected or selected work, *The Freeing of the Dust* gives a reader the sense that the searching vicissitudes of American poetry during the past half century have brought us to an art capable of expressing (and first recognizing) both "despair" and "wildest joy."

<div style="text-align: right">Linda Wagner. South Carolina Review.
Spring, 1979, pp. 18–21</div>

When Levertov makes myth serve humanity—that idol of prophets and politicians—it is sluggish in its duties. She is a dreamer at heart, and her best moments are stolen, solitary ones, glimpses of a landscape at one A.M. when "humanity" has long since gone to bed. Recently Levertov has used dream to diagram experience (the anguish of her mother's death, the uncertainty of a love affair); but if these are to be read as dreams at all we can be sure the superego has done a lot of work to get them into their present, analyzable shape, for again the language is more illuminating when it is aimed at the

border between the human and the non-human, or into the caverns of the unconscious. In *The Double Image,* in fact, she is a little wary of dream, which does not so much clarify her relations with others as disrupt them, and draws her away from the security of familiar rooms. As the "walls of dream" close behind her, they open onto a stunning landscape of solitude. The native inhabitants of that landscape are the blind, who have been her visionary guides since *The Double Image.* Her initial ambivalence toward these "seers" is apparent in "Fear of the Blind." But in "Life in the Forest" they have become her compatriots, and she is dedicating poems to them, for wiping clean a world smudged with pain. . . .

Levertov is really a romantic poet, giving what she gazes at "the recognition no look ever before granted it." This is much the same compliment Coleridge paid to Wordsworth, and it is how Levertov identifies her archetypal poet in the lyrical "Growth of a Poet." That the poem is paired with another more discursive and anecdotal "Conversation in Moscow," which deals with the poet as social critic, suggests a continued division between her private and public selves. The two come together rhetorically in the "mineshaft of passion," but between the deep canyon of "duende" and the Black Sea of "human reality" lies a continent she is only beginning to cross.

<div style="text-align:right">Bonnie Costello. Parnassus. Fall/Winter,
1979, pp. 201, 211</div>

To Stay Alive (1971), her most significant exploration of political themes in her poetry, gave her a base on which all her subsequent political poetry rests. In that book she succeeded in enunciating for herself a politically revolutionary position through the medium of poetry which remains open-ended and exploratory. She expresses her commitment to partisan political questions, but in ways which clarify "not answers but the existence and nature of questions." How she accomplishes this will emerge from a close examination of the re-organizing and completion of the long poem-sequence called "Staying Alive."

To Stay Alive is made up of two sections of poems, "Preludes" and "Staying Alive," containing poems drawn from four different sections of the two previous books. The ordering of the poems has changed substantially, and the final poem sequence has almost tripled in length. In her Preface Levertov says that the justification for bringing these poems together is esthetic: "It assembles separated parts of a whole." As "a record of one person's inner/outer experience in America during the 1960s and the beginning of the 1970s," the book presents a search for integrity in both political utterance and poetic form. For Levertov, however, the only valid test of the book is esthetic: whether it creates that sense of wholeness, that intensity of inner experience and reflection upon it which alone satisfies the "reader within." . . .

While political activism provides a structure and an outlet for Levertov's deeply felt moral outrage, it also engenders new dilemmas: an awareness of

history as it impinges on the present moment, of reality beyond her direct apprehension, and of unassimilable dualities at odds with her innate impulse to synthesize experience through poetic vision. The interpenetration of inner and outer that sustains psychic equilibrium in Levertov's first six books becomes polarized, after the war, in an almost Manichean opposition of good (life as she has known it, human potential as she can envision it, poetic power as she has enacted it) and evil (the knowledge, simultaneously, of war [and] suffering) . . .

But the poem is neither loosely sprawling nor merely associational. Its strategy is what it has always been for Levertov, to move from Reverence for Life to Attention to Life, from Attention to Seeing and Hearing, which leads to Discovery and Revelation of Form, and from Form to Song, which is how she describes the process in "Origins of a Poem" in 1968. For her, knowing and making are inseparable. "Staying Alive," however, begins in *interim,* in-between-time—the immediate occasion for which is the impending draft-resistance trial of [her husband] Mitchell Goodman—when everything appears temporary and provisional. Alienation from American society has its counterpart in increasing doubt about the poet's past: where the present lacks meaning, neither a usable past nor a desirable future are easily discovered. The poet's "clear caressive sight" is blurred; language, "virtue of man" erodes, rejects us as we reject it. The thread of connection which ran from Reverence for Life to Form and Song has been broken; no fabric stands whole. Consequently, a new fabric must be made, every strand twisted, pulled and tested.

The poem cannot be woven until the unweaving has occurred. We find our way through it by following the broken threads, by discovering how they are reconnected, and by finding the new, whole threads which draw the pattern together. . . .

"Staying Alive" took its start in broken connections and unraveling threads. The pulse of life was low and irregular. At its conclusion, the knitting and meshing continue, but death has broken some connections forever. Some have found death in the revolution itself. Some have been unable to stay alive. New connections are forming, however; language is regaining its integrity, through the acts of those whose word is good and through the struggle of the poet to unite the two pulses of revolution and poetry so that the singing can begin. The fabric of resistance communities has been tested and borne the strain. The poet has come back to the places which restore her, where her inner life finds a home.

Characteristically, what Levertov has accomplished in comprehending the revolution she has achieved in and through the making of the poem. It is an exemplar of what she has called the poetry of political anguish at its best, both didactic and lyrical. In the pulling together of the poems in *To Stay Alive,* and particularly in the completion of the fragmentary Notebook poem in "Staying Alive" Levertov has substantially enlarged her range as a poet and helped revitalize political poetry in England. She has learned how to

weave together private experience and public event so that both are available to the reader, to show us the inner and outer lives in conflict and in reconciliation, to integrate *reportage* and documentary into lyrical form and find a genuine inscape. At the end of "Staying Alive" we have affirmation but not final resolution. That is as it should be; we could trust no other conclusion. The poem remains open-ended, like the life it celebrates.

<div align="right">Paul A. Lacey. <i>Sagetrieb.</i> 4, 1985,
pp. 64–65, 70–71</div>

Over the past twenty-five years, Denise Levertov's poetry has evolved from a detached, meditatively lyric style, filled with rich evocations of landscapes and moments of ecstatic vision, to one steadfastly grounded in the social and political exigencies of contemporary life: war, nuclear power, the arms race, and the flagrant, widespread abuse of human rights. Many readers and critics alike have reacted hostilely to this development, decrying Levertov's activism as an unfortunate side tracking of her true talent and lamenting the privileging of didacticism over song in her later work.

To deny the validity of this controversial aspect of Levertov's writing—regardless of how strident, radical, or naively idealistic her political views might seem—is to misjudge grievously both the scope of her overall poetic achievement and the very integrity of her identity as an artist. The political poems she began writing in the early 1960s do not represent an abnegation or abandonment of the values articulated in her previous work; on the contrary, they attest to a deepening and intensification of those values through a sustained commitment to social action. The core of Levertov's vision is and always has been humanism; in this respect, the increasingly political nature of her writing from *The Jacob's Ladder* to the present mark the blossoming and maturation of an inherently empathic sensibility. To be a poet means, for her, to be utterly human, fully alive in one's mind and sense, keenly attuned to the diverse rhythms and mysteries of life. In her 1973 collection of essays, *The Poet in the World,* Levertov equates the two terms, stating, "When I say I speak as a poet, it is the same as to say I speak as a human being." The primary task of the poet, in her estimation, is to "translate" this heightened awareness of life's plenitude into language, and in so doing, celebrate and conserve the profound "miracle of being." . . .

For Levertov, silence, resignation, and despair are . . . unacceptable responses to present world conditions; the necessary corrective is rather a summoning of numinous energy. . . . The poet's virtue (and, by extension, his constructive contribution to society) is simply "to be/what he is" . . .—sentient, sympathetic, humane—to register an unflaggingly truthful response to the increasingly dehumanized circumstances in which he lives. This testimony to Levertov, is the "utmost response" that can be expected of any artist. . . .

Levertov's work refuses to let us forget that "we are living our whole lives *in a state of emergency* which is unparalleled in all history" by candidly

documenting her own unremitting struggle to react to, incorporate, and make sense of the external world. Through the luminous sparks of her poetic language, we begin to comprehend the full "extent of the human range," and to perceive what is lacking in our inner lives. Regardless of the nature of one's political views, Levertov's poems are truly revolutionary in this sense.

<div align="right">Kerry Driscoll. Centennial Review.
Spring, 1986, pp. 292–93, 302–3</div>

Levertov's poetry, like most American mysticism, is grounded in Christianity, but like Whitman and other American mystics her discovery of God is the discovery of God in herself, and an attempt to understand how that self is a "natural" part of the world, intermingling with everything pantheistically, ecologically, socially, historically and, for Levertov, always lyrically. Perhaps her search has from the beginning looked like an aesthetic rather than religious quest, though from the beginning she has spoken of God and never seemed to be unwilling to label her own journey as spiritual. But until now her somewhat inconsistent politics, and a stance which certainly embraces no specific religious doctrine or set of religious observances, have confused the issue.

In *Breathing the Water* the linking of body and soul through God is made so clear that even the most obtuse reader can see it. In meditating on the religious mystic Lady Julian of Norwich, Levertov asks that we see the world as a hazelnut placed in the hand in order to understand the relationship between God and humanity. . . .

It hasn't always been so obvious what Levertov was up to, and some of the pleasures of this book come from seeing the focusing of a lifetime career of writing beautiful, lyric poems, interspersed with militant political ones. What becomes apparent in *Breathing the Water* is that a distinct mystical religious vision has informed the poetry from the very beginning, and a struggle to understand God's meaning and intentions for the world.

<div align="right">Diane Wakowski. Women's Review of Books.
5:5, February, 1988, p. 7</div>

LEWIS, JANET (UNITED STATES) 1899–1982(?)

The Invasion would be a distinguished narrative if it offered nothing but its illumination of primitive American idealism. The preoccupation of novelists and poets in the past twenty years with the epic heroism of our national origins has suffered more than it has profited by the enthusiasm of myth-making. In a desire to translate the inchoate material of Indian warfare, agrarian conquest, and political determination into documents of exalted poetic scale, the volition of the subject matter itself—invariably the central

factor in any genuine epic conception—has been sacrificed to the arbitrary schematization imposed on it by authors who were too impatient to master the material of their researches. The authentic American criticism will hardly be forced out of the violent but irresolute ambitions of the average fictional historian. The dignified intentions of novelists from Frank Norris to T. S. Stribling seem destined to frustration through their inability to fuse the objective reality of American experience with a sufficiently persuasive or representative symbolism.

The Invasion, however, exhibits at every turn a profound familiarity with its subject matter. To readers of Miss Lewis's earlier Indian poems, it has been apparent that her researches into Ojibway history were antedated by an intimate personal acquaintance with it. Her novel thus offers none of the aesthetic condescension which artificializes most books of its sort. A faultless detachment operates without prejudice in relation to the two racial elements presented. They are merged by something stronger than the marriage of the educated young Irish trader, John Johnston, to the chieftain Waub-ojeeg's daughter in the Sault Sainte Marie country in 1792. The fusion is more than incidental to the ensuing record of the Johnston family, down to the death of Anna Maria Johnston in 1928. It proceeds from the sympathy which united the rival races in the Northwest wilderness, and which becomes a steady and tangible motivation throughout the record.

Miss Lewis will be compared with Miss Cather, Elizabeth Roberts, and Caroline Gordon in her conscientious approach to historical materials. She deserves the comparison, but in some respects she will suffer by it. Her book lacks the force of created reality. The unobtrusive but powerful dramatic propulsion of *My Ántonia* and *The Time of Man* is missing, and even apart from her sacrifice of purely novelistic interest, Miss Lewis flags at several stages, making the reader wish she had violated her integrity to fact by introducing more conspicuous motivating centers to her tale. She has not even gone so far as Miss Gordon, in *Penhally,* in centering her narrative in local personalities, but the Johnstons, like the southern Crenfrews and Llewellyns, have a specific representative quality. They are a complete record of their country at the threshold of the Northwest.

As a chronicle *The Invasion* avoids surrounding Indian life with false pathos as firmly as it avoids the traditional Indian animosity of nineteenth-century pioneer fiction. The ordeal of the pioneer is not portrayed with pity or rugged heroics. *The Invasion,* though it stands as a history rather than a novel, is an exceptional achievement.

<div align="right">Morton Dauwen Zabel. <i>The Nation.</i>
November 30, 1932, pp. 537–38</div>

The poetry of Janet Lewis has never reached a large audience, although it has revealed, over many years of obscure publication, evidence of the true lyric fire that has become so rare. Her *Poems 1924–1944* (Swallow), published late last year, shows the growth of what is now a mature gift. In such lyrics

as "Girl Help," "Remembered Morning," and "In the Egyptian Museum," feminine song operates, as always in its moments of power, with moving tenderness and simple clarity.

Louise Bogan. *The New Yorker*. November
3, 1951, p. 151

Janet Lewis's novels can be grouped into (1) à pair of regional works—*The Invasion* and *Against a Darkening Sky*—and (2) the "Novels of Circumstantial Evidence"—*The Wife of Martin Guerre, The Trial of Sören Qvist*, and *The Ghost of Monsieur Scarron*. . . .

The Invasion is a deliberately revisionist book; that is, it creates a view of the wilderness and the settlement of the frontier which is consciously at odds with most of its famous predecessors. Lewis explicitly rejects the sentimental view of the Indians represented by Longfellow's *Song of Hiawatha*. By implication, she also rejects the view of the frontier as a masculine epic, a drama of conflicting forces punctuated by violence. This view of the frontier, as it developed from James Fenimore Cooper and the historian Francis Parkman, has worked its way into the American imagination. However, there seems to have been always a literary counter-tradition which saw the key to American history as the creation of its social fabric and which stressed the experience of the family on the frontier, rather than the clash of natural and human forces. Works in this counter-tradition, often written by women who had experience of the early settlement, include, to mention only the most widely known, Caroline Kirkland's memoir of early Michigan, *A New Home*, Louise Clappe's *Shirley Letters* about the gold rush days in California, and the great Nebraska novels of Willa Cather. I see *The Invasion* as belonging to this counter-tradition. . . .

Against a Darkening Sky (1943) was the second of Lewis's novels in order of conception—and for that reason is considered at this point in the study—though it was not published until after *The Wife of Martin Guerre* (1941). No other work caused her more difficulty in its composition. She jokes that the novel was not intended to be a historical novel, but that by the time it was published it was historical. The comment combines wry acknowledgment of her slow writing with pride in capturing the feeling of a time and place now lost, or irretrievably altered. Now, looking back on a book written nearly four decades ago. Lewis feels that capturing "the landscape the way it was" is its best accomplishment. . . .

[T]he Lamson murder trials [which Lewis's husband, Yvor Winters, considered a witch hunt,] led Janet Lewis to *The Wife of Martin Guerre* (1941).

In *Famous Cases* there is the story of Bertrande de Rois, a Frenchwoman of the sixteenth century, wife of a wealthy young peasant. The young man, Martin Guerre, displeases his father, head of the household, and flees. Eight years later, the father dead, Martin Guerre returns. Or rather, a man appearing to be an older Martin Guerre returns. Bertrande accepts him at first, bears him a child, and then, three years after his return, denounces him as

an imposter. Two courts establish the fact that Martin Guerre indeed had a double, Arnaud du Tilh. The first court concludes that Bertrande's present husband is the imposter. The second, after hearing the same testimony, is about the reach the contrary decision when the mystery is solved: Martin Guerre, a veteran with a wooden leg, appears in the court. In side-by-side comparison his identity is proved, and the false Martin, Arnaud du Tilh, is condemned to death. . . .

The Wife of Martin Guerre marks Janet Lewis's complete maturity as a writer of fiction. It is a story of enduring interest, told with simple dignity. . . .

The second story which Lewis borrowed from *Famous Cases,* the basis for *The Trial of Sören Qvist,* already had a long literary history. One of the original trial judges had produced a narrative which was popular in Denmark. Subsequently the story had been retold or adapted by Steen Steensen Blicher, by Alexander Dumas, and—though Lewis did not know this at the time—by Mark Twain in his *Tom Sawyer, Detective.* Of the three stories in *Famous Cases* used by Lewis, it is the one closest to the Lamson affair, since it involves a man unjustly convicted of murder.

The odd twist of the story is that Parson Sören Qvist confessed to the murder. It was not until twenty years after Qvist's execution, when the man presumed murdered reappeared, that Qvist was discovered to be the innocent victim of a conspiracy. . . .

The Ghost of Monsieur Scarron is, as Donald Davie calls it, a fable of authority. In this case, it is of authority abused. Jean Larcher is executed as a public example, without much concern for his actual guilt or innocence. Here, and throughout the novel, we see power rippling down through the social strata, from the king to the lower levels of Parisian life. Janet Lewis began her researches with the belief that Louis was an evil ruler, but she underwent a reversal of judgment: he was "not a very bad man, but perhaps a very stupid man." Louis, the author concluded, wished to rule fairly, but was unable to close the gap with his subjects or to understand completely the events of his time. The distance between the ideal and the reality of Louis' reign is suggested by the impossibly grandiose allegorical statue of the king at the Place des Victoires, which proclaims his authority and immortality, but which contrasts painfully with the near anarchy of the surrounding square and with the tired old man who rules at Versailles. Larcher is caught by a vicious but erratic machine which responds to the many pressures of public policy, the king's personal life, intrigues within his court, and the power of his subordinates. Thus Larcher's death represents injustice committed by the state, but injustice without clear villainy. . . .

The major theme of her poetry is mutability, change, an issue of recurring importance also in her fiction. Kenneth Fields identifies the Ojibway trickster hero Manabozho (Manibush), who appears in her *Indians in the Woods* sequence as "the variant principle of life" and the spirit of her poetry. Manibush, it will be recalled, was described near the beginning of *The Invasion,* running in the woods "sometimes as a rabbit, sometimes as a young Indian."

The idea of the constant flux of the world runs through her career to the present. "The Ancient Ones: Water," a poem in her most recent book, returns to the Navajo perception of water as a "shape-changer" which could not be named with one word. Many of Lewis's poems are meditations upon change as it is part of the experience of everyone: the growth of children, aging, the death of friends.

<div align="right">

Charles Crow. *Janet Lewis* (Boise: Boise State University Press, 1980), pp. 12–13, 17, 25, 30–31, 35, 42–43

</div>

First viewed from without, despite the internalizing devices of the experimental Imagistic movement, in these earlier poems on Indian themes, this characteristic consciousness begins to be explored from within, when, in the next group of poems, beginning with "Lost Garden," she turns to themes drawn from her own daily life and to forms long available in the English and American poetic tradition that permit use of the "I" (and "we") as well as the eye. From this period are three of her finest poems: "The Reader," "The Earth-Bound," and "Love Poem"—all from *The Wheel in Midsummer* (1927). "The Reader," though influenced by Imagistic technique, employs a rhetoric that is not limited to the clear, hard impression, but can express the relationship of sensory perception to conceptual experience more directly. This relationship is the specific concern of "The Earth-Bound" (almost an *ars poetica*), where she defines the need for the sensory metaphor—"The flesh of our celestial thought"—to convey our understanding of conceptual matters—"the heavenly argument"—and also of "Love Poem," where the sensory perception carries the entire weight of the statement—but the direct statement is there, nevertheless. "The Earth-Bound" also, it should be noted, has her characteristic irony—often so gentle that it goes unnoticed.

Beginning with the poems written after 1928, when she first came to live in Northern California, two other important themes appear: time and death. "Time and Music," from the period 1928–1930, is one of her most impressive poems. Defiant in its elegant balancing of the conceptual and the sensory, it stands as the first of several poems (the latest, "The Drum" and "The Chord") that explore the problem of change and stability in terms of music's capacity to order experience—its power, like poetry's, to contain both life and death, as well as beauty. In music, time is the condition that gives being itself to the music, for time is both the "substance and the breath" of music, even while it is the "death" of—provides the end for—melody, the ordering principle. Analogically, she sees the human being, like melody, move through time. Artistic mimesis, whether in music or poetry, is of the ordered repetitions perceived in reality.

This concern with music, time, and, especially, with death as themes is continued in the group of poems written during the Depression and war years, 1930 to 1944, a period during which she also wrote a novel of contemporary

life, *Against a Darkening Sky* (1943), several short stories collected in *Good-bye, Son* (1946), and the historical novel, *The Wife of Martin Guerre*. . . .

The last group of poems, written after an interval of many years, during which she published two historical novels, *The Trial of Sören Qvist* (1947) and *The Ghost of Monsieur Scarron* (1959), includes one of her best: "For the Father of Sandro Gulotta"—a culmination of her preoccupation with the themes of time, death, and birth. In execution it is a faultless handling of the themes.

Helen Trimpi. Introduction to Janet Lewis.
Poems Old and New 1918–78 (Athens, Ohio:
Swallow, 1982), pp. xiii–xv

LI ANG (CHINA) 1952–

In Li Ang's "The Wedding", the hero goes through a Kakfesque maze of passages in search of a woman who holds the meaning to his forced journey. The encounter, however, only reveals to him a world of absurdities resisting interpretation in a conventional light.

The labyrinthine search for meaning is a conspicuous theme in several pieces of Li Ang's earlier writing. The heroine in "The Flowering Season" undertakes a roundabout journey to discover the essence of romance. The hero in "A Journey To The Sea" makes a detour to retrieve the self in the Unconscious. The labyrinthine quest is nevertheless a leitmotif that threads through Li Ang's writings. The "écriture labyrinthe" which Shih Shu uses to designate "The Long-Distance Runner" is an apt expression to describe not only the earlier pieces exhibiting strong modernist influence but also later works of social and feminist concerns. Immanent in all her works is a challenge to the reader to decipher a certain meaning or a particular reading out of a maze of contradictory implications. The contradictions in the works result from a complex interplay between two dominant influences in Li Ang's writings, namely, modernism and feminism.

Criticism of Li Ang's works has generally centered around one of the following aspects: modernist influence in her earlier works and social and feminist concerns in her later works. Commentaries in each area have no doubt shed much light on the understanding of Li Ang's fiction. I, nonetheless, feel that to discover the depths and complexities in her writing, it is important not to treat Li Ang separately as a former modernist and a present feminist but to recognize the paradoxical relations of the two influences. . . .

Li Ang's more recent works may at first glance strike the reader as didactic and propagandist, yet they display the same innovative spirit as that of her earlier writing. The propensity of the feminist to moralize is balanced by the artist's belief in the autonomy of art. The foregrounding of literariness

and the drive toward novelty still display the influence of modernism despite the overt feminist concerns of the later works.

In her feminist as well as non-feminist works, Li Ang challenges the conventional belief that women's writing is sentimental and trivial. Her constant quest for novelty and exploration of psychological truths creates an exciting "écriture labyrinthine" for adventurous readers.

Daisy S. Y. Ng. *Tam Kang Review.* 18, 1987,
pp. 141–42, 149

Dark Night is Li Ang's latest novella concerned with the impact of commercialization and materialism on human nature in contemporary Taiwan. Because of its explicit depiction of sex, indeed, extramarital sex, the work has been fiercely attacked as licentious and immoral. This is ironic in that the descriptions are not erotic in intent, as condemned, but, quite on the contrary, are offered as a critique of the psychology of sex. As such, they cannot be understood apart from the network of symbols used in the novel. . . . This network of symbols provides a unified structural and conceptual framework in which the theme is developed.

The story centers around six characters, two women and four men, and their complex interrelationships. Huang Chengde, a man in his mid forties, is the owner of an electronics manufacturing company. His main source of income, however, is speculation in the stock market. The "tips" essential to such speculation are provided by a reporter named Ye Yuan. Ye, about forty years of age, is married but is a philanderer. In fact, one of his affairs is with Huang's wife, Li Lin. A slender woman brought up in an old-fashioned family (her father having been educated Japanese-style), she plays the traditional role of submissive wife and dutiful mother and acquiesces to Huang's affairs. Her relationship with Ye brings about an awakening to her own sexuality as a woman, and she is passionately in love with him. However, Ye has another mistress at the same time, a young magazine editor, Ding Xinxin. Ding enjoys the expensive gifts from Ye, but she realizes the impossibility of a long-term commitment from Ye and therefore is seeing Sun Xinya, who holds a Ph.D. in computer science and who recently returned to Taiwan from the United States. Yet another man is attracted to Ding, a philosophy student named Chen Tianrui, who nevertheless despises her for her promiscuity. . . .

In the final analysis, *An ye* is a profound critique of Taiwan society today. People are lost in the "floating world" of materialism, self-interest, and moral [emptiness]. It is a sea of darkness which swallows up the values and ideals once held dear by the Chinese. The scene where Ye and Ding take turns reciting passages from the *Analects* of Confucius thus becomes the novel's most important satire on the disintegration of traditional culture:

Michelle Yeh. In Michael S. Duke, ed.
*Modern Chinese Women Writers: Critical
Approaches* (Armonk, New York: M. E.
Sharpe), pp. 78–79, 93–94

In 1973, Li Ang published a story entitled "Renjian shi" (Man's world), in which two unmarried college students engage in sexual activity in the boy's dormitory room, knowledge of which is subsequently divulged to the school counselor by the frightened, sexually naïve, and uninformed girl. Both youngsters are expelled for their "improper" conduct, bringing disgrace to them and to their families. A flood of letters from readers who were outraged by Li Ang's frank and open treatment of sex—illicit sex, at that—poured into the *Zhongguo shi bao* (China times); it was the first time she had been publicly attacked, and in the most degrading personal terms, for writing about sex, but it did not deter her from continuing her exploration, through the medium of fiction and, in recent years, parables and undisguised social commentary, of sexual issues and the use of sex as a vehicle for her social views. . . .

It is surely no exaggeration to state that Li Ang is the most consistent, successful, and influential writer of sexual fiction in Chinese and, because of that distinction, has been one of the most controversial writers on the Chinese literary scene for a number of years. Her interest in, fascination with, and curiosity about sexual relations is apparent in her earliest works, which were written between her sixteenth and eighteenth years, the acknowledged "early period" of her career, including her first published story, "Flowering Season."

The seven stories from this period, which the author has called her most artistic work, can all be characterized as experiments in psychological exploration; they were written under the combined influences of the existential philosophy that informed much of Li Ang's reading at the time as well as the writings of such Western masters as Kafka and Camus, plus the pressures of preparing for nationally held college exams, and her own youthful development. Although frequently based upon actual incidents, these stories create a fictional world filled with symbols and unusual imagery, often a fantastic milieu comprising many forms of conflict and alienation. Sexuality, if not sexual activity per se (although there is some of that as well), plays a significant role in five of these pieces, which is not surprising for stories that deal in large part with the conflict between self and outside forces (society); Li Ang considers "sex [to be] the essential ingredient of self" and, as we shall see, has clearly recognized the potential in sex as a metaphor for relations in general. . . .

The greatest notoriety in Li Ang's career came as a result of her being awarded first prize in the annual fiction contest sponsored by the *Lianhe bao* (United daily news) for her novella *The Butcher's Wife* and its subsequent serialization in 1983. It was the work that, after six years, made her an "immoral person" again. *The Butcher's Wife,* which is based upon an actual incident from Shanghai in the 1930s, with the setting shifted to the Taiwanese city of Lucheng in an unspecified time, is the powerful and highly disturbing story of Lin Shi, a peasant woman who, after suffering constant and intolerable abuse at the hands of her pig-butcher husband, as well as the condemnation of her "feudal"-minded neighbors (all of them women) butchers her spouse

in a highly erotic scene after he has raped her in particularly sadistic fashion. Like her husband, who rolls over heavily and falls asleep each time he has had his way with her, after completing her gory act, "she ate ravenously until she was so stuffed she couldn't swallow another bite [then] leaned up against the warm foot of the stove and fell into a deep, dreamless sleep." Called a "magnificently gory morality tale" by one American reviewer, and perhaps the "meanest, most frightening book ever written about women oppressed by men, or any helpless victim snuffed out by an uncaring society" by another, the novella is about a woman whose, "fate, meant to be both shockingly singular and representative of oppressed women, is certainly among the most pathetic in recent world literature." . . .

The promotional blurb on the cover of the Hong Kong edition of *Dark Nights* (1985) calls the work "A feminist novel that is sure to spark controversy." In strictest terms, it is probably not a "feminist" work at all—unlike *The Butcher's Wife,* which one reader has characterized as "Feminism with a vengeance"—at least not in our understanding of the term in the West. Li Ang herself has indicated more than once that her concern is more with "human nature" *(renxing)* than with "feminine nature" *(nüxing).* . . .

If *Dark Nights* is not nearly as successful as *The Butcher's Wife*—and it is not—it is unarguably the most penetrating exploration of the uses, effects, and sensations of sex in any of Li Ang's fiction. Having now reached the summit, the author, in her subsequent work, appears to be moving away from "sexual fiction" and into new areas of artistic expression. . . .

The major area of convergence of sexual fiction written by men and women is the overwhelming interest in female sexuality, and this is certainly the case with Li Ang. In the main, her characters are weak, dependent women who fall easy prey to opportunistic, manipulative, even bestial males, and who are frequently victimized by the affairs they seem to need so desperately. The implication is that in contemporary Taiwanese society, women are trapped by their sex and their sexuality, no matter what they do.

In this essay I have approached Li Ang's sexual fiction chronologically, pausing along the way to characterize, explore, and illustrate those features of her oeuvre that are both "literary" and "sexual"; the picture that emerges is one of a simultaneous maturation of sexual attitudes and a growing appreciation of its roles in and effects on certain segments of Taiwanese society, as well as a pronounced evolution of writing styles and techniques.

In her early period, the focus is on the mysterious, abstract nature of sex; it is described metaphorically, as something whose effects upon men and women (or boys and girls) are left unexamined. Female breasts, the sole "visible" sign of human sexuality in Taiwanese society, become an obsession with male and female characters alike; sexual passion is fantasized, sexual gratification is vicarious.

The picture changes with the Man's World series; the "romantic" abstraction becomes a physical act whose positive aspects (an expression of love, pleasure, human reproduction) are negated by the complex, and usually

tragic, psychological effects and rigid cultural taboos. This is, of course, what the author had in mind, and the occasionally heavy didactic tone of these stories generally affects their literariness in converse measure to their "boldness."

It is in her longer works that Li Ang begins to examine the truly destructive potential in sex, which becomes the vehicle for brutality *(The Butcher's Wife)* and manipulation *(Dark Nights)*. Gone are the fantasy and the indecent experiments in sexual relations; the author, by this time, has turned her considerable literary talents to the task of tying sexuality to human nature— selectively, to be sure—and it is this "humanizing" of society, this probing of individual feelings, that, more than anything else, has established Li Ang's reputation as one of Taiwan's boldest and most important novelists.

> Howard Goldblatt, ed. *Worlds Apart: Recent*
> *Chinese Writing and Its Audiences*
> (Armonk, New York: M. E. Sharpe, 1990),
> pp. 150–52, 157–62

LIDMAN, SARA (SWEDEN) 1923–

In literature . . . internationalism changed radically the work of two writers, Sara Lidman and Per Wästberg . . . who were converted on the road to Africa. Sara Lidman went to South Africa in 1960 and was expelled for infringing the race laws: the result was two African novels and a passionate indignation at the evils of colonialism and imperialism that widened from Africa to other underdeveloped areas. . . .

The anti-colonial and anti-imperialist sentiments prompted by . . . writers' experiences of Africa and Asia came to a head in the campaign in Sweden against the American involvement in the Vietnam War. The FNL-movement in support of North Vietnam led to a thorough radicalizing of many Swedish writers' attitudes. This in turn rubbed off on home affairs and was compounded by the effects of the students riots in Paris and Berlin and the appearance of a more democratic Communism in Prague, all in 1968. Sara Lidman, deeply involved in the fate of the Vietnamese, also turned her attention to the iron-ore mines of northern Sweden, and in her book *Gruva* (1968) tried to show how the miners there were exploited and oppressed by the economic and class system. When the miners went on strike in the winter of 1969–70 they were eagerly supported by radicals in Stockholm: the strike was the most serious industrial conflict in Sweden since the engineering workers' strike of 1944 (itself described by Delblanc in *Stadsporten* 1976). It might seem that the Revolution was at hand but the established order reasserted itself. . . .

The narrator in *Jag och min son* (1961, revised 1963) is a nameless Swede who comes to Johannesburg with his young son Igor. He aims to make a lot of money in South Africa and return to his farm in Jämtland, and is willing to do anything to protect his son and provide for his future, including stealing and selling out his friends to the police. . . . He is a rootless individual who moves from job to job, and through him a picture of South African society emerges: the shanty towns, the political unrest, the iniquity of the pass laws and apartheid. The novel consists of a fevered monologue, the confessions of a man torn between his compassion for the subjected Africans and his love of his son. He builds a shell around himself, denying to himself that he is part of the exploitation, and as the novel ends he is seen driving frantically toward Durban to try to take his sick son home.

Much more satisfying both as a novel and an informed view of an African culture is *Med fem diamanter* (1964), which is set in Kenya. The viewpoint here is entirely African and whites are presented as caricatures rather than real people, yet despite this and the criticism of conditions under which urban blacks live, the narrator remains more concerned with human relationships than political ideologies. . . .

Sara Lidman now leaves conventional fiction behind. *Samtal i Hanoi* (1966) is her report on a visit to battle-scarred North Vietnam, yet the book is also a very personal document. The material—depictions, reflections, interviews, quotations—is arranged in an effective pattern. Nor does the narrator seek to present an objective, that is to say dispassionate, report; rather as in the African novels she tries to get inside the skin of the people. There are some passages which shock, particular the testimony of an FLN guerrilla about torture in South Vietnam. But there is a general spirit of hope too: amid the ruins of a bombed-out hospital Sara Lidman finds the flowers still blooming in the patients' little gardens.

<div style="text-align: right">

Gavin Orton and Philip Holmes. In Irene Scobbie, ed. *Essays on Swedish Literature* (Aberdeen, Scotland: Aberdeen University Press, 1978), pp. 237–38, 247–49

</div>

The novel with which the Swedish author Sara Lidman made her debut in 1953, *Tjärdalen* (The tar pit), is a neat and reassuring moral tale. Set in a tiny village in the far north of the country, it describes how a man known as The Fox wrecks the elaborate structure from which one of the village men is just about to start extracting many barrels of precious tar, breaks his leg in the process and is left to die as punishment for his sin. The novel's critique of the Lutheran concept of man as guilt-ridden and deserving of judgment points ahead to Lidman's more recent works, as does the highlighting of the corruptive powers of capitalism: the only man to speak out against the murder of The Fox turns out to be wholly in the hands of that far-sighted neighbor who exploits the tragedy for the sake of money. Significantly, however, the plot runs full circle, with the life of the community returning to normal once the

death of The Fox has produced a spate of purely personal reckonings; and any potentially far-reaching criticisms are rendered harmless by the confines of the setting, the highly polished plot and the sheer verbal brilliance demonstrated by the author.

In many respects, *Tjärdalen* is a typical example of Swedish writing of the 1950s; and Lidman's entire output can be seen as adding up to a paradigm of the changing preoccupations of Swedish authors over the past three decades. Having attempted a collective approach in *Hjortronlandet* (1955; Cloudberry country) and delved further into the psychology and morality of individual characters in *Regnspiran* (1958; The rain bird) and *Bära mistel* (1960; Carrying the mistletoe), Lidman abandoned her native Norrland as a setting for her novels. In the early 1960s she had gone to live in Africa, where she spent several years, first in South Africa, then in Kenya and Tanzania. The experience of South Africa, she has testified, became a watershed in her development. Her two African novels, *Jag och min son* (1961; I and my son) and *Med fem diamanter* (1964; With five diamonds), contributed to that process of national consciousness-raising which, during the 1960s, transformed the isolated Swedish idyll into part of the contemporary, conflict-ridden world. In the middle of the decade, Lidman emerged as a leading figure in the influential Swedish movement against the Vietnam War, and the urgency of the issues with which she found herself involved was such that she ceased to write novels, preferring instead the direct line of communication provided by journalism. This change was symptomatic, with reports and documentary novels dominating Swedish writing during the second half of the 1960s. Lidman has spoken of the impact made on her by Jan Myrdal's *Rapport från kinesisk by* (1962; Report from a Chinese village); and in articles about North Vietnam, which she visited during the war, she depicted the tenacious efforts of its people to maintain a functioning society in the face of systematic devastation. *Samtal i Hanoi* (1966; Conversations in Hanoi) has been followed by *Vänner och u-vänner* (1969; Friends and emerging friends) and *Varje löv är ett öga* (1980; Every leaf is an eye), the title of the last book paying tribute to that respectful interrelationship between man and his environment which Lidman had encountered in North Vietnam. When, in *Varje löv är ett öga*, articles about Vietnam and Sweden appear side by side, the author is drawing our attention not only to the universality of the patterns of exploitation, but also to mankind's total dependence on a delicately balanced and increasingly threatened environment.

The 1970s saw a return to the conventional novel in Sweden, with many authors bringing with them a sharpened political awareness and an eye for the significance of documentary material. Conspicuous among the novels of the 1970s and early 1980s are multivolume historical works tracing aspects of the development of Swedish society in vivid and often carefully researched detail. Sven Delblanc, Lars Ardelius and Kerstin Ekman have all written series of this type; and to this category also belong Lidman's more recent

novels: *Din tjänare hör* (1977; Thine obedient servant), *Vredens barn* (1979; The children of wrath) and *Nabots sten* (1981; Naboth's stone). . . .

Writing "in defense of people and forests," as she herself has put it, Lidman in these three novels presents a comprehensive refutation of society's—and Luther's—exploitative stratifications, forcing us to face, ultimately, that indifference to our fellow human beings which is their prerequisite. The language, the treatment of individual characters (especially those who are oppressed), the composition of the narrative and the structuring of the plot are all integral parts of this artistic statement which, in the last instance, turns on precisely those "digressions" to which the author refers, half apologetically, on the back cover to *Vredens barn*.

The language in these three novels can be felt to be wrenched out of the harsh environment in which its users live: a sparse and condensed medium, relying on a range of precise and vivid dialect words and frequently resorting to biblical turns of phrase and nineteenth-century spellings, it palpably carries the sum total of precious human experience and tradition. Lidman places strong emphasis on the sheer pleasure of communicating. . . .

Lidman succeeds, in these three books, in giving us a novelist's version of the Arndtian universe and alerting us to the delicate balance of a creation in which everything is dependent upon everything else. What makes Lidman's achievement so exciting is the fact that hers is, in every sense, a work in progress, with the author's continuing exploration of her medium becoming bolder, more original and seemingly more crucial with every volume.

Helena Forsås-Scott. *World Literature Today*. 58, 1984, pp. 5, 7, 9

This powerful, socially conscious work [*Naboth's Stone*] aptly displays the talents of Swedish author Lidman. Particularly noteworthy is Lidman's portrayal of nature: she depicts a northern Swedish setting that is stark and potentially deadly, yet fragile and too easily destroyed. Didrik Martensson dreams of bringing modern luxuries to the small nineteenth-century community in Sweden of which he is chairman. To his mind, imported goods and a railroad will bestow prosperity on all. (He ignores hints that modernization may strip the region's resources without enriching it.) At the book's end, the railroad is still only a plan. Didrik's personal life also brings problems: his wife, Anna-Stava, cannot nurse their newborn son and a wet-nurse, Hagar, is hired. Mysterious and aloof, she is feared and distrusted by the household. Yet as the story progresses, it becomes apparent that the dependence of Didrik's family on Hagar's is as fundamental as that of the child on the nurse. The third book in a series of five, the novel stands on its own, but readers must gradually pick up information about characters who are not fully reintroduced and look to future installments for some dramatic resolutions.

Sybil Steinberg. *Publishers Weekly*. June 8, 1990, p. 48

LINDGREN, ASTRID (SWEDEN) 1907–

From Sweden come . . . three books by the inimitable Astrid Lindgren who goes on being just as funny and just as sensitive as ever to the workings of the mind of the small child. Her faultless sense of language and the economy of her style always put her in a class by herself. In *Jul i Stallet* (Christmas in the manger) a child sits on her mother's knee before the fire in a cottage in Sweden and asks to hear about Christmas. Her mother tells her of the first Christmas and the child pictures it happening on their own farm. An exquisitely produced book, with color printing of the highest order. In *Lotta på Bråkmakargatan* (Lottie in Troublemaker Street) Lottie wakes up one morning in a very bad temper and tries to be as naughty as she can. Then she has an idea; she goes next door and says, "May I live here? I've given notice." The story goes on to describe all that happens to little Lottie and her final reunion with her loving family. A charming piece of work. The third Astrid Lindgren is a de luxe edition of the three Bullerby books *(Bullerbyboken)*, with numbers of suitable pictures by Ilon Wikland.

(London) *Times Literary Supplement.*
December 1, 1961, p. 1180

Pippi Longstocking is about the way many adults abuse their power over children. Pippi, Mrs. Lindgren points out, is not a revolutionary—she is not at war with grownups. (One of the remarkable characteristics of the whole body of work, in fact, is the presence of adults who are kind and have very good relations with the children around them, like the kindly old grandfather of Noisy Village or Emil and his father, who are "excellent friends.") Pippi is simply a person who is ready and able to defend herself when her freedom is infringed upon. Pippi herself is a person with great power, and she does not misuse it. There is nothing the author more abhors, she says, than an abuse of power, whatever form it may take—the adult with the child, the boss with the employee, or the ruler of a nation with its people.

The values prized in the Pippi books are ones that any sensible person would want to inculcate in a child: resourcefulness, generosity, humor, kindness, inventiveness (put a can over your head and it's midnight), self-control (Pippi tells herself when to go to bed, and she's quite strict with herself when she misbehaves), and readiness to defend the underdog. Yet, she always remains a child. . . .

Mrs. Lindgren's most recent novel, *The Brothers Lionheart,* has provoked heated controversy in children's literature circles in Sweden; others urged that she be nominated for the Nobel Prize. The book deals with an eight-year-old boy living under a dictatorship, and with his death.

Ralph Slayton. *Scandinavian Review.* 63,
1975, pp. 47–48

Outrageous, delightful Pippi Longstocking is a character who comes to us in translation from a Scandinavian culture, but is as familiar to us as the little girls who live in our midst. Her most striking characteristic is her great capacity for joy, which we adults recognize from afar, but which has more immediacy for children. The primacy of enjoyment in her life is the key to her deliciousness and her shock value. Pippi does exactly as she wishes, and says so.

That the nature of the comedy is related to the gratification of Pippi's desires is indicated by the episodic structure of the Pippi books. Breaking up a narrative into episodes happens to suit the concentration span of children, but the structure of *Pippi* is organically generated as well. As in a Rabelaisian fantasy in miniature, Pippi moves from one situation to the next, taking from each everything it offers her wild imagination, and incidentally giving the other participants either wonderful bolts of surprise or horrible moments of shock.

A sense of outrage, in fact, is built into the adroit combination of fantasy and reality that Astrid Lindgren gives us. Pippi is a fabulous superheroine who inhabits a real Swedish village. She may be familiar, but that is because we recognize in her our own unfettered impulses; no one we know has her powers or lives the way she does. The life she leads is pure fantasy, placed in the context of the real world. I say "real world" advisedly, for it is sketched in cartoon fashion, and from a child's point of view. Nevertheless, it retains the moralistic strictures which make it identifiable as reality. And the more moralistic the society drawn becomes, the more outrageous Pippi is. . . .

Pippi is funny and moving because her wild and generous impulses and excitement are uncontrolled, and because we spend so much time and energy refining those impulses in ourselves and our own children. As an unrefined female child with superhuman powers she is unique in children's literature; the only figures we can compare her to are witches, and she is not one of that number. We sense the ways in which she is a real child, and we love her, as Lindgren seems to, for her wildness and her appetites.

Laura Hoffeld. *The Lion and the Unicorn.*
1, 1977, pp. 47–48, 53

[O]ne of the unfortunate facts about the way one reads children's literature as a child [is that] girls will read "boys' books," but boys will refuse to read about girls. It was this ingrained categorization and segregation of children's books by sex that made me, when I was young, forgo the experience of reading classics like *Little Women, What Katy Did, Rebecca of Sunnybrook Farm, Anne of Green Gables, Caddie Woodlawn,* and *Strawberry Girl.* And it was only as an adult that I chanced to discover the "Pippi Longstocking" books, by Astrid Lindgren. I became curious about them after four of my closest women friends told me of the strong impression that the character of Pippi Longstocking had made on them when they were young. Since the child is mother of the woman, I decided to find out about Pippi (and so about my

friends) by reading the books, and I thereby came upon one of the greatest characters in children's literature. . . .

There isn't a dull day in any of the three "Pippi Longstocking" books *Pippi Longstocking, Pippi Goes on Board, Pippi in the South Seas),* as Pippi turns into a Thing Finder ("When you're a Thing Finder you don't have a minute to spare") who uncovers articles like a rusty tin can and an empty spool ("The whole world is full of things and someone has to look for them"). She and her new friends Tommy and Annika become inseparable as they hide in a hollow oak tree, where they mysteriously find soda pop to drink and go on picnics. Pippi is always leading the way to new adventures and she has great physical strength. She calls herself "the strongest girl in the world," and she can lift her house with her hands, overpower two policemen who come to take her to a children's home, wrestle with and defeat the strongest man in the world at the circus, exhaust and ward off two burglars, and tame a tiger at a fair.

<div align="right">

Jonathan Cott. *The New Yorker.* February
28, 1983, pp. 46–47

</div>

Pippilotta Delicatessa Windowshade Mackrelmint Efraimsdaughter Longstocking, or Pippi Longstocking for short, is fully as outrageous as her name promises. She is without doubt one of the funniest and most beloved characters in children's literature in the industrial world. Since the publication of *Pippi Longstocking* (1945), *Pippi Longstocking Goes on Board* (1945), and *Pippi in the South Seas* (1948), Astrid Lindgren's story of Pippi has become a touchstone in children's literature. Much of the story's popularity and enduring quality rests on its special kind of humor. . . .

The humor in the *Pippi Longstocking* books is a humor of extravagance and excess. It seems especially appropriate for children, who can and do laugh more often and sometimes at different things than do adults. . . .

Lindgren limits references and allusions to the cognitive and experiential horizon of children. Doing that she can run the whole gamut of humorous expression from the simplest word play through inversion of letters to highly sophisticated self-parodies. Clever puns, parody, and gallows humor are all presented in a manner to which children can relate. All these humoristic rhetorical devices are based on a fundamental emotional situation that is especially strong in childhood, but that lingers on into adult life, namely, the desire to be strong, clever, and independent. Indeed, the argument can be made that all parody and satire belong to the powerless and suppressed who find in parody an underhanded way to set up a new discourse against the dominant one. . . .

The incongruity of the tall tale, in which events disguised as facts are taken far beyond the limits of credibility, is reflected and intensified in the language of the Pippi books. In the guise of Pippi, Lindgren subverts society's suppressive forces through the playful manipulation of language. Substitutions and inversions, distortions and exaggerations appear in the smallest

building blocks of language, in single words and names. They intrude into the sentence structure and grammatical logic, and they are equally omnipresent on the conceptual level. . . .

The most profound and pervasive trait in *Pippi Longstocking* is Pippi's penchant for the extraordinary and her nonchalant approach to the distinction between fact and fiction, between truth and lies. Watching a melodramatic theatre performance, she storms the stage to save the heroine from the brute villain. On the other hand, life for her is just a stage on which she herself performs her stunts and sommersaults. . . .

Read in the 1980s in conjunction with debates about postmodernism, Pippi stands out as the post-modern character par excellence. The role model with which the reader identifies is that of the ultimate child and the ultimate grown-up in one person. She is a wise fool who subverts for the sake of subversion and makes life into an endless game. Pippi is a true "Thing-Finder" and tinkerer, misusing utilitarian objects and basically making her environment into one single tinker toy. With her sophisticated and studied imbecility, she reads the world against the grain. Pippi is full of inconsistencies and contradictions, which are enhanced by her refusal to separate neatly between fact and fiction and life and stage. The perspective mediated by Pippi to the reader/listener is that of a child situated in an eternal present. Pippi does not see any ultimate value in growth and development; instead, she seeks it in the play of things. As a consequence, she decides in the end to remain a child and never to grow up.

<div align="right">

Eva-Maria Metcalf. *Children's Literature*
Association Quarterly. 15, 1990,
pp. 130–32, 134

</div>

My motives for choosing to write about the three volumes about Pippi Long-stocking—*Pippi Longstocking* (1945), *Pippi Goes on Board* (1946) and *Pippi in the South Seas* (1948)—are very personal. I was seven when the first book appeared, and it was a revolutionary experience to me, and very likely to most of my generation. We were brought up in a strict, conventional way, so the meeting with this strong, self-reliant *and* kindhearted little superchild provided both relief and fresh courage. Pippi has been my constant companion. I have read about her for my younger sisters, for my own and other children, and am convinced that she still functions in the same manner. She has now been spread over the world in 52 languages. It seems that children's need for Pippi is universal. . . .

Pippi Longstocking incarnates several ideas that were discussed in the field of education during the thirties and forties. Firstly, she is a completely *free child,* nobody brings her up, leads her, confines her, punishes her. Her mother is an angel in heaven, and her father, so she believes (this turns out to be true) is a Native King on a South Sea island, where he floated ashore after a terrible storm that wrecked the ship whose captain he was. Pippi's independent life in her wonderful old cottage in a small country town is made

possible by her strength and her fabulous riches. But her relationship to her physical strength and to her bag of gold coins is entirely relaxed: her strength she uses only when challenged, and only to defend herself or others (and sometimes to make a funny show), and having money is just practical. It is important here that the children around Pippi share her indifference towards her wealth—only grown-ups are impressed and become ingratiating at the sight of the gold.

Pippi also symbolizes children's desire for power, or, more accurately, superiority. She is not only stronger and richer than the adults, she is also more clever, and thanks to her sharp wit she wins every verbal dispute—sometimes by means of a very special kind of logic. But her power is not the kind that makes her rule others. She just defends her rights, and demands respect from people. The right of children to be respected is a leading theme in Astrid Lindgren's writing for children—and this has been so, as we see in Pippi Longstocking, right from the start.

By means of her freedom, her strength and independence, Pippi is also the sure protector of the children around her. She is warm-hearted, generous and solicitous. In her company nobody has anything to fear. She is revolutionary only in the children's world. . . .

Large sections of the stories consist of Pippi's yarns, which she often commences in order to justify her peculiar behavior. In China, or farthest India it is quite normal to sleep with one's feet on the pillow, or to walk home backwards. She is often carried away by her inventiveness and at times clearly believes what she is saying. When her friends make disbelieving comments, she is ready to admit that she is lying, but only to make her story take an opposite turning that is still more absurd.

Her repartee, moreover, is often excellent, especially in discussions with grown-ups. Her vocabulary is a peculiar mixture of standard phrases, archaisms, slang and sophist turns of phrase. She is irreverent and frank—but in an apparently innocent way. This and her actions serve the obvious purpose of making the normal, conventional way of thinking and acting seem narrow and ridiculous.

Ulla Lundqvist. *The Lion and the Unicorn.*
13:2, 1990, pp. 97, 99–101

LINHARTOVÁ, VERA (CZECH REPUBLIC) 1938–

While in no way invalidating the axiom that art essentially socializes the reader's individuality, because it offers to the separate and finite individual the enjoyment of . . . "the fullness of humanity," Linhartová obeys the rules of the game in a quite unusual manner. Far from augmenting man with anything external to him, she returns to him something that should belong to his

inner being but, as things are, is missing. Her aim is to achieve something that, while of the same order as "the fullness of humanity," is both more particular and more elementary, that is, *"the fullness of man."*

This phrase still retains for us memories of the strongly sensual accent imparted to it by our interwar avant-garde and the narrower significance attributed to it by the poetists, especially Nezval. Linhartová, however, gives the phrase another meaning, more intellectual and abstract, that of *liberating and constituting being*. (But she is not far removed from avant-gardism, being rooted in postsurrealistic poetry, or, more precisely, standing at the intersection of imagination and abstraction). The theme closest to her heart is the rediscovery of man's true existence, *reaffirmation of the independent essence of the human subject*. . . .

With Linhartová, all roads lead to this Rome, in that her writing is coherent and consistent in its method. And the first road is literally that of onslaught on the reader, because it is up to him, by his own effort, to make the last move in establishing his own, distinct attitude toward the world of sensation or of opinions presented by the writer. This world is so provocatively individual that he has no alternative but to take up the glove thrown down by her books, and to battle—to battle with nothing less than his opinions, his values, his certainties, sharpening or discarding them in the process. This is precisely what the writer is after. . . .

Linhartová has cultivated various technical means for introducing the reader into her work as an independent, one might say palpable, figure. In suggesting a dialogue with the reader, she writes passages (intentionally?) so devoid of obvious meaning that they cry out for him to come forward to supply the meaning. Or she paints characters or scenes in such fragmentary fashion that the reader's imagination has to be called in to unify the picture. And so on. Similarly, the narrator is independent, strictly separated from the other characters and from the writer. He is presented as a supreme individual and an omnipotent creator. . . . In the course of the story, other figures also achieve a life of their own. They are estranged from the writer, who then, after being "creator of the universe," becomes "its henchman." And their subsequent behavior is unpredictable; they go their own ways. Interest is now centered not merely on the relationships among the characters, but, unusual as it may seem, between them and the writer, with the narrator serving as a necessary, but somewhat unwelcome, intermediary. [1965]

<div style="text-align: right">

Jiří Opelik. *Nenáviděné řemeslo* (Prague:

Československý spisovatel,

1969), pp. 148–49

</div>

Vera Linhartová belongs to the youngest generation in Czech prose, and her three books, published in rapid succession, have aroused more interest among the reading public and critics than any other literary debut in recent months. We can trace the author's development from her first volume of short stories. *Space for Distinction (Prostor k rozlišeni),* through a lengthier

novella. *Discourse on Elevators (Rozprava o zdviži),* to her most recent book, *Part-Examination of the Recent Past (Mezipr̊uzkum nejblíž uplynulého).* But in all of them there are a few immutables: an individual style and a peculiar view of reality. In this her work differs considerably from everything else that has been written in Czech literature in recent years and this is what has stirred up so much attention and confusion and surprise. . . .

The most striking thing about Linhartová is her effort to show that the events she is writing about never happened, shunning the illusion on which all stories with a plot are built (and realistic art in general), as though the author were simply the narrator of a real incident, whether it happened to him or somebody else. Linhartová starts from the idea of a stage which she herself has created and across which she guides her figures according to her own wishes, making no attempt to conceal from the reader the wires and threads by which she manipulates her puppets.

Her characters are her own fiction and she can do what she wants with them. Unlike the characters of realistic writers, they do not live a life of their "own," seemingly independent. . . . Linhartová, for instance, completely interrupts the movements of her characters all of a sudden in order to introduce a long, episodic reflection which has only a very loose relation to the rest of the text or perhaps none at all. These digressions are typical for Linhartová.

<div align="right">Irena Zitková. Universum. 3, 1967,
pp. 65–67</div>

[Linhartová] restores to language its logic and precision. . . . Precision in the use of language, weighing every single meaning, provides an impulse of enormous importance for Czech fiction, with its traditions of realistic thumbnail sketches, psychological motivation, and the free association deriving from modern poetry. For Linhartová, the art of writing is a matter of linguistic creation—with the emphasis on linguistic. This, seemingly, is the antithesis of the narrative, from which it differs primarily in the connotations of its statements, connotations drawn from the physical sciences and the social sciences. But only seemingly, because narrative supremacy, manifested in mythologizing and irony, belongs to the tradition.

If we are not misled by the peculiarities of individual meanings and if we avoid reading Linhartová's books as if they were storehouses of separate items, if we read them as connected statements, we shall discover that their meaning is not merely a series of communications, although communications there are. It is a very simple and human artistic matter-talk, what a man says to avoid being alone. She admits this herself: ". . . so there shall not be quietness and emptiness, so that an incurable silence shall not fall between us, which can easily happen but is not easy to overcome. And this, more than anything else, is what I suppose I am rather scared of." Through language man realizes himself as a personality.

<div align="right">Vladimir Karfik. Orientace. 6, 1968, p. 87</div>

LISNYANSKAYA, INNA (RUSSIA) 1928–

Divided into two sections, "Right Angle" and "On the Edge of Sleep," Inna Lisnyanskaya's collection of lyrics [*Stikhotvoreniia*] is both grounded in reality and visionary, as the titles suggest. The poems date from as early as 1966–68, but over half were written in 1983, the year that gave rise to this excellent volume. The poems are arranged not chronologically, but rather associatively, forming chains of words, images, and themes. Though often dictated by outside events, the poems have great stylistic unity as well as the unity of their lyric persona.

The speaker, well aware that Russians expect women poets to write love poems, asks, "Where are the poems about love?" They exist ("take me, Lord, instead of him"), but they do not predominate. This is a voice of conscience in a country where memory is dangerous, where things happen that (as the poet writes in a poem about a deported uncle) even Cassandra could not have predicted. The tone often is permeated with helpless anger: "only my heart will be bloodied, My heart and not my fist." Nevertheless the sense of clearheadedness, of protest without self-pity, remains constant.

In the late 1970s, in connection with the *Metropol'* affair, the author resigned from the Writers Union. Born in 1928, she is of an older generation that now has cast its lot with poets never published in the USSR. It seems to have done her poetry good. The poems about Russian existence are particularly powerful. One, mixing quatrains and couplets, takes the reader into the countryside at the beginning of March, where time without space becomes a prison. This poem is a worthy addition to the body of Russian poetry universalizing depression in a few lives and lines. Lisnyanskaya knows well when she is invoking the Russian poetic tradition, and her echoes of Lermontov, Blok, Akhmatova, and Tsvetaeva, among others, are truly her own.

Barbara Heldt. *World Literature Today.* 60,
1986, p. 131

Inna Lisnyanskaya . . . began publishing in the late 1950s. Her early collections *Eto bylo so mnoy* (1957; This happened to me), *Vernost* (1958; Fidelity), *Ne prosto lyubov* (1963; Not simply love), and *Iz pervykh ust* (1966; Right from the source) earned her wide admiration thanks to their very un-Soviet emphasis on passionate love and longing. Primarily because of its lack of civic zeal, Lisnyanskaya's last volume published in the Soviet Union, *Vinogradny svet* (1978; Grape light), was heavily censored. As with Lipkin, the *Metropol* affair drove Lisnyanskaya into internal literary exile, and while still residing in Moscow she has published two volumes of poetry abroad: *Dozhdi i zerkala* (Paris, 1983; Rains and mirrors) and *Stikhotvorenia: na opushke sna* (1984, Ann Arbor; On the edge of sleep). As Iosif Brodsky has observed, Lisnyanskaya's forte is the short lyric, which she invests with an emotional

intensity that approaches Tsvetaeva's. Lisnyanskaya's poems often turn on the pain of loss and portray life as an ordeal ennobled by poetry.

David Lowe. *Russian Writing since 1953: A Critical Survey* (New York: Frederick Ungar, 1987), p. 131

In her "Nechto vrode avtobiografiia" (1990; Something in the way of an autobiography) Lisnyanskaya dismisses her early books as immature, but blames the censorship for the distortion of her talents in the succeeding volumes *Iz pervykh ust* (1966; Right from the source) and *Vinogradnyi svet* (1978; Grape light). From the beginning, Lisnyanskaya's poetry was marked by a distinctively un-Soviet character, since the primary emphasis is on private and not social concerns. In contrast to the "stadium" poets such as Yevgeny Yevtushenko, whom detractors criticized for actively courting the crowd with political pamphlets in verse, Lisnyanskaya has consistently eschewed rhetoric and politics in favor of lyric simplicity and intimacy. Consequently, Lisnyanskaya has become a master of the short form, whose predominant stanzaic measure is the quatrain. However, Lisnyanskaya does not restrict herself to the familiar territory of Russian women's verse, but invokes such ethical problems as conscience and memory.

During the ten years of nonpublication in the U.S.S.R. that followed the *Metropol* [Censhorship] affair, two volumes of Lisnyanskaya's verse appeared in the émigré press: *Dozhdi i zerkala* (1983; Rains and mirrors) and *Stikhotvoreniia: na opushke sna* (1984; Poems: On the edge of sleep). The first volume, which collects works written over a span of more than fifteen years, reveals the full scope of Lisnyanskaya's poetry, in particular the religiosity that the Soviet censorship had previously found unacceptable. *Stikhotvoreniia*, too, includes poems from as early as 1966, but the vast majority date from the 1980s and unmistakably herald a new poetic voice. Perhaps Lisnyanskaya's enforced silence, as well as the freedom from translation work, provided the impetus. Whatever the cause, *Stikhotvoreniia* is generally considered Lisnyanskaya's most successful book, largely due to the unity in theme and style that is achieved. The volume is a lyrical diary in which the persona records her hopes and tragedies as woman, poet, and citizen.

Firmly grounded in the traditions of Russian lyric poetry, most notably the verse of Anna Akhmatova and Marina Tsvetaeva, Lisnyanskaya's work retains its own distinct character. The hallmarks of Lisnyanskaya's style are a conversational diction, a sense of self-irony, and an attention to everyday events or objects, all of which belie the gravity of the lyric persona's anguish and loss.

Ronald Meyer. In Steven R. Serafin and Walter D. Glanze, eds. *Encyclopedia of World Literature in the 20th Century* (New York: Continuum, 1993), p. 390

LISPECTOR, CLARICE (BRAZIL) 1924–77

The style in all of these works [of Lispector's] is interior and hermetic. In most cases the action is seen from the point of view of the characters involved, and the description is also likely to be made through their eyes. This fact places her among the new vanguard of writers who have appeared in Brazil since the end of World War II and who have taken a further step along the path initiated by the so-called "Modernist" renovation of 1922. . . .

The Apple in the Dark represents the high point in the development of Miss Lispector's work, the point toward which she was striving and to which her later novel is, in a sense, a footnote. Most of the elements that go to make up the current trend in Brazilian fiction can be seen in her work. The invention is not as obvious as in [João Guimarães] Rosa because it is less a matter of neologisms and re-creation than of certain radical departures in the use of syntactical structure, the rhythm of the phrase being created in defiance of norms, making her style more difficult to translate at times than many of Rosa's inventions. Nor is the traditional vocabulary here anywhere as rich as in the works of Nélida Piñon. It is precisely in their styles of presentation that the three writers diverge: Rosa using the primitive resources of the language for the creation of new words in which to encase his vast and until then amorphous sensations; Piñon extracting every bit of richness from the lexicon of a very rich language without falling into archaisms or other such absurdities; and Lispector marshaling the syntax in a new way that is closer perhaps to original thought patterns than the language had ever managed to approach before. These three elements are the stylistic basis of all good contemporary Brazilian literature.

<div style="text-align: right">

Gregory Rabassa. Introduction to Clarice Lispector. The Apple in the Dark (New York: Alfred A. Knopf. 1967), pp. x, xii

</div>

Family Ties, a collection of short stories by Clarice Lispector, constitutes a personal interpretation of some of the most pressing psychological problems of man in the contemporary western world. Liberty, despair, solitude, the incapacity to communicate, are the main themes that unite the separate stories into a definite configuration of the author's pessimistic perception of life. Lispector presents a series of characters, "agonic victims," as Miguel de Unamuno would say, who find themselves trying desperately to maintain an equilibrium between "reality" and their own powerful imaginations. Imagination, and by implication solitude, is represented as a double-edged dagger, since on the one hand deviation from the norms that society erects leads to rejection, unhappiness, and alienation, and on the other, to retreat into a personal fantasy world, no more than a cowardly escape mechanism.

The existential struggle, for the author, consists in a series of paradoxes with no solution. How does one establish a balance between the need to

conform and the pulsating inner life that demands expression? If one is in constant fear of revealing oneself, how can one interact with others on an authentic level? The main characters in *Family Ties,* nevertheless, are fully conscious that true communication is impossible: society is an artificial barrier that must not be transcended. Yet their essential problem, as might be expected, is not to find a meaning for their senseless lives, but to run from the meaning they have already acknowledged within themselves and cannot accept. In order to feel themselves part of humanity, in so far as they are able, they force themselves to cover up their deepest feelings with the mechanized actions expected of them, thus perpetuating their own isolation. The outside world, or other human beings, constitute an everpresent threat to the precarious balance necessary in order to avoid the total disintegration of their own personality vis-a-vis the accepted patterns. The word "ties," therefore, has a double significance: the chains of outward conformity that bind each person to others by means of a false set of values, and the ties that bind each one to the other, "sans le savoir," by the total aloneness that they possess in common. Each character lives in his own little world, estranged from the rest of humanity, unable to be free, unable to give, unable to be, and unable to feel solidarity with the universe. Caught in critical moments of their existence, they prefer anything rather than the responsibility of being what they really are—human beings.

As can be seen from this brief introduction, Lispector's mentality, rather than Brazilian, comes very close to the existentialist thought of Albert Camus and Jean-Paul Sartre. Her orientation, however, tends towards a more pessimistic outlook on humanity. Whereas both Camus and Sartre propose positive solutions within this pessimistic framework (the former, that of enjoying life to its fullest and bettering social and economic conditions; the latter with his theory of "engagement"), Lispector offers no redemption for her tortured characters. The psychological anguish from which they suffer ultimately destroys them and their only hope of salvation. It should be mentioned here that in the various stories, nothing of importance really occurs; the emphasis remains on a psychological level; the action is interior rather than exterior. The tension is maintained by use of a coherent and logical stream of consciousness method.

<div align="right">

Rita Herman. *Luso-Brazilian Review.* 4:1,
June, 1967, pp. 69–70

</div>

Brazilian writers have been part of international literature ever since Machado de Assis, and today the number of interesting poets, novelists, and essayists in that country is impressive. Many are comparatively well known to American and English readers, but Clarice Lispector, who must be considered among the most accomplished of contemporary novelists writing in Portuguese, has remained almost unknown here. Miss Lispector, born in 1924 in the Ukraine (while her parents were en route to Brazil), published her first novel at the age of nineteen, and has been highly regarded in her adopted

land for the past twenty years or more. *The Apple in the Dark,* published in Brazil in 1961, is her fourth novel, and the first to appear in English.

A fascinating and distinguished work, it more than explains the esteem in which Miss Lispector is held. Unlike much Brazilian fiction, its appeal derives not at all from its regionalism, for it is quite unconcerned with local color. It is fascinating simply because Miss Lispector is a superb writer, an artist of vivid imagination and sensitivity, with a glorious feeling for language and its uses. She employs words playfully, meaningfully, deceptively, and of course seriously, not necessarily as a poet does but as few novelists do. This makes translation more than normally difficult, and it should be said at once that Gregory Rabassa has succeeded remarkably well.

The book is about many things: the relation between speech and act, knowledge and being, perception and awareness, reality and imitation. Miss Lispector has considered the existentialists, and her ontology is essentially theirs. Superficially *The Apple in the Dark* is the story of a man who has committed a crime, which represents to him a genuine act. . . . At least that is what appears upon the surface; but an outline of the "plot" is in this instance of little value; the action is in the minds and even more specifically in the words of the three principal characters. For Miss Lispector is telling us that the mind is made up in large part of the words it knows. A feeling of "horror" about his crime, Martim [the protagonist] concludes, is "what the language expected of him" and he often "preferred what he had said to what he had really wanted to say." Each character is aware of "how treacherous was the power of the slightest word over the broadest thought."

Such conceits as these would be dangerous for anyone less skillful than Miss Lispector. Words are as elusive as the feelings and thoughts they attempt to represent, and this is true even for writers. Communication may be impossible among people, but the first-rate writer can work with elusiveness and allusiveness to create poetic meaning; and so Miss Lispector, while preoccupied with the difficulty and the danger of words, is able at the same time to demonstrate their power and beauty.

<div align="right">Richard Franko Goldman. Saturday Review
of Literature. August 19, 1967, pp. 47–48</div>

It would be redundant for me to assert that Clarice Lispector's fourth novel, *The Apple in the Dark,* maintains the level of her earlier books, since this novelist, from the publication of her very first novel, has shown herself to be mature and controlled. What we can observe right from the start in *The Apple in the Dark* is the culmination of her conceptual process, heightened in this uncommon novel almost to a provocation. The story, with its episodic movements, is relegated very much to a secondary level, barely a tenuous thread is left, one that can hardly be called a plot, certainly not a conventional one.

It is my belief that Clarice Lispector is the first writer of fiction to make each of her novels into a continuous dramatic action, precluding any possible

historical background on the existence of her characters. Such a dramatic action, unfolded from inside out, proceeds to reveal what is typical about temperament and emotional states. The objective events of life lose their external character and are enveloped by the senses that come to perform the action.

In any quest for analogous literary achievements, we should recall Proust, although the French novelist also stresses evanescence, without ceasing to make a document of his sensory *memories.* Robbe-Grillet's *nouveaux romans,* which also reject plot, go farther in the destruction of the traditional novel. But he [unlike Lispector] also rejects any sort of psychologizing and bases the story on the description of objects. . . . In search of a new language for the novel, Lispector parallels Robbe-Grillet, but they have pursued different experiments.

<div style="text-align: right">

Assis Brasil. *Clarice Lispector, ensaio* (Rio
de Janeiro: Organzação Simões Editôra,
1969), pp. 72–73

</div>

The characters who people the novels and stories of Lispector are not at all spectral or phantasmagoric. Motivated by the desire to be, the profound spring from which their worldly desires derive, naked in their individual existences, they reveal and affirm an immeasurable restlessness. . . . This restlessness, which corresponds to the necessity to be, is sustained by the feeling of existence, whence flow all other feelings.

Associated with anguish and with nausea, the feeling of existence in Clarice Lispector's works, which implies an immediate, intuitive knowledge through the direct vision of each being . . . is primarily manifested as an intuition of the subjectivity of the self. The limits of subjectivity are not, however, the limits of existence. Kierkegaard's *thingness,* limiting reality of the human being to subjectivity, is inadequate in understanding what is contained in the experience of being and of existing as transmitted through the creations of this novelist.

<div style="text-align: right">

Benedito Nunes. *O dorso do tigre* (São
Paulo: Editôra Perspectiva, 1969),
pp. 121–22

</div>

[Lispector sees] existence for the majority of individuals [in *The Luster* as] a sophisticated way of being dead. The very immobility with which the characters in Granja Alta are described allows us to perceive the meaning Lispector sees in those lives. But it is not enough for an artist to understand a phenomenon with sensitivity. . . .

The imperfection of Clarice Lispector's novel results from her not having based her words (which are magnificent in themselves) on an essential concreteness. In its place she develops an immediate perception through intellectualizing divagations, which do not succeed in breaking through the limits of subjectivity or in elevating the philosophical situation. . . . The text attests

to the writer's verbal talent, but it also demonstrates how her capacity for composition, rather than increasing, is annihilated. This circumstance is only a step away from romantic sentiment filled out with existentialist jargon. Therefore . . . what we have is a work of very little courage, the result of its lack of correspondence to a concrete totality, a work in which intellectualizing subjectivity usurps the place of reality and ends up by overwhelming characters and novelistic material.

> Luís Costa Lima. In Afrânio Coutinho, ed.
> *A literatura no Brasil* (Rio de Janeiro:
> Editorial Sul Americana, 1970).
> vol. 5, p. 461

Without a doubt, the most important contribution to the *nouveau roman* in contemporary Brazil has been made by the Russian-born Clarice Lispector, who came to Brazil as a child. More than her novels, her greatest achievements are her masterfully wrought short stories. These stories are surely among the best accomplishments in Brazilian literature of the 1950s and 1960s, although it must be admitted that her works have more in common with Borges and Virginia Woolf—and perhaps even Proust—than with the themes that have shaped and dominated Brazilian literature since 1956 (and before 1930).

One can discern Lispector's search for her literary identity by looking at her early novels: *Close to the Savage Heart, The Luster, The Besieged City*. These works are insecure and groping, largely without a personal style and thematically indecisive. Not until 1955, when the collection of short stories *Family Ties* appeared, did the writer find access to her own poetic world.

Loneliness and hope, passion, love and hate, disappointment and resignation . . . have become her almost constant themes. The action is almost always a spirallike process, which at the crucial point—the moment of truth—explodes the psychological tension and resolves itself in the resigned acceptance of the hopelessness of the human condition. What remains—ordinary daily life—is a disheartened plodding, in which the feelings are permanently drugged so that existence can be borne.

> Günter W. Lorenz. *Die zeitgenössische*
> *Literatur in Lateinamerika* (Tübingen: Horst
> Erdmann Verlag, 1971), p. 250

In a fashion coherent with her existential vision, Clarice Lispector chooses her subjects, human and animal, from the world which she contemplates and investigates. It is they which constitute the mirror in which "I" is reflected and revealed, for the impossibility of a "pure I," as Phenomenology teaches us, leads to the verification that, although there is no "necessity of the world in order to exist," the "I" is radically linked to it.

Hence, the privileged moment, upon which Clarice Lispector bases her cosmic vision, consists, in her short stories, of the character's realization of what is happening in his immediate "circumstance" (excluding only plants) and, at the same time, in the "I" itself and vice versa. The character, upon his liberation from the mystery that inhabits his circumstance, discloses to himself the surrounding world. This sudden insight unveils both the inhabited Cosmos and the microcosm that surrounds the character. Forming a true "phenomenological reduction," the "I" and the universe meet as if for the first time, framed in a halo of original "purity," causing the mutual discovery to become suspended in time, a vision of the most intimate part of reality, without the deformation of thought or prejudice. To discover is thus to return to the Beginning, but only for a brief instant, as clairvoyance would destroy itself were it to last. Endowed with this "ingenuous" vision, the person comprehends his own secret and that of the universe, but must return immediately to his previous (un)consciousness, which allows him to live without major anxiety. He is granted single insight into the most hidden part of man and things and nothing more, as mental blindness is indispensable for him to continue living and surviving.

People (characters) and animals make up the "other," the suddenly discovered reality. As for the characters, they are submerged in an existential milieu like aquatic creatures in their natural element, static, deprived of metaphysical imagination or even of profound inner life. They are aware only of their daily existence, expecting nothing, going nowhere. Undifferentiated as people, "they are constantly reflecting upon what they feel" and they cherish an inner dialogue which, for them, is reduced to the mentalization of their senses' messages from the different stimuli of the outer world. Hypnotized by the contemplation of a spectacle that doesn't vary but occasionally presents surprises, they let themselves drift without aim or anxiety.

Massaud Moisés. *Studies in Short Fiction.*
8, 1, Winter, 1971, pp. 271–72

Clarice Lispector presents thirteen stories under the title of *Family Ties,* a very pertinent label for designating the relations to which she particularly turns in order to give us, on the level of literature, her vision of the world. The common bond of the different impressions released here and there is the sensation of a life that is intolerable, surrounded by dreads and fears which can lead the characters to the extreme of nausea.

The temporariness of the situations created is patent. The bourgeois family is shown in a desperate and cruel search for happiness. The family's chief value, stability, is a precarious one, entirely circumstantial; the ties which it establishes are transformed into a gilded prison, within which the mechanics of everyday life lead to ennui and disgust. The existentialist mark shows vividly in this collection by Clarice Lispector. . . .

In addition to sex, guilt-ridden and appalling, and to the revelation of a lack of conscience, the great stress of the whole book is upon nausea. Even

happiness leads to this end. In the first story, the woman feels that "there were certain things that were good because they were nauseating." In the same place one finds these words about the status of a married person: "disillusioned, resigned, married, contented, slightly nauseated." . . .

All ties show themselves to be dangerous. This is seen in "The Beginnings of a Fortune," when the boy's project for wealth leads to the notion of debt and obligation.

The extreme point of nausea can be found in the story "The Meal," told in the first person by a masculine narrator. Here the narrator watches, repelled and anguished, the meal of an old man in a restaurant. As he himself says: "I am overcome by the gasping ecstasy of nausea. Everything looks huge and dangerous."

So while the narrative prose of Rosa advances towards myth, we can say that on the other hand the fiction of Clarice Lispector emphasizes the values of everyday life trying to reproduce the state of the multiple social relationships that lead to loneliness. . . .

Family Ties thus symbolizes a pessimistic vision of the world, reproducing a cell of the bourgeois family, penetrating into consciences possessed by fear and nausea, wandering in fright and fear towards an empty void. The permanent recourse to plays of contrast, to the description of sentiments in conflict, to the coupling of opposites, indicate the characters' inner vision and search for an impossible identity, within an historically dated picture.

> Fábio Lucas. In Harvey L. Johnson and
> Philip B. Taylor, Jr., eds. *Contemporary*
> *Latin American Literature* (Houston:
> University of Houston, Office of
> International Affairs, 1973), pp. 64–66

Since the publication of her first novel *Perto do Coração Selvagem* (Close to the savage heart) in 1944, when she was only nineteen years old, Lispector has been recognized as one of the small number of true innovators in Brazilian modernism, the only woman to attain a place within that canon. Critics agree that her distinctive contribution lies in her original, often strange language, dense with paradoxes, unusual metaphors, and abstract formulations that at times elude the rational intelligence. João Guimarães Rosa, an acknowledged master of twentieth-century Brazilian fiction and a Joycean innovator in language himself, told an interviewer that "every time he read one of her novels he learned many new words and rediscovered new uses for the ones he already knew." As a woman writer, Lispector did not have the benefit of a tradition in Brazil of important female authors. One could say that Lispector, along with her older and far less innovative contemporary, the poet Cecília Meireles (1901–1964), are the founding members of that tradition, writers whom all younger women writers somehow take into account. Although Lispector mentions her early discovery of Katherine Mansfield and several critics have found in her fiction a kinship to Virginia Woolf's, Lispector preferred

to think of herself as a writer unmodified by the adjective "female." Yet her numerous female protagonists testify to her fascination with the experience of women and the shape of female lives.

In Lispector's eight novels, seven of the protagonists are female, as are most of the main characters in her five collections of short stories. Yet criticism on her work has neglected to inquire into the specifically female dimension of her characters. . . .

Family Ties (*Laços de Familia,* 1960), Lispector's most studied and anthologized collection of short stories and the only one available in English, offers a good starting point for investigating symbolic functions assigned to women in her fiction and for examining her models of female development. Appearing at the beginning of her third and perhaps most fertile decade of publication (Lispector died in 1977), *Family Ties* contains well-made stories, less idiosyncratic and difficult than most of her later work. In addition to the accessibility of these stories, it is perhaps its critical evaluation of family relationships and female life from youth to old age that has gained for this collection its readership.

In only three of the thirteen stories of *Family Ties* are the central characters male. The female protagonists, middle-class women in an urban setting, range in age from fifteen to eighty-nine. The stories in which they appear can be read as versions of a single developmental tale that provides patterns of female possibilities, vulnerability, and power in Lispector's world. The author assigns traditional female roles to her protagonists: adolescents confronting the fantasy or reality of sex, mature women relating to men and children, and a great-grandmother presiding over her birthday party. Through the plots of the stories and the inner conflicts of the heroines, Lispector challenges conventional roles, showing that the allegiances to others those roles demand lead to a loss of selfhood. The protagonists' efforts toward recuperating the self emerge as dissatisfaction, rage, or even madness. The stories present the dark side of family ties, where bonds of affection become cages and prison bars.

All the stories in the collection turn on an epiphany, a moment of crucial self-awareness. In the midst of trivial events, or in response to a chance encounter, Lispector's characters suddenly become conscious of repressed desires or unsuspected dimensions of their psyches. These women experience the reverse of their accepted selves and social roles as mother, daughter, wife, as gentle pardoning, giving females. In their moments of changed awareness, they may realize not only their imprisonment but also their own function as jailers of women and men. Their epiphanies, mysterious and transgressive, bring to consciousness repressed material with potentially subversive power.

<div style="text-align: right">

Marta Peixoto. In Elizabeth Abel, Marianne
Hirsch, and Elizabeth Langland, eds. *The
Voyage In: Fictions of Female Development*
(Hanover: Dartmouth College Press, 1983),
pp. 287–89

</div>

What about the father? He presides over all creation. All those biographies or autobiographies or *Bildungsromane* give the father a very special place. We know about Kafka's father. Joyce's father was very important. For Clarice Lispector, whose work will become a model of "feminine" writings, the father was there too. How? She is the father's daughter, and he is really the one to whom she refers before she does anything. She either acts against him or for him, but she is always under his eyes. He legitimizes the artist. . . .

Clarice, in all her works—and this is her courage—will always say that she knows about the part of the father, she knows how to deconstruct it, but she does not abolish it, she shows it, and then she goes beyond it. What she is going to do later is to state the truth about ovomaltine, that it has a bad taste and that she wants to throw it up. But she will go even further until the time when she can even try to swallow it in order to know everything about life, even what is bad, what is disgusting, until she reaches the point where she can say that everything is as good as anything. She is going to look for a kind of equivalence, not because she abolishes taste, but because she wants to respect everything exactly as it is, because she wants not to lie.

Clarice is going to lead us on a quest for the truth of existence—the truth of life, which is something very difficult. In a way, she will become a kind of mother. Of course, this is idealistic, since not all mothers are good. But what she becomes is a kind of mother of creation, a mother of life, and this will consist in what she calls *taking care of things* very carefully. She will finally elaborate a kind of philosophy, or even a kind of set of morals.

<div style="text-align: right">Hélène Cixous. New Literary History. 19,
1987, pp. 9, 13–14</div>

Critics have long recognized silence as one of the chief distinguishing characteristics of Clarice Lispector's prose fiction. Taking many forms and playing many roles, it permeates her work. Summing up the majority view on this fundamental issue, Elizabeth Lowe notes, "The heart of Clarice Lispector's world is silence, the quiet glow beyond action and beyond words that she, as her own greatest protagonist, tirelessly sought." Pervaded by a sense of blockage, of isolation and frustration, however, Lispector's fiction can be revealingly read as a discourse of silence, a lyrically rendered yet ironically self-conscious commentary on the evanescent relationships among language, human cognition, and reality. In focusing on these metafictional issues, the novels and stories of Clarice Lispector exemplify the kind of writing described as "postmodernist," writing that takes as a primary subject the nature of fiction itself, the processes through which it makes its statements.

But while in Lispector's work [there] are several key aspects of postmodernist literature, none is more representative of this particular mode of writing than her use of silence, an omnipresent feature of her fiction that she develops both metaphorically and metonymically to describe and embody the isolation of the modern human condition. Because silence plays such a central role in Lispector's work, her fiction offers the reader a comprehensive view of how

one of postmodernism's most distinctive attributes functions as the primary shaping force in a fictive universe.

<div align="right">Earl G. Fitz. Contemporary Literature. 28, 1987, pp. 28–29</div>

Clarice Lispector's short story "The Smallest Woman in the World" begins "in the depths of equatorial Africa." The French explorer and hunter, Marcel Pretre, comes "across the tribe of pygmies of surprising minuteness." Among the smallest of these, he comes "face to face with a woman no more than forty-five centimeters tall, mature, black," silent, and pregnant. He names her Little Flower and begins to observe her. He gathers data and sends his findings to newspapers that publish a life-sized color photograph of Little Flower. The narration shifts to the members of various urban families who, upon seeing the photograph of Little Flower, begin, like Pretre, to react, observe, and measure her. Back in Africa, Pretre has learned some of the tribe's few words, so he questions Little Flower. Throughout the narrative, Little Flower's only actions are to scratch herself or to smile; however Lispector's omniscient narrator describes Little Flower's secret thoughts.

Lispector frames her work within myths familiar in Western literature. For "The Smallest Woman in the World," she uses the myth of the great white hunter who penetrates the wilderness, slaughters or subdues the natives, and rapes their women. . . .

The core of "The Smallest Woman in the World" is sexual politics. My reading of Lispector, which may provide a model for reading others of her works, examines the ways in which sexual fantasies compete. At the core of "The Smallest Woman in the World" is a female fantasy of autonomy. This fantasy, as it competes with the male fantasies of domination, charges "The Smallest Woman in the World" with power. Where other critics have stopped short of this core, I read Lispector from the dark center, which is Little Flower, and move my reading outward.

In every way, Little Flower seems to embody the object of male sexual desire. She is mature, black, silent, pregnant, and miniature. Her maturity signifies her sexual ripeness. As a female, she is denied authority and is made vulnerable. As a black female, she is further objectified in a system of racial politics that awards the black female as the prize the white man takes and believes he deserves. Little Flower's silence is a further sign of her desirability: it is woman's acquiescence to being seen and not heard.

Her pregnancy and her diminutive size enhance her desirability because both conditions are used as evidence in the biological argument for male superiority. A woman is limited by anatomy: by her menstrual cycle and by a nine-month confinement as part of her childbearing functions, and by her physique, which is smaller than the male's and reduces her to childlike status. Thus, women are characterized as chronically physically handicapped and biologically destined to subservience. . . .

Lispector's writing is such a radical departure from literature that precedes it that there exists among readers, critics, and translators of her work an effort to normalize Lispector's texts. An example of this occurs in each of two translations of "The Smallest Woman in the World" from the original Portuguese to English, one by Giovanni Pontiero, the other by the American poet Elizabeth Bishop. In Bishop's case, it is particularly striking because, in a poem of hers entitled "Brazil, January 1, 1502," Bishop indicts the imperialist and sexual politics of colonialism. Yet her translation represses the sexual politics inherent in "The Smallest Woman in the World" in at least one instance: Lispector writes *concubino*, a word that, with its masculine *o* ending does not exist in Portuguese. The existing term for concubine is *concubina*, engendered as a female form. Pontiero translates Lispector's term as *mate*. Bishop uses *spouse*. If Lispector had wanted to signify *mate* or *spouse*, she could have used their Portuguese equivalents such as *conjuge, consorte,* or *esposo.* Instead she chose to invent language. By their word choice, the translators perpetuate the structures of male fantasy.

Judith Rosenberg. *Critique.* 30, 1989,
pp. 71–72, 75

Little of Brazilian Clarice Lispector's short fiction became widely available in English translation until after her death in 1977. So even though this collection of 13 stories and more than 100 "chronicles" originally appeared in Portuguese in 1964, the present volume provides for many of us a welcome, if belated, opportunity to encounter one of the most interesting writers of South America.

The stories in the first half of the collection exhibit Lispector's mastery of a wide range of narrative forms, from traditionally plotted tale ("The Misfortunes of Sofia") to reflective essay ("The Egg and the Chicken") to metafictional exploration of alternative accounts ("The Fifth Story"). Most often, she focuses upon a single moment of everyday life, examining it with enough sensual appreciation to invest even the commonplace with astonishing significance.

A majority of the stories deal remarkably with the inner life of children and adolescents, drawing attention to their feelings of isolation and kinship in relation to adults, each other, and animals. "Temptation" elucidates the profound import of the brief eye contact between an unhappy girl and a passing dog; "The Evolution of Myopia" uses a day's visit with a female cousin to observe a boy's initial encounter with "the stability of an unattainable desire." Lispector invariably takes seriously the value of childhood experiences, penetrating their significance by means of fully-realized adult sensibilities while prizing their intrinsic meaning, with no trace of demeaning condescension. . . .

Lispector's style is remarkable throughout the volume, simultaneously spare and ornamental. She invariably conveys her message in few words, yet chooses each for its power to evoke multiply rich associations. The result is

an almost painful intensity; both stories and "chronicles" are tightly condensed but highly charged with emotion. The reader may be enthralled or revolted by the closely aggregated images, but neutrality is impossible.

<div align="right">

Garth Kemerling. *Studies in Short Fiction.*
29, 1992, pp. 222–23

</div>

This last text of Lispector is, perhaps, her finest achievement, a recapitulation and culmination of her obsessive themes and formal strategies. We have a narrator trying to compose a portrait of his heroine, Macabea. He finds that his task is complex. Somehow he must find the words to express her "ugliness" and "dull" existence—her "average" singularity. The text is, therefore, a struggle between the male and the female, between creator and creation. But Lispector does not stop here. She moves from the sexual war to metaphysical significance: she offers another, higher level. Is she trying to suggest that there is an inexplicable "space" between creator and created? Does this space imply a fundamental *difference* in the shape of this world? And, if these two levels are finally open, is she trying also to express that her words are insufficient; that writing is a necessary but incomplete ritual? Her text is, then, about the impossibility of representation or, as the French critics would say, the "presence of absence." The text becomes a meditation on the *processes* of truth-seeking.

The narrator writes at the end of his text—but does any text really end?—that "the silence is such that thought no longer thinks." How strange! Are we to believe that "thought" thinks? Don't *we* create thought? Or does "thought" create *us?* And, if it does create us, who or what creates thought? I believe that Lispector ends her text—about her narrator's text!—with the word *Yes* to disturb us even more. Surely *yes* is not the answer to all the problems I have mentioned. Or have I misread the text? I am left with "a final word" which could mean anything. "Yes" is as mysterious as all the wonderfully obscure words of the entire text.

<div align="right">

Irving Malin. *Review of Contemporary
Fiction.* 12, 1992, p. 204

</div>

LIVESAY, DOROTHY (CANADA) 1909–

Dorothy Livesay so completely repudiates the romantic tradition that she abhors words which are supposedly poetic. She has brooded in the same sequestered places as Emily Dickinson and Elinor Wylie and, in a manner similar to theirs, her emotion receives its final sanction in her mind. Narcissus-like, she sees herself in the limpid mirror of her mind; each poem is a thought expressed through the medium of dry, colored, visual, often feminine images. . . .

It is from [her] courageous facing of our human condition in the intimate present that Dorothy Livesay's latest poems derive their strength. Here is something not felt before in her work. In the earlier poetry her imagery received its ultimate sanction in her mind; it must now adapt itself to an enthusiastic outlook on life. She has developed beyond her egocentrism to devote herself to a human cause.

The change in the complexion of her poetry is parallel to the change in her outlook on life and literature. It was during a stay in Paris in 1931–32, while she was writing a thesis on "The Influence of French Symbolism on Modern English Poets," that she read Eliot as a present-day representative of the symbolist aesthetic. But her European experiences were to turn her so definitely in the direction of communism that symbolist influence on her own poetry could hardly be anything but negligible. . . .

Dorothy Livesay's latest work, then, is a "criticism of life"; if we understand life to mean proletarian existence in capitalist society. We may look upon it as an impassioned justification for revolt against tyranny or consider solely the self-value of the work, its intrinsic value as art. As pure literary critics we admire an art which evolves witty adaptations of modern industrial images to dance rhythms and agricultural routine, that excites us to enthusiasm for a cause, moves us with wonder and ecstasy at the sight of a new country and gives to the human tragedy such a poignant and satirical elegance.

<div style="text-align: right">

W. E. Collin. *The White Savannahs*
(Toronto: Macmillan, 1936), pp. 153,
158–59, 169

</div>

After reading the young Canadian poet, Dorothy Livesay, it is not surprising to learn from the jacket of her book [*Day and Night*] that she comes from literary parents, that she has been a newspaper reporter, a graduate student in poetry at the Sorbonne, a social worker and a wife and mother. All of these things are reflected in her poems.

Her attitude toward poetry is classical, in spite of her experiments with form in rhyme placements and abrupt shifts of rhythm, while her subject matter ranges from the particular experiences of a woman, such as childbirth, to acutely realistic social observations. She is not a prolific poet, but a delicate, careful one. This book, covering the production of nine years, contains seven sizable poems and two groups of shorter lyrics.

In such a slim and undoubtedly selective book it is curious that Miss Livesay should include occasional poems that could have been scribbled by a high school girl feeling the tremors of spring. . . . Fortunately for her reputation and that of her applauding critics, Miss Livesay is more honest and more convincing in poems like "Day and Night" when she is reporting the inhumanity of factory machines and factory systems. . . . The final poem, "West Coast," gives the clearest, most mature expression. It is a full picture of a shipyard in the clatter and swing of war work and describes the approach

and adjustment there of a poet from the mountains. As Miss Livesay's most recently written poem, it is a promising ending to the book.

Ruth Stephen. *Poetry*. January, 1945, pp. 220–22

Miss Livesay's first book, *Green Pitcher,* was published by the Macmillan Company when she was nineteen, and was followed, four years later, by *Signpost.* The poems in these books are of Nature and personal reactions. Her keen observations of plant and animal life and her intense feeling for wind and rain, sunshine and storm and water, are set out in sensitive and lucent language in the nature poems, and are the inspiration for the original and striking symbols and images in her later work. . . .

Dorothy Livesay's poetical output, though not large, allows a dependable assay of its qualities, beauty of pattern and rhythm, fineness of imagery and allusion, strength of emotional conception and expression, and of the sources—disciplined and discerning observation, deep sympathy and understanding, from which, with skill and imagination, the poetry is drawn. Moreover, it gives an exciting prospectus of finer things to come.

Alan Crawley. In W. P. Percival, ed. *Leading Canadian Poets* (Toronto: Ryerson, 1948), pp. 123–24

The documentaries [in *The Documentaries*] reveal the poet's consuming need to describe and to account for the trauma and the fragrance of great moments in history and particularly to describe and to account for those small, private, nonetheless precious responses to those great moments. Miss Livesay's famous involvement with the political and social movements of the 1930s is reflected in those most ambitious of "social protests," "The Outrider" and "Day and Night," but her enduring concern for injustice is everywhere apparent in that poignant yet uncompromising study of the betrayal of the Japanese settlements in the West during World War II. Strangely enough, "West Coast" incorporates a density of thought and language not equaled elsewhere in the volume and yet this poem is about the excitement and opportunity and resolution found in the building of ships that will go down to the sea to fight a war. . . .

Probably she would be considered too ingenuous (and therefore, sentimental) by some of her colleagues and readers. She does not write of doom and darkness for their own sake; she is no skeptic. Doom and darkness do afflict the land, however, but the poet's great faith in the ability of human beings to lift themselves out of chaos and despair makes our fevers transitory.

Victor Hoar. *Quarry*. Summer, 1969, pp. 56–57

Dorothy Livesay is, without doubt, a nature poet who reveals in her poetry the essence of man's experience. Man may attempt to transcend to mystical

heights, or antithetically, he may enclose himself within the trappings of human society. The answer to these often-alternating extremes, she finds, is in man's acceptance of himself as a part of nature. When integrated with nature, man can find both the satisfaction of an individual imaginative experience and the comfort of a human companionship. Through this integration creativity emerges.

An investigation of those poems which have as their theme the creation of poetry, reveals that, for Livesay, creativity seems to have two aspects. She sees it, first, as the result of a natural force to which the poet succumbs. This is a force half-feared, half-welcomed, but it must be accepted in order to bring forth the new creation. Secondly, there is a creativity which takes place within "aloneness." This is a quiet process that works itself through instinctively, for it is the expression of the essence of natural life. No other agent is needed. These two aspects—the acceptance of a creative force, and a self-contained creativity—alternate within the poet. Livesay has apparently tried to reconcile them within the African prophetess in her poem "Zambia" to make clear the integrity of creation.

<div align="right">Doris Leland. Dalhousie Review. Autumn,
1971, pp. 404–5</div>

A Winnipeg Childhood presents fifteen lightly fictionalized episodes within the period of a little girl's growing up in Winnipeg during the second decade of this century. Each of these episodes contains the essence of the child Elizabeth's reaction to a specific segment or event of her life. In their entirety the fragments have the impact of a sun-streaked mosaic composed of distinctive sensitivities of childhood whose patterns are emotionally linked. . . .

The narrative point of view is Elizabeth's. The sensitivity, the primal innocence gradually being transformed, often through hurt, surprise, or disillusionment into a kind of understanding—qualities that thread through all our childhoods—are conveyed through Elizabeth's day-to-day activities and encounters. And by implication the social and moral prejudices that somehow work their way through into the adult mind stand out in relief against the child's initial naïveté.

A sensitive and evocative rendering, Dorothy Livesay's *Winnipeg Childhood.*

<div align="right">J. R. The Tamarack Review.
November, 1973, p. 76</div>

The relationship between public and private commitment is strongest in Dorothy Livesay; in her best work the two kinds of commitment cannot be separated. The notion that personal and social liberation will go hand in hand underlies the jubilant note of affirmation that prevails at the end of Livesay's single most outstanding poem "Day and Night," and at the end of "Lorca." (The same notion explains, also, Livesay's admiration for Isabella Valancy Crawford whom she admires both as "a public and a private poet, a pacifist

and a humanitarian," and as a craftsman who "did amazing feats with language."). . . .

In Livesay's connecting of the personal and social elements of her vision, singing and dancing are central. During her childhood, she always wanted to dance but was unable, she says, to adapt herself to the rigid, highly structured dance routines normally taught. Longing to dance all night, she whirled about alone, outdoors, or flew around her room in her own way, and also wrote poetry—perhaps in compensation. To her, poetry was and is an expression of a fundamental human need—the need for rhythmic, expressive movement and speech. As early as "A Boy in Bronze," which was included in her first published collection (1928). Livesay was stressing the need for fluid movement, flight, and freedom from restraint.

In the social domain (as in political poetry), this need is expressed as a plea for freedom, a plea that others, too, be free to move about, explore, discover, and grow. The poet's impassioned attempt to break through the rigidity of modern and industrial society and to find more human ways of relating and of being is at the heart, not only of "Day and Night," but of poems such as "Fantasia" and "Of Mourners" as well.

> Jonathan C. Peirce. In Lindsay Dorney et
> al., eds. *A Public and Private Voice: Essays
> on the Life and Work of Dorothy Livesay*
> (Waterloo: University of Waterloo Press,
> 1986), pp. 23, 25

It has been observed of Canadians that we have a pronounced fondness for narrative. Certainly some of our finest poets have occupied themselves as energetically with narrative as with lyrics, and frequently with a fascinating combination of the two. The impulse toward narrative has often—perhaps even usually—an historical bent and major Canadian poets from Lampman and D. C. Scott through Pratt to Livesay, Birney, Purdy, Atwood, and Kroetsch have set themselves to document imaginatively the Canadian past and present.

Dorothy Livesay, in particular, has explored this phenomenon in her important essay, "The Documentary Poem: A Canadian Genre," identifying as distinctively Canadian a mode "which is valid as lyrical expression but whose impact is topical/historical, theoretical and moral." Her *Call My People Home* is a remarkable instance of that intent and is of a piece with her narrative poems of social protest in the 1930s and her continuing allusions to current events in her present-day work. Nobody who knows the body of her poetry and prose can doubt Livesay's abiding interest in what she calls "topical data" and her determination to comment upon it. Less familiar is her role as a journalist, as articulate chronicler of modern life, as pragmatic sister to her own poetic self. Many discussions of the woman and her work understandably dwell primarily upon the poetic, regarding as tangential and secondary Livesay's experience as teacher, social worker, literary critic, an-

thologist, cultural historian, fiction writer, editor, activist, and journalist. Yet all of these spheres clearly interlock, are mutually supportive, rather than aberrations or dilutions of her gifts. And Livesay's journalistic career operates not at odds with her "literary" life but as a "popular," productive parallel.

Lee Thompson. In Lindsay Dorney et al., eds. *A Public and Private Voice: Essays on the Life and Work of Dorothy Livesay* (Waterloo: University of Waterloo Press, 1986), pp. 42–43

Critics from W. E. Collin to the present have approached Dorothy Livesay's work using the methods of dialectic, finding contraries in tension with one another. Jean Gibbs, for example, argues that Livesay's vision has been shaped by two contradictory impulses—a Thoreauvian transcendentalism, in which the individual attempts to connect himself with the eternal patterns of nature through contemplation, and, on the other hand, a Lawrencian desire to make this connection through the energy of sexuality. Susan Zimmerman examines the repeated imagery of houses in order to explore Livesay's ambivalence about love and family life; houses suggest at times security and warmth, but at other times restriction and denial of freedom. Desmond Pacey finds in her poems of the 1940s and 1950s "a fascinating combination of innocence and experience, of hope and fear, of faith and doubt."

By far the most commonly observed dichotomy in Livesay's poetry, however, is that of the "public" and the "private" poems, thematic designations which correspond roughly to the forms of the documentary and the lyric. And with a few exceptions, critics have preferred the lyric side of Livesay. . . .

The documentary, with its factual and historical basis, is discursive and didactic: even more than traditional epic, it keeps its audience in view. In the lyric, on the other hand, as John Newlove has recently suggested, "the writer is all by himself," and the impulse comes "from the interior of the soul, [while] in the narrative it most often comes from the exterior." The lyric is the form to which music and rhythm, or, to use Livesay's terms, "song and dance," seem most intimately connected. Yet Newlove argues that these features of the lyric and the narrative are not narrowly exclusive, but are tendencies which may, in some works, shade into one another. In Livesay's own definition, the documentary may contain the lyrical: it is not necessarily an exclusively public form. It is a "mixed" form which implies a certain kind of material and certain attitudes, an assertion that the writer is not "all by himself," but committed to a social order to which he feels responsible. The documentary, then, is the poem of social responsibility, but social responsibility may make room for private experience. Similarly, the lyric may imply a social context, an external world, in which private experience takes place. . . .

No one who has read *Right Hand, Left Hand* or the interviews which Livesay has given in recent years should be surprised to find a political edge to these intensely personal, lyrical books. There is a feminist sensibility here which asserts that the value and identity of the woman is not defined in masculine terms ("Ballad of Me"); there is also a claim that poetry resides in the spoken word and in daily life ("Without Benefit of Tape") and that poetry may be a subversive act more dangerous, in its questioning of conventional wisdom, than the bombs of the FLQ [Québec Liberation Front] ("The Incendiary"). The lyric voice which celebrates the delights of the senses, of love, and of nature, is the same one which proclaims the inadequacy of our youth-centred, homogenized, North American values, of patriarchal, male-defined values, of our naive faith in technology. In Livesay's recent poems, the lyric and the documentary voices, the voices of imaginative ecstasy and of social responsibility, merge. The inner-directed lyric and the socially-directed documentary are aspects of a single sensibility.

<div style="text-align: right">

Paul Denham. In Lindsay Dorney et al., eds.
*A Public and Private Voice: Essays on the
Life and Work of Dorothy Livesay*
(Waterloo: University of Waterloo Press,
1986), pp. 87, 89, 104

</div>

Dorothy Livesay's "women" are not confined to the strong love poems she published in *The Unquiet Bed* as a middle-aged poet in mid-career. As Susan Zimmerman has illustrated, her early poems show women who are "housed" or enclosed. They are trembling, fluttering, drawn to the world, but wanting to avoid hurt and suffering. Increasingly, in the middle love poems, Livesay moves her female lovers out into a world of ferocious light and wind, where they act more confidently, and where they connect intensely with their lovers, with the wind sweeping upon them and within them. The sun is there too, as male lover, as vision, revelation. Then, in the later poetry, women turn into Earth Mothers, figures who take in and harbour men, women of earth and water, drawing on dark subterranean powers. They no longer fear or depend so directly on the tempestuous "male" elements—fire and air. Though the changes in Livesay's women are not neatly divisible (the pressure of sun, for instance, is fairly constant throughout her writing), we can discern a growing presence and strength in her female protagonists.

<div style="text-align: right">

Dennis Cooley. In Lindsay Dorney et al.,
eds. *A Public and Private Voice: Essays on
the Life and Work of Dorothy Livesay*
(Waterloo: University of Waterloo Press,
1986), p. 107

</div>

Livesay was from the start in the vanguard of poetic modernism in Canada. Since that auspicious beginning, Dorothy Livesay has—by action or reac-

tion—been a vital part of the development of the national literature through more than half of this twentieth century.

How is one to take full measure of sixty years of literary accomplishment—dozens of books and hundreds of articles, songs sung and lives touched? Livesay herself leans to the historical approach, telling audiences at home and abroad the tale that is both her life and Canada's.

The poetry of *Green Pitcher* and *Signpost* pointed the way with a new sort of nature poetry, often expressed in the as-yet unaccepted *vers libre* and in stark, spare imagery that celebrated the power of nature in itself rather than simply as metaphor for human conditions. Also departures were the particular directness and spontaneity of *Signpost* and other early poetry in speaking of intimate relationships—their fears, frustrations, and failures. In the 1930s Dorothy Livesay was among the first to respond to hard times and turn her talent to social purpose. Livesay's acute consciousness of a poet's social responsibility, stimulated by Canada's sufferings in the Great Depression, did not abate in the 1940s, even after the trauma of World War II had ended and many poets were retreating into introspection and psychological, metaphysical, or mythical allusion. With twenty years' prescience Livesay concerned herself unfashionably, in poetry and in prose, with native peoples, minority groups, multiculturalism, and women's experience, and she continued, equally unmodishly, to argue the importance of direct and accessible communication in poetry.

Lee Briscoe Thompson. *Dorothy Livesay*
(Boston: Twayne, 1987), pp. 142–43

LORANGER, FRANÇOISE (CANADA) 1913–

By calling her new play *Double Jeu* (Double game), Françoise Loranger is clearly pointing out the intellect-emotion duality. From intellectual activity comes technique; as for emotion, if it continues to have a share in the author's interior world, it remains no less external to that author herself, as she projects it not onto a passive audience but rather provokes that audience, such that the audience expresses itself *by* itself, as a group and as individuals.

Whence the play is reabsorbed back into a sort of canvas onto which each of us, like modern Penelopes, will weave his or her hopes and despairs, his or her magical fantasies and agonies. . . .

Practically speaking, Françoise Loranger has chosen this simple schema: a behavior test. The actors play a group of students, belonging to different social classes (just like the audience). Facing them is their teacher who provokes them with the help of this test. It is not a question of explaining this test which is nothing but a series of symbols attached to one another; it is a question of experiencing it. The students hesitate; one tries then stops; an-

other; little by little the game is established and we are watching the unfolding of this story. A young girl is in love with a boy but a river separates them. As she makes her way, this young girl will go past obstacles, which are harder and harder, since the stake they require is what she holds most dear. It goes without saying that the obstacles are fixed; what counts is not the way that the young girl overcomes them, but the reactions that her way of overcoming them provokes in each of us. To the game of the test as experienced are added the students' comments, then our reaction to ourselves, which is different for each of us. Finally, to the game of the text played by the actors and to our reaction is added the third dimension, which is the audience's active participation. Viewers are invited to come on stage to play just like the actors in the game of the test. Thus the barrier between actor and audience is definitely breached. Before the viewers, in fact, who really are themselves and who, consequently, represent themselves, the audience ends up fundamentally engaged in the unfolding of the drama, which is no longer an abstract example—as it often is in conventional theater—but the very expression of their emotions and their intelligence.

It's no longer a question of entertaining nor of edifying. The question is to make a group aware of the existence of barriers, of prejudices. Without in the least denying collective morality, Françoise Loranger tries to pump back into each of us the awareness of who he is and what he wants. Basically, we are not so far from "Know thyself."

The problem with this kind of theater is knowing how to choose the technique (which is the explainer) and the emotions (which are the provocateur), since it is necessary to go from one world to the other without a break.

Thanks to her sensitivity and sense of what is right, Françoise Loranger has been able to draw the fabric of her play without too many wrinkles. She has imagined that one of the woman students was involved with one of the male students. The test is apparently intended for them. It is they who go forth to discover themselves in order to bring us along in the discovery of ourselves. Thus there is before us a visible conflict, a human one, which excludes all coldness and all abstraction, which is fatal to any theater.

It is to this faculty of emotion and wonder that we owe, theatrically, the most beautiful scenes of this play, scenes that are certainly among the loveliest in French Canadian dramatic literature. One of them is in the second act, the moment when the young girl reveals what she is to those who surround her. Everyone is assembled around her; she sees who she is; the only thing that remains for her to do is to let the world know, to name herself. She names herself, therefore, and introduces herself, such as she is, in her rediscovered identity: "Dyne"; everyone names him or herself in turn. The second moment is in the first act. While the major protagonists act on the main stage, on each side two other couples are installed, expressing themselves according to their personality. We see what Françoise Loranger wants to do: to make her point by means of the multiplicity of scenes, the multiplicity of interpretations, according to the personality of each one. It works in the middle, it works on

the left; but, on the right, the woman in the third couple doesn't manage to
get into the bath; she laughs, refuses everything while regretting her refusal.
Her partner, tired of it all, leaves her; however, all alone as she is, she slowly
lets herself be taken in to the game and finally succeeds in being embodied.

<div align="right">Jean Basile. Le Devoir. January 20, 1969,

n.p.</div>

Françoise Loranger's theater focuses on the process of liberation and affir-
mation of life, from the first to the last of her five full-length plays. In the
first two plays, *Une Maison, un jour* (A house, one day) and *Encore cinq
minutes* (Five minutes more), she depicts the bourgeois family structure as
it had developed in Quebec through the late 1950s. Wife and children were
supposed to subordinate personal desires to the views of the husband/father
in order to preserve the family in the midst of a group of anglophones whose
expectation was for the "French-Canadians" simply to disappear. In both
plays, a household which had formerly enjoyed the services of a domestic
staff no longer has servants, and the wife/mother is seen by other members
of the family as being self-indulgent and disorderly. The household no longer
reflects the elegance and propriety of the ideal bourgeois order. . . .

 With *Double Jeu* (first performed on January 18, 1969, at the Comédie
Canadienne but written before *Le Chemin du Roy*), Françoise Loranger takes
a critical step away from the techniques of traditional theater: the dialogue
is no longer the dominant element and the distinction between spectator and
actor is broken down. The characters are designated by number rather than
by name. During performances, the actors eventually name themselves to
the spectators in order to elicit a reciprocal identification and sense of partici-
pation. Stage directions are printed on the left-hand page in the published
text, and they are, at moments, more extensive than the dialogue. The actors
mingle with the spectators during the intermission, and the second act begins
with improvisations by members of the audience who have been inspired by
the pre-organized but variable "improvisations" carried out by actors during
the first act. . . .

 Le Chemin du Roy (The king's road) was an entertainment of sorts,
depicting the anger and hostility of Anglo-Canadians and the jubilant sense
of renewal and self-affirmation of the *Québécois* on the occasion of General
De Gaulle's truncated visit to Quebec and Canada, in July 1967. The setting
for this play is a parodic hockey game whose players are well-known politi-
cians of Quebec City and Ottawa. In Act I, the game is fought with vigor,
with Quebec scoring all the points (Quebec City—4, Ottawa—0). In scene
[x], De Gaulle's progress along the "Chemin du Roy," from Quebec City
towards Montreal, is broadcast, ending with the playing of the "Marseillaise,"
which brings emotions to a fever pitch. The final scene is the climax of the
first act: as the players cluster around the gigantic feet of an unseen statue
of the General, excerpts of De Gaulle's actual speech from the balcony of City
Hall (July 24) are heard, ending with the (in)famous "Vive le Québec libre!"

In the second act, the game is disrupted by Quebec's withdrawal. The players and majorettes assume various identities and give the reactions of segments of the Canadian and Quebec populace to De Gaulle's speech: reactions of politicians, of people in the street of Montreal, of the media, of the bourgeois, and of demonstrators. In each of the first eight scenes there is a mixture of anglophone and francophone comments. In the last two scenes we hear, first, a sampling of angry anglophone reactions ("I never talked French in Montreal and I never will!") and, finally, the expression of the *Québécois*'s renewed sense of community ("Le Québec est à faire, nous le faisons"). . . .

In *Double Jeu* it was simply suggested, by the surveyor, that the young woman's experience of self-discovery could also represent that of the country. In *Le Chemin du Roy*, the thematic ground of a national identity to be assumed becomes the figure upon which the play is focused. The analogy between play and song is not quite exact—the girl in the song is leaving her parents' house, while Quebec is seen abandoning a husband (Canada). The song is cleverly used, by Loranger and Levac, to make the malaise of the song's parents set a tonality for an analogous yearning for the lost unity between Canada and Quebec. Neither the parents nor Pearson are capable of seeing their own role in provoking the rupture.

Médium saignant (Medium rare) was first produced on January 16, 1970, at Montreal's Comédie Canadienne, just nine months before the kidnappings of Robert Laporte and James Cross by the Front de Libération du Québec. The setting for the play is the "Centre Culturel" of a suburban community of Montreal. The members of the Municipal Council, arriving at the Center for a special meeting, interrupt the preparations of a group of young actors and musicians for a Mardi Gras festival the following day. Although the town clerk forgot to notify the *animateurs*, the Council asserts its prerogative to hold the meeting. Hearing that the language issue will be raised at the meeting, the *animateurs* decide to stay to witness the discussion. The language issue turns out to arouse all the fearful undercurrents of domination and hostility: between *Québécois,* English Canadians, and neo-Canadians; between older and younger generations; between the more conservatively and the more radically oriented citizens. . . .

After reading *Double Jeu* and *Médium saignant* in close sequence, it becomes apparent that a common theme informs both plays: that the individual *Québécois* or *Québécoise,* like the community as a whole, tends to let life slip by because of various fears. They let themselves be dominated and subjected to the worst standard of living and the worst humiliations through fear of not being able to stand up to hostile forces, actual or anticipated. . . .

On the basis of this reading of Françoise Loranger's plays, we can conclude that, while men and women share some of the same fears, the *Québécoises* have been doubly colonized, by patriarchal society as well as by the English Canadians. Loranger's women are thus more often able to recognize and to cope with their own fears, and, as a consequence, they act more

quickly than the men to break the vicious cycle of domination to which they find themselves subjected.

Carrol F. Coates. In Paula Gilbert Lewis, ed. *Traditionalism, Nationalism and Feminism: Women Writers of Québec* (Westport, Connecticut: Greenwood Press, 1985), pp. 83, 85, 87–92

As novelist and playwright, Françoise Loranger began in 1939 a body of work that had particular influence between 1949 and 1971. Through means as varied as radio, books, television, and the stage, she reaches a very wide audience and has enjoyed a great popularity, particularly during the years 1960–70, for her output is connected to the events of the period, in harmony with the deep aspirations of the Québécois people. Usually divided into two periods—the first "traditional," "psychological," "bourgeois," or "French-Canadian of a Québécois nature," the second "modern," "Québécois," or "political," according to the critical terminology—this body of work presents in certain eyes a real break of theme and form, marked in 1968 by the play *Le Chemin du Roy* (The King's Road), subtitled *Comédie Patriotique* (Patriotic Comedy). This point of view, confirmed by numerous fictional and dramatic elements, nonetheless masks the unity of the work which, in its very evolution, reflects the evolution of a group in search of its identity and facing the dangerous complexity of its relations with the outside world. . . .

Françoise Loranger is part of this perspective of living witness. She does not represent any particular literary tendency and is at the crossroads of ideas in the search of the best paths to follow for the French Canadian future. . . .

The reissue of her novel *Mathieu* in 1967 [brought together various themes of collective malaise] expressed by all Quebecois literature: ambivalence of origins, a French and Latin culture out of phase with North American life; perpetuation of a situation of guilt by the clergy which denigrated the flesh in favor of the spirit; finally, the problems for an emerging society of aspiring towards a culture of its own, while continuing to refer back to a mother-culture that it is unable either to reproduce or to forget. . . .

Initially the author of radio plays with snappy lines, Françoise Loranger suffered from never getting any comments from the listeners. She felt she was "crying into the void." That is why she turned to the theater so as to achieve this direct communication with the audience. . . .

Once she was recognized as a dramatic author, Françoise Loranger would not stop considering dialogue as the fundamental tool of revelation. However, when she progressively introduced the middle class into her work, the spoken theatrical text lost the definitive character that it had had earlier. Is this the influence of modern theatrical trends or of a society where certain groups are unaware of or hate each other, as *Medium Saignant* (Medium Rare), the author's most recent creation, shows?

Thérèse Marois. *French Review.* 59, 1986, pp. 868–70

LORDE, AUDRE (UNITED STATES) 1934–92

Though she had been writing for many years, Audre Lorde also achieved wider public notice during the Black Liberation Movement. However, overtly black nationalistic subjects have never constituted the sole thrust of her poetry, though poems such as "Naturally" and "Summer Oracle" have been frequently reprinted to represent her.

Perhaps the single most noteworthy observation to be made about Lorde is that she embodies a conscious and deliberate confluence of black women poets and the women's/feminist movement. Even though she had always written black women and woman-identified poems, it was not until the rise of the second-wave feminist movement that she was able to publish much of this work or to receive any widespread support and recognition for exploring issues of female identity and sexuality, including frankly feminist and lesbian-feminist themes. . . .

Understandably, then, her subjects and moods are many. One of her books, *Between Our Selves,* is illustrative. A hand-set, women-printed, limited-edition volume of only seven longish poems, it yet manages to cover (1) racially resonant topics ("Power," "School Note," and "Between Ourselves") that show Lorde rejecting an "easy blackness as salvation" for the hellish truth of history and its varicolored consequences, (2) personal, woman-related themes ("Solstice" and "Scar") that trace movement from enervation and barrenness to a triumphant rebirth, (3) communication with "the mothers sisters daughters / girls I have never been" ("Scar"), (4) the poet's relationship with her parents and her growing into her selves ("Outside"), and (5) a reluctant abortion ("A Woman/Dirge for Wasted Children").

Recently, it seems that Lorde's style is becoming less dense and inscrutably allegorical, and achieving a light and refreshing clarity. She has even begun to reveal more openly and easily the strain of whimsy and playfulness that women, and especially feminist women, often display with each other. One delightful such manifestation is her poem "The Trollop Maiden," which appeared in the Spring 1977 issue of *Sinister Wisdom.*

Lorde frequently assumes the role of prophetess, crying out for what she calls the most important human movement—"the right to love and to define each of us ourselves." Probably related to this is a newly expressed interest in theory and criticism found in her essay "Poems Are Not Luxuries." In it, she distinguishes two approaches to life: (1) the "european mode," which views living "as a problem to be solved" and relies exclusively on ideas, and (2) the "ancient, black, non-european view of living as a situation to be experienced and interacted with," a view which teaches one "to cherish our feelings, to respect those hidden sources of our power from where true knowledge and therefore lasting action comes."

Gloria Hull. In Sandra M. Gilbert and Susan
Gubar, eds. *Shakespeare's Sisters*
(Bloomington: Indiana University Press,
1979), pp. 179–81

In contrast to [Maya Angelou's] *And Still I Rise,* Audre Lorde's seventh volume of poems, *The Black Unicorn,* is a big, rich book of some sixty-seven poems. While *The Black Unicorn* is as "packaged" as *And Still I Rise* (the prominent half-column of authenticating commentary from Adrienne Rich constitutes much of the wrapping), it really does not need this promoting and protecting shell. Perhaps a full dozen—an incredibly high percentage—of these poems are searingly strong and unforgettable. Those readers who recall the clear light and promise of early Lorde poems such as "The Woman Thing" and "Bloodbirth," and recall as well the great shape and energy of certain mid-1970s poems including "To My Daughter the Junkie on a Train," "Cables to Rage," and "Blackstudies," will find in *The Black Unicorn* new poems which reconfirm Lorde's talent while reseeding gardens and fields traversed before. There are other poems which do not so much reseed as repeople, and these new persons, names, ghosts, lovers, voices—these new I's, we's, real and imagined kin—give us something fresh, beyond the cycle of Lorde's previously recorded seasons and solstices.

While *The Black Unicorn* is unquestionably a personal triumph for Lorde in terms of the development of her canon, it is also an event in contemporary letters. This is a bold claim but one worth making precisely because, as we see in the first nine poems, Lorde appears to be the only North American poet other than Jay Wright who is sufficiently immersed in West African religion, culture, and art (and blessed with poetic talent!) to reach beyond a kind of middling poem that merely quantifies "blackness" through offhand reference to African gods and traditions. What Lorde and Wright share, beyond their abilities to create a fresh, New World Art out of ancient Old World lore, is a voice or an *idea* of a voice that is essentially African in that it is communal, historiographical, archival, and prophetic *as well as* personal in ways that we commonly associate with the African *griot, dyēli,* and tellers of *nganos* and other oral tales. However, while Wright's voice may be said to embody what is masculine in various West African cultures and cosmologies, Lorde's voice is decidedly and magnificently feminine. The goal of *The Black Unicorn* is then to present this fresh and powerful voice, and to explore the modulations within that voice between feminine and feminist timbres. As the volume unfolds, this exploration charts history and geography as well as voice, and with the confluence of these patterns the volume takes shape and Lorde's particular envisioning of a black transatlantic tradition is accessible. . . .

Lorde makes effective use of the principle of repetition that is at the heart of oral composition in all "pre-literate" cultures, and at the heart as well of such conspicuous Afro-American art forms as the blues. (Indeed, each of the stanzas just presented may be said to be a modified but identifiable blues verse.) In the remaining sections of the volume, repetition and other devices which are, in this context, referents in written art to oral forms, are largely forsaken in favor of the kind of taut free verse Lorde usually employs. What is fascinating about this, as suggested before, is that while the declarative voice forged in the first group of poems remains, that voice speaks less

of discovering language and of moving, perhaps, from speech to laughter, and more of poems—of written art readily assuming the posture of a healing force. . . .

Whether or not the subject at hand is love, children under assault, people in prison, childhood "wars," or the quest for a certain rare literacy, the poet in *The Black Unicorn* steadily pursues (and defines in that pursuit) a viable heroic posture and voice for womankind. The success of the volume may be seen in the fact that when the poet declares in the final poem,

> I will eat the last signs of my weakness
> remove the scars of old childhood wars
> and dare to enter the forest whistling

we believe her. In this period between renaissance and/or revolutions, Lorde's verse may need promotion in order to sell, but that doesn't mean that the verse is thin or insignificant. *The Black Unicorn* offers contemporary poetry of a high order, and in doing so may be a smoldering renaissance and revolution unto itself.

<div style="text-align: right">R. B. Stepto. Parnassus. 8, 1979,
pp. 315–16, 318, 320</div>

Like Adrienne Rich, Audre Lorde . . . has also produced a large body of poetry over an appreciable length of time. In her recent poems, including some in *Coal,* she has come to see in the bonding of women an image both of home and of a new world. *The Black Unicorn* (an image which richly summarizes the self-image of the poet) specifically develops the image of woman-bonding as a necessary start to the end of all forms of oppression. She writes in "Between Our Selves" of the selling into slavery of her pregnant great-grandmother. . . .

In creating her version of the Lesbian myth, Lorde draws upon Dahomeian religious myths, which are matriarchal in character, and ritual, in which women figure prominently. This mythic system provides a society of women, and it operates in Lorde's poetry much as the Greek myths do in [Olga] Broumas's, as a remembrance, an archaeology. . . .

More so than her white fellows, Lorde takes violence as a central, dominant theme for her poetry. Seboulisa, the Dahomeian goddess, cut off one breast so that she might fight more easily, but violence is not always seen as so productive. Lorde's poetry is haunted by the images of the "children who become junk": the heroin-drugged girl of "My Daughter the Junkie on a Train," Donald DeFreeze, ten-year-old Clifford Glover who was shot by a white cop, the teenager in the poem "Power" who succumbs to "rhetoric" and rapes and murders an 85-year-old white woman "who is somebody's mother," the women who are "stones in my heart" because "you do not value your own / self / nor me."

<div style="text-align: right">Mary J. Carruthers. Hudson Review. 36,
1983, pp. 316, 318–19</div>

Audre Lorde has been writing now for more than twenty years, and the turbulent events of the past two decades find eloquent voice in her poetry. What is remarkable, however, as one looks back over her work so far is the powerful personal voice of her own struggles with life. Although she is decidedly political and has enjoyed an extremely engaged and active life, the world is seen in her poetry mainly through the conflicts and confrontation of her coming to terms with herself or with very private pain. Indeed, the words anger and rage come up time and again in her poetry, but the key word is pain. And for her pain is private and intimate. When she writes of her personal suffering, the writing is almost clinically precise, original, and direct.

A central poem in this regard, and one of her finest, is "Father, Son, and Holy Ghost," about the death of her father. It is central also to an understanding of the mind of Audre Lorde. It is appropriately not about his death, but about the young daughter's experience of his absence. The poet cannot bear to visit his grave, so massive and vital a presence was he while alive. His presence was intellectual and moral in nature: "he lived still judgments on familiar things." His physical stature invaded the very details of the house. Although the poet has never seen his grave, there is an imagining of its daily routine, visited every day by a "different woman," and a man "who loved but one" thus being cared for each day by a different woman arouses an unacknowledged jealousy in the bereaved daughter. The jealous grief finds solace in the lively memory that he "died/knowing a January 15 that year me."

This poem of 1960 thus established the three central themes and motifs of Lorde's life and the pattern of her poetry: her preoccupation with the male principle and the issue of power; her profound quest for love; and the commitment to intellectual and moral clarity about "familiar things."

It should be noted that the image of her mother in Lorde's poetry is also a dominant one, but of a different order. The mother, for example, in "Black Mother Woman," is a spirit to be exorcised, for there is nothing gentle and maternal in her memory. The daughter must fend through a thicket of anger and fury to find "the core of love." From her mother, she has acquired a "squadron of conflicting rebellions," elsewhere described as a conflict between racial values. The daughter's identity is achieved through standing apart from, against the mother.

The poetry is, then, a prolonged spiritual effort to reach the father, to be transformed into him, and to be his likeness, more son than daughter. This preoccupation with the male principle and with power is a tribute to the father's legacy. And this concern in turn is at the root of those disconcerting, wild, surrealist images that characterize much of her poetry. One has a feeling often of toughness and determination, of anger, in many of the poems. These are the ghosts of the father. . . .

Lorde is a poet for whom writing is a serious moral responsibility. She came to poetic and personal awareness in the late 1950s and early 1960s, but has grown steadily since in both complexity of vision and clarity of purpose. She has worked very hard at her craft and we may expect to see more

changes and growth in the years to come. As I have indicated, she has a devoted following in New York and the East Coast generally, but for the gravity of the issues she raises, for her luminous insight, meticulous research and skill, and for the breadth of her interests, she deserves a far wider audience. One can only hope that this valuable voice will survive all its liberations, and in so doing enlarge our own sense of freedom and capacity for life.

Jerome Brooks. In Mari Evans, ed. *Black Women Writers (1950–1980)* (New York: Anchor, 1984), pp. 269–70, 276

One of the most oft-quoted lines from Audre Lorde's poetry is from her anthology *Coal:* "I am Black because I come from the earth's inside/now take my word for jewel in the open light." Indeed, much of her poetry deals with the nature of the "word" as an entity unto itself. For Lorde, words "ring like late summer thunders/to sing without octave/and fade, having spoken the season." Words "explode/under silence/returning/to rot" Words are alternately Life, Death, Silence, Truth. And they are the natural tool of the poet.

Her themes cross continents, wind through city streets, lavish color and form over seasons, and echo songs of intimacy: visions of tender loves. Browsing through her several anthologies, we see Lorde as multipersona. She is favored companion to African gods. Defender of Black women suffering the injustice of white America. Child-woman seeking still a mother's love. Black mother agonizing the fated issue of her womb. Black lesbian feminist socialist. The "outsider." The "different." The Poet.

It is little wonder that her poetry, indeed all of her writing, rings with passion, sincerity, perception, and depth of feeling far beyond the many voices, bland and putrid, that today cry out "I am a poet!"

The Cancer Journals is an autobiographical work dealing with Audre Lorde's battle with cancer, her horror at discovering that she was being forced to face her own mortality head on, and the lessons she learned as a result of this most painful experience. She talks constantly of fear, anxiety, and strength. And strength is the substance of which she seems made. The opening statement of the Introduction addresses the problem immediately. "Each woman responds to the crisis that breast cancer brings to her life out of a whole pattern, which is the design of who she is and how her life has been lived. The weave of her every day existence is the training ground for how she handles crisis." She further states, "I am a post-mastectomy woman who believes our feelings need voice in order to be recognized, respected, and of use." And we hear her feelings voiced in a manner both eloquent and disturbingly prophetic. As in her poetry, Lorde states her truths with no holds barred in this short but powerful prose work.

Joan Martin. In Mari Evans, ed. *Black Women Writers (1950–1980)* (New York: Anchor, 1984), pp. 277, 287

Audre Lorde's *Zami,* somewhat like [Paule Marshall's] *Brown Girl, Brown-stones* but more explicitly, explores the struggle to define a self amid the overwhelming Caribbean culture of the household. The conventions of auto-biography allow for a centering of a self caught in the conflicts of a Caribbean/American household which eschews any thought of private individual space: "a closed door is considered an insult." Nevertheless, there is an engagement with Caribbean folk culture through the recalling of folk healing, songmaking, the notion of "home." Above all, she is able to make an explicit connection between her lesbianism and the fact that Carriacou women have a tradition of "work[ing] together as friends and lovers." By accepting "Zami," a word still identified negatively in the Caribbean, she is like Michelle Cliff, "claiming an identity" she was taught to despise. The definition of "Zami" is a bold epigraph to the work. And the tension in accepting identity seems to be finally resolved here. Her essay "Grenada Revisited," for example, is one of the best evaluations of the Grenada invasion and, as I see it, a fitting conclusion to *Zami.* Buttressed by concrete images of Grenada, pre-and post-revolution, she concludes with a tribute to the strength and resilience of the Grenadian people. . . .

The heritage/identity question is definitely established in the Grenada essay as is the woman-identification in the acceptance of the term "Zami." But Lorde's expressed connectedness has its impetus from revolutionary Grenada and the sense of possibility which it held. Clearly then, for Lorde, cultural identification has to be addressed along with an overtly, antihege-monic discourse. She therefore moves the discussion, beyond a singular Pan-African identification to a fuller acceptance of a gender-identified relationship with history and an ideological consciousness of the meaning of Grenada's thwarted revolution within the context of power, powerlessness, and empowerment.

<div align="right">

Carole Boyce Davies. In Carole Boyce
Davies and Elaine Savory Fido, eds. *Out of
the Kumbla: Caribbean Women and
Literature* (Trenton, New Jersey: Africa
World Press, 1990), pp. 62–63

</div>

In *Zami* we find an alternative model of female development as well as a new image of the poet and of female creativity. The image of the poet as black lesbian encompasses continuity with a familial and herstorical past, commu-nity, strength, woman-bonding, rootedness in the world, and an ethic of care and responsibility. The image of a connected artist-self who is able to identify and draw on the strengths of women around her and before her is an im-portant image for all of us to consider. What we learn may be as significant for our individual and collective survival as it has been for Audre Lorde.

Never once in *Zami* does Lorde express a conflict between herself as a woman and herself as an artist. As a lesbian, she never transfers her primary emotional and erotic intensity to a man. As a lesbian, all of her relationships

with women partake to some degree of that first loving, sensuous, nurturing relationship with a mother. And as a lesbian poet, her muses are women. Women support her, nurture her, enable her to write. This has profound implications. . . .

Lorde's continuity with her mother includes a deep understanding of the connection between poetry and the erotic, of the erotic connection among women, and of the connection between poetry and survival, as well as of the ways in which as a black woman her voice as an artist continues her mother's. In "Poetry Is Not a Luxury" and "The Uses of the Erotic: The Erotic as Power," Lorde links female eroticism and creativity. Poetry and the erotic are both female resources within us. The erotic is not simply the sexual, but "an internal sense of satisfaction to which, once we have experienced it, we know we can aspire." Lorde speaks of it "as an assertion of the lifeforce of women; of that creative energy empowered, the knowledge and use of which we are now reclaiming in our language, our history, our dancing, our loving, our work, our lives." Poetry can put that ancient woman-knowledge into words "so it can be thought." And once thought, it can be—indeed should be—acted upon. For Lorde both the erotic and poetry are means toward genuine change. They are important because "the aim of each thing which we do is to make our lives and the lives of our children richer and more possible."

<div align="right">Barbara DiBernard. Kenyon Review. 13,
1991, pp. 196, 198, 204</div>

Her official designation as New York State Poet for 1991–93 notwithstanding, Lorde is best known for her prose works (including, besides Zami, The Cancer Journals and the essay collections Sister Outsider and A Burst of Light); for her activism on behalf of women of color; and—among feminists—for her eloquent advocacy of a flexible, non-essentialist identity politics: the "house of difference," she called it. Poetry was the core of her political thinking, as she noted in the essay "Poetry Is Not a Luxury":

> In the forefront of our move toward change, there is only our poetry to hint at possibility made real. Our poems formulate the implications of ourselves, what we feel within and dare make real . . . our fears, our hopes, our most cherished terrors.

Lorde must be counted among a handful of necessary poets of her generation, yet her work has received shockingly little critical attention from any quarter: feminist writers of all colors, African-American critics or the still largely white and male American poetry establishment. . . .

This volume [Undersong], a subtle revision of Chosen Poems—Old and New (1982), spans three decades of production and includes work from Lorde's first five published collections. It is not a "selected poems" in the usual meaning of the term, because it contains no work from her centrally important The Black Unicorn (1978), which she considered too complex and

too much of a unit to be dismembered by excerpting. *Our Dead behind Us* (1986) is also unrepresented. Thus a large chunk of her strongest work is missing—including most of the poems in which she conjured and confronted "the worlds of Africa."

The omissions will disappoint those wanting a volume of "greatest hits"; more important, the reader gets a nagging sense of incompletion from the developmental gap between the early 1970s material out of *New York Head Shop and Museum,* with its vernacular, often anecdotal tone, and the prophetic reach of poems composed at the turn of the following decade. Yet *Undersong* is remarkable both for the power of many individual pieces and for what it reveals of Lorde's poetic journey.

"Am I to be cursed forever with becoming/somebody else on the way to myself?" Lorde writes in "Change of Season." Despite her imposing public presence and her auto-mythologizing, she did not believe in wiping out the traces of less assured earlier selves. As she states in an introduction, her revisions of *Chosen Poems* were undertaken to clarify but not to recast the work—necessitating that she "propel [herself] back into the original poem-creating process and the poet who wrote it." In fact, revision seems to have consisted largely of excising a handful of early poems, substituting others previously unpublished and reworking line breaks and punctuation to give more space and deliberate stress to each stanza and image. This welcome openness is enhanced by the book's respectful layout, allowing one poem per page. . . .

If one axis of the book (and Lorde's work as a whole) is the poet's self-location in the complex space of identity and relationship, then the second is surely her consuming involvement with issues of survival—issues that for her nearly always transcend the personal and private. Images of destruction abound. . . .

The word "nightmare" cycles endlessly throughout Lorde's work, her word for history as glimpsed in surreal previsions and "Afterimages" (the title of a poem linking her memories of Emmett Till's lynching to television pictures of a Mississippi flood). One looks in vain for a "positive" counter-weight, before realizing that the nightmare, for Lorde, is not simply a token of negativity but rather represents the denied and feared aspects of experience that must be accepted for change to occur. . . .

In *The Black Unicorn* and *Our Dead behind Us,* Lorde often moved away from the dailiness of her New York City-centered poems to visions of Africa and pan-African solidarity. In reinterpreting West African cosmology from a woman-identified perspective, she located a language in which to express a mythic dimension of the quest for Black survival. . . .

Yet Lorde never forgot that Dahomey, like Black, was a metaphor, and as fraught with contradictions as the sidewalks of New York. . . .

Near the end of her life, Audre Lorde took the African name Gamba Adisa ("Warrior—She Who Makes Her Meaning Known"). Because she had learned to cherish her nightmares, the powerful meanings her poems serve

are neither singular nor fixed. It seems probable that once she can no longer safely be ignored, the effort to translate "the fused images beneath [her] pain" into palatable slogans will be the next line of defense. Lorde herself knew all about this time-honored tactic, writing in "The Day They Eulogized Mahalia": "Now she was safe/acceptable . . ./Chicago turned all out"; the needless deaths of children, untouchable by art, have the last word:

> BURNED TO DEATH IN A DAY CARE
> CENTER
> on the South Side
>
> . . .
>
> Small and without song
> six Black children found a voice in
> flame
> the day the city eulogized Mahalia.

As with any poet who really counts, there are no useful shortcuts. The only way to do justice to Lorde's meanings is to inhabit all her layers. The only way to honor her memory is to own the nightmare complications demanded by both poetry and hope.

<div style="text-align:right">Jan Clausen. The Nation. February 1, 1993,
pp. 130–33</div>

LOWELL, AMY (UNITED STATES) 1874–1925

Amy Lowell . . . is perhaps the least formula-bound poet now writing. She is an Imagist, but she does not see the world exclusively in the terms of Imagism; she feels, and makes the reader feel, its enormous variety. Her historical sense does not permit her to despise the past, nor to fear the future because it lies around a bend in the road. So she writes freely and flexibly and experimentally, as a poet should who springs from a free, flexible, and experimental people. . . . It is not enough to say that she is a realist, it is scarcely half the truth. She is rather a veritist, and a romantic veritist at that, not seeking to relate the fact to the phantom, but to incorporate the phantom with the fact. She accomplishes this by bringing to bear upon the fact, civilized, conventional, artificial as it must be in her accepted world, senses as acute and unsophisticated as those of a savage.

<div style="text-align:right">Helen Buller Kizer. North American Review.
May, 1918, pp. 739, 742</div>

The style she has chosen to use, whether regarded with a view to rhythm or to color-distribution is essentially pointillistic. Now Miss Lowell should have

known that the pointillistic style is, in literature, suited only to very brief movements. A short poem based on this method may be brilliantly successful; Miss Lowell has herself proved it. A long poem based on this method, even though sustained brilliantly and perhaps in direct ratio to its brilliance, almost inevitably becomes dull. . . . This style, obviously, is ideal for a moment of rapid action or extreme emotional intensity. But its effect when used *passim* is not only fatiguing, it is actually irritating.

> Conrad Aiken. *Scepticisms* (New York:
> Knopf, 1919), pp. 121–22

She has camouflaged an inherent feminine sensibility, so that it appears aggressive, and masculine. *Au fond* she is soft and gentle like Francis Jammes, who excites her profound admiration. Somewhat unfairly to her frank generosity and sensitive appreciation, she will go to remarkable lengths at times to convince us that she is insensitive to the feelings of others, contemptuous of their convictions, disdainful of their beliefs. She has the aggressiveness of Samuel Johnson, the daring of George Borrow and the tenacity of John Bunyan.

> Joseph Collins. *Taking the Literary Pulse*
> (New York: Doran, 1924), p. 61

Miss Lowell . . . comes on things full-face. She walks around them and looks at them. She recognizes them. She knows their names. They belong in her world and she in theirs, and it is a sane, balanced, homogenous world. . . . Miss Lowell is one of the great personalities of our time and one of the great aristocrats of literature. No one who has heard her talk will ever forget it. But . . . Miss Lowell's great achievement as a poet lies in precisely the fact that her poems are the most important thing about her. She has succeeded in creating poems which owe her nothing but their creation, poems which are not the publications of her heart nor the revelations of her philosophy, but finalities, entities, existences.

> Archibald MacLeish. *North American*
> *Review.* March, 1925, pp. 509–10

That Amy Lowell's creative spirit occupied a large and unwieldly body is important because the triumph lay with the spirit. Her handsome head, unflinching in its carriage, had much to reckon with. First, perhaps, a passionate and untrammeled heart. Next, physical illness, disability and a kind of fleshly discomfort that no woman could bear in youth without suffering self-consciousness, and the sense of a lost paradise. Yet I doubt if I have known a maturity as full-flavored and wholly sustaining as Amy Lowell's. Every twisted strand, every quirk in her destiny which earlier challenged normality and happiness, became woven into the warp and woof of a noble and dedicated career.

> Elizabeth Shepley Sergeant. *Fire under the*
> *Andes* (New York: Knopf, 1927), p. 11

The lack of personal emotion in Miss Lowell's verse is due in part to two elements in her nature, her aristocratic ancestry and her great intellectual power. Her inherent pride keeps her from opening her heart too wide in public, and emotion is always somewhat alien to people of marked intellectuality. Emotion Miss Lowell had in plenty, but it was the emotion of the critic and controversialist, not the emotion of the creative artist. Her brilliant mind and her wide reading gave her an immense amount of material for her poetry, so much that it would have tended to crowd out personal experience, if she had been inclined to use it, and her fine critical powers made her labor on the surface of her poetry until it shone like burnished metal.

<div style="text-align: right">Russell Blankenship. <i>American Literature</i>
(New York: Holt, 1931), p. 618</div>

She got away completely from her predecessors' doleful egoism, effeminacy, and conventional moralizings, by recording life as one knows it, not as former poets had written of it. Her flowers came from the gardens of Sevenels, or the fields of Dublin, not from the limited *hortus siccus* of the literary past. Her five senses ranged freely in her sense for sharper and more inclusive perceptions of reality. . . . Amy Lowell was the first of our poets to take full advantage of the civilizations across both the Atlantic and Pacific, and yet remain thoroughly American.

<div style="text-align: right">S. Foster Damon. <i>Amy Lowell</i> (Boston:
Houghton, 1935), p. 724</div>

I like you in your poetry. . . . Why don't you always be yourself. Why go to France or anywhere else for your inspiration. If it doesn't come out of your heart, real Amy Lowell, it is no good, however many colors it may have. I wish one saw more of your genuine strong, sound self . . . full of common sense and kindness and the restrained, almost bitter, Puritan passion. Why do you deny the bitterness in your nature, when you write poetry? Why do you take a pose? . . . When you are full of your own strong gusto of things, real old English strong gusto it is, . . . then I like you very much.

<div style="text-align: right">D. H. Lawrence. Cited in S. Foster Damon,
<i>Amy Lowell</i> (Boston: Houghton, 1935),
p. 278</div>

No poet writing today, I think, save Thomas Hardy, saw and heard with more acute perception, or saw and heard and felt so many shades and tones and shapes of things—brilliant and subtle and fugitive and firm. And joined with this quick sensitiveness to physical impressions was an intellectual honesty as sensitive—a passion for truth which never knowingly falsified the report of what was seen. And that alert and vivid sense of beauty, restless with a poet's craving for expression, yet in expression lucidly exact, has schooled us,

skeptical and reluctant scholars, to a quickened vision of strange loveliness in familiar things.

John Livingston Lowes. *Essays in Appreciation* (Boston: Houghton, 1936), p. 162

She remained a challenging and interesting figure of many and various talents, but not essentially a great writer, if one classifies only those writers as great who are able to extract out of the common and universally human themes of birth, love, loss, death, struggle, achievement, and failure, new meanings of universal import and new notes of perpetual poignancy. She was, and is, a writer well worth reading from every point of technical interest; but it was only towards the very end of her life that she began to use her technique on themes of universally human import. . . . That she had the capacity to do so is abundantly proven. She did not care to exert it often; and this was not so much her own fault as the fault of the public and the critics, who demanded only too often from her a showy brilliance of surface at all costs.

John Gould Fletcher. *Life Is My Song* (New York: Farrar and Rinehart, 1937), p. 208

The rakish cigar and the abnormal stoutness were forgotten five minutes after she had seated herself. One noticed only the marvellous neatness, the fine hands and delicate ankles, the small mobile mouth, the coolly modulated voice, the quick-appraising but not unkind eyes, the fine features and almost transparent skin. One saw a woman who was not only intelligent but—there is no other word for it—pretty.

Louis Untermeyer. *Harper's*. August, 1939, p. 266

The central figure of the poetic life of the 1920s, though not of its literature in general, was Amy Lowell. Yet not so much as a poet as a dynamo, sending impulses of energy wherever interest and excitement were needed. A good poet, an erudite and sometimes insolent critic, a rich and aggressive personality, she would have become a renowned bluestocking in any age. . . . Invalid in body, often moving with difficulty, I have seen her sitting at home like a chained eagle, lunging at what she called the pedantries of Harvard, of which her brother was president, or crushing with one claw some reviewer who lacked scholarship and a gentleman's education.

Henry Seidel Canby. *American Memoir* (Boston: Houghton, 1947), pp. 313–14

She touched a fuse wherever she went, and fire-works rose in the air; and there were no set-pieces more brilliant than hers, no Catherine-wheels or girandoles or fountains. There was no still, small voice in Amy Lowell. Her bombs exploded with a bang and came down in a shower of stars; and she

whizzed and she whirred, and she rustled and rumbled, and she glistened and sparkled and blazed and blared.

Van Wyck Brooks. *A Chilmark Miscellany*
(New York: Dutton, 1948), p. 265

Her second volume, *Sword Blades and Poppy Seed,* which appeared on schedule—September 22, 1914—brought her an instantaneous, phenomenal rise to fame. The title alone, coming at the outbreak of war in Flanders where the poppy fields flourished, was externally apropos, internally symbolizing "fighting truths" vis-à-vis "lulling dreams," as the ardent new Imagist intended when she chose it. (The title, and opening, poem is a rather obvious tale of an aged, wise peddler of words that are used as sharp-edged weapons and as drugs; he is depicted showing his wares to a rank, awestruck beginner.) However intuitive or inadvertently appropriate the title may have been, *Sword Blades and Poppy Seed* marked the beginning of Amy Lowell's career as an experimentalist and leader of the Imagist movement in American poetry. (Although still greatly interested in the French poets and vers libre, she Americanized and adapted the terms at once; vers libre, for example, became "unrhymed cadence" in Lowellese.)

The book created something of a furor with its varied freedom of rhythms and versification of all kinds, written on the theory that "the sound should be an echo to the sense." Coming as it did only two years after the acceptable but quite conventional *Dome,* the new volume seemed to proclaim, as Louis Untermeyer wrote, "that a wholly new poet, and, what was more, a new epoch had appeared. *Sword Blades and Poppy Seed* sounded some of the first notes in the controversy which raged about the New Poetry. The book heralded the era's growing dissatisfaction with traditional measures and the determination to try new verse forms, strange cadences, and unfamiliar responses to standard sentiments." . . .

Jean Gould. *Amy: The World of Amy Lowell
and the Imagist Movement* (New York:
Dodd, Mead, 1975), pp. 139–40

In the nine years between the appearance of her first book in 1912 and Miss Lowell's books of Chinese translations, *Fir-Flower Tablets,* in 1921, the poet was responsible for twelve volumes of verse and prose, as well as seventy-two essays that appeared in various periodicals and newspapers. Among these were some of the most influential literary writings of the time—essays on the appearance of an *American* art, on the *new* poetry, on *original* sources of literary inspiration in foreign cultures—as well as some of the most distinctive poetry that has come down to us from those years. In contrast to the sixty-nine short lyrics composing *A Dome of Many-Coloured Glass,* the poems of these years took many unusual forms, some of them very disturbing to the conservative-minded. Much of this work, as noted above, was prolix and casual, of little more substance than the jottings in a newspaper. But the

core of it was sound, and all of it, as published in periodicals and books, served the useful purpose of reawakening a poetic consciousness in America.

An achievement of this kind in such a short space of time would have been impossible for the groping and inhibited poet of *A Dome.* But Miss Lowell had chosen to "go to school" with the Imagists in England in 1913 and 1914 and she had returned home with a new key to her own experience and the art of expressing it. . . .

After her adoption of Imagist practices in 1913, the poetry of Amy Lowell centered in the treatment of the numinous scene or object with increasing refinement and flexibility. It was not, of course, her only interest, nor could it ever be a formula for writing poetry. Had this been true, Miss Lowell would have been reduced, like Wallace Stevens in the latter part of his career, to the writing of illustrations for a set of reasoned positions subject to the limitations of abstract thought. But the very opposite was true. As we see in her critical essays, systematic thought was uncongenial to Amy Lowell's mind and so she saw the more deeply. . . .

That the new poetry would be aggressive and forthright was soon apparent. In late 1914, Miss Lowell published *Sword Blades and Poppy Seed,* a volume that seemed to echo the belligerence then erupting in Europe. An uneven book, with many blemishes, it nonetheless contained elements of real importance for the advance of American poetry. Among these were its novel free verse and polyphonic forms, its impressionism, and its assertion of a radical social and sexual ethic. This was the first American book in the new, controversial forms. It was very widely read, and the impression it left was of a vigorous and insurgent experimentalism. . . .

One of the reasons for her success was that Miss Lowell had found a means to do justice to her impressions and, at the same time, to integrate these with reflective, ratiocinative, and more purely emotive elements. That this was possible was due to her ten years of continual experimentation with novel forms of verse, which gained her a reputation as a literary radical and filled her volumes with hundreds of pages of verbal exercises, all of which were needed to bring her designs to completion. But this does not mean that Miss Lowell ever devised one all-purpose formula for her work. It was not a question of a single method she consciously developed but rather of the possibility of composing in polyphonic sequence.

<div style="text-align:right">

Glenn Richard Ruihley. *The Thorn of a Rose: Amy Lowell Reconsidered* (Hamden, Connecticut: Archon, 1978), pp. 79, 109, 113, 152–53

</div>

At her death in 1925, Amy Lowell was unquestionably one of the best known and most controversial figures in American poetry. To many, it must have seemed that if the preceding decade belonged to anybody, it belonged to her. Her books sold well and had been widely reviewed. Her poems, essays, and reviews had appeared in numerous journals, and as a popular reader she

probably stirred more interest in poetry than anyone else of her time. On March 2, 1925, *Time* magazine featured her on its cover and called her a "renowned" critic and poet. In a sympathetic obituary-editorial, *The New York Times* called her work "stimulating and vivid." When Lowell died, Ferris Greenslet, her editor at Houghton Mifflin, felt "as if a force of nature had been turned off." Most of her contemporaries felt that her campaign for the New Poetry had made its formative years a far more vital period than they would otherwise have been. "No poet living in America," Louis Untermeyer wrote in 1919, "has been more fought for, fought against, and generally fought about than Amy Lowell."

Today, no one thinks of 1914–25 as the age of Lowell. She has almost— not entirely of course—disappeared from discussions of the era she largely dominated and helped to shape. "Patterns" and perhaps half a dozen other of her poems occasionally appear in text books and anthologies, but she is not included, for instance, in the influential *Norton Anthology of Modern Poetry*. . . .

If Lowell was not as great a poet as she and some of her first admirers thought she was, it does not mean that she was no poet at all. Nor does it follow that she had nothing to say because she often concentrated on the sensory qualities of objects and scenes. She surely wrote more than the seven or eight significant poems usually allotted her. . . .

There is a great deal in Lowell's poetry worth exploring and discussing. She became an accomplished storyteller, and she knew enough about human nature to create such complex characters as those in "The Doll" and "Written on the Reverse." In telling of a fox's infatuation with the moon, or Perry's journey to Japan, she could make her images and symbols both subtle and resonant. In her best lyrics, she paid the same attention to the impact of words, and drew upon their symbolic and connotative possibilities. She was as adept an artist with the figurative colors of her language as she was a word-painter. But even in those poems in which there is no more than what meets the eye, there is much to see; and we have just begun to get to the core of the best of the others. With her amazing diversity, her different experiments, her obtuseness at one moment and her clearheadedness at another, and her many failures and successes, she is not an easy poet to sum up— which makes many of the still prevailing assumptions about her all the more suspect. This much seems sure: she contributed not a little to the age of Yeats, Pound, and Eliot; and it would have been a very different and less exciting time without her.

<div style="text-align: right">

Richard Benvenuto. *Amy Lowell* (Boston: Twayne, 1985), pp. 140, 142–44

</div>

LOY, MINA (GREAT BRITAIN–UNITED STATES) 1882–1966

Mina Loy appears to be the only poet in this bag [*The Others Anthology*] who is really preoccupied with that curious object THE SOUL. It is painful to notice that since the last "Others" she appears to have lost grip. Nor is she less guilty in the matter of "that little afterthought" than her confrères. Her effort is however very much more distinguished.

The same is true of Marianne Moore, whose really very rich pyramids are, I now think, a quite sufficient justification, though bits of the plaster are sadly trivial.

<div align="right">John Rodker. Little Review. 3, 1920, p. 55</div>

For years *Lyric America* and its companion volume, *Our Singing Strength,* kept alive the name of Mina Loy. Both books included one of her "Love Songs," which Denise Levertov, in assessing her own "knowledge" of this "long familiar, legendary" name, aptly enough calls "Pig Cupid":

> Spawn of fantasies
> Sifting the appraisable
> Pig Cupid his rosy snout
>
> Rooting erotic garbage
> "Once upon a time"
> Pulls a weed white star-topped
> Among wild oats sown in mucous membrane
> I would an eye in a Bengal light
> Eternity in a sky-rocket
> Constellations in an ocean
> Whose rivers run no fresher
> Than a trickle of saliva
>
> These are suspect places
>
> I must live in my lantern
> Trimming subliminal flicker
> Virginal to the bellows
> Of experience
> Colored glass.

Kreymborg included two other poems from the same group which had originally appeared in *Others,* and another piece called "Human Cylinders." That Robert McAlmon had published a book of Mina Loy's poems in 1923, as one of the "Contact Editions," almost no one seemed to recall. *Lunar Baedeker* (or "Baedecker," as McAlmon's printer had spelled it) had appeared in an

edition of about three hundred copies, a fragile and not very impressive paperback. A few more poems appeared in McAlmon's *Contact Collection of Contemporary Writers* in 1925. But after that there was nothing, except the four poems Kreymborg included in his anthology and a sample (including "Pig Cupid") in Ezra Pound's cantankerous scrapbook, *Profile.*

That is, there was nothing until 1944, when Kenneth Rexroth published a brief tribute in *Circle.* Then, in 1946, a new poem appeared in *Accent;* and in 1947, three more followed. Another poem was published in *Partisan Review* in 1952. Finally, Jonathan Williams, excited by Rexroth's tribute, tracked down Miss Loy in Colorado; and in 1958 he published *Lunar Baedeker & Time-Tables* as Jargon 23. Williams has recently in *The Nation* written an article in which he reveals his disappointment at the silence with which the book was greeted, for even among the avant-garde who might have been expected to profess excitement at this event, not a bit of notice seems to have been taken of it. William Carlos Williams, Kenneth Rexroth, and Denise Levertov contributed "introductions"; and Henry Miller, Edward Dahlberg, Walter Lowenfels, Alfred Kreymborg, and Louis Zukofsky added their approval and praise on the back cover. . . . Whatever their "intrinsic aesthetic value" or lack of it, whatever "use" they may have to the poets of "a generation or two" as a "foundation," Mina Loy's poems reveal an integrity of impulse that is far more persuasive than the impulse which seems to direct "the only rebellion around."

It is too bad that her "discoverers" and "re-discoverers" have not done her the honor of presenting her work in the round, rather than by a selection which hardly does justice to her early and later accomplishments. The ferment that has continued to vitalize her work, or such examples of it as have been published during the past fifteen years, is less apparent in the section of *Lunar Baedeker & Time-Tables* devoted to "Later Poems" than it might be. William Carlos Williams says in his tribute that the early poems are "by far the most striking, the most brilliant of the author's compositions." Perhaps so. But one ought to have the strange long poem, "Hot Cross Bum," which appeared in *New Directions 12,* in 1950. . . . Ugly, clumsy, brutal as it may be, the saving grace of such experiment is in its unpretentious certitude. The avant-garde could learn something from it.

<div style="text-align: right">

Samuel French Morse. *Wisconsin Studies in Contemporary Literature.* 2:2, Spring–Summer, 1961, pp. 12–13, 18–19

</div>

Mina Loy was a contemporary of Williams and Pound, and although she was born in England, her poems are an important part of the American free verse movement. She published her first poems in Alfred Stieglitz's *Camera Work,* and later appeared in *Little Review, Others, The Dial,* and other prominent American magazines. Like the work of most first-rate writers, her poems were controversial, but she was held in high regard by her contemporaries. In 1921, Pound writes to Marianne Moore: "Also, entre nooz: is there anyone

in America except you, Bill and Mina Loy who can write anything of interest in verse?" *Lunar Baedecker* [sic], containing 31 poems, was published in 1923, and Jonathan Williams, in 1958, published *Lunar Baedeker and Time-Tables,* unfortunately, on his small and little-known press. This book went out of print almost immediately, and today Mina Loy's poems are virtually unobtainable. One of the best poets of the period, she is now scarcely read, and her name appears only in the midst of semischolarly lists compiled by men more interested in history than in distinguished poets. . . .

Such directness may be disconcerting to some, but it is the source of her power. At a time when "cerebral" was a pejorative term, Mina Loy was dealing with ideas. Pound's genius lay in other directions; his importance is his diversity: his mastery of various styles, his influence on the little magazines, and the fragments of a curious sort of scholarship. It may be that Williams, in a few poems only, surpasses Mina Loy stylistically, because of his extraordinary finish and precision, but the body of his work does not compare with her poems; his subjects are frequently trivial and hers are not. And where Marianne Moore is clever and superficial, Mina Loy is profound; where Miss Moore is amusing, Miss Loy is bitterly satirical. The poets of this period tended toward a narrowness which was concerned with the image, "the thing itself," and with the technical aspects of free verse. This sort of brilliant specialization is always beneficial for the sophistication of poetic style, but it may prevent the writer from dealing with broader and more permanent areas of human experience. Thus Williams, because of his skepticism, his desire for communication, and his personal limitations, narrowly restricts his subject in his best poems and presents the isolated object with great clarity. While Pound, who lacks nothing in depth of subject, breaks his material into intractable fragments, resulting in an incoherence of which Pound is most aware. And in the poems of H.D., who cultivates effects of rhythm and sound to a high degree, subject gives way to a monotonous and private ecstasy.

Mina Loy's intelligence enables her to deal with matters of more general concern than those of her contemporaries, while her sharp perceptions and style always render the experience unique. Frequently with great brevity, she handles many of the sentimental stereotypes which had been too easily accepted for some time; and this refusal to accept the merely conventional involves a rigorous examination of states of mind and feeling, and gives to her poems a very personal quality. . . .

The infusoria (lines 12–18) are marvelous. A certain species of these microscopic organisms is shaped something like a chandelier and, seen through a microscope, appears to be tremulously glowing with light. The image describes both the neon lights of Broadway ("Stellectric signs") and the stars of this "Lunar Baedeker"; it is a controlled vision of decay in which macrocosm and microcosm, the telescopic and the microscopic, are united. It is this compression by way of imagery which is peculiar to Mina Loy. It is her own special brilliance.

Mina Loy's versification is unsophisticated and sometimes awkward. Her line resembles neither the quick, nervous line of Williams and H. D., nor the smooth, longer line of Pound, sometimes Stevens, and John Gould Fletcher. Her most serious rhythmic deficiency is a lack of unity from beginning to end of many of her poems. In "Lunar Baedecker," for example, she stops and starts, moving from one subject to the next, the individual stanzas nearly becoming separable sections in themselves. Her rhythms vary in speed, but the movement of most of her verse is slow; if it is uncomplicated, it is nevertheless unpretentious. What is most impressive about her verse, finally, is the incredible energy of her language—and her intelligence.

Kenneth Fields. *Southern Review.* 3, 1967,
pp. 597–99, 602

The poems of the female self are an important preparation for Mina Loy's later work. They construct the metaphysics that shapes all her poetry and ground the spiritual autobiography in uniquely female experience. Sometimes inferior in line, word, and image to later poems, they introduce the technical and structural experiment that is one of Loy's major contributions to American modernism. And they are a distinctive statement in the feminist debate, filling in their metaphysics with a tough-eyed analysis of woman's sexual-psychological and, to a lesser extent, socioeconomic oppression. Few, if any, of the other female poets of the era speak so honestly about the quotidian life of woman. Compared to confessional poetry or today's feminist poetry, Mina Loy's poems, with the exception of "Parturition" and the *Love Songs,* may not seem daring. But Mina Loy felt the conflict between social respectability and the poetic honesty crucial to her own well-being. Writing to Van Vechten (ca. summer, 1915) of her need to use sexuality in her work, she says, "You know I am quite glad of all I write but occasionally get scared of my family—but I am going to just risk everything—and not bother." Similarly, in the spring of 1916 rumor reached her that her meandering husband, halted temporarily in New York, was suggesting that her work was "offensive" and she fit to associate only with "outcasts." She asks Van Vechten, "Now my dear I've got a beautiful daughter—I cant *outcast*—what shall I do[?] reassure me—I have tried my things on *ultra respectable* elderly ladies (not stupid ones of course) and they survive magnificently—will America be so *very* different?" The limited American public for the new poetry seems to have been less sympathetic than the wise ladies of the old world, but whether or not concern for respectability curtailed Mina Loy's analysis of female selfhood is a moot question. I suspect new interests, not fear of the public's disapproval, lessened the number of her poems on women. Nevertheless, her comments reflect the risks she felt she took as a woman and a poet in treating the female experience. . . .

The notoriety of Mina Loy's poetry was due only in part to its honest analysis of female experience. Her poems were also firsthand assimilations of current structural and technical experiments by European painters and

writers, especially the Futurists. As such they defied American expectations of how a poem should mean and look. Alfred Kreymborg, poet and enthusiastic supporter of modern poets, explains the reaction to Mina Loy's poems in *Others:* "Detractors shuddered at Mina Loy's subject-matter and derided her elimination of punctuation marks and the audacious spacing of her lines. These technical factors not only crop up in a later poet, E. E. Cummings, to whose originality later critics have attributed them, but were learned by Mina during a lengthy sojourn in Paris and Florence, where she came under the influence of Guillaume Apollinaire and F. T. Marinetti. Mina had simply transferred futuristic theories to America, and in her subject-matter had gone about expressing herself freely—another continental influence." Even an eager modern like Kreymborg sometimes found Mina Loy difficult. He recalls that "no manuscripts required more readings than those of Mina Loy and Marianne Moore."

> Virginia M. Kouidis. *Mina Loy: American Modernist Poet* (Baton Rouge: Louisiana State University Press, 1980), pp. 47–49

With the whole record before us, we must get around to deciding whether that long neglect might have been deserved: whether her true place was where the conventional histories have placed her, as an exceedingly decorative figure in the margin. Certain of her lines and images will never, I think, be forgotten, but the question is whether her oeuvre as a whole is not somewhat less than its best parts would suggest.

I am left in an awkward spot: I welcomed the chance to review this book, feeling that at last it might be possible to say either: "Look what a magnificent poet you clods have overlooked" or the opposite—and I cannot. In the attempt to break the dead-lock I have tried all sorts of expedients: subjected the text, for instance, to a sort of *sortes Virgilianae,* opening the book at random. The results of that experiment are too inconclusive to describe here.

And I have left months to pass and then gone back to the text, only to find that the current impression varies inversely with the previous one: if I found something particularly noteworthy before, I can be certain that nothing but sprawling angularity and covert spite meets me this time.

So for her whole collected work: you can count on nothing at all.

> Reno Odlin. *Antigonish Review.* 59, 1984, p. 62

In "O Hell" Mina Loy rejects the "excrements" of the past with a stylish defiance. The careful condensation of her language qualifies what might appear to us a childish iconoclasm. To us, perhaps, but hardly to the reader of the 1920s, for even the steadiest among that generation seem to have felt unbearably hampered by the sheer weight of the Victorian inheritance and showed an almost hysterical impatience to throw it out into the street.

Yet it is not as "modern" a poem as it looks. I would suggest, first, that the title is not a flapper's expletive, but a memory of (or reference to) the Blakean hell that is the home of energy as opposed to the establishment church of heaven. After all, in another poem the poet sees herself as "ostracized . . . with God." And there are other echoes from *The Marriage of Heaven and Hell:* in line 6, "Our person is a covered entrance to infinity," and in the last sentence the lineaments of desire become divine when she evokes "Goddesses and Young Gods" (provocatively placing the female before the male!).

No writer passively inherits "the" tradition; you make your own choices, your own incongruous combinations of literary parents. If in this poem Loy takes Blake as iconoclastic sponsor for her iconoclasm, she elsewhere claims relationship to more recent poets like Laforgue. It is the present she emphasizes, aligning herself deliberately and almost programmatically with the avant-garde by including in *Lunar Baedecker* a group of poems praising Joyce, Brancusi, and Wyndham Lewis.

Her contemporaries often compared her with Marianne Moore—naturally enough, since they were both clever women who had started publishing at about the same time. Each had developed her own inimitable kind of free verse; neither went "in fear of abstractions"; both tended toward the epigrammatic. Yet, for all the resemblances, what a difference!

The poem "Lunar Baedeker," a witty guide to the moon as literary symbol, consists of a series of details that are simultaneously image and epigram. It is an effect special to Loy, to be perfected in her poem of World War II, "Omen of Victory." The rather jerky emphases of the short verses suit the overall tone of self-conscious cleverness. Frequency of adjectives, alliteration, internal rhyme and half-rhyme, a dandyish fondness for the obscure epithet—all contribute to a tone of deliberate artificiality. The clotted phrases do not seek to look unstudied, and could never occur in the midst of Moore's equally elaborate discourse with *its* air of conversational improvisation.

The greatest difference is to be found in her attitude toward the human body. For H.D., it was sublimated into emblems like the sea rose; for Moore, it did not exist; for Loy, it was a necessary part of her subject matter. Not that she thought of sexuality as just a matter of mutual fondlings in the sunshine; she and "Johannes" in "Love Songs" are far from the divine adolescents of "O Hell." . . .

Loy writes as a woman, and as a woman standing up for herself. She does not do so as dutiful follower of a political program, but as expression of a quite unforced indignation at the comedy of male complacency, and not incidentally as exploration of new poetic material, of which the potential excites her as a writer. The battle of the sexes in "Love Songs" is between "shuttle-cock and battle-door," a phrase compact with contemporary daring and undated wit. In "Parturition," which would count among her best work if it were cut by half, she writes what I take to be the first poem ever about experiencing labor pains and childbirth. And in "Sketch of a Man on a Plat-

form" she satirizes with admirable vigor the man who is busy, *too* busy, at being a man.

For all her aggressive modernism and feminism, she identifies with a traditional genre more easily than most of her great contemporaries—that of satire. Her satire is never so absolute as in "Der Blinde Junge," which I readily follow Yvor Winters and Kenneth Fields in considering her most moving achievement.

> Thom Gunn. In Vereen Bell and Laurence
> Lerner, eds. *On Modern Poetry* (Nashville:
> Vanderbilt University Press, 1988),
> pp. 46–49

The few critical notices of Mina Loy's work focus on her poems of the 1910s and 1920s. Eliot and Pound both especially liked "Effectual Marriage," Winters quoted approvingly from "Lunar Baedeker" and singled out "Apology of Genius" and "Der Blinde Junge" for highest praise; in a recent essay Thom Gunn discusses the last in some detail. "Parturition" is another among Loy's most remarkable early poems. Her narrative sequence of erotic lyrics, *Love Songs to Joannes,* enjoyed a *succès de scandale* when parts of it appeared in *Others,* and it was probably responsible for New York City customs officials' seizure of the Contact Press *Lunar Baedecker* of 1923 as pornography. A widely circulated early critical remark (which proves to have originated with the author) compares these poems with Sappho's. They do allude to her, and perhaps their combination of melic intensity, incandescent emotion, and ironic honesty about love and sex merits the comparison, but finally Sappho's ironies are much more structural than verbal, whereas Loy's are deeply embedded in her language, which makes the experience of reading her poetry quite different. Sappho's ironies appear when we reflect on what she is telling us, and what she isn't; she may trigger our reflections with a pointedly chosen word, but she stages her poems' ironies in their actions, their narration. Loy's ironies sound in her verbal choices, word by word; they are part of her diction. As a poetic sequence interweaving impassioned lyric apostrophe, implicit erotic narrative, and an ironic philosophy of love, *Love Songs to Joannes* calls more to mind Propertius, whom its fifth section probably echoes, perhaps via Pound's *Homage,* Ovid (the ironic philosopher of the *Ars Amatoria* more than the rhetorical acrobat of the *Amores*), and in some ways the *Sonnets* of Shakespeare.

Loy's other sequential poem, *Anglo-Mongrels and the Rose,* shares with *Mauberley* and *The Waste Land* the attempt of modernist poetry in English to use the lyric sequence as a formal means to recapture ironic portraiture of social life from the novel. Later participants in the transformations of this tradition include *The Bridge, Paterson,* Bunting's "Sonatas" and Zukofsky's *A*; its formal ancestry reaches back through Villon and *La Vita Nuova* to the sequences of Latin erotic elegy and Callimachean Alexandria. As in Pound's *Mauberley,* the central narrative thrust of *Anglo-Mongrels and the Rose* is

toward pseudo-autobiographic Bildungsroman. In Loy's poem this element is more expansively developed, and if this costs her something of *Mauberley's* extreme ironic concision and crystalline form, her work gains in psychological scope and nuance and in social and cultural range—less art, maybe, but perhaps more humanity.

As Loy's poetry becomes more widely read and discussed these earlier works' evident merits should win her a prominent place in the modernist canon. But there is a danger that their more obvious radical dazzle and high modernist period glamour will cast Loy's later poems into undeserved obscurity.

<div align="right">

Jim Power. *Chicago Review.* 37, 1990,
pp. 12–13

</div>

Although a trickle of poems appeared in little magazines after Loy settled in New York in 1936, apart from Kenneth Rexroth and, later, Jonathan Williams (who published *Lunar Baedeker & Time-Tables* in 1958), few saw fit to include her in the modernist pantheon, especially as constructed within academia. The reasons for this neglect are complex. Loy's writing developed in and reflected a cosmopolitan artistic context that was in tension with her English origins and lay somewhat outside the frame of reference of the New Criticism, which would have looked askance at her subject matter had its spokesmen looked at all. Until very recently, Loy's idiosyncratic crossings of "Paris" and "Italy," metaphysics and feminism, have made numerous readers uneasy. But with the advent of feminist criticism, the reshaping of our ideas about what constitutes modernism, and the 1980 publication of Virginia Kouidis's *Mina Loy: American Modernist Poet* followed two years later by *The Last Lunar Baedeker,* the tide is turning as far as her reputation is concerned. Hugh Kenner has praised Loy's "agile, hard, unslushy wit" in Poundian terms, Jerome Rothenberg has claimed that the "counterpoetics" of writers such as Loy "presents . . . a fundamentally new view of the relationship between consciousness, language & poetic structure," and Jed Rasula has stated that "reading Mina Loy is one of the most direct encounters with modernism . . . like defusing an old but still live time bomb." Indeed, we are finally in a position to see that hers is "a voice that was not only ahead if its own time but one which is still out in front," and that we, as readers, must go into training to catch up with her.

<div align="right">

Carolyn Burke. In Bonnie Kime Scott, ed.
The Gender of Modernism (Bloomington:
Indiana University Press, 1990), p. 236

</div>

LOY, ROSETTA (ITALY) 1931–

Rosetta Loy's new novel, her fourth in just under fifteen years and winner of both the Viareggio and Campiello prizes, is cast in the form of a family saga of local life in nineteenth-century Italy. As such, it includes the usual topics of family-centered narrative, all portrayed from the highly individual perspective of nineteenth-century village life: war, disease, the politics of conquest and liberation, the Church, marriage, love, birth, and death. Loy's novel breaks with the tradition of totalizing familial stories in its persistent fragmentation of both narrative perspective and narrative presentation. This genuine strength of *Le strade de polvere,* the freshness of its continually shifting point of view and of its brilliantly suggestive descriptive passages, thus stands at one and the same time as its literary limitation in the book's overall totality, despite its repeated interest in familial organization and genealogy.

One of the principal reasons why this odd combination of nineteenth-century framework, reminiscent of Verga, and twentieth-century fragmentation, reminiscent of Vittorini or even of Hemingway, succeeds so convincingly is to be found in the book's use of language. Occasionally in the narrative's dialogue, which evinces bits of local dialect and of French, and still more consistently in the text's local descriptions, *Le strade di polvere* manages to be at once precise and subtle, its subjects finely drawn yet uncannily evocative. An early example of this blend of effects occurs in the first chapter's description of "il Giai" ("il giallo") as he sits at the edge of a well playing his violin while gazing at the stars reflected in the water below. The perspectives of the seemingly neutral narrator, the frightened wife, and, from a distance, the cousin named "il Mandrognin" all play their parts in composing the scene, which includes not only the timeless elements of myth but also the leitmotiv of the violin, the spectral apparition of the family founder, "il Gran Masten," and the fundamental points of reference for the family as a whole, embodied in the concluding images of the land and the house. . . .

In brief, *Le strade di polvere* is a fine novel, both a pleasure to read and a significant extension of the literary tradition of which it is a part. Its story is molded by the concerns of familial genealogy, but its final subject, as is the case in so much contemporary narrative, is the ever-present if also thoroughly elusive motion of time itself.

<div align="right">Gregory L. Lucente. World Literature
Today. 63, 1989, p. 81</div>

The continuous search for the past predominates in *L'estate di Letuque* (Le Touquet summer) and is also accompanied by stylistic processes and techniques already encountered in other works, but further developed here. In fact, the work constitutes an indispensable stage and in a certain sense is parallel to *Le strade di polvere* (Dust roads). Nonetheless, while in the latter work the past is mixed in with the present in a third person narrative, in

L'estate the temporal snarl is entirely manipulated by a narrating "I." It is thus up to us to explore the continuous alternation of the various temporal levels to arrive at the underlying reasons for such an excavation. . . . The various "times" contained in the novel have the function of transmitting feelings and impressions that would be difficult to perceive in a linear narrative. The reader is present at the retrospective reconstruction of an episode in the life of the narrative "I" that has its roots not only in the character's own past, but also in that of the preceding generations. . . .

The epiphanic moment experienced by the protagonist is precisely the awareness of being able to find herself as she was, and thus to reach the true essence of being that is found in the moment in which past, present, and nontime converge. The book's title is emblematic, in a sense. In the summer of 1937 on the beach at Le Touquet the protagonist's father meets his future wife and love is born. That same summer, the protagonist's grandmother, portrayed with her parasol . . . on the beach at Le Touquet, dies of poisoning. The Le Touquet summer is this the symbol of a time past, lost and then rediscovered in another summer many years later, in which the protagonist experiences the end of love. In the new sorrow that the protagonist-narrator feels the old sorrow experienced by her father revives and with it there reemerges, as well, the old happiness . . . and the past thus lives again in the present.

<div style="text-align: right">

Flavia Brizio. *Romance Languages Annual.*
2, 1990, pp. 160, 165

</div>

The field of feminist literature could be broadened considerably if works of nonmilitant contemporary women writers were scrutinized from a feminist perspective. New horizons would thus be opened to the discourse on the female condition in Italian literature.

In the works of nonmilitant women writers like Loy, for example, there exists in fact a hidden fabric that, if examined through a certain "gender-reading," protests against the condition of woman. This fabric is, however "encoded" and reveals itself only to the reader sensitized to such themes. This is a reader who must take all factors—political, religious, social, and economic, as well as sexual—into account as they determine the differences, at both conscious and unconscious levels, between man and woman in patriarchal society. In short, a "politicized" reader, one capable of bringing together details, differences, and indications more than general categories.

On first reading, Rosetta Loy's *La bicicletta* (1974; The bicycle) could seem like a portrait of a certain social group in a given historical period, as seen through the life of one family. The vicissitudes are encountered in the adolescence and then the youth of the two sons and the two daughters and depict a Catholic-bourgeois mentality that imprisons both the males and the females and conditions them irreversibly. Nonetheless, since the women in the novel seem to pay a much higher price for being channeled into the stable order of a patriarchal system supported by rules of behavior based on class

and sex discrimination, a generic reading of the story of individual characters would be inadequate. In fact, as Clara Saracene maintains, recognizing a common denominator between the woman of the petit or middle bourgeoisie and the proletarian woman, it is really "on the level of the middle class that the new models of behavior, images, and norms are worked out and then diffused through the group." The behavioral model symbolized by this family can be understood simply by comparing the upbringing of the males with that of the females. Through this comparison it will be seen that women are victimized in a sexist and repressive society like that of postwar Italy. . . .

In many of Loy's novels the patriarchal system and women are analyzed in different historic moments, and the recurrence of this fundamental theme provides an image of the female condition that goes beyond the contingent situations of the protagonists to be affirmed as a parameter of a universal condition. Rosetta Loy thus must be added to the field of feminist literature, since in her narrative she has brought together behaviors and ideological schemas that characterize our society.

<div align="right">Flavia Brizio. Romance Languages Annual.
2, 1990, pp. 194–95, 199</div>

Winner of Italy's Viareggio and Campiello prizes, Loy's lush and seductive novel [*The Dust Roads of Monferrato*] captures the internal dramas of a nineteenth-century Piedmontese family and the romantic and mystical intrigues of a society innocent of Freud and industrial-age expediencies. Here relationships grow slowly but unselfconsciously. Maria, beloved by two brothers, is widowed by one and wed by the other; her unmarried sister, meanwhile, remains unswerving in her devotion to Maria's first husband and communes with his ghost. The dynamic continues into the next generation when two of Maria's sons conduct affairs with the same woman. Others among the dreamily evoked figures include a neighbor who uses her granddaughter's powers of attraction to gain young lovers for herself, a bevy of impoverished but worldly sisters who offer their beauty as dowries; an ingenue born of an illicit, much-regretted tryst. Unlike other grand Italian sagas such as *The Leopard*, this novel presents subjects unbowed by the demands of historical change; rather, their lives constitute a history in and of themselves.

<div align="right">Sybil Steinberg. Publishers Weekly.
February 8, 1991, p. 47</div>

In 1988, Rosetta Loy's *Le strade di polvere* (Dust roads) won two of the most coveted Italian literary awards: the Supercampiello Prize and the Viareggio Prize. It does not often happen on the Italian literary scene that an author receives two prizes for the same book. The exceptional nature of the case was confirmed by the judges who defined the novel as one of those works that you cannot put down until it is finished. That the book is "capitivating" and pleased not only the critics but also the general audience was confirmed by its great success: six editions and a hundred thousand copies sold. None-

theless, to discover the mechanism that makes *Le strade* so unusual, the text has to be subjected to close analysis.

Le strade presents itself as a historic-realistic novel insofar as it narrates the life of a family of a certain social milieu in a given historic period. The first reason why *Le strade* appears so familiar, captivating, and hence compelling to the reader should be sought in the material narrated. . . . Increase in wealth, the continuation of the family, and the struggle against the adversities of existence are the preoccupations of [the] patriarchs. Chance plagues them in the form of unexpected illnesses, and accidents; floods and wars take their toll on their work. Fate strikes without warning and, at the end of the book as in daily life, it leaves human beings defenseless, afflicted although still fighting.

Since the novel deals with several generations and the historic events of an era, time takes on a fundamental importance. In fact, generational leaps produce divergence of opinions, habits, and mentalities in the protagonists. . . . Anyone who reads it cannot fail to notice that between . . . the beginning and . . . the end of the book, almost an entire century has intervened and what was not acceptable at the end of the eighteenth century . . . has become so by the end of the nineteenth century, when the book concludes. Time goes by and leaves its mark on the characters. They change and, if they are partially responsible for their actions, they are partially victims of fate. Their loves, too . . . come to an end for various reasons: separations, deaths, loss of interest. Not even passion escapes the eternally ephemeral nature of everything. . . .

If *Le strade* for Loy is a metaphor for human life, . . . we have to conclude that hers is a pessimistic view of the world. The metaphoric discourse contained in the novel brings out two different ways of conceiving the world that subsist in constant tension: time as positive because it is the bearer of possibility, growth, and novelty that allows man to hope and thus struggle to overcome the obstacles of the moment, and time as negative as a course toward destruction and death. Such that, despite the characters' effort to "build" something, be it happiness or wealth, every effort fails miserably in the face of inexorable forces like Nature (what is born is destined to die) and Time (death), which acquire equivalent meaning in the novel. For Loy, precisely because of its brevity, human life acquires a fascination and a heroic dimension, and the roads, even if they are of dust, in their transitoriness become a symbol of the human experience of living.

Flavia Brizio. *Quaderni d'italianistica*. 13,
1992, pp. 71, 80–81

LUFT, LYA (BRAZIL) 1940–

The Island of the Dead (whose title in Portuguese means literally "The Closed Room") is what Luft calls one of her studies of "closed family relationships"; it is an analysis of family members' emotional struggles with self-disclosure in the face of a child's death. In this novel no omniscient narrator mediates between the characters and the reader to inform us of what has really happened or to allow us to escape the claustrophobic confinement of the characters' thought and speech. The action, taking place during a wake for an eighteen-year-old boy named Camilo who has taken his own life, consists almost entirely of the thoughts of the family members: the boy's mother, Renata, who has given up a career as a concert pianist for marriage and motherhood; his father, Martin; his maiden aunt, Clara; his foster grandmother (whom they call "Mother"); and his twin sister, Carolina. The point of view shifts from one mind to another, back and forth, as the characters, through their separate memories, together reconstruct the boy's past. Even the dead boy takes part, in sections headed by the phrase, "If he could speak the dead boy would say. . . ."

Early in the novel Renata reveals her fascination with a reproduction of Böcklin's *Island of the Dead,* which as a child she had on the wall over her piano. Now, as she gazes at the casket in the middle of the room, the casket holding her son, she thinks of the painting and wonders who that white-robed figure might be who stands in the prow of a boat taking a casket across still waters to the Island of the Dead. The painting becomes the source of a metaphorical elaboration on the nature of death, evoked by Renata's questions, "Where is Camilo?" and "What is . . . Death?"

As each of the characters explores the past, always with the question of how Camilo came to kill himself, the reader becomes aware of another figure in the family's history. It is Mother's illegitimate daughter, Martin's cousin, who because of an accident that paralyzed her long ago has rotted in "the closed room" for thirty years as a huge mass of flesh, unable to apeak, attended by Mother.

This creature, repulsive yet fascinating to every member of the family, is Ella, the only character in the novel whose point of view is not represented. Her name carries a strangeness to the Brazilian reader, who hears the word *Ella* as *ela,* or "she," but it loses the ambiguity for the American reader, for whom "Ella" is a first name. "Ella," says Martin. "Who would have chosen for the fatherless girl a name so ambiguous, so prophetic, of half humanity and half absence?" And Ella the character is both present and absent, present as a particular human being whose enormous body no longer functions properly and absent as the person her family once knew: she no longer speaks or even appears to be conscious.

Ella's name is ambiguous in another sense, in that Luft's identification of the character Ella with the personal pronoun *ela* allows the identification,

central to the novel's theme, of Ella/*Ela* with Death, personified as a woman. Because the gender of the noun *morte* ("death") is feminine in Portuguese, Luft refers to death with the pronoun *ela* from the beginning of the novel, naturally. But it is not natural, however, to use the pronoun "she" to signify "death" in English. As translators we had to decide whether to hide the personification of death early in the novel by using the word "it" or to make obvious the personification to the American reader for whom the word "she" would be out of place. We attempted a compromise, avoiding the use of the pronoun when possible early and then using the pronoun "she" later when the personification becomes more evident. We could find no way in English to conflate Ella's name with the personal pronoun "she," and therefore we lose the hints given in the Brazilian original that "Death" is *Ela*/Ella.

> Carmen Chaves McClendon and Betty Jean
> Craige. Translators' Introduction to Lya
> Luft. *The Isle of the Dead* (Athens:
> University of Georgia Press, 1986), pp. x–xi

She taught literary theory. Like most other Brazilian theoreticians, she was trained in the French school of literary thought. Lacan, Foucault, Derrida, and Deleuze were her masters. She read the classics in Brazilian literature and was fascinated by great works in world literature. As a translator she made many works in the German language accessible to Brazilians. She struggled with the ethereal presence of the critic who permeates the texts, albeit surreptitiously. She pondered the relationship among author/text/reader. She came face to face with death and became a prisoner of her own body for longer than one year. Recovering from the nearly fatal accident, she faced her ghosts and began writing fiction. In a recent interview, Luft affirmed that she only has one book in her and that she will continue to write it until she is satisfied with the result. The story that she is struggling to tell deals with existential questions that she has had since she was a child. Why do we die? Why do we love? Why do we alienate ourselves? Why is the happiest of persons also a lonely person?

Lya Luft's five novels to date describe an inner turmoil from the point of view of a female. The narrative is presented in a somewhat claustrophobic structure framed by an overwhelming desire to understand death. Critics have found in her texts the feminist/female voice; they have called her struggle a journey toward feminine self-identity; they have characterized her narrative as "mythical;" they have labeled her works as "gothic" and "morbid." . . .

How does a professor of literature, who is a talented writer, think through a particularly confusing theoretical point? She writes a novel. She creates the artifice, the "other" of the "other." She guides her reader to the observation of language turning back upon itself as if reflected in a linguistic mirror where meaning unfolds as images unfold. Through such "reflections of reflections of reflections" *(Reunião de Família),* Luft creates language through its own

image. Her narrative thus becomes an answer to current theoretical thought. Rather than framing her writing in theory, Luft seems to enter into a dialogue with literary theory. . . .

In *O Quarto Fechado,* death is at the center of the narrative and it provides its limits. Presented at many different levels of reality and symbol, death becomes, in itself, a mirror image which appears as a succession of duplicated images. . . .

Throughout the narrative, Renata (language), her children (the double), and the reflections of others enact their roles. Luft is able to answer Foucault's essay by having language speak of itself while allowing literature to create itself. To do so, Luft takes advantage of the natural ambiguity of Portuguese gender forms. The result is a combination of sounds and metaphors that reflect and reverberate. Renata's story, which includes all stories, is created by a combination of cyclical patterns which are reborn as in a play of mirrors. The images are limitless to infinity.

How does a talented writer who is trained as a theoretician think through a puzzling theoretical point? She writes a novel. She allows her narrative to engage in dialogue with the theoretical narrative in such a way that the resulting product is a new language, a mirror image, a twin. In Foucault's words, "it is as if two twin and complementary languages were born at once from the same central source: one existing entirely in its naiveté, the other within parody; one existing solely for the reader's eyes, the other moving from the reader's simple-minded fascination to the easy tricks of the writer."

Carmen Chaves McClendon. *Chasquí.* 17:2,
1988, pp. 23–24, 26

As parceiras emerges as the chronicle of a woman discovering herself. Throughout the story, the author, the protagonist, Anelise and the reader witness the coming of age of a woman in contemporary society. Great emphasis is given to the character's psychological formation, her selective memory processes, the people who influence her decision making and her ultimate need to act or choose for herself instead of relying on the decisions of others. . . .

Following in the footsteps of other contemporary Latin American women writers, Luft draws on the rich heritage of feminine culture for the multilevel structure of her novel. Its elements are intricately woven in order to create a panoramic view of a minute universe, a feminine microcosm. The use of common literary tools such as development novels, first-person narrative and gothic undertones are employed in a new and innovative way, especially with regard to women's fiction. These tools illustrate the author/narrator/reader relationship that is an integral part of feminist literary analysis. . . .

On the surface, the novel's plot is not complicated. The protagonist, Anelise, returns to her childhood summer home to decide whether to continue her marriage. Anelise's journey to her chronological and psychological past

is constructed with symbolic metaphors. The journey resembles a traditional quest for self-realization. . . .

Anelise is a protagonist who sets out to find herself. Through a series of inversions, she discovers that her identity is inextricably linked with the other women in her life. In order to discover her identity, Anelise has to reexperience her relationship to these shadowy figures. The narrative tactic developed by Lya Luft to ensure this reexperience is primarily derived from technical recourses common to the gothic novel. What is striking, however, is Luft's inversion of the processes generally associated with this traditional form.

A traditional gothic novel juxtaposes a supply of either monsters, madness or fantastic occurrences with incidents of real horror. The problem for the protagonist becomes one of separating the real from the imaginary. The amount of difficulty encountered by the protagonist in making the separation indicates the extent of the reader's active participation in the narrative. While *As parceiras* displays all the necessary ingredients to elicit the reader's active role in Anelise's solution, Luft resorts to a purposeful distancing between character and events. Ghostly images, eerie voices, sightings of ethereal figures and the events recounted as narrative facts are almost always reported by the protagonist in an off-hand manner. . . .

As parceiras as a contemporary female *Bildungsroman* directly confronts the anti-normative position of contemporary women. The protagonist's situation, with all its gothic elements, underscores the difficulties of the contemporary Brazilian women. The ambiguous ending, however, is an indication of the possibility of a new order. Anelise lives to recount her story.

<div style="text-align: right">Susan Canty Quinlan. <i>The Female Voice in
Contemporary Brazilian Narrative</i> (New
York: Peter Lang Publishing, 1991),
pp. 65–66, 97–99</div>

LYNCH, MARTA (ARGENTINA) 1929–85

The most existentially authentic image in Lynch's work is that of the rebellious woman, embodied by Blanca Ordoñez. Blanca rebels against the traditions roles that her society offers her and refuses to adopt pre-established images as models of behavior. Although she does not succeed in her search for personal fulfillment, she is more worthwhile than the other characters because she is aware of her inner dissatisfaction and tries to find a solution that would free her from her frustrating situation.

The novelty of the presentation of the female images lies in the fact that the traditional images (submissive wife, devote other, woman-sexual object, woman-uterus, etc.) are repudiated or considered as ingenuous concepts. The

alienated woman and the rebellious woman represent the first step in the search for a valid alternative for those who do not wish to conform to the traditional roles that the society has assigned them. . . .

The value of Lynch's work resides in the innovative treatment of themes that have been traditionally related to the female character: the couple, eroticism, motherhood, the family, and beauty. The author presents an authentic, demystified, penetratingly realistic view of the life experiences of her heroines, who reflect the existential dilemmas of their sex. Side by side with the thematic innovation is the elaboration of a style appropriate to the representation of the consciousness of the female character. This form enables her to succeed in capturing the essence of the contemporary woman and the conflicts that define her, transcending national boundaries to create characters that are universal.

> Gwendolyn Díaz. Introduction to Marta
> Lynch. *Paginas de Marta Lynch* (Buenos
> Aires: Celtia, 1983), pp. 39–40

Although Blanca Ordóñez in Lynch's novel is an artist and Alejandra in [Silvina Bullrich's] *Mañana digo basta* is both artist and critic, their work is limited to the feminine sphere because it falls within the irrational and creative realm of the imagination as opposed to the rational, logical, and scientific order of the male. Besides, that work does not provide economic independence.

The outward events revolve around romance and marriage, more accurately, romance *or* marriage since the pattern is one of disappointed expectations. Paralleling this plot sequence in the outer world is a more significant internal plot consisting of the complex reactions of each narrator to external events as they impinge upon her sense of self. There then arises in each of these women a new awareness of the incongruity between the inner and the outer worlds. The protagonist, now in a state of *dis*-ease, views her formerly comfortable social world as a place of inauthentic values, rejects as hypocritical her previously satisfying diversions and as meaningless her habitual patterns of social interaction. In the process, her inner world is reduced to a state of constant dissatisfaction, reaching the level of anguish at its most intense moments. Each protagonist's project, that is, marriage, fails either through lack of communication or through monotony. As the subjective experiences described by the characters are not distinctive in each case, their malaise must be considered situational not individual. . . .

The rupture between the individual and her role expectations gives rise to a sense of isolation, formulated in similar metaphors. Detached from a solid familial identity, Blanca Ordóñez finds herself "tan sola y alejada como si fuera un velero fantasma, sacudiéndose en su rada" (as alone and distant as though she were a phantom sailboat, flapping its sails in its bay), and Teresa admits that "a veces sueño con que me dejan sola en un desierto o en un mar, no sé, y despierto sin haberlo sabido; en la pesadilla todos se van

sin mí" (sometimes I dream that they leave me alone in a desert or in a sea, I don't know, and I awaken without having known it; in the nightmare they all leave without me). Although such symptoms of alienation—powerlessness, meaninglessness, normlessness, isolation—are not necessarily sex-linked, self-estrangement *is* directly related in these novels to the protagonists' being-in-the-world as females. It is connected, therefore, with the usage of the term "alienation" in existentialist philosophy. . . .

The body is thus a sign, an indicator of a woman's being-in-the-world as an object valued for its erotic attraction and fertility. For all these women one pathological consequence of the objectification of the body is its metonymic reduction. In Lynch's novel, a woman is appreciated for "un buen útero para concebir" (a good uterus for conceiving); to the father "los hímenes de sus hijas eran sagrados" (his daughters' hymens were sacred); Blanca's sister is admired for "su visible facultad de procrear, tal como si tuviera la matriz entre las cejas" (her visible ability to procreate, as though her womb were between her eyebrows).

<div style="text-align: right">

Marcia L. Welles. In Beth Miller, ed.
*Women in Hispanic Literature: Icons and
Fallen Idols* (Berkeley: University of
California Press, 1983), pp. 281–82, 284, 286

</div>

La señora Ordóñez (1967) by Marta Lynch (Argentina) . . . is, among other things, an informal discourse analysis centered on the heroine's inability to "make her voice heard" or "have a say" in the governance of her own affairs. The events and situations of the novel reveal the mechanisms by which her speech is rendered inefficacious in presenting her point of view. The author does not limit herself to showing the unhappy effects of this faulty communication upon the women who cannot assert their beliefs and wishes. Rather, there is a strong implication that both sexes suffer under the existing conditions for verbal exchange. . . .

When a woman seeks to present herself as an autonomous thinker, she may be easily dissuaded from this view of herself. The woman can retreat from the difficulties of an independent role by reassuming a conventional female role in the interaction. Blanca does exactly this when she agrees that Raúl will accompany her into the art world as a protector and "knight." The pattern shown here—initial attempt to gain "her own voice" and subsequent retreat into womanly submissiveness—will characterize all of Blanca's exchanges with the men in her life.

As the reader proceeds through the novel, confidence in Blanca's ability to narrate objectively diminishes. Whereas the woman initially seems competent and articulate in her unuttered commentary, later passages cast doubt upon her ability to articulate her situation effectively. The first sign of her difficulty is her inability to apply her often excellent insights in order to change her discourse situation. Although she mocks the trivializing verbal

exchanges in which she participates, she cannot or will not break out of this pattern.

Blanca's disabilities become more evident when one finds a massive infusion of prefabricated language in her inner flow of thought. She seems helpless to rid her inner voice of the commonplaces of mass media and lower-middle-class formation; moreover, she has acquired a new set of commonplaces from her chic acquaintances. Blanca disconcerts the reader with her obsessive focus on her physical attractiveness and that of other women. Her credibility as narrator is damaged when she continually makes invidious comparisons between herself and other women.

In her relations with men, Blanca suffers an especially notable loss of control over her discourse—both her utterances to the man and her inner voice. Forced into a submissive role, Blanca is inwardly full of hysterical rage. She directs unuttered vituperations at Raúl, calling him a beast of prey determined "de no soltar la presa que te da tanto poder."

These signs of disorder strongly suggest that women's most difficult and fundamental problem is not that of learning to speak more effectively—although they will, indeed, need to master assertive speaking strategies. Blanca's, and women's, underlying difficulty is to overcome the trivializing and hyperemotive verbal patterns associated with a stereotypically female role. Women must articulate their life concerns clearly, whether in interactions with others or in self-addressed speech acts.

Naomi Lindstrom. *Ideologies and Literature.* 17, 1983, pp. 339, 346–47

"Marta Lynch writes without defenses. Without inferiority complexes. She speaks in Argentinean, thinks in Argentinean, suffers in Argentinean. . . .

So the noted contemporary, Argentinean writer Antonio Di Benedetto . . . tells us about the Argentinean writer Marta Lynch, who committed suicide on October 8th of this year. . . .

Marta Lynch was a worthy representative of Argentinean women's writing, equal to Silvina Bullrich, the Ocampo sisters (Victoria . . . and Silvina . . .), Luis Mercedes Levinson, the poet Olga Orozco, Syria Poletti, and Beatriz Guido, to cite some of the best known names among Argentinean women writers of a generation of writers born between 1900 and 1925, a generation whose contributions brought a rebirth to Argentinean narrative and lyric. . . .

Marta Lynch made her own the best narrative traditions of England (Virginia Woolf, Mansfield, Brontë) and the United States (Carson McCullers, Fitzgerald, Hemingway), to which she . . . remained attached as a sort of spiritual daughter. Contemporary Argentinean history and character were portrayed by his writer in her novels, short stories and newspaper articles. In her journalistic and political work she was concerned with Argentinean reality. . . .

The writer already cited, Antonio DiBenedetto, states: "Marta Lynch is more than a good novelist, she is a natural novelist. Her innate narrative gift distinguishes her. . . . She writes under the rubric of quality. She is overflowing with vital energy. . . . She writes without complexes, unconcernedly. . . . What she narrates is something palpable, made of flesh, everyday flesh. . . . Everything that Marta Lynch writes gives the sense of having been genuinely lived."

Mario Esquivel. *Tragaluz II*. 13, 1986,
pp. 17–19